DATE DUE

JUL 8 1998 R# 37860A67	AUG 23 1999

The Italian Metamorphosis, 1943–1968

Organized by Germano Celant

GUGGENHEIM MUSEUM

**PROGETTI
MUSEALI
EDITORE**

G U G G E N H E I M M U S E U M

The Italian Metamorphosis, 1943–1968

Solomon R. Guggenheim Museum
October 7, 1994–January 22, 1995

Triennale di Milano
February–May 1995

Kunstmuseum Wolfsburg
May–September 1995

© 1994 Progetti Museali Editore, Rome
© 1994 ENEL, Rome
© 1994 The Solomon R. Guggenheim Foundation, New York
All rights reserved

ISBN 0-8109-6871-1 (hardcover)
ISBN 0-89207-116-8 (softcover)
Printed in Italy by Arnaldo Mondadori Editore S.p.A.

Guggenheim Museum Publications
1071 Fifth Avenue
New York, N.Y. 10128

Hardcover edition distributed by
Harry N. Abrams, Inc.
100 Fifth Avenue
New York, N.Y. 10011

Honorary Patrons of the Exhibition

Contents

viii
Acknowledgments
Thomas Krens

xii
You Must Remember This . . .
Umberto Eco

xvi
Reasons for a Metamorphosis
Germano Celant

2
In Total Freedom:
Italian Art, 1943–1968
Germano Celant

20
Painting and Beyond:
Recovery and Regeneration, 1943–1952
Marcia E. Vetrocq

32
Before the End of the Journey:
Testimony across the Atlantic
Anna Costantini

41
Art, catalogue numbers 1–230

220
The Revival of Glass and Ceramics
Micaela Martegani Luini

230
Art in Jewels
Pandora Tabatabai Asbaghi

237
Artists' Crafts, catalogue numbers, 231–329

288
The Literature of Art
Maurizio Fagiolo dell'Arco

314
Reality and Italian Photography
Italo Zannier

324
"*Paparazzi* on the Prowl"
Jennifer Blessing

335
Photography, catalogue numbers 366–471

438
Cinema, the Leading Art
Gian Piero Brunetta

450
Visconti's *Senso*: Cinema and Opera
Teresa de Lauretis

458
Cinema, catalogue numbers 472–501

482
From Haute Couture to Prêt-à-porter
Luigi Settembrini

496
Italian Fashion and America
Valerie Steele

507
Fashion, catalogue numbers 502–602

556
Reconstructing a History
Vittorio Gregotti

567
Architecture, catalogue numbers 603–723

586
Rebuilding the House of Man
Dennis Doordan

596
Italian Design and the Complexity of Modernity
Andrea Branzi

608
Italian Industial Aesthetics and the
Influence of American Industrial Design
Penny Sparke

616
Design, catalogue numbers 724–78

648
The Political History of Italy from the
Fall of Fascism to the Student Revolts
Giorgio Galli

656
Chronology
Lisa Panzera

708
Manifestos

726
Lenders to the Exhibition

This exhibition is sponsored by Moda Made in Italy, a program of the Italian Institute for Foreign Trade (Italian Trade Commission), under the auspices of the Italian Ministry for Foreign Trade, and by the Centro di Firenze per la Moda Italiana.

Significant support has been provided by TELECOM ITALIA, with additional assistance from the Murray and Isabella Rayburn Foundation, Inc. and the National Endowment for the Arts, a Federal agency.

The museum thanks the Italian Ministry of Foreign Affairs for its cooperation and support.

The exhibition catalogue—in a traditional printed version as well as in a CD-ROM format—has been published by ENEL and the Solomon R. Guggenheim Museum.

Sponsor Statement

With *The Italian Metamorphosis, 1943–1968*, the Guggenheim Museum has undertaken an ambitious project: to represent through a wide range of artistic expressions the many transformations that took place in Italy in this period. The challenge was a tempting one, an opportunity not to be missed: to present on the same stage the various facets that help define Italy today—its image as a nation of art whose present is deeply rooted in its past.

Among the various sections included in *The Italian Metamorphosis*, fashion provides a vivid demonstration of just how much Italy has changed. The exhibition recounts the birth of contemporary Italian fashion, first through the vision of a Florentine, and later through the achievements of the top couture houses, which were inspired by the artistic patrimony of Italy to make an important fashion statement. This great period of production and communication gave rise to the phenomenon "Made in Italy," in which fashion and design have been the standard bearers.

We deeply share the Guggenheim's enthusiasm in illustrating this evolution and the underlying technical know-how that has helped to shape it through the past and present. The spirit explored by *The Italian Metamorphosis* is similar to that pursued by the Italian Institute for Foreign Trade and the Italian federations of fashion producers, through the special "Moda Made in Italy" project, which falls under the auspices of the Italian Ministry of Foreign Trade. For this reason, Moda Made in Italy, which seeks to promote Italian fashion, has become the principal sponsor of *The Italian Metamorphosis*.

Since the period covered by this exhibition, fashion—the very embodiment of change—has become an even more important sector in Italy, both as an expression of its culture and as a crucial component of its economy. This has resulted from a uniquely Italian approach, in which sensitivity, craft, taste, and tradition are fused with modern manufacturing technologies to reflect a wider, cultural metamorphosis. Its success is a great testimony to the intuitions of those who, in the early 1950s, believed in Italian fashion and its preeminent role as a cultural and artistic statement.

The extraordinary cooperation the Guggenheim has offered us is due, in part, to the important contribution of the Centro di Firenze per la Moda Italiana, which served as the bridge between the Solomon R. Guggenheim Museum and the project "Moda Made in Italy."

To view the transformations that Italy has undergone, how its forms of artistic expression have changed, and how these changes relate to the wider changes seen throughout our country's history, is an important exercise in reflection for us and for anyone wishing to understand Italy. It helps us to look positively at today's challenges while remembering the road traveled, and forces us to revive the deep and ancient bases of our statements to the world, many of which are still very current, and to recognize them as a rich source of new ideas.

Dr. Ugo Calzoni
Chairman and C.E.O.
Italian Institute for Foreign Trade (Italian Trade Commission)

Sponsor Statement

From its inception, *The Italian Metamorphosis, 1943–1968* has been supported and promoted with enthusiasm by the Centro di Firenze per la Moda Italiana.

Significant for us, apart from the intrinsic value of the event itself, is the unprecedented inclusion of fashion in an exhibition mounted by the Guggenheim Museum, and its presentation alongside other artistic forms to document the Italian contribution to contemporary aesthetics and a crucial moment in the history of Italian society.

Our own work has been moving in this direction for some time. The Centro has become one of the most important laboratories in Italy for the creation of strategies, projects, and cultural and communication events concerning fashion from Italy and abroad.

The commitment of the Centro and its operative companies—Pitti Immagine and EMI—to contemporary fashion and its relationship to culture springs from the knowledge that it represents a new frontier for those creating, producing, and thinking about this area today. In recent years, this commitment has resulted in important exhibitions, theatrical events, fashion shows, congresses, research papers, publications, and training programs. These have allowed us to form valuable working relationships with cultural institutions of international importance, such as the Louvre, the Galleria del Costume, Florence (which we thank for its constant help and support), the Victoria and Albert Museum, the Royal College of Art, the Münchner Stadtmuseum, and now the Guggenheim Museum.

This commitment will take us into the future with new and important projects in the conviction that fashion is one of the great industries of contemporary culture.

Vittorio Rimbotti
Chairman of the Centro di Firenze per la Moda Italiana

Copublisher's Statement

ENEL, the Italian electric power company, has long understood that only with light—the primary element of its business—can art realize its full potential as an evocative and effective communication medium.

The language of art is universal. Art is uniquely able to communicate with a wide audience at the same time it reaches the sensibility and cultural dimensions of an individual. However, this ability is only a potential one.

Every work of art, every monument, requires the proper lighting in order to communicate its meaning successfully. Illumination enhances art's every value.

To aid this fundamental process, ENEL has established the Luce per l'Arte™ (Light for Art) program. This program provides for the design and installation of major illumination systems for masterpieces of Italian art and some of the country's most important monuments; it also encompasses myriad communication tools, such as scholarly volumes on art, CD-ROMs, and multimedia systems.

The goal of ENEL's Luce per l'Arte™ program is to enhance the value of Italy's artistic heritage, so rich in masterpieces and monuments. Understanding art is made easier through these tools of communication, which increase public awareness of art while never betraying the cause of scholarship.

The Italian Metamorphosis, 1943–1968 provides the American public with an opportunity to discover the rich and complex visual culture produced in Italy during this period of great artistic, social, and political transformation.

These were the years of the reconstruction of Italy and development of the "Italian System," in which the electrical industry played a vital role.

ENEL is pleased to participate in this exhibition by lending its skills and resources in the area of communications technology. ENEL has produced—for the first time in the Guggenheim's history—an exhibition catalogue in a CD-ROM format. This innovative technology allows viewers to explore all aspects of this complex exhibition in a new and appealing way; the CD-ROM provides an easy-to-use computerized link between the most important milestones of Italian art of this period, the artists who created them, and the context in which they were made. ENEL is also the copublisher with the Guggenheim of the exhibition catalogue in its more traditional, printed form.

These projects are but two examples of the rich fruits that have been born through ENEL's involvement with Italian art.

Dr. Franco Viezzoli
Chairman of ENEL

Acknowledgments

Thomas Krens

The initiative that has come to fruition in *The Italian Metamorphosis, 1943–1968* has been fostered and sustained by the Solomon R. Guggenheim Foundation's longstanding commitment to European art and its special relationship with Italy.

From its inception in 1937 the Solomon R. Guggenheim Foundation has focused on collecting and exhibiting the work of European artists. Through the direction of his adviser Hilla Rebay von Ehrenwiesen, Solomon R. Guggenheim committed himself to supporting many continental avant-garde artists and presenting their work to the American public—often for the first time. When his niece Peggy Guggenheim bequeathed her important art collection and the Venetian palazzo that housed it to the Guggenheim Foundation in 1976, the foundation became the first, and to this day only, American art institution operating in both Europe and the United States.

Shortly after World War II ended, Peggy Guggenheim had moved permanently from New York to Venice. She brought her famous collection of Surrealist and abstract art with her, showing it at the Venice *Biennale* in 1948 and in various European cities before installing it in her home, the Palazzo Venier dei Leoni, which she opened to the public on a limited basis. For Italians her collection was a revelation; it contained works that were little known since avant-garde art had been suppressed by the Fascist regime. In addition, Guggenheim began to support the work of Italian artists in an effort to help them attain a wider public.

The Solomon R. Guggenheim Museum renewed and expanded Peggy Guggenheim's enterprise with the appointment of Germano Celant to the position of Curator of Contemporary Art in 1988. Celant has long advocated an internationalist stance in contemporary art. As early as 1969, in the Italian and English editions of his book *Arte Povera*, Celant intermingled the work of American and European artists, fomenting an international network of vanguard artistic creativity that he continues to document in such exhibitions as *Mario Merz* in 1989 and the forthcoming *Claes Oldenburg: An Anthology*. Conceived and organized by Celant, *The Italian Metamorphosis* is born of his desire to introduce the American public to the vast panorama of Italian visual culture in the postwar period, which is only now beginning to be examined in a systematic way.

In order to illuminate the complex dynamic and diversity of the arts in Italy in the twenty-five year period from 1943 through 1968, Celant has organized the exhibition into fields of artistic endeavor, calling upon leading experts to curate sections dedicated to their areas of expertise. Celant has curated the Art section, as well as overseen the entire project. Noted architect and designer Andrea Branzi has organized the Design section; Gian Piero Brunetta, the leading film scholar, has curated the Cinema section, as well as provided the presentation of film clips in the exhibition; prominent art historian Maurizio Fagiolo dell'Arco has organized the Literature of Art section, to which he has also lent a considerable number of books and documents from his personal collection; internationally renowned architect and architectural historian Vittorio Gregotti has curated the Architecture section; prominent fashion specialist Luigi Settembrini has curated the Fashion section, documenting the rise of Italian fashion beginning in the early 1950s; consulting curator Pandora Tabatabai Asbaghi has organized the Artists' Crafts section, including ceramics, glass, and jewelry designed by artists; and Italo Zannier, the eminent historian of photography, has curated the Photography section, to which he has also lent works from his personal collection. We are grateful for the tremendous contribution made by each of these curators toward the realization of this exhibition. The vast experience and scholarly commitment of these experts has determined its final contents. And their generous contribution of personal resources, both intellectual and material, has immeasurably enriched it.

Continuing the museum's practice of collaborating with renowned architects and designers, we are most fortunate to have had the opportunity to work with internationally recognized architect Gae Aulenti, who has designed the installation of the exhibition. Aulenti has orchestrated the show's multiplicity of artistic languages into a beautiful chorus that resonates in the Frank Lloyd Wright building and the Gwathmey Siegel addition.

Any exhibition of the scope and scale of *The Italian Metamorphosis* cannot be realized without the support and assistance of many individuals and organizations. For this show we have borrowed

important and cherished works from more than 200 generous individuals and institutions. While every lender is acknowledged in the list on pages 726–27, we reiterate our debt of gratitude to our professional colleagues, whose efforts on our behalf have enabled us to present the exhibition in its final form: at Civico Museo d'Arte Contemporanea, Milan, Maria Teresa Fiorio; at Civico Museo Revoltella, Trieste, Maria Masau Dan; at FAE Musée d'Art Contemporain, Pully-Lausanne, Asher Edelman; at Galleria Civica d'Arte Moderna e Contemporanea, Turin, Rosanna Maggio Serra; at Galleria Comunale d'Arte Moderna, Spoleto, Bruno Rossi; at Galleria del Costume, Florence, Cristina Piacenti; at Galleria Internazionale d'Arte Moderna-Cà Pesaro, Venice, Giandomenico Romanelli; at Galleria Nazionale d'Arte Moderna e Contemporanea, Rome, Augusta Monferini; at Herning Kunstmuseum, Torben Thuesen; at Musée des Arts Décoratifs de Montréal, Luc D'Iberville and Dianne Charbonneau; at Musée National d'Art Moderne, Centre Georges Pompidou, Paris, Germain Viatte; at Museo di Storia della Fotografia Fratelli Alinari, Florence, Claudio De Polo; at the Museum of Fine Arts, Houston, Peter C. Marzio; at the Museum of Modern Art, New York, Peter Galassi, Terence Riley, Kirk Varnedoe, Magdalena Dabrowski, and Cora Rosevear; at the Newark Museum, Mary Sue Sweeney Price; at Kunstsammlung Nordrhein-Westfalen, Düsseldorf, Armin Zweite; at Philadelphia Museum of Art, Anne d'Harnoncourt; and at Rijksmuseum Kröller-Müller, Otterlo, Evert J. van Straaten, J. B. J. Bremer, and Marianne Brouwer.

We express our deep appreciation to the various artists' families and archives that have been exceedingly cooperative in lending, or helping us locate, important works, and graciously responding to myriad queries for information and reproductions: Minsa Craig Burri and Fondazione Palazzo Albizzini, "Collezione Burri," Città di Castello; Valeria Manzoni Di Chiosca; Teresita Fontana and Fondazione Lucio Fontana, Milan; Fabio Carapezza Guttuso and Archivio Guttuso, Rome; Fondazione Marini San Pancrazio, Florence; Marta Melotti; Antonia Mulas, Melina Mulas, and Archivio Ugo Mulas; and Annabianca Vedova and Archivio Vedova, Venice.

We are also greatly indebted to a number of lenders who have been especially generous by sharing a large number of their works, and by personally contributing to the project by offering their time and knowledge in the planning stages: Alberto Bolaffi, Archivio Storico Bolaffi, Milan; Angelo Calmarini; Rosangela Cochrane; Agnese De Donato; Giorgio Franchetti; Gian Tomaso Liverani; Ferruccio Malandrini; Carla Panicali; Henk Peeters; Pier Luigi Pero and Valentina Pero; Marco Rivetti, Fondo Rivetti per l'Arte, Turin; Fabio Sargentini; Gilbert and Lila Silverman; Ileana Sonnabend; and Jacqueline Vodoz and Bruno Danese.

We also thank those who have graciously supported this exhibition by providing resources as well as lending numerous works from their collections. We are most grateful to Salvatore Ferragamo S.p.A., Florence, and the Ferragamo family for their valuable contribution to this exhibition. A special thanks goes to Stefania Ricci and Marie-Hélène Cadario of Ferragamo for their kind collaboration in realizing these loans. The generosity of Venini S.p.A., Murano, through the offices of Eleonora Gardini, is also greatly appreciated. The efforts of Roberto Gasparotto of Venini were essential. We are indebted to Tecno S.p.A. for the generous gift to the museum of Tlinket chairs designed by Gae Aulenti for the media room.

A special acknowledgment goes to those individuals who have provided crucial assistance in obtaining loans and other support: Dario Bellezza; Margaret Bodde, Cappa Productions, New York; Roberta Boschi Belgin, Murray and Isabella Rayburn Foundation, Inc., New York; Dilys Blum, Philadelphia Museum of Art; Nicla Capriolo; James Cuno, Fogg Art Museum, Harvard University Art Museums, Cambridge; Bettina Della Casa, Galleria Christian Stein, Turin–Milan; Daniela De Marco; Flavia Destefanis, Vignelli Associates, New York, and C&C multimedia, New York; Valeria Ernesti, Fondazione Lucio Fontana, Milan; Aurora Fiorentini; Armando Giuffrida; Graziella Folchini Grassetto; Barbara Jakobsen; Roberta Landini; John R. Lane, San Francisco Museum of Modern Art; Anna Lumine, Archivio Vedova, Venice; Patricia Mears, the Brooklyn Museum; Laura Miré; Maurizio Momo; Anna Pazzagli, Pitti Immagine, Florence; Deborah Sampson Shinn, Cooper-Hewitt Museum, Smithsonian Institution, National Museum of Design, New York; Dino Trappetti; and Sally Wiggins, Knoedler & Company, New York.

Twenty-five years of Italian history and culture is examined in *The Italian Metamorphosis* and documented in this catalogue. We are grateful, once again, to the consulting curators, all of whom have contributed texts to the book, thereby mapping their fields and providing welcome routes through frequently unfamiliar terrain. Thanks also go to the additional essayists who lent their scholarly skills to this project, namely: Jennifer Blessing, Anna Costantini, Teresa de Lauretis, Dennis Doordan, Giorgio Galli, Micaela Martegani Luini, Lisa Panzera, Penny Sparke, Valerie Steele, and Marcia Vetrocq. A special note of gratitude goes to Umberto Eco, who took valuable time from his hectic schedule in order to share his recollections of the period.

This catalogue would not be what it is without the talented intervention of Massimo Vignelli, who designed it. Although Vignelli has been involved in many other graphic-design projects for the museum, this undertaking has received extraordinary attention and support from him, which is greatly appreciated.

Other scholars who have generously provided information and advice at crucial moments include Rosemarie Haag Bletter, Melissa Harris, Christopher Phillips, and Abigail Solomon-Godeau.

We are grateful for the assistance of the following individuals who were especially helpful in locating valuable photographs for the catalogue and exhibition documentation: Mary Corliss, the Museum of Modern Art, New York; Virginia Dortch; Mary Engel; Milton Gendel; Maria Vittoria Lodovichi, Corporate Identity Olivetti, Milan; Francesco Masi; Pasquale Ribuffo, Galleria de' Foscherari, Bologna; Pier Marco de Santi; and Antonella Soldaini and Judith Blackall, Centro per l'Arte Contemporanea Luigi Pecci, Prato.

The Italian Metamorphosis is one of the largest and most complex exhibitions ever mounted at this museum. Like *The Great Utopia: The Russian and Soviet Avant-Garde, 1915–1932*, it includes many objects outside the traditional purview of the institution, and it fills virtually the entire Frank Lloyd Wright building and the Gwathmey Siegel addition. The breadth and proportion of this project have presented special challenges for our staff members, who have responded, as always, with tremendous professionalism and good cheer, overcoming every obstacle with unflagging determination.

Very special thanks go to Maryann Jordan, Director of External Affairs, and her staff, who have worked tirelessly to develop and maintain the material support for this project. She has exercised supreme grace and diplomatic skill in her efforts. We thank Catherine Vare, Director of Communications, for the considerable burdens she has assumed in relation to this exhibition, all of which have been met with great tact and proficiency. Linda Gering, Director of Special Events, has skillfully coordinated the complicated logistics of such an extraordinarily large project. Administrative Assistant Alessandra Varisco has gracefully smoothed communications between our various Italian colleagues and internal departments.

Judith Cox, General Counsel, has deftly managed many sensitive negotiations, the successful outcome of which was essential to the project. Lisa Dennison, Curator of Collections and Exhibitions, and Gail Harrity, Deputy Director for Finance and Administration, have lent their support at important junctions. We are sincerely grateful to Amy Husten, Manager of Budget and Planning, who has ably resolved myriad financial matters with intelligence and goodwill. Accounts Payable Analyst Maureen Ahearn has been extremely helpful on many occasions.

We are profoundly grateful for the wide-ranging expertise and resourcefulness of Pamela L. Myers, Administrator for Exhibitions and Programming, who has directed a team comprised of dedicated staff and consultants and overseen the many crucial aspects of the exhibition's installation. She has orchestrated a truly successful collaborative effort with vision and ingenuity. The work of Vittoria Massa, Architect in the office of Gae Aulenti, has been extremely important for the development and realization of this project, and is, accordingly, greatly appreciated. Many thanks are due to Giovanna Buzzi, who designed the Fashion section of the exhibition in Rome, and then installed it so successfully in New York. Peter Read, Jr., Manager of Fabrication Services, along with his staff and Engineering Consultant Ramon Gilsanz, has once again applied his many talents and considerable knowledge of construction to solving complex problems posed by the Frank Lloyd Wright building. Cara Galowitz,

Manager of Graphic Design Services, and Michelle Martino, Project Graphic Designer, skillfully handled all printed and environmental graphics. Martino's skills were also integral to the realization of the catalogue. David Heald, Manager of Photographic Services, met the project's extensive photographic needs. Lighting Technicians Adrienne Shulman and Wendy Cooney used all of the tools at their disposal to light the many objects to their best advantage. Walter Christie, Electrician; Michael Lavin, Senior Electronic Technician; and David Goodman, Network Systems Manager, helped solve many specific technical issues. We also thank Kelly Parr, Project Assistant, and Jocelyn Groom, Museum Technician.

Scott Wixon, Manager of Installation and Collection Services; Anibal Gonzalez-Rivera, Manager of Collection Services; Joseph Adams, Senior Museum Technician; and David Veater, Senior Museum Technician, coordinated the installation. This group, along with Museum Technicians Lisette Baron-Adams, Peter Costa, James Cullinane, Bryn Jayes, William Smith, Dennis Vermeulen, and Guy Walker—the museum's talented art-handling and installation team—deserve the utmost praise for their expert, thorough, and efficient execution of the exhibition installation.

We are extremely fortunate to have had Marion Kahan as Project Registrar for *The Italian Metamorphosis*. It is impossible to imagine that this show's daunting number of loans could have been coordinated without her extraordinary professionalism and grace under pressure. We also thank Kathleen Hill, who has joined us at a crucial moment to assume some of the vast registrarial duties. Lynne Addison, Associate Registrar, has provided welcome support. Associate Conservator Carol Stringari has given assiduous attention and care to the exhibition's artworks and objects.

The catalogue, edited and produced by the Guggenheim's Publications Department, could not have been published without the great skill and commitment demonstrated by Anthony Calnek, Director of Publications; Elizabeth Levy, Production Editor; Edward Weisberger, Assistant Managing Editor; Laura Morris, Associate Editor; and Jennifer Knox, Assistant Editor. Additionally, Morris edited the complex array of didactic materials accompanying the exhibition, and Knox handled many difficult editorial tasks associated with the English version of the CD-ROM.

The chief burden of this project has fallen upon the curatorial team that has worked with Germano Celant to organize this exhibition and prepare its accompanying catalogue. We express our sincere gratitude to Jennifer Blessing, Assistant Curator, who has played a key role in the conceptualization and realization of the catalogue, as well as in coordinating all aspects of the exhibition in her role as project manager. She has led a team of Project Curatorial Assistants, each of whom has made invaluable (and innumerable) contributions to the success of *The Italian Metamorphosis*. Focusing on the hundreds of objects in the Art section, Vivien Greene has acted with diligence and sagacity to resolve myriad art-historical and technical questions. We are grateful for Lisa Panzera's tireless efforts to fulfill her complex curatorial responsibilities pertaining to the show's Architecture, Design, and Photography sections. Carole Perry has swiftly and professionally mastered a wide-range of material unique to this exhibition for the Artists' Crafts, Cinema, and Fashion sections. All of the members of this finely tuned curatorial squad deserve our deepest thanks for their intelligence, professional commitment, and sheer hard work.

A crucial role has been played by our Italian associates who have organized various aspects of the show from Italy. We owe a debt of gratitude to Marco Mulazzani, who has worked with the Architecture, Cinema, Design, and Photography curators to secure important loans and obtain valuable catalogue material. Anna Costantini has ably juggled a wide range of logistic issues and has conducted significant research; her work is sincerely appreciated.

We also gratefully acknowledge our colleagues at the Peggy Guggenheim Collection, Venice, led by Deputy Director Philip Rylands, who have made many and diverse contributions to this project. Annarita Fuso, Public Affairs Assistant, has conscientiously managed press relations in Italy. Renata Rossani, Administrator, has frequently fielded and resolved numerous exhibition-related matters.

We would also like to thank all of the people who have so amiably helped us to organize programming related to the exhibition: at Cinecittà International, Rome, Franco Lucchesi; at Film Foundation,

New York, Raffaele Donato; at the Film Society at Lincoln Center, New York, Richard Peña and Wendy Keyes; at the Italian Cultural Institute, New York, Furio Colombo and Amelia Antonucci; at New Italian Cinema Events, New York, Viviana del Bianco and Sissy Semprini; at Pace Wildenstein Gallery, New York, Marc Glimcher and Mark Pollard; at the Public Theater, New York, Fabiano Canosa; and especially Martin Scorsese.

The Italian Metamorphosis showcases the creative production of an entire country during an important reconstruction phase after a painful period in its history. The exhibition's national significance for Italy has left us the happy recipient of a tremendous amount of support from Italian public and private institutions. Italy's recent engulfment in another difficult period of regeneration has created unique organizational challenges for us, yet has led to the potent collaboration of diverse groups, which united to sustain this initiative.

This exhibition would not be possible without the significant sponsorship of Moda Made in Italy, a program of the Italian Institute for Foreign Trade (Italian Trade Commission), under the auspices of the Italian Ministry for Foreign Trade. The enduring enthusiasm and creative interest on the part of all those associated with the Italian Trade Commission have enriched this project enormously.

We are especially indebted to the Centro di Firenze per la Moda Italiana, whose long-standing devotion to the exhibition has bolstered its progress and aided its final realization.

We also extend our gratitude to TELECOM ITALIA for their generous participation, which came at a pivotal moment in the project's development.

Significant support and assistance were provided by the Murray and Isabella Rayburn Foundation, Inc. We express our sincere thanks to Isabella Rayburn for her initial commitment, when the project was only a nascent idea.

We are also grateful to the National Endowment for the Arts, a Federal agency, for its patronage of the exhibition in its planning stages.

We thank the Italian Ministry of Foreign Affairs for their continuing cooperation and support, and extend particular appreciation to Italy's Ambassador to the United States, Boris Biancheri, whose wise counsel, superb intellect, and humanistic perspective provided much-needed practical advice as well as spiritual sustenance.

The exhibition catalogue—in its traditional printed version as well as CD-ROM format—has been published by ENEL and the Solomon R. Guggenheim Museum. We applaud ENEL's farsighted efforts in applying their innovative technology and communication skills to art, which will enhance our audience's experience of the exhibition.

We also extend special thanks to Alfredo de Marzio, Chairman and C.E.O. of C&C multimedia, who has helped us initiate and foster many crucial contacts as well as navigate the sometimes turbulent, but always exhilarating, cross-cultural seas between our two nations.

Finally, we salute the extraordinary individuals who serve as honorary patrons of the exhibition and who have provided critical guidance and ongoing support to the museum generally as well as to this project specifically: His Excellency Oscar Luigi Scalfaro, President of the Republic of Italy; His Excellency Silvio Berlusconi, President of the Council of Ministers of the Republic of Italy; His Excellency Antonio Martino, Minister of Foreign Affairs of the Republic of Italy; His Excellency Domenico Fisichella, Minister of Cultural Affairs of the Republic of Italy; His Excellency Giorgio Bernini, Minister of Foreign Trade of the Republic of Italy; His Excellency Boris Biancheri, the Ambassador of the Republic of Italy to the United States; The Honorable Reginald Bartholomew, the Ambassador of the United States to the Republic of Italy; His Excellency Francesco Paolo Fulci, Representative of the Republic of Italy to the United Nations; The Honorable Franco Mistretta, Consul General of the Republic of Italy; The Honorable Rudolph W. Giuliani, Mayor of the City of New York; Dr. Ugo Calzoni, Chairman and C.E.O. of the Italian Institute for Foreign Trade (Italian Trade Commission); Dr. Franco Viezzoli, Chairman of ENEL; Ing. Vittorio Rimbotti, Chairman of the Centro di Firenze per la Moda Italiana; Dr. Umberto Silvestri, Chairman of TELECOM ITALIA.

Umberto Eco once wrote:

An Italian character does exist. The first is a transhistorical characteristic which relates to genialità *{ingenuity} and* inventività *{inventiveness} . . . and consists in our ability to marry humanist tradition and technological development. What has undoubtedly acted as a brake on our culture, the predominance of the humanistic over the technological, has also permitted certain fusions, eruptions of fantasy within technology and the technologization of fantasy. Secondly, Italy is a country that has known enormous crises, foreign domination, massacres. And yet (or for this reason) has produced Raphael and Michelangelo. . . . What often fascinates foreigners is that in Italy economic crises, uneven development, terrorism accompany great inventiveness.*

In conclusion, we express our gratitude to—or rather our thankfulness for—the many creative people whose work is exhibited in *The Italian Metamorphosis*. Without the great *genialità* and *inventività* of all the architects, artists, designers, directors, and photographers—modern-day Raphaels and Michelangelos—we truly would have no show at all.

You Must Remember This . . .

Umberto Eco

Reading over the plans for the exhibition *The Italian Metamorphosis, 1943–1968*, I feel as if I am scanning a familiar landscape that in some way belongs to me. In the pages that follow this preface, others will speak of the works and the history of the various trends and movements. I, however, will use this exhibition as a pretext for talking about my own personal history, from when I was eleven years old to when I was thirty-six. But this is not an act of narcissism; on the contrary, my personal memories enable me to bear witness to an entire generation.

In July 1943 I was eleven and a half years old. At that age one never plays a leading role in anything, but one can be a good spectator. Events, images, words, and readings leave impressions deep enough in the mind to remain vivid even fifty years later. I only knew about Fascism what Fascism had taught me. I had absorbed examples of Fascist art from schoolbooks or from the frescoes in pseudo-Roman style that adorned the structures of local Fascist party branches and other public places. This architecture was monumental, as if every such building was supposed to be a coliseum: enormous, out of scale, with very broad arches under which children (like me) of the Fascist Youth would march singing, dressed in black shirts with blue scarves fastened in front by round clasps with the face of Benito Mussolini on them, and equipped with phony leather Balilla "musketeer" gloves and muskets.

This, we were taught, was Italian architecture. And yet in my home town of Alessandria (in the northwest part of the peninsula), two astonishing constructions appeared: one was Ignazio Gardella's antituberculosis dispensary, the other the postal building, upon which ran, along the entire lower section of its façade, a horizontal band of odd mosaics that had very little to do with Fascist iconography. As I later found out, they were by Gino Severini. That was my first contact with Modern art. It troubled me; I sensed that it was different from the official art of Fascism, but I wasn't yet ready to understand it.

This episode is interesting because it tells us that Fascism allowed, alongside its own official architecture and painting, an avant-garde art to live and prosper, an art that included some of the first experiments of architectural Rationalism. It wasn't a sign of democratic openness, however, but an example of ideological confusion: the ideology of Italian Fascism was not monolithic, homogeneous, and paranoid like that of Nazism or Stalinism. Adolf Hitler and Joseph Stalin had a metaphysics and a logic. Mussolini had only a rhetoric. As for his men, they did not even have that; except for one minister, Giuseppe Bottai, they were all uncultured and therefore were unable to think that culture might be dangerous, unless it spoke explicitly against the regime. Thus they left the alternative culture in peace, not because they had anything in common with it, but because it seemed too much trouble to repress it, and because most of the time they didn't even realize it existed.

What did I know of the rest of the contemporary world? I knew America through comic strips and films (which were allowed into Italy until 1942), and England through the news and commentaries of Radio London, the clandestine program that the English broadcast over the entire Italian territory during the war, and that we used to

listen to in the evening, at low volume, with windows closed, savoring the thrill of committing a crime and of listening to forbidden words.

But let's go back to July 26, 1943. On that day we heard on the radio that the king had "fired" Mussolini and that the new head of the government was Marshal Pietro Badoglio. At first nobody, least of all me, understood that this meant the regime had collapsed: the event seemed only like the fall of one man. But the very next day, when I was sent out to buy the newspaper, the newsstand had more newspapers than before. They looked the same as before, had the same kinds of typefaces, the same formats, but the headlines were different. And they each carried a bulletin celebrating the end of the dictatorship, signed variously by the Christian Democratic, Communist, Socialist, Liberal, and Action parties.

That day I had my first news of the existence of democracy. I realized that a country could have many different parties, but that wasn't all: since these parties could not have been born overnight, it meant that they had been there before as well, that they had been living in secret (or abroad), and that they represented another Italy.

Another two years would pass before I could see that other Italy, two terrible years that would last until April 25, 1945, when I found out that Fascism had truly fallen, this time for good. Two days later I saw the first American soldiers. They were reading comic strips I had never seen before, with characters entirely unknown to me, like Lil' Abner and Dick Tracy. I was discovering modernity through Pop art nearly twenty years before the fact.

Later, it was a slow conquest. We were not, however, deprived of foreign literature. Remember that, during the Fascist era, Elio Vittorini, with his anthology *Americana*, had brought the best of United States literature to the Italian public, and that a quasi-clandestine publisher like Rosa & Ballo was rediscovering the masterpieces of German Expressionism that the Nazis had condemned as "degenerate art." But it was, of course, after 1945 that we began to translate nearly everything and to discover previously unknown authors. And then to show us a different world, there was cinema: on the one hand, American films (I must confess that my own personal myth of the United States was formed by watching James Cagney in *Yankee Doodle Dandy*, and that my idea of freedom was reinforced by seeing *Casablanca*); and on the other, masterpieces of Italian neorealism, from Roberto Rossellini to Luchino Visconti.

As for the fine arts, I lived in a provincial town, where there weren't any art exhibits. Every week I used to buy one of the two copies available of a review called *La fiera letteraria* (Literary bazaar). Reading its articles, I learned of the existence of such poets as T. S. Eliot and Paul Eluard; looking at its poor, faded black-and-white photos and drawings, I discovered that a contemporary art existed and that it had existed before and during the war. I tried to understand that new language; I was like someone who until then had seen only Raphael and suddenly found himself looking at *Les Demoiselles d'Avignon*, or like an American who had seen only magazine covers by Norman Rockwell and suddenly was faced with a *New Yorker* cover by Saul Steinberg.

My first epiphany, my first magical discovery, occurred during an exhibition at the Galleria Comunale, which featured a painting by Giorgio Morandi. I am sorry this great painter is not represented in the present show; to many he seems not contemporary enough. I do not agree. In any case, after seeing so much painting in which what mattered was the subject (heroic, celebratory, grandiose), I discovered, for the first time, a painting that painted itself, "painting for painting's sake."

Then I became an adult. Many of the central figures of this Italian metamorphosis were by then well-known to me; little by little, as I grew up, some of them became my friends. I missed out, however, on a fundamental experience: the Milan "scene" in via Brera from 1945 to 1954. When I arrived in Milan, the artists' quarter of via Brera (next to the *accademia* and *galleria* of the same name) still existed. For that matter, it still exists today. But in the second half of the 1940s, it was a magical place, where I feel as though I myself have lived, so much a part of me are the legends I have heard about it. Brera was a Montmartre, a Montparnasse, a Greenwich Village, where things happened at an accelerated pace, because the lost years had to be made up and the new freedom, the chance to attempt every adventure and every experience, enjoyed.

I arrived in Brera after its heroic period, but many of its main figures were still there. Joe Colombo, Enrico Baj, and Sergio d'Angelo had decorated the Santa Tecla, a cellar after the fashion of the existentialist *caves* in Paris. Mysterious, beautiful women dressed in black hung around there, and the most important jazz ensembles of the time played there. In Brera I also met the masters of the previous generation, including Lucio Fontana, as well as the younger artists. Indeed, one day Piero Manzoni signed my wrist in indelible ink, as he did with certain friends to make them into works of art. The ink eventually faded, of course, even though for two weeks I didn't wash my right arm. But this is a problem for some future restorer; I remain a certified work of art by Manzoni, and I am happy he immortalized me that way instead of putting me inside one of his famous little boxes.

From 1954 to 1958 I also worked on the cultural programs of Televisione di Milano. It was a pioneering television station, very primitive but much more "cultured" than present-day TV. I remember working with a now deceased critic, Franco Russoli, on afternoon programs on art and architecture, sometimes on the great avant-garde movements like Dada or Surrealism, other times involving living artists. In the corridors of Televisione di Milano, where I met Igor Stravinsky, Bertolt Brecht, and those who would become the great composers of our age (Luciano Berio, Bruno Maderna, Karlheinz Stockhausen, Pierre Boulez, Luigi Nono), passed the painters and architects of the day. We were young, enthusiastic, and we had created a kind of informal republic in which people working in different fields converged, finding a common ground.

The 1960s were unforgettable. There was the economic boom; Italy had emerged from the sufferings of the war's aftermath. Our contacts with the rest of the world were growing rapidly. We belonged to the generation that had learned how to fly. The world was ours, thanks to Alitalia, and we thought that culture could change it. Gruppo 63 was born, bringing together poets, fiction writers, and essayists at first, and painters, sculptors, musicians, and

architects soon after. Perhaps the most typical symbol of that mood was the 1964 *Triennale* in Milan. The *Triennale* is an exhibition held every three years (sometimes less frequently) featuring architecture and industrial and urban design. The 1964 show was devoted to the question of leisure time, an important subject for a civilization in which television was now dominant and the automobile boom had produced the tourist boom, but in which, simultaneously, people were reading the authors of the Frankfurt School—Theodor Adorno, Max Horkheimer, Walter Benjamin—or else rereading Antonio Gramsci's analysis of popular culture. One wondered whether that nascent *société du spectacle* would inspire a freer way of life, rich in original experiences, or create a new kind of conformism. For the 1964 *Triennale* the decision was made to debate these questions not in written essays but rather in a spectacle that today would be called multimedia, laid out in such a way as to allow multiple choices, anticipating, in a real format, what now would be called a hypertext, a virtual labyrinth.

I was the playwright for this discourse space. But I didn't actually write a conceptual outline or script for the artists to execute. Rather, we spent nights discussing things together; ideas were provoked by visual offerings; the visual offerings were determined according to the spaces; the spaces were delineated on the basis of sound suggestions given by the musicians . . . I don't remember everyone who took part in this adventure, but the general plan was by Vittorio Gregotti, together with Ludovico Meneghetti and Giotto Stoppino; Gae Aulenti conceived a joyously dazzling space; the two Vignellis invented a kind of introductory corridor full of images and afloat with sounds conceived by Berio and the voice of Cathy Berberian. Philosophical or historical questions were confronted in unlikely spaces (pyramids, underground passages, halls of mirrors, trompe-l'oeil stairways) created by painters and sculptors (too many to record their names here, though many are in the present show). The 1964 *Triennale* was a spectacular example of a form of cultural criticism to which all the arts contributed: poets thought like painters, sculptors saw with the eyes of novelists, sociologists spoke the language of images, artists thought with their hands.

A thousand meetings, discussions, and battles come back to me now as I see the names of so many friends in this exhibition: Enrico Castellani, Piero Dorazio, Mario Schifano, Michelangelo Pistoletto, Mimmo Rotella, and so many others. And not just the meetings of Gruppo 63, but the birth of reviews like *Marcatre* (Markthree)—founded by a great friend of mine now deceased, Eugenio Battisti—which brought together a group of young artists and critics from Genoa, among whom, I believe, I first met Germano Celant. Then there were the special issues of the review *Il Verri* on Informale and Action Painting, and on the birth of Arte Povera; the debates of the "neo-avant-garde" against Renato Guttuso, who was accused of making figurative art, although he was well aware of—if polemical to—new trends; the days and nights spent laying out the pages of books with Bruno Munari, that genius of the ephemeral, or devising children's books, conceived by Eugenio Carmi, against the atomic bomb and racism; the Italian Pavilion at Expo '67 at Montreal, which also had a didactic,

theoretical-historical-visual layout, which I worked on with Leonardo Ricci, Carlo Scarpa, and an ebullient (as always) Emilio Vedova. Not to mention the battles waged in support of the provocative new film language of Michelangelo Antonioni (I was a character in *La notte* [*The Night*, 1961] for a few brief seconds, in a rapid transition shot), or the use of the films of Francesco Rosi as occasions for political debate. And then, out of the passionate (and not always friendly) debates with Pier Paolo Pasolini was born the new semiology of cinema.

To repeat: the 1960s were extraordinary, for we thought that a revolution of the languages of art could transform the world. And this conviction brought down the boundaries between the genres, between word, image, object. Ugo Mulas created "metapainting" by photographing painters in action, helping us to understand them better.

Then came 1968, marking the beginning of a new, different period. No longer was it art that wanted to make itself into revolution; it was the revolution that wanted to make itself into art. Indeed I believe that if one is to pass a rapid (and inevitably partial) judgment on the significance of 1968, taking the good with the bad, it must be said that its original sin was its revolutionary aestheticism, its desire to transform politics into a total act that was supposed to include action and reflection, art and philosophy, everyday life and utopia. It was here that different fronts formed, with many artists seeking to live this experience to the full and others carrying on their pursuit in a more secluded manner. It should also be remembered that there were some who played with 1968, seeking to exploit it as a fashion to adapt themselves to.

At the time, I was teaching in the Department of Architecture at the University of Florence. I remember that the Archizoom group had already appeared even before the start of the events of 1968, while the UFO group emerged during the occupation of the university. In Milan, Munari was planning itinerant protest exhibitions—against nuclear politics, for example—which could be contained in a very few boxes, mounted in ten minutes, and quickly taken down when the police arrived. Architecture departments became the arena in which *everything* was debated, because the architect felt responsible for society as a whole. The elderly (I, at thirty-six, already belonged to the prior generation, with the septuagenarians) tried to understand the new world, the new ethics, the new customs, the new aesthetics of the young. There might have been—and there were—moments of (mutual) rejection, but there was never any lack of debate or confrontation.

Nineteen sixty-eight, in other countries, lasted one year or a little more (in the United States it began in 1967). In Italy it lasted ten years. Too long, for the moment of enthusiasm, of utopia, became tainted. The liquidation of 1968 came about in four different ways. First of all, the society absorbed some of the demands of 1968 by neutralizing them, reducing them to convention. Then, some people, in disappointment, became loyal servants of the system they had wanted to destroy ("if you can't beat 'em, join 'em"). What today we call *telecrazia* ("televisionocracy"), the *société du spectacle* that in Italy has become a force of government, is the handiwork of, among others, many of 1968's "repentants" (were they converts or

apostates?—it depends on your point of view). In addition, 1968 as a student force (and in some cases also as a workers' force) turned into the protest of marginalized groups. Lacking a strong ideology such as the Marxism that had dominated 1968, these groups revived in an innocent, "primitive" manner some of the models of the historic avant-gardes and the neo-avant-garde of the 1960s. However, in my opinion, there was no new creativity, just a new aestheticization of everyday life, this time under the banner of the Ugly (a kind of pre-Grunge). Finally, others drifted into terrorism. Terrorism was the expression of politics and a military strategy (both bankrupt), clearly a desperate form of ethics and by no means aesthetic.

It is therefore fitting, perhaps, that this exhibition should end with 1968. That year concludes a span of time in Italian art that runs from the anti-Fascist Resistance to the utopia of a cultural revolution. Afterward, as Rudyard Kipling would have said, it's another story.

One final memory. Perhaps Federico Fellini himself anticipated the end of the story of 1968 with his film *Prova d'orchestra* (*Orchestra Rehearsal*, 1979) and announced the beginning of the next story with *Ginger e Fred* (*Ginger and Fred*, 1985).

Translated, from the Italian, by Stephen Sartarelli.

Reasons for a Metamorphosis

Germano Celant

Dissolution or Dissolve?

After twenty years of euphoria the art system today is fraught with malaise and insecurity. Ever since it agreed that monetary considerations were as important as its own ideal standards and assumptions, there has been a lessening of art's importance and its critical role, a reduction of its otherness and its reasons for being. Art now stands in danger of becoming a metahistorical entity, isolated and separated from the world, with no consensus or social recognition aside from that of its adepts.

The risk is enormous: no matter how many people consider art an elitist value to uphold against society's lack of commitment, the loss of political significance seems to be balanced only by a mass consumption of art, which renders art merely decorative. This corrodes the roots of its ideality and its ethical and critical role, turning it into a fetish, an object of obscurely perceptible reality. It also muddies art's representative, utopian structure, and encourages its enemies to gloat over its ineptitude and superficiality.

Similar problems of mutation seem to render obsolete the differences between pure research and applied research that used to distinguish artistic value from use value. Today the positions are merging. Art, defined by its otherness and its refusal to be a communicational profession, has undergone a process of adaptation to consumer products. It has let itself be dragged into a market that has reduced it to a luxury commodity and thus become more and more identified with the useful and functional. These aspects, until the 1950s, were considered extraneous and secondary to its existence, because "autonomous art contained within itself at least one claim to heteronomy, that of presenting itself as a total alternative to the world of economics."[1]

The collapse of the ideal and the inauguration of functionality imply an impending equivalence between metaphysical and instrumental value. The positions mediate each other and counterpose a suppression of their limits and differences: art becomes an aestheticizing mode of showing and making, with no meaning other than that inferred by the consumer. Similar conditions seem to be leading artistic activity toward a horizon delineated by scepticism and nihilism, by the dissolution of roles and effects, with a resulting loss of identity that makes the products and images merge. The leap toward dissolution is accompanied by an alienation favorable to a purely "functional" role, like that of design, architecture, fashion, graphic art, and advertising.

For those who maintain that art is a pure idea based in radical subjectivity, however, this transition to a state of linguistic precariousness can be defined as a *dissolution* and therefore a total breakdown. For others interested in maintaining the need for a connection and an affinity between art and communication, on the other hand, it can be defined as a *dissolve*, a slow transferral that accepts coexistence with opposites, and transcends the conflict by integrating them. The dissolve is not the triumph of one language over another, since the traditional oppositions have been suppressed. Instead it is the advent of a new aesthetic code involving an interpenetration of the various forms of knowledge and artistic pursuit. Art does not place itself above everything; it declares itself party to a cultural

and social totality based on mixing and juxtaposition, dialogue and transformation. Such metamorphosis obviously throws open another space, one that hinges on the concept of a widespread aestheticism and on the synthesis and osmosis of languages.

If this is true, what becomes of the museum? What norms define its offerings and its interpretations of the artistic past and present? If art's identity is suspended between other identities, is it necessary to find a meaning for it within the sphere of a generalized aesthetics so as not to obscure its links, implications, and consequences with and for other languages? I believe the museum must abandon its monotheism and the theology of art if it is to represent its links with other archipelagoes of communication and production. The plan is to arrive at a critical point of view that accepts different forms of exposition, analysis, and historicizing of the visual language as a dynamic energy and a transgressive movement among the arts.[2] The spilling over, or at very least the mutual involvement, of all the visual practices is essential to an understanding of a historical period, especially if it becomes symbolic of a change or transformation of the culture or society as a whole.

The treatment of a cultural epoch should not admit any disciplinary limits. It is the history of images and ideas, projects and customs, objects and documents, and for this reason it is obliged to include every aesthetic language: architecture, art, comics, cinema, design, fashion, literature, photography, theater, artists' crafts. Such an ambitious approach is rarely attempted, however, because the preference is to maintain a theology of art that defends art as an absolute, unique religion.[3] In the monotheistic, idealizing intentions of its historians, this religion is not supposed to betray any dialectical relationship with the other languages of communication.

Nevertheless this defense of the sanctity of art can be relaxed when the subject ceases to be the most recent contemporary period and instead concerns the past, because in this case there is no danger that the analysis of the relations between art and culture will lead to the dissolution of their mutual boundaries. If it is possible, however, to do this for historical events, why not adopt it for our own present, so as to verify the flow and shift, as well as the proximity and distance, between all the arts in one period? And more important, to highlight the antihistorical schism between art and the arts, as well as the slow dissolution of art's hold on the real, in favor of a theoretical and interpretative dialogue with parallel linguistic forms? These questions arose again when I began to curate *The Italian Metamorphosis, 1943–1968*. The answer immediately pointed toward a project of intermingling the various languages, or at least of having them run parallel. This choice was not only linked to a museological approach already present in *The Great Utopia: The Russian and Soviet Avant-Garde, 1915–1932*, held at the Solomon R. Guggenheim Museum, from September 25, 1992 through January 3, 1993, and to my own critical position; it was also dictated by an identification of the philosophical and artistic characteristics of Italian culture, as well as by a consideration of the historical precedents of the period covered.

On the one hand there is the eclecticism typical of Italian thought in the multiplicity of grafts, juxtapositions, minglings, combinations, stratifications, and tangles of cultures, both ancient and modern, that have coursed through Italy over the centuries. On the other hand there is the determining stroke of Futurism, with its break with all unity and its search for confusion and simultaneity, dynamism and transition, through every artistic language. In Italy this marks the end of the metaphysical value of art in favor of a Babel of the arts.

Against Prettiness

The determining feature of any dialectic among the arts is the movement that makes possible a passage, through subsequent fusion or mimetic contagion, from one polarity to another. In Futurism the languages are subject to an energetic process that cannot be contained in a single model of representation. Heterogeneity and overlapping, with their work of correlation, multiplication, and irradiation, are the general assumptions on which the originality of Giacomo Balla, Umberto Boccioni, Carlo Carra, and Gino Severini is based. Their discovery of an aesthetic concept of linguistic and spatial simultaneity, wherein figures and images move without regard to the opacity and geography of the surrounding materials and conditions, leads to a vertigo of forms that become fused and confused with one another in a kind of unique present—as in Boccioni's series of multimaterial sculptures, which includes *Testa+casa+luce* (*Head+House+Light*, 1911–12) and *Antigrazioso* (*Antipretty*, 1912–13). Here the interweaving of real details and mental components highlights the intermingling of the flows of reality. Futurism moves inexorably toward an indistinctness of forms and volumes, whereas painting and sculpture become nomadic, moving around the intersection of languages, occupying times and spaces of real and virtual mobility, in order to create "dissolves" that upset limits and throw them into crisis for the purpose of exalting the trajectories.

I had thought, as a homage to Futurism, of entitling this exhibition of Italian art *Antigrazioso*, because we are indebted to that historic avant-garde for the quantum leap that undermined the monolithic or reduced dimensions of painting and sculpture in order to include the ambient contrasts of furnishings and architecture, cinematography and typography, theater and dance, music and design. The position taken by the Futurists with respect to the world was the very contemporary one of an all-inclusive process forming a synthetic unity among the arts.

The idea of adopting a title like *Antigrazioso* for an exhibition of the arts in Italy after World War II stemmed from a desire to underscore the polylinguistic role of a creativity that prefers an entire universe in which cars, chairs, sculptures, films, clothing, paintings, photographs, and videos proliferate, and not to rely on a single system of objects. Within that universe one may make distinctions, but what really matters is the total effect. What matters in Italian creativity is the ideology of the new as related to the synthesis of the arts—an ideology that has abandoned the dimension of elegance and prettiness in favor of a creative contagion that abolishes traditional linguistic boundaries toward a global transformation, which Balla and Fortunato Depero called the "Futurist reconstruction of the universe."[4]

The unavoidable reference to Futurism also finds confirmation in the fact that the central figures in Italian postwar art continually alluded to their roots in that movement. The foundations of Italian design, for example, rest on the experiments of Marcello Nizzoli, who in 1914 exhibited with La Famiglia Artistica, a group with ties to the Futurists. In the same vein, postwar cinema, photography, graphic arts, and furniture design would be inconceivable without the prior work of Anton Giulio Bragaglia, Depero, Carlo Mollino, Bruno Munari, and Enrico Prampolini, all of whom were first- or second-generation Futurists. Furthermore all postwar Rationalist architecture, through Giuseppe Pagano and Edoardo Persico, harkens back to Antonio Sant'Elia. In addition, the generation of young artists who began to emerge after 1945 would continually refer back to the language of the Futurist painters. Alberto Burri situated himself in the tradition of Prampolini in his combinations of materials; Piero Dorazio looked to Balla's iridescent, abstract interpenetrations in working on the energy of luminous chromaticism; Lucio Fontana drew inspiration from Filippo Tommaso Marinetti's notion of the incorporeal in regard to radio and cinema, and broadened his language to the point where, between 1949 and 1952, it moved from *Concetti spaziali* (*Spatial Concepts*) through fluorescent light environments to the *Manifesto del movimento spaziale per la televisione* (Manifesto of the spatial movement for television); and Emilio Vedova exploded the enigma of Boccioni's materials only to control it through a gestural theatricality.

There is one final reason for the indirect connection between Futurism and postwar visual culture. During these two periods—the first spanning the Futurist and Metaphysical adventures from 1909 to 1918, the second marked by the clash between realism and abstractionism, and between anarchism and social figurativism, from 1943 to 1968—the international systems of historical and critical interpretation abandoned themselves to a factual shift.[5]

By identifying Futurism with Fascism and neorealism with Communism or Marxist culture, people have demonized all the linguistic experiences of the two movements. Their vision clouded by ideology, they have negated the seeds of a cultural renewal that taught art a process of contamination with the world. Concerning themselves only with sustaining a pure and ideal art beyond action and political militancy, public institutions from the museums to the media, from art historians to cultural ambassadors—in other words, from *Life* magazine to the Museum of Modern Art, New York, from Clement Greenberg to Clare Boothe Luce—have demonstrated a total opposition to any art that identified itself with the absolute actuality of the political. And since the danger might come from either the Right or the Left, the task was to remove from history any artistic manifestation that might be identified with these extremes. And since in Italy art as well as architecture, film as well as design, lived through this damnation of politics (without, however, accepting it, except in the more obtuse moments), the principal formal and linguistic contributions in these media must be grasped outside these now dated oppositions. The dogged hostility long felt toward the past periods of twentieth-century Italian art is now in decline,

yet it has weighed heavily upon the information and recognition of their fundamental role in the history of Modernism.

The new acceptance has led to *The Italian Metamorphosis, 1943-1968*, which attempts to present the broad range of Italian aesthetics in light of the fall of the Fascist regime and the end of the tragic war. The collapse of that regime, the military defeat, and the Resistance swept away nationalistic-rhetorical models of culture in favor of an open, liberal national identity. Intellectuals embarked on a search for the modern that had developed in democratic countries, and a true rebirth of the arts was triggered. The surprising ubiquity of an aestheticization spanning all the linguistic terrains from art to cinema, literature to architecture, produced a cultural metamorphosis whose beginning can be dated to 1943, with the arrival of the Allies in Italy, the toppling of the Fascist regime, the subsequent fall of Benito Mussolini, and the birth of the first strikes and political resistance activities. This date is preferable to the traditionally accepted 1945, when the country was definitively liberated, precisely because it indicates a dramatic but gradual transition from 1941 to 1945, which already saw the affirmation of a different and dissident culture: Renato Guttuso's *Crocifissione* (*Crucifixion*, 1941, cat. no. 15), Carlo Levi's *Cristo si è fermato a Eboli* (Christ stopped at Eboli, 1945), Luchino Visconti's *Ossessione* (Obsession, 1942, cat. no. 472), Elio Vittorini's *Americana* (1942, cat. no. 330). These works managed to announce a culture that would privilege the facts of democratic reality over the simulacra of dictatorial, nationalistic myth.

Starting in 1943, a leftist cultural line, spurred by the hope for imminent liberation from Nazism, began to take shape. It aimed at developing a coherent religion of freedom, a cross between Catholic idealism and Marxist dogmatism. The dialectic between these two poles supported and upheld the dialogue between abstraction and the real, the whole upon which the arts came to renew themselves. The artistic productions that sprang from the clash of these extremes gave way to a new renaissance, the high points of which include the BBPR group's monument to the fallen in German concentration camps (1946, cat. no. 605), Piero Bottoni's QT8 quarter, Corradino D'Ascanio's *Vespa* (*Wasp*) motorscooter (1946, cat. no. 735), Vittorio De Sica's *Ladri di Biciclette* (Bicycle thieves, 1948, cat. no. 477), the Forma group's manifesto (1947), Cesare Pavese's *Il Compagno* (The comrade), Gio Ponti's *Superleggera* (*Superlight*) two-tone chair (1957, cat. no. 740), Vasco Pratolini's *Cronache di poveri amanti* (Chronicles of poor lovers), Roberto Rossellini's *Roma città aperta* (Rome open city, 1945, cat. no. 473), Vittorini's *Uomini o no* (Men or not), as well as his review *Il politecnico* (Polytechnic), and Bruno Zevi's *Verso un'architettura organica* (Toward an organic architecture).

The decade from 1945 to 1955 was marked by reconstruction and benefited from the Marshall Plan, whose financial assistance sustained an economic and social recovery accompanied by strongly pro-American propaganda in favor of conservative forces and against the forces of the Left. The offensive created two fronts typical of a thriving period soon marked (as of 1947) by the Cold War, two fronts characterized by strong polarities:

Catholicism versus Marxism, socialist realism versus abstractionism, neorealist cinema versus escapist cinema, popular architecture versus international architecture, idealism versus materialism, communism versus capitalism. It was a period of manifestos and populist declarations constrained by political formulas yet instilled with a strong civil passion for a culture of the people, a period of myths and dreams that nevertheless was soon swept away by the emergence of a third way, thanks to the very rapid industrial growth that enveloped Italian society around 1957.[6]

In the span of one brief decade Italy was propelled by phenomenal growth, a genuine economic miracle, that modified its social and cultural characteristics. The scene changed; atavistic habits bound to the land and to ancient rites were swept away by a consumerism made up of objects and images that altered the very root of thought and action. A new literature was born between "the apocalyptic and the integrated,"[7] for and against consumerism, and upon its clamorous existence—a mixture of vulgarity and social ascent—were founded the projects for a mass culture.

Contributing greatly to Italy's success was the design sector, which represented a hope for rebuilding and renewal through the tools of industry, which was the true flywheel of the rebirth of a country in a stage of total transformation. Design had been a territory explored most deeply by architects coming out of the Rationalist school and the Bauhaus, and when it was used as a means of cultural and social change, it aimed at a democratic equalization of forms and languages. Productive and creative processes with a social end in view were put on the same level, and around 1957 an equalization of industrial design and art, of architecture and fashion, of cinema and photography, began to emerge.[8]

The decline of the dualisms led to a social integration that reduced all creativity to an aesthetic process within which phenomenal identities were developed that tended to seek their own forms, colors, volumes, techniques. The homogenization of phenomena brought with it the dissolution, or better yet the dissolving, of one language into another. Aesthetic attitudes were no longer distinguished by their ends, whether political or decorative, but rather by their direct or indirect way of representing the social. The struggle moved onto the *representation* or the *presentation* of the processes and materials.

In order to survive the indirect communication of design, film, architecture, and advertisement, art chooses to direct communication and embrace materials and gestures in their raw state. It aims to redeem the person from the industrial system by trusting in an irrational, uncontrolled mode of operation. Art is the last bastion of resistance against the globalization of contemporary society. The psychological and emotional reactions conveyed on the canvas or in the material are a critical declaration against the mechanization of existence.

Nevertheless the process of conditioning and integration among the arts, and among the classes, brings with it a loss of the essential features of their respective historical identities. This process is destined never to end. The whirlwind of models of consumption gives rise to new

subjects that aspire to transcend the distinction between art and life. Banal subjects, like comics or advertisements, manufactured products, garbage, iconic and optical effects, common and luxury commodities, from Pop art to Op art, become solemnized. The new heroes of show business are born and superficiality spreads wildly, contaminating any chance the arts might have for commitment and autonomy. The useless is turned into economics, the object is transferred and becomes a symbolic sign,[9] so as to create a demand and a purely imaginary urge for products.

The advent of these habits and modes of behavior, which arose with the increase of consumption, led to the rapid cultural unification of Italy. A new nation was born based on the categories of modernity and consumption, which defined its ideology as a civil society. Once growth stopped and the industrial euphoria died down, however, the new expectations and behaviors betrayed the backwardness of their consumer origins. In 1968 the demand for a revision of values burst forth, involving both politics and customs. A strong protest among young elites was born in opposition to a sociocultural system that, having chosen consumerism as a way of life, had forgotten the sense of pleasure and freedom that can also run counter to the idea of opulence and economic power that sustains mass society.

Choosing 1968 as the end of a phase in the history of the arts in Italy therefore means determining the closing date of a metamorphosis, only to begin another, from 1968 to today, which remains to be studied. This latter metamorphosis, marked by opposition to generational and economic authority, spearheads a critique and denunciation of the boundaries on which the control of pleasure and feeling is exercised. It gives rise to such attitudes as those of underground film, Arte Povera, radical architecture, and the living theater.

The temporal geography of *The Italian Metamorphosis, 1943–1968* falls within the transition between two thresholds, 1943 and 1968, each marked by a critical culture: the one arising from the anti-Fascist position against a rhetorical-nationalistic society that had led to the tragedy of a fratricidal war; the other informed by antiauthoritarianism and anticonsumerism against a mass society based on the hierarchy of money and opulence. These antitheses are at once the result and the matrix of an enjoyment of life that rejects the allure of death as well as power, a matrix that looks instead toward the affirmation of a cultural identity exalted in every manifestation of the aesthetic, from art to design, from architecture to photography, from opera to the theatre, from music to comics, from fashion to film, from graphic arts to literature. To the exclusion of no languages, toward a jam session of the arts.

1. Mario Perniola, *La società dei simulacri* (The society of simulacra. Bologna, 1980), p. 133.

2. My own personal insistence on this critical approach dates back to 1965, with my collaboration on the architectural review *Casabella* (House beautiful) and my monograph on the designer Marcello Nizzoli. It then addressed the confusion of techniques and languages of Arte Povera in 1967. In 1976 it found expression in the large historical exhibition on the relations between "Art & Environment, 1900–1976" at the Venice *Biennale*, and continued over the years in my collaboration with Ingrid Sischy in *Artforum* (an effort, aimed at a fusion of the arts, that concluded with the "blasphemous" magazine cover devoted to fashion designer Issey Miyake). It finally exploded in the 1980s with a series of exhibitions I curated on the commingling of the arts, from *Identité Italienne* (Italian identity) at Centre Georges Pompidou, Paris, 1981, to *European Iceberg* at Art Gallery of Ontario, Toronto, 1985; from *Futurismo & Futurismi* (Futurism and futurisms, curated with Pontus Hulten) at Palazzo Grassi, Venice, 1986, to *Memoria del Futuro* (Memories of the future, curated with Ida Gianelli) at Reina Sofia, Madrid, 1990, and *Creativitalia* (Creativitaly, curated with Gaetano Pesce) in Tokyo, 1990. Accompanying all this are books on the major figures in contemporary art, design, architecture, photography, and the graphic arts, including monographs on A. G. Fronzoni, Frank O. Gehry, Robert Mapplethorpe, Ugo Mulas, Nizzoli, Pesce, and Lella and Massimo Vignelli. Finally there has been my organization of interaction among the arts, from *Il Corso del Coltello* (The course of the knife), a collaboration in 1985 between Claes Oldenburg, Coosje van Bruggen, and Gehry in Venice to *Osmosis: Ettore Spalletti and Haim Steinbach*, at the Solomon R. Guggenheim Museum, New York, 1993.

3. The greatest push toward an anthropological dimension of art has come from Pontus Hulten with his series at the Centre Georges Pompidou in Paris: *Paris–New York* (1977), *Paris–Berlin* (1978), and *Paris–Moscow* (1979), on the basis of whose method the subsequent imposing European exhibitions were organized, from Harald Szeeman's *Der Hang zum Gesamtkunstwerk* (1983) through Jean-Hubert Martin's *Art & Pub* (1990) to Jean Clair's *L'âme au corps, arts et sciences 1773-1973* (The soul of the body) at Grand Palais, 1993. In contrast a perfect example of monotheistic theologism was *High & Low: Modern and Popular Culture* held at the Museum of Modern Art, New York, 1990–91.

4. Giacomo Balla and Fortunato Depero, *Ricostruzione futurista dell'universo* (Futurist reconstruction of the universe), Milan, March 11, 1915.

5. Serge Guilbaut, *How New York Stole the Idea of Modern Art* (Chicago, 1983), and Serge Guilbaut, ed., *Reconstructing Modernism: Art in New York, Paris, and Montreal, 1945-1964* (Cambridge, 1990).

6. Ernesto Galli della Loggia, "Ideologie, classi e costumi," in *L'Italia Contemporanea 1945-1975* (Contemporary Italy 1945-1975. Turin, 1976), pp. 379–434.

7. Umberto Eco, *Apocalittici ed integrati* (Apocalyptic and integrated. Milan, 1964).

8. Giulio Carlo Argan, *Salvezza e caduta nell'arte moderna* (Salvation and downfall in modern art. Milan, 1961).

9. Jean Baudrillard, *Le Système des objets* (The system of objects. Paris, 1968), and *Pour une critique de l'économie politique* (Toward a critique of political economics, Paris, 1972).

In 1943 Italy was sufferin
and the demands of movir
democracy. It was a mome
caused as much by the defe
scarcity of industrial prod
off the regime as by the em
it. There were strikes at Tr
25 of that year, and the go
thereafter. Benito Mussoli
and the royal administrat
the vacuum of power ended

from the rupture of war

g from Fascism to

nt of crisis and weakness

ats, the bombings, and the

uction that had finished

rging dissidence against

rin and Milan on April

vernment toppled soon

ni was driven out of office

ion fled to the South. Once

l with the Armistice of

n Total Freedom: Italian Art, 1943–1968

Germano Celant

September 8, Italy was a country divided in two: the South liberated by the British and Americans; and central Italy and the North controlled, through the Republic of Salò, by German forces besieged by the Resistance.

It was a year of upheavals. The monopoly on political and cultural power had ended, but a new dualism was beginning between Fascism and anti-Fascism, Right and Left, nationalism and internationalism, officialdom and dissidence. It was an intermediate phase whose roots were already evident in 1942, when the arts in Italy—from film and literature to architecture and painting—sought to distance themselves from nationalism and Fascism in order to seek new solutions consistent with the internationally recognized avant-gardes.[1] Exemplary of the cultural climate in that year were the intellectual and political centrality of Elio Vittorini and his literary anthology *Americana* (1942, cat. no. 330); the scandalization of the Catholic church by ideological expressionism and Renato Guttuso's painting *Crocifissione* (*Crucifixion*, 1941, cat. no. 15), presented at the *IV Premio Bergamo*; the anguished and explosive reality of everyday Italy as portrayed by Luchino Visconti's *Ossessione* (Obsession, 1942; released in English as *Ossessione*), the first neorealist film; and the foreshadowings of urban planning in the *Eur 42* district, the designs of which were still imbued with sublimated Fascist ideology. The country was not yet directly opposing Fascism, but it was asserting a different manner of thinking and looking that, without overtly confronting the rhetorical culture of the regime, began a process of distancing that would blossom in 1945, the year of the final liberation and reunification of Italy.

The 1943 art world, in the wake of Corrente—a group of antiformalist, anti-Modernist painters operating from 1938 to 1943—began to elaborate a theoretical definition of realism that rejected emphatic, evasive art as indifferent to the real world.[2] An argument then arose concerning the role of the artist in society: What was his commitment to the world and his redemption in it, and what sort of dialogue or opposition should he establish with the arena of politics and ideology? The search for an elsewhere that might transcend the extremes of contrary visions such as realism and abstraction unleashed a series of bipolar clashes and arguments—praise versus condemnation of the irrational, individualism versus social commitment—that would become the main current of cultural developments in Italy for the next five years. From 1945 to 1948 the PCI (Partito Comunista Italiano/Italian Communist Party) and Marxist theorists tried to limit the discourse of art, soliciting iconic treatments of political philosophy. Drawing inspiration from the example of Pablo Picasso's *Guernica*, they invited artists to reflect on reality, which for them possessed "a popular solemnity." The risk, however, was that a decline in cultural autonomy and self-regulation would occur, a process of coercive alignment from without. An imposition of propagandistic attitudes of the sort that had compromised the last works of Mario Sironi and the late Futurists was in danger of invalidating the realist aesthetic. The attempt by the party apparatus to co-opt and manipulate the art world found its greatest champion in Guttuso. The PCI made him the manager and defender in all matters of expression and language intended to affirm the extremist bond between art and society, which could only be achieved through realism, the enemy of

abstract formalism. This iconographic subservience to politics immediately reduced art to a "local" phenomenon tied to the PCI leaders, a danger pointed out by Roger Garaudy in a 1946 essay that appeared in Elio Vittorini's review *Il politecnico* (Polytechnic). In it Garaudy asks, "Is avant-garde experiment Marxist? Or is 'subject' Marxist? . . . A communist painter has the right to paint like Picasso. But he also has the right to paint differently from Picasso. . . . Marxism is not a prison: it is a tool for understanding the world. . . . The last word in this matter is this: that there is no last word. To work, then, and in total freedom."[3]

The Communist attempt to fill the vacuum created by the collapse of totalitarian certitudes with other certitudes of a Stalinist cast was opposed not only by artists but also by intellectuals just returned from exile.[4] Their international experience led them to reject any notion of "truth" that might be managed and transformed by an institutionalized or soon-to-be institutionalized power; instead they aspired to alternatives that might bring about a crisis in the continuity of power and its strategies of control. The artistic horizon from 1945 to 1948 thus grew richer from remarkable returns and surprising reappearances.

The art historian Lionello Venturi, who had chosen exile rather than support the Fascist regime, returned to Italy in 1945 and assumed the chair in his field at the Università di Roma. At the same time the Art Club was born in Rome under the patronage and management of the Futurist Enrico Prampolini, who in 1932, along with Adalberto Libera, Marcello Nizzoli, Sironi, and Giuseppe Terragni, had extolled the "Fascist Revolution."[5] Although Venturi and Prampolini had very different experiences and histories, both of them remembered the energy of the avant-gardes and fought for an internationalization of the Italian critical and artistic imagination. At their urging, the future generations slowly began to move again. Giulio Carlo Argan and Palma Bucarelli opened up to French art, instigating a reconsideration of the Cubist, nonfigurative generation not only in a Picassian light but also in accordance with the guidelines of an analytical language close to the abstract mentality. Young artists like Renato Birolli, Leoncillo {Leoncillo Leonardi}, Giulio Turcato, and Emilio Vedova, in their fight for a renewal of Italian art, gave birth to the Nuovo Secessione Artistica Italiana, aspiring to a language that would reflect history while maintaining its own absolute autonomy. In Rome the solitary Alberto Burri adopted Prampolini's practice of using various materials in a single work of art, avoiding any involvement in the fierce polemics and disputes of post-Fascism and favoring instead an art that found its own referent in colors and crude materials. In Milan this sort of attempt to discover the self-generating poetry of materials and things found champions in Lucio Fontana and Fausto Melotti, who were dedicated to an approach unbound to any theory other than that of the self-sustaining artist.

In 1947 Spazialismo was born in Milan under the influence of the *Manifesto Blanco* (White manifesto) drafted in 1946 by Fontana's students in Argentina. At the same time in Milan the Fronte Nuovo delle Arti was formed, also in Milan, inspired by a Cubism of abstract tendencies, which provoked criticism by Communist

ideologues because it fell outside the aesthetic purview of the PCI. Also in 1947 the review *Forma* (Form) published a manifesto signed by Carla Accardi, Pietro Consagra, Piero Dorazio, and Turcato, who polemically declared themselves "formalists and Marxists" and sought to inject their "intermediary" experiment into the art system so as to establish a modus vivendi between political engagement and the relative autonomy of the signs and processes of art. All of this activity triggered an avalanche of debates and impassioned diatribes about the concept of renewal and aesthetic engagement. Although almost all of the artists and theorists of the time professed leftist political views, they constructed conflicting arguments around the idea of artistic militancy, and clashes arose between different conceptions of "materiality." For some this became visual creation bound to "low," popular subjects of society (demonstrations, strikes, squattings); for others it was bound to the dark, unconscious wellsprings of existence or to the lavalike quality of things. Groups and alignments were also formed that, despite local misunderstandings and sectarianism, nevertheless revolved around the artistic leadership of the only political force interested in discussing the public role of the artist and in having a cultural identity: the Communist party.

The *XXIV Biennale* in 1948 became the arena for clashes between those seeking to represent the workers and the Stalinist word and those engaged in formal and abstract experiments reminiscent of Vasily Kandinsky and Paul Klee. Venice also hosted the conflict between the historical reevaluation of Alberto Magnelli and the first presentation in Italy of Picasso, who was introduced in the catalogue by Guttuso. Each side branded the other as reactionary, but in the end it was a sterile debate arising perhaps from an artistic illiteracy developed during twenty years of disinformation and ideological sectarianism against all the international avant-gardes. Such ignorance constrasted sharply at the *Biennale* with the presentation of the Peggy Guggenheim collection, which featured, aside from the masters of abstraction and Surrealism, such young proponents of Action Painting and Abstract Expressionism as Jackson Pollock and Willem de Kooning.

Imploded Forms and Materials

Nineteen forty-eight was a crucial year for Italy. With the elections of April 18 the DC (Democrazia Cristiana/Christian Democratic party) consolidated its power and succeeded in excluding the progressive forces, both Socialist and Communist, from the political and cultural management of the country. This victory proved to be Italy's ticket for entering a larger economic sphere, first the European, then the American, which was vaster and more advanced. The Western powers demanded a broad, united market in order to counterbalance the Soviet bloc,[6] and with an economic recovery sustained by aid from the Marshall Plan, Italy was prompted to open up and liberalize foreign trade between 1948 and 1952. This necessitated the reconversion of its entire industrial system through advanced technologies and obliged the country to accept foreign protection, which translated into the exportation of consumer goods throughout Europe. Running athwart the urgent need for production reconversions and trade openings, however, was the

backwardness of Italian industry, which was divided into leading sectors (quick to adapt and therefore open to exchanges) and retrograde sectors (unprepared and therefore closed).

Culturally in 1948 it was difficult to distinguish between Right and Left. Catholic conformists, following their popular vocation, constructed nothing more than a conservative attitude bent on defending the middle class. The Left started from a contrary position, but although it claimed to be rooted in the country's living reality and aspired to create a new cultural fabric, it got mired in the rhetoric of realism and displayed a shocking hostility toward, and an obtuse misunderstanding of, the historic avant-gardes in science, psychoanalysis, linguistics, and ethnology. It was a losing position accompanied by a refusal to come to terms with the cultural thematics of the century, and it had implosive results. Intellectuals, subjected to pressures from all sides to become instruments of the transmission of local power as well as aggregates of a colonizing culture of Anglo-American origin, underwent an involution. They isolated themselves, or at least they declined the invitation to choose between commanding and obedience imposed on them in the name of a collective utopia. Instead they attempted to explore the disorientations and new ways of perceiving the world that these social, political, industrial, and ideological upheavals had produced.

The rejection of any nostalgia for the past and any sanctification of the present, along with the renunciation of ideological controls, was welded to the assertion of a broad, European view and a market economy that spurred individuals into entering a multiplicity of identities. This in turn prompted intellectuals and artists to favor a discourse without utopia or soul, without plans or referents other than their own identity and individuality. The sudden emergence of the European solution was immediately embraced by the Forma group when they asserted that "we are progressives who want to speak a European language,"[7] and the loss of political and ideological hierarchies that emerged with the refusal to submit to the demands of the political parties highlighted the singularities of individuals. In 1949 Fontana, who had returned from Argentina in 1947, and Burri, who had returned from Texas in 1946, adopted explosive positions in the territory of Italian art based on a visual knowledge and composition connected with everyday existence, which is fragmentary and occasional, inorganic and subjective, and extraneous to the extremist bond between art and politics. They were starting anew from the source of the biological and material self. Of importance here was gesture and space, the object and sign produced or used by the artist, who no longer conforms to ideology but seeks other centers of radiation and transmission and finds them in the high intellectual thematics of scientific and technological discoveries or the low ones of rough and crude materials hard-pressed by the struggle of survival.

Fontana, in his Spazialismo, abandoned himself to the certitude of the idea and the definition of a space outside of realistic and naturalistic representation: the artist and the movement compelled the reason of the senses to sink into nothingness behind the canvas, where space is vast, even infinite. This *Concetto spaziale* (*Spatial Concept*) was

obtained by piercing the uncut surface of the paper or canvas, which then grew until in 1949 it became an *Ambiente spaziale* (*Spatial Environment*), a territory of fluorescent colors illuminated by electrical lighting, which anticipated later experiments in Environmental and Minimal art that explored the mysterious and magical relationship between light and architecture.[8] Art for Fontana did not involve the calculation and formulation of a cultural strategy; instead it worked with the incomprehensible and with the territories that lay beyond it. In this sense, his holes and cuts must not be taken in a negative light but a constructive one. They show an unexplored universe outside the usual academic and traditional paths.

In Rome in 1950 the Origine group was formed by Mario Ballocco, Burri, Giuseppe Capogrossi, and Ettore Colla. Ballocco elaborated: "origin . . . as starting point of the inner principle . . . to make non-figurative art . . . liberation from the multiple superstructures . . . identification as truth contained within ourselves."[9] This was yet another group that opted for de-ideologization and an opposition to realism in order to explore the mute aspects of art, its primary and material languages, which cannot be mediated by theories or declarations but are entrusted to tar, sacks, slag, and personal hieroglyphics assembled in free and open arrangements. Everything seems to be crumbling under the banner of a will to change the life of art. The artists proceed by solderings and stitchings, amputations and cuts, patches and burns, punctures and lacerations; they seek to assert that the force from below is not only ideological but energetic and physical. Their results are still those of a painting and sculpture with surfaces and montages of materials afflicted by wounds, gouges, sulfurous cuts, bloody emulsions, corroded and musty spatial visions panting between life and death, between permanence and precariousness.

The period from 1949 to 1953 was a time in which forms imploded, broke loose from systems of traditional reference, burnt themselves alchemically from within to attain new life. Beyond absoluteness, the autonomy of the aesthetic asserts its rights, and thus the individual may express himself and move toward full self-realization. In the absence of a petit-bourgeois or utopian model of behavior, an interest in the negative truth of the historic avant-gardes was reborn. The premises of Futurism were suddenly recuperated, from the dynamism of Umberto Boccioni to the mixed-media *polimaterismo* (polymaterialism) of Prampolini, from the luminous discompositions of Giacomo Balla to the global art projects of Balla and Fortunato Depero. These became points of discussion for the Spazialismo and Informale of Fontana and Burri, as well as linguistic guarantees for an abstraction and an integration of the arts in such artists as Dorazio and Melotti. People looked to the contemporary relevance of Cubist, Futurist, and Dadaist collage and thus recuperated scraps of cloth and sacks, industrial finds and metal fragments. A similar attention to the languages of the international avant-gardes informed the propagation of Italian art: in 1949 Christian Zervos published works by Burri and Capogrossi in his *Cahiers' d'Art*, and the Museum of Modern Art in New York mounted *Twentieth Century Italian Art*, curated by James Thrall Soby and Alfred H. Barr. In 1950 *Art Italien Contemporain* (Contemporary Italian art) was held in Amsterdam and Brussels, and in 1953, James Johnson Sweeney invited Burri to show in *Younger European Painters* at the Solomon R. Guggenheim Museum in New York.

Nevertheless, although the American and Western European powers were pressing for Italy's entry into the Western bloc, the memory of the brutal fight against the antidemocratic forces of Fascism, and later of Stalinism, still colored their decisions as to cultural policy. This attitude of suspicion and rejection was reflected in matters concerning the recognition of Italian art. Developments from between the two world wars (Futurism and Metaphysical art) were dismissed because they were either involved or contemporary with the birth and growth of Fascism and therefore ideologically contaminated. Developments subsequent to 1943, though averse to nationalism and its rhetoric, were too much in line with "leftist" thought, to which the West demonstrated an absolute aversion. This dogmatic, restrictive vision, which is also reflected in New York developments, resulted in a dismissal of Italian art. For the same reason even the various currents and groups, their members and leading figures, active between 1909 and 1949, were rejected despite the common democratic vocation of Western European and American culture.

Exceptions did exist. In the field of cinema the many innovations of neorealism brought Italy to the attention of the major Hollywood studios; MGM and Fox reopened their agencies in Italy, and RKO and Universal established branches. In painting and sculpture artists like de Kooning, Alberto Giacometti, Philip Guston, Matta {Roberto Sebastiàn Matta Echaurren}, Pollock, Robert Rauschenberg, Cy Twombly, and Wols came to Italy to discover Afro {Afro Basaldella} and Burri and the Venice Biennales, or they were exhibited at Italian galleries like the Naviglio in Milan and the Obelisco in Rome.[10] Aside from the interest of a small part of the art world, however, the Italian experience, albeit fascinating, was ignored. The memory of recent history was still alive.

Alongside the political reasons and monopolistic strategies regarding culture (the French, for example, were determined to preserve the leadership of Paris in the art world[11]), the rejection of Italian art may also have been caused by its sensual and "baroque" extremism, which has its roots in a "low" and material, but also sacred and Catholic, vision of the world. To a Puritan culture with reductive and minimizing tendencies, it is impossible to conceive of the impurity and agony of political as well as physical materiality. The contradictory and dialectical dichotomies between matter and spirit, social and individual, essential and redundant, ephemeral and permanent, history and present, fusion and confusion, which systematically mark Italian art, confounded the linear Anglo-Saxon mind. The mixtures and ambivalences of memory and future, engagement and disengagement, Fascism and anti-Fascism, democracy and Communism, tradition and innovation, so typical of creative activity in Italy, frightened the observers. Having arrived as liberators, the cultures of the Anglo-Saxon world intended to assert their own truth, which could not be identified with any story of Left or Right. Proof of this was in the

marginalization of politically engaged artists that took place around 1949 in New York in favor of the visual spectacularity of Pollock,[12] which had negative repercussions for almost all contemporary French art.[13]

In this light all Italian art became suspect, guilty of the sin of "political engagement," which is the real subject of the aesthetic conflict between realism and Informale between 1948 and 1959. The idea was that art must be purged of all spurious elements and ideological contaminations. It must be beatified, but only through the individualist idealism of Abstract Expressionism and its leading figures, from Pollock to de Kooning; or it must be annulled in images of a popular banality. From 1949 to 1963 the expression of Italian art is subjected to an informational death.

Around 1952 the whirlwind of Informale shook Italian art to its very foundations. It involved a realization of the genetic dimension of artistic formation, which works with the germs or embryos of the painting or sculpting process. One focused on the gesture and the act, on the magma latent in the materials and in primary signs. It was a new start, from the flesh to the stain, from the limitation of the surface and of space to the opening of free and irrational assemblage. A diffuse, continuous amorphism was unleashed, a reconnoitering of the elements of the artistic act.

The Furor and the Concept, Lava and Equilibrium

Amid the constant pressure to mediate a conception of art as the referent of an ideal but secular model of the human, Burri has always tried to define painting in a concrete and material manner as subject to the vicissitudes of time. His paintings since 1948 have been covered with abrasions, tears, rags, holes, patches, mildews, and scars that, when sewn together—the artist is also a medical doctor—form a corroded skin of the developments of history: witness *Gobbo* (*Hunchback*, 1950, cat. no. 5), or the intense and lavalike *Catrame* (*Tar*) series (see cat. nos. 1, 2). Burri's works are at once tactile and visual, and what matters in them is the occurrence and amplification of a sensual self-construction and self-corrosion. They display the pleasure of touching and leave aside all forms of careful elaboration, including that of literary justification, in order to highlight the various strata and levels of the existence of materials. These are bodies that grow, as in *Gobbo*, in which the painting's skin protrudes and loses its function as passive support in order to assert itself as organized, living matter in motion. The image of tension toward the external attests to the artist's desire to make painting ardent, or impatient with the limits of its surface. Burri wants to resort to the furor of Tintoretto and the passion of Bernini to confront the weight, the interweavings, the heat and burden of the image. His *Sacchi* (*Sacks*) make matter speak, revealing the secret power and energy that allow it to survive industrial anonymity. The sack is of the age, 1950, a degraded, devalued, worthless material, a nothing out of which the artist makes an everything. He discovers a vast meaning and task for it, making it capable of replacing color, to the point where his paintings sometimes present the same compositions as those of Piet Mondrian, with the place of blues and reds taken by pieces of sack. The sack is neither an extra-artistic material nor a painterly supermaterial; it

is what it is, and its being passes and perishes like any form of existence. The sacks interweave with gold, red, and white—as in *Bianco* (*White*, 1952, cat. no. 30) and *Sacco e bianco* (*Sack and White*, 1953, cat. no. 32)—and establish a broadening and extension of painting into the world, an opening that caught the eye of Rauschenberg when he visited Burri in Rome in 1952.[14]

Burri's iconoclasm, combined with the contemporary and equally radical iconoclasm of Fontana in Milan, provoked endless discussions and reactions.[15] His material exasperation of the language of painting corrodes the stereotyped formulas of abstraction and figurative art over which the supporters of various groups were getting so excited and eclipses the debate with the poeticization and exaltation—sacred, though secular[16]—of the scrap, the vestige. Starting in 1952 Burri widened his range of materials and techniques to include plastic, wood, and iron, using a torch and fire as pigments and painting implements. Such works as *Grande Ferro M4* (*Large Iron M4*, 1959, cat. no. 38), *Grande legno combustione* (*Large Wood Combustion*, 1958, cat. no. 39), and *Rosso Plastica* (*Red Plastic*, 1964, cat. no. 75) are infernal, volcanic pages wherein the material erupts from the pictorial crater and manages to occupy the uncut space of the wall. They rasp at the dynamics of painting, reflecting contortions, fevers, burns, and wounds, and they clear the way for the works of subsequent generations, from Piero Manzoni to Jannis Kounellis.

Fontana's path, although parallel to Burri's, began farther away. He emerged from the abstract experiences of the 1930s and formed himself in the wake of Boccioni's assertion that art must become "the lyric expression of the modern conception of life, based on the speed and contemporaneity of knowledge and communication."[17] For Fontana art is a vital act displayed as creative, anarchic power with respect to the scientific developments of one's time. It lives freely together with emerging theories of space and energy and glorifies behavioral dynamism. For this reason its activity is related to the need to open up new paths or universes of artistic consciousness, to create and enter the black holes of space. Thus Fontana's peregrinations, after the experiences of 1931–48—in which he liquefied figures until they came to form a shape or a figure in space (see *Scultura spaziale* [*Spatial Sculpture*, 1947, cat. no. 8], and *Crocifissione* [*Crucifixion*, 1948, cat. no. 10])—lead him to the *buco* (hole).

The extraordinary appearance of perforations in paper in 1949—the *Concetti spaziali* (*Spatial Concepts*, see cat. nos. 11–13)—carries to an extreme the petrification and crystallization of the idea of space, that unknown universe on this side of and beyond the painted surface. The act of puncturing or cutting the painting violates its absoluteness, makes it pass from consistency to immateriality. It sets in motion a mechanism of the impalpable imaginary, not that represented in the oneiric figurations of the Surrealists but the same concrete one experienced by anyone passing through darkness. In 1949, in fact, Fontana constructed his *Ambiente spaziale* (*Spatial Environment*) with black light, wherein the spectator can penetrate the very substance of his spatial concepts. The desire is to question the gesture-boundary,[18] the plane of conjuction and separation between light and dark, above

and below, known and unknown, whose dialectic dramatically emerges. At times the preciousness of the discovery is heightened by a material marvel, like the stones in some *Concetti spaziali* (*Spatial Concepts*, see cat. nos. 46, 47) or the shape of the color figure in *Concetto Spaziale. Forma* (*Spatial Concept. Form*, 1957, cat. no. 49). At other times it is intensified by the very outline of the painting itself, which transforms itself into a system of energetic chain reactions in *Concetto Spaziale. I Quanta*, (*Spatial Concept. The Quanta*, 1960, cat. no. 57), or into a symbol of reproduction in *Concetto Spaziale. La Genesi* (*Spatial Concept. Genesis*, 1963, cat. no. 94). Once materiality has been singled out, the function of the cut, compared to the hole, becomes clear. In *Concetto Spaziale. Attese* (*Spatial Concept. Expectations*, 1958, cat. no. 52) the material register becomes subtler, loses its voluptuousness, turns cold. The cut penetrates, bites into the smooth sruface, but the material and carnal influx has been interiorized and gives way to the idea. The alteration of the surface becomes transparent, veiled, so that the light passes through a black gauze. The light abandons the torment of the dramatic rupture and the material consistency typical of the hole, dematerializing in exaltation of the concept in all its spatial absoluteness.[19]

Vedova's adventure also has its roots in the 1930s and intersects in the postwar period with the battles and clashes over the renewal of Italian art. Vedova's, however, is a journey marked by anarchy and an intolerance of any sort of definition, a journey that takes shape in the labor of a discourse that wants to free itself of all limits. He began in 1937, and until 1948 his paintings, although figurative and neo-Cubist, were of interest because of the brushstrokes and the lively, absolute colors. They betrayed an anguish that would lead him to break with every group and collective, from Corrente and the Nuovo Secessione Artistica Italiana to Fronte Nuovo delle Arti and Gruppo degli Otto. His works, from *Autoritratto con lo specchio a terra* (*Self-portrait with Mirror on the Ground*, 1937) to *Geometrie* (*Geometries*, 1948), are an incubation and maturation of formal and expressive means, which in 1950, after the explosions of *La lotta–1* (*The Struggle–1*, 1949, cat. no. 25) and *Europa '50* (*Europe '50*, 1949–50, cat. no. 26), freed his imprisoned soul and led to the *Ciclo della protesta* (*Protest Cycle*, 1956, see cat. no. 64) and the *Scontro di situazioni* (*Conflicting situations*, 1957, cat. no. 67). Pure scratches furrow the surface like accidental, unexpected galaxies, vestiges of vanished constellations of emotion, given to capturing unconscious intensities and spewings of memory. On the space of the canvas, a true arena of torments and fears, of sweetness and rage, the Venetian artist presents himself without defenses, offering his existential anxieties to others in order to become their horizon.

If the artistic moment between 1952 and 1958 was defined by the polarity between Abstract Expressionism and Informale, Vedova cuts out his own specific territory from within, the territory of the "errant" sign, which proceeds by leaps and bounds, through hinges and cracks. Compared to the Abstract Expressionists, who display a tendency to control and define, Vedova lets the signs take the initiative and dominate the stage, lets them come from his eyes—which are closed when he paints—and wreak havoc in the

paths and plans for producing segments and fragments from which the troubled spaces are formed. Compared to the idealism of the Americans, for Vedova there is no future recompense, no linear perspective or advent of a new (American) society, no celebration. There is no sense of death in Franz Kline's blacks, but there is in Vedova's deeply felt colors, so much so that his explosions of material and color serve to reconstruct the image—a description used by German artist Georg Baselitz in regard to his Neo-Expressionist work. From 1959 to 1964 still another transformation takes place in Vedova: the blade of the picture becomes scissor and pincer. First the surface folds in a corner, in osmosis with the space; then it gives birth to the *Plurimi*, as in the *Absurdes Berliner Tagesbuch '64, Plurimo N. 5/7* (*Absurd Berlin Diary '64, Plurimo, No. 5/7*, 1964, cat. no. 68), consisting of clusters of finds and pictorial limbs meant to consolidate even further a revolt against the beatitude of forms and figures. Placed in their historical moment, 1964, they become linguistic blockades against the closed system of Arte Programmata and Minimalism. They stand against the reductive desire to dematerialize the object in order to annul it in architectural space.[20]

Compared to painting, sculpture was decidedly oriented toward Informale, but it still lived on the dialectic between the formless and the iconic, between the exaltation of a wealth of found materials recomposed in fanciful, mythic assemblage, as in Melotti and Colla, and a construction of individual and suggestive magmas in which the attack on figuration is cause for iconic memories with references to abstraction, as in Consagra, Leoncillo, Marino Marini, and Arnaldo Pomodoro. These two poles were based in Milan and Rome. The first was devoted to planned construction, similar to the synthesis of the arts as concerns design and architecture, and anticipated the pure visibility of Op art and Arte Programmata. The second was inclined to a freer, less linear assemblage, since it was burdened by the weight of history and therefore more interested in attacking conventions and destroying traditions. Positions were taken based on the fragmentation and reproposition of the object in a neo-Dada vein: on the one hand the stele-sculptures of Fontana and the magic-invisible sculptures of Melotti, on the other the concrete, ponderous vision of Colla's assemblages, which consist of mechanisms stripped of context and combined according to an image, and Leoncillo's tumescences and puckerings of terra-cotta crossed by sudden strokes of smooth surface.

Melotti's sculpture combines light and felicitous materials. It represents a ceremony in which the rhythmic ecstasy of things and elements passes between stasis and movement. The fragments of cloth and metal, the cardboard surfaces and touches of color, evince an energy that provokes an almost sensual well-being, a visual joy. They evoke inner and outer movement, as though art were presenting itself as a moment of excitation and play, an invitation to the pleasure that makes one forget time.[21] This agitation among the unknown essences of the sculptural code, as rigorous as they are happy and playful, oscillates between the material register and the mental impetus and allows Melotti to carry out, in time, continual linguistic shifts that lend a systematic charm to his artistic landscape. Always new and always renewed, the pleasure of

forms is incessantly slipping and rebuilding itself. It curves, swells, multiplies, and deepens the tactility of the materials, becomes alive and velvety, multicolored and turgid. These multiple exuberances date from 1925 and continually grow; they culminate, after a long period of silence and devotion to ceramics, in the bas-reliefs and little theatres of 1944–46—as in *Solo coi cerchi* (*Alone with the Circles*, 1944, cat. no. 21)—and in the metal works of 1958–1964: for example, *La casa dell'orologiaio* (*The Watchmaker's House*, 1960, cat. no. 168) and *Josephine Baker* (1962, cat. no. 167). Each sculpture lives by surprise and by the gentle aerial tension between the voids and the images. In it, space begins again and again, as if it were breathing. The inner breath or flow of air, whose linguistic matrix lies with Alexander Calder or Joan Miró, two of Melotti's historical references, help align the Milanese artist's works with their surroundings. The elements are almost transformed into musical instruments making inaudible sounds articulated between solidity and immateriality.

In Rome, after various group experiences, from Fronte Nuovo delle Arti to Origine, marked by political figurativism and Classical and Renaissance sculptures, Leoncillo and Colla entered a new sculptural phase in 1952–56 inspired by the lavalike qualities of crude materials and the identity of metals already worked. After some experience with figurative ceramics, as in *Madre romana uccisa dai tedeschi I* (*Roman Mother Killed by the Germans I*, 1944, cat. no. 16), Leoncillo turned his attention in 1952 to the contorted and swollen "flesh" of terra-cotta. He moved from the representative expressionism of portraits and still lifes of 1944–46 and the neo-Cubist constructions of 1948–56 to a formal experimentation with light passing through the materials, as in *Taglio bianco* (*White Cut*, 1959, cat. no. 59). Resorting to a single, uncolored substance on which the cuts evoke the leavening, the ebullition, the interior of his spirit, he gives us *San Sebastiano II* (*Saint Sebastian II*, 1962, cat. no. 106). The intention is to highlight the gesture trapped in a formless primordial energy, earthen mixture, and chaos.

Displaying a greater sense of structure is the sculpture of Colla. This artist, who worked with the scraps and residues of the industrial present, finds in factory vestiges a universe of mythological and primitive figurations.[22] Drawing equal inspiration from Dada poetics and Cubist assemblage, he looks for fragments and objects he can rearrange in narratives. Colla makes ironic, vigorous totems with names like *Orfeo* (*Orpheus*, 1956, cat. no. 41) or rigorous structures that turn ironic and playful, as in *Le chiavi di San Pietro* (*St. Peter's Keys*, 1962, cat. no. 82). They may even become reductive elements, almost monochrome paintings, as in *Rilievo con bulloni* (*Relief with Bolts*, 1957–59, cat. no. 44).

The spread of Informale and its appeal to circumscribing the ungraspability of space and materials, which for Fontana and Burri are problematically heavy entities, did not preclude lightness, as synthesized in the search for chromatic effects and luminosity. Color's whirlwind and tumult of light and liquid energy always attracted Afro, who after his early neo-Cubist experiences and his trip to New York devoted himself to brightening and liquefying his colors. His paintings after 1950, which combine features of Mark Rothko and Arshile Gorky, live on the instability

of their chromatic phenomena. They are light, sensible universes, like *Per una ricorrenza* (*For an Anniversary*, 1955, cat. no. 27), in which the dissolution of form presents a scenario of crumbling, sick, feverish images. Afro is not interested in fortifying materials but in unfleshing, debilitating, and nebulizing them to make them refined and sublime: *Volo di notte* (*Night Flight*, 1957, cat. no. 28) is one instance.

Afro and Turcato were the most shining examples of experimentation in the pleasure of color.[23] Turcato's free and open forms are forever seeking the closest possible relation to the source of light, abolishing all depth in order to become dazzling structures, as in *Deserto dei Tartari* (*Desert of the Tartars,* 1956, cat. no. 61). They are larval luminescences that live on the very epidermis of color and wander tense and suspended on the surface of the canvas, sometimes losing their features in favor of the glowing circularity of the painterly gesture and the superimposition of chromatic modules: *Ciò che si vede* (*That Which Can Be Seen*, 1956, cat. no. 63), for example. This interest in the phenomenon of light is rooted in Futurism, in Balla and his analyses of "iridescent interpenetrations," wherein natural luminosity is analyzed from the perspective of an artificial vision, that of the science of electrical energy. Dorazio was also concerned with radiance and its chromatic agitations, but he was less interested in the Futurist vortex or eddy than in its lines of force.[24] Thus he painted their continuum first as undefinable and portentuous—*Tantalo T* (1958–59, cat. no. 85)—then as structured and displayed—*Long Distance* (1963, cat. no. 88).

The magnetic force of the material, the energetic charge of the gesture, and the electricity of the color, reminds us that Informale, like Action Painting, contains a universe of hieroglyphics and personal signs through which the artist identifies himself. The graffito is testimony to his will to be in the world. The fulfillment of a desire to exist, a desire neither irrational nor material, characterizes the work of Capogrossi, who belonged to the Origine group together with Burri and Colla. In 1949–50, after a number of Cubist- and Futurist-inspired experiments with typographical characters, he began to identify a basic sign, a gearlike iconography with toothed wheels, that could be combined with other signs of the same matrix, as in *Superficie 67* (*Surface 67*, 1950, cat. no. 6). His hieroglyphs are indecipherable archetypes that form lines and interweave, move arbitrarily or rigorously about to create informal and optical effects. At times the combination produces a bubbling of currents and flows, creating constellations and abstract forces with infinite openings, as in *Superficie 210* (*Surface 210*, 1957, cat. no. 7).

Finally there is Accardi, who joined in the study of free signs but rejected the cold and rational analysis[25] employed by Capogrossi to achieve a unitary whole. Hers is rather a painting of unbridled signs, a painting in search of the extreme instance between rational and irrational, between positive and negative, as in *Grande Integrazione* (*Large Integration*, 1957, cat. no. 71). Her labyrinths display a sensual magnetism, cultivating a ferment that tends toward an agglomeration of materials and colors—limitless, structural, and environmental—as in *Losanghe rossoverde* (*Red-Green Lozenges*, 1964, cat. no. 72) and *Rotoli* (*Rolls*, 1965–68, cat. no. 70).

The period from 1949 to 1959 in Italian art found expression in an ideological free spiritedness that favored linguistic self-confidence. Power was located not so much in the path to the social and the public as in the push into the primary coordinates of painting and sculpting, of gestures and materials. It was not a will to ideological blindness that the artists were after but rather an analysis of the product and producer of signs and traces, the propulsive terms of a new aesthetics linked to the industrial boom, to the consolidation of the means of mass communication, and to the consumerism that would mark the decade to come.

The Synthesis

In the five-year period from 1958 to 1963, Italian industrial development accelerated and was joined by an ever growing increase in exports. The country was modernizing and the economic miracle unfolding, bringing well-being to every social class. The rapid expansion, together with the considerable productivity, made possible a greater distribution of wealth. It was not just an Italian phenomenon; the entire Western European economy was in a state of expansion. The distances between individual countries grew shorter, the social imbalances diminished. Cities grew beyond measure, with a tremendous amount of new building taking place. Builders and decorators, the businessmen associated with architecture and design, benefited from all this. There was a great increase in work opportunities related to housing, appliances, and furnishing.

In a ten-year span Italy had changed face and soul. Lifelong habits were overturned, and objects, consumerism, the mass mentality began to emerge triumphant. The handicraft and peasant mentalities went into crisis as industrial culture established itself. While actual distances grew shorter, the space between tradition and novelty shrank. The car was the symbol of movement, and a stimulus to the flourishing consumption. Every social class became familiar with mass-produced objects. At the same time the masses were subjected to exhortations that they look after their bodies through fashion and beauty treatments. A mass integration of tastes took place, becoming the subject of scientific studies.[26]

In the sphere of artistic languages, the erosion of differences was reflected in an integration and synthesis of the arts. Architecture, design, and industrial photography dragged the arts into their domains. The idea of interdisciplinarity based on the collaboration of visual techniques and research took hold. In 1958 many new groups were formed, from Gruppo T to Gruppo N, exhibiting new models and mass-produced visual products marked by a programmed approach to work and perception. At the same time, taking their cue from late Futurists like Bruno Munari and movements like Spazialismo and Arte Nucleare (which had attempted a broadening of architecture), young artists from Enrico Castellani and Gianni Colombo to Enzo Mari and Francesco Lo Savio founded La Nuova Tendenza, which centered around cine-visual experiments that would lead to Arte Programmata. The aspiration to an osmosis among languages did not, however, become a dialogue but rather helped to formulate a working strategy revolving not

around an ideological utopia but rather a utopia of technology and the mass distribution of the work of art. The growth of these trends was linked to the attempt to define and construct new, perception-based models of action.

The technological asceticism of industrial design led Lo Savio to abandon the subjective personalism of Informale in favor of a design approach involving vision and light. The tiniest entities became the objects of his attention; art is reduced to the level of inner communication, concerned mostly with the analysis of its own visual phenomena. The awareness of having to resolve the artifact through its own primary elements led him in 1959, at the outset of his career, to posit the coordinates of his art by painting works entitled *Nero* (*Black*) and *Giallo* (*Yellow*) before passing on to transparencies between these two chromatic poles. The paintings span a dilation of reduced elements, like the "black" paintings of Ad Reinhardt, except that for the Roman artist the goal is to create an optical flow of light expanding from the center to the perimeter, from the painting and into the room. His Minimalist work began in 1962, but all of his short-lived efforts (he died in 1963) were an attempt to produce an effect of visual seismography that would affect the continuity of space: a theoretical and practical anticipation of the phenomenological procedure of Minimal art with respect to architecture. In fact his *Spazio-luce* (*Space-Light*) series (see cat. no. 107) proposes to analyze the energetic and luminous limits of color, which expands from the center to the edges. Later, in his *Filtri* (*Filters*) series, the artist attempts to create a threshold through which light should pass and expand into the surrounding space. This effect is created with black metals, as in *Metallo nero opaco uniforme* (*Uniform Opaque Black Metal*, 1960, cat. no. 109), in which the dilation of the object, though limited to curved or diagonal surfaces, expands the area of light. Finally there is *Articolazione totale* (*Total Articulation*, 1962, cat. no. 111), a cube of white cement with curved black metal wherein the relation between inside and outside, between light and space, establishes minimal relations and events that set a precedent recognized even by American sculptors.[27]

The eclipse of Informale was also attributed to the association between Castellani and Manzoni, who in 1959 founded the review *Azimuth* and opened the gallery *Azimut*—both of these outlets began to champion the purity and simplicity of the artistic act, developing a critical stance toward the rhetoric of the irrational gesture and the chaotic piling of material onto the canvas. Though indebted to Burri and Fontana, Castellani and Manzoni aimed at turning away from gesturality and returning to an art of ideas. They defined a rational, analytical method, first subjecting the painting to a tabula rasa, as in Castellani's monochromes and Manzoni's *Achromes*, then embarking on experiments in the concept of art as optical and perceptive process (Castellani) and as operative and corporeal process (Manzoni). In *Superficie bianca, n. 5* (*White Surface No. 5*, 1964, cat. no. 78) Castellani, through simple sequences of protruding points both positive and negative, creates rhythms cadenced by lights and shadows and in continual movement, achieving a virtual three-dimensionality entirely centered around optical and purist effects. The new models of industrial culture and

consumption, however, which were interwoven with a certain hedonistic ideology,[28] created a crisis, or at least a hindrance, for any idea of purist intervention or renewal. Consumerism and mass behavior took on virulent aspects, which left artists feeling crushed and unprepared. It was difficult to recover one's balance in the clash between traditional values, like those of Catholic Italian culture, and the materialistic, secular avalanche informing modern capitalist aesthetics.

Manzoni's work is concerned with the duality of an artistic existence that leads to the realization of products and the exaltation of appearances. From the very beginning he insisted that it is impossible to separate the work of art from the imprint of humanity, and indeed that they must exist together. All his activity involved a synthesis of the two poles. Thus the object reincarnates itself as a self-producing entity in the *Achromes* (see cat. no. 116), and the subject reincarnates himself in his own physical and bodily residues in *Merda d'Artista* (*Artist's Shit*, 1961, cat. nos. 132–160) and *Fiato d'Artista* (*Artist's Breath*). As a member of the post-Informale generation that had left behind the ideological and liberational myths of the postwar period, Manzoni posits no future path, no utopia; any element whatsoever is a sign of loss and negation, as well as of irony and critique of the consumeristic acceleration of art.[29] The *Achromes* are paintings that turn against all mimetic value, interpreting no other flux than that of the materials— kaolin, wool fibers, cotton, rabbit skin, fluorescent pigment. The artist dives into his viscera and proclaims a work of art: his feces. And if there is no incompatibility between the primary elements of which art is composed— the painting and the artist—then the drawing and its line, the instrument of drawing and the apparatus of presentation, can be offered as absolute. Starting in 1959, Manzoni executed a number of lines of varying length, from 0.78 meters to 19.11 meters, which he placed in black cardboard containers. The longest line is *Linea m 7200, 4 Iuglio 1960* (*Line 7200 m, July 4, 1960*, 1960, cat. no. 117) produced at a paper-mill in Herning, Denmark, between 4:00 pm and 6:55 pm. *Base del mondo* (*Base of the World*, 1961, cat. no. 166), is one of those magic bases that have the power to transform whatever is placed on them into a work of art. *Base del mondo* takes this rite to its extreme: being turned upside down, it supports the sphere of the earth, whereby it transforms, to this very day, every person, animal, and thing on earth into art.

In Rome, Tano Festa, Kounellis, Lo Savio, and Mario Schifano initially succeeded in annulling realistic illusion and the conception of an elsewhere, which is typical of Guttusian realism and Informale, by effecting a total reduction to nothingness that transformed art into the negation of drawing and representation. Their white or red screens with bands, linear structures, writings, or objects, reveal the gratuitiousness of the games of representation and formlessness so dear to the preceding generations. They seek to revive the potential of the painting and sculptural system as a primary and primordial procedure. Thus Kounellis and Schifano began painting in 1960 with systems of elementary signs—traffic markers, signboards, letters of the alphabet. They highlight the reality of banal, everyday codes that, when placed against large monochrome backgrounds—Kounellis (see cat. nos. 101,

102)—or defined perimetrically as screens—Schifano's *A De Chirico* (*To De Chirico*, 1962, cat. no. 200)—produce a nonsense symptomatic of a fragmentary, shattered, and therefore "metaphysical" culture: that of the mass media and industry. Schifano thinks of the painting as a fragment of memory, the filmic photogram passing swiftly by, whereas for Kounellis the painting is a multidimensional score of words and sounds that will lead the artist to transform his art into a panoply of sensory experiences evoked by the use of such materials as fire and cacti (see cat. nos. 212, 213). These processes of drawing from everyday urban life can be taken as attempts to put oneself in harmony with the narratives large and small of metropolitan industrial culture, from neon bar signs to the great screens of the movie houses. Instead of producing new icons, Schifano, Kounellis, and Festa display an awareness of those already in existence: pedestrian crossing stripes, the Roman she-wolf, the obelisk, Esso and Coca-Cola billboards, graffiti on city walls.

Festa and Mimmo Rotella share an identification with street subculture and the icons of mass communication. Festa linguistically cuts out and tears away the sacred icons of art, from the hands of Adam and Eve in *Giudizio Universale* (*Last Judgment*, 1962) to *Obelisco* (*Obelisk*, 1963, cat. no. 93),[30] and through a process of filtration he reduces them to advertising copy, using industrial colors and fluorescent paints. Rotella, a member of the Nouveaux Réalistes, does the opposite, tearing posters away physically and creating décollages. The re-presentation of the layers of posters without any painterly intervention is intended to underscore the creative significance of mass-media communication, and to point out that material and chromatic causality is linguistic density.

The theme of synthesis unites Manzoni and Michelangelo Pistoletto, except that the latter is interested in the dialectic between reality and reflection bound together by the umbilical cord of art. Thus while Manzoni wants to go beyond the artifact to bring the artificer into the picture as well, Pistoletto creates a vertigo or point of contact between being and appearing, stasis and history, the fixed past presented in images and the continuous present of the reflected situation, all of which meet on the threshhold of the mirroring surface: *Uomo di schiena. Il presente* (*Man Seen from the Back. The Present*, 1961, cat. no. 190), for example. The idea is to realize a work with the strength to remain perpetually available,[31] by means of reflection, to the present moment of a world changing in time. The intention is to explore a dialogue between the essential subjectivization of art on the one hand and the cauldron of life on the other, the first captured by means of painterly representation or photographic paper, the second reflected in a continuous flow on the surface of a mirror. This is an unending process of registration, whose precariousness counterbalances the stasis of the photographed figure. It surrounds a static presence with a dynamic, infinite present. With works like *Donna seduta di spalle* (*Seated Woman*, 1962–63, cat. no. 192), Pistoletto has produced the most potent painterly instrument art has ever imagined or dreamed of for mastering chance and time, which are returned to static, mimetic vision. He has created a surface almost like a film or video recording, a surface as "interface in which a constant activity, in the

form of exchange, reigns between the two substances brought into contact."[32] This device overturns the meaning of painting as relative substance (Marcel Duchamp) or as accident (Pollock), because it makes placement in space not only an open window but a movie camera. In the dialectical joining of presence and absence, immanence and transcendence, painting floats in the *doublure* (lining) in which meaning and meaninglessness meet, where one passes from the pulsation to the order of things and to the order of culture.

The work of Domenico Gnoli moves in a dimension uniting the universal and the contingent. In his paintings the magnetism of detail affecting objects and bodies bespeaks a being that converses with the nonbeing of inanimate elements. He looks at reality as if it were a total abstraction, a place of grand illusions and hyperreal representations. Instead of merely dwelling on the reality of this or that place, event, or time, Gnoli reverences the flashes and flickers found in cutting out a portion of reality. He confers meaning upon the detail of a shirt in *Giro di collo 15 ½* (*Neck Size 15 ½*, 1966, cat. no. 100), and his eyes are struck by an insignificant reality in *Tavoli* (*Tables*, 1966, see cat. no. 99). By extracting provisional, relative fragments from the flow of images catching our eye, the artist underscores the relativity of what we know, which derives solely from the attempt to fit the ego into the world, a subjectivity that saves us from a terrifying but vital and mysterious objectivity.[33]

Certainly these concerns with things and events as cumbersome and metaphysical impositions on art can be historically traced to Pop art's concern with the ephemeral. This trend, as of 1962, effected a poeticization of the surrounding world by conferring aesthetic significance on popular everyday images from the mass media: advertisements, comic books, billboards, photographic reproductions. The rediscovery of urban contextuality transformed the surrounding space into text, whereby the city and its architecture, furniture, and people could be read like a map. With Gnoli they became significant. Art takes the form of a gaze directed at the enigma of the world, the solution of which recedes further and further into the distance as the investigation proceeds.

At the opposite pole of this investigation of sight is the examination of its basic components: the squaring of the paper, the paintbrush, the can of paint, the canvas, the painting, and the painter. From the very start of his career, Giulio Paolini has attempted to formulate his doctrine of art, from the theoretical to the concrete, through a body of analytical work. His ideas on language have aimed at the construction or definition of a whole based on the fundamental principles of seeing and being seen. His artistic approach seemed at first directed toward continuing a tradition of analysis of painting and visual design that celebrates the repertoire of forms and volumes and raises them to the status of "architecture," understood as the science of building. This tradition runs from Vitruvius to Leon Battista Alberti, from Velázquez to Poussin. Over the years Paolini has addressed the problem of knowing the nature of the materials that make up the "art" system; he has explored, catalogued, overturned, and uncovered the rationales of painting, which consist of concrete things like crude canvases with their front and

back—as in *Senza titolo* (*Untitled*, 1962–63, cat. no. 180)—or the figure of the artist himself: as in *Monogramma* (*Monogram*, 1965, cat. no. 184). Once the coordinates are identified, they interweave and overlap in time. The photograph of the artist in *Diaframma 8* (*Diaphragm 8*, 1965, cat. no. 220) is reflected two years later in *D867* (1967, cat. no. 221). Elsewhere he constructs a self-portrait from layerings of his works and his classical references, as in *Delfo* (*Delphi*, 1965). The cycle closes and opens each time anew, to the point where it becomes the cycle of the life of art and the artist.

Whereas Paolini is totally anchored to the functioning of images and their imaginer, for Luciano Fabro art is "consciousness in motion," "invention that disturbs peace attained, manifests dissatisfaction, presents the dilemma between stillness and stimulus."[34] What matters for him is the image as attribute and episode, not as subject to be sustained and developed. He therefore looks for an incoherence of subjects that might sustain the coherence of the procedure. From this he derives the notion of an artist of many faces, an artist in continual metamorphosis, who does not base his identity on the unity and repetition of images but rather on their multiplicity. For him, the identity of art is a polyidentity. It manifests itself by continual rethinkings; it is not linear but problematic. He is therefore concerned with innovations with which to bring one's methods of seeing and sculpting up-to-date. In 1963, the year of his first works, he presented a reflection of his audience in a work, *Buco* (*Hole*), the crystal surface of which is freely organized into mirroring parts and transparent parts, with a large hole in the middle. The dialogue between reflected sight and direct sight bears in mind both the idea of art as representation, or *imitatio*, and art as direct experience of the world. It is a dialectical form of dialogue between construction and experience, which in *Ruota* (*Wheel*), 1964, becomes tension in action. It inhabits the space in a geometrical, design sense and stretches it taut with its physical elasticity. We are witness to the articulation of a moment that emits or sutures visual energy with architecture, unites the gaze with the physical dimension of the body.

This was the start of a concern with the indeterminacy and latency of the making of art, which wavered between discontinuity and the explosion of forms. It was a rejection of the univocal vision that yielded a variety of voices and movements, a web of artistic relativism that ran parallel with the new events of history. From 1966 to 1968, in Italy as in the rest of the world, one witnessed the spread of a "cultural revolution," the ethical-social rebellion fostered by students and by the minorities of the third world as well as the second and third sexes. They rejected the polluted stability of opulence and attempted to undermine the concentrated power of repression created by the system of consumption and mass communication, which needed passive entities in order to function. Nineteen sixty-six was a year of formation (the conflagration would come two years later, in Paris, Chicago, Berkeley, etc.), yet the process of debate had begun and would expand the area of incidence and attack for the anticapitalist forces. There was great hope—later proved ephemeral—for a world as nirvana and as a place of pleasure. Students and proletarians, women and diverse beatniks and hippies,

attempted to inject into the system the desire for an "other" world in which the brutality of armed struggles, from Algeria to Vietnam, would turn against the hegemony of power and throw it into crisis. Dogmas collapsed and the absolute truths of Marxism and Freudianism wore thin; the phallo-patriarchal system tottered and the blocs of ideological power, the American and the Soviet, were definitively besieged. There was widespread acknowledgement of the value of hedonistic and orgiastic philosophies of the sort preached by Norman O. Brown, Herbert Marcuse, and Wilhelm Reich, and protest mounted against diversions of the libido and the psyche. All delegations of power to political parties were called into question, as was the authority of the family, in an attempt to formulate a pleasurable praxis which, by eliminating the claim to universality of the models proposed by the ideologue and father, might manage to build a base on which the demand of "we want everything" would work.[35]

The years 1965 and 1966 were very important in the development of Italian art. The first anti-Pop art and anti-Minimal experiments were under way, reacting against the rigidity and monumental peremptoriness of primary structures as well as the extreme iconism of the mass media, from which Pop artists drew so heavily. The point was to reject a certain American cultural colonialism that had first developed in 1964 with the prize given to Rauschenberg at the *XXXII Biennale* and to establish Italy's own artistic difference, deep-rooted in the history of images, in accordance with a critical and ironic, oneiric and personal vision that had nothing in common with mass culture and its various apparati.

Some artists, like Pistoletto and Pino Pascali, realizing the danger of monolithicism and repetititive rigidity inherent in the standardization and mass production of Pop and Minimal painting and sculpture, at first sought a way out in the sensory and fantastic. They produced works like Pistoletto's *Oggetti in meno* (*Minus Objects*) series (see cat. nos. 194–196), and Pascali's *Armi* (*Arms*) series (see cat. nos. 187–89) whose iconographic and scalar impact, combined with the flexibility and energy inherent in the materials, invited visual experiment to plunge into a vortex of free and contradictory images in which what mattered was making a spectacle of one's own inner feelings and thoughts. These inner movements might range from play to dream, producing fake cannons and machine guns, antimilitarist "toys"—like the *Cannone "Bella Ciao"* ("*Bella Ciao*" Cannon, 1965, cat. no. 189), made of discarded car parts, pipes, radiators, and barrels—that mocked the wars being fought at the time, both in Vietnam and in the art world;[36] or they might lead to the construction of oneiric projections on a three-dimensional scale, as with Pistoletto, who replaced the multiplicity of the mirroring surface with the multiplicity of his own infinite imagining. His *Scultura lignea* (*Wood Sculpture*, 1965–66, cat. no. 193), *Sfera di giornali* (*Mappamondo*) (*Oggetti in meno*) (*Sphere of Newspapers* {*Globe*} {*Minus Objects*}, 1966–68, cat. no. 195), and *Rosa bruciata* (*Oggetti in meno*) (*Burnt Rose* {*Minus Objects*}, 1965, cat. no. 196) are projections of dream and memory that work on the contrasted coherence or incoherence of various images and underscore the importance of a multiple creative identity: that of the artist

who wants not to repeat oneself but to create continuously, who produces art to free oneself and to get rid of one's ideas and images, the "minus objects."

The departure from linearity in favor of multiplicity subjects art to a process of continuous transformation, destruction, and reconstruction. A pantheistic vision emerges capable of bringing any natural, animal, or artificial element into the language of art. The aesthetic spans all the materials of every physical and conceptual realm, resulting in a linguistic polydimensionality within which operates the highest possible degree of fluidity and transitoriness. In this context Arte Povera began to take shape, with its desire to move from a creation of art no longer based on a phenomenal or conceptual minimum of extension and calculation but rather on the fullness and fluidity, the elasticity and energetic completeness of the materials. These range from fire, earth, animals, stones, and trees to sulfur, gold, and rags. We have left Minimalism and entered the contemporary baroque. With Arte Povera, the immense subtlety of things and the senses unfolds: architecture and history, chemical reactions and natural events. It is art premised on the wish to remain, at all costs, on a direct line with reality.

The point is to question every level of existence, not only color and line, canvas and form, volume and space, but to operate in harmony and a state of tension with the enigma of beings and the elements, letting go of all linguistic injunctions in order to move freely through all realms, from sea to meadow, ice to air, intimate to social, symbolic to historical, chemical to alchemical. Art thus moves beyond the limitations of the consensus in favor of this or that genre and is tranformed into an aesthetic totality that knows no limits. Among the artists taking part in this heady experiment were those emerging from the experiences of the early 1960s: Fabro, Kounellis, Mario Merz, Marisa Merz, Paolini, Pascali, and Pistoletto, as well as the younger artists Giovanni Anselmo, Alighiero Boetti, Pier Paolo Calzolari, Giuseppe Penone, Emilio Prini, and Gilberto Zorio.

The reasons for this pantheism were many and varied. First of all there was an interest in the natural and physical world, which art had lost sight of over the course of time as it came closer and closer to technology. This sense of loss was offset by the use of primary materials—such as fire in Kounellis's *Senza titolo* (*Untitled*, 1967, cat. no. 212)—or the invocation of peasant tradition and its custom of grafting trees, with the variant of the artist's own body being part of the graft—as in Penone's *L'albero continuerà a crescere tranne che in questo punto* (*The tree will keep growing except at this point*, 1968). Moreover, the rejection of the notion of art as immobile and the embracing of an evolutionary perspective of its development as an image and object in motion was of great importance in emphasizing the notion of the work's vitality and survivability. The work does not disappear in a closed and rigid intellectual and conceptual structure but provides an existence. It must be assisted and nourished with new food, such as salad in Anselmo's *Struttura che mangia l'insalata* (*Structure That Eats Salad*, 1968, cat. no. 204); or it may be transformed, in an energetic process that makes the image self-generate, in *Tenda* (*Tent*, 1967, cat. no. 230), by Zorio. Elsewhere it is the need to bear witness to a sublimity deriving from the

absoluteness of a material like ice, which comes to underscore the artistic lifestyle in Calzolari's *Un flauto dolce per farmi suonare* (*A Dulcet Flute for Me to Play*, 1968, cat. no. 208). What is at stake is the transmittal of the pulsation of life with respect to the representation of art. The emergence of the indeterminate, polysignificant condition of Arte Povera also derives from the mutations brought about by a linguistic interchangeability rooted both in Informale's exaltation of materials and in the dialectical mingling of image and reality, figure and art history, everyday icon and painting, gesture and nature, tradition and present day, private and public, developed by such artists as Fabro, Kounellis, Mario Merz, Marisa Merz, Paolini, and Pistoletto.

This movement triggered a profound transformation, which in 1966–67 took the shape of encounters and clashes of images and cultures. The combination of beauty and tactility, classical and ephemeral, eternal and transitory, each reflected mutually in Pistoletto's *Venere degli stracci* (*Venus of the Rags*, 1967, cat. no. 228), revealing the magnetism between opposites. A similar dialogue was established by Mario Merz between industrial energy and human energy, logic and action, when he put the inside of his own raincoat in contact with the flash of a fluorescent light in *Impermeabile* (*Raincoat*, 1967, cat. no. 216). Elsewhere he establishes a relationship between thought and political nomadism, between the statement of General Giap and the igloo, in *Igloo di Giap. Se il nemico si concentra perde terreno se si disperde perde forza* (*Giap Igloo. If the Enemy Masses His Forces He Loses Ground; If He Scatters He Loses Strength*, 1968, cat. no. 214).

The dialectic between nature and industry, southern and northern, desert and factory, between natural and artificial color, represented in the clash between cacti and metal containers running through one another in *Senza titolo* (*Untitled*, 1967, cat. no. 213), is one way Kounellis calls attention to the need to keep different cultures together and to maintain a common language, however distant the various hemispheres of its provenance, in the face of the destructive impact of mass production. For Pascali coexistence occurs between play and primitive history, true and false, between nature and artificiality. His concern for nature is expressed in substances like water and earth, which he reconstructs in theatrical fashion in *36 metri quadrati di mare* (*Thirty-six Square Meters of Sea*, 1967). In *Ponte* (*Bridge*, 1968, cat. no. 224) he uses steel wool in a search for the fantastic world of the jungle, a universe of adventures staged through the utilization of industrial artificiality.

The conflict between private and public, inner worlds and social participation, with the concomitant pressure on the individual, is the subject of the work of Marisa Merz. The *Altalena per Bea* (*Swing for Bea*, 1968), for example, is a work based on individual identity, the personal world of her own body, and her daughter Beatrice. It is an irregular, anomalous structure in which play can become dangerous and love can turn into tension and risk—a continuous, unsundered problematic between consciousness of self and of the other, of the feminine in regard to the masculine, of the individual in regard to society. The new relationship between art and existence dissolves history into single realms, linguistic and cultural territories. If the eighteenth

century accustomed humanity to think of art as a special entity in isolation from other things, the baroque effect of the years 1967–68 affirmed the fascination of the coexistence among things and languages. The notion of a field open to all conditions and coexistences was introduced. Paolini's *Averroè* (*Averroës*, 1967, cat. no. 222) is based on an accumulation of flags, of linguistic identities, brought together to create a series of crosswise connections and interrelations, so that differences of every sort collapse. Finally there are Fabro's transitions and shiftings of the image, an image no longer bent to the rhetoric of coherence but to the constitution of a method. He often cites Francis Bacon to show that the artist must always be on guard not to repeat himself, not to settle into a codified, recognizable personality, but rather to overturn every manner of iconic stereotype, as in *Italia appesa* (*Italy Hanging*, 1967) and the *Piedi* (*Foot*) series (see cat. nos. 209, 210)

The Arte Povera group brought about a gradual emancipation of art from the monolithic, reductive, and minimal object, as well as from univocal, unidirectional concerns: "my generation deserves recognition," asserts Fabro, "for having taken many immediately usable liberties: self-indulgence, hyperbole, digression, madness . . . rejuvenating the classical rhetorics with undeniable qualities."[37] For this reason 1968 was as much the end of an era as the beginning of another. With all these artists taken together, an artistic lexicon appeared on the horizon, open to the unleashing of every sort of force: physical and mental, dramatic and behavioral, natural and artificial. This is the final result of the course of Italian art from 1943 to 1968, developed "in total freedom."

1. This term, which suggests an attempt to go beyond Right and Left to find a third solution to political and cultural conflicts, is drawn from Norberto Bobbio, *Destra e sinistra* (Right and Left. Rome: Donzelli, 1994).

2. The first text on "realism" was drafted in 1943, but it remained clandestine. It was later published in 1946 as "Realismo e poesia" in the first issue of the review *Il '45* (1945). See Giorgio de Marchis, "L'arte in Italia dopo la seconda guerra mondiale," in *Storia dell'Arte Italiana* (History of Italian Art. Turin: Einaudi, 1982); and Luciano Caramel, ed., *Arte in Italia 1945–1960* (Art in Italy 1945–1960. Milan: Vita e Pensiero, 1994).

3. Roger Garaudy, "Non esiste un estetica del partito comunista," *Il politecnico* (Polytechnic), Milan, September 1946, pp. 33–34.

4. Particularly notorious was the uproar caused in 1948 when the PCI Secretary Palmiro Togliatti, using the pen name Roderigo di Castigli, panned a contemporary art exhibit held in October of that year at the Alleanza della Cultura. The review provoked an angry though measured and timorous response in a letter signed by militant artists and critics within the party itself, including Consagra, Nino Franchina, Guttuso, Leoncillo, and Turcato.

5. Sergio Polano, *Mostrare* (Exhibiting. Milan: Lybra Immagine, 1988).

6. Augusto Graziani, "Mercato e relazioni internazionali," in *Italia Contemporanea 1945–1975* (Contemporary Italy 1945–1975. Turin: Einaudi), pp. 307–336.

7. Mino Guerrini, "Perché la pittura," *Forma 1* (Form 1), Rome, April 1947.

8. In 1949 Fontana, at the Galleria del Naviglio in Milan, created a "black environment" wherein the spectator upon entering saw hanging spatial forms illuminated by black light, produced by a Wood lamp. His interest in displaying his art environmentally and architecturally led him to adorn the great entrance staircase of Milan's *IX Triennale* in 1951 with an arabesque of light, suspended from the ceiling and consisting of fluorescent tubes arranged along a linear pathway over one hundred meters long. For his relations with Californian Environmental Art and New York Minimalism, see Germano Celant, *Arte Ambiente, dal futurismo alla body art* (Environment Art, from Futurism to Body Art. Milan: Electa, 1977).

9. Mario Ballocco, "Origine," *A.Z. arte d'oggi* (A.Z. art of today), Milan, no. 6, November 6, 1950.

10. Germano Celant, *Roma–New York 1948–1964*, exhibition catalogue (Milan: Charta, 1994).

11. In Italy, Turin was the city most open to accepting and perpetuating the unilateral relationship with French art. In 1951 a series of Italy–France shows were curated by Luigi Carluccio, while Michel Tapié was consultant at the Centre of Aesthetic Research, introducing Jean Fautrier and the Japanese Gutai group to an Italian public. The other principal cities, Rome and Milan, were more oriented toward American and northern European culture. Contacts were made with various dealers and museums. Leo Castelli and Ileana Sonnabend looked to Rome, whereas Catherine Viviano began showing Afro and Birolli in New York. Milan, through Lucio Fontana and the MAC group, established the first contacts with Dutch, Swiss, and German artists ranging from the COBRA group to Max Bill. See Ida Gianelli, ed., *Un'avventura internazionale, Torino e le Arti 1950–1970* (An international adventure. Turin and the arts, 1950–1970. Milan: Charta, 1993); *Roma '60*, exhibition catalogue (Rome: Palazzo Esposizioni, 1992); and Guido Ballo, *La Linea dell'arte italiana* (The direction of Italian art. Rome: Mediterranee, 1964).

12. Serge Guilbaut, *How New York Stole the Idea of Modern Art* (Chicago: The University of Chicago Press, 1983).

13. Serge Guilbaut, ed., *Reconstructing Modernism* (Cambridge: MIT Press, 1990).

4. For Rauschenberg's linguistic debt to Burri, see Celant, *Rome–New York 1948–1964*, pp. 19–23.

15. Maurizio Calvesi, *Alberto Burri* (Milan, 1977).

16. The practice of intensifying material, based on unleashing pure energies, is typical of a Catholic culture that aspires to secularity by removing spirituality while in fact confirming it everywhere: in sacks, in artist's shit (Piero Manzoni), and in natural materials such as fire, cacti, stones in the work of such artists as Jannis Kounellis and Giovanni Anselmo. See Germano Celant, *Alberto Burri*, text for RAI broadcast, Rome, July 7, 1984, printed in *L'arte italiana* (Italian art. Milan: Feltrinelli, 1988).

17. Umberto Boccioni, *Pittura e scultura futuriste (Dinamismo plastico)* (Futurist painting and sculpture [plastic dynamism]. Milan, 1914).

18. Bernard Blisten, ed., *Lucio Fontana* (Paris: Musée National d'Art Moderne, Centre Georges Pompidou, 1987).

19. Germano Celant, "Fontana nomade," in *Esperienze dell'astrattismo italiano* (Experiences in Italian abstraction), exhibition catalogue (Turin: Galleria Notizie, 1968).

20. Germano Celant, *Emilio Vedova* (Milan: Electa, 1984).

21. A.M. Hammacher, *Fausto Melotti* (Milan: Electa, 1975).

22. Lawrence Alloway, *Ettore Colla: Iron Sculpture* (Rome, 1960).

23. Augusta Monferini, ed., *Giulio Turcato* (Rome: Galleria Nazionale d'Arte Moderna, 1987).

24. Adachiara Zevi, *Piero Dorazio* (Ravenna: Essegi, 1985).

25. Vanna Bramanti, *Carla Accardi* (Ravenna: Essegi, 1983).

26. Gillo Dorfles, *Le oscillazioni del gusto* (The oscillations of taste. Milan: Lerici, 1958).

27. Richard Serra dedicated a large work, *Lo Savio*, to the Roman artist, an indirect homage to his experiments in the interpenetration of art and architecture, articulation and volume.

28. Ernesto Galli della Loggia, "Ideologie, classi e costume," in *Italia Contemporanea, 1945–1975*, p. 419.

29. Germano Celant, "Piero Manzoni, un artista del presente," in *Piero Manzoni*, exhibition catalogue (Paris: Musée d'Art de la Ville de Paris, 1991).

30. Achille Bonito Oliva, *Tano Festa* (Rome: Ex Birreria Peroni, 1988).

31. Germano Celant, *Pistoletto* (Milan: Fabbri, 1990).

32. Paul Virilio, *L'espace critique* (The critical space. Paris: Christian Bourgois, 1984), p. 14.

33. Vittorio Sgarbi, *Domenico Gnoli* (Milan: Ricci, 1985).

34. Luciano Fabro, "Lettere ai Germani," in *Aufhamger* (Cologne: König, 1983).

35. Germano Celant, "Pour une identité italienne," in *Identité italienne* (Italian identity. Paris: Musée National d'Art Moderne, Centre Georges Pompidou, 1981).

36. Vittorio Rubiu, *Pino Pascali* (Rome: Attico, 1976).

37. Luciano Fabro, *La natura* (Nature), exhibition catalogue (Essen: Museum Folkwang, 1981).

Painting and Beyond: Recovery and Regeneration, 1943–1952

Marcia E. Vetrocq

When Allied forces invaded the islands of Pantelleria and Lampedusa in June 1943, Italy entered a protracted season of occupation. Nearly two years would pass before the conclusion of hostilities. Ahead lay the worst deprivations and atrocities as well as the first successes of the anti-Fascist coalitions, coalitions whose fragile unity would unravel in the postwar jockeying for power. There were at least two Italies by the close of 1943, and possibly five: the territories controlled by the two occupying armies, Allied in the South and German in the North; their respective puppets, the Kingdom of the South and Benito Mussolini's Republic of Salò; and the Comitato di Liberazione Nazionale per l'Alta Italia (National Committee for the Liberation of Upper Italy), the coordinating umbrella of the Resistance. When the war finally ended in the North in April 1945, the Resistance had grown to well over 100,000, and in the process had offered the hungry country a necessary ration of heroism and moral certainty. After twenty years of Fascist duplicity and betrayal, good and evil had become clear once again. It was that clarity that united priest with Communist—and damned collaborator with Nazi—in Roberto Rossellini's paradigmatic Resistance story, *Roma città aperta* (Rome open city, 1945; released in English as *Open City*), whose filming began in the spring of 1944 while German forces still lingered in the city. From the South came a different picture. Curzio Malaparte's book *La pelle* (The skin, 1949), a bitter, first-person account of Neapolitan life under Allied "protection," describes the corruption of a city neither free nor conquered, a city of prostitutes, shoeshine boys, hucksters, and black marketeers. With ill-concealed envy, Malaparte, a former Fascist, contrasted the degradation of Neapolitans struggling to stay alive with the virtue of those in the North still fighting to escape death. Yet for most Italians the truth of those years lay somewhere, everywhere, in between.

History finds just as many truths for the wartime experiences of Italian artists, as can be seen by taking "core samples" of 1943 from the lives of three who would number among the most important protagonists of the postwar period: Emilio Vedova, Alberto Burri, and Lucio Fontana. The year 1943 found the young and largely self-trained Vedova in the center of the paradox that was art under Fascism. That year his work was included in the government-sponsored *Quadriennale d'Arte Nazionale* in Rome and was also the last to be exhibited by the dissident Corrente group before its gallery in Milan was raided by the national security police.¹ After the Germans occupied Northern Italy in September, Vedova joined the Resistance; he returned to his native Venice at the end of the war. Burri, who was not yet an artist in 1943, was taken prisoner while serving as a physician with the Italian army in Tunisia. He began to paint while detained in a Texas prisoner-of-war camp (see fig. 1) and renounced medicine for his new vocation upon repatriation to Rome in 1946. Fontana, academically trained and already a mature artist who worked in both figurative and nonfigurative modes, was in the middle of a self-imposed Argentinian exile in 1943. He would return to Milan four years later as the prophet of a radical movement that would challenge prevailing assumptions about the nature of art itself.

In the course of the decade 1943–52 Italy's artists and

critics would begin the job of reviving the country's visual culture, a task parallel to, if not at the very heart of, the wider project of social and political reconstruction.[2] At various moments different antinomies would be advanced as the defining issue: abstraction versus realism, creative autonomy versus collective responsibility, national versus international culture. Each set of choices, however, represented only a single aspect of a difficult process of self-definition. The decade began with the engagement of Italian artists in a "local" struggle to overcome the effects of twenty years of Fascist cultural dogma. The regime had not crushed artistic inquiry so much as it had denatured and warped it with a poisonous mixture of nationalistic bombast and exasperated tolerance. Not surprisingly, the first impulse of most Italian artists was to embrace the surviving remnants of the international avant-garde that had been denigrated under Fascism's campaign of cultural autarchy. The decade ended with Italian artists, like their European and American counterparts, acknowledging the exhaustion of prewar Modernism and formulating the terms of a new art. In the first rounds of this contest the privileged medium was painting, but the solutions that emerged from the fray eventually would subvert painting's preeminence and open up a limitless field of materials and forms to creative investigation.

In 1943 there already were anticipations of the complex mood of solemnity and euphoria that would seize so many artists and intellectuals at the end of the war. That summer two veterans of Corrente, the painters Ernesto Treccani and Ennio Morlotti, collaborated on the *Primo manifesto di pittori e scultori* (First manifesto of painters and sculptors).[3] Here the rhetoric of art and resistance conjoined in a militant rejection of irony, indecision, melancholy, indifference, pessimism, aestheticism—in sum, any condition of consciousness that would impede action, as well as any definition of art as being other than a complete and revolutionary engagement in life. The painters of the preceding generation, whether nonobjective "concrete" artists or practitioners of the archaizing tendencies of the Novecento movement, were condemned for having abandoned lived experience. The expressionism so recently embraced by the Corrente painters themselves as an authentic counter to the celebratory falsehoods of Fascist art now was castigated for the sins of interiority and isolation, while Pablo Picasso, in the first of many such endorsements, was praised for having overcome the cult of personality to express the anti-Fascist struggle of an entire generation. At the start of 1946, in an essay named for Picasso's *Guernica*, a jubilant, almost feverish Morlotti heralded the beginning of a new moral era as the last "individual" lay buried beneath the ruins of the war and painting prepared to assume its collective and social responsibilities.[4] At issue was more than just repudiating the moribund academicism, bloated classicism, and provincial nostalgia of the art favored by the fallen regime. It was also necessary to overcome the disengagement born of Crocean dealism, which had held culture separate from politics and had allowed inaction to pass for anti-Fascism.[5] For this a different and less blatant culpability needed to be acknowledged, as is clear from the acerbic recollection of the art historian Giulio Carlo Argan:

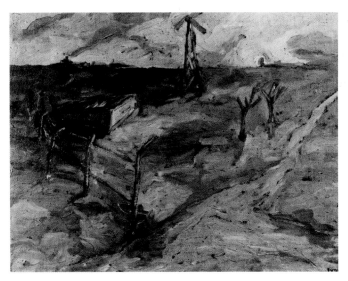

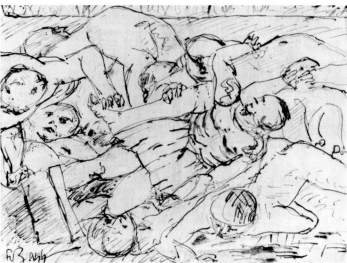

fig. 1. Alberto Burri, Texas, 1945. Oil on canvas, 47 x 60.5 cm. Tersigni Collection, Rome.

fig. 2. Renato Biroli, Disegno della resistenza, da "Italia 1944" (Drawing of the Resistance, from "Italy 1944"), 1944. Ink on paper, 16 x 21.4 cm. Birolli Collection, Milan.

Fascism fell, but after a war that was morally and materially disastrous; the ruin of things and of ideals. . . . The moral damage was no less than the material damage: monuments destroyed, cities devastated, masterpieces stolen, and within a desolate sense of emptiness. Italy was objectively guilty: for the most part intellectuals had succeeded in preserving their dignity as scholars, but they could not or did not know how to impose their cultural authority on a regime that was hostile to culture. They yielded to force. The immunity of culture was an illusion.[6]

For the most part, however, it was elation mixed with a sense of rectitude, not self-recrimination, that propelled the initial floodtide of exhibitions, manifestos, and artists' organizations. Galleries throughout the country exhibited works commemorating hardships so recently endured. Celebrated among these were Vedova's drawings of life among the partisans; Renato Birolli's album of drawings that came to be called *Italia 1944* (Italy 1944), which chronicled the suffering in Lombardy during the German occupation (see fig. 2); and Renato Guttuso's tribute to the victims of the Ardeatine caves massacre, the drawings published as *Gott mit Uns* (God with us, cat. no. 332), so named for the motto inscribed on the holsters of the German executioners. Late in the summer of 1944 the once-clandestine Communist paper *L'unità* (Unity) sponsored the exhibition *L'arte contro la barbarie* (Art against barbarism). Rome's painters and sculptors took part in a show of solidarity and belated defiance. The occasion also elicited some early attacks in the Communist press on the "evasive" art of Giorgio Morandi and other "intimists," and an early endorsement of "appropriate" national and popular content. It was a presage of the intolerance that, a few years later, would trap the PCI (Partito Comunista Italiano/Italian Communist Party) into a blanket condemnation of abstraction.[7]

Behind the first efforts of intellectuals to shape a new Italian culture, one senses the sheer pleasure of open communication after the double-talk and suppression of the Fascist era and the Occupation. The months that spanned the end of 1945 and the beginning of 1946 saw three significant new journals of ideas launched in Milan: *Il politecnico* (Polytechnic), *Numero* (Number), and *Il '45* (1945). Manifestos poured from studios and cafés as artists and writers proclaimed their determination to reform art, to transcend superficial differences of style, and to sustain a moral consensus. In March 1946 *Numero* published the *Manifesto del realismo* (Manifesto of realism), a statement more familiarly known by the name *Oltre Guernica* (Beyond Guernica). The ten signatories (Giuseppe Ajmone, Rinaldo Bergolli, Egidio Bonfante, Gianni Dova, Morlotti, Giovanni Paganini, Cesare Peverelli, Vittorio Tavernari, Gianni Testori, Vedova) declared painting and sculpting to be acts of participation in the total contemporary human reality. With perhaps more fervor than intelligibility they proclaimed, "Realism therefore does not mean naturalism or verism or expressionism, but rather the concretized reality of one person, when this participates in, coincides with, and is equivalent to the reality of others; when it becomes, in short, a common measurement of reality itself."[8]

As a result of a 1945 meeting in Venice came the 1946 founding manifesto of the Nuovo Secessione Artistica

Italiana, soon to be renamed the Fronte Nuovo delle Arti in an exchange of the nomenclature of dissent for that of political activism. The eleven who signed (Birolli, Bruno Cassinari, Guttuso, Carlo Levi, Leoncillo Leonardi [see cat. nos. 16, 17], Morlotti, Armando Pizzinato, Giuseppe Santomaso [see fig. 3], Giulio Turcato [see cat. nos. 23, 24], Vedova, Alberto Viani) announced their intention to guide their "only apparently contrasting" styles toward a future and as yet unrecognizable synthesis based on a fundamental moral necessity.[9] More partisan was the manifesto of the Forma group, published in Rome in March 1947 (see cat. no. 336), in which eight artists (Carla Accardi, Ugo Attardi, Pietro Consagra, Piero Dorazio, Mino Guerrini, Achille Perilli, Antonio Sanfilippo, Turcato) proclaimed themselves "formalists and Marxists." In response to the growing schism within the Left between proponents of a legible popular art and proponents of abstraction, these artists dismissed realism as exhausted and conformist, and committed their efforts to a revolutionary, if not altogether definable, abstraction: "we are interested in the form of the lemon, and not the lemon." No less significant than their choice of an abstract visual language was their characterization of the historical moment in which that choice was made: "The need to bring Italian art to the level of the current European language forces us to take a clear-cut position against every silly and biased nationalist ambition and against the gossipy and useless province that present-day Italian culture is today."[10]

The Forma group's condemnation was not directed solely at unrepentant practitioners of the conservative figural styles that had found favor with the fallen regime. Even the ostensibly progressive artists of *Oltre Guernica* were reprimanded for having reduced the possibilities of Cubism to "Picasso explained to the masses" and for having compromised the "Europeanness" of their paintings with a homegrown Lombard expressionism.[11] Nor were the Roman abstractionists alone in setting the issue of style squarely within the larger problem of Italy's relationship to European Modernism. Many artists and writers decried an Italy that had been all but absent from the history of Modern art—what Argan had called the "incontestable backwardness of Italian painting" in an essay of 1946.[12] The exceptions to the rule of Italian irrelevance, Futurism and Metaphysical art, were dismissed as isolated adjustments to the general French piloting of the avant-garde, while Futurism seemed fatally dishonored by its association with the belligerent posturing of Mussolini's regime. Moreover, Fascist cultural autarchy had left behind a culture with only fragmentary knowledge of what had been accomplished beyond Italy's borders.

To combat the aftereffects of cultural nationalism and its emphasis on *italianità* (Italianness), many postwar intellectuals embraced the concept of *europeismo* (Europeanism), which was perceived as a rational, progressive, humanistic, and international culture to which Italy sought admittance through reeducation. For many the first lessons were taught by the art historian Lionello Venturi.[13] After returning from exile in the United States, Venturi mounted an exhibition of color reproductions of French art from Impressionism to the present at Rome's Galleria Nazionale d'Arte Moderna in 1946. In the words of

Dorazio, "This exhibition was the saving grace for modern art in Italy because it was visited and discussed by all the artists from Palermo to Milan and presented works and formal problems whose very existence no one had ever suspected."[14] Other painters—Birolli, Consagra, Morlotti, Sanfilippo, and Turcato among them—made their way to Paris to learn at the source.

Of course there lurked a fateful incongruity between committing to *aggiornamento*, the process of catching up, as a means of rejoining European culture and striving to make an independent and wholly original contribution to that culture. Nothing would demonstrate the danger of overdependence more than the zealous "picassism" that gripped so many painters in the first years after the war. The self-conscious and angular geometry of post-Cubism overtook the canvases of Guttuso, Morlotti (see fig. 4, Pizzinato, and Vedova, while Birolli and Cassinari sought to capture the perfume of Picasso's Antibes painting in Mediterranean idylls of their own (see fig. 5). Morlotti later recalled, "Picassism was a curse, because I couldn't tear it off my back. I felt its weak sides, but I couldn't see anything other than this imprimatur: Picasso."[15]

At the time only a handful of critics raised an alarm at the ignorance and self-loathing that underlay both the wholesale disparagement of early Modernist efforts in Italy and the boundless francophilia of the young. The art historian Cesare Brandi dismissed *europeismo* as a fiction that masked the suffocating influence of the School of Paris. He argued that the fear of provincialism combined with a poorly understood Marxism was blinding young artists to what had been the originality of Futurism and Metaphysical art.[16] In 1946 Giuseppe Marchiori published *Pittura moderna italiana* (Modern Italian painting), a brief illustrated history of twentieth-century Italian painting, in which he sought to reweave the fabric of recent Italian painting and thus minimize the rupture of the Fascist era.[17] Marchiori, who contributed substantially to the founding ideas of the Fronte Nuovo delle Arti, condemned the academicism of the acolytes of Picasso and singled out Vedova among the newest painters, discerning in the young Venetian a passionate and "medieval" temperament that had been able to penetrate beyond the formalism of Picasso's art to its essential brutality.

The ideas and issues that would define the progressive edge of postwar art in Italy began to sharpen in the years 1947–49, although their full import was temporarily obscured by the eruption of an acrimonious debate about realism and abstract art. The mounting extremism of the Cold War era altered the moral landscape for Italian artists, undermining the spirit of unity and forcing artists on the Left to choose between observing the proscription against abstraction promulgated by the Communist party and exercising the creative autonomy that the end of Fascism had seemed to promise. Even Picasso fell from grace before the party's insistence on the obligation of the artist to immerse himself in subjects drawn from the immediate social reality and to communicate in a language comprehensible to all. It might be said that Italy's postwar age of innocence, marked by widespread political and artistic faith in the healing power of coalitions, ended in 1948. The April elections gave a clear mandate to the Center-Right, the DC (Democrazia Cristiana/Christian

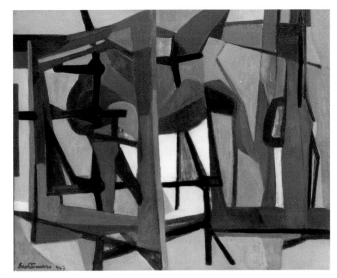

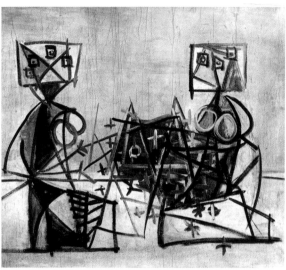

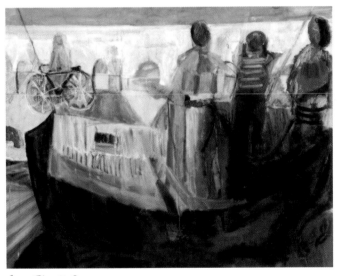

fig. 3. Giuseppe Santomaso, Finestra n. 3 *(Window No. 3), 1947. Oil on canvas, 60 x 75 cm. Cappellin Collection, Italy.*

fig. 4. Ennio Morlotti, La rete *(The Net), 1950-51. Oil on canvas, 208 x 232 cm. Cumani Collection, Milan.*

fig. 5. Bruno Cassinari, Pescatori del Porto di Antibes *(Fishermen of the Port of Antibes), 1949. Oil on canvas, 70 x 90 cm. Istituti Artistici e Culturali, Città di Forlì.*

Democratic party), which already had maneuvered the Left out of the government and whose electoral drive had been propelled by unstinting assistance from the Catholic Church and the United States State Department. Safely within the Western alliance the country now was eligible for Marshall Plan aid and membership in NATO.[18]

In the world of art there was perhaps no more significant indication of Italy's resumption of European citizenship than the resurrection of the Venice *Biennale* in the summer of 1948. Boasting an encyclopedic survey of early French avant-garde masters, an exhibition of painters who had been banned as "degenerate" by the Nazis, and Peggy Guggenheim's collection of Surrealist and abstract art, the new *Biennale* aimed to demonstrate the openness of culture in post-Fascist Italy and to continue the education of a domestic audience that only two years before had contented itself with Venturi's color reproductions. Toward contemporary Italian art the *Biennale* maintained a studied position of cautious liberalism and allowed the Fronte Nuovo delle Arti to exhibit as a group, thus endorsing the artists' contention that ethical unity superseded aesthetic diversity. It proved a futile gesture, as the circumstances surrounding a notorious exhibition later that year would prove. During the fall, several Fronte members, realist and abstract painters, appeared in a show that was mounted in Bologna by the Communist-sponsored Alleanza della Cultura (Alliance of Culture). The event was dedicated to demonstrating the heterogeneity and vitality of contemporary Italian art. When the PCI chief Palmiro Togliatti unleashed a torrent of invective against the incomprehensibility and sheer ugliness of the exhibition's abstract art, fourteen party members—including Fronte adherents Guttuso, Leoncillo, and Turcato—wrote a letter of protest, contending that an Italian art committed to social struggle could be improved by belatedly practicing the European lessons of avant-garde dissidence. The PCI hierarchy remained unmoved, and the deepening rift led to the disintegration of the Fronte within a year.[19]

The intransigence of Togliatti and his circle served to diminish the PCI's influence among artists, although it succeeded in imposing a distorted and unproductive polarity on much of the period's critical discussion. Even Guttuso, the most highly respected yet least typical and obedient among Communist figurative painters (see fig. 6, cat. nos. 14, 15), publicly sustained the party's position. At a conference occasioned by the Alleanza exhibition, he parroted the official line that the single significant choice facing Italy's painters was between a realist or abstract style.[20] But no less consequential was the choice of *which* abstract style to practice. The wholly nonfigurative and essentially geometric, or "concrete," art of the Concretisti, which had been centered in Milan and Como during the 1930s, offered another model for postwar painting that rivaled post-Cubism's claim to being a progressive and "European" prescription for artistic renewal at home. That claim was embodied in an international exhibition of Concrete Art held at Milan's Palazzo Reale at the beginning of 1947, which featured Italian artists Gillo Dorfles, Osvaldo Licini, Bruno Munari, Manlio Rho, and Luigi Veronesi in the company of Jean Arp, Max Bill, Jean Herbin, Vasily Kandinsky, Paul Klee, Sophie Taueber-Arp, Georges Vantongerloo, and other international figures.[21] At

the end of 1948 Dorfles (see fig. 7), Gianni Monnet, Munari, and Atanasio Soldati (see fig. 8) formally founded the MAC (Movimento d'Arte Concreta).[22] Their first exhibition included Forma members Dorazio, Guerrini, and Perilli, three Roman colleagues with whom the Milanese group shared the rejection of referential impurities in art but not the commitment of art to the cause of social and political renewal, an extra-artistic issue from which the Concretisti kept a determined distance.

The chilly remoteness of Concrete Art ultimately would limit its viability as the language of Italian regeneration. To their credit Italy's nonfigurative artists of the 1930s had maintained a steady call for rationalism, internationalism, and resistance to the accommodating revivalist styles that had flattered the pretensions of Fascist authority. But in the turbulent postwar climate, in a world transformed by Auschwitz and Hiroshima, the recourse of Concrete artists to the eternal language of geometry could seem no less anachronistic than Fascist classicism had been. Indeed the majority of the avenues ardently investigated and defended by so many Italian painters during 1947–49—realist, expressionist, post-Cubist, Concrete—were rooted in the artistic experiences of prewar Europe. It was at precisely this point that Vedova, Burri, and Fontana put aside the limited goal of *aggiornamento* and began to set forth the initial technical breakthroughs and theoretical insights that would shape Italian art for the next decade and beyond. Their achievements were all the more remarkable for the fact that, to one degree or another, each of the three vindicated something of the original project of Italian Futurism. Vedova did so by exploring the inherent dynamism of the abstract gesture and by reanimating the precept that the imperative of contemporaneity in art inevitably led the artist to an oppositional position; Burri by contaminating the pure painted surface with flagrantly non-art materials; and Fontana by rejecting easel painting and pedestal sculpture (see cat. nos. 8–10) altogether, by granting technology preeminence over nature and tradition as the source of current artistic truth, and by outlining visionary programs in manifestos before he had discovered the physical means for their realization.

During 1947 and 1948 Vedova rekindled the painterly fire of his work after a cool post-Cubist interlude in 1946. From the very beginning in the 1930s his art had evinced a brooding resonance and a scenographic extravagance, both of which were closer in spirit to the work of his historical Venetian compatriots Tintoretto and Piranesi than to that of his contemporary associates in Corrente, who favored a more primitivizing, Van Gogh–inflected expressionism. The youthful melodrama and sometimes brutal handling of his early renderings of the human figure and architectural views had resolved, by 1945, into a confident gestural style of terrific intensity and freedom. Drawing upon the historical moment for inspiration (*Assalto alle prigioni* [*Assault on the Prisons*, 1945], *Incendio del villaggio* [*Burning of the Village*, 1945], *Il comiziante* [*Man at a Political Meeting*, 1946]), Vedova unleashed an automatism of seismic ferocity, unsurpassed as a correlative of the chaos of the times. All of this was suspended during 1946 for an obligatory acquiescence to picassism. With monumental personages comprised of collage-like components (*Cucitrice, n. 1* [*Seamstress, No. 1*, 1946], *Il pescatore* [*The Fisherman*, 1946])

and abstract compositions based on the flat patterning of the Cubist armature (*Immagine del tempo* [*Image of Time*, 1946], *Poemetto della sera* [*Evening Poem*, 1946], *Reticolati* [*Barbed Wire*, 1946]), Vedova dutifully prolonged the formal life of the superannuated French manner. In the course of the next two years, however, his innate turbulence reasserted itself. With several important paintings a shot of Futurist energy seems to have rocketed through the brittle structures of Cubism, shattering forever their stability and poise. In *Esplosione* (*Explosion*, 1948, fig. 9), *Lo Stregone* (*The Sorcerer*, 1948), and *Uragano* (*Hurricane*, 1948) he forged Cubism's geometric fragments into sickles and blades, claws and bayonets, and then sent them rotating through space against lurid bursts of raw color (see also cat. nos. 25, 26). The lofty authority of French art folded in the face of sheer temperament, expressive immediacy, and a fierce morality that committed painting to expressing a sense of historical crisis. By now Vedova had established himself as a formidable personality of the new generation. He already had shows in Milan, Genoa, Rome, Mantua, Turin, and Venice to his credit, and five of his 1948 paintings (*Il combattimento* [*The Battle*], *Esplosione*, *Il guado* [*The Ford*], *Morte al sole* [*Death in the Sun*], *Uragano*) were displayed in the Fronte Nuovo delle Arti section of the 1948 *Biennale*. Togliatti paid him the dubious honor of illustrating his infamous attack on the abstract art of the Alleanza exhibition with a photograph—printed upside down—of the painting *Uragano*.

During this same period Burri took his first steps as a professional painter in Rome. Already past thirty, the self-trained artist would budget little time for the initial exercises of personal discovery, for the identification of sources and affinities and the preliminary mapping of an independent course. Few works survive from these years in which he made a swift and decisive conversion to abstraction. Burri debuted in July 1947 at Galleria La Margherita with a group of still lifes and landscapes, a few dating back to his detention in Texas. The images were thickly painted, directly rendered, and free of unnecessary detail, revealing neither the descriptiveness of the naive artist nor the willful distortion of the novice expressionist, but rather a determined pursuit of immediacy, of actuality, in the material and color of paint itself. The following May, in his second solo at the Margherita, Burri offered nonobjective works flavored by the inspiration of Paul Klee. Before the year was out an understanding of Joan Miró, Arp, and Enrico Prampolini informed what was taking shape as Burri's idiosyncratic fusion of a governing rectilinear infrastructure with buoyant ovoid and bulbous elements. The surfaces remained resolutely anti-illusionistic and soberly monochromatic, but they were animated by the play of matte and glossy paint, by sudden eruptions of bright color, and by collaged patches of coarse canvas. Burri's work received scant critical attention, but his participation in the exhibitions of two art associations indicate that his efforts were taken as coinciding with the general aim of reintegrating Italian painting with the surviving strains of Europe's prewar avant-garde. Rome's Associazione dell'Art Club, founded in 1945 by Prampolini and Jozef Jarema to reconnect Italy with the progressive currents of international art, included compositions by Burri in its annual shows of 1947 and 1949, the latter a

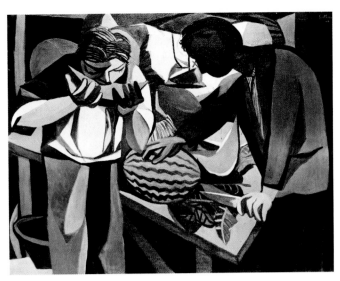

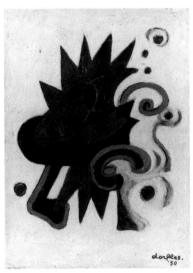

fig. 6. Renato Guttuso, Mangiatori di Angurie *(Melon Eaters), 1948. Oil on canvas, 89 x 116 cm. The Museum of Modern Art, New York, Purchase (by exchange).*

fig. 7. Gillo Dorfles, Composizione con 8 Creste *(Composition with 8 Crests), 1950. Oil on canvas, 30 x 40 cm. Courtesy of the artist, Milan.*

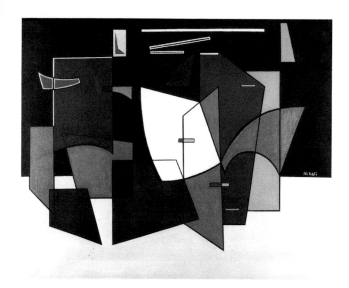

fig. 8. Atanasio Soldati, Allegro e fuga, 1950. Oil on canvas, 79 x 98 cm. Galleria Gian Ferrari Arte Moderna, Milan.

fig. 9. Emilio Vedova, Esplosione (Explosion), 1948. Oil on canvas, 150 x 130 cm. Philadelphia Museum of Art, Philadelphia.

crucial year that also saw Burri's first trip to Paris and the inclusion of his work in the Salon des Réalités Nouvelles. The Salon had sprung from the prewar Abstraction-Création group, and by 1949, after tolerating a certain heterodoxy in the definition of nonfigurative art, it had narrowed its support to an essentially retrospective practice of geometric Purism.[23]

Paradoxically, Burri already had set out to subvert the very tradition the Salon defended, for by now he was adding sand, pumice, and tar to his paintings, building a heterogeneous surface that asserted a grossly existential presence in utter defiance of the transcendence promised by the nonfigurative art of the past. This violation of the surface by extrapictorial materials (see fig. 10, cat. nos. 1–5) bears some kinship with the *matiérisme* (matter painting) of Jean Fautrier and Jean Dubuffet, whose work Burri doubtless saw in Paris. But where the French artists embedded an image, however latent or primal, in the physically charged surface, Burri banished any trace of image making in favor of defining painting as a wholly material practice. Perhaps more to the point than contemporary French efforts was the Futurist concept of *polimaterismo* (polymaterialism), which had urged artists to overthrow the traditional unity and preciousness of sculpture by combining materials of the most heterogeneous and least exalted nature, from transparent celluloid and metal strips to cloth, mirrors, and electric lights.[24] Burri's Roman colleague Prampolini had reanimated these ideas during the 1930s with a group of audacious mixed-media works (see fig. 11). In his 1944 book summarizing the working principles of *polimaterismo*, Prampolini made a crucial distinction between the collages of the early masters of Futurism, Cubism, Dada, and Surrealism, who had sought to create a relationship between painting and the applied element, and the utterly uncompromising contemporary practice he was advocating, which would exchange painting and its illusions for material reality and its innate expressive value:

Polymaterial art is a free artistic conception that rebels against the beloved use and abuse of colored pigment, the mixer, the adulterator, the mystificator; against the function of the visual illusionism of pictorial means, from the most reactionary to the most revolutionary. To make the most unthinkable materials rise to a sensitive, emotive, artistic value constitutes the most uncompromising critical assertion against the nostalgic, romantic, and bourgeois palette.[25]

Prampolini's words might be taken as a license for Burri's deeds. After 1949 Burri incorporated canvas sacking, scrap iron, wood, and plastic in his art, each time revealing the eloquence of "the most unthinkable materials" (see cat. nos. 29–40, 73–75). Yet if the transcendence and integrity of traditional painting were mortified by his actions, the heroism of the art object and its creator was enhanced. Indeed the more determinedly Burri scavenged among the low and seemingly inexpressive materials of modern life, the greater seemed his power to transform those substances into organized expressions of feeling and value, expressions that were centered on an object that, for all its transgressions, insisted on being included within an enlarged category of "painting." Prampolini's essay,

however, called for more than a revolution in materials. He opened the door for a conceptual revolution as well. Beneath the epigram "L'éphémère est éterne [sic]" (The ephemeral is eternal) he proclaimed that the essence of a work of art lay not in the enduring physical fact of the product but in the "spectacular instant" of the visual experience.[26]

The undated manifesto of the artists who called themselves Spazialisti advanced a comparable if more militantly stated desire to liberate art from a nostalgic and retentive attachment to objects:

Art is eternal, but it cannot be immortal. . . . It will remain eternal as gesture, but will die as material. . . . We believe we can free art from material, to free the sense of the eternal from the preoccupation with immortality. And it does not matter to us if a gesture, once completed, lives but a moment or a millennium, because we are truly convinced that, once completed, it is eternal.[27]

Despite their grandiloquent evocation of the eternal the Spazialisti nonetheless felt themselves uniquely of the moment in their certainty that the work of art was a means and not an end in itself, that the purpose of a valid art was to crystallize the experience of the contemporary, and that the nature of the contemporary would be disclosed through the insights of science. The formulation of these convictions was guided and inspired by the charismatic Fontana. From the outset of his career in the 1930s Fontana had shown a restless and irreverent approach to materials. Whether scratching improvisational and wayward abstract designs on concrete tablets or contradicting the actual mass of his figural sculpture with applications of gold leaf or mosaic to the surfaces, he seemed to be testing the traditional limits of art. In 1939 an admiring if somewhat baffled Argan wrote of Fontana's "unstable, liquid space" and of the paradoxical dialectic of his work, which took as its theme nothing less than "the problem of volume and of plane, of single or multiple or simultaneous vision, and, in short, the dilemma of painting and sculpture."[28] Fontana's position among the various factions and alliances within the art world of Fascist Italy had been no less mercurial. He exhibited with the nonfigurative artists of Galleria del Milione and with the expressionists of the Corrente group. He competed successfully for official recognition throughout the 1930s; in 1938, he appeared on the list of progressive artists singled out in a right-wing effort to establish Italy's own group of "degenerate" artists.[29]

When Fontana returned to Milan in April 1947, he already had directed his Buenos Aires students in composing the *Manifiesto blanco* (White manifesto), the 1946 document that laid the groundwork for Spazialismo. Announcing the exhaustion of painting and sculpture in a "mechanical" era, the students had called for a four-dimensional art involving color, sound, movement, and time.[30] With no diminution of enthusiasm, they conceded that the means were as yet unknown. The successive statements by the Spazialisti testify to the difficulty of establishing those means. Their manifesto of March 1948 described "artificial forms, rainbows of wonder, and luminous writings" created in the sky, as well as photographs of the earth from a rocket in flight—none of

which strayed very far from the Futurist vision.[31] The turning point was Fontana's *Ambiente spaziale con forme spaziali ed illuminazione a luce nera (Spatial Environment with Spatial Forms and Black-Light Illumination)*, an installation that occupied Galleria del Naviglio for six days in February 1949. With emanations of black light playing across spiraling forms painted in fluorescent colors, the *Ambiente* amounted to an experience in actual space and time that put the viewer/participant at the center of the artwork as no Futurist painting, all mimetic vortices and whirlpools, had ever done. Fontana's creation was neither painting nor sculpture, nor was it even permanent, though from the perspective of the Spazialisti it was surely "eternal." According to writer and Spazialismo adherent Beniamino Joppolo, "spaces" had become the new plastic and colored material.[32] Henceforth Fontana would contest the physical objectness of art as determinedly as Burri would reinforce it. Also in 1949 Fontana created his first *bucchi*, or "holes," compositions consisting of multiple perforations in fields of white paper or canvas (see cat. nos. 11–13). The *bucchi* superceded any previous gesture of negating the physical surface of painting, from Renaissance linear perspective to Monet's *Nymphéas* to the metaphoric white "infinity" in which hovered Kazimir Malevich's Suprematist components. As light pierced the blackness of the *Ambiente* to render a composition in real space and time, so light traversed the punctured and permeable canvas to enter the measureless black space beyond. Fontana called these works *concetti spaziali*, or "spatial concepts," a title he first had coined for a ring-shaped sculpture of 1947 and would continue to use throughout his career (see cat. nos. 45–57, 94–97).[33] Taken together, these efforts anticipated, in both name and intent, conceptual art's "dematerialization" of the object twenty years later.

In terms of Italian national life the year 1950 did not so much inaugurate a new decade significantly different from its predecessor as open the final chapter of the post-Fascist experience. Not yet discernible on the horizon was Italy's stunning transformation from a predominantly agricultural country to a car-enamored stronghold of consumer capitalism, a metamorphosis whose symbolic beginning has been identified variously with the introduction of the Fiat 600 in 1953, with the commencement of regular television broadcasting in 1954, and with the more statistically determined birth of the "economic miracle" in 1958.[34]

If events of the later 1950s laid the foundation for 1960s-style prosperity, the very early 1950s were still flavored by a sense of "aftermath" and transition. These years saw the last of the labor unrest and peasant uprisings that had inherited the insurrectionary momentum of the anti-Fascist front and finally crumbled in the face of the government's conservative policies on monetary, wage, and agricultural reform. In filmmaking the starkly confrontational and crusading spirit with which neorealism had chronicled the struggles of the poor survived to around 1953, when it yielded to the sentimentally resolved melodramas of "pink neorealism" and a growing public appetite for escapist comedies. Fewer artists' statements and manifestos pledged their authors and signatories to collective action for social and political regeneration. One was more likely to encounter declarations of art's

fig. 10. Alberto Burri, Nero I (Black I) 1948. Tar, oil, enamel, and pumice-stone on canvas, 57 x 48.5 cm. Fondazione Palazzo Albizzini, Collezione Burri, Città di Castello.

fig. 11. Enrico Prampolini, Intervista con la materia (Interview with the Material), 1930. Mixed media, dimensions unknown. Location unknown.

uncompromising creative liberty—Vedova compared it to the experimental freedom of the scientist—and the assertion that the "moral" position now coincided with resistance to every extra-art consideration.[35]

Typical of the moment was the manifesto of the Gruppo Origine, signed in Rome in January 1951 by Mario Ballocco, Burri, Giuseppe Capogrossi (see cat. no. 6), and Ettore Colla (see cat. no. 42). The styles and interests of the signatories were as divergent as those of the Fronte Nuovo delle Arti members had been. Unlike the Fronte, however, Origine's solidarity did not call for activism and community in the face of historical necessity. Rather the four subscribed to the belief that "the morally most valid starting point of the 'non-figurative' exigencies of expression" was complete individual freedom with no concessions to content, decoration, or pleasure.[36]

Even more characteristic of the emerging situation is the story of Gli Otto, an affiliation formed in 1952 to promote the critical and commercial fortunes of its membership: Afro [Afro Basaldella], Birolli, Antonio Corpora, Mattia Moreni, Morlotti, Santomaso, Turcato, and Vedova.[37] Some of the painters resolved to keep their political opinions to themselves lest they jeopardize the image then being crafted by their chosen spokesman, Venturi. With one eye firmly fixed on the international audience, Venturi portrayed Gli Otto artists as independents victimized by the contentious factionalization of the Italian art world. Still determined to insert Italian painting into a continuing history of European Modernism, he assured his readers that the eight were "up-to-date" and that they were securely positioned at the end of an avant-garde genealogy that could be traced back to Cubism, Expressionism, and early abstraction. In another identification of morality with the values of autonomy and individual sensibility, Venturi explained that Gli Otto was dedicated above all to protecting the uncompromised "formal whole" that is the painting, and that here was to be found the "complete, disinterested moral responsibility which is necessary to every work of art."[38]

It is tempting to consider Vedova, Burri, and Fontana during the years 1950–52 as emblems of the multiple cultural impulses of their changing country. Vedova remained the committed leftist reborn as the lone existential warrior, venting his considerable terribilità in paintings that evoked conditions of strife and flux. By 1951, with such works of that year as Aggressività (Aggressiveness), Immagine del tempo (Sbarramento) (Image of Time {Barrier}, fig. 12), and Scontro di situazioni (Collision of Situations), he was unleashing great storms of paint, titanic encounters between hefty thrusting forms and reckless slashes of pigment. The tempestuous compositions corresponded to the inner human condition—what Vedova called "the data of interior equivalences"—rather than to specific and objective circumstances of conflict, though the artist's avowed preoccupation with the renewal of social relationships was undiminished.[39]

Burri's individualism was less truculent, although more pessimistic. His works, at once imperious and introverted, seemed to declare what has been described as the artist's "disdainful secession" from a postwar culture whose spiritual condition could not fail to disappoint him but whose anguish he could not help but express.[40] In 1950

Burri introduced the *Sacchi* (Sacks, see fig. 13, cat. nos. 31, 32, 34, 35, 37), compositions whose surfaces were fields of torn and weathered burlap and whose crude materiality threw the definition of painting into crisis.[41] For all the filthy degradation of the material the works were elegantly structured according to an implicit, if flexible, grid. If on the one hand this seemed a belated reaffirmation of Cubist geometry and of the transformative powers of the artist in the manner of Picasso and Kurt Schwitters, it was also argued, most notably by Argan, that Burri had created something of an unprecedented and subversive nature, a "simulation of a picture, a sort of *trompe-l'oeil* in reverse, in which it is not painting which simulates reality, but reality that simulates painting."[42]

Fontana likewise opened up a new avenue of transit between art and "reality," though one that undermined the very category of painting, counterfeit or otherwise. He followed the voids of the *bucchi* with their physical converse, canvases strewn with irregular "stones" of translucent Murano glass. Pushing his exploration of space and light, he created his first *ambiente* with neon at the 1951 Milan *Triennale*. The *Arabesco fluorescente* (*Fluorescent Arabesque*, see cat. no. 624), about 300 meters of tangled neon tubing suspended from a ceiling, proposed a new form of gestural art, linear yet three-dimensional, temporary, electric. It was followed in 1952, at the Fiera Campionaria in Milan, by the *Soffitto spaziale* (*Spatial Ceiling*), which featured simpler forms comprised of standardized light elements. That same year Fontana and seventeen colleagues, including Burri, signed the *Manifesto del movimento spaziale per la televisione* (Manifesto of the spatial movement for television), a prescient, pre–Marshall McLuhan insight into the potential of electronic broadcasts to serve as the "plastic" material of art.[43]

The achievements of Italian artists by 1952 would soon be adduced by critics and historians as evidence of Italy's full and timely participation in the new art of the postwar avant-garde, an avant-garde that had been purged of idealism, rationalism, and any other vestigial influences, and whose participants shared an engagement with the phenomenological presentness of the materials of art. The elastic rubric *Informale*—wording borrowed from French critic Michel Tapié's formulation of Art Informel—came into favor at the end of the 1950s and subsequently was applied to a wide range of expressions, although writers would disagree on the essential roster of Informale artists: for some Burri's work was too elegantly structured, or Morlotti's thickly painted landscapes were more neoromantic than gestural, or Fontana showed too much of the optimism of the old-style avant-garde paladin when he claimed to sever all ties with the past. Argan described Informale as an art of pure existence in the present to be experienced without memories or reflections, an art of absolute alienation in which intentionality has supplanted ideology, an art freighted with postwar despair.[44] For Renato Barilli, Informale was an art that insisted on the world and all of its chaos, disorder, and contingency.[45] The elusive yet inclusive category was summed up cautiously by Maurizio Calvesi:

More than a movement and a trend, in fact, it was an instance, a point of convergence of the newest researches, a critical and creative attitude characteristic of a period of crisis and development. Informale evidently did not have national limits, even if it could assume altogether differentiated physiognomies in individual countries. If, therefore, Informale was not a movement of precise and outwardly classifiable linguistic characteristics so much as a new mental angle on the aesthetic phenomenon, the establishment of a new relationship between the artist and his work, a new and different awareness of the artistic event and of the making of art, then it is no surprise that its breadth was so great as to embrace contrasting extremes of expression and widely divergent creative attitudes.[46]

According to Calvesi, it was Italy's sporadic and incomplete acquaintance with the early avant-garde, along with the soul-searching and false starts of the first postwar years, that accounted for the rich diversity within the art of Informale in Italy, compared to the more straightforward stylistic coherence of American Action Painting. The chronic liability had become an asset after all. It might be too much to say that the old fears of provincialism, dependence, and inferiority had been assuaged forever by Vedova, Burri, and Fontana, but with their unassailable confidence in their own pertinence and their willing exchange of the debts of the past for the unlimited possibilities of the present, the three artists established a vital standard of independence and experimentation that granted Italian art its moment of being finally, unapologetically, Modern.

fig. 12. *Emilio Vedova*, Immagine del tempo (Sbarramento) *(Image of Time [Barrier]), 1951. Egg tempera on canvas, 130.5 x 170.4 cm. Peggy Guggenheim Collection, Venice.*

fig. 13. *Alberto Burri*, Sacco *(Sack), 1952. Burlap and oil on canvas, 99.5 x 85.5 cm. Fondazione Palazzo Albizzini, Collezione Burri, Città del Castello.*

Research for this essay was conducted with the support of the Summer Stipend Program of the National Endowment for the Humanities.

Quotations from the original Italian have been translated into English by the author. The manifestos of artists' groups are reprinted in the Appendix that appears at the end of this volume, as well as in the sources cited by the author.

1. Mario de Micheli, "Gli Anni di Corrente," in Carlo L. Ragghianti et al., *Corrente: il movimento di arte e cultura di opposizione 1930–1945* (Corrente: art movement and culture of opposition, 1930–1945. Milan: Vangelista, 1985), pp. 106–07, 113 n. 18. De Micheli quotes the painter Ernesto Treccani on events leading up to the 1943 raid. Other catalogues have referred erroneously to a date of 1942.

2. A comprehensive historical picture is provided by Paul Ginsborg, *A History of Contemporary Italy: Society and Politics 1943–1988* (London: Penguin, 1990). Essential general histories of Italian art of this period include the landmark documentary study by Tristan Sauvage, *Pittura italiana del dopoguerra (1945–1957)* (Italian postwar painting [1945–1957]. Milan: Schwarz, 1957); Enrico Crispolti, *L'Informale storia e poetica* (Informale: history and poetics. Assisi-Rome: Beniamino Carucci, 1971); and Renato Barilli et al., *L'Informale in Italia* (Informale in Italy. Milan: Gabriele Mazzotta, 1983). Collections of documentary material include Paola Barocchi, ed., *Storia moderna dell'arte in Italia III: tra neorealismo ed anni novanta, 1945–1990* (Modern history of art in Italy III: between neorealism and the 1990s, 1945–1990. Turin: Einaudi, 1992); and Germano Celant, *L'Inferno dell'arte italiana: materiali 1946–1964* (The inferno of Italian art: materials 1946–1964. Genoa: Costa & Nolan, 1990). The political context is detailed by Nicoletta Misler, *La via italiana al realismo: la politica cultura e artistica del P.C.I. dal 1944 al 1956* (The Italian road to realism: the cultural and artistic policy of the PCI from 1944 to 1956. Milan: Gabriele Mazzotta, 1972).

3. Ernesto Treccani and Ennio Morlotti, *Primo manifesto di pittori e scultori*, 1943, reprinted in Sauvage, pp. 221–22.

4. Ennio Morlotti, "Guernica," *Numero* 2 (January–February 1946), reprinted in Sauvage, pp. 229–31.

5. Benedetto Croce (1866–1952), arguably the most influential anti-Fascist intellectual in Italy after 1925, advocated a position of scholarly "resistance" according to which it was morally sufficient to keep one's research and writing free of Fascist influence without having to engage in outright anti-Fascist activity. With the growth of repression in Italy, however, the preservation of intellectual autonomy came to be viewed, particularly by the Left, as an untenable luxury and an evasion. See Fabrizio Onofri, "Irresponsabilità dell'arte sotto il fascismo," *Rinascita* (Rebirth) 1 (1944), reprinted in Misler, pp. 98–107; and R. Bossaglia, *Parlando con Argan* (Speaking with Argan. Nuoro: Illiso, 1992), pp. 22–23.

6. Giulio Carlo Argan, "L'impegno politico per la libertà della cultura," in Giorgio Cortenova et al., *Da Cézanne all'arte astratta: omaggio a Lionello Venturi* (From Cézanne to abstract art: homage to Lionello Venturi. Milan: Gabriele Mazzotta, 1992), p. 12.

7. Misler, pp. 21–22.

8. "Manifesto del realismo," *Numero* 2 (March 1946), reprinted in Sauvage, pp. 232–33, the quotation is on p. 232.

9. Manifesto reprinted in Sauvage, p. 234. See also Enzo Di Martino, *Il Fronte Nuovo delle Arti* (The Fronte Nuovo delle Arti. Milan: Fabbri, 1988).

10. Manifesto reprinted in Sauvage, pp. 248–49, both quotations appear on p. 248.

11. Mino Guerrini, "Perchè la pittura," *Forma 1*, April 1947, cited in Sauvage, p. 112.

12. Giulio Carlo Argan, "Pittura italiana e cultura europea," *Prose* 3 (1946), reprinted in Giulio Carlo Argan, *Studi e Note* (Studies and notes. Rome: Fratelli Bocca, 1955), pp. 21–56, the quotation is on p. 32. For a detailed discussion of the issue of internationalism and painting in postwar Italy, see Marcia E. Vetrocq, "National Style and the Agenda for Abstract Painting in Post-War Italy," *Art History* 12, no. 4 (December 1989), pp. 448–71.

13. On Venturi's continuing role as Italy's leading advocate of international Modernism, see Vetrocq, pp. 458–61.

14. Piero Dorazio, *La fantasia dell'arte nella vita moderna* (The fantasy of art in modern life. Rome, 1955), cited in Augusta Monferini, "Dagli

'Archivi dell'Impressionismo' al museo-scuola," in Cortenova et al., p. xii.

15. Quoted in Sauvage, from a conversation with Morlotti, p. 199.

16. Cesare Brandi, "Europeismo e autonomia di cultura nella pittura moderna italiana," *L'immagine* (Image) 1 (1947), pp. 3–11, 69–86, 133–56.

17. Giuseppe Marchiori, *Pittura moderna italiana* (Modern Italian painting. Trieste: Stampe Nuove, 1946). Vedova is discussed on p. 28.

18. On the developing ideology of the DC, see Ginsborg, pp. 182–85. American intervention in the Italian elections literally became a textbook case for foreign policy students. See Morris Janowitz and Elizabeth Marvick, "U.S. Propaganda Efforts and the 1948 Italian Elections," in William Daugherty, *A Psychological Warfare Casebook* (Baltimore: Johns Hopkins, 1958), pp. 320–26; and James E. Miller, "Taking Off the Gloves: The United States and the Italian Elections of 1948," *Diplomatic History* 7, no. 1 (Winter 1983), pp. 35–55.

19. On the Alleanza exhibition and its aftermath, see Misler, pp. 57–60. Togliatti's review and the letter, along with his response, are reprinted in Barocchi, pp. 77–84. The Fronte Nuovo delle Arti was declared officially dissolved in March 1950.

20. The occasion is recalled by Emilio Vedova in *Scontro di situazioni* (Collision of situations. Milan: All'Insegna del Pesce d'Oro, 1963), p. 10 n. 3.

21. Sauvage, pp. 91–95. For prewar background, see Paolo Fossati's standard study *L'immagine sospesa: pittura e scultura astratte in Italia, 1934–40* (The suspended image: abstract painting and sculpture in Italy, 1934–40. Turin: Einaudi, 1971); and Fossati's essay "Abstract (and Non-Figurative) Art of the 1930s," in Pontus Hulten et al., *Italian Art 1900–1945* (New York: Rizzoli, 1989), pp. 223–34.

22. The 1951 *Manifesto del MAC*, written by Gillo Dorfles, is reprinted in Sauvage, pp. 235–37.

23. Dominique Viéville, "Vous avez dit géométrique? Le Salon des Réalités Nouvelles 1946–1957," in Germaine Viatte et al., *Paris-Paris: créations en France 1937–1957* (Paris–Paris: creations in France 1937–1957. Paris: Centre Georges Pompidou, 1981), pp. 270–82.

24. Maurizio Calvesi, "Futurism and the Avant-Garde Movements," in Hulten et al., pp. 62–64.

25. Enrico Prampolini, "Introduzione all'arte polimaterica," reprinted in Giovanna De Feo et al., *Arte astratta in Italia 1909–1959* (Abstract art in Italy 1909–1959. Rome: De Luca, 1980), pp. 15-16.

26. Ibid., p. 15.

27. Sauvage, p. 265. The undated manifesto, reprinted in Sauvage, pp. 265–66, was signed by Lucio Fontana, Giorgio Kaisserlian, Beniamino Joppolo, and Milena Milani. Giampiero Giani, a participant in the movement and the author of the early historical study *Spazialismo: origini e sviluppi di una tendenza artistica* (Spazialismo: origins and developments of an artistic movement. Milan: Edizioni della Conchiglia, 1956), and Crispolti, *L'Informale*, p. 305, attribute the manifesto to 1947, which seems to be supported by a reference within the *Proposta di un regolamento del movimento spaziale* (Proposal for a regulation of the spatial movement), sometimes called the *Terzo manifesto del spazialismo* (Third manifesto of Spazialismo) and dated April 2, 1950. Sauvage places it after the manifesto of March 18, 1948.

28. Argan, "Lucio Fontana," reprinted in *Studi e note*, p. 213.

29. Enrico Crispolti, "Futurism and Plastic Expression Between the Wars," in Hulten et al., pp. 211, 213.

30. Reprinted in Celant, *L'Inferno*, pp. 75–82.

31. Reprinted in Sauvage, p. 264.

32. Quoted in Crispolti, *L'Informale*, pp. 313–14. Joppolo's original essay appeared in the catalogue that accompanied the *Ambiente* installation.

33. Ibid., pp. 306, 313.

34. Ginsborg, pp. 210–17; and Stephen Gundle, "L'Americanizzazione del quotidiano: televisione e consumismo nell'Italia degli anni cinquanta," *Quaderni storici* (Historical notebooks) 62, no. 2 (August 1986), pp. 561–94.

35. Emilio Vedova, "Tutto va rimesso in causa," *Quaderni di San Giorgio* (Notebooks of San Giorgio), no. 2 (1954), reprinted in Germano Celant, *Vedova 1935–1984* (Milan: Electa, 1984), pp. 88–90.

36. Reprinted in Sauvage, p. 250.

37. For a detailed history of the group, see Luisa Somaini, "*Otto pittori italiani*" 1952–1954 ("Eight Italian painters" 1952–1954. Rome: De Luca and Milan: Arnoldo Mondadori, 1986).

38. Lionello Venturi, *Otto pittori italiani* (Eight Italian painters. Rome: De Luca, 1952), pp. 9–10.

39. In Celant, *Vedova*, p. 88.

40. Maurizio Calvesi, *Alberto Burri*, trans. Robert E. Wolf (New York: Harry N. Abrams, 1975; 1971), pp. 13–14. On this point Calvesi likens Burri to Morandi.

41. It has been noted frequently that discarded burlap sacks were the material on which Burri made his first paintings in Texas. Significant, too, is the collage *SZ1* (1949), in which Burri incorporated a fragment of a sack stamped with the markings of an American relief shipment. It was in 1949 that bread rationing finally ended in Italy. With their gaping holes, stitches, and patches, the *Sacchi* were ripe for interpretation as metaphors for the flesh—wounded, sutured, and scarred, as well as allusions to Burri's foresaken medical career, all of which the artist refuted.

42. Giulio Carlo Argan, "Alberto Burri," 1960, reprinted in Giulio Carlo Argan, *Salvezza e caduta nell'arte moderna* (Salvation and failure in modern art. Milan: Il Saggiatore, 1977; 1964), p. 260.

43. Manifesto reprinted in Sauvage, p. 270.

44. Giulio Carlo Argan, "Materia, tecnica e storia nell'Informale," 1959, reprinted in Argan, *Salvezza e caduta nell'arte moderna*, pp. 81–89.

45. Renato Barilli, "Considerazioni sull'Informale," *Il Verri*, no. 2, 1961, reprinted in Renato Barilli, *Informale oggetto comportamento* (Informale object behavior), vol. 1 (Milan: Feltrinelli, 1979), pp. 38–54.

46. Maurizio Calvesi, "L'Informale in Italia fino al 1957," first published 1963, reprinted in Maurizio Calvesi, *Le due avanguardie: dal Futurismo alla Pop art* (The two avant-gardes: from Futurism to Pop art. Milan: Lerici, 1966), pp. 205, 207.

Before the End of the Journey: Testimony across the Atlantic

Anna Costantini

The exchanges of ideas about art between the United States and Italy in the twenty years after World War II consist of physical encounters that changed beliefs, the painstaking pursuit of information and comparisons, and, most important, the personal testimony, oral and written, of the principal figures involved. With the help of such testimony, we can now re-create those encounters and that period, following private, ephemeral threads through a narrative mosaic of letters, photographs, and remembrances to isolate and characterize an epoch, a place, an atmosphere.

A radical transformation in the mode of artistic communication can clearly be dated, in Italy at least, to the period between the end of the 1960s and the beginning of the 1970s, the moment when the increasing expansion of the audience, and the consequent birth of a more organized culture industry, made all artistic activity public and official—and therefore more rapidly and broadly communicable. The growing number of specialized reviews, almost all of them bilingual and with a network of correspondents who followed international art events, as well as the publishing industry's own interest in the diffusion of information about art, which spawned the publication of the first critical surveys of the contemporary scene and the first retrospective exhibitions on the 1950s and 1960s—all represent the beginning of an increasingly accelerated mechanism of information that abandoned personalized forms of transmission, thus producing an essential change in the ideas of displacement and travel, and gave rise to a preferred, autonomous channel for the transmission of information and to the speed with which it was received.

The personal account, however, remains the means for retracing the hypothetical journey of ideas and people among Rome, Venice, New York, and Turin from the end of World War II to the end of the 1960s. It is a journey in which time is still proportional to distance, a journey recounted, photographed, and recorded in writing at each of its stages. The end of this system of communication, in those years, in art—but even more so, in general, the end of a way of life—presupposes the concomitant exhaustion of the very concept of testimony.

Rome

Throughout 1946 and early 1947 the center of artistic and political debate in Rome was the studio of Renato Guttuso on via Margutta. This was the meeting place for young Italian artists who had emerged from the experience of the war and had not yet been polarized by the polemics between abstractionists and realists, which were just beginning to heat up with the pro-abstraction positions included in the manifesto of the Forma group, published in March 1947. Also on via Margutta were the studios of, among others, Afro [Afro Basaldella, see figs. 4, 8], Nick Carone (an Italian-American painter), Angelo Savelli, Salvatore Scarpitta (born in New York but a resident of Italy since 1939), and Giulio Turcato.[1]

It was in Guttuso's studio in 1946 that Piero Dorazio (see figs. 1, 9) first met Ione Robinson, the American artist, photographer, and journalist who had come to Rome, along with Allied troops, as a correspondent for *Stars and Stripes*. A friend of Diego Rivera and José Clemente Orozco, Robinson had frequented the artistic milieu of Paris and

had then gone on to fight in Spain during the Civil War. Back in the United States she had met and assisted Count Carlo Sforza during his exile. Sforza was Foreign Minister of the fifth Giovanni Giolitti government in 1920 and the last Italian Ambassador to Paris before the advent of Fascism; he returned to Italy in 1945 and became President of the Council of State. In Rome, Robinson spearheaded the project, supported by Sforza, to transform the Foro Mussolini into a European center for the arts. She sought the participation of the major international artists of the time, most of whom she had met in Paris: Georges Braque, Fernand Léger, Henri Matisse, Joan Miró, and Pablo Picasso. In a letter to Dorazio she wrote: "For the U.S. it would be wonderful if in the press they read that the Italians were finally going to make this project. . . . It is for young Italians like you [and] Pietro [Consagra] to fight to realize something for the artists. If you insist and insist . . . there will be a way."[2] Unfortunately the project was never realized, but Robinson remained in Rome until mid-1948, contributing to the international flow of information and bringing to that city the first news of and contacts with American culture of the time, and with European culture that had taken refuge across the ocean during the war.

The Chilean artist Matta [Roberto Sebastián Matta Echaurren, see fig. 2] was particularly important in this process of bringing Italy up to date. By 1949, when he arrived in Rome, Matta had already absorbed the Surrealist experience, both directly, through contact with André Breton, Marcel Duchamp, Paul Eluard, Man Ray, and others in Paris, and indirectly, through the impact of Surrealism on the New York scene, for which Matta, especially to the younger generation, represented a point of reference. At the time of his arrival in Rome, Matta already knew Carone, who took him into all the important painters' studios, which Matta then frequented assiduously, "always in search of the truth, of something to be found and to discuss with others. Matta brought to Rome a wind of innovation that contained the whole intellectual debate about art that was raging in New York at the time. He wanted to go beyond Surrealism."[3] For Roman artists the first moment of exchange with the United States was mainly tied to a need to reenter the international debate— a debate that had been almost entirely lacking since 1936, when the Mussolini regime took an imperialist turn. The prestige of Paris, which had always been the primary reference point for those Italian intellectuals who had continued to look beyond their own national boundaries, had crumbled once and for all with the Nazi occupation. Nevertheless what occurred culturally and artistically in Rome with the arrival of the Allied troops was still influenced by the Parisian experience, which continued to dominate the international trends and market in art through its place of exile in New York.

In 1950 the New York art critic Milton Gendel settled in Rome, having just accompanied the American photographer Marjorie Collins, who was documenting the effects of the Marshall Plan for the U.S. State Department, on a trip to Sicily. During this journey Gendel produced his own photoreportage (see fig. 3), a series of shots that show the strong "influence of the neo-Realist films, with their hinterland of social realism à la Soviet cinema and their feelings and sensations derived from novels by the

fig. 1. Piero Dorazio photographed by Milton Gendel, Piazza di Spagna, Rome, 1950.

fig. 2. Toti Scialoja (left) and Matta (right) photographed by Milton Gendel, Rome, early 1960s.

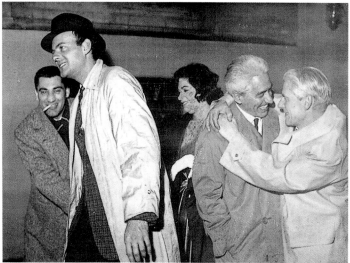

fig. 3. *Milton Gendel,* Palermo, *1950.*

fig. 4. *Left to right: Plinio de Martiis,
Cy Twombly, Ruth Klingman, Afro,
and Willem de Kooning, Rome, 1959.*

likes of [the] Narodniki [Russian populists], Knut Hamsun, and the rural Americans."[4] But although Gendel's very ordinary and humble Sicily—his gaze on reality and truth—represents a convergence of intents with the anti-Fascist generation of Italians who came of age politically in the pages of Elio Vittorini's review *Il politecnico* (Polytechnic), the artistic experiences that colored his thinking were still tied to Surrealism and to the European culture in exile in New York. In 1942 Gendel had been a fellow student with Robert Motherwell at Columbia University, and the two of them had been invited by Breton to coedit the review *VVV,* which was to be the New York replacement for the famous Parisian journal *Minotaure* (Minotaur). They would have causes for dispute with Breton well before the publication of the first issue of the review, but for these two young men the months spent preparing *VVV* had represented a chance to get to know the entire Surrealist group, and more generally the European artistic milieu that had formed in Greenwich Village. In 1943 Gendel had enlisted in the army "to rid the world of Hitler, Mussolini and Hirohito: . . . I decided to join the Army because I could not think of any good reason why I should stay out. The evening I told Breton that I was going into uniform, he looked at me with an ironic expression and said: 'Vous voulez participer à cette bêtise, mais je dois dire que c'est con' [You want to take part in this idiocy, but I must say that it's stupid]."[5]

Venice

American Abstract Expressionist art arrived in Italy at the *XXV Biennale,* the first *Biennale* of the postwar period, in 1948. In the Greek pavilion Peggy Guggenheim showed her collection, which would remain in Venice from then on. The collection brought with it the Surrealist experience and its New York assimilation—which was clearly becoming increasingly autonomous—in works by such artists as William Baziotes, Arshile Gorky, Motherwell, Jackson Pollock, and Mark Rothko.[6] Two years later, also in Venice, Peggy Guggenheim, in collaboration with the Italian publisher Bruno Alfieri, organized Pollock's first solo exhibition in Italy and Europe. The exhibition, held in the Sala Napoleonica, featured some twenty oils, drawings, and gouaches from Guggenheim's collection, plus two paintings obtained on loan from the Stedelijk Museum, Amsterdam.

The Italian response to the New York School, however, was still a long way from real comprehension. A slow but gradual acceptance only came about through direct acquaintance with the central figures themselves, from 1954 through 1956, when Italian artists and collectors made their first trips to New York. One of these collectors, Giorgio Franchetti, left for the United States in December 1957, shortly after meeting Cy Twombly (see fig. 4), who by then had decided to settle definitively in Rome. In New York, Franchetti bought some paintings and works on paper by Franz Kline, as well as two paintings by Rothko: *Purple Brown* (1957), which later found its way into the collection of Giuseppe Panza di Biumo (and eventually into that of The Museum of Contemporary Art, Los Angeles), and *Black in Deep Red* (1957). Panza was struck by the reproduction of a work by Kline published in the review *Civiltà delle macchine* (Culture of the machines, see fig. 5), and with his 1957 acquisition from Sidney Janis (see fig. 9)

of Kline's *Buttress* (1956, which is also now in the collection of The Museum of Contemporary Art, Los Angeles), he began to train his collector's eye on American art.[7] Indeed it was because of a deeper appreciation of the work of Gorky (whose first solo exhibition in Italy was presented by Afro at the Galleria dell'Obelisco, Rome in 1957) and to the news of American art now appearing in up-to-date reviews like *Arti Visive* (Visual arts) that the new American art came to be definitively consecrated in the great Pollock retrospective organized by the Galleria Nazionale d'Arte Moderna in Rome (with Palma Bucarelli as its curator) in 1958 (see fig. 6).

New York

The situation had become very tense for abstract artists in Rome by the late 1940s. For those who had emerged from the war sharing the ideals of the liberation, the disappointment in finding the PCI (Partito Comunista Italiano/Italian Communist Party) firmly opposed to bringing the art scene into line with international trends was severe. Dorazio and the Forma group were the first to feel the effects of this, suffering a kind of excommunication for espousing an art of formal experiment rather than one of figurative expression. The primary destination for those wishing to burst free of these already stifling limitations was still Paris, where Dorazio, for example, went in 1948 on a scholarship. But the idea of America was becoming increasingly powerful, and the desire of so many young people to look elsewhere was often accompanied by this idea of a country that knew about freedom and "had in its own constitution the principle of the pursuit of happiness."[8] A number of Italian artists with a variety of aspirations and expectations left for the United States at this time: Afro, who went to New York in 1950 for his first American solo exhibition at the Catherine Viviano Gallery; Mimmo Rotella, who went to Kansas City on a scholarship in 1951; Dorazio, who was invited to Harvard University in 1953 for the Harvard International Summer Seminar; and Savelli, who went from via Margutta to Paris and then on to New York, where he settled permanently in 1954. The mythified expectations of New York's openness to art and artists that had been created on the European side of the ocean were disappointed. In 1956, for example, when Toti Scialoja (see fig. 2) and his wife, Gabriella Drudi (see fig. 7), arrived in New York just after Pollock's death, the Abstract Expressionist group had all the qualities of a closed community living on the margins of the city, misunderstood and plagued by economic woes. Most of the artists had other jobs in order to earn enough to live, and the luckier ones enjoyed teaching positions.[9]

For young Italian artists the point of reference in New York became the Catherine Viviano Gallery, which, aside from the quasi-annual shows of Afro, exhibited work by such artists as Fausto Pirandello (1955), Scialoja (1956), Luciano Minguzzi (1956), Mirko [Mirko Basaldella] (1957), Renato Birolli (1958), Ennio Morlotti (1959), and Dino Basaldella (1961). The New York market was still dominated by European art, and Catherine Viviano (see fig. 8), who had worked for many years with the dealer Pierre Matisse, struck out on her own in an enterprise analogous to Matisse's earlier strategy with French artists, presenting the recent Italian painting most closely linked,

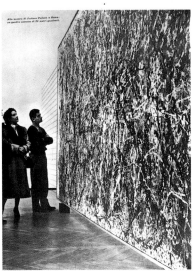

fig. 5. Cover of Civiltà delle macchine *5, no. 4 (July–August 1957), showing detail of a work by Franz Kline.*

fig. 6. Back cover of Civiltà delle macchine *6, no. 3–4 (May–August 1958), showing the Jackson Pollock retrospective at the Galleria Nazionale d'Arte Moderna, Rome.*

fig. 7. Gabriella Drudi (left) and Willem de Kooning (right) photographed by Toti Scialoja, at de Kooning's Tenth Street studio, New York, October 1956.

fig. 8. Catherine Viviano (left) and Afro (right), Venice, 1950s.

for the moment at least, to the post-Cubist tradition.

When Leo Castelli (see fig. 9) and his wife Ileana transformed their New York apartment into an exhibition space in February 1957, the inaugural show, despite the presence of Willem de Kooning (see figs. 4, 7), Pollock, and David Smith, attested to a marked reliance on the European culture centered in Paris, a culture to which Castelli, by origin and by choice, clearly belonged. The following year the Castellis traveled to Italy in search of a circuit of artists, and therefore of buyers, that would involve Europe. In August, Castelli wrote to Dorazio: "I want to tell you again how much I liked the milieu in Rome. I think you've made tremendous progress in the last two years, and with an intelligent exchange policy (in which, with your and Plinio [de Martiis]'s help, I would like to play an important part), Rome could become the third center of world art."[10]

Castelli visited the *Biennale* in Venice with the intention of establishing a policy for his New York gallery: "I stopped a long time in the section for young Italian and foreign artists, and also for older Italians, mostly to look at those artists you've spoken to me about, who might be taken into consideration for a group show in New York."[11] Nevertheless the Leo Castelli Gallery would evince no further interest in contemporary Italian art in the seasons that followed, except for an exhibition, during the 1958–59 season, of work by Savelli, then a resident of New York.

Turin

If Castelli's interest in Italian and European art gradually diminished in the three years from 1959 to 1962—the year in which Roy Lichtenstein, whom Castelli had met the year before,[12] had his first solo exhibition at Castelli's gallery—the search for a possibility of exchange with Italy, and especially with Rome, continued with Castelli's ex-wife Ileana, who in the meantime had married Michael Sonnabend. Nineteen sixty-one was the year of her first attempt to open an exhibition space in Rome, for which she again sought the help and collaboration of de Martiis (see fig. 4).[13] She was also looking for Italian artists to exhibit and soon signed a contract with the Roman artist Mario Schifano, a relationship that would prove to be short-lived and fraught with conflict.

Ileana Sonnabend's European debut would take place in 1962, not in Rome but in Paris, and would have immediate consequences for the Italian art scene.[14] The link would be Turin, the base of operations for Michelangelo Pistoletto and in 1960 the site of his first solo exhibition at the Galatea gallery (where the future art dealer Gian Enzo Sperone would soon work as an assistant). In 1963, after his second show at Galatea, Pistoletto went to Paris and met Sonnabend.[15] His first foreign show would take place in the Sonnabend exhibition space on Quai des grands Augustins on March 4, 1964, just a few months after their meeting. Indeed it was through Pistoletto that Sperone, by now director of Il Punto gallery and soon to become a dealer in his own right, met Sonnabend in Paris.[16] This introduction gave birth to the exhibition and market circuit that would lead to Lichtenstein's first solo exhibition in Italy, at Il Punto, in December 1963, six months before the definitive establishment of Pop art in Italy and Europe at the famous *XXXII Biennale* in Venice.

Rome continued to sustain a spontaneous international milieu, which enabled galleries like Gian Tomaso Liverani's La Salita to present the first Italian solo exhibitions of Christo [Christo Jaracheff] in 1963 (see fig. 10) and Richard Serra in 1966, but in the early 1960s a gradual shift took place. The international art circuit in Italy slowly moved to the North, in particular to the industrial triangle of Turin, Genoa, and Milan. This clearly arose from the establishment of a circuit of collectors, which gave rise to a growing demand for information, which in turn was fostered and fed by the industrial expansion during the years of the *miracolo italiano* (Italian miracle).[17] The Italy now taking shape was a consumer Italy far closer to the American model so idealized by the generation of Italian artists and intellectuals born in the 1920s, but for this very reason it was also called into question at the end of the 1960s, primarily by artists. The birth of Arte Povera in Genoa (where the first Arte Povera exhibition, curated by Germano Celant, was presented in 1967 at La Bertesca gallery) and Turin (where Sperone represented every artist of the movement, all of whom had been born or long active in that city) was the ideological confirmation of an Italy now fully emerged from the war, which had embraced rather than spontaneously generated a model of production historically foreign to it. It was also Turin that hosted the first Italian exhibition to bring together Land Art, Arte Povera, and Conceptual Art, a show, again curated by Celant, that bore witness, even through the acceleration of the information process, to the growing pointlessness of singling out one center to move toward or away from. In the foreword to the catalogue of the 1970 show at the Galleria Civica d'Arte Moderna, the very conception of the exhibition catalogue was analyzed:

catalogue as
. . . space where public or private
documents are reproduced
sign of a passage, memory, testimony, vestige
. . . all this serves to document, to provide
means or informative material in a specific field
of research
object of study
historical testimony
. . . critical interpretation of the events to be
remembered
what makes the past relive in the mind
. . . work's maximum entropy in art
knowledge of a being-there conditioning what and
how we perceive today.[18]

Paradoxically, the very experiences of Land Art and Arte Povera, which imply yet again a dialogue between the United States and Italy, as well as an expansion of the concept of the place of art and its documentation, represent a transition, a change in the methods of transmitting the artistic act. They bring to an end the gradual exhaustion of that system in which the concepts of the journey—as path and exchange, as quest for comparison and vision—and testimony were seen as the exclusive, indispensable premises of communication for an entire generation.

Translated, from the Italian, by Stephen Sartarelli.

fig. 9. Left to right: Piero Dorazio, Sidney Janis, and Leo Castelli photographed by Virginia Dortch, Caffè Paradiso, Venice, early 1960s.

fig. 10. Christo at Villa Borghese, Rome, 1963.

This text should be considered a first step toward future explorations and a continuation of the research that began in 1993 with Germano Celant and Anna Costantini's *Roma–New York 1948–1964*, the idea for which originated with Celant. The notations contained herein were written thanks to the help and generosity of many people, foremost among them Piero Dorazio. To him and Giuliana, I express my heartfelt gratitude. My thanks go also to Gaspero Del Corso, Virginia Dortch, Barbara Drudi, Gabriella Drudi, Maurizio Fagiolo dell'Arco, Milton Gendel, Mario Graziani, Matthew Horton, Maria Grazia Indrimi, Toti Scialoja, and the Catherine Viviano Estate.

1. Laura Cherubini, "Da via Sallustiana a via del Lavatore. Per luoghi con gli artisti," in Achille Bonito Oliva, ed., *Tutte le strade portano a Roma?* (Do all roads lead to Rome?), exhibition catalogue (Rome: Edizioni Carte Segrete, 1993), especially pp. 33–37.
2. Ione Robinson to Piero Dorazio, New York, November 9, 1948, Archivio Dorazio, Todi.
3. Piero Dorazio, conversation with Anna Costantini, February 13, 1994, Todi.
4. Milton Gendel, "Nota dell'autore," in *Milton Gendel. Fotographie del 1950* (Milton Gendel. Photographs of 1950), exhibition catalogue (Palermo: Sellerio, 1988), p. 12.
5. Milton Gendel, *Da margine a centro/The Margin Moves to the Middle* (Rome: 2RC Edizioni d'arte, 1993), pp. 1, 7.
6. Enzo Di Martino and Philip Rylands, *Flying the Flag for Art. The United States and the Venice Biennale 1895–1991* (Richmond: Wyldbore & Wolferstan, 1993), pp. 83–97, 277–79.
7. Interview with Giuseppe Panza di Biumo by Christopher Knight, in *Arte anni Sessanta/Settanta. Collezione Panza* (Art of the sixties and seventies. The Panza collection. Milan: Jaca Book, 1988), pp. 18–19. An article on Kline, signed by the Roman artist Achille Perilli, appeared in *Civiltà delle macchine*, no. 3 (May–June 1957). In the following issue the review devoted its cover to a work by Kline; this, according to Franchetti, "particularly marked the understanding of the American phenomenon in the artistic and cultural world of Rome." See Germano Celant and Anna Costantini, *Roma–New York 1948–1964*, trans. Joachim Neugroschel, exhibition catalogue (Milan: Charta, 1993), p. 141.
8. Toti Scialoja, conversation with Anna Costantini, February 13, 1993, Rome.
9. Celant and Costantini, pp. 120–22.
10. Leo Castelli to Piero Dorazio, August 9, [1958], Archivio Dorazio, Todi. The year is not indicated, but it can be traced through the letter's precise references to the 1958 *Biennale*. In the short time since his gallery had opened, Castelli had already presented the first solo exhibition of Jasper Johns in January and a show of Robert Rauschenberg's combines in March. De Martiis's Galleria La Tartaruga on via del Babuino, Rome had been open for four and a half years.
11. Ibid. Castelli continued:

Perilli is good, but perhaps not autonomous enough yet. Certainly worth following. Turcato, *like Capogrossi {whom Castelli had exhibited in New York a few months earlier, in April}, probably wouldn't have much success in America at the moment.* Scanavino, *many of whose paintings I've seen at the Cavallino, already has a physiognomy that is rather all his own. A bit solid, perhaps.* Chighine, *on the other hand, seemed less interesting to me. A bit too precious. I've been to see* Vedova. . . . *I like his painting a lot. I think that Vedova may be one of the most mature painters in Italy. Well, there you have very briefly a few of my fleeting and very incomplete impressions, from which you will have gathered that I haven't yet arrived at any final conclusion as to who would make up my group. Perhaps you've given it a little thought yourself and have some ideas. . . . For the moment, the nucleus would seem to be Dorazio, Vedova, and Scanavino. As for Scarpitta, I have other plans, since his current works can no longer be called paintings.*

12. For Castelli's discovery of Pop art through his friendship with Lichtenstein, see Ann Hindry, *Claude Berri rencontre/meets Leo Castelli* (Paris: Renn, 1990), pp. 101–03.
13. According to de Martiis, "Mrs. Sonnabend came in 1960 and we talked about running a gallery together in Rome. In 1961, she came for good with her new husband. I even found her an apartment on Passeggiata di Ripetta, and we began work together on the gallery. Things didn't go very well, however, and we split up after only a few months." See Federica Pirani, "Intervista a Plinio de Martiis," in Maurizio Calvesi and Rosa Siligato, eds., *Roma anni '60. Al di là della pittura* (Rome in the '60s. Beyond painting), exhibition catalogue (Rome: Edizioni Carte Segrete, 1990), p. 339.
14. For the story of Ileana Sonnabend's activities, see Michel Bourel, "Les galeries d'Ileana Sonnabend," in *Collection Sonnabend*, exhibition catalogue (Bordeaux: Musée d'Art Contemporain, 1988), especially pp. 11–30.
15. See Germano Celant, ed., *Pistoletto*, exhibition catalogue (Milan and Florence: Electa, 1984), pp. 26–29, where Pistoletto recalled:

And so I took a trip to Paris and relaxed a little. There I met Beppe Romagnoni, who told me about a gallery that showed strange, interesting paintings. So I went to the Sonnabend gallery, I asked to see these paintings, and thus I was able to see, for the first time, the paintings of Rauschenberg, Jasper Johns, Rosenquist, and Lichtenstein, and the sculptures of Segal and Chamberlain. They asked me if I was a critic and I replied: No, I'm an artist. When they asked what I did, I showed them the catalogue from the Galatea gallery and a painting. They took over the contract with Tazzoli, and an extremely important situation for me was begun: being projected into an international dimension, beyond the exclusively Turinese situation.

16. Ida Gianelli, "Intervista a Gian Enzo Sperone," in Germano Celant, Paolo Fossati, and Ida Gianelli, *Un'avventura internazionale. Torino e le arti 1950–1970* (An international adventure. Turin and the arts 1950–1970), exhibition catalogue (Milan and Rivoli: Charta/Castello di Rivoli, 1993), p. 170.
17. Germano Celant, ed., *Identité italienne. L'Art en Italie depuis 1959* (Italian identity. Art in Italy since 1959. Paris: Centre Georges Pompidou, Musée National d'Art Moderne, 1981), pp. 60–61, 119–21.
18. Germano Celant, ed., *Conceptual Art, Arte Povera, Land Art*, exhibition catalogue (Turin: Galleria Civica d'Arte Moderna, 1970), p. 7.

Carla Accardi
Afro {Afro Basaldella}
Giovanni Anselmo
Alighiero Boetti
Alberto Burri
Pier Paolo Calzolari
Giuseppe Capogrossi
Enrico Castellani
Ettore Colla
Piero Dorazio
Luciano Fabro
Tano Festa
Lucio Fontana
Domenico Gnoli
Renato Guttuso
Jannis Kounellis
Leoncillo {Leoncillo Leonardi}
Francesco Lo Savio
Piero Manzoni
Marino Marini
Fausto Melotti
Mario Merz
Marisa Merz
Giulio Paolini
Pino Pascali
Giuseppe Penone
Michelangelo Pistoletto
Mimmo Rotella
Mario Schifano
Giulio Turcato
Emilio Vedova
Gilberto Zorio

1. Alberto Burri
Catrame (Tar), *1949. Oil, collage,
tar, and pumice on canvas, 57 x 64 cm.
Collection of the artist.*

2. Alberto Burri
Catrame II (Tar II), *1949. Tar and
oil on canvas, 43.5 x 50 cm. Courtesy of
Galleria d'Arte Niccoli, Parma.*

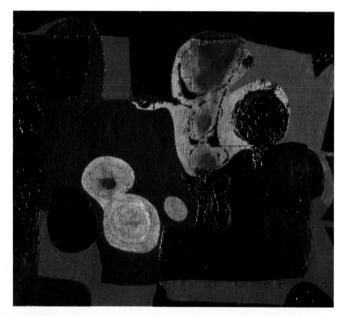

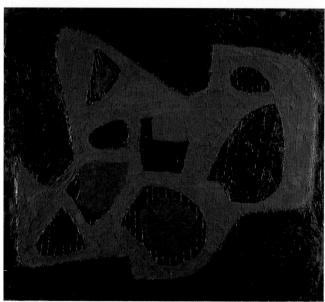

3. Alberto Burri
Composizione (Composition), *1949.*
Oil and burlap on canvas, 67.5 x 83 cm.
Collection of Ennio Tersigni, Rome.

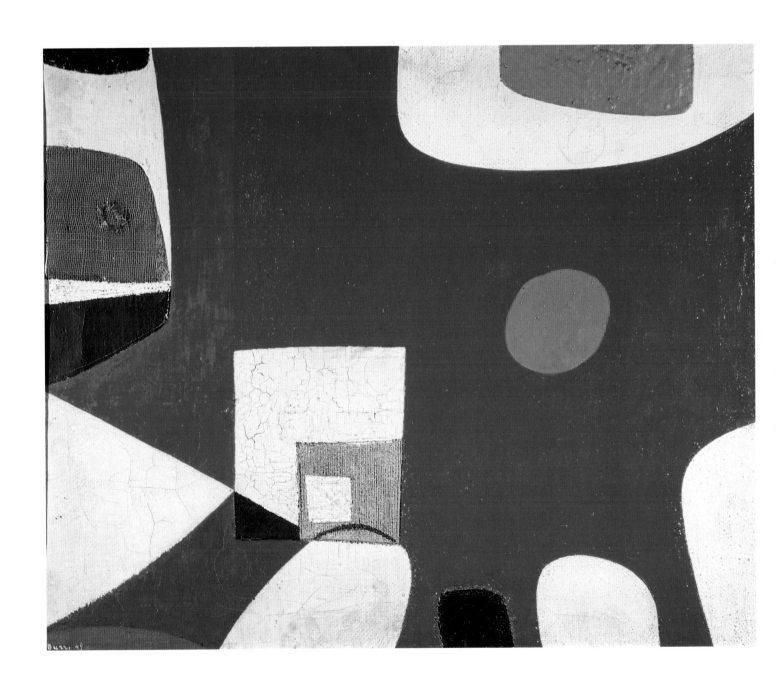

4. Alberto Burri
Rosso (Red), *1950. Oil and pumice on canvas, 67.7 x 58.4 cm. Private collection.*

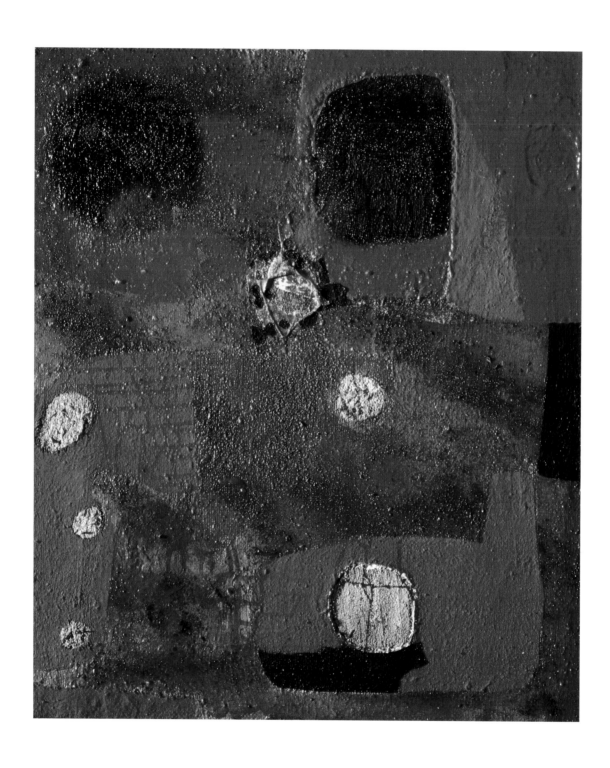

5. Alberto Burri
Gobbo *(Hunchback), 1950. Oil on*
textile with brackets, 57 x 64 cm.
Galleria Nazionale d'Arte Moderna e
Contemporanea, Rome.

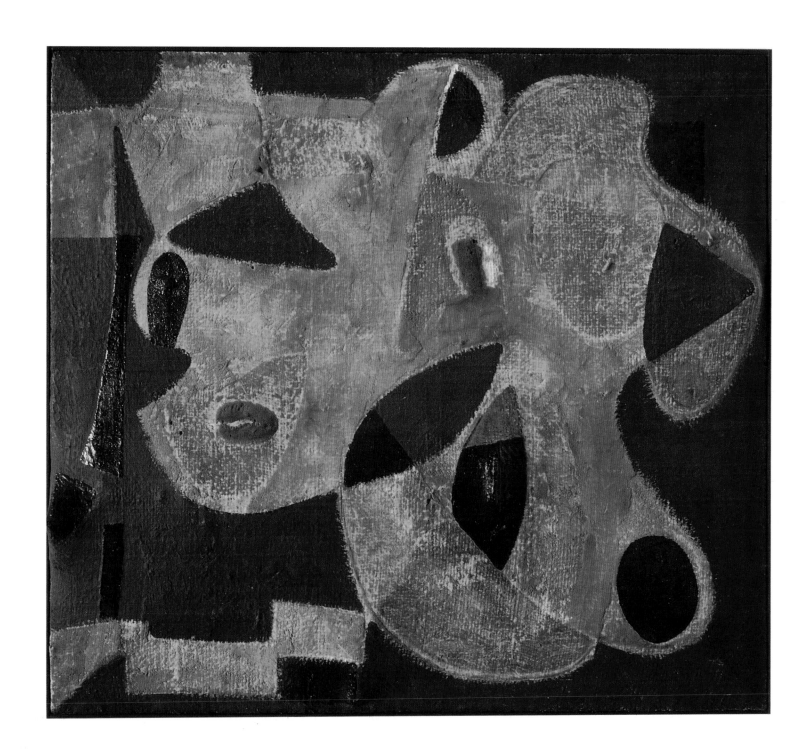

6. Giuseppe Capogrossi
Superficie 67 (Surface 67), 1950.
Oil on canvas, 210 x 86 cm. Galleria
del Naviglio, Milan.

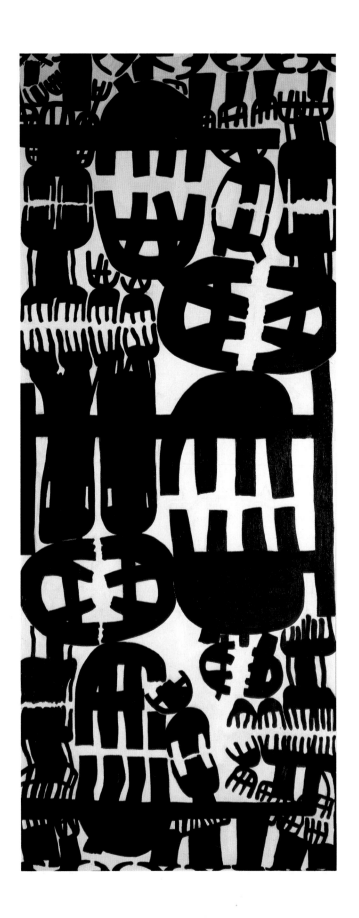

7. Giuseppe Capogrossi
Superficie 210 (Surface 210), 1957. Oil on canvas, 206.7 x 159.4 cm. Solomon R. Guggenheim Museum, New York.

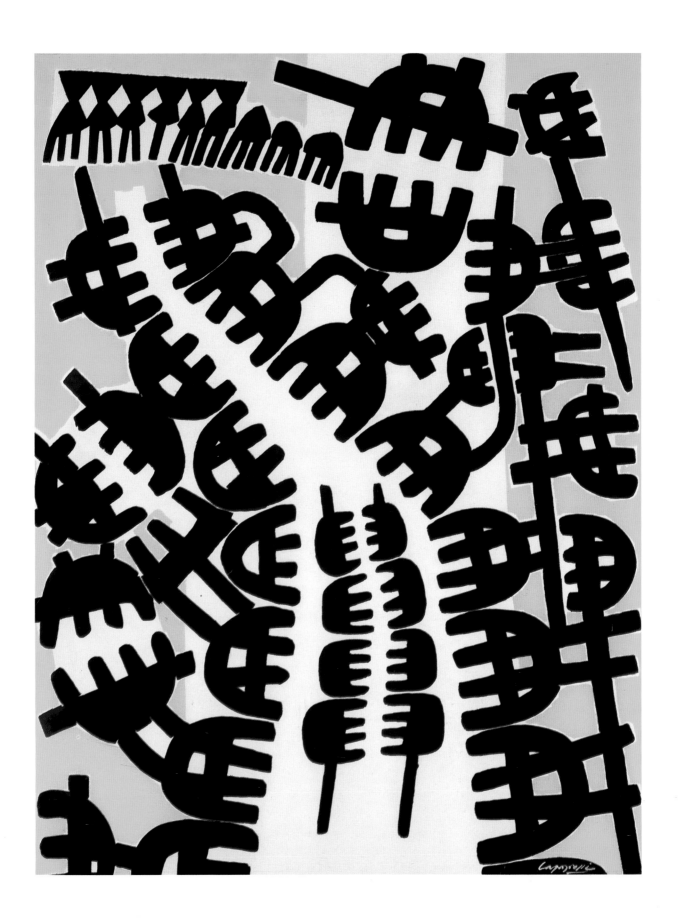

8. Lucio Fontana
Scultura spaziale (Spatial Sculpture),
*1947. Bronze, 59 cm high. Fondazione
Lucio Fontana, Milan.*

9. Lucio Fontana
Ritratto di Teresita (Portrait of
Teresita), *1949. Glazed ceramic,
70 x 45 x 31 cm. Collection of Teresita
Fontana, Milan.*

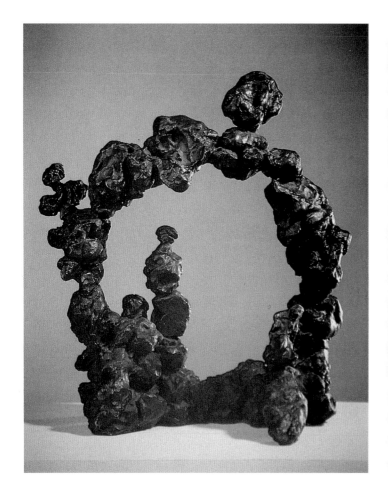

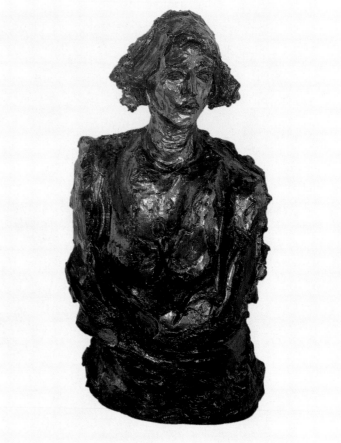

10. Lucio Fontana
Crocifissione (Crucifixion), *1948.*
Ceramic, 48.6 x 31.4 x 23.2 cm. The
Museum of Modern Art, New York,
Purchase, 1949.

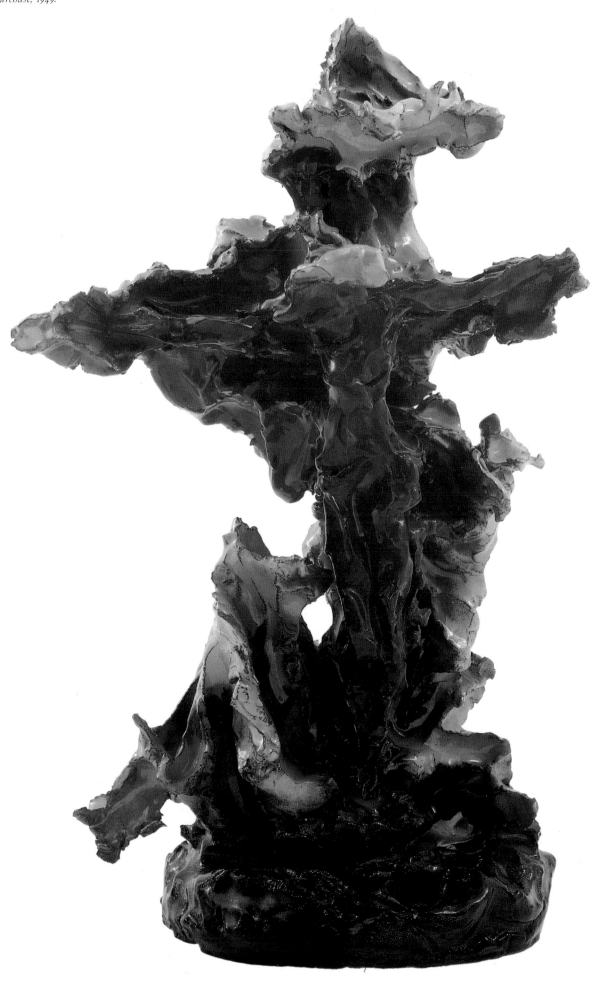

11. Lucio Fontana
Concetto spaziale (Spatial Concept),
*1949. Linen paper mounted on canvas,
100 x 100 cm. Galleria Nazionale
d'Arte Moderna e Contemporanea,
Rome.*

12. Lucio Fontana
Concetto spaziale (Spatial Concept),
*1949. Linen paper mounted on canvas,
100 x 100 cm. Kunstsammlung
Nordrhein-Westfalen, Düsseldorf.*

13. Lucio Fontana
Concetto spaziale (Spatial Concept),
1949. Linen paper mounted on canvas,
100 x 100 cm. Collection of Teresita
Fontana, Milan.

14. Renato Guttuso
Massacro d'agnelli *(Massacre of*
the Lambs*), 1947. Oil on canvas,*
95 x 123 cm. Collection of David
Mezzacane, Rome.

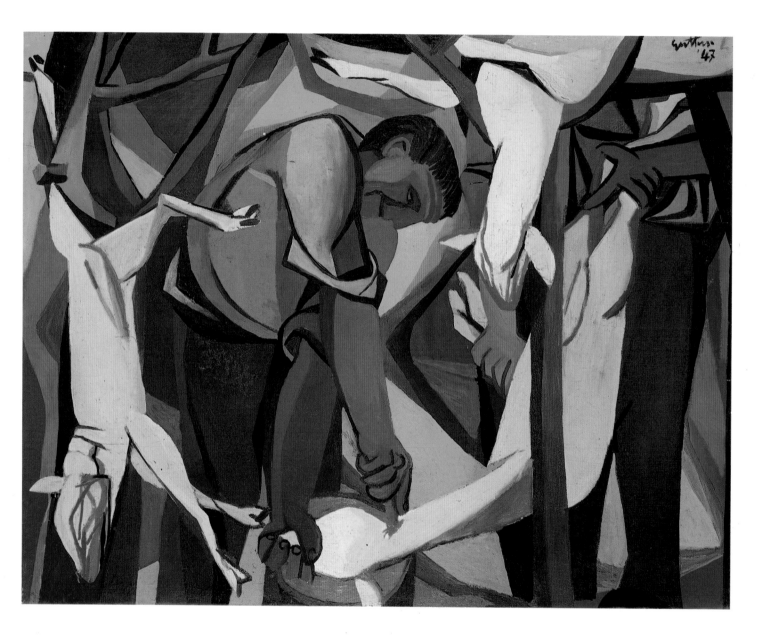

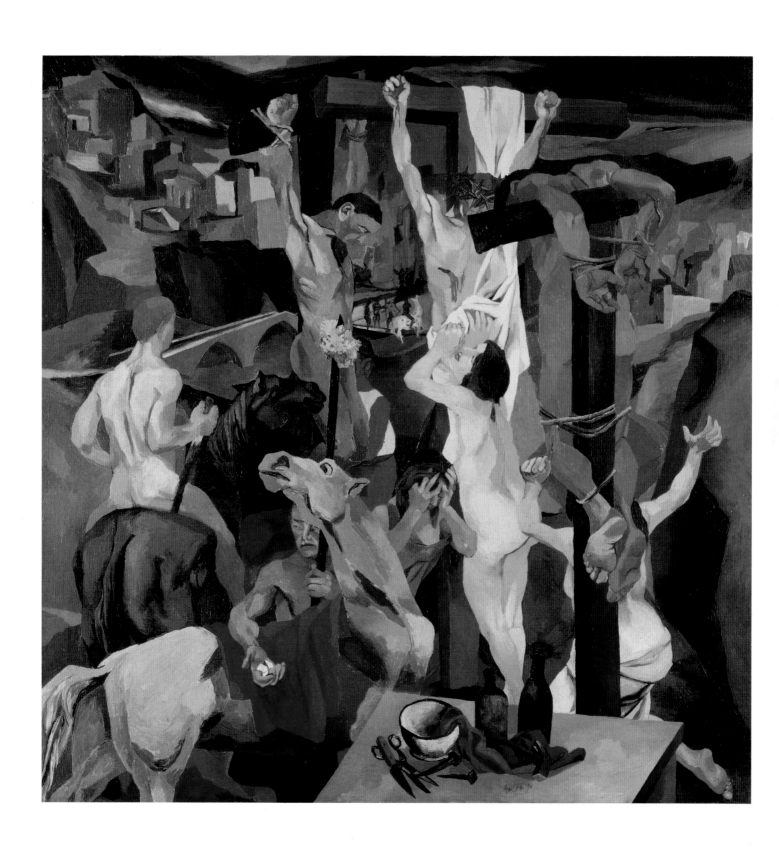

16. Leoncillo [Leoncillo Leonardi]
Madre romana uccisa dai tedeschi I
(Roman Mother Killed by the
Germans I), *1944. Polychrome ceramic,*
13 x 50 x 24 cm. Private collection.

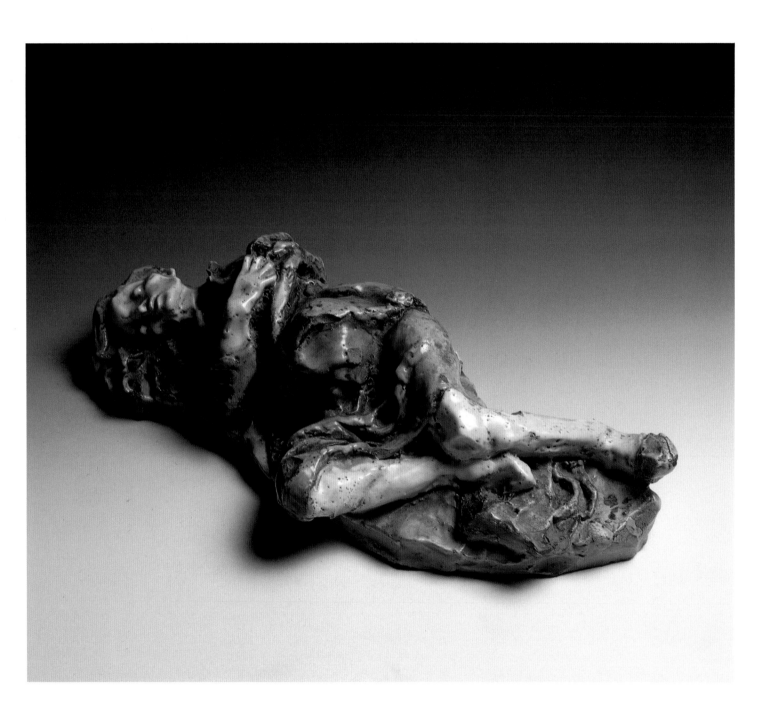

17. Leoncillo [Leoncillo Leonardi]
Ritratto di Elsa (Portrait of Elsa),
1948. Polychrome majolica, 55 x 55 x
35 cm. Regione dell'Umbria and
Comune di Spoleto, Gift of Elsa
de Giorgi.

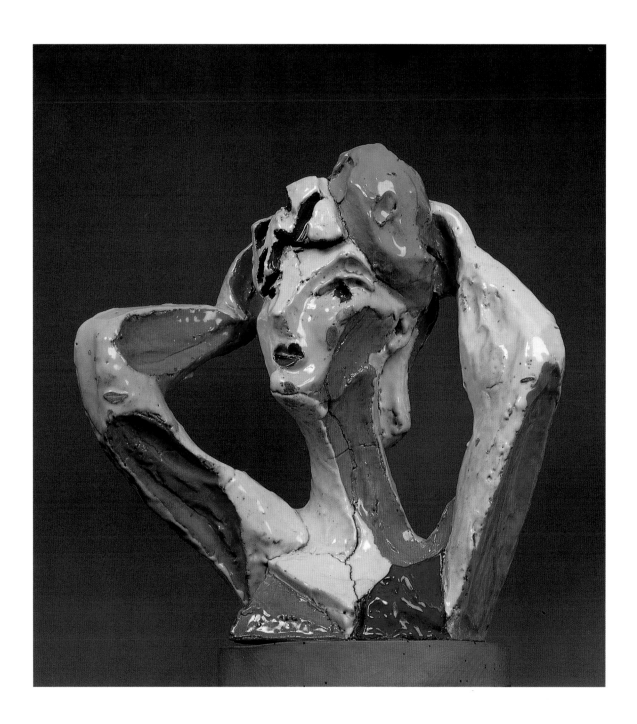

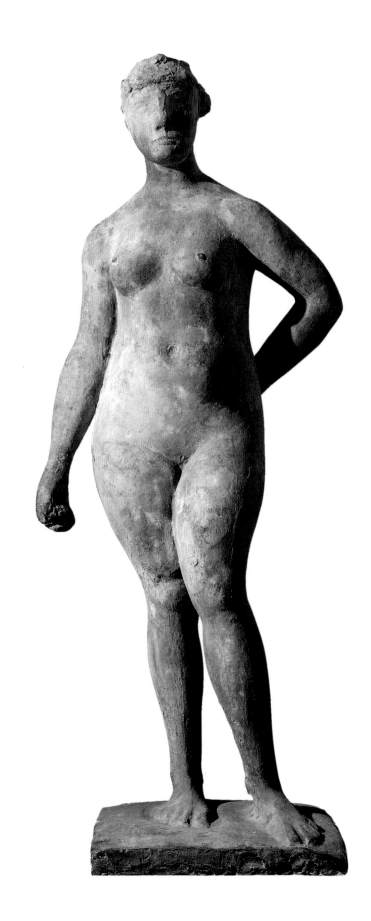

19. Marino Marini
Piccolo cavaliere *(Little Rider)*, *1948.*
Polychrome plaster, 60 cm high. Museo
Marino Marini, Florence.

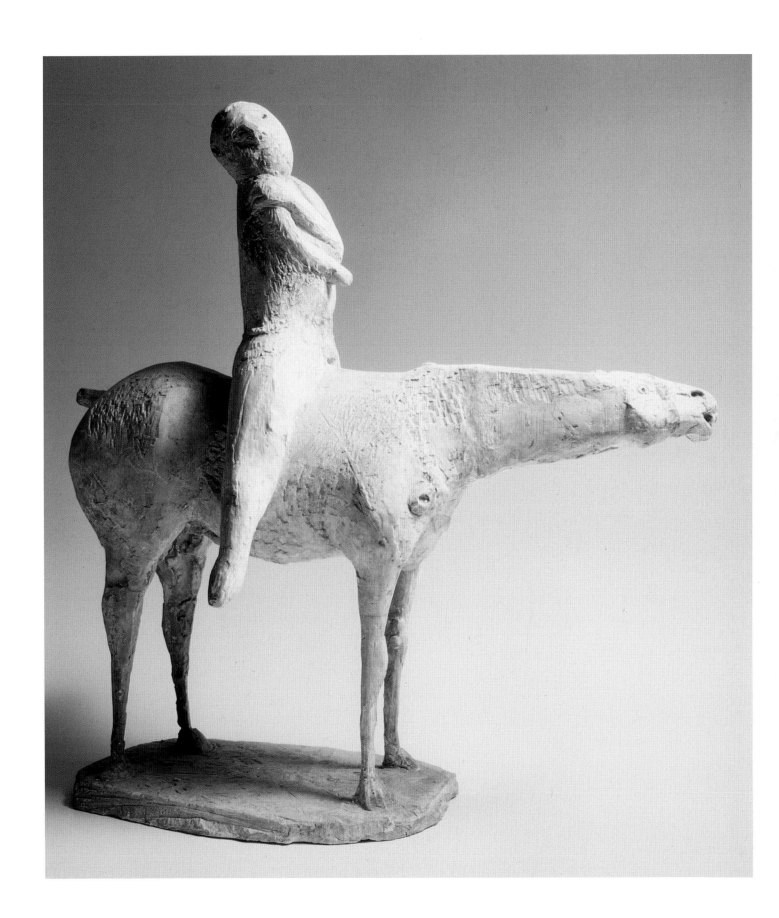

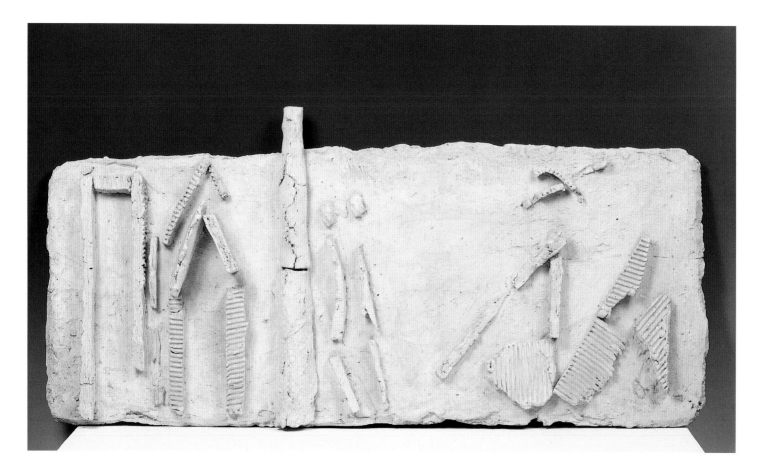

21. Fausto Melotti
Solò coi cerchi (Alone with the
Circles), *1944. Terra-cotta, 41 x 27 x
19 cm. Private collection, Novara.*

22. Fausto Melotti
Le mani (The Hands), *1949. Painted
terra-cotta and brass, 35 x 29 x 9 cm.
Collection of Cristina Melotti,
New York.*

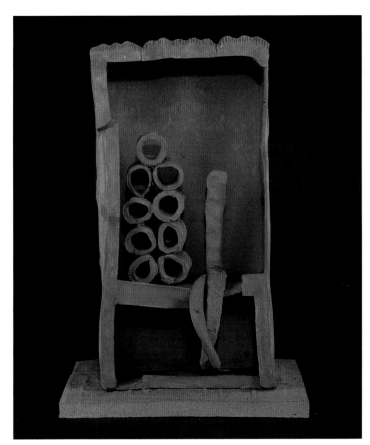

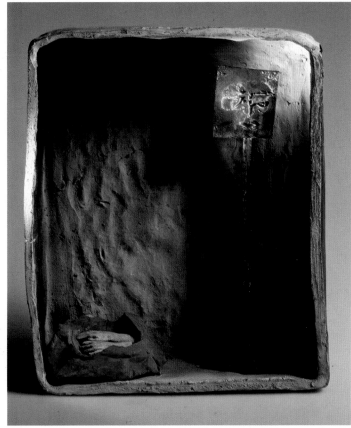

23. Giulio Turcato
Rovine di Varsavia *(Ruins of Warsaw)*, *1949. Oil on canvas, 90 x 115 cm. Anna D'Ascanio Gallery.*

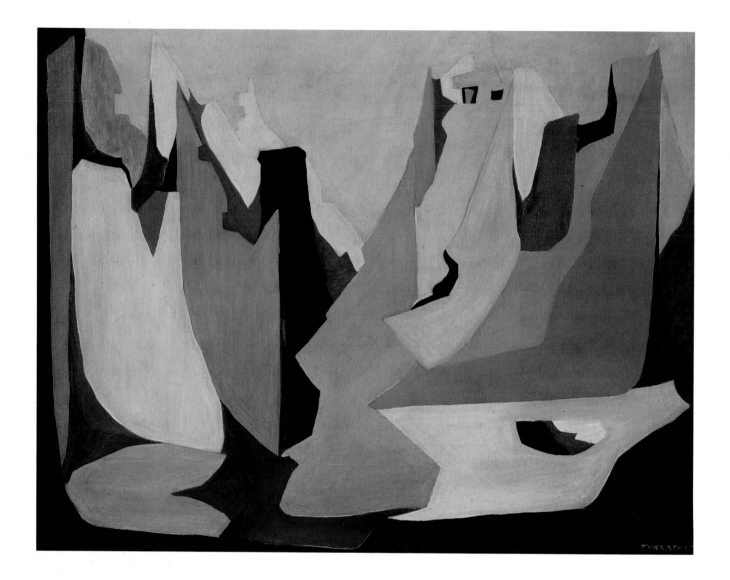

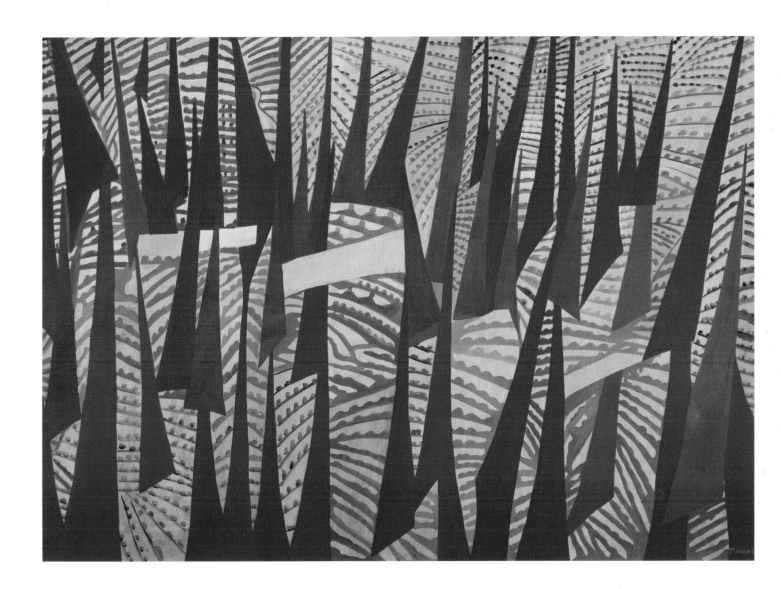

25. Emilio Vedova
La lotta–1 (The Struggle–1), 1949.
Oil on canvas, 130.5 x 126 cm. Collection
of the artist, Venice.

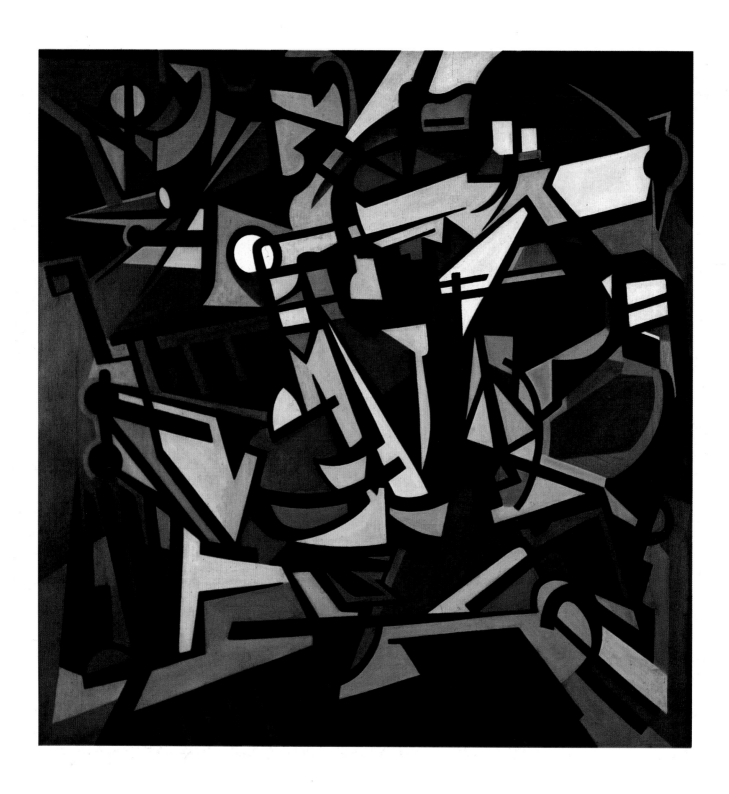

26. Emilio Vedova
Europa '50 (Europe '50), 1949–50.
Oil on canvas, 123 x 126 cm. Galleria
Internazionale d'Arte Moderna
Cà Pesaro, Venice.

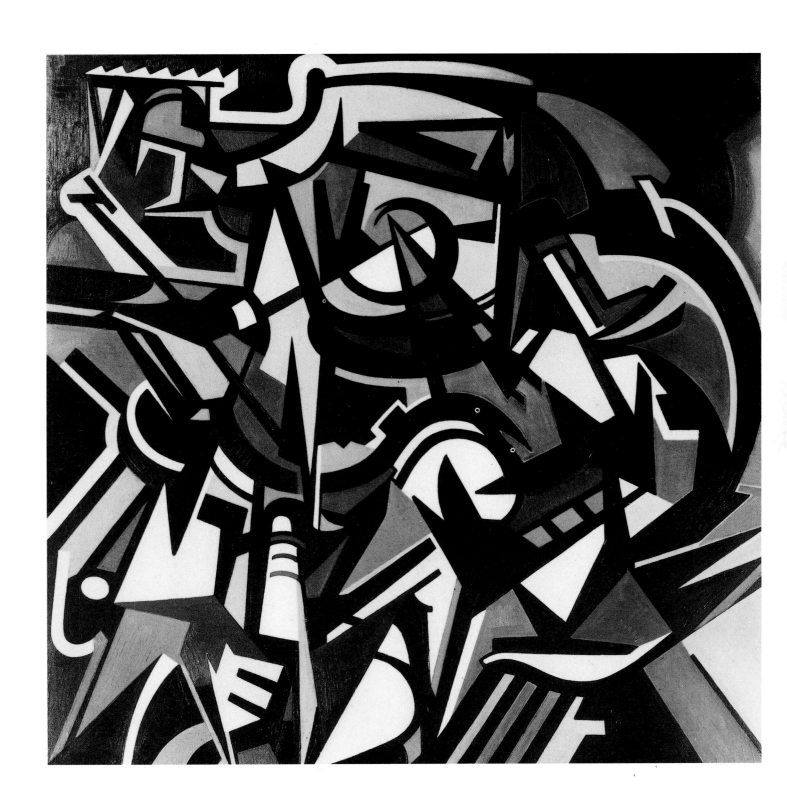

27. Afro [Afro Basaldella]
Per una ricorrenza (For an
Anniversary), *1955. Mixed media on
canvas, 149.9 x 199.7 cm. Solomon R.
Guggenheim Museum, New York,
Gift, Mr. and Mrs. Joseph Pulitzer, Jr.,
St. Louis, 1958.*

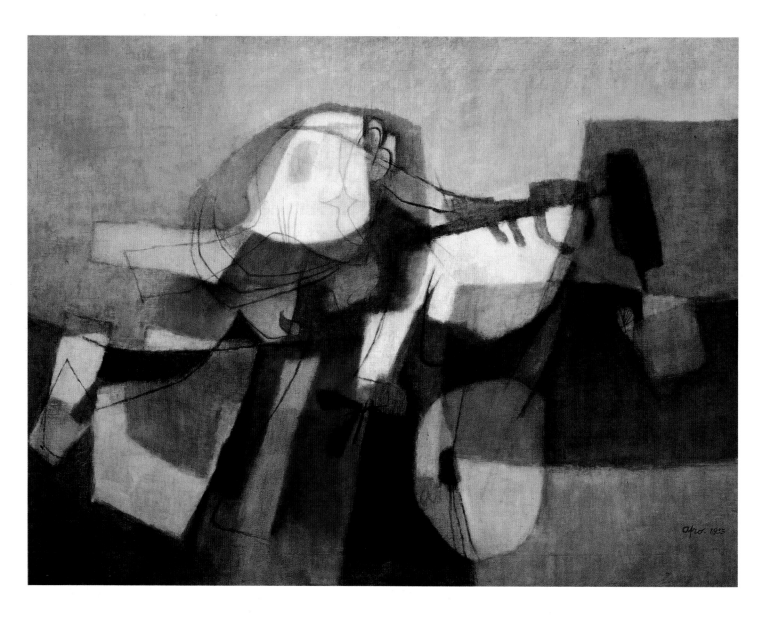

28. Afro [Afro Basaldella]
Volo di notte (Night Flight), *1957.*
Mixed media on canvas, 114 x 145.7 cm.
Solomon R. Guggenheim Museum,
New York.

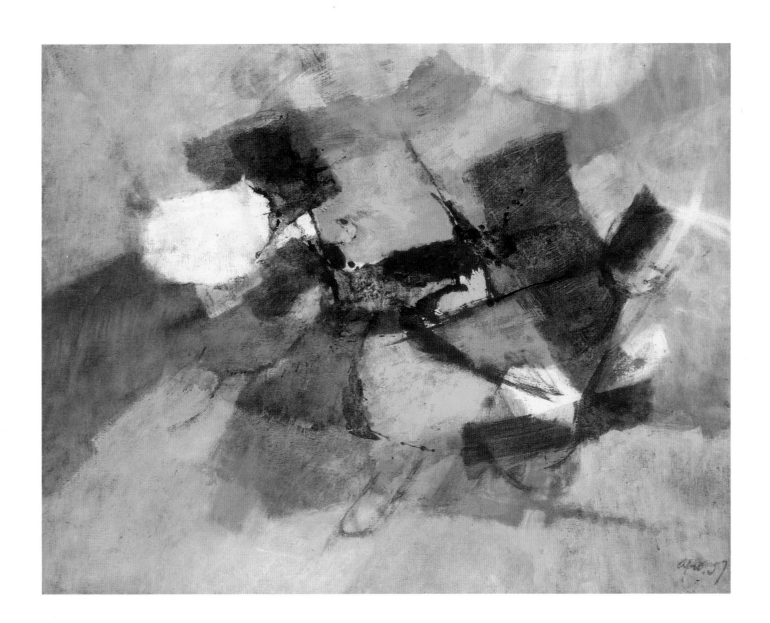

29. Alberto Burri
Lo strappo (The Rip), *1952. Oil and canvas on canvas, 87 x 58 cm. Collection of Beatrice Monti della Corte.*

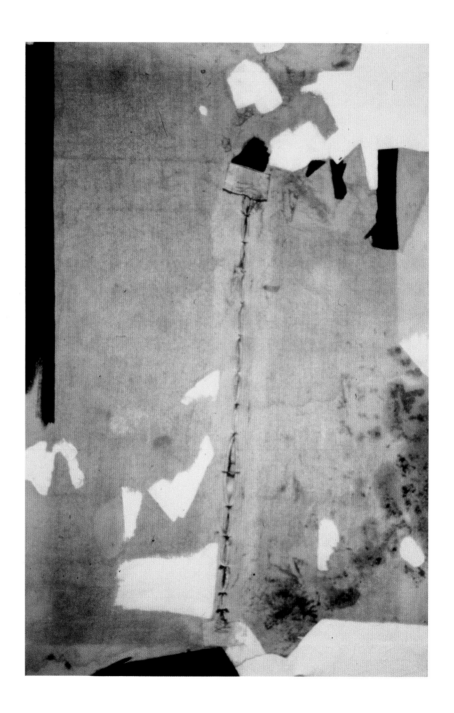

30. Alberto Burri
Bianco (White), *1952. Oil, paper, and muslin on muslin, 100 x 86 cm. San Francisco Museum of Modern Art, Gift of Mr. and Mrs. Nathaniel Owings.*

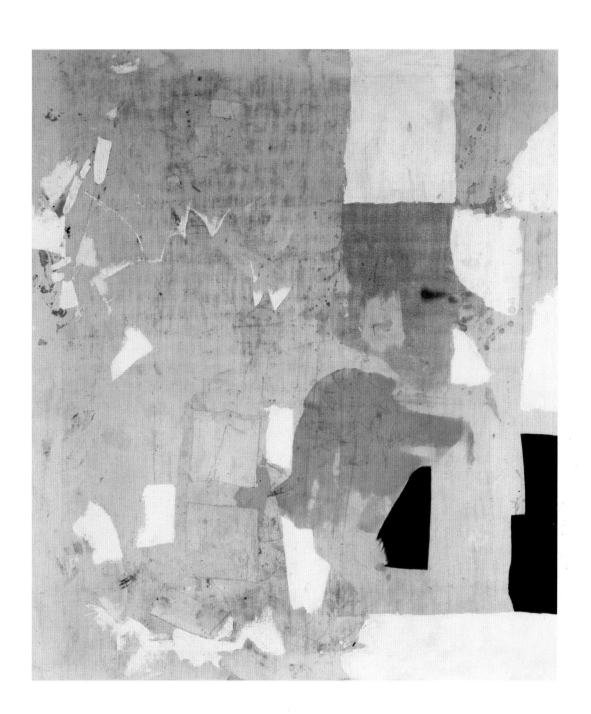

31. Alberto Burri
Grande sacco (Large Sack), 1953.
Burlap, canvas, oil, and rope on canvas,
144.1 x 250.1 cm. The Newark Museum,
Gift of Mr. Stanley Joseph Seeger, 1977.

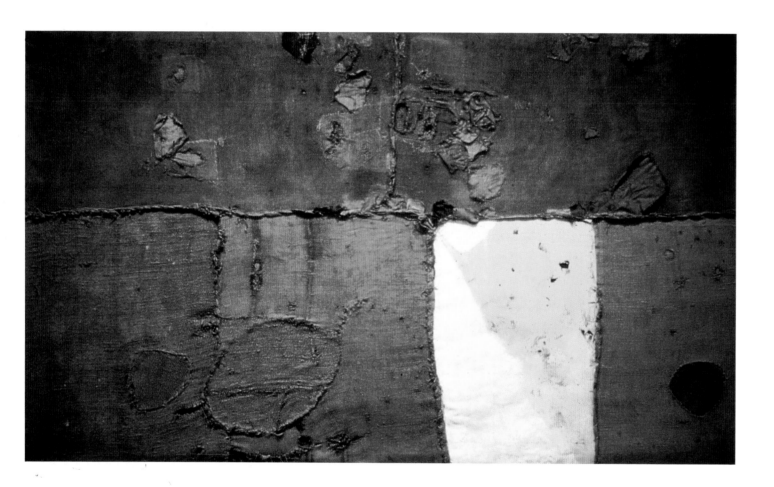

31. Alberto Burri
Grande sacco (Large Sack), 1953.
Burlap, canvas, oil, and rope on canvas,
144.1 x 250.1 cm. The Newark Museum,
Gift of Mr. Stanley Joseph Seeger, 1977.

32. Alberto Burri
Sacco e bianco (Sack and White),
1953. Oil and burlap on canvas,
149 x 249.5 cm. Musée National d'Art
Moderne, Centre Georges Pompidou,
Paris. Gift of the State, 1976.

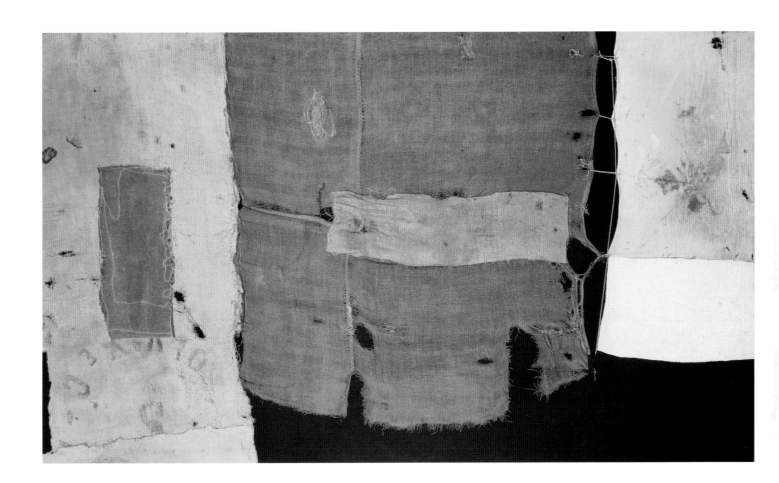

33. Alberto Burri
Composizione (Composition), *1953.*
Burlap, oil, and gold on canvas,
86 x 100 cm. Solomon R. Guggenheim
Museum, New York.

34. Alberto Burri
Sacco 1953 (Sackcloth 1953), *1953.*
Burlap sewn, patched, and glued over
canvas, 86 x 100 cm. The Museum of
Modern Art, New York, Mr. and Mrs.
David Solinger Fund, 1954.

35. Alberto Burri
Sacco H8 (Sack H8), *1953. Burlap, oil,*
and Vinavil on canvas, 86 x 100 cm.
Private collection, Italy.

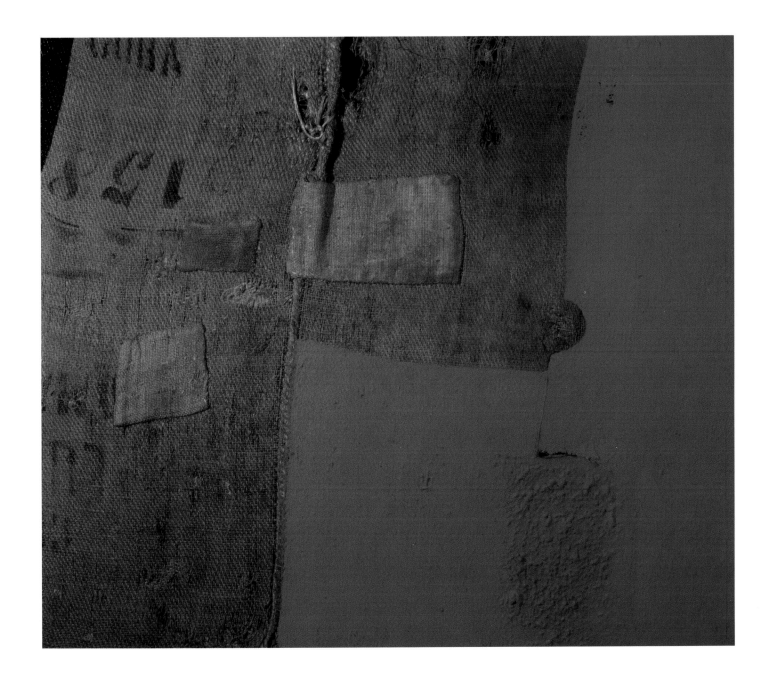

36. Alberto Burri
Legno e bianco 1 (Wood and
White 1), *1956. Combustion, oil,
tempera, and wood on canvas, 87.6 x
159.1 cm. Solomon R. Guggenheim
Museum, New York.*

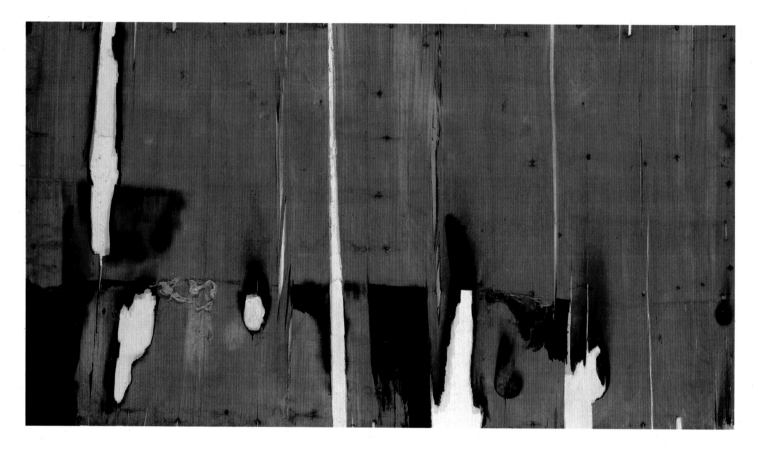

37. Alberto Burri
Grande sacco: Congo Binga (Large Sack: Congo Binga), *1958. Found burlap, canvas, string, and oil medium on canvas, 158 x 256 cm. The Museum of Fine Arts, Houston, Museum Purchase.*

38. Alberto Burri
Grande ferro M4 *(Large Iron M4)*,
1959. Iron on wood frame, 200 x 188 cm.
Solomon R. Guggenheim Museum,
New York.

39. Alberto Burri
Grande legno combustione
(Large Wood Combustion), 1958.
Wood, acrylic, combustion, and Vinavil
on canvas, 200 x 186.5 cm. Private
collection.

40. Alberto Burri
Rosso nero (Red Black), *1955. Fabric,*
oil, and Vinavil on canvas, 100 x 86 cm.
Private collection, Turin.

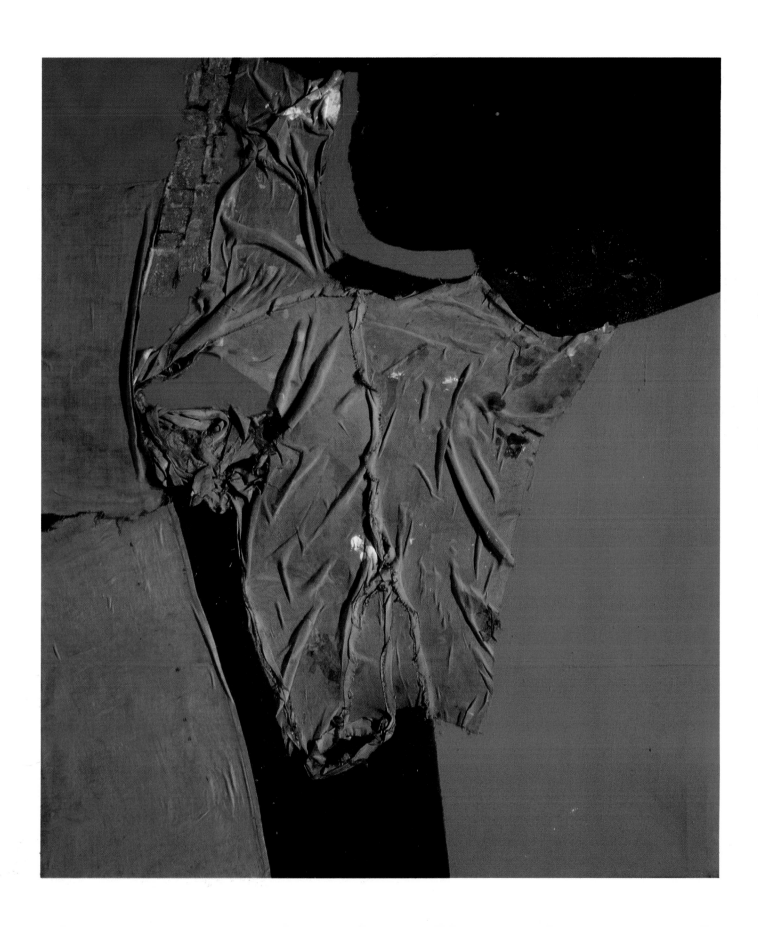

41. Ettore Colla
Orfeo (Orpheus), *1956. Assemblage of*
found iron pieces, 224 cm high. Galleria
L'Isola, Rome.

42. Ettore Colla
Continuità (Continuity), *1951. Welded*
construction of five iron wheels, 242.8 x
142.2 x 99 cm. The Museum of Modern
Art, New York, Purchase, 1961.

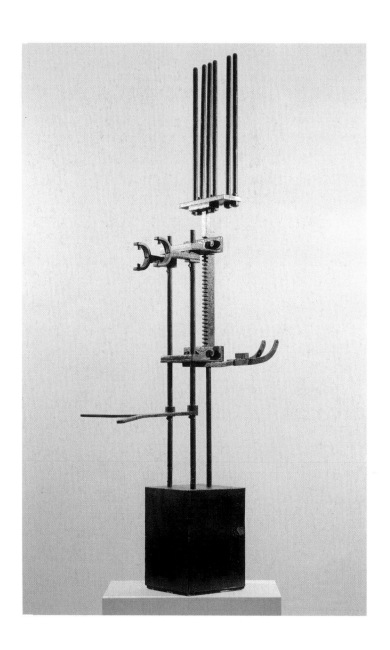

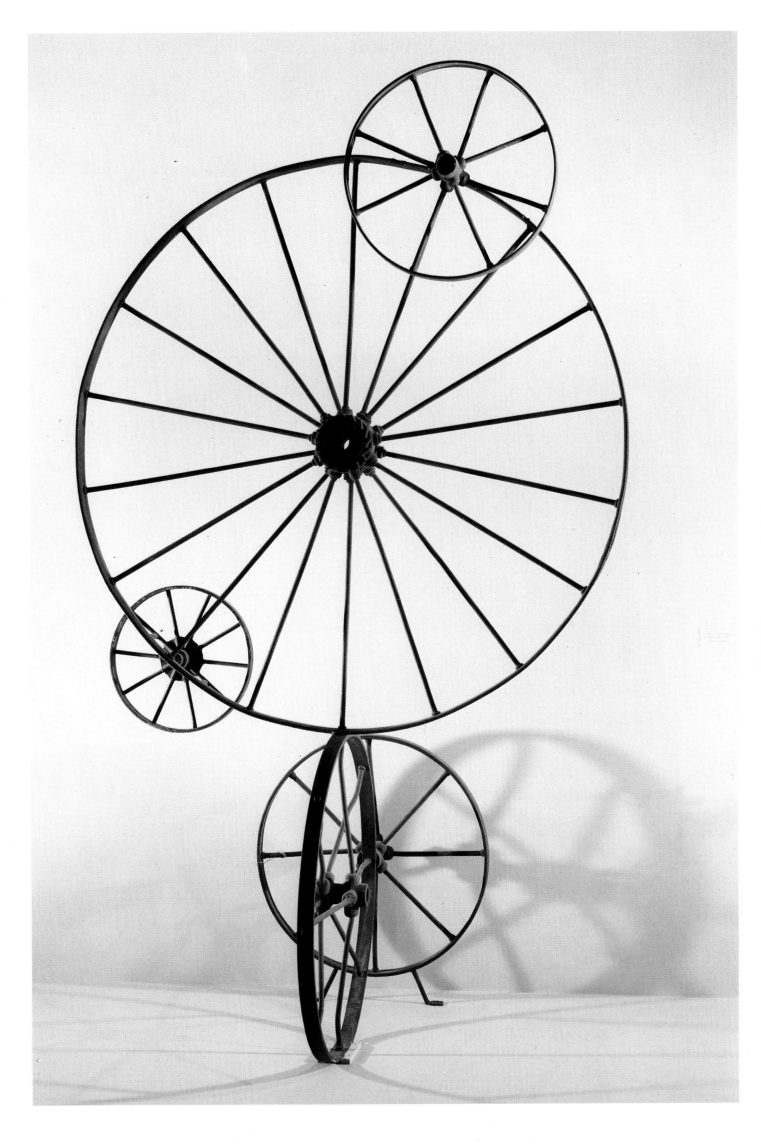

43. Ettore Colla
Concavo e convesso (Concave and
Convex), *1957. Assemblage of found
iron pieces, 71 x 86 cm. Collection of
Achille and Ida Maramotti, Albinea.*

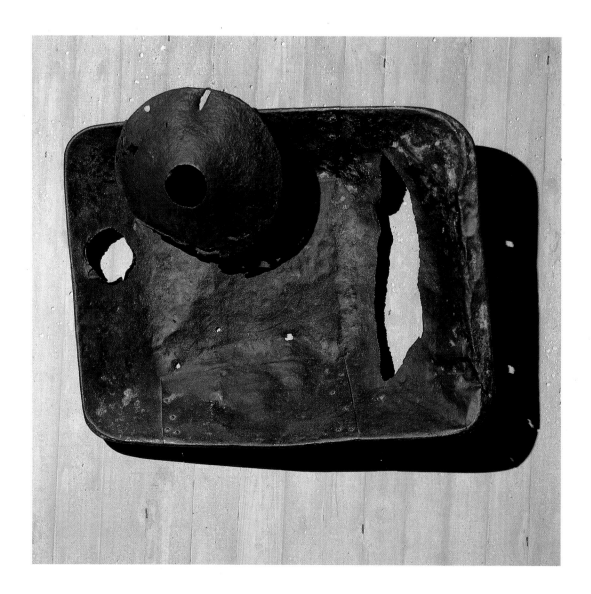

44. Ettore Colla
Rilievo con bulloni *(Relief with Bolts), 1957–59. Assemblage of found iron pieces, 96 x 132 cm. Galleria Nazionale d'Arte Moderna e Contemporanea, Rome.*

45. Lucio Fontana
Concetto spaziale. Crocifissione
(Spatial Concept. Crucifixion), *1954.*
Mixed media on particle board,
176 x 125 cm. Civico Museo d'Arte
Contemporanea, Collezione Boschi di
Stefano, Milan.

46. Lucio Fontana
Concetto spaziale (Spatial Concept),
1956. Mixed media on canvas, 125 x
90 cm. Private collection, Milan.

47. Lucio Fontana
Concetto spaziale (Spatial Concept),
1956. Mixed media on particle board,
95 x 175 cm. Civico Museo d'Arte
Contemporanea, Collezione Boschi di
Stefano, Milan.

48. Lucio Fontana
Concetto spaziale (Spatial Concept).
1958. Ink and collage on unprimed
canvas, 165 x 127 cm. Collection of
Teresita Fontana, Milan.

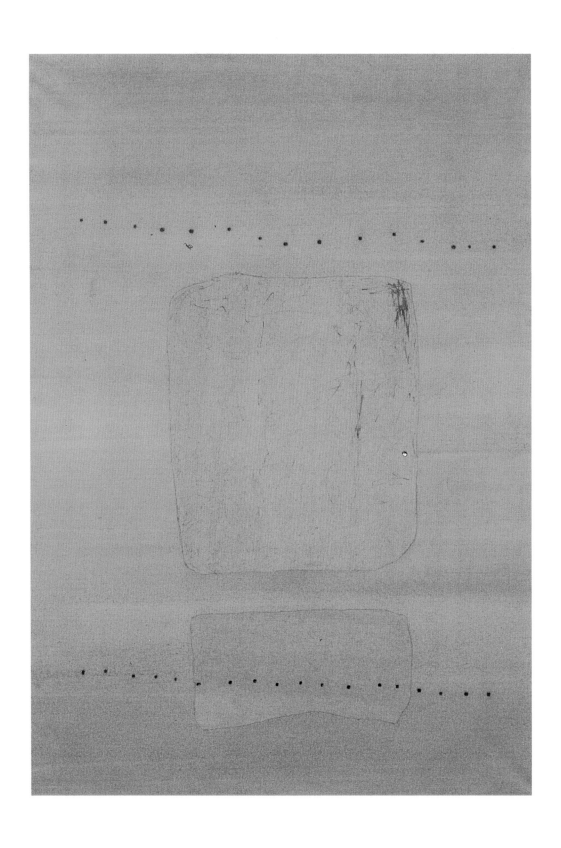

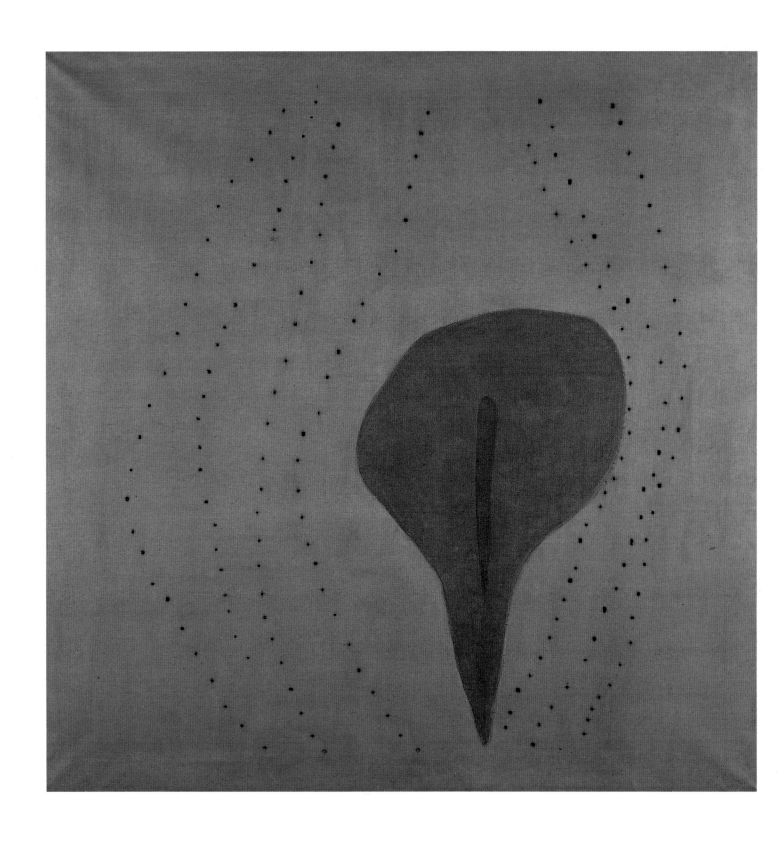

50. Lucio Fontana
Concetto spaziale (Spatial Concept),
1958. Iron, 243 cm high. Collection of
Teresita Fontana, Milan.

51. Lucio Fontana
Concetto spaziale (Spatial Concept),
1957. Painted iron, 174 cm high.
FAE Musée d'Art Contemporain,
Pully-Lausanne.

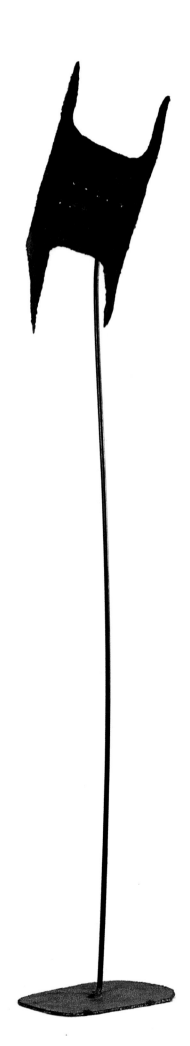

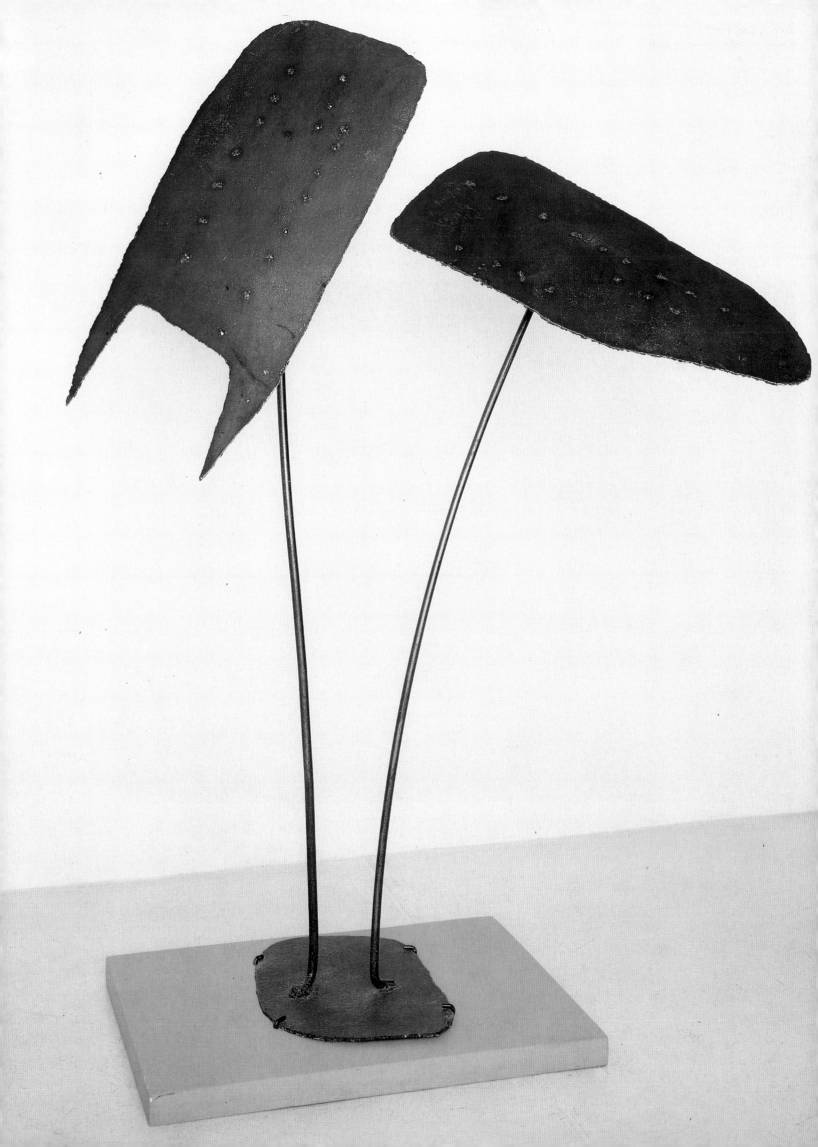

52. Lucio Fontana
Concetto spaziale. Attese (Spatial
Concept. Expectations), 1958.
Aniline on canvas with slashes and
holes, 100 x 130 cm. Fondazione Lucio
Fontana, Milan.

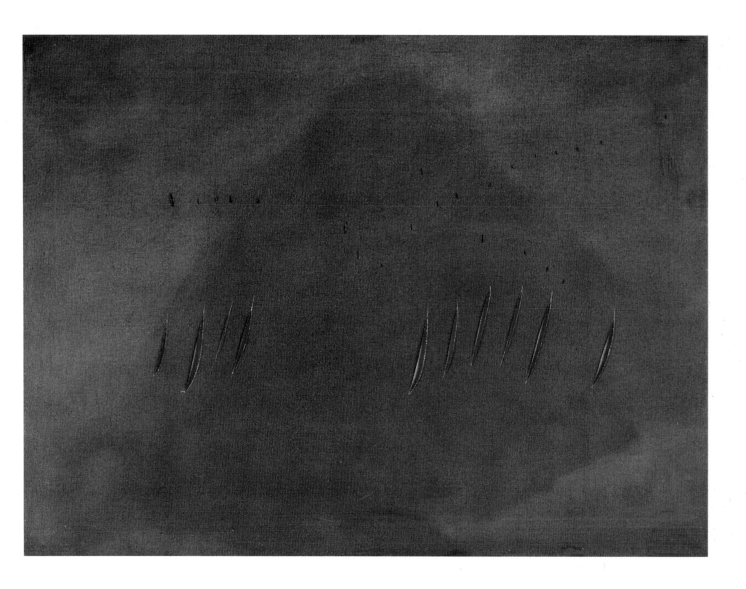

53. Lucio Fontana
Concetto spaziale. Attese (Spatial
Concept. Expectations), *1958.*
Aniline on canvas with slashes and
holes, 98 x 135 cm. Fondazione Lucio
Fontana, Milan.

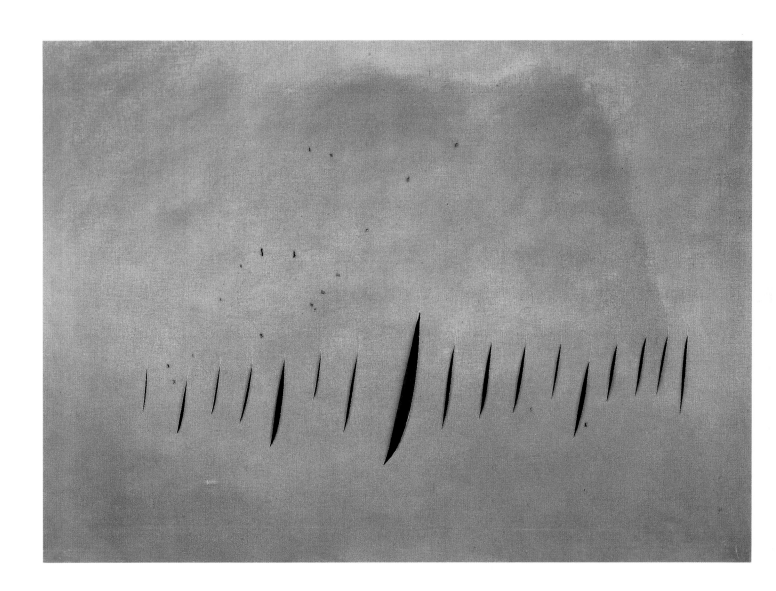

54. Lucio Fontana
Concetto spaziale. Natura *(Spatial Concept. Nature)*, *1959–60. Bronze, 75 cm diameter. Collection of Teresita Fontana, Milan.*

55. Lucio Fontana
Concetto spaziale. Natura *(Spatial Concept. Nature)*, *1959–60. Bronze, 60 cm diameter. Collection of Teresita Fontana, Milan.*

56. Lucio Fontana
Concetto spaziale. Natura *(Spatial Concept. Nature)*, *1959–60. Bronze, 55 cm diameter. Collection of Teresita Fontana, Milan.*

57. Lucio Fontana
Concetto spaziale. I quanta *(Spatial Concept. The Quanta)*, *1960. Emulsion on canvas with slashes; nine canvases, dimensions variable. Collection of Teresita Fontana, Milan.*

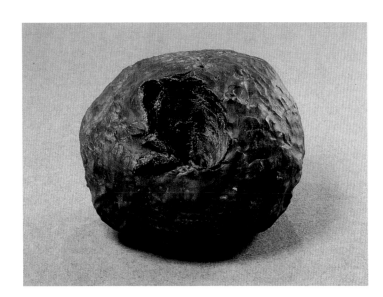

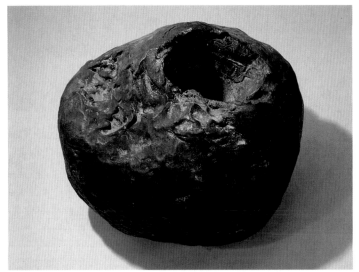

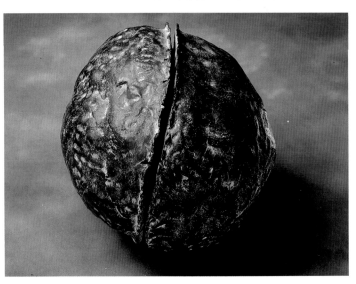

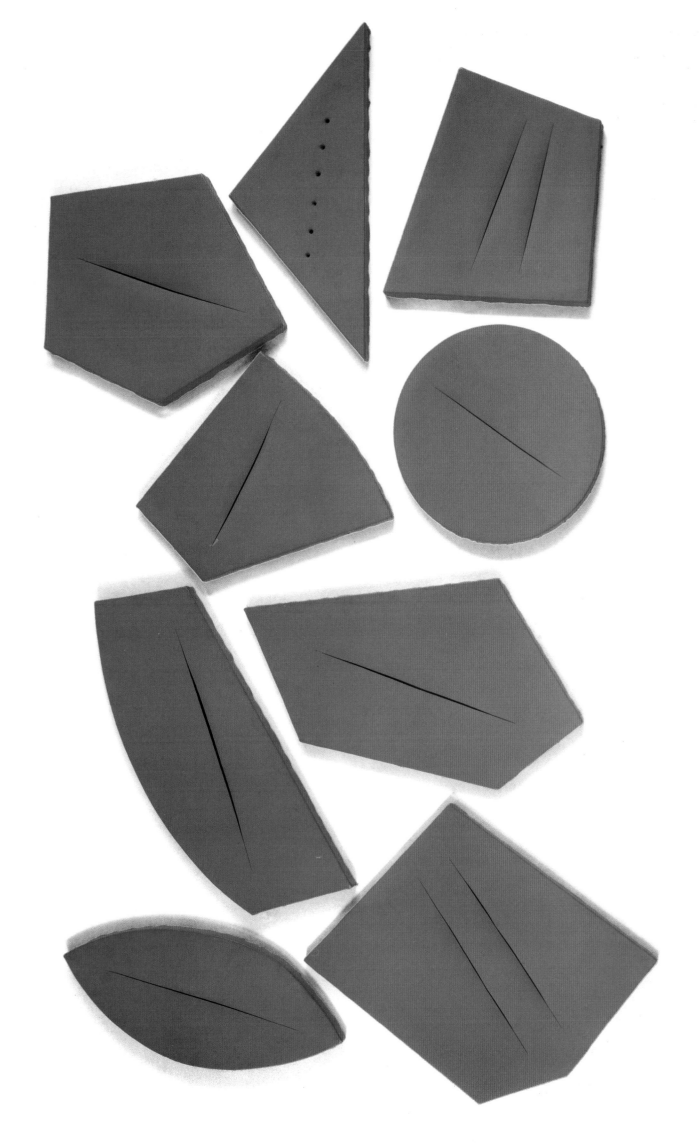

58. Leoncillo [Leoncillo Leonardi]
Vento rosso *(Red Wind)*, *1958. Terra-*
cotta and enamel, 25 x 196 x 106 cm.
Collection of Fabio Sargentini, Rome.

59. Leoncillo [Leoncillo Leonardi]
Taglio bianco *(White Cut)*, *1959.*
Glazed terra-cotta, 151 x 106 x 20 cm.
Private collection.

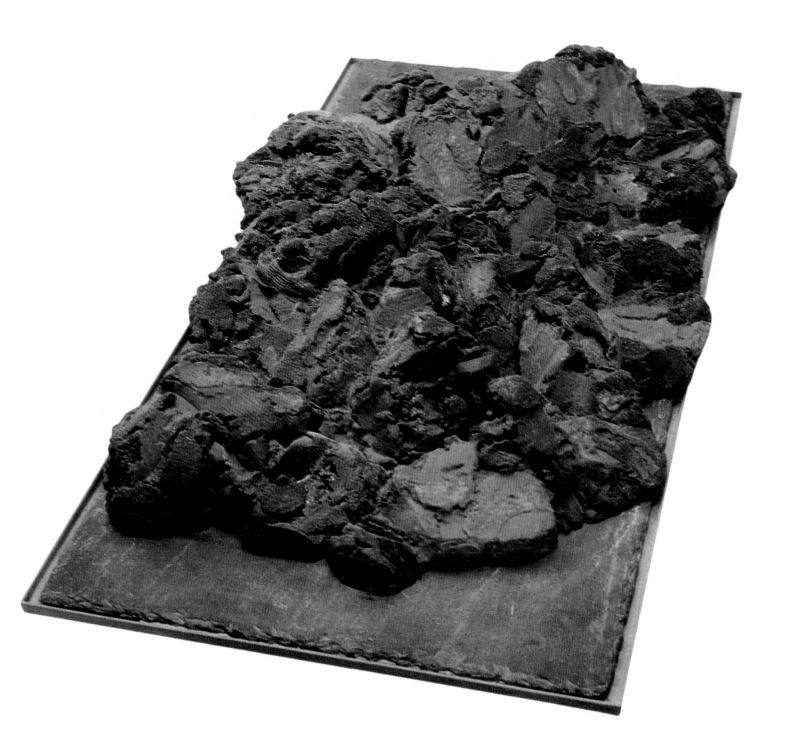

58. Leoncillo [Leoncillo Leonardi]
Vento rosso (Red Wind), *1958. Terra-*
cotta and enamel, 25 x 196 x 106 cm.
Collection of Fabio Sargentini, Rome.

59. Leoncillo [Leoncillo Leonardi]
Taglio bianco (White Cut), *1959.*
Glazed terra-cotta, 151 x 106 x 20 cm.
Private collection.

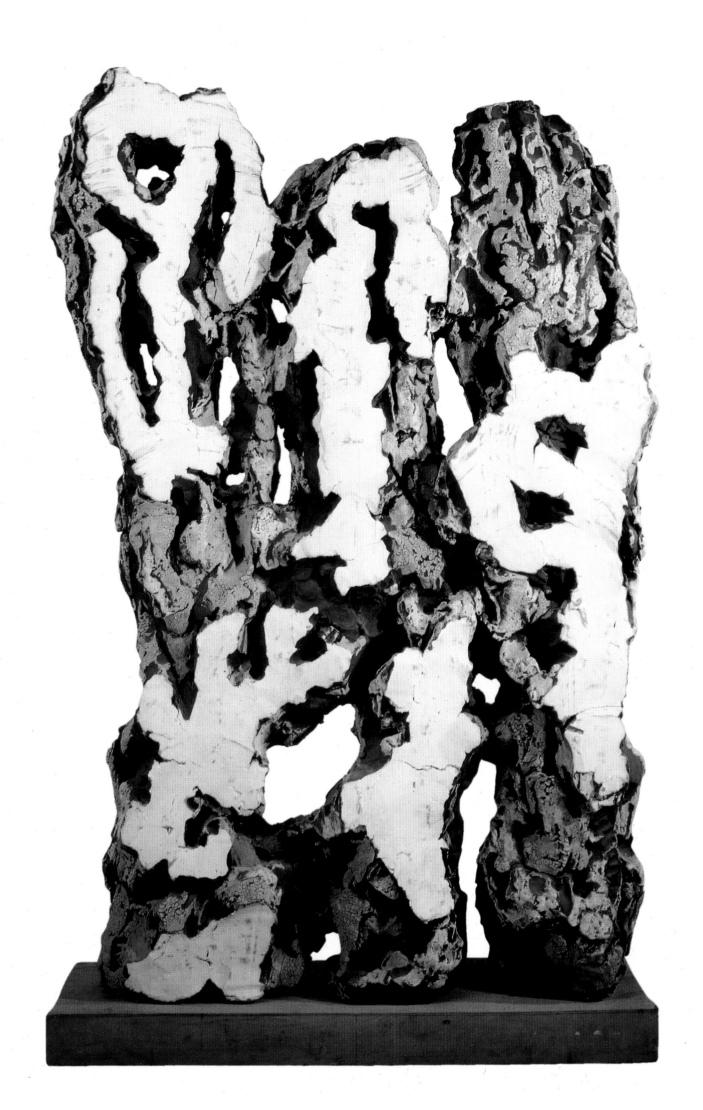

60. Giulio Turcato
Grande reticolo (Large Network),
1954. Oil on canvas, 196 x 130 cm.
Collection of Amedeo Cocchi, Milan.

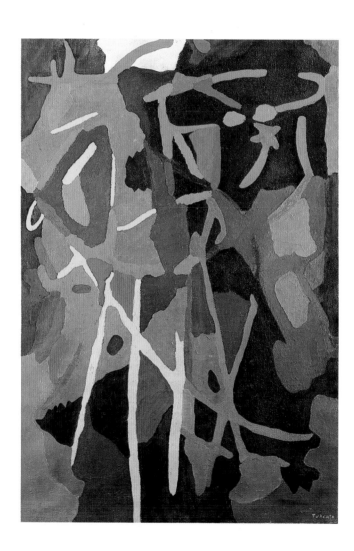

61. Giulio Turcato
Deserto dei Tartari *(Desert of the
Tartars), 1956. Oil on canvas, 186 x
260 cm. Private collection, Rome.*

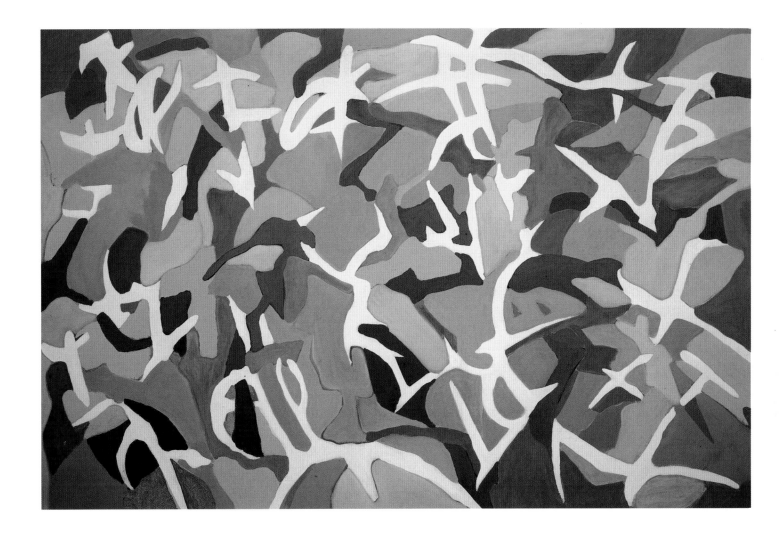

62. Giulio Turcato
Deserto dei Tartari (Desert of the
Tartars), *1956. Oil on canvas, 160 x
240 cm. Private collection, Rome.*

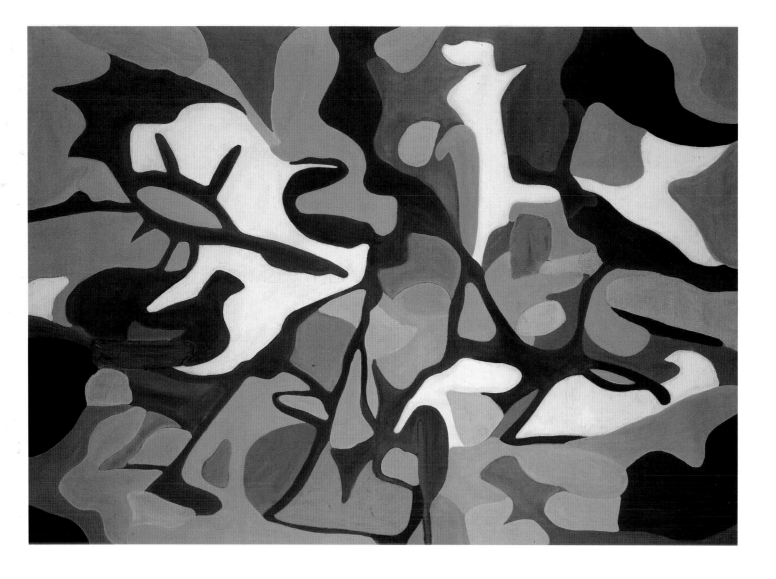

63. Giulio Turcato
Ciò che si vede (That Which Can
Be Seen), *1956. Oil on canvas, 196 x
130 cm. Collection of Amedeo Cocchi,
Milan.*

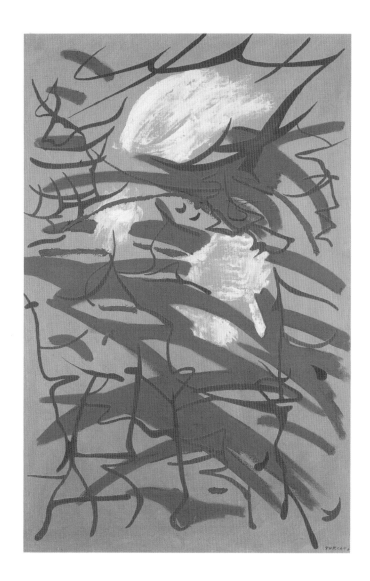

64. Emilio Vedova
Dal ciclo della protesta 1956−3
(Brasile, gli uomini rossi)
(From the 1956 Protest Cycle−3
[Brazil, The Red Men]), 1956.
Oil on canvas, 200 x 90 cm.
Civico Museo Revoltella, Trieste.

65. Emilio Vedova
Dal ciclo della protesta 1953−3
(Per non dimenticare) (From the
1953 Protest Cycle−3 [So as Not to
Forget]), 1953. Oil on canvas, 200 x
90 cm. Collection of Nico Abramo,
Genoa.

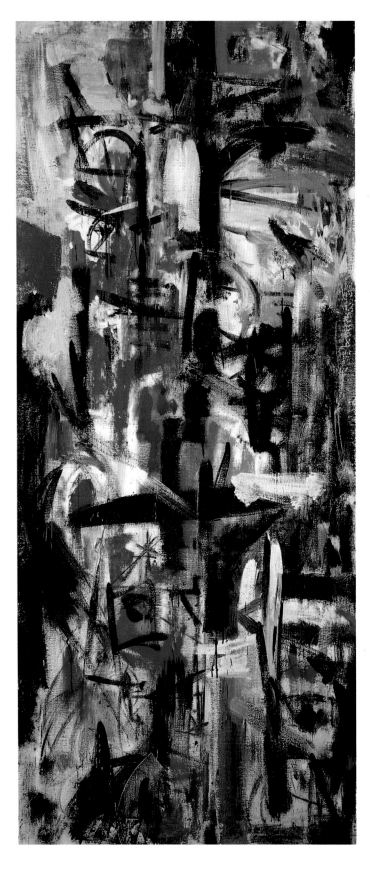

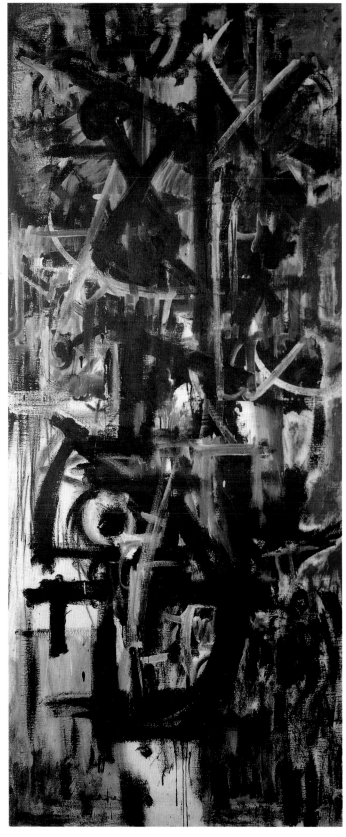

66. Emilio Vedova
Dal ciclo della protesta 1953–7
(Sedia elettrica) (From the 1953
Protest Cycle–7 [Electric Chair]),
1953. Oil on canvas, 208 x 89 cm.
Collection of Antonio Caruana.

Following two pages:
67. Emilio Vedova
Scontro di situazioni–I–1
(Conflicting Situations–I–1),
1959. Oil on canvas, 275 x 445 cm.
Private collection.

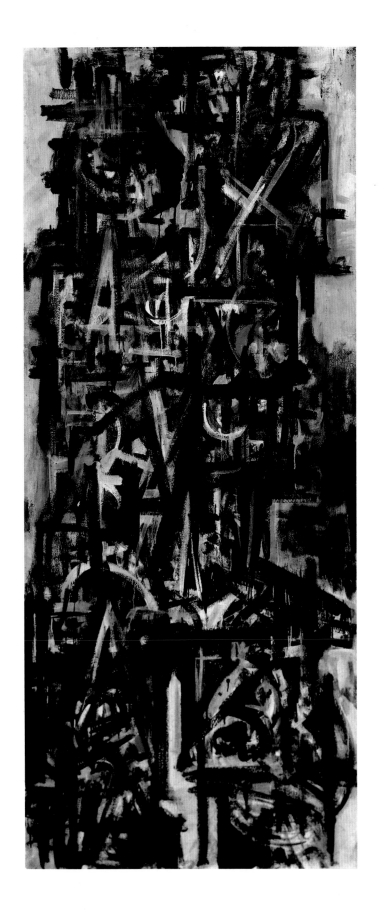

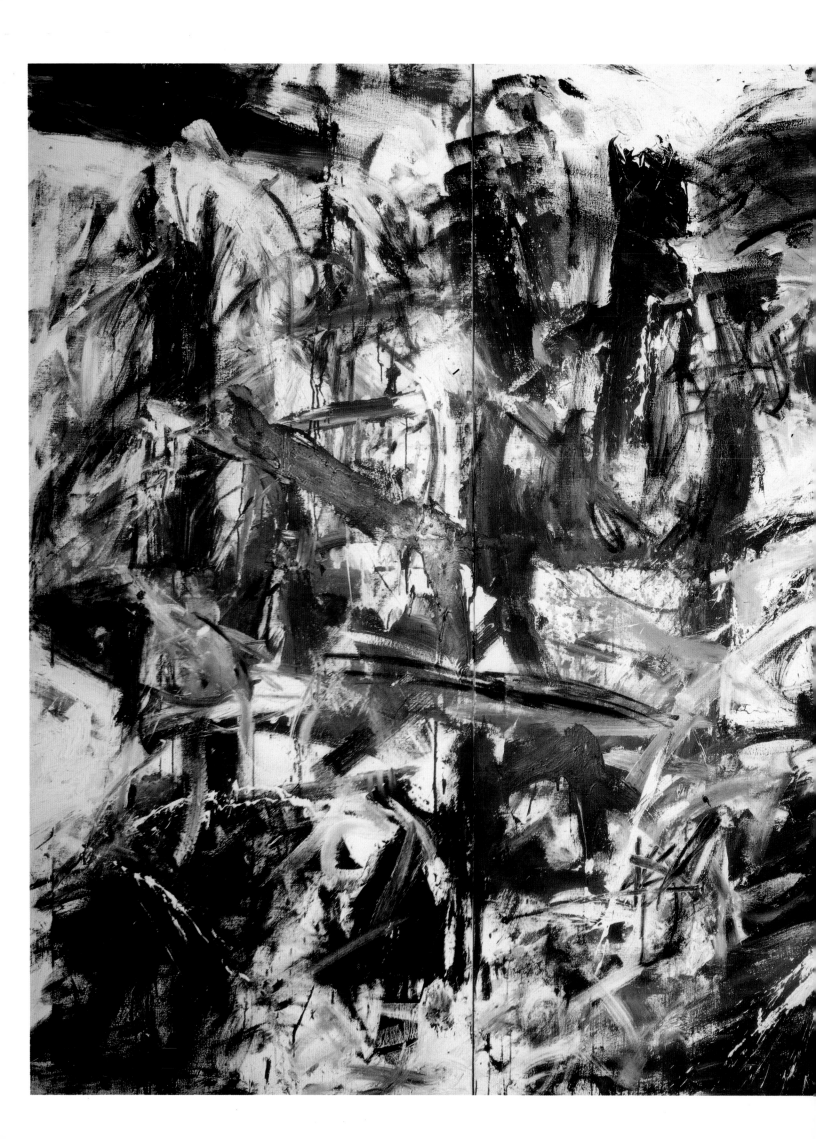

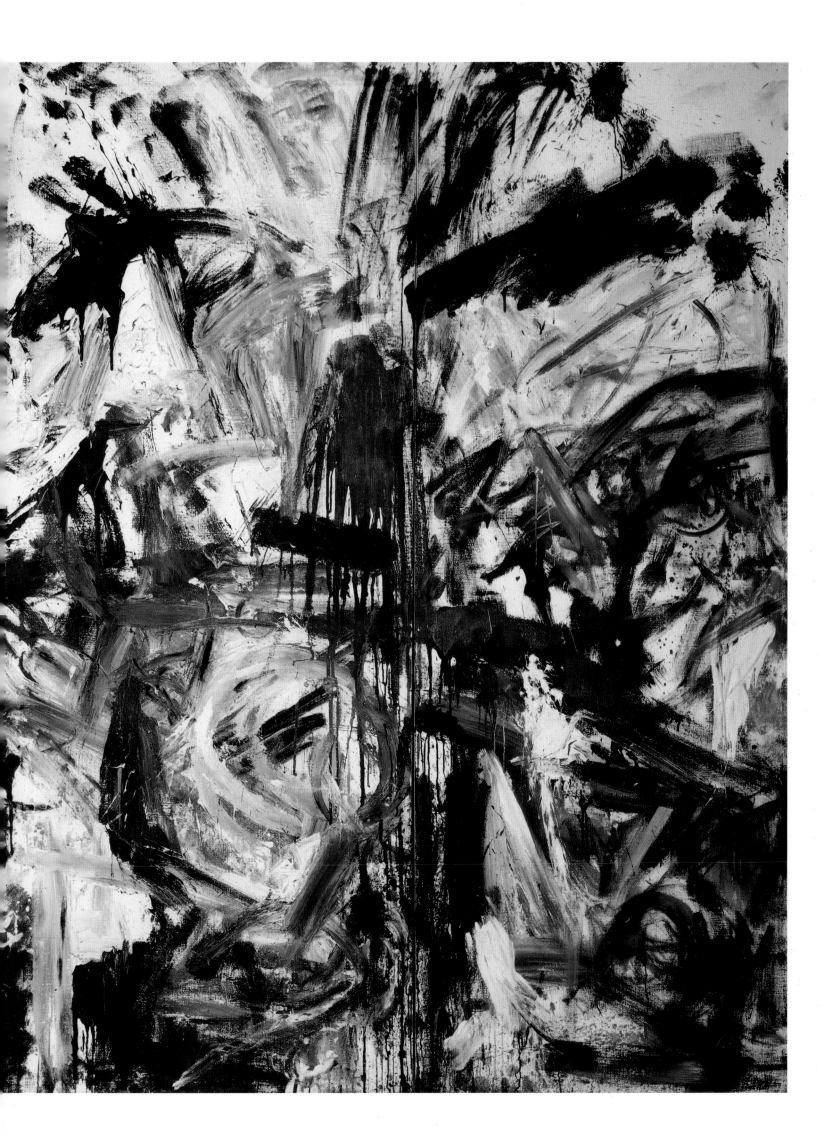

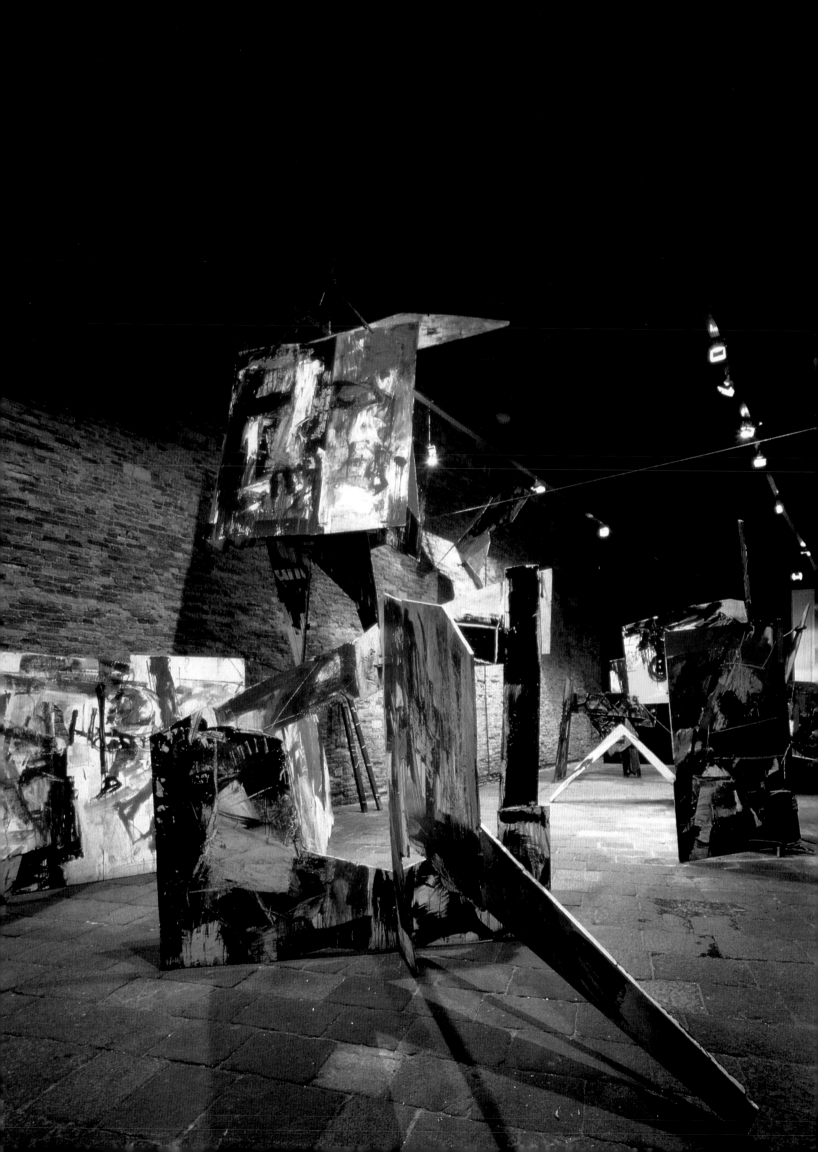

68. Emilio Vedova
Absurdes Berliner Tagebuch '64,
Plurimo N. 5/7 (Absurd Berlin
Diary '64, Plurimo No. 5/7), 1964
(open view). Oil and mixed media
on wood with iron hinges, pulley, and
ropes, 384 x 260 x 90 cm (open).
Collection of the artist, Venice.

69. Emilio Vedova
Ciclo '62–B.B.9 (Cycle '62–B.B.9),
1962. Oil on canvas, 149 x 250.5 cm.
Private collection.

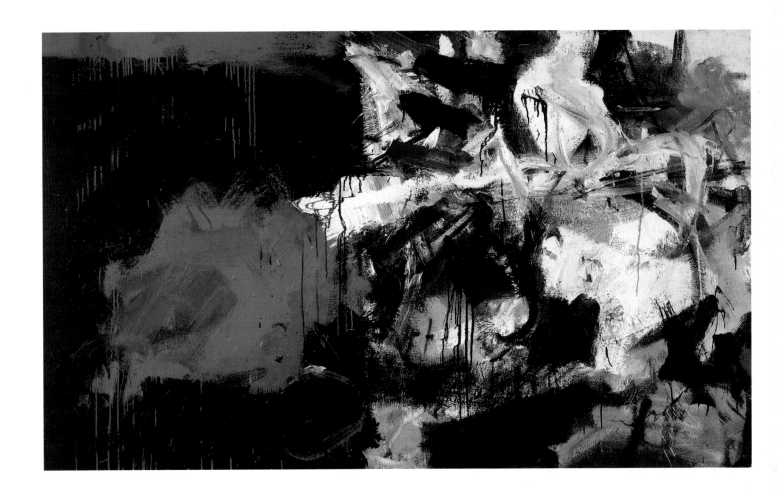

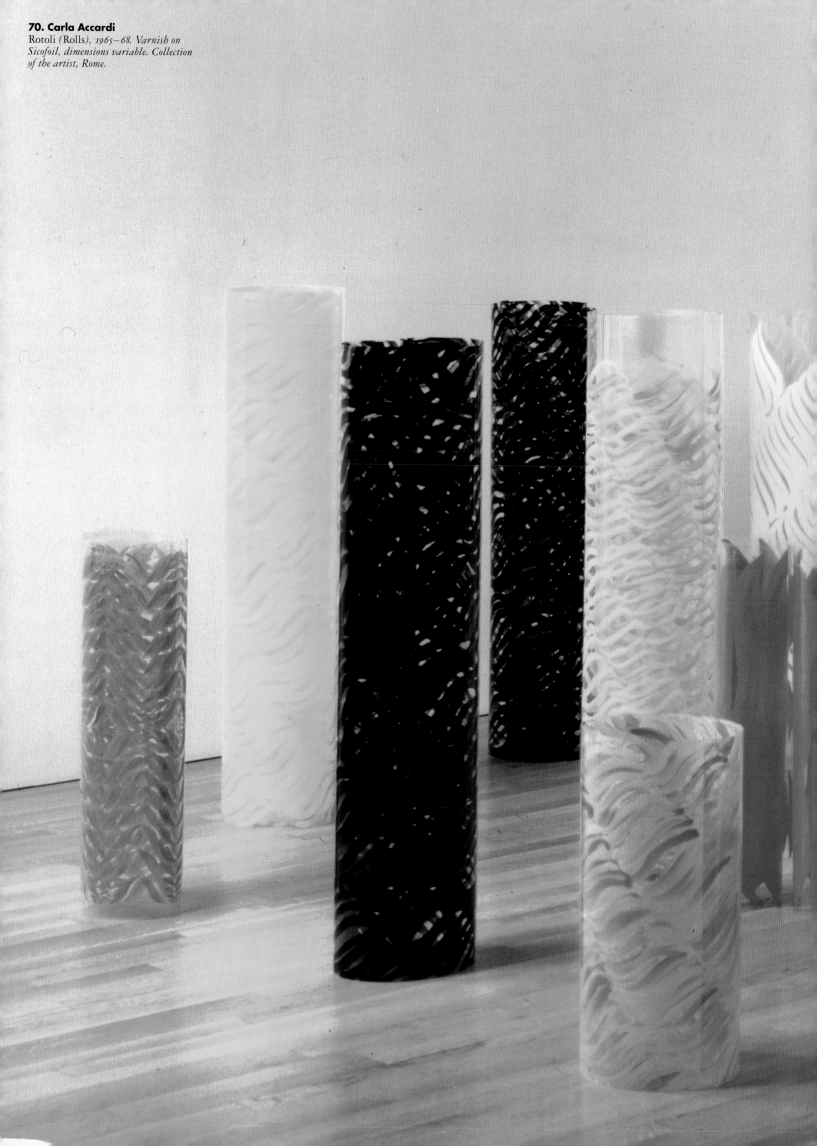

70. Carla Accardi
Rotoli (Rolls), *1965–68. Varnish on Sicofoil, dimensions variable. Collection of the artist, Rome.*

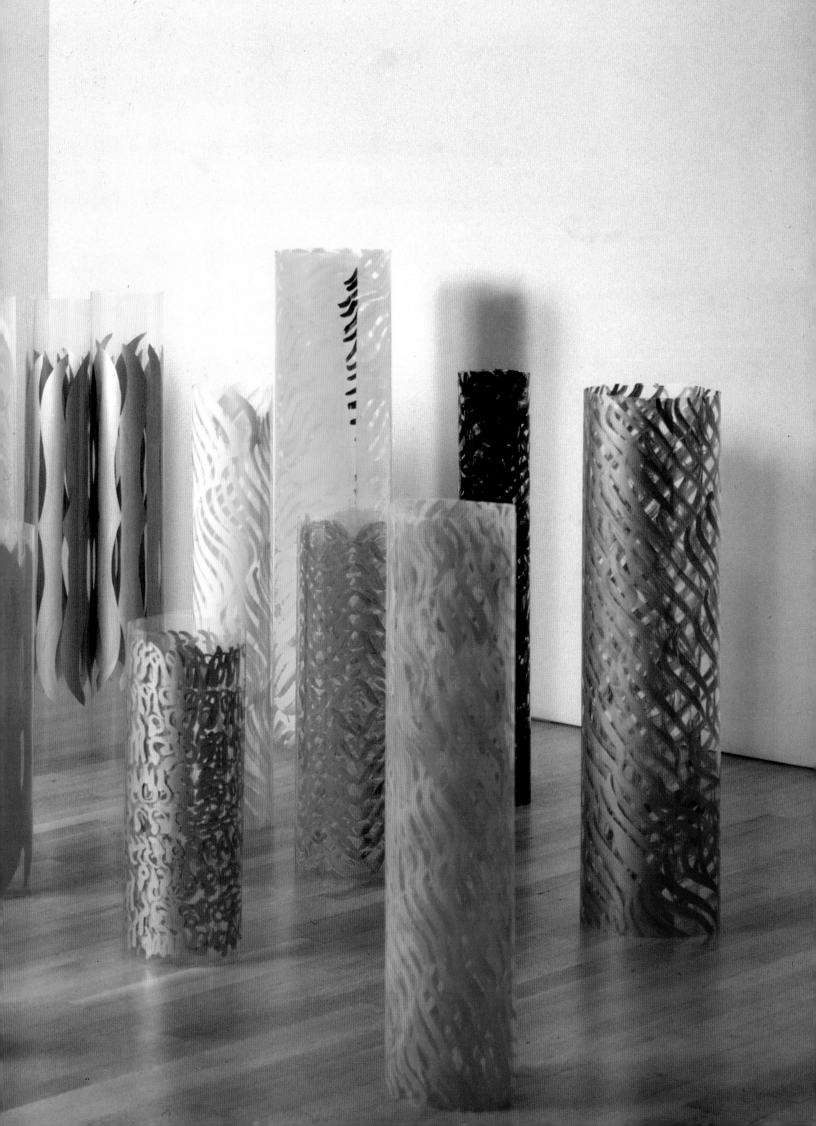

71. Carla Accardi
Grande integrazione (Large
Integration), 1957. Casein tempera
on canvas, 133 x 265 cm. Civico Museo
d'Arte Contemporanea, Milan.

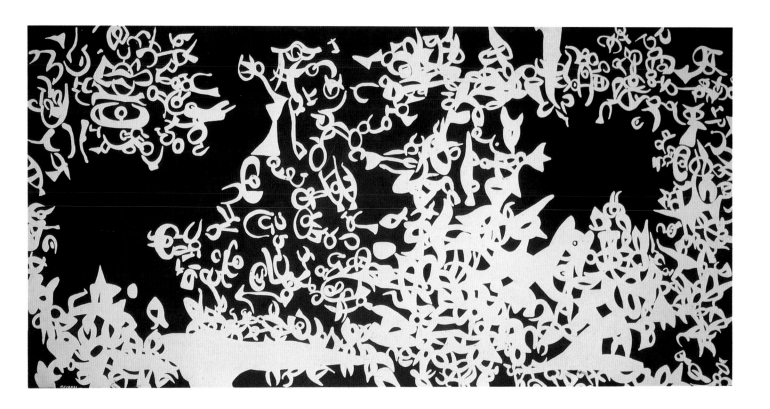

72. Carla Accardi
Losanghe rossoverde (Red-Green
Lozenges), *1964. Casein tempera on
canvas, 194 x 355 cm. Collection of
the artist, Rome.*

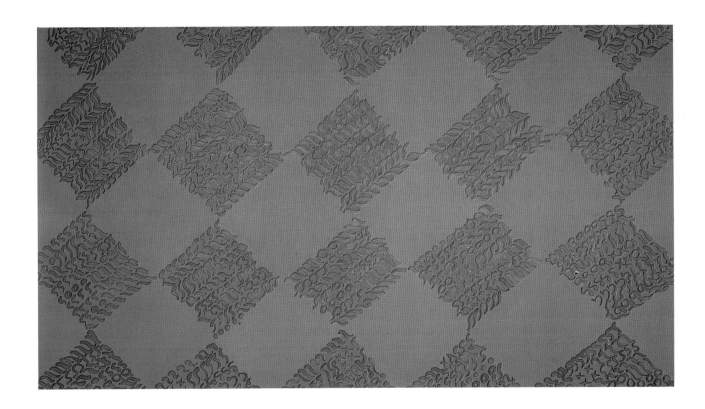

73. Alberto Burri
Combustione (Combustion), 1963.
Plastic and combustion, 199 x 248 cm.
Collection of the artist.

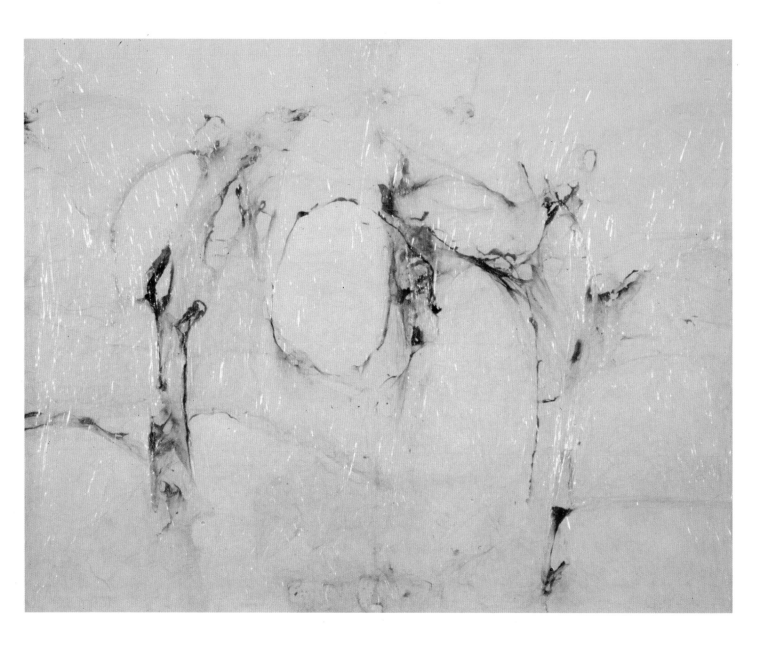

74. Alberto Burri
Plastica 4 *(Plastic 4), 1962. Plastic*
and combustion on aluminum stretcher,
100 x 86 cm. Collection of the artist.

75. Alberto Burri
Rosso plastica *(Red Plastic),*
1964. Plastic, Vinavil, and combustion
on canvas, 200 x 190 cm. Galleria
Nazionale d'Arte Moderna e
Contemporanea, Rome.

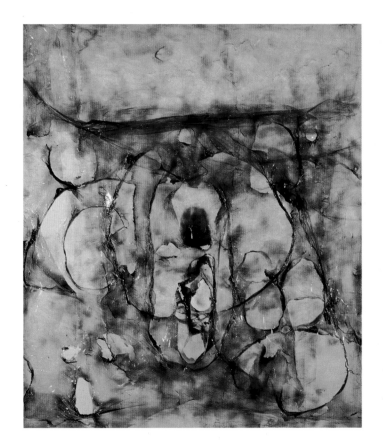

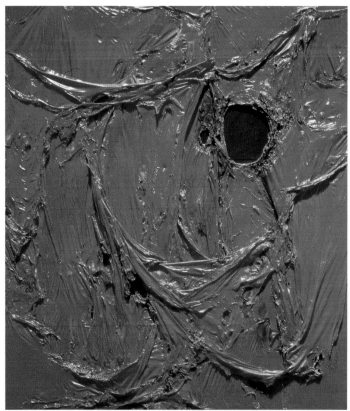

76. Enrico Castellani
Senza titolo (Untitled), *1961. Fabric
on stretcher frame, 75 x 100 x 8 cm.
Collection of Henk Peeters, Hall.*

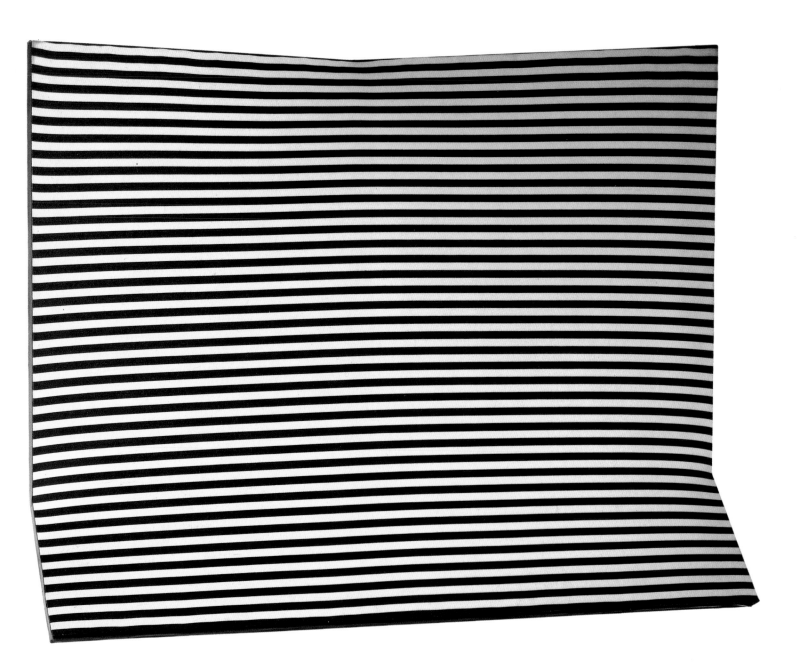

77. Enrico Castellani
Superficie gialla (Yellow Surface),
1965. Tempera on canvas, 146 x 120 cm.
Private collection, Milan.

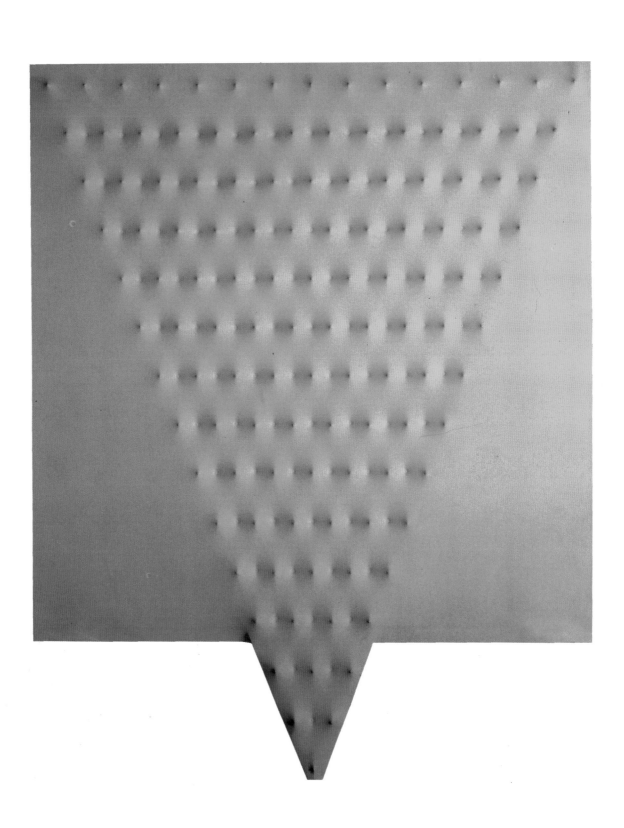

78. Enrico Castellani
Superficie bianca, n. 5 *(*White
Surface No. 5*), 1964. Tempera on
canvas, 114 x 146 x 30 cm. Private
collection, Foligno.*

79. Enrico Castellani
Senza titolo (Untitled), *1959.*
Tempera on canvas, 114 x 145 cm.
Private collection, Rome.

80. Ettore Colla
Rilievo policromo (Polychrome
Relief), 1958–60. Assemblage of found
iron pieces, 56 x 80 cm. Galleria
L'Isola, Rome.

81. Ettore Colla
Rilievo legno e ferro (Wood and
Iron Relief), *1961. Assemblage of iron
and wood, 121 x 115 cm. Galleria
L'Isola, Rome.*

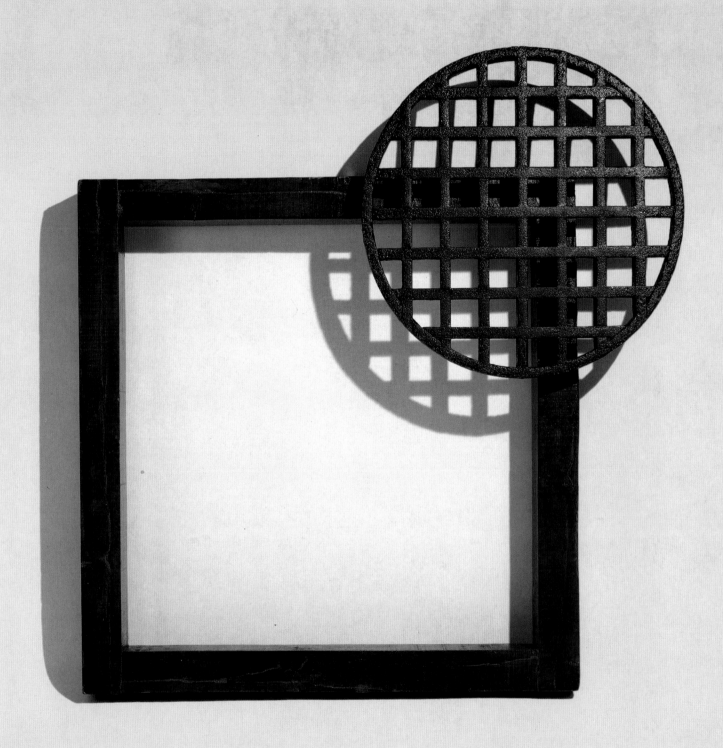

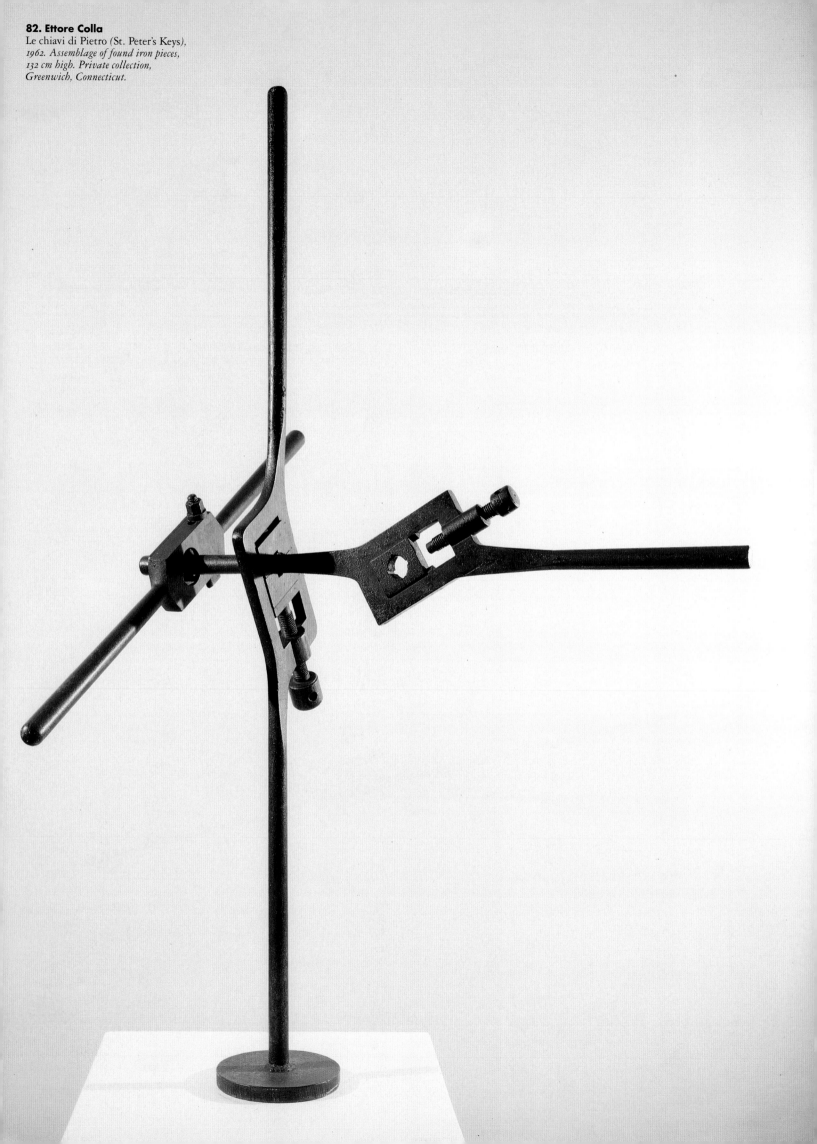

82. Ettore Colla
Le chiavi di Pietro (St. Peter's Keys),
1962. Assemblage of found iron pieces,
132 cm high. Private collection,
Greenwich, Connecticut.

83. Ettore Colla
Spirale (Spiral), *1962. Iron,*
101 cm high. Galleria Comunale d'Arte
Moderna, Spoleto, Gift of Giovanni
Carandente, Honorary Curator.

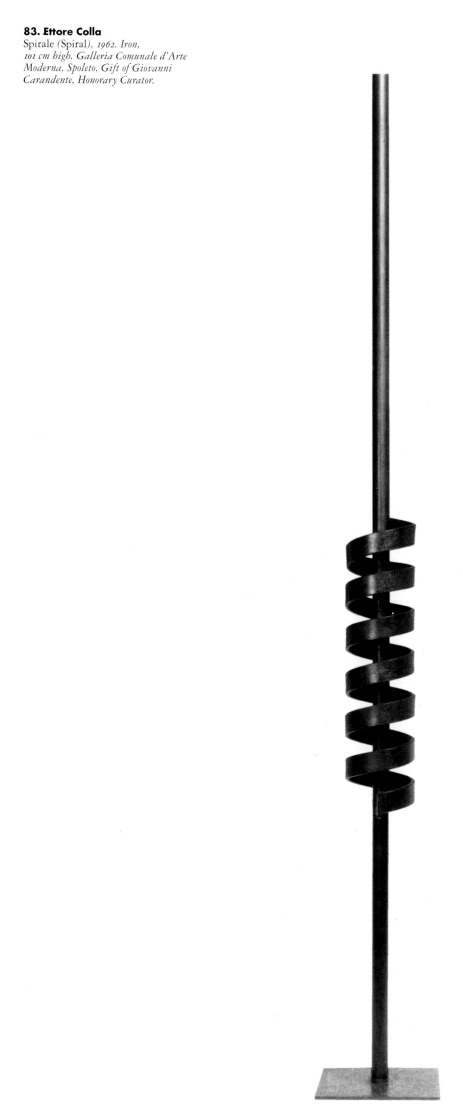

84. Piero Dorazio
Georgicon. *1958. Oil on canvas, 197 x 130 cm. Collection of the artist.*

85. Piero Dorazio
Tantalo T. *1958–59. Oil on canvas, 160 x 120 cm. Collection of the artist.*

86. Piero Dorazio
Mythification, *1962. Oil on canvas,*
130 x 160 cm. Collection of the artist.

87. Piero Dorazio
Mano della clemenza (Hand of
Mercy), 1963. Oil on canvas, 162.6 x
130.3 cm. The Museum of Modern Art,
New York, Bertram F. and Susie
Brummer Foundation Fund, 1965.

88. Piero Dorazio
Long Distance, *1963. Oil on canvas,*
185 x 250 cm. Private collection,
New York.

89. Luciano Fabro

Struttura ortogonale tirata ai quattro vertici (Orthogonal Structure Pulled at Four Vertices), 1964. Polished brass tubing, 88 x 188 x 3 cm. Collection of the artist, Milan.

90. Luciano Fabro

Ruota (Wheel), 1964. Steel tubing, 50 x 1 x 142 cm. Collection of the artist, Milan.

91. Luciano Fabro

Buco (Hole), 1963. Mirrored, transparent glass and metal; glass: 105 x 84 cm; stand: 110 x 87 cm. Collection of Agostino and Patrizia Re Rebaudengo, Turin.

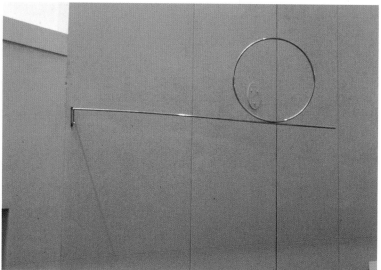

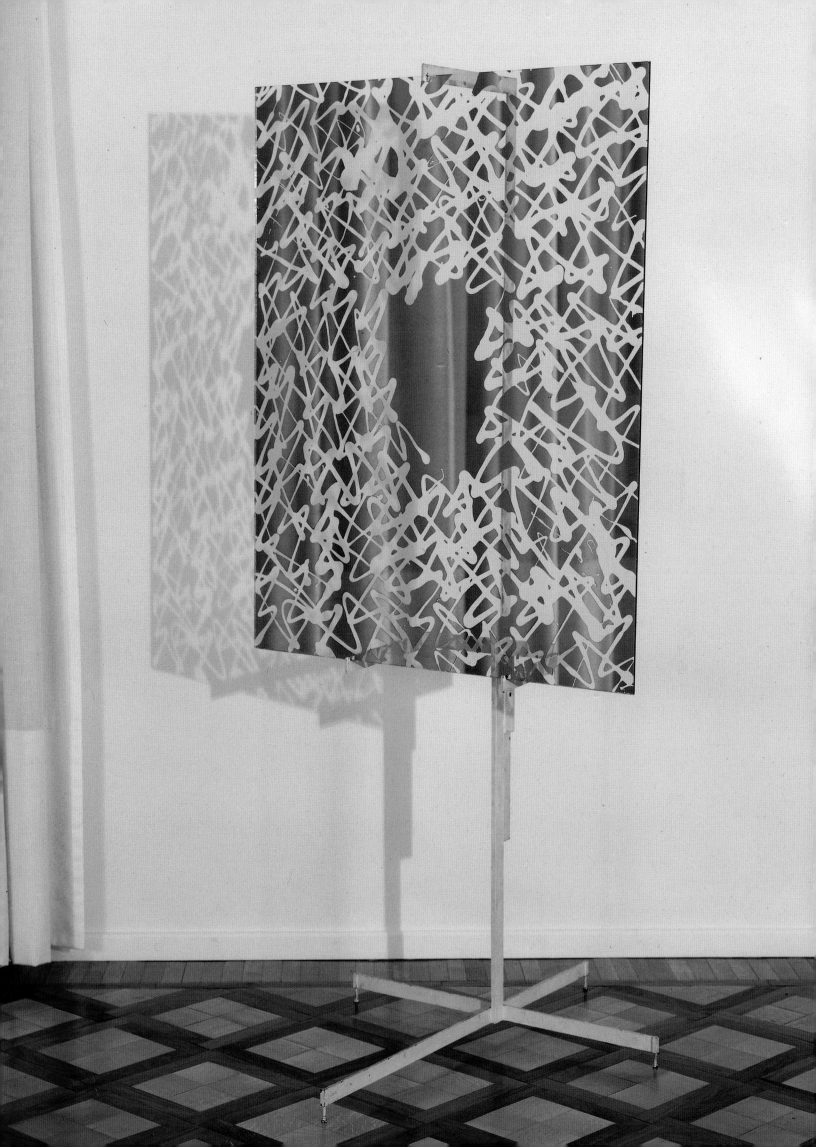

92. Tano Festa
La porta rossa (The Red Door), *1962.*
Enamel on wood, 200 x 100 cm.
Collection of Giorgio Franchetti, Rome.

93. Tano Festa
Obelisco (Obelisk), *1963. Enamel on*
wood, 116 x 89 cm. Collection of Giorgio
Franchetti, Rome.

92. Tano Festa
La porta rossa (The Red Door), *1962.*
Enamel on wood, 200 x 100 cm.
Collection of Giorgio Franchetti, Rome.

93. Tano Festa
Obelisco (Obelisk), *1963. Enamel on*
wood, 116 x 89 cm. Collection of Giorgio
Franchetti, Rome.

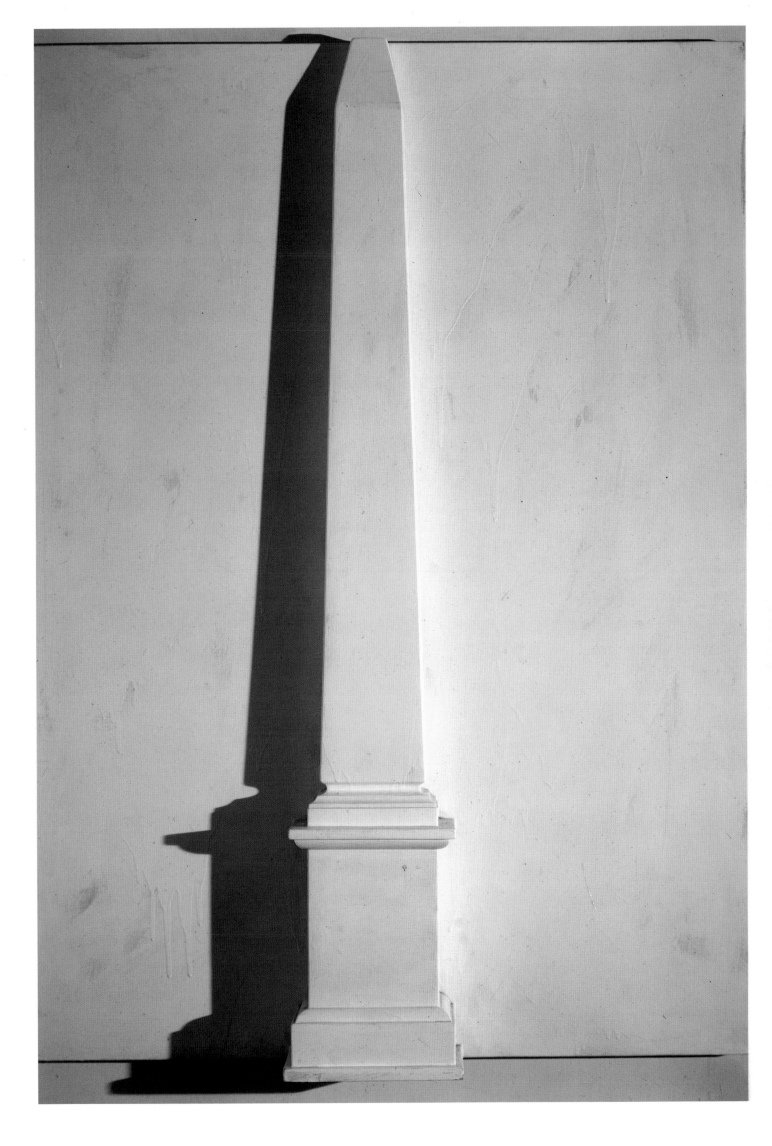

94. Lucio Fontana
Concetto spaziale. La Genesi (Spatial
Concept. Genesis), *1963. Oil and
graffiti on canvas with slashes, 178 x
123 cm. Private collection, Milan.*

98. Domenico Gnoli
Dormiente n. 2 (Sleeper No. 2),
*1966. Oil and sand on canvas, 85 x
70 cm. Collection of Jan and Marie-
Anne Krugier-Poniatowski, courtesy of
Galerie Jan Krugier, Geneva.*

99. Domenico Gnoli
Tavole di ristorante (Restaurant
Tables), *1966. Oil and sand on canvas,
150 x 160 cm. Collection of Jan and
Marie-Anne Krugier-Poniatowski,
courtesy of Galerie Jan Krugier,
Geneva.*

100. Domenico Gnoli
Giro di collo 15½ (Neck Size 15½),
1966. Oil and sand on canvas, 120 x
160 cm. Krugier-Ditesheim Art
Contemporain, Geneva.

101. Jannis Kounellis
Senza titolo (Untitled), *1959–60.*
Oil on canvas, 125 x 205 cm. Collection
of Nicola Bulgari, New York.

102. Jannis Kounellis
Senza titolo (Untitled), *1959–60.*
Tempera on graph paper mounted on
canvas, 136 x 254.9 cm. The Museum of
Modern Art, New York, Purchase.

103. Jannis Kounellis
Senza titolo (Notte) (Untitled
[Night]), *1965. Oil on canvas, 120 x
180 cm. Galerie Neuendorf, Frankfurt.*

104. Jannis Kounellis
Senza titolo (Giallo) *(*Untitled [Yellow]*), 1965. Oil on canvas, 188 x 226 cm. Private collection.*

105. Leoncillo [Leoncillo Leonardi]
San Sebastiano I *(Saint Sebastian I),*
1962. Glazed terra-cotta, 192 x 60 x
45 cm. Collection of Fabio Sargentini,
Rome.

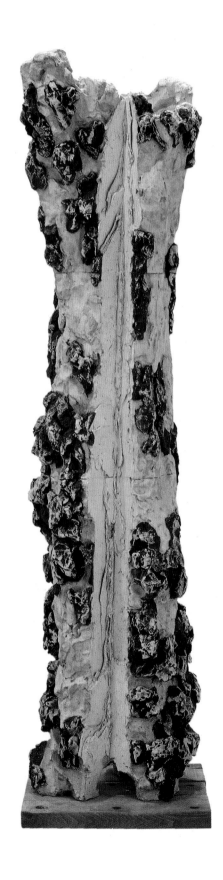

106. Leoncillo [Leoncillo Leonardi]
San Sebastiano II (Saint Sebastian II),
1962. Glazed terra-cotta, 190 x 52 x
40 cm. Collection of Fabio Sargentini,
Rome.

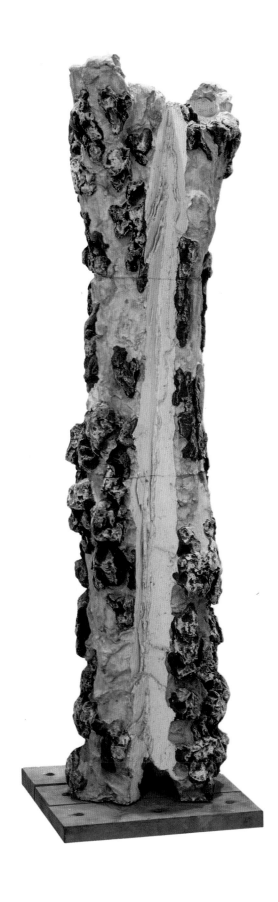

107. Francesco Lo Savio
Spazio-luce (Space-Light), *1959.*
Synthetic resin on canvas, 155 x 170 cm.
Collection of Gian Tomaso Liverani,
Galleria La Salita, Rome.

108. Francesco Lo Savio
For nothing, *1960. Synthetic resin on canvas, 155 x 177 cm. Collection of Gian Tomaso Liverani, Galleria La Salita, Rome.*

109. Francesco Lo Savio
Metallo nero opaco uniforme
(Uniform Opaque Black Metal),
1960. *Varnished black sheet metal, 100 x
200 x 20 cm. Collection of Gian Tomaso
Liverani, Galleria La Salita, Rome.*

110. Francesco Lo Savio
Metallo nero opaco uniforme,
articolazione di superficie orizzontale
(Uniform Opaque Black Metal,
Horizontal Surface Articulation),
1960. *Varnished black sheet metal,
95 x 200 x 20 cm. Collection of Gian
Tomaso Liverani, Galleria La Salita,
Rome.*

111. Francesco Lo Savio
Articolazione totale (Total
Articulation), 1962. Cement and
varnished black sheet metal, 100 x 100 x
100 cm. Collection of Gian Tomaso
Liverani, Galleria La Salita, Rome.

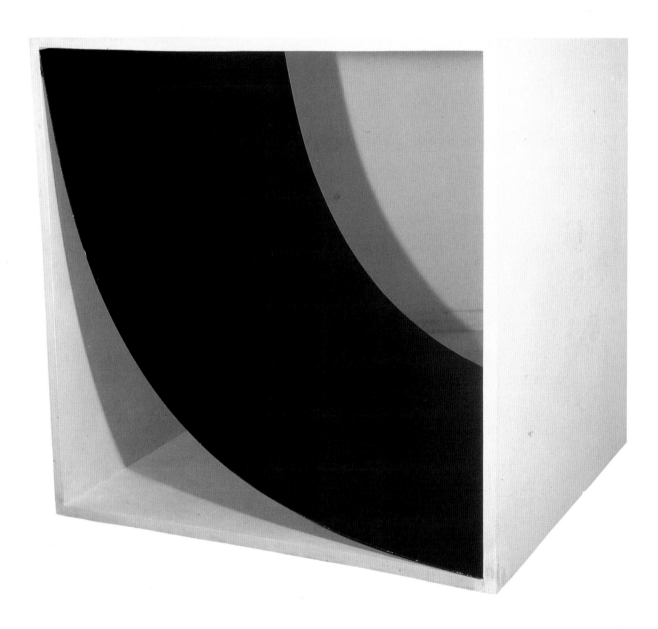

112. Piero Manzoni
Alfabeto (Alphabet), *1958. Ink and
kaolin on canvas, 25 x 18 cm. Collection
of Angelo Calmarini, Milan.*

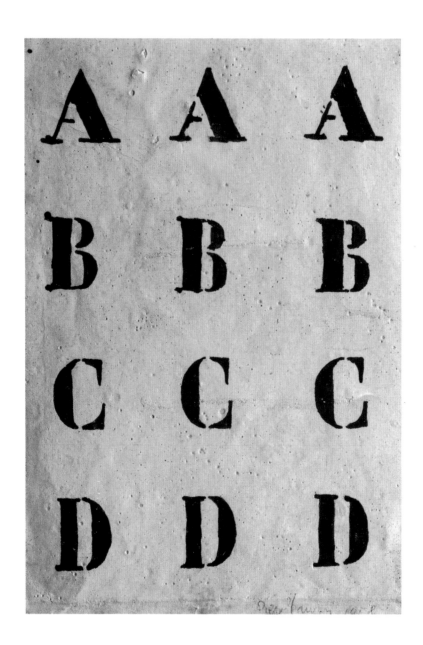

113. Piero Manzoni
1–30 settembre *(September 1–30)*,
1959. Ink on paper, 65 x 50 cm.
Collection of Angelo Calmarini, Milan.

114. Piero Manzoni
Achrome, *1959. Kaolin on creased
canvas, 140 x 120.5 cm. Musée National
d'Art Moderne, Centre Georges
Pompidou, Paris, 1981.*

115. Piero Manzoni
Achrome, *1958. Kaolin on creased
canvas, 130 x 160 cm. Galleria Civica
d'Arte Moderna e Contemporanea,
Turin.*

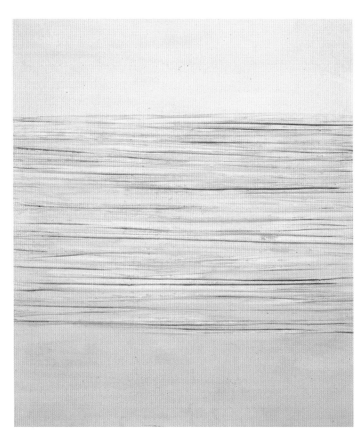

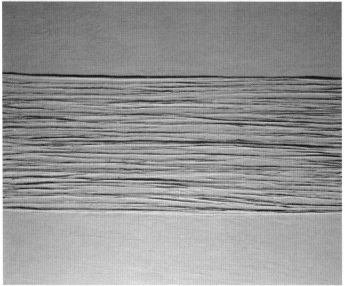

116. Piero Manzoni
Achrome, *1959. Kaolin on sewn canvas,*
130.5 x 97.6 cm. Herning Kunstmuseum.

116. Piero Manzoni
Achrome, *1959. Kaolin on sewn canvas,*
130.5 x 97.6 cm. Herning Kunstmuseum.

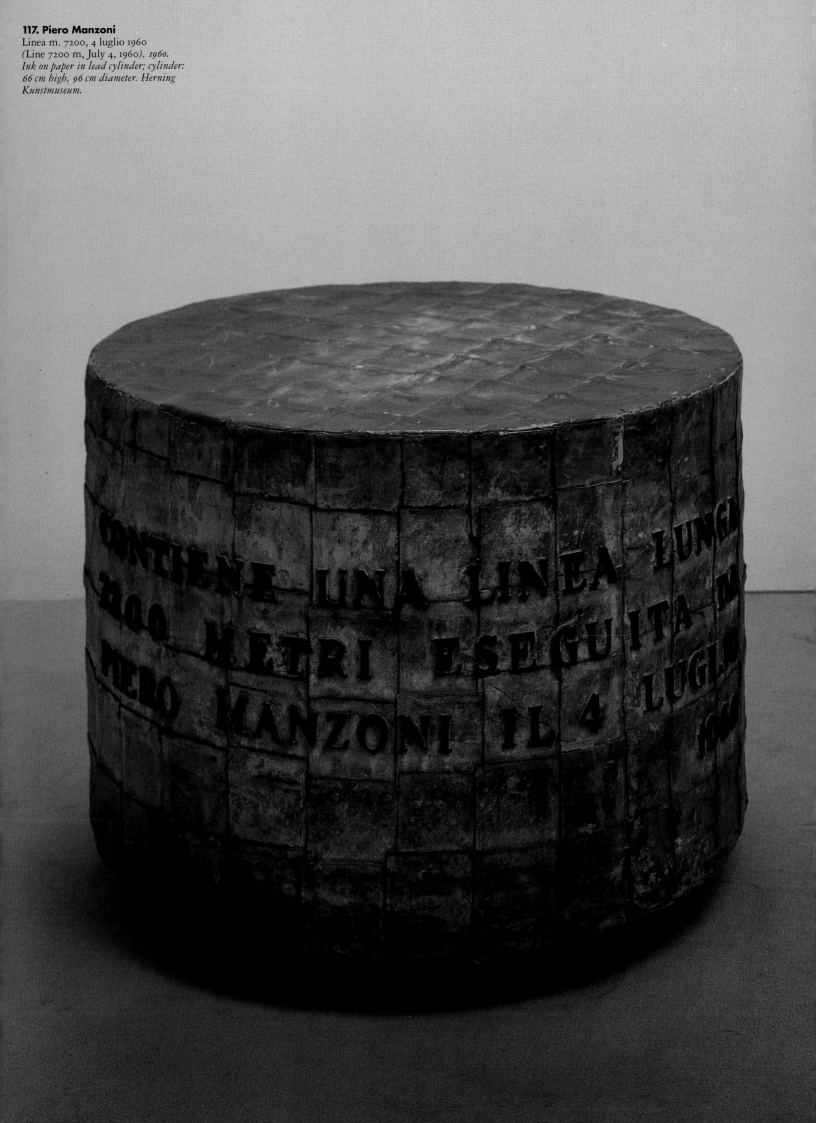

117. Piero Manzoni
Linea m. 7200, 4 luglio 1960
(Line 7200 m, July 4, 1960), 1960.
Ink on paper in lead cylinder; cylinder:
66 cm high, 96 cm diameter. Herning
Kunstmuseum.

118. Piero Manzoni
Linea m. 6, settembre 1959
(Line 6 m, September 1959), 1959. Ink
on paper in cardboard cylinder;
cylinder: 25.8 cm high, 6 cm diameter.
Collection of the Manzoni family,
Milan.

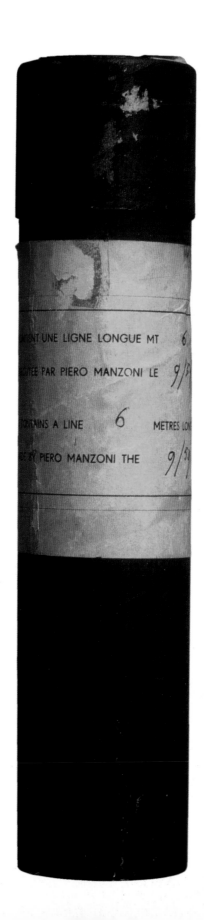

119. Piero Manzoni
Linea m. 10.06, settembre 1959
(Line 10.06 m, September 1959), *1959.*
Ink on paper in cardboard cylinder;
cylinder: 22.8 cm high, 6 cm diameter.
Collection of Arturo Schwarz, Milan.

120. Piero Manzoni
Linea m. 15.78, settembre 1959
(Line 15.78 m, September 1959), *1959.*
Ink on paper in cardboard cylinder;
cylinder: 22 cm high, 6 cm diameter.
Collection of Giuseppe Zecchillo, Milan.

121. Piero Manzoni
Linea m. 19.11, settembre 1959
(Line 19.11 m, September 1959), 1959.
Ink on paper in cardboard cylinder;
cylinder: 26.5 cm high, 7 cm diameter.
Collection of the Manzoni family,
Milan.

122. Piero Manzoni
Linea m. 0.78, ottobre 1959
(Line 0.78 m, October 1959), 1959.
Ink on paper in cardboard cylinder;
cylinder: 15.2 cm high, 5.7 cm diameter.
Courtesy of Hirschl & Adler Modern,
New York.

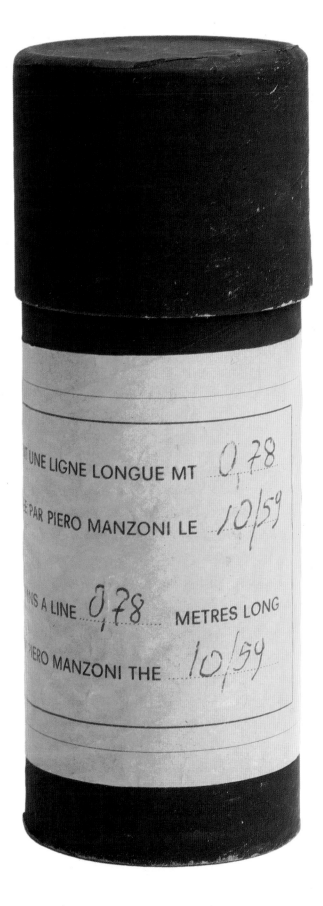

123. Piero Manzoni
Linea m. 4.51, ottobre 1959
(Line 4.51 m, October 1959), 1959.
Ink on paper in cardboard cylinder;
cylinder: 21 cm high, 6 cm diameter.
Collection of Achille and Ida
Maramotti, Albinea.

124. Piero Manzoni
Linea m. 5.10, ottobre 1959
(Line 5.10 m, October 1959), 1959.
Ink on paper in cardboard cylinder,
dimensions unknown. Private collection,
Milan.

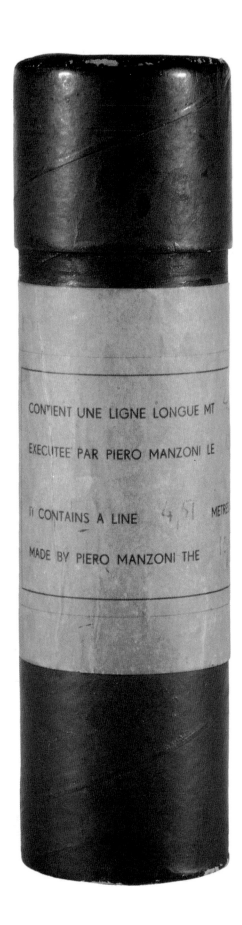

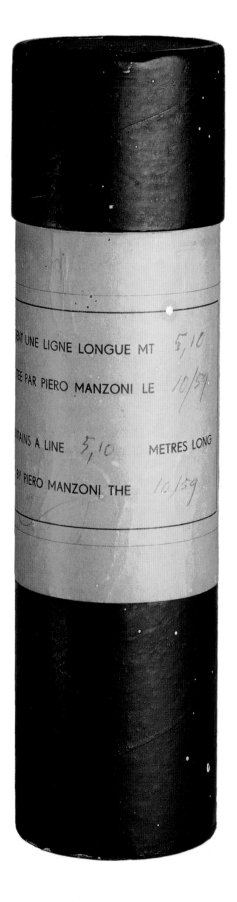

125. Piero Manzoni
Linea m. 33.63, ottobre 1959
(Line 33.63 m, October 1959), 1959.
Ink on paper in cardboard cylinder;
cylinder: 41 cm high, 8.5 cm diameter.
Collection of Angelo Calmarini, Milan.

126. Piero Manzoni
Linea m. 11.94, novembre 1959
(Line 11.94 m, November 1959), 1959.
Ink on paper in cardboard cylinder;
cylinder: 16.4 cm high, 6 cm diameter.
Collection of Angelo Calmarini, Milan.

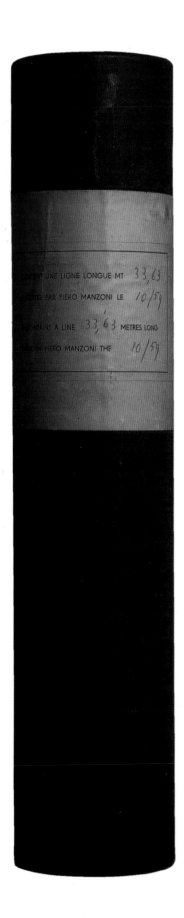

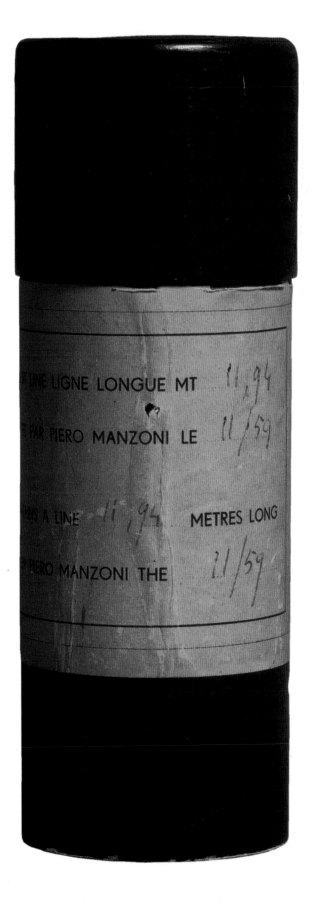

127. Piero Manzoni
Linea m. 4.50, dicembre 1959
(Line 4.50 m, December 1959), 1959.
*Ink on paper in cardboard cylinder;
cylinder: 22 cm high, 6 cm diameter.
Collection of Attilio Codognato, Venice.*

128. Piero Manzoni
Linea m. 8.25, dicembre 1959
(Line 8.25 m, December 1959), 1959.
*Ink on paper in cardboard cylinder;
cylinder: 22.7 cm high, 6 cm diameter.
Collection of Angelo Calmarini, Milan.*

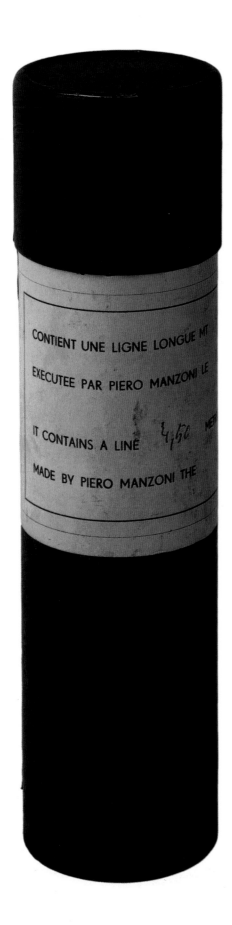

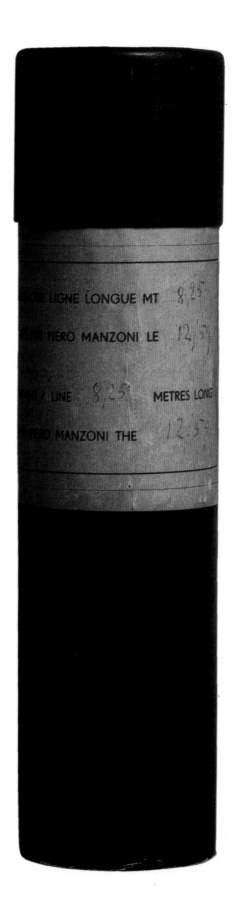

129. Piero Manzoni
Linea m. 9.24, dicembre 1959
(Line 9.24 m, December 1959), 1959.
Ink on paper in cardboard cylinder;
cylinder: 22 cm high, 6 cm diameter.
Collection of Angelo Calmarini, Milan.

130. Piero Manzoni
Linea m. 10, dicembre 1959
(Line 10 m, December 1959), 1959.
Ink on paper in cardboard cylinder;
cylinder: 22.5 cm high, 5.7 cm diameter.
Collection of Gilbert and Lila
Silverman, Detroit.

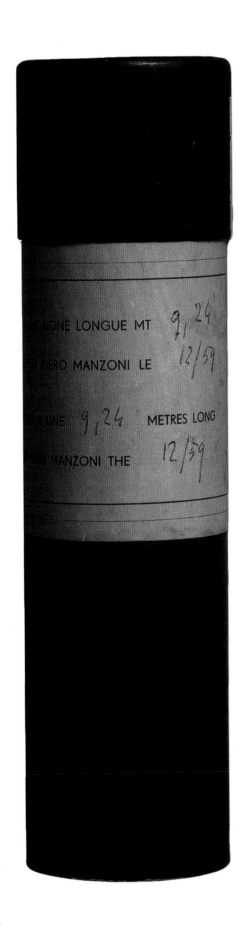

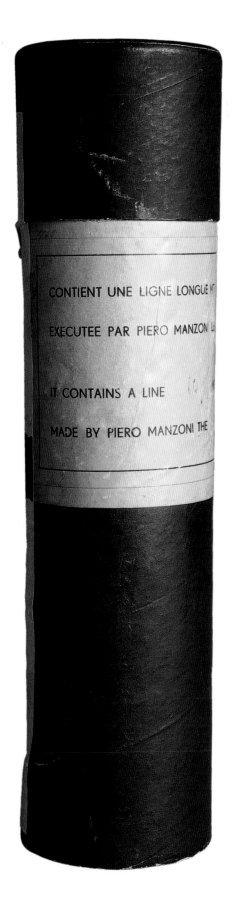

131. Piero Manzoni
Linea di lunghezza infinita (Line of
Infinite Length), *1960. Ink on paper
in wood cylinder, cylinder: 15 cm high,
4.8 cm diameter. Collection of the
Manzoni family, Milan.*

132. Piero Manzoni
Merda d'artista n. 001 (Artist's Shit
No. 001), *1961. Metal can, 4.8 cm high,
6.5 cm diameter. Collection of Nanda
Vigo, Milan.*

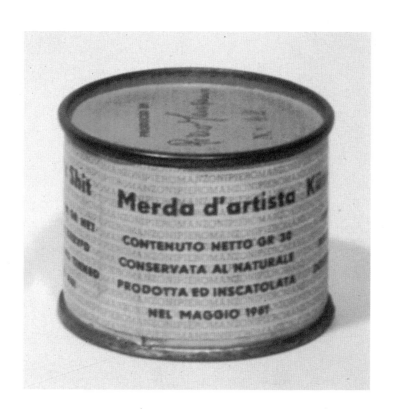

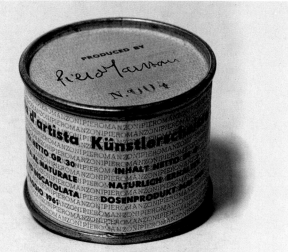

133

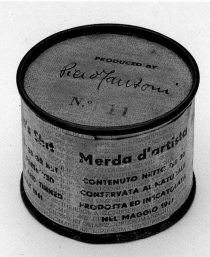

134

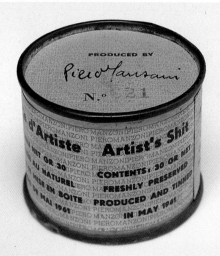

135

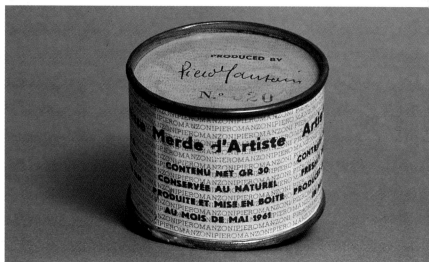

136

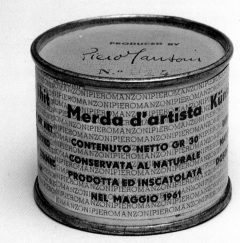

137

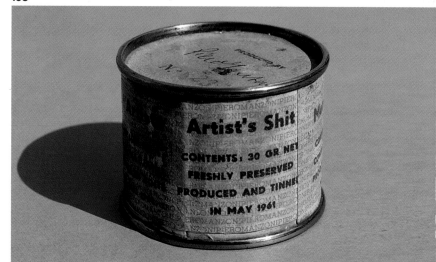

138

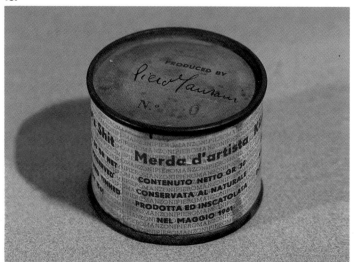

139

140

141

142

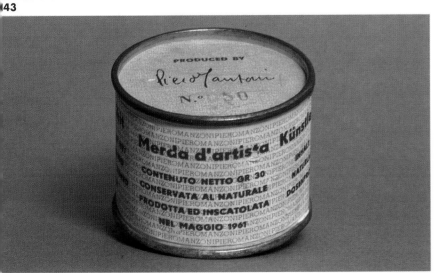

143

144

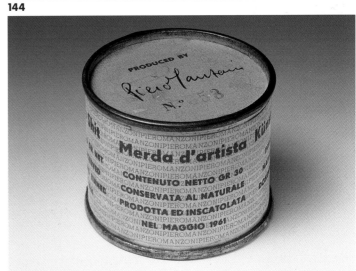

145

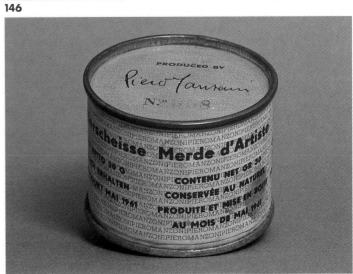

146

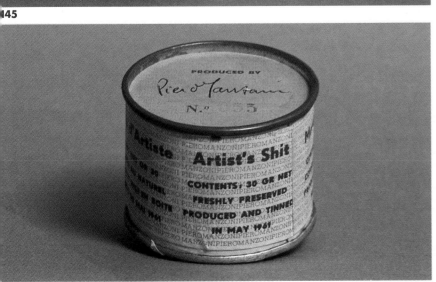

147

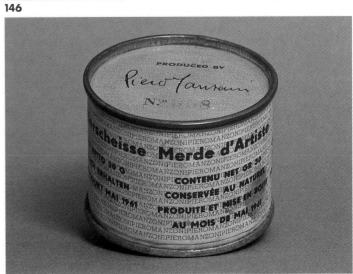

148

133. Piero Manzoni

Merda d'artista n. 004 (Artist's Shit No. 004), *1961. Metal can, 4.8 cm high, 6.5 cm diameter. Private collection.*

134. Piero Manzoni

Merda d'artista n. 011 (Artist's Shit No. 011), *1961. Metal can, 4.8 cm high, 6.5 cm diameter. Private collection, Foligno.*

135. Piero Manzoni

Merda d'artista n. 014 (Artist's Shit No. 014), *1961. Metal can, 4.8 cm high, 6.5 cm diameter. Private collection.*

136. Piero Manzoni

Merda d'artista n. 020 (Artist's Shit No. 020), *1961. Metal can, 4.8 cm high, 6.5 cm diameter. Collection of the Manzoni family, Milan.*

137. Piero Manzoni

Merda d'artista n. 021 (Artist's Shit No. 021), *1961. Metal can, 4.8 cm high, 6.5 cm diameter. Collection of Danielle and François Morellet, Cholet.*

138. Piero Manzoni

Merda d'artista n. 023 (Artist's Shit No. 023), *1961. Metal can, 4.8 cm high, 6.5 cm diameter. Collection of Gilbert and Lila Silverman, Detroit.*

139. Piero Manzoni

Merda d'artista n. 030 (Artist's Shit No. 030), *1961. Metal can, 4.8 cm high, 6.5 cm diameter. Collection of Dadamaino.*

140. Piero Manzoni

Merda d'artista n. 031 (Artist's Shit No. 031), *1961. Metal can, 4.8 cm high, 6.5 cm diameter. Musée National d'Art Moderne, Centre Georges Pompidou, Paris, Gift of the Galerie Durand-Dessert, 1994.*

141. Piero Manzoni

Merda d'artista n. 033 (Artist's Shit No. 033), *1961. Metal can, 4.8 cm high, 6.5 cm diameter. Herning Kunstmuseum.*

142. Piero Manzoni

Merda d'artista n. 038 (Artist's Shit No. 038), *1961. Metal can, 4.8 cm high, 6.5 cm diameter. Collection of Angelo Calmarini, Milan.*

143. Piero Manzoni

Merda d'artista n. 042 (Artist's Shit No. 042), *1961. Metal can, 4.8 cm high, 6.5 cm diameter. Collection of Nanda Vigo, Milan.*

144. Piero Manzoni

Merda d'artista n. 047 (Artist's Shit No. 047), *1961. Metal can, 4.8 cm high, 6.5 cm diameter. Collection of Attilio Codognato, Venice.*

145. Piero Manzoni

Merda d'artista n. 050 (Artist's Shit No. 050), *1961. Metal can, 4.8 cm high, 6.5 cm diameter. Collection of the Manzoni family, Milan.*

146. Piero Manzoni

Merda d'artista n. 053 (Artist's Shit No. 053), *1961. Metal can, 4.8 cm high, 6.5 cm diameter. Private collection, Milan.*

147. Piero Manzoni

Merda d'artista n. 055 (Artist's Shit No. 055), *1961. Metal can, 4.8 cm high, 6.5 cm diameter. Collection of the Manzoni family, Milan.*

148. Piero Manzoni

Merda d'artista n. 058 (Artist's Shit No. 058), *1961. Metal can, 4.8 cm high, 6.5 cm diameter. Collection of the Manzoni family, Milan.*

149. Piero Manzoni

Merda d'artista n. 060 (Artist's Shit No. 060), *1961. Metal can, 4.8 cm high, 6.5 cm diameter. Collection of Giuseppe Zecchillo, Milan.*

150. Piero Manzoni

Merda d'artista n. 063 (Artist's Shit No. 063), *1961. Metal can, 4.8 cm high, 6.5 cm diameter. Collection of the Manzoni family, Milan.*

151. Piero Manzoni

Merda d'artista n. 066 (Artist's Shit No. 066), *1961. Metal can, 4.8 cm high, 6.5 cm diameter. Collection of Danielle and François Morellet, Cholet.*

152. Piero Manzoni

Merda d'artista n. 068 (Artist's Shit No. 068), *1961. Metal can, 4.8 cm high, 6.5 cm diameter. Collection of the Manzoni family, Milan.*

153. Piero Manzoni

Merda d'artista n. 072 (Artist's Shit No. 072), *1961. Metal can, 4.8 cm high, 6.5 cm diameter. Collection of Giuseppe Zecchillo, Milan.*

154. Piero Manzoni

Merda d'artista n. 076 (Artist's Shit No. 076), *1961. Metal can, 4.8 cm high, 6.5 cm diameter. Collection of Nanda Vigo, Milan.*

155. Piero Manzoni

Merda d'artista n. 078 (Artist's Shit No. 078), *1961. Metal can, 4.8 cm high, 6.5 cm diameter. Collection of the Manzoni family, Milan.*

156. Piero Manzoni

Merda d'artista n. 079 (Artist's Shit No. 079), *1961. Metal can, 4.8 cm high, 6.5 cm diameter. Courtesy of Galleria Minini, Brescia.*

157. Piero Manzoni

Merda d'artista n. 080 (Artist's Shit No. 080), *1961. Metal can, 4.8 cm high, 6.5 cm diameter. Collection of the Manzoni family, Milan.*

158. Piero Manzoni

Merda d'artista n. 084 (Artist's Shit No. 084), *1961. Metal can, 4.8 cm high, 6.5 cm diameter. Collection of Lucio Amelio, Naples.*

159. Piero Manzoni

Merda d'artista n. 086 (Artist's Shit No. 086), *1961. Metal can, 4.8 cm high, 6.5 cm diameter. Collection of Vanni Scheiwiller, Milan.*

160. Piero Manzoni

Merda d'artista n. 088 (Artist's Shit No. 088), *1961. Metal can, 4.8 cm high, 6.5 cm diameter. Collection of Nanda Vigo, Milan.*

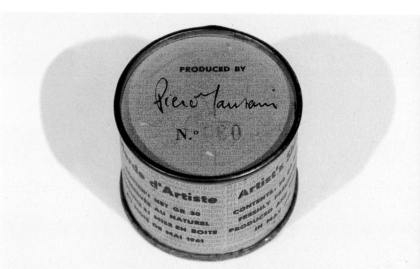

149

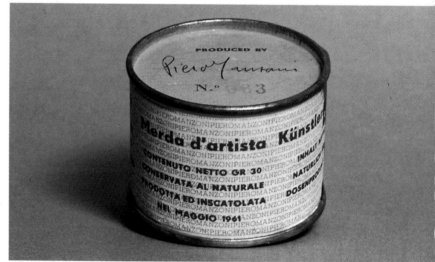

150

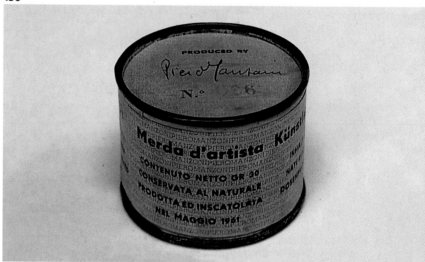

151

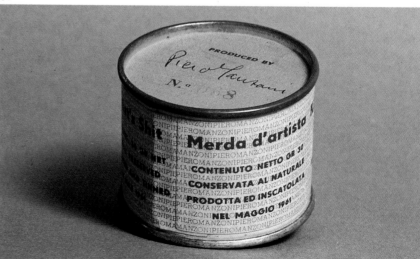

152

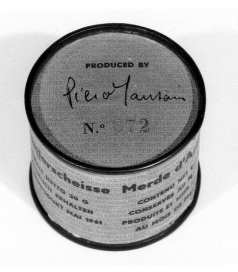

153

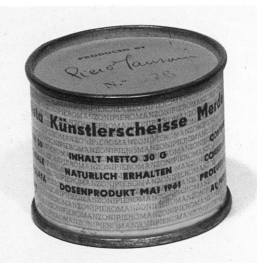

154

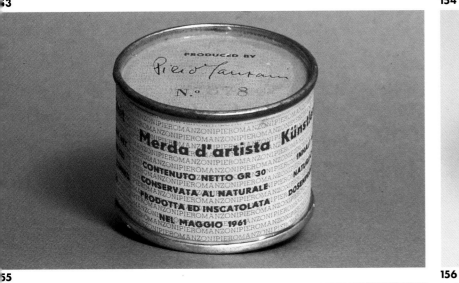

155

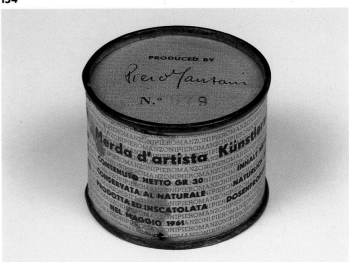

156

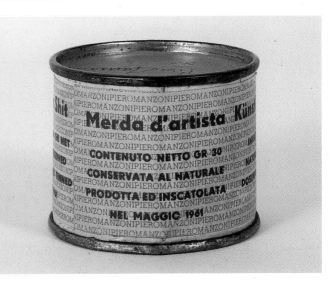

157

158

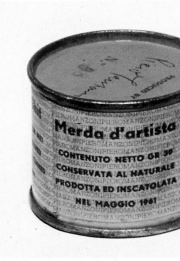

159

160

161. Piero Manzoni
Achrome, *1961. Fiberglass, 82 x 65 cm.*
Collection of Rosangela Cochrane.

162. Piero Manzoni
Nuage (Achrome) *(Cloud [Achrome]),*
1961. Fiberglass, 95.5 x 84.5 x 21.5 cm.
Collection of Geertjan Visser.

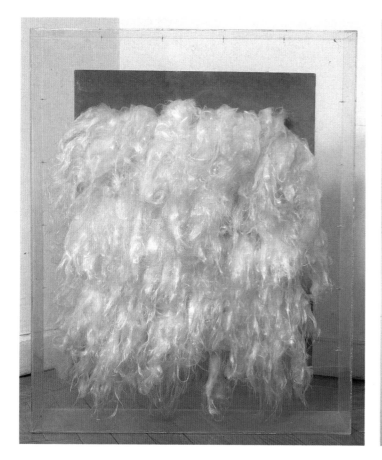

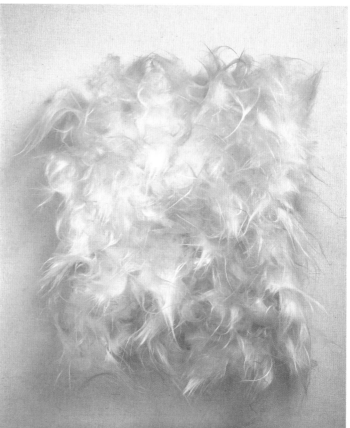

163. Piero Manzoni
Nuage (Achrome) (Cloud [Achrome]),
1962. Fiberglass, 130 x 110 x 27 cm.
Kröller-Müller Museum, Otterlo,
The Netherlands.

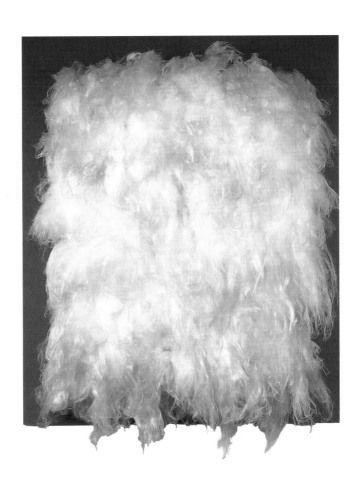

164. Piero Manzoni
Achrome, *1961. Rabbit fur and skin:
45.5 cm diameter; burnt-wood base:
46.9 x 46.9 x 46.9 cm. Herning
Kunstmuseum.*

165. Piero Manzoni
Achrome, *1961. Straw and kaolin:
68.3 x 45.8 x 44.5 cm; wood base: 19.5 x
51.5 x 50.6 cm. Herning Kunstmuseum.*

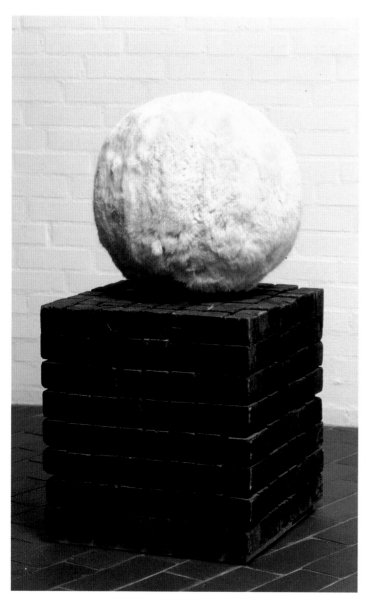

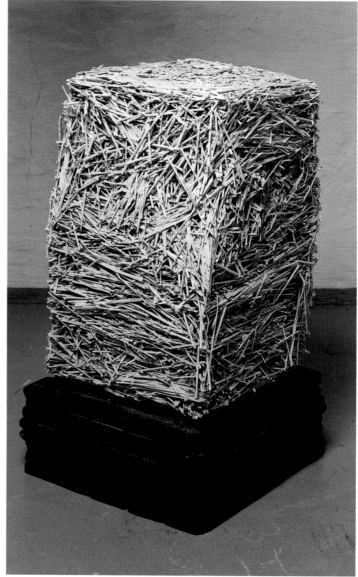

166. Piero Manzoni
Base del Mondo (Base of the World).
1961. Iron and bronze, 82 x 100 x
100 cm. Herning Kunstmuseum.

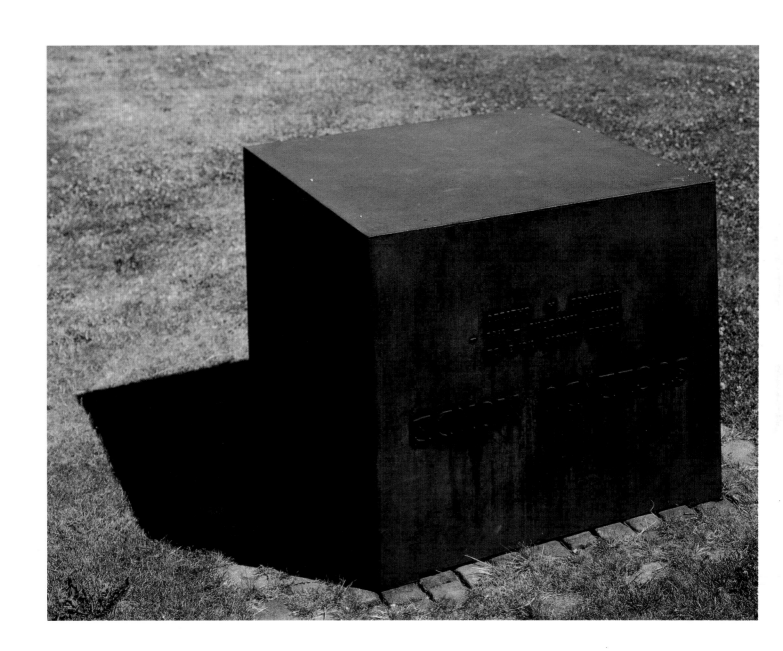

167. Fausto Melotti
Josephine Baker, *1962. Brass
and bronze, 52 x 10 x 10 cm. Private
collection, New York.*

168. Fausto Melotti
La casa dell'orologiaio *(The
Watchmaker's House), 1960. Brass,
115 x 37 x 16 cm. Melotti Collection,
Milan.*

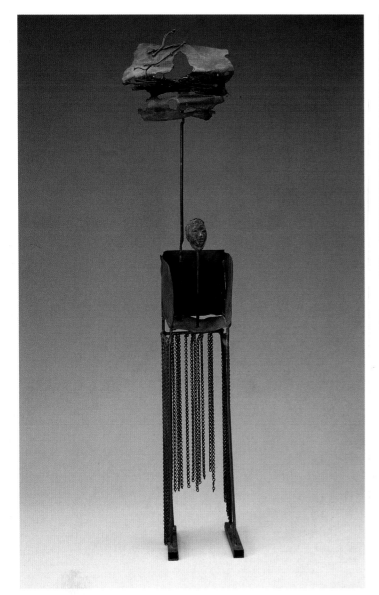

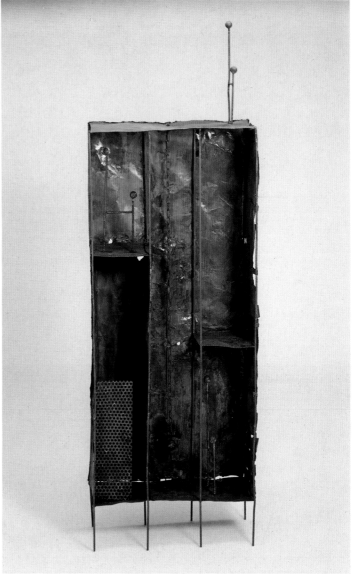

169. Fausto Melotti
Il magazzino delle idee (The
Warehouse of Ideas), 1960. Brass,
106 x 30 x 13 cm. Collection of Cristina
Melotti, New York.

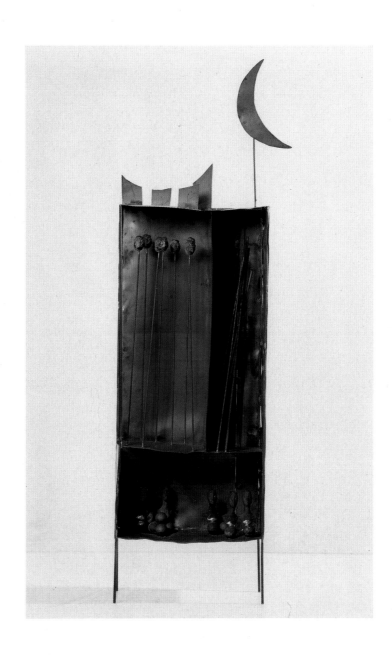

169. Fausto Melotti
Il magazzino delle idee (The
Warehouse of Ideas), 1960. Brass,
106 x 30 x 13 cm. Collection of Cristina
Melotti, New York.

170. Fausto Melotti
Incendio bianco (White Fire), *1961.*
Painted terra-cotta, paper, cotton,
glazed ceramic, and pumice, 49 x 39 x
11 cm. Collection of Attorney Mario
D'Urso, Rome.

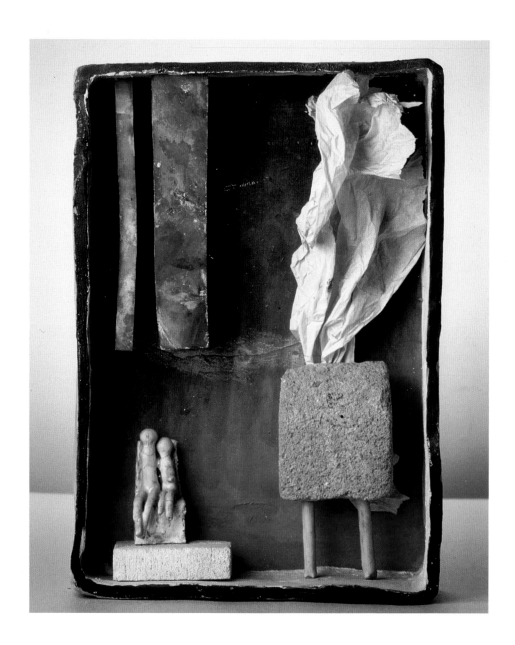

171. Fausto Melotti
La vita a pezzi (Life in Pieces), *1961.*
Painted terra-cotta, brass, and bronze,
55 x 49 x 13 cm. Private collection,
Milan.

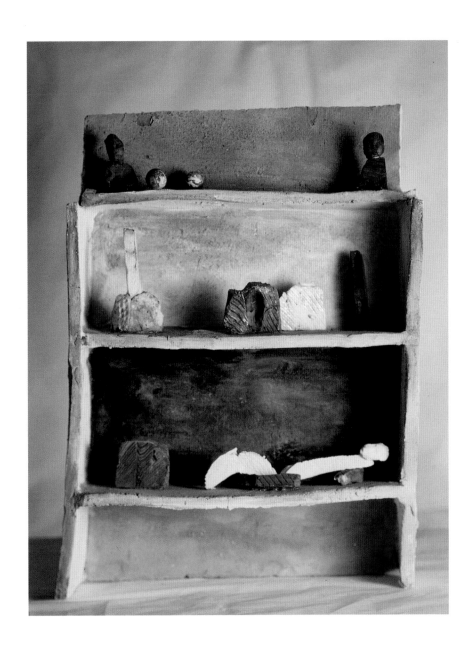

172. Fausto Melotti
Il viaggio (The Journey), *1961.*
Brass, bronze, and painted wood,
210 x 100 x 35 cm. Collection of
Marta Melotti, Milan.

173. Fausto Melotti
Reti (Nets), *1961. Brass, 101 x 37 x*
16 cm. Private collection, Milan.

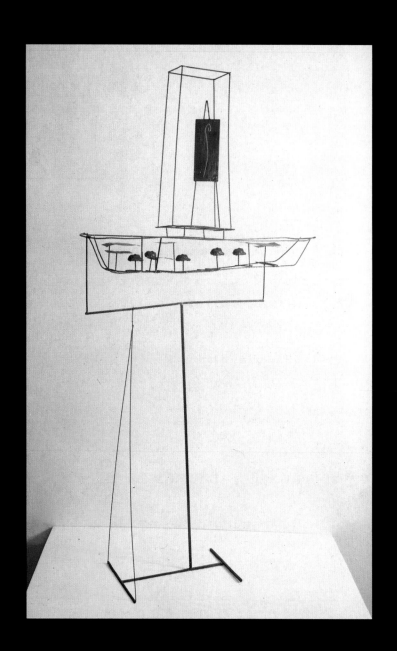

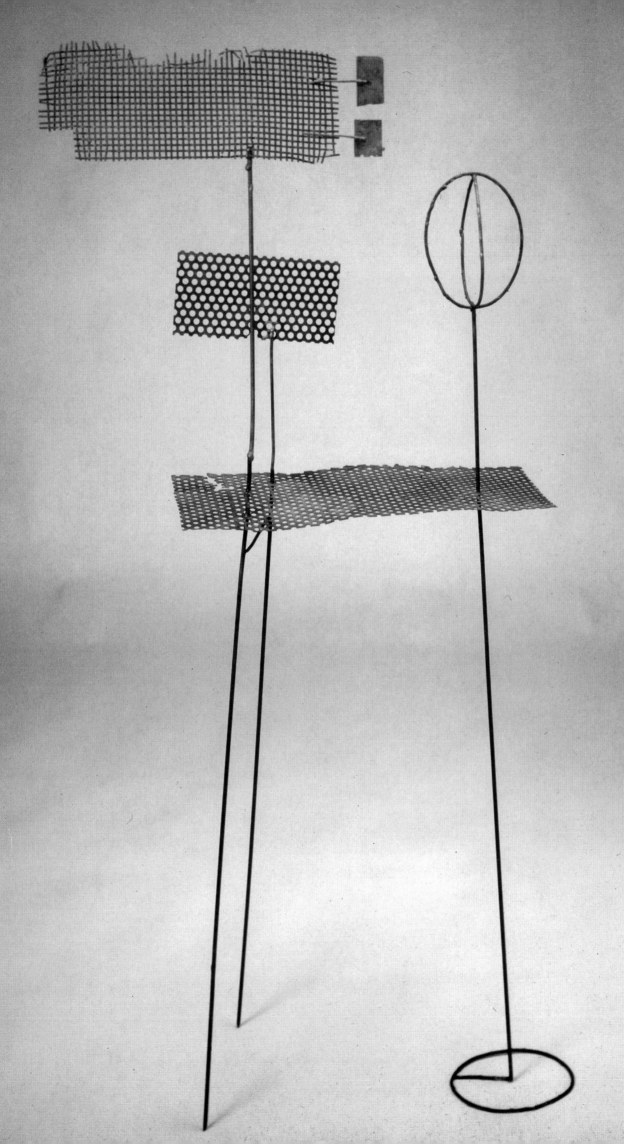

174. Fausto Melotti
Gli stracci (The Rags), *1963. Painted
terra-cotta, fabric, brass, and glazed
ceramic, 60 x 34 x 14 cm. Collection of
Roberto Antonini, Novara.*

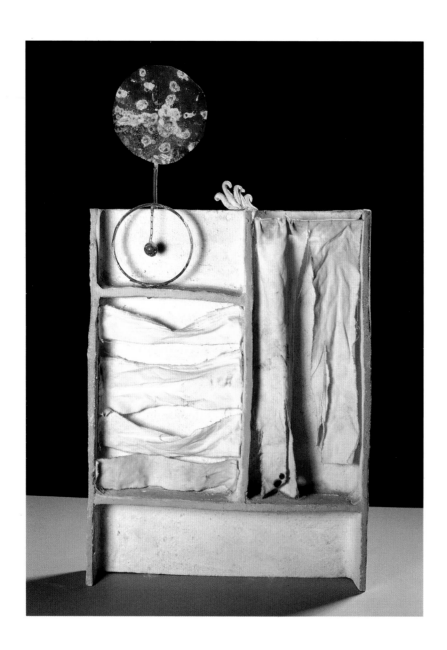

175. Fausto Melotti
Gli oggetti (The Objects), *1962.*
Painted terra-cotta, 40 x 28 x 9 cm.
Collection of Marta Melotti, Milan.

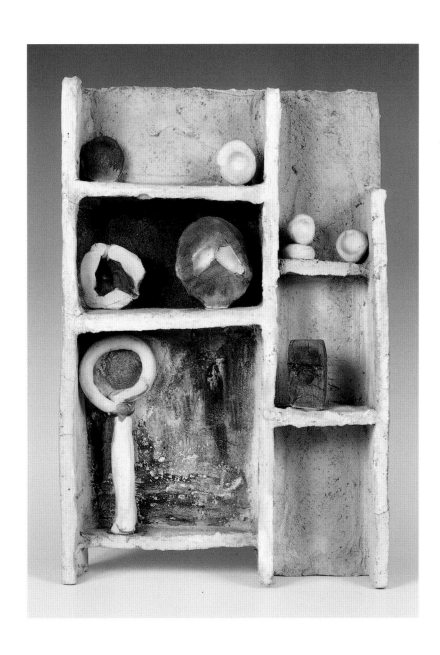

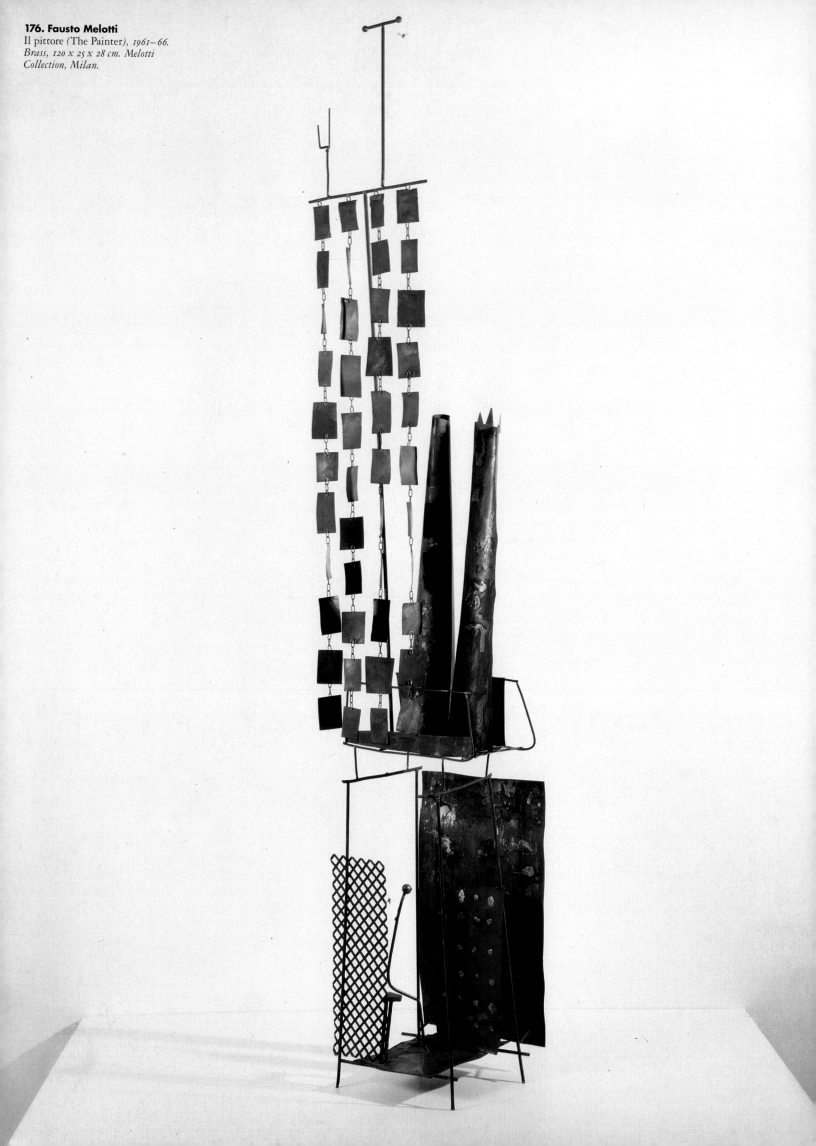

176. Fausto Melotti
Il pittore (The Painter), *1961–66.*
Brass, 120 x 25 x 28 cm. Melotti
Collection, Milan.

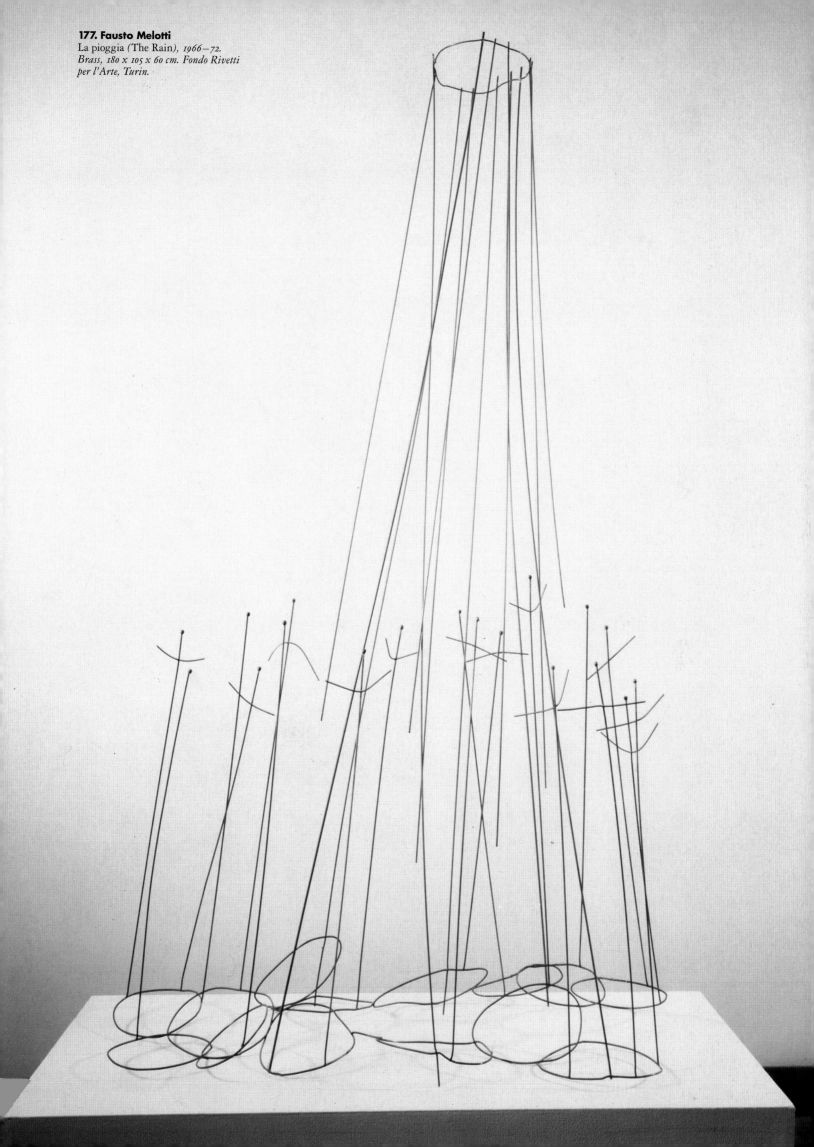

177. Fausto Melotti
La pioggia (The Rain), 1966–72.
Brass, 180 x 105 x 60 cm. Fondo Rivetti
per l'Arte, Turin.

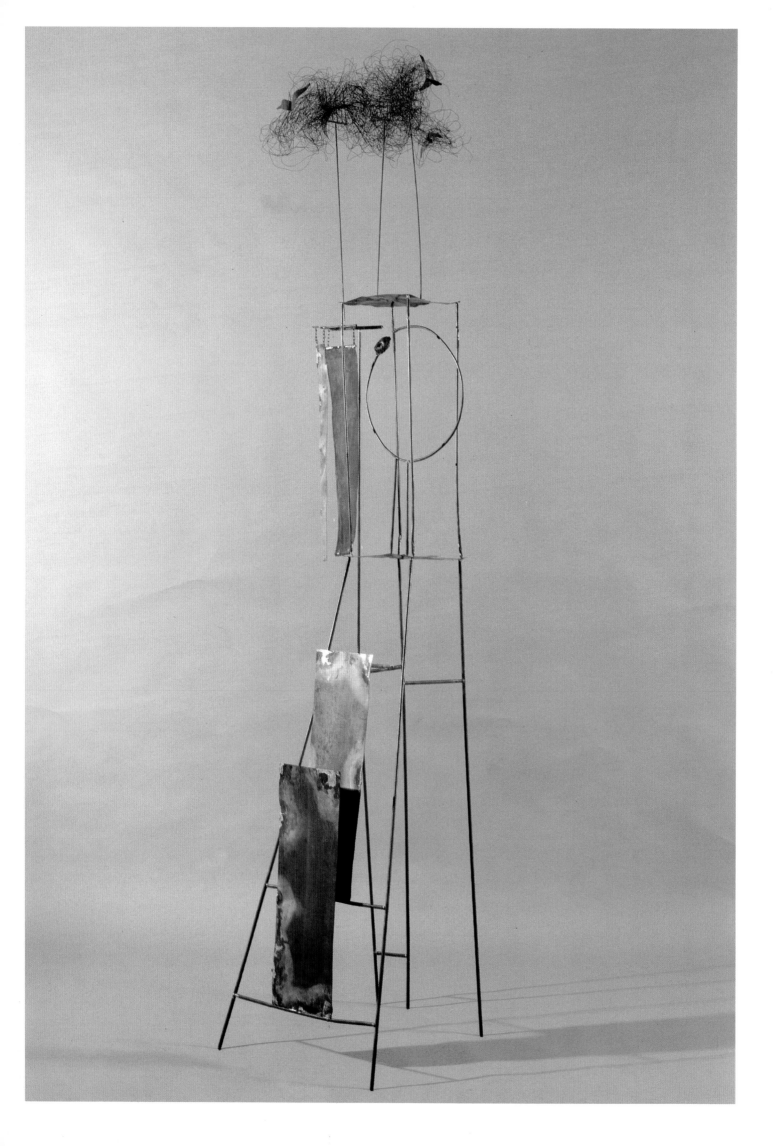

178. Fausto Melotti

Ahi come presto stridono i venti,
misti alla fredda pioggia autunnal . . .
(da un duetto di Mendelssohn) (Oh
How Quickly the Winds Screech,
Mixed with the Cold Autumnal
Rain . . . [from a Mendelssohn duet]),
*1966. Brass, 240 x 59 x 54 cm. Private
collection, Milan.*

179. Fausto Melotti

Uomini (Men), *1966. Brass, 111 x 41 x
24 cm. Private collection, New York.*

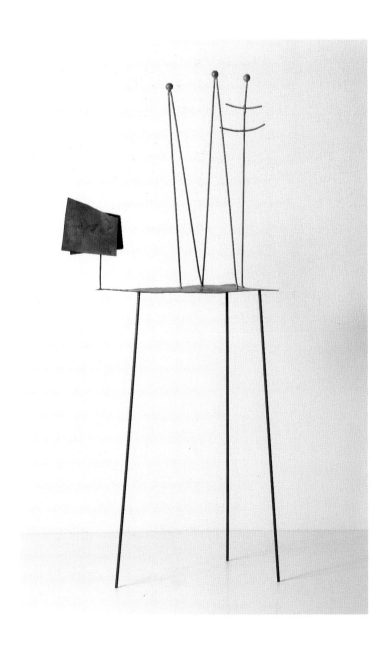

180. Giulio Paolini
Senza titolo (Untitled), 1962–63.
Canvas and wood, 50 x 60 cm.
Collection of Rosangela Cochrane.

181. Giulio Paolini
E, 1963. Printed reproduction on
Masonite, mounted on wood frame,
26 x 19 cm. Collection of the artist,
Turin.

182. Giulio Paolini
2200/H, 1965. Drawing on
photographic silkscreen print, 125 x
90 cm. Private collection.

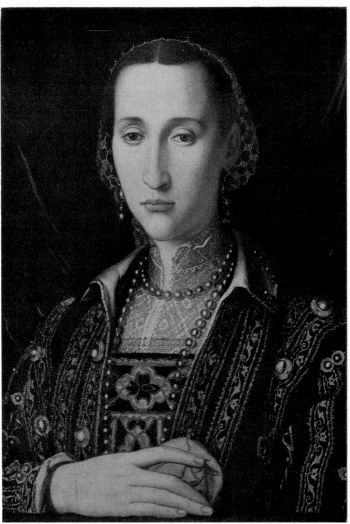

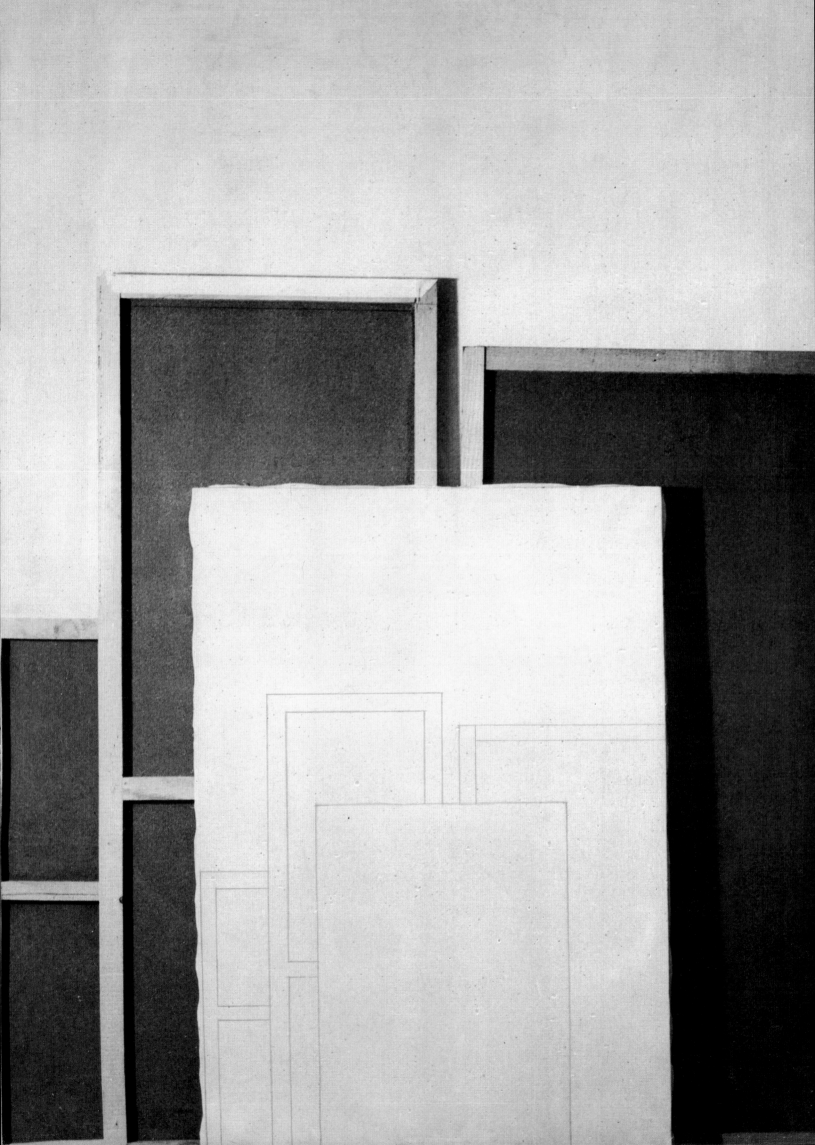

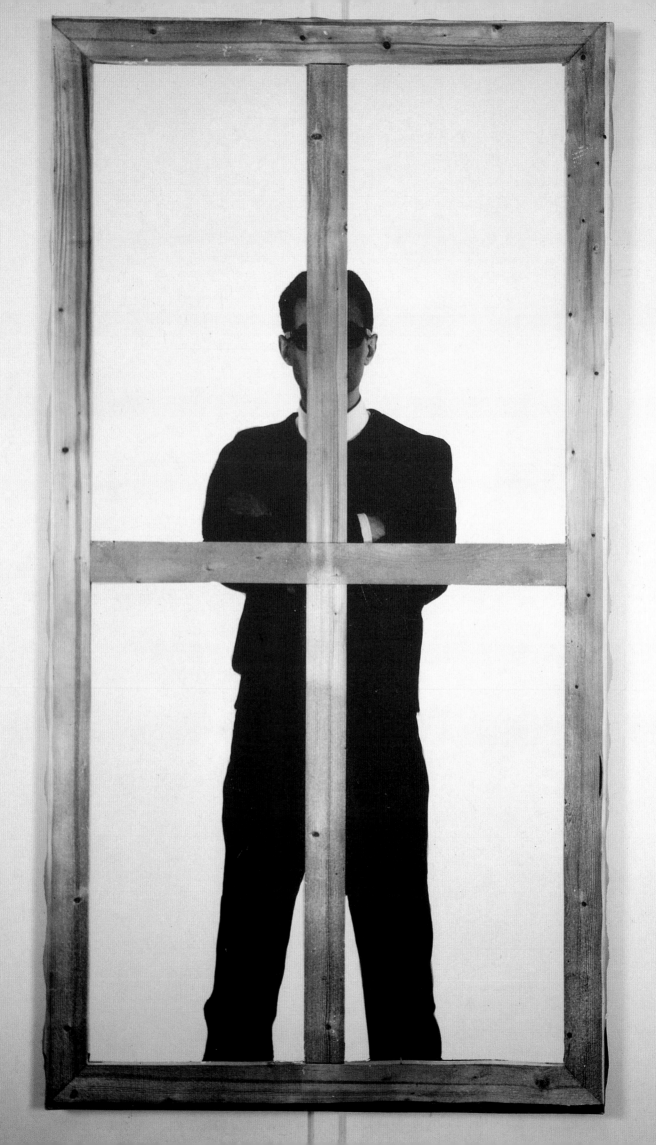

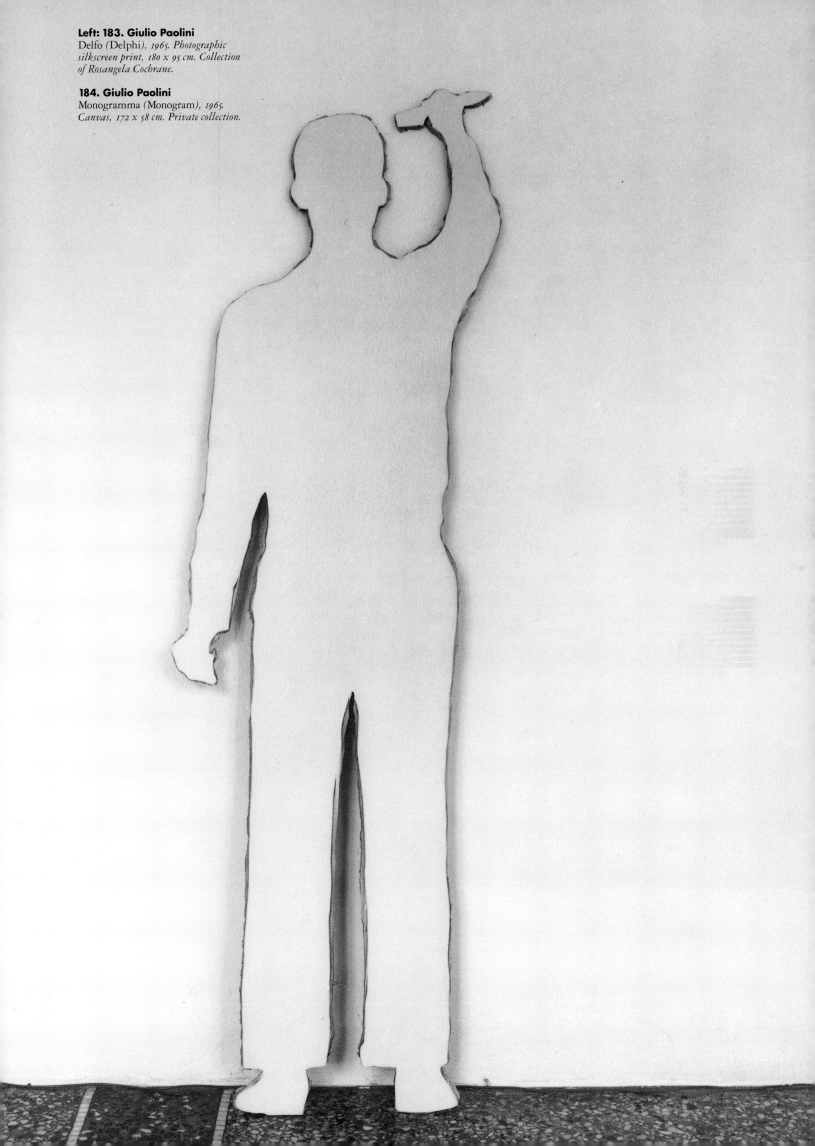

Left: 183. Giulio Paolini
Delfo (Delphi), 1965. Photographic
silkscreen print, 180 x 95 cm. Collection
of Rosangela Cochrane.

184. Giulio Paolini
Monogramma (Monogram), 1965.
Canvas, 172 x 58 cm. Private collection.

185. Pino Pascali
Colosseo (Colosseum), *1964. Enamel*
on canvas and cloth, mounted on wood,
170 x 220 cm. Private collection, Italy.

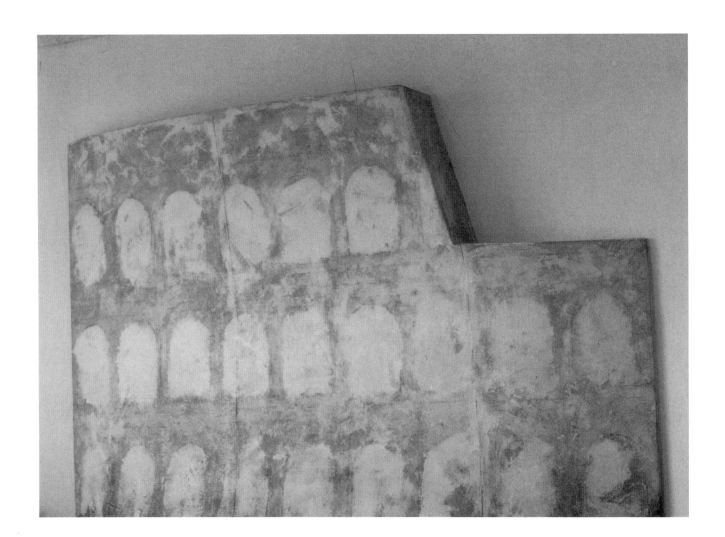

186. Pino Pascali
Labbra rosse omaggio a Billie
Holiday (Red Lips: Homage to Billie
Holiday), *1964. Enamel on canvas,
mounted on wood, 164 x 120 x 22 cm.
Galleria Civica d'Arte Moderna e
Contemporanea, Turin.*

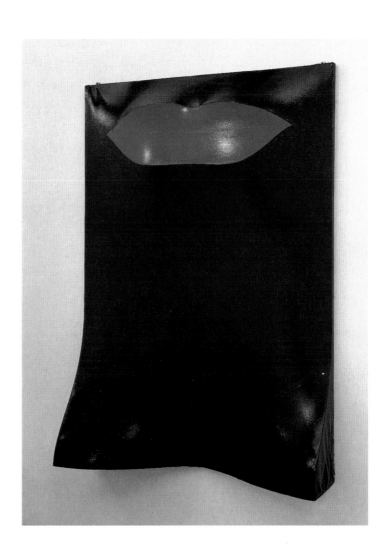

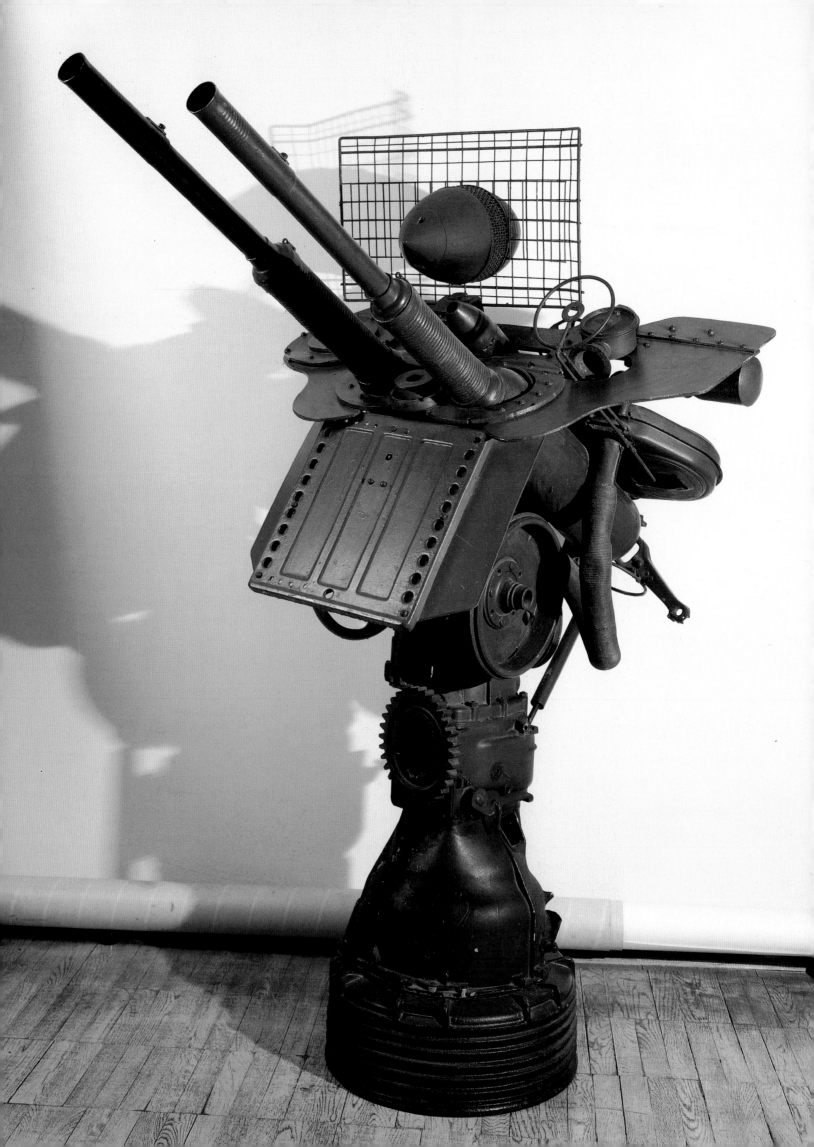

187. Pino Pascali
Contraerea (Antiaircraft Artillery),
1965. Found objects, 170 x 95 x 130 cm.
Collection of Giorgio Franchetti, Rome.

188. Pino Pascali
Mitragliatrice (Machine Gun), 1965.
Wood, scrap metal, and varnish, 140 x
125 x 68 cm. Galleria Gian Enzo
Sperone, Rome.

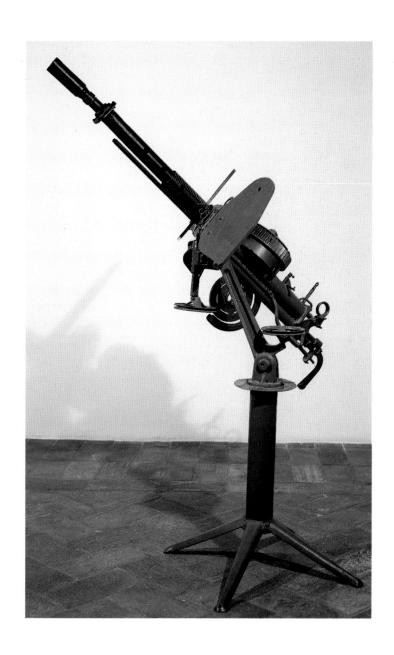

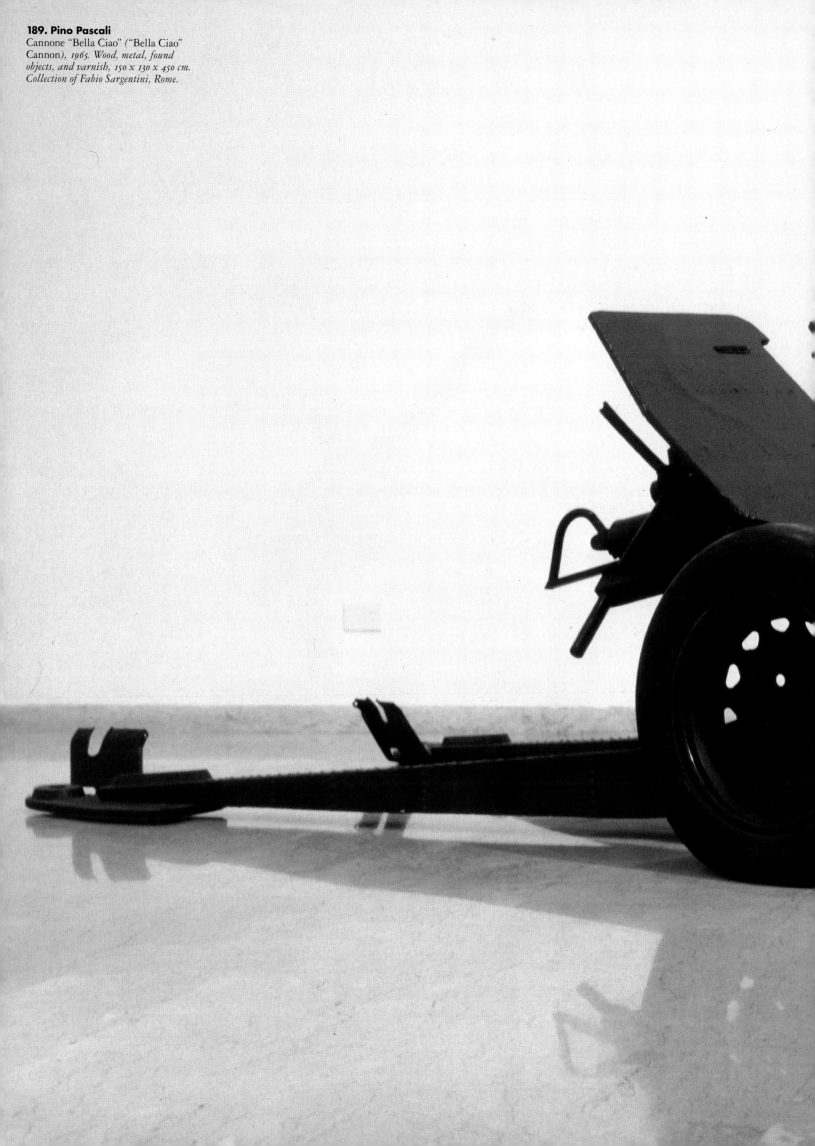

189. Pino Pascali
Cannone "Bella Ciao" ("Bella Ciao"
Cannon), 1965. Wood, metal, found
objects, and varnish, 150 x 130 x 450 cm.
Collection of Fabio Sargentini, Rome.

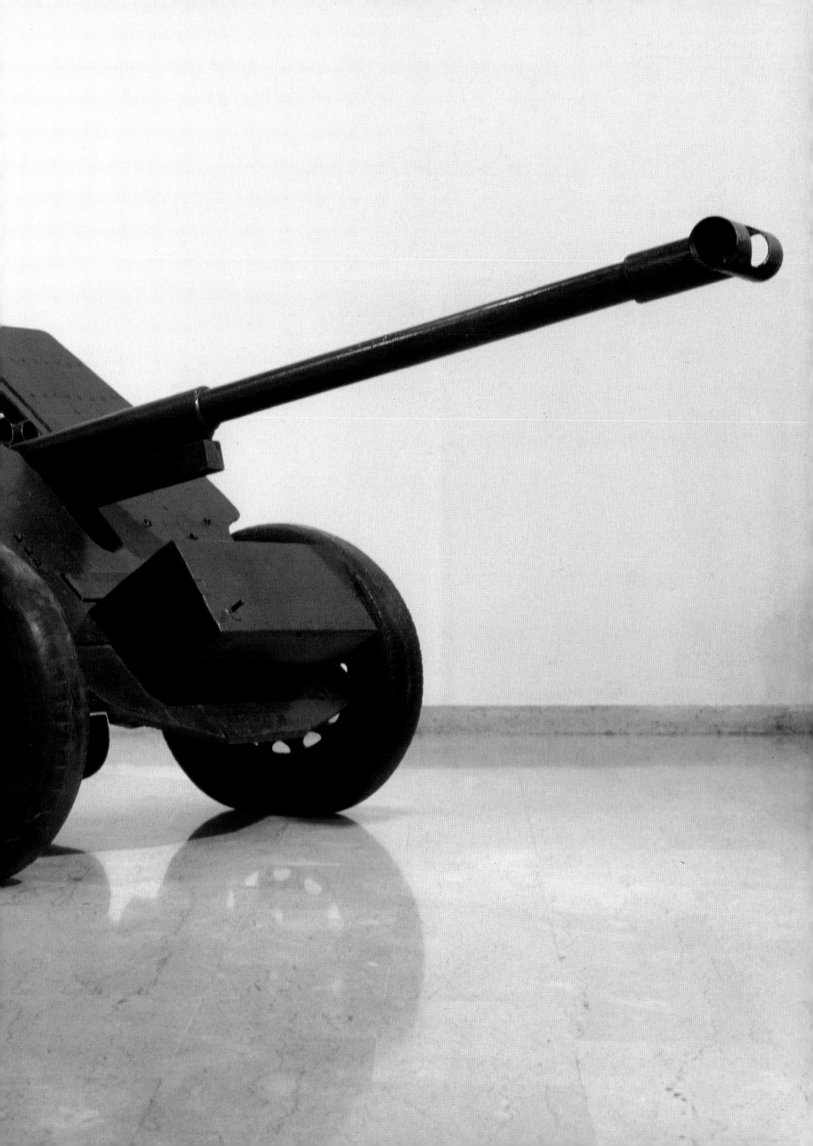

190. Michelangelo Pistoletto
Uomo di schiena. Il presente (Man
Seen from the Back. The Present).
1961. Varnish, acrylic, and oil on
canvas, 200 x 150 cm. Collection of
Romilda Bollati.

191. Michelangelo Pistoletto
Persona di schiena (Person Seen from
the Back). 1962. Painted tissue paper
on polished stainless steel, 200 x 120 cm.
Collection of the artist.

192. Michelangelo Pistoletto
Donna seduta di spalle (Seated
Woman). 1962–63. Painted tissue
paper on polished stainless steel,
220 x 120 cm. Sonnabend Collection.

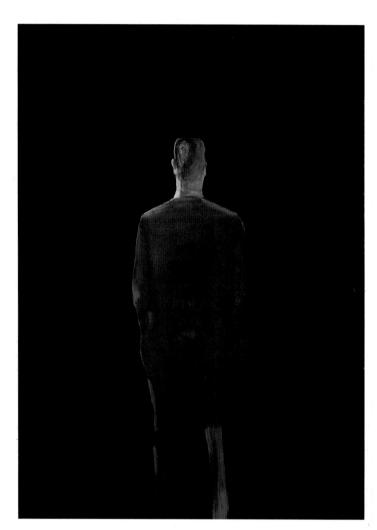

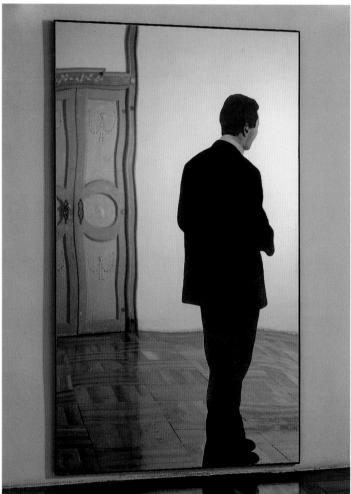

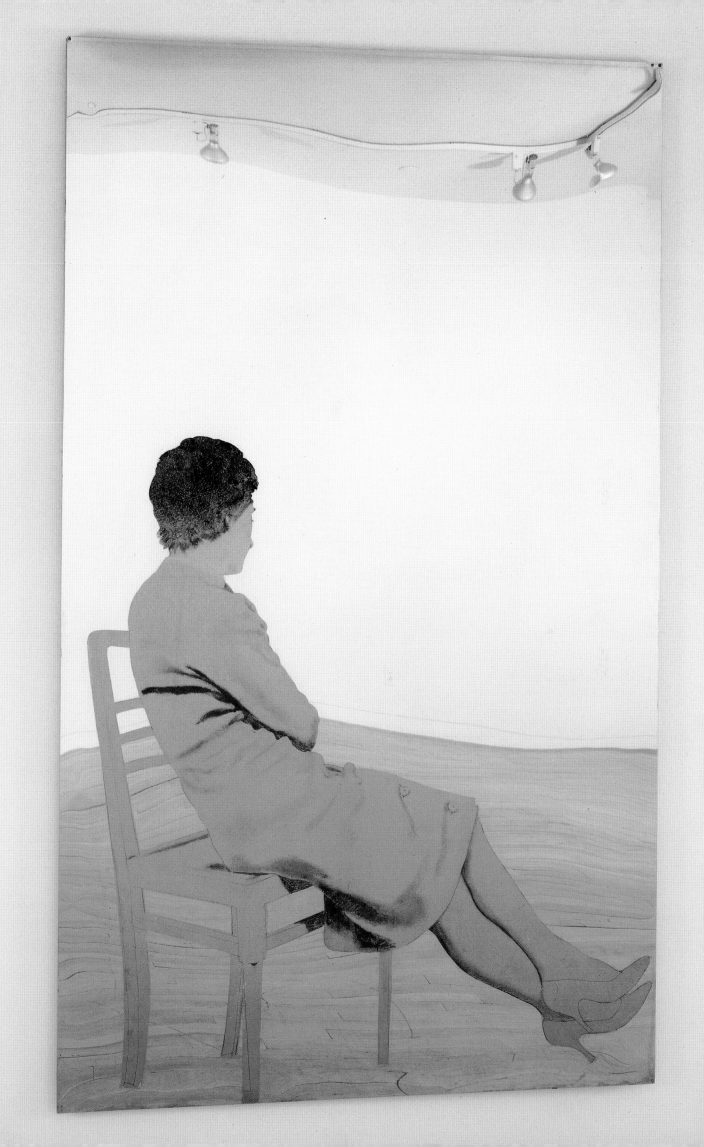

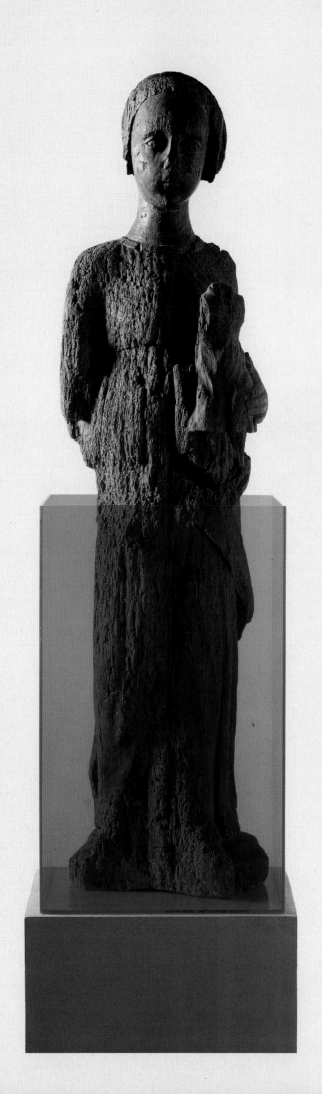

194. Michelangelo Pistoletto
Paesaggio (Oggetti in meno)
(Landscape [Minus Objects]), *1965.*
Cardboard box with colored paper, rags,
and crêche figurines, 70 x 40 x 20 cm.
A.C.P. Collection, Turin.

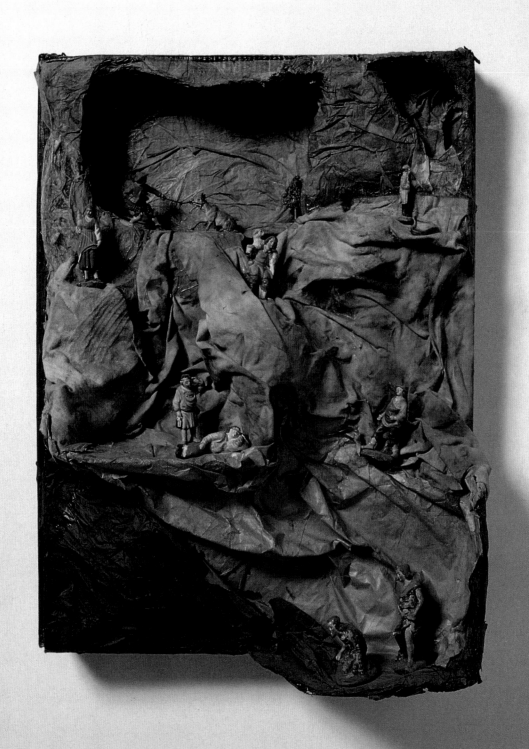

194. Michelangelo Pistoletto
Paesaggio (Oggetti in meno)
(Landscape [Minus Objects]), *1965.*
Cardboard box with colored paper, rags,
and crêche figurines, 70 x 40 x 20 cm.
A.C.P. Collection, Turin.

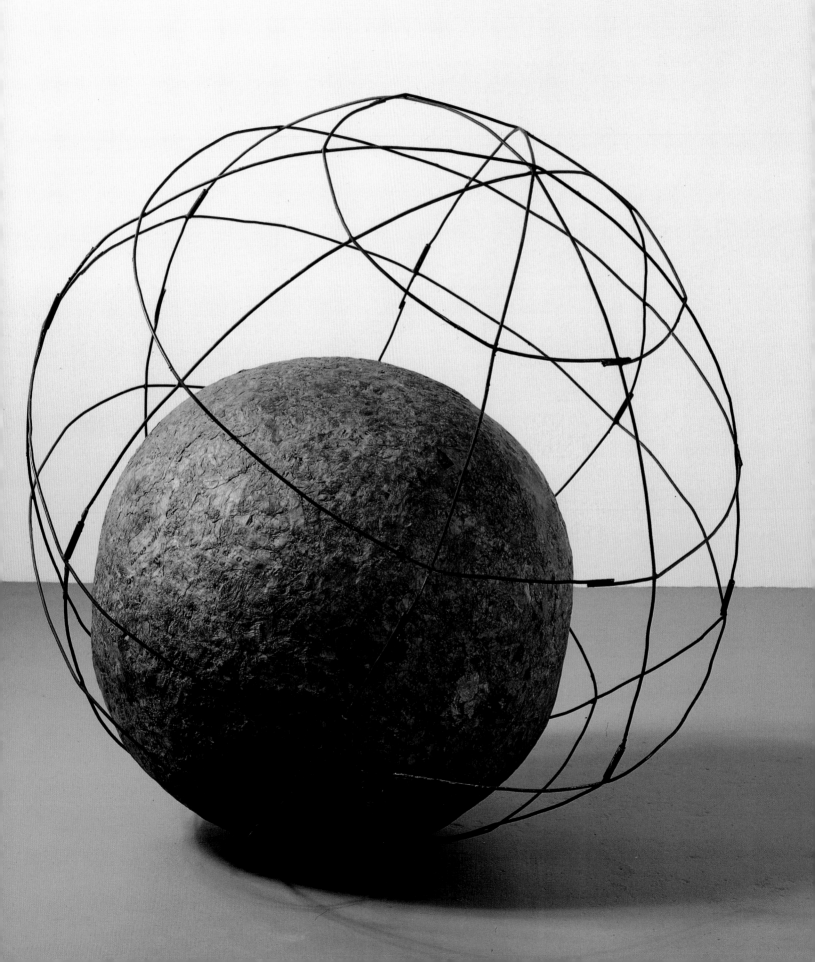

195. Michelangelo Pistoletto
Sfera di giornali (Mappamondo)
(Oggetti in meno) *(Sphere of
Newspapers [Globe] [Minus
Objects])*, *1966–68. Pressed newspaper
and iron rods, 180 cm diameter.
Courtesy of Lia Rumma.*

197. Mimmo Rotella
La tigre (The Tiger), *1962. Décollage,*
108 x 64 cm. Collection of Giorgio
Franchetti, Rome.

198. Mimmo Rotella
Sua maestà la Regina (Her Majesty
the Queen), *1962. Décollage, 136 x*
93 cm. Collection of Giorgio Franchetti,
Rome.

199. Mimmo Rotella
Mitologia (Mythology), *1962.*
Décollage, 164 x 190 cm. Collection of
Giorgio Marconi, Milan.

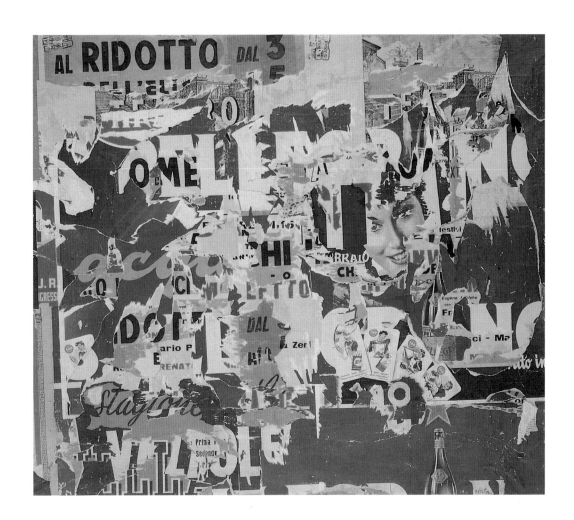

200. Mario Schifano
A De Chirico (To De Chirico), *1962.*
Enamel on paper, mounted on canvas,
170 x 150 cm. Sonnabend Collection.

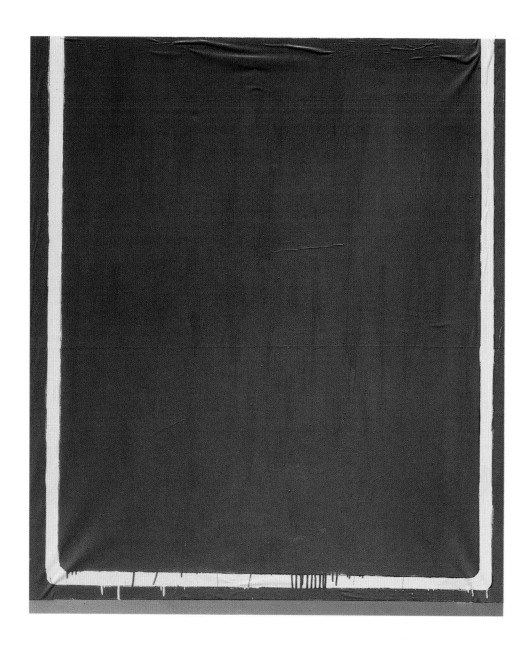

201. Mario Schifano
Tempo moderno (Modern Times).
1962. Enamel on paper, mounted on
canvas, 180 x 180 cm. Sonnabend
Collection.

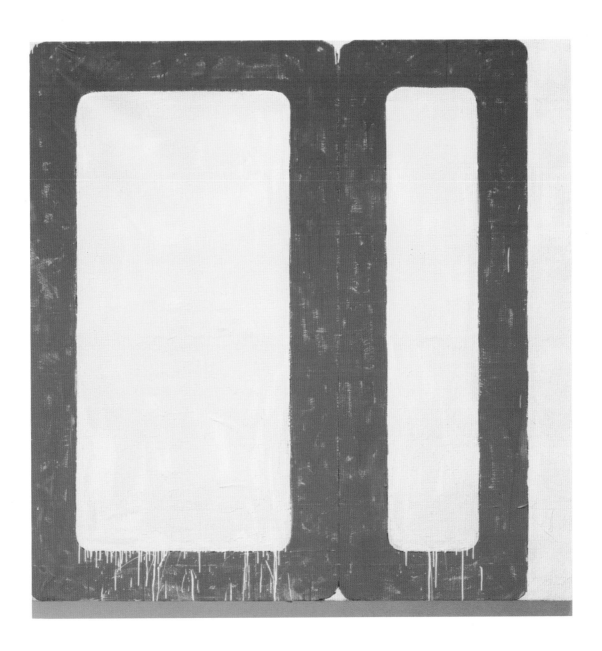

202. Giovanni Anselmo
Torsione (Contortion), *1968. Iron and flannel, 230 x 186 x 30 cm. Sonnabend Collection.*

203. Giovanni Anselmo
Direzione (Direction), *1967–70. Rock, compass, and glass, 17 x 225 x 83 cm. Sonnabend Collection.*

204. Giovanni Anselmo
Struttura che mangia l'insalata (Structure That Eats Salad*), 1968. Granite, salad, copper wire, and sawdust, 65 x 30 x 30 cm. Sonnabend Collection.*

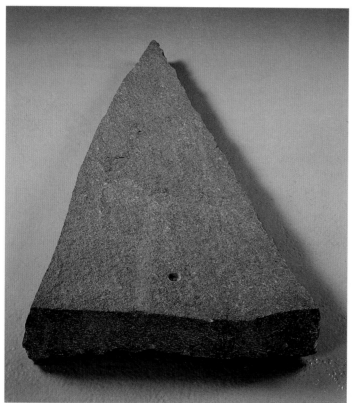

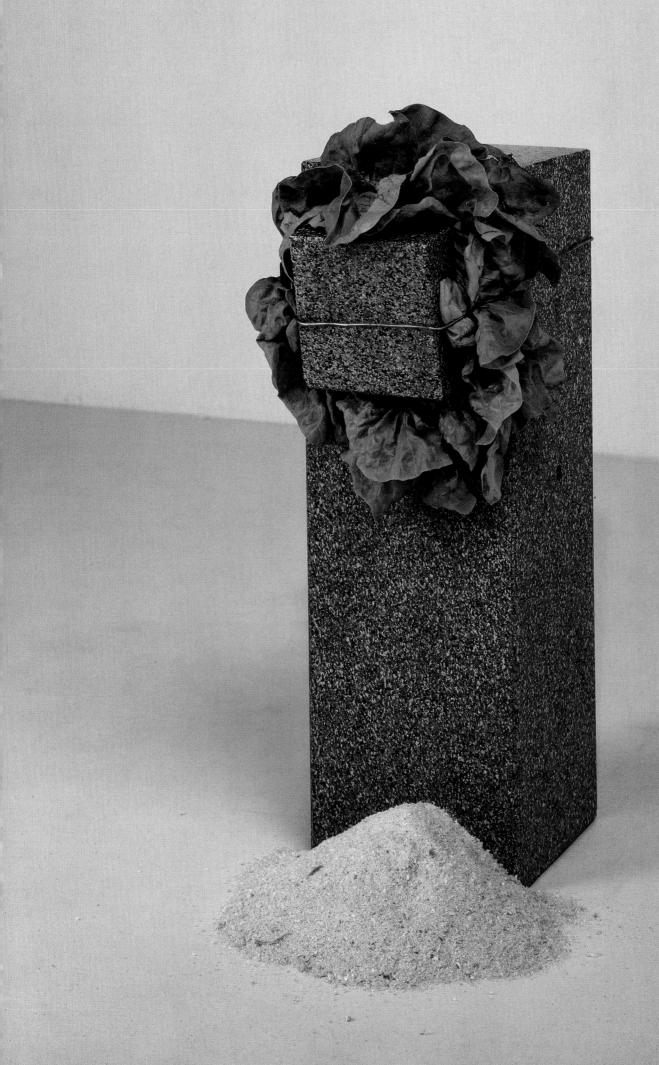

205. Alighiero Boetti
Colonna tubi PVC *(Column PVC
Tubes), 1966. PVC tubes, 280 cm high,
160 cm diameter. Christian Stein
Gallery, Turin-Milan.*

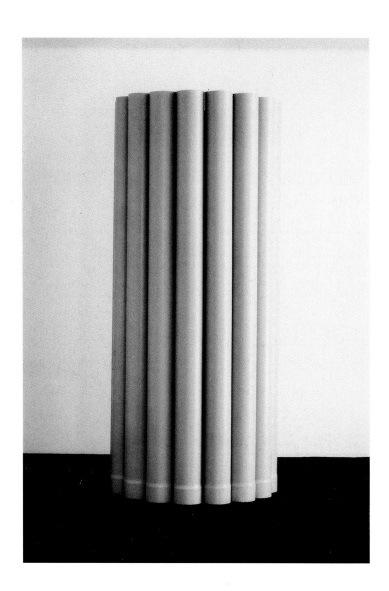

206. Alighiero Boetti
Mimetico (Mimetic), *1966.*
Camouflage fabric, 249.5 x 348.6 cm.
Courtesy of Salvatore Ala Gallery,
New York.

207. Pier Paolo Calzolari
Oroscopo come progetto della mia
vita (Horoscope as a Project for My
Life), 1968. Lead and freezing unit,
325 x 386 cm. Fondo Rivetti per l'Arte,
Turin.

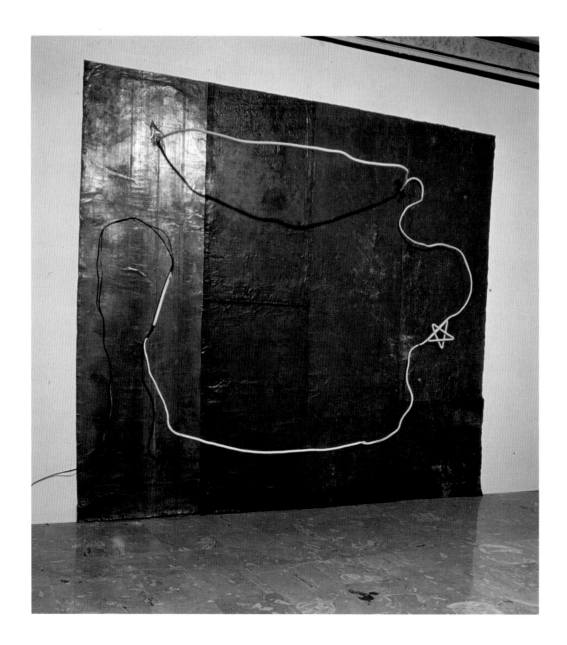

208. Pier Paolo Calzolari
Un flauto dolce per farmi suonare
(A Dulcet Flute for Me to Play),
1968. Lead and freezing unit, 46 x
88 cm. Collection of Pier Luigi Pero,
Radda in Chianti.

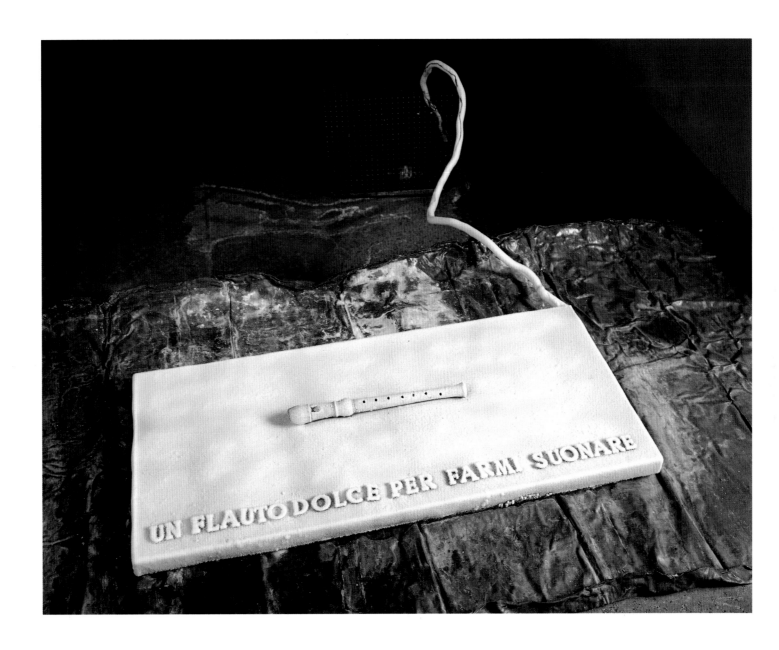

209. Luciano Fabro
Piede (Foot), *1968–71. Brittania*
metal and silk, 420 x 163 x 155 cm.
Private collection, courtesy of Laura
Carpenter Fine Art, Santa Fe.

210. Luciano Fabro
Piede (Foot), *1968–71. Colaticcio*
marble and silk sock, 300 x 110 x 70 cm.
Christian Stein Gallery, Turin-Milan.

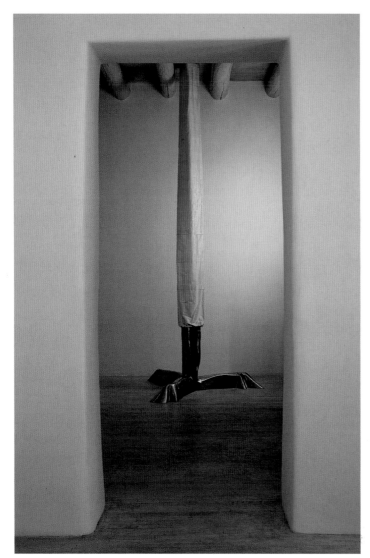

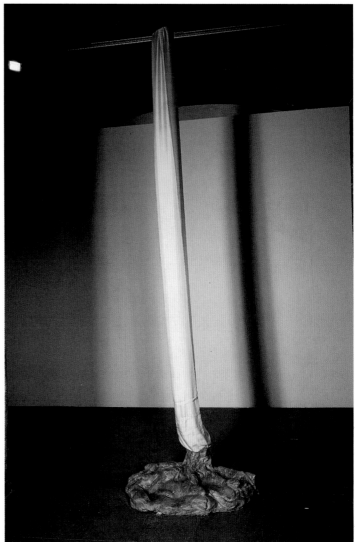

211. Luciano Fabro
Tre modi di mettere le lenzuola
(Three Ways to Make the Bed), 1968.
Cotton and wool; three sheets, each 200 x
250 cm. Collection of the artist, Milan.

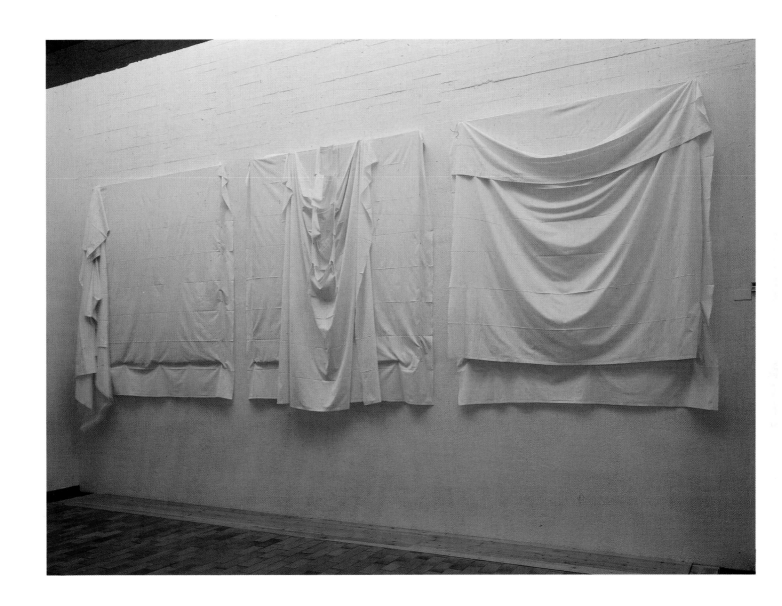

212. Jannis Kounellis
Senza titolo (Untitled), *1967. Iron
structure with burning gas flame,
100 cm diameter. Collection of Mario
Pieroni, Rome.*

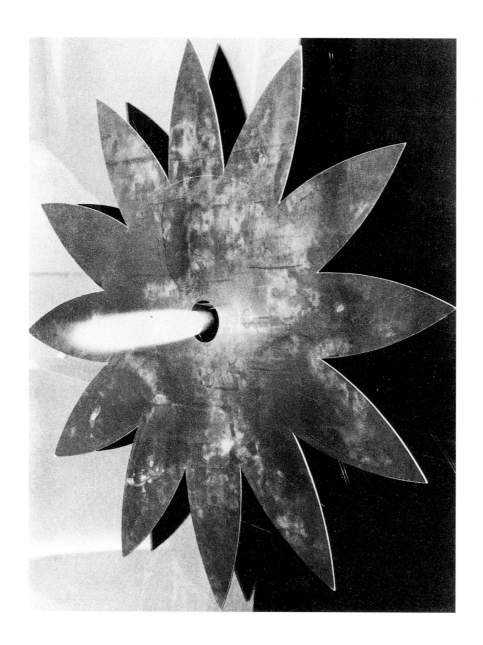

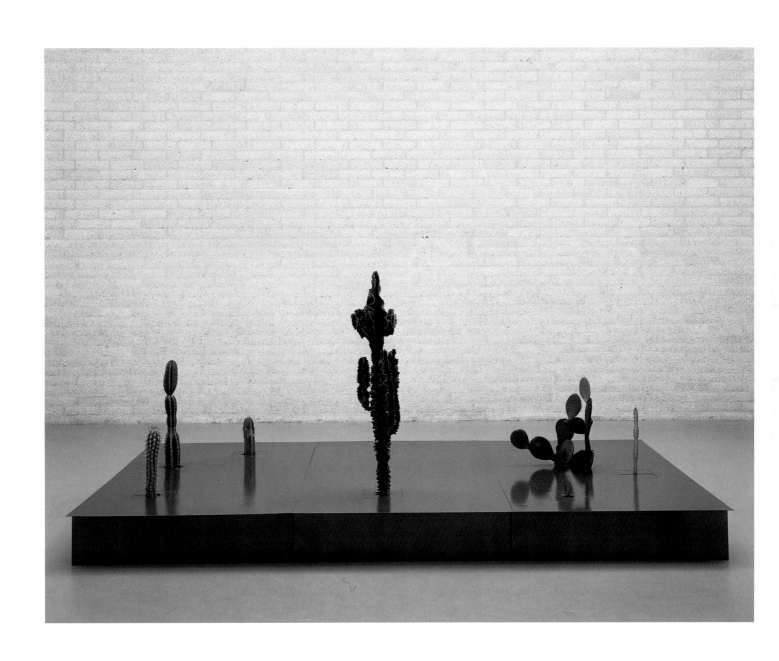

214. Mario Merz
Igloo di Giap. Se il nemico si
concentra perde terreno se si disperde
perde forza (Giap Igloo. If the Enemy
Masses His Forces He Loses Ground;
If He Scatters, He Loses Strength),
1968. Wire mesh, sacks of earth, neon,
and batteries, 120 x 200 cm.
Musée National d'Art Moderne, Centre
Georges Pompidou, Paris, 1982.

215. Mario Merz
Teatro cavallo (Horse Theater), *1967.*
Plastic tube and neon tube, 250 x
300 x 50 cm. Private collection, Milan,
courtesy of Sperone Westwater,
New York.

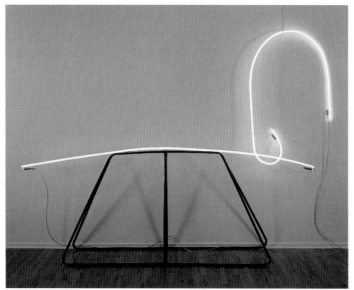

216. Mario Merz
Impermeabile (Raincoat), 1967.
Raincoat, wax, wood, and neon tube,
125 x 170 x 40 cm. Christian Stein
Gallery, Turin-Milan.

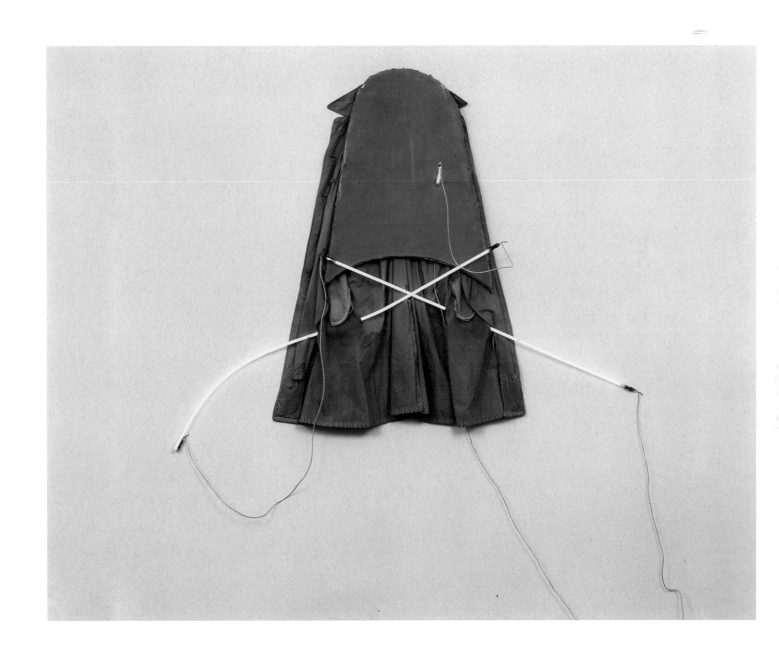

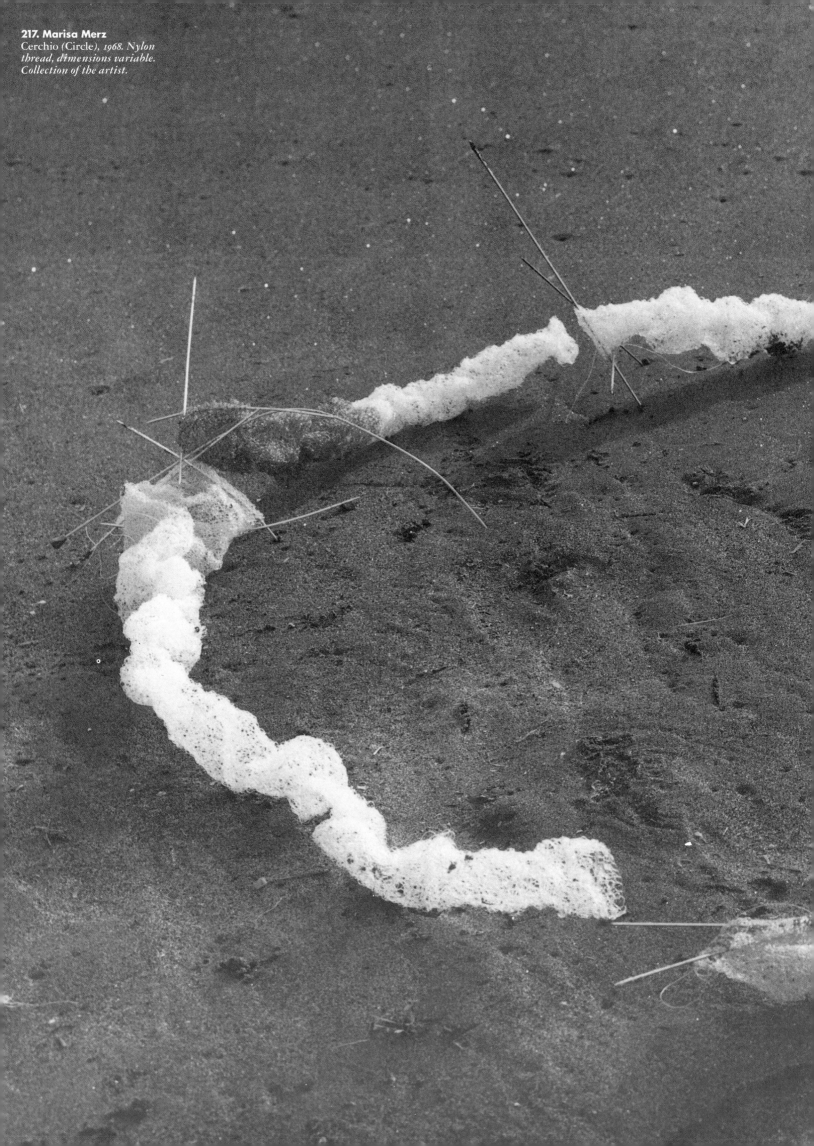

217. Marisa Merz
Cerchio (Circle), 1968. Nylon
thread, dimensions variable.
Collection of the artist.

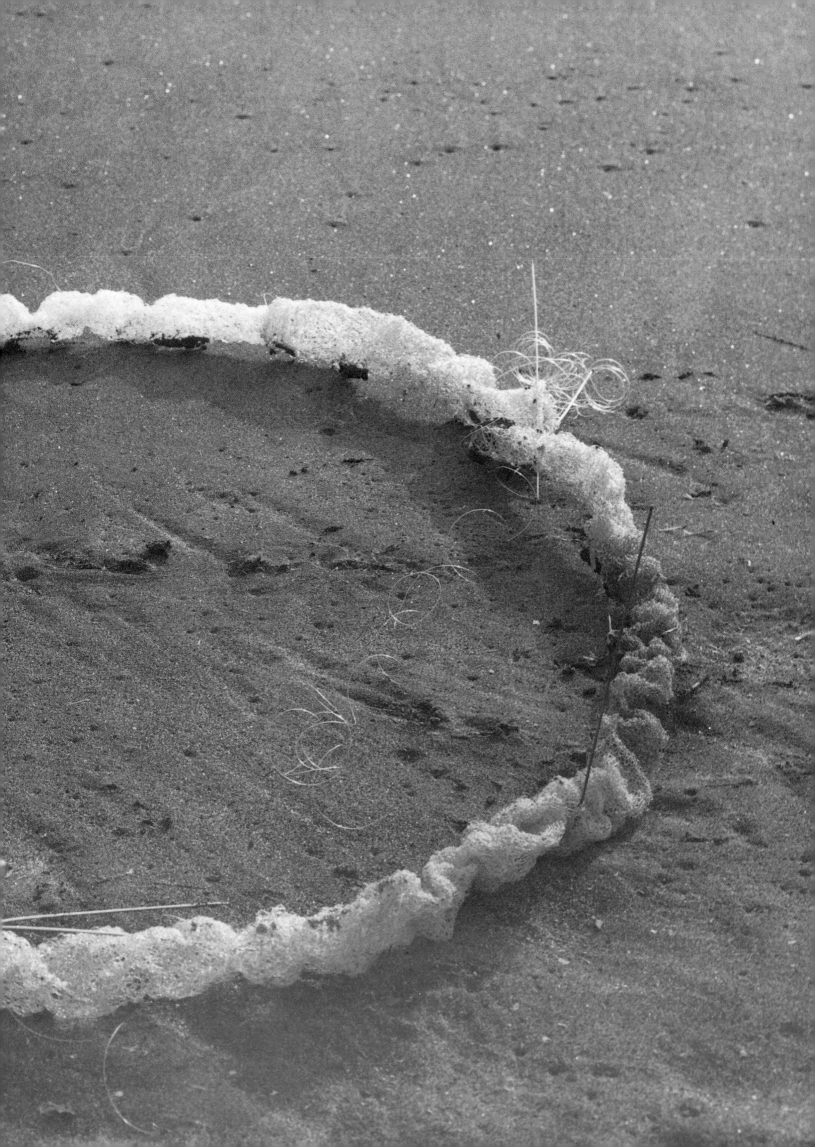

218. Marisa Merz

Bea, *1968. Nylon thread, 91 x 110 x*
15 cm. Collection of the artist.

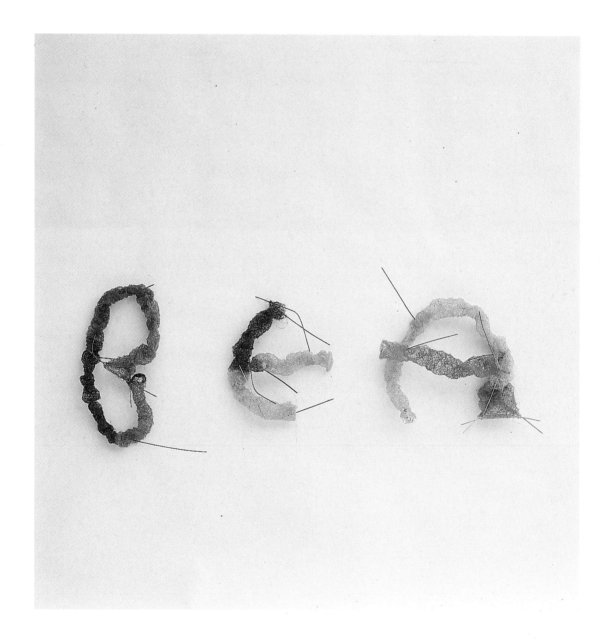

219. Marisa Merz
Scarpette (Little Shoes), *1968. Nylon*
thread, dimensions unknown. Collection
of the artist.

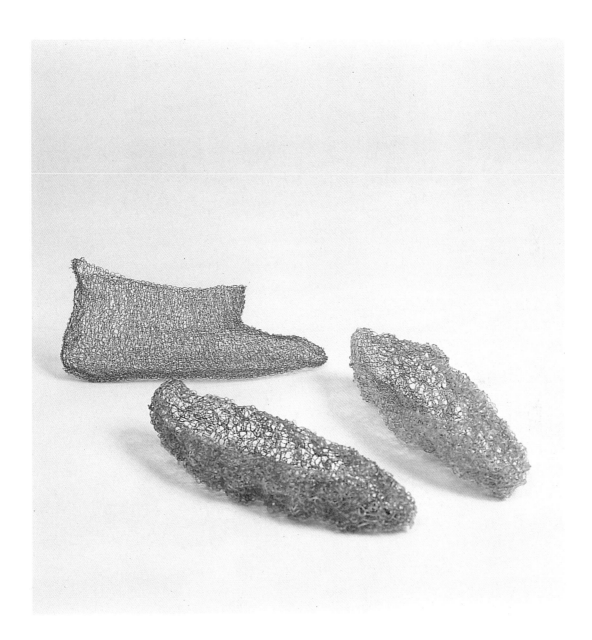

220. Giulio Paolini
Diaframma 8 *(Diaphragm 8), 1965.*
Photographic silkscreen print,
80 x 90 cm. Collection of Rosangela
Cochrane.

221. Giulio Paolini
D867, *1967. Photographic silkscreen*
print, 80 x 90 cm. Collection of
Rosangela Cochrane.

222. Giulio Paolini
Averroè (Averroës), *1967. Fifteen flags,
steel pole, and brass ornament,
180 cm high. Collection of the artist,
Turin.*

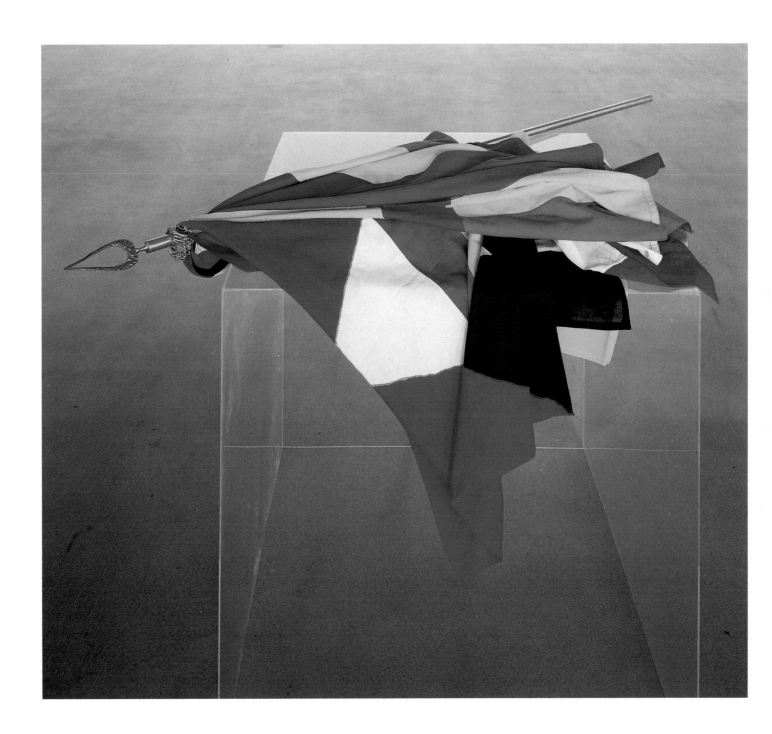

223. Pino Pascali
Ponte levatoio (Drawbridge), *1968.*
Steel wool on wood and wire structure,
220 x 120 cm. Collection of Fabio
Sargentini, Rome.

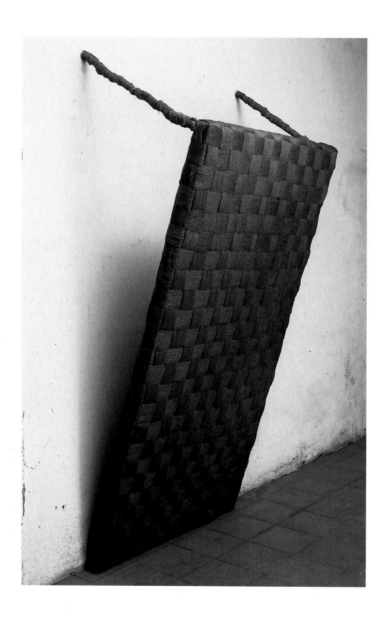

224. Pino Pascali
Ponte (Bridge), *1968. Steel wool woven
on metal structure, 800 cm long.
Collection of Fabio Sargentini, Rome.*

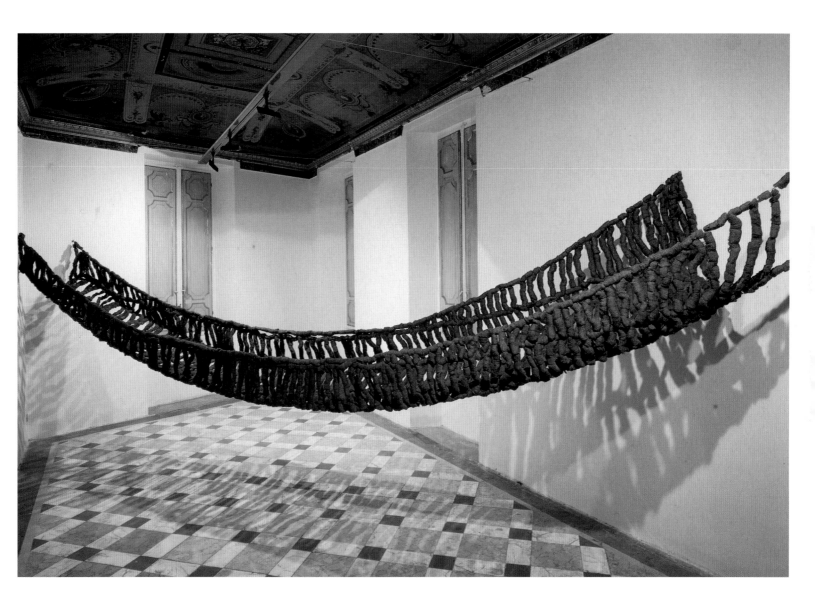

Below: 225. Giuseppe Penone
Ho intrecciato fra loro tre alberelli
(I Wound between Them Three
Trees), *1968–78. Tree trunk; one of
three tree trunks from the installation
Tre alberi (Three Trees), 323 x 35 x
85 cm. Collection of Liliane and Michel
Durand-Dessert, Paris.*

226. Giuseppe Penone
Senza titolo (Untitled), *1968. Six
photographs, each 70 x 50 cm.
Courtesy of Marian Goodman Gallery,
New York.*

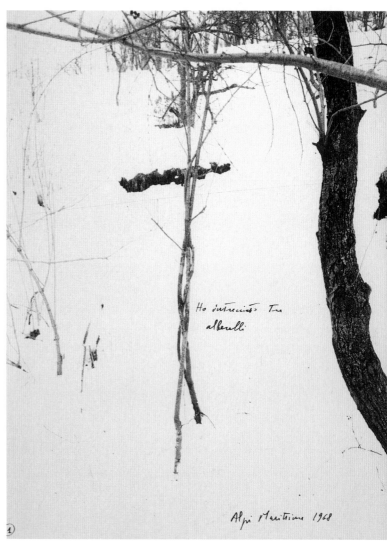

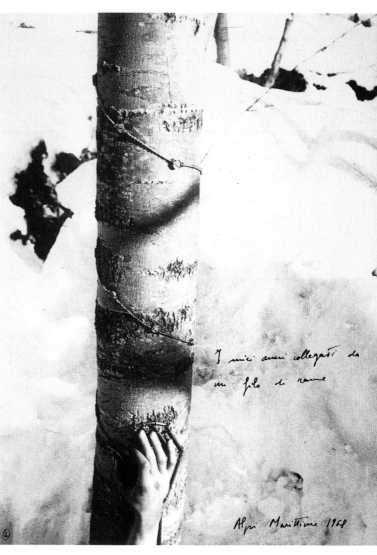

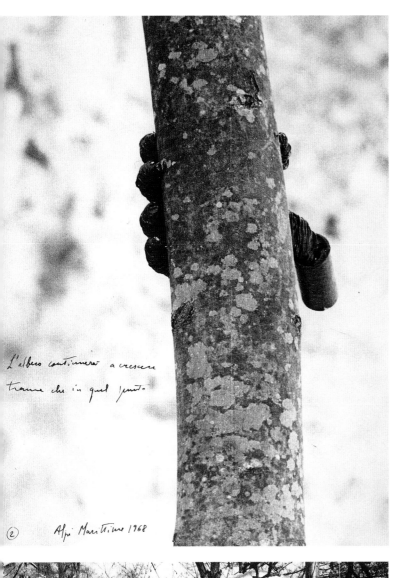

L'albero continuerà a crescere
tranne che in quel punto

② Alpi Marittime 1968

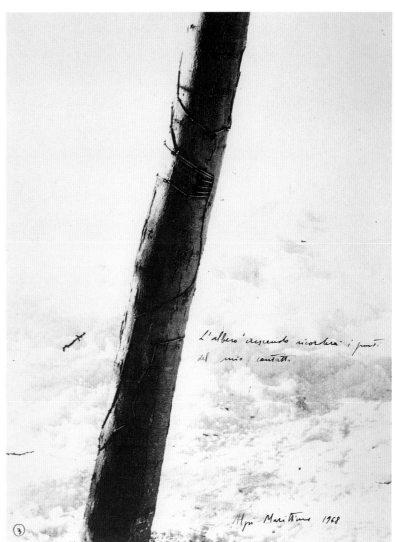

L'albero crescendo ricorderà i punti
del mio contatto.

③ Alpi Marittime 1968

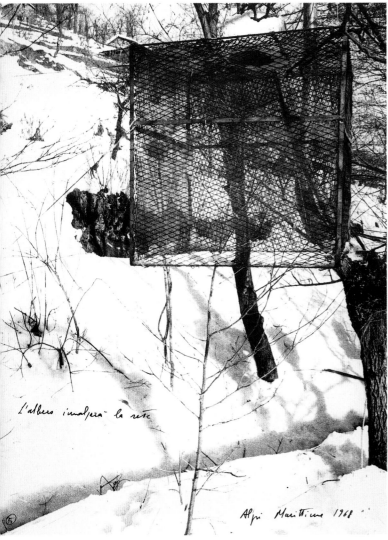

L'albero inalzerà la rete

⑤ Alpi Marittime 1968

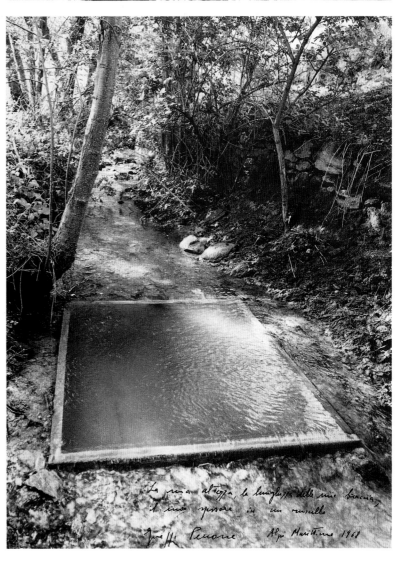

La sua altezza, la lunghezza delle mie braccia,
di uno spessore in un ruscello

Giuseppe Penone Alpi Marittime 1968

227. Michelangelo Pistoletto
Pietra miliare *(Milestone), 1967.*
Stone, 80 cm high, 40 cm diameter.
Collection of the artist.

228. Michelangelo Pistoletto
Venere degli stracci *(Venus of the*
Rags*), 1967. Reproduction of a classical*
Venus, mica, and rags, dimensions
variable. Collection of Tommaso and
Giuliana Setari, Milan.

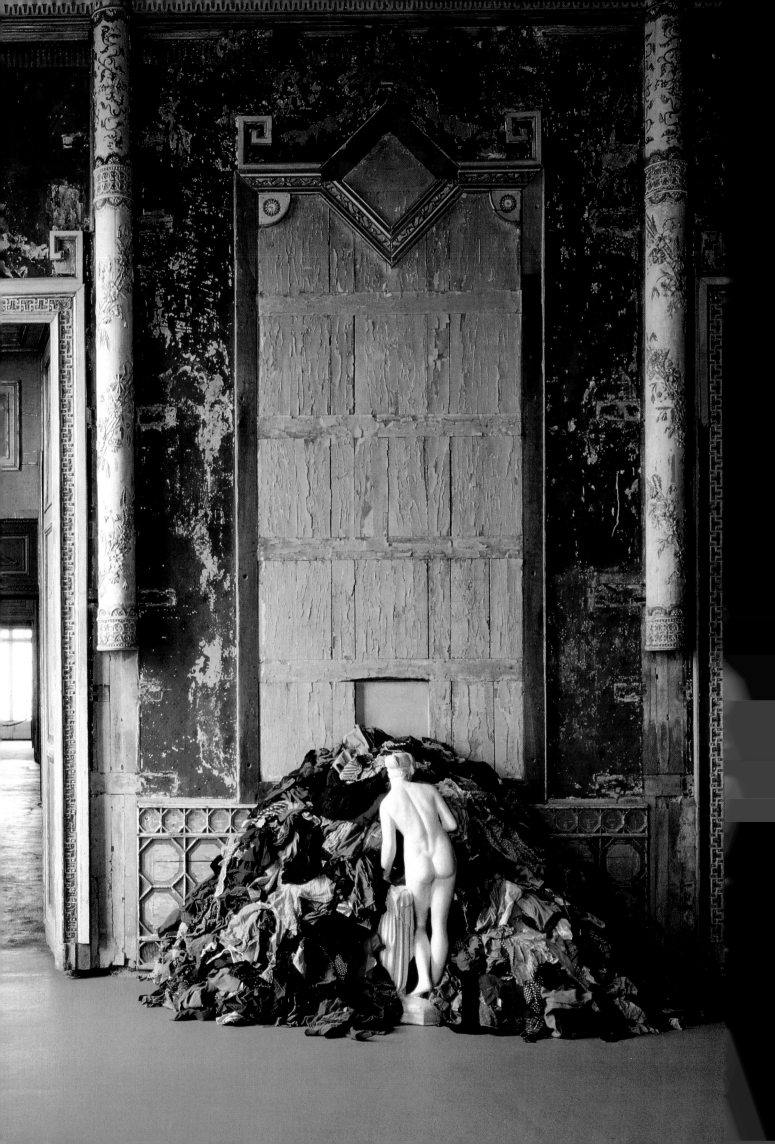

229. Gilberto Zorio
Letto (Bed), *1966. Metal tubes, rubber,
and lead plate, 100 x 220 x 220 cm.
Collection of the artist, Turin.*

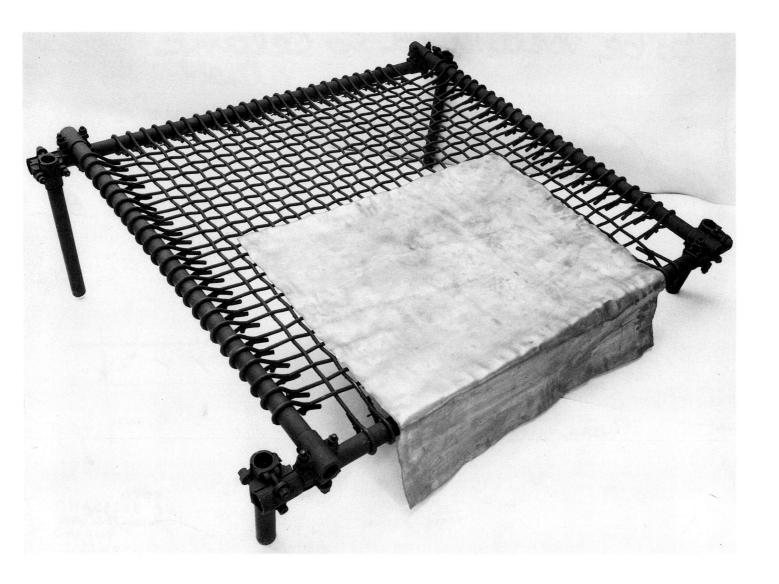

230. Gilberto Zorio
Tenda (Tent), *1967. Dalmine tubes,*
fabric, and seawater, 170 x 120 x
120 cm. Collection of the artist, Turin.

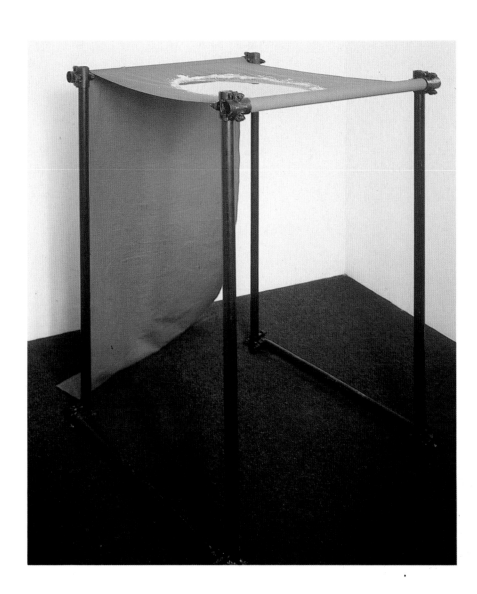

Fire, both loved as a preci
deadly weapon, has been
at times even deified. Cha
regenerating liver devoure
paid for the sin of having
and giving it to us mortal
having stolen it from Hep
rather than from the sun,
only as protection and ma
underlying all creative eff
denominator of glassmak

us tool and feared as a

evered by all cultures and

ned to a rock, his eternally

l by an eagle, Prometheus

tolen fire from the gods

I prefer to imagine his

aestus's mythical forge

o emphasize its heat not

rix of life but as the sweat

rt. Fire is the common

ng and ceramics. Through

The Revival of Glass and Ceramics

Micaela Martegani Luini

the intoxicating heat of this primal element, the creator moves with assurance, limbs and mind focused upon the imposing task of bending matter to human will. The use of fire in working with glass—a formless, incandescent substance that flutters at the end of a blowpipe as it is shaped—or with clay—a handful of insignificant earth mixed with water that suddenly comes to life when it is molded—is a testimony to the undying human ambition to create. Italy boasts an important tradition in both of these very ancient crafts. Both have had long periods of splendor, but by the nineteenth century they had been reduced to mere eclectic virtuosity for its own sake, characterized by the repetition of age-old motifs.

The Italian glassmaking industry, centered primarily on the tiny Venetian island of Murano, began to blossom around the middle of the fifteenth century. In the early sixteenth century many of the glassmaking techniques known today were perfected, and methods of achieving exceptional lightness and transparency—which are now considered the hallmarks of Murano glass (along with its pure, intense color)—were discovered. The dominance of Murano glass lasted into the eighteenth century, when other European centers began to create their own styles, competing directly with Venice.[1] The splendor of glassmaking in Murano came to an end with the surrender of the Republic of Venice to Austria in 1797, after nearly a thousand years of independence.

In the nineteenth century most of the ancient glassworks closed. The Murano workshops still in operation produced tired, unimaginative forms for the tourist market. There was no more innovation, and, even worse, the high quality that had always distinguished Murano glass almost entirely disappeared. Aware of this desperate situation, Abbot Vincenzo Zanetti, in 1861, opened a small museum on the island of Murano, gradually building up a collection of glass, and then established an adjacent school of design and craft. He wanted the Muranese to be inspired and stimulated by the masterworks of the past and the skill and creativity of earlier craftsmen.[2] In 1866 the final annexation of the Veneto to Italy during the Third War of Independence constituted a turning point that would lead to improved political, social, and economic conditions in Venice. That same year Vicenza lawyer Antonio Salviati, who was a supporter of Abbot Zanetti's school, opened the Salviati & Co. glass workshop on Murano, hiring the island's finest masters and spurring them on to re-create the celebrated lightness and technically bold glassworks of the past. It was a slow, arduous process, but eventually the new craftsmen succeeded in surpassing the technique and mastery of their forebears.

In 1921 Paolo Venini, a Milanese lawyer, together with Giacomo Cappellin, a Venetian antiquarian, founded Vetri Soffiati Muranesi Cappellin-Venini & Co.,[3] appointing master craftsman Vittorio Zecchin the company's first artistic director. From the start Venini's aesthetic stressed purity and simplicity—as evident in forms free of all unnecessary ornament—and an exquisite sense of color. Today it is difficult to imagine the power of such an innovative charge upon the field of glassmaking in the 1920s. On the occasion of Venini's death in 1959 Astone Gasparetto eulogized:

When his first glass works emerged from the oven nearly forty years ago, people spoke almost of a revolution, at the sight of those forms that were yet so simple, so pure, so classical in their closed geometry, so accustomed had we become to seeing in our glasswork nothing but pseudo-Baroque frills and perforations at best mixed with a few silly Art Nouveau flourishes.[4]

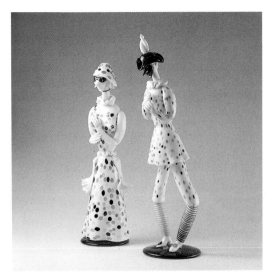

A man of great sensitivity and perception, Venini understood how to choose his collaborators. Yet he was also a great entrepreneur who succeeded in building an international reputation for his company through designing pieces that went on to enjoy great commercial success (for example, the *Incisi* series, see cat. no. 250). The company's fame continued to grow; Venini glassworks were selected frequently for prestigious exhibitions such as the Venice *Biennale* and the Milan *Triennale*. In particular the *Biennale*, perhaps because of its Venetian site, came to be used by the Muranese as a forum for introducing technical and aesthetic innovations and for gauging changes of taste.[5]

The story of modern Italian glassmaking can be seen to begin with the Biennales of 1940 and 1942, when Venini first introduced highly innovative lines, bold and extremely clean, thus anticipating the style that would predominate after World War II. Many of the products presented at these Biennales—most of them designed by Carlo Scarpa, who collaborated with Venini from 1932 to 1947—remain today among the cornerstones of their collection.[6]

Scarpa's sense of plasticity and color and his inexhaustible urge to innovate definitively transformed the Muranese glassmaking tradition. His forms (see cat. nos. 239–43), which are underscored by their brilliant coloration, achieve such a sublime rarefaction that one can see in them the mellow colorism of Venetian Renaissance painting, the soft, full sensuality of Titian's Venus, and also the sobriety and reduction of Bauhaus design. He is also credited with the invention of numerous techniques, and the revival of others, such as murrhine glass, which had been used by the Romans. To make murrhine glass, a number of differently colored rods are joined, then heated to obtain a single mass that is then cut transversally, forming a mosaic. By shaping and finishing the amalgam on a lapidary's wheel, Scarpa could create very thin glass with semitransparent effects (see cat. nos. 244–47).[7]

Although many glassmakers were forced to close down or diversify their production during the war (Venini, for example, began to produce light bulbs), the end of the conflict brought an atmosphere of optimism. Many companies definitively abandoned traditional or Novecento-style forms and developed imaginative new products.

Fulvio Bianconi, a well-known illustrator and caricaturist, succeeded Scarpa as the artistic director of Venini's company in 1947. Bianconi soon demonstrated his creative talents in designing, the following year, the delightful *Maschere della commedia dell'arte italiana* (*Masked Figures of the Italian Commedia dell'Arte*) of white opaline glass with colored accents (fig. 1). In addition to these elegant fantasies, Bianconi designed other pieces that enjoyed wide commercial success, such as the *Fazzoletto* (*Handkerchief*) vase (1949–50, cat. no. 256)—which was inspired by the equally popular *Cartoccio* vase designed by Pietro Chiesa in 1932 for Fontana Arte of Milan[8]—and the

fig. 1. Fulvio Bianconi, Maschere della commedia dell'arte italiana *(Masked Figures of the Italian Commedia dell'Arte), 1948, executed for Venini. Blown Lattimo glass; Arlecchina: 52 cm high, Arlecchino; 57 cm high. Museo Venini, Murano.*

fig. 2. Ermanno Toso, Bottles, 1959, executed for Fratelli Toso. Left: metalized glass, 50 cm high; right: metalized glass, 44 cm high. Collection of Vittorio Ferro, Murano.

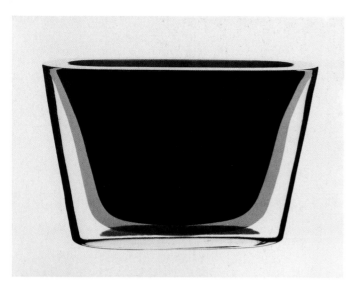

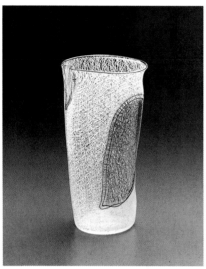

fig. 3. Flavio Poli, Compote, 1960. Sommerso glass, dimensions unknown.

fig. 4. Archimede Seguso, Merletto (Lacework) vase, 1952. Blown glass embossed with amethyst, 24 cm high, 12.5 cm diameter. Vetreria Seguso Archimede, Murano.

Multicolori or Pezzati (Multicolor or Dappled) vases (1952, cat. nos. 257–59), which were executed with a relatively simple but visually very impressive technique.

The long-necked, polychrome bottles of 1959 (fig. 2) by Ermanno Toso, head of Fratelli Toso, were created in a similar fashion. His workshop successfully interpreted changing tastes and market demands by renovating techniques from the ancient glassmaking tradition of Murano in a lively and captivating manner. By contrast the Rationalist and almost Northern flavor of the designs of Flavio Poli, evident in his use of essential forms and primary colors (see fig. 3), became greatly appreciated abroad. Poli, the artistic director of the Seguso Vetri d'Arte workshop, would be one of the best-known artists in his field, particularly in America.

In the early 1950s one of the greatest master glassmakers of the century, Archimede Seguso—who had left Seguso Vetri d'Arte in 1942 and opened his own workshop in 1946—pushed the limits of Renaissance filigree techniques in his deservedly popular series of Merletti (Lacework) vases.[9] In fig. 4, a mad lacework motif first tangles together then spreads out, slips away to retrace its steps, then slowly finds order and direction. Because the pattern does not cover the entire surface of the vase, the pure transparency hiding behind the netlike tangle is unveiled. Around 1953 Seguso began the Piume (Feather) series (see fig. 5), which incorporates a variation of the filigree technique. With more massive forms and new colors that play on yellow and brown hues, this series heralded the severity of forms and colors that predominated in the glass of the decade to follow.

Similarly subdued colors and a slightly archaic appearance distinguish the forms of Ercole Barovier, a member of one of the oldest families of Murano glassmakers and for forty years the artistic director of the Barovier e Toso workshop. His technical achievement lies for the most part in his experimentation, beginning in 1935–36, with "hot coloring without melting," which involves the introduction of "nonmeltable substances, or of substances not allowed the necessary time to melt, into the pot so as to give the mass specific coloristic effects."[10] With this technique, Barovier was the first to use heavy, thick glass, unlike the traditionally favored very light glass. Artistically, he is famous for executing some of the most beautiful glass series of the 1950s and 1960s, including Saturnei (Saturnian) of 1950, marked by alternating bands of opaque-white glass piping and colored murrhine glass, and the more geometric Millefili (Thousandthreads, 1956, fig. 6), composed of a checkerboard pattern of colored tesserae, some squares of which contain parallel threads.[11] Works from the latter series were exhibited at the 1956 Biennale. The "primitivism" he desired, which can be deduced from the very names of such series as Neolitici (Neolithic) and Aborigeni (Aboriginal) of 1954 and Nuragici of 1957 (named after the Nuraghi, the neolithic stone structures of Sardinia), is obtained through Barovier's use of basic, sometimes irregular forms and hues restricted to dark greens, browns, and shades of yellow-amber.

In the 1960s the styles of the previous decade—encompassing light, irregular, and organically derived forms and delicate yet complex decorations—gave way to more sculptural and rational objects. Between 1958 and

1960 Seguso executed his earliest one- and two-color vases in transparent or opaline glass, anticipating a trend that would be followed by many. The use of opaline glass, opaque surfaces, and abrasive acids to corrode surfaces gained popularity. Two glass workshops, in particular, were successful in perfectly interpreting the new market demands of the 1960s: the Vistosi company, founded by Guglielmo Vistosi in 1945 and managed by his brother Oreste after his death in 1952, and the Carlo Moretti workshop, founded by Moretti in 1958 and currently managed by him along with his brother Giovanni. The objects produced by Vistosi, designed by Luciano Vistosi and Alessandro Pianon, are distinguished by their geometric simplicity and abstract stylization. Carlo Moretti is known for its table items designed by Moretti himself with basic forms and clean lines. While plastic, functional forms triumphed in this period, the growing practice of employing professional designers, along with the taste for geometric forms leading to the use of molds, contributed to an overall decline in the island's age-old tradition of craftsmanship.

The history of Italian ceramics follows a path somewhat parallel to that of glass. The great period of Italian ceramics began in the late fourteenth century, exploding in the second half of the fifteenth with the perfection of majolica ware. Among the most refined examples of Italian ceramics were those produced from the fifteenth through the sixteenth centuries. Over the next two centuries ceramic wares were gradually supplanted by the exquisite elegance of Eastern porcelain; in the nineteenth century the glorious and antique craft tradition was reduced to the serial production of haphazardly diverse works.

The story of the renewal of Italian ceramics in the twentieth century is in some ways more complex than that of glassmaking. One must first of all make a distinction between the painted ceramic vases of certain artists working around the turn of the century, such as Marc Chagall, Henri Matisse, or Pierre Auguste Renoir, and the programmatic revival of clay crafts that was achieved first by Art Nouveau and Art Deco creators and later by members of the historic avant-garde, from Dutch De Stijl to Russian Suprematism and Constructivism, to Italian Futurism and the German Bauhaus. While the former phenomenon is limited to the simple transfer of painterly motifs onto ceramics, the latter brought about violent shifts that radically revolutionized the very forms of, and means of making, objects. However, even in the case of members of avant-garde movements, artists usually limited themselves to conceiving pieces rather than being directly involved in their realization. In general these artists did not want to create single, unique objects, nor works of art, but rather items for common use that could be produced on a broad scale.[12] What was of interest was not the rediscovery of clay as an artistic material nor its direct manipulation; rather, the medium of ceramics was a means to address people, to enter into average homes, to spread ideas.[13] Even though, as Enrico Crispolti reveals, in its revival of ceramics the school started by studying local crafts made by hand,[14] the goal of the Bauhaus was to reconcile art, handicrafts, and industrial products, and therefore to redefine the object in terms that, while certainly including

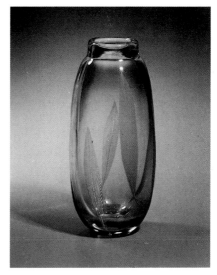

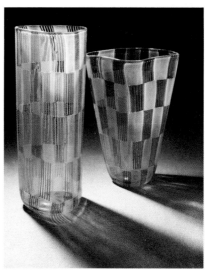

fig. 5. Archimede Seguso, Vase, Piume (Feather) series, 1953. Blown glass, 23 cm high, 9.5 cm diameter. Vetreria Seguso Archimede, Murano.

fig. 6. Ercole Barovier, Vases, Millefili (Thousandthreads) series, 1956, executed for Barovier e Toso. Blown Lattimo and Bluino glass; left: 32 cm high, right: 29 cm high.

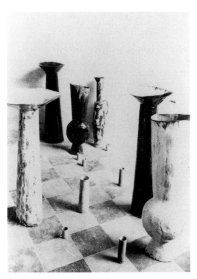

fig. 7. Fausto Melotti, Large vases at the
IX Triennale, Milan, 1951.

aesthetics, were above all concerned with function and the goal of large-scale production.

In Italy the patriarchal, multifaceted Tullio (Mazzotti) d'Albisola was certainly the leader in the reevaluation of clay handicrafts. In 1938, with Filippo Tommaso Marinetti, he signed the *Manifesto della ceramica e aeroceramica* (Manifesto of ceramics and aeroceramics), which recognized the town of Albisola as one of the main centers of Futurist ceramics and Tullio as its major representative.[15] Italian Futurist ceramics are distinguished by heavy, brightly colored decoration that, in the best cases, as Crispolti notes, manages to blend "into the form of the object itself."[16] For more than forty years, well beyond the duration of the Futurist experience, Tullio remained at the center of contemporary artistic debate, cultivating fruitful exchanges with many artists through a very active correspondence.[17] He welcomed to his workshop and aided the major artists involved in the medium, from Lucio Fontana to Agenore Fabbri, Emilio Scanavino and Aligi Sassu to the artists of the COBRA group. Over the years Tullio fought for the recognition of the ceramic object as a unique work of the highest quality and of expressive, plastic innovation, in an attempt to tear down the wall traditionally existing between art and craft.

The other central figure in the battle for the revalorization of ceramics was Gio Ponti, whose interests and goals lay in opposition to Tullio's. In the 1920s and 1930s Ponti championed a figurative porcelain[18] of great elegance, refinement, and very high quality in his long collaboration with Richard Ginori.[19] In the 1940s and 1950s he presented himself as the defender of Italian handicrafts, which in his words "represent the highest, liveliest abilities of our country and perhaps the best part of our people."[20] From the pages of *Domus*, the review he founded in 1928, Ponti promoted not only ceramics but also glassmaking, enameling, fabrics, and painted furniture.

Heir to Tullio's legacy, Fontana began to work in ceramics as early as 1937 at Sèvres, but it was above all at Albisola, in the Mazzotti workshop, that he really came to understand the material.[21] He would continue to return to the atelier in Albisola periodically to work. By the end of the 1930s Fontana was using ceramics as a new medium of expression, drawing upon its malleable nature and its capacity to capture otherwise unachievable effects.[22] In this sense his ceramics from this period owe something to the art of Auguste Rodin, who was one of the first to rediscover the ancient, supple material of clay as a material for finished sculpture, and, to cite a more recent, Italian example, of Arturo Martini, who had worked assiduously in ceramics in the 1920s and 1930s, always in Albisola, making sculptures and vases. Fontana went on to achieve a fuller knowledge of clay in the period following his 1939–47 stay in Argentina.

The exhibition that marked the turning point in twentieth-century Italian ceramics in a broad sense was the *IX Triennale*, held in 1951. Fontana exhibited his spatial ceramics, begun in 1949–50, from which iron spirals shoot up as if toward the cosmos.[23] He destroyed the polished surfaces of his plates and vases with aggressive, vortexlike brushstrokes and loud stains of pure color, then he scratched, perforated, and further profaned them. By this point Fontana had so deeply, so absolutely absorbed the

culture of ceramics that his work in it becomes indistinguishable from contemporary work in other mediums. Through his pieces, artistic inspiration bends to the laws of ceramics, while the ceramic medium is broadened to embrace artistic inspiration.

At that same *Triennale* Fausto Melotti was awarded the Grand Prize in ceramics for a series of very large vases, some more than a meter in height although very light and fragile. In fact Melotti's material becomes thinner and thinner, until it is an extremely light sheet that continually challenges the forces of cohesion (see fig. 7).

Melotti, who can be seen as the successor to Ponti's artistic credo, had by the 1920s already begun working in ceramics, making little sculptures. Yet he did not apply himself totally to clay until after the public and critical misunderstanding of his 1935 sculpture exhibition at Milan's Galleria del Milione, and after his 1941–43 stay in Rome, where he worked on *E42*, a monumental project for the *Esposizione universale Roma '42*. For nearly twenty years he concentrated upon ceramics. In the 1940s Melotti produced, on two parallel paths, small sculptures and functional objects, ever wavering between the abstract and the figurative. In the 1950s he concentrated entirely on vessels, though investing them with expressiveness and imagination and often undermining their functionality. A series of vases made from the end of the 1940s to the early 1950s plays with a zoomorphic transfiguration of geometric form. Such works demonstrate the pervasive flash of irrationality and mischievousness that mitigates Melotti's Rationalist faith (see cat. nos. 235, 236). In the 1950s Melotti energetically collaborated with Ponti on various projects, including large public and private commissions such as the 1954 Alitalia terminals in the airports of Milan and New York, where he covered the walls entirely with blue and white ceramic tile.[24] After devoting twenty years to ceramics, he abandoned it in the 1960s, returning to sculpture in other mediums.

Whereas Fontana, more in keeping with the dictates of Tullio, totally negated the distinction between art and craft by championing what he defined as "monotype" ceramics—the single piece that, because it is directly modeled by the artist, attains the level of art[25]—Melotti represented, in a certain sense, the traditional dichotomy between art and handicraft. Lisa Ponti poetically sums up Melotti's attitude as follows: "Melotti laughs at the things he makes: at his shelves full of armies of little angels and families of 'odd animals'. . . . They're things I do under the table, of course, he says; everyone knows they're not sculpture."[26] To him ceramics was a game, an amusement, and a way to survive during a twenty-year period of crisis (many of his objects were commercialized, created in series). In interviews from the 1960s Melotti spoke repeatedly of this "crisis," which was brought about through a lack of critical and popular recognition for his work as well as wartime and postwar difficulties. Yet he would not have been able to attain the innovative force and expressive purity of his 1960s sculpture had he not spent those twenty years "surviving" by concentrating upon a handicraft. His ceramic work of the 1940s and 1950s, then, is significant because it is the expression of a "silent search and inner elaboration," in the words of Giovanna Amadasi.[27]

There are many more connections between Melotti and Fontana than might initially appear. Aside from their esteem and respect for each other they are united by a love for ceramics.[28] In addition, in the work of both artists there is a latent schizophrenia, which drove them to waver indefinitely between a rational, minimalist purity and an expressive, almost baroque eccentricity. If Fontana violated pure forms by laceration and perforation, or, at times in a final act of defiance, by painting them in bright and purposely jarring colors, Melotti gave his magical and sometimes anguishing imagination free rein, often allowing it to prevail over an object's function (see cat. no. 237).

Hints of the impetuous physicality of Fontana (and of some of Melotti's oeuvre) can be found in the work of Leoncillo [Leoncillo Leonardi], who concentrated upon ceramics from the very start of his career in 1939 at the Rometti workshop at Umbertide. Later he worked independently, for the most part in Rome. Through his expressive, baroque exuberance and strident use of the figurative, he brought decoration to new heights of dignity, as in the beautiful ceramic panels he made for the Ariston Cinema and in his interpretation of a classical motif—the sleek marble caryatid—as a jagged, tormented ceramic supporting not the columns of a stately temple but rather the crystal top of a common table. In such works figurative sculpture completely penetrates the domain of ceramic design. Leoncillo's bright, sometimes even irritating colors seem to be a bitingly ironic comment on the banality and bad taste of many popular ceramics of the time.

Fontana and Melotti represent the two sides of the debate that raged in the 1950s around the reconciliation of art and craft (to which Ponti would have added architecture). The 1960s would bring about the collapse of this utopian goal, and an ever deeper gulf would come to separate craft (and the burgeoning field of industrial design) from art. Fontana, after the cosmic explosion of his terra-cotta *Nature* (*Natures*, 1959–60), gradually abandoned ceramics, as did Melotti. Other important artists, such as Emilio Scanavino, made ever-clearer distinctions between artistic and mass production in ceramics.[29] Until his death in 1968 Leoncillo pushed clay to the extreme, echoing the valences of Art Informel in a personal parable of "pain and splendor," to use Fabrizio d'Amico's term.[30]

Although in the previous decade glass and clay were still seen as materials for making exclusive objects—that is, unique works, fragile, precious, and prohibitively expensive—in the 1960s the field of industrial design idealized simply designed objects based on rigorously geometric shapes, incorporating pure and strongly contrasting hues, captivating in appearance yet produced in mass quantities for broad distribution. Changing attitudes brought about the return of a distinct separation between everyday objects and artworks, thereby privileging the utilitarian qualities of objects over their artistic merits. The 1970s would prove this to be yet another ideal failed, as had the utopian vision of the 1950s.

1. One such competitor was Bohemia, which began to use, in place of the sodium employed by Venetian glassmakers, potassium obtained from wood ashes, thus creating the famous crystal, with its exceptional brilliance. By the early nineteenth century the quality of English crystal was recognized. For the historical background of Murano glassmaking, see Rosa Barovier Mentasti, *Venetian Glass: 1890–1990* (Venice: Arsenale Editrice, 1992), pp. 8–9, and, by the same author, *Il vetro veneziano: Dal medio evo al novecento* (Venetian glass: from the Middle Ages to the twentieth century. Milan: Electa, 1982).

2. Barovier Mentasti, *Venetian Glass*, pp. 8–9.

3. This company was dissolved in 1925, when Venini founded Vetri Soffiati Muranesi Venini & Co.

4. Astone Gasparetto, quoted in Giuliana Duplani Tucci, ed., *Venini: Murano 1921* (Milan: Franco Maria Ricci, 1989), p. 32.

5. The glass section of the *Biennale* was abolished in 1972.

6. See the catalogues to the *XXII Biennale Internazionale d'Arte* (1940) and the *XXIII Biennale Internazionale d'Arte* (1942).

7. All information about glassmaking techniques was obtained from the useful appendix, "Le tecniche," in Franco Deboni, *I vetri Venini* (Venini glass. Turin: Allemandi, 1989), pp. 206–17.

8. In 1938 Fausto Melotti also designed a very similar vase of glazed ceramic.

9. Filigree is made by inserting threads of white or colored glass inside slender crystal tubes and then arranging them on the *bronzin*, a cold iron shelf (which used to be made of bronze, hence the name). Incandescent glass is then rolled over them. See Barovier Mentasti, *Venetian Glass*, p. 196.

10. Attilia Dorigato, *Ercole Barovier 1889–1974, Vetraio Muranese* (Ercole Barovier 1889–1974, Muranese glassmaker. Venice: Museo Correr, 1989), p. 18.

11. Ibid., p. 28.

12. Enrico Crispolti, *La ceramica futurista da Balla a Tullio d'Albissola* (Futurist ceramics from Balla to Tullio d'Albisola. Faenza: Museo Internazionale delle Ceramiche, 1982), p. 6.

13. Compare, however, Pablo Picasso's, Joan Miró's, and Fernand Léger's use of ceramics to create pure artworks.

14. Crispolti, *La ceramica futurista*, p. 8.

15. The manifesto was first published in Turin's *Gazzetta del Popolo*, September 7, 1938. Reprinted in Crispolti, *La ceramica futurista*, p. 8.

16. Crispolti, *La ceramica futurista*, p. 8.

17. See Danilo Presotto, ed., *Quaderni di Tullio di Albissola* (Notebooks of Tullio di Albissola. Savona: Liguria Editore, 1981–87).

18. For a technical explanation of ceramics and porcelain, see Natale "Theo" Veirana, "Tecnica della ceramica," in Fulvio M. Rosso, *Per virtù del fuoco: Uomini e ceramiche del novecento italiano* (By virtue of fire: men and ceramics in twentieth-century Italy. Aosta: Musumeci, 1983), pp. 201–02: "Technically, one defines as ceramic any product made of solid, inorganic, nonmetallic materials that is shaped cold and hardened with heat." Ceramics and porcelain are both made of clay; the particular clay for porcelain is called kaolin (from its Japanese name). When fired at a very high temperature (above 1200° C), it forms a dense white, nonporous ware.

19. Fausto Melotti also collaborated with Richard Ginori in the early 1930s.

20. Gio Ponti, "Che cosa significa la nostra copertina," *Stile* (Style), no. 3 (March 1946), p. 2.

21. In his work of those years Fontana wavered between abstraction and figuration, although he is mentioned in the *Manifesto della ceramica e aeroceramica* as an "abstract" ceramist.

22. The fascination that ceramics held for Fontana during this period is also attested to by the fact that in numerous solo exhibitions of 1938–39 he showed only ceramics. See Enrico Crispolti, *Fontana: Catalogo generale* (Fontana: general catalogue. Milan: Electa, 1986), p. 14.

23. For a preview and review of the exhibition, see Gio Ponti, "La ceramica italiana," *Domus*, no. 260 (July–August 1951), and "Le ceramiche italiane alla Triennale," *Domus*, no. 262 (October 1951).

24. Gio Ponti, "Il nuovo 'terminal' dell'Alitalia a Milano," *Domus*, no. 371 (October 1960), pp. 5–7.

25. See the acceptance speech for his nomination as Italian Representative to the International Academy of Ceramics of Geneva in *Céramique 1: Etudes céramologiques* (Ceramics 1: ceramic studies. Geneva, 1954), p. 35.

26. Lisa Ponti, "Il Mago Melotti," *Domus*, no. 230 (1948), p. 26.

27. Giovanna Amadasi, "Le ceramiche e le terracotte di Fausto Melotti negli anni '40 e '50: Continuità di un percorso artistico" (The ceramics and terra-cottas of Fausto Melotti in the 1940s and 1950s: the continuation of an artistic path), university thesis, Milan, Università degli Studi, 1992–93, p. 10.

28. Fontana and Melotti together attended the courses of Adolfo Wildt at Milan's Accademia di Brera in 1928–29, and both joined the Gruppo degli Astrattisti Italiani in 1934.

29. Many others were working in a variety of ways in ceramics during the years of the Italian metamorphosis. Aside from the already mentioned Scanavino and Leoncillo, some of the best known were Agenore Fabbri; Salvatore Fancello, who died very young; Marino Marini; and Aligi Sassu, all of whom gravitated around the Mazzotti workshop in Albisola.

30. Fabrizio d'Amico, "Leoncillo," in Pier Giovanni Castagnoli, Fabrizio d'Amico, and Flaminio Gualdoni, eds., *Scultura e ceramica in Italia nel novecento* (Sculpture and ceramics in twentieth-century Italy), exhibition catalogue (Bologna: Galleria d'Arte Moderna "Giorgio Morandi," 1989), p. 29.

Art in Jewels

Pandora Tabatabai Asbaghi

To develop a consciousness of art means to rediscover its power of genesis; it means above all to regain possession of the alchemical spirit[1] that penetrates substances and transforms them into a docile tool at the service of imagery. To know about art is to draw closer to the laws that regulate this spirit, found in the ancient workshop of the alchemist. It is there that the transmutation of base matter into gold, thoughts into wisdom, existence into terrestrial immortality, takes place.

The need to establish a circularity between art and alchemy, between sculpted or painted images and gold, is rooted in the age-old relationships between the occult and the creative, between the formulae of painting and the hermetic charms of colors, between the liberating action of metals and jewels, which were understood as sculptures to be worn for propitiatory and salvational motives.

The intermingling of colors and gold, artist and goldsmith, began in the Middle Ages and was glorified in the Renaissance, when specialized manuals of painting and sculpture contained chromatic instructions and metallic formulae equally useful to artists, illustrators, glassworkers, and jewelers. Nitric acid, a solvent common among goldsmiths and alchemists, was used by Francesco Mazzola (better known as Parmigianino), Albrecht Dürer, and Antonio del Pollaiuolo to renew the language of etching and engraving. Benvenuto Cellini and Andrea del Verrocchio explored the field of jewelry making[2] and extended the terrain of artistic activity to include decoration and ornament, for which their works won acceptance as *scultura miniata* (illuminated sculpture). Their extreme refinement, however, did not succeed in bringing microsculpture and jewelry in from the margins of art, to which they had been consigned by a profound lack of interest in the decorative arts, which were excluded from the great theoretical and philosophical debates. The search for fantastic and imaginary ornament, although it stood directly in the evolutionary history of culture (sharing its symbology and tied to its rites of magic and religion as well as to the rituals of power), was left to the high craftsmanship of the master jeweler, who adapted to the styles and fashions of the age. What was produced from the seventeenth to the nineteenth centuries reflects a mere elaboration of the techniques of cutting and joining, fusion and impasto of precious stones and metals, so that the sculptor slowly tended to be distinguished from the goldsmith and the jeweler.[3]

Only in the late nineteenth century, with a market expanding under the influence of the petit bourgeoisie that came to power after the French Revolution, did jewelry and miniature sculpture find a new audience and popular appraisal. The Romantic spirit induced a revaluation of individual beauty, seduction, and appeal, while the discovery of the exotic, as a consequence of archaeological excavations and the exploitation of mineral deposits in the countries of the colonized Orient, gave rise to new passions among the nouveaux riches. Now they desired ornaments inspired by antiquity and "primitive" cultures and loaded with precious stones and rare metals.

The totalizing vision of the Art Nouveau environment transformed ornaments into objects of design that could be made from common materials worked according to new industrial techniques. The beauty of the jewel and of the

miniature object for the person or the home, together with the aesthetic redefinition of apparel and environmental accessories, was no longer tied to the intrinsic value of materials and stones but to the originality of the conception and of its decorative and formal elements. Diamonds and rubies were flanked by glass, enamel, green gold, cultivated pearls, silver, amber, onyx, and opal, all of which enriched the chromatic and formal palette of jewelry.

The re-emergence of creativity in design and visual conception, the new openness toward common materials, and above all the languid and floral aestheticism of the Pre-Raphaelites, brought artists back into the fold. From Joseph Hoffmann to Koloman Moser, from Henry Van de Velde to Philip Wolfers, the languages of sculpture and painting, modeling and planning called attention to their own aesthetic impact: to the styles and volumes, the interlacing of colors and materials, the forms and figuration of jewelry in the history of art. Nevertheless, at the beginning of the twentieth century, artists who attempted the adventure of jewelry or of wearable sculptural ornaments were still rare; and their interest was almost always due to their concern for economic survival, given the difficulty of selling their sculpture and painting.

Those who did work with jewelry included Julio González, starting in 1913;[4] Alberto Giacometti (for Schiapparelli), beginning in 1924;[5] and Alexander Calder, after 1930.[6] They executed bracelets and necklaces, lockets and earrings, in common materials like iron, bronze, enamel, and silver; and they enjoyed the intellectual company of Marcel Duchamp, who in 1921 proposed to Tristan Tzara the idea of making an "amulet/jewel" composed of the words "DaDa, cast separately in metal, strung on a chain, and sold to raise money for the Dada movement. The insignia would protect against certain diseases, against numerous annoyances of life . . . something like those Little Pink Pills which cure everything . . . a universal panacea, a fetish in this sense."[7]

The greatest commitment to the field was made by Calder. In 1930 he was busily searching for bits of blue pottery with which to make a necklace for his mother. His interest in jewelry turned professional in 1933, when, at the request of his sister, he began to produce buckles and metal jewels to sell in small shops.[8] These objects were gradually refined, and in the 1940s and 1950s they became marvelous necklaces (see fig. 1), brooches, earrings, bracelets, and belts in bronze and silver interlaced with wood and minerals, based on the motif of the spiral, a constant element of his mobiles and toys. With Calder, the first artistic experimentation in jewelry was established: he was the true seeker of an avant-garde of bodily ornament based not on the value and symbolic power of gold and precious stones, but on the inventive charge of the forms and gems, which marked out an individual design sensibility distinguished by an abstract and fluid play of shapes.

The recourse to poorer materials during the years between the Wall Street Crash and the end of World War II was also determined by the state of production in the world as a whole. Because of the reduction in the availability of gold, diamonds, rubies, and platinum due to the closure of national borders and the drop in international trade, jewels began to be manufactured in

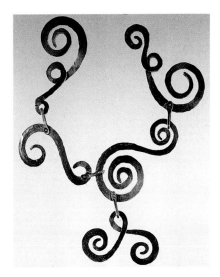

fig. 1. Alexander Calder, Necklace, ca. 1940. Silver, length 66 cm. Collection of Mr. and Mrs. Klaus Perls, New York.

fig. 2. Pablo Picasso, Brooch, ca. 1959. Gold, dimensions unknown.

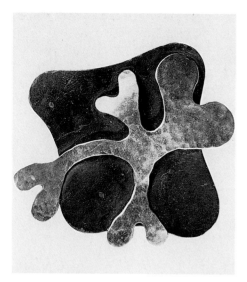

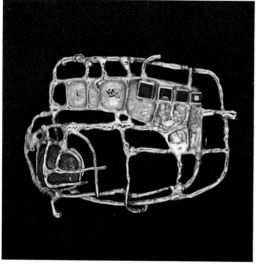

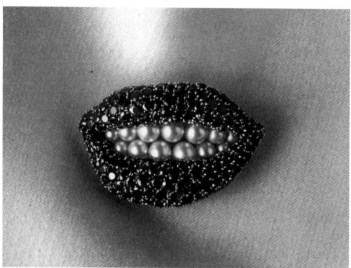

fig. 3. Jean Arp, Brooch, 1960. Silver, 6 x 7 cm.

fig. 4. Salvador Dalí, Ruby Lips, 1949. Gold, rubies, and pearls, 3 x 5 cm. Owen Cheatham Foundation.

fig. 5. Edgardo Mannucci, Brooch, 1953. Gold, rubies, and emerald, dimensions unknown.

semiprecious materials such as aquamarine and synthetics. This development helped to curtail the ostentation of the wealthy.[9] It also gave rise to a flowering of low-cost ornamental and decorative accessories made of Bakelite, ceramics, glass, and wood, which attracted a broader public and initiated a more democratic dissemination of jewelry. This became particularly evident during the heyday of Art Deco.

In the years immediately after the war, Europe's economic rebirth brought an authentic explosion in the production of jewelry, which was increasingly associated with the ephemeral and frivolous creations of fashion. Artists were inspired by friends and important collectors like Peggy Guggenheim,[10] or pressed by such famous goldsmiths as Frédéric Boucheron, Jean Fouchet, and Pierre Hugo;[11] and once they overcame the ideological impediments to an interest in the decorative arts, they began to execute microsculptures and wearable works of art. Between 1948 and 1963, Jean Arp, Georges Braque, Giorgio de Chirico, Max Ernst, Man Ray, Meret Oppenheim, Pablo Picasso, Yves Tanguy, and Dorothea Tanning worked on miniaturizing their images to transform them into earrings, necklaces, and pins bearing iconographic and linguistic motifs tied to the traditions of Cubism, Dada, Metaphysical Painting, and Surrealism (see, for example, Picasso's *Brooch* of ca. 1959, fig. 2, and Arp's of 1960, fig. 3).

With the increased popularity of jewelry, artists began to take radical stands for or against this form of dissemination of their personal and cultural identity, which in future decades would assume the dimensions of a mass market. Salvador Dalí, taking the notion of jewelry as pure and absolute (hence unwearable and exorbitantly expensive) sculpture to its absurd extreme, used platinum, diamonds, gold, malachite, rubies, and sapphires to make a series of objects in the form of hearts, crosses, hands, eyes, lips (fig. 4), and telephones, whose *raison d'être*, he stated, was "a protest against emphasis upon the cost of the materials of jewelry. My object is to show the jeweler's art in true perspective, where the design and craftsmanship are to be valued above the material worth of gems, as in Renaissance times."[12]

Yet, with the turn-around in market interest sustained by a worldwide economic revival; with the renewed passion of collectors for works of art and high craftsmanship; and with the reawakened interest of the fashion houses, which saw a territory open up for designer jewelry and fanciful objects to blend with their garments or to reinforce their cultural images, the making, promotion, and sale of jewelry spread throughout the world. In France, Italy, the United States, Germany, Scandinavia, and Great Britain, the great goldsmiths invited artists to apply themselves to the modeling of microsculptures.

During this period Braque created 133 jewels (in two years' time) for Heger de Löwenfeld, and Dalí fabricated thirty-seven precious sculptures for Alemany & Co. In every country, risky and experimental collaborations took place between jewelers and younger artists whose roots lay in the early twentieth-century avant-gardes but whose ideas had been formed by postwar movements, from Action Painting to Art Informel.

The Preciousness of Italian Art

Italy was devastated and desolate at the end of World War II. The economic and industrial situation was catastrophic, and there was a shortage of precious metals. Nevertheless revival came quickly, born of a will to rebirth and a desire to forget the historical nightmare as soon as possible. During the following ten years, production and incomes rose enormously, and if in 1952 Italy was not yet out of the woods, it had certainly left the worst behind and was well on its way to recovery.

The innovative spirit of the liberation forces stimulated Italian culture and led to a renewal of all those arts, from cinema to painting, music to literature, that aspired to abandon the old and engage in a new experiment with an appeal to a much broader public. That experiment was neorealism. With the mobilization of democracy and the broader dissemination of information and culture, attention turned to areas that had been undervalued previously, like those of fashion and design. This development brought with it a reassessment of the aesthetic of the object.

After 1945 art became one of the chief agents in the process of liquidating traditional conservative culture, first by defining the conflict between realism and abstraction, and then, after 1949, with the advent of Art Informel, by starting research toward a work of art characterized by openness and flexibility. These cultural and economic developments were accompanied by an increase in the production of objects for the person and the home, notably jewelry, which, as we have seen, spread throughout the middle classes, relinquishing its status as a prerogative of the few to become an extension of personality touching all levels of society.

Survival was difficult in the early postwar years, which meant that many artists, in order to carry on their sculptural and painterly experiments, had to find second jobs. In the happier cases, these paralleled their primary interests. Some became illustrators, others potters; many found security in teaching, and a few in making jewelry. Between 1944 and 1950, Mirko [Mirko Basaldella] and Fausto Melotti made decorative objects inspired by a certain "primitivism," with references to Etruscan and Roman art; and Carla Accardi, who was connected with the group Forma, made for herself a pin in gold, brilliants, pearls, and coral, based on one of her abstract compositions (cat. no. 267). These, however, were isolated episodes representing a personal desire to seek individual expression through the magic and ritual of ornament.

It was only in the late 1950s, with the advent of Art Informel, that artistic jewelry reached its maturity. Thick impasto and uncontrolled movement, the use of malleable materials, and the notions of chaos and the unfinished work permeated this movement. In this culture of the formless, gold, with its extreme flexibility and fluidity, was one of the prime elements that allowed artists to transform the world alchemically.

The pleasure of obtaining and freely molding a substance opened up a plastic universe in 1953 to Edgardo Mannucci, an artist born in Fabriano in the Marches, but living in Rome. He is known for working with raw, unfinished materials such as scrap metal in order to realize dynamic configurations, monuments that seem weightless.

His practice as a sculptor and goldsmith can be considered the matrix of the creative development of artists' jewelry in Italy after 1960, from Afro [Afro Basaldella] to Alberto Burri, from Corrado Cagli to Giulio Turcato. Mannucci's dramatic figurations of brute matter, molded of an impasto of metals and wood, offer prime examples of organic drippings in gold, bronze, and silver (see fig. 5). In 1962, they led to the first experiments in jewelry by Burri, who commissioned Mannucci to execute pieces following his designs. After a first collaboration, which led to the execution of a remarkable belt/necklace and a small powder-box, Burri asserted his autonomy in the brooches of 1965–67 (see cat. nos. 276–78), which reflect his artworks of burned plastic in the *Combustione* (*Combustion*) series. Gold was melted directly with a blowtorch to give soul to the auric substance. It is an outstanding example of a wearable illuminated image in which the energy of the material is transformed into painterly magic—an enigmatic moment in which gold gives evidence of its alchemical power to transmute vision and thought.

Another artist introduced to jewelry by Mannucci, as well as by his own brother Mirko, is Afro, who turned toward a more iconic ornamentation in 1962 (see cat. nos. 268–75). Repeatedly in his necklaces, rings, bracelets, and pins, we encounter figural memories of natural motifs, which are reminiscent of the primitivism of his brother's work in jewelry. Precious stones like emeralds and rubies create a dialectic between water and fire, smoothness and roughness—a ferment of contrasting elements that exalts the sensual pleasure of the images and forms.

The desire to create a breach in the universe of jewelry also stimulated Turcato, who led ornamentation back to a barbaric identity (see cat. nos. 318–25). A forceful visual and metaphorical energy transforms his tiara of 1965 into a scene from an initiation rite of aggressive sexuality, his pin and bracelet into ritual talismans. The material, of white or yellow gold, liquifies on the arm or chest, almost as if it wished to form a river of vibrant lava, a vital current capable of adapting to all of the body's sensuality.

A fundamental contribution to the history of the art of jewelry was made by Arnaldo and Giò Pomodoro, who legitimized the poetry of bodily ornamentation as illuminated sculpture (see cat. nos. 304–17). In 1954, at the Galleria Montenapoleone in Milan, they held the first exhibition of miniature objects and jewelry in which the meticulous craftsmanship and refined technique of high goldsmithing were placed at the disposal of sculptors. The imaginative power of totemistic spheroids and pyramids emerges amid the polished surfaces, the etchings in gold, the embedded rubies and sapphires.[13]

Eventually the brothers' elaborations would begin to diverge. After 1964 Arnaldo turned toward a dialectic between positive and negative sculptural erosions in diamonds and gold, based on the forms of the cylinder and the sphere; his necklaces and bracelets with "destroyed" surfaces were transformed into objects with architectural elements that connect the fingers to the wrist and the upper arm to the neck. Following a very different vein, Giò moved from raw and wounded forms to elements conjuring images of galactic and earthly landscapes. His creations of 1964 were expanses of shrubs and rocks, buildings and mountains; those of 1966 became strange universes from

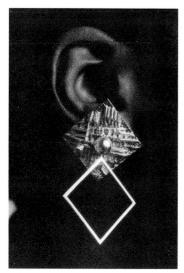

clockwise from top left:
fig. 6. Ugo Mulas, Earring by Arnaldo
Pomodoro, *Milan, 1969. Gelatin-silver
print, 38.7 x 27.5 cm on sheet 40.3 x
31 cm. Archivio Ugo Mulas.*

fig. 7. Ugo Mulas, Ring by Arnaldo
Pomodoro, *Milan, 1969. Gelatin-
silver print, 38.7 x 27.5 cm on sheet 40 x
30.2 cm. Archivio Ugo Mulas.*

fig. 8. Ugo Mulas, Ring by Arnaldo
Pomodoro *(produced by GEM-
Montebello, Milan), 1969. Gelatin-
silver print, 25.5 x 38 cm on sheet 35.5 x
48 cm. Archivio Ugo Mulas.*

fig. 9. Ugo Mulas, Necklace by
Arnaldo Pomodoro, *Venice, 1969.
Gelatin-silver print, 37 x 25.8 cm on
sheet 40.5 x 52 cm. Archivio Ugo Mulas.*

fig. 10. Ugo Mulas, Bracelet by Lucio
Fontana, *Milan, 1964. Gelatin-silver
print, 27 x 18 cm on sheet 31.5 x 21.5 cm.
Archivio Ugo Mulas.*

fig. 11. Ugo Mulas, Bracelet by
Arnaldo Pomodoro, *Milan, 1969.
Gelatin-silver print; 38 x 25 cm on sheet
50 x 40 cm. Archivio Ugo Mulas.*

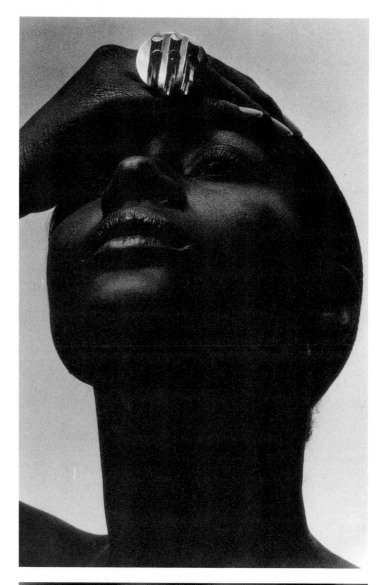

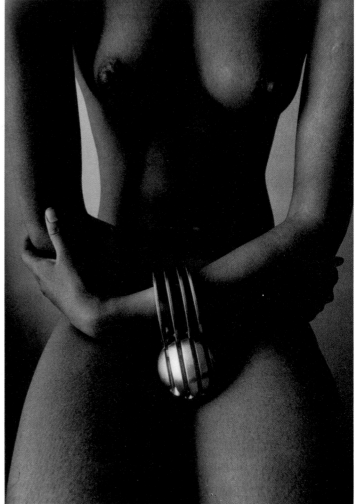

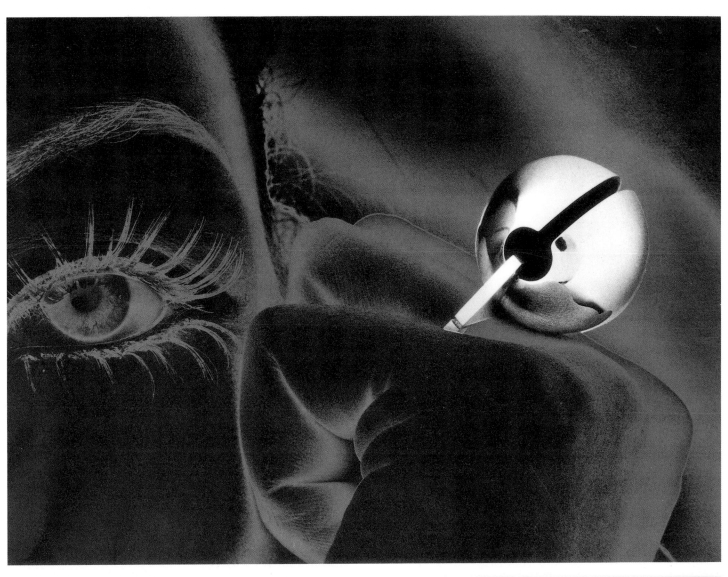
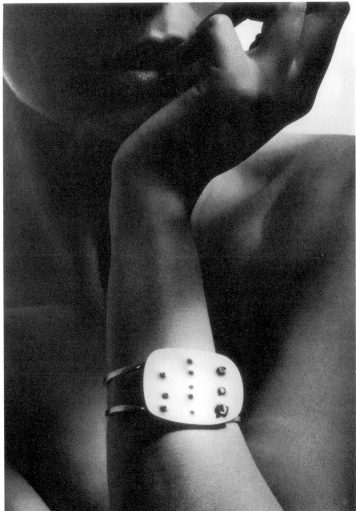
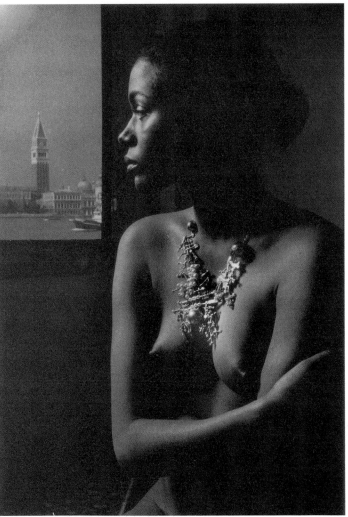

which irradiations and fantastic edifices arose; and those of 1967–68 were imaginary ensembles of sculptural and chromatic vibrations in enamel and diamond that radiated alchemical fireworks.

The Pomodoro brothers were organizers as well as creators.[14] In 1957 they were charged with overseeing the Goldsmithing section of the *XI Triennale* in Milan, to which they invited their artist friends, including Enrico Baj, Sergio Dangelo, Gianni Dova, Lucio Fontana, Emilio Scanavino, and Ettore Sottsass, Jr. This was a first for Fontana, who set about questioning the surface with slashes and holes and making various *Concetti spaziali* (*Spatial Concepts*) in the form of rings or bracelets between 1957 and 1967 (see cat. nos. 287–93). It is as if he were seeking a hidden energy in gold, an underside capable of bursting forth as pure space. The play of relativity also deeply interested the sculptor Fausto Melotti, of whom Fontana thought very highly and with whom he had shared the excitement of abstraction in the 1930s. Melotti's small sculptures in bronze and lesser metals thrive on their indeterminate interlacings and on the vibrations of their open structures, a light occupation of space that gold and precious gems would have made too heavy (see cat. nos. 294–98).

Artists, however, were not the only propulsive force in the field. There were also jewelers who, in addition to their work of traditional, classical inspiration, explored more experimental paths. The need for change arose from an altered market, in which women pursued a more aggressive and antitraditional image and therefore became interested in a more radical design. Danilo Fumanti, Gherardi, and Mario Masenza in Rome, as well as the young Montebello in Milan, approached painters and sculptors during the 1960s to create jewelry and other items that emphasized the twofold creativity of art and master craftsmanship. Among the artists, Afro, Giuseppe Capogrossi, Pietro Consagra, Fontana, Nino Franchina, Renato Guttuso, Leoncillo [Leoncillo Leonardi], and the Pomodoro brothers made precious ornaments which, in several cases, were consecrated in photographs by the esteemed Ugo Mulas (see figs. 6–11).

The phenomenon of the abstract graphic mark, which multiplies on the surface to form a mosaic of strange hieroglyphics, was the motif adopted by Capogrossi to investigate the value of optical movement in painting. He applied the same technique to his jewels, in which the chromatic substances of painting are replaced by diamonds, onyx, and coral (see cat. nos. 279–80). If Capogrossi's mark tends to create a compact surface, the folds and pathways of Consagra's pieces (see cat. nos. 282–84) bespeak lacerations of the sculptural surface, conflicts and encounters of fullness and emptiness; and Piero Dorazio's creations in gold, sapphires, and diamonds (see cat. nos. 285–86), by bearing the absolute analytic rigor of his painting, betray the awareness of making art.

Finally, there is a generation of artists and jewelers who received their training and made their names in Milan, Rome, and Turin, and who sought to overcome the chaotic, materialistic vision of Art Informel to propose an art based on the analysis and reduction of forms and images. Oscillating between a universe of popular figuration and optical structuring, artists like Getulio Alviani, Mario

Ceroli, Gabriele De Vecchi (see cat. nos. 328–29), and Giuseppe Uncini (see cat. nos. 326–27) endeavored to move jewelry toward a simple dimension based on materials like wood and aluminum in order to underscore the value of carving and reflection, montage and mobility. Finally, Giulio Paolini (see cat. nos. 302–03) and Maurizio Mochetti (see cat. nos. 299–301), from two opposing perspectives, seem to shift attention to the study of the jewel as an autonomous entity, the former defining the impact of the fist that passes through and lacerates the gold surface, the latter making the necklace a living, active thing through a small automated device that reacts to light.

If jewelry or bodily ornamentation can either perform or result from an action, then its effects can reach beyond the limits of art to become an area of mystery and magic that joins the artist with the person who wears his creations.

1. *Pneuma, souffle*, Breath, *d'Er-Ruh* has been universally identified with the life principle. From the Celts to the Stoics, from the Muslims to the Hebrews, it has been the symbol of the divine spirit that animates the world, giving it order and direction. In the Old Testament it means the Word. See Jean Chevalier and Alain Gheerbrant, *Dictionaire des Symboles* (Dictionary of Symbols. Paris: Editions Robert Laffont et Editions Jupiter, 1969), pp. 899–900.
2. Jacques van Lennep, *Alchémie* (Alchemy. Brussels: Gemeenthrediet, 1984), pp. 299–300.
3. Jean Lanllier and Marie Anne Pini, *Five Centuries of Jewelry in the West* (New York, 1983).
4. Thomás Llorens, "La colecciónes de esculturas de Julio González en el IVAM," in *Julio González*, exhibition catalogue (Madrid: Centro de Arte Reina Sofia, 1986).
5. René Sabatello Neu, *Jewelry by Contemporary Painters and Sculptors*, exhibition catalogue (New York: Museum of Modern Art, 1967).
6. Daniel Marchesseau, *The Intimate World of Alexander Calder* (Paris: Solange Thierry, 1989).
7. Quoted in Neu, unpaginated.
8. Marchesseau, pp. 254–56.
9. David Bennet and Daniela Mascetti, *Understanding Jewellery* (Suffolk, 1989), p. 330.
10. Bennet and Mascetti, p. 333.
11. *Gioelli e Legature, artisti del XX secolo* (Jewelry and bookbinding, artists of the twentieth century. Padua: L'Orafo Italiano Editore, 1990).
12. Quoted in *Salvador Dalí: A Study on His Art-in-Jewels* (New York: New York Graphic Society, 1959), unpaginated.
13. Luciano Caprile, "Spheres, Pyramids, Cones and Doors," in *Art*, September–December 1992.
14. The goldsmithing experiments of Arnaldo and Giò Pomodoro have been widely appreciated by art historians. A few essential references include: Guido Ballo, "I gioielli di due nuovi scultori: Arnaldo e Giò Pomodoro," *Novità*, Milan, January 1962; Willy Rotsler, "Schmuck von Pomodoro," *Du*, Zurich, January 1962; Maurizio Fagiolo dell'Arco, "I gioielli non costano soltanto, possono diventare opere d'arte," *L'avvenire d'Italia*, Bologna, July 7, 1964; and Giorgio Soavi, "Gioielli d'autore," *Novità*, Milan, January 1965.

Carla Accardi
Afro {Afro Basaldella}
Fulvio Bianconi
Alberto Burri
Giuseppe Capogrossi
Ettore Colla
Pietro Consagra
Gabriele De Vecchi
Ludovico Diaz de Santillana
Piero Dorazio
Lucio Fontana
Fausto Melotti
Maurizio Mochetti
Giulio Paolini
Arnaldo Pomodoro
Giò Pomodoro
Gio Ponti
Carlo Scarpa
Tobia Scarpa
Giulio Turcato
Giuseppe Uncini
Paolo Venini
Massimo Vignelli
Pierantonio Zuccheri

231. Lucio Fontana
Concetto spaziale (Spatial Concept)
vase, 1953. Terra-cotta, 50 cm high,
28 cm diameter. Collection of
A. Minola, Turin.

232. Lucio Fontana
Concetto spaziale (Spatial Concept)
vase, 1953. Terra-cotta, 50 cm high,
30 cm diameter. Collection of Luigi
Grampa, Busto Arsizio.

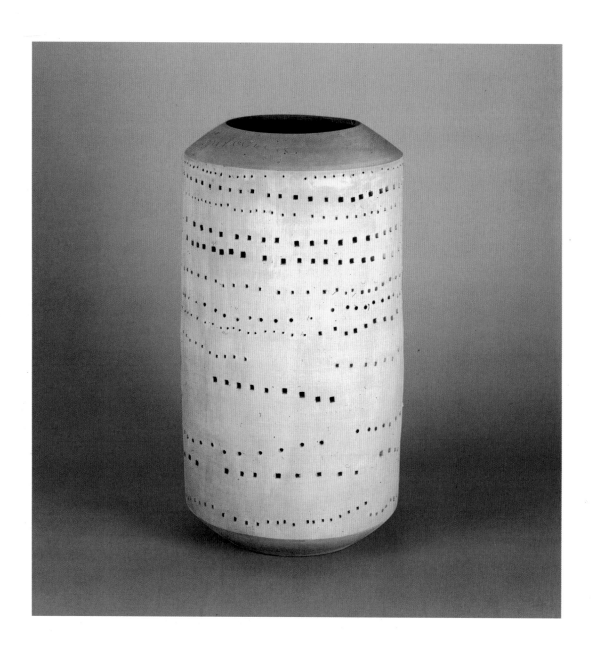

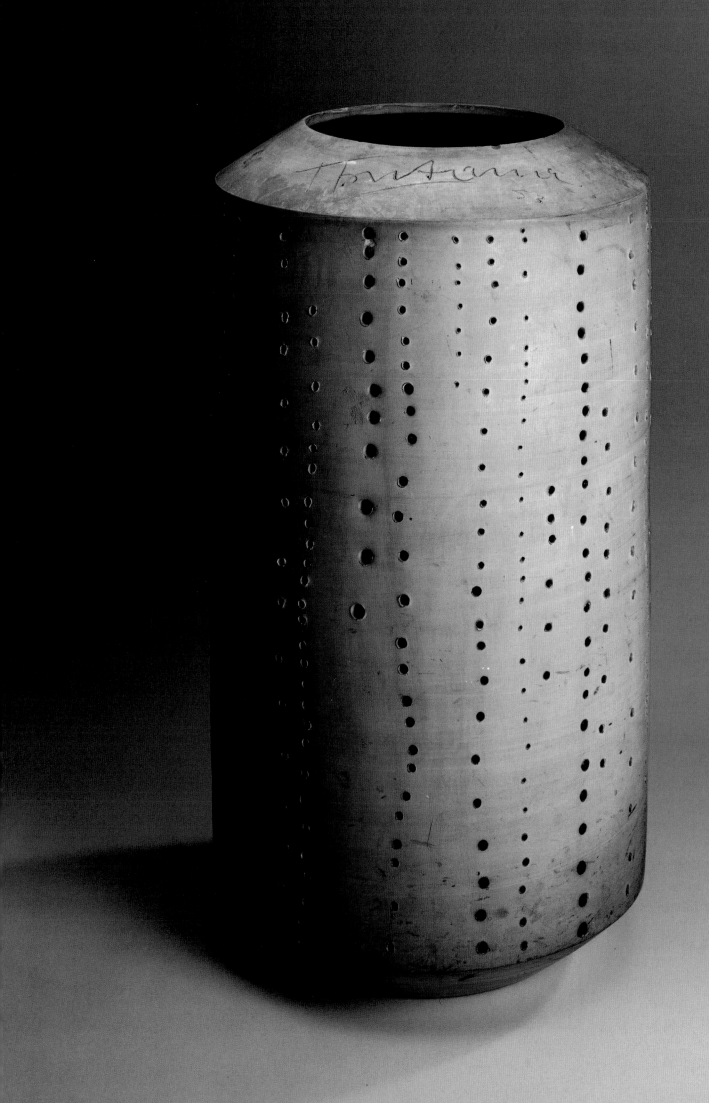

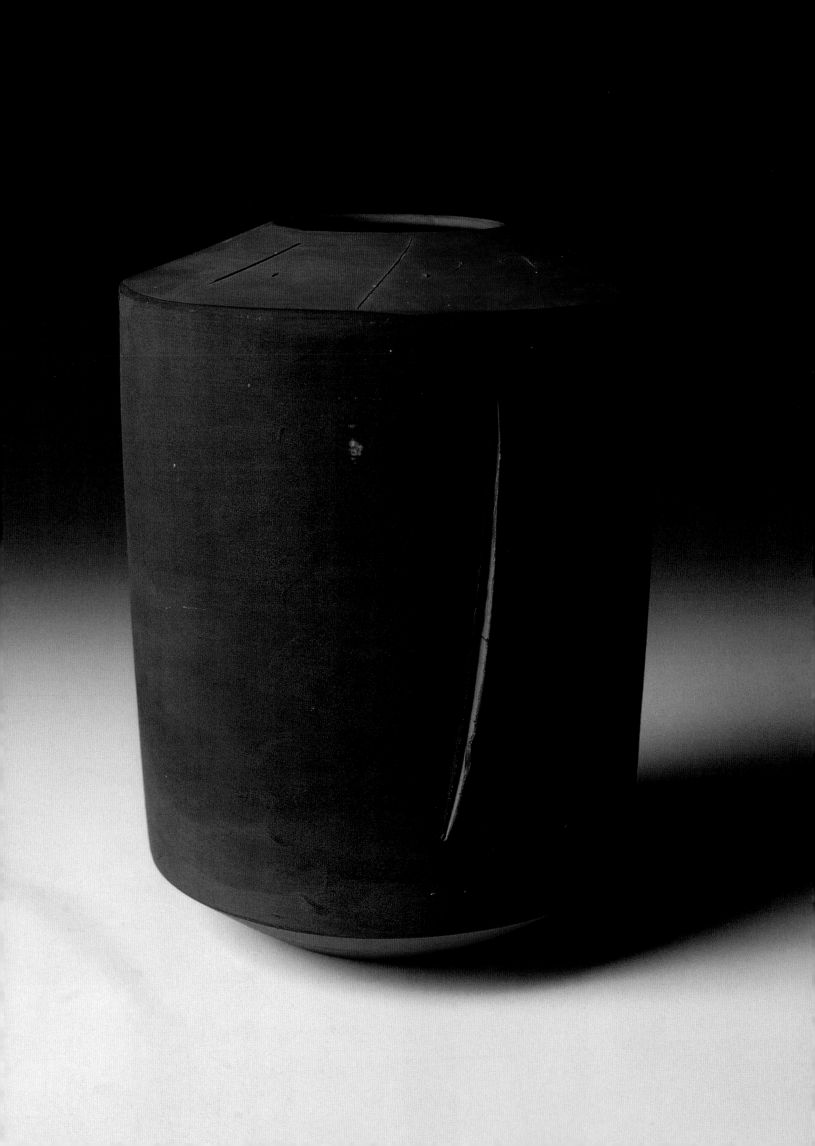

233. Lucio Fontana
Concetto spaziale (Spatial Concept)
vase, 1957. Ceramic, 21.5 cm high,
16.5 cm diameter. Collection of Gian
Tomaso Liverani, Galleria La Salita,
Rome.

234. Lucio Fontana
Concetto spaziale (Spatial Concept)
vase, 1955. Terra-cotta, 51 cm high,
27 cm diameter. Collection of Carlo
de Stefani, Vittorio Veneto.

235. Fausto Melotti
Gatto (Cat) *vase, 1949. Glazed
ceramic, 58 cm high. Private collection,
Milan.*

236. Fausto Melotti
Pesce (Fish) *vase, 1949. Glazed
ceramic, 56 cm high. Private collection,
Milan.*

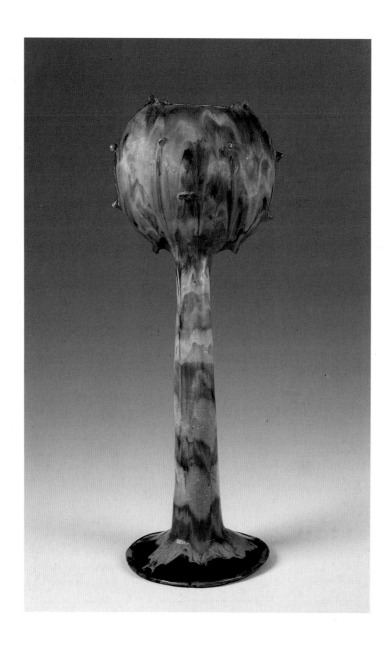

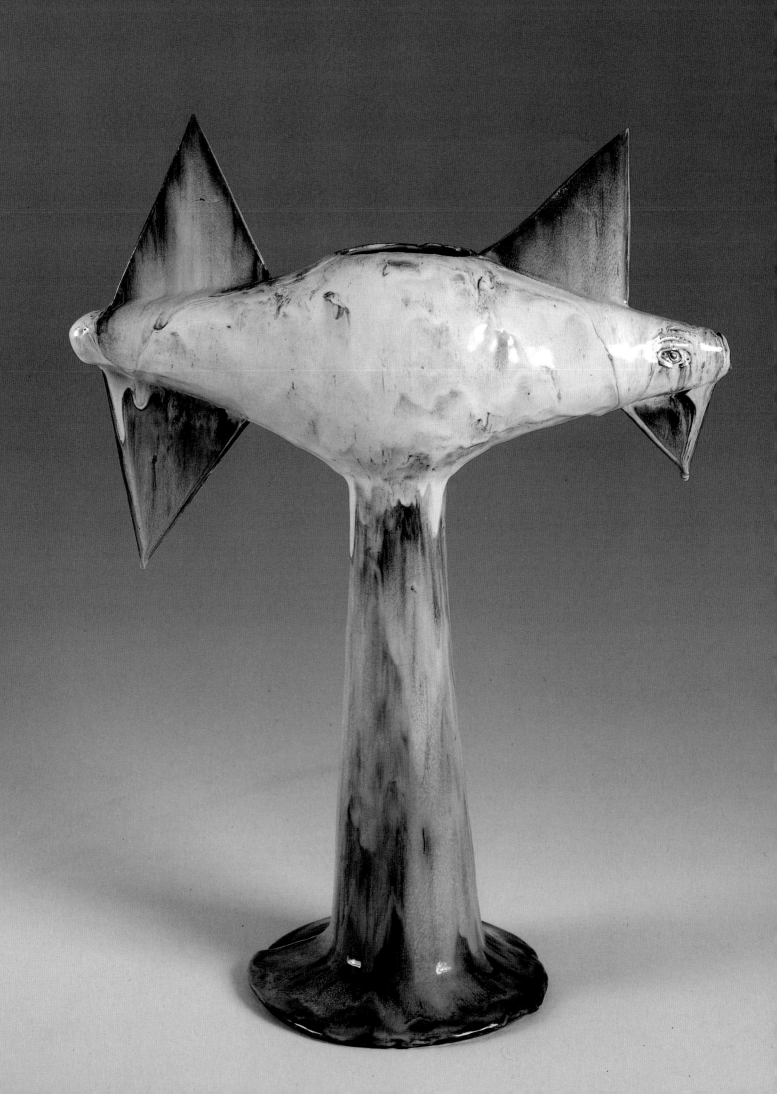

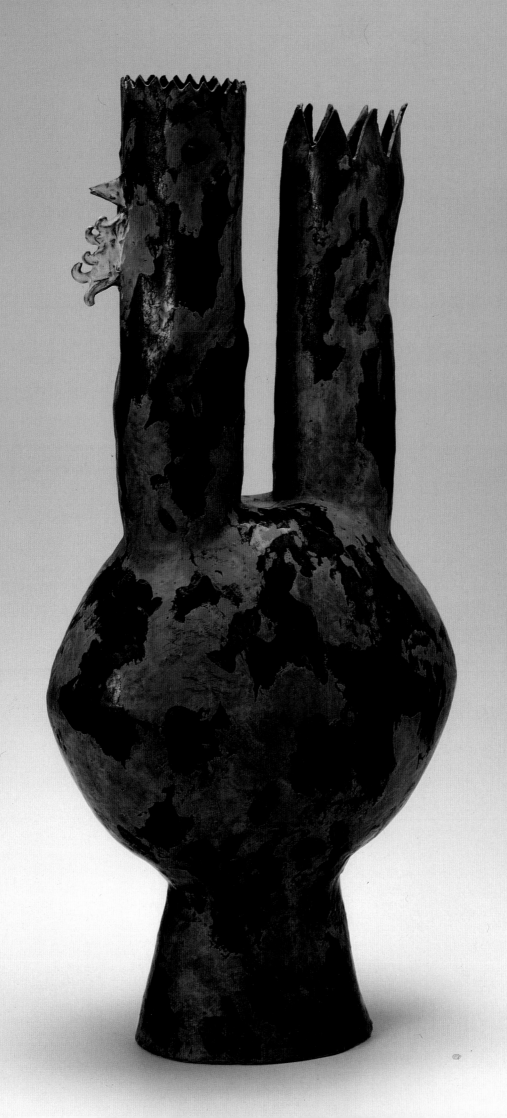

237. Fausto Melotti
Gallo (Cock) *vase, ca. 1950.*
Glazed ceramic, 65 x 30 x 21 cm.
Private collection, Milan.

238. Fausto Melotti
Vase, ca. 1950. Ceramic, 37 x 33 x 19 cm.
Private collection, Milan.

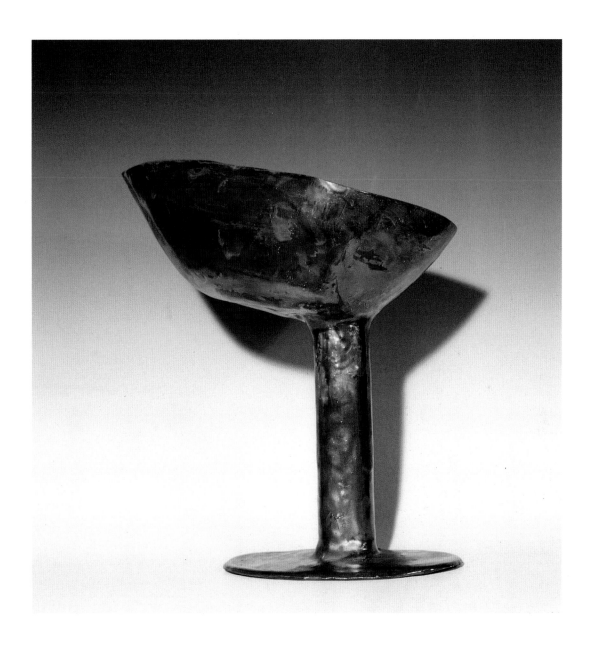

239. Carlo Scarpa
Vase, Tessuti (Fabric) series, 1940. Blown and handcrafted glass, 43 cm high, 16 cm diameter. Venini S.p.A., Murano.

240. Carlo Scarpa
Bowl, Tessuti (Fabric) series, 1940. Blown and handcrafted glass, 4 cm high, 16.5 cm diameter. Venini S.p.A., Murano.

241. Carlo Scarpa
Flask, Tessuti (Fabric) series, 1940. Blown and handcrafted glass, 24 cm high, 14 cm diameter. Venini S.p.A., Murano.

242. Carlo Scarpa
Flask, Tessuti (Fabric) series, 1940. Blown and handcrafted glass, 33 cm high, 12 cm diameter. Venini S.p.A., Murano.

243. Carlo Scarpa
Flask, Tessuti (Fabric) series, 1940. Blown and handcrafted glass, 20 cm high, 11 cm diameter. Venini S.p.A., Murano.

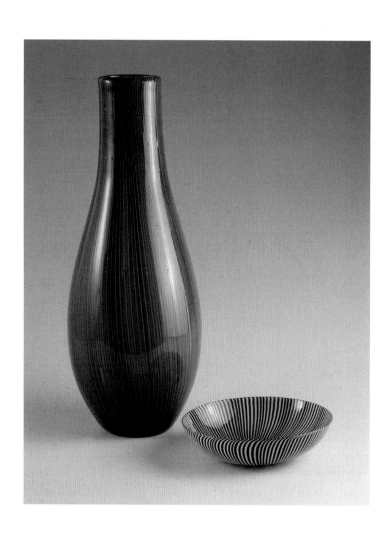

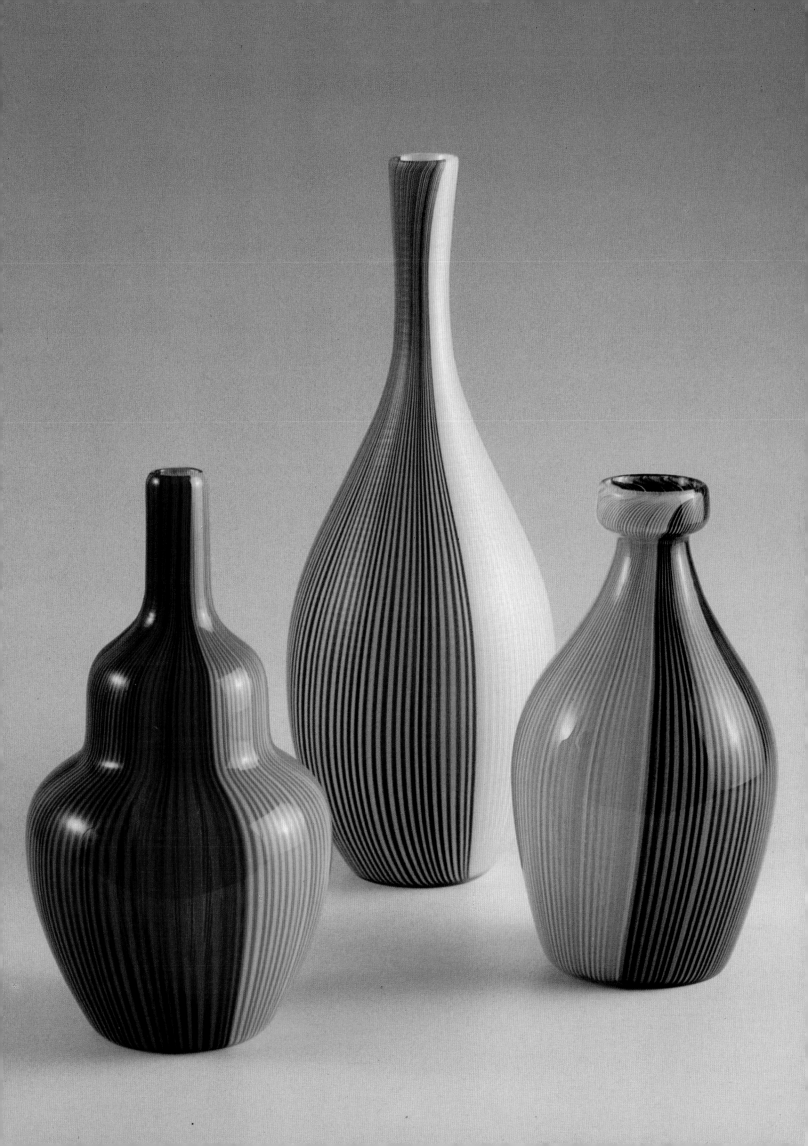

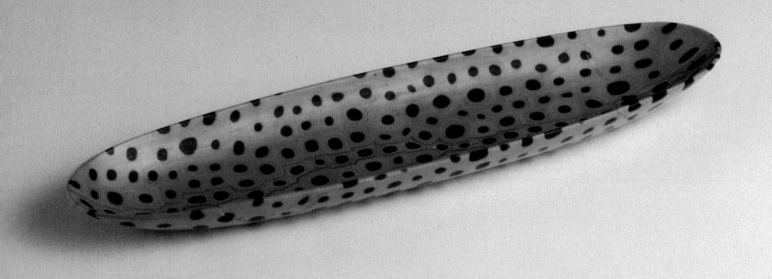

244. Carlo Scarpa
Plate, Murrine opache *(Opaque Murrhine) series, 1940. Opaque murrhine glass, 3 x 25.5 x 8 cm. Venini S.p.A., Murano.*

245. Carlo Scarpa
Plate, Serpente murrine opache *(Serpent Opaque Murrhine) series, 1940. Opaque murrhine and lattimo glass, 7.5 x 35 x 24 cm. Venini S.p.A., Murano.*

246. Carlo Scarpa
Plate, Murrine opache *(*Opaque Murrhine*) series, 1940. Opaque murrhine glass, 6.5 cm high, 27 cm diameter. Venini S.p.A., Murano.*

247. Carlo Scarpa
Plate, Murrine opache *(*Opaque Murrhine*) series, 1940. Opaque murrhine glass, 6.5 cm high, 27 cm diameter. Venini S.p.A., Murano.*

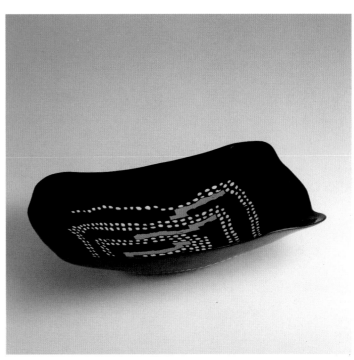

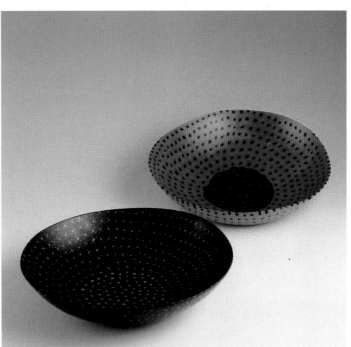

248. Carlo Scarpa
Vase, Battuti (Hammered) *series,*
1940. Blown and handcrafted glass,
11 cm high, 13 cm diameter.
Venini S.p.A., Murano.

249. Carlo Scarpa
Vase, Battuti (Hammered) *series,*
1940. Blown and handcrafted glass,
32 cm high, 20 cm diameter.
Venini S.p.A., Murano.

250. Carlo Scarpa
Vase, Incisi (Engraving) *series,*
1942. Blown and handcrafted glass,
32 cm high, 18 cm diameter.
Venini S.p.A., Murano.

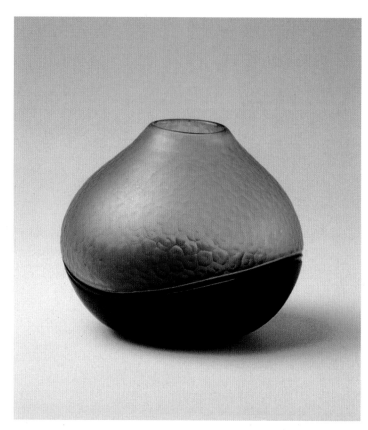

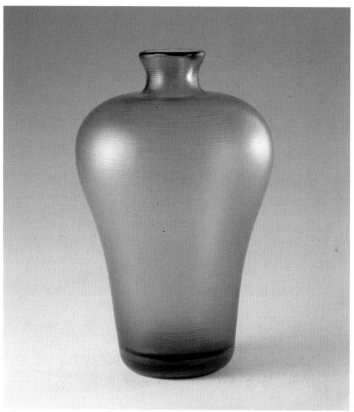

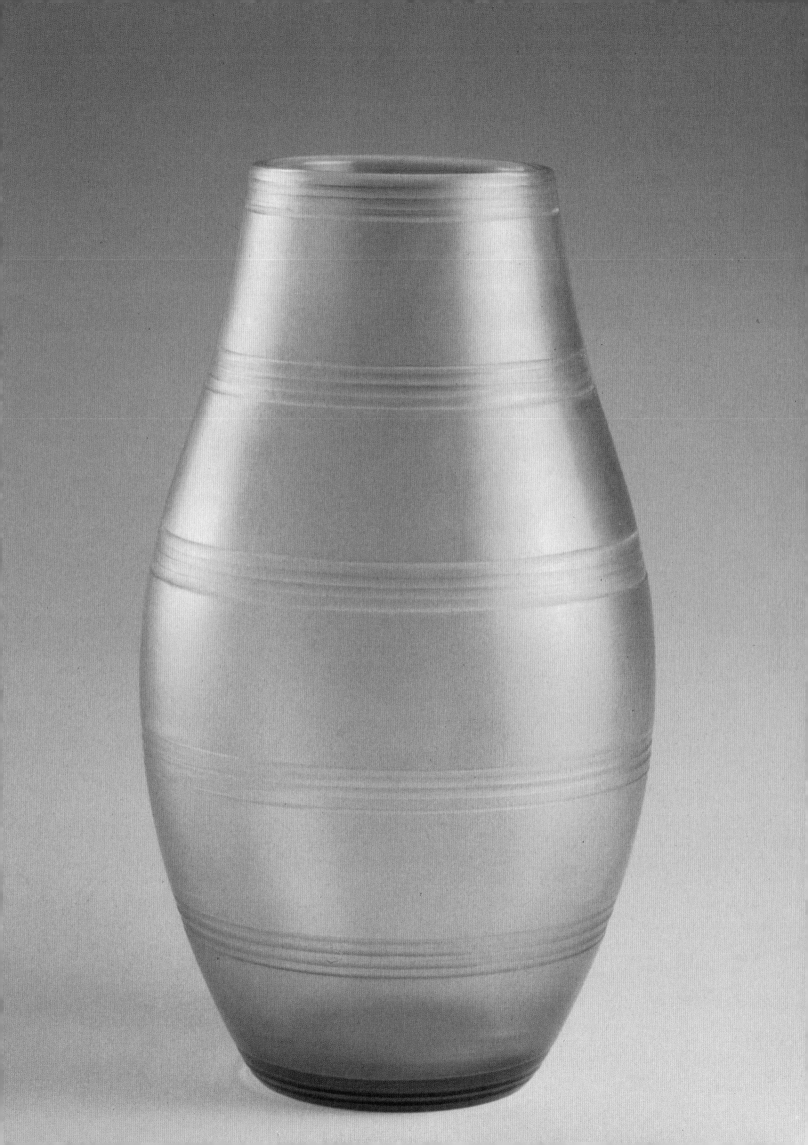

251. Carlo Scarpa
Plate, Bicolori con macchie
(Two-Tone with Spots) *series, 1942.*
Blown and handcrafted glass, 5 x
27 x 24.5 cm. Venini S.p.A.,
Murano.

252. Carlo Scarpa
Vase, Fili (Thread) *series, 1942.*
Blown and handcrafted glass, 24
cm high, 16 cm diameter. Venini
S.p.A., Murano.

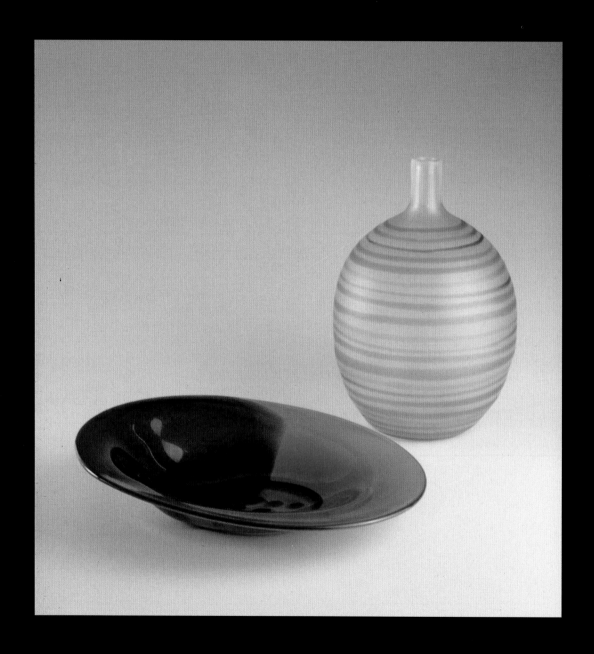

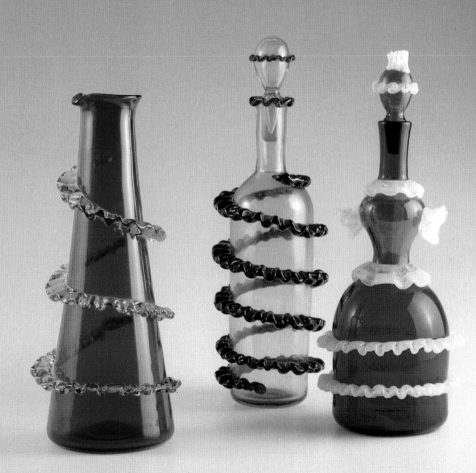

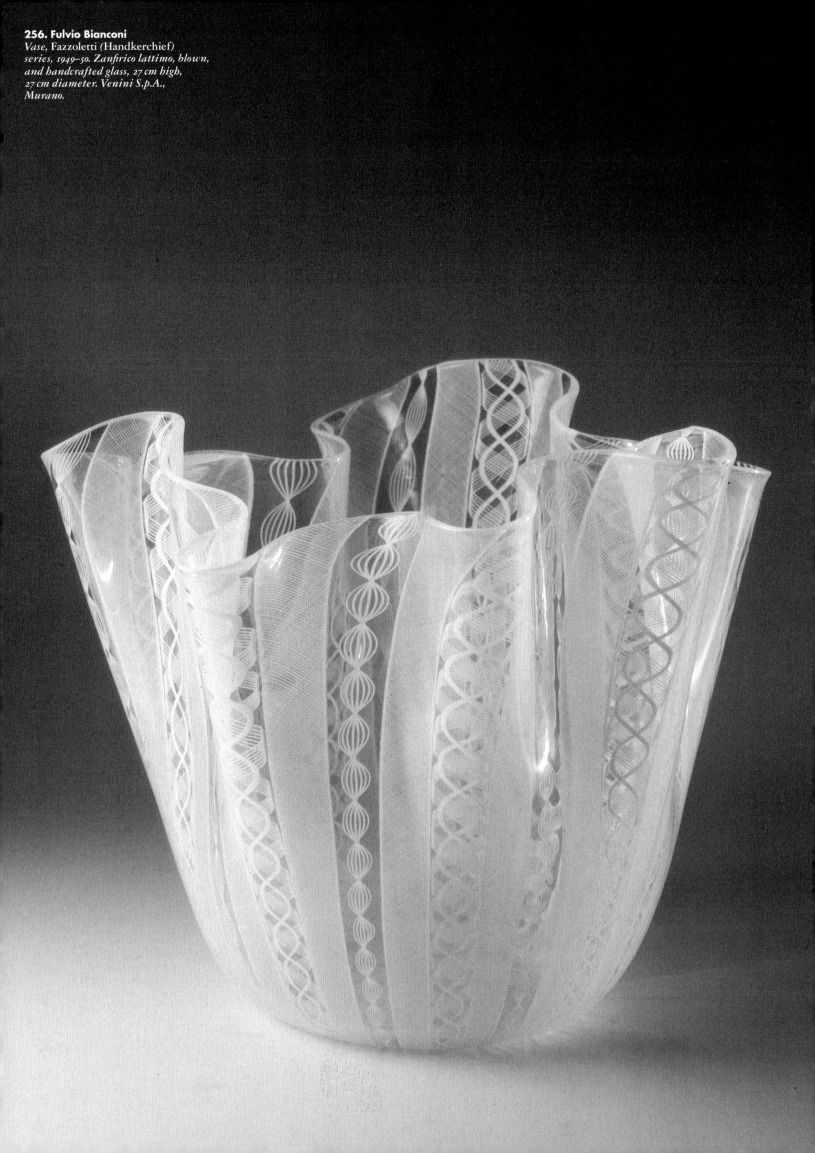

256. Fulvio Bianconi
Vase, Fazzoletti (Handkerchief)
series, 1949–50. Zanfirico lattimo, blown,
and handcrafted glass, 27 cm high,
27 cm diameter. Venini S.p.A.,
Murano.

257. Fulvio Bianconi
Vase, Multicolori (Multicolor) *series,*
1952. Blown and handcrafted glass,
20 cm high, 15 cm diameter. Venini
S.p.A., Murano.

258. Fulvio Bianconi
Vase, Multicolori (Multicolor) *series,*
1952. Blown and handcrafted glass,
27 cm high, 9 cm diameter.
Venini S.p.A., Murano.

259. Fulvio Bianconi
Vase, Multicolori (Multicolor) *series,*
1952. Blown and handcrafted glass,
22 cm high, 12 cm diameter.
Venini S.p.A., Murano.

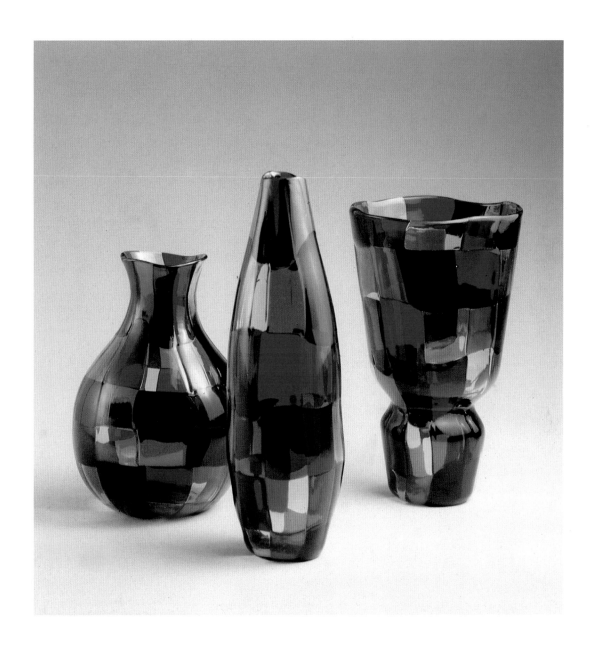

260. Paolo Venini
Vase, Incisi (Engraving) *series,*
1956. Blown and handcrafted glass,
38 cm high, 13 cm diameter.
Venini S.p.A., Murano.

261. Paolo Venini
Vase, Incisi (Engraving) *series,*
1956. Blown and handcrafted glass,
32.5 cm high, 11 cm diameter.
Venini S.p.A., Murano.

262. Paolo Venini
Vase, Incisi (Engraving) *series,*
1956. Blown and handcrafted glass,
32 cm high, 20 cm diameter.
Venini S.p.A., Murano.

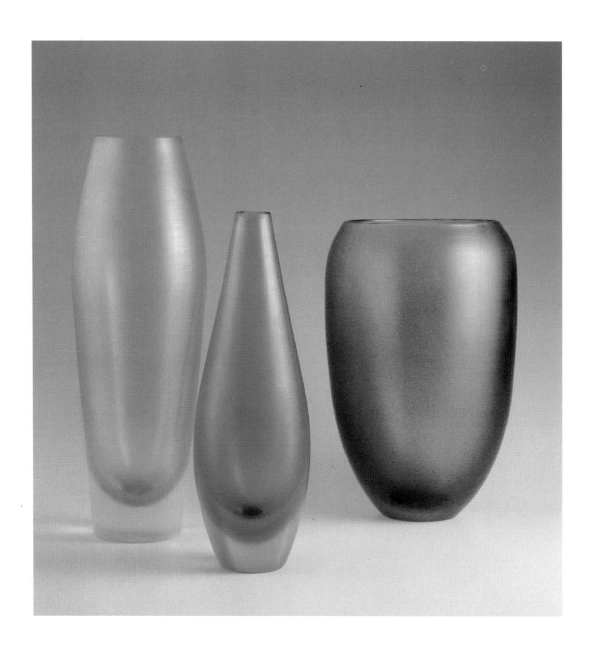

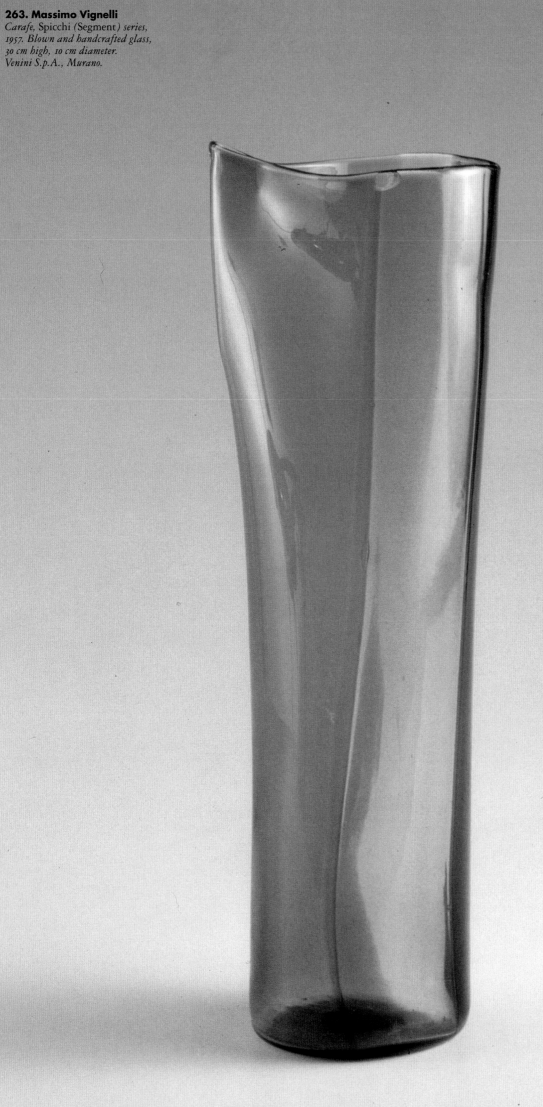

263. Massimo Vignelli
Carafe, Spicchi *(Segment) series,*
1957. Blown and handcrafted glass,
30 cm high, 10 cm diameter.
Venini S.p.A., Murano.

**264. Ludovico Diaz de Santillana
with Tobia Scarpa**
Vase, Battuti (Hammered) *series,*
1960. Blown and handcrafted glass,
45 cm high, 35 cm diameter.
Venini S.p.A., Murano.

**265. Ludovico Diaz de Santillana
with Tobia Scarpa**
Bowl, Battuti (Hammered) *series,*
1960. Blown and handcrafted glass,
6 x 60 x 12 cm. Venini S.p.A., Murano.

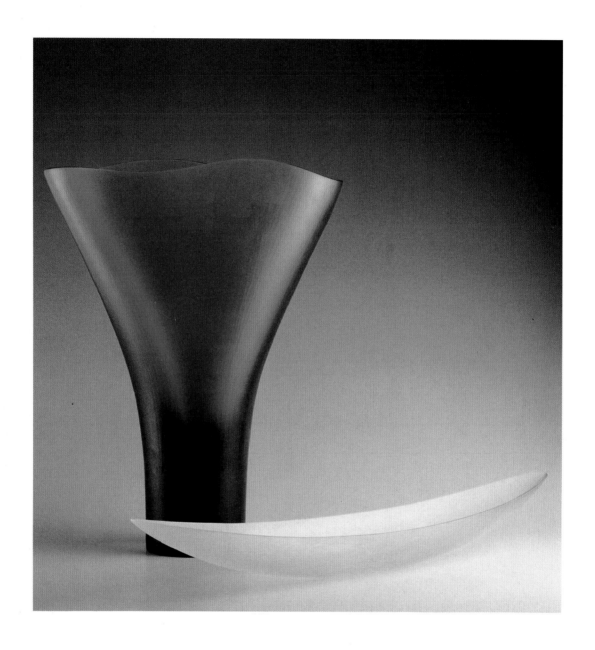

**264. Ludovico Diaz de Santillana
with Tobia Scarpa**
Vase, Battuti (Hammered) *series,*
1960. Blown and handcrafted glass,
45 cm high, 35 cm diameter.
Venini S.p.A., Murano.

**265. Ludovico Diaz de Santillana
with Tobia Scarpa**
Bowl, Battuti (Hammered) *series,*
1960. Blown and handcrafted glass,
6 x 60 x 12 cm. Venini S.p.A., Murano.

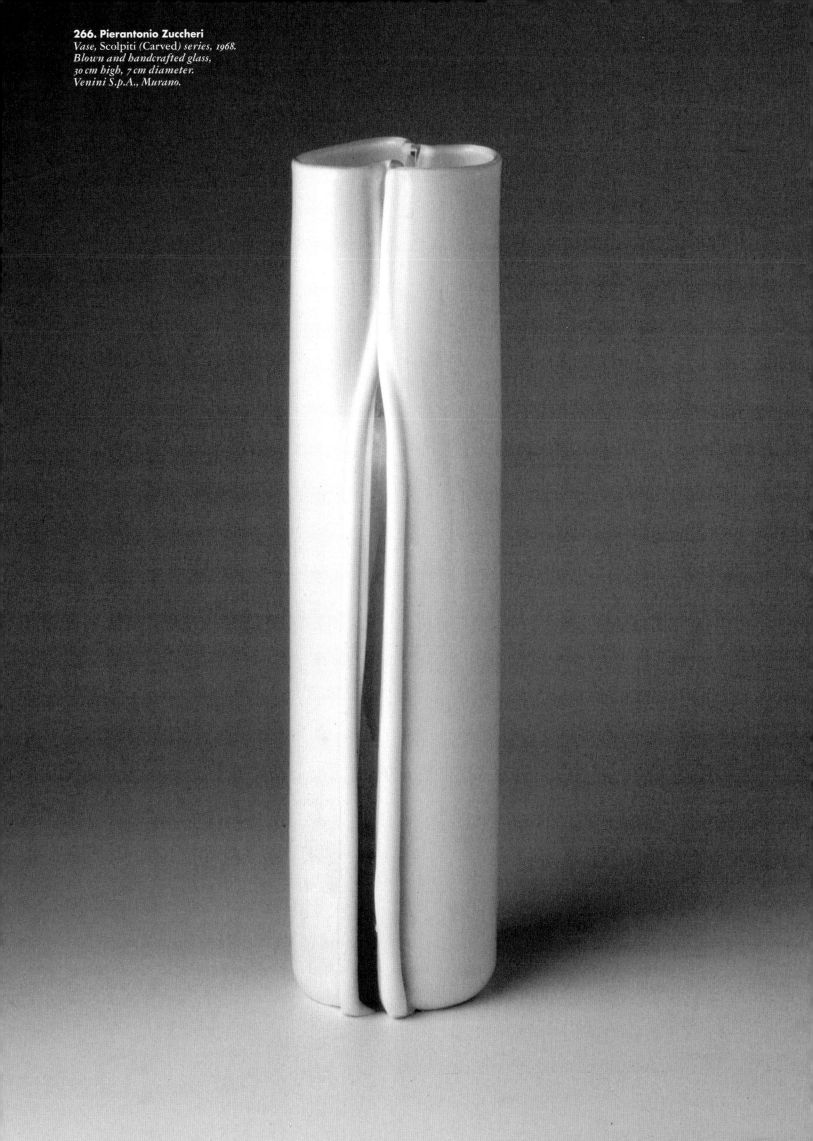

266. Pierantonio Zuccheri
Vase, Scolpiti *(Carved) series, 1968.*
Blown and handcrafted glass,
30 cm high, 7 cm diameter.
Venini S.p.A., Murano.

267. Carla Accardi
Brooch, 1949. Yellow gold, brilliants, pearls, and coral, 3 x 7 cm. Collection of the artist.

268. Afro [Afro Basaldella]
Brooch, produced by Masenza, ca. 1958. Yellow gold, rubies, and brilliant, 3.9 x 2.3 cm. Private collection, Rome.

269. Afro [Afro Basaldella]
Brooch, produced by Masenza, ca. 1956. Yellow gold, rubies, emeralds, and sapphire, 6.3 x 5 cm. Private collection, Rome.

270. Afro [Afro Basaldella]
Earrings, ca. 1949. Yellow gold, emeralds, and rubies, each 6.3 x 2.7 cm. Private collection, Rome.

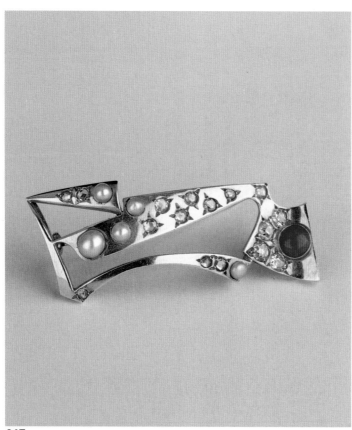

267

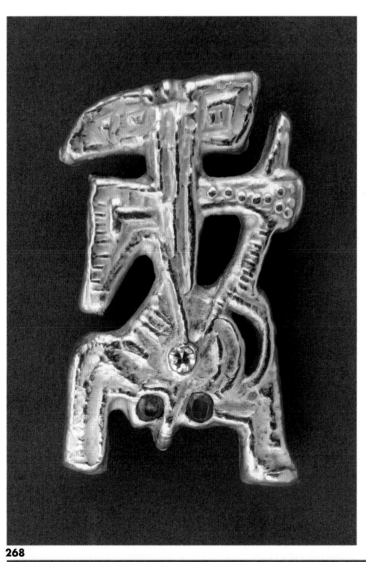

268

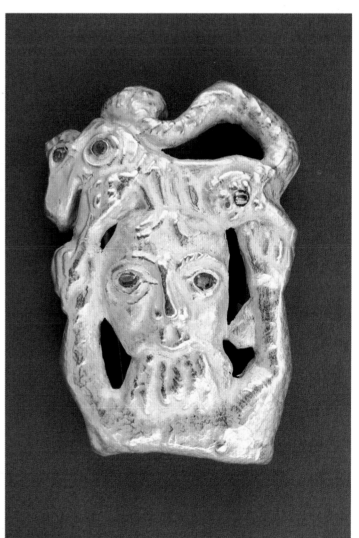

269

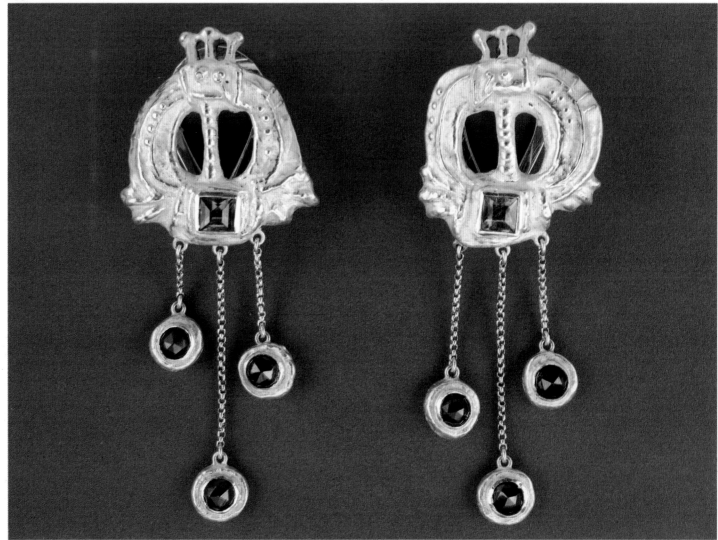

270

271. Afro [Afro Basaldella]
Necklace, ca. 1966. Yellow gold, emeralds, and brilliants, 13.5 cm diameter. Private collection, Rome.

272. Afro [Afro Basaldella]
Ring, ca. 1968. Yellow gold, emeralds, and brilliant, 2.5 cm diameter. Private collection, Rome.

273. Afro [Afro Basaldella]
Brooch, produced by Masenza, ca. 1960. Yellow gold, emeralds, and brilliants, 3.6 x 3.2 cm. Private collection, Rome.

274. Afro [Afro Basaldella]
Brooch, ca. 1965. Yellow gold, emeralds, and brilliants, 5.1 x 3.4 cm. Private collection, Rome.

275. Afro [Afro Basaldella]
Bracelet, ca. 1964. Yellow gold, 3 cm high, 6.3 cm diameter. Private collection, Rome.

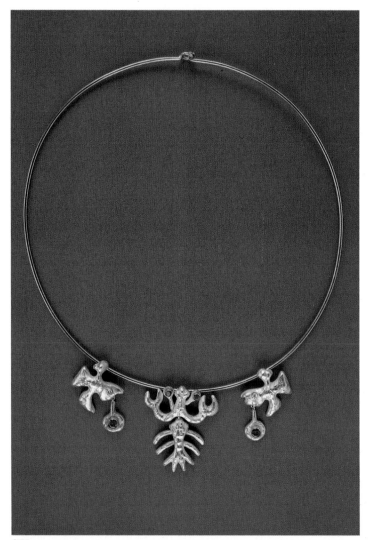

271

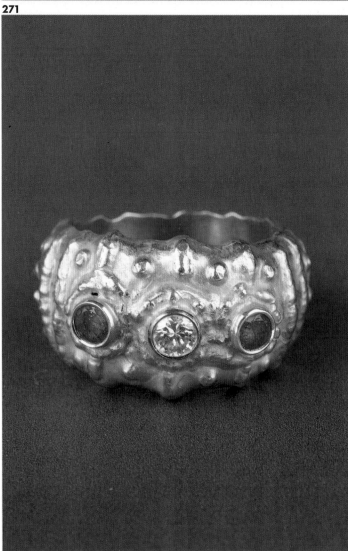

272

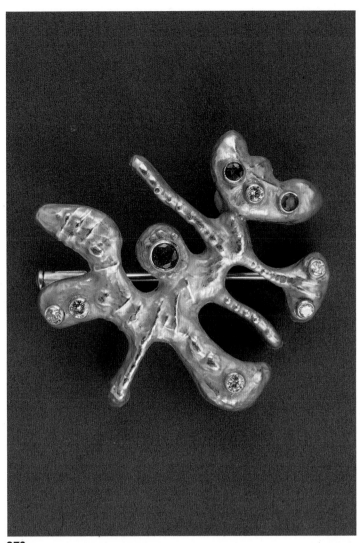

273

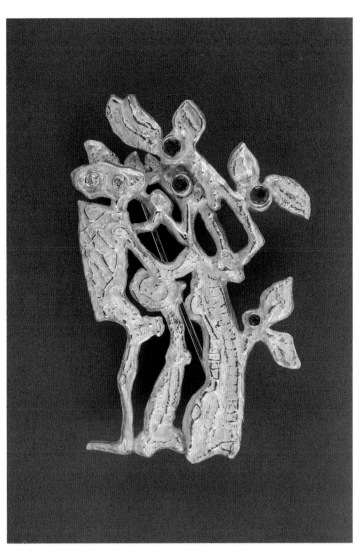

274

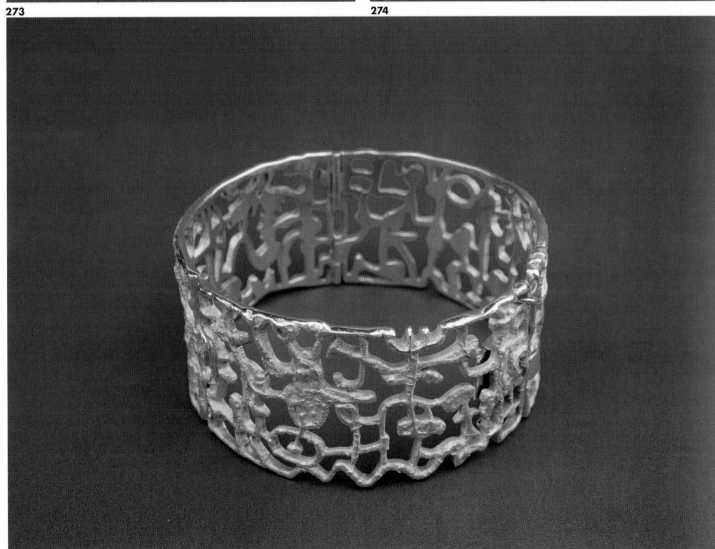

275

276. Alberto Burri
C.S.L. *brooch, 1965. Yellow gold,*
3 x 5 cm. Private collection, Italy.

277. Alberto Burri
V.V.P. *brooch, 1967. Yellow gold,*
5.6 x 5.9 cm. Private collection.

278. Alberto Burri
Gold Brooch No. 1 *brooch,*
1967. Yellow gold, 6.5 x 5 cm. Private
collection.

276

277

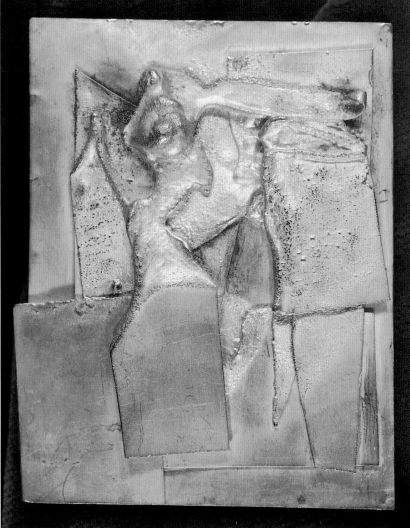

278

279. Giuseppe Capogrossi
Brooch, ca. 1950. Yellow gold, yellow diamonds, and white diamonds, 4.2 x 2.7 cm. Collection of Marta Nistri d'Amico, Rome.

280. Giuseppe Capogrossi
Brooch, produced by Fumanti, ca. 1950. Yellow gold, diamonds, coral, and onyx, 6.5 x 4.5 cm. Private collection, Rome.

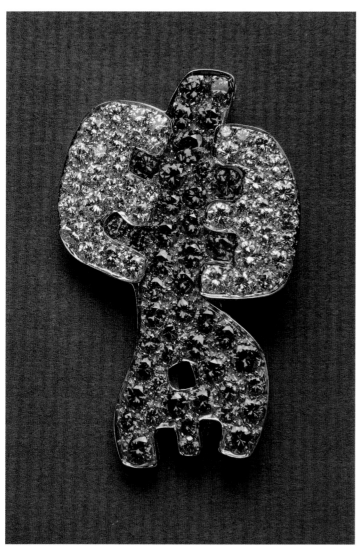

279

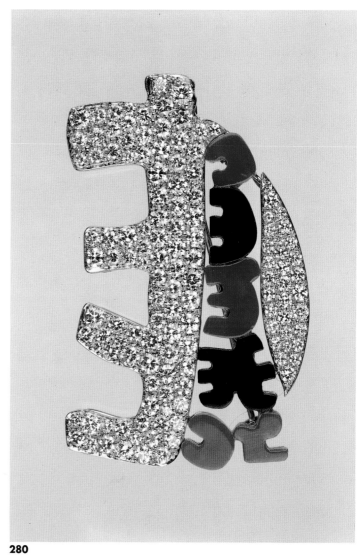

280

281. Ettore Colla
Brooch, 1964, based on a 1953 relief. Yellow gold, 7 x 5 cm. Collection of Carla Panicali.

282. Pietro Consagra
Brooch, ca. 1964–66. Platinum and diamonds, 5 x 4.8 cm. Private collection, Rome.

283. Pietro Consagra
Brooch, ca. 1959–60. Yellow gold and silver, 6 x 4.8 cm. Collection of Agnese De Donato, Rome.

284. Pietro Consagra
Brooch, ca. 1964. Yellow gold, 6 x 4.5 cm. Private collection.

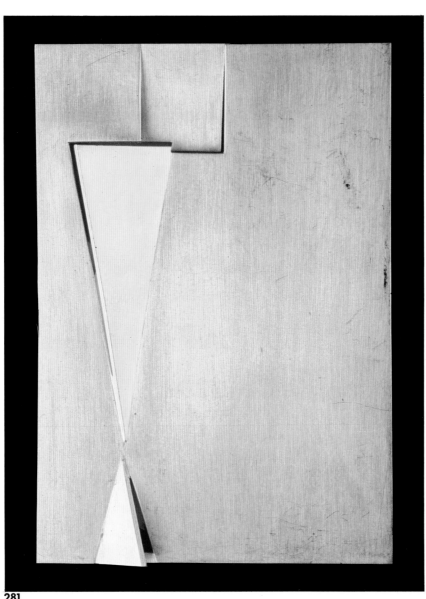

281

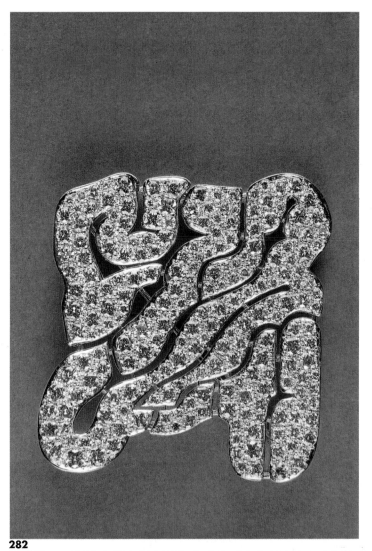

282

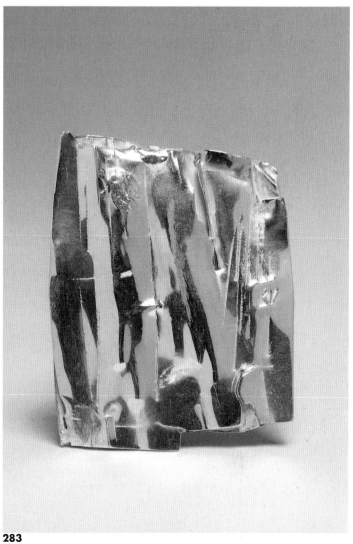

283

284

285. Piero Dorazio
Brooch, 1964. Yellow gold, 2.5 x 5.5 cm.
Private collection, New York.

286. Piero Dorazio
Brooch, 1964. Yellow gold, ruby,
brilliant, blue sapphire, and yellow
sapphire, 2.5 x 5.5 cm. Private
collection, New York.

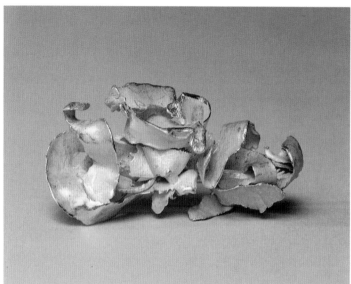

285

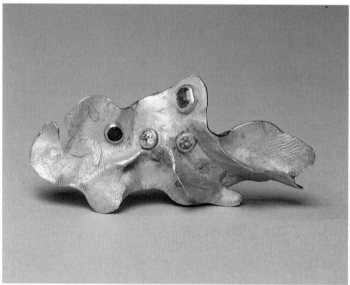

286

287. Lucio Fontana
Concetto spaziale (Spatial Concept)
*ring, ca. 1962. Yellow gold; band:
2.3 cm diameter; ornament: 3 x 2.1 cm.
Collection of Federico and Maria Luisa
Brook.*

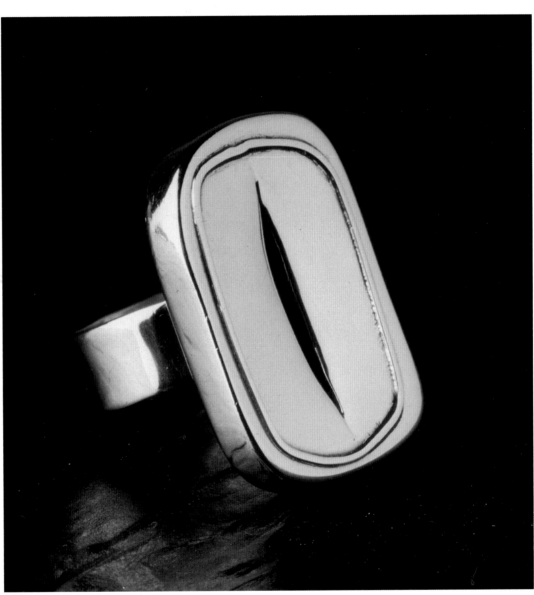

287

288. Lucio Fontana
Bracelet, 1962. Yellow gold; ornament: 4 x 6 cm. Private collection, Milan.

289. Lucio Fontana
Brooch, 1962. Yellow gold and tinted glass, 4.8 x 3.7 cm. Private collection, Milan.

290. Lucio Fontana
Brooch, 1964–65. Yellow gold, 4 x 3 cm. Collection of Carla Panicali.

291. Lucio Fontana
Ellisse (Ellipse) bracelet, edition 10/150, 1967. Silver and lacquer; ornament: 15 x 7 cm. Private collection, Milan.

292. Lucio Fontana
Ellisse (Ellipse) bracelet, produced by GEM-Montebello, edition 5/150, 1967. Silver and lacquer; ornament: 15.2 x 6.7 cm. Collection of Joan Sonnabend, Obelisk Gallery, Boston.

293. Lucio Fontana
Bracelet, 1967. Yellow gold; band: 4 cm high; ornament: 4.5 x 3.5 cm. Private collection.

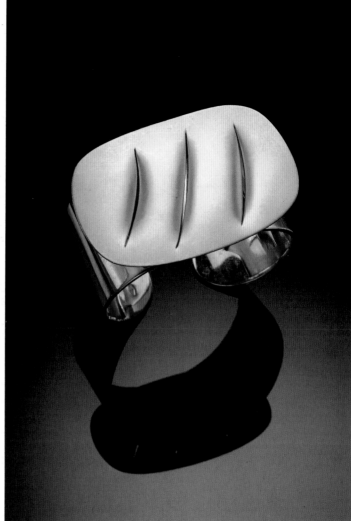

288

289

290

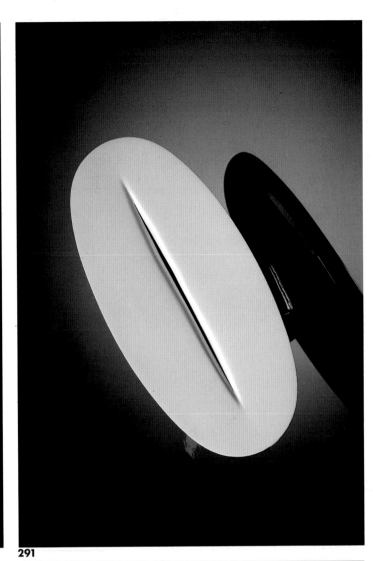

291

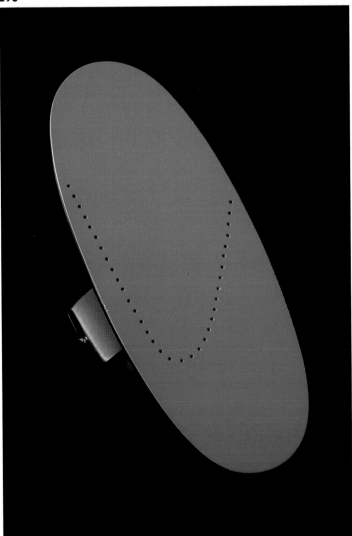

292

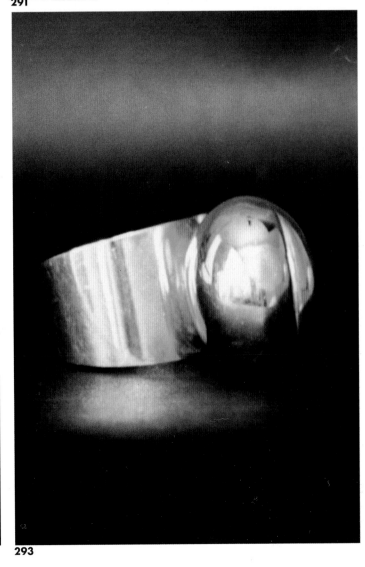

293

294. Fausto Melotti
Necklace, ca. 1947. Terra-cotta and brass, 75 cm long. Collection of Marta Melotti, Milan.

295. Fausto Melotti
Necklace, ca. 1950. Ceramic, 41 cm long. Collection of Marta Melotti, Milan.

296. Fausto Melotti
Necklace with ornament, prototype, ca. 1966. Brass; ornament: 9 x 14 cm. Collection of Marta Melotti, Milan.

297. Fausto Melotti
Necklace with ornament, prototype, ca. 1966. Brass; ornament: 25 x 7 cm. Collection of Marta Melotti, Milan.

298. Fausto Melotti
Brooch, prototype, 1959–60. Brass, 6.5 x 4.5 cm. Collection of Marta Melotti, Milan.

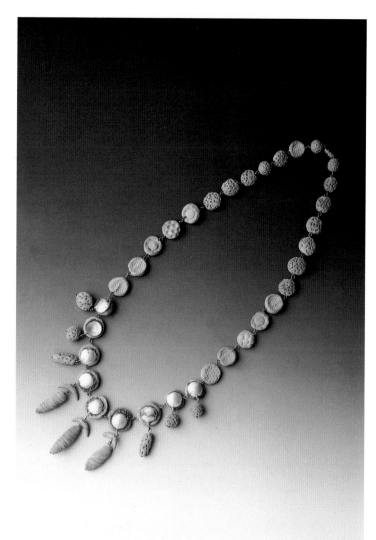

294

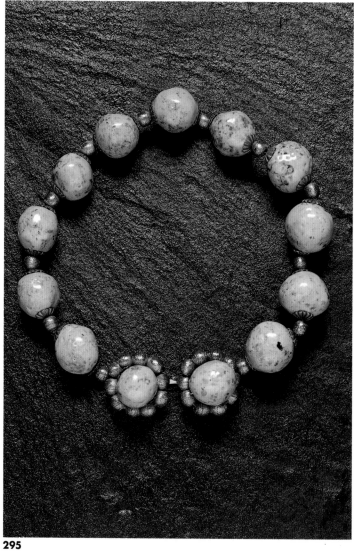

295

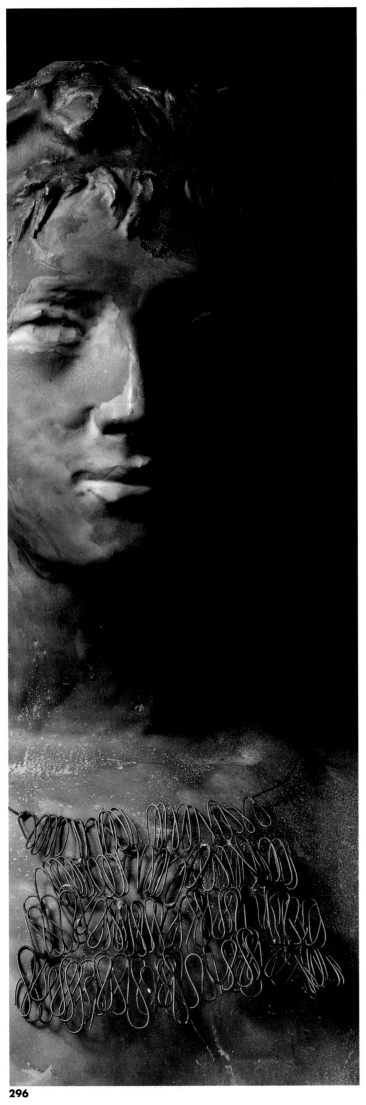

296

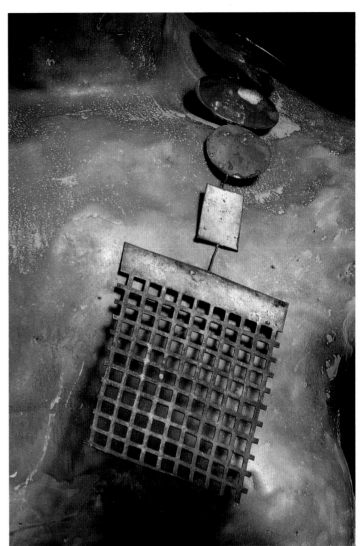

297

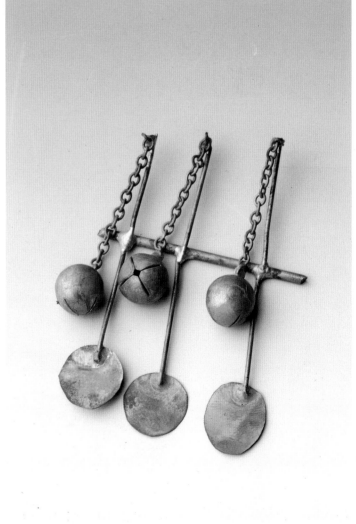

298

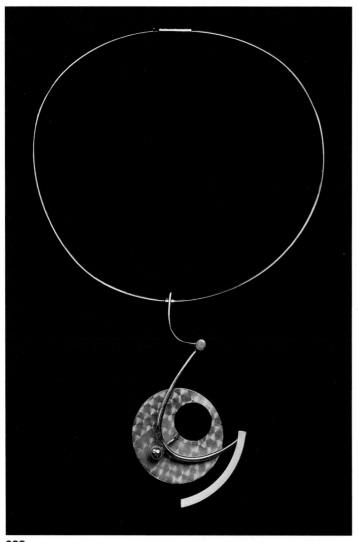

299

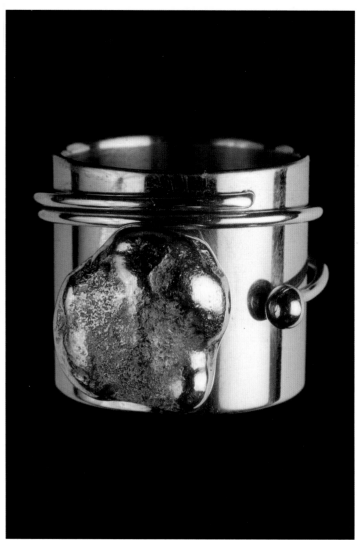

300

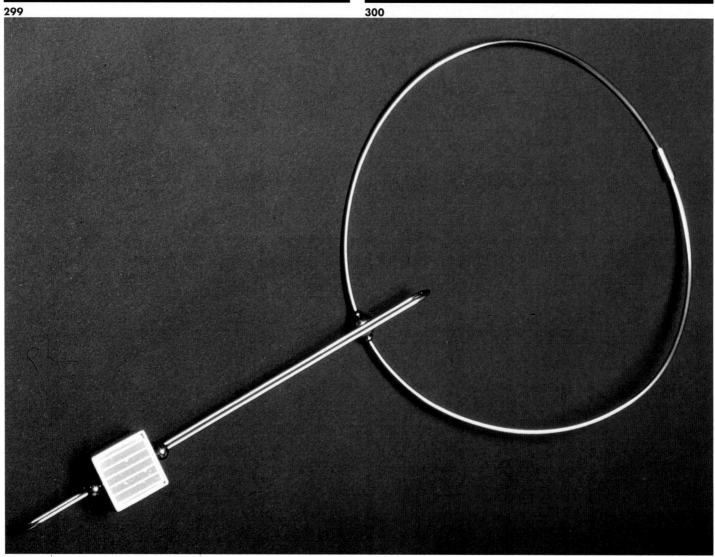

301

299. Maurizio Mochetti
Necklace with pendant, ca. 1964. Gold and metal; necklace: 14 cm diameter; pendant: 10 x 7 cm. Collection of Carla Panicali.

300. Maurizio Mochetti
Ring, ca. 1964. Gold and metal, 7 cm high. Collection of Carla Panicali.

301. Maurizio Mochetti
Elettra *necklace with pendant, 1967. Stainless steel, solar cells, and gold; necklace: 15 cm diameter; pendant: 2 x 2 cm. Collection of Bianca M. Casadei, Rome.*

302. Giulio Paolini
Bracelet, 1967. Yellow gold, 2 cm high, 6.5 cm diameter. Collection of Marcella Marchese, Genoa.

303. Giulio Paolini
Ring, 1967. Silver, 2 cm diameter. Collection of Marcella Marchese, Genoa.

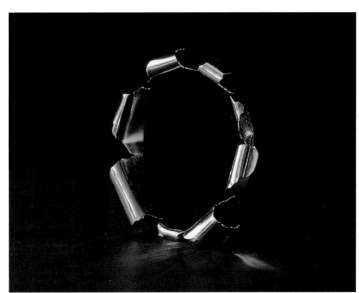

302

303

304. Arnaldo Pomodoro
Brooch, 1964–65. Yellow gold, white gold, brilliants, and rubies, 4 x 7 cm. Collection of Carla Panicali.

305. Arnaldo Pomodoro
Necklace with ornament, 1966. Hammered gold and mother-of-pearl; necklace: 46 cm long; ornament: 13.5 x 11 cm. Private collection, Milan.

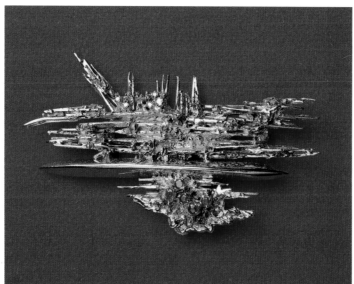

304

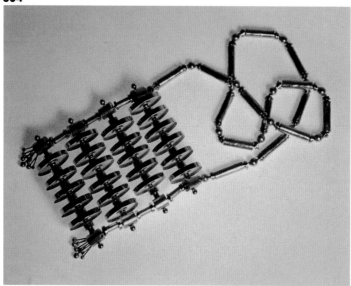

305

306. Arnaldo Pomodoro
Bracelet with pendant and two rings, 1967. Yellow gold, diamond, and brilliants, 16 cm long. Collection of Carla Panicali.

307. Arnaldo Pomodoro
Necklace with pendant, 1966. Yellow gold, white gold, and brilliants; necklace: 37 cm long; pendant: 7 x 6 cm. Private collection, Rome.

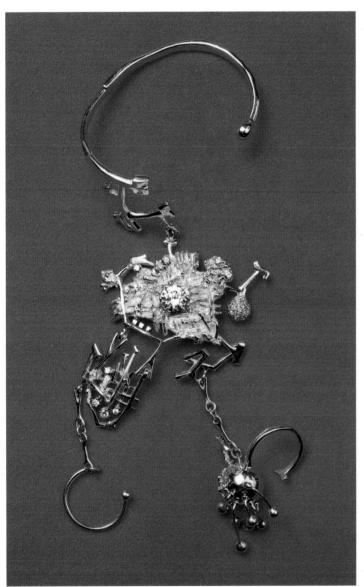

306

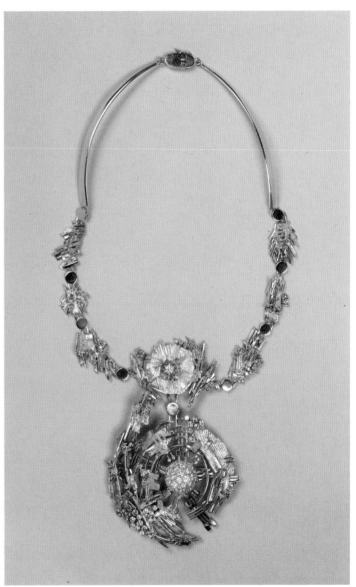

307

308. Arnaldo Pomodoro
Ornamente (Ornament) *necklace with*
pendant, 1968. White gold and red gold,
50 cm high overall.
Private collection, Milan.

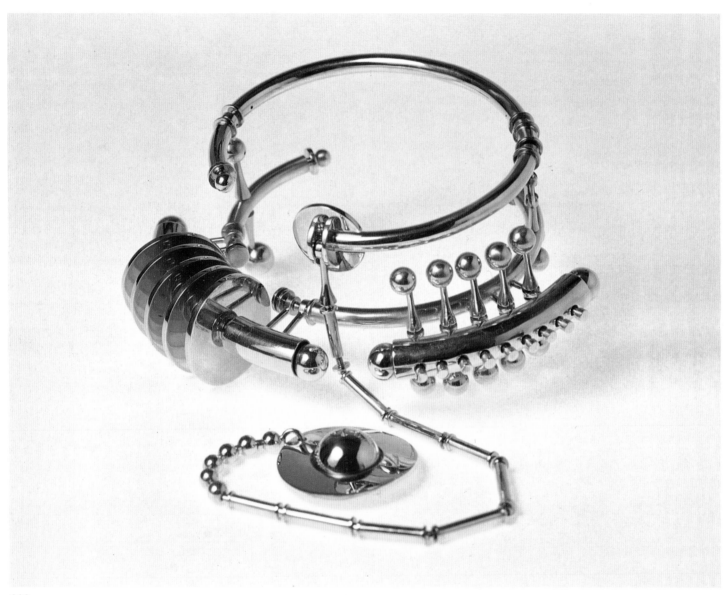

309a, b. Arnaldo Pomodoro
Ornamente (Ornament) *earrings,*
1968. White gold and red gold,
dimensions unknown. Private collection,
Milan.

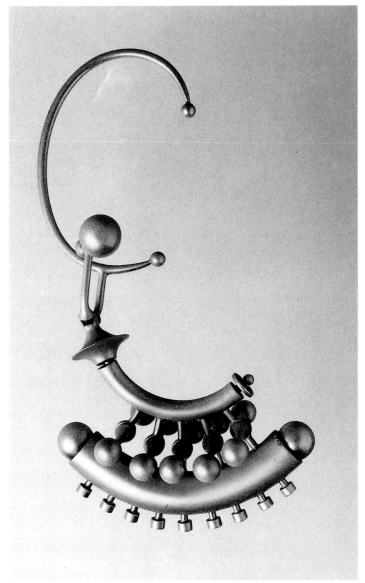

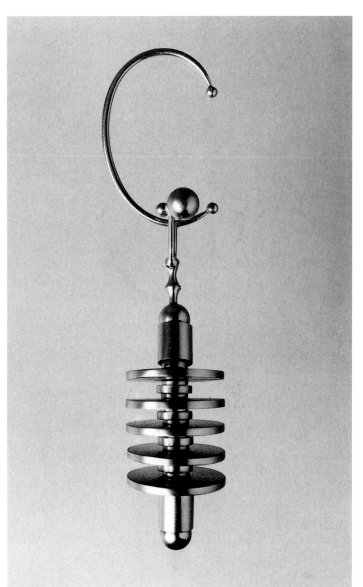

309a

309b

310. Giò Pomodoro
Ring, produced by Giuseppe Fusari, 1966. Yellow gold, white gold, enamel, and diamond; setting: 3.6 cm high. Collection of Angioletta Miroglio, Milan.

311. Giò Pomodoro
Bracelet, produced by Giuseppe Fusari, 1967. Yellow gold, white gold, enamel, and diamond; ornament: 7.5 x 5.5 cm. Collection of Giuseppe Fusari, Milan.

312. Giò Pomodoro
Brooch, 1966. White gold and enamel, 8.5 x 6.5 cm. Collection of Alba P. Lisca, Milan.

313. Giò Pomodoro
Necklace, 1966. Yellow gold, white gold, red gold, and enamel; ornament: 8.5 x 12.5 cm. Collection of Alba P. Lisca, Milan.

314. Giò Pomodoro
Bracelet, 1966. White gold and enamel; ornament: 8 x 6.5 cm. Collection of Alba P. Lisca, Milan.

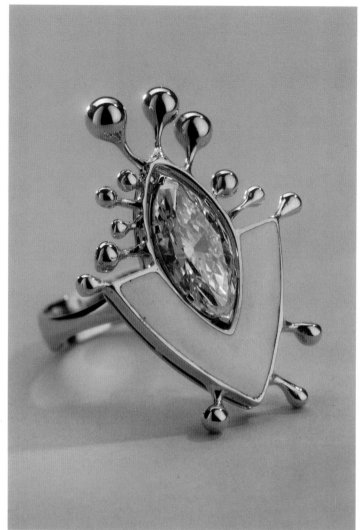

310

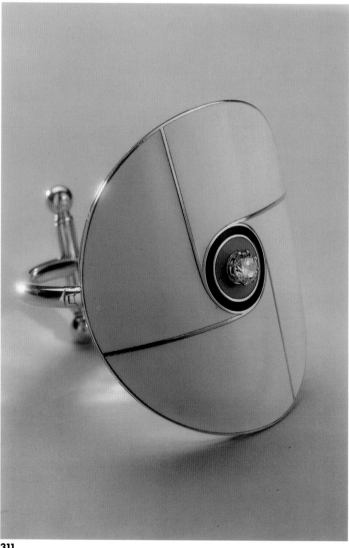

311

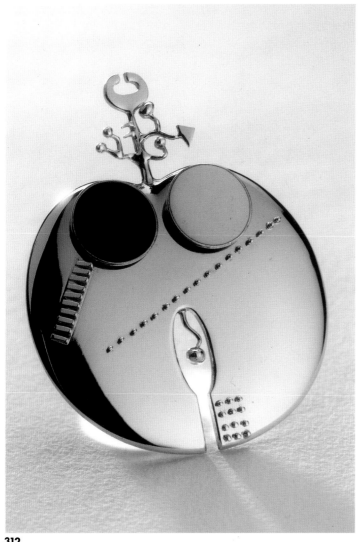

312

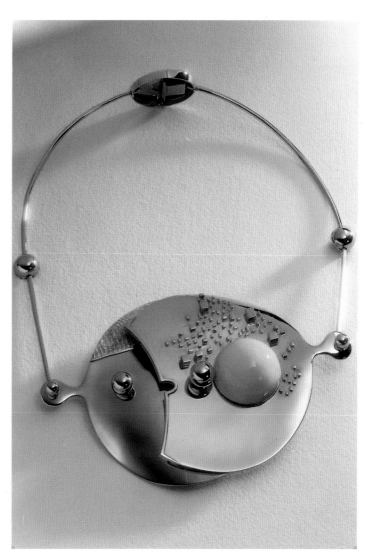

313

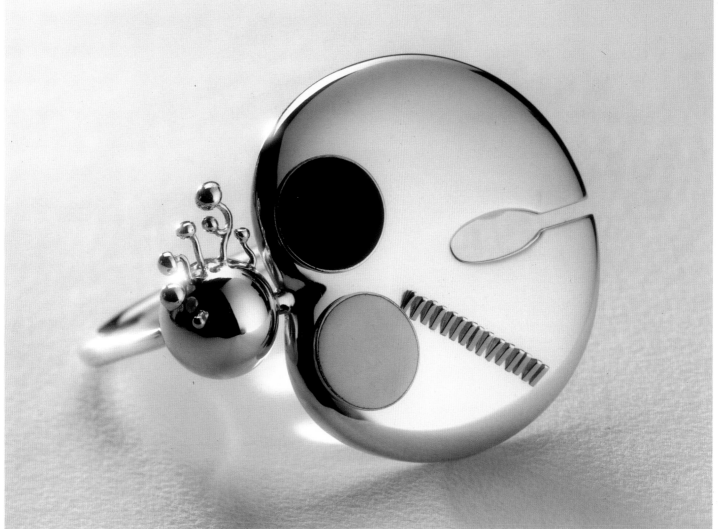

314

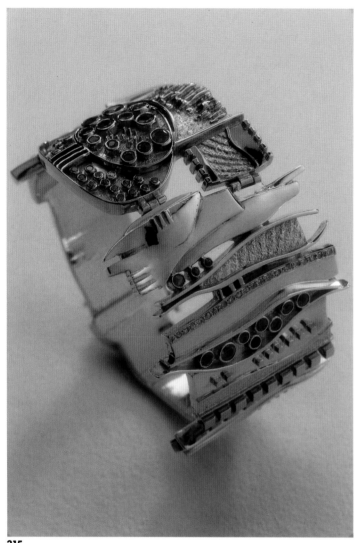

315

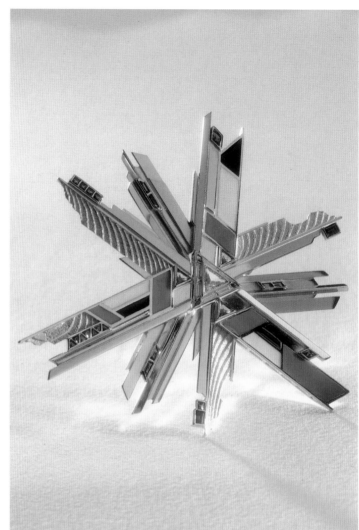

316

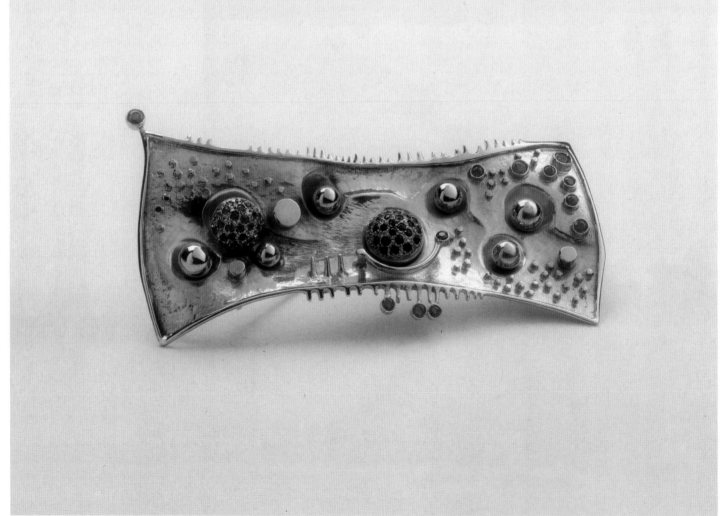

317

315. Giò Pomodoro
*Bracelet, 1967. Yellow gold, white gold,
rubies, and diamonds, 4.3 cm high,
6.4 cm diameter. Collection of Gigliola
Gagnoni Pomodoro.*

316. Giò Pomodoro
*Brooch, produced by Giuseppe Fusari,
1968. Yellow gold, enamel, and
diamonds, 8.5 x 10 cm. Collection of
Giuseppe Fusari, Milan.*

317. Giò Pomodoro
*Brooch, 1964. Yellow gold, white
gold, red gold, and rubies, 5.3 x 8.5 cm.
Collection of Gigliola Gagnoni
Pomodoro.*

318. Giulio Turcato
*Schiava (Slave) bracelet, 1967.
Hammered yellow gold, 14 cm high,
7 cm diameter. Private collection, Rome.*

319. Giulio Turcato
*Schiava (Slave) bracelet, 1965. Silver,
11 cm high. Private collection, Rome.*

Following two pages:
320. Giulio Turcato
*Scaramatica (Talismanic) brooch, 1965.
White gold, yellow gold, and emeralds,
7.5 x 4 cm. Private collection, Rome.*

321. Giulio Turcato
*Fantasioso (Fanciful) brooch, 1965.
White gold, yellow gold, brilliants, and
emeralds, 7.5 x 5.5 cm. Private
collection, Rome.*

322. Giulio Turcato
*Diadem, 1965. Silver and yellow gold,
7.5 x 20 cm. Private collection, Rome.*

323. Giulio Turcato
*Segnico (Sign) brooch, 1966.
Yellow gold and coral, 9.5 x 6 cm.
Private collection, Rome.*

324. Giulio Turcato
*Trio brooch, 1967. White gold, yellow
gold, and brilliants, 6 x 8 cm. Private
collection, Rome.*

325. Giulio Turcato
*Metamorfosi (Metamorphosis) brooch,
1968. White gold, yellow gold,
brilliants, and emerald, 5.5 x 7.5 cm.
Private collection, Rome.*

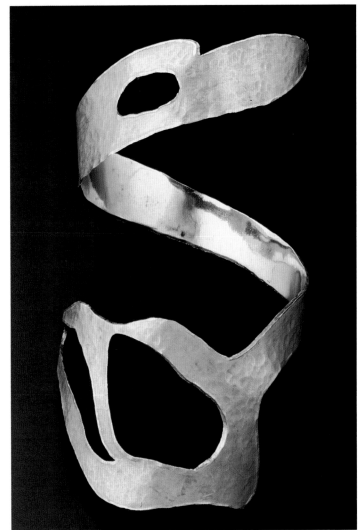

318

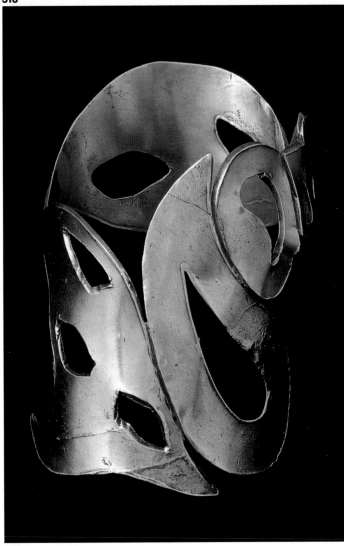

319

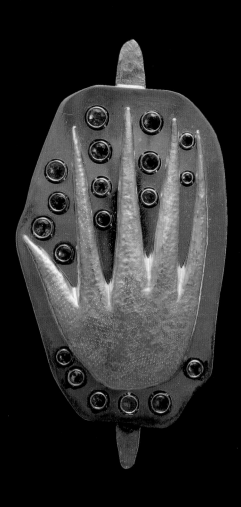

320

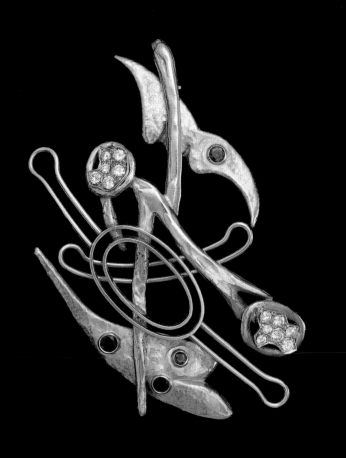

321

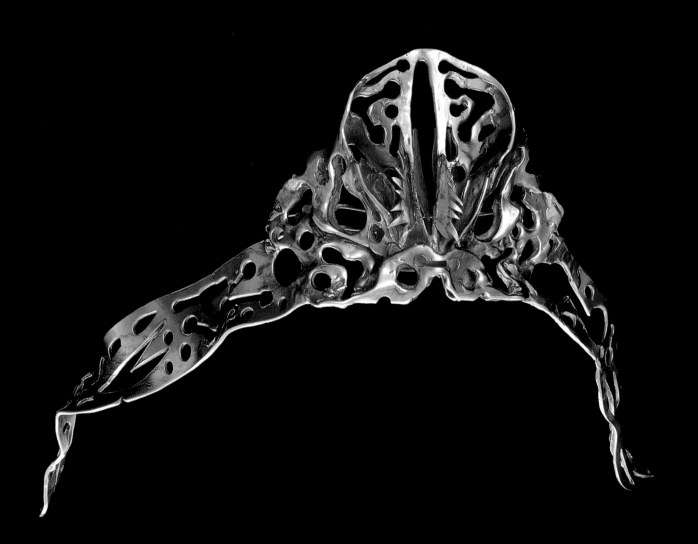

322

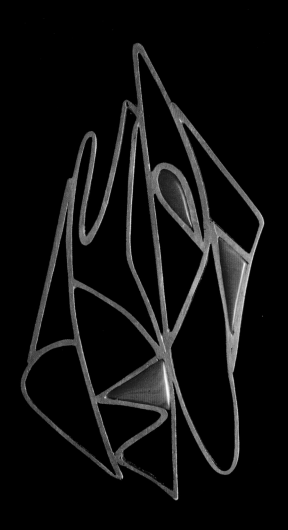

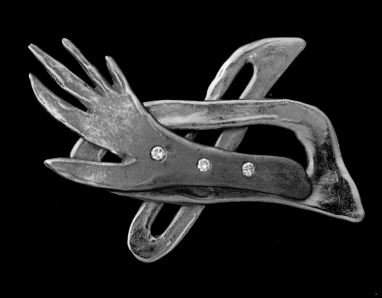

323

324

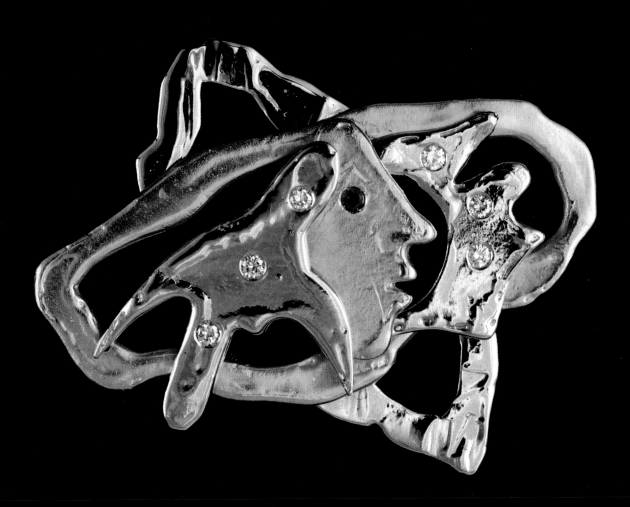

325

326. Giuseppe Uncini
Brooch, ca. 1950–60. Yellow gold and sapphires, 8 x 4.5 cm. Private collection, Padua.

327. Giuseppe Uncini
Earrings, produced by Masenza, ca. 1965. Yellow gold and diamonds, each 4 x 1.5 cm. Private collection, Padua.

328. Gabriele De Vecchi
Necklace, 1966. Silver; necklace: 17 x 15 cm; pendant: 5 x 3.9 cm. Collection of Marcella Marchese, Genoa.

329. Gabriele De Vecchi
Ring, 1966. Silver, 2 cm high; 1.5 cm diameter. Collection of Marcella Marchese, Genoa.

326

327

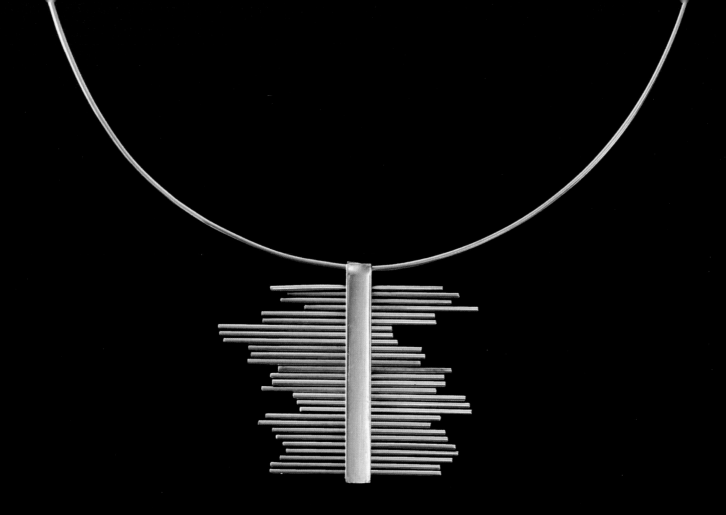

328

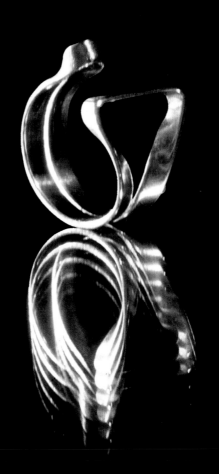

329

This collection of nearly 2,
under twelve themes, prop
but instructive manner, tu
developments in Italy. It i
manifestos, exhibition cata
illustrated books, playbill
works of theory. My inten
the panorama of the perio
the contrary, to evoke its u
problems, to register action
the entire debate, in short.

o documents, gathered
ses to review, in a subtle
enty-five years of artistic
volves a selection of
logues, periodicals,
 autobiographies, and
ion here is to reconstruct
 without flattening it; on
 wvelike succession of
 and reactions — to recall
And because the discussion

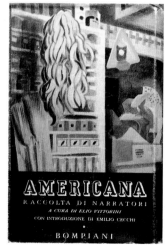

The Literature of Art

Maurizio Fagiolo dell'Arco

of fine art assumes more precise form when seen in relation to neighboring arts—literature, cinema, polemics, and poetry—these disciplines are all explored in considerable detail.

Through these documents, one passes from the climate of war to the republican postwar period; from the various modes of abstraction to realism (a fierce polemic); from Art Autre (which in Italy took the form of the Spazialismo and Informale movements) to the different trends of the 1950s and from there to the emergence of some independent figures—the so-called "disturbers"; from the climate of nothingness—the "zero" of art theory—to the new space of the image in the 1960s and, at the end of that decade, to Arte Povera. One section is devoted entirely to the relationship between Italy and the United States.

Virtually all of the material included in this exhibition comes from my own collection. For the dozen or so supplements needed to round off the selection, I am indebted to the kind assistance of my bookseller friends: Gildo Maresca Riccardi, Antonio Pettini, Bruno and Paolo Tonini, and Mario Lampariello. Elena Gigli helped me with this work.

The decline of Fascism; war; renewal

The fall of Benito Mussolini's Fascist regime in July 1943—its collapse hastened by the Allied invasion of Italy—was the outward sign of a total breakdown. Nazi reprisal, the release of Rome, the Allied advance, and liberation followed. The arts had registered tensions for some time. In 1939, a group of artists and intellectuals came together in Milan under the banner of Corrente—"A movement," wrote Renato Guttuso, "a place of encounters and clashes." Corrente held two exhibitions, which included work by Pericle Fazzini, Guttuso, Mario Mafai, Ennio Morlotti, and Emilio Vedova; both were promoted by Renato Birolli. The members of the group published a journal, a series of books (rather loose in theme, it included Salvatore Quasimodo's *Lirici greci* [Greek lyrics]; the poems of Scipione [Gino Bonichi], *Carte segrete* [Secret papers], 1942; and the photographs of Alberto Lattuada in *Occhio quadrato* [Square eye], 1941), and pamphlets featuring the emergent realism of the group's central figures.

The spirit of the age was reflected in exhibitions, as well as in the poetry of abstraction's central figure, Fausto Melotti (in *Il triste minotauro* [The sad minotaur]); the prose of Massimo Bontempelli (*Introduzione all'apocalisse* [Introduction to the apocalypse]); and the emblematic poetry collections of Eugenio Montale, Quasimodo, Umberto Saba, Leonardo Sinisgalli, and Giuseppe Ungaretti.

These were years of struggle, but also years of reflection. The Bergamo prize went to the grim paintings of Guttuso and Mafai. Italian painters such as Carlo Carrà, Enrico Prampolini, Alberto Savinio, Gino Severini, and Ardengo Soffici reconsidered the lessons of Pablo Picasso (who utilized the recent European past as a guide to an uncertain present).

The Galleria Nazionale d'Arte Moderna in Rome reopened, having been closed during the war. Literary figures explored the subjects of Christianity and Communism (Alberto Moravia) and the fate of Europe (Savinio). The United States and the Soviet Union, victorious in the recent conflict, began to clash on the Italian stage. The memorable *Americana*, an anthology edited by Elio Vittorini, with translations by Montale, Moravia, Cesare Pavese, and many others, came out while the Fascist regime was still in power, but it became the banner of a cultural renewal.

330.
Americana: raccolta di narratori
dalle origini ai nostri giorni
(*Americana: a collection of fiction from
the beginnings to the present day*).
Edited by Elio Vittorini. Milan:
Bompiani, 1942. Front and back covers.

331.
50 disegni di Pablo Picasso
(1905–1938) (*Fifty drawings by Pablo
Picasso 1905–1938*). Novara: Edizioni
di Posizione, 1943.

332.
Renato Guttuso, Gott mit Uns
(*God is with us*). Rome: Galleria la
Margherita, 1945.

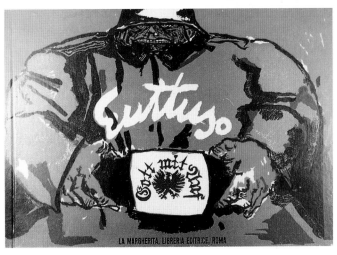

Publications in this section

Italia 1943 (Italy 1943). Florence: Marzocco, 1943. A small popular encyclopedia.

Massimo Bontempelli, *Introduzione all'apocalisse* (Introduction to the apocalypse). Rome: Edizione della Cometa, 1942. A reprint of the introductory text to a volume of twenty lithographs by Giorgio de Chirico, entitled *L'apocalisse* (The apocalypse), published in 1941 by Edizioni della Chimera, Milan.

Fausto Melotti, *Il triste minotauro* (The sad minotaur). Milan: Edizioni Garotto, 1944. A slim volume of poems by the great abstract sculptor.

Americana: raccolta di narratori dalle origini ai nostri giorni (Americana: a collection of fiction from the beginnings to the present day). Edited by Elio Vittorini. Translated by Giansiro Ferrata, Carlo Linati, Eugenio Montale, Alberto Moravia, Cesare Pavese, et al. Milan: Bompiani, 1942.

Vladimir Mayakovsky, *Lenin, poema* (Lenin, a poem). Milan: Einaudi, 1946. Neo-Constructivist jacket designed by Albe Steiner.

Alberto Moravia, *La speranza, ossia cristianesimo e comunismo* (Hope, or Christianity and Communism). Rome: Documento, 1944.

Alberto Savinio, *Sorte dell'Europa* (The fate of Europe). Milan: Bompiani, 1945.

Le macchine di Munari (Munari's machines). Turin: Einaudi, 1942.

Egidio Bonfante and Juti Ravenna, *Arte cubista* (Cubist art). Venice: Edizioni Ateneo, 1945.

50 disegni di Pablo Picasso (1905–1938) (Fifty drawings by Pablo Picasso 1905–1938). Texts by Carlo Carrà, Enrico Prampolini, Alberto Savinio, Gino Severini, and Ardengo Soffici. Novara: Edizioni di Posizione, 1943.

IV Premio Bergamo (Fourth Bergamo prize). Exhibition catalogue. Bergamo: Istituto d'Arti Grafiche, 1942.

Renato Guttuso, *Gott mit Uns* (God is with us). Preface by Antonello Trombadori. Rome: Galleria la Margherita, 1945.

Mafai: 24 disegni e una tavola a colori (Mafai: twenty-four drawings and a panel painting). Preface by Antonino Santangelo. Milan: Edizioni Galleria della Spiga and Corrente, 1943.

Renato Birolli. Edited by Sandro Bini. Milan: Edizioni di Corrente, 1941.

Gino Severini, *Matisse*. Anticipazioni (Anticipations), edited by Enrico Prampolini. Rome: Bocca, 1944.

Giorgio de Chirico. Exhibition catalogue, with introduction by Isabella Far. Rome: Galleria del Secolo, 1945.

Mostra di artisti contemporanei alla Galleria del Secolo (Exhibition of contemporary artists at Galleria del Secolo). Exhibition catalogue. Rome: Galleria del Secolo, 1944. The exhibition included works by Giorgio Morandi.

National Gallery of Modern Art: Exhibition of Contemporary Italian Art. Exhibition catalogue, with introduction by Palma Bucarelli. Rome: Galleria Nazionale d'Arte Moderna, 1944–45. English edition of the catalogue for the reopening of the Galleria Nazionale d'Arte Moderna. Cover designed by Orfeo Tamburi.

Salvatore Quasimodo, *Ed è subito sera* (And suddenly it's night). Milan: Mondadori, 1944.

Giuseppe Ungaretti and Orfeo Tamburi, *Piccola Roma* (Little Rome). Rome: Urbinati, 1944. Includes a poem by Ungaretti.

Eugenio Montale, *Le occasioni* (The occasions). Fourth edition. Turin: Einaudi, 1939; 1943.

Umberto Saba, *Il canzoniere 1900–1945* (Collected poems 1900–1945). Rome: Einaudi, 1945.

Leonardo Sinisgalli, *Furor mathematicus*. Rome: Urbinati, 1944. Book and invitation to its presentation at the Studio di Villa Giulia, Rome 1946.

The reconstruction years; Fronte Nuovo delle Arti

Postwar events followed one another in rapid succession: a referendum determining the country's political structure was held, a constitution signed, and a moderate government formed. Among artists' groups, whose principal form of communication and theorizing was once again the manifesto, the changes were just as rapid. One of the groups found in Rome in 1947 was Forma, whose members, including painters Carla Accardi, Piero Dorazio, and Giulio Turcato, proclaimed themselves "formalists and Marxists."[1] The Fronte Nuovo delle Arti, a more ecumenical group with adherents in Rome, Milan, and Venice, counted Renato Birolli, Bruno Cassinari, Renato Guttuso, Ennio Morlotti, Armando Pizzinato, Giuseppe Santomaso, Turcato, and Emilio Vedova among its members. A neo-Cubist movement, in which Guttuso and Turcato were involved, was also born in Rome. For artists active in the prewar period, it was a time for reflection: immediately after the war, the memoirs of Carlo Carrà, Giorgio de Chirico, and Gino Severini appeared. Autobiography became a vehicle for theory and criticism, for unabated polemics, and for planning the new.

The problem appeared to be a clash between abstractionists and realists, but it was actually a question of political loyalties. In his journal *Il politecnico* (Polytechnic), Elio Vittorini proclaimed that the intellectual was free to embrace the grand illusion of being autonomous, and should not feel constrained to "play the fife of the Revolution."[2]

A masterpiece among postwar books was Luigi Bartolini's *Ladri di biciclette* (Bicycle thieves), a literary inspiration for neorealist films, such as Roberto Rossellini's *Roma città aperta* (Rome open city, 1945; released in English as *Open City*); and the collaborations of Vittorio de Sica and Cesare Zavattini, including their adaptation of Bartolini's novel in 1948. It was the same atmosphere one found in the books of Carlo Levi, Curzio Malaparte, and Vittorini as well as in the debate promoted by Pier Luigi Nervi, Gio Ponti, and Alberto Sartoris, architects who questioned whether architecture was an art or a science.

Italian artists were once again exhibiting in Europe and the United States. In New York in 1949, one found a near synthesis of history and current events in the memorable exhibition *Twentieth-Century Italian Art* at the Museum of Modern Art in New York.

1. Untitled manifesto, *Forma 1* (Form 1), Rome, no. 1 (April 1947), p. 1.
2. Elio Vittorini, "Suonare il piffero per la rivoluzione?," *Il politecnico* (Polytechnic), 2, no. 35 (January–March 1947), p. 1.

333.
Twentieth-Century Italian Art. *Exhibition catalogue. Edited by Alfred H. Barr, Jr. and James Thrall Soby. New York: The Museum of Modern Art, 1949.*

334.
Luigi Bartolini, La repubblica italiana: considerazioni e proposte *(The Italian republic: considerations and suggestions). Milan: Mondadori, 1946.*

335.
Pier Luigi Nervi, Scienza o arte del costruire? Caratteristiche e possibilità del cemento armato *(Science or art of building? Characteristics and possibilities of reinforced concrete). Rome: Edizioni della Bussola, 1945.*

Publications in this section

Costituzione della repubblica italiana (Constitution of the Italian Republic). Special edition of the *Gazzetta ufficiale* (Official gazette), Rome, Saturday, December 27, 1947.

Il '45: Italian Review of Art and Poetry, Milan, no. 1 (1946). The editorial staff included Bruno Cassinari, Raffaele de Grada, Mario de Micheli, Alfonso Gatto, Renato Guttuso, Ennio Morlotti, Ernesto Treccani, and Elio Vittorini. Cover designed by Cassinari.

Il politecnico (Polytechnic), Milan, no. 21 (February 16, 1946). A weekly magazine edited by Elio Vittorini.

Carlo Carrà, *La mia vita* (My life). Edited by Leo Longanesi. Milan: Rizzoli, 1945.

Gino Severini, *Tutta la vita di un pittore: Roma Parigi* (The whole life of a painter: Rome Paris). Milan: Garzanti, 1946.

Giorgio de Chirico, *Memorie della mia vita* (Memoirs of my life). Rome: Astrolabio, 1945.

Alberto Savinio. Exhibition catalogue, with introduction by Raffaele Carrieri. Milan: Galleria Borromini, 1947.

Art concret. Exhibition catalogue, with introduction by Jean Arp. Paris: Galerie René Drouin, 1945. Alberto Magnelli was among the artists exhibited.

Salon des réalités nouvelles — art abstrait, concret, constructiviste, non figuratif (Salon of the new realities: abstract, concrete, constructivist, nonfigurative art). Exhibition catalogue. Paris: Palais des Beaux-Arts de la Ville de Paris, 1946. Alberto Magnelli was among the historic abstractionists exhibited.

Gino Severini, *The Artist and Society*. London: The Harvill Press, 1946.

Prima mostra del Fronte Nuovo delle Arti (First exhibition of the Fronte Nuovo delle Arti). Exhibition catalogue, with introduction by Giuseppe Marchiori. Milan: Galleria della Spiga, 1947. Renato Birolli, Antonio Corpora, Pericle Fazzini, Nino Franchina, Renato Guttuso, Leoncillo [Leoncillo Leonardi], Ennio Morlotti, Armando Pizzinato, Giuseppe Santomaso, Giulio Turcato, Emilio Vedova, and Alberto Viani were exhibited.

Art Club, Libera Associazione Arti Figurative (Art Club, Free partnership for the figurative arts). Exhibition catalogue, with introduction by Gino Severini. Rome: Grafico Tiberino, 1945. Catalogue to the first exhibition of Art Club.

Vedova: Diario di Burano (Vedova: Burano diary). Exhibition catalogue, with introduction by Giuseppe Marchiori. Venice: Galleria Sandri, 1947.

Twentieth-Century Italian Art. Exhibition catalogue. Edited by Alfred H. Barr, Jr. and James Thrall Soby. New York: The Museum of Modern Art, 1949. A vast historical survey that ran from Futurism and Metaphysical painting, through the Fascist era, to the most recent trends.

Da Roma città aperta *alla* Ragazza di Bube: *il cinema italiano dal '45 a oggi* (From *Rome open city* to *The Girl from Bube*: Italian cinema from '45 to today). Edited by Adelio Ferrero, Guido Oldrini, et al. Milan: Edizioni Cinema Nuovo, 1965.

Luigi Bartolini, *La repubblica italiana: considerazioni e proposte* (The Italian republic: considerations and suggestions). Milan: Mondadori, 1946.

Curzio Malaparte, *Kaputt*. Second edition. Naples: Casella, 1944; Rome: Aria d'Italia, 1948.

Elio Vittorini, *Uomini e no* (Men and nonmen). Milan: Bompiani, 1945. Cover designed by Ennio Morlotti.

Carlo Levi, *Cristo si è fermato a Eboli* (Christ stopped at Eboli). Turin: Einaudi, 1945. Painting by the author on the cover.

Gio Ponti, *L'architettura è un cristallo* (Architecture is a crystal). Milan: Editrice Italiana, 1945.

Alberto Sartoris, *No: posizione dell'architettura e delle arti in Italia* (No: the position of architecture and the arts in Italy). Florence: Edizioni Il Libro, 1947.

Pier Luigi Nervi, *Scienza o arte del costruire? Caratteristiche e possibilità del cemento armato* (Science or art of building? Characteristics and possibilities of reinforced concrete). Rome: Edizioni della Bussola, 1945.

Forma in Rome; MAC in Milan; various forms of abstraction

Around 1950 the status of abstraction, which was in search of a history and an identity, was clarified and crystalized. In 1948 in Milan, MAC (Movimento Arte Concreta/Movement of Concrete Art), which was centered around Bruno Munari and Atanasio Soldati, began to gain strength. In 1949, also in Milan, Lucio Fontana created the first spatial environment. Meanwhile, Giuseppe Capogrossi came to maturity with his 1950 show in Rome; the catalogue to the exhibition included an introduction by Corrado Cagli. Elsewhere, other paths were being proposed for abstraction by Afro [Afro Basaldella] and Emilio Vedova.

One point of reference singled out at this time was the painting of Vasily Kandinsky, which was presented in Rome by Piero Dorazio. The artists named their precursors; among Italian ones, Osvaldo Licini and Soldati were still active. An international audience was found: in 1950, a large volume of Christian Zervos's *Cahiers d'art* was devoted entirely to Italy; in 1952, a special issue of *Art d'aujourd'hui* (Art of today) on the same subject appeared. Roman abstraction had its own magazine, *Arti visive* (Visual arts), edited by Ettore Colla and the poet Emilio Villa, and had at its disposal a high-profile gallery, the Fondazione Origine, which singled out Giacomo Balla (with a show of his work in 1952) as an important historical reference point. The exhibition *Arte astratta e concreta in Italia* (Abstract and concrete art in Italy), presented in 1951 at the Galleria Nazionale d'Arte Moderna, Rome, seemed a promising beginning, but proved almost to be the end of a period rich in ferment.

In Milan, Guido Le Noci, who would become the principal dealer of Spazialismo and later of Nouveau Réalisme, curated *Mostra storica dell'astrattismo italiano* (Historic exhibition of Italian abstractionism), while MAC gathered its most vital forces around the publication of a bulletin and the mounting of group shows. In these years, the word "abstract" equaled "modern," just as, in other connections, the words "Cubist" or "realist" became adjectives for modernity with the addition of the prefix neo (neo-Cubism, neorealism).

Today it is easy to see that this vast array contained a greatly varied assortment of positions, choices, and theories. There were many abstractions, not just one.

336.
Forma 1 *(Form 1), Rome, no. 1 (April 1947).*

337.
Arte astratta e concreta in Italia *(Abstract and concrete art in Italy). Exhibition catalogue. Rome: Galleria Nazionale d'Arte Moderna, 1951.*

338.
Arte concreta *(Concrete art), Milan, no. 1 (November 1951).*

 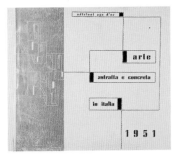 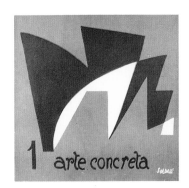

Publications in this section

Forma 1 (Form 1), Rome, no. 1 (April 1947). A monthly journal of the figurative arts. The first issue opens with a manifesto signed by Carla Accardi, Ugo Attardi, Pietro Consagra, Piero Dorazio, Mino Guerrini, Achille Perilli, Antonio Sanfilippo, and Giulio Turcato.

Arte astratta e concreta in Italia (Abstract and concrete art in Italy). Exhibition catalogue, with texts by Bruno Alfieri, Giulio Carlo Argan, Piero Dorazio, Gillo Dorfles, Giusta Nicco Fasola, Albino Galvano, Joseph Jarema, Bruno Munari, Achille Perilli, Enrico Prampolini, and Ernesto Nathan Rogers. Rome: Galleria Nazionale d'Arte Moderna, 1951.

Wassily Kandinsky. Exhibition catalogue, with text by Piero Dorazio. Rome: Galleria dell'Obelisco, 1951.

Mostra storica dell'astrattismo italiano (Historic exhibition of Italian abstractionism). Invitation and bulletin. Milan: Galleria Bompiani, 1951. The show was curated by Guido Le Noci, who would go on to become an advocate of Spazialismo.

Italie 1951, special issue of *Art d'aujourd'hui* (Art of today), Paris, no. 2 (1952). Cover designed by Bruno Munari.

Omaggio a G. Balla Futurista (Homage to G. Balla, Futurist). Exhibition catalogue. Rome: Galleria Origine, 1951.

Arte concreta (Concrete art), Milan, no. 1 (November 1951). Cover designed by Atanasio Soldati.

Arte concreta, no. 2 (December 1951). Cover designed by Giacomo Balla.

Arte concreta, no. 5 (March 1952). Cover designed by Bruno Munari.

Arte concreta, no. 6 (April 1952).

Arte concreta, no. 7 (September 1952).

Arte concreta, no. 8 (October 1952). Cover designed by Atanasio Soldati.

Arte concreta, no. 10 (December 1952). Cover designed by Bruno Munari.

Emilio Vedova. Exhibition catalogue, with introduction by Giuseppe Marchiori. Venice: Edizioni di Arti, 1951. The exhibition was held at the Catherine Viviano Gallery, New York.

Afro. Exhibition catalogue. Rome: Studio d'arte Palma, 1951.

Capogrossi. Exhibition catalogue, with introduction by Corrado Cagli. Rome: Galleria del Secolo, 1950.

Realism in painting, theater, film, and literature

Postwar Italian realism seemed to fall under the spell of Gustave Courbet's realism (Feltrinelli published a selection of Courbet's writings edited by Mario de Micheli and Ernesto Treccani, the principal figures of Corrente) or else was marked by a Goyaesque despair. This climate did not last long, however.

In cinema, "realism" became "neorealism" in the convergent paths of Cesare Zavattini and Vittorio De Sica (*Miracolo a Milano* [1950; released in English as *Miracle in Milan*]), Luchino Visconti (who was also a stage director), and Roberto Rossellini. In literature, the epic of the Resistance did not produce any texts worth reading, with the exception of Italo Calvino's *Il sentiero dei nidi di ragno* (The path of the spider's nests, 1947). The leading figure in literature was Alberto Moravia, author of the novel *Gli indifferenti* (The indifferent, 1929), who was destined to become a guiding light of the Left. (Renato Guttuso's artworks were held in the same regard). Meanwhile, new leaves began to sprout on the tree of realism: Pier Paolo Pasolini, for example, rediscovered reality in Friulian, the dialect of his origins.

The painters of the time were Guttuso, Fausto Pirandello, and Alberto Ziveri, exponents of the Roman school still active today. Roberto Longhi would later place Ziveri's work alongside that of Guttuso. Giulio Carlo Argan would present the work of Mario Mafai, who was destined to become an abstractionist. Mafai's realist mentality was ancient, that is, rooted in the past: "To discover reality, to accept reality, to undertake not to change reality, and to find yet within the confines of reality the stuff of illusion and dream."[1] The theoretical and painterly project of Guttuso was entirely bound to the present: "I should like to succeed in becoming a tragic painter-poet, worthy of this dramatic, heroic age."[2]

As in all such groupings, the supporting roles inevitably fade from memory. I note here only the presence of two younger figures, Bruno Caruso and Renzo Vespignani, who worked out a kind of new realism that was half "American scene" and half introspection.

1. Mario Mafai, *Diario, 1926–1965* (Diary, 1926–1965) (Rome: Edizioni della Cometa, 1984), entry for February 5, 1959.
2. Renato Guttuso, "Paura della pittura," *Prospettive* (Perspectives), January 1942, pp. 25–27.

339.
Luigi Bartolini, Ladri di biciclette *(Bicycle thieves). Milan: Longanesi, 1948.*

340.
Luchino Visconti presenta Zio Vania di Anton Pavlovic Cecov (*Luchino Visconti presents Anton Pavlovich Chekhov's Uncle Vanya). Playbill. Rome, Milan, 1955.*

341.
Renato Guttuso. *Exhibition catalogue. Rome: Studio d'Arte Palma, 1947.*

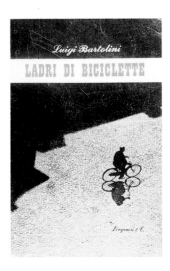 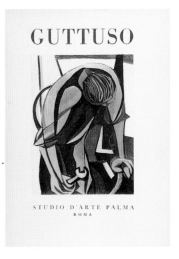

Publications in this section

Gustave Courbet, *Il realismo: lettere e scritti* (Realism: letters and writings). Edited by Mario de Micheli and Ernesto Treccani. Milan: Feltrinelli, 1954.

Luigi Bartolini, *Ladri di biciclette* (Bicycle thieves). Milan: Longanesi, 1948.

Cesare Zavattini, *Totò il buono* (Totò the good). Milan: Bompiani, 1943. Cover art by the author. Zavattini used this story as the basis of his screenplay for Vittorio de Sica's *Miracolo a Milano* (1950; released in English as *Miracle in Milan*).

Guida al cinema (Guide to the cinema). Edited by Vittorio Calvino. Preface by Vittorio De Sica. Milan: Accademia, 1939.

Luchino Visconti presenta Zio Vania di Anton Pavlovic Cecov (Luchino Visconti presents Anton Pavlovich Chekhov's *Uncle Vanya*). Playbill. Rome, Milan, 1955.

Renato Guttuso. Exhibition catalogue, with introduction by Corrado Alvaro. Rome: Studio d'Arte Palma, 1947.

Renato Guttuso. Edited by Giuseppe Marchiori. Milan: Edizione Moneta, 1952.

Alberto Ziveri. Introduction by Leonardo Sinisgalli. Rome: De Luca, 1952.

Fausto Pirandello. Exhibition catalogue. Rome: Galleria La Nuova Pesa, Rome, 1965.

Cesare Brandi, "La fine dell'avanguardia" (The end of the avant-garde). *L'immagine* (Image), Rome, nos. 14–15 (1950). Essay published in volume form by La Meridiana, Milan, 1952.

Ciarrocchi/Sadun/Scialoja/Stradone. Exhibition catalogue, with introduction by Cesare Brandi. Rome: Galleria del Secolo, 1947. Brandi defined Arnaldo Ciarrocchi, Piero Sadun, Toti Scialoja, and Giovanni Stradone as "four artists off the beaten track."

Mafai. Exhibition catalogue, with introduction by Giulio Carlo Argan. Studio d'Arte Palma, Rome, 1951.

Renzo Vespignani. Exhibition catalogue, with introduction by Pier Paolo Pasolini. Rome: Galleria dell'Obelisco, 1956.

Bruno Caruso. Exhibition catalogue, with introduction by Libero de Libero. Rome: Galleria dell'Obelisco, 1954.

Italo Calvino, *Il sentiero dei nidi di ragno* (The path of the spider's nests). Turin: Einaudi, 1947.

Alberto Moravia, *Il conformista* (The conformist). Milan: Bompiani, 1951.

Pier Paolo Pasolini, *Tal cour di un frut* (In a young lad's heart). Udine: Edizioni Friuli, 1953.

Polemics of the 1950s: reality and fantasy

The question gripping Italy during these years— "abstraction or figuration?"—would have yielded only a sterile kind of painting or sculpture of propaganda. The artists involved in the polemics almost always remained bound to ideas of progress and renewal; they were in most cases "of the Left," as was said in those days.

The polemicists operated by means of pamphlets, more or less forgotten now, like those of Giusta Nicco Fasola or Giorgio Kaisserlian. The artists presented a more international vision, and one can hardly forget Piero Dorazio's book *La fantasia dell'arte nella vita moderna* (The fantasy of art in modern life, 1955). The clash became increasingly harsh. Renato Guttuso, the fiercest polemicist of the period, faithfully fell in line with the ideology of the Italian Communist party. Others believed in the autonomy of the intellectual, while nevertheless declaring themselves Marxists.

Elio Vittorini wrote a monograph about Guttuso, who also enjoyed the support of Roberto Longhi. The abstractionists had the support of Lionello Venturi, and the intervention of this great art historian (who fled Italy during the years of Fascism) further complicated the situation of abstraction. Venturi's *Otto pittori italiani* (Eight Italian painters, 1952) and *Pittori italiani d'oggi* (Italian painters of today, 1958) presented an unstable balance between Renato Birolli and Giulio Turcato, Afro [Afro Basaldella] and Emilio Vedova, Ennio Morlotti and Giuseppe Santomaso, Bruno Cassinari and Mario Mafai, Fausto Pirandello and Toti Scialoja. The hybrid brand of painting known as the "abstract concrete" was thus born.

The opposing camps of abstraction and figuration fought over the right to claim the legacy of Picasso, who came to Italy in 1953 for a retrospective curated by Venturi in Rome. The debate continued in the reviews *Realismo* (Realism) and *La Biennale di Venezia* (The Venice Biennale), which devoted special issues to the Resistance and to realism, respectively, and *Arti visive* (Visual arts) in Rome and *I 4 Soli* (The four suns) in Turin, which debated, between the two cities, the function of abstraction and the new paths of the Informale, including American Action Painting.

342.
Galleria Nazionale d'Arte Moderna,
Pablo Picasso. *Exhibition catalogue.*
Rome: De Luca, 1953.

343.
Lionello Venturi, Italian Painters of
Today. *New York: Universe Books,*
1959.

344.
Piero Dorazio, La fantasia dell'arte
nella vita moderna *(The fantasy of art*
in modern life). Rome: Polveroni e
Quinti, 1955.

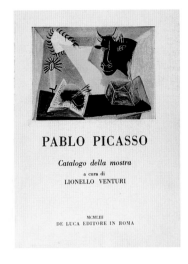

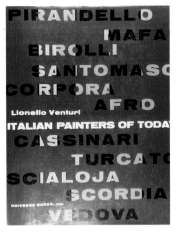

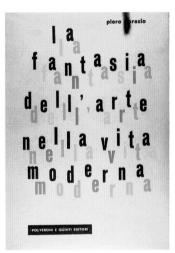

Publications in this section

Astratto o figurativo? (Abstract or figurative?), special issue
of *Ulisse* (Ulysses), Florence, 1959. *Ulisse* was edited by
Maria Luisa Astaldi.

Futurismo e pittura metafisica (Futurism and Metaphysical
painting). Exhibition catalogue. Zurich: Kunsthaus, 1950.

Giusto Nicco Fasola, *Ragioni dell'arte astratta* (The reasons
for abstract art). Milan: Istituto editoriale, 1951. Cover
designed by Max Bill.

Galleria Nazionale d'Arte Moderna, *Pablo Picasso.*
Exhibition catalogue, with introduction by Lionello
Venturi. Rome: De Luca, 1953.

Arti visive (Visual arts), Rome, nos. 6–7 (summer 1957).
Special issue, devoted to Arshile Gorky, of the review of the
Fondazione Origine, edited by Ettore Colla.

I 4 Soli (The four suns), Turin, 1, no. 1 (January 1954). A
review of contemporary art, edited by Adriano Parisot.

Lionello Venturi, *Italian Painters of Today.* New York:
Universe Books, 1959. The Italian edition was published by
De Luca, Rome, in 1958.

Otto pittori italiani (Eight Italian painters), edited by
Lionello Venturi. Rome: De Luca, 1952.

Piero Dorazio, *La fantasia dell'arte nella vita moderna*
(The fantasy of art in modern life). Rome: Polveroni e
Quinti, 1955.

Piet Mondrian. Exhibition catalogue, with introduction by
Palma Bucarelli. Rome: Galleria Nazionale d'Arte
Moderna, 1956.

Kandinskij. Exhibition catalogue, with introduction by
Palma Bucarelli. Rome: Galleria Nazionale d'Arte
Moderna, 1958.

Il pericolo incombe (Danger looms), a play by Alfredo
Zennaro. Illustrations by Renato Guttuso. Milan:
Palcoscenico Popolare, 1950.

Realismo (Realism), Milan, 3, no. 2 (1955). Special issue
devoted to the Resistance, including text by Mario de
Micheli, Renato Guttuso, Ennio Morlotti, Armando
Pizzinato, Giovanni Testori, and Giulio Turcato, and
illustrations by Renato Birolli, Guttuso, Mario Mafai,
Morlotti, Armando Pizzinato, Aligi Sassu, and Emilio

Vedova. *Realismo*, a review of the figurative arts, was
founded in 1953.

Elio Vittorini, *Storia di Renato Guttuso* (The story of Renato
Guttuso). Milan: Edizioni del Milione, 1960.

La Biennale di Venezia (The Venice Biennale), Venice, 12,
nos. 46–47 (December 1962). Special issue devoted to
realism, with writings by Guido Aristarco, Rosario
Assunto, Luigi Chiarini, Corrado Maltese, and Paolo
Portoghesi.

Alberto Ziveri. Exhibition catalogue, with introduction by
Roberto Longhi. Rome: Galleria La Nuova Pesa, 1964.

Origine; Spazialismo; Informale

From abstraction's rib were born the first manifestations of Art Informel in Italy—Informale—around 1949. Artists associated with this movement experimented with materials, signs, and the liberated gesture. In 1951, a small catalogue of the Origine group, which consisted of Mario Ballocco, Alberto Burri, Giuseppe Capogrossi, and Ettore Colla, was published in Rome. Having returned from Argentina, where he had launched the *Manifiesto blanco* (White manifesto) in 1946, Lucio Fontana had been active in Milan since 1947. His Spazialismo was a magnanimous attempt to revive connections with the universality of Futurism's ideas.

Michel Tapié was the real theorist of Art Informel in Europe from 1951. That year, he mounted the show *Véhémences confrontées* (Juxtaposed vehemences), in which he placed paintings of Capogrossi alongside those of Willem de Kooning, Georges Mathieu, Jackson Pollock, and Wols [Alfred Otto Wolfgang Schulze-Battmann]. He published *Un art autre* (Art Autre) in 1952, the same year that Harold Rosenberg coined the term "action painting."

American museums, galleries, and critics were immediately interested in the collage canvases of Burri, who would go from tar to sacks to wood to iron in his works; Capogrossi, who in his *Superfici* (Surfaces) series developed the theory of the rhythmic sign; and Colla, who came out with assemblages of scrap iron, classically arranged. Architect Luigi Moretti, in his review *Spazio* (Space) and elsewhere, rallied behind Tapié and became interested in the techniques of Informale. The poet Leonardo Sinisgalli, with the review *Civiltà delle macchine* (Culture of the machines), was the technological fellow-traveler of these artists, who seemed to reject mathematics and even composition.

As with abstraction, we can speak of several informalisms, because there were different variations of the problem. Isolated in Venice, Emilio Vedova arrived at a dramatic structure that could only recall the work of Pollock. Ennio Morlotti complicated Informale with the "ultimate naturalism" theorized by Francesco Arcangeli, Roberto Longhi's pupil. Surrounded by imitators, Fontana expanded the value of experiment beyond art itself by realizing Umberto Boccioni's prophecy: "the painting will no longer suffice."[1]

1. Umberto Boccioni, *La scultura futurista manifesto tecnico* (Futurist sculpture technical manifesto. Milan, 1913).

345.
Michel Tapié, Un art autre: où il s'agit de nouveaux dévidages du réel *(An other art: in which it is a question of new unwindings of the real). Paris: Gabriel Giraud, 1952.*

346.
Giampiero Giani, Spazialismo, origini e sviluppi di una tendenza artistica *(Spatialism: origins and growth of an art movement). Milan: Edizioni della Conchiglia, 1958.*

347.
The New Decade: Twenty-two European Painters and Sculptors. *Exhibition catalogue. New York: The Museum of Modern Art, 1955.*

Publications in this section

Michel Tapié, *Un art autre: où il s'agit de nouveaux dévidages du réel* (Art Autre: in which it is a question of new unwindings of the real). Paris: Gabriel Giraud, 1952. Among the Italians included in Tapié's discussion were Giuseppe Capogrossi and Gianni Dova.

Origine. Manifesto by Mario Ballocco, Alberto Burri, Giuseppe Capogrossi, and Ettore Colla. Rome, January 1951. The manifesto was issued simultaneously with an eponymous exhibition of Origine, the Informale group of Rome.

Burri. Exhibition catalogue. Rome: Galleria dell'Obelisco, 1954.

Paintings by Alberto Burri. Exhibition catalogue, with introduction by James Johnson Sweeney. Pittsburgh: Carnegie Institute, 1957. The exhibition traveled to Chicago, Buffalo, and San Francisco in 1958.

Michel Seuphor, *Capogrossi*. Venice: Edizioni del Cavallino, 1954.

Colla. Exhibition catalogue, with introduction by Lawrence Alloway. London: Institute of Contemporary Arts, 1959.

Accardi. Exhibition catalogue, with introduction by Hereward Lester Cooke. Rome: Galleria San Marco, 1955.

Spazio-caratteri della pittura d'oggi (Space-characteristics of today's painting). Exhibition catalogue, with introduction by Luigi Moretti and Michel Tapié. Rome: Galleria Spazio, 1954. The exhibition included works by Alberto Burri, Giuseppe Capogrossi, and Gianni Dova alongside those by Sam Francis, Georges Mathieu, Jackson Pollock, Mark Tobey, Wols, and the COBRA artists.

Giampiero Giani, *Spazialismo, origini e sviluppi di una tendenza artistica* (Spazialismo: origins and growth of an art movement). Milan: Edizioni della Conchiglia, 1958. Works by Giuseppe Capogrossi, Luigi Crippa, Mario De Luigi, Lucio Fontana, and others are considered.

Fontana. Exhibition catalogue, with introduction by Agnoldomenico Pica. Venice: Edizioni del Cavallino, 1955.

Fontana. Introduction by Giampiero Giani. Venice: Edizioni del Cavallino, 1958.

Arte nucleare (Nuclear art). Exhibition catalogue, with introduction by Beniamino del Fabbro. Venice: Ca' Giustinian, 1954.

Younger European Painters, with introduction by James Johnson Sweeney. New York: Solomon R. Guggenheim Museum, 1953. Alberto Burri and Giuseppe Capogrossi were exhibited together with some thirty Europeans and Americans.

The New Decade: Twenty-two European Painters and Sculptors. Exhibition catalogue, with introduction by Andrew C. Ritchie. New York: The Museum of Modern Art, 1955. Included in the exhibition were Afro [Afro Basaldella], Alberto Burri, Giuseppe Capogrossi, Luigi Minguzzi, and Mirko [Mirko Basaldella], alongside Francis Bacon, Jean Dubuffet, André Soulages, and others.

The Art of Assemblage. Exhibition catalogue. New York: The Museum of Modern Art, 1961. The exhibition, which was curated by William C. Seitz, included works by Enrico Baj, Alberto Burri, Ettore Colla, and Mimmo Rotella, alongside those by Jean Dubuffet, Louise Nevelson, Robert Rauschenberg, and others.

Francesco Arcangeli, "Una situazione non improbabile" (A not unlikely situation). *Paragone* (Comparison), Florence, no. 85 (1957). Arcangeli's theory of ultimate naturalism coincides with the theory of Informale.

Morlotti. Exhibition catalogue, with preface by Giovanni Testori. Ivrea: Olivetti, 1957.

Leoncillo Leonardi. Introduction by Roberto Longhi. Rome: De Luca, 1954.

Emilio Vedova, *Blätter aus dem Tagebuch* (Pages from the diary). Edited by Werner Haftmann. Munich: Prestel, 1960.

Spazio (Space), Rome, 1, no. 1 (July 1950). A review of art and architecture edited by Luigi Moretti.

Civiltà delle macchine (Culture of the machines), Rome, 1, no. 2 (March 1953). A review edited by Leonardo Sinisgalli.

The 1950s: cinema, literature, criticism, architecture, and magazines

Italian culture of the 1950s aroused the interest of the entire world. There was a whole range of new offerings in the fields of design, poetry, and cinema during the period of reconstruction that led to the boom of the "economic miracle."

Italian cinema conquered Europe and won Oscars in Hollywood. There were the poetic reportage of Federico Fellini (assisted by, among others, the writer Ennio Flaiano), the historical reconstructions of Visconti, the estrangement and alienation of Michelangelo Antonioni, and the first explosive images of Pasolini.

Literature was alive and well with posthumously published books by Cesare Pavese (who committed suicide in 1950), the early broadsides of Leonardo Sciascia, and the unprecedented success of *Il gattopardo* (The leopard) by Giuseppe Tomasi di Lampedusa, not to mention highly interesting books by Giorgio Bassani and Carlo Emilio Gadda.

Architecture witnessed the rise of Gio Ponti's new style, which was reminiscent of Art Deco but clearly of the 1950s. Franco Albini, Ignazio Gardella, and Luigi Moretti (with his great interest in art-world developments) were the examples to be followed.

The world of journals and reviews was rich and varied. In 1950, Roberto Longhi started the art review *Paragone* (Comparison), which also had a literary alter ego directed by his wife, Anna Banti. For poetry, there was the international *Botteghe oscure* (Dark shops), while for new fiction there was *Il menabò di letteratura* (The blueprint for literature), edited by Elio Vittorini and Italo Calvino. The leftist culture of the moment was represented by such reviews as *Il contemporaneo* (The contemporary), while *Officina* (Workshop) heralded the terms of the cultural debate of the 1960s.

In the area of art criticism, Giulio Carlo Argan succeeded Lionello Venturi, while Gillo Dorfles in Milan offered an international vision of current criticism. The review *Città aperta* (Open city), edited by Renzo Vespignani, had no certainties to offer, only doubts.

348.
Federico Fellini, La dolce vita *(The sweet life). Bologna: Cappelli, 1960.*

349.
Lionello Venturi, Arte moderna *(Modern art). Rome: Bocca, 1956.*

350.
Il Menabò di letteratura (The blueprint for literature), no. 1 (1959), Turin.

Publications in this section

Federico Fellini, *La dolce vita* (The sweet life). Edited by Tullio Kezich. Bologna: Cappelli, 1960. The film first appeared in movie theaters in 1960.

Ennio Flaiano, *Un marziano a Roma* (A martian in Rome). Turin: Einaudi, 1960. Notebooks of the Teatro Popolare Italiano.

Bertolt Brecht, *L'anima buona di Sezuan* (The good spirit of Szechwan). Playbill. Milan: Piccolo Teatro della città di Milano, 1957–58. Playbill for a performance directed by Giorgio Strehter.

Henry Miller, *Uno sguardo dal ponte* (A view from the bridge). Playbill. Rome: Teatro Eliseo, January 18, 1958. Playbill for a performance of Miller's play directed by Luchino Visconti.

Michelangelo Antonioni, *Il grido* (The outcry). Edited by Elio Bartolini. Bologna: Capelli, 1957.

Cesare Pavese, *La bella estate* (The beautiful summer). Turin: Einaudi, 1950.

Giuseppe Tomasi di Lampedusa, *Il gattopardo* (The leopard). Milan: Feltrinelli, 1958. Written in the last years of the author's life, its publication, overseen by Giorgio Bassani, was posthumous.

Giorgio Bassani, *Cinque storie ferraresi* (Five stories of Ferrara). Turin: Einaudi, 1956.

Pittori che scrivono (Painters who write). Edited by Leonardo Sinisgalli. Milan: Edizione della Meridiana, 1954. An anthology of writings and drawings including text by Giuseppe Capogrossi, Lucio Fontana, Renato Guttuso, Mario Mafai, Ennio Morlotti, Fausto Pirandello, Toti Scialoja, Giulio Turcato, and Alberto Ziveri.

Lionello Venturi, *Arte moderna* (Modern art). Rome: Bocca, 1956.

Giulio Carlo Argan, *Studi e note* (Studies and notes). Rome: Bocca, 1955.

Gillo Dorfles, *Ultime tendenze nell'arte di oggi* (The latest trends in contemporary art). Milan: Feltrinelli, 1961.

Gio Ponti, *Amate l'architettura —l'architettura è un cristallo* (Love architecture: architecture is a crystal). Genoa: Vitali e Ghiandi, 1957.

Botteghe oscure (Dark shops), Rome, no. 21 (1958). A review under the direction of Marguerite Caetani and edited by Giorgio Bassani. The review was founded in 1948. On the frontispiece, there is a table of contents in English.

Il menabò di letteratura (The blueprint for literature), Turin, 1, no. 1 (1959). Edited by Elio Vittorini and Italo Calvino, ten issues of the review were printed, up to 1960. This first issue includes Lucio Mastronardi's "Il calzolaio di Vigevano" (The shoemaker of Vigevano).

Officina (Workshop), Bologna, 3, nos. 9–10 (June 1957). A bimonthly poetry pamphlet edited by Francesco Leonetti, Pier Paolo Pasolini, and Roberto Roversi, twelve issues were published, from 1955–59. Nos. 9–10 contains "La libertà stilistica" (Freedom of style) by Pasolini and "Piccola antologia neo-sperimentale" (Small neo-experimental anthology).

Paragone (Comparison), art series, 1, no. 1 (January 1950).
Paragone, literature series, 1, no. 6 (June 1950).
A review edited by Roberto Longhi (art series) and Anna Banti (literature series).

Il contemporaneo (The contemporary), Novara, no. 9 (December 1958). A review edited by Antonello Trombadori, with an editorial committee consisting of Renato Guttuso, Carlo Melograni, Velso Mucci, Carlo Salinari, and Albe Steiner.

From the United States to Rome and vice versa

Even during the Fascist era, one of the horizons of freedom was the United States. In 1953, three years after his death in 1950, Cesare Pavese's anthology *La letteratura americana* (American literature) was published. Young and not so young Italian artists thought of the United States as the ultimate audience for their efforts.

A number of important exhibitions in the 1950s were curated by universities and museums, such as Columbia University in New York, the Institute of Contemporary Art in Boston, and the Wadsworth Atheneum in Hartford. Among the Italian artists exhibited in the United States were Afro [Afro Basaldella], Piero Dorazio (who moved to New York in 1954), Lucio Fontana, and Toti Scialoja. In Rome, the Rome–New York Art Foundation was instituted, on the Isola Tiberina.

The opposite was also true, however: for many American painters and researchers, Rome, Milan, and Venice were still promised lands. At the Venice *Biennale*, the latest trends were presented every two years. In 1947, Peggy Guggenheim settled in Venice with her fine collection of Surrealist and abstract art, and every now and then held exhibitions of Italian artists as well. In 1953, the Fondazione Origine presented an exhibition of works from the collection of the Solomon R. Guggenheim Museum. The works of Arshile Gorky, Franz Kline, Robert Rauschenberg, Mark Rothko, and Cy Twombly came to Italy, as did many of the artists themselves. Often it was Italian artists who provided the support for their colleagues from across the ocean—Afro presented an exhibition of work by Gorky at Galleria dell'Obelisco, Rome, in 1957, for example.

It might be said that, as with the infusion of American film stars and directors drawn to Rome's Cinecittà (the "Hollywood on the Tiber"), one could witness Action Painting in the Piazza del Popolo in Rome; at the tables of the Bar Rosati, Twombly could be seen with Afro and Giulio Turcato, while Rauschenberg chatted with dealers or poets. What went on was a mutual discovery between Italy and the United States that would culminate in the triumph of Pop art at the 1964 *Biennale*. These solid, valid points of contact would soon shatter, however.

351.
*Rome–New York Art Foundation,
New Trends in Italian Art/Nuove
tendenze dell'arte italiana. Exhibition
catalogue. Rome: Isola Tiberina, 1958.*

352.
*Painting in Post-War Italy,
1945–1957. Exhibition catalogue. New
York: Columbia University, 1957.*

353.
*Arshile Gorky. Exhibition catalogue.
Rome: Galleria dell'Obelisco, 1957.*

Publications in this section

Rome–New York Art Foundation, *New Trends in Italian Art/Nuove tendenze dell'arte italiana*. Exhibition catalogue, with introduction by Lionello Venturi. Rome: Isola Tiberina, 1958. The exhibition included works by Carla Accardi, Afro, Giuseppe Capogrossi, Pietro Consagra, Ennio Morlotti, Mimmo Rotella, and Emilio Vedova.

Cesare Pavese, *La letteratura americana e altri saggi* (American literature and other essays). Turin: Einaudi, 1953.

Leonardo Sinisgalli, *Viaggio a New York* (Journey to New York). Rome: Mobili Mim, 1961.

Italy at Work: Her Renaissance in Design Today. Exhibition catalogue. Chicago: The Art Institute of Chicago, 1950. Cover designed by Corrado Cagli.

Italian Artists of Today. Exhibition catalogue, with preface by Giulio Carlo Argan. Rome: Art Club, 1951.

Painting in Post-War Italy, 1945–1957. Exhibition catalogue, with introduction by Lionello Venturi. New York: Columbia University, 1957.

Salute to Italy. Exhibition catalogue. Hartford: Wadsworth Atheneum, 1961.

Young Italians. Exhibition catalogue, with introduction by Alan Solomon. Boston: Institute of Contemporary Art, 1968.

De Chirico. Exhibition catalogue. New York: Acquavella Gallery, 1947.

Afro. Exhibition catalogue, with introduction by Lionello Venturi. New York: Catherine Viviano Gallery, 1955.

Afro. Exhibition catalogue, with introduction by Lionello Venturi. New York: Catherine Viviano Gallery, 1960.

Scialoja. Exhibition catalogue. New York: Catherine Viviano Gallery, 1956.

Fontana. Catalogue from the exhibition *Ten Paintings of Venice*. New York: Martha Jackson Gallery, 1961.

Piero Dorazio, *Cartographies*. New York: Rose Fried Gallery, 1954.

Museum of Non-objective Painting: Loan Exhibition. Exhibition catalogue. New York: Solomon R. Guggenheim Foundation, 1950. Four paintings by Dorazio were included in the exhibition.

Mostra Fondazione R. Solomon Guggenheim [sic]. Exhibition catalogue. Rome: Fondazione Origine, 1953. Catalogue to an exhibition of works from the Solomon R. Guggenheim Foundation.

Peggy Guggenheim, *Una collezionista ricorda* (A collector remembers). Venice: Cavallino, 1956.

Mostra di scultura contemporanea presentata da Peggy Guggenheim (Exhibition of contemporary sculpture, presented by Peggy Guggenheim). Exhibition catalogue. Venice: Peggy Guggenheim, 1949. Catalogue to an exhibition including works by Jean Arp, Constantin Brancusi, Alexander Calder, Pietro Consagra, Alberto Giacometti, Marino Marini, Mirko [Mirko Basaldella], Henry Moore, Nikolas Pevsner, and Alberto Viani.

Jackson Pollock. Exhibition catalogue, with introduction by Peggy Guggenheim and texts by Bruno Alfieri, Oreste Ferrari, and Giuseppe Marchiori. Venice: Sala Napoleonica, 1950.

American Artists Paint the City. Exhibition catalogue, with introduction by Lionello Venturi. Venice: Biennale di Venezia, 1956. Catalogue to the American section of the 1956 *Biennale*. Works by Willem de Kooning, Edward Hopper, Franz Kline, Reginald Marsh, Georgia O'Keeffe, Jackson Pollock, Ben Shahn, Joseph Stella, and Mark Tobey were exhibited.

25 anni di pittura americana (Twenty-five years of American painting). Exhibition catalogue. Rome: Galleria Nazionale d'Arte Moderna, 1958. The exhibition included works by Willem de Kooning, Arshile Gorky, Edward Hopper, Jackson Pollock, Mark Rothko, and Mark Tobey.

Arshile Gorky. Exhibition catalogue, with introduction by Afro. Rome: Galleria dell'Obelisco, 1957.

Franz Kline. Exhibition brochure. Rome: Galleria La Tartaruga, 1958.

Mark Rothko. Exhibition catalogue. Edited by Palma Bucarelli. Rome: Galleria Nazionale d'Arte Moderna, 1962.

Twombly. Exhibition catalogue, with introduction by Palma Bucarelli. Rome: Galleria La Tartaruga, 1958.

354.
James Thrall Soby, Giorgio de Chirico. *New York: The Museum of Modern Art, 1955. Frontispiece and title page.*

355.
Pier Paolo Pasolini, Una vita violenta *(A violent life). Milan: Garzanti, 1959.*

356.
Carlo Mollino, Il messaggio dalla camera oscura: fotografia, storia ed estetica *(The message of the darkroom: photography, history, and aesthetics). Turin: Chiantore, 1949.*

Independent painters, writers, architects, and filmmakers

Those isolated writers and painters who, though having seemingly completed their vital cycle, nevertheless continued to affect the cultural scene with their disturbing presence, merit a section apart.

In New York, while James Thrall Soby was publishing his important study of Giorgio de Chirico for the Museum of Modern Art, the artist, very much alive and kicking, produced some nostalgic but high-quality painting and inspired a renewal of figurative offerings from other artists. The same was also true of Mario Mafai and Giorgio Morandi, both of whom finally found real recognition. Such abstractionists as Osvaldo Licini and Fausto Melotti found a new youthfulness during the 1950s and 1960s.

Carlo Emilio Gadda, an engineer from Milan, offered writing that combined dialect and linguistic overlappings, and was strikingly close to the experimentation of artists at the time. The work of Pier Paolo Pasolini achieved sudden success, and he passed quickly from philology and poetry to the realist novel and hyperrealist filmmaking. The work of Tommaso Landolfi, Eugenio Montale, Aldo Palazzeschi, and Sandro Penna continued to evolve: isolated but hardly marginalized, through literature they brought Futurism and Surrealism up to date. In Turin, Italo Calvino offered a kind of fable apparently outside of time, with a writing style reminiscent of Jorge Luis Borges's *Biblioteca di Babele* (Library of Babel), which was translated into Italian in 1955.

Of note among nonliterary works, the books of Carlo Mollino, an ingenious architect/designer, passed blithely from the world of photography to that of sports.

Publications in this section

James Thrall Soby, *Giorgio de Chirico*. New York: The Museum of Modern Art, 1955.

Giorgio de Chirico. Exhibition catalogue. Rome: Circolo della Stampa, 1960.

Giorgio Morandi. Exhibition catalogue, with introduction by James Thrall Soby. London: Royal Academy of Arts, 1970.

Mario Mafai. Introduction by Libero de Libero. Rome: De Luca, 1949.

Mino Maccari, *Il superfluo illustrato* (The illustrated superfluous). Rome: Rossetti, 1948.

Osvaldo Licini. Exhibition catalogue, with introduction by Giuseppe Marchiori. Ivrea: Centro Culturale Olivetti, 1958.

Fausto Melotti. Exhibition catalogue. Edited by Maurizio Fagiolo dell'Arco. Turin: Galleria Notizie, 1968.

Alberto Savinio, *Scatola sonora* (Resonance box). Milan: Ricordi, 1955. A posthumous collection of Savinio's writings on music.

Carlo Emilio Gadda, *Quer pasticciaccio brutto de via Merulana* (That awful mess on via Merulana). Milan: Garzanti, 1957.

Poesia dialettale del Novecento (Twentieth-century dialect poetry). Edited by Mario dell'Arco and Pier Paolo Pasolini. Parma: Guanda, 1952.

Pier Paolo Pasolini, *Una vita violenta* (A violent life). Milan: Garzanti, 1959.

Aldo Palazzeschi, *Roma* (Rome). Florence: Vallecchi, 1953.

Sandro Penna, *Poesie* (Poems). Milan: Garzanti, 1957.

Tommaso Landolfi, *Ombre* (Shadows). Milan and Florence: Vallecchi, 1954.

Eugenio Montale, *La bufera e altro* (The storm and other poems). Venice: Neri Pozza, 1956.

Italo Calvino, *Il barone rampante* (The rearing baron). Turin: Einaudi, 1957.

Jorge Luis Borges, *La biblioteca di Babele* (Library of Babel). Translated by Franco Lucentini. Turin: Einaudi, 1955. An important book for artistic thought of the 1960s, the first Italian edition was published as part of Elio Vittorini's series *I gettoni* (The tokens).

Carlo Mollino, *L'auditorium di Torino* (The auditorium of Turin). Turin: Edizioni ERI, 1962.

Carlo Mollino, *Il messaggio dalla camera oscura: fotografia, storia ed estetica* (The message of the darkroom: photography, history, and aesthetics). Turin: Chiantore, 1949.

Carlo Mollino, *Introduzione al discesismo* (Introduction to downhill racing). Rome: Edizioni Mediterranee, 1950.

After Informale; monochrome; *Azimuth*

Experimentation with sign, gesture, and material struggled hard to assert itself, and as usual, in the space of a few years, it had given rise to an array of followers only to become a tired, common language. It became necessary to find a way out. The first new idea, whose prophet was Lucio Fontana, was to reduce the overloaded value of color. Progressive art found links between Milan and Düsseldorf, Rome and Leverkusen, Padua and Amsterdam. Within a very few years, between 1958 and 1963, the new avant-garde was in many ways consistent with the New York neo-Dada of the time.

One programmatic exhibition was *Monochrome Malerei* (Monochrome painting), curated by Udo Kultermann at Leverkusen in the spring of 1960; Enrico Castellani, Piero Dorazio, Fontana, Francesco Lo Savio, Piero Manzoni, and Salvatore Scarpitta were among the artists exhibited. The *Koncrete Kunst* show, curated by Max Bill, put recent developments into a historical context. In 1961, John Cage published his influential writings under the emblematic title *Silence*.

Yves Klein's *Twelve Chromatic Propositions*, exhibited at Galleria Apollinaire in Milan in 1957, seemed to have been prompted by Fontana's instigations. In 1958, Manzoni presented his *Achromes* in Milan, and Francesco Lo Savio worked on his idea of *Spazio-luce* (space-light) in Rome.

In 1959, the ranks closed. Dorazio exhibited his sensual monochromatic grids in Berlin (accompanied by a catalogue essay written by Giulio Carlo Argan); Manzoni exhibited his *12 linee* (Twelve lines) in Milan and, with Enrico Castellani, founded the review *Azimuth*, which had its own gallery. Also in Milan, Gruppo T was born, as was Gruppo N in Padua; both groups engaged in experiments with technology and the reduction of the image to nothing.

In 1960, Franco Angeli, Tano Festa, Lo Savio, Mario Schifano, and Giuseppe Uncini—five painters for whom monochromaticism had become law—exhibited in Rome. Group Zero was born in Düsseldorf. The offerings of Jannis Kounellis and Scarpitta were presented in Rome, while Lo Savio exhibited with Ad Reinhardt at Leverkusen. In 1962, the year in which Klein died, the movement reached its summit; in 1963, with the deaths of Manzoni and Lo Savio, experimentation with light in all its valences, with a degree zero in painting, with the solemn beauty of nothingness, came to an end.

357.
Zero, Dinamo *(Zero, dynamo),*
Düsseldorf, 3 (1961).

358.
Piero Manzoni: 12 linee *(Piero*
Manzoni: twelve lines). Exhibition
catalogue. Milan: Galleria Azimut,
1959.

359.
Ad Reinhardt, New York–Francesco
Lo Savio, Rom–Jef Verheyen,
Antwerpen. *Exhibition catalogue.*
Leverkusen: Stadtisches Museum, 1961.

Publications in this section

Zero, Dinamo (Zero, dynamo), Düsseldorf, 3 (1961). The
review featured works by Enrico Castellani, Piero Dorazio,
Lucio Fontana, and Piero Manzoni alongside those by
Arman, Pol Bury, Yves Klein, Heinz Mack, Marc Piene,
Raphael Soto, and Jean Tinguely.

Gruppo o (Group Zero). Exhibition catalogue. Amsterdam:
Stedelijk Museum, 1962. Works by Piero Dorazio, Lucio
Fontana, and Francesco Lo Savio were exhibited.

Koncrete Kunst. Exhibition catalogue, with introduction by
Max Bill. Zurich: Helmhaus, 1960. An exhibition, curated
by Bill, of work by the historical central figures of concrete
art along with the most recent developments.

Monochrome Malerei. Exhibition catalogue, with
introduction by Udo Kultermann. Leverkusen: Stadtisches
Museum, 1960. An exhibition, curated by Kultermann,
including work by Italians Enrico Castellani, Piero
Dorazio, Lucio Fontana, Francesco Lo Savio, Piero
Manzoni, and Salvatore Scarpitta alongside work by other
European artists.

John Cage, *Silenzio* (Silence). Edited by Renato Pedio.
Milan: Feltrinelli, 1971. The book was first published in
English in 1961 as *Silence: Lectures and Writings.*

Buchi e tagli di Lucio Fontana (Holes and cuts of Lucio
Fontana). Exhibition catalogue. Turin: Politecnico di
Torino, 1966.

Piero Dorazio. Exhibition catalogue, with introduction by
Giulio Carlo Argan. Berlin: Galerie Springer, 1959.

Yves Klein le monochrome, il nuovo realismo del colore (Yves
Klein the monochrome, the new realism of color).
Exhibition catalogue, with introduction by Pierre Restany.
Milan: Galleria Apollinaire, 1961.

Azimuth, Milan, no. 1 (1959). *Azimuth,* no. 2 (January 1960).
A review edited by Enrico Castellani and Piero Manzoni.

Piero Manzoni: 12 linee (Piero Manzoni: twelve lines).
Exhibition catalogue, with introduction by Vincenzo
Agnetti. Milan: Galleria Azimut, 1959.

Castellani e Manzoni (Castellani and Manzoni). Exhibition
brochure. Rome: Galleria La Tartaruga, 1961.

*Roma 1960: Cinque pittori—Angeli, Festa, Lo Savio, Schifano,
Uncini* (Rome 1960: five painters—Angeli, Festa, Lo Savio,
Schifano, Uncini). Exhibition catalogue, with introduction
by Pierre Restany. Rome: Galleria La Salita, 1960.

*Ad Reinhardt, New York–Francesco Lo Savio, Rom–Jef
Verheyen, Antwerpen.* Exhibition catalogue. Leverkusen:
Stadtisches Museum, 1961.

Francesco Lo Savio, *Spazio-luce: evoluzione di un'idea* (Space-
light: the evolution of an idea), volume 1. Texts by William
Demby, Udo Kultermann, and Leonardo Sinisgalli. Rome:
De Luca, 1962.

Kounellis. Exhibition brochure. Rome: Galleria La
Tartaruga, 1960.

Scarpitta. Exhibition catalogue, with texts by Salvatore
Scarpitta and Leonardo Sinisgalli. Rome: Galleria La
Tartaruga, 1958.

Rauschenberg, Twombly, Kounellis, Tinguely, Schifano.
Exhibition brochure. Rome: Galleria La Tartaruga, 1961.

The 1960s: experimentalism, figuration, and planning

The 1960s were years in which the economic miracle of the previous decade was consolidated. Italy was now without question a full member among industrial nations. In the visual arts, an increasingly rich revival of the image was in evidence. In 1964, the arrival of American Pop art in Venice was a decisive moment that divided critics into two camps. Literature turned a new page with the Novissimi and Gruppo '63; the trend was subdivided into the "open work" of Umberto Eco, the informalism of Edoardo Sanguineti, the bare poetry of Elio Pagliarani, and the imaginative richness of Alberto Arbasino.

Many of the artists of the preceding decade attained the status of "classics": for example, Alberto Burri, with his explorations of the disturbing beauty of plastic; Lucio Fontana, who, starting out from silence (the white cut, the monochrome canvas), ended up at his *Teatrini*, works full of irony; Mimmo Rotella, who was able to build new images with trash from the street. The Nouveau Réalisme theorized by art historian Pierre Restany had become a major avenue.

New types of images cropped up in rapid succession, especially in Rome, Milan, and Turin. In Rome, Franco Angeli, Tano Festa, and Mario Schifano offered echoes of Informale, while Jannis Kounellis presented alphabetical letters floating in primary space. New paths were opened by Pino Pascali, who worked with theatrical gesture and primordial elements.

In Turin, Michelangelo Pistoletto focused on divided and existential images that took off from Francis Bacon but bordered on Pop art; Giulio Paolini presented the enigma of the concept. In Milan, there arose the neo-Metaphysical and neo-Purist quests of Lucio del Pezzo and Valerio Adami, respectively.

The increasingly animated abstraction scene also continued to develop. Piero Dorazio offered an art of highly colored signs. Various groups offered multiplied, planned, or kinetic works.

It was a lively decade, one that witnessed, among other things, the deeply nostalgic phenomenon of the "new figuration," which in the end would leave few marks.

360.
New Realists. *Exhibition catalogue.*
New York: Sidney Janis Gallery, 1962.

361.
XXXII esposizione Biennale
Internazionale d'Arte–Venezia 1964–
Stati Uniti d'America–Quattro pittori
germinali, quattro artisti più giovani
(*Thirty-second Biennale exhibition–*
Venice 1964–United States of
America–four germinal painters, four
younger artists). *Exhibition catalogue.*
New York: The Jewish Museum, 1964.

362.
Arte programmata: arte cinetica, opere
moltiplicate, opera aperta (*Planned*
art: kinetic art, multiplied works, open
work). *Exhibition catalogue. Milan:*
Negozio Olivetti, 1962.

Publications in this section

I novissimi: poesie per gli anni '60 (The Novissimi: poems for the 1960s). Edited by Alfredo Giuliani. Milan: Rusconi & Paolazzi, 1961. Includes poems by Nanni Balestrini, Alfredo Giuliani, Elio Pagliarani, Antonio Porta, and Edoardo Sanguineti.

Gruppo '63: la nuova letteratura, Palermo ottobre 1963 (Gruppo '63: the new literature, Palermo, October 1963). Edited by Nanni Balestrini and Alfredo Giuliani. Milan: Feltrinelli, 1964. The record of a conference whose participants included Alberto Arbasino, Gillo Dorfles, Umberto Eco, Giorgio Manganelli, Elio Pagliarani, and Cesare Vivaldi.

Umberto Eco, *Opera aperta: Forma e indeterminazione nelle poetiche contemporanee* (Open work: form and indeterminacy in contemporary poetics). Milan: Bompiani, 1962.

Alberto Arbasino, *Fratelli d'Italia* (Brothers of Italy). Milan: Feltrinelli, 1963.

Giorgio Manganelli, *La letteratura come menzogna* (Literature as lie). Milan: Feltrinelli, 1967.

Maurizio Fagiolo dell'Arco, *Rapporto 60: le arti oggi in Italia* (1960s report: the arts in Italy today). Rome: Bulzoni, 1966.

Carla Lonzi, *Autoritratto: Accardi, Alviani, Castellani, Consagra, Fabro, Fontana, Kounellis, Nigro, Paolini, Pascali, Rotella, Scarpitta, Turcato, Twombly* (Self-portrait: Accardi et al.). Bari: De Donato, 1969.

Burri. Exhibition catalogue, with introduction by Cesare Brandi. Rome: Galleria Marlborough, 1962. Catalogue to the first show of Burri's *Plastiche* (Plastics).

Rotella: dal décollage alla nuova immagine (Rotella: from décollage to the new image). Edited by Pierre Restany. Milan: Edizioni Apollinaire, 1963.

New Realists. Exhibition catalogue. New York: Sidney Janis Gallery, 1962. Enrico Baj, Tano Festa, Mimmo Rotella, and Mario Schifano were shown alongside Nouveau Réalisme and Pop artists in what the gallery called an exhibition of "factual paintings and sculpture."

Rauschenberg. Exhibition brochure. Rome: Galleria La Tartaruga, 1959.

Lichtenstein. Exhibition catalogue. Turin: Galleria Il Punto, 1963. Roy Lichtenstein's first solo exhibition in Italy.

Jim Dine. Exhibition catalogue. Turin: Galleria Sperone, 1965.

XXXII esposizione Biennale Internazionale d'Arte–Venezia 1964–Stati Uniti d'America–Quattro pittori germinali, quattro artisti più giovani (Thirty-second Biennale exhibition–Venice 1964–United States of America–four germinal painters, four younger artists). Exhibition catalogue. New York: The Jewish Museum, 1964. The entries in the American section of this *Biennale* were part of the explosion of Pop art in Europe.

New Dada e Pop art Newyorkesi (New Dada and New York Pop art). Exhibition catalogue, with introduction by Luigi Mallè. Turin: Museo Civico di Torino, 1969. A survey, curated by Mallè.

Una generazione: Adami, Angeli, Aricò, Castellani, Del Pezzo, Festa, Mari, Pozzati, Recalcati, Schifano (A generation: Adami, et al.). Rome: Galleria Odyssia, 1965.

Pistoletto: A Reflected World. Exhibition catalogue. Minneapolis: Walker Art Center, 1966.

Kounellis, Schifano, Twombly. Exhibition brochure. Rome: Galleria La Tartaruga, 1961.

Kounellis. Exhibition catalogue, with introduction by Cesare Vivaldi. Rome: Galleria La Tartaruga, 1964.

Pascali. Exhibition brochure, with text by Cesare Vivaldi. Rome: Galleria La Tartaruga, 1965.

Maurizio Fagiolo dell'Arco, *Piero Dorazio.* Rome: Officina, 1966.

Arte programmata: arte cinetica, opere moltiplicate, opera aperta (Arte Programmata: kinetic art, multiplied works, open work). Exhibition catalogue, with introductions by Bruno Munari and Umberto Eco. Milan: Negozio Olivetti, 1962. Catalogue to an exhibition curated by Munari.

Miriorama 10. Exhibition brochure, with introduction by Lucio Fontana. Rome: Galleria La Salita, 1961. Catalogue to the first exhibition in Rome of Gruppo T of Milan: Giovanni Anceschi, Davide Boriani, Gianni Colombo, Gabriele De Vecchi, and Grazia Varisco.

A new degree zero

Over the course of a few years, the triumph of the image quickly became a redundant spectacle without quality, as had happened a decade earlier with the experimentation of Informale. Thus a new degree zero, of nothingness, was imposed. Some achieved it through a reduction to pure elements; others through a return to the simplicity of the concept. Still others achieved it through the rediscovery of matter in the material state; thus Arte Povera was born.

Arte Povera was named in 1967, with an exhibition, curated by Germano Celant, that included works by Alighiero Boetti, Luciano Fabro, Jannis Kounellis, Giulio Paolini, Pino Pascali, and Emilio Prini alongside a number of proponents of image painting. The reference points for these artists were the "poor theater" of Jerzy Grotowsky and Minimal art, the new American trend that was reducing the Pop iconosphere to zero. In Turin, at Galleria Sperone, the Pop artists were replaced by the leading figures of Minimal art. In 1967, Michelangelo Pistoletto had come out with the prophetically titled pamphlet *Le ultime parole famose* (Famous last words).

What was taking place was a search for new spaces and new modes of behavior that went beyond the simple elaboration of the artistic object. One major figure was Giulio Paolini, a Borgesian alchemist of the concept, while in Rome Pino Pascali and Jannis Kounellis proposed in their work a return to the zero base of nature and the elements.

The sensitive seismograph of artistic experimenters anticipated political and social events. It was the age of global revolt against the system, the crises of 1968. It was a true cancellation that did not seem to propose a new beginning for artistic research.

Translated, from the Italian, by Stephen Sartarelli.

363.
Germano Celant, Arte povera. *Milan: Gabriele Mazzotta, 1969.*

364.
Minimal Art. *Exhibition catalogue. The Hague: Haags Gementemuseum, 1968.*

365.
Michelangelo Pistoletto, Le ultime parole famose *(Famous last words). Turin: Author, 1967.*

Publications in this section

Arte povera (Boetti, Fabro, Kounellis, Paolini, Pascali, Prini)— Im-Spazio (Bignardi, Ceroli, Icaro, Mambor, Mattiacci, Tacchi). Exhibition catalogue, with introduction by Germano Celant. Genoa: Galleria La Bertesca, 1967.

Jerzy Grotowsky, *Per un teatro povero* (Toward a poor theater). Rome: Bulzoni, 1968. The English edition, *Toward a Poor Theater*, was also published in 1968.

La povertà dell'arte (The poverty of art). Texts by Umbro Apollonio, Francesco Arcangeli, Renato Barilli, Vittorio Boarini, Renato Bonfiglioli, Achille Bonito Oliva, Maurizio Calvesi, Germano Celant, Antonio Del Guercio, Giorgio De Marchis, Maurizio Fagiolo, Renato Guttuso, and Lamberto Pignotti. Bologna: Galleria de' Foscherari, 1968.

Germano Celant, *Arte povera*. Milan: Gabriele Mazzotta, 1969.

Conceptual Art, arte povera, land art. Exhibition catalogue. Edited by Germano Celant. Turin: Galleria Civica d'Arte Moderna, 1970.

Minimal Art. Exhibition catalogue. The Hague: Haags Gemeentemuseum, 1968. The exhibition included works by Carl Andre, Dan Flavin, Donald Judd, Sol LeWitt, and Robert Morris.

Dan Flavin. Exhibition catalogue. Milan: Galleria Sperone, 1967.

Robert Morris. Exhibition catalogue. Turin: Galleria Sperone, 1969.

Giulio Paolini, 2121969. Exhibition catalogue. Milan: Galleria De Nieubourg, 1969.

Giulio Paolini, *Ciò che non ha limiti e cui per la sua stessa natura non ammette limitazioni di sorta* (That which has no limits and by its own very nature accepts no limitations whatsoever). Turin: Author, 1968.

Germano Celant, *Giulio Paolini*. New York: Sonnabend Press, 1972.

Pino Pascali. Exhibition catalogue. Turin: Galleria Sperone, 1966. Pascali's *Cannons* were exhibited.

Kounellis. Exhibition catalogue. Rome: Galleria l'Attico, 1967.

Michelangelo Pistoletto, *Le ultime parole famose* (Famous last words). Turin: Author, 1967.

Pistoletto. Exhibition catalogue, with introduction by Giulio Carlo Argan. Rome: Galleria l'Attico, 1968.

Lo zoo presenta due spettacoli (The Zoo presents two shows). Performance brochure, with introduction by Achille Bonito Oliva. Naples: Galleria Centro, 1969.

Mario Merz. Exhibition catalogue, with introduction by Germano Celant. Turin: Galleria Sperone, 1968.

Giovanni Anselmo. Exhibition catalogue, with texts by Germano Celant and Maurizio Fagiolo. Turin: Galleria Sperone, 1968.

Gilberto Zorio. Exhibition catalogue, with introduction by Tommaso Trini. Turin: Galleria Sperone, 1968.

Contestazione estetica e azione politica (Aesthetic revolt and political action), special issue of *Cartabianca* (Carte blanche), Rome, 1, no. 0 (November 1968). *Cartabianca* was edited by Alberto Boatto.

Fotografia *was published* Editoriale Domus *in Feb before the fall of the natio seven months before the an and optimistically, began democratic Italy. Presente advanced experimentatio photographers, the annua rather exceptional — in b assortment of photographs and thematic variety, avo*

n Milan by Gruppo
uary 1943, five months
al Fascist regime and
nistice that dramatically,
he story of the new
l as a synthesis of the most
by contemporary Italian
was emblematic—and
nging together an
hat, despite their aesthetic
ded both the reigning

Reality and Italian Photography

Italo Zannier

Pictorialism and contamination by Fascist elements. *Fotografia: Prima rassegna dell'attività fotografica in Italia* (Photography: first survey of photographic activity in Italy) was designed by Albe Steiner, who would later leave an authoritative mark on elite Italian publishing, and in perusing the book's large, glossy pages, one notices above all an up-to-date graphic sense, European in style and emphasis. In a brief preface the publisher, Gianni Mazzocchi, declared his wish, "with the publication of this volume, to affirm the technical and artistic maturity of Italian photographers," adding that it was the first time in Italy that "so complete a survey was being published." The goal was to be "a documentation of the art and technique of our photographers, which will also serve to erase the old prejudice of foreign superiority in the field of photography."[1] Italian photography, in fact, had long been isolated, if not actually marginalized, from international debate, especially that provoked by the various avant-garde movements. In the first decades of the twentieth century the avant-gardes—Dada and Surrealism in France and the interdisciplinary experimentation, Rationalist and Constructivist, of the Bauhaus in Germany—had stirred up a revolutionary fervor that extended to photographic aesthetics. In the 1920s such journals as the French *Vu* (Seen), edited by Lucien Vogel, and the German *Berliner Illustrierte Zeitung* (Berlin illustrated magazine), edited by Stefan Lorent, for example, were known for their explorations in the new genre of photojournalism.

In Italy, however, despite such new developments as the abstractionist aesthetic of the Modernist school (represented by Vincenzo Balocchi [see cat. nos. 380, 422], Achille Bologna, Stefano Bricarelli, and Giuseppe Pagano [see fig. 1]), which avoided the ruling kitsch of Pictorialism, the milieu of photography remained provincial and amateurish. The path taken by Italian photography, at this time, can be followed in the pages of a handful of specialized magazines, especially *La fotografia artistica* (Artistic photography), published from 1904 to 1917 in Turin by Annibale Cominetti and featuring contributors from all over the world[2]; and, after World War I, *Il corriere fotografico* (The photographic courier), published in Turin by Carlo Baravalle, Bologna, and Bricarelli. Then, in 1933, Luigi Andreis became the editor of the monthly *Galleria* (Gallery), an Italian version of the Viennese *Die Galerie*. Although this publication provided information on international photographic trends, it neglected, perhaps for political reasons, the work of the avant-garde. Consequently the photographs of such artists as Man Ray and László Moholy-Nagy were known only to a handful of Italian intellectuals, who kept privately, almost clandestinely, in touch with "extremists" abroad, especially in Paris.

Luigi Veronesi, whose experiments with non-objective photography (cat. no. 379) made him, with Franco Grignani, among the most advanced photographers in 1930s Italy, corresponded with the Bauhaus refugee Moholy-Nagy. Separately and in isolation, Veronesi, who was above all an abstract painter, and Grignani, an architect, designer, and graphic artist, pursued an aesthetic that distinguished itself from both Pictorialism and Modernism. At the same time a second wave of Futurism, represented by such photographers as Arturo Bragaglia, Tato [Guglielmo

Sansoni], and Wanda Wulz, began to emerge. Images created by these photographers tended to comply with the Fascist rhetoric of the time: "swift ocean liners, airplanes, cars, rumbling engines, the glorious militias of Mussolini."[3] There was an emphasis on the old Marinettian myths, which had been dusted off especially in anticipation of the great Rome exhibition in 1932, organized in celebration of the Fascist regime's first decade. One need only recall *Il tavolo degli "orrori"* (*The Table of "Horrors,"* 1932), a Pier Maria Bardi photomontage, which was exhibited alongside the collages of Bruno Munari (whose primary formal influences were the German avant-gardists Raoul Hausmann, John Heartfield, and Hanna Hoch, but whose political ideology was somewhat different).

Much more significant for the future direction of Italian photography, however, were the photodynamist experiments of the brothers Anton Giulio and Arturo Bragaglia, which had been carried out between 1911 and 1913. For the Bragaglia brothers photography was no longer to be merely descriptive and informative; the image was to be expressive of an idea. In one of the first essays on the aesthetics of photography, one that took its bearings from the European avant-garde, Anton Giulio Bragaglia reflected, "We can now advance along two great paths: the scientific one, for the analysis and the individual study of every movement; and the artistic one, for the re-evocation of the dynamic sensation that the transcendental part of a gesture produces on our retina, on our senses, and in our spirits."[4]

This was a revolutionary hypothesis when one considers the street scenes of the likes of Count Francesco Chigi, Baron Francesco Saverio Nesci, and Count Giuseppe Primoli, and the Pictorialism of such figures as Giulio Gatti-Casazza, Rho Guerriero, and Guido Rey—sunsets, shepherd boys in pastures, figures dressed in Greek and Roman costume, and so on—which dominated the field of traditional Italian photography at the time.

The yearning for a photography intended not only as an art but as a language found its sole outlet in the 1920s and early 1930s in a number of publications of architecture and design, among them *Casabella* (House beautiful), edited by Edoardo Persico and Giuseppe Pagano, and *Domus*, edited by Gio Ponti. Ponti, in fact, wrote one of the most lucid and prophetic considerations of the modernity of photography, which appeared three years after Antonio Boggeri's famous essay on advertising photography. Published in 1929 in the annual *Luci ed ombre* (Lights and shadows), Boggeri's text emphasized the importance of advertising for the development of photography. For Boggeri it is to advertising that "we owe the greatest advancements in photography as creation and detachment from representative realism, and in whose fundamental aim—the valorization, by the hidden personality, of the thing represented—lies the seed from which the *photogram* is born."[5] To Boggeri's idea of photographic reality Ponti added, "The photographic aberration is for many things *our only reality*; it is for many things our very *consciousness*, and it is therefore our *judgment*. It constitutes a large part of our visual perception" (italics in original).[6]

Photography found increasingly broader applications over the next ten years, especially in the representation of

fig. 1. *Giuseppe Pagano,* Fontana Pretoria *(Pretoria Fountain), 1938. Gelatin-silver print, 13.5 x 8.5 cm. Collection of Ferruccio Malandrini, Florence.*

fig. 2. *Pietro Donzelli,* Atmosfera *(Atmosphere), 1946. Gelatin-silver print, 9 x 6 cm. Archivio Pietro Donzelli, Milan.*

architecture, which was, in fact, the area in which research and enthusiasm for the "new art" grew most rapidly. Architectural images fill the 1943 *Fotografia* yearbook, which, it may be recalled, was published by the architectural magazine *Domus*. And many of the photographs in the volume were by architects—such as Vito Latis, Gabriele Mucchi, Pagano, and Enrico Peressuti—or designers and graphic artists—such as Grignani, Steiner, and Veronesi.

Italian photojournalism was also coming into its own, as defined by Federico Patellani (see cat. nos. 382–87) in the pages of *Fotografia* in an essay entitled "Il giornalista nuova formula" (The new formula journalist). In that essay Patellani brought into focus his recent experiences as a photojournalist for the weekly magazine *Tempo* (Time), which Alberto Mondadori had begun publishing in 1938 on the model of such photomagazines as *Life* from America and *Signal* from Germany, and his reflections on the identity of photography, which he championed with the same ideas as Henri Cartier-Bresson, a better-known photographer and the influential theorist of the *image à la sauvette* (image on the run). For Patellani movement was all important: "Quickness is the quality with which the photographer-journalist must be endowed. . . . It is more interesting to photograph something living and in motion. . . . Photography of movement requires the choice of a narrative moment that the cinema has accustomed us to seeing."[7]

Although the *Fotografia* annual may have represented advanced practice in the medium of photography, a number of counter-tendencies existed as well. In 1943 Alex Franchini Stappo and Giuseppe Vannucci Zauli (see cat. no. 378) published a little volume entitled *Introduzione per un'estetica fotografica* (Introduction for an aesthetics of photography), in which a number of aesthetic criteria for the practice of photography were proposed. Among the necessary preconditions for a valid Modernist photography, according to the authors, is a balance among lighting, moment, and "rendering," that is, the rigorous control and planning of the final print: "These three values (lighting-moment-rendering) are but three aspects of the aesthetic unity: they cannot exist separately from one another."[8]

Such a formalist position influenced, while sharing some of the values of, the still-elitist amateur photography scene, the only area, at the time, where an attempt was being made to claim photography as an autonomous artistic language. Among its emergent figures were Balocchi, Giuseppe Cavalli, Ferruccio Leiss, and Federico Vender, who were among the few to attempt advanced explorations without betraying the perceived objectivity of the medium. The one exception was Veronesi, who was especially influenced by the Bauhaus and by the work of Georges Vantongerloo's Parisian group Abstraction-Création, which Veronesi joined in 1930.

For its part professional photography in the 1940s was given over to studio craft—the Alinari brothers' smooth and classical style of art and architectural photography and portraiture dating from 1852 to 1920—and to advertising and industrial photography. Mario Crimella, for example, operated an important art photography studio in Milan with Mario Castagneri, a fine portraitist

of the 1920s, and Vittorio Villani gained renown for his efficient industrial laboratory in Bologna.

Among the most effervescent and fashionable portraitists of the period was Elio Luxardo, who soon established himself as a sublime photographer of film stars. Luxardo, who hailed from Brazil but was of Dalmatian origin, opened an elegant studio in Rome in 1932 to serve the artists of the Cinecittà film studios. His style was, from the first, lively, cheerful, almost syncopated, like the Italian jazz of the period. Luxardo's photographs, composed on the diagonal, are characterized by back-lit contrasts, often animated by a spotlight that had been projected onto the subject's fan-tousled hair. The photographs were inevitably retouched, but with a lightness of hand that, while removing imperfections, did not affect the spontaneity of the subject's expression. This "Luxardo style" quickly spread to the provinces, where it had an effect on fashions in photoportraiture into the postwar years.

In 1944 Luxardo went to Milan and became dangerously involved with the Fascist Republic of Salò. He had been, in fact, one of the most representative photographers of Benito Mussolini's national regime, and his work displayed a hedonism that could almost make one forget the war and its sacrifices. His photographs—including a series of male nudes that today make one think of Robert Mapplethorpe—tended above all to evidence the ultimate myths of *italica bellezza*, or Italianate beauty (cat. nos. 366–370). At the same time that Luxardo was part of the last ditch efforts of Fascists in the North, the brutal subject matter of war was now being featured in the liberated South in illustrated magazines like *Tempo*, where Patellani and Lamberti Sorrentino began to make names for themselves as special correspondents in the tradition of the senior Luigi Barzini and Orio Vergani. And the consequences of the Allied bombings are forever captured in the Archivio Publifoto in Milan, one of the most important archives of the Italian photographic patrimony.

. Italian photography was, in any case, acquiring a new face, abandoning, as Ermanno Scopinich pointed out in the 1943 *Fotografia* annual, "the themes of sheep at pasture, light reflections, and sunsets on the lake [and] concerning itself instead with 'the world, life, and the changing mentality.'"[9]

These new concerns can be seen in *Occhio quadrato* (Square eye), a little book of photographs by Alberto Lattuada (see cat. nos. 371–73), published in 1940 by the courageous publishing house of Scheiwiller. This volume contained a few images in sequence, "naked geometries, squalid tenements, a grim and sad atmosphere," as Giuseppe Turroni later wrote, "prefiguring the formal structure of many short films of the postwar period,"[10] such as those of Michelangelo Antonioni, Luigi Comencini, and Francesco Maselli. Lattuada can be said to have anticipated the style of neorealism, which came to dominate the style of Italian photography for at least a decade. Even the photographers of the agencies, such as Peppino Giovi, Tino Petrelli, and Fedele Toscani—all from the Publifoto agency (see cat. no. 388), founded by Vincenzo Carrese in 1936—or the "boys" of Tullio Farabola's agency began to address the themes of poverty and urban decay.

The outskirts of the big cities, with their shanties, poor people, and undernourished children—images that

inspired the great films of such directors as Vittorio De Sica and such scriptwriters as Cesare Zavattini—were the subjects of the new photographic iconography. Such photography had no pretensions to art but rather saw itself as pure testimony, as compared to the more intellectual commitment of a Patellani or, soon after him, the neorealist group. Its practitioners, largely amateurs, were culturally guided by a leftist ideology. In 1946, for example, Elio Vittorini founded in Turin *Il politecnico* (Polytechnic), a journal in which photography came to occupy a dialectical function that went beyond mere illustration. It was in this magazine, in fact, that Luigi Crocenzi, a scholar of cinematic and photographic language, would launch his pioneering experiments in visual narration, influenced by the semiological schemata of the popular picture magazines, especially the new genre of the *fotoromanzi* (photonovels). A signifcant amateur photographer of the time was Carlo Mollino, an architect by profession, who beginning in the 1930s had found in photography a congenial medium for his metaphysically influenced creativity (see cat. nos. 374, 375).

"The early artistic intentions of photography," complained Leo Longanesi in 1949 in *Il mondo che cambia* (The changing world), "have given way to the documentary sensibility. . . . Photographic beauty has found its proper realm in violent death."[11] Longanesi was alluding to the first crime news reports, which had been forbidden under the Fascist Ministry of Culture. But, as Antonio Arcari later wrote, "there have also been those who have taught us that history is also the history of those who till the land, who build the houses, who work in the factories."[12] Arcari was thus synthesizing the aspirations of neorealism, which had a profound effect on postwar Italian culture, gaining many adherents among young photographers.

The main ideologue of photographic realism—though not its champion—was Pietro Donzelli (see fig. 2, cat. nos. 419–21), who at the time was especially influenced by the photographers of the United States's Farm Security Administration, in particular Walker Evans and Dorothea Lange. Donzelli's realism combined an expressionistic roughness, perhaps caused by the simultaneous influence of theorist and photographer Otto Steinert's *subjektive fotografi* (subjective photography) and a "lyrical realism," Franco Russoli's description of the Italian tendency to sweetness, which Russoli detected in the work of Piergiorgio Branzi (see figs. 3, 4, cat. nos. 416, 417, 447–49), Toni Del Tin (see cat. nos. 427–29), Nino [Antonio] Migliori (see cat. nos. 430, 431), and Fulvio Roiter (see fig. 5, cat. nos. 423–26).[13]

Not everyone, however, jumped on the neorealist bandwagon. In 1947 Giuseppe Cavalli (see cat. nos. 407–10) founded the group La Bussola (The compass) with Mario Finazzi (see cat. nos. 412, 413), Leiss (see cat. no. 415), Vender (see cat. no. 411), and Veronesi (see cat. no. 414). Their intention was to orient photographic practice in a formalist direction and away from neorealist and documentary trends. "It is necessary for La Bussola to truly guide its followers in the field of art, leading them away from the wrong paths," Cavalli wrote. By "wrong paths" he meant "documenting the ruins of war, machines and men in the context of the present civilization of speed and mechanics." "The document is not art," he added preemptorily, laying down the gauntlet in the bitter

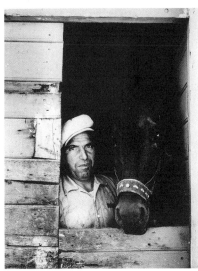

fig. 3. *Piergiorgio Branzi,* Nozze a Valencia *(Wedding in Valencia), ca. 1950. Gelatin-silver print, 31 x 29 cm. Collection of Ferruccio Malandrini, Florence.*

fig. 4. *Piergiorgio Branzi,* Contadino del sud *(Southern Farmer Peasant), ca. 1955. Gelatin-silver print, 38.8 x 29 cm. Collection of Italo Zannier, Venice.*

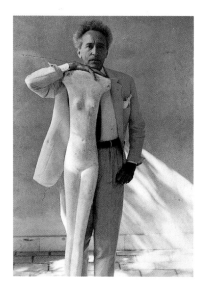

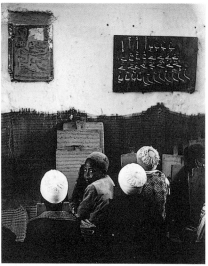

fig. 5. Fulvio Roiter, Jean Cocteau chez Peggy Guggenheim in Venice *(Jean Cocteau at Peggy Guggenheim's in Venice), 1959. Gelatin-silver print, 28.5 x 20.8 cm. Museo di Storia della Fotografia Fratelli Alinari, Collezione Italo Zannier, Florence.*

fig. 6. Alfredo Camisa, Scuola coranica *(Koranic School), 1956. Gelatin-silver print, 35 x 29 cm. Collection of Ferruccio Malandrini, Florence.*

postwar debate about what Italian photography should be.[14] As Turroni pointed out in his critical writings, Cavalli actually aggravated "the famous conflict—experienced particularly in socially backward cultures—between 'art for art's sake' and 'art for life's sake.'"[15]

Mario Giacomelli (see cat. nos. 434–39, 444), a student of Cavalli's, was one of the few photographers to remain genuinely indifferent to the debate, while nevertheless combining the seemingly contradictory positions of the formalists and the neorealists. Developing his own poetics of photography, he embraced theologian Theihard de Chardin's notion of "terrestriality": mankind integrated into the primitive terrestrial landscape from which one receives the vital sap. Captured directly from reality by an eye both lucid and selective, Giacomelli's images poetically and dramatically suggest this concept.

In effect, photography in postwar Italy was rediscovered not only as an artistic language but also as a means of bearing witness. In the postwar period young photographers began to travel a great deal, even on bicycle, especially to the South of Italy. There they discovered a landscape and a culture that had largely been ignored since the nineteenth century, when the South of Italy had been part of the Grand Tour of Americans and Europeans before crossing the Mediterranean on their way to Greece and the Middle East.

The South became a kind of rite for Italian photographers. Ando Gilardi and Franco Pinna were among the first to catalogue the secular and religious rituals of Calabria and Lucania, which they did in 1946 for the anthropologist Ernesto De Martino. Tino Petrelli (see cat. no. 389), in 1948, discovered the misery of Africo, a little village perched atop a mountain in the Calabrian Appenines; three years later, Mario De Biasi (see cat. nos. 390, 391, 440) photographed the *bassifondi* (underworld) of the poor in Naples, whose ground-level hovels so characterized the city. Roiter brought to visual life the labors of the sulphur miners in Sicily. Others discovered their own little corners of Italy, continuing up to the feature stories of Alfredo Camisa (see fig. 6, cat. no. 446), who followed the tuna and swordfish fishermen as they pursued their labors; the work of Branzi, who ventured among the blinding rocks of Matera; and the images of Enzo Sellerio (see fig. 7), who wandered the working-class quarters of Palermo.

Then in the late 1950 a highly transgressive form of photography came on the scene. Its practitioners, the creators of an unconscious but functional iconographic transgression, were the paparazzi, as they came to be called after Federico Fellini recounted their deeds in the film *La dolce vita* (The sweet life, 1960; released in English as *La Dolce Vita*). One of the best known of these "terrible" photographers was Tazio Secchiaroli (see cat. nos. 404–06), who began his career with Adolfo Porry-Pastorel, a pioneer in this sort of impertinent, aggressive photography, at a time when the craft was considered almost insignificant, or at any rate subservient, to written journalism. Together with Elio Sorci and Sergio Spinelli (see fig. 8, cat. no. 403), Secchiaroli founded Rome's Press Photo Agency, which for a number of years was an important photo source for the national illustrated magazines.

In the late 1950s and early 1960s Italian journalism

became increasingly gossipy and scandal-oriented. A number of unusual and almost exclusively photographic weeklies—among them *Le ore* (The hours), *Settimo giorno* (Seventh day), and *Crimen* (Crime)—found their place alongside the mass-market picture magazines—*L'europeo* (The European), *Epoca* (Epoch), and *Oggi* (Today). These new publications were supported by a public curious about scandalous events, especially when the people involved were the exiled royals or Hollywood movie stars who had moved to the banks of the Tiber in Rome and could be counted on for boisterous behavior in the bars and hotels of via Veneto.

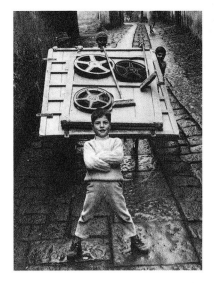

The likable "gang of slum photographers" who recorded the antics of these stars and aristocrats did not have too many qualms about privacy (with characteristic moralism, they were called "infamous"); rather, they pursued, in addition to money, the goal of revealing the "other" Italy. This was decidedly *not* the peasant Italy of the neorealists, which was disappearing and no longer of interest. Nor were the paparazzi concerned with the proletarian struggles in the South, which inspired the works of such poets as Rocco Scotellaro and such painters as Renato Guttuso (see cat. nos. 14, 15). Nonetheless, by the 1960s, despite their aggressive tactics and less-than-elevated subject matter, the paparazzi had gained legitimacy, even as artists; later, they would be given retrospectives and even be integrated into the academic history of Italian photography. But their newfound acceptance was not because of the aesthetic qualities of their photographs, which, in any case, were not new if one considers the unscrupulous use of the flash in the 1930s by Weegee [Arthur H. Fellig] in New York. Instead, it was because of the impertinence of their images, which were caricatural, harsh, and demythifying in a way that had never been seen before in Italy. As Arrigo Benedetti, grand old man of Italian journalism, observed: "Luckily this is a relatively peaceful country. Nevertheless, we must recognize that photographers are always cropping up where life is most dramatic. . . . It is a moment in which the photographer, without knowing, and without wanting to be so, is at once artist, social critic, and satirical poet."[16]

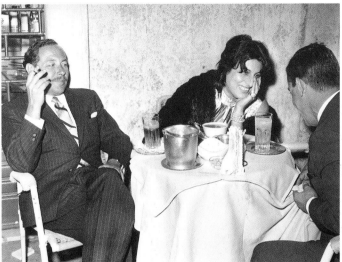

fig. 7. Enzo Sellerio, Three Children Carrying Film Reels to a Movie Theater, *1963. Gelatin-silver print, 34.5 x 26.5 cm. Collection of Ferruccio Malandrini, Florence.*

fig. 8. Sergio Spinelli's photograph of Tennessee Williams and Anna Magnani, Hollywood sul Tevere *(Hollywood on the Tiber), 1959. Gelatin-silver print, 30 x 40 cm. Archivio Sergio Spinelli, Roma.*

The paparazzi brought professional photographers more into the cultural mainstream and left a profound mark on the photojournalism of the period. At the same time art photography, influenced by the formalism of the 1940s "Bussola style," continued to be practiced in Italy. Such groups as the Venetian La Gondola (The gondola), under the guidance of the masterful Paolo Monti (see cat. nos. 441–43), formed the style of such prominent art photographers as Giuseppe Bruno, Del Tin, Gianni Berengo Gardin (see cat. nos. 396, 433, 445, 454), and Roiter. Roiter was the first Italian photographer to become involved in international publishing, working on a number of important photobooks with the Guilde du Livre of Lausanne.

By the mid-1960s photography had begun to find other venues, other *raisons d'être*, in the realms of advertising, fashion, and tourism. The peasant culture was vanishing as Southerners emigrated to the cities of the North and Italy became increasingly industrialized. Photojournalism, for its own part, entered a period of crisis, especially when television sets became a mass commodity, and television

fig. 9. *Ugo Mulas,* Verifica 13.
Autoritratto con Nini
*(*Verification 13. Self-portrait with
Nini*), ca. 1971–72. Gelatin-silver
print, dimensions unknown. Archivio
Ugo Mulas, Milan.*

fig. 10. *Mimmo Jodice,* Vesuvio
*(*Vesuvius*), ca. 1971. Gelatin-silver
print, 30 x 40 cm. Archivio Mimmo
Jodice, Naples.*

replaced print mediums as *the* medium of information. The photographer seemed to become less necessary to the newspapers, which reduced both the format and numbers of photographs published. Meanwhile the heroic myth of the photojournalist began slowly to fade, though it had been greatly embraced by the young, who were attracted by the exotic romanticism of such international figures as Werner Bischof and Robert Capa, both of whom died in 1954 (Capa was killed while covering the war in Indochina), or Jean-Pierre Pedrazzini, who was in Budapest during the 1956 Hungarian uprising with De Biasi, the "crazy Italian," as he was called, who was the first Western photojournalist to have crossed the Iron Curtain laden with dramatic rolls of film.

But it was not just the industrialization of Italy or the transformation of the mass media that led to the shift in photographic practice. Equally important was the cosmopolitanism of Italian culture in general, which by the mid-1960s had become integrated into international trends. In film there emerged, even before the French New Wave of Alain Resnais and others, such groundbreakers as Michelangelo Antonioni, Federico Fellini, and Roberto Rossellini, who displayed an imagination liberated from the ideological constraints of neorealism. At the same time the fantastic fictions of Italo Calvino were pointing to a new path in literature. Hailed by the intellectuals of Gruppo 63 as a revolution, Calvino's work effaced, almost in a single stroke, an entire epoch that had had the great realist Cesare Pavese as its main literary reference point. The painters, in turn, forgot the myth of political realism, going to the point of renouncing painting itself in favor of a linguistic experimentation that was "conceptual," as they called it, taking as its aesthetic vocabulary gestures, "poor" signs (as in Arte Povera), and minimal images, including photographs, or shreds thereof.

This new and fruitful integration of painting and photography signaled the end of a cycle in the history of photography and the initiation of a free investigation of the medium that is ongoing in Italy today. Artists such as Giulio Paolini (see cat. nos. 181–83, 220, 221), Luca Patella, Emilio Prini, and Franco Vaccari neglected the traditional aesthetic specificity of the medium, exploiting instead the possibilities of using it as an ambiguously "objective" language. For his part, Ugo Mulas, a proponent of "straight" photography (he had once been a photojournalist), launched a series of examinations of the very identity of the medium (see fig. 9, cat. nos. 392–94, 457, 458). Mulas was much affected by the photographs of such American colleagues as Robert Frank, Lee Friedlander, and Garry Winogrand, as well as the photowork of the Pop artists Robert Rauschenberg and Andy Warhol. He also visited the grand old man Marcel Duchamp, that perennial rule-breaker, in New York during the shooting for Mulas's important book on the art of those years, a volume of photographs entitled *New York, arte e persone* (New York, arts and people, 1967; published in English as *New York: The New Art Scene*). In 1967 Lanfranco Colombo, an enthusiastic promoter of international photography, opened Il Diaframma in Milan. The first photography gallery in Europe, it is still in existence.

It was at this time that Italy saw the development of a widespread protest movement (of students and intellectuals

more than the working class) that sought to demythify the entire postwar era, with its rampant consumerism and the continuing decline of traditional peasant culture. The revolution launched by the younger generation had profound cultural implications, despite its anarchic aspects and connections with political terrorism. So, in the realm of photography, the image was rejected as structured by conventions considered academic and therefore threadbare. Noteworthy among the new photographers were Lisetta Carmi, who explored the world of Florentine transvestites with a previously unknown precocity; Mario Carrieri (see cat. nos. 450, 451), who published a bitter volume of photos of Milan in the provocative style of William Klein; and Carla Cerati (see cat. nos. 467–69), who observed Milanese high society with an ironic gaze, while also recording the first urban battles. As Luigi Carluccio, a critic with a keen interest in photography who lived through the turbulent period of the 1960s, would write a few years later: "The fundamental fascination of the photographic image is in its effective ability to reproduce the mystery of life."[17]

For Mulas, as for many others, 1968 signaled the end of one era and the beginning of another: "Protest—the police pummeling painters—[took] on an indicative meaning, that of an end" (see cat. nos. 470, 471).[18] At that point the consciousness of a need to reflect "on photography" (as did Susan Sontag) became particularly keen, with such artists as Mario Cresci, Guido Guidi, and Mimmo Jodice on the front lines. In his photowork Cresci sought the interdisciplinary connections between graphics and design. Guidi, rather than dwell on metalinguistic experimentation (like Mulas and others), devoted himself to revealing a landscape, even a human one, rendered grotesque by his transgression of "straight" photography (see cat. nos. 459–64). Using the snapshot, he demystified composition—perspective and "the pose"—the beautiful image that had so characterized such photography as the images of Ansel Adams, Cartier-Bresson, or Edward Weston. For his part, Jodice revisited neo-Dada modes: photomontage and technical strategies for decomposing the image (see fig. 10, cat. nos. 455, 456). The main reference points in these diverse photographic trends, which are active in Italian photography even today, are Evans, Frank, and Friedlander—that is, a straightforward, direct photograpy that follows in the footsteps of Alfred Stieglitz. Yet it is a photography, for example, that Guidi, in a curve that leads back to neorealism, has set on a path of personal intimacy culturally befitting his own "provincial" reality. This ultimately is an Italian reality— one that is presented, as Giacomelli has presented it, out of a poetic demand.

Translated, from the Italian, by Stephen Sartarelli.

1. *Fotografia: Prima rassegna dell'attività fotografica in Italia* (Milan: Gruppo Editoriale Domus, 1943), p. 3.
2. *La fotografia artistica* was also published in a French edition.
3. Mario Bellavista, "Evoluzione di un 'arte,'" in *Annuario nazionale Italiano di fotografia artistica* (National Italian yearbook of artistic photography. Turin: USIAF, 1939), p. 5.
4. Anton Giulio Bragaglia, *Fotodinamismo futurista* (Futurist photodynamism. Rome: Nalato, 1912), p. 52.
5. Antonio Boggeri, "Commento a 'La photographie est actuelle' di C. De Santeul," in *Luci ed ombre: annuario della fotografia artistica italiana, Il corriere fotografico* (Lights and shadows: yearbook of Italian artistic photography, the photographic courier. Turin: Corriere Fotografico, 1929), p. 14.
6. Gio Ponti, "Discorso sull'arte fotografica," *Domus*, no. 5 (May 1932), p. 8.
7. Federico Patellani, "Il giornalista nuova formula," in *Fotografia*, p. 134.
8. Alex Franchini Stappo and Giuseppe Vannucci Zauli, *Introduzione per un'estetica fotografica* (Introduction for a photographic aesthetic. Florence: Cionini, 1943), p. 56.
9. *Fotografia*, p. 7.
10. Giuseppe Turroni, *Nuova fotografia italiana* (New Italian photography. Milan: Schwarz, 1959), p. 15.
11. Leo Longanesi, *Il mondo che cambia* (The changing world. Milan: Longanesi Editore, 1949), p. 8.
12. Antonio Arcari, "Significato di una scelta," in *La famiglia italiana in 100 anni di fotografia* (The Italian family in 100 years of photography. Bergamo: CIFE-Il Libro Fotografico, 1968), p. 5.
13. Franco Russoli, "Introduzione," in *Fotografi italiane* (Italian photographers. Milan: Antonio Salto, 1953), p. vii.
14. The manifesto of La Bussola, in *Ferrania*, Milan, 1 (May 1947), p. 5.
15. Turroni, p. 24.
16. Arrigo Benedetti, in Vincenzo Carrese, *Un album di fotografie: racconti* (An album of photographs: stories. Milan: Il Diaframma, 1970), p. x.
17. Luigi Carluccio, "Note per un'introduzione," in Luigi Carluccio and Daniela Palazzoli, eds., *Combattimento per un immagine: fotografi e pittori* (Battle for an image: photographers and painters. Turin: Amici dell'Arte Contemporanea Galleria Civica d'Arte Moderna, 1977), p. 5.
18. Ugo Mulas, *La fotografia* (Photography. Turin: Einaudi, 1973), p. 30.

"Paparazzi on the Prowl": Representations of Italy circa 1960

Jennifer Blessing

With regard to many of these photographs, it was History which separated me from them. Is History not simply that time when we were not born? . . . Thus the life of someone whose existence has somewhat preceded our own encloses in its particularity the very tension of History, its division. History is hysterical: it is constituted only if we consider it, only if we look at it — and in order to look at it, we must be excluded from it. As a living soul, I am the very contrary of History, I am what belies it, destroys it for the sake of my own history. . . . That is what the time when my mother was alive before *me is — History (moreover, it is the period which interests me most, historically).*
—*Roland Barthes*[1]

Living in New York, it is impossible not to know Ruth Orkin's 1951 photograph *American Girl in Italy* (fig. 1), in which a hip young woman runs a gauntlet of ogling men on an Italian city street. For years, it hung in the old Rizzoli bookstore on Fifth Avenue, but you do not have to be a bibliophile to see it: every neighborhood Italian restaurant or pizzeria seems to have a print or poster, and postcards of the image abound in stores that appeal to tourists.

I do not recall when I first saw that photo, just that it annoyed me. I presumed it was supposed to be amusing, and that it should elicit some nostalgic yearning for an Italian vacation—why else should it be found in businesses that were linked to Italy? Yet I could not but identify with the woman in the picture who, with downcast eyes and a pained expression of trepidation, mechanically continues down the street, trying to ignore the unwanted attention. Years later, I was bothered by the apparent slur on Italian men, who look like imbeciles with their silly eager faces and leering eyes. Obviously, this photo represents a canonical stereotype of Italianness, seemingly both for Americans and Italians—but why? The search for an explanation of the conundrum that Orkin's photo embodies is, on some level, what motivates this text.

The locus or case study for this research is the work of a group of Italian photographers called paparazzi. In 1960 these pesky freelance photojournalists were immortalized in Federico Fellini's internationally popular film *La dolce vita* (The sweet life; released in English as *La Dolce Vita*) (fig. 2). After the movie's release, the word "paparazzi" came to be used to describe these photographers, suggesting that there was something new and untranslatable, something specifically Italian, about these men and the images they made. An analysis of the photographs in terms of the intentions of their makers, the participation of their subjects, and the response of their viewers indicates the way Italians perceived themselves, how they perceived Americans, and, through the international distribution of these images, the way Americans saw Italy circa 1960.

In order to compete with the growing popularity of television, Hollywood in the mid-1950s began to produce epic dramas in foreign lands, dazzling their audiences with colorful spectacles that exploded on the new oversize CinemaScope and VistaVision screens. Italy, through Cinecittà, offered experienced personnel at lower wages and perfect locations for historical epics like William Wyler's *Ben Hur* (1959). Since the Italian profits of American companies could not leave the country, the United States filmmakers were forced to reinvest, and their stars were happy to use the tax advantages of working abroad. With the influx of American movie people, Rome became known as "Hollywood on the Tiber," and as the airlines enabled easier cross-Atlantic travel, the city turned into a playground for the so-called "jet set," whose nocturnal amusements centered on the cafés and nightclubs on and around via Veneto, the only illuminated part of an otherwise rather provincial city (see fig. 3).[2]

A group of photojournalists staked out "the beach," as via Veneto was known to Americans at that time, waiting to get a shot of some action they could sell to the print

media. Certainly newshound press photographers had been around for decades at this point (though they were censored in Italy during the Fascist period), yet this particular group of photographers made an art of getting their celebrity (or celebrity-wannabee) subjects to act out or react for the camera. Although some of their most important photographs were surreptitious shots of Italian politicians and aristocrats caught in scandalous circumstances, the international reputation of the paparazzi was built on the record of their confrontational encounters with show-business personalities. Their canonical images involve those perennial commodities— sex (a drunken starlet *en déshabillé*, dancing in the street) and the aroma of violence (the minor male actor attacking the photographer [see figs. 4, 5]). They are frequently shot at night, with a flash, and often the subject is moving, resulting in a photograph that catches a minutely abbreviated action and flattens it against the black background of the night, giving the image a caricatural quality.[3]

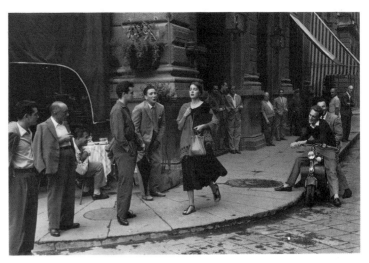

By all accounts, the heyday of these Roman photo-reporters was 1958. A watershed event occurred that year during the August weekend of the *Ferragosto* holiday, when the photographer Tazio Secchiaroli scored a hat trick. In one night he managed to elicit the ire of the exiled playboy-king Farouk of Egypt; Anita Ekberg's husband, the actor Anthony Steel, tried to beat him up; and he caught Ava Gardner and Tony Franciosa, costars shooting Henry Koster's *The Naked Maja* (1959), fighting in the street.[4] Fellini apparently witnessed the Farouk confrontation, and shortly thereafter, he started hanging out with the photographers, learning their trade as part of the research for his next movie.

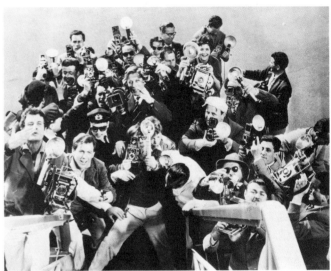

The director had been a provincial kid who came to Rome and was both awed and alienated by what he perceived as the sophistication of the city. He barely subsisted on the money he made drawing caricatures of tourists and pirating American comics. Perhaps he was drawn to the caricatural quality of the photojournalists' images, which, like the sketches Fellini drew throughout his life, emphasize grotesque exaggeration for comic effect. In any event, his next film, *La dolce vita*, focused on the life of a jaded journalist, Marcello (played by Marcello Mastroianni), and his photographer colleague, Paparazzo (Walter Santesso), a character modeled on Secchiaroli. The origin of the name Paparazzo is disputed, but its onomatopoeic resemblance to the Sicilian word for an oversize mosquito, *papataceo*, seems apt in light of Fellini's statement, "*Paparazzo* suggests to me a buzzing insect, hovering, darting, stinging."[5] His drawing of the character (fig. 6), in which the photographer swoops over his prey in a fluid, seemingly airborn arabesque, unhampered by the mechanical limitations of human bone structure, suggests a rather vampirish insectile quality, and implies that paparazzi, like mosquitoes, are also *parassiti*.

fig. 1. Ruth Orkin, American Girl in Italy, *1951. Gelatin-silver print, 20.3 x 25.4 cm. Estate of Ruth Orkin. © 1952, 1980 Ruth Orkin.*

fig. 2. Paparazzi in a scene from Federico Fellini's La dolce vita, *1960.*

fig. 3. Sergio Spinelli, Orson Welles acquista giornali a via Veneto *(Orson Welles Buys Newspapers on via Veneto), 1958, printed 1993. Gelatin-silver print, 40.5 x 30.5 cm. Collection of the artist, Rome.*

La dolce vita reenacts various scandals and haute bourgeois escapades reported in newspapers and shot by the paparazzi in the late 1950s. Fellini claimed that he was putting newspapers and weeklies on film, and many of the vignettes that make up the movie refer directly to news stories.[6] For example, the opening shot of a statue being

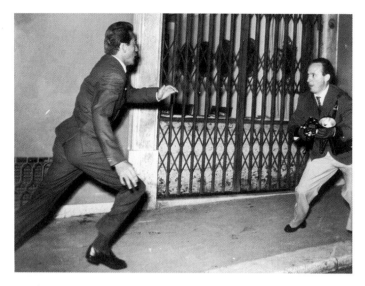

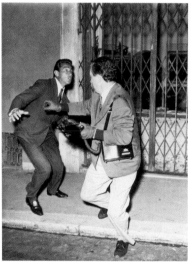

fig. 4. Elio Sorci, Walter Chiari and Tazio Secchiaroli, *1958. Gelatin-silver print. Agenzia Masi, Milan.*

fig. 5. Elio Sorci, Walter Chiari and Tazio Secchiaroli, *1958. Gelatin-silver print. Agenzia Masi, Milan.*

transported by helicopter over Rome recalled an event that took place in 1950; the film's "miracle" at Terni, in which some children claim to see the Virgin, developed from a Terni boy's story, which Secchiaroli scooped; and the character of Steiner, who murders his children and commits suicide, was based on a French news item Fellini had read.

Stills from *La dolce vita* often look like paparazzi photos. At times, in fact, it is difficult to tell them apart, which underlines Fellini's success at capturing the essence of the photographers' work, while indicating the director's desire to blend art and life in a kind of Pirandellian continuum. The images of Ekberg are a case in point. Pierluigi Praturlon's 1957 photograph of the actress dipping her feet into the Trevi Fountain, a canonical paparazzi image, was internationally syndicated and inspired the famed synonymous scene in *La dolce vita* (fig. 7).[7] Fellini made a practice of hiring paparazzi to shoot on the set, for publicity purposes, and so Praturlon came to photograph the cinematic reenactment of the event he had originally recorded.[8] Fellini's film complicates Susan Sontag's dictum that "the photographed world stands in the same, essentially inaccurate relation to the real world as stills do to movies."[9] By reanimating paparazzi photographs, which originally focused on freezing frenzied movement, the equation is reversed. Secchiaroli has said that his challenge was to capture action (as opposed to shooting fixed subjects like those of Weegee, for example), and Fellini preferred the medium of film "because it re-creates life in movement."[10] In *La dolce vita*, the director appears to have re-created the fixed photographs of movement as life on film.[11] Like Pirandello's characters in search of an author, the paparazzi-inspired media events Fellini found begged for a story.

Fellini further confounded the art/life (or fantasy/reality) dialectic in *La dolce vita* by hiring as actors the minor celebrities and social figures who were the actual objects of the Roman paparazzi. Not only was Ekberg the subject of the famous Trevi Fountain scoop, but her husband Anthony Steel was the protagonist of the notorious *Ferragosto* series of photos in which he chased Secchiaroli. Thus the film scene in which the Ekberg character's drunken husband beats up Marcello refers rather explicitly to her real husband's antics.[12] This kind of "realism" is exactly the opposite of neorealist practice, in which the story, locations, and actors reflect the lived experience of economically disadvantaged protagonists. In *La dolce vita*, in fact, the re-enactment of actual events and the employment of non-actors engenders an intense feeling of artificiality. The simulation becomes real, while real events seem artificial.

There is a surrealistic flavor to the publicity stills from Fellini's films. Frequently he could be found on the set among the actors, giving instructions, as in the famous shot, taken during the filming of *Otto e mezzo* (1963; released in English as *8 1/2*), of the director cracking a whip as Mastroianni looks on. It is as if Fellini had crossed over and entered the film; like the young wife in *Lo sceicco bianco* (*The White Sheik*, 1951), who is swept into the production of the romantic photographic comic strip she fantasizes about, he breaks the fiction's membrane and joins his characters. In some ways, the technique of the paparazzi

resembles that of the director, in that the photographer often orchestrated his picture and became a part of it, rather than passively happening upon a scene to record.

In *Camera Lucida*, Roland Barthes notes that "a photograph can be the object of three practices (or of three emotions, or of three intentions): to do, to undergo, to look." [13] The subjects of these verbs are the photographer, the thing photographed, and the viewer, respectively. Meaning that devolves from, or is interpreted as residing in, a photographic representation is intermingled in these three practices. In traditional art-historical analysis, the first term, that of the creator, is privileged: the genius of the painter or sculptor solely determines the image he (this tradition usually presumes male genius) constructs. The artist inscribes meaning into his work without the significant intervention of the other practices cited by Barthes. This conception of the heroic creator was not readily applied to the photographer because the camera's mimetic capability argued for the objectivity associated with technology and thus, conversely, the photographer's reduced ability to leave his distinct personal mark on the image captured by the machine. The use of photography in scientific investigation and journalistic documentation continues to cloud its status as an art form. Instead, the photographer is categorized as a species of scientist; in Barthesian terms, that which undergoes is more significant than he who does (a photographer "takes" rather than "makes" a picture). The paparazzi, unwittingly perhaps, blasted assumptions about the scientific objectivity of the medium by transgressing the imagined boundary between the photographer/observer and the subject of his images. They do not fit the model of the passive scientific recorder, nor that of the solitary artistic genius unaffected by his subject. Like Fellini, they have crossed over into the world of their images, implicating themselves in their pictures. [14]

The paparazzi actively created the scenes they shot, recording their subject's response to the fact of their possession of a camera. If nothing exciting enough to sell was happening that day, they baited drunken actors in order to capture their ire on film, they posed pictures to look as if they had occurred spontaneously, and they were not above puncturing a tire to generate some action. Certainly their subjects were willing participants in the process: minor actors gave them their evening's itinerary so that they would be photographed in the company of more famous celebrities, hoping their stock would rise by association; and all manner of starlets would perform an "improptu" dance or sanitized striptease for the camera. Paparazzi photos usually include other photographers, often being chased or threatened by their prey. [15] Or the entire shot will be filled with paparazzi and their prominent cameras and unwieldy flashes, emphasizing that the true subject of the picture is less the celebrity than the celebrity being pursued by hordes of photographers. The photographers themselves—their existence and their actions—are the manifest subject; without them, by definition, the image would not exist.

When *La dolce vita* was released, a few critics argued that Fellini wanted to show the decadent flipside of the American luxury life-style promoted in postwar Italy through the Marshall Plan and its reconstruction

fig. 6. Federico Fellini's drawing of Paparazzo, a character in his film La dolce vita, *1960.*

fig. 7. Anita Ekberg in Federico Fellini's La dolce vita, *1960.*

fig. 8. Nadia Gray in Federico Fellini's
La dolce vita, 1960.

fig. 9. Tazio Secchiaroli, Il Rugantino,
1958, printed 1993. Gelatin-silver print,
39.5 x 30.5 cm. Collection of the artist,
Rome.

initiatives.[16] Perhaps, concomitantly, the paparazzi, whose caricatural images are arguably critical of the inanities of their subjects, could be said to share this motivation.[17] If this is the case, then, like so many moralists, Fellini and the paparazzi are a little too enamored of their salacious nemeses. The debaucheries of *La dolce vita* conclude with a beach-house party in which a new divorcée performs a striptease in celebration of her liberation (fig. 8). This rather tedious gathering was meant to be seen as an orgy, since burlesque was illegal in Italy (as was divorce), though both were available abroad and, as such, could be perceived as imports, possibly "Made in America." Once again, this film scene was based on a canonical paparazzi scoop, a series of Secchiaroli photographs of a striptease performed at a high-society party, which had been hosted by an American millionaire in a Trastevere restaurant called Il Rugantino (fig. 9, cat. nos. 404–06). The images of socialites absorbed by the stripper created a huge scandal, and the police tried to confiscate the negatives.[18]

Striptease itself certainly had American associations for Europeans: it was developed in the American burlesque theater, and often the word was not translated from English, reiterating its non-European roots.[19] If the inclusion of a striptease in *La dolce vita* was an oblique reference to the infiltration of American customs into Italian society, Ekberg's character in the film was an obvious and undeniable portrait of that trademark Hollywood export, the buxom, platinum-blond sex goddess.[20] In the film, Ekberg seems larger than life; she is the European stereotype of the hypertrophied American woman, monumentalized.[21] "Bombshells" like Ekberg, Linda Christian, Jayne Mansfield, and Kim Novak were the stock-in-trade of the paparazzi, and aspiring starlets of this variety flocked to Rome in the late 1950s, where they satisfied a publicity-market niche.

The international dissemination of paparazzi photographs, and especially Italian films, gave Americans the opportunity to see postwar Italy. Although portraits of Americans in Italy were often available in these representations, American viewers usually seemed less willing or able to recognize themselves, and more interested in the quaintness of a foreign land and people. American criticism of *La dolce vita* upon its 1961 United States release emphasizes Fellini's moralism, typically not reading references to its American implications, but centering instead on the decadence of the ancient city of Rome. *Life* magazine carried a picture spread of stills from the film, with a sizable doublespread of the stripping divorcée from the orgy finale, under the heading, "Angry Cry against a Sinful City."[22]

The incorporation of the word paparazzi into the English language is inextricably tied to the popular reception of Fellini's film. In 1961, shortly before the release of the movie, which had been anticipated from the time of its controversial opening in Italy the year before, *Time* magazine introduced the Italian word to the American public in an article entitled "*Paparazzi* on the Prowl."[23] Below a paparazzi image of a throng of photographers blocking the car of a princess visiting Rome, the text describes the newshounds as "a ravenous wolf pack of freelance photographers who stalk big names for a living

and fire with flash guns at pointblank range." The article lists the American stars who are taunted by the "bullyboys" who sell their photos to the Italian press. Clearly, *paparazzo* was a derogatory term: "Legitimate news photographers," the text discloses, "scorn the *paparazzi* as streetwalkers of Roman journalism." [24]

Two points are implicit in this and other United States reports about paparazzi. First, the inference is that this type of photojournalism is new. Certainly other photographers received payment for their prints, so the commercial interest of these photographers was hardly indictable. Yet the *Time* reference suggests the unique crassness of the paparazzi, that they were not known for the quality of their images but rather for the rarity of their subjects, which they not only captured through a tenacious pursuit of their prey but which they actually manufactured. And second, the persistence of the word paparazzi (instead of "freelance photographer" or "press photographer") suggests that foreigners had invented this debased form of journalism; it could thus be inferred that Americans were above such a practice. Up until this time, in the American moral universe as represented on film, an ambitious reporter of questionable ethics might pursue his target with relentless and deceitful ingenuity, but, in the end, these characters would do the right thing when their healthy ethical sensibility was awakened. Just such a story is William Wyler's *Roman Holiday* (1953), a film in which Gregory Peck plays a down-and-out expatriate reporter who proves himself the consummate gentleman by not revealing princess Audrey Hepburn's nocturnal escapades. [25] Mastroianni's character in *La dolce vita* is the Peck character's evil twin, the (more realistic?) obverse of the mythological Wyler creation.

The definitive paparazzi image, like the print published by *Time*, shows a woman surrounded by a gaggle of male photographers. Variations on this theme abound. In 1962 Fellini published a personal essay in an Italian weekly about the genesis of *La dolce vita*, which was profusely illustrated with paparazzi photos. The next year, *Esquire* printed a translation of the text, accompanied by a photospread somewhat different from the Italian version. [26] As could be expected, the articles' illustrations summarize paparazzi style. Along with the famous Steel and Chiari fistfights are numerous spectacles of female sexuality: an Italian actress doing the cancan for the camera; an American aspiring starlet with a hula hoop; an American dancer performing on the street; and, of course, Ekberg, are all included. One caption reads, "Jayne Mansfield unbuckles armor in near-strip." In several images, the woman is surrounded by leering men or by craning photographers with their cameras. The repetition of this image underlines the hunting metaphors associated with photography in general and paparazzi in particular. In this case, the woman is the prey, whose capture the photo-reporter seeks. While the photographer is the model of the masculine hunter extraordinaire, the female subject is conceived in animalistic terms, nowhere more obviously than in Fellini's portrayal of Ekberg as a trophy whose bestial behavior—she runs barefoot through the city streets, makes a companion of a kitten, and actually bays at the moon—heightens her sexual appeal.

Many paparazzi photographs express, on some level, a notion of a particularly American kind of feminine sexual absorption and flamboyance, which indicates Hollywood-inspired Italian stereotypes about Americans. Americans, meanwhile, were equally involved in projecting an analogously sexual national identity for Italians. The preponderance of paparazzi photos of women surrounded by leering men recall the Orkin topos, despite the typical seductively smiling faces in the photo-reporters' shots, which counter the Orkin model's expression of shame.

Orkin's photo, originally part of a series of posed images suggesting the activities of a young female tourist in Italy, was first printed in a *Cosmopolitan* article with the caption:

Public admiration in Florence shouldn't fluster you. Ogling the ladies is a popular, harmless, and flattering pastime you'll run into in many foreign countries. The gentlemen are usually louder and more demonstrative than American men, but they mean no harm. [27]

This leitmotiv of intercultural scopophilia—the leering Italian man who inspects the demure, guileless tourist—recurs frequently in American journalistic accounts of Italy in the 1950s and 1960s. [28] Although the image suggests notions of guilt and shame not so close to the surface in the paparazzi photos, they are nevertheless linked. [29] The trope of gazing male/gazed-upon female, whether imbued with suggestions of imposed shame, complicit delight, or both, was prolifically produced by both Americans and Italians, proclaiming a uniquely Italian delight in the specular.

Mario De Biasi, in his 1953 photograph *Gli italiani si voltano* (*The Italians Turn Around*), participated in the construction of this formula (fig. 10). Images like his and Orkin's offer a shorthand way to convey Italianness, an Italianness wound in sexual tension. In 1964 the American-educated Milanese critic Luigi Barzini published *The Italians*, a wide-ranging analysis of the country's culture and norms grounded in several centuries' worth of history and literature. [30] In a review of Barzini's best-selling book, which narrowly focused on a picturesque history of foreigners' attraction to Italians, *Time* reused Orkin's thirteen-year-old photo with the enigmatic caption "Italian Street Scene, Deceptions can be disastrous." [31] A *Newsweek* review carried a photograph by Nicola Sansone of the author ogling some young women with the caption "Barzini in Rome: The ecstasy and the anguish." [32]

These representations are symptomatic of the American delight in conceiving of the sensual Italian Other. Models of excess in this vein are Paul Schutzer's 1963 *Life* photo-essay, "The Italian Man," which is a rhapsody of bulging muscles and overblown prose:

The Italian man is the most natural of men. . . . As his country—and his spirits—revived, the world has become better acquainted and even fascinated with his engaging qualities. For his candid enthusiasm and sensuality have helped fill the world with music and art, laughter and love and a particular kind of triumphant masculinity. . . . He has an explicit and unaffected delight in himself and in his world and seems lost in admiration for both. In fact, he seems completely unable to decide which is more wonderful—the world or himself. [33]

During this period, a series of Italian actors (Rossano

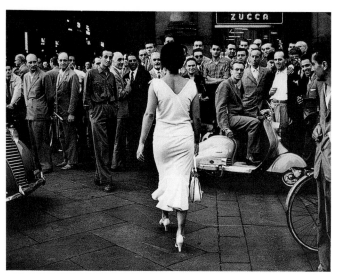

fig. 10. *Mario De Biasi, Gli italiani si voltano (The Italians Turn Around), 1953. Gelatin-silver print, 30.5 x 40 cm. Collection of the artist, Milan.*

Brazzi, Marcello Mastroianni, Sofia Loren, Gina Lollobrigida) became international movie stars and sex symbols beloved in the United States. A favorite fantasy movie theme of the period was the story of an American woman's trip to Italy, where she finds love in the arms of an Italian stranger. Examples include David Lean's *Summertime* (1955), with Brazzi and Katharine Hepburn; Jose Quintero's *The Roman Spring of Mrs. Stone* (1961), in which Warren Beatty, with a preposterous Italian accent, plays a gigolo; and Delmer Daves's *Rome Adventure* (1962), in which Brazzi appears as a school teacher's romantic interest. A *Reader's Digest* excerpt from Letitia Baldridge's memoir of her sojourn as social secretary to Ambassador Clare Boothe Luce, *Roman Candle*, reads like a trailer to one of these films:

Nowhere is a girl made to feel so desirable, so sought after, so conscious of her sex as in Italy. . . . This awareness, one sex of the other, pervades the whole day. . . . At my garage I find Eduardo—six feet three of bronzed muscle, topped with a Praxiteles head and black curls, and with chestnut eyes that could melt an iceberg. . . . It's this wonderful tensione *between the sexes that is an important part of the charm of living in Italy. There is no other country where a "he" feels more like a "he" and a "she" feels more like a "she"—and terribly glad of it.*[34]

Baldridge's reverie highlights the sexual crucible in which American-Italian stereotypes were formed. The Italian is the fantasy fulfillment of sexual desire, possessing unique access to a world of sensual fulfillment. In order to construct such a privileged Other, the self must be posed as the opposite: thus, in her text, Baldridge distinguishes Latin characteristics from Anglo-Saxon ones. An identity trait can only exist in juxtaposition to another trait; in other words, the trait of thriftiness can only exist if someone else is spendthrift. The theoretical underpinning of this assertion can be found in Saussure's linguistic analysis, or simply extrapolated from the old biblical exegesis that evil exists only as a way to define good.

Of course, stereotypical presumptions were also registered in the other direction, with Italians perpetuating myths about Americans, and subsequently taking the moral high road for themselves. Fellini, whose film *La dolce vita* can be read as an indictment of the life it portrays, frequently recounted stories about Americans' enthusiastic response to the film, perhaps implying that the Americans were unable to understand the film's critique, since they themselves unwittingly espoused the decadence portrayed.[35] Certainly paparazzi photos, because of their subject matter and the nature of photography itself, propagated the dynamic of American-Italian sexual clichés. Sontag could have been summarizing the operation of paparazzi images when she wrote, "But essentially the camera makes everyone a tourist in other people's reality, and eventually in one's own."[36]

Paparazzi photos should not be judged by traditional aesthetic criteria. They operate as social documents, and as such are more productively read as performance documentation than as static masterpieces intended for exhibition. Their mode of dissemination, through

magazines and newspapers, is central to their existence, and framed prints can only recall their primary role. They were intended to serve not an elite but a mass audience, and to give this audience the sensation of access to a world beyond its own. Stylistically, through their occasionally haphazard framing and frequently unflattering poses, they suggest the family snapshot, and the embarrassing moments of *Candid Camera*, when any average Joe might find a few minutes in the limelight through personal humiliation.

Like a family portrait in which nasty cousin Billy jumps in at the last second and makes the sign of devil's horns behind Aunt Susie's head, the paparazzi represent a familiar juvenile impulse to wreck the picture, to make a fool of someone else, and to become, finally, the privileged subject of the photo. In Fellini's Oscar-winning film *Le notti di Cabiria* (1956; released as *The Nights of Cabiria* and later as *Cabiria*), the eponymous prostitute expresses a comparable desire to document herself at center stage when she asks the film star who has unexpectedly asked her to his home to inscribe a publicity still to her, so that she will be able to prove that she had been there.[37] Nevertheless, Cabiria's associates do not believe her; only a photograph showing her with the star would have presented incontrovertible proof.

Because paparazzi photos were circulated through the press, any reader could, in essence, own the picture through possession of the magazine or newspaper in which it was printed. Unlike film, or television, whose fleeting images constantly frustrate the desire to linger over them, the photograph invites leisurely perusal. There is a fetishistic component to the pleasure of "owning" the picture in a magazine, which the paparazzi photo shares with pornography. Significantly, pornographic magazines began to be widely disseminated in roughly the same period as the rise of paparazzi journalism, with which it shares a number of characteristics.[38] The frequently risqué sexual subject matter of paparazzi photos obviously overlaps with that of porn magazines, as does their fetishistic mode of commodity consumption.[39] And both pornography and paparazzi photos privilege images in which the subject directly addresses the viewer, by looking at the photographer, thereby destroying the image's fictional narrative. This mode of direct address has been identified by film theorists as a characteristic of pornographic cinema, in which an especial exhibitionistic pleasure is derived from the shot of a woman gazing out at the male viewer.[40]

The status of the celebrity as mythical object of desire makes the paparazzi's confrontational behavior both explicable and necessary. He expresses for his viewers their desire to have access to the oracle for themselves. Of course, the most satisfying shot is the direct, frontal one, that of religious icons, in which the subject looks straight at the camera. This yields the voyeuristic thrill Barthes yearns for but does not find in disaster photo-reportage, when he laments, "Oh, if there were only a look, a subject's look, if only someone in the photographs were looking at me!"[41] It does not matter if this subject is flipping you the bird or smiling, it is *you* who are addressed, with all the attendant pride and delight at being the object of attention.[42] Literary critic Eve Kosofsky Sedgwick has noted recently that the roots of shame are said to lie in the child's consciousness of his/her mother's turning away, breaking the visual circuit

of mirroring and acknowledgment on which the child thrives.[43] Perhaps the intensity of the desire to feel the gaze returned is inherited from the first moments of shame, relief from which occurs only with the return of attention.

If the developmental roots of shame lie in *not* being looked at, it is interesting how shame, almost as a kind of compensation, comes to be associated with being the object of attention. In adulthood, the desire to be looked at is frequently perceived as vanity, which is often considered a defect for which the bearer ought to (but significantly does not) feel shame. Attitudes toward shame and vanity, like all values, vary according to the identity of the parties involved. Thus, Orkin's photo of the demure tourist fits ingrained societal expectations of "proper" feminine behavior. Pleasure is traditionally the domain of the viewer, typically the male viewer, and female pleasure is always suspect. Any doubts about this assumption can be resolved by imagining alternate scenarios: an elated, swaggering female tourist would immediately suggest the sexually provocative exhibitionism that is the province of performers (and the subject of paparazzi). A male tourist surrounded by leering Italian women taxes the imagination.[44]

If, in constructing identity stereotypes, the party who sets the terms of the construction can be expected to assimilate superior attributes to itself; and if it is believed that it is morally superior to feel shame and, conversely, morally inferior to be vain; then, naturally, shame will reside in the determining party and vanity will be the province of its Other. For example, the Orkin model's downcast eyes connote her embarrassment and fit American expectations of suitable feminine deportment, whereas the "shameless" starlets captured by the paparazzi probably conform to Italian expectations of Americans. Here, both Italian and American ideals of femininity are shared; they diverge in terms of who is perceived as possessing them. Such does not obtain in the case of masculine behavior, where shame is not considered a morally superior attribute for any man, though attitudes toward vanity arguably differ. Thus the exhibitionistic Italian man portrayed in Schutzer's *Life* photospread receives a backhanded compliment—he is, in implicit contrast to the American male, seen as vain.[45] Endless examples like this one exist, each informed by infinitely complex nuances of cultural, sexual, and racial presumption, to name just three factors. Picking them apart analytically to expose their myriad determining threads yields a panoply of local variations.

A 1988 exhibition catalogue entitled *Paparazzi* reproduces a 1958 series of brothel photographs by Velio Cioni that recall Brassaï's grainy images of thirty years earlier. In each of the pictures, the eyes of the *casa di tolleranza* patrons have been obscured in the most rudimentary way, by scratching through the shiny emulsion coating of the print, exposing the matte white photographic paper underneath. This low-tech precursor of video's black bar over the eyes and computer-generated interference shares with them a thoroughly unconvincing attempt to mask the identity of its subject, suggesting that, in some circumstances, the (universal?) desire to be seen involves not being seen seeing.

The word paparazzi is still used to describe a kind of

intrusive multimedia celebrity journalism, despite the fact that its practice was developed beyond Rome's city limits and expanded to television long ago. The in-your-face confrontational style of *60 Minutes*, progenitor of today's reality-based TV, owes something of its influential methodology to the paparazzi's newsmaking practice. The history of paparazzi photography, its influences and dissemination, is a significant chapter in the history-in-process that is the globalization of communications in the twentieth century.

I would like to thank the following interns who assisted in the preparation of this manuscript: Maura Pozzati, Giorgio Pace, Hilda Werschkul, and, especially, Jennifer Miller.

1. Roland Barthes, *Camera Lucida: Reflections on Photography*, trans. Richard Howard (New York: Farrar, Straus and Giroux, 1981), pp. 64–65.

2. See Hollis Alpert, *Fellini: A Life* (New York: Atheneum, 1986), pp. 6f; and the interview with Tazio Secchiaroli in *Fotologia* 7 (1987), p. 50.

3. See Italo Zannier, "Naked Italy," in *Paparazzi: Fotografie 1953–1964* (Paparazzi: photographs 1953–1964), exhibition catalogue (Venice: Palazzo Fortuny/Florence: Alinari, 1988), p. 26. Professor Zannier is the foremost authority on paparazzi photography; see, among his many publications, *Storia della fotografia italiana* (History of Italian photography. Rome: Editori Laterza, 1986).

4. See Federica di Castro, "Tazio Secchiaroli. Il reale e l'immaginario" (Tazio Secchiaroli. The real and the imaginary) in Uliano Lucas and Maurizio Bizzicari, eds., *L'informazione negata: Il fotogiornalismo in Italia 1945/1980* (Denied as information: photojournalism in Italy 1945–1980), exhibition catalogue (Bari: Dedalo libri, 1981), p. 111; and Massimo Di Forti, "Flash Warning: The Paparazzi Are Coming," in "Immagini Italiane" (Italian images), *Aperture* 132 (summer 1993), pp. 20–25.

5. Federico Fellini quoted in "*Paparazzi* on the Prowl," *Time*, April 14, 1961, p. 81. The *papataceo* comparison was first made by Andrea Nemiz in his book *Vita, dolce vita* (Life, sweet life. Rome: Network Edizioni, 1983), pp. 110–11, who notes that Fellini's screenplay collaborator, Ennio Flaiano, claimed that the name was that of a Calabrian innkeeper in George Gissing's book *By the Ionian Sea*. Nemiz is cited in Zannier, "Naked Italy," p. 11, who also offers an alternative explanation, that Paparazzo was the name of the owner of a hotel on the Ionic where Fellini had once stayed. See also Peter Bondanella, *The Cinema of Federico Fellini*, with a foreword by Federico Fellini (Princeton: Princeton University Press, 1992), p. 136.

6. Eileen Lanouette Hughes, "La Dolce Vita of Federico Fellini," *Esquire* 54 (August 1960), p. 75: "Properly speaking, it is not a movie in the conventional sense, but in [Fellini's] own words 'a newspaper or rotogravure' on film." ("Rotogravure" is a literal translation of *rotocalco*, signifying glossy weekly magazine.)

7. In another borrowing from life, the evening gown that Ekberg wears in her cinematic nocturnal romp through Rome resembles a gown she wore one night in 1958, which was captured in a series of images by Secchiaroli, among other photographers.

8. The photographs that Pierluigi Praturlon took on the set are often mistaken for film stills, intensifying the dizzying overlap between the film and paparazzi images.

9. Susan Sontag, *On Photography* (New York: Anchor Books, 1990; 1977), p. 81.

10. Di Castro, p. 113; and "Playboy interview: Federico Fellini," *Playboy* 13 (February 1966), p. 58. Fellini continues, "It's not just an art form; it's actually a new form of life. . . ."

11. Sometimes the correspondence between news event and the film scene is less literal. For example, after the orgy finale, Marcello and his fellow partiers see a strange "monster" washed up on the beach. The long shots of the beach crowded with the curious revellers resemble Velio Cioni's photos of the visit of the court to the crime scene of the famous Montesi affair, in which a young woman was found dead on the beach after an all-night party. Robert Neville suggests the similarity in "The Soft Life in Italy," *Harper's Magazine* 221 (September 1960), p. 68, noting that Fellini denied the connection in "Poet-Director Of the Sweet Life," *The New York Times Magazine*, May 14, 1961, p. 86.

12. It could refer as well to any number of other actors who chased the paparazzi, such as Walter Chiari, Ava Gardner's then-beau, who is seen pursuing Secchiaroli in a famous series of photos by Elio Sorci that were reproduced worldwide, including *Esquire* magazine (figs. 4, 5). The actor who played Ekberg's husband in the film was Lex Barker, another habitué of the via Veneto scene.

13. Barthes, 9ff, who identifies the subjects of the verbs as the operator, the spectrum, and the spectator.

14. For an interesting, relevant discussion, see Paolo Costantini, "Evidenze" (Evidence), in *Paparazzi*, p. 37.

15. Ibid., p. 26.

16. See, for example, Neville, "The Soft Life in Italy," pp. 65–68.

17. See Zannier, "Naked Italy," p. 25.

18. The character who performed the scene in *La dolce vita* was called Nadia and was played by Nadia Gray. (The stripper at Il Rugantino was Turkish dancer Aiché Nanà.) In the script, from which Fellini freely diverged, a character in this scene says, *"Ragazzi, adesso Katherine farà lo strip-tease. Un applauso per Katherine!"* (Kids, now Katherine will do a striptease. A round of applause for Katherine!). From Federico Fellini, *La dolce vita* (Milan: Garzanti Editore, 1981), p. 143. Just as "real life" events suggested the film scene, the movie spawned imitators, such as aspiring American actress Nadia Par's improvised strip, which was photographed by paparazzo Marcello Geppetti.

19. There was an international revival in the popularity of striptease on film in the late 1950s and early 1960s (in which *La dolce vita* played a part). Witness the following films: George Sidney's *Pal Joey* (1957); Marc Allégret's *Mademoiselle Striptease*, with Brigitte Bardot (1957); Don Schain's *Too Hot to Handle*, with Jayne Mansfield (1959); Mervyn LeRoy's *Gypsy* (1962, based on the 1957 Broadway musical); Franklin J. Schaffner's *The Stripper* (1963); and the "Tomorrow" story of Vittorio De Sica's *Ieri, oggi, domani* (*Yesterday, Today and Tomorrow*), with Sophia Loren (1964).

20. Fellini found the inspiration for Ekberg's character in an American magazine photograph, according to Alpert, p. 125. Neville, "The Soft Life in Italy," p. 67, argues that Anouk Aimée's American car suggests her Americanization, thus justifying her "nymphomaniac" behavior and treatment in the film.

21. The director refers to the actress as "Anitona" (Big Anita) in Federico Fellini, "La storia di via Veneto," *L'Europeo* 18 (July 1962), p. 60. That Europeans believed Americans to be obsessed with extremely large breasts is indicated by various comments in Denys Chevalier, *Métaphysique du strip-tease* (Metaphysics of the strip-tease. Paris: Jean-Jacques Pauvert, 1961); see, for example, p. 69.

22. *Life* 50 (May 12, 1961), pp. 54–55.

23. See note 5, above.

24. Negative descriptions of paparazzi were to be the standard fare in subsequent published references; see, for example, Hollis Alpert, "Adventures of a Journalist," *Saturday Review* 44 (April 22, 1961), p. 33; and John Simon, "The Sour Truth about the Sweet Life," *Horizon* 4 (September 1961), pp. 110–12.

25. Other films in this vein are *Mr. Deeds Goes to Town* (Frank Capra, 1936) and *His Girl Friday* (Howard Hawks, 1940).

26. Fellini, "La storia di via Veneto," cited in note 21, above, translated as Federico Fellini, "End of the Sweet Parade," *Esquire* 59 (January 1963), pp. 98–108, 128–29; republished as "Via Veneto: dolce vita," in Anna Keel and Christian Strich, eds., *Fellini on Fellini*, trans. Isabel Quigley (New York: Dell Publishing Co., Inc., 1976), pp. 67–83.

27. Emily Jay, "When You Travel Alone . . . ," *Cosmopolitan* 133 (September 1952), pp. 30–34. See Ruth Orkin, *A Photo Journal* (New York: Viking Press, 1981), p. 90, regarding the genesis of the photograph.

28. See, for example, Edith Templeton's diatribe on oversexed Italian men, "Warning to Women Traveling in Italy," *Harper's Magazine* 214 (April 1957), pp. 34–37, which includes an illustration of a matronly woman with glasses besieged by "cherubic" Italian men (that is, short and fat with haloes).

29. In Italy, the tourist was perceived as more complicit, if not a downright seductress. See, for example, Robert Neville's report, "La Dolce Vita Sans Kissing," *The New York Times Magazine*, March 18, 1962, pp. 79, 96. (The article includes an illustration of a statuesque woman surrounded by ogling men with the caption "Irresistible—Italian males are apt to display admiration endlessly and openly.") See also the letters responding to Templeton's article in *Harper's Magazine* 214 (June 1957), p. 6.

30. Luigi Barzini, *The Italians* (New York: Atheneum Publishers, 1964).

31. "Reflections on the Italians," *Time*, September 25, 1964, p. 100.

32. "Putting Up a Front," *Newsweek*, August 24, 1964, p. 85.

33. "The Italian Man," with photographs by Paul Schutzer, *Life* 55 (August 23, 1963), pp. 55ff.

34. Letitia Baldrige, "Why I Love Italian Men," *Reader's Digest* 71 (July 1957), pp. 58–60.

35. Fellini frequently claimed that the via Veneto scene was created after the film, by thrillseekers who came to find the life depicted on screen. The director stressed that Americans, especially, begged him to show them "the sweet life." See Fellini, "End of the Sweet Parade," p. 99. See also the director's "Playboy interview," p. 66, in which he mentions that American women besieged him because they thought he had the "key to happiness." There is no doubt that the film influenced tourists' itineraries. Note, for example, the scene in Paul Wendkos's *Gidget Goes to Rome* (1963), in which a *paparazzo* falls into a fountain. Fellini called this "Sviluppi del Gotico" (developments of the gothic), as quoted in Secchiaroli, p. 64, who facetiously notes (p. 65) that *"gli americani vennero in Italia per girare queste scene di paparazzi che cadevano nelle fontane"* (Americans came to Italy to film these scenes of paparazzi falling into fountains).

36. Sontag, p. 57.

37. She tells the star to write, "'Cabiria Ceccarelli was a guest at my house—Alberto Lazzari.'" Earlier, she had screamed to two haughty streetwalkers, "Look! Take a look who is with me!" Clearly, Cabiria's self-worth is determined by association. Correspondingly, the newsworthiness of a *paparazzo's* encounter with a star is largely determined by the celebrity's status. Note that one *paparazzo* is quoted as saying, "I make the Via Veneto, and it makes me," in "Paparazzi on the Prowl," p. 81.

38. The first issue of *Playboy*, with Marilyn Monroe on the cover, appeared in December 1953.

39. Once again, parallels in Fellini's work arise. Note, for example, Christian Strich, ed., *Fellini's Faces*, with a foreword by R. D. Laing, and an introduction by Federico Fellini (New York: Holt, Rinehart and Winston, 1982), which consists of photographs from Fellini's "archive" of potential actors. Numerous images resemble the variety of amateur photograph sent to pornographic magazines, and at least one professional sex worker, Chesty Morgan, is included.

40. See Paul Willemen, "Letter to John," in *Screen, The Sexual Subject: A Screen Reader in Sexuality* (London and New York: Routledge, 1992), pp. 171–83.

41. Barthes, p. 111.

42. Note, for example, Secchiaroli's photo of Fellini making an obscene gesture directly at the camera. See also Ron Galella's book *Offguard: A Paparazzo Look at the Beautiful People* (New York: McGraw-Hill Book Co., 1976), which is filled with photos of celebrities covering their faces or angrily confronting the camera. Galella was instrumental in disseminating the concept of a "*paparazzo* approach" in the United States, because he frequently defended his work by referring to it in this way, most notably in the legal proceedings that resulted from his hounding of Jacqueline Kennedy Onassis in the early 1970s.

43. Eve Kosofsky Sedgwick, "Queer Performativity: Henry James's *The Art of the Novel*," *GLQ: A Journal of Lesbian and Gay Studies* 1 (1993), pp. 1–16.

44. This means of analysis through reversal owes a debt to Linda Nochlin's ground-breaking essay, "Eroticism and Female Imagery in Nineteenth-Century Art," in Thomas B. Hess and Linda Nochlin, eds., *Woman as Sex Object* (New York: Newsweek, Inc., 1972), pp. 8–15; reprinted in Nochlin, *Women, Art, and Power and Other Essays* (New York: Harper & Row, 1988), pp. 136–44.

45. Many other depictions of Italian male vanity could be cited, along with the implication, typical of American commentators, that this vanity renders their masculinity in question. While the gigolo is frequently a comic character in both Italian and American films, it is perhaps significant that the illustrations to the Italian version of Fellini's article include many photos of American actresses in the company of Italian men, none of which were reproduced in the United States publication. These editorial decisions may reflect differing standards of journalistic moral responsibility and perceptions of reader taste. They may also indicate more deep-seated cultural anxieties.

Photography
Catalogue numbers 366–471

Vincenzo Balocchi
Mario Bellavista
Gianni Berengo Gardin
Carlo Bevilacqua
Gianni Borghesan
Piergiorgio Branzi
Alfredo Camisa
Mario Carrieri
Giuseppe Cavalli
Carla Cerati
Carlo Cisventi
Cesare Colombo
Mario De Biasi
Toni Del Tin
Pietro Donzelli
Mario Finazzi
Mario Giacomelli
Guido Guidi
Mimmo Jodice
Alberto Lattuada
Ferruccio Leiss
Elio Luxardo
Nino {Antonio} Migliori
Carlo Mollino
Paolo Monti
Ugo Mulas
Federico Patellani
Antonio Persico
Tino Petrelli
Publifoto
Fulvio Roiter
Chiara Samugheo
Ferdinando Scianna
Tazio Secchiaroli
Sergio Spinelli
Giuseppe Vannucci Zauli
Federico Vender
Luigi Veronesi
Italo Zannier

366. Elio Luxardo
L'Italica bellezza (The Italianate
Beauty), *ca. 1940. Gelatin-silver print,
39.7 x 29.7 cm. Fototeca 3M, Milan.*

367. Elio Luxardo
Torso di uomo (Man's Torso), *ca. 1940.
Gelatin-silver print, 38 x 28.5 cm.
Fototeca 3M, Milan.*

366. Elio Luxardo
L'Italica bellezza (The Italianate
Beauty), *ca. 1940. Gelatin-silver print,
39.7 x 29.7 cm. Fototeca 3M, Milan.*

367. Elio Luxardo
Torso di uomo (Man's Torso), *ca. 1940.
Gelatin-silver print, 38 x 28.5 cm.
Fototeca 3M, Milan.*

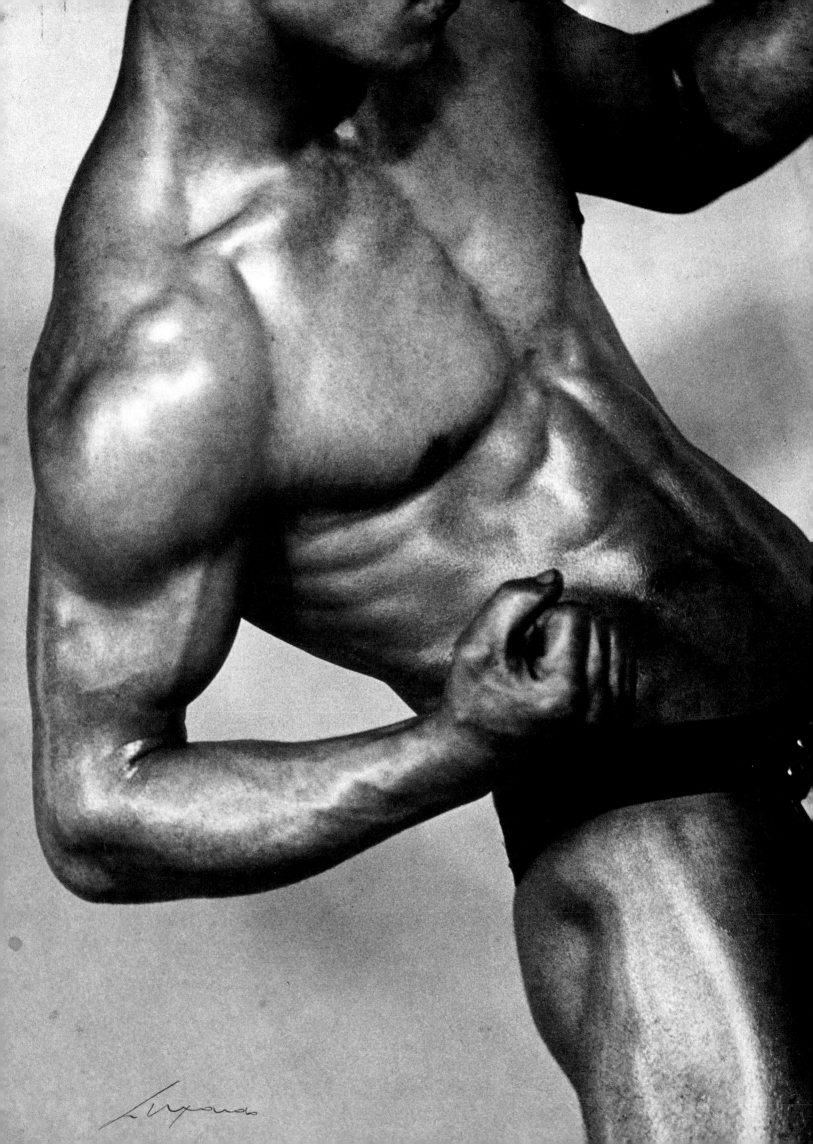

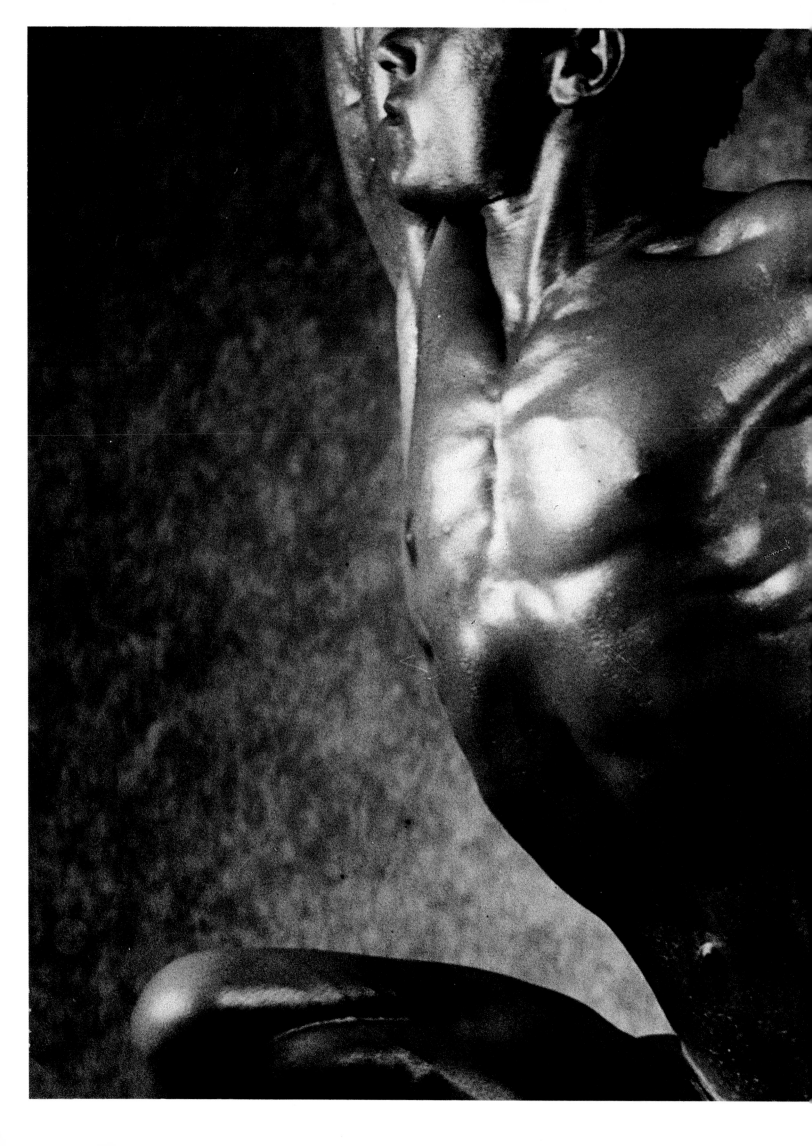

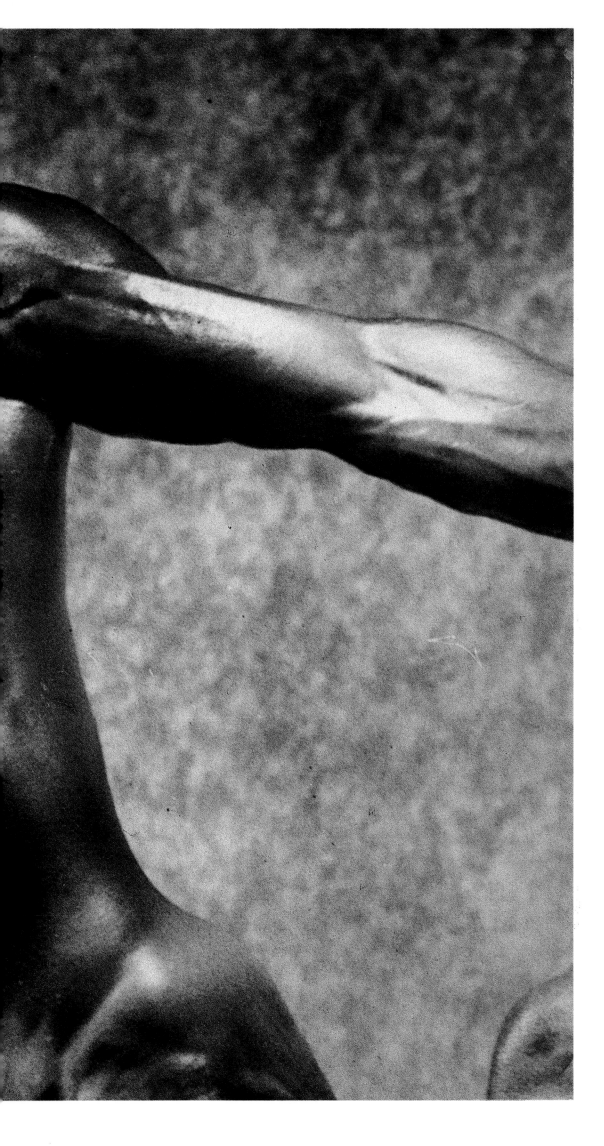

368. Elio Luxardo
Torso di uomo (Man's Torso), *ca. 1940.*
Gelatin-silver print, 30 x 40 cm.
Fototeca 3M, Milan.

369. Elio Luxardo
Torso di donna (Woman's Torso),
ca. 1940. Gelatin-silver print, 39 x
29.5 cm. Fototeca 3M, Milan.

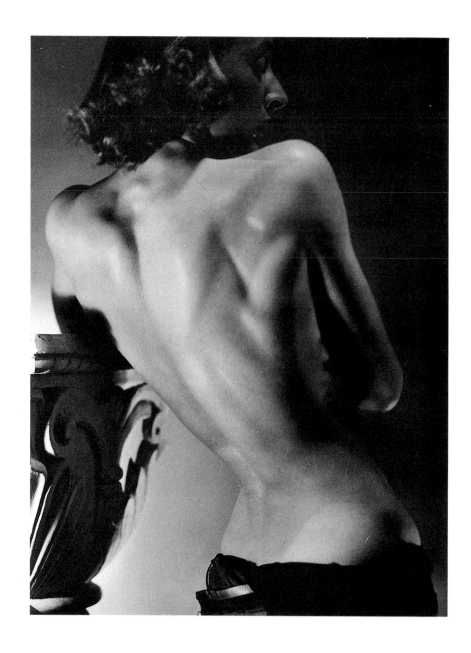

370. Elio Luxardo
Torso di donna *(Woman's Torso),*
ca. 1940. Gelatin-silver print, 38 x
28.5 cm. Fototeca 3M, Milan.

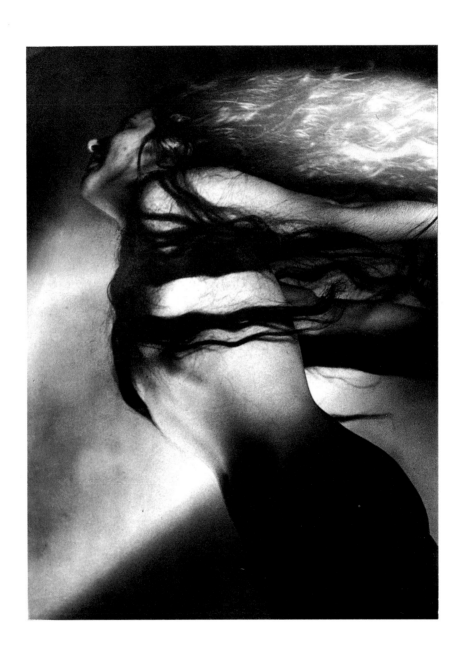

371. Alberto Lattuada
La Fiera di Senigallia, Milano
(The Fair in Senigallia, Milan). *1940,
printed 1993. Gelatin-silver print, 28 x
28 cm. Archivi Alinari, Archivio
Lattuada, Lattuada Gift, Florence.*

372. Alberto Lattuada
La Fiera di Senigallia, Milano
(The Fair in Senigallia, Milan). *1940,
printed 1993. Gelatin-silver print, 28 x
28 cm. Archivi Alinari, Archivio
Lattuada, Lattuada Gift, Florence.*

374. Carlo Mollino

Senza titolo (Untitled), *ca. 1937,
printed 1989. Gelatin-silver print,
38 x 30 cm. Politecnico di Torino,
Sistema Bibliotecario, Biblioteca
Centrale di Architettura, Archivio
Carlo Mollino, Turin.*

375. Carlo Mollino
Genesi (Genesis), *1935. Gelatin-silver*
print, 31.6 x 26.8 cm. Politecnico di
Torino, Sistema Bibliotecario,
Biblioteca Centrale di Architettura,
Archivio Carlo Mollino, Turin.

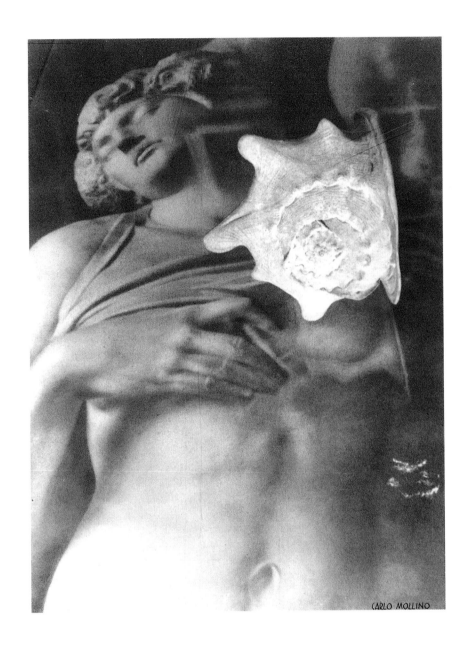

376. Mario Bellavista
Sinfonia (Symphony), *ca. 1940.*
Gelatin-silver print, 22.8 x 22.8 cm.
Museo di Storia della Fotografia
Fratelli Alinari, Collezione Zannier,
Florence.

377. Mario Bellavista
Prua (Bow), *ca. 1945. Gelatin-silver print, 23.5 x 23.5 cm. Collection of Italo Zannier, Venice.*

378. Giuseppe Vannucci Zauli
Ballerinette *(Little Dancers),*
ca. 1946. Gelatin-silver print, 17.8 x
23.3 cm. Museo di Storia della
Fotografia Fratelli Alinari, Collezione
Zannier, Florence.

379. Luigi Veronesi
Fotogramma (Photogram), *1938.*
Gelatin-silver print, 24 x 28.5 cm.
Collection of the artist, Milan.

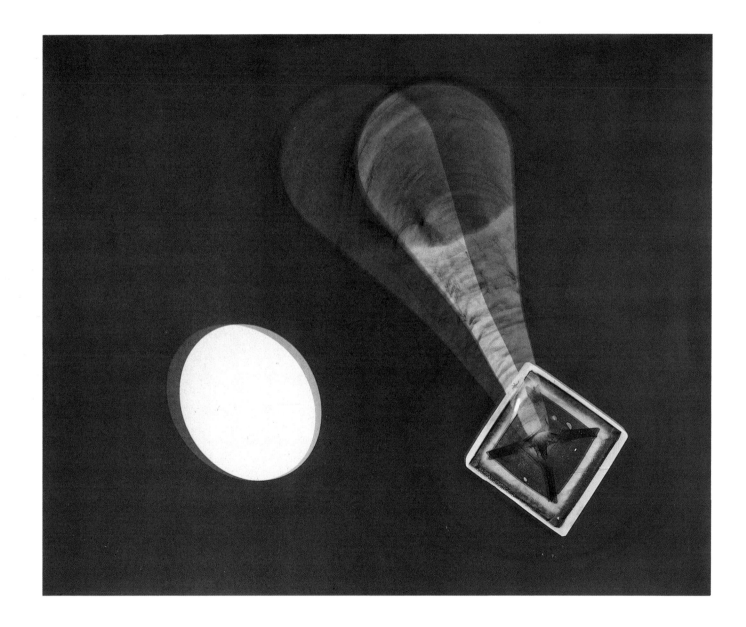

379. Luigi Veronesi
Fotogramma (Photogram), *1938.*
Gelatin-silver print, 24 x 28.5 cm.
Collection of the artist, Milan.

380. Vincenzo Balocchi
Mani (Hands), *1940. Gelatin-silver print, 39.8 x 29.2 cm. Museo di Storia della Fotografia Fratelli Alinari, Archivio Balocchi, Florence.*

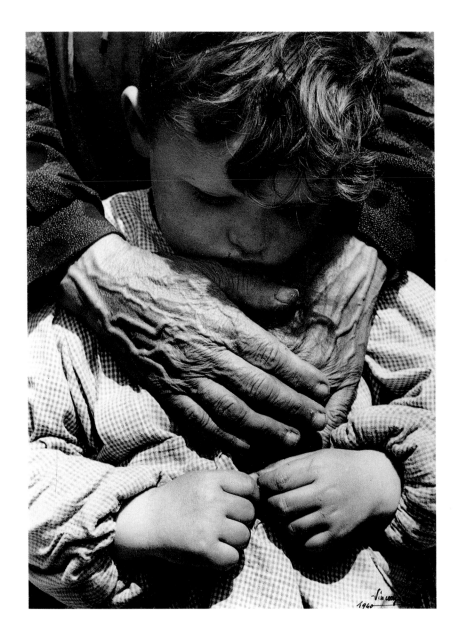

381. Antonio Persico
Senza sorriso *(Without a Smile)*, *1953.*
Gelatin-silver print, 37.5 x 25 cm.
Museo di Storia della Fotografia
Fratelli Alinari, Collezione Zannier,
Florence.

Following two pages:
382. Federico Patellani
Occupazione delle terre *(Occupation*
of the Land), *1950, printed 1993.*
Gelatin-silver print, 24.5 x 36 cm on
sheet 30.7 x 40.5 cm. Archivio Federico
Patellani, Milan.

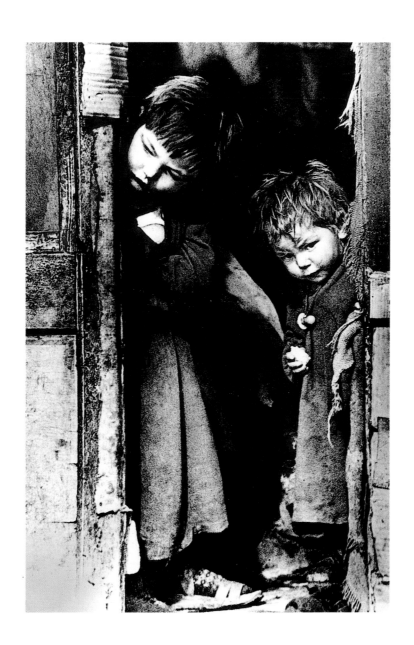

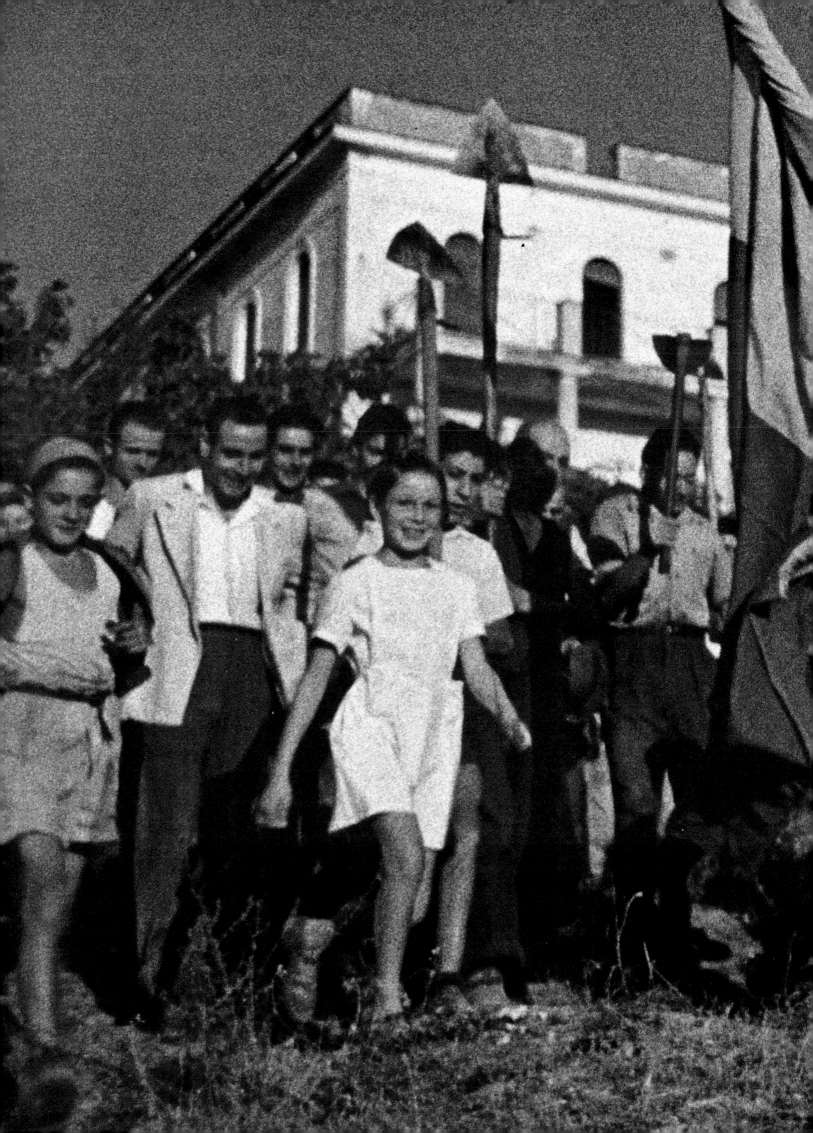

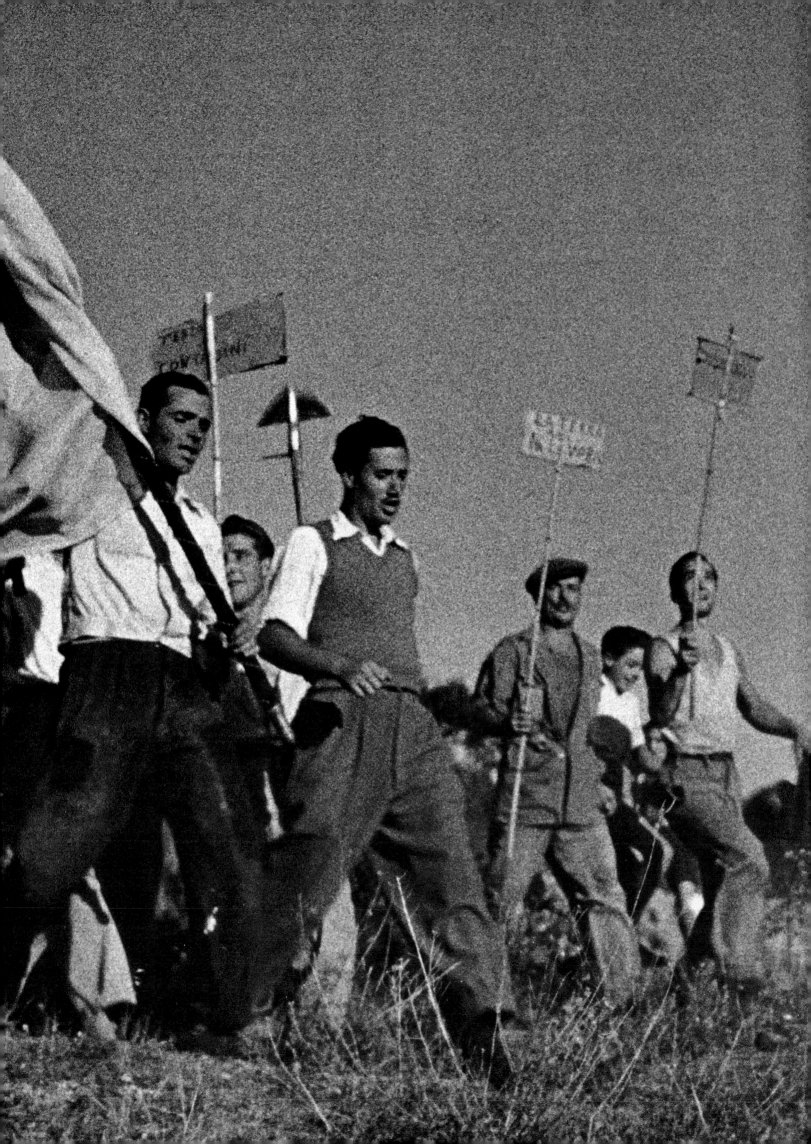

383. Federico Patellani
Sicilia (Sicily), *1947. Gelatin-silver*
print, 30.2 x 40 cm. Collection of Italo
Zannier, Venice.

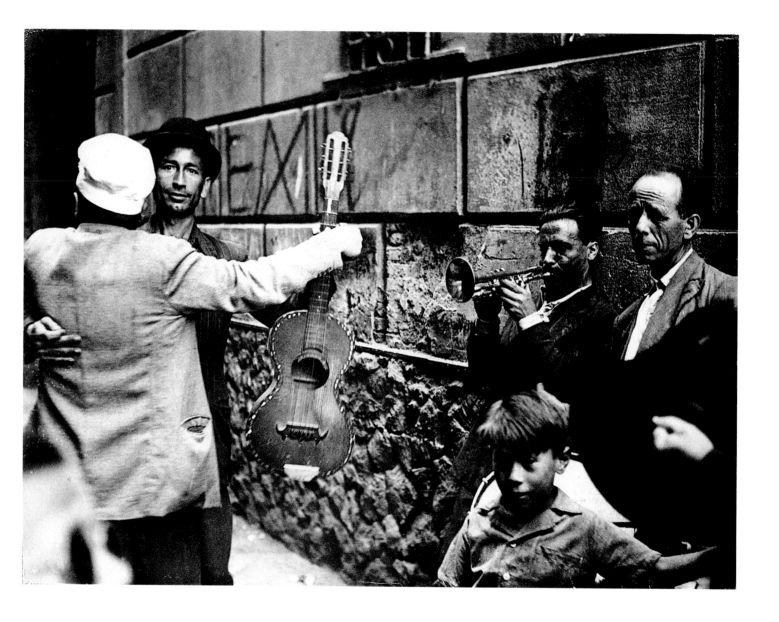

384. Federico Patellani
Il dramma di Carbonia (The
Carbonia Incident), *1950, printed 1993.*
Gelatin-silver print, 27.8 x 34.5 cm.
Archivio Federico Patellani, Milan.

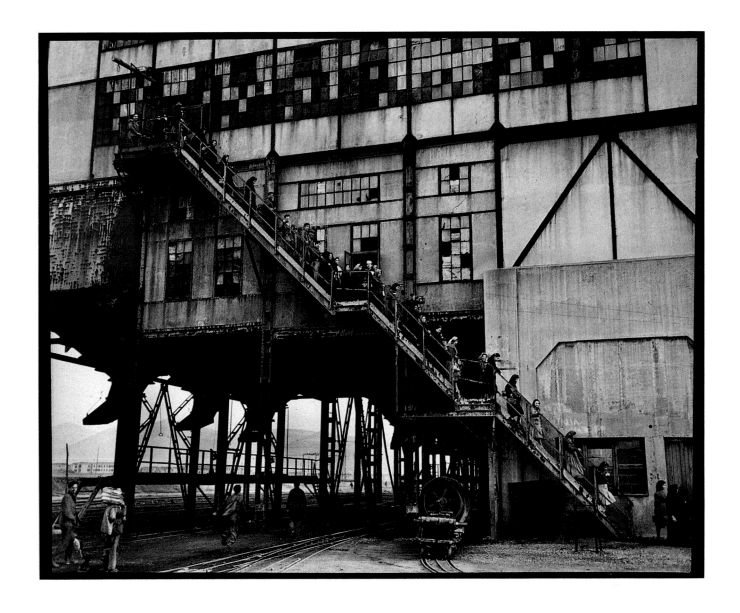

385. Federico Patellani
Il dramma di Carbonia (The
Carbonia Incident), *1950, printed 1993.*
Gelatin-silver print, 28.3 x 27.2 cm on
sheet 40.5 x 30.7 cm. Archivio Federico
Patellani, Milan.

386. Federico Patellani
Il dramma di Carbonia (The
Carbonia Incident), *1950, printed 1993.*
Gelatin-silver print, 28.5 x 27.2 cm on
sheet 40.5 x 30.7 cm. Archivio Federico
Patellani, Milan.

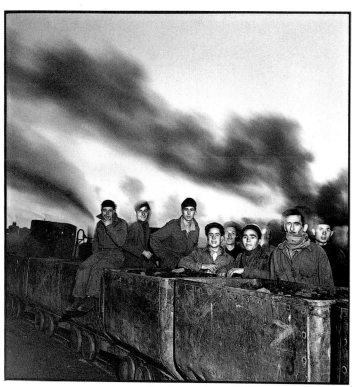

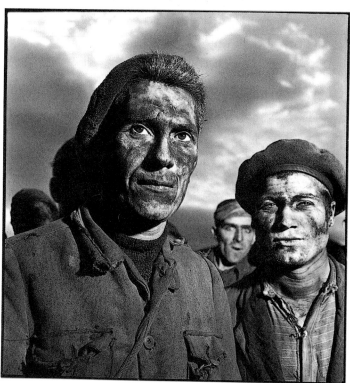

Il dramma di Carbonia (The
Carbonia Incident), *1950, printed 1993.*
Gelatin-silver print, 28.5 x 27.2 cm on
sheet 40.5 x 30.7 cm. Archivio Federico
Patellani, Milan.

387. Federico Patellani
Il dramma di Carbonia *(The
Carbonia Incident)*, *1950, printed 1993.
Gelatin-silver print, 28 x 34 cm on
sheet 30.7 x 40.5 cm. Archivio Federico
Patellani, Milan.

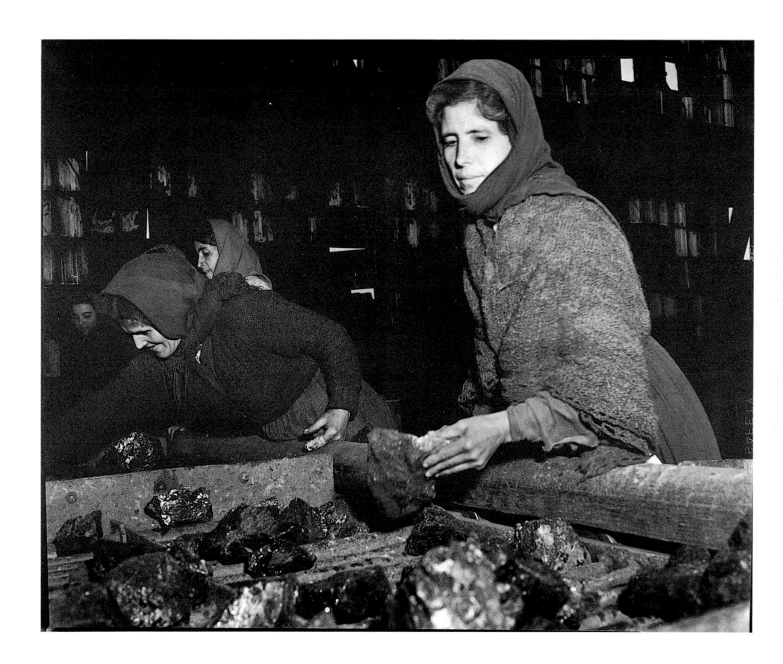

388. Publifoto
L'esodo dei milanesi (The Exodus of
the Milanesi), *1943, printed 1993.*
Gelatin-silver print, 31 x 38.5 cm.
Agenzia Publifoto, Milan.

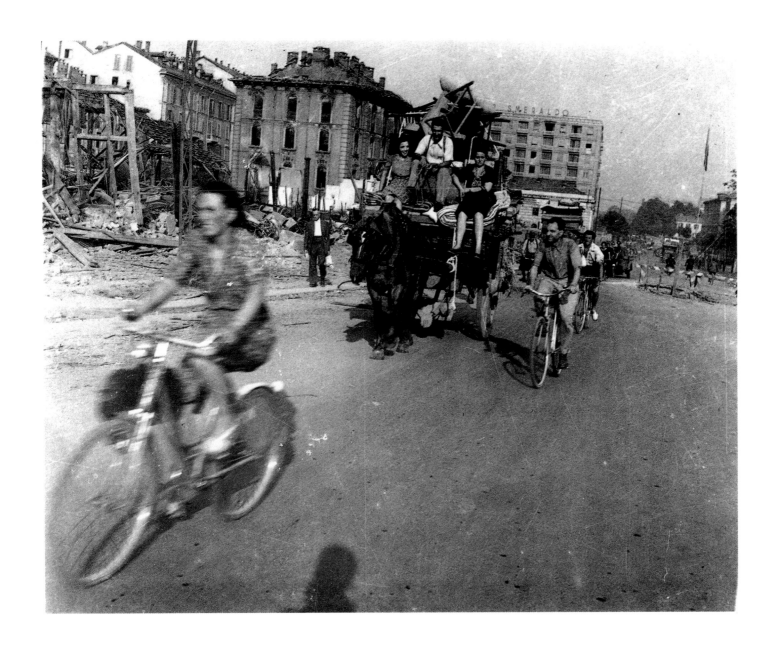

388. Publifoto
L'esodo dei milanesi (The Exodus of
the Milanesi), *1943, printed 1993.*
Gelatin-silver print, 31 x 38.5 cm.
Agenzia Publifoto, Milan.

389. Tino Petrelli
Borsa nera *(Black Market)*, *1945,*
printed 1993. Gelatin-silver print,
40.5 x 31 cm. Agenzia Publifoto, Milan.

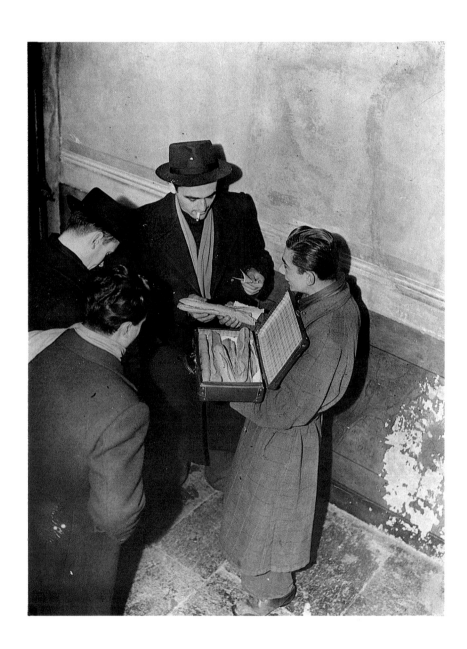

390. Mario De Biasi
L'incappucciato (The Hooded One),
*1950. Gelatin-silver print, 39.8 x
30.4 cm. Collection of the artist, Milan.*

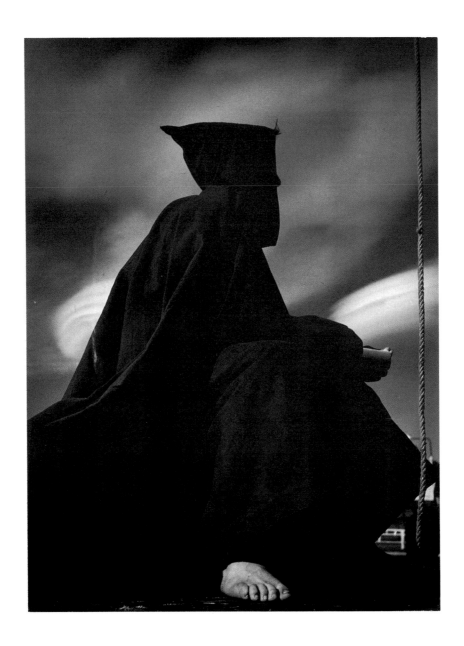

391. Mario De Biasi
Il sagrato del Duomo, Milano
(The Parvis of the Duomo, Milan),
*1951. Gelatin-silver print, 39.8 x
30.4 cm. Collection of the artist, Milan.*

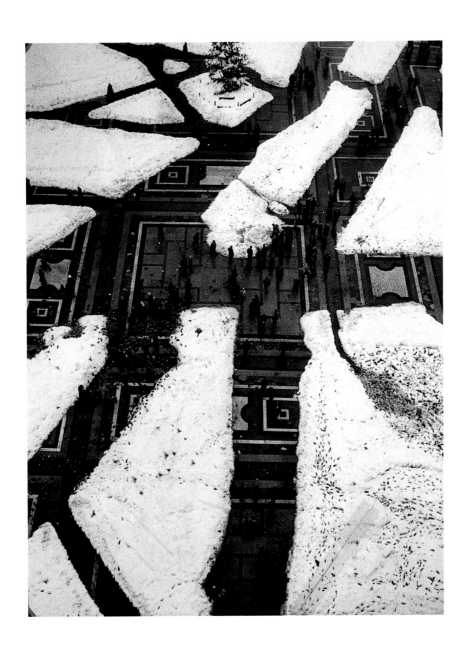

392. Ugo Mulas
Milano (Milan), *1954. Gelatin-silver*
print, 38 x 37 cm. Archivio Ugo Mulas,
Milan.

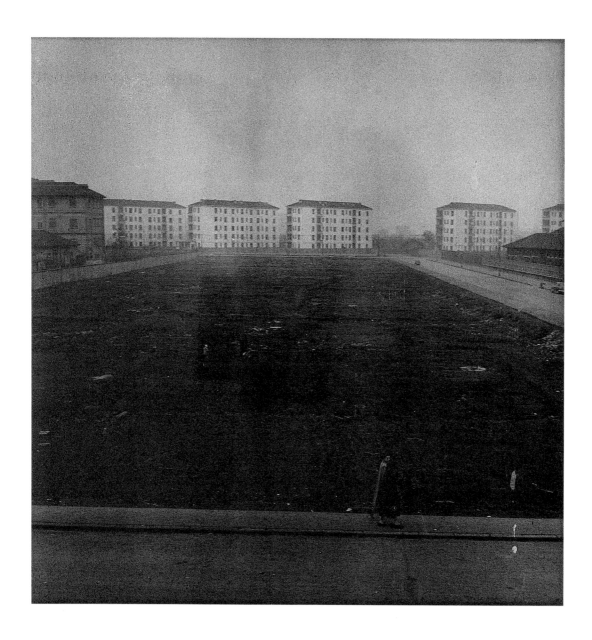

393. Ugo Mulas
Milano. Bar Giamaica (Milan. Bar
Giamaica), *ca. 1953–56. Gelatin-silver
print, 37 x 38 cm. Archivio Ugo Mulas,
Milan.*

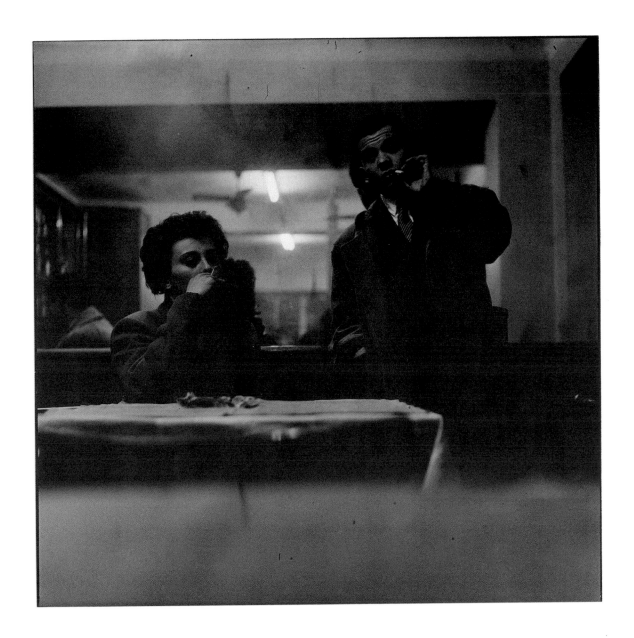

394. Ugo Mulas
Milano. Bar Giamaica (Milan. Bar
Giamaica), *ca. 1953–56. Gelatin-silver
print, 37.2 x 37.8 cm. Archivio Ugo
Mulas, Milan.*

395. Carlo Cisventi
I pazzarielli *(Carnival in Naples),
1961. Gelatin-silver print, 39.4 x
29.5 cm. The Museum of Modern Art,
New York, Purchase.*

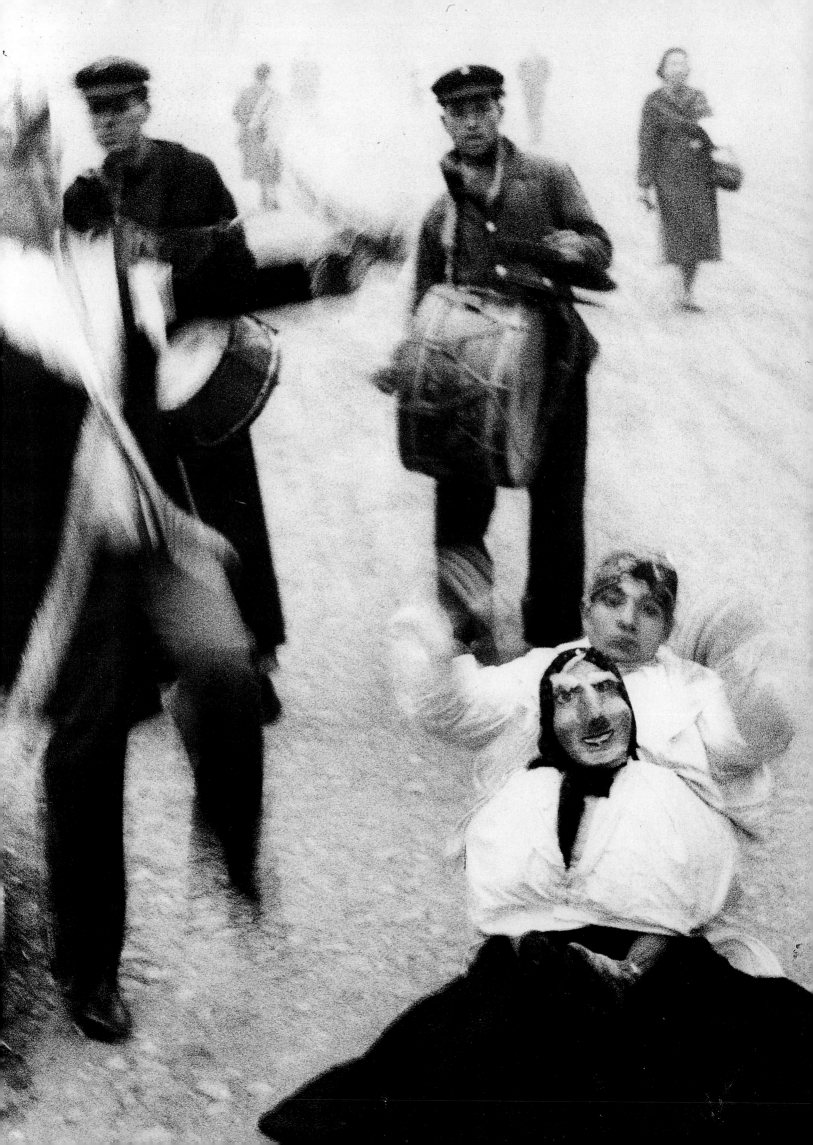

Preceding two pages:
396. Gianni Berengo Gardin
Napoli (Naples), *1954, printed 1993.*
Gelatin-silver print, 26 x 38 cm.
Collection of the artist.

397. Chiara Samugheo
Madre (Mother), *1955, printed 1993.*
Gelatin-silver print, 30.5 x 24 cm.
Collection of the artist.

398. Chiara Samugheo
Miracolata di Sant'Antonio (Miracle
of Saint Anthony), *1954, printed 1993.*
Gelatin-silver print, 30.5 x 24 cm.
Collection of the artist.

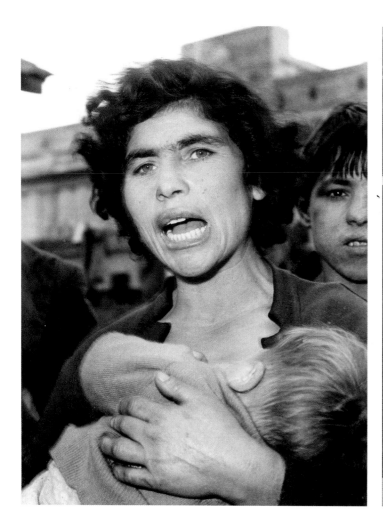

399. Chiara Samugheo
Sottano, *1955, printed 1993. Gelatin-silver print, 30.5 x 24 cm. Collection of the artist.*

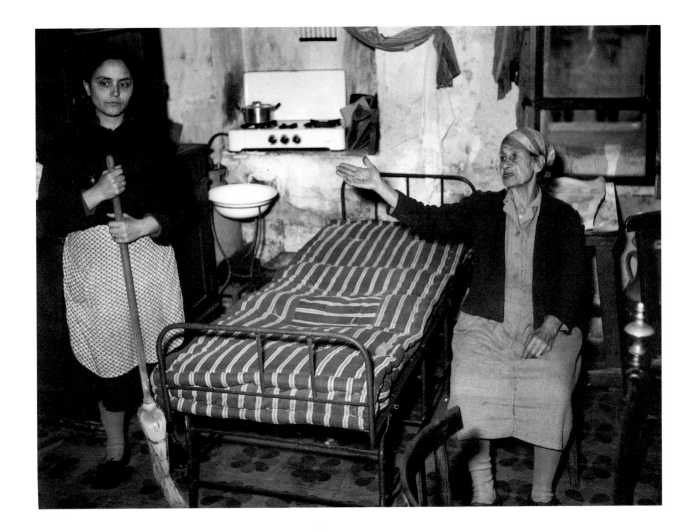

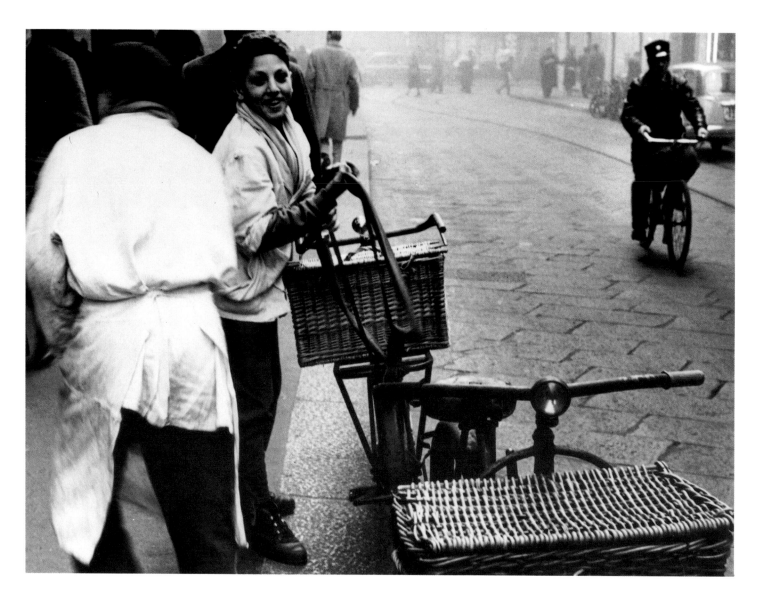

401. Cesare Colombo
Milano (Milan), *1955. Gelatin-silver print, 18 x 24 cm. Collection of the artist, Milan.*

402. Gianni Borghesan
Bambini di Tauriano (Children of
Tauriano), *1954, printed 1993. Gelatin-
silver print, 30.5 x 37 cm. Collection of
the artist, Spilimbergo.*

403. Sergio Spinelli
Orson Welles acquista giornali a
via Veneto *(Orson Welles Buys
Newspapers on via Veneto), 1958,
printed 1993. Gelatin-silver print,
40.5 x 30.5 cm. Collection of the artist,
Rome.*

404. Tazio Secchiaroli
Il Rugantino, *1958, printed 1993.*
Gelatin-silver print, 30 x 40 cm.
Collection of the artist, Rome.

405. Tazio Secchiaroli
Il Rugantino, *1958, printed 1993.*
Gelatin-silver print, 30.5 x 40.7 cm.
Collection of the artist, Rome.

406. Tazio Secchiaroli
Il Rugantino, *1958, printed 1993.*
Gelatin-silver print, 39.5 x 30.5 cm.
Collection of the artist, Rome.

407. Giuseppe Cavalli
Natura Morta *(Still Life), 1948.*
Gelatin-silver print, 23.5 x 17.8 cm.
Collection of Daniele Cavalli, Rome.

408. Giuseppe Cavalli
Natura morta con pesce *(Still Life*
with Fish*), 1950. Gelatin-silver print,*
27.5 x 38.8 cm. Collection of Italo
Zannier, Venice.

409. Giuseppe Cavalli
Grano e ulivi (Wheat and Olive
Trees), *ca. 1943. Gelatin-silver print,
30 x 40.4 cm. Collection of Ferruccio
Malandrini, Florence.*

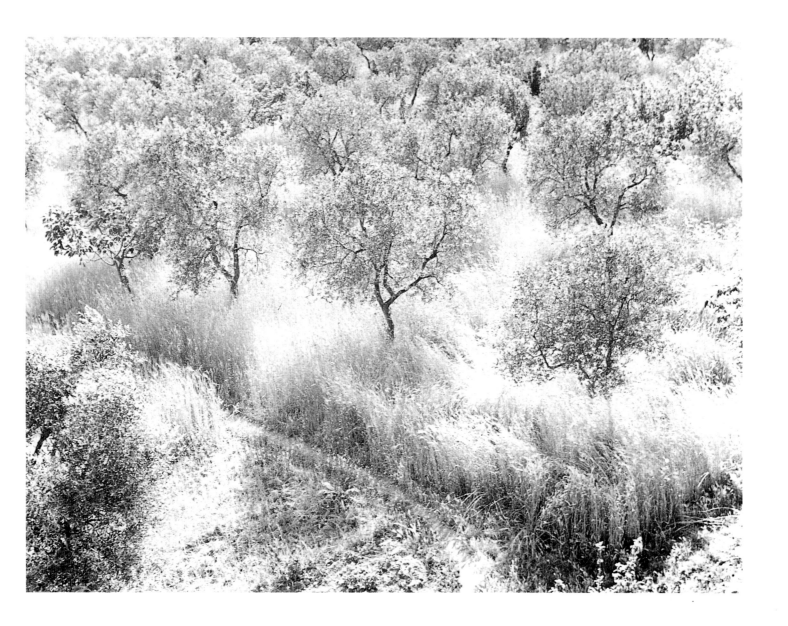

410. Giuseppe Cavalli
Muretto al mare (Wall by the Sea),
*1950. Gelatin-silver print, 38.7 x
28.5 cm. Collection of Daniele Cavalli,
Rome.*

411. Federico Vender
Michelle Morgan, *ca. 1948.*
Gelatin-silver print,
36.9 x 29 cm. Collection of Italo
Zannier, Venice.

412. Mario Finazzi
Studio su due triangoli (Study
of Two Triangles), *1954.*
Gelatin-silver print, 33.5 x
29.5 cm on sheet 40 x 29.5 cm.
Collection of Italo Zannier,
Venice.

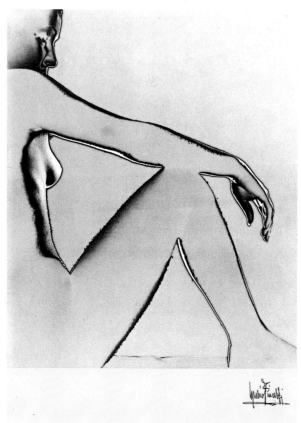

413. Mario Finazzi
Uova (Eggs), *1953. Gelatin-silver
print, 30.5 x 40.5 cm. Collection of Italo
Zannier, Venice.*

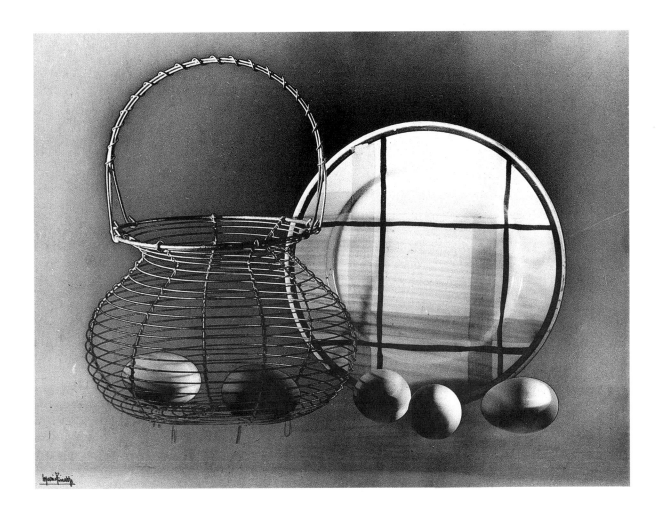

414. Luigi Veronesi
Fotogramma (Photogram), *1964.*
Gelatin-silver print, 25.5 x 37.5 cm.
Collection of the artist, Milan.

415. Ferruccio Leiss
Sottoportego del Banco Salviati
(Banco Salviati Arcade), *1948.*
Gelatin-silver print, 39.7 x 29.8 cm.
Fototeca 3M, Milan.

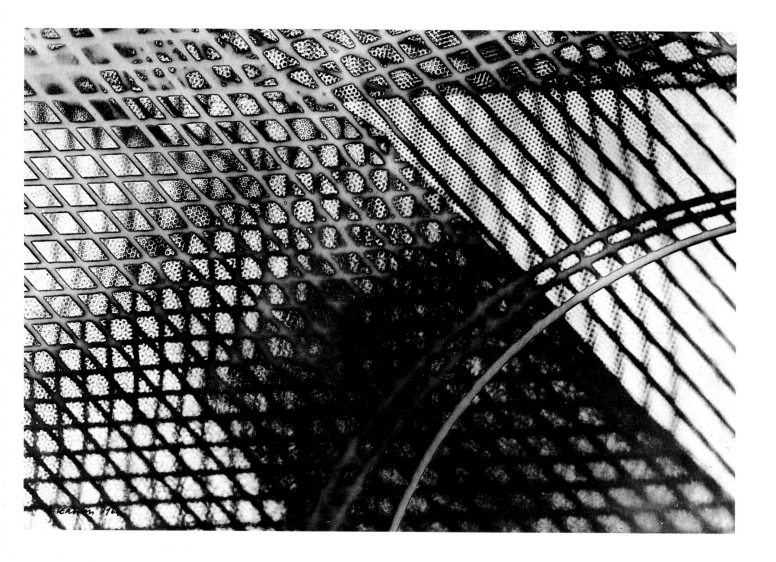

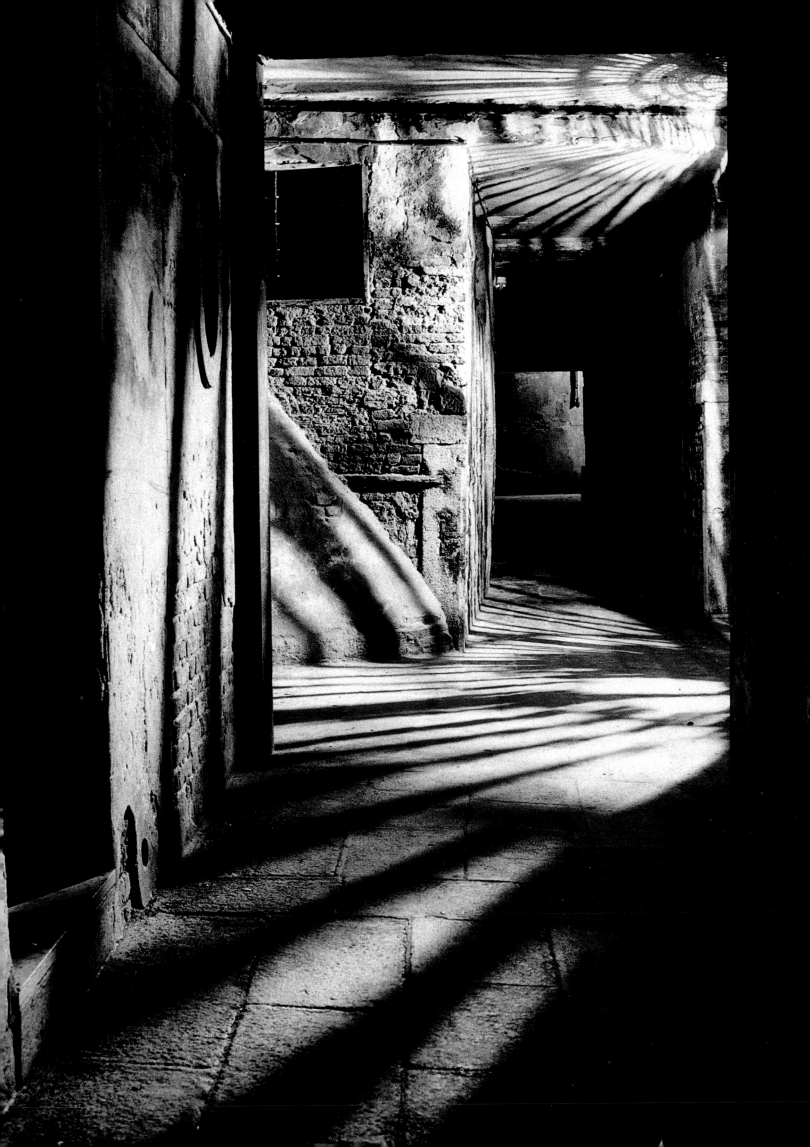

416. Piergiorgio Branzi
Pasqua nell'Italia meridionale (Easter in Southern Italy), *ca. 1955. Gelatin-silver print, 24 x 29.5 cm. Museo di Storia della Fotografia Fratelli Alinari, Collezione Zannier, Florence.*

417. Piergiorgio Branzi
Uova (Eggs), *1956. Gelatin-silver print, 37 x 23.2 cm. Collection of Italo Zannier, Venice.*

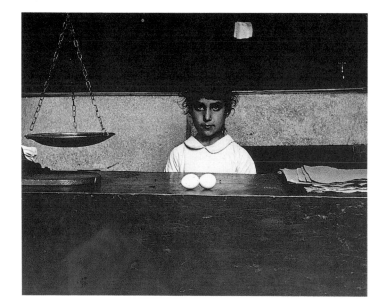

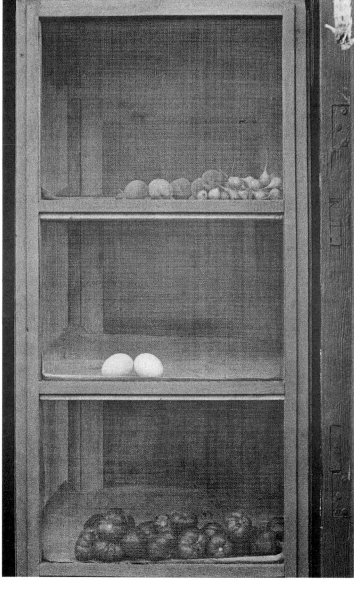

418. Carlo Bevilacqua
Coreografia d'ambiente
(Environmental Choreography), *1952.*
Gelatin-silver print, 34.5 x 26.8 cm.
Collection of Italo Zannier, Venice.

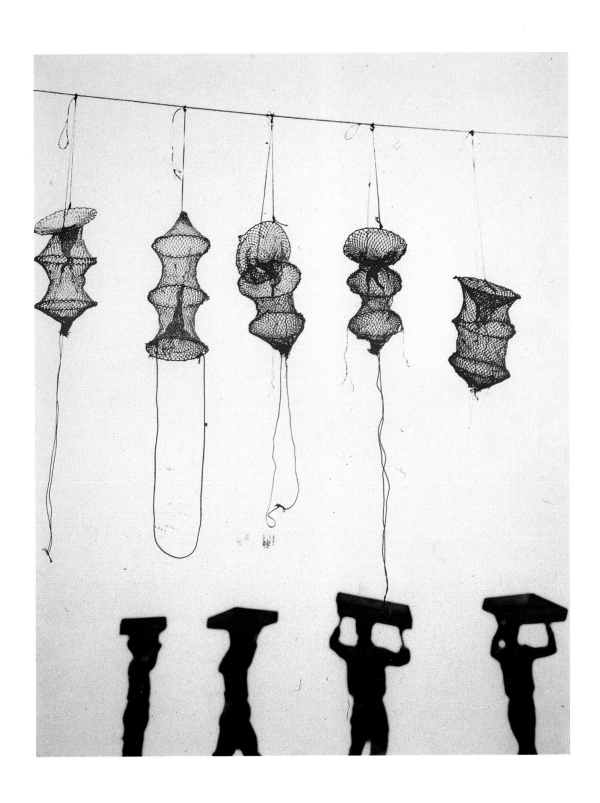

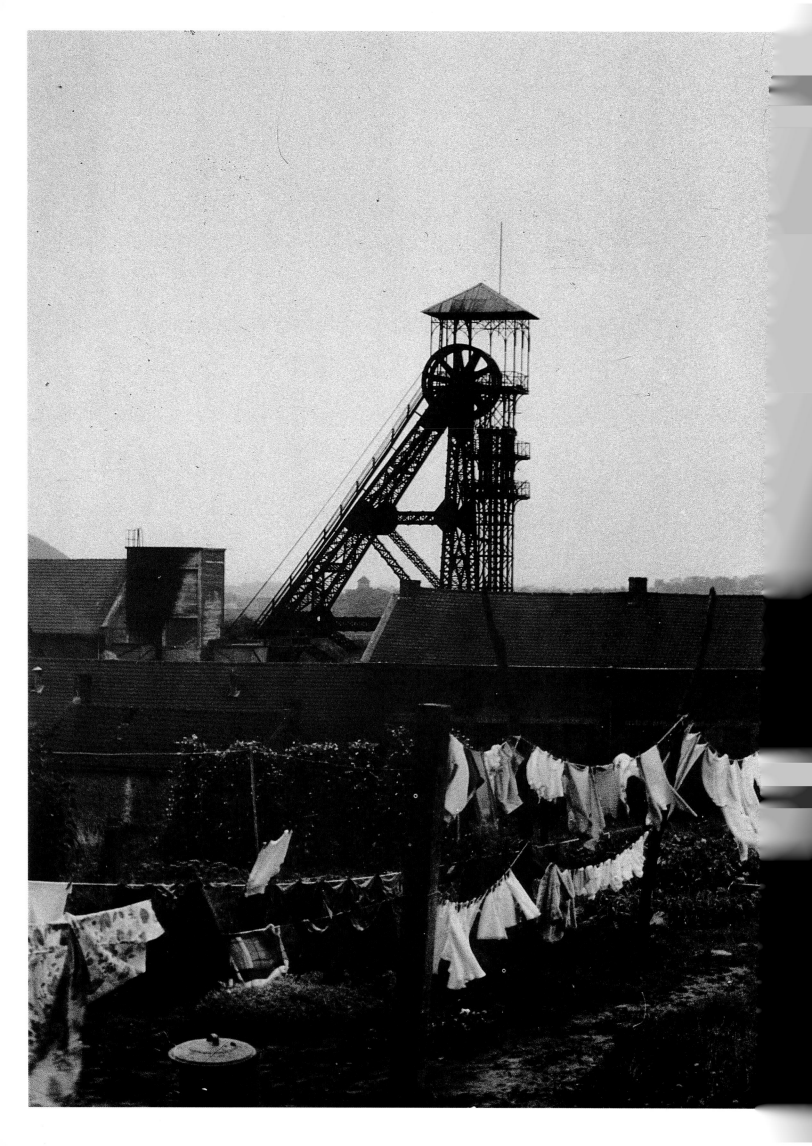

419. Pietro Donzelli
Marcinelle otto anni dopo
(Marcinelle Eight Years Later), *1964.*
Gelatin-silver print, 23.8 x 30.4 cm.
Fototeca 3M, Milan.

420. Pietro Donzelli
Marcinelle otto anni dopo
(Marcinelle Eight Years Later), 1964.
Gelatin-silver print, 21.5 x 30.5 cm.
Fototeca 3M, Milan.

421. Pietro Donzelli
Manichini (Mannequins), 1953.
Gelatin-silver print, 37.5 x 30.3 cm.
Fototeca 3M, Milan.

Following two pages:
422. Vincenzo Balocchi
Colli di Siena (Hills of Siena), 1959.
Gelatin-silver print, 27.1 x 38.5 cm.
Museo di Storia della Fotografia
Fratelli Alinari, Archivio Balocchi,
Florence.

Vincenz Bala
59

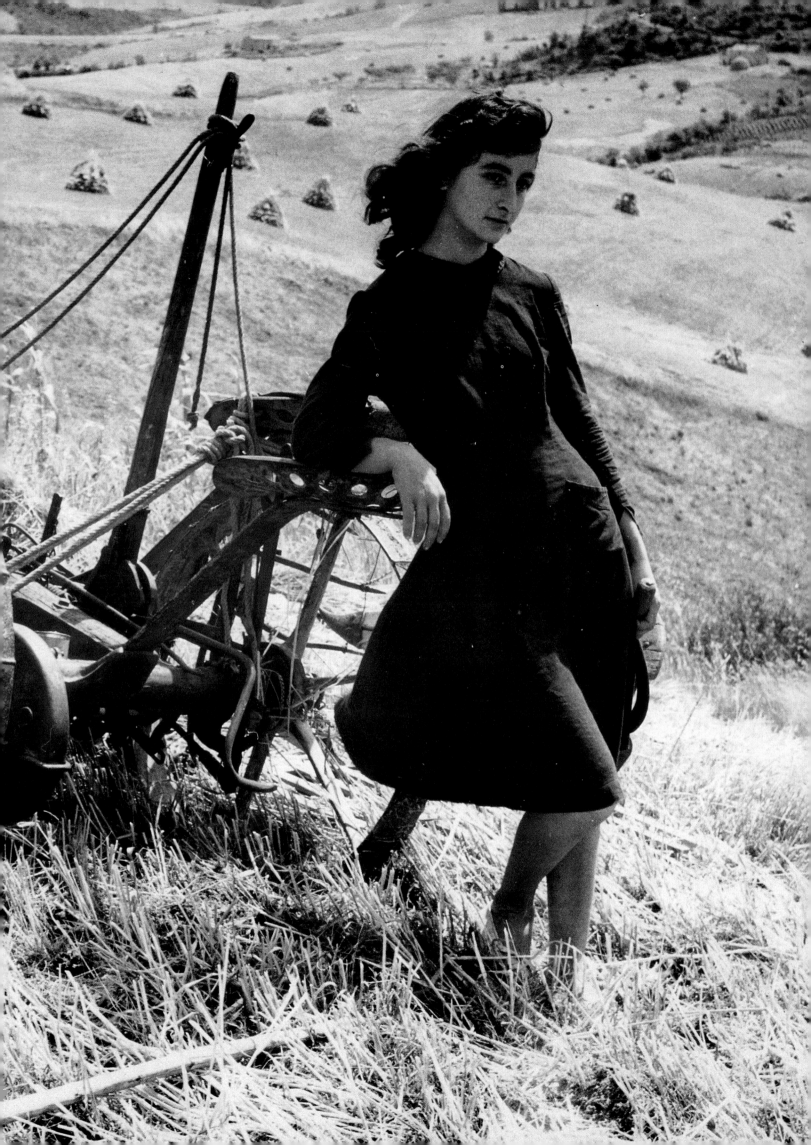

423. Fulvio Roiter
Sicilia (Sicily), *1953. Gelatin-silver
print, 29.5 x 23.6 cm. Collection of Italo
Zannier, Venice.*

424. Fulvio Roiter
Sicilia: in una cava di zolfo (Sicily:
In a Sulphur Mine), *1953. Gelatin-
silver print, 39 x 29 cm. Collection of
Italo Zannier, Venice.*

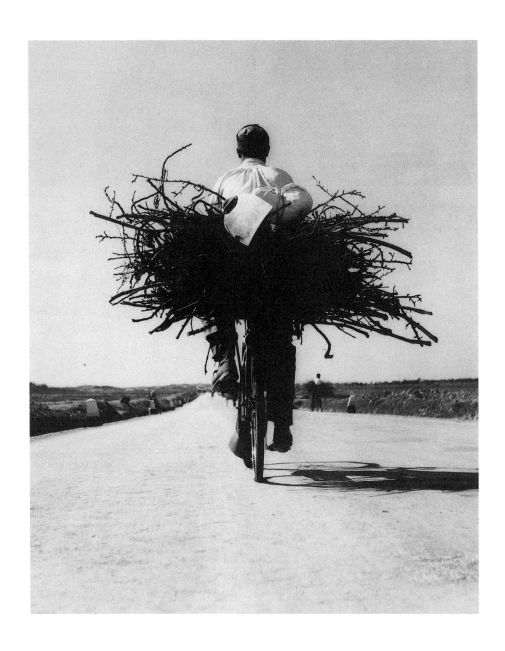

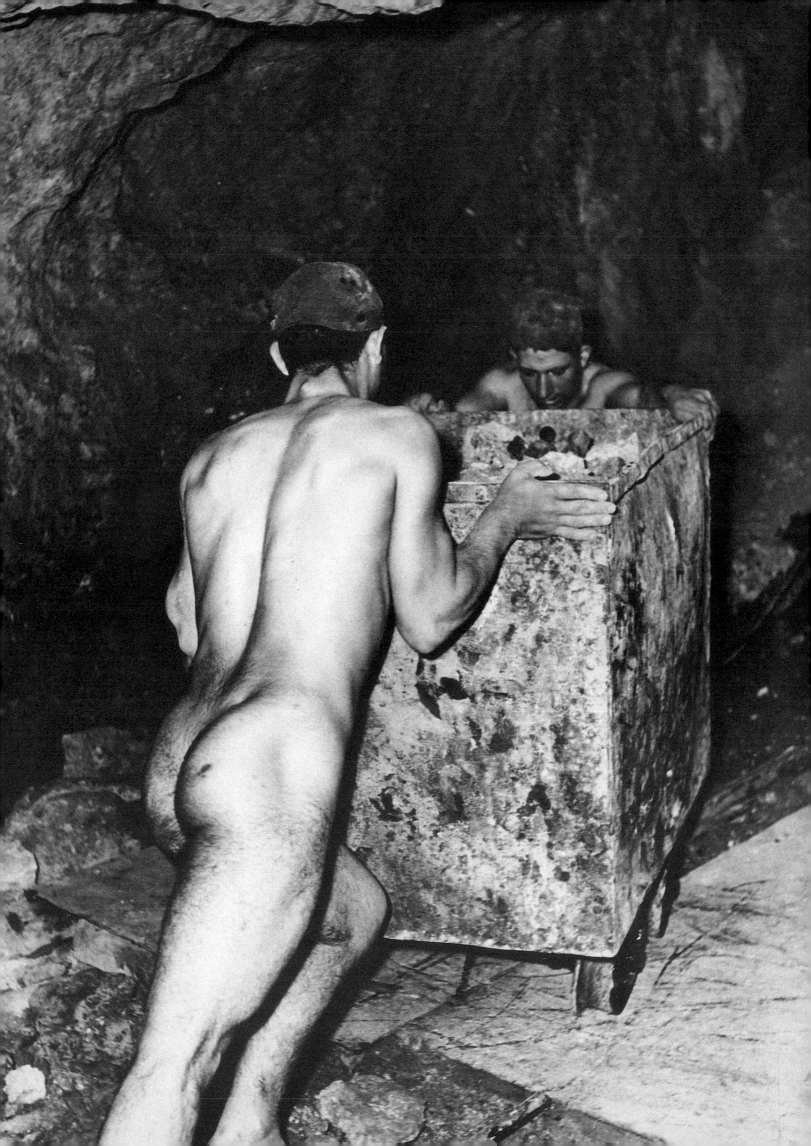

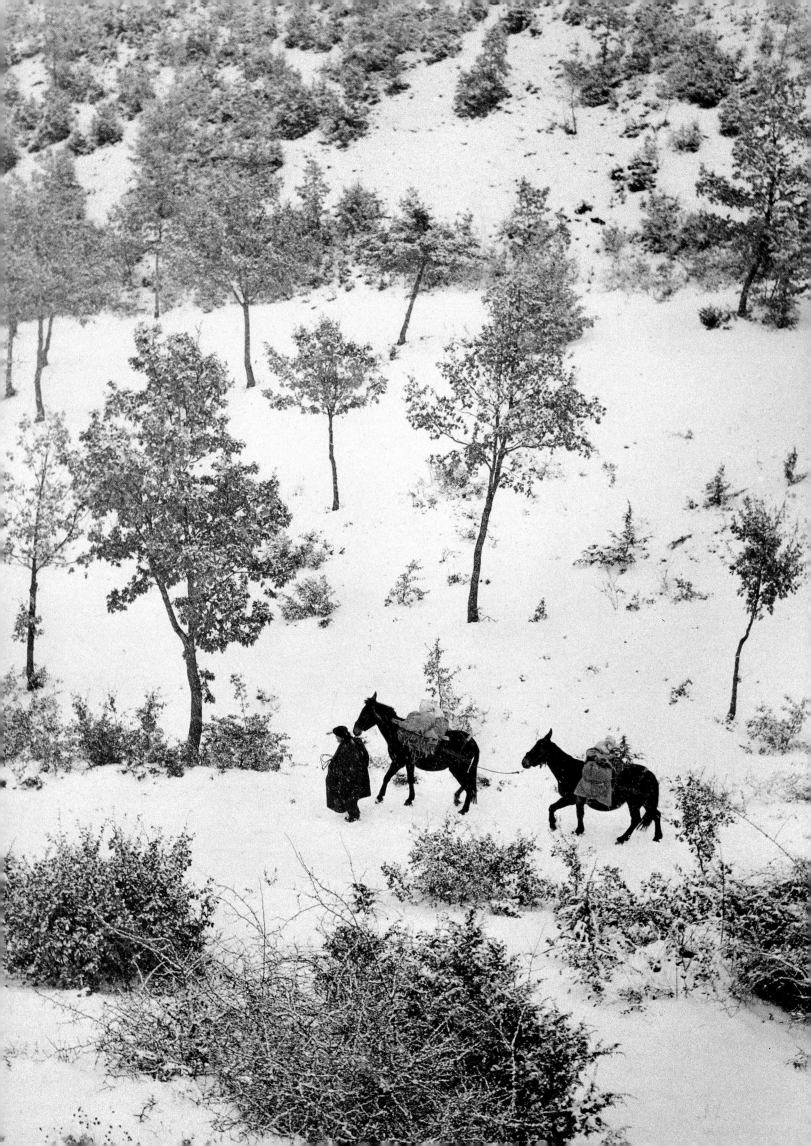

425. Fulvio Roiter
Umbria, *1954. Gelatin-silver print,*
30 x 23.8. Collection of Italo Zannier,
Venice.

426. Fulvio Roiter
Je vous attends *(I Await You), 1955.*
Gelatin-silver print, 30 x 24 cm.
Collection of Italo Zannier, Venice.

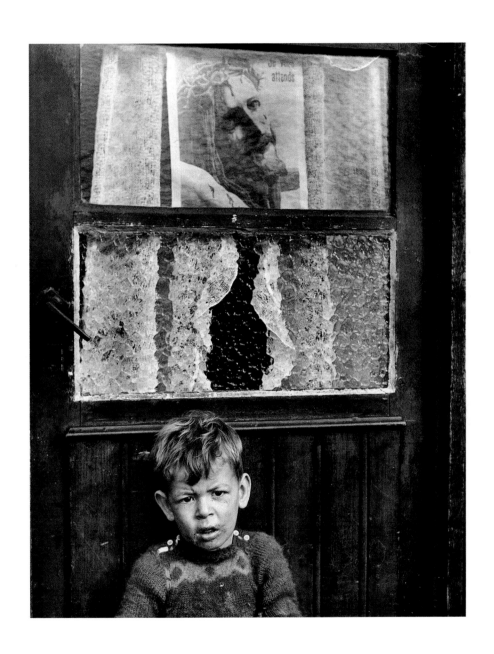

427. Toni Del Tin
Musica amara (Bitter Music),
1955. Gelatin-silver print, 37.8 x
29.6 cm. Collection of Italo
Zannier, Venice.

428. Toni Del Tin
Ora X (X Hour), *1950. Gelatin-*
silver print, 30 x 23.9 cm.
Collection of Italo Zannier, Venice.

429. Toni Del Tin
Nozze a Burano (Wedding in
Burano), *ca. 1955. Gelatin-silver*
print, 30.3 x 24 cm. Fototeca 3M,
Milan.

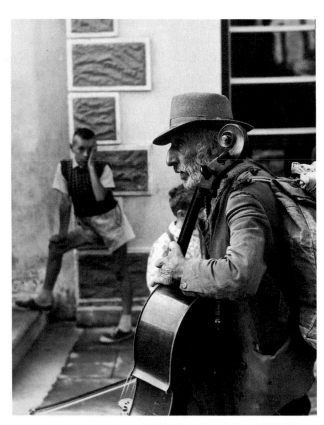

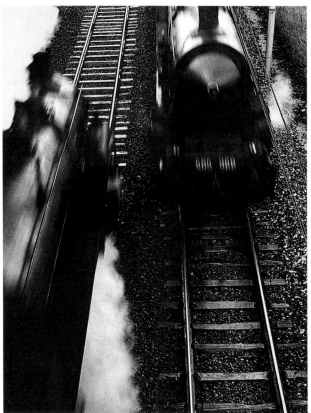

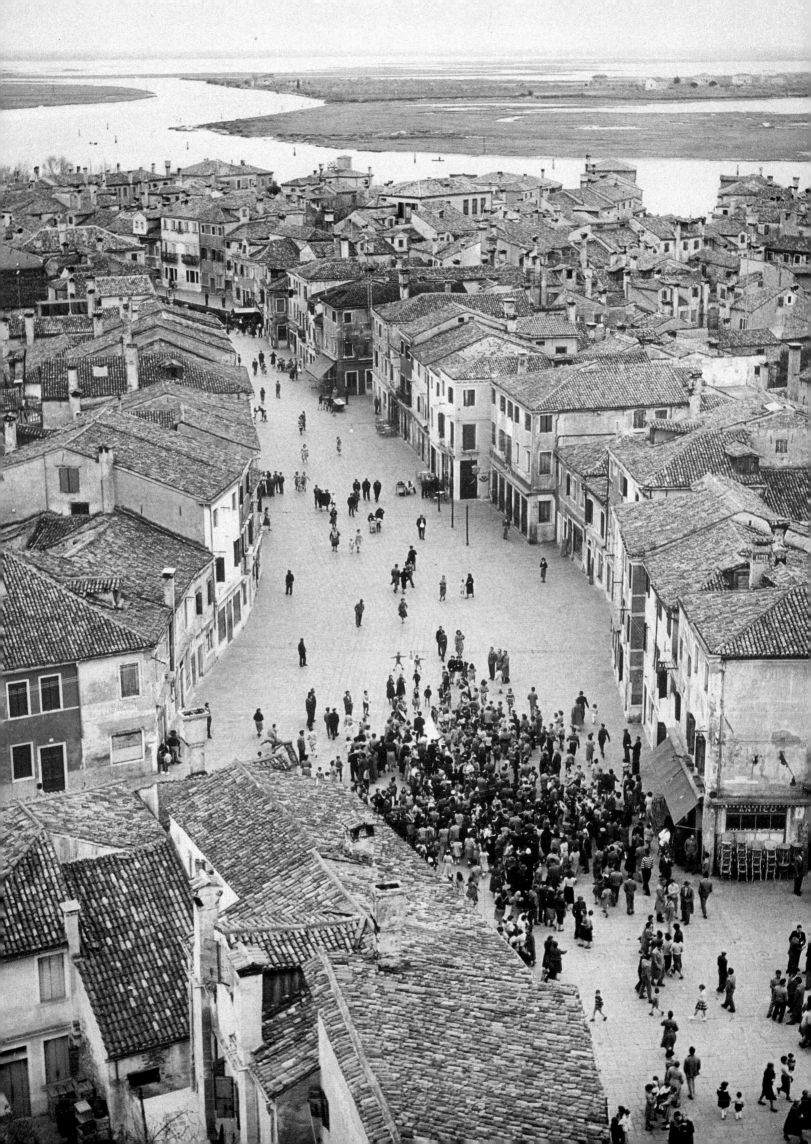

430. Nino [Antonio] Migliori
Senza titolo (Untitled), *1958. Gelatin-*
silver print, 62.8 x 48 cm. Collection of
the artist, Bologna.

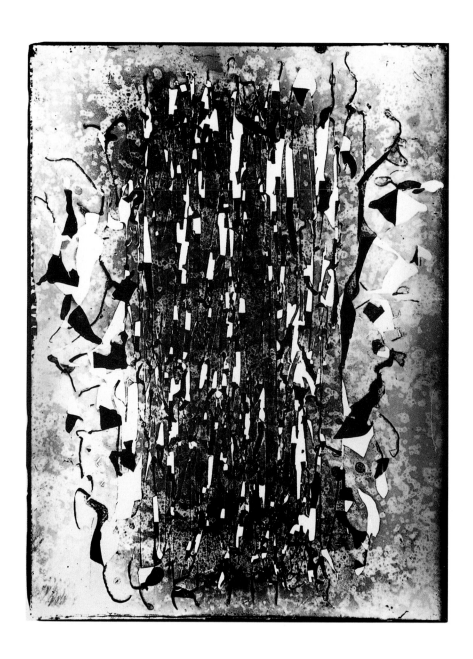

431. Nino [Antonio] Migliori
La mia città (My City), *1958. Gelatin-
silver print, 68.5 x 51.5 cm. Collection of
the artist, Bologna.*

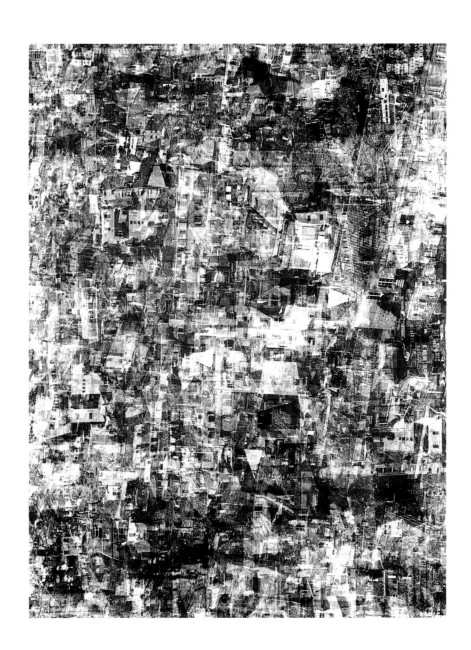

432. Italo Zannier
Donna carnica (Woman of Carnia),
1953. Gelatin-silver print, 28.5 x 24 cm.
Collection of the artist, Venice.

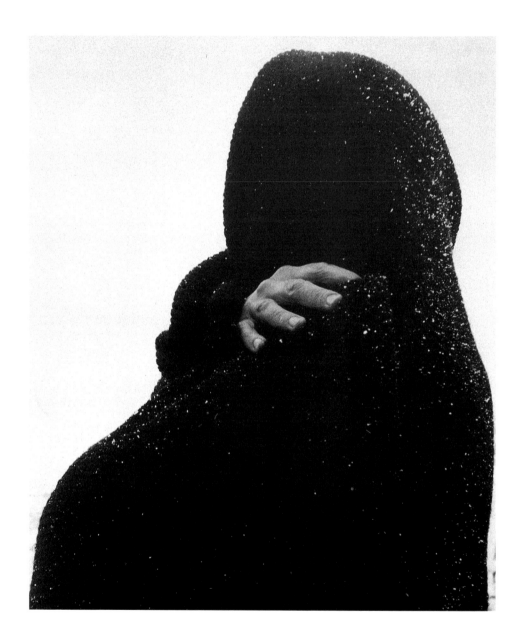

433. Gianni Berengo Gardin
Venezia, acqua alta a San Marco
(Venice, High Tide in San Marco),
*1960. Gelatin-silver print, 28.6 x
20 cm. Collection of Italo Zannier,
Venice.*

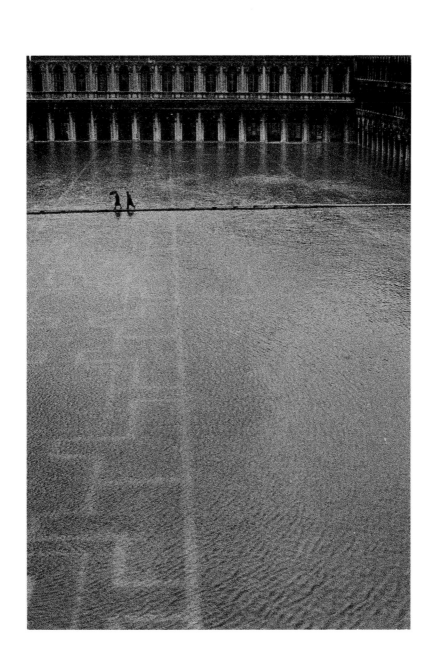

434. Mario Giacomelli
Marco l'orfano *(Marco the Orphan),*
ca. 1955. Gelatin-silver print, 28 x
19 cm. Fototeca 3M, Milan.

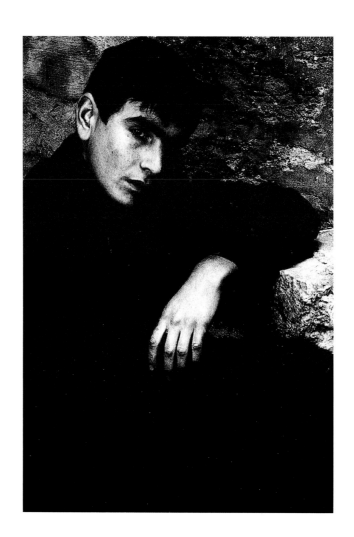

435. Mario Giacomelli
I pretini (The Seminarians),
ca. 1961- 63. Gelatin-silver print,
18.8 x 28.8 cm. Fototeca 3M, Milan.

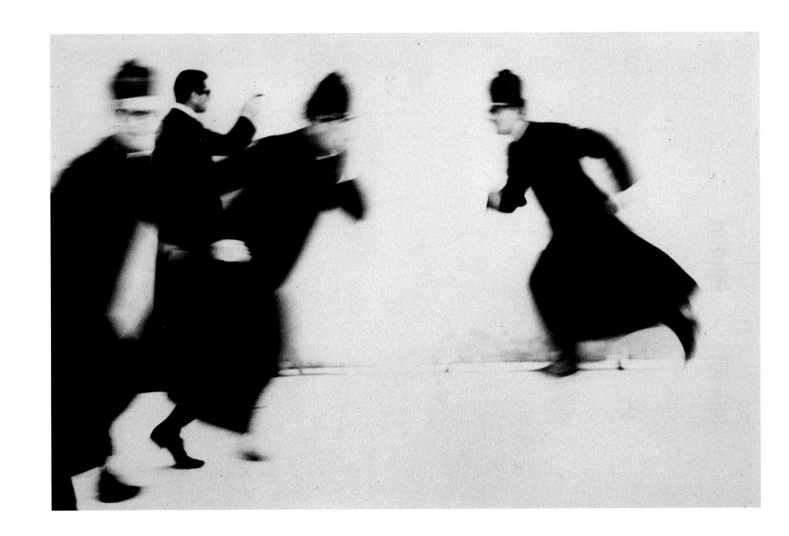

436. Mario Giacomelli
Paesaggio Neris (Neris Landscape),
1958. Gelatin-silver print, 27.5 x
39.5 cm. Fototeca 3M, Milan.

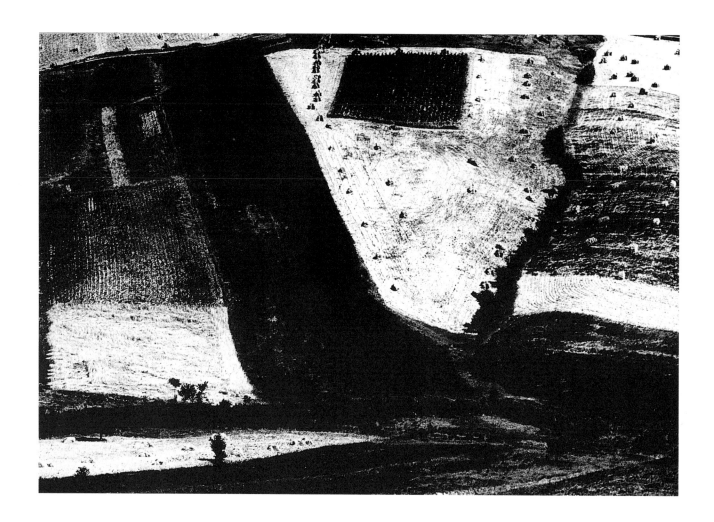

437. Mario Giacomelli
Il lavoro dell'uomo *(Man's Labor)*,
1959. Gelatin-silver print, 24.5 x
39.5 cm. Collection of Italo Zannier,
Venice.

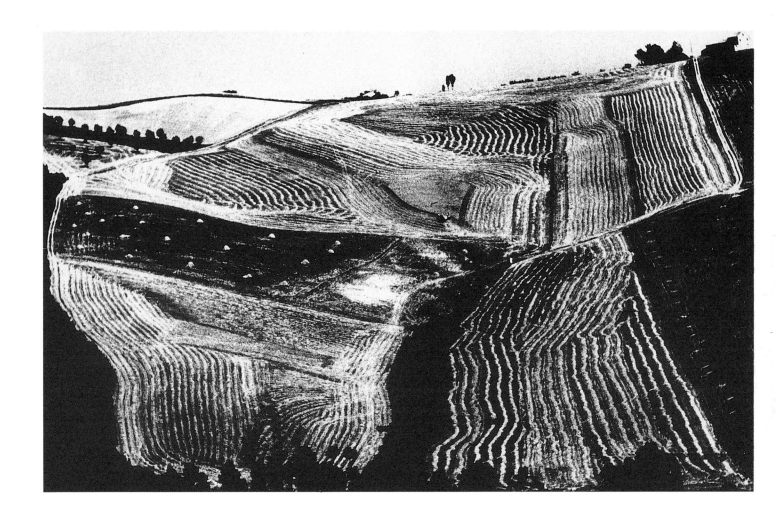

438. Mario Giacomelli
Paesaggio (Landscape), *ca. 1955.*
Gelatin-silver print, 15.5 x 35.5 cm.
Fototeca 3M, Milan.

439. Mario Giacomelli
Paesaggio Rita *(Rita Landscape),*
ca. 1954. Gelatin-silver print, 23.5 x
38.7 cm. Fototeca 3M, Milan.

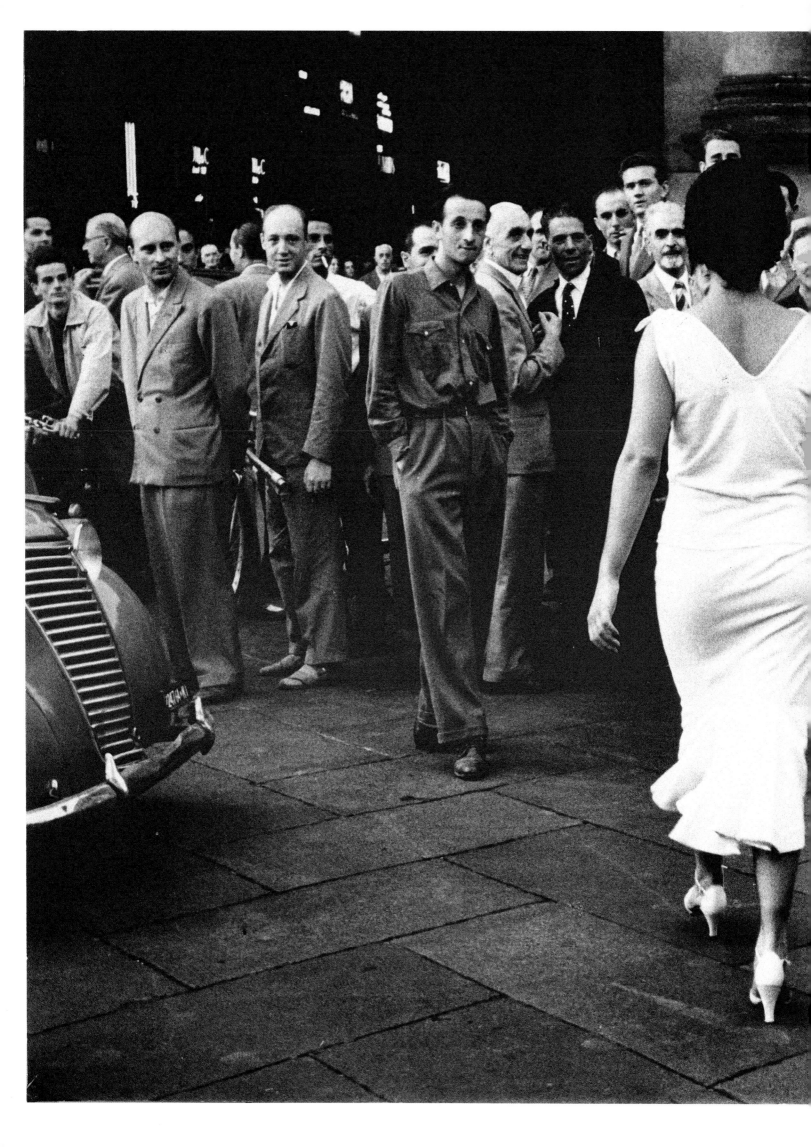

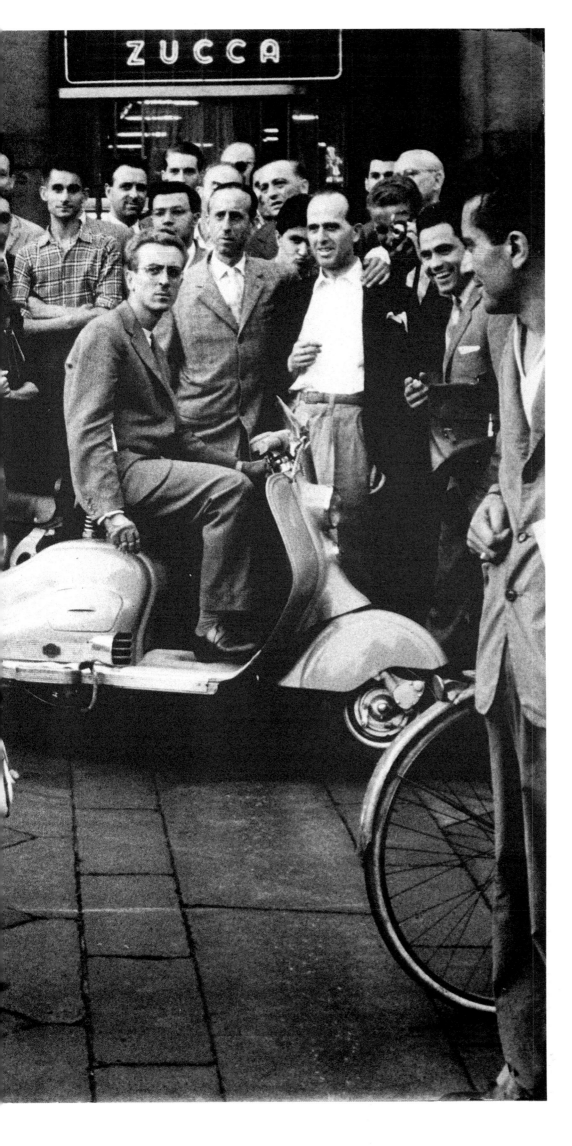

440. Mario De Biasi
Gli italiani si voltano (The Italians
Turn Around), *1953. Gelatin-silver
print, 30.5 x 40 cm. Collection of the
artist, Milan.*

441. Paolo Monti
Milano (Milan), *ca. 1955, printed 1990.*
Gelatin-silver print, 25.4 x 20.5 cm on
sheet 30 x 20.5 cm. Archivio dell'Istituto
di Fotografia Paolo Monti, Milan.

442. Paolo Monti
Milano (Milan), *1955, printed 1990.*
Gelatin-silver print, 24.8 x 19.2 cm.
Archivio dell'Istituto di Fotografia
Paolo Monti, Milan.

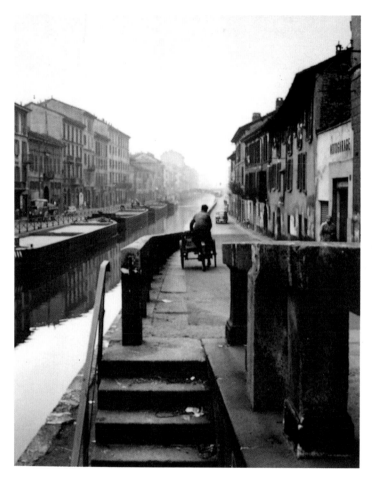

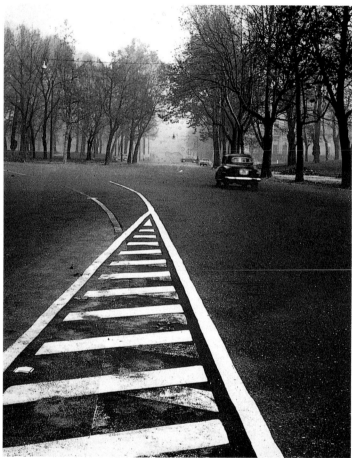

443. Paolo Monti
Cappello Nero (Black Hat), *1956,*
printed 1990. Gelatin-silver print,
25.4 x 23.2 cm on sheet 25.9 x 23.2 cm.
Archivio dell'Istituto di Fotografia
Paolo Monti, Milan.

444. Mario Giacomelli
Un uomo, una donna, un amore
(A Man, a Woman, a Romance), 1961.
Gelatin-silver print, 23.8 x 38.8 cm.
Collection of Italo Zannier, Venice.

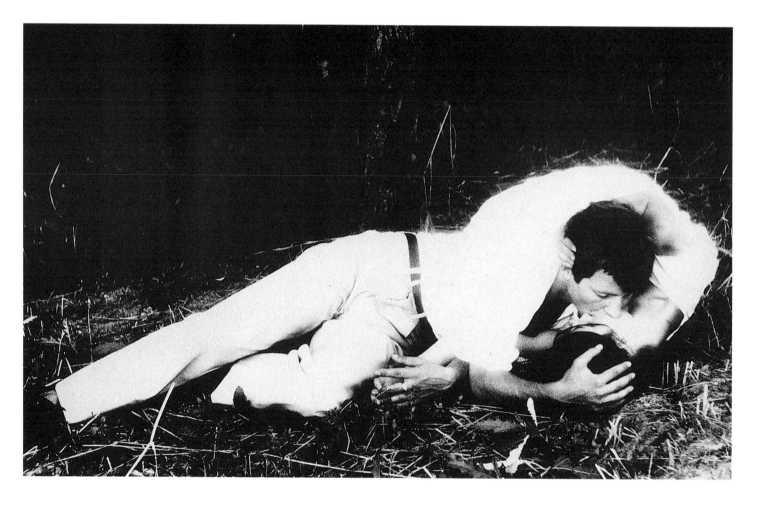

445. Gianni Berengo Gardin
Venezia, il Lido (Venice, the Lido),
*1958, printed 1990. Gelatin-silver print,
36.5 x 25.5 cm. Collection of the artist.*

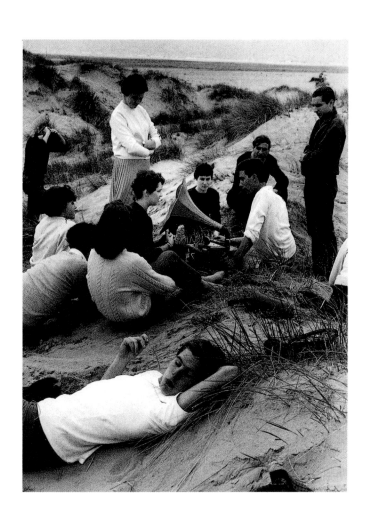

446. Alfredo Camisa
Siesta, *1955. Gelatin-silver print,
37 x 29.5 cm. Collection of the artist.*

447. Piergiorgio Branzi
Donna a Matera (Woman in Matera),
*1956. Gelatin-silver print, 29.7 x
21.5 cm. Collection of Italo Zannier,
Venice.*

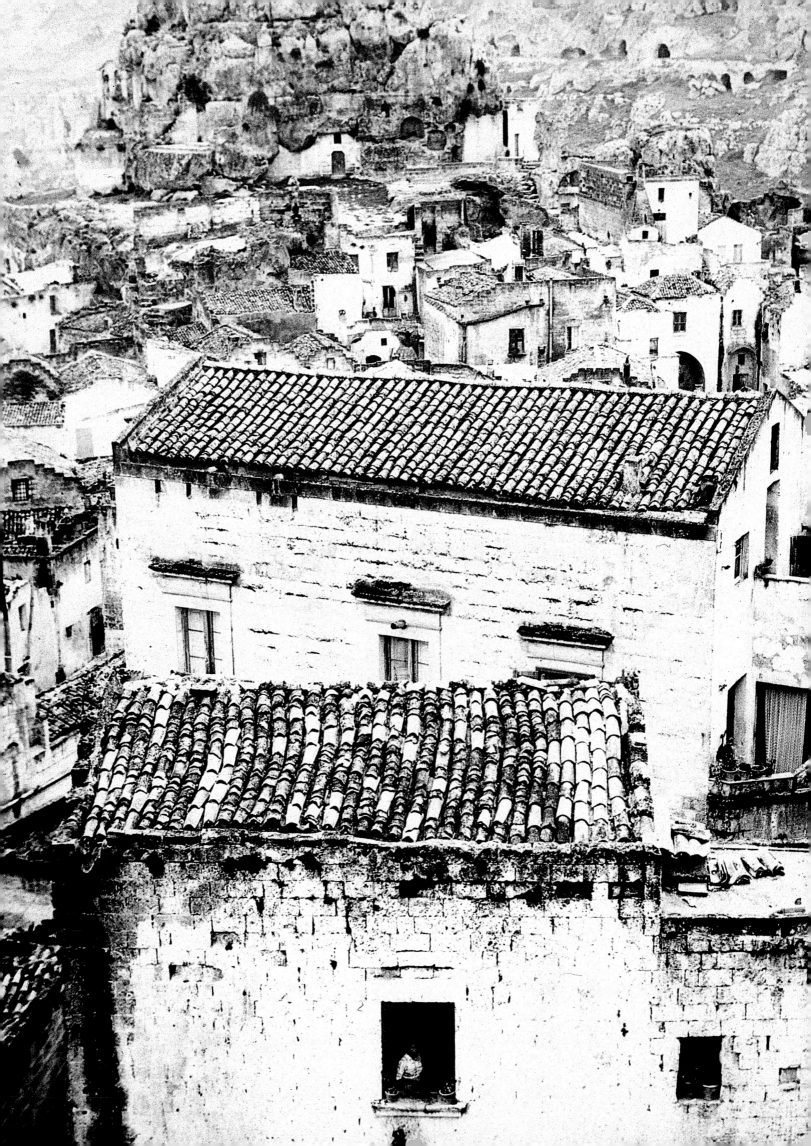

448. Piergiorgio Branzi
Contadini di Puglia (Farmers of
Puglia), *1955. Gelatin-silver print,
38.8 x 29.5 cm. Collection of Italo
Zannier, Venice.*

449. Piergiorgio Branzi
Ragazzo con orologio (Boy with
Clock), *1958, printed 1992. Gelatin-
silver print, 37.4 x 29.5 cm. Collection of
Italo Zannier, Venice.*

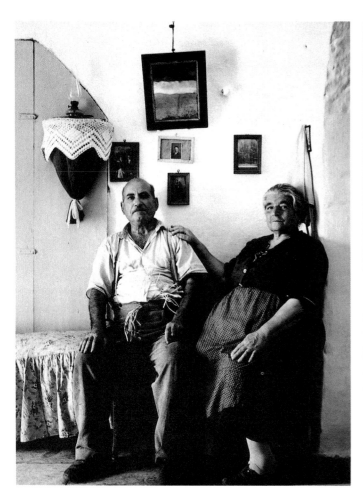

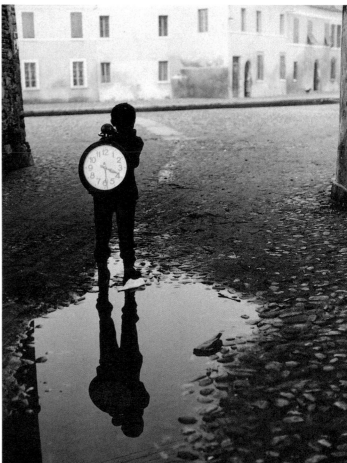

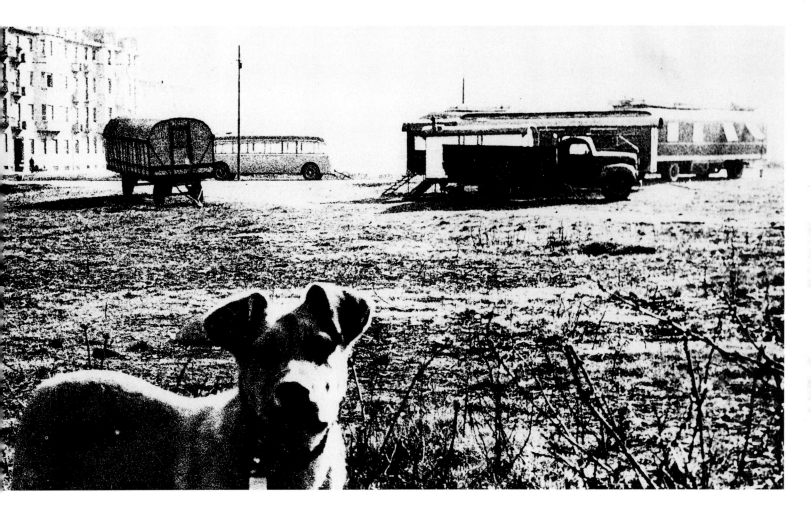

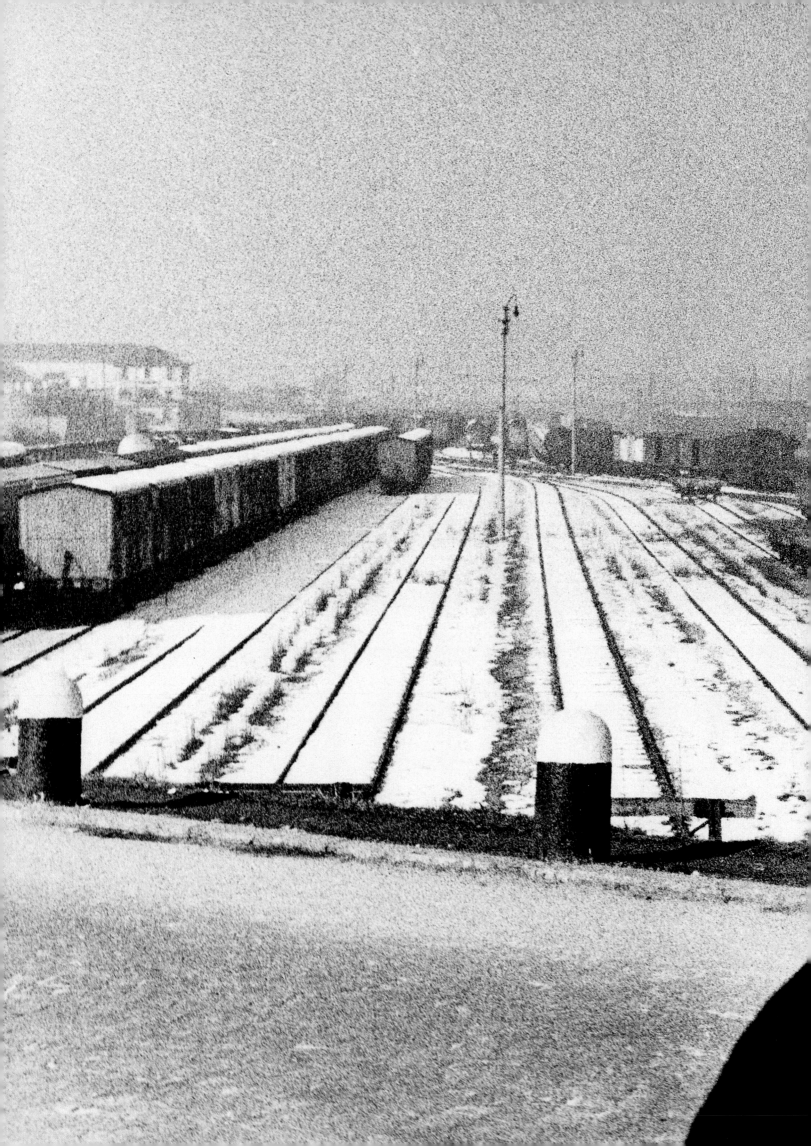

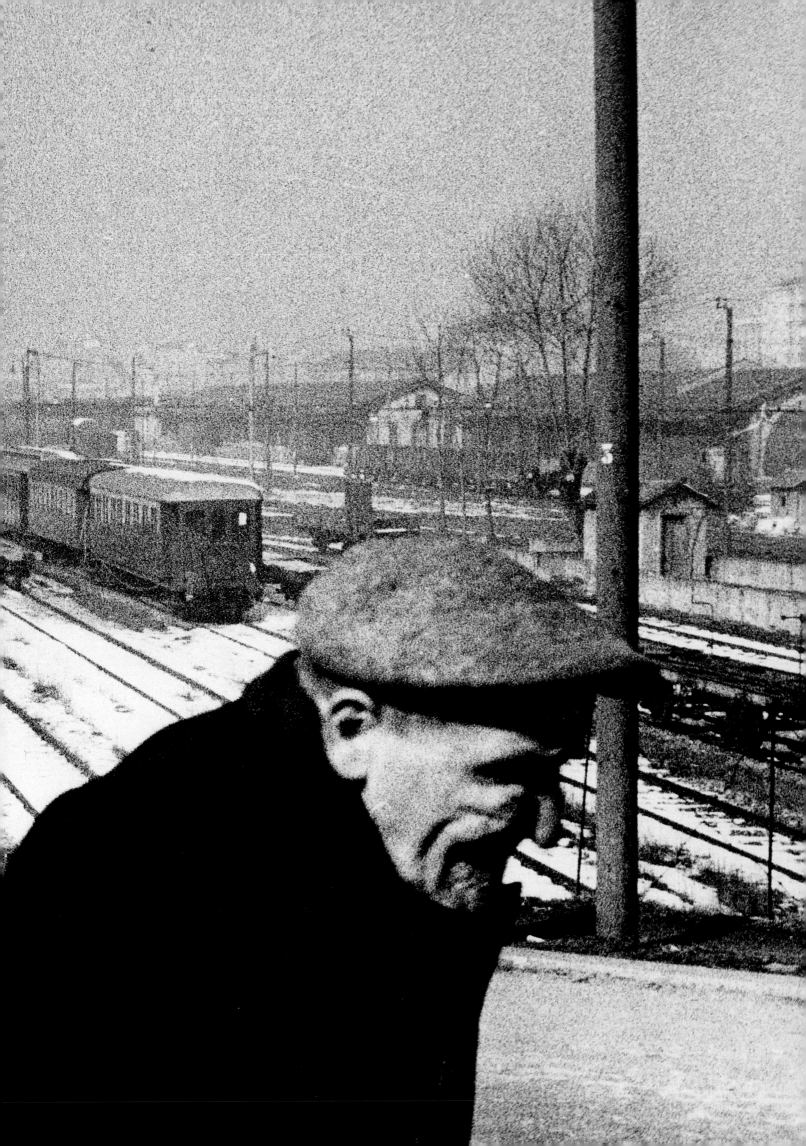

452. Italo Zannier
Interno presso Aquileia *(Interior
Near Aquileia), 1969. Gelatin-silver
sepia-tone print, 24.8 x 24.8 cm.
Collection of the artist, Venice.*

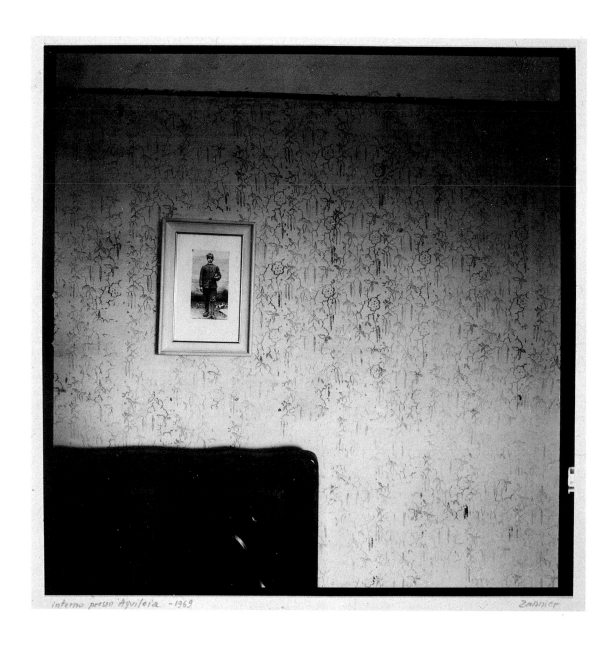

453. Italo Zannier
Interno presso Aquileia (Interior
Near Aquileia), *1969. Gelatin-silver
sepia-tone print, 24.8 x 24.8 cm.
Collection of the artist, Venice.*

Following two pages:
454. Gianni Berengo Gardin
Istituto psichiatrico (Psychiatric
Institute), *1968. Gelatin-silver print,
21 x 32 cm. Collection of Italo Zannier,
Venice.*

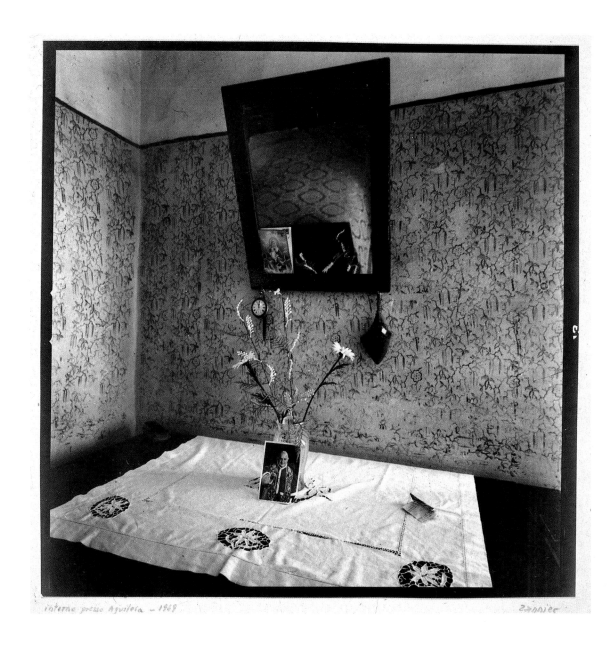

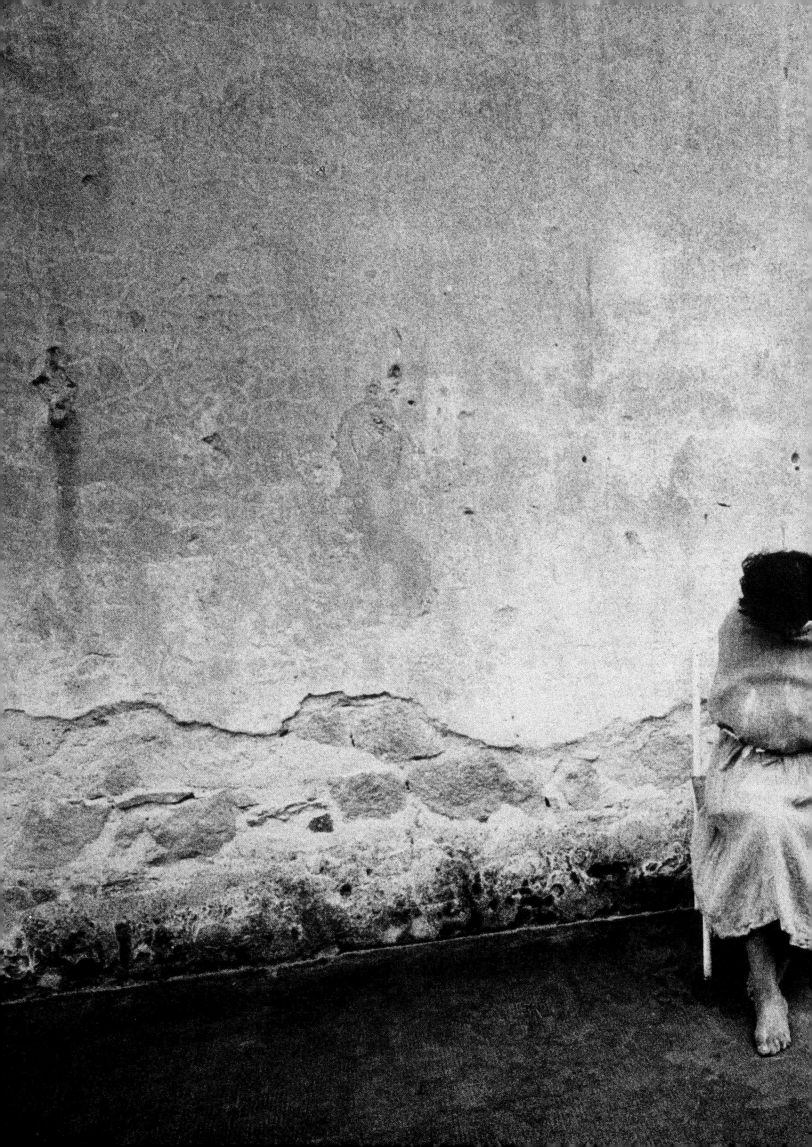

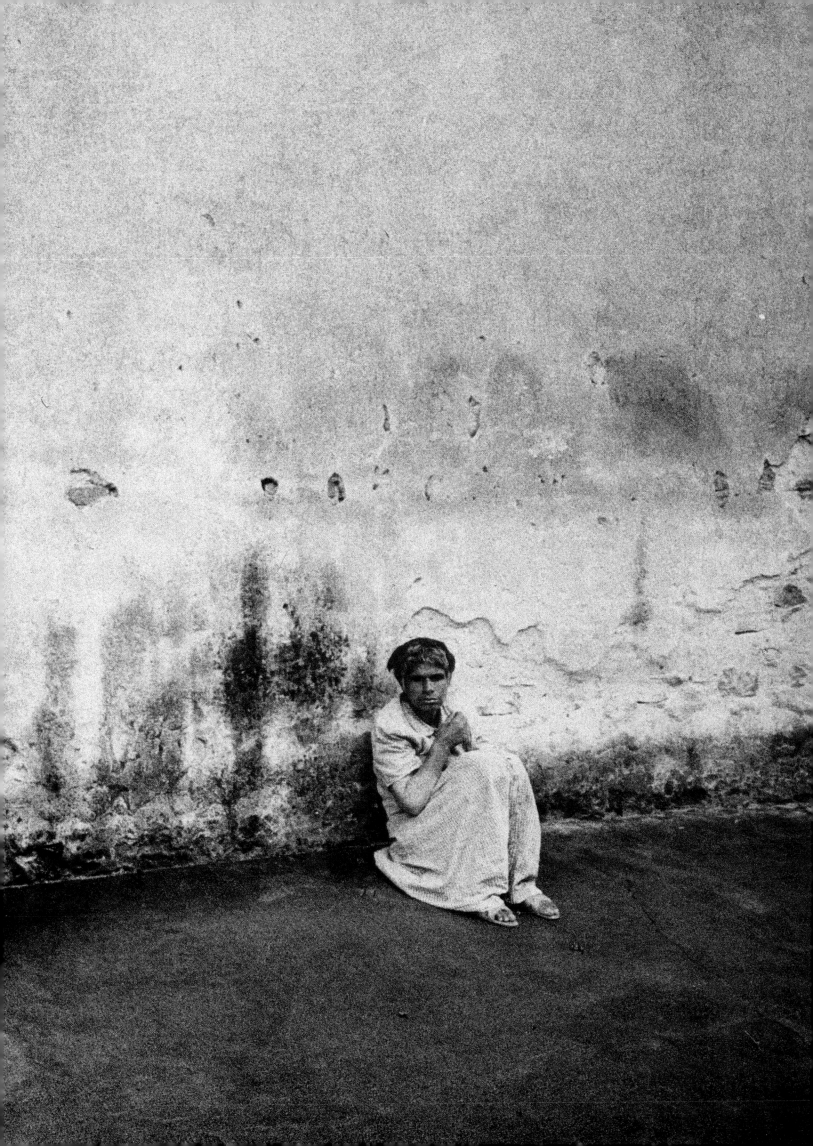

455. Mimmo Jodice
"Figura" ("Figure"), *1968. Gelatin-silver print, 39 x 28.5 cm. Collection of the artist.*

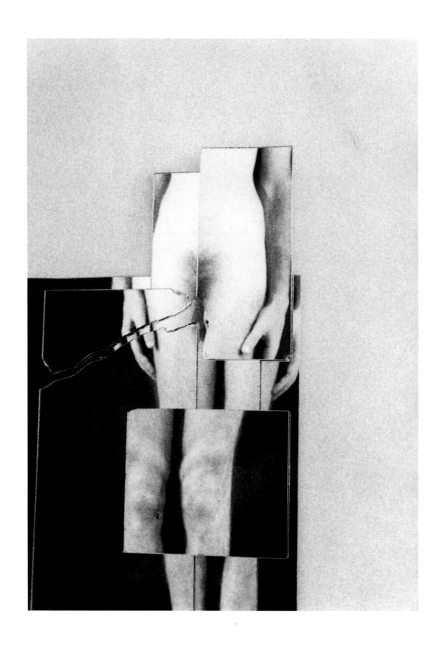

456. Mimmo Jodice
Morano Calabro, *1969. Gelatin-silver print, 19 x 29.5 cm. Collection of the artist.*

457. Ugo Mulas
Biennale di Venezia (Venice
Biennale), *1964. Gelatin-silver print,
40 x 50 cm. Archivio Ugo Mulas,
Milan.*

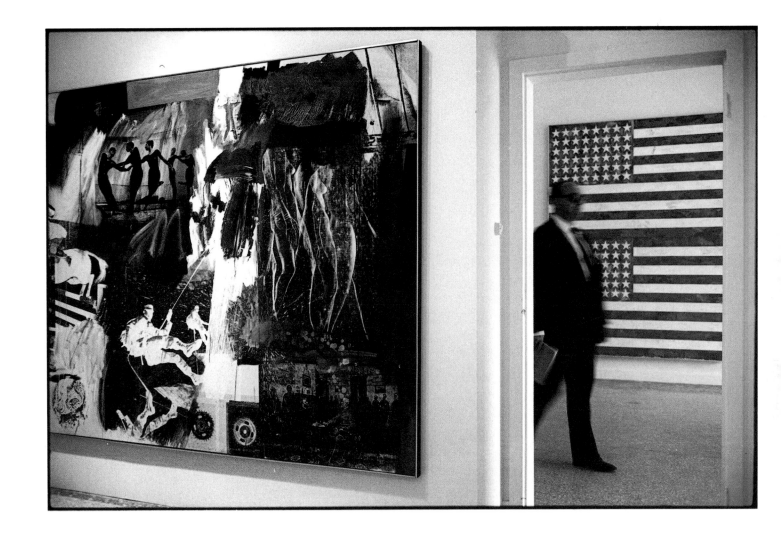

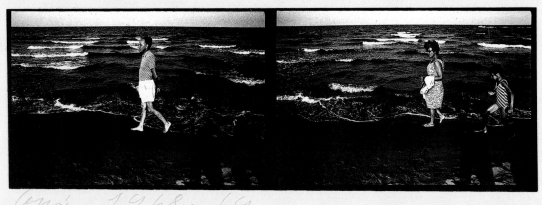

Lenu, 1968-64

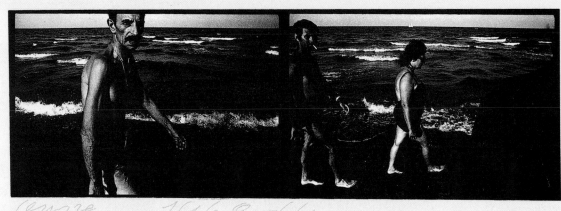

Lenu, 1968-64

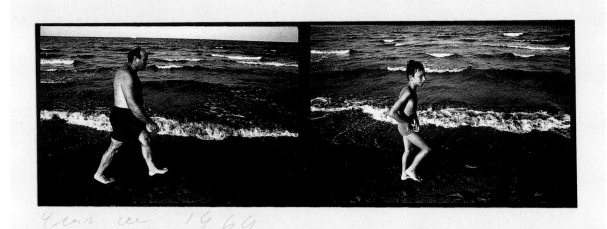

Lenu, 1969

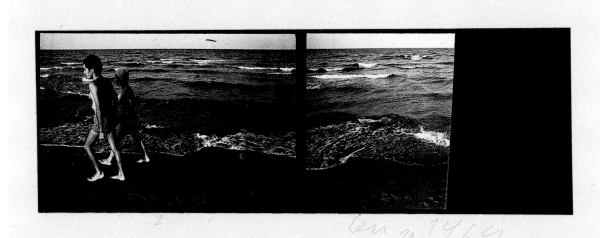

Lenu, 1969

459. Guido Guidi
Cervia, *1969. Gelatin-silver sepia-tone print, 8.5 x 26.5 cm on sheet 12 x 30 cm. Collection of the artist.*

460. Guido Guidi
Cervia, *1969. Gelatin-silver sepia-tone print, 9 x 26.5 cm on sheet 12 x 30 cm. Collection of the artist.*

461. Guido Guidi
Cervia, *1969. Gelatin-silver sepia-tone print, 9 x 26.5 cm on sheet 12 x 30 cm. Collection of the artist.*

462. Guido Guidi
Cervia, *1969. Gelatin-silver sepia-tone print, 8.8 x 26.8 cm on sheet 12 x 29.8 cm. Collection of the artist.*

463. Guido Guidi
Ronta, *1969. Gelatin-silver sepia-tone print, 8.3 x 24.2 cm on sheet 12 x 30 cm. Collection of the artist.*

464. Guido Guidi
Cesena, *1969. Gelatin-silver sepia-tone print, 8.3 x 24.2 cm on sheet 12 x 30 cm. Collection of the artist.*

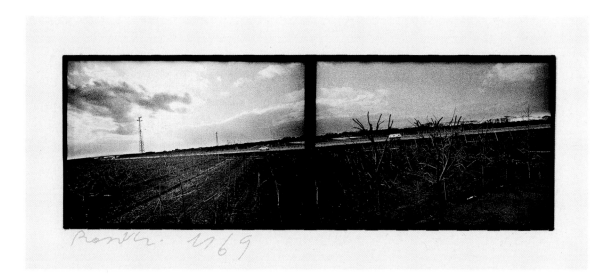

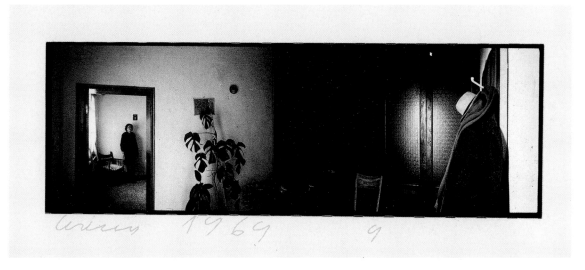

465. Ferdinando Scianna
Ciminna: Venerdì Santo (Ciminna:
Good Friday), 1962. Gelatin-silver
print, 13.2 x 24 cm. Collection of the
artist, Milan.

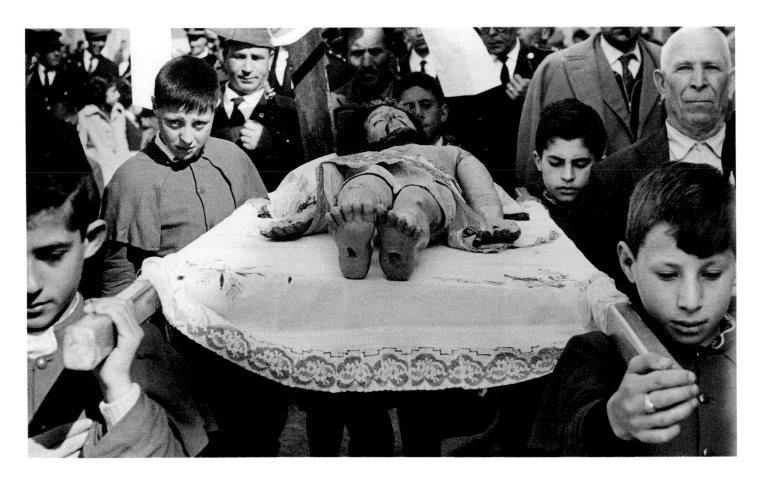

466. Ferdinando Scianna
Prizzi: Pasqua *(Prizzi: Easter), 1963.*
Gelatin-silver print, 26 x 40 cm.
Collection of the artist, Milan.

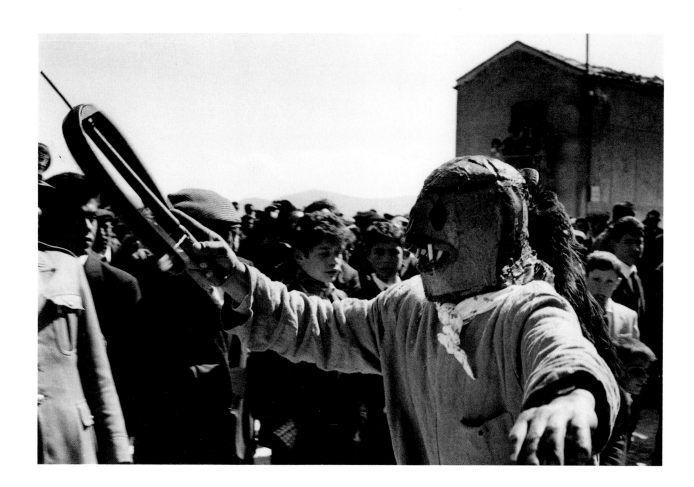

467. Carla Cerati
Antigone, Living Theater, scena
finale. Milano–Teatro Durini–Aprile
1967 (Antigone, Living Theater, Final
Scene. Milan–Teatro Durini–April
1967), 1967, printed 1993. Gelatin-
silver print, 24.5 x 36 cm on sheet 30.5 x
40 cm. Collection of the artist.

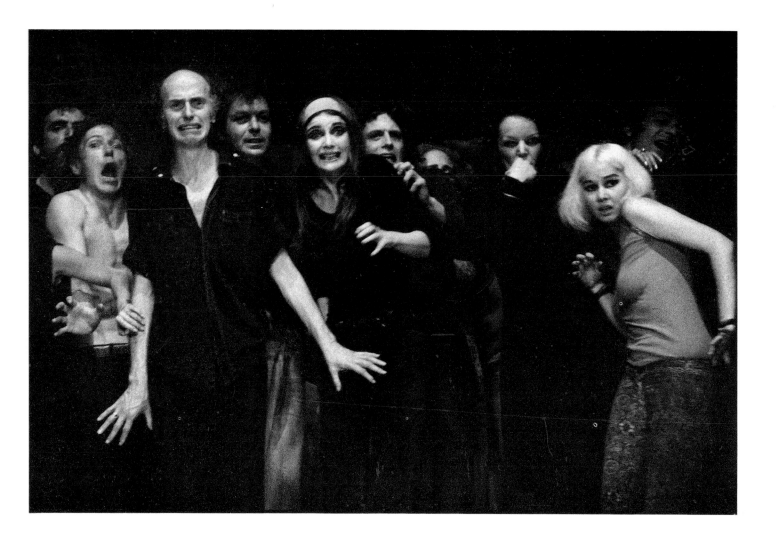

468. Carla Cerati
Inaugurazione del negozio di Willy
Rizzo e Nucci Valsecchi, Milano
(Opening of Willy Rizzo and Nucci
Valsecchi's Store, Milan), 1970,
printed 1993. Gelatin-silver print,
24.5 x 36 cm on sheet 30.5 x 40.3 cm.
Collection of the artist.

469. Carla Cerati
Manifestazione del movimento
studentesco in Galleria Vittorio
Emanuele, Milano (Student
Demonstration in the Galleria
Vittorio Emanuele, Milan), *1968,
printed 1993. Gelatin-silver print,
24.5 x 36 cm on sheet 30.5 x 40.5 cm.
Collection of the artist.*

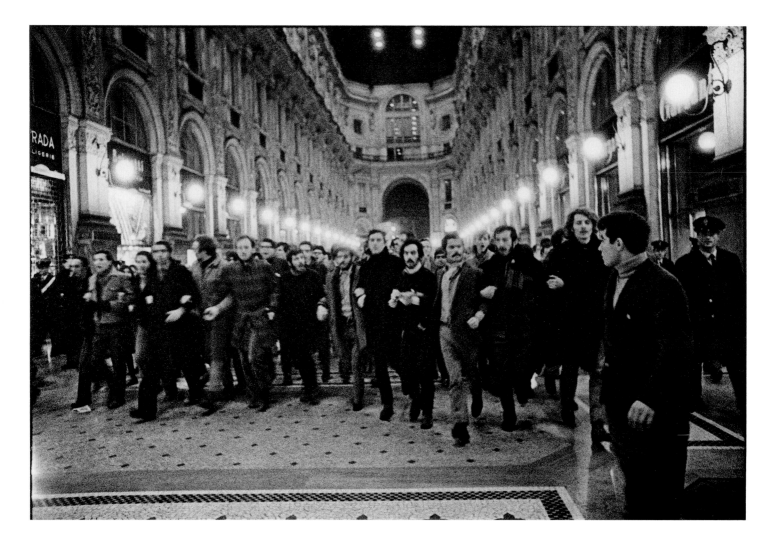

470. Ugo Mulas
Biennale di Venezia *(Venice Biennale), 1968. Gelatin-silver print, 38.3 x 37.5 cm. Archivio Ugo Mulas, Milan.*

Following two pages:
471. Ugo Mulas
Biennale di Venezia *(Venice Biennale), 1968. Gelatin-silver print, 49.5 x 39.5 cm. Archivio Ugo Mulas, Milan.*

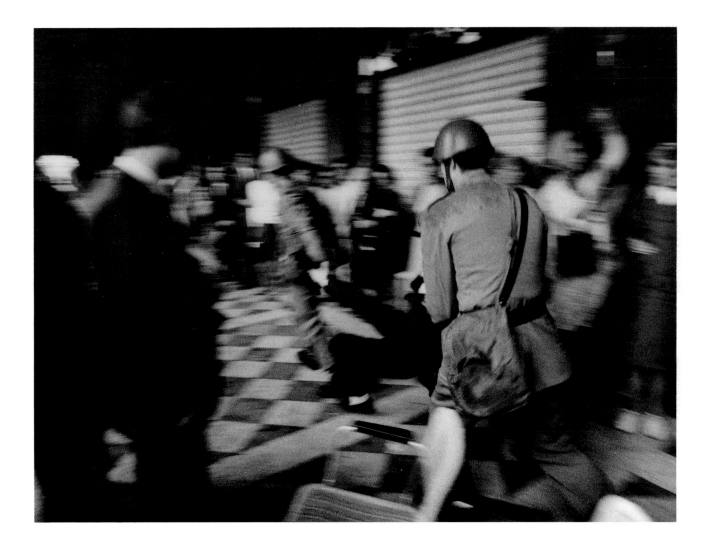

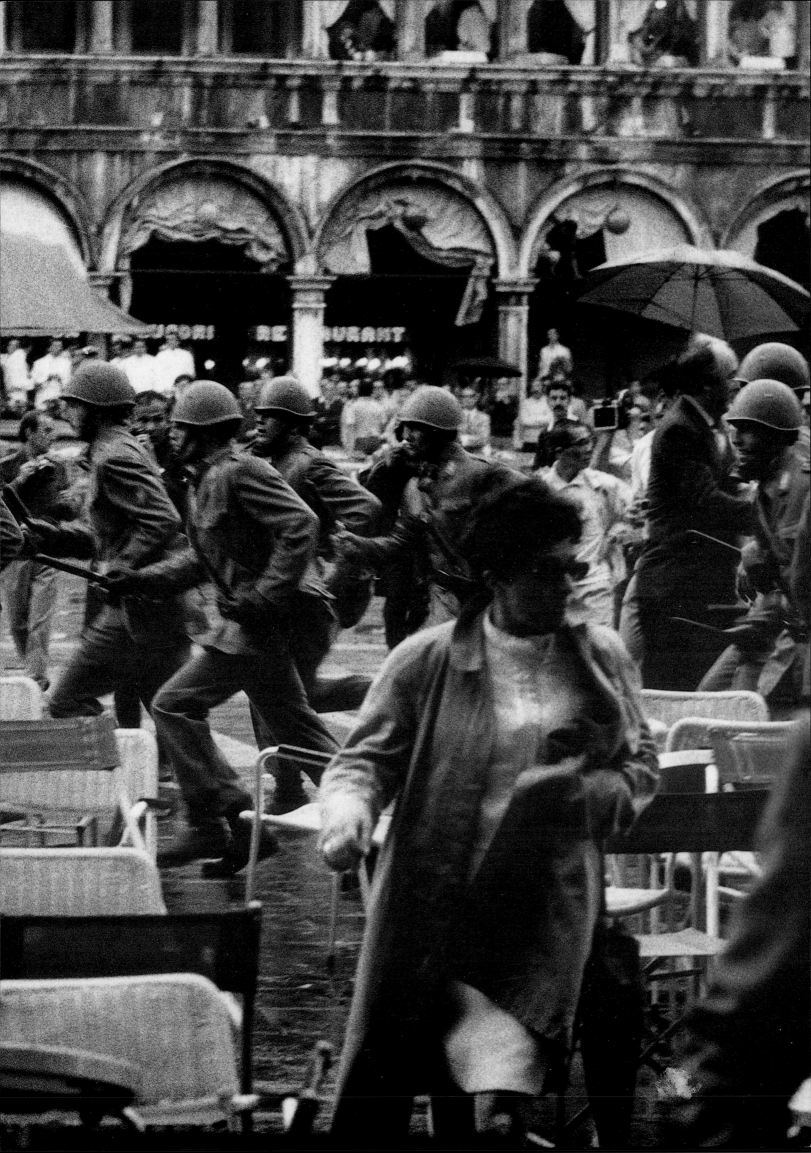

All the lines of force of Ita
through the 1960s, pass th
theory, the critical battles,
cinematic models, the sear
and for a long-term film
this film. Space and time s
and to respond to a new r
and a new narrative ana
From this moment on, and
manner with Roberto Ros
the cinema will become th

an cinema, from the 1930s

ugh Ossessione. *All the*

he literary, visual, and

h for a common poetics

ogrammatics, converge in

m to dilate stereoscopically

ythmics, a new metrics,

epresentational syntax.

in an even more decisive

llini's Roma città aperta,

privileged metronome

Cinema, the Leading Art

Gian Piero Brunetta

The essential aspects of what has been called cinematic neorealism find their ultimate definition in Luchino Visconti's Ossessione, *more so than in* La terra trema. *In that archetype, the repertory of characters, shots, topographical choices, and visual cues is rooted in the soil of a vast figurative culture. . . . This, however, is an investigation that art criticism has yet to conduct; the story that has followed, which has beginnings with Visconti and with his perception of Italy in a cinematic light, is taking place before our eyes, with such richness and variety that one is forced to acknowledge film as today's leading art, just as operatic music was during the Romantic age or architecture during the early Renaissance.*
—Federico Zeri[1]

of the cultural and social processes of postwar Italian life.

On Visconti's set the labors of a group of young people mesh, the same young minds who, a few years earlier, had extensively debated the themes that would form the basis of neorealist poetics. Following the embryonic phase with its idea of cinema as a possible world, *Ossessione* (Obsession, 1942; released in English as *Ossessione*) opened a new phase for Italian cinema, one of real morphogenesis, the result of which would be the emergence of a series of distinguished filmmakers with strongly autonomous visions.

From its opening shots *Ossessione* displays, in explicit fashion, its cinematic, literary, and visual ancestry as well as its ideological and expressive charge (see fig. 1). Overcoming the mediation of literature without feeling any inferiority toward it (the plot was freely drawn from James M. Cain's novel *The Postman Always Rings Twice*, 1934), the scene seems to open up, for the first time, onto an Italy previously excluded from the glories of cinematic representation. "The film's story is a rather terrifying one, and situated in the sweetest, loveliest of Italian landscapes, a piece of Italy that had never before been seen," concludes Umberto Barbaro in a 1943 article, written right after the fall of Fascism's national regime.[2] With its landscape passages teeming with a life at times independent of the drama of Gino (Massimo Girotti) and Giovanna (Clara Calamai), at times symbiotically related to it, the film disconcerts its audience. The director's gaze is so powerful that, as if by synesthesia, it multiplies and dilates sounds emerging from the inert, silent backgrounds of the previous decades and transforms them into a scream of exceptional violence.

Contemporary critics realized they were witnessing an extraordinary event. Some of them, like Barbaro, theorist and spiritual father of many aspiring young directors, recognized in it the strains of a genetic patrimony with roots in Renaissance painting: "Doesn't the apparition of the ice-cream cart, so oddly fantastical, have heraldic precedents that perhaps go back to Ercole de' Roberti?"[3] As Guido Aristarco would write a few years later, *Ossessione* was to have, for many young critics, an importance every bit as great as that of Thomas Mann's *Der Zauberberg* (1924; published in English, in 1927, as *The Magic Mountain*).[4]

Thanks to Visconti and to the young people working with him, it was as though the spirit of the splendid painters of the quattrocento Ferrarese workshop—Cosmè Tura, Francesco del Cossa, and de' Roberti—had come back to life. A bond with a vast artistic heritage was thus recuperated through a process of fusion analogous to that achieved with matter a short while earlier by the young physicists gathered around Enrico Fermi on via Panisperna. Once activated, the chain reaction in the film universe released an uncontrollable energy and power of a sort never before seen. Now cinema—an art form considered secondary and lacking its own identity and expressive autonomy—would be granted a veritable leadership role within the international universe of the arts, from literature and theater to music and painting.

Though the great critical and historical mythologies of neorealist film have long asserted a cohesion and homogeneity, the landscape I am attempting to describe here is anything but cohesive. On the contrary, it is quite variegated, though marked by genetic characteristics that

give rise to a narrative and visual universal language. Immediately after *Ossessione*, there was in any case a leap, an interval or pause in the evolutionary chain, followed in 1945 by the appearance of *Roma città aperta* (Rome open city, 1945; released in English as *Open City*, fig. 2), a work destined to have even more far-reaching effects on world cinema. The Visconti of *Ossessione* and the Rossellini of *Roma città aperta* can be included in the same list, yet they did not possess—it is wise to clarify this at once—the same cultural and ideological chromosomes and would go on to create rather dissimilar and distinct oeuvres.

Although neorealism may have had its day, it has endured as an overarching plane of expression, ethics, ideology, and aesthetics, offering a platform, points of view, and common references in various types of works and for diverse filmmakers, without ever strictly coinciding with any such work or filmmaker. When one looks more generally at the characteristics and dynamics of Italian cinema in the decades after 1945, the notion of a phylogeny—the evolutionary lines of specific groups of individuals and works—becomes quite clear, articulated into phases that follow the historic, economic, and ideological dynamics of the nation and the world at large.

For a few years between the end of World War II and the period of reconstruction and the Cold War, the sensibility dominating the poetics-in-progress of Italian film was anthropocentric, coinciding in a common will to watch and tell the stories of people who have no story. Beyond the expressive quests and risk-taking of individual directors, a certain "middle language" was achieved thanks to neorealism, an idiomatic dialect—an accepted visual lexicon and narrative syntax—that conferred a new, definitive identity upon Italian cinema.

"The films bearing the label neorealism," wrote Jean Cocteau in his diary in the late 1940s, "were nothing more than Oriental tales. Like the Orient, Italy lives in the streets. The Caliph, instead of dressing up as a man of the people, dresses up as a movie camera and seeks out the mysterious intrigues that take place in the streets and in the homes. In *Miracolo a Milano* [1951; released in English as *Miracle in Milan*], [Vittorio] De Sica pushes the Oriental tale to the limit."[5] In an unusual move that went entirely against the neorealist current, Cocteau, faced with Rossellini's films *Roma città aperta* and *Paisà* (Compatriot, 1946; released in English as *Paisan*) and De Sica's films *Sciuscià* (1946; released in English as *Shoeshine*) and *Ladri di biciclette* (Bicycle thieves, 1948; released in English as both *The Bicycle Thief* and *Bicycle Thieves*, fig. 3), invited the public not to content itself with the screen's ability to reflect, like a mirror, the living conditions of an entire nation. Cocteau was suggesting, rather, an equation between the great oral tradition and its clamorous reincarnation in the tales of Rossellini and De Sica. And he was hailing the possibility of entering the mirror to discover, like Alice or the Caliph in *The Thousand and One Nights*, the elusive and unpredictable dimensions of the thousand and one Italies in motion and in rapid transformation.

In *Paisà* Cocteau had seen occur, before his own eyes, the miracle of a man, the filmmaker, expressing himself through a people, and of a people that in turn expressed itself through the filmmaker. Things were starting over

fig. 1. Massimo Girotti and Clara Calamai in Luchino Visconti's Ossessione, *1942.*

fig. 2. Roberto Rossellini's Roma città aperta, *1945.*

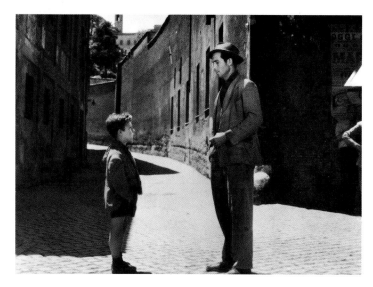

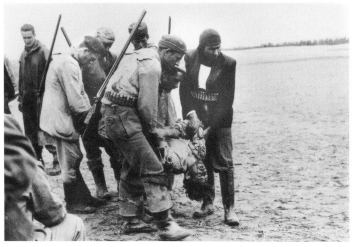

fig. 3. *Lamberto Maggiorani and Enzo Staiola in Vittorio De Sica's* Ladri di biciclette, *1948.*

fig. 4. *Roberto Rossellini's* Paisà, *1946.*

from scratch. The movie camera's eye seemed to have returned to the point from which the Lumière brothers' cameramen had begun. Beginning anew also means rediscovering the world as if it were appearing before the director's eyes for the very first time. In reappropriating the powers of the gaze one realizes that the criteria, the units of measurement, and the systems of reference for the representation of reality have to be reestablished. The Rossellinian tale unfolds in distinct frames with a simplicity and dramatic power akin to that of the great medieval fresco cycles of Giotto.

The unit of measurement for this new, central phase in the history of Italian cinema—in a country destroyed economically and politically, morally and spiritually, physically and materially—was provided, on the one hand, by the war's ruins (the physical remains) and, on the other hand, by the need to translate at once that little bit of vital energy still in circulation (the nonphysical remains, as it were) into cultural energy. However briefly it may have lasted, the men who contributed to the resumption and reconstruction of cinematic activity had the exultant and unprecedented sense of having free access to all the surfaces of the visible and to all the surfaces of the utterable.

Reconstruction also held open the possibility of once again breathing the air of international culture. Cinema became—without the need for any further diplomatic action—the most rapid means for a torn and vanquished Italy, impoverished and lacking credibility, to regain great international credit: "There is no doubt," wrote Georges Auriol in 1948, "that at the present time, in Europe, if not the world over, the cinema has its head in Rome."[6] And there is no doubt that, for a few years, the cinema born and raised in the ruins not only represented a will to rebirth, but also assumed absolute leadership in the territory of Italian and international art. Thanks above all to Rossellini and De Sica, for a few years the rhythms of world cinema sought to coincide with those of Rome rather than those of Hollywood.

The poetics of neorealism did not arise from a common plan worked out over a café table but rather from its powerful voice, the *lacrimae rerum* (tears of the things). The movie camera discovered what Eugène Minkowski called "lived synchronism," that is, the penetration of screen time into the real time of the entire country.[7] The movie camera's eye assumed the role of retinal backdrop, a backdrop against which converged thousands of unforeseen images from which emanated a pathos and an ethos never before known. Such vastly different filmmakers as Alessandro Blasetti, Mario Camerini, Renato Castellani, Giuseppe De Santis, Pietro Germi, Alberto Lattuada, Rossellini, Mario Soldati, Visconti, Luigi Zampa, and Cesare Zavattini inhabited, for a few seasons, the same field of tension. "Neorealism," wrote André Bazin, "throws cat and dog into one bag."[8]

Even though Rossellini, unlike Visconti, was not immediately recognized as the Messiah incarnate, his *Roma città aperta* introduced a new way of looking at human beings and their relationship to things that was destined to become the common patrimony of world cinema and to orient, like a compass needle, the stylistic, thematic, and narrative choices of many filmmakers of subsequent

generations. The director felt himself invested with the role of interpreter of the history of all people. Whereas in Visconti there is a convergence and metabolization of artistic and literary tradition, with Rossellini the cinema suddenly freed itself from this tradition, which had to some degree determined its prior direction. Indeed, at this point, the relationships were actually reversed: it was no longer cinema drawing sustenance from the major arts and translating literary language into images, or popularizing the products of the pictorial and figurative traditions; rather, it was cinematic writing that now transformed and influenced the various forms of artistic writing.

It is important to underscore this change, this assertion of autonomy. In certain sequences of *Paisà*, for example, the compassion incited in the viewer and the epic of observed reality combine in an absolutely natural manner. The result evokes great exemplars of Italian painting and sculpture from Giotto to Nicolo dell'Arca, passing through Michelangelo and the tradition of Caravaggian realism all the way up to the paintings, drawings, or sculptures of Renato Birolli, Renato Guttuso, Mario Mafai, and Giacomo Manzù that were created in the days of wartime struggle, resistance, and liberation. How can one fail to see a kind of ideal convergence and contiguity between Leoncillo's ceramic *Madre romana uccisa dai tedeschi I* (*Roman Mother Killed by the Germans I*, 1944, cat. no. 16)—made in memory of and in homage to Teresa Gullacci, killed in Rome during a demonstration with other women in March 1944—and the sequence of the death of Signora Pina (Anna Magnani) in *Roma città aperta*? How can one fail to sense the same high tone of tragedy found in medieval and Renaissance sculpture groups in the recovery of the partisan's body in the sixth episode of *Paisà* (fig. 4)?

Filmmakers of the time had the heady sensation of being out to discover and able to conquer potentially all the possible loci of Italian reality. Above all they discovered a multiplicity of unprecedented forms of verbal and gestural communication, of perfect interaction between human beings and the environment: they made faces speak; they made silences, emptiness, objects, landscape speak; they rediscovered meanings and purposes in insignificant objects; they ennobled every little gesture. "Man," wrote Zavattini, "stands there before us, and we can watch him in slow motion to confirm the concreteness of every tiniest thought of his."[9]

The neorealist gaze was an all-inclusive gaze that aimed to embrace the whole of the Italian territory. *Paisà* and Germi's *Il cammino della speranza* (1950; released in English as *The Path of Hope*) feature journeys that wend from Sicily to northern Italy. The neorealists moved from Sicilian mines to the rice fields of the Vercelli region in the Piedmont, from the mouth of the Po to the towns of the Ciociaria southeast of Rome, from the neighborhoods of Naples to the ramshackle suburbs of Rome, and entered people's homes to let the movie camera encounter reality naturally, without mediation or distortion. By spreading out the visual coordinates, the screen's virtual space was made to coincide with the space of an imagined Italian nation still to be reconstructed and from which it was understood as possible to build a new identity.

The reaffirmation of an anthropocentric and anthropomorphic cinema found its highest expression, after the masterpieces of Rossellini and De Sica, in Visconti's *La terra trema* (1948; released in English as *The Earth Trembles*), loosely inspired by Giovanni Verga's novel, *I malavoglia* (1881; published in English, in 1890, as *The House by the Medlar Tree*). Visconti went to the South in 1948, to Aci Trezza in Sicily, to shoot his film among real fishermen and in the same settings as those in the novel. He had been thinking for many years of transcribing the Verga work to the screen; in a 1941 article illustrated with drawings by Guttuso, he told of how, through direct contact with the land of Sicily, he had seen Verga's language incarnate in the landscape, had seen it transformed into body, soul, blood: "To a Lombard reader such as I . . . the primitive, gigantic world of the fishermen of Aci Trezza and the shepherds of Marineo had always seemed upraised by the imaginative, violent tone of epic: to my Lombard eyes, though contented with the sky of my own land . . . Verga's Sicily had always truly seemed the Island of Ulysses."[10] This strong statement, in which reality is directly perceived in its mythic and symbolic aspects (perhaps he had been influenced by a reading of Elio Vittorini's *Conversazione in Sicilia* [Conversation in Sicily, 1941; published in English, in 1949, as *In Sicily*]), would also help to determine the formal choices of *La terra trema*: "The power and suggestiveness of Verga's novel seem to rest entirely on its intimate, musical rhythm . . . a rhythm that gives a religious, fateful tone of ancient tragedy to this humble tale of everyday life, this story seemingly made up of discards and rejects, of things of no importance."[11]

Such a poetics clearly prefigures Visconti's dominant directorial practices and choices. Approaching *this* Sicily meant, for Visconti, approaching a reality in which any gesture, any drama, had the power to burst forth at the height of its primitive energy and acquire something of the sacred value of Greek tragedy. Conceived as the opening segment of a great trilogy, and realized visually in part under the influence of the documentaries of directors Robert Flaherty and Joris Ivens and the painting of Guttuso, *La terra trema* is a great voyage of catabasis—a return to the source, a descent to the roots of the national folk culture. The visual score successfully conveys the sense of both the violence of class exploitation as well as the fishermen's titanic struggle against the forces of nature. In this film the director achieved a figurative tension, an ability to see and charge the object of his vision with meaning, that was never repeated. Neither the sumptuous nineteenth-century picture gallery that is *Il Gattopardo* (1963; released in English as *The Leopard*) nor the exploration of chromatic possibilities and splendor of *Senso* (Sense, 1954; released in English as *The Wanton Countess*) nor the infinite gamut of black-and-white half-tones of *Le notti bianche* (1957; released in English as *White Nights*, fig. 5) possesses the innovative power of *La terra trema*, which, nevertheless, in terms of public response, was one of the most clamorous failures in the history of Italian film.

In the early 1950s Visconti and a few other filmmakers— Mario Camerini with *Ulisse* (1954; released in English as *Ulysses*), Renato Castellano with *Giulietta e Romeo* (1954; released in English as *Romeo and Juliet*), Guglielmo Giannini with *Carosello napoletano* (Neapolitan carousel, 1952; released in English as *Neapolitan Fantasy*), and Visconti with *Senso*—confronted the problems of color as

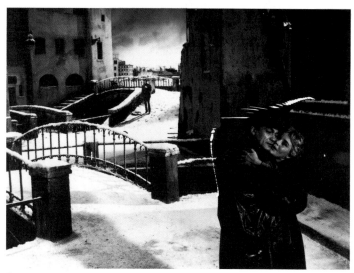

fig. 5. Jean Marais, Maria Schell, and Marcello Mastroianni (background) in Luchino Visconti's Le notti bianche, *1957.*

an expressive medium, achieving results that were in many ways original and memorable, but the advent of color did not automatically revolutionize cinematic ways of seeing. For there was, in Italy, a distrust of color as a form of expression that simplified and therefore reduced the possibilities of signification; it is notable that Federico Fellini would not make his first color feature, *Giulietta degli spiriti* (released in English as *Juliet of the Spirits*), until 1965.

In their early color films the directors, cameramen, and screenwriters recuperated their pictorial heritage by drawing liberally from sixteenth- and seventeenth-century Mannerist and Baroque painting, from the eighteenth-century townscapes of Francesco Guardi and Antonio Canaletto, and from the paintings of the nineteenth-century Italian Impressionists, the Macchiaioli. The time machine of Italian film, which had seemed to be in constant acceleration, experienced a slowdown in these films, modulating itself in relation to cultural, not social, temporality. Painting found its way onto the screen mostly through quotation (as in *Senso* and *Giulietta e Romeo*), though in many cases the quotation found an added value on the screen, as in *Carosello napoletano*, a cinematic transcription of a musical show that, in 1950, Giannini had taken around Europe with great success. Of all those musicals produced in Italy during the 1950s, this film alone can compete, as an equal, with the great American musicals. Taking off from the very old song *Michelemmà* and working his way up to the nineteenth- and twentieth-century songs *Funiculì funiculà, Santa Lucia lontana* (Santa Lucia far away), *Partono i bastimenti* (The ships are leaving), *O vita, O vita mia* (Oh life, my life), *Quando spunta la luna a Marechiaro* (When the moon rises at Marechiaro), in a kind of grandiose "songbook" of unparalleled emotional, visual, and cultural intensity, the director succeeded in using a phantasmagorical play of lights and colors, gestures and sounds, scents and odors to illuminate and accompany the glorious and sorrowful epic of the population, culture, and folk civilization of the great city of Naples. And Giannini managed to capture on screen, through a color that kinesthetically becomes sound—and, vice versa, through a sound that bursts into a continuous symphony of color—the city's solar spirit. It was not until the 1960s, with the emergence of Michelangelo Antonioni's and Federico Fellini's color films, that we would again see movies in which color is given so dominant an expressive role.

For both Antonioni and Fellini, whether working in black and white or in color, there was an imperative beyond objective reality—which in any case is difficult to define—to define the elusive dimensions of subjectivity. They were beginning to understand the importance of the invisible that lies beyond the visible. The faith in the cognitive power of reason—the certitudes provided by ideologies, on the one hand, and by the "facts" of reality, on the other hand—was being replaced by epistemological doubts, by new questions, by perceptions of the problematics of the real. Accordingly, in their films, objects and forms in space begin, little by little, to lose their identities, often appearing to be signals pointing to another dimension. The visible, thanks to the gazes of these two directors, begins to be presented as a multidimensional reality; the empirical data of the everyday begin to fall apart, providing no certitudes and mutating in accordance

with the mutations of the inner conditions of the subject.

More than anyone else, Antonioni, the creator of *Il grido* (1957; released in English as *The Outcry*), *L'avventura* (The adventure, 1960; released in English as *L'Avventura*), and *Deserto rosso* (1964; released in English as *Red Desert*), breathed the spirit of Modern and contemporary painting—from Gianni Morandi to Alberto Burri, from Giorgio de Chirico all the way to Francis Bacon. From his first documentaries and feature films he managed to communicate—often with a single image—the feeling of malaise, the growing power of emptiness enveloping and separating people and things (see fig. 6). In his work of the 1950s and 1960s, Antonioni sought to replace real spaces with topologies that would help to measure the distances separating individuals from others or dividing them from themselves. In Antonioni's films the perception of space is overturned: not only are sight and point of view determined by objects, but objects themselves become manifest, seeming to incarnate an unprecedented meaning. Emptiness prevails over fullness; absence has a greater consistency, a greater narrative and dramatic weight, than presence. On several occasions the director seemed to want to capture on film even the inner radiations of the imaginations of his characters as they attempt to flee the everyday.

During a visit to New York in the early 1960s Antonioni asked if he could visit the studio of Mark Rothko, a painter for whom he felt a great affinity. After admiring the paintings a long time, he observed that those canvases, like his own films, speak of "nothingness." The art critic Richard Gilman, who was present at the studio visit, later pointed out that though not abstract, *L'avventura* and *La notte* (1961; released in English as *The Night*), like much painting of the time, are self-representational—absolute works that do not describe any action, inasmuch as they create an action in themselves.[12]

With *L'avventura* there coalesces in Antonioni's development, though not only for him, a new phase in which a closer relationship with the characters was sought, and an attempt was made to correlate their movements through space—a space suddenly become enigmatic, elusive, unknowable—with the movements of the mind. In the films of the 1960s the perception of space and of its inner coordinates became at once sharper and more uncertain. In the opening sequences of *L'avventura*, but especially in *L'eclisse* (1962; released in English as *Eclipse*), space, as in the paintings of Piet Mondrian, is reduced to its elementary structures, only later to open up onto other dimensions, as in Metaphysical painting.

The turn to color in the 1964 *Deserto rosso* extended Antonioni's formal and expressive ranges. Now the figures in the landscape dissolve, tending to become spots of color. As Carlo DiCarlo wrote of the film:

All is color. The green and silver of the cisterns; the black of the smokestacks, the junction lines, the trestles; the yellow and minium red of the structures; the milky white, the golden yellow, the gray and black of the gas blow-pipes; the violet-green rust of the grass; the few plants that twist about themselves almost weeping onto the burned, bluish-ocher, gray-sepia, lead-colored earth; everywhere a melting pot of incredible, unreal, irreducible tints, almost resembling the meteorological impasti of Dubuffet.[13]

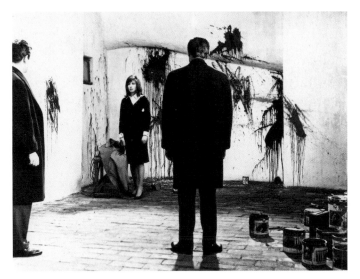

fig. 6. Monica Vitti in Michelangelo Antonioni's Deserto rosso, *1964.*

fig. 7. David Hemmings in Michelangelo Antonioni's Blow-Up, *1966.*

fig. 8. Federico Fellini on the set of Otto e mezzo, 1963.

fig. 9. Marcello Mastroianni in Federico Fellini's Otto e mezzo, 1963.

Antonioni went so far as to force these colors, making them, even more than the objects, a mirror of the emotional and existential state of his characters. The cinema seemed to become for him a means of synthesizing and reformulating contemporary developments in painting, music, and aesthetics. In *Blow-Up* (1966) he transferred these elements to center stage, making them the object of the story (see fig. 7). Once the dissolution of the subject within the space of the Italian reality had been established and presented anew in various forms, Antonioni began to feel the need—as would also happen to Pier Paolo Pasolini—to verify the facts on a broader scale and to force himself into a sort of expatriation, which was followed by a literal cultural and iconographical repatriation in the latter half of the 1960s, with *Blow-Up*, made in England, and then *Zabriskie Point* (1970), made in the United States.

If Antonioni's vision encompassed one of the most advanced and far-flung frontiers of visual experimentation in postwar cinema, Fellini's was more limited and compressed in a geographical sense, seeming, by contrast, to fall almost entirely along the Rimini-Rome axis in the twenty-year period of interest to us. In fact, however, Fellini, too, aimed at exploring and suggesting dimensions beyond the details of the visible and at making autobiographical memory coincide with collective memory. Fellini was one of the few directors in the entire history of film who were able to build, in film after film—in a vast body of work extending from *Luci del varietà* (1951; released in English as *Variety Lights*) to *La voce della luna* (1990; released in English as *Voice of the Moon*)—a true cosmology based on discrete experiences that expand in space and time, indefinitely and limitlessly.[14] He could move with great simplicity from the spaces of reality to those of dream; capable of making several different moments coexist in the same sequence, he seemed, like a magician, able to control time.

From *La dolce vita* (The sweet life, 1960; released in English as *La Dolce Vita*) on, Fellini's first-person involvement in the production process was quite similar to that of many American Action Painters. His is an exceptional case of "action filming": without destroying the object of his narrative, the director almost physically penetrated his own film, letting his own vital energies imbue the images and creating a kind of stream of consciousness through the cinematic medium. In fact Carl Jung and James Joyce are the most recognizeable tutelary deities of Fellini's cinema after *La dolce vita*.

After 1960 Fellini abandoned any real interest in the mimetic representation of everyday life, deciding to enter his own inner world in a more definite manner through the insertion of oneiric elements into the metacinematic structure. One of the foundations of neorealist poetics—the attempt to make the real coincide with the visible—was left behind, and the movie camera began to stray ever more constantly toward the realms of dream and the imagination. The dream acquired a material consistency and reality seemed but an illusory game of mirrors and masks.

The key work of the Fellinian cosmogony is *Otto e mezzo* (1963; released in English as *8½*). In this film, the director defined a structure, achieved a rhythm, and organized the shots in a perfect, mutual, internal equilibrium achieved

through a simultaneous movement toward chaos and the height of entropy and the sudden and almost magical ability to reorder components and rejoin the scattered and incomprehensible strands of life experience (see figs. 8, 9). In this film, which occupies a position with respect to the rest of Italian postwar cinema like that of the Sistine Chapel with respect to the rest of Renaissance painting, the boundaries of realism are crossed but not entirely lost sight of. Through the destructuring of the coordinates of space and time, a whole imaginative world is brought into the picture and fitted into a grandiose framework. Several different threads of time overlap and interweave, while inner time dictates the real narrative.

Otto e mezzo placed Fellini at the highest level of visionary filmmaking, alongside the likes of Ingmar Bergman, Luis Buñuel, Akira Kurosawa, and Orson Welles. In Fellini's subsequent works of the 1960s—films as different as *Giuletta degli spiriti* and *Fellini Satyricon* (1969)—in a state of creative grace, he continued to pull out of his hat a vast quantity of images and emotions integrating his own experience and personal memories with the collective experiences and memories of a world, playing with a palette of vastly changing, iridescent colors, now dense, rich, bright, and velvety, now cold and ghostly. Fellini's journeys were the initiatory journeys into the discovery of oneself. Deep down he loved static realities and indelible emotions, understanding the imaginative power to be found when the mechanism of time was oriented against the clock or toward the spaces of the mind and the imagination rather than those of reality.

Although he had once worked with Fellini, collaborating on the script of Fellini's *Le notte di Cabiria* (1956; released in English as *The Nights of Cabiria* and later as *Cabiria*), Pier Paolo Pasolini was to take a very different approach to filmmaking. Pasolini was an exceptional man, an orchestra unto himself, a King Midas capable of exercising direct control over his materials and transforming them even by the most elementary contact. He moved quite naturally from being a painter to being a screenwriter of films set in the run-down suburbs of Rome; little by little, in a process that lasted almost ten years, his eyes drew closer and closer to the movie camera. In his first two films as director, *Accattone!* (Beggar!, 1961; released in English as *Accatone!*)[15] and *Mamma Roma* (Mama Rome, 1962; released in English as *Mama Roma*), Pasolini discovered the image and its coordinates with equal excitement and set out on a visual quest in which he proved himself capable of creating perfect cinematic equivalents to the painting of Piero della Francesca, Masaccio, and Masolino.

If, as we have seen, Barbaro succeeded in grasping the connections between the painting tradition and Italian cinema, it was the lectures of the great art historian Roberto Longhi that, in the long run, seem to have acted most profoundly and directly on the work and vision of Pasolini. For Pasolini, Longhi's work constituted a fundamental reference point, and his charismatic teaching at the University of Bologna became the vital lymph, the flesh and blood of his poetics and expression. To Longhi, Pasolini owed illuminations that became first poetry, then prose, then cinematic images.[16]

Pasolini's films continually give the impression of a director mesmerized by every face and body he filmed,

fig. 10. Pier Paolo Pasolini in his *Il decamerone*, 1971.

separating them from the story and violating all the preexisting rules of cinematic grammar and syntax. Film brought out the best in his painterly education, which for over a decade had remained in a latent state, ready to explode in many different directions. At the same time, his writing had been ready to transform itself into images and to do so in such a way that the transition was almost unnoticeable. By the end of the 1950s writing could no longer afford him the sense of total identification with its object, compared to the often stunning power of images randomly discovered by moving one's gaze in a circle and stopping suddenly on a face that directly expresses the material reality of an idea.

With the use of color the possibilities grew considerably, and the Longhi influence, after a long distillation, yielded the stupendous images of "La ricotta" (an episode in the anthology film *Rogopag*, 1962; released in English as *Rogopag*): the play of dissonance and chromatic and aural counterpoints, of quotations, of sacredness and the desacralizing of the figurative and the possibility of giving it new form and life on the screen. Film, compared to fiction, had a tremendous regenerative effect on Pasolini, acting almost as an intravenous infusion, a complete renewal of his poetic circulatory system. Yet the traditions of painting and of literature would, throughout his career, remain the favored territories of his creative inspiration.

Compared to the filmmakers of the French New Wave, who saw reality only through the lens of cinematic experience, Pasolini observed the world of the Roman periphery through the filter of his artistic education. Painting, for him, was a means of access, a magical assistant enabling him to enter effortlessly into the space of film. And in his early films he created a time that is not the time of cinematic narration, nor that which found its way into French film through the École du Regard. Rather, it is the time of the spectator's sight when viewing a painting. His idea of space and time is comparable to that of a medieval painter: Pasolini seemed to know only two-dimensional space and to be entirely ignorant of perspective. And yet even when making an obvious quotation from one painting or another, he always sought to give cinematic life to the iconography of reference.

Pasolini truly wanted to use the movie camera as a paintbrush and went so far as to appear in *Il Decamerone* (1970; released in English as *The Decameron*), his film based on Boccaccio's fourteenth-century classic, as a Giottolike painter who moves about and observes the world with a precinematic eye (fig. 10). The classics—in such films as *Il vangelo secondo Matteo* (1964; released in English as *The Gospel According to St. Matthew*), *Edipo re* (1967; released in English as *Oedipus Rex*), and *I racconti di Canterbury* (1972; released in English as *The Canterbury Tales*), among others—served him as a kind of natural environment in which to camouflage, project, recognize, and reveal himself according to the needs and the stages of a journey that seemed already entirely written out and anticipated in the pages of the great literature of the past.

Yet even when he used literary space to tell of himself, Pasolini acted in the spirit of a nomad. He used the classics to move between history and myth—between "the vain movement of present time"[17] and the sense of repetition, of return, of original stasis, between the linear narrative path

with its sense of closure and the notion of infinite circularity. For Pasolini the primary concern was the deep meaning of the parable of individual and collective existence, the exemplary significance of every parable or tale. Literature and painting were for him a means of an obsessive search for paradise lost and an observation point from which to gaze on the present and the future.

Even if Bernardo Bertolucci's first film, *La commare secca* (1962; released in English as *The Grim Reaper*), seems to have been born of one of Pasolini's ribs, in it his gaze gradually reveals itself as a perfect blend of the geniuses of artistic tradition and cinematic tradition. In Bertolucci, more than in any other filmmaker of his generation, there is also a cross-contamination and constant fusion between elements specifically linked to Italian cinema and culture (Verdian opera especially) and motifs that immediately give his films an international scope and frame of reference. Though Bertolucci was driven from his very first films to go on a kind of journey in search of his father and his own family roots, these films are informed by a stereoscopic gaze through which every space is a place of places, an intersection of autobiographical emotions and memories and international artistic, literary, and cinematic influences.

La strategia del ragno (1970; released in English as *The Spider's Stratagem*) can be considered the young director's moment of arrival, and a decisive turning point in his work. Among many other things the film is also an exceptional repertory of painterly images—from the Surrealist painting of René Magritte to the Metaphysical painting of Giorgio de Chirico to the realism of Edward Hopper and the visions of various naïfs scattered about the Po River valley—that the director has reordered and revived. And with this film he began his association with the cinematographer Vittorio Storaro: thanks to Storaro, and to their combined meditation on the transformative role of light, its connotative function would start to become clear, assigned the task of orchestrating—playing an even more important role than music—the meaning of the film.

An implacable light immobilizes the characters under the sun of the first afternoon or under the rays of the moon, a light that communicates tactile sensations and sound vibrations and lends magic and mystery to the figures in the landscape. In *Il conformista* (1970; released in English as *The Conformist*) "the separation of light and shade in Rome and the fusion of light and shade in Paris, the utilization of effects of blue and orange, of gray and white and violet, both indoors and outdoors, the plays of backlighting, up to the visionary immersions in darkness in the last part of the film, build up a visual fabric so suggestive that it becomes the very focal point of the linguistic system."[18] The results of Bertolucci and Storaro's collaboration—which with the passage of time became a true creative intermarriage—would effect, in the decades to follow, a profound change in the consciousness of the role of light for filmmakers all over the world.

The visual quest of post-neorealist Italian cinema does not, however, reside only in Antonioni, Fellini, Pasolini, and Bertolucci. We cannot forget such other important names as Mauro Bolognini, Franco Brusati, Marco Ferreri, Ermanno Olmi, Elio Petri, Gillo Pontecorvo, Francesco Rosi, Ettore Scola, Florestano Vancini, and Valerio Zurlini,

all of whom participated in this cinematic deconstruction of the visible world.

In the 1970s, because of shifts in the economic, ideological, and cultural landscape, Italian film began to lose its creative and vital energy and, with it, its cultural hegemony. In a rather short space of time, despite the fact that certain directors—Antonioni, Bertolucci, Fellini, Olmi, Rosi, and Scola—continued to create important works, there was a general withdrawal from artistic experimentation and linguistic creativity. In this climate of doubt neither literature nor art, which had served Italian filmmakers so well in the postwar years, could continue to serve as an authentic source of creative support or reference. Rather, the artistic patrimony seems to have become excess baggage, ballast that the new generation of directors, whose dominant models and visual and narrative syntax owe more to television and MTV, have attempted to jettison.

Translated, from the Italian, by Stephen Sartarelli.

1. Federico Zeri, *La percezione visiva dell'Italia e degli italiani* (The visual perception of Italy and the Italians. Turin: Einaudi, 1989), p. 63.
2. Umberto Barbaro, "Realismo e moralità," *Film* 6, no. 31 (July 31, 1943), p. 3.
3. Umberto Barbaro, "Neo-realismo," *Film* 6, no. 23 (June 5, 1943), p. 4.
4. Guido Aristarco, "Il neorealismo cinematografico," *L'europeo* 34 (June 4, 1976), p. 34.
5. Jean Cocteau, *Le passé défini* (The past defined. Paris: Gallimard, 1983), p. 351.
6. Georges Auriol, "Entretiens romains," *La revue du cinéma*, no. 13 (May 1948), p. 54.
7. Eugène Minkowski, *Il tempo vissuto* (Time lived. Einaudi: Turin, 1983), p. 20.
8. André Bazin, *Qu'est-ce que le cinéma, IV: Une esthétique de la réalité dans le néo-réalisme* (What is cinema, IV: an aesthetics of reality in neorealism. Paris: Editions du Cerf, 1962), p. 16.
9. Cesare Zavattini, speech given at the Perugia conference on "Il cinema e l'uomo moderno" (The cinema and the modern man), 1949. Reprinted in Mino Argentieri, ed., *Neorealismo* (Neorealism. Milan: Bompiani, 1979), p. 63.
10. Luchino Visconti, "Tradizione e invenzione," in *Stile italiano nel cinema* (Italian style in cinema. Milan: Daria Guarnati, 1941), p. 78.
11. Ibid., p. 79.
12. Seymour Chatman, "All the Adventures," in Seymour Chatman and Guido Fink, eds., *L'avventura* (The adventure. New Brunswick, N.J.: Rutgers Film in Print, 1989), p. 3.
13. Carlo DiCarlo, "Il colore dei sentimenti," in Michelangelo Antonioni, *Deserto rosso* (Red desert. Bologna: Cappelli, 1964), p. 17.
14. The most recent, complete, and coherent analysis of Fellini's universe can be found in Peter Bondanella, *The Cinema of Federico Fellini* (Princeton: Princeton University Press, 1992).
15. *Accatone!* was based on Pasolini's novel *Una vita violenta* (1959; published in English, in 1968, as *A Violent Life*).
16. Gian Piero Brunetta, "Longhi e l'officina cinematografica," in Giovanni Previtali, ed., *L'arte di scrivere sull'arte* (The art of writing about art. Rome: Editori Riuniti, 1982), pp. 47–56.
17. Pier Paolo Pasolini, *Edipo re* (Oedipus rex), ed. Giacomo Gambetti (Milan: Garzanti, 1967), p. 130.
18. Paolo Bertetto, "Filosofia della visione," in Paolo Bertetto, ed., *Vittorio Storaro, Un percorso di luce* (Vittorio Storaro, a path of light. Turin: Allemandi, 1989), p. 9.

Visconti's *Senso*: Cinema and Opera

Teresa de Lauretis

In cinema, history is nowhere else but in representation. . . .
The historical film is full of cinema, *not of the* past. *Any move
of the eye (the camera's* and *the spectator's) that establishes a
relationship between nationality and history is reactionary if it
is not crossed by a reflection on its reality "in progress," a reality
that* ipso facto *includes the institution and the specific
mechanisms of representation.*
—*Dedi Baroncelli*[1]

History and cinema are two sites and anchorage points of
Italian aesthetics and social thought throughout the
twentieth century. Their imbrication in one another and in
other forms of art both high and popular—from literature
and music to theater, painting, fashion, and stage or set
design—is what characterizes the cinema of Luchino
Visconti as a reflection on "reality in progress," a reality
that includes, most explicitly, the various apparatuses of its
representation and the institutions within which they
operate.

Visconti's first black-and-white features were *Ossessione*
(Obsession, 1942; released in English as *Ossessione*), adapted
from James M. Cain's popular novel *The Postman Always
Rings Twice* (1934), and *La terra trema* (1948; released in
English as *The Earth Trembles*), which transposed into film
language the unique linguistic experiment of Giovanni
Verga's novel *I Malavoglia* (1881; published in English, in
1890, as *The House by the Medlar Tree*). These two films
transform literary works into altogether new cinematic
forms, in which the specificity of local histories (of the Po
delta region and of Sicily, respectively), while remaining
implicit, is evoked in the graininess or stark contrast of the
images, the slow tracking shots of roads and landscapes,
the sound of the waves, the long, silent takes. It is with
Senso (Sense, 1954; released in English as *The Wanton
Countess*),[2] Visconti's first color feature, that the reflection
on history becomes explicit, foregrounded, thematized.

A story of sexual passion clashing against political and
familial loyalties, set in Venice under Austro-Hungarian
rule just before Italy's Third War of Independence in 1866,
Senso is scripted from Camillo Boito's eponymous novella,
but significantly recast. Boito's *Senso* (1883), written some
twenty years after the historical events that are its
backdrop, indirectly remarks on the waning of the
patriotic ideals and wholesome values that animated the
Risorgimento, the drive of the Italian middle classes to
national independence and nationhood that went on from
the 1830s to 1870. Made not even ten years after the end of
Italy's civil war and the Resistance to Nazism and Fascism,
Visconti's *Senso* reproposes Boito's cynical tale of passion
and betrayal, reframing it in the light and sounds of a
traditionally "Italian" form of representation, *melodramma*,
making history integral to the emotional structure of the
drama, and music integral to the formal structure of the
film. In other words, the film is an experiment in form, in
film as opera—a cinematic opera.

Visconti's *Senso* is about Livia, Countess Serpieri (played
by Alida Valli), who falls in love with a young Austrian
officer, Franz Mahler (played by Farley Granger), and
becomes his mistress. Livia's much older husband (played
by Heinz Moog) is a high-ranking civilian collaborator; her
cousin, the Marquis Roberto Ussoni (played by Massimo
Girotti), is a patriot and a member of the Venetian
liberation movement, to which Livia is also sympathetic ("I
am like my cousin," she tells Franz early in the narrative, "a
true Italian"). Thus she will accept in safekeeping the funds
collected to aid the patriots' insurrection (or, as Visconti
has Ussoni say, "our revolution"). While Livia discovers
sexual love in sleeping with the enemy, Franz is fickle and
jaded; soon after their first night together, he begins
missing their appointments in a rented room. Livia goes to
look for him in his quarters, exposing herself to the

derision of the other officers, only to discover that he has been spending his time with other women and has sold the precious locket she had given him.

At the war's outbreak the Serpieris leave Venice for their country villa; Livia is frantic, for she had been unable to find Franz before her departure. When he suddenly appears at the villa, professing his love and telling her a story of a "friend" who had bribed the military doctors to avoid going to the front, she offers him the patriots' money to buy his own release and promises to join him in Verona as soon as he can send word. But as the news from the front makes her fear a possible Italian victory, which would separate the two lovers indefinitely, Livia departs on an arduous and dangerous journey through a war-torn landscape. Arriving at last in Verona, she finds Franz in his apartment in the company of a young prostitute with whom he has spent the night. Drunk, disheveled, and wallowing in self-pity, Franz brutally scorns Livia, giving the lie to her romantic hero: he is a coward, he flaunts, but why not? Austria may win this battle but will lose the war, and the world to which they belong is doomed to end. He insults and cruelly humiliates her by forcing her to confront the prostitute as a younger and more attractive version of herself. Crazed with jealousy, loss, and humiliation, Livia denounces Franz as a deserter to his commanding officer, and then, calling his name, wanders in despair through the night streets where drunken Austrian soldiers celebrate their victory in the battle of Custoza. At dawn Franz is executed.

With his scriptwriter, Suso Cecchi D'Amico, and the collaboration of Giorgio Bassani, among others, as well as Tennessee Williams and Paul Bowles, who wrote the dialogue in English (for free, Williams recalled, out of admiration for the director),[3] Visconti rewrites Boito's story, adding the pivotal character of Ussoni to establish the link between private and political betrayal: ineffectual and undeveloped as a character, Ussoni is the dramatic trope through which sociopolitical events affect personal history, and history inflects story. In Boito's misogynous *Senso*— told in the first person, retrospectively, by its aging protagonist—the young Countess Serpieri first meets Lieutenant Remigio Ruz in a fashionable café on Piazza San Marco, where, off duty between battles, the Austrian officers entertain the ladies of the Venetian Austrophile aristocracy; she has no interest in politics or concern for the Italian cause. In Visconti's *Senso*, on the contrary, a slightly older and patriotic Livia meets the handsome young lieutenant at a performance of Giuseppe Verdi's *Il trovatore* at La Fenice, Venice's opera house. When he insults the Italian patriots engaged in an anti-Austrian demonstration and is challenged by Ussoni, Livia asks to be introduced to him, hoping to prevent the duel. The lieutenant's name is now Franz *Mahler*.

Verdi and Gustav Mahler. Two points of reference paradigmatic of an artist, an intellectual, and a cultural figure whose work in film from *Ossessione* in 1942 to *L'innocente* (released in English as *The Innocent*) in 1976 is at once haunted by the phantasms of a singular personal history and yet representative of the contradictions of Italy's social and political history. Visconti was an aristocrat, a man of privilege whose Communist beliefs and homosexuality—the latter widely rumored and never publicly avowed—made him eccentric, as becomes "the artist," but did not relegate him to the isolation of the margin, the embarrassing vulnerability of a Pier Paolo Pasolini. "Franz Mahler" is the name of Visconti's romance with German music and (what we now call) high culture, which he inscribed, exposed, indicted, and returned to in his films again and again, as to the structure of an obsession. As Mahler's Third and Fifth symphonies will accompany the descent, the love and death, of Gustav von Aschenbach in Visconti's 1971 recasting of Thomas Mann's *Der Tod in Venedig* (1912; published in English, in 1925, as *Death in Venice*), here Anton Bruckner's Seventh Symphony underscores, in counterpoint to Verdi, Franz's and Livia's mutual and multiple betrayals, their respective dishonor and lust for death, the utter degradation of their world.

Critics have spoken of Visconti's "duplicity," or what I would rather call his double vision.[4] On the one hand are his unhesitating commitment to anti-Fascism and later to a progressive, left-wing cultural politics partial to Lukácsian realism; his invention of the cinematic language that was to become known as neorealism[5]; his iconoclastic stage productions of theatrical classics; and his singular role in the resurgence throughout Europe of Verdi and Italian opera, in contrast to "Wagnerism." (From 1954, the year of *Senso*, to 1957, Visconti directed five Italian operas for La Scala in Milan, all starring Maria Callas in her now legendary performances of Gasparo Spontini's *La vestale*, Vincenzo Bellini's *La sonnambula*, and Verdi's *La traviata*; his production of Verdi's *Macbeth* in 1958 virtually launched the Spoleto Festival dei Due Mondi; his 1964–66 directing seasons included *Il trovatore* and Richard Strauss's *Der Rosenkavalier* in London and Verdi's *Falstaff* in Vienna.)[6] On the other hand, these very choices and his partiality to the past, to looking back toward or examining a given cultural formation in its last stages of dissolution, went hand in hand with an individualistic, aristocratic conception of the artist, the intellectual, and the work of directing.

Senso was seen as the crystallization of Visconti's own contradictions. For some it stood as the great divide between the impressionistic, rough, unfinished products of neorealist aesthetic and the mature dramatic, narrative, and filmic complexity of a proper cinematic realism. For others it was the confirmation of an aestheticizing, nostalgic, decadent vision that belied the director's progressive image; they reproached him for not producing *the* exemplary text of Marxist realism. As Adelio Ferrero noted, Visconti directly contributed to the construction of this critical image of himself through his organic role in the construction of "a certain history of a progressive and antifascist Italian culture."[7] I would add that he also contributed to the critical controversy by the integrity with which he pursued his double vision and inscribed his own personal-political contradictions in the film. For this very reason, I suggest, *Senso* retains an edge, a sense of irresolution, a fantasmatic quality that exceeds the definition of realism and insistently foregrounds, instead, the question of representation.

From its opening shots through the finale of Franz's execution *Senso* is grand opera, drama in music. It opens with an extreme long shot of the stage on which the lovers Leonora and Manrico sing a farewell duet at the end of

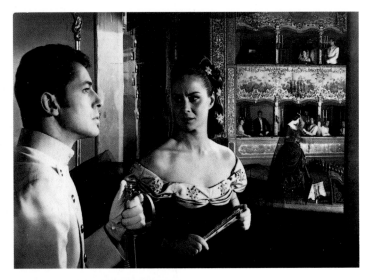

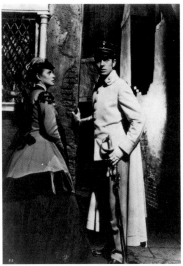

figs. 1, 2.

Act III of *Il trovatore*, while the opening credits appear in a slow succession of lap dissolves, followed by two tracking shots of Manrico singing the incendiary aria "Di quella pira" (Of that pyre), then by a series of slow zigzagging pans that reveal the orchestra pit, the orchestra, and the boxes crowded with Venetian civilians and Austrian officers (the Austrians also love opera). It closes with the tableau of Franz's execution, also in an extreme long shot from behind and to the right of the firing squad: his white uniform against the background of a naked brick wall, the drums rolling, his body on the ground, then dragged off screen. The field remains empty for a while before the end credits begin to roll. Between these strongly marked operatic moments the spectator is caught up in a self-reflexive and ironic operatic world. In a way the Austrian lieutenant and the Italian countess never leave the theater; nor do we: they replace Manrico and Leonora, and resignify their story for us. As one of the film's most perceptive viewers, Guido Fink, observed, "Even though we may think we have left La Fenice, *Senso* keeps relaying [our look] from one curtain to another, as in the scene of the thousand doors flung open by Livia [at the villa], and the last curtain is the black veil, now thick and impenetrable, that Franz rips off the woman after shouting the truth in her face."[8]

But *Senso* is not a filmed opera like Joseph Losey's *Don Giovanni* (1978); not a melodrama in the Anglo-American sense of a staged play with a sensational appeal to audience emotions. Nor is it a film melodrama in the best Hollywood tradition of, say, Douglas Sirk's *Written on the Wind* (1956), itself a story of familial (oedipal) and class conflict conveyed by the high aesthetic values of its mise-en-scène, expressionistic use of color, and pervasive formal excess. *Senso* is *melodramma* in the specific Italian understanding of a dramatic composition for voice and music. If Sirk's film, perhaps owing to his German background and sensibility, does come close to Visconti's in its meticulous and formal regard for mise-en-scène, still the difference between melodrama and *melodramma* rests on the latter's use of music as an equally constitutive formal element of the film.[9]

Although the protagonists of *Senso* do not sing, it is the music on the soundtrack that expresses their feelings and inner conflicts more subtly than do their words, and that conveys to the spectator what they, indeed, may not yet know. Take the meeting of Livia and Franz in the long opening sequence at La Fenice. After Manrico's aria and the chorus of his men ready to fight or die ("To arms!"), the balcony explodes with applause and shouts of "Long live Italy!" and various equivalents of "Austrians go home," and the theater is inundated with tricolored flower bouquets and leaflets. During the ensuing confusion, as Livia watches from the proscenium box she and her husband share with the Austrian general, Franz laughs at the Italians, who "prefer to make war with confetti and mandolins," and Ussoni calls him a coward (prophetically) and slaps him with his gloves. As Franz looks at him and simply walks away, a patriot is being arrested; Ussoni gets into a fight with the guards (he too will be arrested), and Livia conceives her plan to prevent the duel and save Ussoni. She coyly asks the general to be introduced to Franz, who is the talk of the town as a ladies' man.

On stage, Act IV of *Il trovatore* begins: Leonora

approaches the tower where Manrico is imprisoned; she
plans to save him by offering herself to his captor, Conte di
Luna (as Livia plans to save Ussoni by flirting with Franz,
although, unlike Verdi's heroine, Livia will be caught in her
own desire). Franz appears at the box door in medium
close-up. A tracking shot follows his entrance reflected in a
large mirror: we see his back, the general and Livia seated,
Leonora singing on the stage in the background.
Throughout the scene of Mahler's introduction and their
conversation in code ("Do you like opera, Lieutenant
Mahler?" "Yes, very much, Countess, when it is an opera I
like. . . . What about you?" "I like it too. But not when it
takes place off stage . . . or when someone acts as a
melodrama hero . . . without thinking of the grave
consequences of his impulsive action"), their words are
juxtaposed with Leonora's voice singing of her love for the
imprisoned Manrico.

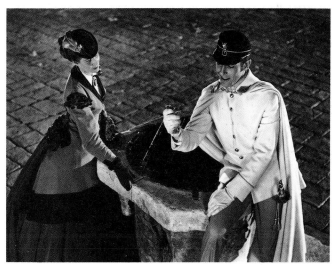

fig. 3.

At this point the camera reframes them so that the left
half of the frame is occupied by Franz and Livia and the
other half by the stage and Leonora (fig. 1). In a visual
equation Franz thus becomes symmetrical with the empty
place of Manrico on the stage, occupying, that is, the place
that in Livia's conscious intentions should properly be
Ussoni's. Cut to a full, low-angle shot of Leonora alone—
only her voice is heard—then again to Livia and Franz,
who asks to see her again. Livia suddenly "feels ill" and
rises to leave. Leonora is singing "Ma deh, non dirgli . . . le
pene del mio cor" (But please don't tell him of the grief in
my heart), and it is her voice, Verdi's music, that explains
to us, if not yet to Livia, why she feels "ill."

Franz and Livia meet again the next evening when she
goes to say good-bye to Ussoni, who is being deported into
exile. "When I saw that officer again, I realized why I was
afraid," her voice confesses off screen, unexpectedly
revealing that the whole film is a memory (although its
subject of enunciation is left undefined, for we never see
the Livia who is remembering). What we do see is her
effort to avoid him. Franz, however, insists on
accompanying her home because of the curfew. He denies
any responsibility in the sentence of exile and intimates
that Ussoni is Livia's lover. As she walks away ("No
gentleman would use his advantage to insult an unescorted
woman"), he laughs and follows her. On the soundtrack
Bruckner's Seventh Symphony begins.[10] Undermining the
"virile and patriotic notes of *Il trovatore*," as Fink puts it,
the "subtle poisons" of Bruckner's first movement (*allegro
moderato*) follow Franz following Livia at some distance,[11]
across a bridge and along the dark portico of the
fondamenta Riello, the shimmering bluish lights reflected
on the water casting eerie shadows on the decaying low
buildings. She protests his following, he demurs—their
words, like a recitative, only briefly interrupting the
music—until she almost stumbles on the corpse of a
white-uniformed young man; then Franz overtakes her,
examines the dead Austrian soldier, and drags Livia into a
dark archway (fig. 2), lowering the veil on her face just as
an Austrian patrol enters the frame. After the soldiers
leave with the body, cursing the Venetians, Livia lifts her
veil, thanks Franz, and walks away from him toward
the camera.

With Livia's "thank you," the music resumes. Insinuating,
persistent, in crescendo, the second theme of Bruckner's

figs. 4, 5.

Adagio signals to the spectator that a turning point has been reached. Indeed, as Franz persists in following her, speaking of the young Austrians' loneliness so far from home, in a hostile country, Livia finally yields to a more intimate dialogue: she stops and turns to tell him that Ussoni is not her lover but her cousin, "the person I most admire in the world." Again she walks away, bidding Franz good night; again he follows. But now the music invades the screen, sensual, overpowering, and, in unison with Livia's voice-over ("We walked together along the deserted streets. . . . My forebodings had vanished. . . . Time stood still. Nothing existed but my guilty pleasure at hearing him talk and laugh"), enclosing them in an intimacy that, as if in judgment, the high camera angle denies (fig. 3).

Throughout this scene—starting with the handcuffed Ussoni's departure, through the discovery of the dead Austrian soldier (a foreshadowing of Franz's end) and the patrol's curse on the Venetians, to the conversation about the approaching war by the well in the Campo del Ghetto—the sensual suggestiveness of the music contrasts with the aloofness of the camera and the proxemic distance of the two actors (Franz walks at least two paces behind Livia, even during the voice-over shots). One is reminded of Fedele D'Amico's recollection of Visconti's production of *Don Carlos* at the London Royal Opera: "Music alone had the task of revealing the inner depth of the soul, of unraveling the twisted thread of the drama, while the mise-en-scène laid before our eyes the outward covering, the appearances. And one realized that nothing would suit this story of hypocrisy and passions smothered by the State better than such a contrast."[12] In *Senso*, as well, it is the music that constructs the scene as one of seduction, over against the images, dialogue, and locations, which are about war, enmity, and death. Indeed, the music flows uninterrupted, bridging a temporal ellipsis of four days, into the next sequence—Livia's capitulation, her decision to become Franz's mistress, her breathless trip across the city to him.

The music and the camera tell different versions of the story, marking an ironic distance between internal, subjective perception and external or historical judgment. The latter, however, is not proffered from a transcendent vantage point outside the story but is inscribed in the telling of the story and thus is conditional upon its representational apparatuses, cinema and *melodramma*. Realism, or the reality effect produced by on-location filming and by the painstaking attention to costume, furnishings, lighting, and interior decor that recreate a believable nineteenth-century ambience, is undercut by the very setting of the story: the "real" buildings, bridges, and canals of a most theatrical city, as well as the magnificent villa Godi di Valmarana (built by Palladio in 1540–42) with its trompe-l'oeil frescoes of the Veronese school (figs. 4, 5), contain the figures of Livia and Franz *en abîme*, within a history of representation, a history that is itself, always, representation.[13]

In *Senso* cinema and *melodramma* weave together history and story, the political and the personal, in a tightly crafted, allegorical symmetry of events, gestures, and figures that return obsessively in visual rhymes— doublings, foreshadowings, mirror images. These, however, are semantically and ironically reversed: Leonora and Livia;

Livia and the prostitute; the dead Austrian soldier and Franz; Franz and Ussoni; Livia walking across Venice to Franz and Livia wandering through Verona after the final betrayal; the lowering and raising of Livia's veil by Franz (fig. 6), which punctuate their encounters to signify not only the divisions but also the *complicities* between public and private, social convention and erotic fantasy, honor and desire.

If history returns, if the betrayal of the Risorgimento is *Senso*'s figure for the betrayal of the Resistance in the 1950s, then history returns in representation, as an effect of signification, a meaning effect—as Verdi's opera returns in Visconti's cinema and as Leonora's love returns in Livia's (for love, too, is in history and in representation). The distance that the film remarks between them, by its excess of signification, is in the ironic, self-reflexive consciousness that individual and social histories are mutually constituted in both contradiction and complicity. But the consciousness that can hear Verdi through Bruckner or Mahler, and see the insistence of history in representation, is itself historical; it belongs to that "certain history" of Italian culture, progressive and anti-Fascist, yet skeptical and self-reflexive, resistant to the forward-looking "democracy" of the 1950s, to simplistic notions of progress, to teleological revisions of history.

Visconti wanted to end the film with Livia's mad wanderings and the image of "a little Austrian soldier, very young, about sixteen, completely drunk, leaning against a wall and singing a victory song. Then he would stop singing and cry and cry and cry, shouting "Long live Austria!"

figs. 6, 7.

I *{Visconti} intended to draw a comprehensive picture of Italian history on which was etched the personal story of Countess Serpieri, but she herself was, after all, only the representative of a particular class. What I wanted to tell was the story of a wrong war, that was made by one class and ended in a disaster. . . . The young soldier, symbol of those who are paying for the victory . . . cries because he is drunk. Or rather, he sings because he is drunk, cries because he is a man, and shouts "Long live Austria!" on the day of a victory which doesn't serve any purpose because Austria will soon be destroyed, just as Franz said. . . . In short, the film was to be entitled* Custoza *and end with "Long live Austria!"*[14]

As he announced his intention, Visconti recalled, there was "a cry of indignation on the part of the producer, the Minister, the censor"—the battle of Custoza (see fig. 7) was a major Italian defeat, even though, in the end, it was Austria that lost the war. However, the producer, minister, and censorship were part and parcel of the institution of cinema, that is to say, of the film's conditions of possibility. The director-artist fought for his vision as well as he could, but the film as finally released bears the mark of cinema's own history.[15]

At a time of serious economic crisis the Italian film industry was willing to gamble on quality products with mass appeal and high production values. Lux Film needed a box-office success and asked Visconti to bid for a high-budget, "spectacular" film of "high artistic level."[16] The film went through two screenplay versions; the second bore the anodyne title *Uragano d'estate* (*Summer storm*) because

Senso was considered too risqué, but the latter title was subsequently reinstated in the final version, the continuity script. Visconti tried to cast Ingrid Bergman and Marlon Brando in the lead roles—a sort of "last tango in Venice" before the fact, as Bernardo Bertolucci no doubt divined—but Bergman was exclusively Rossellini's actress at the time, and the producer rejected Brando as not sufficiently well known. Lux also demanded two additional sets of cuts, one after the editing and another after the dubbing. As a result the opening scene on the stage, many of the love scenes, and others that contributed motivation and a fuller characterization of Livia were reduced. The battle scenes were also drastically cut, and a scene in which Italian government forces evict Ussoni's Venetian "partisans" (who resembled much too closely those of the Resistance, which in a 1950s Italy under DC [Democrazia Cristiana/Christian Democratic party] rule, neither the producer nor the Minister wanted to be reminded of) was omitted altogether.

Even so, and in spite of the film's later success, its presentation at the *Venice Film Festival* "was a scandal," as one viewer reported, because the film was considered left-wing, because it mentioned the defeat at Custoza, because it mixed up the Risorgimento with a love story, because not everyone appreciated the operatic aspect of Visconti's cinema, and lastly because the Venetian audience was offended by the character of Livia. "During the scene in which she gives [the patriots' money] to her Austrian lover . . . a gentleman sitting next to me stood up and shouted: 'This is an insult to Venetian women!' " [17] The Golden Lion award, that year, went to Castellani's pretty *Giulietta e Romeo* (released in English as *Romeo and Juliet*). That was in 1954, of course. But I note as not insignificant the fact that *Senso* was released in the United States only in 1968.

From his directorial debut in 1942 with *Ossessione* to his last great film, *Morte a Venezia* (1971; released in English as *Death in Venice*), created very much within a pre-1968 aesthetic and cultural climate, a dozen or so feature-length and short films made Visconti the figure and the measure of metamorphosis in Italian cinema. It is not coincidental that his two assistant directors in *Senso*—a film whose credits read like a who's who of cinema during the period—were Francesco Rosi and Franco Zeffirelli: their future careers and stylistic choices were to develop from the two souls of Visconti's work, history and opera. And the influence of his cinema is palpable in some of the most interesting film artists of the next generation, such as Bertolucci and Liliana Cavani. To them, in an interview in *La stampa* (The press), given a few years before his death in 1976, Visconti left the task of representing the new world:

I have been young myself, when I made La terra trema, Ossessione, Senso. . . . *Now I'm too old to confront the problems of a reality I do not fully know: I am at the age in which employees are already retired; I still work, but only because working is fun, and because I need it. I think it is for the young to tell the story of their time.* [18]

1. Dedi Baroncelli, *Macchine da presa: narratività, piacere e memoria del cinema* (Movie cameras: narrativity, pleasure and memory of the cinema. Faenza: Edizioni Essegi, 1987), p. 99. This and all other quotations from Italian texts are in my translation.

2. The following are the credits for *Senso*. Director: Luchino Visconti. Screenplay: Luchino Visconti and Suso Cecchi D'Amico, from the novella *Senso* by Camillo Boito, with the collaboration of Carlo Aianello, Giorgio Bassani, Giorgio Prosperi, and, for the dialogue, Tennessee Williams and Paul Bowles. Cast: Alida Valli (Countess Livia Serpieri); Farley Granger (Lieutenant Franz Mahler); Massimo Girotti (Marquis Roberto Ussoni); Heinz Moog (Count Serpieri); Rina Morelli (Laura); Marcella Mariani (the Prostitute); Christian Marquand (Bohemian Officer); Sergio Fantoni (Luca); Tonio Selwart (Colonel Kleist). Music: Giuseppe Verdi, *Il trovatore*, and Anton Bruckner, Seventh Symphony (Orchestra Sinfonica della Radiotelevisione Italiana directed by Franco Ferrara). Directors of Photography: G. R. Aldo and Robert Krasker. Camera Operator: Giuseppe Rotunno. Editor: Mario Serandrei. Assistant Directors: Francesco Rosi and Franco Zeffirelli. Art Directors: Ottavio Scotti and Gino Brosio. Costumes: Marcel Escoffier and Pietro Tosi. Make Up: Alberto De'Rossi. Assistants to the Director: Aldo Trionfo and Giancarlo Zagni. Sound: Vittorio Trentino and Aldo Calpini. Technicolor: John Craig and Neil Binney. Producer: Lux Film. Director of Production: Claudio Forges Davanzati. Assistant to the Producer: Gina Gulielmotti. Studios: Scalera (Venice) and Titanus (Rome). Copyright: Lux Film, Italy, 1954. Premiere: Venice, 3 September 1954. Length: 3,250 m.

3. See Tennessee Williams, cited in Franca Faldini and Goffredo Fofi, eds., *L'avventurosa storia del cinema italiano raccontata dai suoi protagonisti 1935–1959* (The adventurous story of Italian cinema, told by its protagonists 1935–1959. Milan: Feltrinelli, 1979), p. 326. Both Granger and Valli spoke their lines in English and were later dubbed (p. 327).

4. Adelio Ferrero, "La parabola di Visconti," in Adelio Ferrero, ed., *Visconti: Il cinema* (Visconti: Cinema. Modena, 1977), pp. 14–16.

5. The term was first used, according to Visconti, by Mario Serandrei, the editor of *Senso*, who worked with him from *Ossessione* in 1942 to *Vaghe stelle dell'Orsa* (Faint stars of the she-bear; released in English as *Sandra*) in 1965. When he received the first takes of *Ossessione*, Serandrei wrote to Visconti in Ferrara: "I don't know how else I could define this kind of cinema if not 'neo-realistic.'" Visconti, cited in Faldini and Fofi, p. 67.

6. Fedele D'Amico, "Visconti, regista d'opera," in Mario Sperenzi, ed., *L'opera di Luchino Visconti* (The work of Luchino Visconti. Florence: Premio Città di Fiesole, 1969), pp. 172–73. This is still the most thorough evaluation of Visconti's achievement as an opera director and, in particular, of his renovation of Italian nineteenth-century opera. D'Amico all but suggested that Visconti, in effect, *invented* the role of opera director.

7. Ferrero, p. 17.

8. Guido Fink, "'Conosca il sacrifizio . . .': Visconti fra cinema e melodramma," in Ferrero, *Visconti: Il cinema*, p. 91.

9. On the development and theorization of Hollywood melodrama as a film genre, see Pam Cook, ed., *The Cinema Book* (London: British Film Institute, and New York: Pantheon, 1985), pp. 73–84. This monumental, multiauthored, British critical guide to cinema supports my point here: its description of *Senso* as "a costume picture that offers a highly dramatized figuration of personal and class conflict in a nineteenth-century Risorgimento setting" (p. 38) makes no mention of music or in any way relates the film to the genre of melodrama. *Senso* was released in Great Britain in 1957 as *The Wanton Countess*.

10. Bruckner composed his Seventh Symphony in 1883, the year of Camillo Boito's *Senso* and of Richard Wagner's death (in Venice). As Michèle Lagny pointed out in her admirably thorough critical study of the film, Visconti cited fragments of the first two movements, *allegro moderato* and *adagio molto lento e maestoso*, which "form a sort of Requiem," for the first theme was inspired by the death of a friend of Bruckner's and the second was composed as a "Funeral Ode to the memory of Richard Wagner." See Michèle Lagny, *Luchino Visconti, Senso: Étude critique par Michèle Lagny* (Luchino Visconti, Senso: Critical study by Michèle Lagny. Paris: Éditions Nathan, 1992), p. 62. For my reading of this sequence, I am also indebted to the musical expertise of Dale Johnson.

11. Fink, p. 91.

12. D'Amico, pp. 181–82.

13. As Lagny noted, a dominant iconographic influence in the film is provided by the mid-nineteenth-century paintings of Giovanni Fattori and Telemaco Signorini, who belonged to the Macchiaioli group, especially in the outdoor country scenes by the villa. Also notable are the scenes of the battle of Custoza (fig. 7), which can be traced to Fattori's *Il quadrato di Villafranca* (*The Square of Villa Franca*, if not directly to his *La battaglia di Custoza* (*The Battle of Custoza*). See Lagny, pp. 96–97.

And what is one to make of the fact that the scene of Franz's execution was filmed in Rome's Castel Sant'Angelo, the execution site of a famous opera character—Mario Cavaradossi, patriot, painter, and Tosca's lover in Giacomo Puccini's *La Tosca* (1900)? The spectator of *Senso* has no way of recognizing the real location, which in the film looks every bit like a stage backdrop, and may not know that Visconti collaborated on the film *La Tosca* (1940), which was begun by Jean Renoir but finished by Carl Koch. Nonetheless he or she is quite likely to read Livia's "murder" of Franz as an off-key replay of Tosca's murder of Scarpia and, therefore, to read Livia as a degraded (or, depending on the spectator's own ideological location, a more complex or campy or even feminist) icon of the prima donna, opera's enduring representation of "woman."

14. Visconti, cited in Faldini and Fofi, pp. 326–27.

15. See Luchino Visconti, *Senso*, ed. G. B. Cavallaro (Bologna: Cappelli, 1977; 1955), a collaborative volume containing, among other contributions, Boito's novella, the two screenplays, the final continuity script, and the two lists of cuts demanded by the producer, followed by Visconti's responses and arguments. In translation, see Luchino Visconti, *Two Screenplays: La Terra Trema. Senso* (New York: Orion Press, 1970).

16. See Fernaldo Di Giammatteo, ed., *La controversia Visconti* (The Visconti controversy. Rome: Studi Monografici di *Bianco e nero*, 1976), p. 27. This volume also includes a complete filmography with the credits for each film.

17. John Francis Lane, cited in Faldini and Fofi, pp. 332–33.

18. Visconti, cited in Faldini and Fofi, p. 403.

472. Artist Unknown
Poster for Luchino Visconti's
Ossessione, 1942. Offset lithograph
on paper, 71 x 51 cm. Collection of
Gian Piero Brunetta, Padua.

473. Artist Unknown
Poster for Roberto Rossellini's Roma
città aperta, *1945. Offset lithograph*
on paper, 100 x 70 cm. Archivio
Storico Bolaffi, Turin.

474. Antonio Mancinelli
Poster for Roberto Rossellini's Paisà,
1946. Offset lithograph on paper,
140 x 100 cm. Archivio Storico
Bolaffi, Turin.

475. Pasqualini
Poster for Vittorio De Sica's Sciuscià,
1946, reprinted 1948. Offset
lithograph on paper, 100 x 70 cm.
Archivio Storico Bolaffi, Turin.

476. Rinaldo Geleng
Poster for Giuseppe De Santis's
Caccia tragica, *1947. Offset*
lithograph on paper, 140 x 100 cm.
Archivio Storico Bolaffi, Turin.

477. Ercole Brini
Poster for Vittorio De Sica's Ladri
di biciclette, *1948. Offset lithograph*
on paper, 200 x 140 cm. Archivio
Storico Bolaffi, Turin.

478. Averardo Ciriello
Poster for Luchino Visconti's La terra
trema, *1948, reprinted 1949. Offset*
lithograph on paper, 140 x 100 cm.
Archivio Storico Bolaffi, Turin.

479. Carlo Antonio Longhi
Poster for Pietro Germi's In nome
della legge, *1949. Offset lithograph*
on paper, 140 x 100 cm. Archivio
Storico Bolaffi, Turin.

480. Averardo Ciriello
Poster for Alberto Lattuada's Il
mulino del Po, *1949. Offset*
lithograph on paper, 140 x 100 cm.
Archivio Storico Bolaffi, Turin.

481. Valcarenghi
Poster for Giuseppe De Santis's
Riso amaro, *1949, reprinted 1964.*
Offset lithograph on paper, 200 x
140 cm. Archivio Storico Bolaffi,
Turin.

482. Michele Majorana
Poster for Vittorio De Sica's
Miracolo a Milano, *1950. Offset*
lithograph on paper, 140 x 100 cm.
Archivio Storico Bolaffi, Turin.

483. Artist Unknown
Poster for Luchino Visconti's
Bellissima, *1951. Offset lithograph*
on paper, 100 x 70 cm. Archivio
Storico Bolaffi, Turin.

484. Nicola Sinbari
Poster for Alberto Lattuada's Il
cappotto, *1952. Offset lithograph on*
paper, 140 x 100 cm. Archivio Storico
Bolaffi, Turin.

485. Dante Manno
Poster for Roberto Rossellini's
Europa '51, *1952. Offset lithograph*
on paper, 140 x 100 cm. Archivio
Storico Bolaffi, Turin.

486. Enrico de Seta
Poster for Federico Fellini's I
vitelloni, *1953. Offset lithograph on*
paper, 200 x 140 cm. Archivio Storico
Bolaffi, Turin.

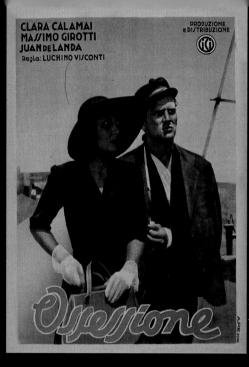

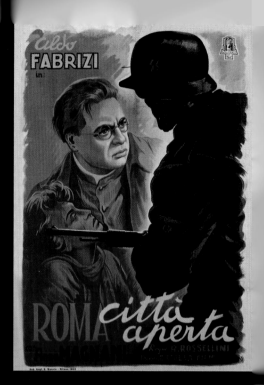

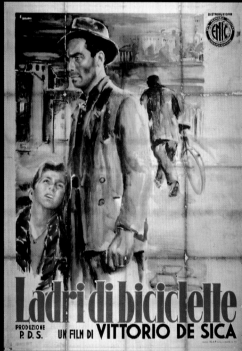

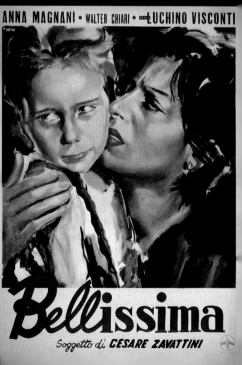

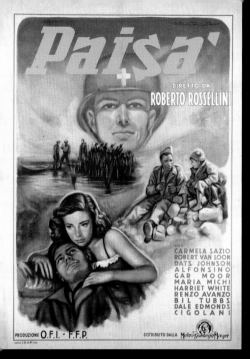

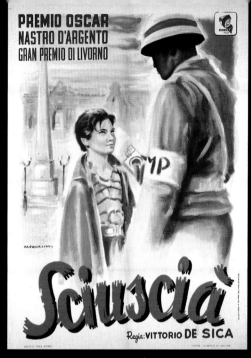

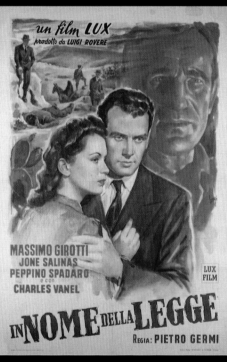

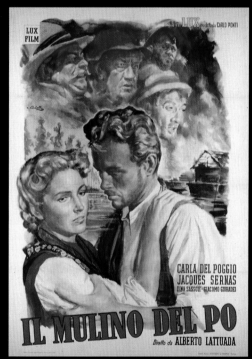

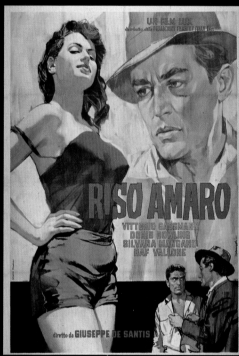

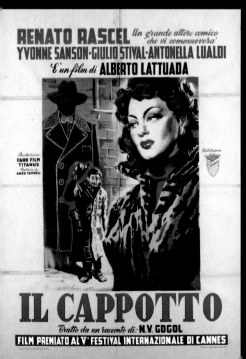

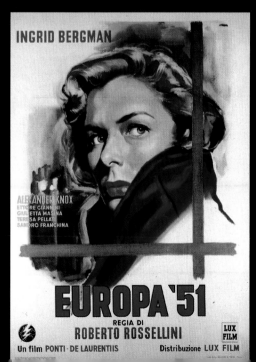

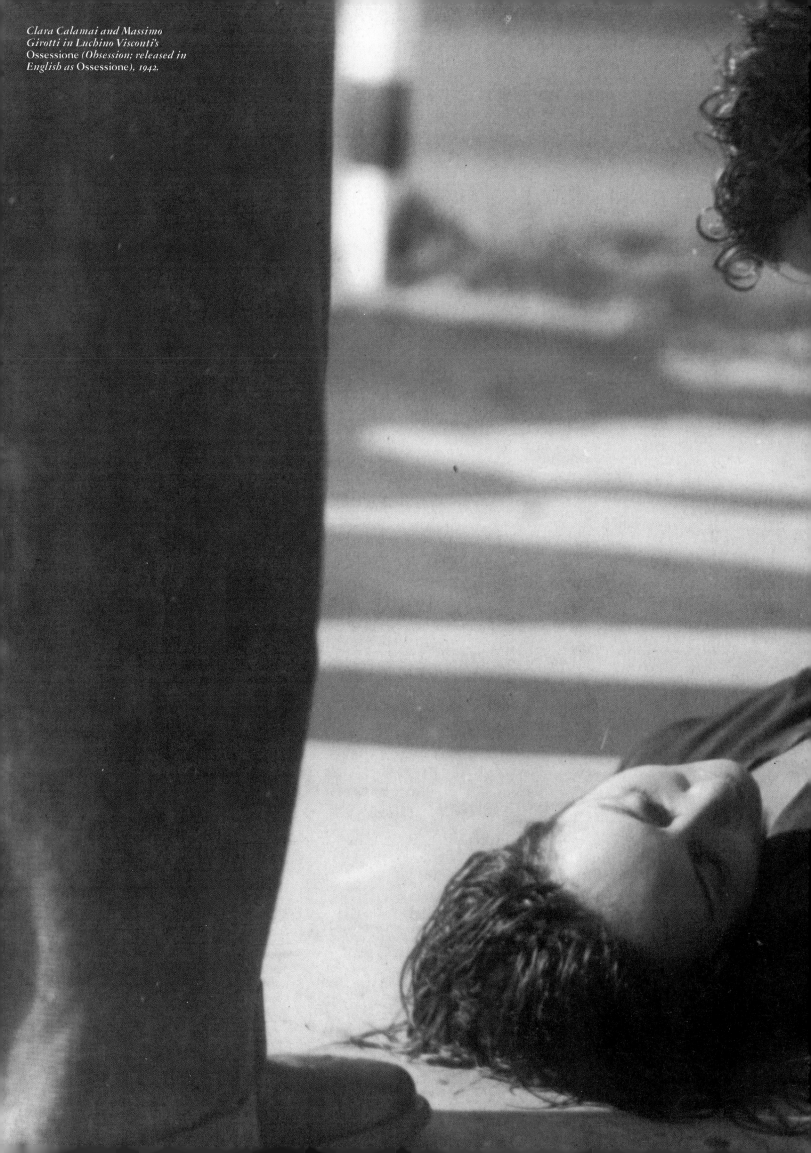

Clara Calamai and Massimo Girotti in Luchino Visconti's Ossessione *(Obsession; released in English as* Ossessione*), 1942.*

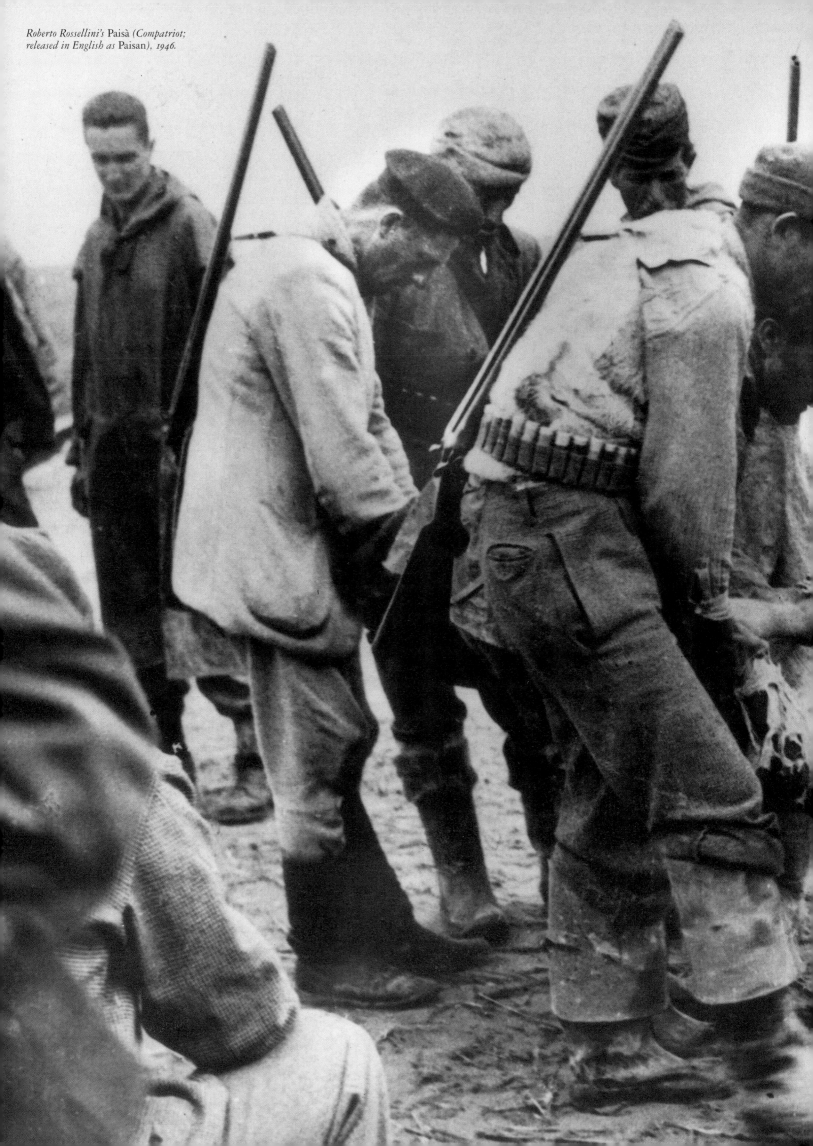

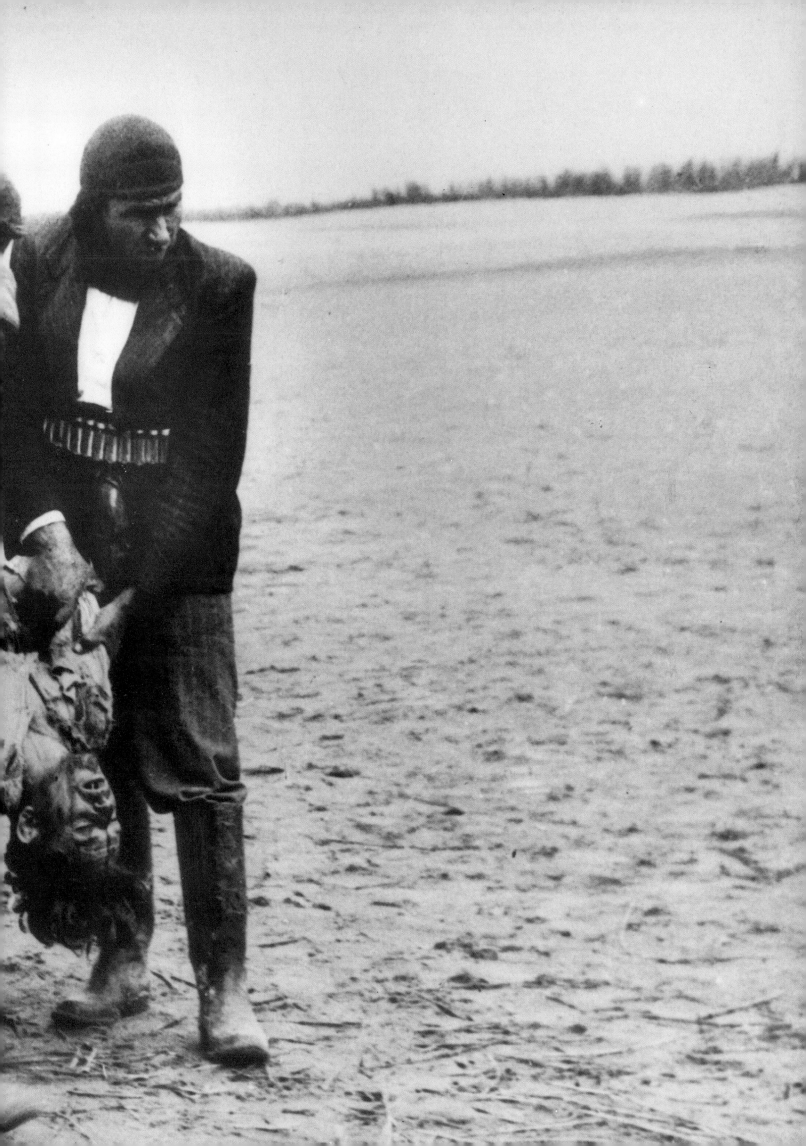

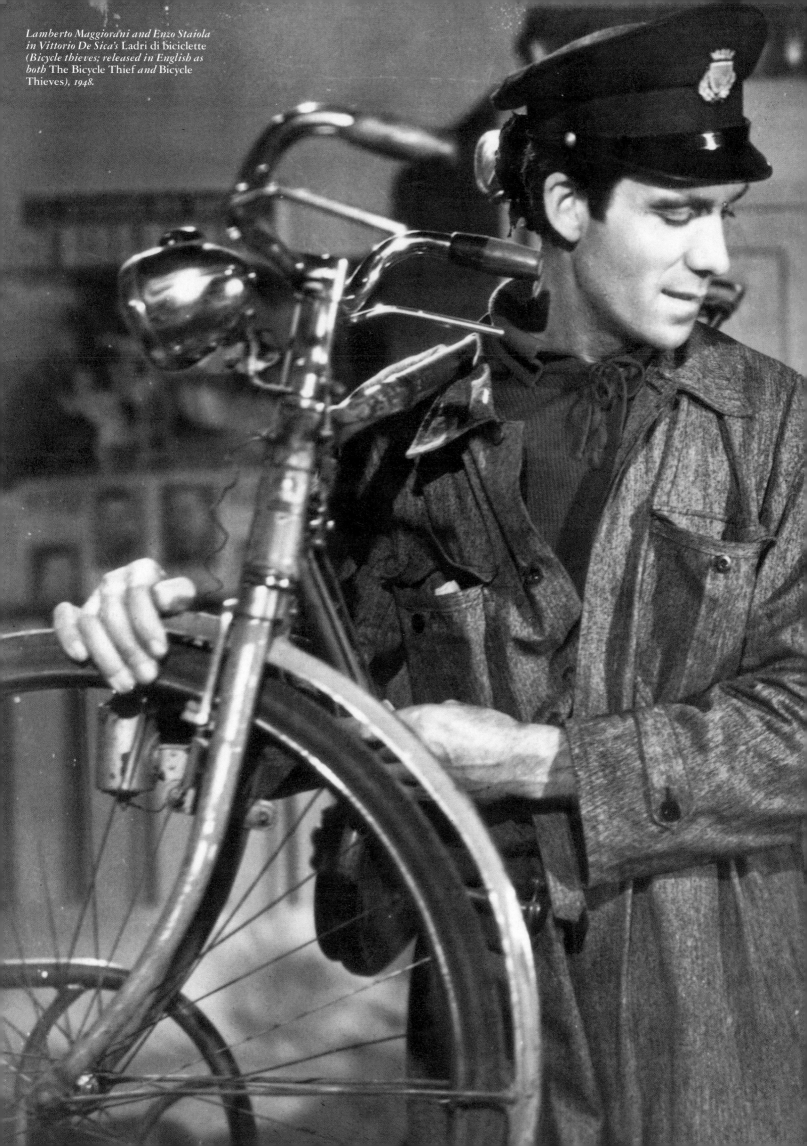

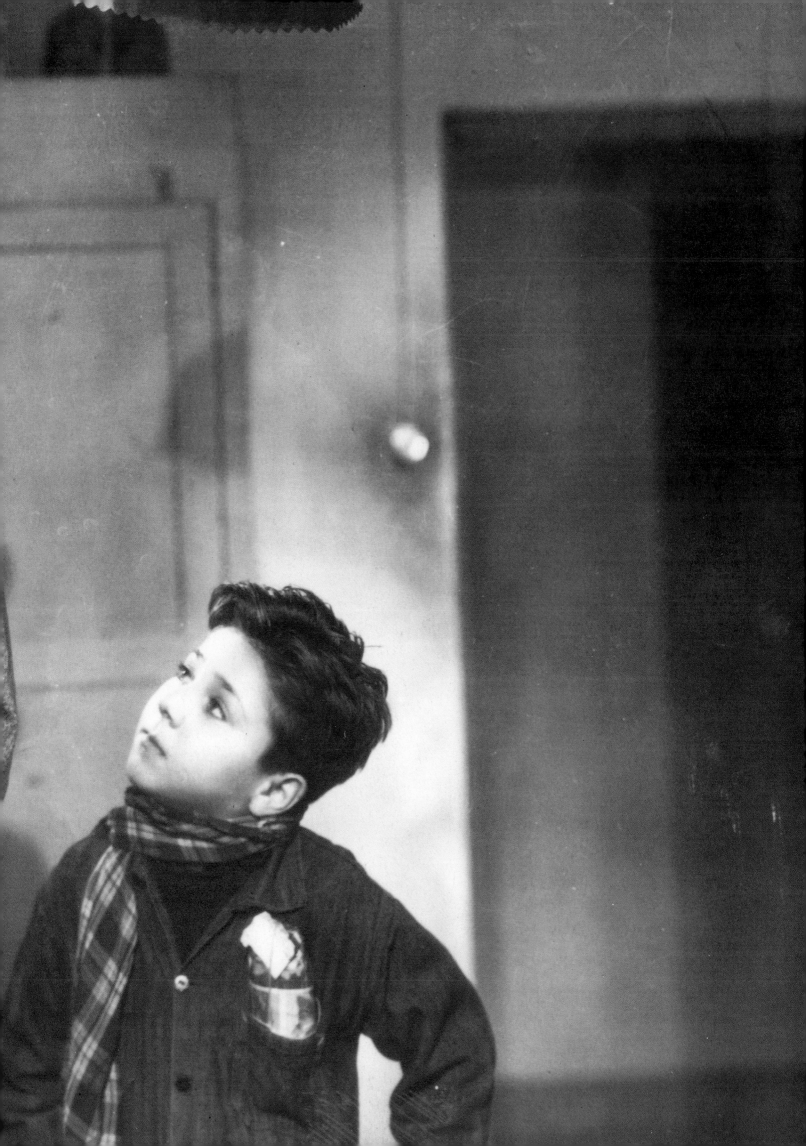

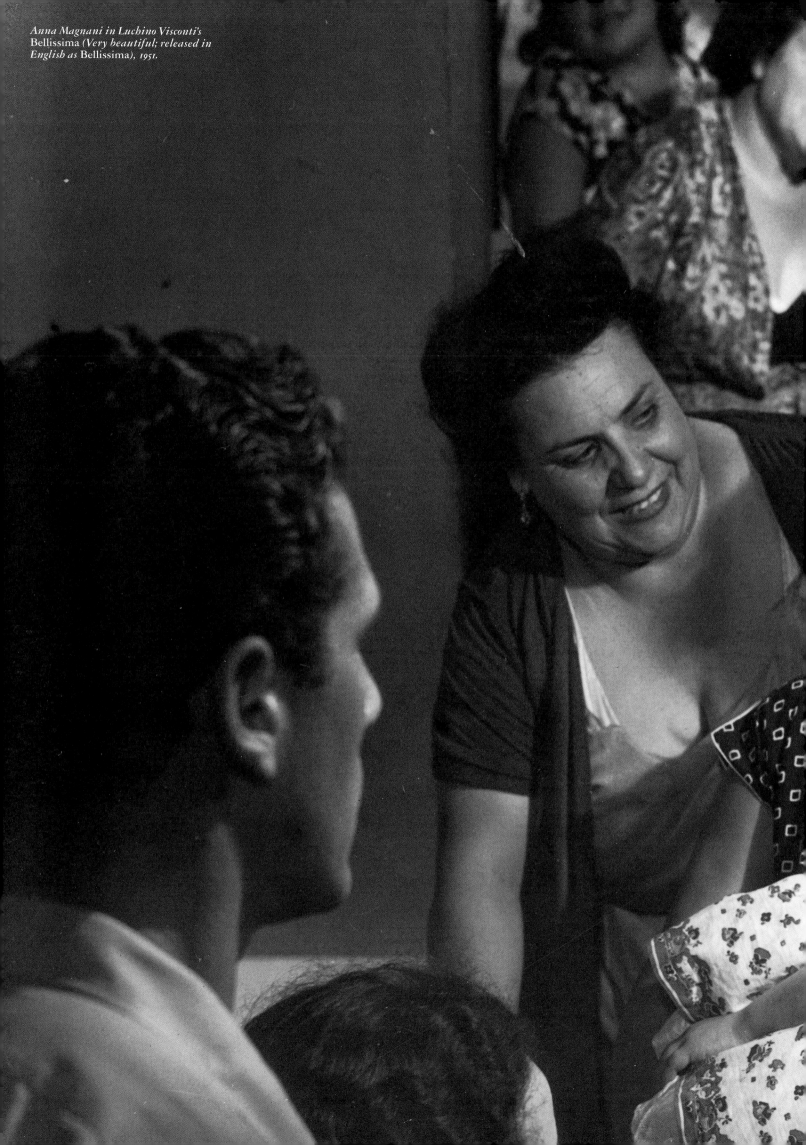

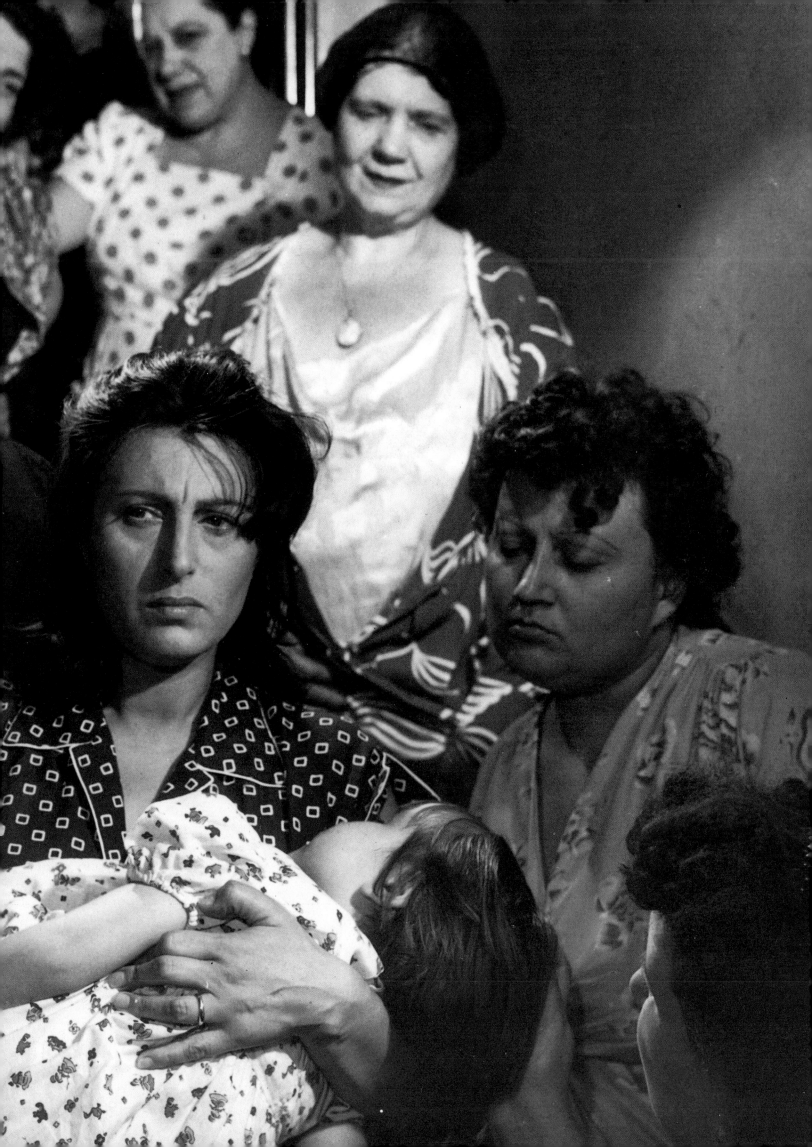

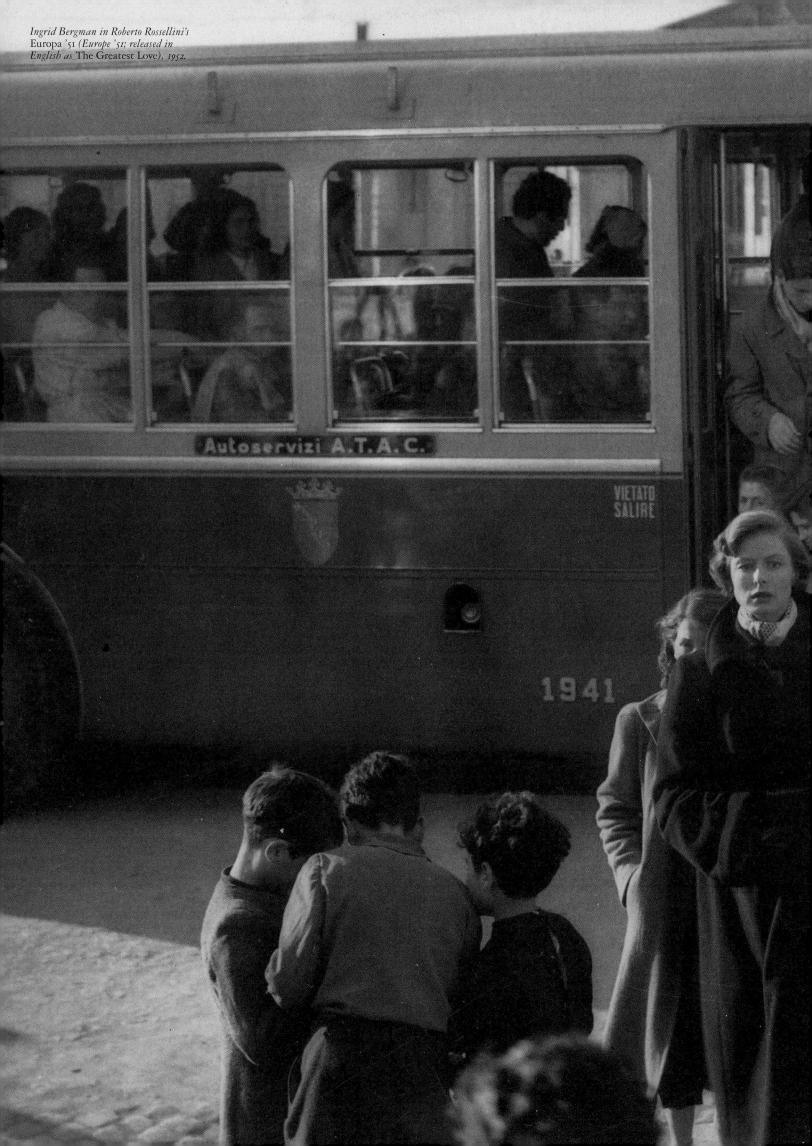

Ingrid Bergman in Roberto Rossellini's
Europa '51 *(Europe '51; released in*
English as The Greatest Love*), 1952.*

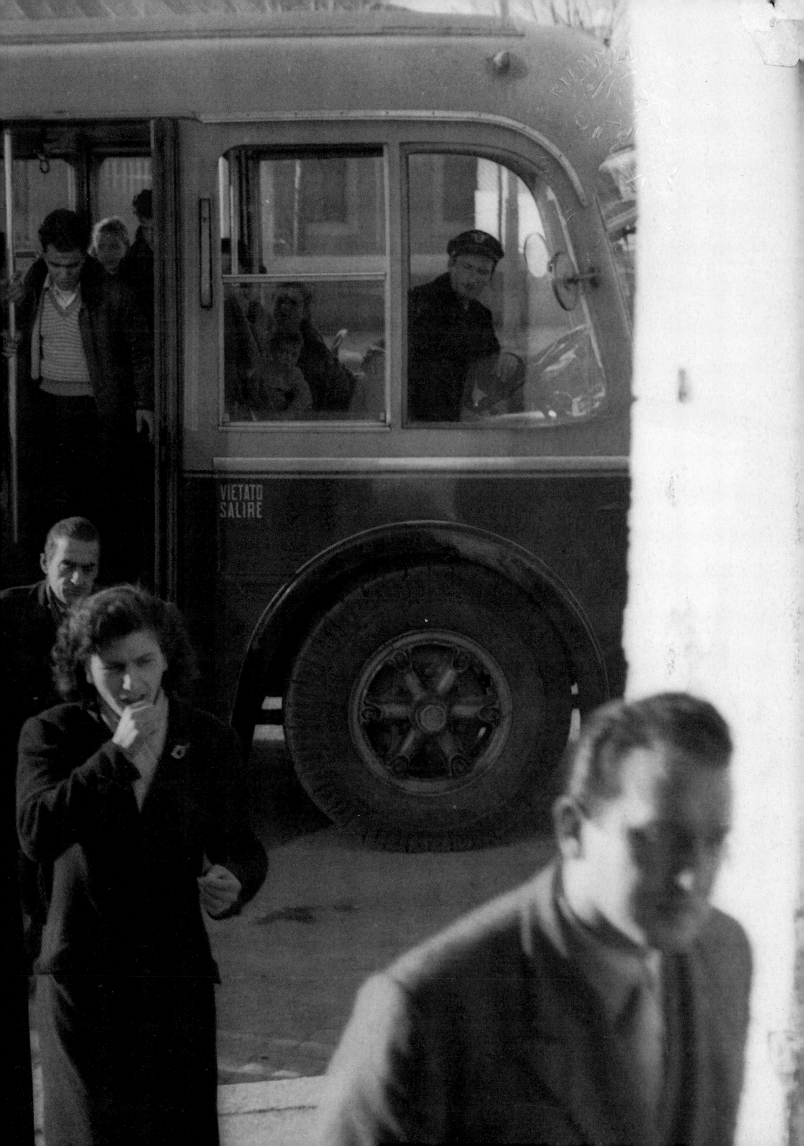

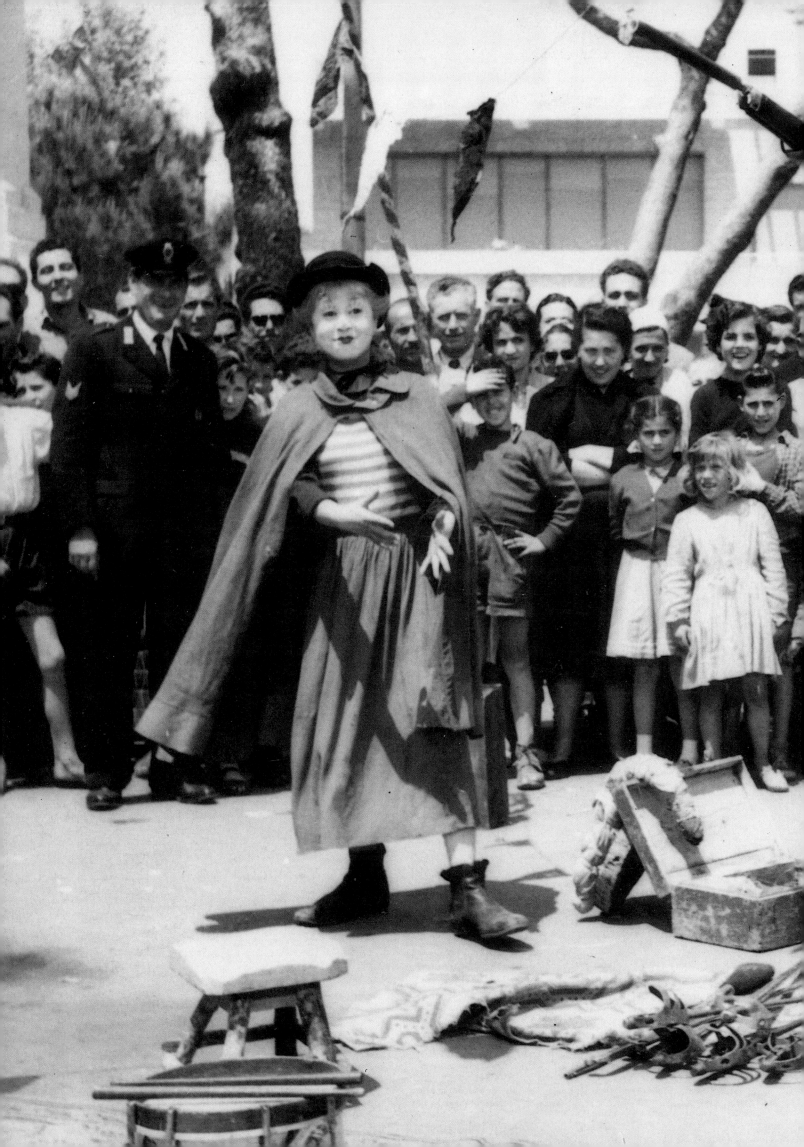

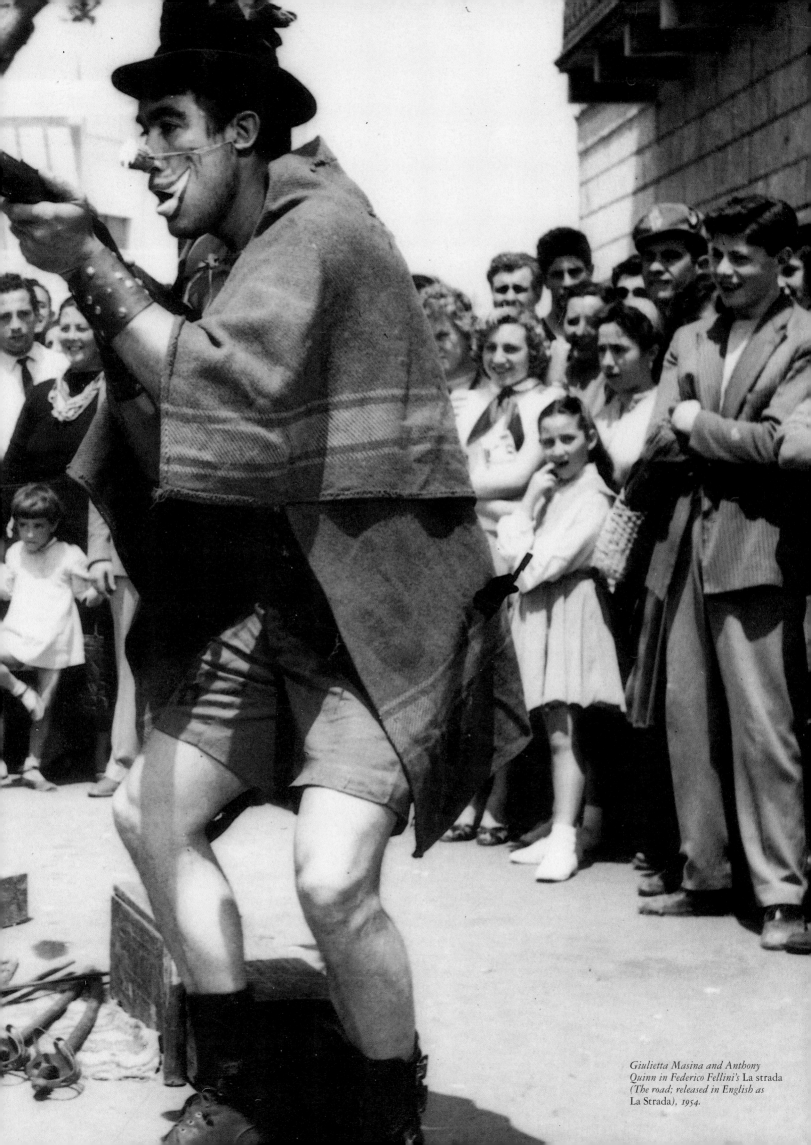

Giulietta Masina and Anthony Quinn in Federico Fellini's La strada *(The road; released in English as* La Strada*), 1954.*

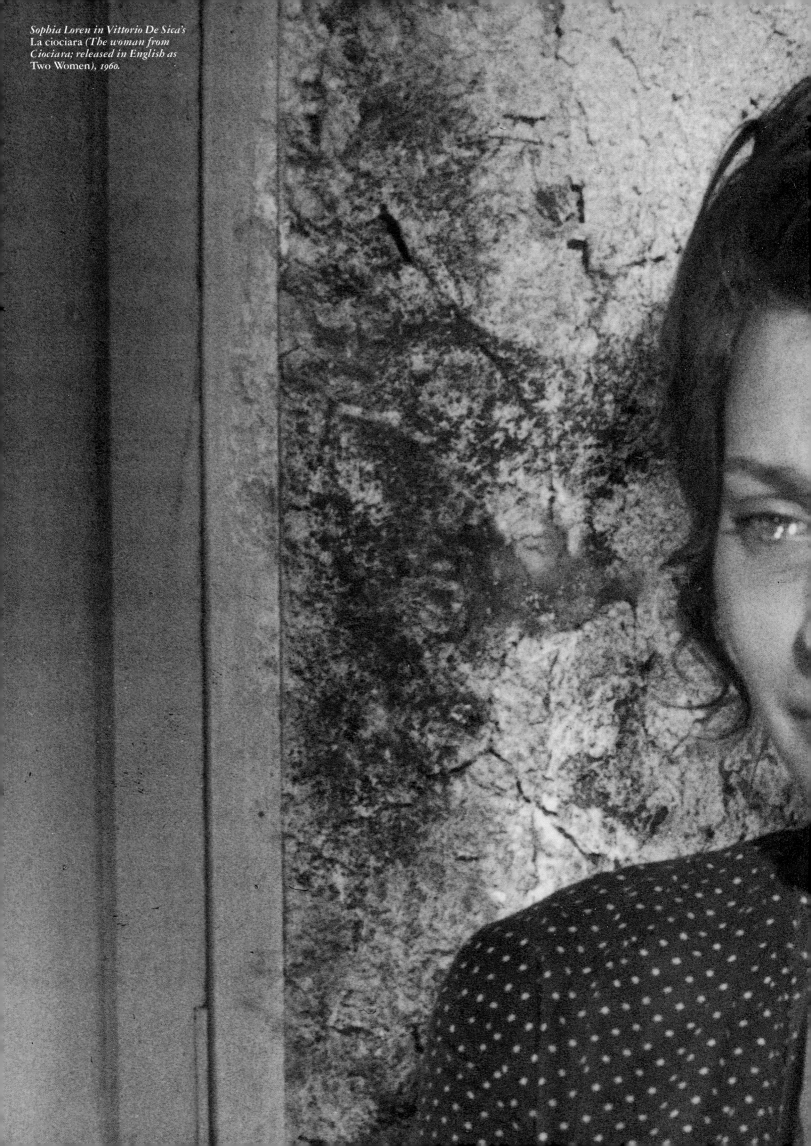

Sophia Loren in Vittorio De Sica's
La ciociara (*The woman from*
Ciociara; released in English as
Two Women), *1960.*

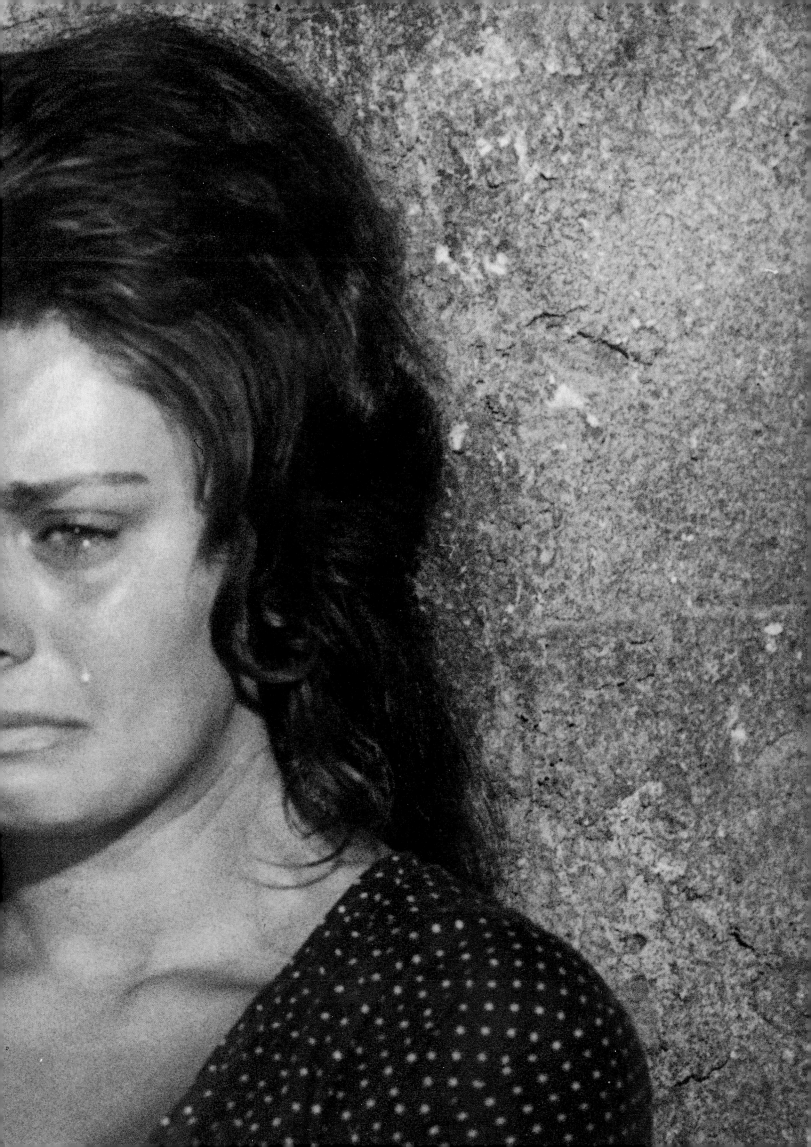

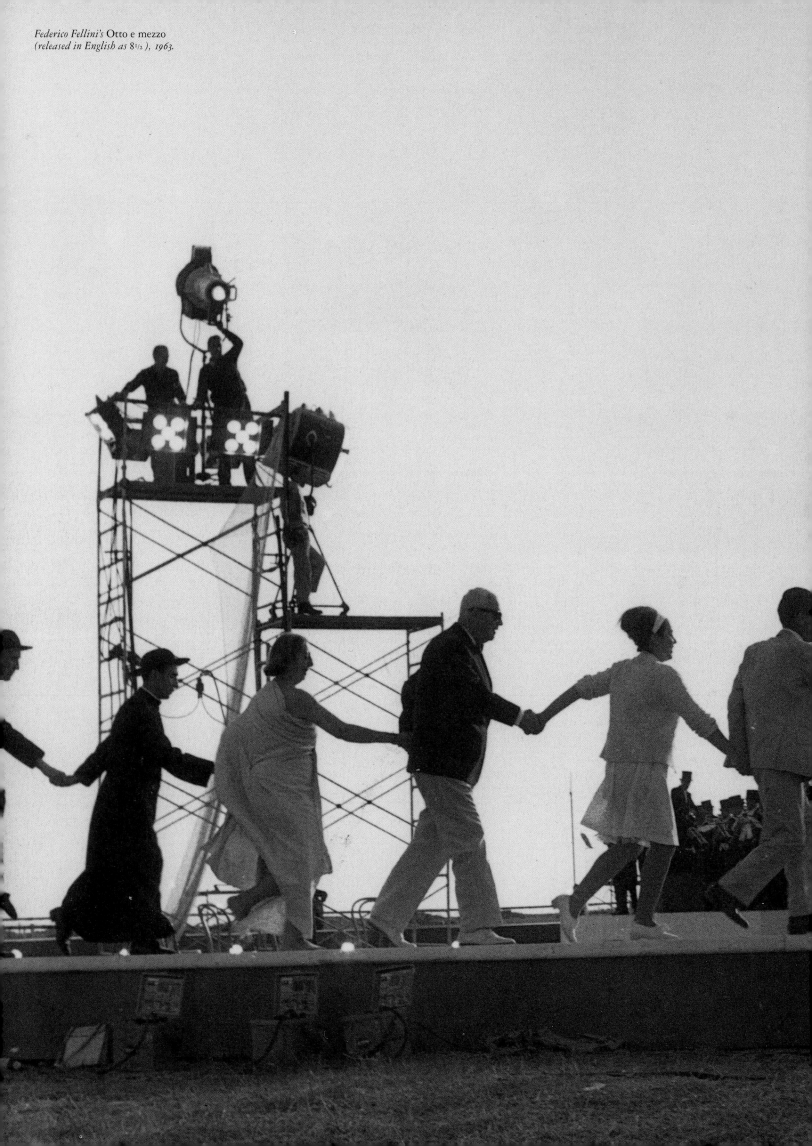

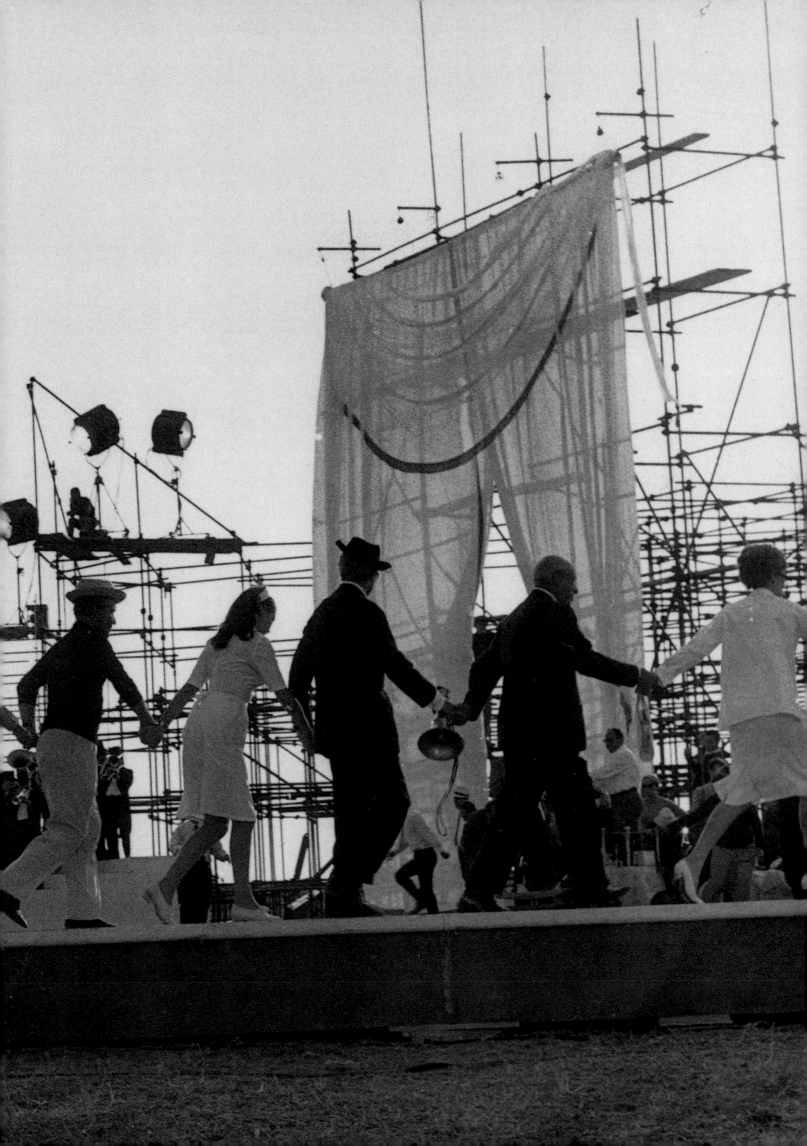

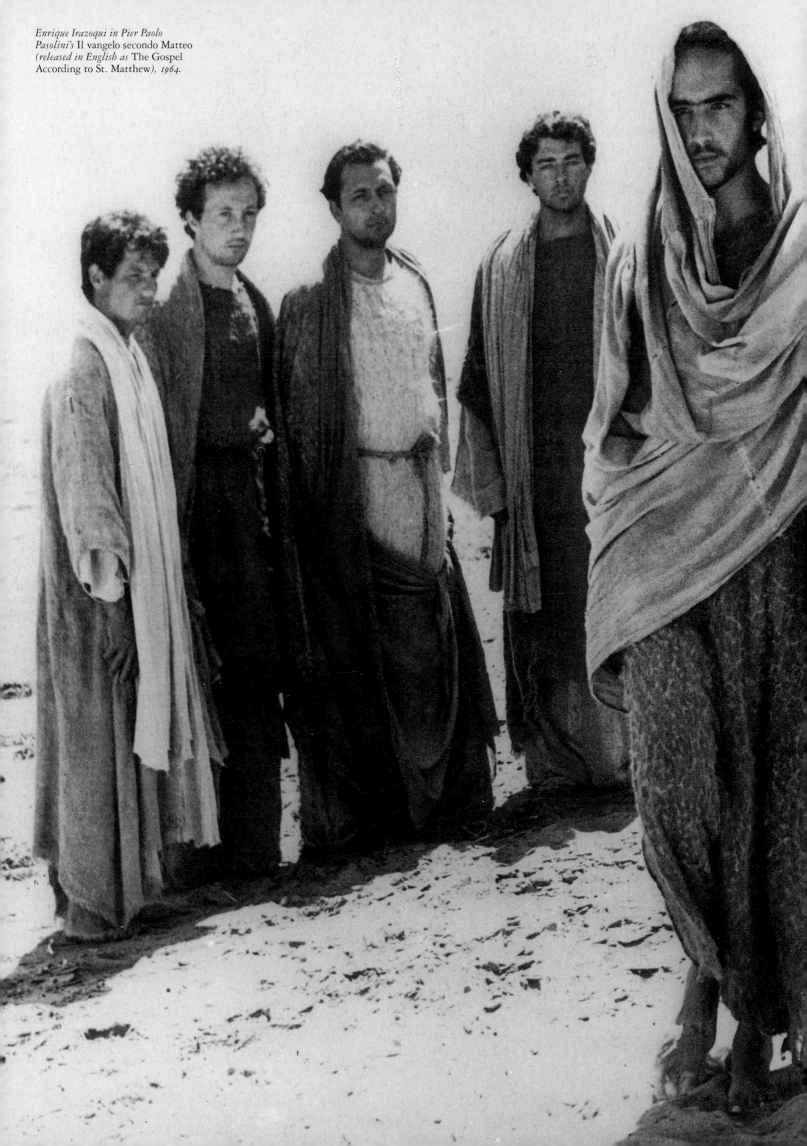

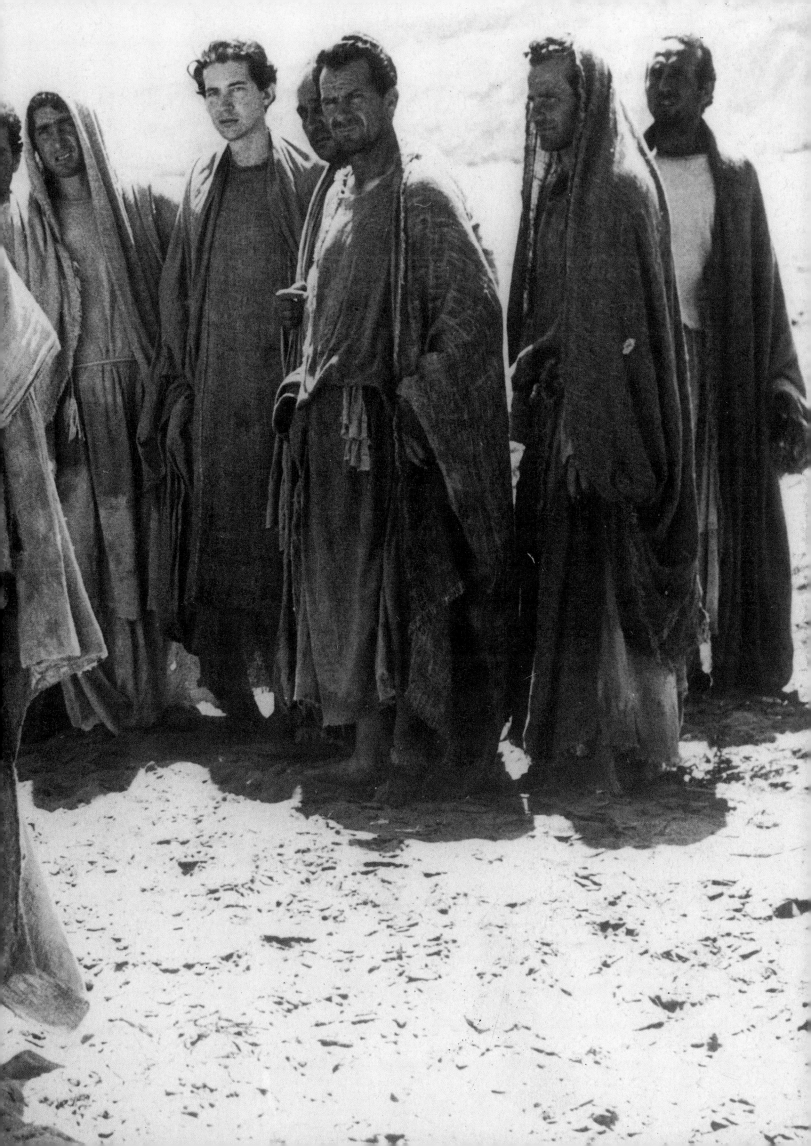

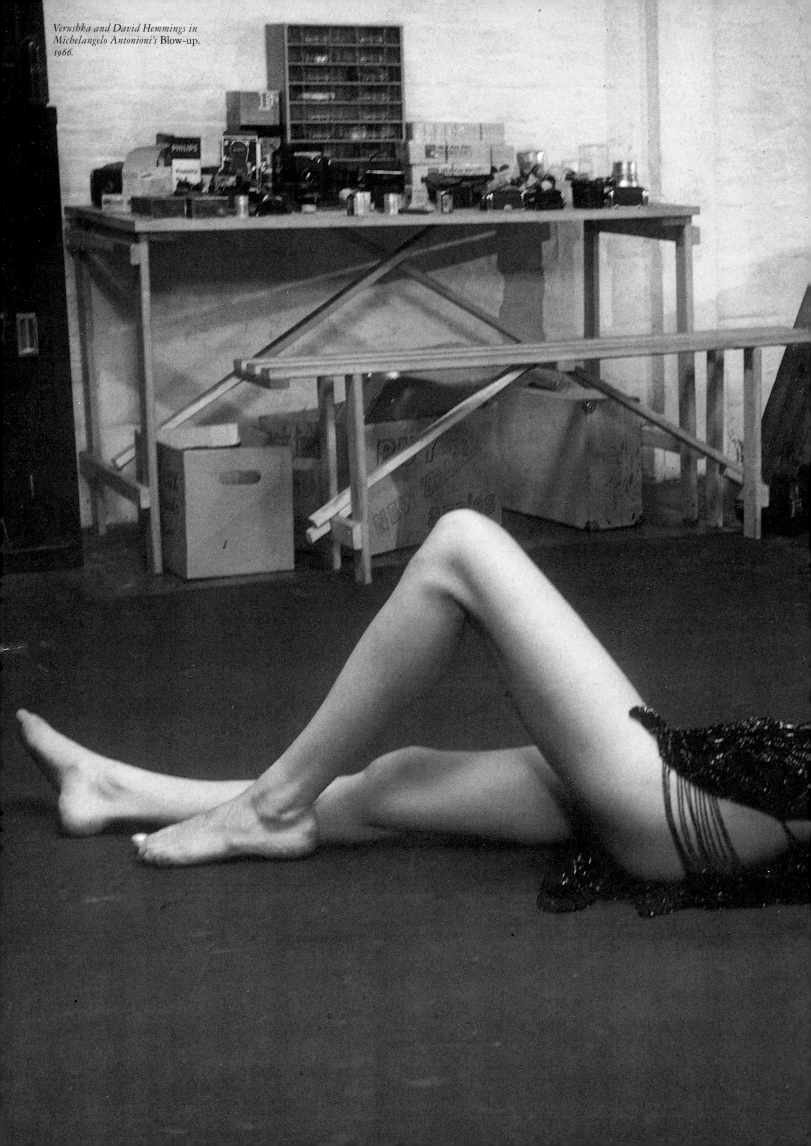

Verushka and David Hemmings in Michelangelo Antonioni's Blow-up, *1966.*

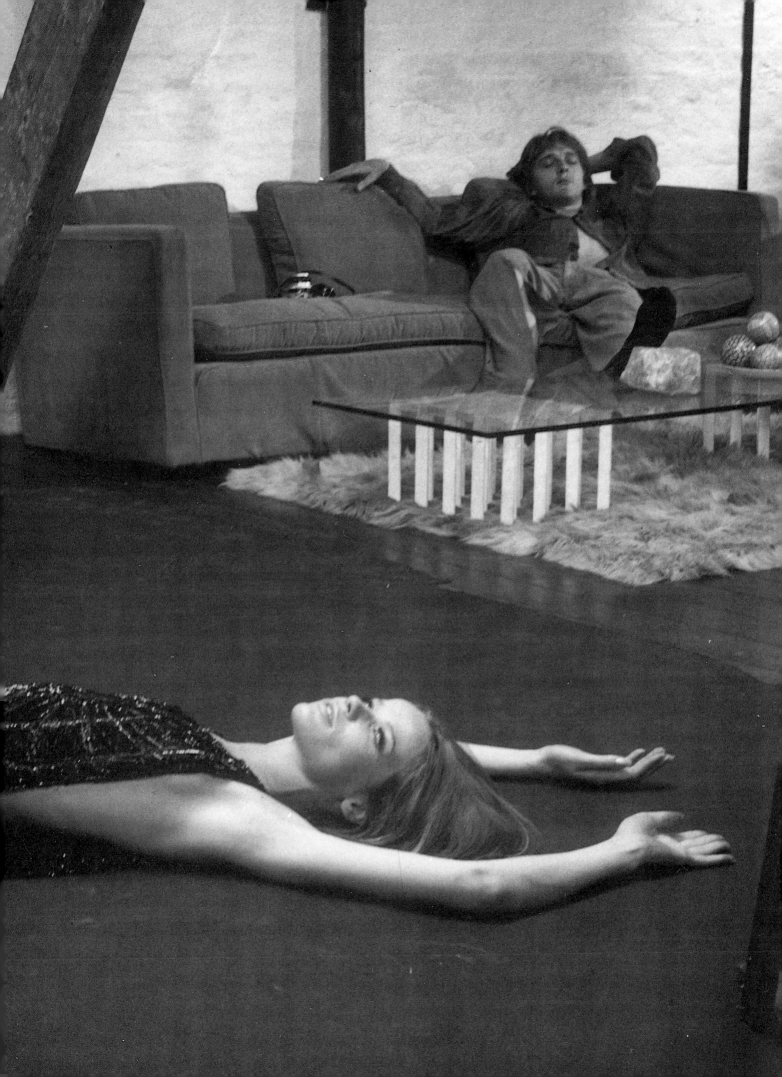

DINO DE LAURENTIIS presenta

ANTHONY QUINN · GIULIETTA MASINA · RICHARD BASEHART

LA STRADA

PREMIO OSCAR PER IL MIGLIOR FILM STRANIERO PER 1957

IL CAPOLAVORO DI
FEDERICO FELLINI

Titanus
CARLO PONTI presenta
UN FILM DI VITTORIO DE SICA

SOPHIA LOREN in
LA CIOCIARA

JEAN PAUL BELMONDO · Eleonora BROWN · Raf VALLONE

MORAVIA · CESARE ZAVATTINI

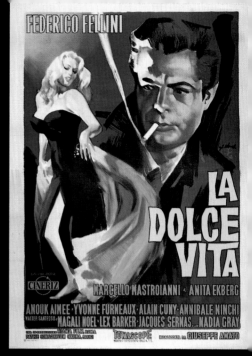

FEDERICO FELLINI

LA DOLCE VITA

CINERIZ MARCELLO MASTROIANNI · ANITA EKBERG

ANOUK AIMEE · YVONNE FURNEAUX · ALAIN CUNY · ANNIBALE NINCHI
WALTER SANTESSO · MAGALI NOEL · LEX BARKER · JACQUES SERNAS · NADIA GRAY

TOTALSCOPE GIUSEPPE AMATO

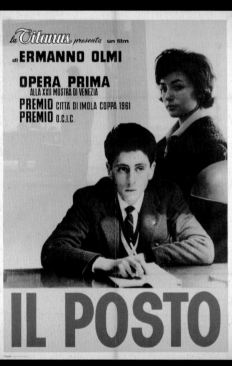

la Titanus presenta un film
di ERMANNO OLMI

OPERA PRIMA
ALLA XXII MOSTRA DI VENEZIA
PREMIO CITTA DI IMOLA COPPA 1961
PREMIO O.C.I.C.

IL POSTO

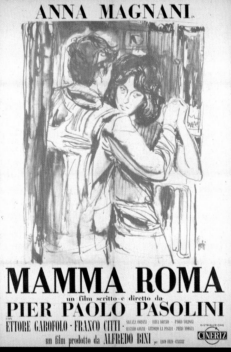

ANNA MAGNANI in

MAMMA ROMA

un film scritto e diretto da
PIER PAOLO PASOLINI

ETTORE GAROFOLO · FRANCO CITTI

un film prodotto da ALFREDO BINI CINERIZ

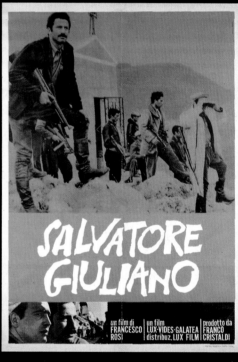

SALVATORE GIULIANO

un film di FRANCESCO ROSI un film LUX-VIDES-GALATEA distribuz. LUX FILM prodotto da FRANCO CRISTALDI

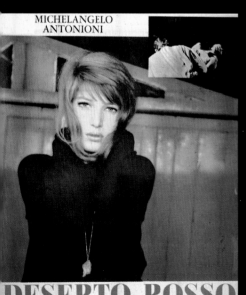

MICHELANGELO
ANTONIONI

DESERTO ROSSO

MONICA VITTI · RICHARD HARRIS
CARLO CHIONETTI · XENIA VALDERI
RITA RENOIR · ALDO GROTTI

PRODOTTO DA ANTONIO CERVI CINERIZ
TECHNICOLOR

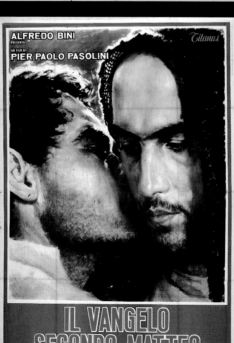

ALFREDO BINI presenta Titanus
PIER PAOLO PASOLINI

IL VANGELO SECONDO MATTEO

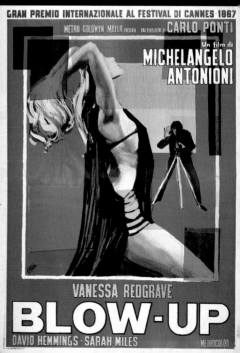

GRAN PREMIO INTERNAZIONALE AL FESTIVAL DI CANNES 1967

METRO GOLDWYN MAYER presenta una produzione di CARLO PONTI

un film di
MICHELANGELO ANTONIONI

VANESSA REDGRAVE
BLOW-UP

DAVID HEMMINGS · SARAH MILES METROCOLOR

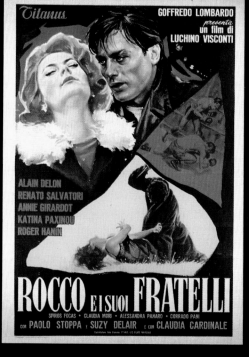

487. Enrico de Seta
Poster for Federico Fellini's La strada, *1954, reprinted 1958. Offset lithograph on paper, 200 x 140 cm. Archivio Storico Bolaffi, Turin.*

488. Artist Unknown
Poster for Vittorio De Sica's La ciociara, *1960. Offset lithograph on paper, 200 x 140 cm. Archivio Storico Bolaffi, Turin.*

489. Giorgio Olivetti
Poster for Federico Fellini's La dolce vita, *1960. Offset lithograph on paper, 200 x 140 cm. Archivio Storico Bolaffi, Turin.*

490. Artist Unknown
Poster for Luchino Visconti's Rocco e i suoi fratelli, *1960. Offset lithograph on paper, 140 x 100 cm. Archivio Storico Bolaffi, Turin.*

491. Averardo Ciriello
Poster for Pietro Germi's Divorzio all'italiana, *1961. Offset lithograph on paper, 200 x 140 cm. Archivio Storico Bolaffi, Turin.*

492. Artist Unknown
Poster for Ermanno Olmi's Il posto, *1961. Offset lithograph on paper, 140 x 100 cm. Archivio Storico Bolaffi, Turin.*

493. Ercole Brini
Poster for Pier Paolo Pasolini's Mamma Roma, *1962. Offset lithograph on paper, 140 x 100 cm. Archivio Storico Bolaffi, Turin.*

494. Studio Favalli
Poster for Francesco Rosi's Salvatore Giuliano, *1962. Offset lithograph on paper, 140 x 100 cm. Archivio Storico Bolaffi, Turin.*

495. Artist Unknown
Poster for Luchino Visconti's Il gattopardo, *1963. Offset lithograph on paper, 140 x 100 cm. Archivio Storico Bolaffi, Turin.*

496. Artist Unknown
Poster for Federico Fellini's Otto e mezzo, *1963. Offset lithograph on paper, 140 x 100 cm. Archivio Storico Bolaffi, Turin.*

497. Artist Unknown
Poster for Michelangelo Antonioni's Deserto rosso, *1964. Offset lithograph on paper, 200 x 140 cm. Archivio Storico Bolaffi, Turin.*

498. Artist Unknown
Poster for Pier Paolo Pasolini's Il vangelo secondo Matteo, *1964. Offset lithograph on paper, 200 x 140 cm. Archivio Storico Bolaffi, Turin.*

499. Ercole Brini
Poster for Michelangelo Antonioni's Blow-Up *(1966), 1967. Offset lithograph on paper, 200 x 140 cm. Archivio Storico Bolaffi, Turin.*

500. Bob De Seta
Poster for Pier Paolo Pasolini's Edipo re, *1967. Offset lithograph on paper, 200 x 140 cm. Archivio Storico Bolaffi, Turin.*

501. Artist Unknown
Poster for Michelangelo Antonioni's Zabriskie Point, *1970. Offset lithograph on paper, 200 x 140 cm. Archivio Storico Bolaffi, Turin.*

In writing about Italian

World War II through th

almost inevitable for one's

the powerful pull exerted

which Italian style —par

manifested in fashion and

attracted the world's atten

deceptively simple to view

as nothing more than a pr

spectacular "finale." Inter

leap, however, are a num

ıshion from the end of
late 1960s, it seems
ıttitude to be skewed by
y the 1980s, the decade in
icularly as it was
industrial design—so
ion. It is tempting and
he promising "prologue"
baration for the
upting this interpretive
er of complications and

From Haute Couture to Prêt-à-porter

Luigi Settembrini

much conflicting information. (Not least among them is the unease, so widespread today, concerning some unsavory aspects of the 1980s. This sense of unease—heightened by the recent recession and an ensuing state of cultural confusion—has soured the flavor of Italy's recent, spectacular success.) This will explain, from the outset, why a historical review of Italian fashion requires something more complex and demanding than a comfortable and nostalgic tour of the past. Although Italian fashion may be comfortably middle-aged in chronological terms, it has, fortunately, by no means settled into a state of middle-aged complacency.

Alongside the simple history of Italian fashion as a reflection of and counterpoint to the history and culture of Italy, from the end of the war to the watershed year of 1968, must be set a series of greater overarching changes that span the same period: gradual but fundamental shifts in the paradigms of production and consumption and in the links between the fashion industry and a modern society that was already beginning to ask whether it might not be postmodern. Fashion's capacity for reflecting all that surrounds it (including fears, desires, yearnings, and ambitions) is the distinguishing feature of its profoundly superficial nature, its "unbearable lightness." A welter of problems, historical and contemporary, Italian and not, must be considered in any review of Italian fashion of those years, considered in a multidisciplinary manner, making matters complex and less than linear, while at the same time far more interesting and intriguing.

These observations lead us promptly to mention a prime aspect—perhaps the most pronounced and important—of Italian fashion, and indeed of all of Italian culture after the fall of Fascism and the end of the war: its rapid international integration, the result of Italy's eager openness to all that was foreign and new, so long desired and finally made possible. In the book *Gite a Chiasso* (Excursions to Chiasso) Alberto Arbasino took a small Swiss city just across the Italian border and turned it into a symbol of Italy's desire for new discoveries and contacts with Europe and the rest of the world, finally free of the filter of propaganda, after so many years of forced isolation.

In fashion the natural point of reference was not Switzerland, of course, but France. Under the Fascists, though, an effort was made to develop national fashion, driven by the policy of autarchy, by cultural provincialism, and by ideological stupidity, an effort that, like so many other projects undertaken by the Fascist regime, proved wildly overambitious. The monopoly on taste remained firmly in the hands of the French. Stylish Italian women of the time were able to spot true Parisian fashion just as quickly and surely as they could tell the difference between real coffee and the undrinkable surrogates of wartime.

After the war, things changed, in both France and Italy. In the space of a few years a number of French couturiers—Coco Chanel and Edward Molyneux among them—left the scene, and the creations proffered by such newcomers as Christian Dior were considered too advanced to meet the requirements of the marketplace. There was, moreover, no longer the same fruitful contact between French fashion designers and the artistic avant-garde that had so distinguished the first four decades of the twentieth century, beginning with Paul Poiret and continuing with

Chanel and Elsa Schiaparelli, designers who had successfully understood and translated into the medium of clothing some of the most important transformations of taste and intellect in modern society.

At last *grandeur*—that age-old foible of French culture and politics—reasserted itself, engendering commercial isolationism and protectionism. The best-known Parisian houses were extremely restrictive about allowing their creations to be copied and manufactured in more "wearable" versions outside of France; this, along with their very high prices, chilled relations with their most important clients, the buyers for leading American department stores. And these same buyers—at first with some skepticism, and then with swelling enthusiasm; at first in small numbers, and then in crowds—attended the first runway presentations of Italian fashion in Florence, beginning in 1951. It was these buyers who allowed Italian fashion admittance into the highest spheres of international elegance.

The Italians moved with originality, intelligence, and admirable promptness to take advantage of this moment of weakness in French couture. They were also taking advantage of the particular interest and sympathy that their country—then just emerging from the ruins of war—seemed to spark across the ocean. This favorable attitude was fed by the remarkable creations that Italian fashion, industrial design, and cinema were then producing. These three "new arts" were working in close contact with the mass market and with industry, although each was marked by sharply differing timing, processes, and social and cultural connotations. Each was to play a key role in the creation of a new international image of a modern Italy, moving beyond the stereotypes of a land of love, art, mandolins, sunshine, seashores, spaghetti, ruins, the Mafia, and the pressboard suitcases of emigrants.

The birth of modern Italian fashion may be identified quite precisely: it took place in Florence, on February 12, 1951, a Monday, in a handsome villa set in a park just behind the venerable medieval city walls. It was here that Giovanni Battista Giorgini, a fifty-year-old gentleman of aristocratic descent, organized a fashion presentation for a number of American and Canadian buyers who had been adroitly and specifically lured to Florence following their seasonal buying trip to Paris. The runway presentation featured the creations of a dozen fashion houses and boutiques in Florence, Milan, and Rome: Carosa [Giovanna Caracciolo di Avellino Giannetti, see cat. no. 512], Mirsa de Gresy, La Tessitrice dell'Isola, Alberto Fabiani (see cat. no. 513), Sorelle Fontana [Fontana Sisters, see cat. nos. 561–65], Germana Marucelli (see cat. nos. 529–34), Noberasco, Emilio Pucci (see cat. nos. 538–47), Emilio Schuberth (see cat. nos. 551–55), Vanna, Jole Veneziani (see cat. no. 576), and Simonetta Visconti—most of whom were virtually unknown at the time.

Although these names had not yet attained their international luster, Italy had long been famous for remarkable craftsmanship, a resource about which the Parisian fashion houses were perfectly well informed and upon which they relied: small manufacturers of silks, wools, skins and furs, and straw; workshops for embroideries and hat trimmings, whose excellent

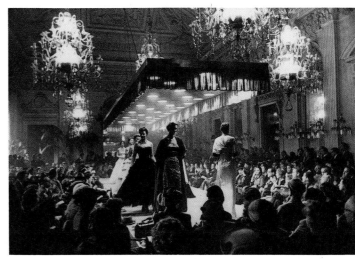

fig. 1. The first fashion show in the Sala Bianca, July 1952, photographed by David Lees.

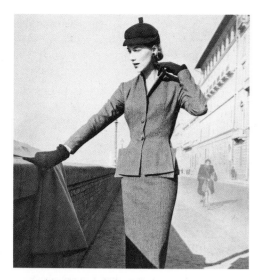

fig. 2. Dress by Roberto Capucci, 1952.

fig. 3. Giovanni Battista Giorgini with
sugar miniature of Palazzo Vecchio,
photographed by Locchi at the Grand
Hotel, Florence, January 24, 1953.

workmanship ended up anonymously in the creations of
French fashion. The war had done no substantive damage
to this patrimony.

There was also a long-lived tradition of dressmakers and
pattern makers, both Italian and of Italian descent, many of
whom were employed by the houses of Paris, both before
and after the war (among them was Cesare Guidi, who, as a
forerunner of Gianfranco Ferré, designed collections for
Dior in 1946). The tradition was well known in the United
States, where, some of the leading dressmakers in New
York bore such names as Blotta, Casella, and D'Andrea.
And the talent of Italian costume makers had been
appreciated in Hollywood for quite some time. But none of
this activity, which belonged to a premodern notion of
production and image, could rightly be said to constitute a
bonafide fashion industry.

There were also a few individual, isolated cases,
involving limited volume in terms of production and sales,
that pointed to future success but were too small to
constitute a new international trend. Pucci is a prime
example. After the war, decorated with the numerous
medals he had won as an officer in the Italian air force,
Pucci—a debt-ridden Florentine marquis—had begun to
produce (with the help of craftsmen from Capri) a line of
brightly colored outfits and sandals for some of his women
friends, practically as a pastime. In a 1948 feature on St.
Moritz, *Harper's Bazaar* favorably described the elegant cut
and the comfort of his clothing, especially his skiwear
made of elastic fabrics. Enveloped in an aura of aristocracy
and high society, Pucci's creations made their way to
Fifth Avenue in New York, to the display windows of
Lord & Taylor. But it was not until the late 1950s and the
1960s, when Pucci and his resortwear attained their apex,
that the genuine fashion genius of the marquis-dressmaker
was to become evident. Another Italian designer who
enjoyed early notice was Salvatore Ferragamo (see cat.
nos. 577–602), who, in 1947, won the prestigious Neiman
Marcus award, America's fashion Oscar.

The creations presented in Florence that Monday in
February, at what was billed as the first "Italian High
Fashion Show," still owed a great deal to Parisian
fashion, as was to be expected. The Italian offerings stood
out, however, for their greater simplicity and their
sophisticated use of color and attention to decorative
details. Moreover, their cost was less than half that of their
French counterparts, a fact not lost on the buyers in
attendance. The young Italian fashion houses had received
market-oriented advice from Giorgini (who was very
familiar with the United States, as he had long worked
as a *commissionaire*, or buyer, for a number of major
American department stores). Giorgini emphasized the
importance of such features as wearability, practicality,
and simplicity of cut, ideas that were particularly
welcomed by American buyers and apparel manufacturers.
The same qualities could be found, in even more
pronounced terms, in the boutique collections that
accompanied the high-fashion showings. Knitwear, casual
wear, and sportswear; beachwear and leisure wear;
raincoats, accessories, and costume jewelry were all offered
in versions that were more appropriate to everyday elegance
and the sensibilities of modern women, especially
American women, who were understood as active and

working. It is these collections that represent a truly new departure in the understanding of fashion and of how women dress.

The boutique collections did the most to differentiate the Florentine shows from their Parisian equivalents: they provided a venue for the unfettered expression of fanciful shapes and colors, the inclusion in a humorous and irreverent vein of the boundless resources of Italy's history of art and folklore, the surprising juxtaposition of a wide array of diverse fabrics, from the plainest to the most exquisite. The boutique collections were forums for freer experimentation, in terms of materials and in terms of production and cut. It was in the boutique presentations that such prestigious labels as Laura Aponte, Avagolf, Avolio, Avon Celli, Le Sorelle del Mare, Eliglau, Glans, Mirsa, Myricae, Naka, and Valditevere made their reputations. And it was in the boutique collections of the 1950s that Franco Bertoli presented skirts made of ribbon, elasticized straw, and flounces painted with seventeenth-century landscapes; Roberta di Camerino showed trompe-l'oeil effects on cottons and twills; and Giuliano Fratti showed earrings made of raffia and colored stones. It was here, moreover, in the 1960s, that Pucci presented his coordinated gear, his shirt outfits and wrinkle-proof "Emilioform capsules," his outfits made of jersey that weighed only ounces. It was here that Ken Scott (see cat. nos. 556–60) showed Pop-art fabrics (with their designs of spectacularly enlarged noodles, vegetables, and fruit) and that Missoni (see cat. nos. 535–37), soon followed by Krizia [Mariuccia Mandelli, see cat. nos. 521–24], showed remarkable jersey sweaters and coordinated outfits.

During the 1950s a great many of the haute-couture (high fashion, or *alta moda* in Italian) designers (Biki, Giovannelli, Marucelli, and Veneziani in 1951; Fabiani and Simonetta in 1955; and Maria Antonelli in 1956) designed and produced their own boutique collections, more versatile and sprightly, and far more affordable than their haute-couture lines. This duality between haute couture and boutique provoked a great deal of discussion and debate, but the development was inevitable: mass production clearly became, from the end of the decade onward, the only practical direction in which to move, as the costs of manufacturing for a narrow elite rose higher and higher. This was clear, for example, to Valentino [Valentino Garavani, see cat. nos. 566–75], perhaps the greatest couturier of the new generation. Valentino would remain closely tied to the image and allure of haute couture, and yet he was successful in distilling this image perfectly into prêt-à-porter (ready-to-wear) as well. This was probably the true hallmark of his production from the very beginning. In 1967, while he was inaugurating his new atelier on via Gregoriana, in Rome, he also opened an American-style boutique, inside the Milanese department store La Rinascente, setting an example that was quickly followed by others who, like him, intended to expand their markets and find new customers. When we look back on these boutique collections, we can say that they were soon to serve as a springboard for the coming boom in prêt-à-porter in the later 1960s and the 1970s, a boom that was to mark the definitive obsolescence of a nineteenth-century idea of fashion and inaugurate a new chapter in the history of clothing and style.

Giorgini's insistence on the *Italian* nature of the creations being presented in Florence—an insistence that was dutifully repeated by the international press—did nothing to undercut the general surge of excitement and enthusiasm about the rest of the world that was sweeping Italy. The pressing issue in fashion, however, was not so much to deny the vital influence of the French, which could hardly be questioned, but to cater to the huge American market. The idea was to position Italian fashion as the modern expression of an aesthetic taste well trained in the natural elegance of line, in the harmony between shape and concrete function, in an expressive use of color, and in an inventive relationship with materials. These were all qualities that Italian fashion clearly shared with industrial design in those years, as can be seen in the first products to emerge from that field in the postwar period: automobiles, scooters, typewriters, furniture, and other design objects of all sorts.

Is it possible to understand these qualities in anthropological and cultural terms? Is it possible to define Italian fashion and design in terms of an eclectic mindset: an ability to reconcile the vast and conflicting artistic patrimony; an attention to the corporeal and to individual expression; a gift for improvisation; a particular hard-eyed and sardonic streak of realism; and so on? Perhaps. The risk of this sort of reasoning, however, is the perpetuation of stereotypes. It is more important, then, to note the taste and openness with which the references to Italianness in the fashion collections presented in Florence in 1951 were employed and positioned, to salute the recognition on the participants' parts that they were engaged in creating something original, something that would come to be known as real "Italian style."

The second Florentine runway presentation, in July 1951, reaffirmed the general air of expectation. Although this second event featured only a few more names than the first one, the audience of buyers and journalists was quite large. (A noteworthy absence among designers represented was the nineteen-year-old Roberto Capucci [see cat. nos. 502–11], excluded because of petty last-minute rivalries, although he was allowed to present his collection during a special evening event, and to spectacular acclaim.) In addition to the American network of clothing marketers, who by 1952 would be attending in full force, the leading French and Italian newspapers sent reporters, as did *Life* and *The Los Angeles Times*; also present were two prestigious fashion journalists, Bettina Ballard from *Vogue* and Carmel Snow from *Harper's Bazaar*. In its headline *Life* took the view that "Italy Challenges France," while *Paris-Presse* acknowledged, with concern, that "the Italian offensive [has been] implemented with skill and a fine sense of psychology. This is a time when the Americans are unwilling to tolerate the maneuvers of Dior and [Jacques] Fath: the American market is at stake, and losing it would be a fatal blow."

The tale that Italian fashion told of itself during those years had a Florentine setting, and the intention of the promoters of the event was clear—to emphasize the great past that is the ultimate source of modern Italian fashion. The locations for the photoshoots staged by the press tended to reiterate this idea. For the most part they were painterly in inspiration, or else followed the styles of

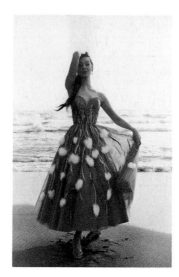

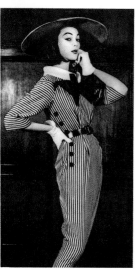

fig. 4. Emilio Schuberth and models, photographed by David Lees in 1953.

fig. 5. Gown by Emilio Schuberth, photographed by Regina Relang in 1953.

fig. 6. Dress by Carosa, photographed by Gérard Herter in January 1954.

photojournalism, borrowing very little from the formal qualities of avant-garde photography. As for the shows themselves, beginning in 1952 (and continuing until 1973) they were moved to the Sala Bianca, a mirror-lined ballroom filled with neoclassical stuccoes and immense crystal chandeliers inside Palazzo Pitti, which over time became a sort of factory seal for genuine Italian fashion. Palazzo Strozzi, another jewel of Florentine architecture, came to be a second link in the chain, serving as the center for the dressmakers' showrooms during the presentations.

The same historicizing tendency marked the many social events and receptions that were held in the Boboli Gardens or in villas in the hills around Florence. One costume party held at Palazzo Vecchio in 1953 actually took the form of a historical reenactment of the wedding of Eleonora de' Medici and Vincenzo Gonzaga.

The presence of a great many aristocrats on the Italian fashion scene of the time strengthened the ties to Italy's grand past. Aside from Pucci, the fashion crowd included Carosa (the princess of Carosa); Irene Galitzine (see cat. nos. 518–20), a princess of Russian descent; Mirsa, who was the Marquise Olga de Gresy; Simonetta (the daughter of a duke and the wife of a count); and many other aristocrats, not to mention the many runway models, young and willowy women from the finest Italian families, among them Marella Caracciolo (now Marella Agnelli) and Gioia Marconi. It was as a runway model, in fact, that "La Galitzine" began her career.

Giorgini cannily emphasized the snob appeal that the noble ties possessed, especially in America, and in 1956 he organized a promotional tour to New York: eight countesses, in the dual role of ambassadors and runway models, presented creations by Antonelli, Capucci, Carosa, Fabiani, Marucelli, Schuberth, Simonetta, and Veneziani; the presentation was broadcast by *NBC*. The critical acclaim was tremendous—perhaps most important, the tour garnered favorable comments from Diana Vreeland, the powerful fashion editor of *Harper's Bazaar*. (In the next decade, Giorgini would become a prisoner of the image he created. The radical transitions of the 1960s were to throw into crisis the entire network of elitist cultural and social points of reference upon which the Italian fashion system had been based until then.)

Closely interwoven with this aristocratic connotation, but even more effective in making Italian fashion fashionable, were the movies. Films allowed Italy and the United States to undertake an intense and reciprocal exchange of mythologies during the 1950s. If, in this trade, Italy was importing the practical everyday luxury item called the "American way of life," at the same time Italy was exporting to the United States an updated and revivified image of Italy, of the Italians, and of their magnificent heritage—an image that was warm, romantic, and lively.

Film, more than any other medium, helped to engender an aura of sympathy around Italy and things Italian, especially during the early 1950s—an image-driven sense of solidarity, a feeling that was at once humble and international. This miracle of mythmaking, however, was not the creation of the great Italian neorealist cinema of the time—a school of filmmaking that is still loved by cinephiles the world over but that shows aspects of Italy

that most Italians would just as soon forget. Rather it was American films—touristy and sentimental, shot in the most entrancing piazzas and streets of Capri, Florence, Naples, Rome, Sorrento, and Venice—that launched a formidable promotional campaign on Italy's behalf, though with unlikely stories and highly fictive characters. *September Affair* (1950, with Joseph Cotten and Joan Fontaine), *Roman Holiday* (1953, with Audrey Hepburn and Gregory Peck), and *Three Coins in the Fountain* (1954, with Clifton Webb, Louis Jordan, Jean Peters, Dorothy McGuire, and Rossano Brazzi, an unfailing fixture in those years in the cardboard role of the Latin lover) were just trailblazers for the mountains of footage that, in the years to come, purveyed to viewers worldwide an image of Italy as an enchanting, carefree, cheerful land, full of high culture, good feelings, and simplicity. All the things, perhaps, that Italy is not.

During these same years, Clare Boothe Luce—wife of Henry Luce, founder and owner of *Time, Life*, and *Fortune*—was the American Ambassador to Italy. Intelligent, accomplished, and ambitious, she was perfectly aware of the true state of things in Italy; she also clearly understood that it was best to heavily retouch that reality. No more bicycle thieves but elegant Roman princes instead: these were the years of the Marshall Plan, and Italy, in order to provide the required economic returns on that huge international investment, had to be repositioned. Ambassador Luce certainly played a major role in that process. Italy, therefore, contrary to all expectations, suddenly found itself to be "in fashion."

This was the golden age of Cinecittà, the Hollywood-on-the-Tiber, where major American studios often found they could produce films cheaply. American actors and actresses swarmed throughout Italy, and the most important Italian haute-couture ateliers, especially those in Rome, generated publicity for themselves by dressing the most famous Italian and American stars, on and off the set. The Fontana sisters, Giovanna, Micol, and Zoe—Sorelle Fontana, as they were known—began in 1949 by designing the clothes for the wedding of Linda Christian and Tyrone Power; in 1954 they designed Ava Gardner's costumes for *The Barefoot Contessa*. Later, Italian dressmakers did work for the American star Myrna Loy and for the British actresses Phyllis Calvert, Peggy Cummins, and Merle Oberon, as well as many other stars, who were often photographed while being fitted in the ateliers. Several Italian stars who gained formidable reputations in the United States—among them Gina Lollobrigida, Sophia Loren, and Alida Valli—also formed part of the procession (the first two were dressed by Schuberth).

Fashion itself began to influence film: a pair of famous runway models, Lucia Bosè and Elsa Martinelli, made it big as actresses. Fashion, politics, and celebrity mingled just as freely: in 1953 Schuberth created thirty outfits for Soraya, the young and beautiful empress of Persia, and Sorelle Fontana designed Jacqueline Bouvier's wedding dress for her marriage to John Fitzgerald Kennedy. (When, in 1968, she married Aristotle Onassis, it was Valentino's turn to dress the world's most famous woman.) The trade press recognized a good story when it heard it, and the paparazzi of the mass-market Italian photo weeklies were busy taking shots of the fairy-tale lives of high society. In the pages of these weeklies, the various aristocracies—of film, of money

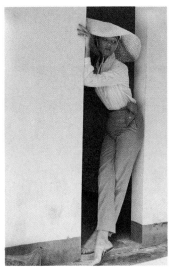

fig. 7. Emilio Pucci and model in front of Palazzo Pucci, photographed by David Lees in 1954.

fig. 8. Outfit by Emilio Pucci, photographed by Scrimali in 1954

and power, and of actual nobility—were shown in an unending round of parties, travel, and love stories, and living in their villas with huge pools. Federico Fellini's film *La dolce vita* (The sweet life, 1960; released in English as *La Dolce Vita*) portrayed this world when it was already clearly on the wane.

A different sort of alliance, far less glamorous but more enduring than that between fashion and film, emerged in the 1950s between fashion and industry, both those industries driven by traditional crafts and those with a more modern structure. As early as the late 1940s, Snia Viscosa, Europe's largest manufacturer of artificial textile fibers, had initiated its policy of paying closer attention to the creative process of fashion, and in 1950 the company hired Marucelli, the dressmaker, as a consultant. The new fibers (with patently artificial names like rhodianzino, wollena, daynolegler, and lilion) were to constitute throughout the 1950s a new frontier for experimentation in shape and texture for Italian dressmakers. This became even more the case in the subsequent decade, as the market for fashion expanded, and the mythology of technological progress and competition between the United States and the Soviet Union in the space race caught the imagination of the public.

Along with the more traditional materials (the silks of the Como region, the linens and wools of Biella and Prato, and the cottons of the Val di Susa, all of which were continuously reinvented through blends, colors, prints, and finishes that could make them soft or rustic, playful or deadly serious, practical or sumptuous, depending on the outfit and the requirements of the market), Italian fabrics were immediately recognized as being among the world's finest, and they were to contribute to the international success of Italian style.

"Made in Italy" would come to represent a new fashion system with a vertical integration that included research, the production of threads, yarns, and fabric, and finished garments and accessories. This system encompasses an array of large manufacturers along with an extremely intricate network of small and mid-size companies, arranged in specific and homogeneous territorial sectors, thus attaining great flexibility for production and a capacity for innovation. At the end of the 1950s, however, this system was still in its infancy. During those years, the fashion paradigm was still haute couture, a form of fashion imposed from on high and patterned on elevated models of society, rather than brought up from below, from street culture, rock and roll, and, with time, from the world of sports and consumer technology, as was the case from the second half of the 1960s onward. This was a notion of fashion that, strictly divided into lines, colors, fabrics, decorations, had an equally strict view of how, when, and by whom particular types of clothing were to be worn. Fashion was divided by class, sex, age, social occasions, the requirements of work, free time, holidays, and sport. This was certainly not the casual, taboo-breaking fashion of today (a change that is a product of the long-term shifts engendered by the radical social transformations of those years), where the distinctions between formal and casual wear, between menswear and womenswear, between the way the old and the young dress, are subtle and at times nonexistent. This was an understanding of fashion, finally, that tended to see in the dressmaker and in the creations of the dressmaker an artist more than a designer and to value the creation more than the design.

The decline of the social and cultural framework that engendered haute couture, and the emergence of another that lent itself to prêt-à-porter, made this period one of confusion but also of vitality and ferment. This was the time of Italy's economic miracle; Italy was modernizing both socially and culturally, and many Italians finally and truly savored the fruit of the new opulent society.

Although the newly democratic modes of consumption for the most part took the form of faddish consumerism at its heady worst, everyday clothing emerged that served more as confirmations of status than as utilitarian tools. *Dolce vita* was not just a term for a carefree Italy that had suddenly discovered she was rich; it was also the Italian word, *dolcevita*, for turtleneck sweaters, which could be worn with a blazer in an elegant, casual manner that had already become a trademark of Italian style. This look was an expression of the subterranean current of informality that wends through all modern and contemporary fashion.

Italian fashion made its way through this crucial season in the history of the nation with the added cachet of a well-consolidated international reputation, reflected in noteworthy economic results: by 1958 Italy had already overtaken France and England as the leading European exporter to the United States of textiles, apparel, and accessories; exports of women's clothing rose from 45 million articles in 1950 to 2 billion articles in 1957; shoes rose from 208 million in 1950 to nearly 19 billion in 1957; and in the same seven-year period, exports of woolen and silk fabrics rose five-fold, exports of knitwear rose eight-fold, and exports of knit outerwear rose sixteen-fold.

Giorgini's farsighted vision of Italian fashion was as a coherent, well-articulated phenomenon, aware of its own identity and ancient traditions. The runway presentations in Florence had, from their beginnings, been collective efforts, so that all of the dressmakers would show—in the same location and on the same day—a representative selection of their creations. (A more complete and thorough showing was available later in the various showrooms.) This approach was greatly appreciated by buyers and journalists, for they no longer had to rush from one atelier to the next, as was the case in Paris. More important, it allowed them to grasp at a glance the emerging directions and the quality of the various collections.

If a single runway helped to heighten the excitement of a newborn movement in search of an original language in which to express itself, it also entailed an excessively direct comparison, specific criteria for the order of appearance of collections and fashion houses, a considerable reduction in the number of creations presented (a maximum of sixty for haute couture, fifteen to twenty for boutique fashion), and great rivalry for the starring role among the individual designers. As a result, there were soon betrayals and defections.

As early as the late 1950s Rome began competing with Florence for the role of primary showcase for Italian haute couture. One of the advantages Rome boasted was the close relationship between its ateliers and the aristocratic high society of the city, as well as the film crowds and the cosmopolitan glamour that these social circles emanated.

The dressmakers of Rome organized their own runway shows, and these became an alternative venue to the runway presentations of Florence. Milan and Turin, boasting closer ties to the manufacturing infrastructure, also presented their candidacies to replace Florence. In 1954 SAMIA (Salone Mercato Internazionale Abbigliamento/International Market Clothing Salon), an apparel trade show, was instituted in Turin, and lasted until 1969; in 1956 MITAM (Mostra Internazionale Tessile Abbigliamento/Arredamento Milano/International Textile, Clothing Furnishings Exhibition, Milan) was inaugurated in Milan, and became the leading meeting place in Europe for many years thereafter.

Strengthening Milan's position was the fact that the weekly magazine *Novità* (which became *Vogue Italia* in 1966) was published there; the magazine paid close attention to the formal aesthetics and the construction of clothing, and tended to present fashion as a phenomenon of cultural behavior; it still paid respect to the French, often recognizing France's superiority in research and experimentation. The editorial line of the other leading fashion magazine in Italy during this period, *Bellezza* (Beauty), was radically different, taking fashion as a luxury item, profoundly Italian and full of exquisite artifice, a fairy tale featuring noblewomen and famous actresses. It is no coincidence that this magazine was published in Rome.

Paris, after emerging from its initial postwar confusion and regaining momentum, first with Dior and then—crucially—with Cristobal Balenciaga and Pierre Balmain, began to lure famous designers away from Italy (Capucci left in 1962), reaffirming the venerable Parisian leadership precisely through the city's traditional aptitude at adopting as its own the finest talents in the world, wherever they might arise, a skill in which neither Florence nor Italy has been able to excel over the past few centuries.

Nevertheless, despite the quarrels, the small-minded rivalries, and the profusion of fairs and events, which distracted and confused the foreign fashion press, along with the manifold efforts to found associations and national coordinating organizations that might attain the same level of prestige as their French forerunners, the capital of Italian fashion remained solidly based in Florence. And the locus of Florentine fashion was, at least until 1965, when Giorgini left its helm, the Sala Bianca. This event was to introduce such names as Balestra, Baratta, Rocco Barocco, Biki, Roberta da Camerino Falconetto, Patrick de Barentzen, Federico Forquet (see cat. nos. 515–17), Galitzine, Krizia, Pino Lancetti (see cat. nos. 525–28), Missoni, Mila Schön (see cat. nos. 549, 550), Scott, and Valentino, who made his debut in 1959 (as a beginner, he was forced to show on the last day, but he still received considerable attention, and sold all his creations).

The Sala Bianca was the setting for the premieres of a great number of stylistic innovations. Nineteen fifty-seven witnessed, Marucelli's *Pannocchia* (*Corncob*) line, Simonetta's *Palloncino* (*Balloon*) line, and Schuberth's *Convertibile* (*Convertible*) outfits. That same year Pucci's *Palio* collection was presented (see cat. no. 538), demonstrating once again the designer's level of mastery of printed silk and fabrics printed in Mediterranean colors, such as geranium red, Emilio pink, and Capri blue. Later

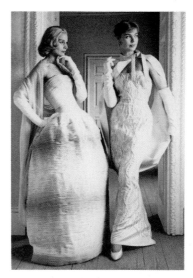

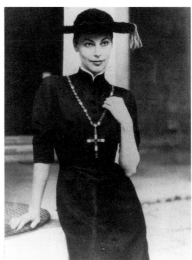

fig. 9. *Gowns by Emilio Schuberth and Jole Veneziani, photographed by Fatigati at Osterly Park, London, 1956.*

fig. 10. *Ava Gardner wearing a Sorelle Fontana dress, 1956. Archivio Sorelle Fontana.*

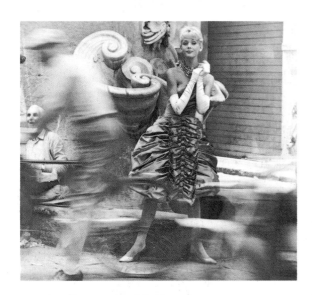

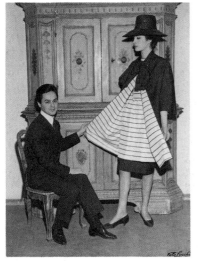

fig. 11. *Dress by Carosa, photographed by Regina Relang in Florence, 1959.*

fig. 12. *Roberto Capucci and model, photographed by Locchi in 1960.*

years saw a parade of influential innovations: Capucci's *Scatola* (*Box*) line (see cat. no. 507) in 1958; the palazzo pajama by Galitzine (see cat. nos. 518–20) in 1960; Lancetti's *Militare* (*Military*) line in 1963; and Valentino's *Collezione bianca* (*White Collection*), twenty-five all-white outfits dedicated to Jacqueline Kennedy, in 1967.

In 1960 the "Italian High Fashion Shows" of Florence were renamed the "Italian Fashion Showing" as part of an ongoing effort to reduce the emphasis on haute couture. Throughout the preceding decade new sections had been added to the event: in 1952 fabrics for and collections of men's fashion were presented, followed in 1954 by children's clothing, in 1955 by furs, and in 1956 by a number of collections of prêt-à-porter. In 1962 fashion for teenagers was presented, as was women's underwear, designed by Galitzine. Haute couture, however, was still at the center of the organizers' concerns, and, in general, at the heart of the entire system of thought about style of the time.

Haute couture remained a central stylistic point of reference, at least until the second half of the decade, for the large manufacturing concerns. This was a major factor in holding back experimentation and the creation of a style proper to prêt-à-porter that might go beyond the canons of codified elegance; thus the apparel industry of the time missed its opportunity to satisfy a sensibility that even then was breaking free from haute couture, that was, in fact, waging an open rebellion against all the conservative values that haute couture embodies.

Giorgini—and with him the majority of Italian dressmakers—sensed that haute couture, at least as they had always known it, was doomed. Giorgini, however, could not refrain from thinking of haute couture as the sole authentic laboratory for creativity, which was linked unfailingly to an artistic and crafts background, to a rhetoric of Renaissance values, to an aristocracy of invention with its roots sunk deeply and unmistakably in the idealism of the nineteenth century: a sort of Promethean forge where ideas were formed at white heat, then cooled gradually until they attained final solidity in the manufactured apparel.

Giorgini and the dressmakers of the old generation were missing an important point: that prêt-à-porter could very well become a Promethean workshop, where fashion design took on all the full creative dignity of the old process, and where the act of creation was filtered through the various steps of industrial manufacturing, while maintaining close contact with the market in order to meet the demands of the final retail customer.

Once the powerful and vehement antifashion sentiments of the 1960s and 1970s had been overcome—sentiments that were part of the new sensibility and the moralizing opposition to consumerism that in time became a style of its own (a phase that followed the feverish consumption of all that was new in the boom years)—the new awareness of prêt-à-porter as a legitimate field of endeavor began to emerge. Once they were filtered through the diffuse creativity of the Italian fashion system, and through the personal interpretation of intelligent individual designers, from the second half of the 1970s onward, many of the themes developed by the antifashion trend themselves became factors in the success of that phenomenon known as "Made in Italy."

The social revolution that took place in the late 1960s amounted to a death sentence for the old concept of fashion. A new understanding of the human body and its primary symbolic function, along with the creative aspects of consumption, were perhaps the two most important conceptual components generated in the late 1960s. Fashion became contemporary art (an aspect of design or a personalized expression of the human body and of the behavior of the individual, the communication of a style of life, through the medium of clothing) at the point where art and fashion revealed their similarities and their self-awareness. Among these was the inevitable character of marketing that attached itself to every aesthetic creation, a process that marked both the moment of creation and conception and that of reception, while rendering obsolete all traditional idealistic and romantic constructions.

In 1936 the critic Walter Benjamin posed a fundamental question as to whether the invention of photography had changed the overall nature of art. We may pose just such a question about the relationship between fashion (considered as an applied, "lesser" art) and art in the age of mechanical reproduction, in a time of mass production. But thoughts of this sort were certainly not expressed in the 1960s; such a way of looking at fashion has emerged only gradually, in recent years, when we have begun to question the idea of fashion as being defined as *the designer* and *the label* that the fashion designer imposes—with an egocentric and increasingly self-referential attitude—on the personal stylistic development pursued by consumers.

Greater critical awareness about fashion was shown from the mid-1960s onward by Italy's school of "radical design," which considered the industrial designer to be a slave to styling as a function of the production/consumption cycle. In its theories, it captured the cognitive and creative aspects that consumption and consumer objects have taken on in advanced capitalist society. These are the foundations of postmodern thought.

With respect to this theoretical awareness, it would be relatively pointless, as well as quite difficult, to trace the more profound artistic influences on individual designers in the recent history of Italian fashion, under the superficial overlay of various borrowings, or to indicate some of the working relationships between certain Italian designers and artists during the 1950s and 1960s. And yet these relationships—although they tended to be sporadic and to remain limited to the decorative aspects of clothing, thus remaining outside the bounds of the central design process—did exist.

The Milanese designer Marucelli (a fairly unusual character in the panorama of Italian fashion, considering that her atelier-qua-drawing room was frequented by such writers, artists, and architects as Eugenio Montale, Giuseppe Ungaretti, Gio Ponti, Felice Casorati, Massimo Campigli, and Lucio Fontana) was perhaps one of the most active supporters of an interdisciplinary relationship between fashion and art. In 1948 she worked with Piero Zuffi, a painter and set designer (who applied patently Surrealist designs to the fabrics used in clothing designed by Marucelli); she went on to work with Giuseppe Capogrossi and Paolo Scheggi. In 1960 she took inspiration for her *Vescovi* (*Bishops*) line from the sculptures of Giacomo Manzù, and then in 1965 she worked with

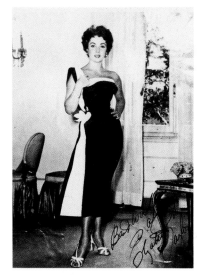

fig. 13. Elizabeth Taylor wearing a Sorelle Fontana dress in 1961.

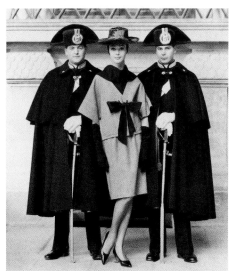

fig. 14. Two-piece suit by Simonetta Visconti, photographed by Regina Relang in 1961.

Getulio Alviani, one of the better-known kinetic artists, on the fabrics for the *Optical* line (vertical and horizontal motifs alternating with spirals, patterns repeated in accessories and stockings); in 1968 came the *Alluminio* (*Aluminum*) line, with its hybrid of the soft surfaces of wools and the rigidity of large metal rings (see cat. nos. 533, 534). Marucelli took ideas from classical art as well: the *Fraticello* (*Little monk*) line in 1954 openly declared its sources—the palettes of Masaccio, Fra Angelico, and Paolo Uccello.

Capucci merits separate consideration. The young designer played with a number of different references: Marcel Duchamp, Futurism, Rationalism, English Pop. In Capucci's work fashion design becomes increasingly abstract, and clothing becomes sculptural, made to be set in a certain environment.

During the 1960s the general climate of experimentation and hybridization among the widest range of languages encouraged greater contact and exchange between art and fashion. Fashion designers chiefly chose to view this in terms of citations: in addition to Marucelli, we should consider the work of Schön (with the geometric abstractions of the 1966 collection and the slashed material, based on Fontana's cuts, in the 1968 collection); the work of Pucci, featuring "psychedelic" colors; that of Krizia, with Pop decorations worked into the knitwear; and of course the metal and plastic clothing made by Barocco, Centinaro, and Lancetti. Among the rare cases of concrete interest in fashion on the part of artists and industrial designers, we could mention the ideas for hairstyles and jewelry conceived by Enrico Castellani, Arnaldo Pomodoro, and Ettore Sottsass, Jr., as well as the "opera outifts" that Jannis Kounellis was to create in the 1960s and 1970s.

Beginning in the second half of the 1960s, in the wake of a more mature relationship with fashion and with modern design culture and the culture of urban planning that contributed so much to the success of Italian fashion, Milan began to boast star status as a fashion capital, where designers such as Giorgio Armani, Ferrè, and Gianni Versace began to establish their reputations; throughout the 1980s Milan was to be the city that symbolized Italian fashion. In the 1990s, with the return of a slightly less hard-edged approach to fashion and greater attention to the overall quality of life—but also thanks to a more aggressive and modern policy of image-building on the part of the Florentine fashion shows—a certain amount of interest has shifted to Florence and to the enormous, perhaps unique potential for prestige and spectacle that Florence can offer the Italian fashion industry as it looks toward the future.

It is inevitable, and a clear sign of vitality, that a historical review of twenty-five years of Italian fashion should be closely interwoven with more current and more general issues. After the spectacular successes of the 1970s and the 1980s Italian fashion now has a more critical view of itself. There are a great many different reasons for this attitude, stemming from factors inherent to fashion but also from factors separate from fashion: economic and cultural factors, specific national factors and others that are global. The impression that one comes away with is that in the 1990s, just as in the 1960s, we are confronted with a deep-seated shift—in the methods of production of fashion, and in the ways in which we consume and conceive of fashion—the shape and nature of which are not yet entirely clear.

The openness to the world, the cultural flexibility and the manufacturing flexibility of the Italian fashion system, and the integrated and widespread support that it offers to the individual creativity of Italian and non-Italian designers who work with this system, are the vital qualities that Italy can still offer in the cardgame of international fashion and fashion design as it promises to be played during this wide-open end of the century.

Translated, from the Italian, by Antony Shugaar.

Italian Fashion and America

Valerie Steele

Italian fashion's chic image is so powerful today that it may come as a surprise to realize how recently it acquired a high international profile. It was only in the late 1970s that the Italian fashion system, based in Milan, produced superstars like Giorgio Armani and Gianni Versace. So apparently insignificant was the Italian fashion presence prior to this time that many histories of modern fashion do not mention Italy at all, or make only passing references to a few designers, such as Roberto Capucci and Emilio Pucci.[1] Even Italian scholars, concerned with distinguishing between clothes that were merely "made in Italy" and those that exemplify "the Italian look," sometimes question whether we can legitimately speak of Italian fashion before the 1970s.[2] It is appropriate to reevaluate this judgment because it is now clear that Italian fashion in the immediate postwar decades was far more important than has been generally thought.[3] Contrary to what most fashion histories have led us to believe, Italian fashion was *not* peripheral to the development of international style. Indeed, to attain an accurate picture of twentieth-century fashion, it is essential to reassess the Italian contribution. This essay focuses on the American perception of Italian fashion in the period from 1943 to 1968 as a preliminary stage in what must be a collective effort on the part of many scholars to compose a truly international picture of fashion history.

The stylistic analysis of garments in museum collections in New York City not only reveals considerable talent on the part of individual Italian designers but also provides evidence for the development of a genuine national style.[4] In contrast to the opulent formality of French couture, Italian postwar fashion was characterized by an uninhibited yet sophisticated sense of style. Playful, sexy, and effervescent, Italian clothes appealed by virtue of their gay colors, imaginative surface decoration, and unconventional use of materials. Produced within the context of craft-oriented workshops that tended to be small in scale and geographically dispersed, Italian fashion was not only artistically inspired but also so commercially successful that it proved instrumental in Italy's rapid postwar economic recovery.

Italian fashion has been neglected for several, related reasons. Italy has a long tradition of elegant craftmanship, but craft per se is not equivalent to art, not even the art of fashion. Moreover, although Italy produced high-quality clothes, some of which had been imported into the United States as early as the turn of the century, it is nonetheless true that the dominant aesthetic of Italian fashion was for many years derived from Parisian couture. Italian artisans were, in fact, often employed by French couture houses to do fine handwork, such as embroidery, and to create accessories, such as lingerie and shoes. Indeed, Italian accessories were world famous, and well-dressed women everywhere bought purses by Gucci (established in Florence by Guccio Gucci in 1906) and shoes by Ferragamo (established in 1927 in Florence by Salvatore Ferragamo, see fig. 1, cat. nos. 577–602). But a pair of shoes or a purse, however beautiful, has generally been regarded as secondary to the dress, the major element in the ensemble.

Traditionally, then, Italian fashion was in a subordinate position vis-à-vis French fashion and Paris, the international capital of fashion since the seventeenth century. Indeed, Elsa Schiaparelli, the most famous Italian-

born designer of the 1930s, had established her couture house in Paris, where she achieved the international recognition denied to designers based elsewhere. During World War II, Schiaparelli fled to the United States, but she continued to insist, "It is not possible for New York or any other city to take the place of Paris."[5] The Italian Fascist elite did not agree, however, arguing that clothing should be national in character, drawing inspiration from classical Rome, regional costumes, and the Italian Renaissance. Despite this nationalist propaganda the wives of Fascist leaders tended to wear dresses that were essentially copies of French designs. But even Italy's subordinate position was threatened when Benito Mussolini's Ethiopian adventure resulted in the League of Nations sanctions of 1936, which, combined with the autarchical economic policies of the Fascist regime, crippled the Italian fashion industry. With the outbreak of war in Europe, in 1939, craftsmen were drafted, production plummeted, trade with the Allied countries ceased, and raw materials became unobtainable; Ferragamo, for example, had to use cork, paper, and crocheted cellophane in place of leather.

The development of an authentic Italian style and a modern fashion system occurred only after World War II, within the context of a new international fashion system. Italy's relationship with the United States was particularly relevant. Like Italy the United States had traditionally copied French fashion. But because the American fashion industry was entirely cut off from trends in France by the Nazi occupation of Paris, designers were forced to develop a genuinely American style. The wartime rise of American sportswear was to have an important influence on the subsequent development of Italian fashion. The postwar revival of the Italian clothing and textile industries played a cathartic (and highly visible) role in Italy's economic reconstruction. By the mid-1940s many Italian fashion companies were regaining strength and actively promoting international trade, especially via connections with the Italian-American community in New York. The initial emphasis was on prewar Italian export items, such as shoes, handbags, and straw hats, but this soon expanded to clothing as well. Because the United States constituted Italy's primary overseas market at this time, American attitudes toward fashion had a major impact on the development of the fashion system in both countries.

The discourse on Italian fashion in the American press provides important insights into the development of what came to be known as "the Italian look." Fashion journalists at that time were often justifiably enthusiastic about the work of Italian designers, but they also perceived Italian fashion through a veil of stereotypes. The first important article on Italian fashion was published in 1947 in America's premier fashion magazine, *Vogue*. The language is quintessential *Vogue*speak, inasmuch as the formal elements of fashion (fabric, design, and workmanship) are assimilated into an idealized personality type, as seen through the lens of national, class, and gender stereotypes. Consider the opening paragraph:

The sophisticated Italian woman has, at the outset, two great advantages: Wonderful materials and an apparently inexhaustible pool of hand labor. The Italian woman of

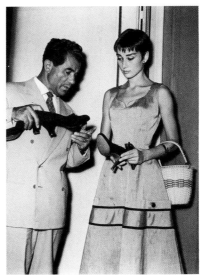

fig. 1. Salvatore Ferragamo and Audrey Hepburn, photographed by Locchi in 1954.

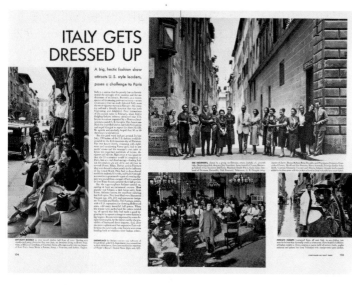

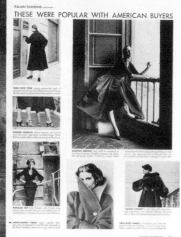

figs. 2, 3. Two spreads from "Italy Gets Dressed Up," Life, August 20, 1951. Photographs by Milton Green.

breeding also has a certain quality of relaxation (not unnatural since she seldom works) which endows her clothes with an easy grace, a free, uninhibited movement. Her thonged sandals help too, for her legs and feet are possibly the best in Europe.[6]

If, for *Vogue*, "fashion" equaled "woman," then Italian fashion was represented by a sophisticated and beautiful aristocrat, whose naked legs and uninhibited body language implied the eroticism of a modern odalisque. This woman was an alluring role model for American women. Yet *Vogue*'s reporter, Marya Mannes, defensively criticized what she regarded as the flaws of Italian style: "Italian clothes are inclined to be as extrovert as the people who wear them . . . gay, charming, sometimes dramatic, but seldom highly imaginative or arresting." A "lack of imagination" (that is, a reliance on French silhouettes) was not the real problem for Mannes; rather, it was the inherently "extrovert" drama of Italian style that made her nervous. Bold prints and bright colors might look well "under that blanching sun," but they seemed too "intense" and "unsubtle" for American tastes. Italian accessories, however, were more familiar, so not only Gucci's prestigious bucket bag but even Ferragamo's rather eccentric Oxford shoes made of scaly pink fish skin were praised, as were sexy Italian playsuits: "little-girlish but in no way innocent." And the prices (about $100 for a day dress and $200 for an evening dress) "are far lower than in Paris."[7] The subtext was: "Go to Italy and buy these clothes," most of which were not yet available in American stores.

Italian fashion was often promoted in the American press in conjunction with stories about vacations in a warm and beautiful land, which served as the "pretext for stereotyped touristic–anthropological digressions."[8] Typical titles in the American popular press included "Italy: Her Wonderful People"[9] and "These Enchanting Italians."[10] "Italian Ideas for Any South," an article on beach and resort wear in *Vogue*, promoted Italian "sun clothes" as chic and stylish. The allure of the Italian woman was again emphasized: "It's a game they play in the European resorts—guessing how many well-dressed women are Italians."[11] The "souvenir effect" of Italian fashion played a distinct role in its early success with Americans. If Italy was the beautiful and sexy "other" for Americans, the United States played a complimentary role for Italians as the rich and successful cousin. But Italian reconstruction could not depend solely on free-spending American tourists. It was necessary to involve the American market on a much wider scale, and the fashion show provided an obvious way to promote Italian clothing design. Italian fashion was, from the beginning, turned into a spectacle.

In the early 1950s the idea was to woo American journalists and department-store buyers, not so much by providing a design alternative to Paris as by demonstrating that "the Italians were as good as anyone at putting on a 'show.'"[12] The first important Italian fashion show was held in May 1950 at the Teatro della Pergola in Florence. Mannequins emerged from reproductions of famous Renaissance paintings, emphasizing the connection between fashion design and Italy's heritage of art and culture. The commercial "invention" of Italian fashion, however, is generally credited to the Florentine

businessman Giovanni Battista Giorgini, who organized a second show, in February 1951, at the Villa Torrigiani. From America only one journalist (Elisa Massai) and eight department store buyers attended. However, *Women's Wear Daily* published a front-page article, "Italian Styles Gain Approval of U.S. Buyers," with the slightly misleading subheading, "Many from Top Fashion Stores Attend Florence Showing of 180 Models and Accessories."[13] When Giorgini organized another "big, hectic fashion show" in July 1951,[14] featuring designers from Rome, Milan, Turin, and Florence, almost 200 American buyers and journalists came, along with another hundred from Italy and other European centers.

Soon after Giorgini's second show America's most important mass-market periodical, *Life*, published a major article, "Italy Gets Dressed Up" (figs. 2, 3), which reported rhapsodically on how Italy's "amazing postwar recovery" had resulted in the development of a "fledgling fashion industry" that attracted American buyers and was even said to "pose a challenge to Paris." The article's tone, however, was slightly condescending: American fashion leaders "descended on the little museum city of Florence" like a "friendly invasion"; the fashion show was crowded and disorganized, "but the eager-to-please Italians" did their best and ended by "scoring" a real success; "Italy . . . made a good beginning in its upstart attempt to enter fashion's big leagues."[15] In fact the French clearly felt threatened by the appearance of regular fashion shows in Florence, and the July 1951 show provoked anguished editorializing, epitomized in the headline: "La bombe de Florence a ébranlé les salons de la Haute Couture Parisienne et menacé son monopole"(The bomb from Florence has shaken the salons of the Parisian haute couture and threatened its monopoly).[16] But Americans were not about to abandon Paris, although they did very much like Italian sportswear, fabrics, *and* prices.

After Giorgini's pioneering 1951 shows it was decided that the fourth "Italian High Fashion Show," in July 1952, would be held in one of Florence's most beautiful settings: the Sala Bianca of the Palazzo Pitti. For five days in the sweltering heat, 350 spectators, including representatives from American companies such as Macy's and Neiman Marcus, studied fashions by nine haute couture, or *alta moda*, houses and sixteen houses presenting sportswear and boutique styles. The Italians had succeeded in putting Florence on the international fashion circuit. Fashion could no longer be thought of as radiating from Paris to the provinces. Rather "the white and crystal splendour of the Pitti Palace" provided an appropriately impressive setting for Italy's seasonal fashion shows; as Florence became a venue for fashion designers from all over Italy, the Pitti Palace was regularly "jamful for buyers and the press for the Italian Collections . . . even some Iron Curtain countries were represented."[17] As a result of the publicity engendered by these fashion shows and the appearance of Florence as a world fashion capital, the volume of Italian clothes sold abroad increased dramatically. Many clothes were directly imported into the United States; in other cases American manufacturers bought the rights to copy Italian designs. Whether or not particular clothes were actually "made in Italy," they were increasingly perceived as representing "the Italian look."

"Just like the Chianti, Italy's fashions are becoming as well known as its table wine," reported *Life* in a 1952 article on Italian imports that was featured on the magazine's cover (figs. 4, 5). For Americans in the 1950s a straw-covered bottle of Chianti was an integral element in the popular image of a young and bohemian life style. Inexpensive by contrast to fine French wine, Chianti was regarded as young, sexy, romantic, and cosmopolitan—all attributes that could equally be applied to Italian fashions, such as Simonetta Visconti's "puffy playsuit," available at Bergdorf Goodman in New York for $40. Italian fashion was no longer seen primarily "in terms of handbags and umbrellas."[18] *Vogue* covered the Italian collections in 1952 and concluded:

There are three exciting things about Italian fashion today. The first is that Italy is capable of producing a kind of clothes which suit America exactly. . . . Namely: clothes for outdoors, for resorts . . . {and} separates, fads . . . all the gay things, all the boutique articles and accessories.

The second is the fabrics—anything and everything pertaining to Italian fabrics is newsworthy.

The third is the evening dresses, marvellously made in marvellous silks at a relatively low cost. (Evening life is something that the Italians understand thoroughly. . . .)

These are the three things in which the Italians need to be encouraged; they should be given wings to develop their native specialities, and urgently discouraged from French adaptations.[19]

Italian evening dresses were more derivative of French fashion and therefore less historically significant than Italian fabrics and boutique fashions. Nevertheless we can identify important designers and styles. A striking use of color is typical of many Italian designers. An evening gown made in 1952 by Roman couturier Emilio Schuberth (in the collection of The Costume Institute, The Metropolitan Museum of Art, New York; see also cat. nos. 551–55), for example, consists of bands of pink-mauve grading into a dark cerise that alternate with black bands, the whole decorated with appliquéed black lace. The dress was worn with pale old-rose satin ten-button gloves. The lavish use of supplementary decoration is also typical of much Italian fashion. This is hardly surprising; we have seen that even the French couturiers frequently employed skilled Italian craftsmen to decorate their dresses. Moreover it is stylistically congruent with the theatrical, even glittering quality characteristic of Italian evening dresses as well as film costumes.

The influence of the movies on Italian fashion was unquantifiable but immense. Because production costs in Rome were low in the 1950s, not only Italian films but also many American films were produced there. Movie stars like Ava Gardner and Gina Lollobrigida consequently tended to wear Italian high fashion on screen and off. Even when a Hollywood costume designer like Edith Head created the star's wardrobe, as she did for Audrey Hepburn in William Wyler's *Roman Holiday* (1953), an American film shot on location in Rome, most viewers probably associated the star's clothes with Roman high style. Rome became a combination of Paris and Hollywood. Giovanna, Micol, and Zoe Fontana, working under the name Sorelle Fontana (Fontana Sisters, see cat. nos. 561–65), were Roman

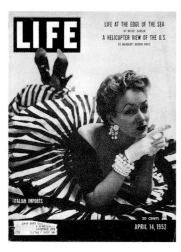

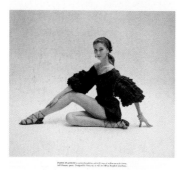

Just like the Chianti

ITALY'S FASHIONS ARE BECOMING AS WELL KNOWN AS ITS TABLE WINE

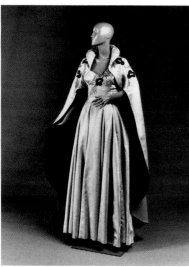

figs. 4, 5. *Cover and page from "Italian Imports," Life, April 14, 1952. Dress on cover was designed by Jole Veneziani and reproduced by Hannah Troy of New York. Photographs by Mark Shaw.*

fig. 6. *Micol Fontana, Ball gown, 1954, satin, peach leather, cotton, and velvet. The Brooklyn Museum, New York. Gift of Signora Micol Fontana.*

couturiers, famous both for their wedding dresses (President Harry S Truman's daughter Margaret wore one) and evening gowns as well as for their film costumes. They also designed costumes for Gardner in another American production filmed in Italy, Joseph Mankiewicz's *The Barefoot Contessa* (1954). One of the dresses from the film is a strapless pink evening gown, decorated with a biomorphic floral design in sequins and velvet, and accompanied by a fitted cape with exaggeratedly long open sleeves for an effect of theatrical glamour (fig. 6).

Italian fabrics were visually striking and exceptionally innovative. Many textile manufacturers hired talented artists to design for them, and willingly experimented with such labor-intensive techniques as floral "prints" made of individual appliquéed petals. Trompe-l'oeil effects were popular, from linen painted to look like wood to complicated Op art prints, like those designed in 1966 by the painter Getulio Alviani for Germana Marucelli (cat. nos. 533, 534, see also cat. nos. 529–32). So apparently newsworthy were Italian fabrics that the captions in fashion magazines often included such information as the following: "Emilion: Zebra dress of hand-painted linen (Fabric: Line e Lani)."[20] Indeed, Pucci's success was inseparable from his textile designs (see cat. nos. 538–47). The appeal of the kaleidoscopic mixture of colors typical of Pucci's prints made them international bestsellers. A single scarf might be printed in more than a dozen colors, in a swirling abstract design. Pucci also pioneered the use of lightweight artificial fabrics, especially those that stretched. As early as 1948 his ski and resort fashions were featured in *Harper's Bazaar*,[21] but he really came into his own in the 1950s, when he adapted the look and comfort of ski pants to astonishingly directional play clothes, such as jumpsuits in stretch fabric. He also paired capri pants with silk shirts in bold scarf-print designs, helping to establish one of the classical styles of the twentieth century. By the 1960s his featherweight silk-jersey separates had become international symbols of the jet set. Indeed, in 1965–66 Pucci also designed stewardess uniforms for Braniff Airlines (fig. 7). The Italian contribution to informal fashion, what *Vogue* called "clothes for outdoors [and] resorts," was a major factor in the success of Italian fashion in America. Sportswear had been the big hit of the Florence fashion shows from the very beginning. Knit tops, tight black slacks, and sweaters were especially popular by virtue of their "easy casualness" and "low prices."[22]

Yet snob appeal was also an important element in the success of Italian fashion. "Hard-up aristocrats . . . turned to designing after the war," explained *Life*, lovingly citing Italy's noble fashion designers, such as Marchese Emilio Pucci, Principessa Giovanna Caracciolo di Avellino Giannetti of Carosa (see cat. no. 512), Baronessa Gallotti, and, especially, Contessa Simonetta Visconti (fig. 8).[23] The discourse in the popular press demonstrates how Italian fashion was simultaneously perceived as cheap-and-cheerful and also prestigious, cultivated, even noble. Italian fashion was constantly associated with "Italian fashionables," like the "six contessas and two marchesas—wearing the latest creations of major Italian designers—[who] patriotically partied their way across the ocean to New York" on a three-week promotional tour. "Even the cloakroom girl at El Morocco asked me where I got my

dress," declared Contessa Marisa Brandolini."[24] As Italian fashion rapidly became identified with status, American department stores were "quick to capitalize on the fact that snobbery sells" by importing hundreds of millions of dollars worth of products.[25] This snob appeal was ironic given the fact that the most important and most widely consumed segment of Italian fashion consisted of informal clothing, produced in opposition to the stuffy opulence of the French couture. Simonetta's career is especially revealing in this respect, and it also sheds light on attitudes toward women designers.

Life called Simonetta the "Titled Glamour Girl of Italian Designers."[26] She was born in 1922, the daughter of Duke Giovanni Colonna. After the war she married Count Galeazzo Visconti di Modrone, and used her married name, Simonetta Visconti, when she began designing clothes in 1946. Her marriage to Count Visconti was terminated in 1949, but press reports continued to alternate between her paternal and marital titles for several years. "Donna Simonetta Colonna di Cesaro bought her summer-in-Capri wardrobe in America . . . for $56," announced *Vogue* in 1951. Four pictures of the beautiful Roman designer in her "American play wardrobe" were juxtaposed with a full-page formal portrait showing her wearing her own silk coat.[27] In other words it was not her pedigree alone that appealed to American journalists; just as important was its conjunction with an apparently unpretentious personality.

Described as the "youngest, liveliest member"[28] of the Italian fashion world, the "petite and coquettish"[29] Simonetta handled the press with finesse. A vacation in America "sold her on the U.S. way of wearing clothes," happily reported *Life*. "Both her personal wardrobe and her collections show an affinity for American style." In fact Simonetta traveled frequently to America and was obviously an astute judge of American publicity. Whether or not her popular capri pants and corduroy jackets were really "designed especially for lounging Americans," they strongly appealed to the American market.[30] In 1953 Simonetta married Alberto Fabiani, another well-known Roman fashion designer (see fig. 9, cat. no. 513). "Simonetta's forte is young, ultrafeminine sports and cocktail clothes," reported the New York press, whereas husband Fabiani was known as "the surgeon of suits and coats" for his clean, rather conservative tailoring.[31] After their marriage they maintained separate, rival establishments in Rome. "Fashion design is a mad business," Simonetta explained to one reporter. "While I'm doing a collection, I work until three in the morning for days at a time. If my husband were a lawyer he would not understand this. But, you see, he's doing the same thing. . . . My husband is known for his style and I for mine."[32] Simonetta's silhouettes tended to follow the currently fashionable lines, originating in Paris and copied in Italy and America, but her use of materials was often imaginative. An afternoon dress from about 1955 (in the collection of The Museum at F.I.T., New York) consists of rows of raffia interspersed with bands of pink ribbon: "the Italians reinvent the grass skirt," joked the museum's coordinator of costume collections, Fred Dennis. A strapless evening dress from 1950 (in the collection of The Costume Institute, The Metropolitan Museum of Art, New York) is equally unorthodox, with a skirt made of

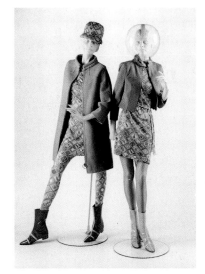

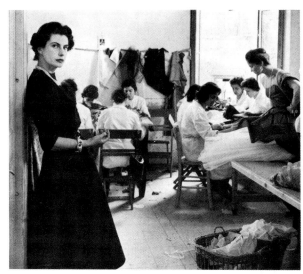

fig. 7. Emilio Pucci, Braniff Airlines hostess uniforms, 1965–66. Texas Fashion Collection, University of North Texas, Denton.

fig. 8. Simonetta Visconti in her Rome workshop, photographed by Arnold Newman for "Italy: Her Wonderful People," Holiday, April 1955.

figs. 9, 10. Left: Dress by Alberto Fabiani, with Pirelli skyscraper, Milan. Right: Dress by Roberto Capucci, with ceramics by Fornasetti. Both photographed by Mark Kauffman for "Dramatic Decade of Italian Style," Life, December 1, 1961.

fig. 11. Irene Galitzene and Jacqueline Kennedy in Capri, in 1960.

wide strips of black velvet and jersey loosely woven in a checked pattern.

Simonetta was a talented designer whose clients included the fashion editors Bettina Ballard of *Vogue* and Carmel Snow of *Harper's Bazaar*. In terms of formal construction, however, the most innovative Italian designer was Capucci (see fig. 10, cat. nos. 502–11). Described by *Vogue* in 1952 as "easily Rome's most promising young designer," Capucci designed clothes that "if too costume-y, at least are completely original and full of ideas."[33] Whereas French couture had a place for extreme artistry, Capucci remained an isolated figure in Rome. In 1962 he left for Paris, followed by Simonetta and Fabiani in the same year. In a piece whimsically titled "Bonjour Paris, Addio Rome, Say Couture Duo," *Women's Wear Daily* reported, "The mother and father of Italian fashion, Simonetta and Fabiani, are off to Paris . . . a real blow to the Italian couture which just recently lost Capucci to the French capital."[34] Although none of them was ultimately successful in Paris, their defection did not hurt the Italian fashion system. Their abscence may actually have "clear[ed] the way for new talents," like Valentino [Valentino Garavani, see cat. nos. 566–75) and Russian-born Princess Irene Galitzine, as well as shorter-lived talents like Federico Forquet and Patrick de Barentzen.[35]

In 1961, ten years after the breakthrough Florence fashion shows, *Life* celebrated "The Bold Italian Look that Changed Fashion." The essay, "Dramatic Decade of Italian Style," begins by stressing Italy's achievements in all areas of design, not only fashion: "Italy in a few brief years has changed the way the world looks—the cars, buildings, furniture and, most universally, the women." In terms of fashion per se it had been a "Dramatic Decade," full of "Knockout Clothes." Despite the hyperbole (the cover screamed "Explosion in Style") *Life's* analysis of Italy's contributions to fashion was amazingly acute. There is a brief survey of recent accomplishments: the Italian collections were now a major stop on the fashion circuit; Italy exported more clothes than any other country. "But Italy's fantastic fashion record does not rest on volume alone. Her designers have contributed an outstanding list of style changes," including the vogue for knits, stretch pants, scarf-print shirts, shoes with pointed toes, and men's silk suits. Italians came up with "the most striking color combinations, the tightest pants, [and] the wildest prints." Among the clothes depicted are a sexy stretch-fabric catsuit by Pucci, "for entertaining at home"; a gold at-home outfit by Simonetta, also in stretch fabric; three evening slack outfits by Galitzine; as well as dresses by Fabiani and Capucci (figs. 9, 10).[36]

From the perspective of the 1990s we can see that Italian fashion design was profoundly directional. Many of the clothes, such as the stretch pants, evening slacks, and scarf-printed shirts, could be worn thirty years later. The combination of luxury and at-home casualness remains particularly striking. The Italian style also exerted a profound influence on menswear: elegant in a casual way, it was also streamlined, body-conscious, and colorful. As *Vogue* observed in 1956: "Italian influence on men's clothes is a fact now—and American men are getting to know the facts: that Italian tailoring can be very much at home in America; that naturally slender jackets and straight-

hanging cuffless trousers . . . are smart and comfortable at the same time."[37]

Part of the appeal of Italian clothing for Americans derived from the characteristics that they associated with the Italian people. At a time when most American men were still the products of a sexually repressed culture, straitjacketed into rigid gender stereotypes of appropriate "manly" behavior, the appeal of an alternative masculine role was powerful indeed. Later, in the 1970s and 1980s, the Armani mystique would draw on this same American belief in the supersensuality of the Italian male. We saw the stereotype of the sophisticated Italian woman in *Vogue*, and we see the male version in the photo-essay "The Italian Man," published in *Life* in 1963. "He dresses up to present a *bella figura*," we are told, although most of the pictures show men in sleeveless undershirts or bathing suits. But the point was that whatever "he" wore expressed a particular personality, which was characterized as natural, spontaneous, and self-confident. Endowed with enthusiasm and innocent egotism, "laughter and love and a particular kind of triumphant masculinity," he could cry like a baby and still remain a "he-man." His "sensuality" enabled him to move and dance, to "show-off" without inhibitions: "He *knows* the girl will sigh with bliss."[38]

It is often assumed that the "Peacock Revolution" of the 1960s originated in "swinging" London. The "mod" clothes (the term was an abbreviation of "modern") worn on Carnaby Street were indeed a visible sign of London's vibrant youth culture, and gained notoriety when worn on the backs of pop music stars. Yet Italian fashion design had a great influence on London's fashion revolution. Throughout the 1950s the Vespa motorscooter and the espresso bar were modern design icons; so also were imported Italian men's clothes. The streamlined and colorful menswear coming out of Italy—the soft boxy jackets, slim trousers, and bright colors—were highly attractive to trendsetting young British males. "I liked the Italian stuff," recalled pop star David Bowie, "the box jackets and the mohair."[39] Colin MacInnes's 1959 novel of English youth, *Absolute Beginners*, also clearly emphasizes the importance of Italian style in the self-presentation of a character called the Dean: "College-boy smooth crop hair with burned-in parting, neat white Italian round-collared shirt, short Roman jacket very tailored (two little vents, three buttons), no turn-up narrow trousers with seventeen-inch bottoms absolute maximum, pointed toe shoes, and a white mac folded by his side."[40]

It was London, however, not Florence, that emerged as the capital of "Youthquake" fashion. Not only did Italy lack a genuine youth culture (which centered around popular music), but the Catholic Church attacked youth fashions like the miniskirt as immodest. There were other problems with the Italian fashion system, as well, which prevented it from exploiting the progress that had been made since 1950. Geographical fragmentation was a major stumbling block. Florence had been the citadel of Italian fashion for some years, but it was increasingly challenged by Rome. Designers based in Rome complained that they were tired of traveling 190 miles to show their collections in Florence, where, moreover, they were restricted in the number of ensembles they could present in the group shows at the Pitti Palace.

The competition between Florence and Rome did not work to Italy's advantage. "If the Italian clothes designers would pull together, they could probably match the French. . . . Instead they are too busy sticking pins into each other," complained *Newsweek*. Buyers and fashion reporters "were forced either to take sides in the battle or split up into two teams to cover both cities because of openings that conflicted."[41] A compromise was worked out, whereby Florence showed accessories and boutique fashions, what *Time* magazine called "the gags," fun fashions like "hip-hugging chiffon pants" and "backless bikinis," while Rome became the center of the couture, showing luxurious ensembles such as "patio pyjamas (patterned in mauve and pea-green poppies) and open-front, open-back nightgowns."[42]

Over time, Rome began to receive the lion's share of American attention. A refuge for luxury in a world of fast-moving youth fashions, the Roman couture seemed perfectly designed for *la dolce vita*. According to the American fashion press, the "beautiful people" not only wore Italian high fashion, they often were themselves aristocratic Italian fashion designers. Galitzine, for example, was an elegant society woman who achieved international fame in 1960 when she showed, at the Pitti Palace, what *Vogue* editor Diana Vreeland dubbed "palazzo pajamas" (cat. nos. 518–20). Her subsequent collections varied in quality, "depending on which young designer she . . . recruit[ed] for that particular season."[43] In any case, she was featured in the press for her private parties with friends like Jacqueline Kennedy as much as for her designs (fig. 11). Palazzo pajamas epitomized the look of Italian haute couture in the 1960s. The Italian couture had long been associated with glamour. But whereas glamour in the 1950s had signified evening dresses with boned bodices and long skirts, by the 1960s there was a growing tendency to emphasize informal styles—especially pants. These were not tailored pantsuits for working women, however. An orange-silk halter top and loose-floating trousers from the mid-1960s (in the collection of The Museum at F.I.T.) evoked an almost Middle Eastern image of femininity. An alternative style in 1963 consisted of Simonetta et Fabiani's one-piece costume with a full gathered skirt that folded under at the center front to form pants (in the collection of The Costume Institute, The Metropolitan Museum of Art, New York). Luxurious Italian at-home clothes like these were designed for women whose "job" was to entertain. The elegant dinner party, not the boardroom, was their fashion arena.

Italian fashion received a great deal of favorable publicity in fashion magazines like *Vogue* and *Harper's Bazaar*, but almost always in conjunction with the theme of international high society. Even a trade publication like *Women's Wear Daily* increasingly emphasized the connections between fashion and high society, writing of Valentino, "He's made it big with the Social Register . . . and the cash register."[44] The fashion status game worked to the advantage of a designer like Valentino, who was not only a great talent but who had the business acumen to expand successfully from couture to various licensing agreements. In 1968, for example, the New York department store Lord & Taylor bought "26 outfits for copying and 22 designs for which the store will take orders

to be custom made." According to *The New York Times*, Valentino's clothes "disappeared with the rapidity of green carnations on St. Patrick's Day."[45]

It is not our purpose to enumerate the many talented designers of the 1960s, but two examples, Forquet and Barentzen, may throw light on the vicissitudes of Italian fashion. Forquet was a man of the world who amused himself for several years by working as a couturier, creating some unusually beautiful garments. Hailed by *Women's Wear Daily* in 1966 as a "Leader of the Italian Couture," he used "opulent fabrics and colors, such as emerald checkerboard silk moiré" (see cat. nos. 515–17).[46] Vreeland was one of his clients (a dress made for her, circa 1962, is in the collection of The Museum at F.I.T.), as was socialite Baby Jane Holzer; for the latter he designed a strange and beautiful evening jumpsuit covered with silver latticework (in the collection of The Costume Institute, The Metropolitan Museum of Art, New York). But Forquet, who appeared in Marilyn Bender's *The Beautiful People*, primarily in connection with a "charming little dinner party" attended by international society ladies, was not able to sustain his career.[47] Nor was Barentzen, another "hot Italian talent" in the 1960s, whose clothes were frequently shown in *Vogue*; according to James Brady, former publisher of *Women's Wear Daily*, Barentzen "played the grand seigneur with people who had earlier helped his career along, and when he went broke there were few to weep for him."[48] Even Galitzine, "friend and dressmaker for Mrs. John F. Kennedy and other leading members of international society," suddenly went bankrupt in 1968.[49]

The expansive economy and avid consumerism of the 1960s theoretically should have provided a hospitable climate for fashion. And although, in fact, the mid-1960s was a golden age for Rome's haute-couture houses, the couture was becoming peripheral to the main thrust of international fashion, with its growing emphasis on prêt-à-porter, or ready-to-wear. Only a few Italian fashion businesses, like Fiorucci, a store that specialized in young styles, were successful at attracting the burgeoning youth market. Where the Italians would ultimately excel was in the realm of luxury sportswear for both men and women. The locus for such sportswear was Milan, and by the 1970s that city had emerged as the new capital of Italian fashion, eclipsing both Rome and Florence. Foreign press coverage of Roman couture dwindled yearly as international attention shifted decisively toward the work of such designers as Armani and Versace. Designers who were already committed to refined sportswear moved first. Missoni, a family-owned company specializing in knitwear, had already, in the 1960s, pioneered new mixtures of yarns and colors (see cat. nos. 535–37). Krizia, the fashion house headed by Mariuccia Mandelli (see cat. nos. 521–24), had also focused on stylish prêt-à-porter. Mandelli was frustrated by the limits imposed by the Italian system, which, because of the age-old inferiority complex with regard to France, persisted in the view that prêt-à-porter was somehow unworthy of fashion shows. The artificial division between Florence and Rome left no venue for prêt-à-porter, stylish or not. As Mandelli recalled, she talked with Missoni and a few others and "they all said: all right, we'll show in Milan, too."[50]

The rise of Milan coincided with the international emergence of Italian menswear under the influence of designers like Armani, who had spent the 1960s working first as a buyer for a department store, then as a designer for Nino Cerruti, and finally as a freelance designer, before showing his first collection in 1974. It is beyond the scope of this essay to describe how Armani revolutionized menswear, except to say that he built on a foundation of men's tailoring already existing in the 1950s, as well as exploiting the established reputation of Italian men for sensual masculinity.[51] Moreover Italian fashion, for both men and women, could only have emerged from a system that long had emphasized the production of high-quality textiles, the basic *materials* of fashion.

1. Yvonne Deslandres and Florence Müller, *Histoire du costume au XXe siècle* (History of twentieth-century fashion. Paris: Somogy, 1986), does not mention Italian fashion at all, although Valentino [Valentino Garavani] and Nino Cerruti are listed in the appendix. Elizabeth Ewing, *History of Twentieth-Century Fashion* (London: B. T. Batsford, 1974) devotes three paragraphs to Italian fashion, pp. 170–72. Michael and Ariane Batterberry, *Fashion: The Mirror of History* (New York: Greenwich House, 1977), makes only a short reference to Italy, p. 35. For the period 1943–68, see also Jane Mulvagh, *Vogue History of 20th-Century Fashion* (New York: Viking, 1988), pp. 186–87, including one paragraph each for Pucci and Capucci. Caroline Reynolds Milbank, *Couture: The Great Designers* (New York: Stewart, Tabori and Chang, 1985) includes sections on Valentino, Capucci, and (post–1970) Armani.

2. For a discussion of "made in Italy" versus "the Italian look," see, for example, Chiara Gianelli Buss, "Stylism in Men's Fashion," in Grazietta Butazzi and Alessandra Mottolo Molfino, eds., *Italian Fashion: From Anti-Fashion to Stylism* (Milan: Electa, 1987), p. 232. For an analysis of the Italian fashion system, which "was first developed in the Seventies," see Silvia Giacomoni, "A Fashion which Has Altered the Landscape," in Olga Cardazzi and Silvia Giacobone, eds., *Profilo Italia un certo stile Made in Italy: Design, arts, creatività italiana in mostra a Torino* (Italian profile of a certain style Made in Italy: design, arts, Italian creativity on display in Turin. Turin: Palazzo Vela, 1990), p. 35.

3. This reevaluation is already under way. See, for example, Guido Vergani, *The Sala Bianca: The Birth of Italian Fashion* (Milan: Electa, 1992).

4. Grateful acknowledgments are made to Richard Martin, curator, and Dennita Sewell, study storage assistant, The Costume Institute, The Metropolitan Museum of Art, New York; Patricia Mears, research associate, The Brooklyn Museum of Art, New York; collector and freelance curator Beverley Birks; and Fred Dennis, coordinator of costume collections, The Museum at F.I.T. (Fashion Institute of Technology), New York, for permission to see the Italian garments in their collections.

5. Elsa Schiaparelli, cited in Valerie Steele, *Paris Fashion: A Cultural History* (New York: Oxford University Press, 1988), p. 269.

6. Marya Mannes, "Italian Fashion," *Vogue*, January 1, 1947, p. 119.

7. Ibid., pp. 119, 155.

8. Orella Morelli, "The International Success and Domestic Debut of Postwar Italian Fashion," in Gloria Bianchino, ed., *Italian Fashion: The Origins of High Fashion and Knitwear* (Milan: Electa, 1987), p. 60.

9. "Italy: Her Wonderful People," *Holiday*, April 1955, pp. 34–38, 40–42, 118–22, 124–25.

10. "These Enchanting Italians," *Reader's Digest*, August 1956, pp. 34–36.

11. "Italian Ideas for Any South," *Vogue*, November 15, 1951, p. 124.

12. Bonizza Giordani Aragno, "The Mirror's Role in the Atelia," in *Italian Fashion: The Origins of High Fashion and Knitwear*, p. 98.

13. "Italian Styles Gain Approval of U.S. Buyers," *Women's Wear Daily*, February 15, 1951, p. 1.

14. "Italy Gets Dressed Up," *Life*, August 20, 1951, p. 104.

15. Ibid., pp. 104–12.

16. "La bombe de Florence a ébranlé les salons de la Haute Couture Parisienne et menacé son monopole," *Paris-Presse*, August 6, 1951, p. 1.

17. "The Good Word on Italy—and Italian Fashion," *Vogue*, April 1, 1961, p. 135.

18. "Italian Imports," *Life*, April 14, 1952, p. 89.

19. "Italian Collections Notebook," *Vogue*, September 15, 1952, p. 154.

20. Ibid., p. 154.

21. "An Italian Skier Designs," *Harper's Bazaar*, December 1948, pp. 130–31.

22. "Italian Collections Notebook," pp. 104, 107, 108.

23. "Italy Gets Dressed Up," p. 108.

24. "Fashions from Italy," *Look*, May 1, 1956, p. 68.

25. "Italian Snob Appeal," *Look*, January 17, 1961, pp. 65–66.

26. "Italy Gets Dressed Up," p. 110.

27. "Donna Simonetta Colonna di Cesaro . . . and Her $56 American Play Wardrobe," *Vogue*, May 15, 1951, pp. 94–95.

28. Virginia Pope, "Carosa of Rome Shows Creations," *The New York Times*, July 24, 1954, p. 16.

29. Eugenia Sheppard, "Countess Visconti Here With Collection for Bergdorf Goodman," *The New York Herald Tribune*, November 14, 1951, p. 26.

30. "Italy Gets Dressed Up," p. 110.

31. Nan Robertson, "Happily Wed Pair Compete for Rome's Fashion Trade," *The New York Times*, October 19, 1955, p. 37.

32. Hope Johnson, "Business Makes Heart Grow Fonder," *New York World Telegram and Sun*, September 22, 1955, p. 20.

33. "Italian Collections Notebook," p. 155.

34. "Bonjour Paris, Addio Rome, Say Couture Duo," *Women's Wear Daily*, April 3, 1962, p. 1.

35. Elissa Massai, "The Little-Big Story of Italian Fashion," in Pia Sola, ed., *Italia, the Genius of Fashion* (New York: Fashion Institute of Technology, 1985).

36. "Dramatic Decade of Italian Style," *Life*, December 1, 1961, pp. 66–69. Photographs and captions continue for another ten pages.

37. "The Men's Pages: Summer Basics from Italy," *Vogue*, April 1, 1956, p. 100.

38. "The Italian Man," *Life*, August 23, 1963, pp. 55, 56, 58.

39. Kurt Loder, "Stardust Memories: The *Rolling Stone* Interview with David Bowie," *Rolling Stone*, April 23, 1987, p. 80.

40. Colin MacInnes, *Absolute Beginners* (1959), quoted in Dick Hebdidge, *Hiding in the Light* (London: Routledge, 1988), p. 110.

41. "Battle of the Pitti Palace," *Newsweek*, August 2, 1965, p. 44.

42. "*Alta Moda*, Italian Style," *Time*, January 29, 1965, p. 42.

43. James Brady, *Super Chic* (Boston: Little Brown, 1974), p. 36.

44. Quoted in Sola, p. 108.

45. "Designer Is Jubilant as the Racks Are Emptied," *The New York Times*, March 19, 1968, p. 50.

46. "Forquet in Anticipo," *Women's Wear Daily*, July 19, 1966, p. 14.

47. Marilyn Bender, *The Beautiful People* (New York: Dell, 1967), p. 126.

48. Brady, p. 36.

49. "Galitzine Bankrupt," *The New York Times*, January 24, 1968, p. 40.

50. Quoted in Silvia Giacomoni, *The Italian Look Reflected* (Milan: Mazzotta, 1984), p. 104.

51. See Valerie Steele, "The Italian Look: American Perceptions of Contemporary Italian Fashion," in Irma Jaffe, ed., *Insight and Inspiration: The Italian Presence in American Art* (New York and Rome: Fordham University Press and the Italian Encyclopedia Institute, in press).

Fashion
Catalogue numbers 502–602

Roberto Capucci
Carosa {Giovanna Caracciolo di Avellino Giannetti}
Alberto Fabiani
Fendi
Salvatore Ferragamo
Federico Forquet
Irene Galitzine
Krizia {Mariuccia Mandelli}
Pino Lancetti
Germana Marucelli
Missoni
Emilio Pucci
Wanda Roveda
Mila Schön
Emilio Schuberth
Ken Scott
Sorelle Fontana {Fontana Sisters}
Valentino {Valentino Garavani}
Jole Veneziani

502. Roberto Capucci
*Evening gown, fall/winter 1956–57.
Silk faille. Galleria del Costume,
Florence.*

503. Roberto Capucci
*Evening gown, 10 gonne (10 Skirts)
collection, spring/summer 1956. Silk
taffeta. Roberto Capucci, Rome.*

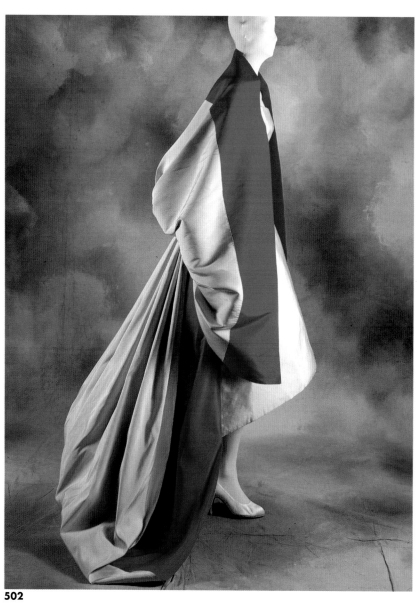

502

502. Roberto Capucci
*Evening gown, fall/winter 1956–57.
Silk faille. Galleria del Costume,
Florence.*

503. Roberto Capucci
*Evening gown, 10 gonne (10 Skirts)
collection, spring/summer 1956. Silk
taffeta. Roberto Capucci, Rome.*

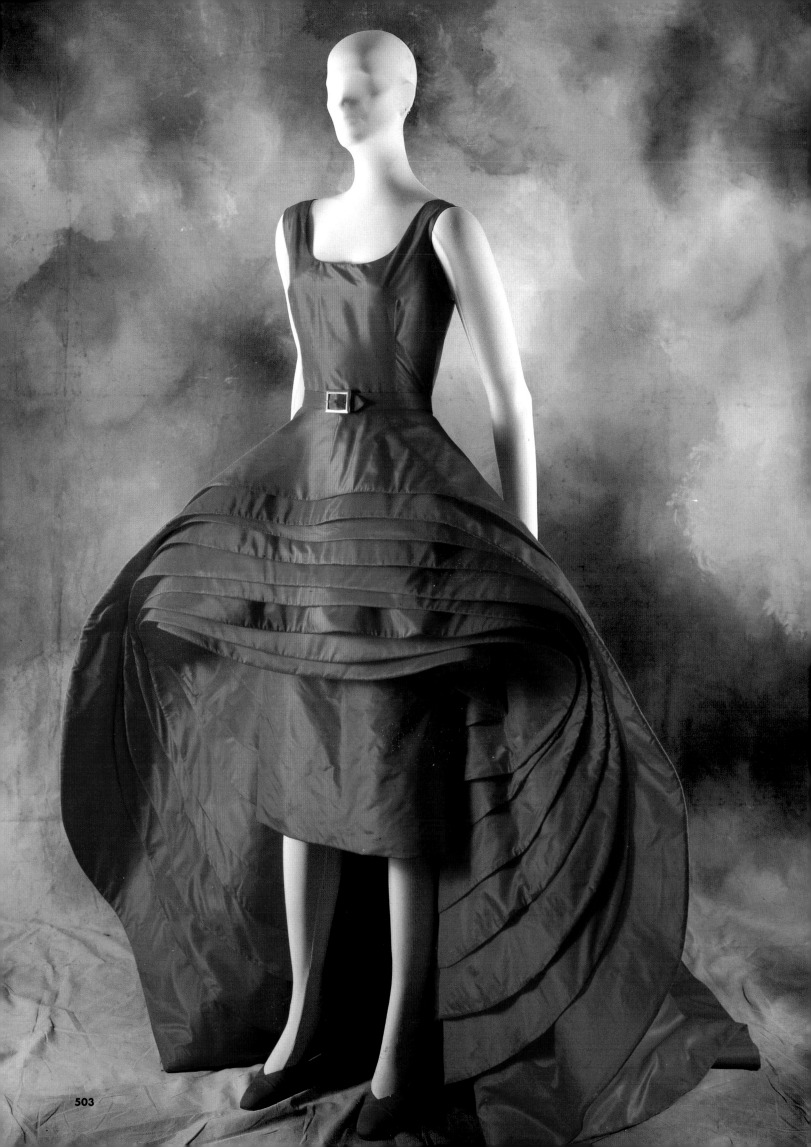

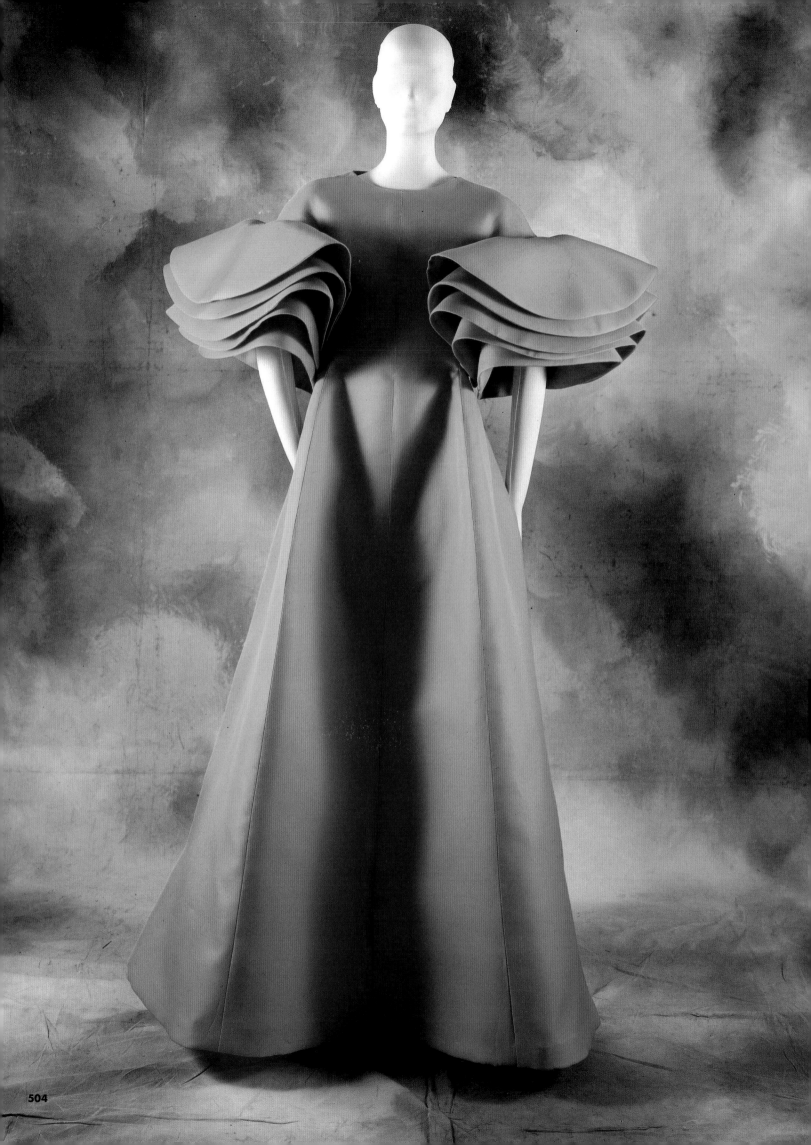

504. Roberto Capucci
Evening gown, spring/summer 1958. Silk gazar. Roberto Capucci, Rome.

505. Roberto Capucci
Evening gown, Calla collection, fall/ winter 1956–57. Silk satin. Roberto Capucci, Rome.

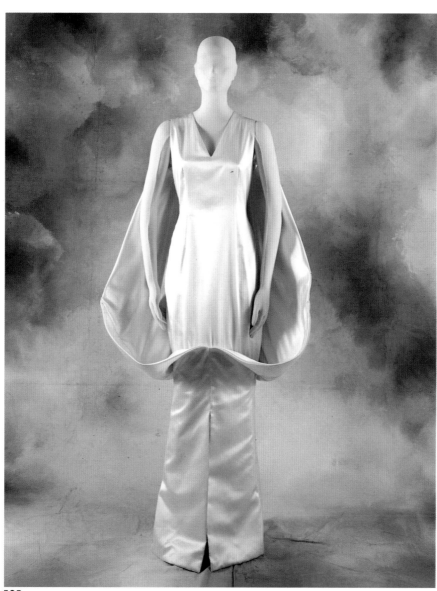

505

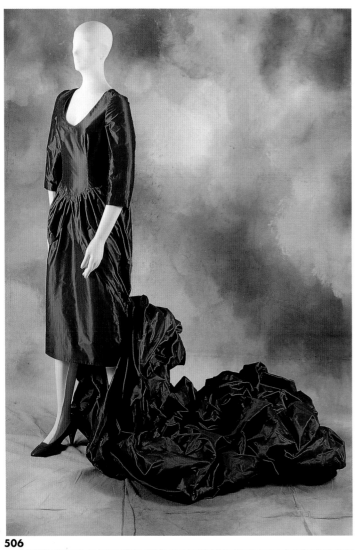

506

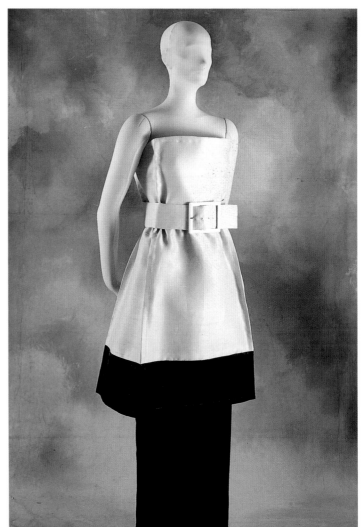

507

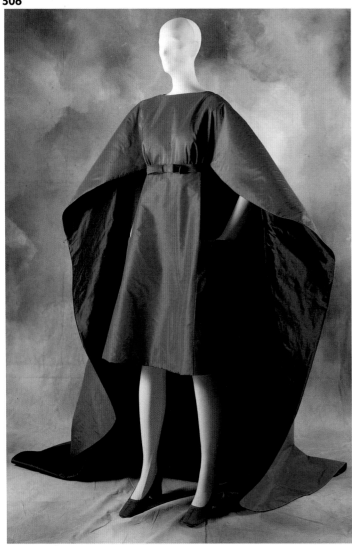

509

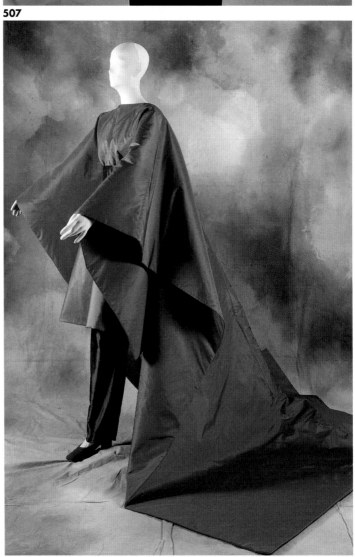

510

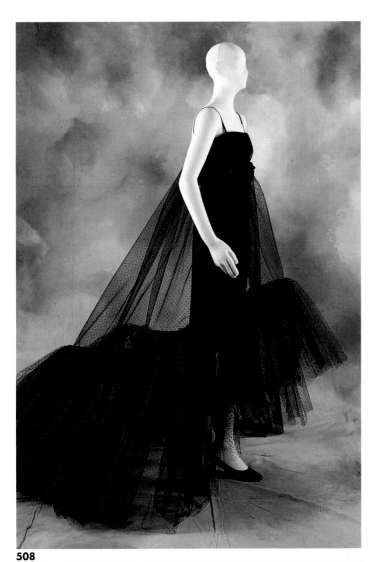

508

506. Roberto Capucci
Evening gown, Crete *collection, fall/winter 1952–53. Silk taffeta. Roberto Capucci, Rome.*

507. Roberto Capucci
Evening gown, Scatola (Box) *collection, fall/winter 1958–59. Silk satined organza with silk-satin underskirt. Collection of Consuelo Crespi, Rome.*

508. Roberto Capucci
Evening gown, fall/winter 1959–60. Silk taffeta and silk tulle, with velvet belt. Roberto Capucci, Rome.

509. Roberto Capucci
Evening gown, spring/summer 1961. Silk taffeta. Roberto Capucci, Rome.

510. Roberto Capucci
Pantsuit with poncho cape, spring/ summer 1961. Silk faille. Roberto Capucci, Rome.

511. Roberto Capucci
Evening gown, spring/summer 1961. Silk organza. Roberto Capucci, Rome.

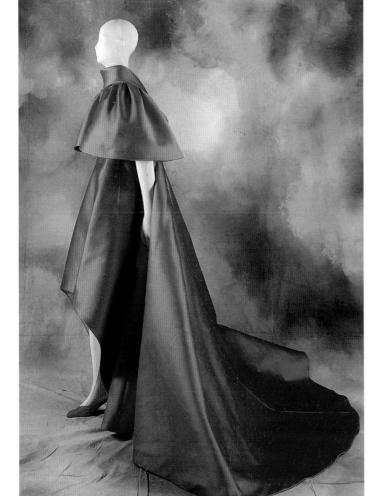

511

512. Carosa [Giovanna Caracciolo di Avellino Giannetti]
Evening gown, fall/winter 1963–64. Silk organza embroidered with glass beads, paillettes, studs, pearls, crystals, and ostrich feathers. Umberto Tirelli, Rome.

513. Alberto Fabiani
Coat, fall/winter 1968–69. Printed wool. Umberto Tirelli, Rome.

514. Fendi
Cloak, fall/winter 1967–68. Mole and nylon tulle. Fendi, Rome.

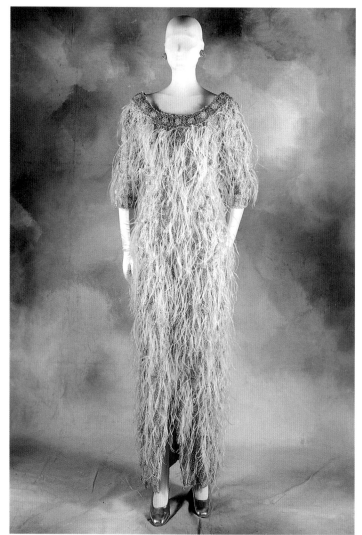

512

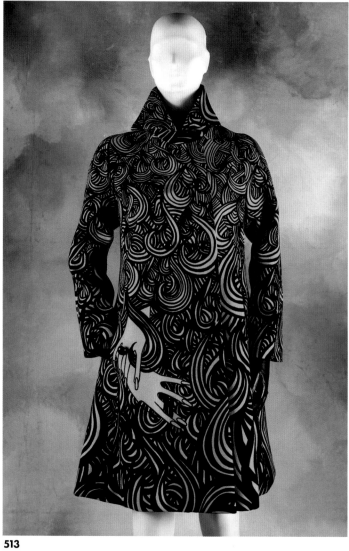

513

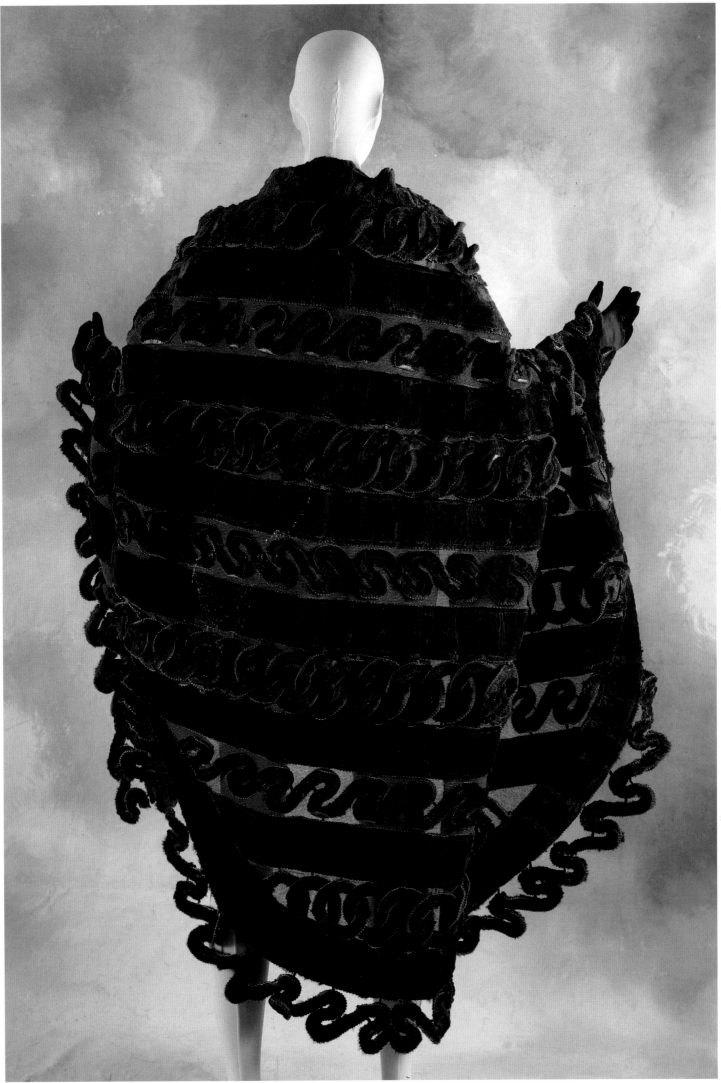

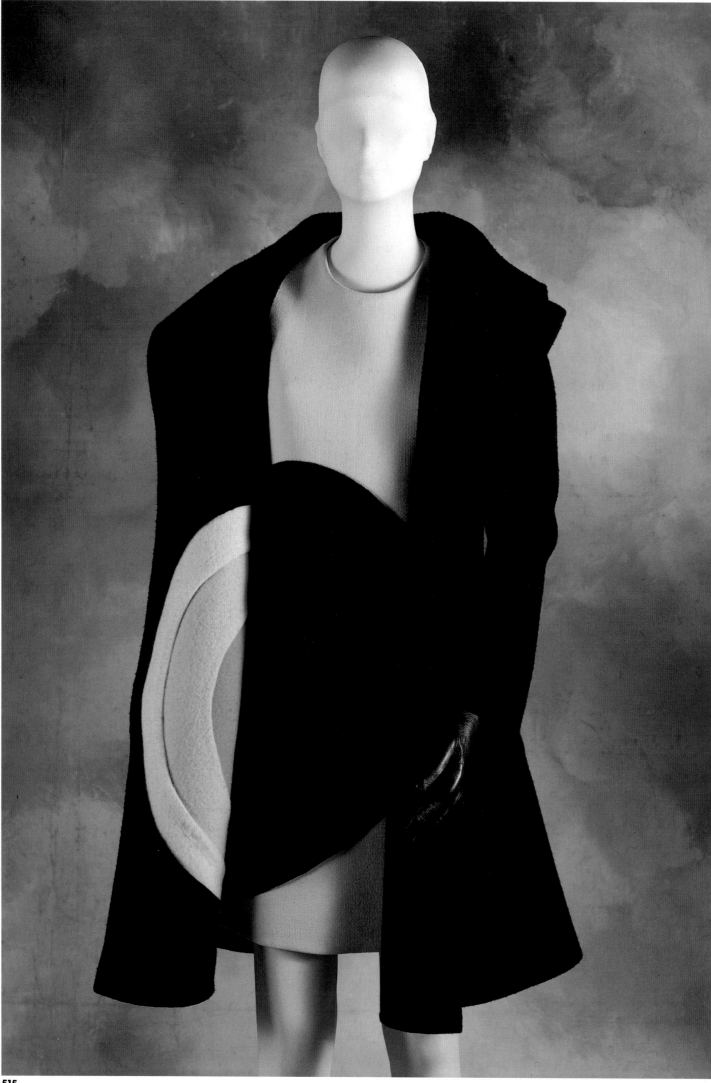

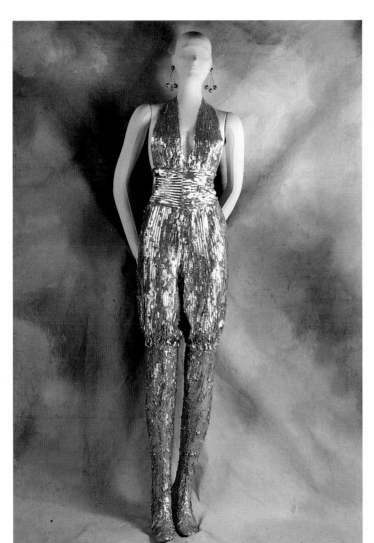

515. Federico Forquet
Dress and coat, fall/winter 1967–68. Wool with inlaid decoration. Belonged to Anna Bozza. Galleria del Costume, Florence.

516. Federico Forquet
Evening jumpsuit with boots, fall/winter 1967–68. Silk chiffon embroidered with paillettes. Belonged to Gioia Marchi Falck. Galleria del Costume, Florence.

517. Federico Forquet
Evening dress, fall/winter 1967–68. Silk crepon embroidered with paste and glass beads. Belonged to Catherine Spaak. Galleria del Costume, Florence.

516

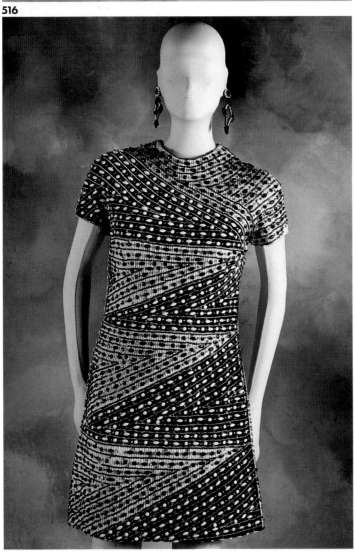

517

518. Irene Galitzine
*Palazzo pajamas, spring/summer 1960.
Silk crepe covered with glass-bead
fringe. Irene Galitzine, Rome.*

519. Irene Galitzine
*Palazzo pajamas, fall/winter 1964–65.
Silk mikado jacket and pants,
embroidered with plastic beads. Irene
Galitzine, Rome.*

520. Irene Galitzine
*Palazzo pajamas, spring/summer 1960.
Silk mikado jacket and pants. Irene
Galitzine, Rome.*

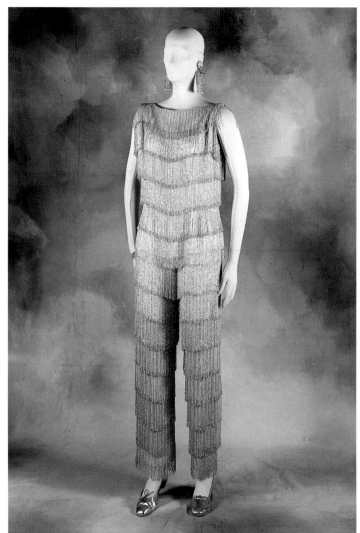

518

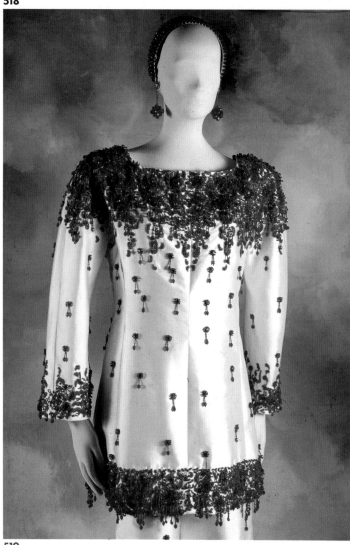

519

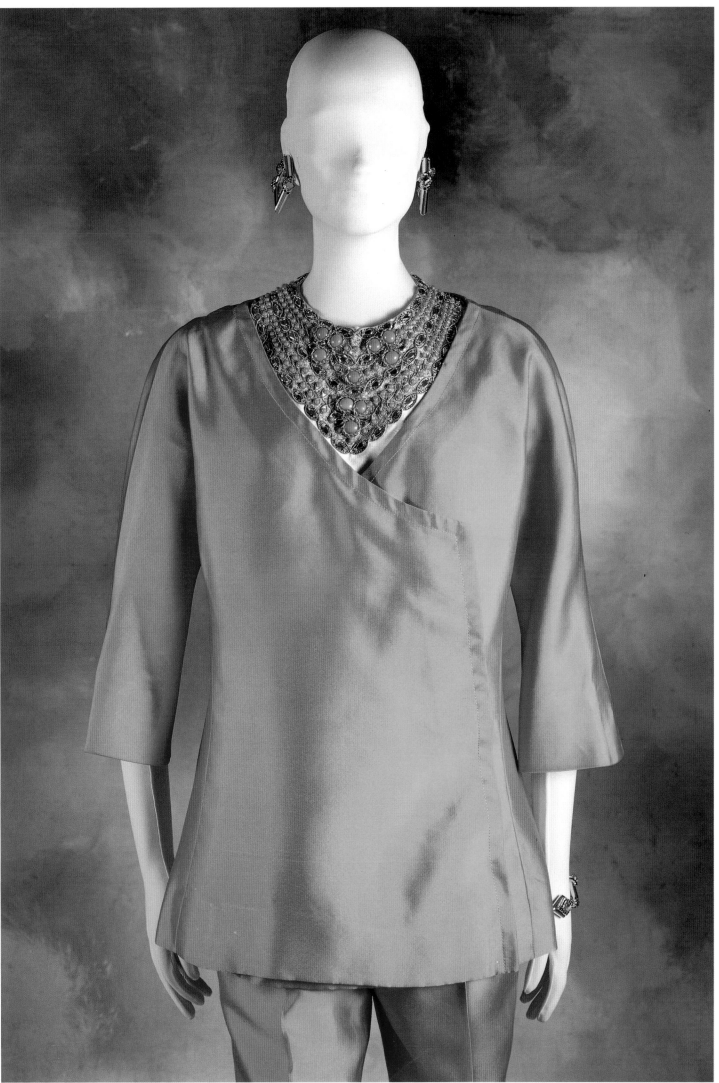

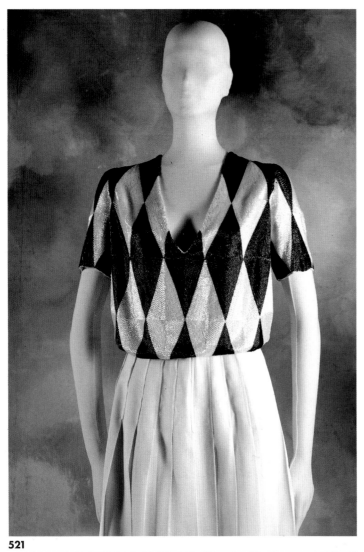

521

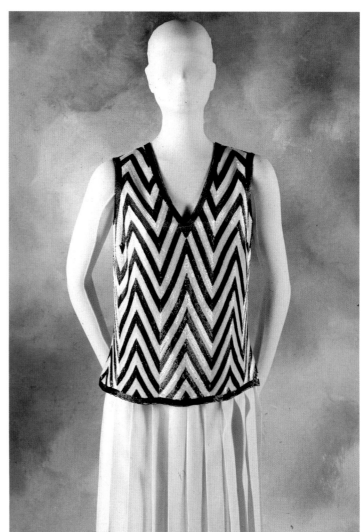

522

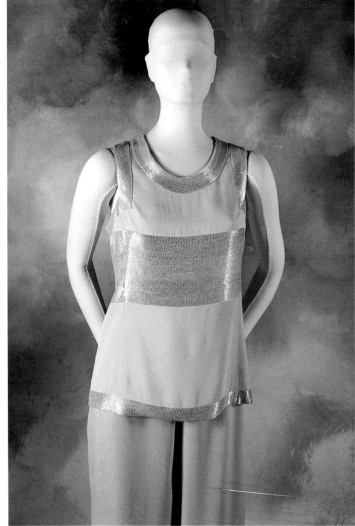

523

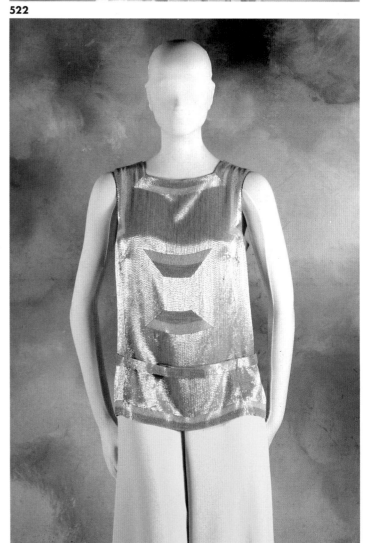

524

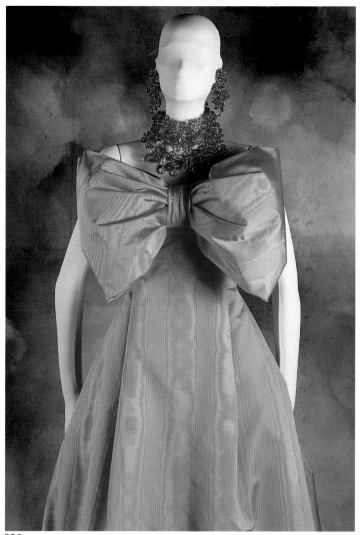

525

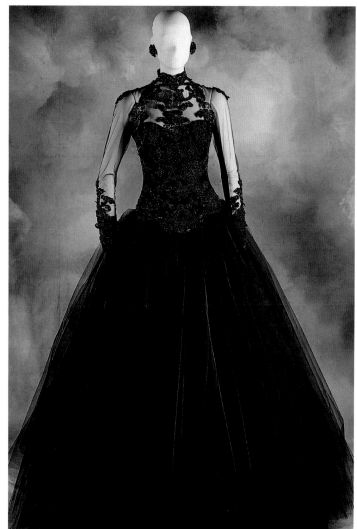

526

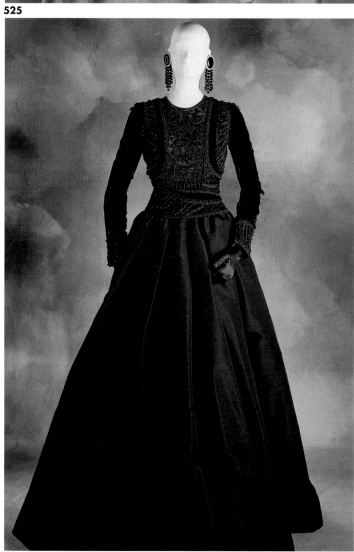

527

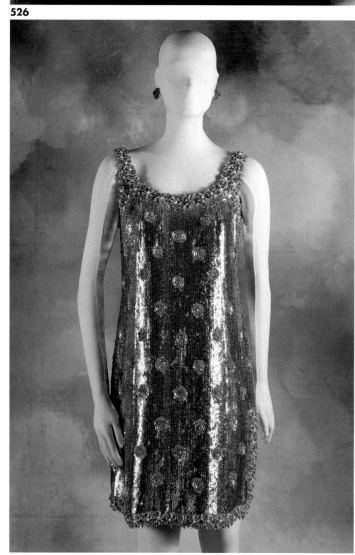

528

Preceding two pages:

521. Krizia [Mariuccia Mandelli]
Evening outfit, fall/winter 1964–65. Silk crepe embroidered with glass beads. Krizia, Milan.

522. Krizia [Mariuccia Mandelli]
Evening outfit, fall/winter 1964–65. Silk crepe embroidered with glass beads. Krizia, Milan.

523. Krizia [Mariuccia Mandelli]
Eve1 .ng outfit, fall/winter 1966–67. Silk crepe embroidered with glass beads. Krizia, Milan.

524. Krizia [Mariuccia Mandelli]
Evening outfit, fall/winter 1966–67. Silk crepe embroidered with glass beads. Krizia, Milan.

525. Pino Lancetti
Evening gown, fall/winter 1962–63. Silk moiré. Pino Lancetti, Rome.

526. Pino Lancetti
Evening gown, fall/winter 1963–64. Nylon tulle embroidered with beads and paillettes. Created for Romy Schneider. Pino Lancetti, Rome.

527. Pino Lancetti
Evening gown, fall/winter 1964–65. Silk grosgrain and silk-and-viscose velvet, embroidered with beads and trimmings. Pino Lancetti, Rome.

528. Pino Lancetti
Evening dress, fall/winter 1966–67. Silk organza embroidered with beads and paillettes. Belonged to Catherine Spaak. Galleria del Costume, Florence.

529. Germana Marucelli
Dress, early 1950s. Silk taffeta with handpainted designs by Giuseppe Capogrossi. Collection of Giancarlo Calza, Milan.

530. Germana Marucelli
Dress, early 1950s. Silk taffeta with handpainted designs by Giuseppe Capogrossi. Collection of Giancarlo Calza, Milan.

531. Germana Marucelli
Evening dress, early 1960s. Silk organza with designs by Giuseppe Capogrossi, embroidered with paillettes. Umberto Tirelli, Rome.

532. Germana Marucelli
Evening dress, Totem collection, fall/winter 1967–68. Silk organza embroidered with paillettes. Collection of Giancarlo Calza, Milan.

533. Germana Marucelli, in collaboration with Getulio Alviani
Armor outfit, Alluminio (Aluminum) collection, fall/winter 1968-69. Aluminum vest and silk-crepe Moroccan culottes. Collection of Susi Giusti, Florence.

534. Germana Marucelli, in collaboration with Getulio Alviani
Armor outfit, Alluminio (Aluminum) collection, fall/winter, 1968–69. Polished-leather and aluminum bodice, wool shorts with aluminum disks, and ostrich-feather vest. Collection of Giancarlo Calza, Milan.

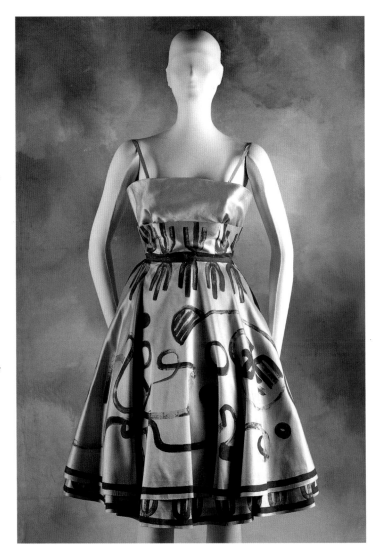

529

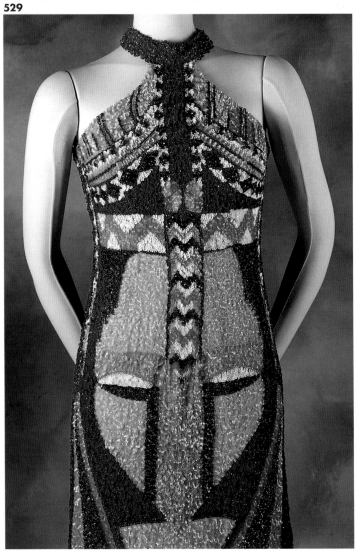

532

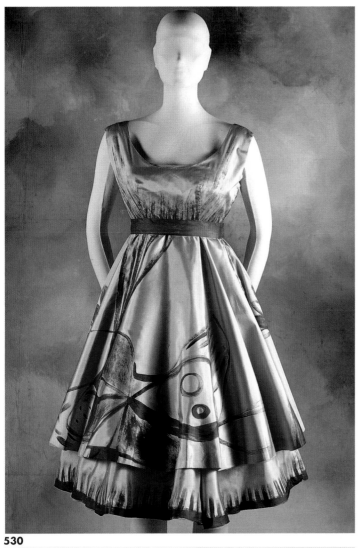

530

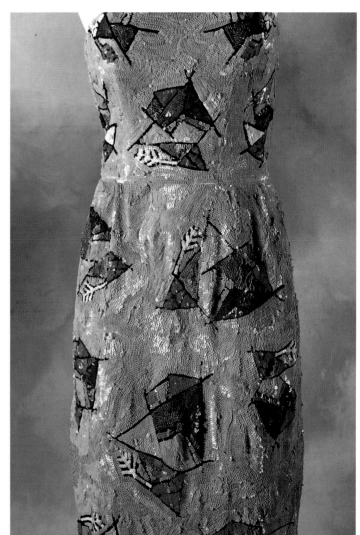

531

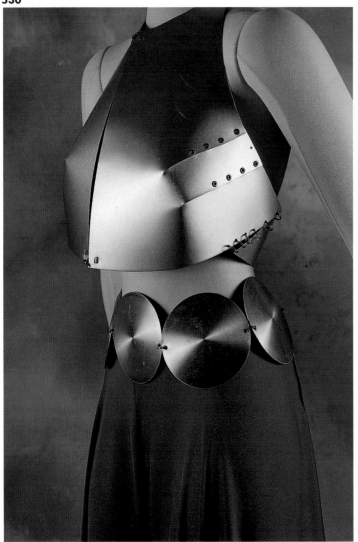

533

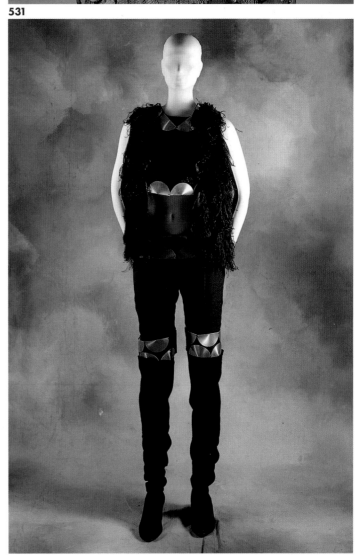

534

535. Missoni
Three-piece kimono-style outfit, spring/summer 1968. Knitted rayon tulle. Missoni, Milan.

536. Missoni
Tunic and skirt, spring/summer 1968. Knitted rayon tulle. Missoni, Milan.

537. Missoni
Midriff top and skirt, spring/summer 1968. Knitted rayon tulle. Missoni, Milan.

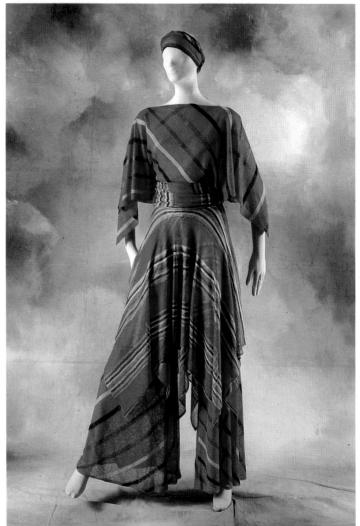

535

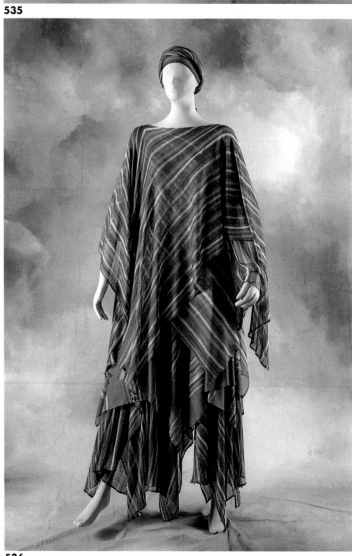

536

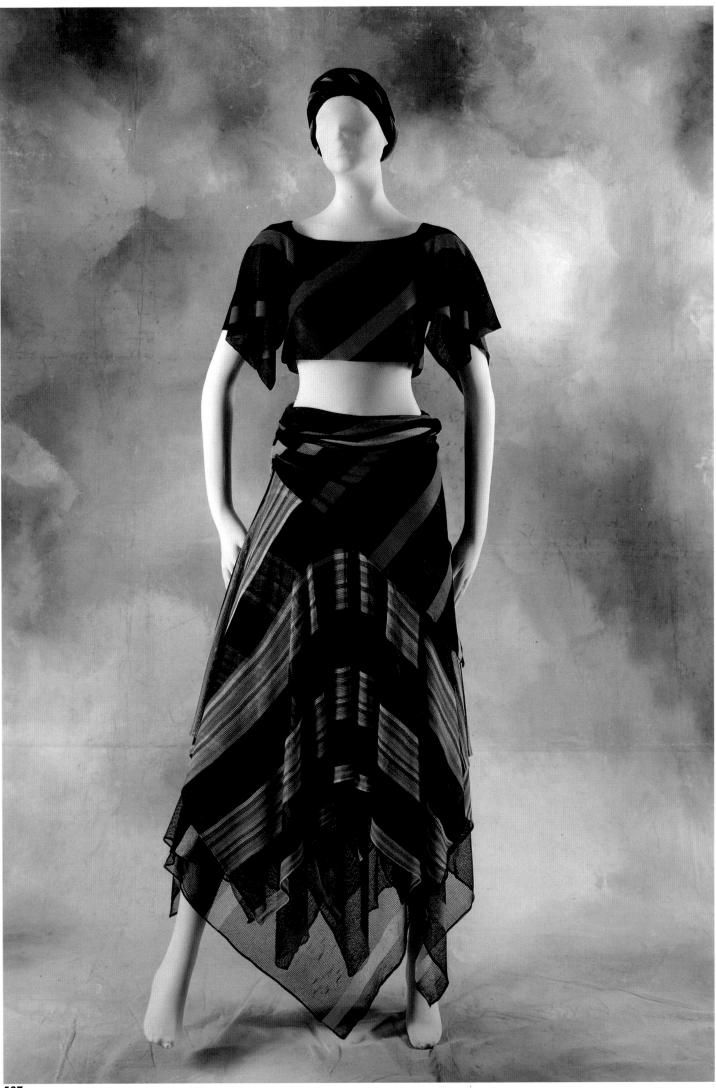

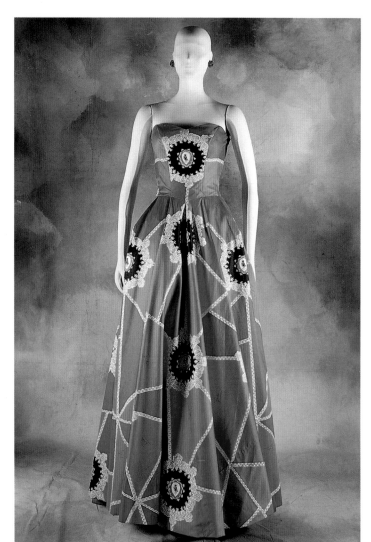

538

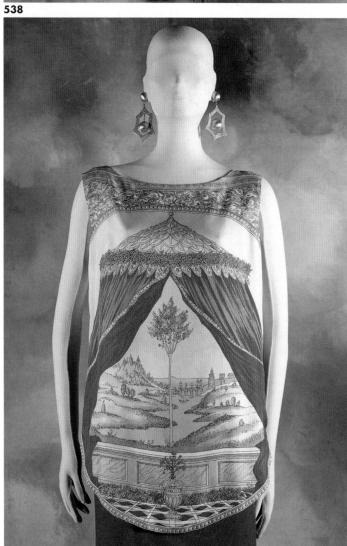

539

538. Emilio Pucci
Evening gown, Palio collection, spring/summer 1957. Cotton poplin printed with symbols of the Palio of Siena. Emilio Pucci, Florence.

539. Emilio Pucci
Evening outfit, spring/summer 1959. Silk-twill top printed with Padiglione (Pavilion) design; silk-jersey skirt. Emilio Pucci, Florence.

540. Emilio Pucci
Evening gown, Palio collection, spring/summer 1957. Cotton poplin printed with symbols of the Palio of Siena. Emilio Pucci, Florence.

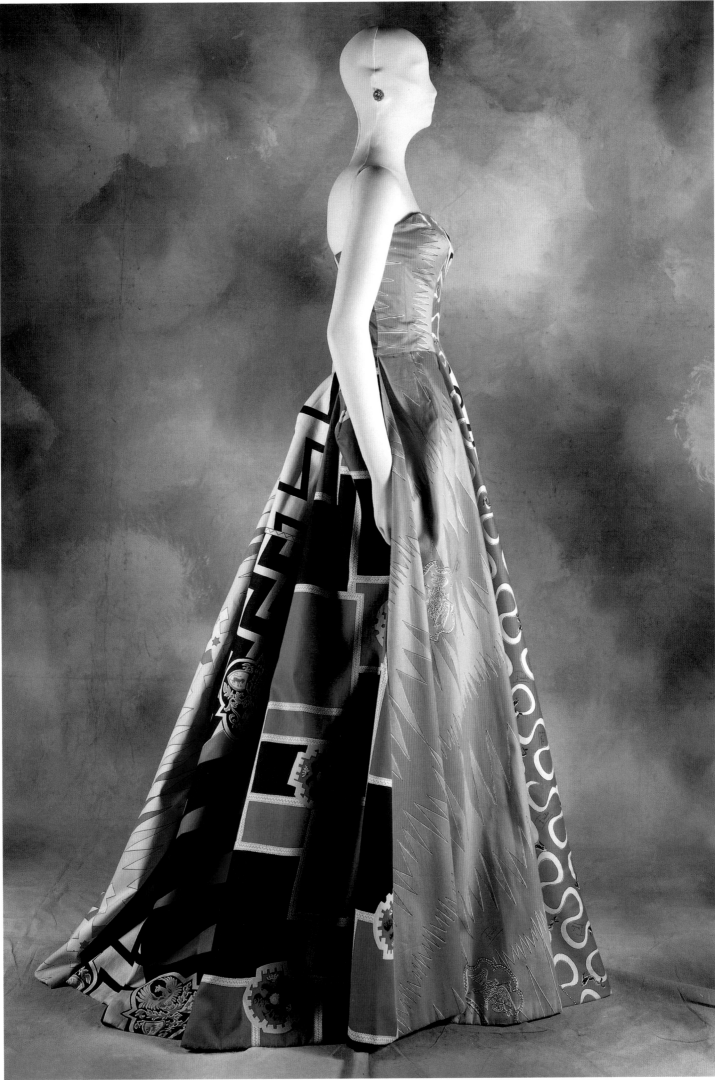

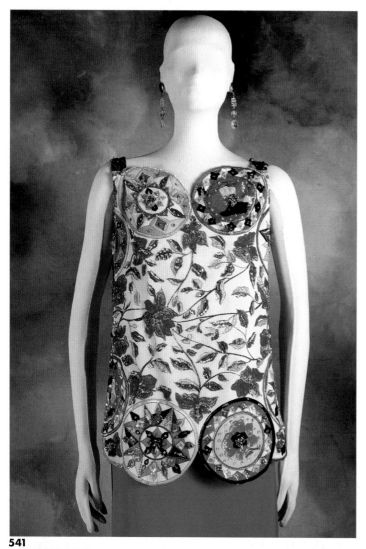

541

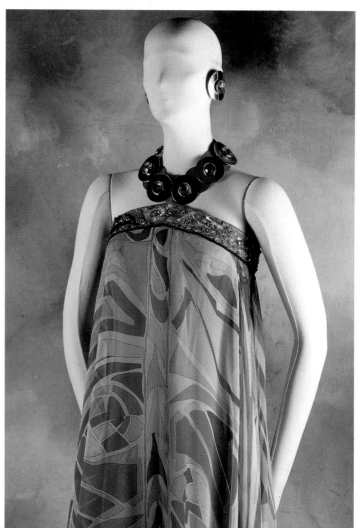

542

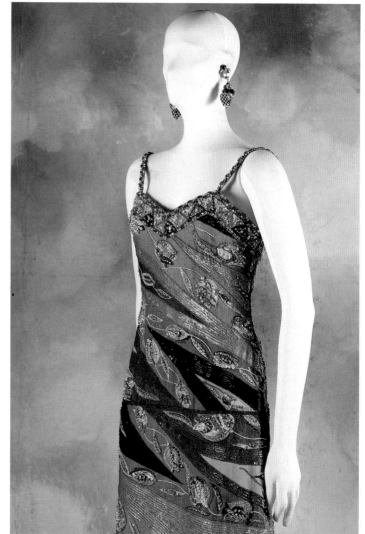

543

544

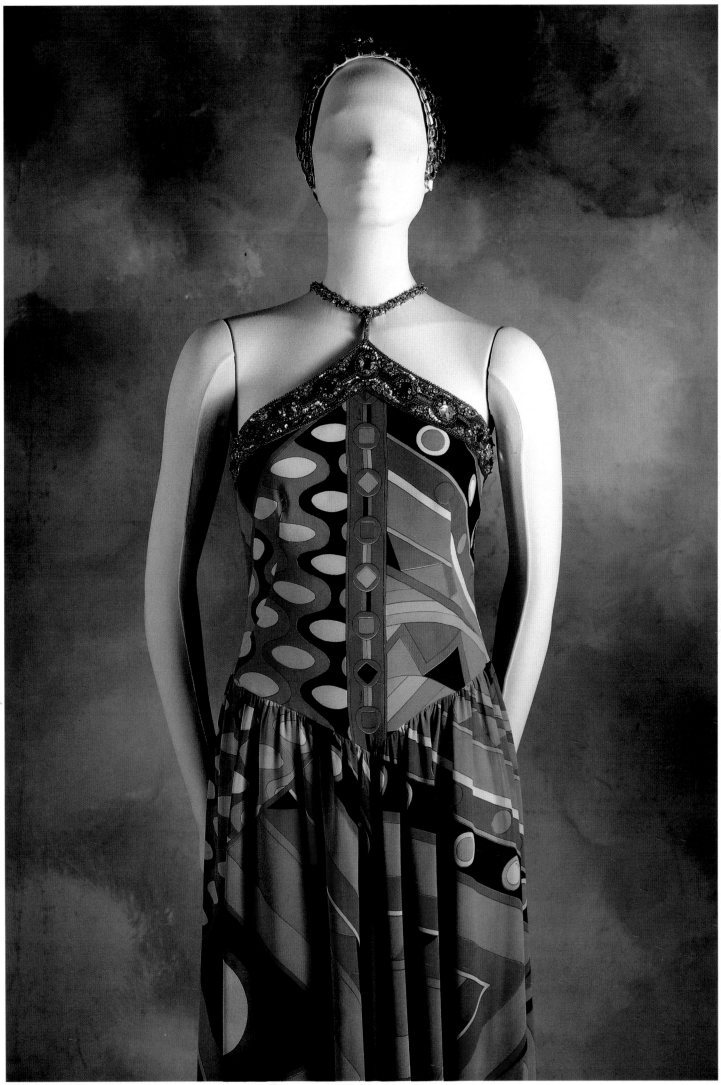

Preceding two pages:
541. Emilio Pucci
Evening outfit, Gothic Line *collection, spring/summer 1963. Silk-chiffon top printed with* Marina *(Marine) design and embroidered with paillettes; silk-cady skirt. Emilio Pucci, Florence.*

542. Emilio Pucci
Evening gown, Vivace *(Lively) collection, spring/summer 1967. Silk chiffon printed with* Lance *design and embroidered with studs and rhinestones. Emilio Pucci, Florence.*

543. Emilio Pucci
Evening pantsuit, spring/summer 1967. Silk chiffon printed with Bangkok *design and embroidered with Swarovski crystals. Emilio Pucci, Florence.*

544. Emilio Pucci
Evening gown, fall/winter 1967. Silk chiffon printed with Giacinti *(Hyacinth) design and embroidered with Swarovski crystals. Emilio Pucci, Florence.*

545. Emilio Pucci
Jumpsuit, Vivace *(Lively) collection, spring/summer 1967. Silk chiffon printed with* Menelik *design and embroidered with Swarovski crystals. Emilio Pucci, Florence.*

546. Emilio Pucci
Mini evening dress, spring/summer 1968. Silk chiffon printed with Occhi *(Eye) design and embroidered with Swarovski crystals. Emilio Pucci, Florence.*

547. Emilio Pucci
Bodysuit, fall/winter 1968–69. Lycra jersey printed with Vivara *design. Emilio Pucci, Florence.*

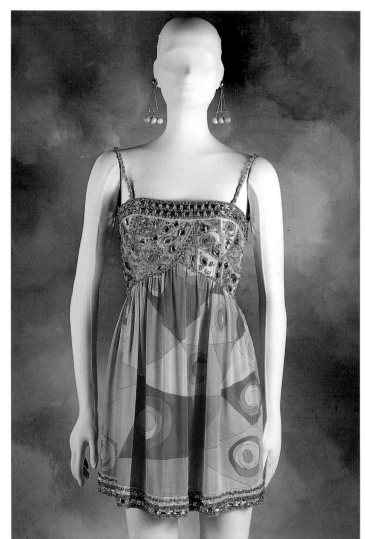

546

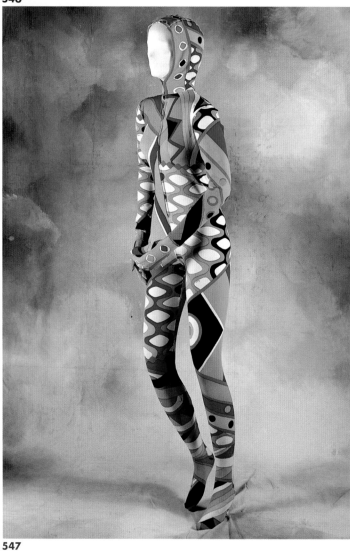

547

548. Wanda Roveda
Bridal gown, spring/summer 1967.
Shantung silk with silk-organza petals
on veil. Wanda Roveda, Milan.

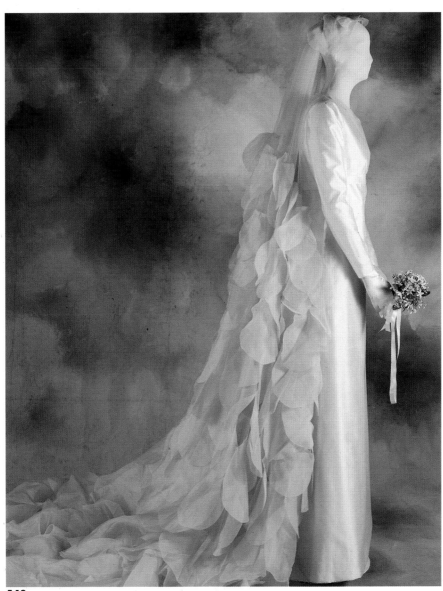

548

548. Wanda Roveda
Bridal gown, spring/summer 1967.
Shantung silk with silk-organza petals
on veil. Wanda Roveda, Milan.

549. Mila Schön
Evening gown, fall/winter 1966–67.
Silk georgette embroidered with glass
beads, silver beads, and gold beads.
Mila Schön, Milan.

550. Mila Schön
Evening gown, fall/winter 1966–67.
Nylon tulle embroidered with glass
beads, silver beads, and gold beads.
Made for Gioia Marchi Falck.
Galleria del Costume, Florence.

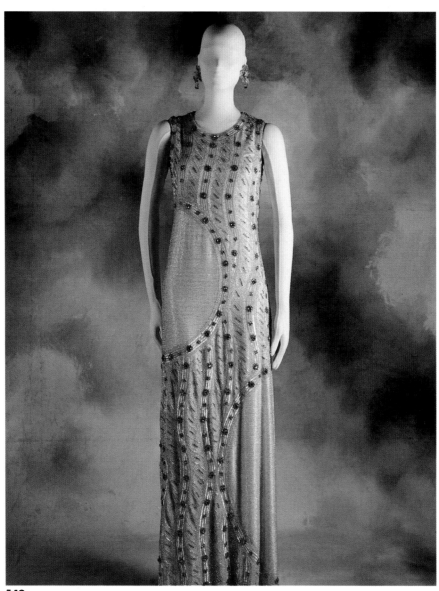

549

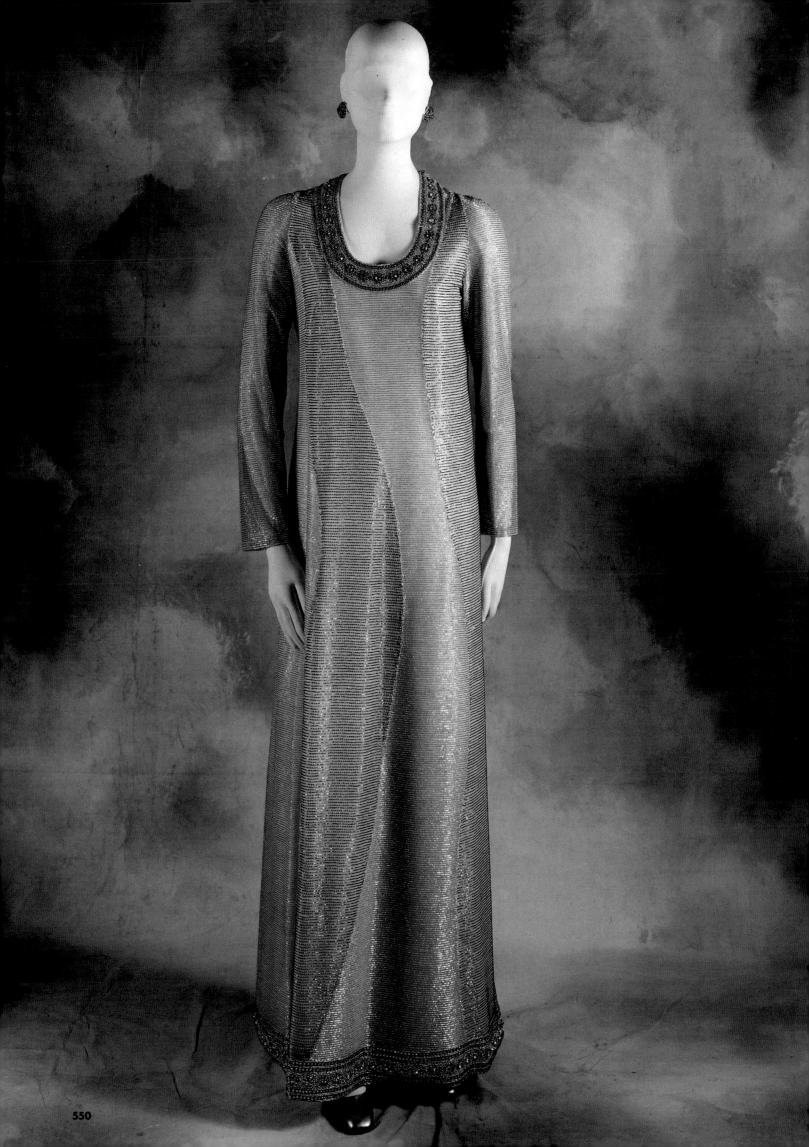

551. Emilio Schuberth
Evening gown, fall/winter 1951–52. Silk satin embroidered with silk, metallic thread, glass beads, and rhinestones. Gabriella Lo Faro, Rome.

552. Emilio Schuberth
Evening gown, spring/summer 1951. Silk satin appliquéd and embroidered with silk and glass beads. Gabriella Lo Faro, Rome.

553. Emilio Schuberth
Evening gown, spring/summer 1953. Silk organza with silk and raffia decorations. G.P. 11, Rome.

554. Emilio Schuberth
Cocktail dress, spring/summer 1955. Silk taffeta. Sartoria Farani, Rome.

555. Emilio Schuberth
Evening dress, Solare (Solar) collection, spring/summer 1957. Pleated silk chiffon, with silk-grosgrain hem and skirt. Belonged to Gina Lollobrigida. Galleria del Costume, Florence.

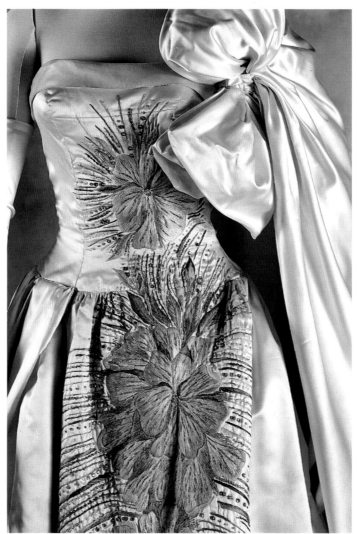

551

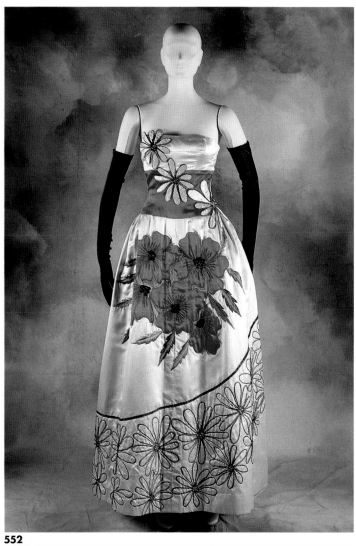

552

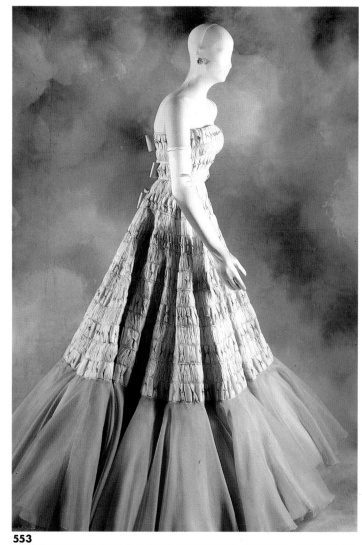

553

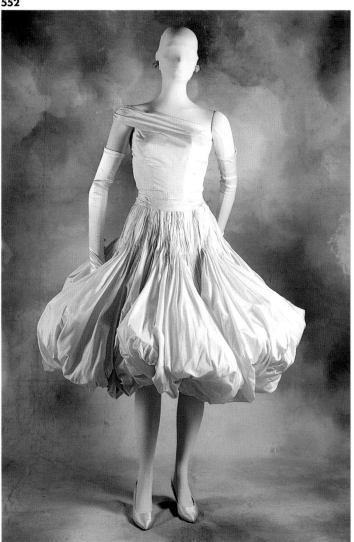

554

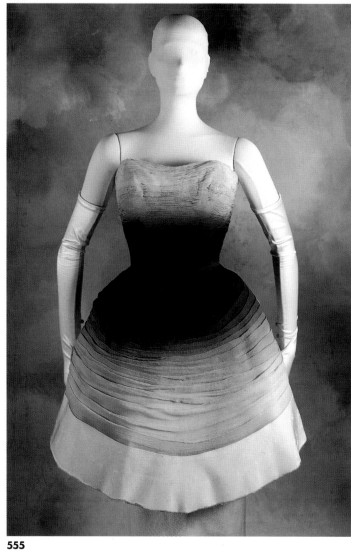

555

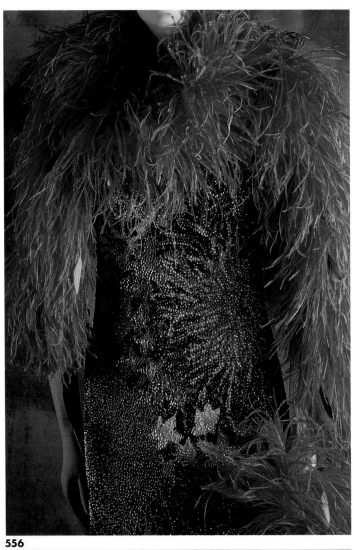

556

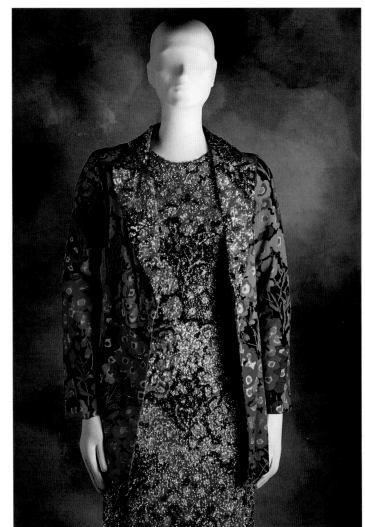

557

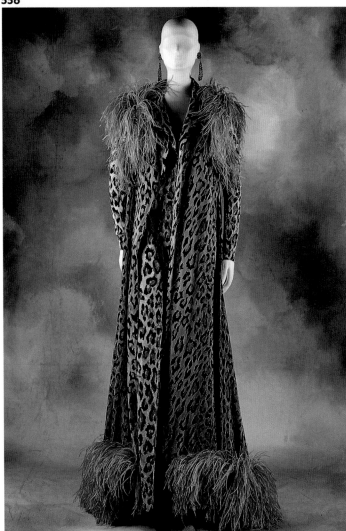

558

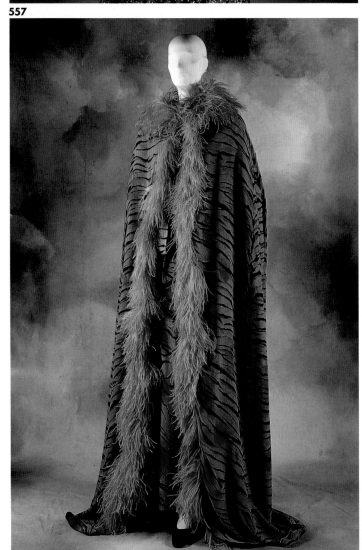

559

556. Ken Scott
Evening gown, spring/summer 1967. Silk jersey embroidered with paillettes; ostrich-feather boa. Ken Scott, Milan.

557. Ken Scott
Evening suit, spring/summer 1967. Banlon jersey embroidered with paillettes. Umberto Tirelli, Rome.

558. Ken Scott
Evening suit, Circo (Circus) collection, fall/winter 1968–69. Cotton-jersey gown; silk-georgette cape with feathers. Ken Scott, Milan.

559. Ken Scott
Evening suit, Circo (Circus) collection, fall/winter 1968–69. Banlon-jersey gown; silk-georgette cape with feathers. Ken Scott, Milan.

560. Ken Scott
Evening gown, Circo (Circus) collection, fall/winter 1968–69. Silk jersey embroidered with paillettes; ostrich-feather boa. Collection of Susan Nevelson, Florence.

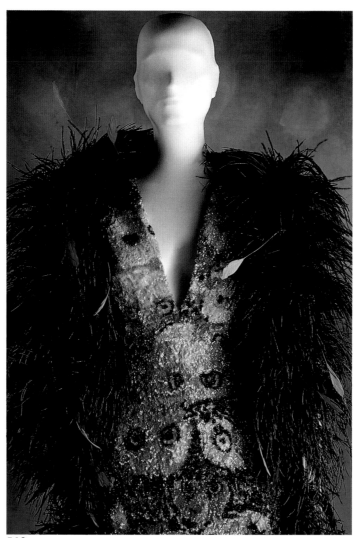

560

**561. Sorelle Fontana
[Fontana Sisters]**
Evening gown, fall/winter 1951–52. Silk georgette appliquéd with lace and embroidered with paillettes. Galleria del Costume, Florence.

**562. Sorelle Fontana
[Fontana Sisters]**
Evening gown, fall/winter 1953–54. Silk crepe lined with silk chiffon. Belonged to Beatrice di Torlonia. Sorelle Fontana, Rome.

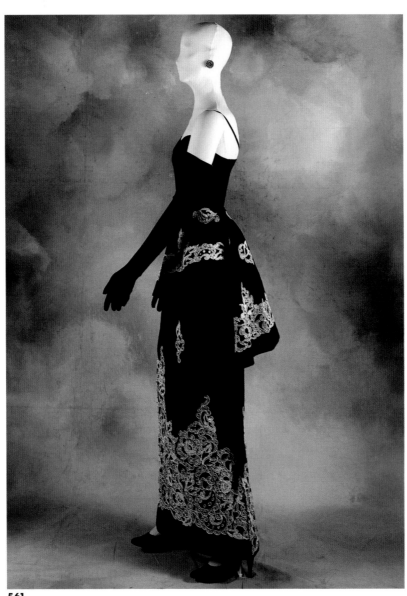

561

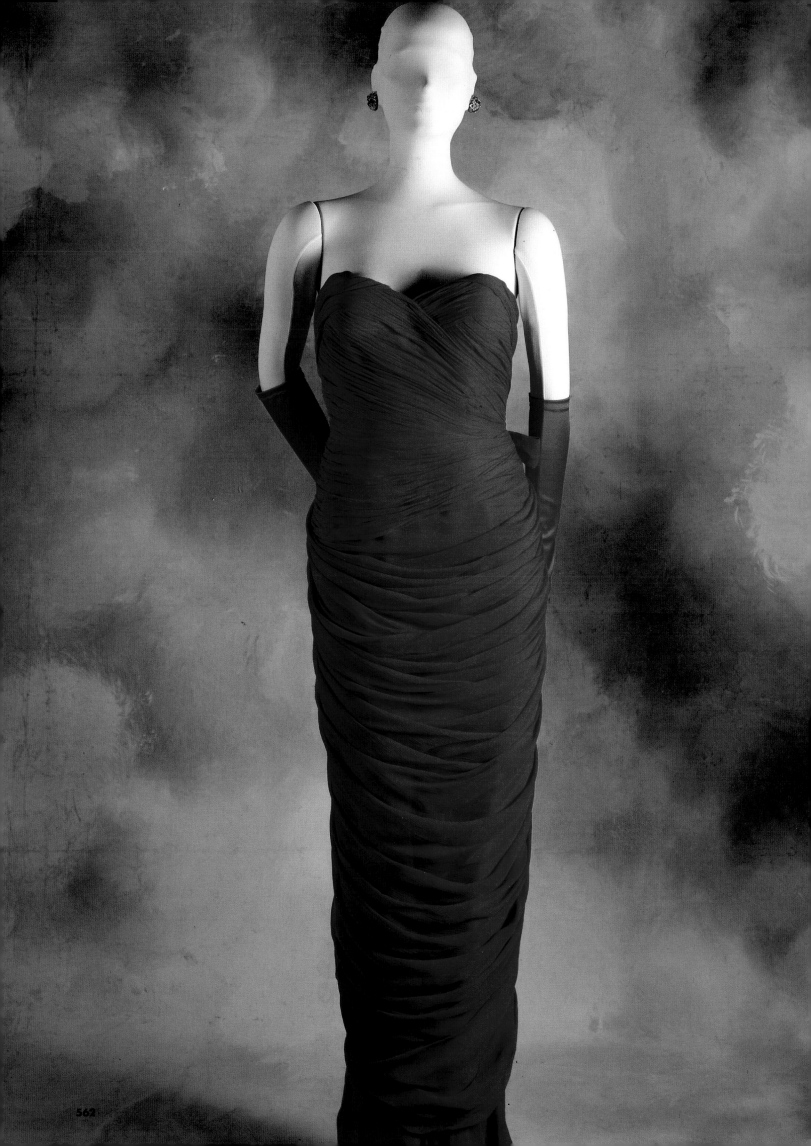

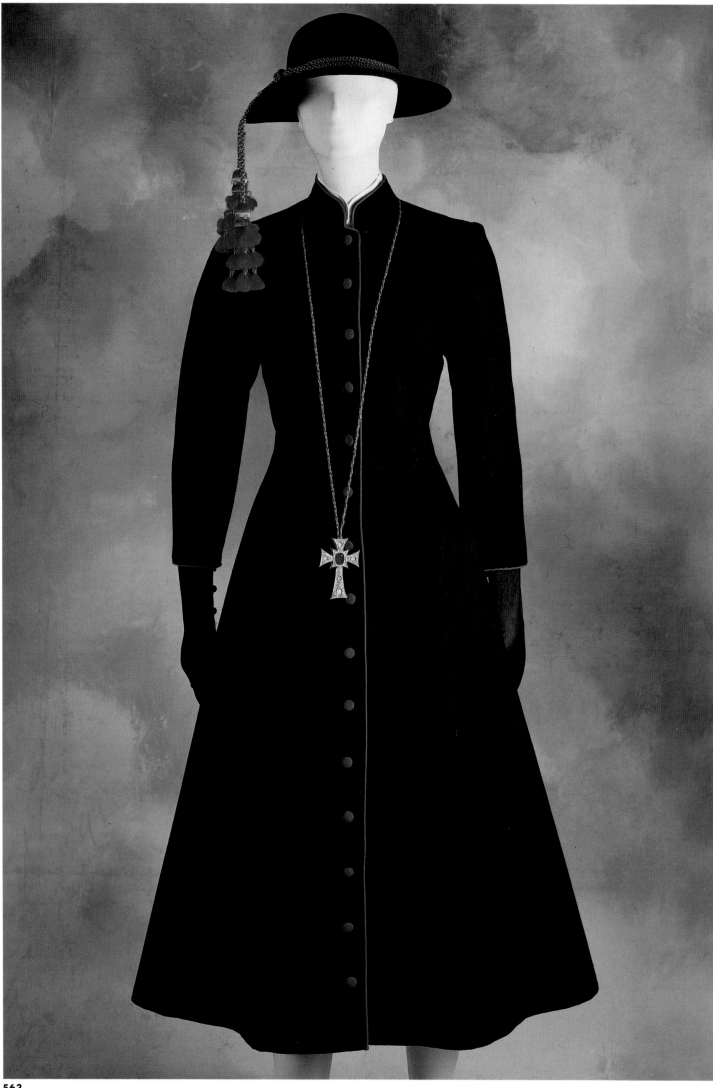

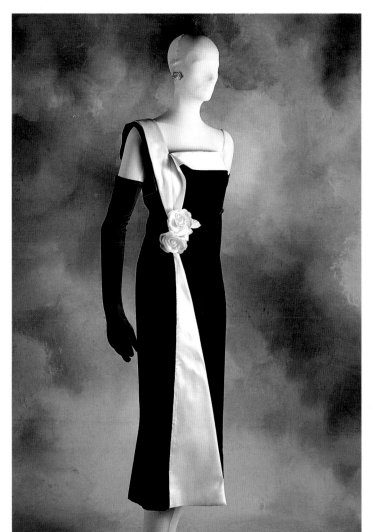

564

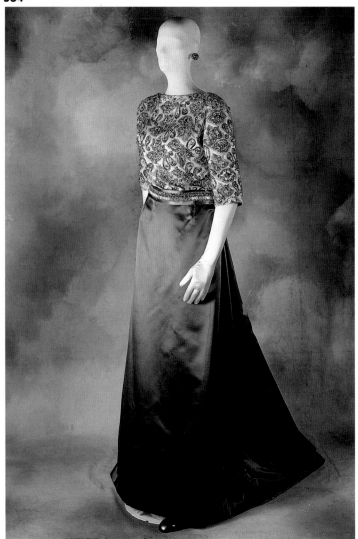

565

563. Sorelle Fontana
[Fontana Sisters]
Cocktail dress with hat, Cardinale (Cardinal) *collection, spring/summer 1956. Wool-and-silk blend. Belonged to Ava Gardner. Sorelle Fontana, Rome.*

564. Sorelle Fontana
[Fontana Sisters]
Cocktail dress, 1961. Silk crepe and silk satin. Made for Elizabeth Taylor. Sorelle Fontana, Rome.

565. Sorelle Fontana
[Fontana Sisters]
Evening gown, ca. 1965. Silk satin lined with crinoline, organdy, and silk satin, and embroidered with paillettes. Collection of Flaminia Marignoli, Rome.

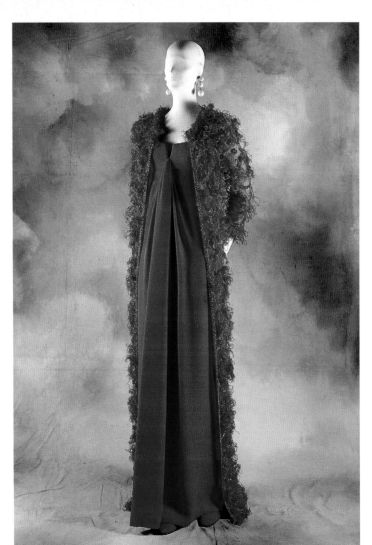

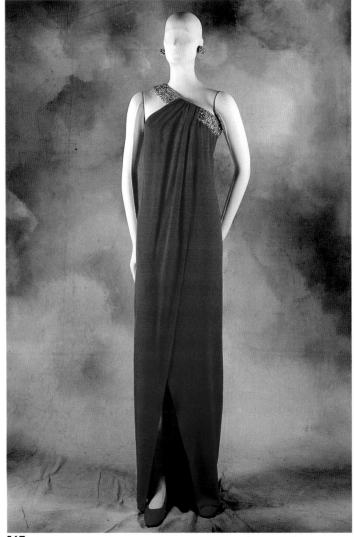

566. Valentino
[Valentino Garavani]
Evening gown and cape, fall/winter
1965–66. Silk-cady gown and silk-tulle
cape covered with ostrich feathers and
embroidered with stones. Valentino,
Rome.

567. Valentino
[Valentino Garavani]
Evening gown, fall/winter 1967–68.
Silk crepe. Collection of A. Vanderbilt,
New York.

568. Valentino
[Valentino Garavani]
Evening gown, spring/summer 1959. Silk
tulle. Valentino, Rome.

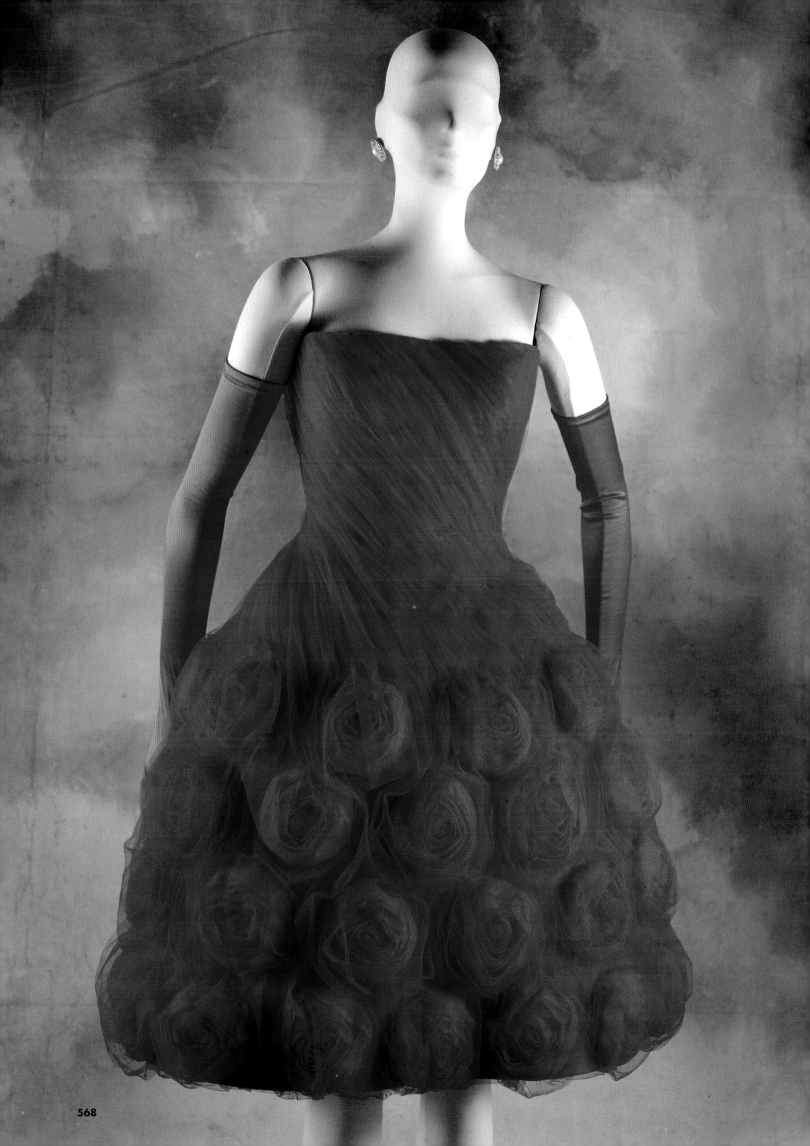

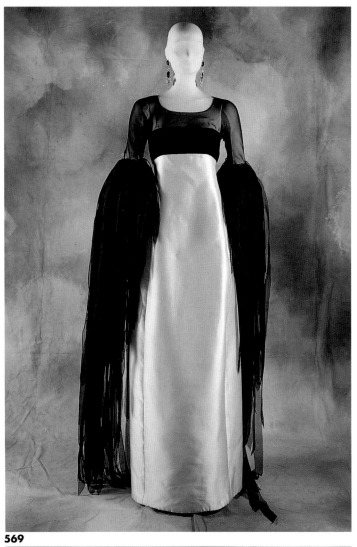

569

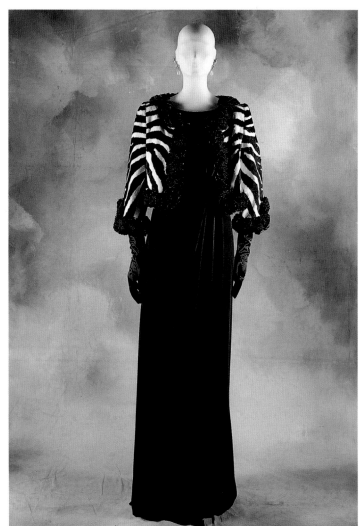

570

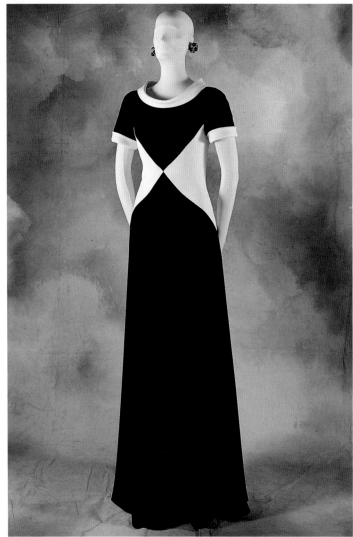

572

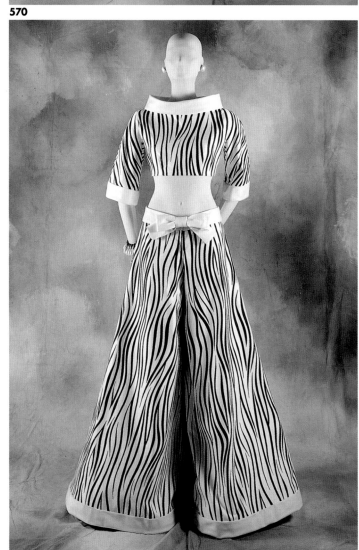

573

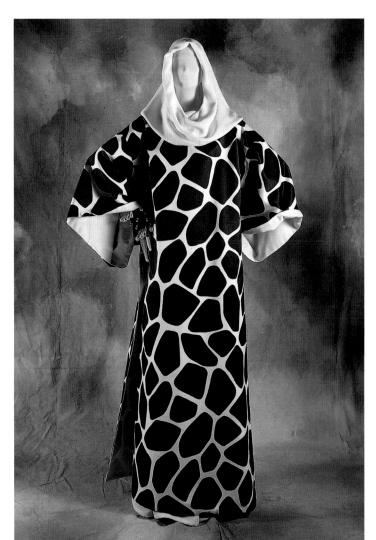

571

569. Valentino
[Valentino Garavani]
*Evening gown, Ottimista (Optimist)
collection, spring/summer 1963. Silk
faille and silk organza. Belonged to
Gaea Pallavicini. Museo Fortuny,
Venice.*

570. Valentino
[Valentino Garavani]
*Evening suit, spring/summer 1963. Silk-
cady dress with satin bow; jacket in
zebra-printed horsehide embroidered
with beads and paste. Valentino, Rome.*

571. Valentino
[Valentino Garavani]
*Evening gown, spring/summer 1966.
Cotton-poplin dress printed with
Giraffe design; silk-georgette hooded
pantsuit. Valentino, Rome.*

572. Valentino
[Valentino Garavani]
*Palazzo pajamas, spring/summer 1966.
Silk crepe. Collection of Princess
Luciana Pignatelli, Rome.*

573. Valentino
[Valentino Garavani]
*Evening suit, spring/summer 1966.
Cotton-poplin top; cotton-poplin pants
with silk-crepe bow. Valentino, Rome.*

574. Valentino
[Valentino Garavani]
*Palazzo pajamas, spring/summer 1967.
Silk chiffon and silk crepe. Valentino,
Rome.*

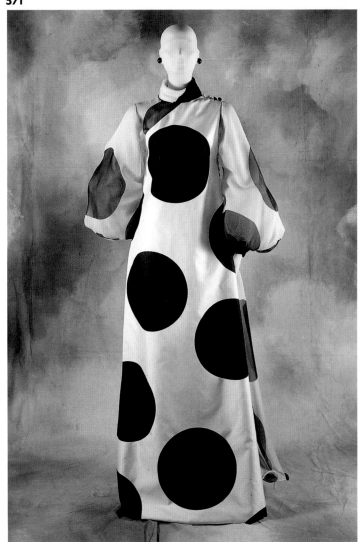

574

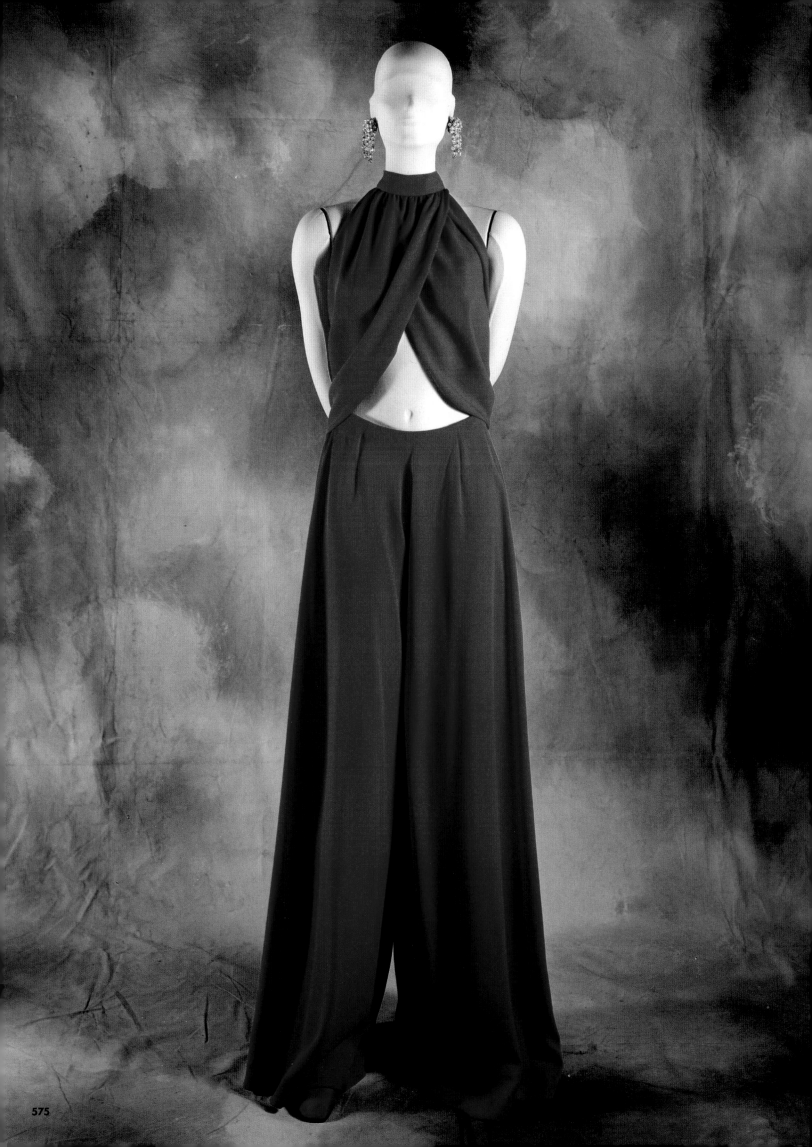

**575. Valentino
[Valentino Garavani]**
*Palazzo pajamas, spring/summer 1966.
Silk crepe. Valentino, Rome.*

576. Jole Veneziani
*Evening gown, fall/winter 1957–58.
Silk damask embroidered with glass
beads and paillettes. Federico Bano,
Padua.*

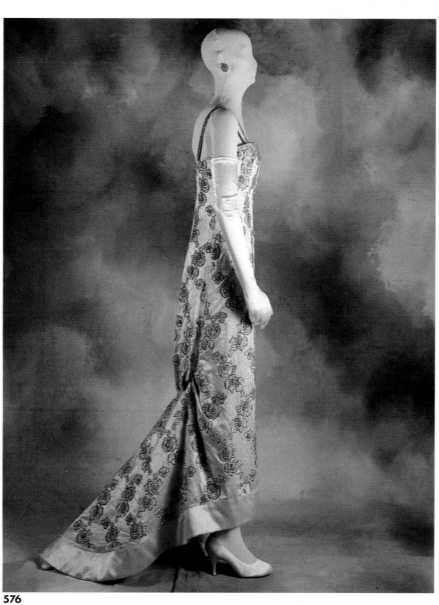

576

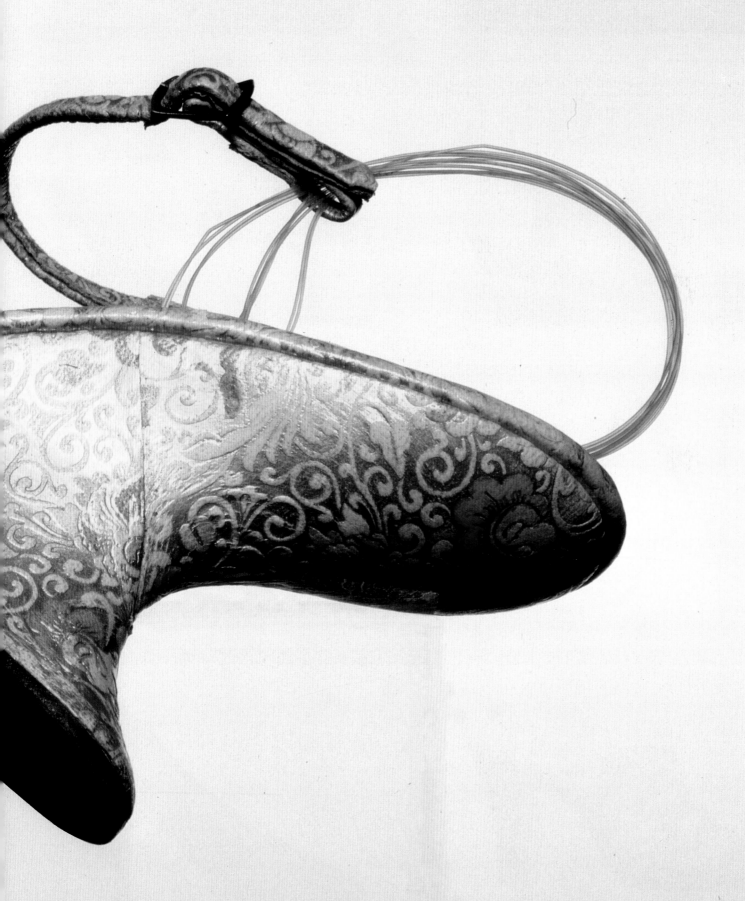

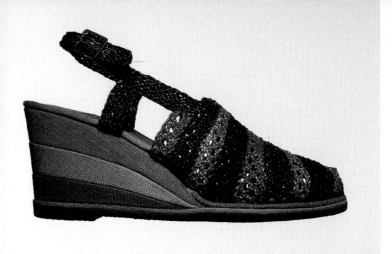

578

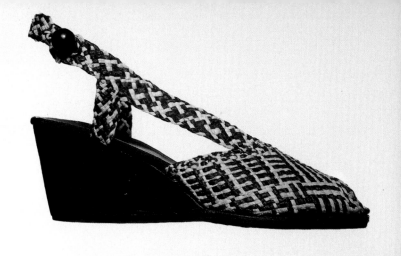

579

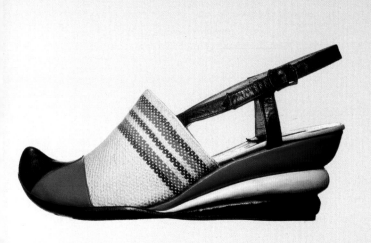

582

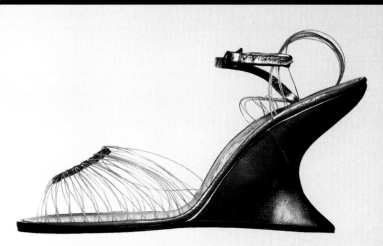

583

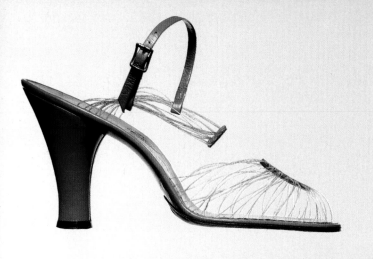

586

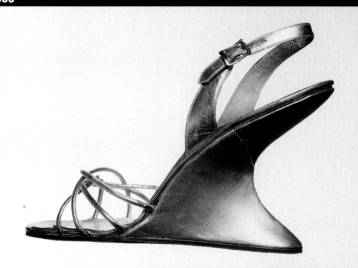

587

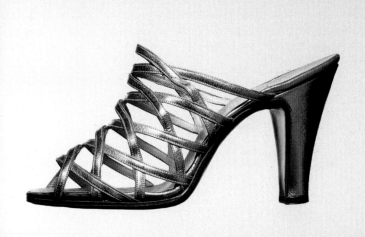

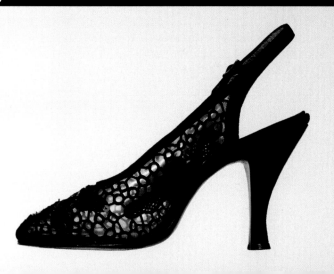

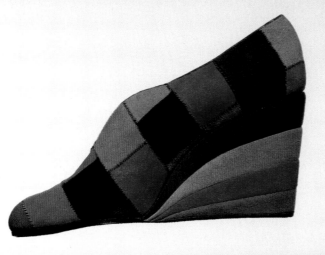

580

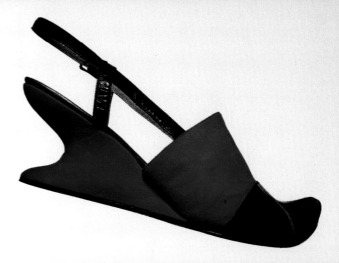

581

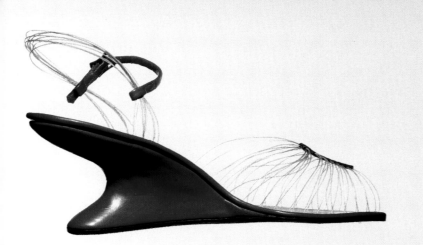

584

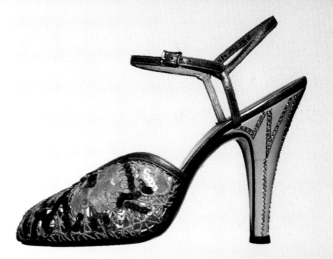

585

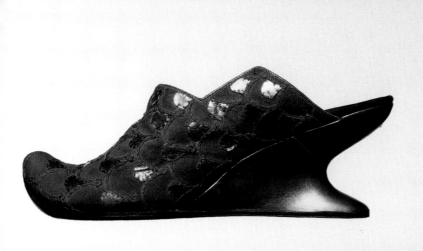

588

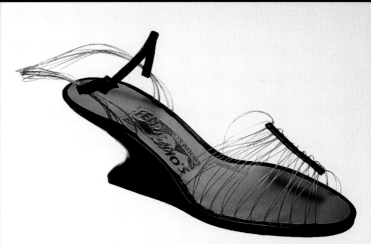

589

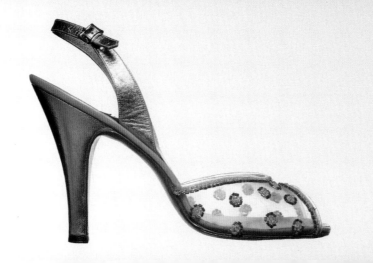

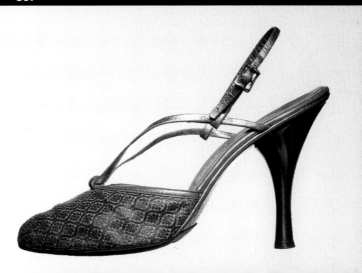

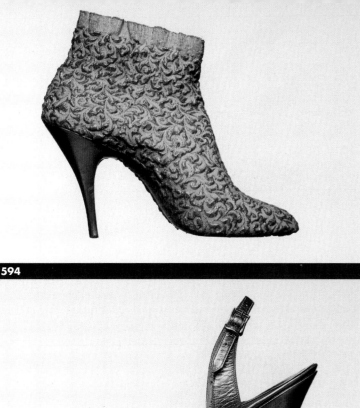

594

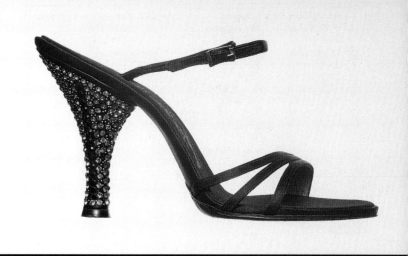

595

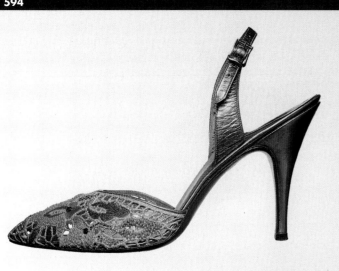

596

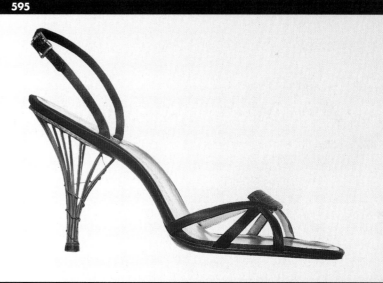

597

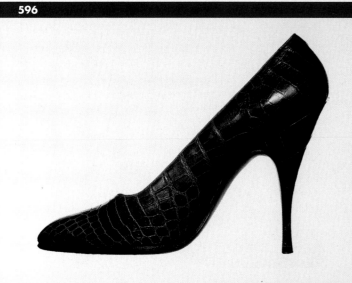

598

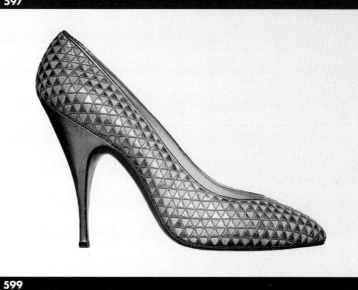

599

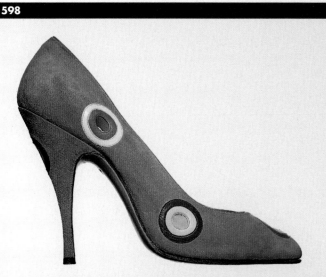

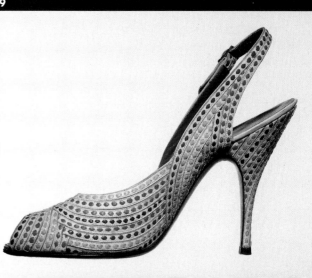

Preceding three pages:

578. Salvatore Ferragamo
Sandal, 1942–44. Cellophane upper; cotton-covered cork heel. Salvatore Ferragamo S.p.A., Florence.

579. Salvatore Ferragamo
Sandal, 1942–44. Woven-raffia upper; painted wood heel. Salvatore Ferragamo S.p.A., Florence.

580. Salvatore Ferragamo
Shoe, 1942–44. Suede-patchwork upper; suede-covered cork heel. Salvatore Ferragamo S.p.A., Florence.

581. Salvatore Ferragamo
Arabesca (Arabesque) sandal, 1944–45. Suede upper with kid toe; kid-covered wood heel. Salvatore Ferragamo S.p.A., Florence.

582. Salvatore Ferragamo
Sandal, 1944. Hemp upper; kid-covered cork heel. Salvatore Ferragamo S.p.A., Florence.

583. Salvatore Ferragamo
Invisible sandal, 1947. Nylon-thread and kid upper; kid-covered wood heel. Salvatore Ferragamo S.p.A., Florence.

584. Salvatore Ferragamo
Invisible sandal, 1947. Nylon-thread and calf upper; calf-covered wood heel. Salvatore Ferragamo S.p.A., Florence.

585. Salvatore Ferragamo
Invisible sandal, 1947. Nylon-thread and calf upper; kid-covered wood heel. Salvatore Ferragamo S.p.A., Florence.

586. Salvatore Ferragamo
Invisible sandal, 1947. Nylon-thread and kid upper; kid-covered wood heel. Salvatore Ferragamo S.p.A., Florence.

587. Salvatore Ferragamo
Sandal, 1948–50. Kid-and-vinyl upper; kid-covered wood heel. Salvatore Ferragamo S.p.A., Florence.

588. Salvatore Ferragamo
Goccia (Drop) mule, 1948–50. Suede upper decorated with kid and embroidered with silk thread; kid-covered wood heel. Salvatore Ferragamo S.p.A., Florence.

589. Salvatore Ferragamo
Sandal, 1950–52. Tavarnelle-lace upper decorated with sequins; plastic-lamina-covered wood heel decorated with paste. Salvatore Ferragamo S.p.A., Florence.

590. Salvatore Ferragamo
Kimo sandal, 1950–52. Kid upper; kid-covered wood heel. Salvatore Ferragamo S.p.A., Florence.

591. Salvatore Ferragamo
Sandal, 1950–52. Tavarnelle-lace upper decorated with sequins and with mica lining; satin-covered wood heel. Designed for Anna Magnani. Salvatore Ferragamo S.p.A., Florence.

592. Salvatore Ferragamo
Vitrea (Vitreous) sandal, 1952–54. Vinyl upper decorated with glass beads; kid-covered wood heel. Salvatore Ferragamo S.p.A., Florence.

593. Salvatore Ferragamo
Sandal, 1955. Silk-brocade upper; mica heel. Salvatore Ferragamo S.p.A., Florence.

594. Salvatore Ferragamo
Damigella (Damsel) pull-over, 1955–56. Elasticized-silk upper; kid-covered wood heel. Salvatore Ferragamo S.p.A., Florence.

595. Salvatore Ferragamo
Cassandra sandal, 1955–56. Satin upper; satin-covered heel decorated with paste. Salvatore Ferragamo S.p.A., Florence.

596. Salvatore Ferragamo
Sandal, 1955–56. Tavarnelle-lace upper embroidered with silk thread and Murano beads; calf-covered wood heel. Salvatore Ferragamo S.p.A., Florence.

597. Salvatore Ferragamo
Calypso sandal, 1955–56. Satin upper; brass heel. Salvatore Ferragamo S.p.A., Florence.

598. Salvatore Ferragamo
Pump, 1958–59. Crocodile upper; crocodile-covered wood-and-metal heel. Designed for Marilyn Monroe. Salvatore Ferragamo S.p.A., Florence.

599. Salvatore Ferragamo
Court shoe, 1958–59. Suede-and-kid upper; kid-covered wood-and-metal heel. Salvatore Ferragamo S.p.A., Florence.

600. Salvatore Ferragamo
Court shoe, 1958–59. Suede-and-kid upper; suede-covered wood-and-metal heel. Salvatore Ferragamo S.p.A., Florence.

601. Salvatore Ferragamo
Sandal, 1959–60. Calf upper; calf-covered wood-and-metal heel. Salvatore Ferragamo S.p.A., Florence.

602. Salvatore Ferragamo
Invisible *sandal, 1947. Nylon-thread
and suede upper; suede-covered wood
heel. Salvatore Ferragamo S.p.A.,
Florence.*

When I enrolled in the Sc

Università di Milano, in

War II had ended just a

was still full of rubble, an

everyone got about on bicy

image of Modern architec

represented by the countles

regime: simple, slightly si

the weight of the stone-cou

tower in one spot or anoth

rhetorical elements. The p

ool of Architecture at the

November 1945, World

w months before. Milan

as there were few trolleys,

les. For me, the concrete

ure in Italy was mostly

onstructions of the Fascist

ster volumes for which

red surface and a low

r were the dominant

ncipal challenge of my

Reconstructing a History

Vittorio Gregotti

entire disinformed generation when we first started at the School of Architecture was to go back from this rough data and try to begin to understand, distinguish, and judge. What small bits of information could be gleaned about the period between the two world wars usually concerned, somewhat confusedly, the roles of Futurism and Rationalism—on the one hand with magazines like *Casabella* (House beautiful)[1] and *Quadrante* (Quadrant), on the other with publications like *Architettura* (Architecture), which tried to reconcile academia, moderation, and modernity of style. They all seemed at odds with one another over the representation of Fascism. Although relations between Rationalism and the regime in the preceding years had been ambiguous, this fact was redeemed in our eyes by the widespread participation of Rationalist architects in the Resistance, and more remotely, by the mythic figure of Edoardo Persico.

Through these initial schemas, we students managed to stitch together a history; we reconstructed the tradition of modernity in Italy. It was a tendentious reconstruction, yes, but it enabled us to take our first naive steps toward the idea of actual reconstruction, for there were still enemies who had to be fought. Architecture departments in the Italian universities had, moreover, remained firmly in the hands of those we dismissed as "academics." What seemed most interesting to us occurred outside of their purview. As students, we used to read the review *Domus*—edited by Ernesto Nathan Rogers from 1946 to 1947—which taught us not only to orient ourselves about what was happening outside Italy but also helped us to understand how architecture was part of a culture and to appreciate its collective responsibilities. Over the course of a few issues, *Casabella* published the AR (Architetti Riuniti) plan for Milan (1944, presented 1945), which had been worked out during the Resistance and was based on the principles of the struggle against speculation, respect for the historic center of the city, and the indispensibility of regional interrelationships. In the period right after the war Giovanni Michelucci had proposed a project (1945) in the same spirit, which was never realized, for the reconstruction of the area around the Ponte Vecchio in Florence. News from Rome came through the review *Metron*, founded by Bruno Zevi, in which he began to speak of "organic architecture." With the goal of spreading this idea, the APAO (Associazione per l'Architettura Organica/Association for Organic Architecture) was founded, in opposition to the Milanese MSA (Movimento di Studi per L'Architettura/Movement of Studies for Architecture), which was Rationalist by tradition. Indeed, relations between Rome and Milan were characterized by mutual suspicion, given the differing cultural traditions. Only Mario Ridolfi and Ludovico Quaroni's project (with others) for the competition for the passenger terminal of Stazione Termini (1947, cat. no. 609) and Quaroni's church in the Prenestino quarter (1947, cat. no. 610), both in Rome, had aroused interest in Milan. Milan's monument to the fallen in German concentration camps (1946, cat. no. 605) by BBPR [Lodovico Barbiano di Belgiojoso, Enrico Peressutti, and Rogers][2] and Rome's monument to the Ardeatine caves massacre (1944–47, cat. nos. 603, 604) by Mario Fiorentino, Giuseppe Perugini, and colleagues, both projects very much admired, give a very good sense of the

different figurative sensibilities of the two cities.

In 1948 many of us students of architecture worked as volunteers on the *VIII Triennale*, the "Triennale della ricostruzione" (Reconstruction triennial), headed by Piero Bottoni. This event witnessed the first realizations of the experimental quarter of low-cost housing at San Siro (see cat. no. 607), on the outskirts of Milan, next to the artificial hill built from the rubble of the destruction wrought upon the city by the bombings.

In those years there came across our desks such "Modern" textbooks as the one by Irenio Diotallevi and Franco Marescotti, *Il problema sociale, economico e construttivo dell'abitazione* (The social, economic, and construction problem of housing, 1948), which informed us as to what had been done in Europe between the two world wars, and the *Manuale dell'architetto* (The architect's manual, 1946), a compendium of details of construction, at the highest technological levels, of Italian building production, a kind of "vernacular Esperanto" that among other things was the basis for the neorealist experience of the early 1950s. After 1948 and the political defeat of the Left, the review *Il politecnico* (Polytechnic), founded by Elio Vittorini, whose editorial staff I associated with, came into conflict with the directives of the PCI (Partito Comunista Italiano/Italian Communist Party), which had adopted a position contrary to the avant-garde tradition. This had a considerable effect on architecture as well.

We students had some lively cultural organizations that, unlike the universities, invited notable figures from the international cultural scene to give lectures and attempted to bring architecture students from the different Italian schools into contact with one another. I believe I was attending my fourth year at the School of Architecture (which to me seemed particularly ramshackle; Giovanni Muzio was teaching urbanism there, but at the time we saw him as our cultural enemy) when Richard Neutra came to give a lecture. Introducing him was a stylish, brilliant man, Giuseppe De Finetti. Certain connections were beginning to become clear to me: first of all, the names of the great Austrian émigrés who had gone to America—Frederick Kiesler, Adolf Loos, who had been De Finetti's teacher, Neutra, and Rudolph Schindler—and the position of certain figures of the moderate avant-garde of the Novecento movement. De Finetti, aside from editing a small review, *La città architettura e politica* (The city. Architecture and politics), was putting forward, unbenownst to most, a series of proposals (see cat. no. 606) for the reconstruction of Milan that would prove more realistic than the AR plan, which was immediately shelved by the institutional powers. At that time—somewhat out of an unjust hatred of school—I went to seek work at BBPR, which at the time was a studio with a great international reputation where one could meet the likes of Alvar Aalto, Walter Gropius, and Le Corbusier or artists like Alexander Calder and Saul Steinberg. They assigned me some research on medieval towers, and it was not until some time later that I discovered my work was going toward their Torre Velasca project (1950–58, cat. no. 657).

The cultural restlessness that the Torre Velasca project manifested in its search for a connection with the city's historical memory was certainly not an isolated case: Franco Albini and Luigi Colombini, with the Pirovano

lodge project (1949–51, cat. no. 626); Ignazio Gardella with his house of a viticulturist (1945–46, cat. no. 608); Michelucci with the Pistoia mercantile exchange (1949–50, cat. no. 623); and BBPR with their house on via Bigli (1948) in Milan, all resumed a "national path" to Rationalism that had already been started in the late 1930s.

I also remember the admiration I and others had at the time for the rigor of Mario Asnago and Claudio Vender, for Luigi Figini and Gino Pollini's office and apartment building on via Broletto (1947–48, cat. no. 621) in Milan, for the sublime solution of Franco Albini's Palazzo Bianco museum (1950–51, cat. no. 628) in Genoa, and for the Harar quarter (1951) by Gio Ponti and Figini and Pollini (see cat. no. 622) in Milan. These architects inspired our curiosity and admiration as students, especially in the way they compared to the great figures of Italian Rationalism of the 1930s—in particular, Giuseppe Terragni, whose colleague Pietro Lingeri, still active in the 1950s, was one of the supporters, upon my graduation, of my admission into the MSA.

Turin, at this time, remained a rather separate cultural entity, and despite all the promotion made in their favor by Ponti, who succeeded Rogers as editor of *Domus* in 1948, the ingenious designs and works of Carlo Mollino, such as the Lago Nero sled-lift lodge (1946–47, cat. no. 613), had little success in Milan. On the other hand, Adriano Olivetti–because of his long history as an industrialist interested in Modern architecture and design and his interest in urbanism–was a great influence on the Milanese architects of the time. He was one of the key figures in the foundation of the INU (Istituto Nazionale di Urbanistica/National Institute of Urbanism), and for many years he financed the review *Urbanistica* (Urbanism), edited by Giovanni Astengo. The INU was a strong binding force of national culture, where urbanists from northern Italy could clash and conduct a cultural as well as disciplinary battle with Romans such as Luigi Piccinato and Ludovico Quaroni, and where the older generation could confront such younger minds as Giuseppe Campos, Pierluigi Cervellati, Piero Moroni, and Vittorini. The Olivetti group also published the review *Comunità* (Community), which in those years boasted a group of positively first-rate contributors. They were intellectuals of various backgrounds and disciplines bound by radical, lay political convictions often of Gobettian extraction (Piero Gobetti was the most noteworthy theoretician of liberal socialism in the 1930s). All of them were striving toward a modernization of the country that would be at once anti-Fascist and anti-ideological, though in the end their ideas proved to have little political weight.

In the 1950s the number of works commissioned by Olivetti was quite considerable. Luigi Cosenza built him the Pozzuoli factory (commenced 1951, cat. no. 634), using a kind of architecture that expressively presents the workplace as a site of socialization. At Ivrea the complex of social buildings (1954–57, cat. no. 635) was designed by Figini and Pollini (see also cat. no. 633), who had been Olivetti's architects in the 1930s as well; the cafeteria for Olivetti employees (1955–59, cat. no. 637) was the work of Gardella; and the services center (1952–55) was by a then very young Eduardo Vittoria. Marco Zanuso built the two Olivetti factories at São Paulo (1954–59, cat. no. 681)

and Buenos Aires (1954–62, cat. no. 682–84).

In addition, the introduction of the American school of sociology contributed more than a little to the cultural choices presiding over the realization of the La Martella village (1951–54, cat. nos. 618, 619), designed by Quaroni's group—one of the noblest examples, despite its lack of practical success, of the attempt to recuperate the communal values of rural culture. It was a response, however unstructural, to the great "southern question," which was returning quite dramatically as a subject of debate at that time.

Of course by the early 1950s a great many figures who had been culturally compromised by their roles in the old regime had already returned to their command posts, including Marcello Piacentini, who was carrying out his senseless plan for the new via della Conciliazione (1947–51) in Rome. The DC (Democrazia Cristiana/Christian Democratic party) had promoted its integration, just as with their seven-year plan for subsidizing low-cost housing they had promoted a policy of dispersive initiatives that was not backed up by any urban plan of containment. What was actually taking shape was a policy of building reconstruction aimed entirely at keeping unemployment down and at accumulating capital.

In 1951, shortly before my graduation, I was called on to take part in preparing the exhibition of the Italian group at CIAM (Congrès Internationaux de l'Architecture Moderne/International Congress of Modern Architecture) VIII, held at Hoddesdon, near London; the theme of the conference was "the urban core." Beyond my personal good fortune in having a chance to meet the great figures of the Modern movement at CIAM VIII (I had already, in 1947, worked a short time in Auguste Perret's studio in Paris), this event was also an initial indication of the difficulty my generation would have in opening itself up to the international scene.

There were not many architectural books circulating in Italy in the 1950s nor were there many direct contacts with such masters as Ludwig Mies van der Rohe, Le Corbusier, Frank Lloyd Wright, or Aalto, yet their influence was great, even though it was still pretty much a synthesis of the overall vision we had of them. After I graduated, Rogers, who was clearly the most prominent figure in Italian architectural culture in the 1950s and 1960s, asked me to work with him and Giancarlo De Carlo and Zanuso on the new incarnation of *Casabella*, then named *Casabella continuità* (House beautiful continuity), of which he was Editor in Chief from 1953 to 1964, and as his assistant at Milan's School of Architecture, where he had finally succeeded in becoming a professor. De Carlo, who soon thereafter would quit the editorial staff after disagreements over the direction of the magazine, was a man of exceptional charm and intelligence, as his subsequent career would demonstrate (see cat. no. 655).

The review's first issue published works of Gardella and Ridolfi. Gardella, in the early 1950s, had built some of his finest works: the residential building for Borsalino employees (1950–52, cat. nos. 641, 642) in Alessandria, the Padiglione d'Arte Contemporanea (1949–53) in Milan, and the restructuring of the Regina Isabella baths (1950–53, cat. no. 629) on the island of Ischia. No discussion of Gardella, however, can fail to mention the contributions of

Luigi Caccia Dominioni, an architect whose role as link between neoclassicism—the tradition of the Novecento movement—and international Modernism would reveal itself to be increasingly important; Dominioni also defined some of the linguisitic elements that would become rather widespread in the Milanese building industry of the 1960s. I remember *Casabella*'s publication of Dominioni's Beata Vergine Addolorata convent and girl's school (1946–54, cat. no. 638) and his Loro Parisini office building (1955, cat. nos. 639, 640), both in Milan. Later, throughout the 1960s, he did a great many buildings in the historic streets of Milan (see cat. no. 644).

Yet it was above all *Casabella* that first opened the discussion about the phenomenon of neorealism in architecture–or rather, the discussion about what might be called an aspiration to reality, which is a constant in all the different forms of Italian architecture throughout the 1950s. The form it assumed in northern Italy was that of an aspiration to the social-democratic models of northern Europe, as in the case (aside from Gardella's projects) of such projects as the Falchera quarter (ca. 1950, cat. no. 616), in Turin, by Giovanni Astengo's group, or the low-cost housing neighborhood of Cesate (1951), near Milan, by Albini, Gianni Albricci, Belgiojoso, Gardella, Peressutti, and Rogers; it also assumed forms of modernization related to the first symptoms of a nascent consumer society, as in the Triennale's efforts to move toward a culture of industrial design. As for the subsidized housing industry, we had moved, due especially to the pressure of the INU, toward an attempt at coordinated interventions, which led, for better or worse, to a series of projects, throughout the 1950s, on the neighborhood scale rather than for individual buildings. Among these the most noteworthy were the Forte Quezzi neighborhood project (1956–58, cat. no. 715) by Luigi Carlo Daneri and colleagues in Genoa; Adalberto Libera's project at the Tuscolano in Rome; and the via Cavedone quarter (1957) in Bologna, which was perhaps the most convincing response, in its own terms, to the scale and conditions of the intervention.

In Rome and south-central Italy, the aspiration to reality found its forms of expression in the representation of a national-populist path toward socialism. The descriptive art media–painting, literature, and cinema–had already provided an image of this reality. Without the feelings implicit in this background, it would be difficult to explain the generous efforts made by the Quaroni and Ridolfi group for the project for the INA–Casa (Istituto Nazionale Abitazioni–Casa/National Housing Institute–Casa) complex on via Tiburtino (1949–54, cat. no. 611) in Rome. Ridolfi and Wolfgang Frankl's INA–Assicurazioni residential towers on viale Etiopia (1950–54, cat. no. 614) in Rome and their INA–Casa complex in Cerignola (1950, cat. no. 612) were for my generation two of the most intense architectural works of that period; they best expressed an attempt to find the roots and specificity of an experience of modernity consistent with the new themes of the progressive parties of the Left.

My generation came onto the scene during these years. The group gathered around *Casabella* was influenced by many factors: a constant eye on the international debate, the reading of Marxist thought from a phenomenological point of view, Theodor Adorno's critique of consumer society, and a critical reflection upon the modern tradition of using history and theory as structural materials in planning. Giulio Carlo Argan's book, *Walter Gropius ed il Bauhaus* (Walter Gropius and the Bauhaus, 1951) had a tremendous influence on us. Along these lines, I had begun in 1953 to design a residential building for Bossi textile workers (1953–56, cat. no. 651) and a number of interiors; Gae Aulenti had built a villa (1957, cat. no. 647) in San Siro, on the outskirts of Milan; and around the same time in Turin, Roberto Gabetti and Aimaro Isola (see cat. no. 643) as well as Giorgio Raineri (see cat. no. 645) were working on their buildings with a more pronounced sense of memory and nostalgia. By the end of the 1950s, Paolo Portoghesi (already for some time connected with the Turin group) had given his first comprehensive interpretation of the phenomenon in two essays: "Dal neorealismo al neoliberty" (From neorealism to neoliberty, 1958), published in *Comunità*, and "Architettura e ambiente tecnico" (Architecture and technical environment, 1960), published in *Zodiac*.

The influence of this critical radicalization was, I believe, of equally great importance for those whom we continued to admire and to consider our masters. In the years that immediately followed, Gardella completed the Cicogna house on the Zattere (1953–58, cat. no. 654) in Venice; Albini and Franca Helg, the treasury museum of San Lorenzo (1952–56, cat. nos. 630, 631) in Genoa and La Rinascente department store (1957–61, cat. nos. 659, 660) in Rome; BBPR, the Torre Velasca (1950–58, cat. nos. 656, 657) and the beautiful renovation and installation of the museums of Castello Sforzesco (1954–56, cat. no. 658), both in Milan. These buildings, of course, were all more complex, mature, and successful than our youthful efforts, and in them one sensed the will to go beyond all forms of populism in an attempt to bring the discourse to the root of the place that history and tradition were supposed to occupy in the methodology of the modern.

Also involved in this debate, though in a different manner, were the Roman architects: Quaroni—who with his constant pessimism was the most thoughtful of the group—with his house at Genoa (1956; see also cat. no. 662); Giuseppppe Samonà—who in the meantime had opened up the IUAV (Istituto Universitario d'Architettura di Venezia) to the protagonists of the Modern movement in Italy—with his INAIL (Istituto Nazionale Assicurazione Infortuni sul Lavoro/Institute of National Disability Insurance) office building in San Simeone (1950–56, cat. no. 664) in Venice; and Saverio Muratori with his ENPAS (Ente Nazionale Previdenza Artisti dello Spettacolo/National Performing Artists Security Organization) office building (1952–57, cat. no. 646) in Bologna. The influence of Muratori's research in the area of urban analysis would be felt most by the mid-1960s. Samonà built the last buildings of his "palazzata a mare" (palazzata on the sea, 1953–58, cat. no. 663) in Messina using a Perretian vocabulary that particularly interested me because around the same time I was constructing what was perhaps the first building in Italy to use prefabricated curtain panels with many stylistic elements deriving from the Perret Brothers [Auguste and Gustave Perret]. This language, with its clear distinction between structure and content,

had been used in previous years by BBPR and by Albini
(for example, in his INA [Istituto Nazionale
Assicurazioni/National Insurance Institute] office building
[1950–52, cat. no. 627] in Parma) and then became rather
widespread as the common language of properly modern
construction in the north-central region of Italy.

In 1955 the MSA broached the question of the critique of
Modernism in a lively and at times dramatic debate in
which some of its membership refused to accept so radical
a revision. Ponti (who had never been accepted into the
MSA) took advantage of this conflict to present himself as a
defender of the International Style with his interesting
project (with others) for the Pirelli skyscraper (1956–61,
cat. no. 674) in Milan. In those years, the generation that
fell between us youngsters and the older masters was
beginning to establish itself in an original manner, giving
expression to a possible accord with a popular majority that
had by now ceased to reject Modernism. Vittoriano Viganò
built the headquarters for the combined Marchiondi
Spagliardi and child welfare institutes (1953–57, cat.
nos. 675, 676) in the style of international "brutalism." Vico
Magistretti used a similar style in his building on via
Leopardi (1960; see also cat. no 679) in Milan, as did
Zanuso when he designed a series of office buildings (1958),
also in Milan.

Also belonging to this world, which reflected the
themes under passionate debate during those years, were
such great and internationally well-known figures as
the engineers Antonio Nervi, Pier Luigi Nervi (see cat.
nos. 665, 666), Riccardo Morandi (see cat. nos. 669, 670),
and Silvano Zorzi (cat. no. 668). The building of the
superhighways, the *autostrade*; the 1960 Olympic games in
Rome; and the 1961 Exposition at Turin were among the
many opportunities to which the abilities of Italian
Rationalist engineering could apply itself, while it also was
realizing great works all over the world.

Propelled by the desire for a renewed language, a
number of works of considerable stylistic elegance had been
produced in the early 1950s in Milan, such as Luigi
Moretti's palazzine (a building type that later became very
widespread in Rome) and Luciano Baldessari's experiments
at the Breda pavilion (1952, cat. no. 625). These are in any
case examples that had very little influence on my own
generation, which was interested in more structural
questions, on the levels both of theory and of political and
urbanistic involvement—an involvement that was
desperately attempting to obtain more free spaces, more
green spaces, more services, in short, a control over the
social use of the terrain.

One should bear in mind that Italy went from a
production of 543,000 rooms in 1951 to nearly 2 million
rooms by 1961, with an annual growth of 12 percent as
compared to an industrial growth of 8.2 percent and a
predicted increase, by the government, of 5 percent in
annual revenue. This growth made it necessary to
undertake an energetic defense of the land and the historic
patrimony. The Italia Nostra (Our Italy) association was
founded in 1955; the conferences of the INU (such as the
one at Gubbio in 1960) were also devoted to this problem,
though they never managed to reach any kind of agreement
with the governing or legislative powers. Such efforts
would have to wait until the late 1960s before finding, as

they did in the example of Bologna, a normative and methodological system with a number of small examples of urban restoration interventions. This too was the result of the studies initiated in the 1950s by Muratori and his group; the early 1950s Rogersian theme of contextually preexisting buildings was shifting to the level of the structure of the city.

Between the late 1950s and early 1960s we all had the feeling that the foundations of our work were changing. The need to think on a scale of broader, more comprehensive intervention was growing along with the complexity of functions and exigencies dictated by the modernization of the country. At the same time, however, the sense of the city's importance as the central locus of development and control was also growing. Corresponding to this on the level of national politics was the formation of a government open to the Socialists; the need to spur economic and physical development through scheduling, regional planning, and the formation of research institutes for land development; and the attempt to produce new plans for Italy's cities, including Rome. The last project failed, but by the end of the decade it had yielded a proposal for a system of management offices, traces of which still exist today.

These interests also had a considerable effect in the sphere of the architectural project, especially through the great competitions for vast and complex commissions, such as that for the neighborhood on the sandbanks of San Giuliano (1959, cat. no. 661) in Venice, which proved to be a great opportunity for Quaroni's group to design a project of exceptional quality. Elsewhere, the competitions for the management districts of Bologna and Turin began to bring out the younger architects of my own generation: Carlo Aymonino, Guido Canella, Aldo Rossi (see cat. no. 704), among others.

"Opulent urbanism" had, however, its theoretical foundations in the book by Samonà, L'urbanistica e l'avvenire della città (Urbanism and the future of the city, 1959), which reaffirmed, as had been done at the INU conference of the same year at Lecce, the principle of the inseparability of architecture and urbanism. Then appeared Leonardo Benevolo's Storia dell'architettura (History of architecture, 1960), which followed Zevi's history, published in 1950, and laid down the technical bases for a call to order in the Rationalist manner, an appeal that found expression in a number of the projects submitted to the competition for the new Biblioteca di Roma (1957) and in the establishment of the SAU (Società di Architettura ed Urbanistica/Society of Architecture and Urbanism), also in Rome.

Another aspect of the change that took place in the early 1960s was the critique made of the relationship between ideology and language by the neo-avant-garde movement in the fields of literature and music. This found its visual manifesto in the introductory section of the XIII Triennale, in 1964 (see also cat. no. 705). On that occasion, Nanni Balestrini, Luciano Berio, Tinto Brass, Umberto Eco, Achille Perilli, and Massimo Vignelli worked together with my group on a critical presentation of the problem of free time and consumer society, where the system of positions and relations, the heterogeneity and polysemy of materials, and the theatricalization of space all contributed to the

construction of a physical environment of particular intensity. As Manfredo Tafuri wrote many years later, "In the new vision of the avant-gardists there was no nostalgia for the irrational but rather a recognition of the new forms to which the project is given."[3] This new vision was accompanied by the appearance of new reviews—such as Il menabò di letteratura (The blueprint for literature), edited by Vittorini and Italo Calvino; 15, the review of the so-called Gruppo 63; and Edilizia moderna (Modern building), edited by myself—in the field of architecture and urbanism. In cinema, this activity found its counterpart in the celebrated films of Michelangelo Antonioni of the early 1960s.

In 1965 the INU held a conference in Trieste to discuss the themes of the large-scale territorial project. The report I presented on this occasion became, the following year, one of the central chapters of my book Il territorio dell'architettura (The territory of architecture). Aldo Rossi then published L'architettura della città (The architecture of the city, 1966), which was followed a year later by Giorgio Grassi's La costruzione logica dell'architettura (The logical construction of architecture) and Aymonino's research on the city of Padua. Our generation was taking a position on questions that would soon be put to the test by the projects in Palermo for the ZEN residential quarter (1969–73, see cat. nos. 722, 723) and the Università di Palermo (1968), and by Rossi's and Aymonino's buildings for the Monte Amiata residential complex in Gallaratese (1969–73 and 1967–74, respectively, cat no. 721) in Milan. The same ideas regarding the outstanding importance of urban history were reconfirmed in the project devised by Luciano Semerani and Gigetta Tamaro, Romano Burelli, and others for the historical center of Trieste (1969, cat. no. 720).

Another sign of the changing times was the fact that architectural culture was now being presented with diverse realities rooted in regional and cultural differences (though their significance went well beyond the individual region). On the one hand, Giovanni Michelucci was building the church of San Giovanni Battista (1960–64, cat. nos. 685, 686) on the Autostrada del Sole in Campo Bisenzo, while the works of Leonardo Ricci (see cat. nos. 687–90) and Leonardo Savioli (see cat. nos. 691–93) were being developed with a vigorous plasticity that owed a lot to the Art Informel in painting of a few years earlier. On the other hand, it was not until the early 1960s—very late, that is—that the importance of the work of Carlo Scarpa (see cat. nos. 694–98) was finally recognized, though the great consistency and poetic power of his projects for Venice had been clear for years. Especially in the area of museums—Palazzo Abatellis (1954) in Palermo, the restoration and installation of the Castelvecchio museum (1956–67, cat. no. 697) in Verona, the Venezuela pavilion (1954–56, cat. no. 694) at the Giardini della Biennale di Venezia—and in a number of other refurbishings (see cat. no. 698), Scarpa had become for us a model of originality and independence. But his lessons did not allow for imitators, and thus his best students turned out to be those who distanced themselves the most from him: Marcello d'Olivo, with his works in Manacore sul Gargano (see cat. no. 700; see also cat. no. 699), and especially the seemingly antithetical Gino Valle, who in the 1970s and 1980s would prove to be one of the finest

talents in all of Italian architecture, and who in the early 1960s had produced a work of the caliber of the Zanussi office building (1959–61, cat. no. 672) in Porcia, which was more comparable to the best English work of that period than to anything Italian.

Two rather special individuals entered the Italian architectural debate around this time: Maurizio Sacripanti, above all for his experimental projects, including the one (with Andrea Nonis) for the competition for the new civic museum (1967, cat. no. 712) in Padua, and Ettore Sottsass, Jr. (see cat. no. 702), who, though working mostly in the field of industrial product design, advanced a position that the generation of 1968 would later watch with great interest (his ties to Indian culture by way of the American Beats were well known). Parallel to this, in a way, was the great craftmanship reputation of the Castiglioni brothers, Achille and Pier Giacomo, who were industrial product designers (see cat. nos. 724–26, 749–51, 756, 775).

It is worth noting that Italian culture at this time still preserved a unity between architecture and design not to be found in any other European country, though this unity was obviously stronger in Milan than in other parts of Italy. One product of this very special condition is the fine work that Albini and Helg did for the Line 1 stations of the Metropolitana subway system (1960, cat. no. 701) in Milan.

The 1960s also saw continued and energetic production from the masters I discussed above: in 1968, for the AGIP motel (cat. no. 716) at Settebagni, Ridolfi and colleagues designed a tower that is a very interesting reprise of an old project of his from the 1920s, while at the same time building a number of urban edifices at Terni and the beautiful Lina house; Gardella won the competition for the Vicenza theater in 1968 and built the church of Metanopoli in Milan; BBPR built the office building on Piazza Meda, also in Milan. In Rome, the Passarelli brothers, Vincenzo, Fausto, and Lucio, renewing the stylistic tradition of Luigi Moretti (see cat. no. 620), built a lovely house on viale Campania (1965; see also cat. no. 717). In 1965 Quaroni's group drew up a plan for a government center at the Kasbah in Tunis (cat. no. 708) that kept a keen eye on the teachings of Louis Kahn. My own work of the period from 1962 to 1965 (see cat. no. 703) also shows the definite influence of Kahn, whom I had met during a trip to the United States in 1959. Samonà, after the extraordinary project (with others) for the Sacca del Tronchetto (1965, cat. no. 703) in Venice and the disappointment of the projects (with others) for the reconstruction of Gibellina, began in 1968 to build, with many allusions to historical memory, the new headquarters of the Banca d'Italia in Padua.

An entire generation of Roman architects found themselves vying with one another in the competition for the new offices for the Chamber of Deputies (1967, cat. nos. 707, 709–11) in Rome. On this occasion, Quaroni and his colleagues revealed exceptional skill in interpreting the relationship between the building and the urban fabric. Throughout the 1960s, De Carlo produced a series of works, most of them in Urbino, in which, through the Università di Urbino, he established a very special relationship of guardianship with that city (see cat. no. 713). In Milan, Magistretti's house on via Conservatorio (1966, cat. no. 679) was one of his most interesting buildings.

My generation, no longer young, was starting to produce works that began to gauge, in a new perspective, its capacity for critical as well as creative continuity. Gabetti and Isola built the new center for the Turin riding club (1959–61, cat. nos. 648, 649) and the school in the Vallette quarter (1964), both in Turin, and (with Luciano Re) the fine semicircular building of the Olivetti residential center (1969–71, cat. no. 719) in Ivrea. Also in Turin, Raineri built the novitiate of the Sisters of Charity (1962, cat. nos. 652, 653). Among architects in Turin, the influence of Sergio Iaretti, Elio Luzi, and the younger Piero De Rossi began to grow.

In Milan, Canella, Michele Achilli, Daniele Brigidini, and Laura Lazzari built the expressionistic town hall (1963–66, cat. no. 714) in Segrate, asking Rossi to contribute a design for a fountain. Rossi and Aymonino competed with each other for the reconstruction of the Teatro Paganini in Parma, submitting rather different projects (1964) and later worked alongside one another on two residential buildings (see cat. no. 721) in Milan. Valle designed an industrial prefabrication system (see cat. no. 673) that in the years to come would have a great deal of influence, just as the earlier system (see cat. no. 671) designed by Angelo Mangiarotti had done.

Having become at this time a professor at the School of Architecture of the Università di Palermo, I was commissioned to design, together with the great Pollini, the university's new science complex. My group was also entrusted with building the ZEN quarter, having won the competition for this that same year, but this project was to remain disastrously unfinished. In Rome, Vittorio De Feo (see cat. no. 718) designed and built a middle school of rather great formal impact.

By the end of the decade, groups such as the Stass and the GRAU had formed in Rome, collectives of planning and design strongly shaped by the relationship between form and ideology. After 1968 such groups as the Florentine Superstudio and Archizoom were formed that fell midway between the psychedelic experience and the technology of infinite communication theorized by the "plug-in city" at the start of the 1960s. The anticonstruction Ludditism of those years claimed to base itself in the ideologies of the New Left.

Casabella, under the new editorship of Alessandro Mendini (Rogers was ousted as editor in 1964), became the standard-bearer for a closer relationship between the neo-avant-gardes in art and architecture. With the crisis of 1968, heralded in Italy by student movements since 1966, and with the dashing of the utopian hopes contained therein—a disillusionment justified by a series of distractions in political and intellectual behavior, but a disillusionment nonetheless—a new chapter was opened in the history of architecture in Italy as it was everywhere else.

Translated, from the Italian, by Stephen Sartarelli.

1. The magazine, first published in Milan in 1928, changed its name several times over the years: from *La Casa bella* to *Casabella*, *Casabella costruzioni*, *Costruzioni casabella*, *Casabella continuit*à, and finally to *Casabella* once more. In December 1943, publication of the magazine was prohibited by the Fascist regime, and althought it resumed publication briefly between March and December 1946, it resumed continuous publication only in 1953. For convenience, the magazine is referred to herein as *Casabella*.

2. The other founding member of BBPR, Gianluigi Banfi, had died in a concentration camp in 1945.

3. Manfredo Tafuri, *Storia dell'architettura italiana 1944–1985* (History of Italian architecture 1944–1985. Turin: Einaudi, 1986), p. 116.

Franco Albini
Franco Albini and Luigi Colombini
Franco Albini and Franca Helg
Nello Aprile, Cino Calcaprina, Aldo Cardelli,
 Mario Fiorentino, and Giuseppe Perugini
Giovanni Astengo
Gae Aulenti
Gae Aulenti, Carlo Aymonino, Ezio Bonfanti,
 Cesare Macchi Cassia, Jacopo Gardella, and Steno Paciello
Carlo Aymonino
Luciano Baldessari
BBPR
Angelo Bianchetti, Gian Luigi Giordani, Marcello Nizzoli,
 and Cesare Pea
Luigi Caccia Dominioni
Guido Canella, Michele Achilli, Daniele Brigidini, and
 Laura Lazzari
Aldo Cardelli, Arrigo Carè, Giulio Ceradini,
 Mario Fiorentino, Ludovico Quaroni, and Mario Ridolfi
Luigi Cosenza
Luigi Carlo Daneri
Costantino Dardi
Giancarlo De Carlo
Vittorio De Feo and Errico Ascione
Giuseppe De Finetti
Mario De Renzi, Saverio Muratori, Lucio Cambellotti,
 Giuseppe Perugini, Dante Tassotti, and Luigi Vagnetti
Marcello D'Olivo
Luigi Figini and Gino Pollini
Roberto Gabetti and Aimaro Isola
Ignazio Gardella
Vittorio Gregotti, Franco Amoroso, Hiromichi Matsui, and
 Franco Purini
Vittorio Gregotti, Lodovico Meneghetti, and Giotto Stoppino
Vittorio Gregotti, Lodovico Meneghetti, Giotto Stoppino, and
 Peppo Brivio
Vico Magistretti
Angelo Mangiarotti
Luca Meda, Gianugo Polesello, and Aldo Rossi
Giovanni Michelucci
Carlo Mollino
Gianemilio, Piero, and Anna Monti
Riccardo Morandi
Luigi Moretti
Saverio Muratori
Pier Luigi Nervi
Pier Luigi and Antonio Nervi

Gio Ponti, Antonio Fornaroli, Alberto Rosselli,
 Giuseppe Valtolina, and Egidio Dell'Orto
Ludovico Quaroni
Ludovico Quaroni, Luigi Agati, Federico Gorio,
 Piero Maria Lugli, and Michele Valori
Ludovico Quaroni, Massimo Amodei, Roberto Berardi,
 Adolfo De Carlo, and Behamin Hagler
Ludovico Quaroni, Adolfo De Carlo, Andrea Mor, and
 Angelo Sibilla
Ludovico Quaroni, Gabriella Esposito, Marta Lonzi, and
 Antonio Quistelli
Ludovico Quaroni and Mario Ridolfi
Giorgio Raineri
Leonardo Ricci
Mario Ridolfi and Wolfgang Frankl
Mario Ridolfi, Wolfgang Frankl, and Domenico Malagricci
Umberto Riva and Fredi Drugman
Maurizio Sacripanti and Andrea Nonis
Giuseppe Samonà
Giuseppe and Alberto Samonà
Giuseppe Samonà and Egle Renata Trincanato
Leonardo Savioli, Emilio Brizzi, and Danilo Santi
Leonardo Savioli and Danilo Santi
Carlo Scarpa
Luciano Semerani and Gigetta Tamaro
Ezio Sgrelli
Ettore Sottsass, Jr.
Studio Asse
Gino Valle
Vittoriano Viganò
Marco Zanuso
Silvano Zorzi

**603. Nello Aprile,
Cino Calcaprina, Aldo Cardelli,
Mario Fiorentino, and Giuseppe
Perugini, with sculpture by
Mirko [Mirko Basaldella] and
Francesco Coccia**
*Monument to the Ardeatine caves
massacre, Rome, 1944–47. Plaster
model, fabricated in 1993 by
Domenico Annicchiarico (after a model
by Giuseppe Perugini), 10 x 74.5 x
59.5 cm. Solomon R. Guggenheim
Museum.*

**604. Nello Aprile,
Cino Calcaprina, Aldo Cardelli,
Mario Fiorentino, and Giuseppe
Perugini, with sculpture by
Mirko [Mirko Basaldella] and
Francesco Coccia**
*Monument to the Ardeatine caves
massacre, Rome, 1944–47.*

**605. BBPR
[Lodovico Barbiano di Belgiojoso,
Enrico Peressutti, and Ernesto
Nathan Rogers]**
*Monument to the fallen in German
concentration camps, Cimitero
Monumentale, Milan, 1946. Iron and
Plexiglas model, fabricated in 1993 by
Luigi Morellato, 25 x 30 x 30 cm.
Solomon R. Guggenheim Museum.*

606. Giuseppe De Finetti
*Design for Strada Lombarda, Milan,
1944–46.*

**607. Angelo Bianchetti, Gian
Luigi Giordani, Marcello Nizzoli,
and Cesare Pea**
*Diorama of the experimental quarter
QT–8, VIII Triennale, Milan, 1948.*

608. Ignazio Gardella
*House of a viticulturalist, Castana
(Pavia), 1945–46.*

**609. Aldo Cardelli, Arrigo Carè,
Giulio Ceradini, Mario
Fiorentino, Ludovico Quaroni,
and Mario Ridolfi**
*Competition project for the
passenger terminal of Stazione Termini,
Rome, 1947.*

610. Ludovico Quaroni
*Project for a church in the Prenestino
quarter, Rome, 1947.*

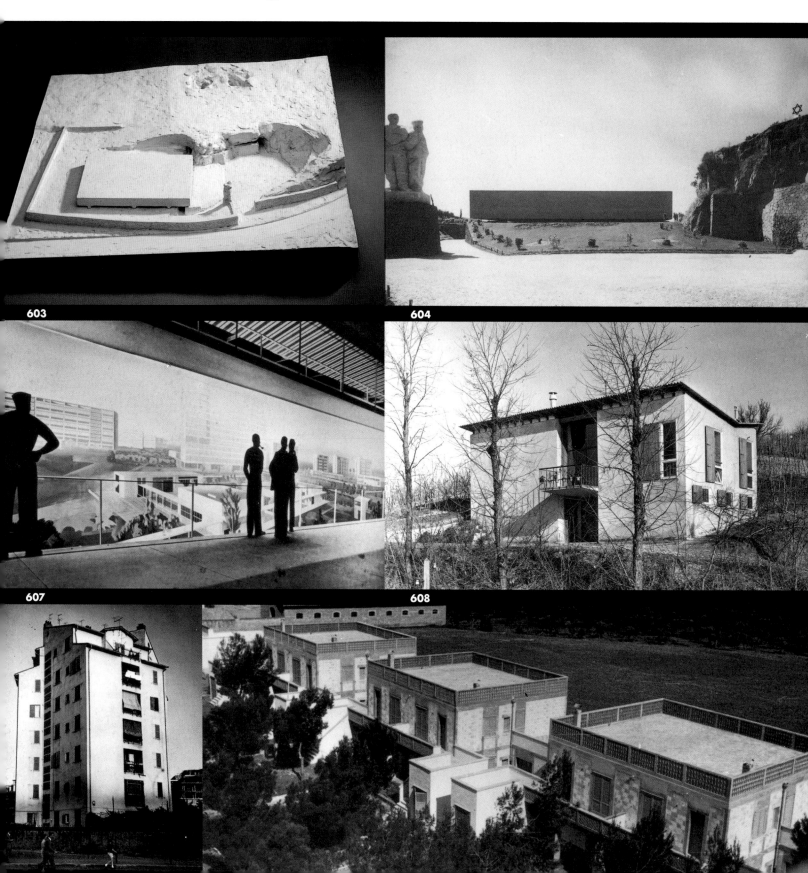

603

604

607

608

611. Ludovico Quaroni and Mario Ridolfi (team leaders), with Carlo Aymonino, Carlo Chiarini, Mario Fiorentino, Federico Gorio, Maurizio Lanza, Sergio Lenci, Piero Maria Lugli, Carlo Melograni, Giancarlo Menichetti, Giulio Rinaldi, and Michele Valori
INA–Casa complex on via Tiburtino, Rome, 1949–54.

612. Mario Ridolfi and Wolfgang Frankl
INA–Casa complex, Cerignola, 1950.

613. Carlo Mollino
Lago Nero sled-lift lodge, Salice d'Ulzio, 1946–47. Wood model, fabricated in 1993 by Falco and Boulanger, 17.5 x 40 x 30 cm. Solomon R. Guggenheim Museum.

614. Mario Ridolfi and Wolfgang Frankl
INA–Assicurazioni residential towers on viale Etiopia, Rome, 1950–54.

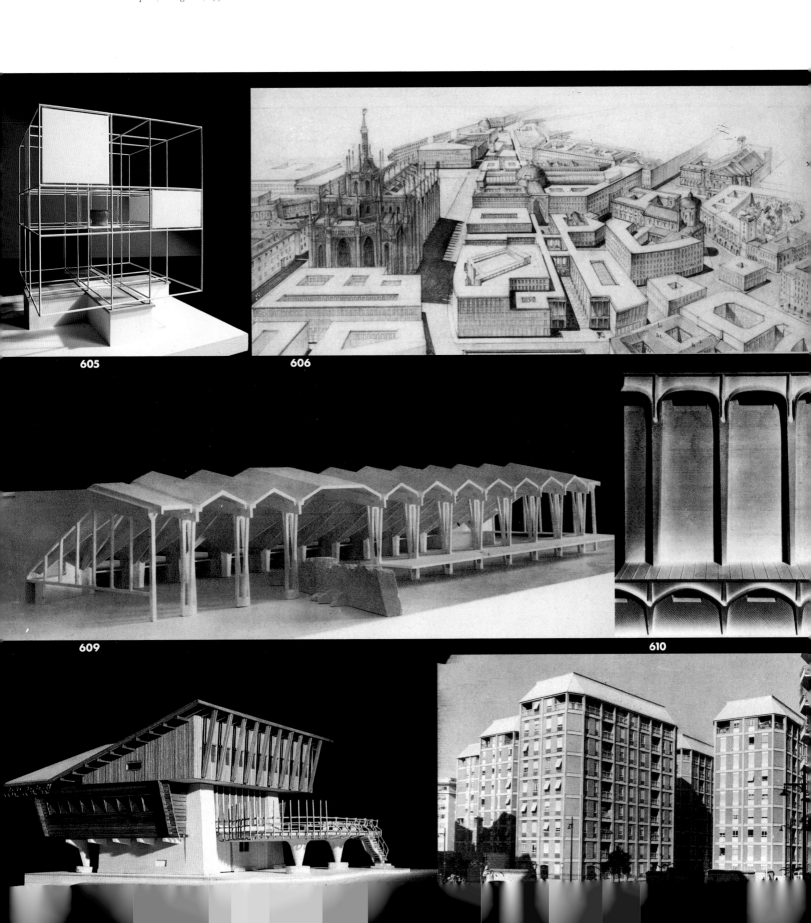

605

606

609

610

615. Mario Ridolfi and Wolfgang Frankl
Palazzina on via Marco Polo, Rome, 1952. Wood model, fabricated in 1993 by Igor Silic, 22 x 32 x 32 cm. Solomon R. Guggenheim Museum.

616. Giovanni Astengo (team leader), with Sandro Molli-Boffa, Mario Passanti, Nello Renacco, and Aldo Rizzotti
La Falchera quarter, Turin, ca. 1950.

617. Mario De Renzi, Saverio Muratori, Lucio Cambellotti, Giuseppe Perugini, Dante Tassotti, and Luigi Vagnetti
Tuscolano quarter, Rome, 1952–55.

618. Ludovico Quaroni, Luigi Agati, Federico Gorio, Piero Maria Lugli, and Michele Valori
La Martella village, Matera, 1951–54.

619. Ludovico Quaroni
Church of the village of La Martella, Matera, 1951–54.

620. Luigi Moretti
Residential building, Milan, 1948–50.

621. Luigi Figini and Gino Pollini
Office and apartment building on via Broletto, Milan, 1947–48.

622. Luigi Figini and Gino Pollini
Building in Harar quarter, Milan, 1951.

623. Giovanni Michelucci
Mercantile exchange, Pistoia, 1949–50.

624. Luciano Baldessari
Installation of artworks, including cirrus-shaped neon structure by Lucio Fontana, in the scalone d'onore (grand staircase of honor) of the Palazzo dell'Arte, IX Triennale, Milan, 1951.

625. Luciano Baldessari
Breda pavilion at the XXX Fiera Internazionale, Milan, 1952.

626. Franco Albini and Luigi Colombini
Pirovano lodge, Cervinia, 1949–51.

627. Franco Albini
INA office building, Parma, 1950–52.

628. Franco Albini
Installation of Palazzo Bianco museum, Genoa, 1950–51.

629. Ignazio Gardella
Regina Isabella baths, Lacco Ameno, Ischia, 1950–53.

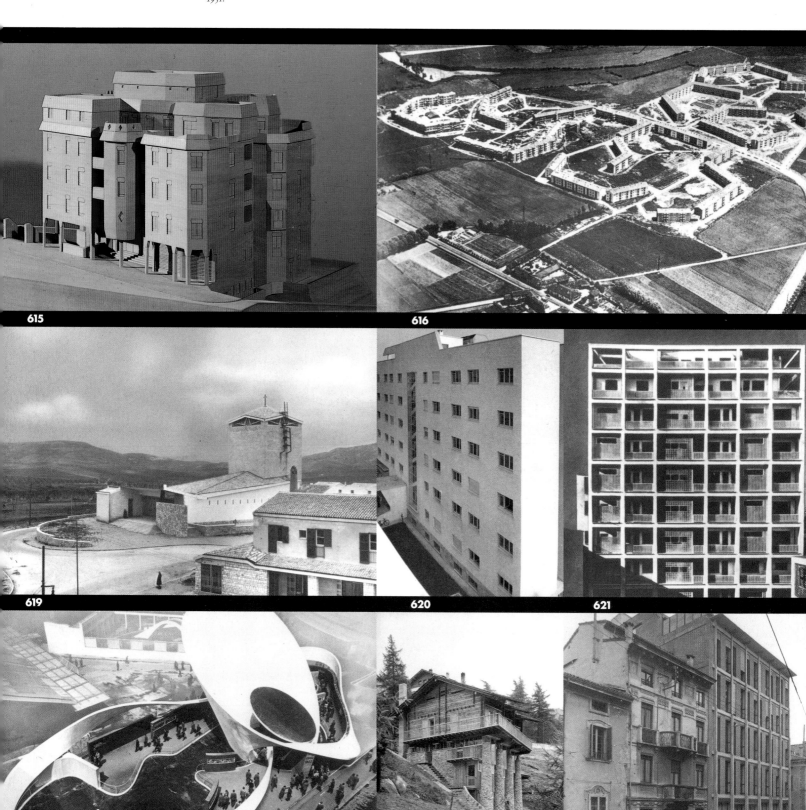

615

616

619

620

621

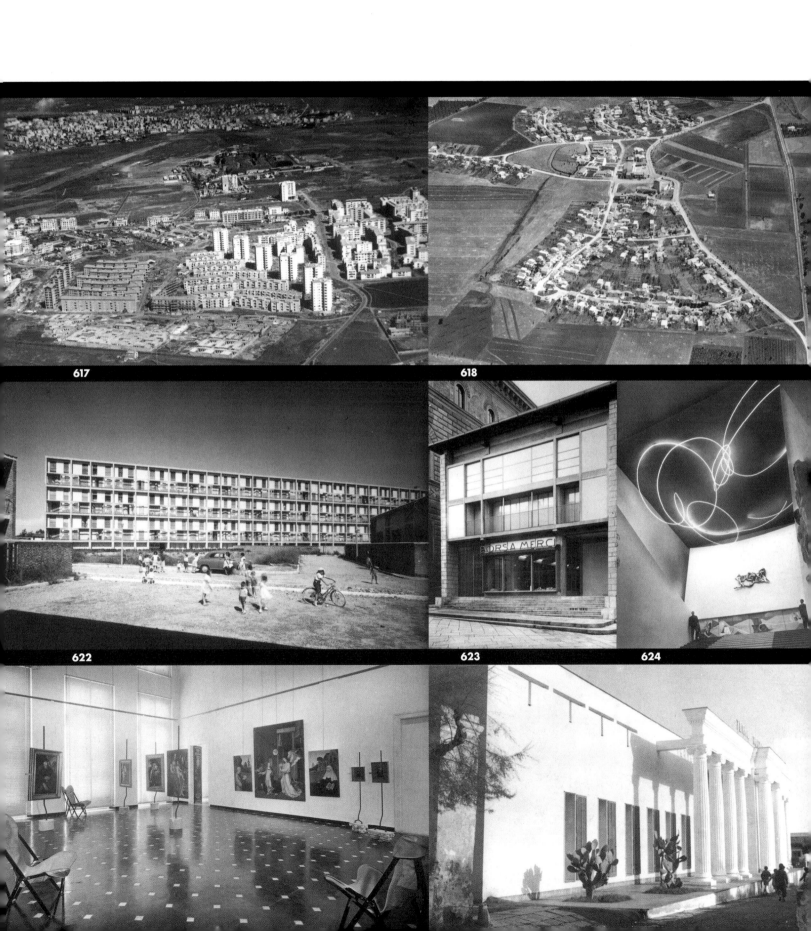

617

618

622

623

624

630. Franco Albini and Franca Helg
Treasury museum of San Lorenzo, Genoa, 1952–56. Wood, cardboard, Plexiglas, plaster, and felt model, 29 x 125 x 82 cm. Centro Studi e Archivio della Comunicazione, Università degli Studi di Parma, Sezione Progetto.

631. Franco Albini and Franca Helg
Treasury museum of San Lorenzo, Genoa, 1952–56.

632. Luigi Figini and Gino Pollini
Church of the Madonna dei Poveri, Milan, 1952–54.

633. Luigi Figini and Gino Pollini
Olivetti complex of social buildings, Ivrea, 1954–57.

634. Luigi Cosenza, with Piero Porcinai (landscape architect) and Marcello Nizzoli (color designer)
Olivetti factory, Pozzuoli, commenced 1951.

635. Luigi Figini and Gino Pollini
Olivetti complex of social buildings, Ivrea, 1954–57. Wood model, fabricated in 1993 by Igor Silic, 16 x 70 x 30 cm. Collection of Marilisa and Maurizio Pollini, Milan.

636. Mario Ridolfi and Wolfgang Frankl
Nursery school in the Canton Vesco quarter, Ivrea, 1955–63.

637. Ignazio Gardella
Cafeteria for Olivetti employees, Ivrea, 1955–59.

638. Luigi Caccia Dominioni
Beata Vergine Addolorata convent and girls' school, Milan, 1946–54.

639. Luigi Caccia Dominioni
Loro Parisini office building, Milan, 1955. Wood model, fabricated in 1993 by Studio Guzzetti, 11 x 90 x 25 cm. Solomon R. Guggenheim Museum.

640. Luigi Caccia Dominioni
Loro Parisini office building, Milan, 1955.

641. Ignazio Gardella
Residential building for Borsalino employees, Alessandria, 1950–52. Wood model, fabricated in 1991 by Gianni Testi, 36 x 91 x 60 cm. Istituto Universitario di Architettura di Venezia, Archivio Progetti Angelo Masieri.

630

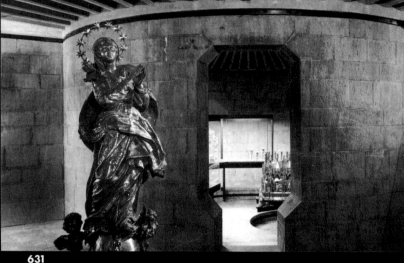

631

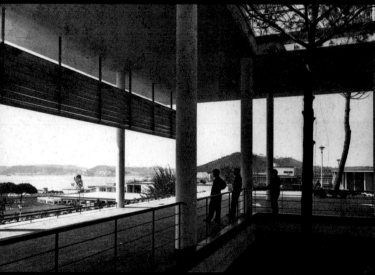

634

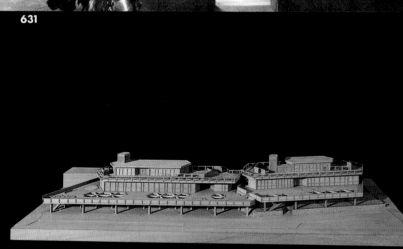

635

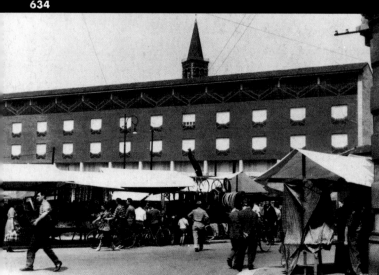

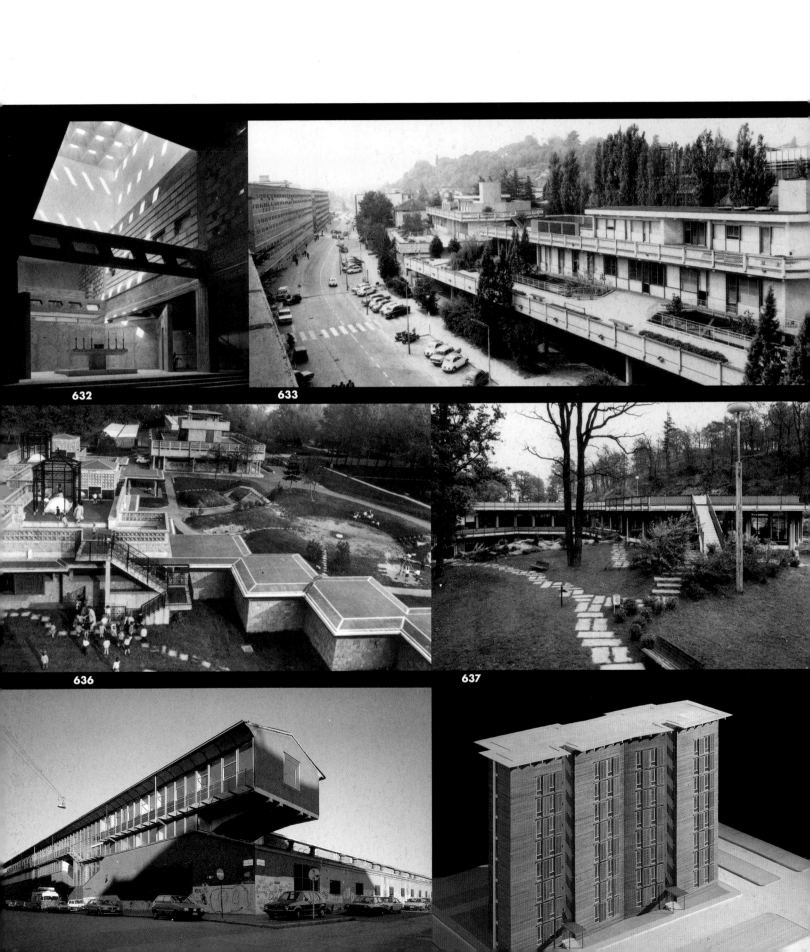

632

633

636

637

642. Ignazio Gardella
Residential building for Borsalino employees, Alessandria, 1950–52.

643. Roberto Gabetti and Aimaro Isola
Bottega d'Erasmo, Turin, 1953–54.

644. Luigi Caccia Dominioni
Apartment house in piazza Carbonari, Milan, 1960–61.

645. Giorgio Raineri
Addition to the school of the Gesù Bambino institute, Turin, 1957–58.

646. Saverio Muratori
ENPAS office building, Bologna, 1952–57. Wood model, fabricated in 1993 by Igor Silic, 24 x 41.5 x 20 cm. Solomon R. Guggenheim Museum.

647. Gae Aulenti
Villa in San Siro, Milan, 1957.

648. Roberto Gabetti and Aimaro Isola, with Giuseppe Raineri (structural engineer)
New center for the Turin riding club, Nichelino (Turin), 1959–61. Wood model, 12 x 33 x 45 cm. Archivio Gabetti e Isola.

649. Roberto Gabetti and Aimaro Isola, with Giuseppe Raineri (structural engineer)
New center for the Turin riding club, Nichelino (Turin), 1959–61.

650. Vittorio Gregotti, Lodovico Meneghetti, and Giotto Stoppino
Office building, Novara, 1957.

651. Vittorio Gregotti, Lodovico Meneghetti, and Giotto Stoppino
Residential building for Bossi textile industry workers, Cameri, 1953–56.

652. Giorgio Raineri
Novitiate of the Sisters of Charity, Turin, 1962. Wood model, 14 x 36 x 36 cm. Archivio Giorgio Raineri.

653. Giorgio Raineri
Novitiate of the Sisters of Charity, Turin, 1962.

654. Ignazio Gardella
Cicogna house on the Zattere, Venice, 1953–58.

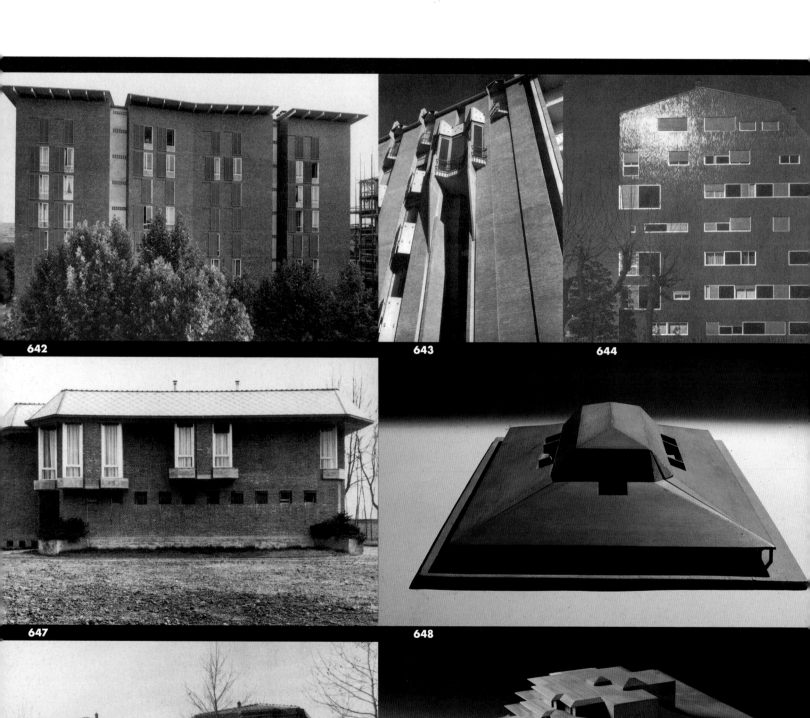

642 643 644

647 648

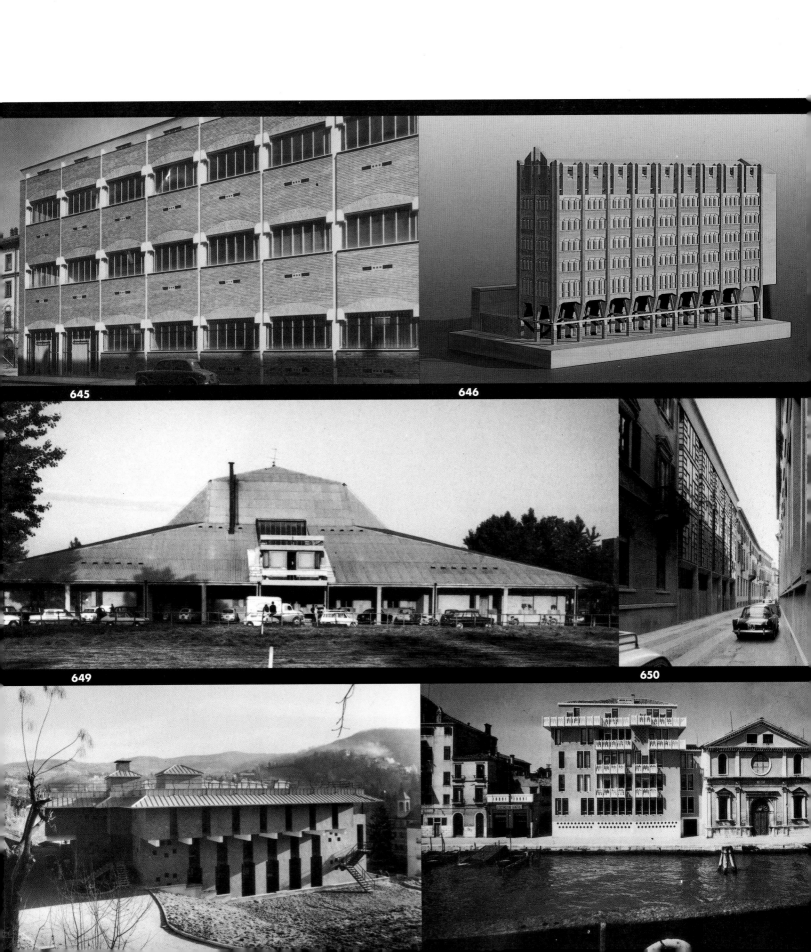

645

646

649

650

655. Giancarlo De Carlo
Building for apartments and stores in the Spine Bianche quarter, Matera, 1954–57.

**656. BBPR
[Lodovico Barbiano di Belgiojoso, Enrico Peressutti, and Ernesto Nathan Rogers]**
Torre Velasca, Milan, 1950–58. Wood model, fabricated in 1973 by Luigi Morellato, 120 x 105 x 105 cm. Studio Architetti BBPR, Milan.

**657. BBPR
[Lodovico Barbiano di Belgiojoso, Enrico Peressutti, and Ernesto Nathan Rogers]**
Torre Velasca, Milan, 1950–58.

**658. BBPR
[Lodovico Barbiano di Belgiojoso, Enrico Peressutti, and Ernesto Nathan Rogers]**
Renovation and installation of the museums of Castello Sforzesco, Milan, 1954–56.

659. Franco Albini and Franca Helg
La Rinascente department store, Rome, 1957–61, model of the first project.

660. Franco Albini and Franca Helg
La Rinascente department store, Rome, 1957–61.

661. Ludovico Quaroni (team leader), with Massimo Boschetti, Adolfo De Carlo, Gabriella Esposito, Luciano Giovannini, Aldo Livadiotti, Luciana Menozzi, Ted Musho, and Alberto Polizzi
Competition project for the CEP quarter on the sandbanks of San Giuliano, Mestre, 1959.

662. Ludovico Quaroni, Adolfo De Carlo, Andrea Mor, and Angelo Sibilla
Church of the Sacra Famiglia, Genoa, 1956.

663. Giuseppe Samonà
Palazzata on the sea building, Messina, 1953–58.

664. Giuseppe Samonà and Egle Renata Trincanato
INAIL office building in San Simeone, Venice, 1950–56.

665. Pier Luigi Nervi
Exhibition pavilion at Parco del Valentino, Turin, 1948.

666. Pier Luigi and Antonio Nervi
Palazzo del Lavoro (palace of work), Esposizione Italia '61, Turin, 1959–60.

667. Vittorio Gregotti, Lodovico Meneghetti, and Giotto Stoppino
Apartment building, Novara, 1957.

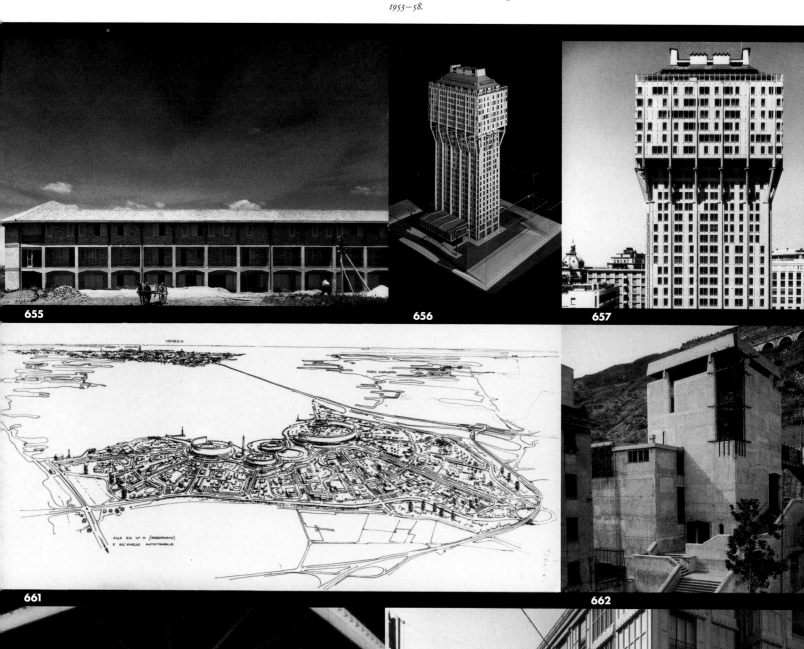

655

656

657

661

662

668. Silvano Zorzi
*Bridge over the Arno river on the
Autostrada del Sole, Incisa (Florence),
1962.*

669. Riccardo Morandi
*Viaduct over Polcevera, Genoa,
1962–67.*

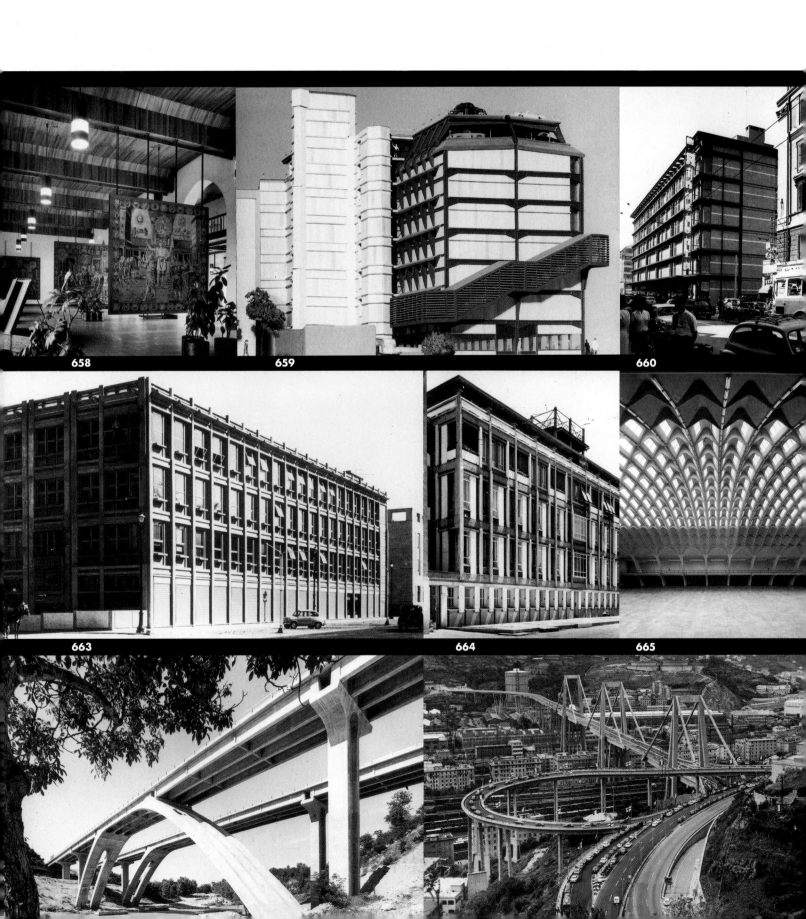

658 659 660

663 664 665

670. Riccardo Morandi
Viaduct over the Maracanà lagoon, Maracaibo, Venezuela, 1957–61.

671. Angelo Mangiarotti
Prefabricated-structure warehouse, Mestre, 1963.

672. Gino Valle
Zanussi office building, Porcia (Pordenone), 1959–61. Wood model, fabricated in 1994 by Igor Silic, 14 x 74 x 28.2 cm. Collection of the architect.

673. Gino Valle
Prefabricated-panel factory building for Zanussi, Porcia (Pordenone), 1963–64.

674. Gio Ponti, Antonio Fornaroli, Alberto Rosselli, Giuseppe Valtolina, and Egidio Dell'Orto, with Pier Luigi Nervi and Arturo Danusso (structural engineers)
Pirelli skyscraper, Milan, 1956–61. Wood model, fabricated in 1993 by Igor Silic, 32 x 32.5 x 28 cm. Regione Lombardia.

675. Vittoriano Viganò
Headquarters for the combined Marchiondi Spagliardi and child welfare institutes, Milan, 1953–57. Bakelite model, fabricated in 1954, 25 x 20 x 25 cm. Collection of the architect.

676. Vittoriano Viganò
Headquarters for the combined Marchiondi Spagliardi and child welfare institutes, Milan, 1953–57.

677. Umberto Riva and Fredi Drugman
Vacation house, Tonnare di Stintino, 1959–60.

678. Ezio Sgrelli
Montedison office building, Brindisi, 1961–64.

679. Vico Magistretti
House on via Conservatorio, Milan, 1966.

680. Gianemilio, Piero, and Anna Monti
Commercial building, Pugnochiuso di Vieste (Foggia), 1967.

681. Marco Zanuso
Olivetti factory, São Paulo, Brazil, 1954–59.

682. Marco Zanuso
Olivetti factory, Buenos Aires, 1954–62.

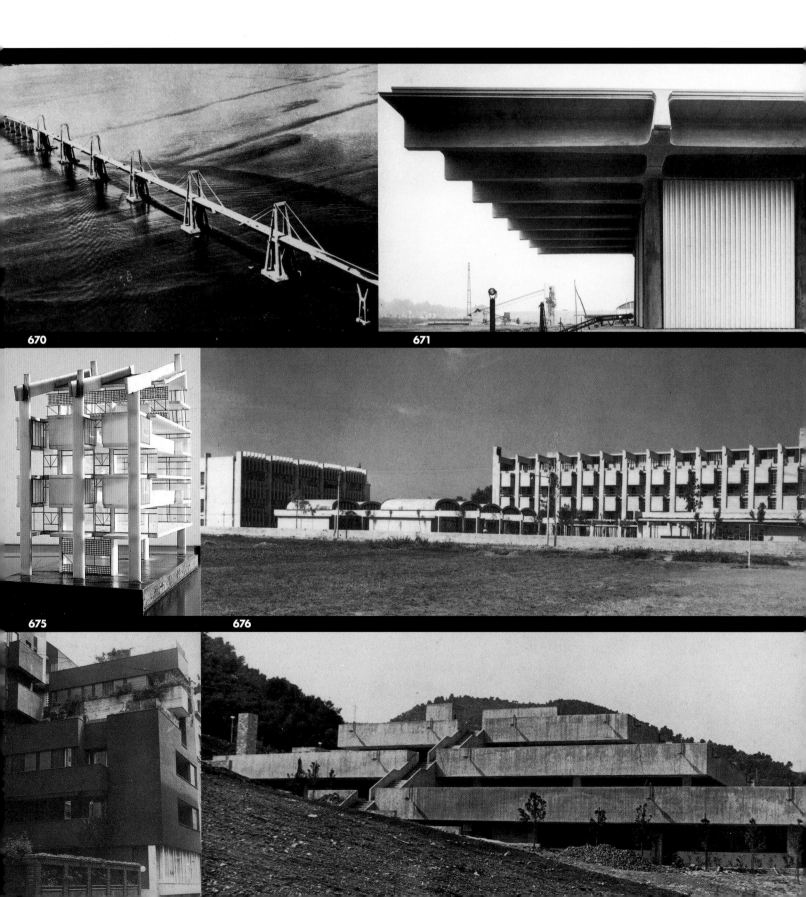

670

671

675

676

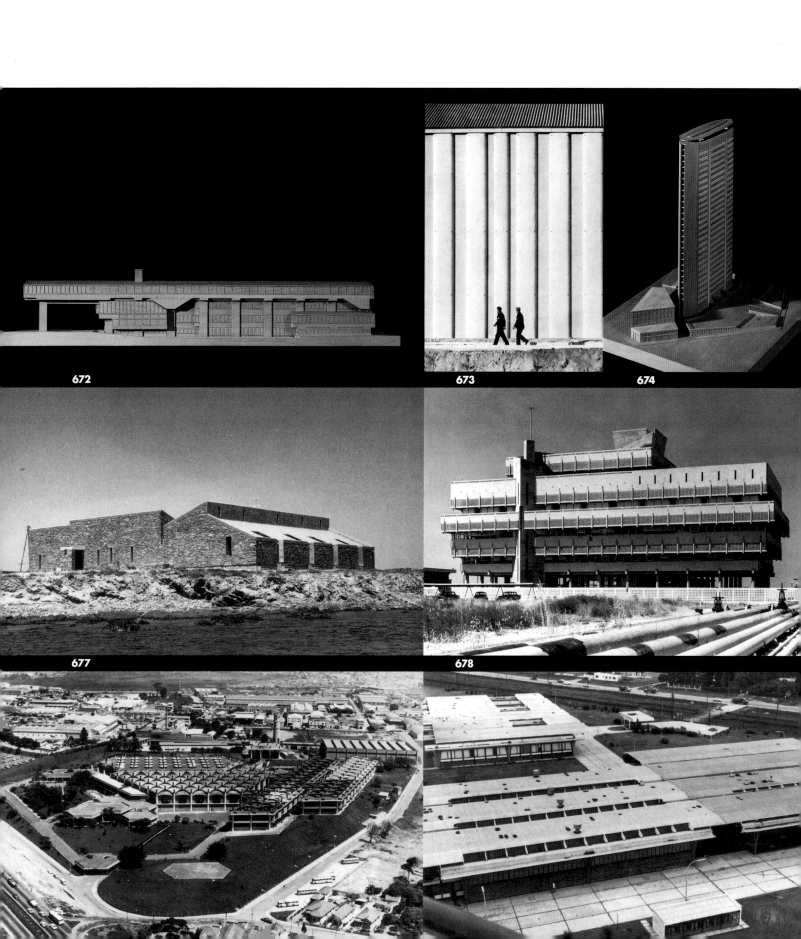

672

673

674

677

678

683. Marco Zanuso
Olivetti factory, Buenos Aires, 1954–62. Plexiglas model, fabricated in 1993 by Luigi Morellato, 18 x 98 x 35 cm. Solomon R. Guggenheim Museum.

684. Marco Zanuso
Olivetti factory, Buenos Aires, 1954–62.

685. Giovanni Michelucci
Church of San Giovanni Battista on the Autostrada del Sole, Campi Bisenzio (Florence), 1960–64. Bronze model, 29 x 78.5 x 58 cm. Centro di Documentazione Giovanni Michelucci, Pistoia.

686. Giovanni Michelucci
Church of San Giovanni Battista on the Autostrada del Sole, Campi Bisenzio (Florence), 1960–64.

687. Leonardo Ricci
Nursery school in the Monte degli Ulivi community, Riesi, 1963–66.

688. Leonardo Ricci
Apartment building in the Sorgane quarter, Bagno a Ripoli (Florence), 1963–66.

689. Leonardo Ricci
Casa Balmain, Elba, 1958. Wood model, 22 x 104 x 64 cm. Collection of the architect.

690. Leonardo Ricci
Casa Balmain, Elba, 1958.

691. Leonardo Savioli and Danilo Santi
Apartment house on via Piagentina, Florence, 1964.

692. Leonardo Savioli, Emilio Brizzi, and Danilo Santi
Enlargement of the municipal cemetery, Montecatini Alto, 1966–68. Wood model, 20 x 71 x 110 cm. Collection of Flora Savioli.

693. Leonardo Savioli, Emilio Brizzi, and Danilo Santi
Enlargement of the municipal cemetery, Montecatini Alto, 1966–68.

694. Carlo Scarpa
Venezuelan pavilion at the Giardini della Biennale di Venezia, 1954–56.

695. Carlo Scarpa
Veritti house, Udine, 1955–61. Wood model, fabricated in 1984 by Igor Silic, 16 x 27 x 41 cm. Collection of Onorina Brion.

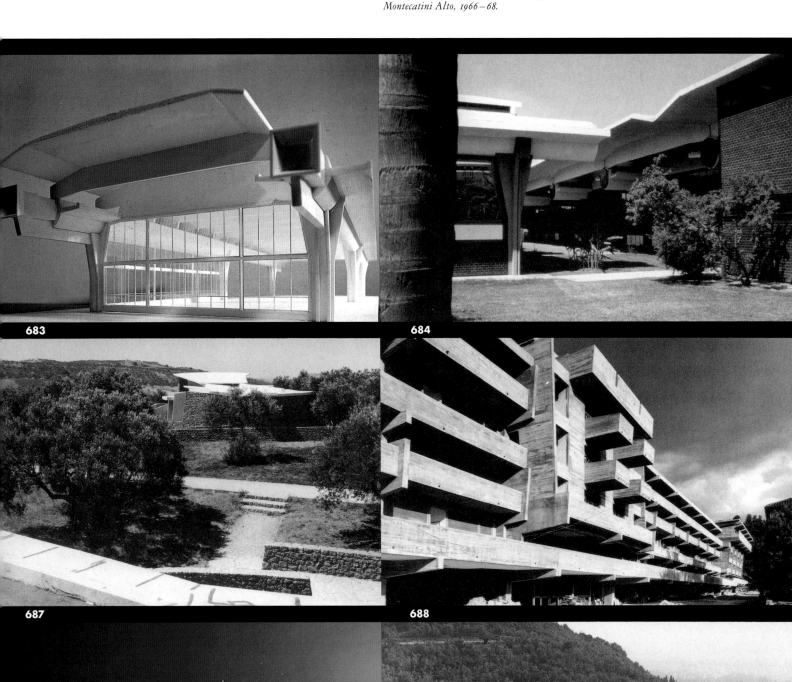

683

684

687

688

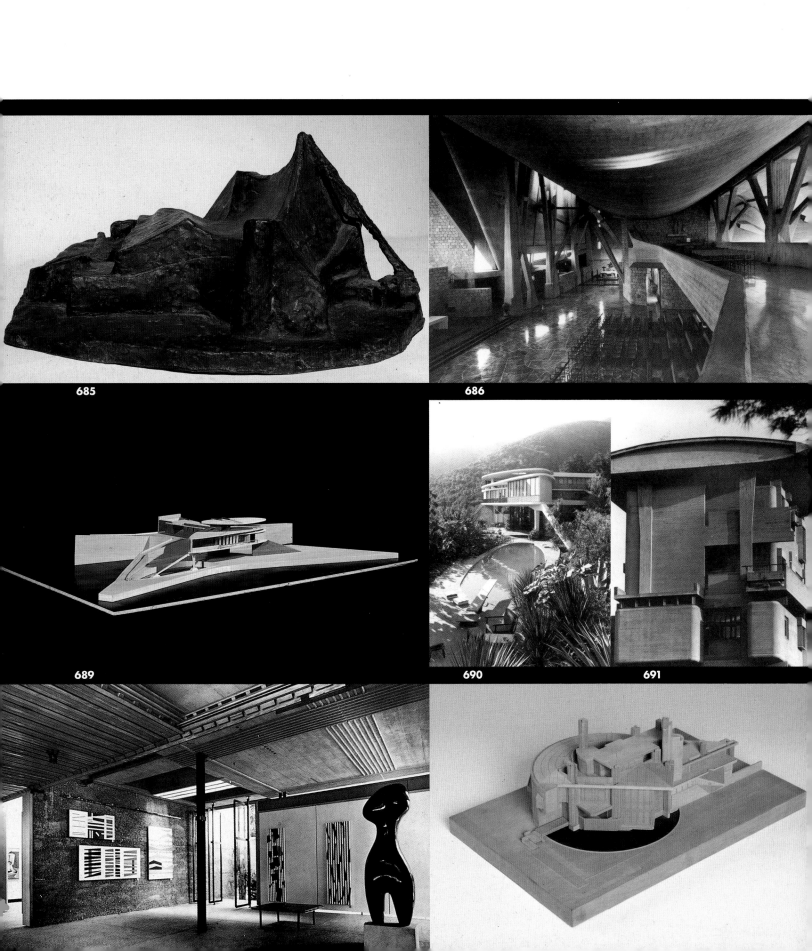

685

686

689

690

691

696. Carlo Scarpa
Veritti house, Udine, 1955–61.

697. Carlo Scarpa
Restoration and installation of the Castelvecchio museum, Verona, 1956–67.

698. Carlo Scarpa
Olivetti store in Piazza San Marco, Venice, 1957–58.

699. Marcello D'Olivo
Urban plan of Lignano Pineta, 1953–56.

700. Marcello D'Olivo
Hotel Gusmay, Manacore sul Gargano, 1963–64.

701. Franco Albini and Franca Helg, with Bob Noorda (graphic designer)
Line 1 stations of the Metropolitana subway system, Milan, 1962–64.

702. Ettore Sottsass, Jr.
Entrance to the XII Triennale, Milan, 1962–64.

703. Vittorio Gregotti, Lodovico Meneghetti, Giotto Stoppino, and Peppo Brivio
Kaleidoscope room, XII Triennale, Milan, 1964.

704. Luca Meda, Gianugo Polesello, and Aldo Rossi
Competition project for the business district, Turin, 1962.

705. Gae Aulenti, Carlo Aymonino, Ezio Bonfanti, Cesare Macchi Cassia, Jacopo Gardella, and Steno Paciello, with Antonio Ghirelli (design collaborator)
L'arrivo al mare (The arrival at the sea), display for the Italian section, dedicated to "Leisure Time and Water," XIII Triennale, Milan, 1964.

706. Giuseppe Samonà (team leader), with Costantino Dardi, Luigi Mattioni, Valeriano Pastor, Gianugo Polesello, Gigetta Tamaro, Luciano Semerani, and Egle Renata Trincanato
Novissime project for the Tronchetto inlet, Venice, 1964.

707. Ludovico Quaroni, Gabriella Esposito, Marta Lonzi, and Antonio Quistelli
Competition project for the new offices of the Chamber of Deputies, Rome, 1967.

696

697

701

702

703

708. Ludovico Quaroni, Massimo Amodei, Roberto Berardi, Adolfo De Carlo, and Behamin Hagler
Project for a government center at the Kasbah, Tunis, 1965.

709. Giuseppe and Alberto Samonà
Competition project for the new offices of the Chamber of Deputies, Rome, 1967. Plaster model, 26 x 65.5 x 41 cm. Centro Studi e Archivio della Comunicazione, Università degli Studi di Parma, Sezione Progetto.

710. Costantino Dardi
Competition project for the new office center of the Chamber of Deputies, Rome, 1967.

711. Costantino Dardi
Competition project for the new office center of the Chamber of Deputies, Rome, 1967.

712. Maurizio Sacripanti and Andrea Nonis
Competition project for the new civic museum, Padua, 1967.

713. Giancarlo De Carlo
First complex of university dormitories, Urbino, 1962–66.

714. Guido Canella, Michele Achilli, Daniele Brigidini, and Laura Lazzari
Town hall, Segrate, 1963–66. Wood model, fabricated in 1993 by Studio Canella, 30 x 60 x 40 cm. Archivio Guido Canella.

715. Luigi Carlo Daneri, with Claudio Andreani, Eugenio Fuselli, Mario Pateri, Gustavo Pulitzer, Robaldo Morozzo dalla Rocca, and Antonio Sibilla (team leaders)
INA–Casa complex for 4,500 people at Forte Quezzi, Genoa, 1956–58.

716. Mario Ridolfi, Wolfgang Frankl, and Domenico Malagricci
Project for an AGIP motel, Settebagni (Rome), 1968.

717. Studio Asse
[Vicio Delleani; Mario Fiorentino; Riccardo Morandi; Fausto, Vincenzo, and Lucio Passarelli; Ludovico Quaroni; and Bruno Zevi; with Gabriele Scimemi, consultant]
Proposal for the business district in Rome, 1967–70.

718. Vittorio De Feo and Errico Ascione
Project for the Giuliano da Sangallo technical institute, Terni, 1968–69.

719. Roberto Gabetti and Aimaro Isola with Luciano Re
Olivetti residential center, Ivrea, 1969–71.

720. Luciano Semerani and Gigetta Tamaro (team leaders)
Competition project for the historical center of Trieste, 1969.

721. Carlo Aymonino
Monte Amiata residential complex in Gallaratese, Milan, 1967–74; including a building by Aldo Rossi, 1969–73. Wood model, fabricated in 1993 by Geneviève Hanssen, Studio Aymonino, 15 x 70 x 60 cm. Solomon R. Guggenheim Museum.

711

712

715

716

717

722. Vittorio Gregotti, Franco Amoroso, Hiromichi Matsui, and Franco Purini
Competition project for residential quarter for 20,000 inhabitants (ZEN), Palermo, 1969. Wood model, 11 x 79 x 159 cm. Archivio Gregotti Associati.

723. Vittorio Gregotti, Franco Amoroso, Hiromichi Matsui, and Franco Purini
Residential quarter (ZEN), Palermo, 1969–73.

713

714

718

719

722

723

Rebuilding the House of Man

Dennis Doordan

The January 1946 issue of *Domus* magazine opened with an editorial statement by its new editor, Ernesto Nathan Rogers: "On every side the house of man is cracked," he wrote.[1] His image of a house open to the winds and filled with nothing but the "laments of women and children"[2] evokes an Italy devastated morally as well as physically by war. As he would do so often over the course of the next decades, Rogers spoke for an entire generation of Italian architects when he proposed to rebuild the "house of man" in a way that would reshape Italian society: "It is a matter of forming a style, a technique, a morality as terms of a single function. It is a matter of building a society."[3]

In the early 1950s Italian efforts to rebuild received positive reviews from abroad. After a 1951 visit to Italy Walter Gropius wrote to the Milanese architect Piero Bottoni: "I have been through six countries in Europe, but nowhere have I seen so much drive from the cultural point of view as in Italy. It is a strange fact that after wars all of a sudden some nations rise in their cultural attitudes, and Italy seems to be definitely in the foreground."[4] Within a decade, however, the optimism of the initial postwar period had begun to fade. Increasingly, Italian architects and critics spoke of an "atmosphere of disenchantment" and an "uneasiness" with the condition of architecture and urbanism throughout the peninsula.[5] By the late 1960s the rebellious demands of students, workers, and a new generation of designers had replaced the "laments of women and children" that Rogers had urged his colleagues to heed.

The frustration and disillusionment of the late 1960s set the tone for studies of postwar architecture produced by Italian historians and critics. Today, the act of reflecting on the significance of the alleged "failures" of postwar Italian architects to, in Rogers's evocative words, repair the house of man unfolds in a very different intellectual climate. In this era of skepticism regarding the doctrinal rigidity of the Modernist movement in architecture, it is easier for us to concede that diversity is a sign of vitality than it was for historians writing only a few short years ago. A critical analysis of the debates concerning design theory and the constituent elements of architectural production in Italy between 1943 and 1968 reveals an architectural culture of unusual sophistication and subtlety. From the vantage point of the 1990s, it is possible to recognize that what was perceived by many Italians as a record of failures and frustrations was really one of the first sustained postwar challenges to the hegemony of Modernist models.

The immediate postwar years constituted a period of remembrance and reconstruction. In August 1944 German troops withdrawing from Florence had destroyed five of the six bridges spanning the Arno river, including Bartolomeo Ammannati's Renaissance masterpiece, the Ponte Santa Trinità. Perversely, they left the medieval Ponte Vecchio intact. In order to deny the approaching Allied forces the use of the bridge, however, the Germans dynamited the buildings lining the approaches at either end. With the cessation of hostilities, discussions were begun concerning plans or rebuilding the devastated parts of the *centro storico* (historic center). At issue was a question destined to become one of the central themes in postwar European discussions of architecture: What is the proper relationship between new designs and historic surroundings? In Italy,

one faction advocated the exact reconstruction of the destroyed buildings with the slogan, *Dove erano e come erano* (Where they were and how they were). Another side replied, *Indietro non si torna* (You can't go back), and argued for a modern reconfiguration of the damaged areas as an integral part of a new masterplan for the entire city.[6]

As rebuilt, the bridges and streets of central Florence are the product of a compromise. Ammannati's Ponte Santa Trinità was meticulously reconstructed, while other spans were replaced by new bridge designs. Along the streets leading to the Ponte Vecchio, traditional materials and textures, particularly at street level, evoked the character of the old neighborhood and masked new structural and mechanical systems within (see fig. 1). Progressive Italian architects considered the rebuilding of Florence (and also parts of central Milan) a "lost opportunity" to reconfigure the country according to their own Modernist visions.[7] Today, such an assessment appears too harsh; we have grown to appreciate sensitive responses to context as much as we once admired bold departures from precedent. The rebuilding of the center of Florence should be recognized as a commendable solution to the problem of repairing a historic urban fabric devastated by war.[8]

Also on the public design agenda in the immediate aftermath of the war was the question of memorials to the victims of the war, the Resistance struggle, and the Nazi–Fascist terror campaigns. In Milan, the architectural firm BBPR (Lodovico Barbiano di Belgiojoso, Enrico Peressutti, and Rogers [the other founding member, Gianluigi Banfi, had died in a concentration camp in 1945]) designed a memorial for those who perished in Nazi concentration camps (1946, fig. 2, cat. no. 605). A metal framework, proportioned according to the golden section, delineates a simple cubic volume. In the center, a second, smaller volume holds an urn containing ashes from different concentration camps. The gridded, transparent volume of the memorial reaffirmed the commitment of the BBPR studio to the design principles of the prewar Rationalist movement.[9]

The Roman equivalent of the Milanese memorial is the monument to the victims of the Ardeatine caves massacre (1944–47, fig. 3, cat. nos. 603, 604). In March 1944 German troops executed 385 Roman prisoners in the caves located on the outskirts of the city. The murders were in reprisal for a partisan attack on German troops stationed in the city. Within weeks of the liberation of Rome, a competition was announced for the design of a memorial to the victims.[10] A team headed by Mario Fiorentino and Giuseppe Perugini received the commission.[11] Their design calls upon the visitor to retrace the steps of the condemned men through the caves before exiting into the *sacrario* (shrine) containing the victims' tombs. The sacrario is covered by a huge cement-and-stone lid measuring 25 by 50 meters and over 3.5 meters deep. Six slender concrete piers lift this lid off the bermed walls of the enclosure, thus creating a narrow open clerestory along the perimeter. Suggestive of the subterranean space of the cave, the dimly lighted interior of the sacrario and the ponderous form of the monument's covering evoke the crushing finality of death. But the slim band of natural light visible around the periphery of the sacrario prevents the massive lid from sealing the memorial forever. This fragile band of light

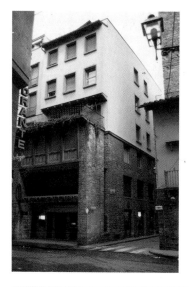

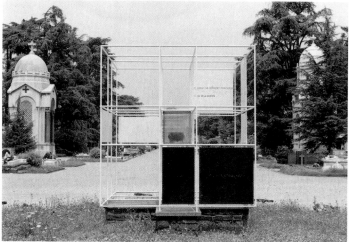

fig. 1. Edoardo Detti, Riccardo Gizdulich, and Italo Gamberini, Reconstructed building on the via di Por Santa Maria in the centro storico, *Florence, 1947–50.*

fig. 2. BBPR {Lodovico Barbiano di Belgiojoso, Enrico Peressutti, and Ernesto Nathan Rogers}, Monument to the fallen in the German concentration camps, Cimitero Monumentale, Milan, 1946.

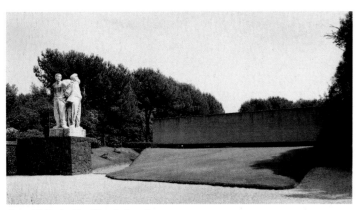

fig. 3. Nello Aprile, Cino Calcaprina, Aldo Cardelli, Mario Fiorentino, and Giuseppe Perugini, with sculpture by Mirko {Mirko Basaldella} and Francesco Coccia, Monument to the Ardeatine caves massacre, Rome, 1944–47.

serves as the postwar equivalent to the rainbow that appeared after the biblical flood: a symbol of hope for those who survived and a promise to those who perished that they will not be forgotten.

The difference between the cerebral abstraction of the Milanese memorial and the visceral impact of the Roman monument reflects the different design sensibilities evident in the architectural cultures of these two Italian centers. Diversity, not uniformity, would prove to be the hallmark of Italian architecture in the postwar years. This diversity is evident in the discussions of theory as well.

Numerous Italian architects in the mid-1940s faced an ideological and professional crisis. In the 1930s the attempt by progressive architects to integrate political and architectural ideologies led them to identify Rationalism in design and Fascism in politics as twin revolutionary movements destined to transform society.[12] The collapse of Fascism revealed this perceived affinity to be an illusion and forced many architects to reconsider the principles on which they based their practice. At the same time, the level of horror made possible by military technology compelled many architects (along with the rest of society) to question their faith in modern technology as the ultimate answer to problems confronting society. Three emergent trends can be discerned in Italian architectural culture of the period: neorealism, organicism, and Rationalism.

Neorealism was a pervasive presence in postwar Italian culture.[13] Neorealist architecture involved, among other things, the explicit rejection of classical models and of the cultural elitism associated with classicizing tendencies. A new sense of an elemental human solidarity, one capable of transcending regional and class divisions, found its architectural reification in forms derived from the anonymous tradition of rural building. Modern architects began to appreciate Italy's rich heritage of folk architecture in the late 1930s, but the neorealist sensibility invested the simplicity and enduring quality of rural buildings with a new moral and political significance.

Although the origins of neorealism can be traced back to the prewar era, the organic movement constituted a novel development in Italian architecture. The animating force within the organic movement was Bruno Zevi. In 1945 Zevi founded the APAO (Associazione per l'Architettura Organica/Association for Organic Architecture). The APAO manifesto defined organic architecture as "a social, technical, and artistic activity, directed toward creating the climate for a new democratic civilization."[14] The organic architecture of Frank Lloyd Wright served as Zevi's model for the "new democratic civilization." Zevi had acquired his enthusiasm for Wright during his student days in America and, upon his return to Italy, became a tireless advocate of Wrightian principles.

Wright's appeal for Italian architects in the 1940s and early 1950s was as complex as it was improbable. Many, including Zevi, saw the variety inherent in Wright's organic architecture as a viable design alternative to the normative Rationalism characteristic of Central European Modernism. While Wright's vision of Broadacre City was completely alien to Italian settlement patterns and urban traditions, his democratic idealism was an attractive, indeed inspirational, alternative to the totalitarian

philosophies of both the political Right and Left. Wright's own turbulent career reaffirmed the romantic ideal of the heroic artist capable of redemption through creation. Wright had proved it was possible to survive adversity; his work transcended the circumstantial, nurtured profound human experiences, and articulated universally shared aspirations. For many Italian architects still recovering from the trauma of war, Wright's life and work seemed to articulate, if not always resolve, many of the dilemmas they confronted.

Translating Wrightian principles into Italian forms proved to be problematic. The Tiburtino quarter (1949–54, figs. 4, 5, cat. no. 611), a housing complex on the outskirts of Rome, is an excellent example of the interweaving of neorealist attitudes and organic principles at work in Roman architecture. Tiburtino was designed by a group of Roman architects headed by Ludovico Quaroni and Mario Ridolfi with Carlo Aymonino.[15] In his account of the project, Aymonino described the intention behind the design: "From the beginning of the design of the *quartiere*, the idea was accepted to reject a composition of the rationalist type."[16]

The philosophy that guided the designers emerged directly from the discussions of organic architecture, initiated in Rome in 1944 and 1945, in which most of the members of the group participated. They deliberately sought an alternative to the planning models popularized by the CIAM (Congrès Internationaux d'Architecture Moderne/International Conference of Modern Architecture)[17] before the war, which were based on the uniform arrangement of rationalized housing typologies. Instead, the Tiburtino design group turned to recent Scandinavian housing projects for models and sought to infuse the design with what Aymonino called a "spatial reality," a Wrightian principle of organic architecture. European Rationalists depended upon a conceptualization of space rendered most clearly in the two-dimensional abstraction of plans. In contrast, understanding the "reality" of organic architectural space came through direct human experience, that is, through inhabiting the space.

If the philosophy behind the Tiburtino quarter reflected an interest in foreign models and lessons, the forms employed were derived from native vernacular traditions. In order to avoid the sterility of uniformity, the architects varied the design and positioning of balconies and stairs, adjusted fenestration patterns, and skewed the alignment of buildings to one another. The results did indeed avoid the repetitive uniformity of Rationalist models and succeeded in evoking the "sapient irregularity of old villages."[18] Critics, nonetheless, described the results as "mannered" and "picturesque" and argued that village models were inappropriate for the new urban, working-class neighborhoods like Tiburtino that were sprouting around the periphery of Italy's metropolitan centers.

In contrast to the proponents of organic and neorealist architecture, some designers attempted to preserve the essence of the prewar Modernist position and to extend or renew the Rationalist tradition on the basis of a refined appreciation of its Central European heritage. One of the seminal contributions to this effort was Giulio Carlo

figs. 4, 5. Ludovico Quaroni and Mario Ridolfi (team leaders), with Carlo Aymonino, Carlo Chiarini, Mario Fiorentino, Federico Gorio, Maurizio Lanza, Sergio Lenci, Piero Maria Lugli, Carlo Melograni, Giancarlo Menichetti, Giulio Rinaldi, and Michele Valori, INA–Casa complex on via Tiburtino, Rome, 1949–54.

fig. 6. Luigi Figini and Gino Pollini, Housing on via Dessié, Milan, 1951.

fig. 7. Luigi Moretti, Apartment building on via Jenner, Rome, 1949.

fig. 8. Luigi Caccia Dominioni, Apartment building in piazza Carbonari, Milan, 1960-61.

Argan's study of Gropius and the Bauhaus, published in 1951.[19] For Argan, Modernism in design and the visual arts was the expression of an enlightened, contemporary consciousness that was truly international in scope. The neorealist fascination with urban or rural vernacular traditions, like the prewar fixation with Italy's classical heritage, according to Argan, threatened to isolate Italian culture from the European mainstream.[20] He presented Gropius and the Bauhaus as the reigning embodiment of this progressive and internationalist force in European twentieth-century history. Argan, however, had to counter the postwar criticism of the Bauhaus model of industrialized design as ultimately soulless and dehumanizing. In describing Gropius's program at the Bauhaus, Argan wrote, "It is, on a theoretical level, the defense of industry understood as the empowerment of talent against 'Fordism' and the degradation of personality through the mechanism of production."[21] Rather than discrediting Rationalism, Argan argued, the war had created the opportunity for Italians to sever the bonds of tradition, class prejudice, and cultural provincialism and to assume full partnership in a thoroughly modern European civilization.

Many architects were eager to do just that. As it had before the war, Milan served as the center for postwar Rationalist thinking in architecture and design. In 1945 progressive architects in Milan founded the MSA (Movimento di Studi per l'Architettura/Movement of Studies for Architecture) as a forum for discussion and promotion of a reinvigorated Rationalist movement. The MSA included the survivors of the prewar Rationalist movement and a new generation of designers who had completed their university studies during the war years. The character of the revived Rationalism is evident in the housing blocks on via Dessié in Milan (1951, fig. 6) by Luigi Figini and Gino Pollini. The exposed frame, flat roof, and gridded elevations of the via Dessié blocks provide a dramatic contrast to the contemporary Tiburtino quarter in Rome.

Progressive architects had long realized that comprehensive urban planning was a critical corollary to modern architecture and design. Even before the end of hostilities, in 1944, a group of Rationalist architects in Milan, calling themselves AR (Architetti Riuniti), began working on a new urban plan for the city.[22] Published in July 1945 as "the AR plan," the proposal was based on the planning tenets articulated by the CIAM in "The Athens Charter" of 1933.[23] It was truly regional in its scope and addressed the major Italian planning concern of the period: the control of explosive development along the urban periphery. More important for our analysis than the specifics of the plan is the *principle* of planning embodied in the document. The collapse of Fascism forced Italians to confront the challenge of defining a new political order for the nation. With its regional premise and its expectations regarding the ability of planning agencies to control real estate speculation, the AR plan was a blueprint for regional government even more than it was a description of urban form.

This faith in the efficacy of Modern architecture as an instrument of social and political regeneration was pervasive in the Italian architectural culture of the 1940s.

Bottoni, a member of the AR group and one of the most politically active architects in the anti-Fascist Resistance movement, spoke for many of his contemporaries when he emphasized the political dimensions of design efforts. "The 'new construction' of the country," Bottoni wrote in February 1945, "is essentially a problem of a moral and political order."[24] It was the clash of political and moral imperatives beyond Italy's borders, however, that proved to be critical for postwar developments. As the Superpower competition between the United States and the Soviet Union intensified, the Cold War "froze" political systems on both sides of the Iron Curtain. The hopes that Bottoni and many of his fellow architects nurtured for the dramatic reconfiguration of the political, economic, and social structure of Italy were frustrated by the elections of 1948. The triumph of the DC (Democrazia Cristiana/Christian Democratic party)—aggressively supported by the United States during the election campaign—appeared to preclude the radical restructuring of the political and economic order that was such a prominent theme in the deliberations of architectral groups like the APAO and the MSA.

The DC never embraced the planning ethic central to the thinking of the architectural profession in the late 1940s. Instead of the comprehensive industrial and urban planning outlined in the AR plan, the DC–led governing coalition offered Italians a national housing plan. The Fanfani Plan, named for the DC Minister (later Prime Minister) responsible for its implementation, Amintore Fanfani, called for the creation of INA–Casa (Istituto Nazionale Abitazioni–Casa/National Housing Institute–Casa). The 1949 legislation creating INA–Casa was officially entitled "Provisions for increasing worker employment, facilitating the construction of labor housing."[25] It was first and foremost an attempt to alleviate unemployment by stimulating the construction industry through a limited national program of state-subsidized housing construction. As a result, INA–Casa's efforts tended to discourage industrialization and mechanization within the construction industry in favor of labor-intensive practices. The INA–Casa program thus effectively blunted one of the major thrusts of advanced architectural thinking: the modernization of design and construction practices through the introduction of technologically sophisticated materials and methods.

INA–Casa housing projects demonstrated considerable variety, and the quality of individual projects was indisputable. Both the Tiburtino quarter in Rome and the via Dessié housing in Milan were INA–Casa–sponsored efforts. But the Fanfani Plan contained few if any provisions for comprehensive urban planning of the type that many architects were advocating. The lack of stringent planning controls allowed land speculators to reap enormous profits at public expense as land costs soared, and this, in conjunction with the migration of large numbers of people to the urban centers of northern Italy, encouraged the proliferation of new neighborhoods on the urban periphery. The undesirable effects of the INA–Casa program also revealed the inherent weakness of groups and movements like the APAO and the MSA. Their unofficial status as cultural organizations rather than state entities or professional regulatory bodies rendered them powerless to affect the course of government actions, and they gradually withered and died as viable professional organizations.

The pace and vigor of postwar economic recovery—Italy's famous "economic miracle"—generated plenty of activity for architects. Foreign observers were impressed with both the volume of activity and the quality of individual designs. In his review of postwar European architecture, the critic George Everard Kidder Smith noted, "For well more than a decade following the war, contemporary Italian architecture was the brightest, most imaginative, and most stimulating in all Europe."[26] It was also some of the most varied, as Italian architects explored a range of design idioms. Luciano Baldessari's exuberant exhibition designs for the Breda pavilions at the annual Milan trade fairs in the early 1950s (see cat. no. 625), for example, translated the gestural immediacy of drawing into built form and betrayed his own early experiences as a Futurist. Franco Albini invested his designs for museum installations in Genoa with a haunting and surreal quality that called into question the very nature of the museum experience (see cat. nos. 628 and 630–31). Pier Luigi Nervi's plans for Rome's 1960 Olympics sports facilities, among the most celebrated engineering designs of the decade, demonstrated his command of the aesthetic as well as the structural potential of reinforced concrete structures. After his early Rationalist and neorealist work, Giovanni Michelucci moved in the direction of a more dramatic and expressionistic type of imagery. The complex volumes and convoluted framework of his famous church of San Giovanni Battista (1960–64, cat. nos. 685–86) on the Autostrada del Sole outside Florence conjure up images of caves, tents, and groves of trees as metaphors for places of ritual assembly.

This litany of individual sensibilities and unique accomplishments could be continued almost indefinitely. In 1961 Douglas Haskell, editor of *Architectural Forum*, described recent Italian architecture as "the pure poetry of an intensely personal art."[27] Such an "intensely personal art" defies easy generalizations. An examination of three residential buildings by different architects in different cities reveals the remarkable variety possible within the same building typology. Luigi Moretti's apartment building on via Jenner (1949, fig. 7) in Rome consists of a complex volume articulated by eccentrically shaped planes and openings. In the absence of a clearly defined orthogonal matrix (the ubiquitous grid of the Rationalist tradition), Moretti's planes float precariously over the street. In Milan, Luigi Caccia Dominioni's residential building in piazza Carbonari (1960–61, fig. 8, cat. no. 644) is a single, blunt volume enlivened only by an arrangement of windows dictated strictly by the internal layout of rooms. In Venice, the fenestration pattern, the arrangement and detailing of the balconies, and the informal massing of Ignazio Gardella's apartment house on the Zattere (1954–58, cat. no. 654) beautifully reflects the urban vernacular buildings of the local tradition.

One pervasive feature of postwar Italian design is the mural character of the work. Italian buildings tend to be opaque rather than transparent; they feature walls with individual windows cut into surfaces rather than continuous window-walls of glass. This is hardly surprising

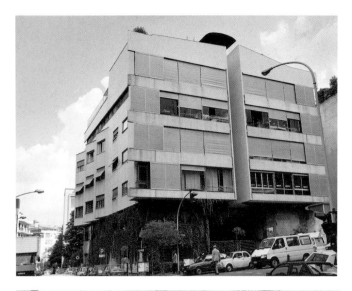

fig. 9. Luigi Moretti, Casa Girasole,
Rome, 1950.

fig. 10. Luigi Moretti, Casa Girasole,
Rome, 1950, detail.

in Italy, with its millennial tradition of mural architecture. But for decades, Modernists had repeatedly identified transparency as one of the distinguishing features of Modern architecture, and the Italian preference for articulated mural surfaces appeared strangely at odds with international theory and practice.

In a 1951 essay Moretti expressed his reservations concerning the simplistic equation of Modernism with transparency:

Certain masters of early Rationalism, and how many disciples, thought to attain, exhaust or somehow resolve their drive towards a pure, crystalline world, with the very material of crystal itself, glass. They thereby inadvertently tumbled from the exigencies of plastic language into the exigencies, by homonymy, of literary diction. That aspiration towards an inexorable formal neatness, which is the pride of the modern spirit, became confused in its expression with the effective neatness of the material, with the lucidity and transparency of the surfaces.[28]

Ancient architects, Moretti maintained, understood the expressive potential inherent in a mural surface and that if one wanted to realize this potential "it is necessary to operate on it in some way, to excite and evoke its forces, to cause gestures and corrugations to erupt from it which exalt its presence."[29] For the street-level wall of his Casa Girasole (1950, figs. 9, 10) in Rome, Moretti "operated on" the surface to "exalt its presence" with eccentric patterns and varied textures.[30]

In Turin, Roberto Gabetti and Aimaro Isola demonstrated their own idiosyncratic appreciation of the expressive character of mural architecture with their 1954 design for an apartment building known as the Bottega d'Erasmo (after an antiquarian bookshop that occupies the street level) (figs. 11, 12, cat. no. 643). When the building was published in *Casabella continuità* (House beautiful continuity), the designers wrote, "It did not seem necessary to us, in order to be modern, to cover it with strange materials or to reveal the reinforced concrete framework."[31] Instead, they detailed the stone and brick façade in a manner that reflected their appreciation of such designers as Hendrik Petrus Berlage, Riccardo Brayda, Charles Rennie Mackintosh, and Wright. As one of the most prominent examples of what critics dubbed Neo-Liberty (Stile Liberty was the name used in the early twentieth century to identify the Italian version of Art Nouveau), the building soon became an international cause célèbre. In a sharply worded attack in the April 1959 issue of *Architectural Review*, Reyner Banham characterized it along with other recent developments in Italian architecture as "a retreat from modern architecture."[32] Banham's was not the only harsh voice from abroad. At the 1959 CIAM meeting in Otterlo, for example, the Dutch architect Jacob Bakema warned the Italian delegates, "You are resisting to the life of our times."[33] At that same meeting, the British architect Peter Smithson criticized BBPR's Torre Velasca project (1950–58, cat. nos. 656–57) and warned the designers, "Your building does not, in my opinion, exist in the same world as the artifacts of our era."[34] In retrospect, the foreign condemnations of the emerging eclecticism within Italian architectural culture reflect the stifling narrowness of Modernist orthodoxy rather than a regressive quality in

Italian design.

It was Rogers who sensed the potential in much of the Italian work for a more coherent and sensitive approach to the issue of contextual design. In the 1950s he began to write eloquently about the need to consider existing conditions and national traditions when designing modern buildings. In place of solutions prefigured by the designer's commitment to a normative design philosophy (the charge made most frequently against Rationalist architecture), Rogers argued for a design approach based on a case-by-case analysis of the physical, cultural, and historical environment to be shaped. The willingness on the part of many Italian architects to investigate formal issues at odds with the orthodox principles of Modern architecture appears prescient of contemporary, Postmodernist sensibilities. But we should be wary of facile attempts to equate Rogers's concern for local traditions with Postmodernist contextualism. Rogers insisted that his concern for "pre-existing conditions" could be reconciled with a commitment to the principles of Modernism:

If one admits, with sufficient modesty, that we are still operating within the orbit of the methodological process initiated by Gropius, one can easily recognize that a vast evolution is possible by following along the path undertaken, not only without falling into any contradiction with its original postulates, but increasingly by carrying those same principles to their utmost consequences: this same method allows us to enlarge the horizons of research and to include in them new, coherent results.[35]

Rogers's insistence on this point is significant. For European designers, the design legacy of Gropius and the Bauhaus represented not only the formal tradition of Modern architecture but the moral and ethical values of an enlightened social vision as well. Rogers's generation was not yet ready to abandon the cause of Modernism, even though, increasingly, their work challenged Modernism's formal language.

Inherent in the "pure poetry" (to borrow Douglas Haskell's description) of postwar Italian design was the provocative thesis that the rationalized forms of Modern architecture and the sense of lightness inherent in a Modern aesthetic of transparency were incapable of bearing the weight of the present, much less the burden of the past. The sense of failure that slowly pervaded Italian architectural culture lay in the realization that architects like Gabetti and Isola could evoke the forms but not the reforming zeal of early-twentieth-century masters. During the difficult years of war and reconstruction, the design profession had sustained itself with the vision of a new moral and political order enshrined in a new architecture. The bourgeois commissions that filled the studios of Italian architects—commissions that emphasized comfort and convenience and depended on conservative notions of private property and public finances—appeared totally incapable of realizing the profession's sense of mission.

In 1961 Gardella ruefully described the predicament designers faced: "The best Italian architects find themselves in the situation of someone painting the walls of a room and discussing what color to select while the house burns."[36] To many design professionals, the achievements of postwar architecture appeared too meager a return on the

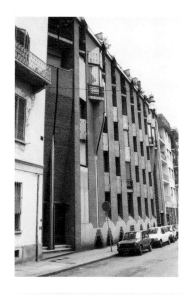

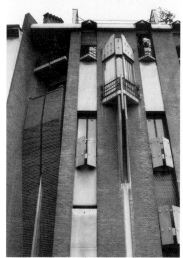

fig. 11. Roberto Gabetti and Aimaro Isola, Bottega d'Erasmo, Turin, 1953–54.

fig. 12. Roberto Gabetti and Aimaro Isola, Bottega d'Erasmo, Turin, 1953–54, detail.

psychic as well as physical effort invested in rebuilding the nation. One way to resolve the dilemma of Gardella's "burning house," many argued, was to sever the links between existing patterns of governmental and bourgeois patronage and architectural production.

In the late 1960s and early 1970s dramatic design alternatives to the status quo appeared. Megastructures, for example, offered the promise of achieving comprehensive design on a truly regional scale through the integration of physical and social planning in a single matrix. The very nature of megastructures transcended traditional conceptions of private property, civic form, and personal space.[37] Now, the "house of man" was conceived as a living pod attached to an enormous megastructure.

The interest in megastructures and the advent of radical architecture groups like Superstudio, Archizoom, and Group 9999 marked the end of an era in Italian architecture. "We need in fact to begin all over again," Superstudio argued in one of its early manifestos.[38] A new generation was poised to assume the leadership of the architectural profession, shaped by a different set of experiences, with different goals, and new ideas about the potential of architecture to rebuild the "house of man."

1. Ernesto Nathan Rogers, "Programma: *Domus*, la casa del'uomo," *Domus*, no. 205 (January 1946), reprinted in Joan Ockman, ed., *Architecture Culture 1943–1968: A Documentary Anthology* (New York: Rizzoli, 1993), p. 78.

2. Ibid.

3. Ibid.

4. Giancarlo Consonni, Lodovico Meneghetti, and Graziella Tonon, *Piero Bottoni: opera completa* (Piero Bottoni: complete works. Milan: Fabbri Editore, 1990), p. 439.

5. See, for example, Francesco Tentori, "Dieci anni della gestione INA–Casa," *Casabella continuità* (House beautiful continuity), no. 248 (February 1961), pp. 52–53.

6. For a review of the events surrounding the destruction and rebuilding of Florence, see Fabrizio Brunetti, *L'architettura in Italia negli anni della ricostruzione* (Architecture in Italy in the years of reconstruction. Florence: Alinea Editrice, 1986).

7. The architect Giovanni Michelucci lamented the decision of his fellow citizens to recreate the character of the medieval urban fabric: "Out of fear of the new was born the idea to recover that which was lost." For Michelucci's comments, see Giorgio Ciucci and Francesco Dal Co, *Atlante dell'architettura italiana del Novecento* (Atlas of Italian architecture of the twentieth century. Milan: Electa, 1991), p. 171.

8. The entire topic of the rebuilding of portions of Italian cities and the repair of historic structures damaged in the war awaits careful consideration and additional study.

9. For the BBPR studio there was a particular poignancy associated with this memorial. One of the names inscribed on the plaques around the memorial was that of Gianluigi Banfi. Before the war, Banfi had been part of the BBPR studio. In addition to Banfi, other architects named on the memorial included Giuseppe Pagano, Raffaello Giolli, Giorgio Beltrami, and Giorgio Labo. Lodovico Barbiano di Belgiojoso was captured along with Banfi and sent to the concentration camp at Mauthausen for his activities as a member of the Resistance movement. For Belgiojoso's account of his experience, see Cesare De Seta, ed., *Belgiojoso: intervista sul mestiere di architetto* (Belgiojoso: interview on the craft of the architect. Bari: Laterza, 1979), pp. 69–75.

10. For a summary of the events surrounding the design and execution of this project, see Amadeo Belluzzi and Claudia Conforti, *Architettura italiana 1944–1984* (Italian architecture 1944–1984. Bari: Laterza, 1985), pp. 92–94.

11. In addition to Fiorentino and Perugini, the team included Nello Aprile, Cino Calcaprina, and Aldo Cardelli.

12. For a discussion of Italian architecture in the 1930s, see Dennis P. Doordan, *Building Modern Italy: Italian Architecture 1914–1936* (New York: Princeton Architectural Press, 1988); and Richard Etlin, *Modernism in Italian Architecture, 1890–1940* (Cambridge: MIT Press, 1991).

13. Stuart Woolf, "History and Culture in the Postwar Era, 1944–1968," in Emily Braun, ed., *Italian Art in the 20th Century: Painting and Sculpture 1900–1988* (Munich: Prestel, 1989), pp. 273–79.

14. The APAO manifesto is reprinted, in translation, in Ockman, p. 69.

15. In addition to Quaroni, Ridolfi, and Aymonino, the design group included: Carlo Chiarini, Mario Fiorentino, Federico Gorio, Maurizio Lanza, Sergio Lenci, Piero Maria Lugli, Carlo Melograni, Giancarlo Menichetti, Giulio Rinaldi, and Michele Valori.

16. Carlo Aymonino, "Storia e cronaca del Quartiere Tiburtino," *Casabella continuità* (House beautiful continuity), no. 215 (April–May 1957), p. 20.

17. The Congrès Internationaux d'Architecture Moderne (CIAM) was founded in 1928 by leading modern architects in Europe to formulate and promote the principles of Modernism in architecture.

18. The phrase comes from Ignazio Gardella, "The Last Fifty Years of Italian Architecture Reflected in the Eye of an Architect," in Fabio Nonis and Sergio Boidi, eds., *Ignazio Gardella* (Milan: Harvard GSD and Electa, 1986), p. 14.

19. Giulio Carlo Argan, *Walter Gropius ed il Bauhaus* (Walter Gropius and the Bauhaus. Turin: Giulio Einaudi, 1951).

20. For an excellent discussion of the ramifications of Argan's argument for postwar Italian visual arts in general, see Marcia E. Vetrocq, "National Style and the Agenda for Abstract Painting in Post-War Italy," *Art History* 12, no. 4 (December 1989), pp. 448–71.

21. Argan, 1951, p. 19.

22. The group included Franco Albini, Piero Bottoni, Ignazio Gardella, Gabriele Mucchi, Enrico Peressutti, Mario Pucci, Aldo Putelli, and Ernesto Nathan Rogers. Ludovico Belgiojoso and Ezio Cerutti joined the group upon their return to Milan.

23. For a detailed description of the AR plan, see Maurizio Grandi and Attilio Pracchi, *Milano: guida all'architettura moderna* (Milan: guide to modern architecture. Bologna: Zanichelli, 1980).

24. Piero Bottoni, "La casa a chi lavora" (1945), reprinted in Giancarlo Consonni, Lodovico Meneghetti, and Luciano Patetta, "Bottoni: 40 anni di battaglie per l'architettura," *Controspazio* (Counterspace) 5, no. 4 (October 1973), p. 78.

25. The INA–Casa program was authorized originally for a period of seven years. The program was renewed for an additional seven years in 1955 and eventually replaced, in 1963, by a new state housing agency called GESCAL (Gestione Case Lavoratori/Administration of Workers' Houses). For a thorough discussion of the financial and policy aspects of INA–Casa, see Lando Bortolotti, *Storia della politica edilizia in Italia* (History of building policy in Italy. Rome: Editori Riuniti, 1978).

26. George Everard Kidder Smith, *The New Architecture of Europe* (Cleveland: Meridian Books, 1961), pp. 159–60.

27. Douglas Haskell, "Risposta alle domande," *Casabella continuit*à, no. 251 (May 1961), p. 22.

28. Luigi Moretti, "The Values of Profiles," trans. Thomas Stevens, *Oppositions*, no. 4 (October 1974), p. 118.

29. Ibid., p. 116.

30. In a similar vein, the steel "entablature" and corrugated surface of Franco Albini and Franca Helg's La Rinascente department store (1957–61, cat. nos. 659–60) in Rome asserts the mural character of the building. Since the corrugations contain the ducts for the heating and air-conditioning systems, the wall itself becomes the mark of the building's modernity and, at the same time, a recognition of the mural tradition of Roman architecture.

31. Roberto Gabetti and Aimaro Isola, "L'impegno della tradizione," *Casabella continuit*à, no. 215 (April–May 1957), p. 64.

32. Reyner Banham, "Neoliberty: The Italian Retreat from Modern Architecture," *The Architectural Review* 125, no. 747 (April 1959), p. 231.

33. Sara Protasoni, "The Italian Group and the Modern Tradition," *Rassegna* 14, no. 52 (December 1992), p. 28.

34. Ibid., p. 28.

35. Ernesto Nathan Rogers, "Le preesistenze ambientali e i temi pratici contemporanei," *Casabella continuit*à, no. 204 (February–March 1955), reprinted in Ockman, p. 202.

36. Ignazio Gardella, "Risposta alle domande," *Casabella continuit*à, no. 251 (May 1961), p. 15.

37. For illustrations and accounts of Italian megastructures, see Marco Dezzi Bardeschi, ed., *Italian Architecture 1965–1970* (Rome: ISMEO, 1970); Metamorph Group, ed., *Italian Architecture in the Sixties* (Rome: Stefano De Luca, 1972); and Lara Vinca Masini, ed., *Topologia e morfogenesi: utopia e crisi dell'antinatura* (Topology and morphogenesis: utopia and the crisis of antinature. Venice: Edizioni La Biennale, 1978).

38. Superstudio, "Invention Design and Evasion Design," *Domus*, no. 475 (June 1969), reprinted in Ockman, p. 440.

When we speak of "Italia[n]
something other than the [p]
goods within the territori[es]
nation. Generally, the te[rm]
actual cultural category,
with technology and ind[u]
difficult to describe, yet ea[ch]
striking fact about the ph[e]
is that almost none of the
growth of design would a[p]
There is no large industr[y]

design," we mean

ere production of consumer

confines of the Italian

is used to indicate an

particular relationship

try. It is a relationship

to recognize. The most

nomenon of Italian design

nditions favorable to the

bear to exist in Italy.

no rationally organized

Italian Design and the Complexity of Modernity

Andrea Branzi

market, no culture of planning capable of developing unified and incisive social theorems. Modernity in Italy was born more as artistic intuition than as the result of real processes of social and technological transformation. Furthermore, design developed there rather late compared to the rest of Europe and was unaccompanied by any adequate theoretical debate. The Futurists may have promulgated a scandalous, radical, and dynamic idea of modernity, but it was essentially divorced from reality. The first laboratories of applied art, organized by such right-wing Futurists as Giacomo Balla and Fortunato Depero, were more like applications of the Futurist code to the home rather than true design operations. What was totally lacking was the idea of industrialized production.

In addition, one might point to the absence of any real Rationalist movement in Italy between the two world wars. Modernism there produced two great models of thought and aesthetic production, both of which were foreign to modern Rationalism. The first is Futurism, with its scandalous metaphors, the notion of technology as a dynamic element of social transformation, and the idea of modernity as a permanent revolution. The second is represented by Metaphysical art and by the Novecento movement, both of which aimed to reconstruct a deep-rooted continuity with the Latin past, even within the forms of modernity. The great political and cultural success of Fascism among intellectuals was caused at least in part by such hybridization of cultural categories. Mussolini nonetheless held up the Futurist revolution as *the* Latin identity, and continuity with the classical tradition as *the* scandal of Modernism.

In Italy the works of the so-called Rationalists, even those of extraordinarily high quality, were produced by such isolated figures as Franco Albini, Luigi Figini, Ignazio Gardella, Giuseppe Pagano, Edoardo Persico, Gino Pollini, Giuseppe Terragni, and Giuseppe Vaccaro. They, however, were all architects who moved about the narrow frontier joining the territories of Futurism and Metaphysical art, of which their work now and then bears obvious marks. They were also exponents of an eccentric manner of designing— sometimes dynamic (as with Luciano Baldessarri), sometimes monumental (as with Giovanni Muzio), but never methodological, although their work often has great figurative energy.

If architecture and design, for the European Modernists, was the locus of a quest for a possible unity of technologies and human experience, for the Futurists this locus was the metropolis, with its dynamism and its multiplicity of languages. The metropolis was the scene of an irreparable rupture between modernity and history, between public and private, between architecture and city, between intimism and technical development. Balla's "city that grows" is already a *fractal*: the sign of a complex and abstract system that develops according to no destiny.

Within the political and human scope of Italian Futurism lies another important key to understanding certain achievements of Italian culture of this century. Out of a purely behavioral subversion—"We wish to exalt aggressive movement, febrile insomnia, the racing step, the mortal leap, the slap and the punch," wrote Marinetti in *Le Figaro* in 1909—Futurism began a course that would lead it first to experiment with the applied arts, as in the case of

Balla, and later, through the work of Depero and his handicraft workshops in Rovereto, to prefigure in almost every respect what would become the language of Italian Rationalism. The fact that Italian Futurism, in its mature phase, gave birth to the exact opposite of itself ("Down with intelligence!" Marinetti had said), and that the abstract, dynamic forms of Futurism would engender a code of geometric forms from which the Italian Rationalists would take their cue, prefigured other transitions that Italian culture would achieve in later years.

In 1925 Ivo Pannaggi executed what historians recognize as the first project of Italian Rationalism: the furnishing of Casa Zampini. The oddity is that Marinetti hailed the interior of Casa Zampini as a Futurist achievement. This was an indirect confirmation that the work, which was rich in Internationalist references, was born on the boundary marking the transition from late Futurism to Modernism, and that it belongs to both. Thus out of the irrationalism of the early avant-garde was born the improper rationalism of the later vanguard: dynamic, problematic, experimental, but also (thanks to the influence of Metaphysical art and the Novecento movement) authoritarian, enigmatic, and monumental.

The political conflict between Fascism and Rationalism arrived late; Rationalists and Fascists continued to work on the same projects for many years. In Germany and Russia the same tensions exploded sooner, and each of those revolutions took a very different course. The twenty-year collaboration between Fascism and Modern architecture in Italy came about by virtue of a very simple but efficient hypothesis: Fascism was realizing a new society politically, while the Modern movement in Italy was realizing the architecture appropriate to it. In this symbiosis, Fascism never renounced its presumption to being the tool of a radical modification of the social scene, whereas Rationalism never renounced its own presumption to being the new architecture for the new society. The crisis came to a head later, when the Rationalist architects began to look beyond architecture, as Pagano put it—beyond the role of a disciplinary revolution with a schizophrenic relationship to what was occurring politically.

In Italian architectural culture, however, the principle of designing a new architecture for a new society would remain in place as the very definition of the Modern movement. This society might be fascist, democratic, reformist, or socialist, but in any case Italian architecture would present itself, always uselessly, as the operative tool of a political project (and not of actual power), as the constructive action of a social program that would never be carried out in full.

In the period following World War II, Italian industry was weak, often backward. There were no national schools, museums, or theorists of design, yet out of this ensemble of seemingly negative circumstances arose the syndrome we might call "the Italian case"—that is, by exploiting specific positive situations it became possible to reverse the negative factors and to transform them into an entirely new strategic framework. What in fact was created in Italy was a different model of design, one that proved in certain ways to be an alternative to the classical European model.

There are two types of modern culture in Europe, and each is bound, among other things, to the form of government in which it arises. On the one hand, there is the reformist modernity of the great democratic monarchies such as Belgium, Denmark, Great Britain, The Netherlands, Norway, and Sweden, which, hardly by accident, are also the countries in which Modernism was carried out with great formal continuity. This is an enlightened modernity, rational, reassuring, and broadly accepted by the public, to whom it offers new and real values. The other kind of modernity arises in more politically unstable and troubled countries like Italy, where modernity implies opposition, fracture, discontinuity, and crisis. It produces creative tension and polemical signs of great expressive vitality and high conceptual quality. Such an understanding of the modern generally engenders not a unified landscape of elegance and order but a contested field in which alternatives vie for prominence.

For this reason it could be said that one of the distinguishing characteristics of Modern architecture in Italy lies precisely in its consideration of its own discontinuity with respect to the environmental and political context as a preliminary condition of the project itself. Whereas in the rest of Europe Modern architecture was nearly always the formal outcome of a complex balance of already stabilized urban and social values, in Italy it found itself acting within an uneasy context and a contested sociopolitical framework, first during the Fascist period and then in the thirty years of centrist governments after the war. The individual project, far from constituting a building block of continuity, always represented an alternative, the testimony of an opposition; its discontinuity with respect to the ongoing reality became its qualitative premise. From this derives the essentially polemical nature of Modern architecture in Italy, which is based more on opposition than on equilibrium. Its history, therefore, is made up of names rather than schools, of individual works rather than territorial units.

Similarly, the struggle of Italian design, with its synergistic relationship to Italian architecture and its eccentricity with respect to the history of European design, is marked by a wealth of contradictions. Even in its initial experimental phase, in the 1950s, Italian design, which burst on the scene with an unexpected inventiveness and vigor, revealed itself as entirely separate from the tradition of international functionalism and untouched by the false certitudes of an industrial culture based on the myth of infinite mass production and the final product. Italian design developed its own equation, an unstable equilibrium between the culture of consumption and the culture of production, mediating between two opposed utopias (final products *and* the endless transformation of products) and searching for a solution that was never complete but always provided a residual, perfectible error, and therefore a possibility for further development.

The critical code of which Italian design is the vehicle has ensured that it bears the signs of an active contradiction, a stimulating oscillation between integration and rejection, between consensus and opposition. It is from this inner conflict that its great richness of expression and experiment was born. The contradiction is unresolved and perhaps, luckily, unresolvable. The absence of either a central school or museum of design has, for a long time, proven favorable to

the development of a vision of design as a great, open-ended problem. Design, understood in this sense, has a dynamic history in a perpetual state of unfolding that can be kept up with only through the experimental laboratories and the many periodicals that promote their findings and posit new problematics. One might call it a theory of design aimed not at resolving problems but at finding new ones.

Consumer culture was something entirely foreign to prewar Italy and Europe. The model of growth developed by European capitalism to overcome the grave economic crisis of the 1930s envisioned a process of accelerated industrialization, though within the canons of a stable society solidly organized by the great right-wing dictatorships. In this sense even the European design already defined by the Bauhaus did not envision adopting or promoting the logic of consumption, but rather that of production. The center of its attention was the factory, not the market. Its model for humanity was the worker, not the consumer.

It was the United States, during this same period, that developed a model of growth based on individual and collective consumption to escape from its own Depression. Consumerism thus was born, and from this point on American design took a different path from European design, concentrating on products of great figurative strength (instead of structural research) and on great narrations (instead of critique). Products were designed not according to the logic of mechanics (the credo of the Bauhaus) but rather the logic of their effect, that is to say, velocity (the work of industrial designer Raymond Loewy, for example). Thus we have the supermarket, not the factory, and styling over rationalism.

This ideology of consumption came face to face with European reformism, both fascist and democratic, when the Americans invaded Italy in 1943 and Allied troops landed in France in 1944. The result, beyond the eventual defeat of the Axis powers, was the defeat of a model of industrial production (headed in Germany by an architect, Albert Speer) upon which an entire class of intellectuals and politicians had conferred a deep cultural and moral significance. Whether fascist or antifascist, the European elites understood industry as a tool for reforming society. The American example, on the other hand, confronted the Europeans with the consumer ideology of immediate happiness, not future satisfaction, an ideology understood as the sole possible foundation for a real human society to which industry would bring immediate health, abundance, surplus, and well-being.

The American example was simple and coarse, but it was also victorious. To a European culture accustomed to measuring itself against history as against a difficult stepmother, America offered the example of a total absence of history—almost like an absence of original sin. Domestic Italian functionalism could now compare itself to the great ergonomic systems of a flexible, hyperorganized army. New modes of behavior and fashion transformed the social body profoundly and immediately. For the first time since the Muslim invasions of the sixteenth century, Europe was violated at its deepest historical core, transformed by a civilization that differed from it down to

its most secret cultural roots. Europe's historic values, and the entire operative framework of its moral culture, were transformed by a profound influx of new values and new utopias. Democracy brought in a different sort of optimism, a new openness to the everyday.

Nevertheless consumer culture encountered a good deal of opposition in Italy. The two parties to emerge from the Resistance as the dominant political forces, the DC (Democrazia Cristiana/Christian Democratic party) and the PCI (Partito Comunista Italiano/Italian Communist Party), were decidedly not in favor of modernizing society or of developing consumerism. For entirely different reasons, each party aimed at protecting the family economy and traditional education, the foundations on which Fascism too had built its social policies. Indeed the entire political culture of postwar Italy was against consumerism and looked upon the American way of life with great suspicion. In an October 1947 article published in *Horizon*, Marshall McLuhan wrote:

A few months ago an officer in the American army, the Italian correspondent for Printer's Ink, *remarked with dismay that Italians can tell you the names of all the government ministers but not the names of the favorite products of their country's celebrities. On top of this, the walls of Italian cities are more covered with political slogans than with commercial ones. According to the predictions of this officer, there is little hope that Italians will ever achieve a state of prosperity or inner peace unless they begin worrying more about the competition between rival brands of oat flakes or cigarettes than about the abilities of their politicians.*

In fact politics has always been the national sport of Italians. And this is not because they consider politics a sporting matter, but because, on the contrary, they consider even sports a political matter.

The Italian intellectual class that emerged from the Resistance, which in large part had adhered to leftist programs of popular renewal, underwent a traumatic imprinting during this period that would profoundly affect its future. The defeat of the Left in the elections of April 18, 1948 made it impossible for intellectuals to participate actively in the material and cultural reconstruction of the country. Instead they watched from the sidelines as a chance to establish direct contact with the masses vanished. Confirmed in their historic separation from the country and its ruling powers, Italian intellectuals found themselves to be a "minority that is right in a country that is wrong."

The historic turning-point of early postwar Italy drove people to a rediscovery of reality—of that very reality that, for too many years, had been mystified by the Fascists but in fact kept at bay. "We all feel," wrote novelist Cesare Pavese, "that we live in an age when it is necessary to bring words back to the solid, naked clarity of the time when man first created them for his own use." It is not difficult, as Manfredo Tafuri would later remark, to see the connection between what Pavese was saying and what was going on in all areas of cultural expression, from neorealism in cinema to literary and philosophical realism, from both the abstract and realistic tendencies in art to psychological functionalism in architecture, which soon

thereafter became a subject of theory. Nevertheless the 1950s, the era of realism, were more replete with myths and dreams than most other decades: one was forever in search of formulas that might miraculously mend the rift between culture and reality, that might make it possible to step over the institutional hurdles of politics and open up new channels of action (urbanism, functionalism, planning, sociology, design) to change the world. Design in turn created other myths: mass production, modularity, multidisciplinarity, the synthesis of the arts. The subject of interior design was one of the favorite themes of 1950s urban society, just as the movie theater was its intellectual gymnasium.

Industrial design also represented the hope of bringing about, through the tools of production, the cultural revolution that was stifled by political institutions and by the clerical tradition. Design also made it seem possible to get around the impasses represented by Italy's culture and backwardness through the implementation of a program carried out together with industry. Industry was a new tool in a position to affect the country's reality directly and to change it in a controlled manner. Industrial design was immediately posited as a great means of administrating democracy, modernizing the country, and running a regulated market of private consumption. It is no accident that the first blueprint of the new Italian design was not for an industrial project per se but for the monument to the fallen in the German concentration camps, Cimitero Monumentale, Milan (cat. no. 605), designed in 1946 by Lodovico Barbiano di Belgiojoso, Enrico Peressutti, and Ernesto Nathan Rogers of the BBPR studio (whose other founding member, Gianluigi Banfi, had died in a German concentration camp in 1945). Design was not just about products; it meant anti-Fascism and new culture. It also involved the genuine interests of industry, which saw a chance to reassert on the national and international stages an immediate image of the Italian line that would brilliantly make up for any technical weaknesses in the product and thereby defeat the competition.

Although the results might seem to confirm the opposite, in Italy the collaboration between industry and design has always been based on the principle of mutual autonomy—in the sense that Italian design has never presumed to exhaust its possibilities in a product's commercial success but has always defined itself in relation to the larger culture and to debates over the metropolis and over history in general. Similarly, Italian industry has never sought to turn design into a function of business; instead it has accepted an experimental, nonbusiness design as another part of the market. The success of industry lies precisely in its ability to be responsive to and guide this kind of creative energy; it does not treat design as a cultural crusade but rather exploits it within the parameters of its own business strategies.

Generally speaking, the Italian design industry consists of small- to medium-size firms. One should not, however, be misled by size, for Italian design entrepreneurs are not like small manufacturers, who are bound to their plants. In Italy the historical concept of the factory as a closed circuit has been replaced by that of the factory as an open-ended entity related to a more complex, regionwide manufacturing sector, perhaps the best known of which is

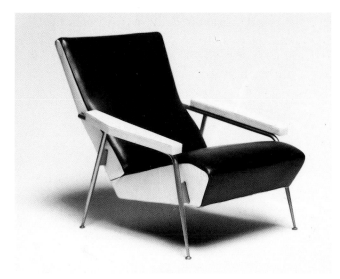

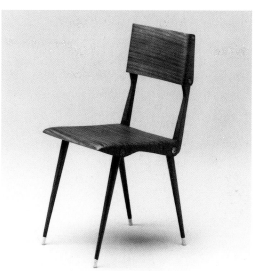

fig. 1. *Gio Ponti,* Distex *armchair, 1953. Manufactured by Cassina.*

fig. 2. *Carlo De Carli, Chair, model 683, 1954. Manufactured by Cassina.*

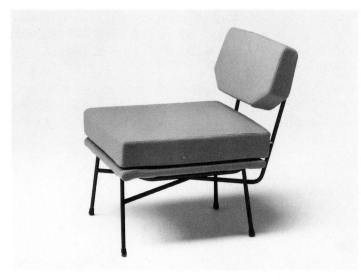

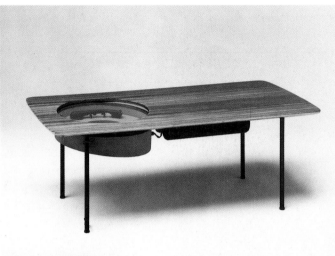

fig. 3. BBPR {Lodovico Barbiano di Belgiojoso, Enrico Peressutti, and Ernesto Nathan Rogers}, Elettra armchair, 1958. Manufactured by Arflex.

fig. 4. Osvaldo Borsani, Turntable console, 1956. Manufactured by Tecno.

the Brianza, the historic cradle of Italian design that stretches from Milan to the foot of the Alps. Here new technologies are revisited in a craftsmanly light, technologies that make possible the use of many different forms of production, with great organizational flexibility. Chairs, lamps, and other products either pass from one workshop to another, or come together as separate components in the final assembly, a method that guarantees the high quality of each phase of production. With regionwide access to research laboratories and microproducers, Italian design entrepreneurs may better be spoken of as converters and industrialists, not because they always own their own factories but because they can elaborate plans on an industrial scale. In this sense Modern design in Italy is the offspring of such companies as B & B Italia, Cassina, Kartell, and Zanotta, which pioneered design and small-scale industry from the 1960s on.

Such an understanding of production mechanisms and forms of manufacturing should properly be spoken of as postindustrial, for it corresponds to a notion of the industrial not as hegemonic but as open to intense interchange with both the civic and creative cultures active in Italian society. Here the ownership of factories and machines does not suffice to define the manufacturer's role. The factory is no longer a place separate from society; it becomes a reflection of that society.

Today the products of 1950s Italian design hardly ever look like true industrial products or authentic handicrafts. The great thrill they offer is one of expression; indeed, the limitation of much of the design of those years is how resolutely it signals a 1950s style (see figs. 1–4). This style, quickly attained and then consistently maintained except for a few internal modifications, was the most fitting representation of a design philosophy that was intentionally engaged in an intense, diligent, willful exploration of form, almost believing it could give unity and value, through the right form, to a reality that was contradictory and in some ways not understood. Although this may have constituted a limitation in terms of the culture of planning, in other ways it was a rich source of inspiration. It cannot be said to represent a design revolution, but it came close.

The basis of the style, the design, which was developed on an architectural model, lay in the radical breaking down of the product, its reduction to simple, expressive forms, the identification of the structure with the object's outward signification, and the explicit flaunting of the materials of which it was made. It was a directly architectural way of confronting industrial design as the closing phase of a project that began with urban planning and, through architecture, arrived at the object and the tool. In actuality, however, this often consisted of an attempt to industrialize objects of furniture, which were conceived as components of a larger container—architecture—whose spatial and structural arrangement they reflected, and of which they were considered the practical realization.

Despite the operational limits within which it was called upon to act, the excessive freedoms it sometimes faced, and the political and cultural misunderstandings within which it grew, Italian design in the 1950s enjoyed extraordinary popular success. Indeed it was so tremendously widespread, even on the international level, that it might be said to have been the first truly popular

modern style. Perhaps its ability to represent, rather than resolve, the problems inherent in modern production facilitated its nearly uncontested adoption. In this sense the phenomenon of 1950s design exceeded the limits of the project out of which it was born and was greater than the sum of the individual designers working at the time, who actually participated in only one small part of its overall social application. It was a phenomenon that even went beyond the definition of design, for one took one's cue from design to make far-reaching applications in other sectors. In this paradoxical sense, although the design, architectural, and urban revolution ultimately may have failed, it enjoyed success as a stylistic code, which came to be used freely and indiscriminately. Even the small carpenter's workshop quickly learned to build café counters that looked as if they had been designed by Gio Ponti; the modest electrical shop immediately began to make lights that looked like those of Vittoriano Viganò; the local upholsterer amused himself by making models of armchairs that resembled those of Marco Zanuso. Such indiscriminate and irreverent pillaging led to an early formal renewal of the entire middle tier of Italian society: it was a style that definitively replaced Fascist tinsel and nineteenth-century provincialism, and made it possible to formulate, in a provisional yet complete manner, an initial conception of modern Italy.

In general the designers themselves did not appreciate this free use of their stylistic codes, which from their point of view diluted their exclusivity. But just as television at the time was modifying the language of Italians and introducing them to new cultures of consumption, so design in Italy represented the first mass utilization of a style. It was also something more—for through the pointed table legs, the vinyl chair backs, the surrealist ashtrays, industry and society were bearing witness to a real renovation in cultural references. This in fact was the message that all 1950s design expressed in an almost frantic manner: it represented an optimistic faith in the country, in industry, in imagination.

Much of the optimism of those years later proved to be naïve. The economic boom of the late 1950s, represented both the start of a true secularization of Italian society and an explosion of the inner contradictions of the system. Industry could no longer simply be considered a cultural tool clandestinely exploited by aesthetic brokers to civilize the country further. Industry and economics were in reality far more complex mechanisms endowed with their own specific logic, and only political measures and planning could ensure the necessary stability.

In the late 1950s Italian design itself underwent a critical and expressive maturation that developed on two different levels. First there was Neo-Liberty, which referred to Stile Liberty, Italy's Art Nouveau movement, which was named after the London company, Liberty. Neo-Liberty was at once a critique of anti-historicist Rationalism, a rejection of populism, and a polemical way out of the impasse of 1950s style. Gestural design was countered with the learned matrices of a historic culture, demagoguery was countered with a clearly bourgeois culture, one style was countered with another style. But Neo-Liberty was not only a polemical strategy; it provided as well the possibility of identity for an enlightened intellectual class still too fragile

to assume the weighty responsibility of governing and renewing the country. In the years of the economic miracle, a new manner of understanding design was maturing: design was no longer conceived as a response to functional requirements but rather as a function of the creation of demand itself, and thus as an active tool for the modification of behavior and the creation of new functions and freedoms. Already in 1954 Ettore Sottsass, Jr. was writing: "When Charles Eames designs his chair, he designs not just a chair but a way of being seated; that is, he does not design for a function, but rather designs a function." This is the first sign of a new and different attitude toward the despised culture of consumption, and it was to have ramifications throughout Italian society.

In 1953 Vittorio Valletta invested vast amounts of capital in the first great Italian assembly line. Its products, the Fiat 500 and Fiat 600, gave rise to mass motorization, as Henry Ford's Model-T had done decades before. Between 1950 and 1964 the number of privately owned cars went from 342,000 to 4.67 million, and the number of motorcycles from 700,000 to 4.3 million. In 1958 only 12 percent of Italian families owned a television set; by 1965 this figure had risen to 49 percent. In the same period those owning refrigerators went from 13 percent to 55 percent, those with washing machines from 3 percent to 23 percent. In 1947 the Candy company produced one washing machine a day; ten years later, it was producing one every fifteen seconds. From 1958 to 1963 industrial production in Italy more than doubled (with a record average annual growth rate of 6.3 percent), and exports, especially to the new European Economic Community (EEC), grew an average of 14.5 percent a year. Italy began to export refrigerators, washing machines, cars, typewriters, plastic products, and precision instruments. Its electrical appliance industry became the third largest in the world, after that of the United States and Japan.

This great leap forward, of course, produced grave cultural dislocations. As Paul Ginsborg wrote in *Storia d'Italia dal dopoguerra a oggi* (History of Italy from the postwar period to today; 1989): "The first of these was the so-called distortion of consumption. A growth oriented toward exportation brought with it an emphasis on private consumer goods, especially luxury products, without any corresponding public consumption. Schools, hospitals, homes, transportation, all goods of primary necessity, would remain well behind the rapid growth in the production of private consumer goods."

In 1958 the first Center-Left government with the direct participation of the Socialists offered to correct these imbalances. They proposed a kind of Italian New Deal, according to which a national path to growth was to be sought by tempering the savage laws of the free market with economic planning—a centralized state regulation of the market. How this regulation was to be enacted was never clearly stated, however, and the Center-Left coalition ended up merely coopting the Socialists in the government without carrying out any structural transformation of the national economy, a situation that continued right up to the "Clean Hands" investigations into corruption begun in the early 1990s.

The battle waged around the Center-Left was not only a political matter; it raised broader cultural questions as

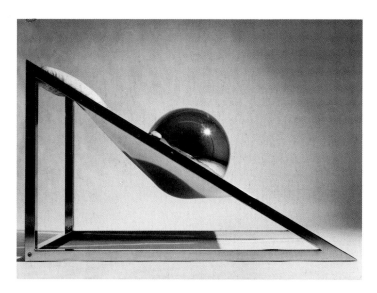

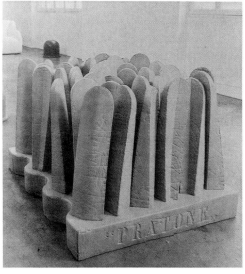

fig. 5. Archizoom {Dario Bartolini, Lucia Bratolini, Andrea Branzi, Gilberto Corretti, Paolo Deganello, and Massimo Morozzi}, Mies armchair, 1968.

fig. 6. Gruppo Strum {Giorgio Ceretti, Piero De Rossi, and Riccardo Rosso}, Il pratone (The Big Field) divan, 1969–70. Manufactured by Gufram.

well, as the story of Italian design in the early 1960s clearly attests. It was assumed that all the processes of industrialization would, in due course, bring with them a rational transformation of both society and the material world. The disorder, the contradictions, the discontinuity of Italian society were attributed to backwardness, considered to be merely temporary realities destined to disappear during the process of industrial modernization. Design, for its part, was supposed to battle against commodities in favor of an intelligent and demystified industrial product.

In those years the Arte Programmata movement—whose participants included such designers as Giovanni Anceschi, Enzo Mari (see cat. nos. 762, 765, 772), and Bruno Munari (see cat. nos. 748, 770, 771, 773), and the theoreticians Carlo Giulio Argan and Lea Vergine—was also involved in a parallel quest to develop a mass-produced, monological design program that, in the face of the prospect of the "death of art," sought to reestablish aesthetic signs using industrial technologies as a starting point. Their references were the gestalt theories of Germany's Ulm school, under the direction of Argentinian design theorist Tomás Maldonado, and they developed rigorous technological, linguistic, and creative metaphors for the modern world. In part they prefigure computer electronics, in part the utilization of mass production as a scientific philosophy of method and history. They too were trying to combine the energy of industrial capitalism with the monological culture of socialism: they accepted technology but not consumerism. They wanted growth but not the complexity and diversification that would come with it. In this sense Arte Programmata really was the "last avant-garde" that Lea Vergine said it was: a single logical system, a rigid, abstract program for transforming reality. It was the last monotheistic movement, at the threshold of an entirely polytheistic age.

It was, however, the contemporaneous Arte Povera movement—theorized by Germano Celant and practiced by Jannis Kounellis (see cat. nos. 212, 213), Mario Merz (see cat. nos. 214–16), Emilio Prini, and many others—that would mark an original rebirth of Italian art, based entirely on the use of "poor," natural materials beneath the interests of modern science. It was an art directed entirely toward a search for simple, anthropological gestures that gained power from their humanistic uncertainty.

At the same time, in the United States, Pop art was being born. In 1964 it was presented in the American pavilion at the Venice Biennale, with works by Robert Rauschenberg, Jim Dine, and Roy Lichtenstein, while in Rome, Galleria Marlborough was exhibiting James Rosenquist's great Fill. Shortly thereafter Robert Venturi's Complexity and Contradiction in Architecture (1966) began to circulate in Italy as well.

Pop art overturned the ethics of Modernism, which aimed at transforming and reducing an unaccepted reality. Instead it celebrated the codes of mass communication, of advertising and consumerism, and thereby encouraged people to look at and accept the world in all its commercial reality and all its persuasive vulgarity. For the nascent, youthful, new avant-garde in Italy, however, consumer culture was not a tool for integration into the system. On the contrary it was a Trojan horse to be introduced into the

citadel of social democracy—a missile capable of upsetting the balance of a moralistic society in the name of liberating gesture and behavior. In this way the system would move toward a more radical modernization. It was in this profoundly changed atmosphere that political and cultural processes took shape that would shortly thereafter usher in a new political era and a profound renewal of design.

All of this produced an extraordinary capacity for theory and criticism that thrived in the very security system spawned by the international politics of the opposing Blocs. In those years the Cold War produced only two geopolitical centers, the United States and the Soviet Union, and turned the rest of the world into a great province or commissariat, with limited responsibilities. Partly because of that the 1950s, on an international level, was a provincial decade par excellence, marked by great imagination but also by a dramatic political void in which the individual had ceased to matter because politics had shifted to a planetary level separate from day-to-day life. It was a period in which people spoke about maximum systems yet lacked the tools to intervene in daily life, in which excesses of freedom served as counterattractions to the frustrations of governing. Italy was one country that tried to emerge from this provincialism in the decade that followed.

The fertile period from 1964 to 1968 was largely brought to an end by the events of 1968. In the field of design a new theorem of planning was beginning to mature. A new generation was coming into the spotlight and proposing a different way of interpreting reality: the discontinuity, diversification, and complexity of the physical and social world were no longer viewed as temporary conditions fated to disappear within the rational order produced by industrialization. Such contradictions instead were understood as destined to grow and become more complicated precisely by virtue of the growth of industrial labor; the world's complexity is industrialism's ripest fruit, not its precursor. The future held in store a world of extreme complexity, both social and material, and modernization would take place not among order but in the discontinuity of technologies and languages.

Complexity thus became the category of reference of the entire new culture. The old Rationalist order could no longer provide us with the tools for understanding this reality; one would now seek a new, exalted rationality capable of confronting even the irrational, the emotional, the oneiric. This new reading of the world plunged into crisis both the old concept of classical modernity, which is based on the search for processes of simplification, and the old alignment of the Italian Left, which played its card of governance and opposition on this idea of planned modernization. And so, from a cultural point of view, the Italian postwar period was brought to an end, just as, a few years earlier, the postwar period had ended with the economic boom. Unfortunately the change was not accompanied by corresponding political renewal.

This is not the occasion for writing an essay on 1968 in Italy, but it should be pointed out that its peculiarity with respect to 1968 in France lies in its rootedness in the country's profound malaise and in the conflict that this produced (to the point of terrorism) in civilian places such as factories, schools, universities, and city streets—though

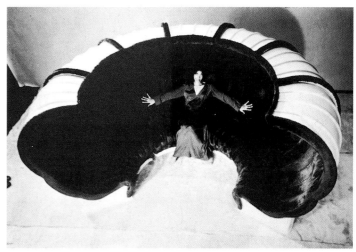

fig. 7. Superstudio {Cristiano Troaldo di Francia, Piero Frassinelli, Alessandro Magris, Roberto Magris, and Adolfo Natalini}, Bazaar *sofa*, 1968. Manufactured by Giovannetti.

never in the government or in parliament, which remained impervious to structural reform. What this tormented period did produce of great originality, even compared to other European countries, was the elaboration of a new global idea of modernization.

The idea of modernity as complexity was, for the most part, already present in the genetic structure of Italian postwar design—in its nonchalant ability to use both "high," industrial technologies and "low," handicraft technologies; in the search both for new languages of standardization and for the improvisation of anarchic and heretical signs; in the enviable ability to go from limited to mass production without conflicts of method. Italian design was produced in a country of contradictions that did not seek certainties in planning but rather new frontiers of growth, in accordance with the notion of Italian modernity, which in discontinuity finds its own true historical continuity.

Already in 1966 Celant christened as Architettura Radicale a whole series of antiauthoritarian, antidisciplinary, experimental works that the Italian avant-garde had created and would continue to create throughout the 1960s and 1970s. This was the first true movement to criticize classical Modernism, and the artists allied themselves with the examples of Pop art, the English group Archigram, and the Viennese work of Hans Hollein and Walter Pichler, not to mention the new music, fashion, and texts of the youth generation. It is worth pointing out that the foremost of these avant-garde groups—such as Archizoom (see fig. 5, cat. no. 778), Gruppo Strum (see fig. 6), Superstudio (see fig. 7), and UFO (see cat. no. 777)—were the first to accept consumer culture as a new historical condition within which one must work with a critical eye, forever abandoning the elitist, outsider position so dear to European design. After a period of intense work on the theme of the metropolis (a theme in continuity with the Futurists, in this discontinuous history) these groups made an important strategic shift, choosing to work directly on the design of commodities, on the languages of the inducement to consumption. They all courageously chose to enter a compromised and difficult reality, seeking to create a new metropolis of objects. The renewal enjoyed by Italian design in the 1960s and 1970s did not, however, correspond to any similar renewal of national architecture, which rested precariously on its compositional traditions and waited until 1978 to confront the crisis of classical Modernism at the Venice *Biennale* under Paolo Portoghesi.

Today Italian life is marked by a grave economic and moral crisis, while an era begun in the period between 1946 and 1968 is coming to a definitive close. Complexity is no longer the primary cultural category of reference; socialism is vanishing, as is the notion of the unlimited growth of the system of production. For the first time we find ourselves living in a society that has only one model of development—postindustrial capitalism—and is faced with great environmental and political limitations. The challenge for the future lies in the ability of this system to regulate itself from within and to reform itself constantly, so that it may overcome the constant crises of growth. Design, in this sense, is going back to being a strategic as well as a political tool, one capable of playing an active role in the construction of the lived environment. But that is already another story. And the work has already begun.

Translated, from the Italian, by Stephen Sartarelli.

Italian Industrial Aesthetics and the Influence of American Industrial Design

Penny Sparke

The year 1943 marked the end of Benito Mussolini's national Fascist rule in Italy and the beginning of economic, ideological, and cultural intervention by the Allies. From 1943 until the late 1950s Italy received large amounts of foreign aid, most of it from the United States. Between 1943 and 1946 it received $2.2 billion from the United States, and aid under the Marshall Plan contributed another $1.5 billion in the following five years.[1] Italy's stunningly successful *Ricostruzione* (Reconstruction) would, in fact, have been impossible without the funding provided by the Western powers. A new concept of "design" played a key role in the reconstruction of Italy, which took place on many fronts, and what subsequently was dubbed "Italian design" became widely thought of as being among Italy's significant contributions to postwar international culture.

Given the key role of the United States in Italy in the postwar period, it would be useful to examine the influence that American industrial design, which was well established by the end of the 1930s, had on the development of Italian design. What influence did American methods of integrating design into systems of production and patterns of consumption have on its Italian counterpart? What influence did the styles of American products have on the work of Italian designers? To what extent did Italian designers look to the United States for a model of professional practice? And to what extent were conditions in Italy so unique that postwar Italian design evades such an international comparison? Such questions are worth examining in order to portray the way in which what we know of as "Italian design"—a movement that reached its apotheosis in the early 1960s—came into being.

By 1939 the United States had already developed a highly institutionalized and emphatically commercial industrial-design movement, which was firmly rooted in an advanced industrial structure of mass production and in the model of individual consumption and democratic idealism that dominated American life in the interwar years.[2] This is generally considered to be the first example of a modern concept of design that came complete with a strategy for industrial intervention and an active and effective profession. Unlike earlier instances of industrial-design practice, which grew out of a reforming idealism that wished to break with the past and create a new, modern industrial culture—historians commonly cite the late-nineteenth- and early twentieth century designers Christopher Dresser in Great Britain[3] and Peter Behrens in Germany in this context—American industrial design developed primarily out of economic exigency and commercial pragmatism and only secondarily can be seen as a representation of that country's cultural and political program. When Eastman Kodak approached the American industrial designer Walter Dorwin Teague to restyle its Box Brownie camera in 1927 and the Gestetner Duplicating Machine Company asked Raymond Loewy to redesign its duplicating machine, an early version of the photocopier, in 1929, these companies were looking, in essence, to fend off their competitors by means of a new way of marketing their goods. The evocative streamlined forms that resulted were marks of an economy looking to visual appeal as one means of fighting its way out of the Depression.

The particular type of industrial design that emerged from these and many similar initiatives in the United

States throughout the 1930s came with a set of free-lance professionals—complete with large offices and networks of collaborators—many of whom had arrived through advertising and store design at this new, highly lucrative career. The industrial designer's essential role was to enable large-scale manufacturers of consumer goods—whose factories were all organized according to Fordist production principles—to keep the wheels of private consumption moving by creating "dreams that money can buy." The success of this formula stimulated many such initiatives and, by the end of the decade, as the New York World's Fair of 1939 made abundantly clear, the American model of industrial design was in place and visible for all the world to see.

In Italy in the 1930s, in contrast, the concept of industrial design, as well as that of a design profession, was only partly formed. What little of it existed had developed, for the most part, in isolation and far away from external influences. Even though the ceramics manufacturer Richard Ginori employed the architect Gio Ponti to provide designs (see fig. 1) for his factory products (a perpetuation of the Italian decorative-arts tradition)[4] and, at the very end of the decade, Adriano Olivetti employed the graphic designer Marcello Nizzoli to work as a designer within the machine division of his company, these were exceptions rather than the norm. Olivetti had traveled to the United States in the 1920s and visited the Ford Motor Company's River Rouge plant in Michigan. On his return to Italy he reorganized Olivetti's system of production, recognizing the importance of design in this system. Such isolated examples apart, however, Italian manufacturing in the interwar years was generally small scale, craft based, and traditional in orientation. Technological and consumer-goods industries were still few and far between, and where the creation of the material environment was concerned, architecture was the focus for debate, both aesthetic and ideological.

In the decade following 1945, however, the concept of industrial design, complete with its design profession, began to find a place on Italian soil. To some extent the political conditions prevailing in Italy in the late 1940s and early 1950s were dictated by those in the United States. When, for example, the Communists were finally expelled from the coalition government in 1947, it was clear that this was largely the result of American attempts to mold the new Italian democracy. The Marshall Plan was not merely charity but a means of keeping Europe as far as possible out of the Communist Bloc, in addition to turning Europe into a viable trading partner for the United States. There was therefore strong pressure from the United States on Italy to develop the same conservative model of political democracy that characterized its own political system, as well as to adopt the Fordist model of industrial manufacturing that had dominated American production since early in the century. Aid included, in fact, not only transfers of money but also of know-how, and groups of Italian industrialists visited American plants to see how the transformation could be achieved on the ground.

If the political and industrial climate of late-1940s Italy was infused with a strong American flavor, did it penetrate the nascent world of industrial design as well? The pages of the magazine *Domus*, an influential architectural and

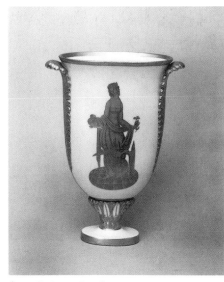

fig. 1. Gio Ponti, Porcelain vase, late 1920s. Manufactured by Richard Ginori.

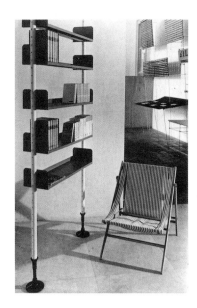

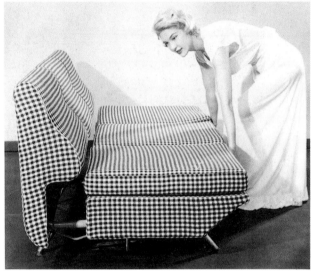

fig. 2. Vico Magistretti, Bookcase and folding armchair, 1946. Illustrated in Domus, March 1946.

fig. 3. Marco Zanuso, Sofa-bed, 1955. Manufactured by Arflex.

design journal that had been in existence since 1928 (it ceased publication for a few years during World War II but was reestablished in 1947), bear witness to the shifts in the ideological climate that took place in the world of design thinking in the second half of the 1940s. In many ways they mirror the shifts in political thinking and the move toward an American model of democracy and consumption.

In the January 1946 edition of *Domus*, for instance, the left-wing architect Ernesto Nathan Rogers made a moving plea for a design rebirth that would be an intrinsic part of Italy's complete program of reconstruction, operating in the spheres of politics, culture, and economics: "It is a question of forming a taste, a technique, a morality, all terms of the same function. It is a question of building a society."[5] Rogers also coined the phrase "from a spoon to a city,"[6] in an attempt to show the need for design to move forward simultaneously across all the disciplines if it were to have a significant effect on cultural and ideological regeneration as a whole. For Rogers this inevitably meant the preeminence of architecture in realizing his vision, but he also felt that it should be accompanied by all the design disciplines. On one level Roger's words seem to evoke Loewy's famous slogan "from a lipstick to a steamship,"[7] which suggests the multidisciplinarity of American industrial design. The equivalence, however, is only superficial. American industrial designers had their roots in the generalist area of advertising, and as a result they could apply their skills to a broad spectrum of industries. Rogers's understanding of design derived from another context entirely, that of the idealistic, left-wing program of European architectural and design Modernism, which embraced multidisciplinarity, internationalism, and socialist revolution.

In 1946 Rogers's vision of the new "taste," which was at one with the program of industrial reconstruction and the cultural and ideological underpinnings of the new Italy, was manifested in practical terms in the need to construct vast numbers of basic homes to meet the needs of Italy's many homeless. Countless pictures of building programs filled the pages of *Domus* at this time. Rogers also introduced the concept of *La casa umana* (The human house), which was predicated upon the continuity of the family and which placed the human being firmly at the center of things. As he himself explained, "In the program of reconstruction, the real and the ideal home must be seen as parts of the same problem."[8] Design was part of the same picture. At this time a number of young architect-designers, among them Paolo Chessa, Ignazio Gardella, Vico Magistretti (see fig. 2), and Marco Zanuso (see fig. 3), proposed ranges of simple, flexible, and compact furniture items that could be used within limited living spaces. Furniture became, in this context, an important symbol of regeneration.

Rogers's aim, in brief, was the construction and furnishing of 15 million homes, which he felt had to be built to make up for the housing already needed before the war and to replace homes destroyed during the hostilities. He formulated these aims within the ideological framework of European architectural Modernism, which included design. These ideas were expressed at a time when there was still a strong left-wing (including Communist) element within the Italian coalition

government. When this element was expelled in 1947 the DC (Democrazia Cristiana/Christian Democratic party) came to the fore and American influence became more evident. This shift was also reflected in the world of design. In 1948 Ponti, after an absence of five years, once again took over editorship of *Domus*, and the ideological emphasis in the editorial content changed to one that was in line with the American model of private consumption. The American idea that democracy is built up on the basis of a shared materialism began to filter into the design discussion. By 1953 Ponti could write, "Our ideal of the 'good life' and the level of taste and thought expressed by our homes and manner of living are all part of the same thing."[9]

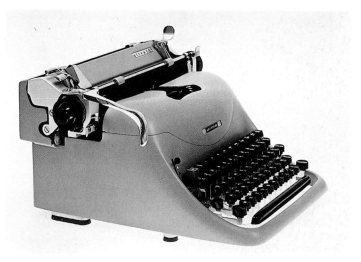

From this point onward design in Italy could be seen to have been ideologically linked to an ideal of improved standards of living based upon the consumption of previously unobtainable consumer goods, many of them produced in Italy for the first time in these years. Although some of these goods—vacuum cleaners, refrigerators, television sets, and eventually cars—were consumed fairly democratically by the Italian home market, it was to the middle-class residents of cities in the North, within the industrial triangle of Milan, Turin, and Genoa, that goods with a strong design input were directed in the early years of the 1950s. Although Italy's economic boom was based on the rising graph of its exports in this period, the real expansion did not take place until after 1957 and Italy's entry into the European Economic Community (EEC). Prior to that time it depended strongly on a home market to consume large numbers of the kinds of goods that it would eventually direct toward the international marketplace. Goods manufactured on a small to medium scale, such as furniture items, lighting, and certain electrical appliances for the home, all played a role here and lay at the heart of the new Italian design movement.

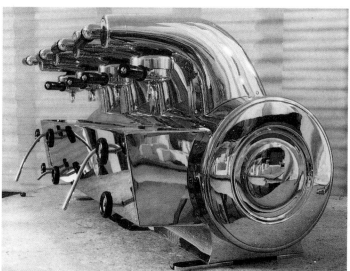

fig. 4. Marcello Nizzoli, Lexicon 80 typewriter, 1948. Manufactured by Olivetti.

fig. 5. Gio Ponti, Coffee machine, 1947. Manufactured by La Pavoni.

Thus by the early 1950s there was a sense in which design in Italy functioned to keep the wheels of home consumption moving, as they had been in the United States before it. In the Italian context, however, that consumption was aimed primarily at the middle class rather than at the whole of society, and it was represented, therefore, by a higher level of visual sophistication. This was evident in the aesthetics of many of the goods in question. Whereas in the United States the bulbous forms of the style known as "streamlining" were frequently adorned with chrome strips that acted as evocative and seductive highlights emphasizing their popular appeal, in Italy a more somber version of this idiom took hold, demonstrating a more ambivalent attitude toward mass consumption. In Italy's streamlined objects sensuality was combined with references to abstract, organic sculpture. This suggested a more sophisticated market, one that understood the world of fine art, to some extent, and that wished to participate in that world through the consumption of goods.

Among the seminal objects in what came to be called "the Italian line"[10] were a number of mass-produced metal goods—among them Marcello Nizzoli's *Lexicon 80* typewriter (1948, fig. 4) for Olivetti; Piaggio's *Vespa* motor scooter (1946, cat. no. 735); the *Cisitalia* car designed by Battista Pininfarina (1951); and Ponti's *La Pavoni*

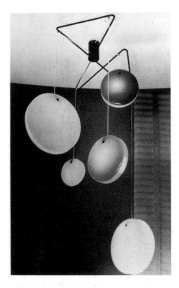

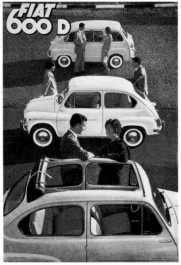

fig. 6. Gino Sarfatti, Hanging lamp, model 2072, 1953. Manufactured by Arteluce.

fig. 7. Poster for the Fiat 600D, 1956.

coffeemaker (1947, fig. 5)—whose pressed and stamped forms exhibited the familiar curves of streamlining. At the same time this was stripped-down streamlining, which appealed through the balance and proportion of its curves rather than through the surface impact of shiny chromium. Those details that were emphasized were structural rather than aesthetic—a good example being the seam on the body of the *Lexicon 80*, used by Nizzoli to reveal, rather than conceal, the fabrication process of the product in addition to creating a strong visual highlight. This was a version of streamlining that merged, on the one hand, with the earlier functionalist tenets of Modernism, which decreed that "form ever follows function," [11] and, on the other, with the biomorphic preoccupations of such contemporary abstract sculptors as Jean Arp, Barbara Hepworth, and Henry Moore. The sculptural influence was particularly significant in the area of furniture design, as in the curved wooden and glass forms of works by the Turin-based designer Carlo Mollino (see cat. no. 758) and the bulbous pieces filled with the new polyurethane foam by such designers as Osvaldo Borsani (see cat. no. 757) and Zanuso. Sculptural associations were even clearer in many of the designs for lighting from this period—items by Gino Sarfatti for Arteluce (see fig. 6), for instance, which closely resemble the hanging mobiles of Alexander Calder. At the same time, however, the organic aesthetic was also visible in contemporary furniture designs by the American Charles Eames, demonstrating that this new art-inspired approach toward design was influential on both sides of the Atlantic. And in fact Eames's designs were frequently illustrated in *Domus* in the late 1940s.

In the area of consumer appliances and machinery, however, the high-culture, fine-art element of early Italian postwar design clearly distinguishes them from their American streamlined predecessors. The niche market that Italian manufacturers—most of them still relatively small compared with their American counterparts—aspired to cater to, first at home and later through exports, was, unlike the American mass market, characterized by cultural sophistication and social elitism. Because of the traditionally modest scale of its manufacturing industry (with only a handful of exceptions, such as Fiat, Montecatini, Montedison, Olivetti, and Pirelli); its longstanding reputation as the home of fine art; the much more structured and hierarchical nature of its indigenous society; and its decision to enter the international marketplace through niche rather than mass marketing, Italy demonstrated its newfound sense of modernity in a rather different material manner from that of the United States. Thus, while clearly influenced by the general framework offered by the United States, to some extent the discussion in Italy in the decade after the war focused on the concept of "industrial aesthetics" rather than that of "industrial design." During these years the *Triennale* exhibitions in Milan, which were important showcases of international design trends, always contained displays of Italian goods. The titles of these displays—*La Forma dell'Utile* (The form of the useful, 1951) and *La Produzione dell'Arte* (The production of art, 1954)—bear witness to the Italian preoccupation with aesthetics.

If Italy was beginning to define its Modern design movement in a way that had as much to do with its own

traditions, its own industrial and sociocultural characteristics, and its own postwar trade strategies as it did with influences from the United States, this did not mean that the Americans had no interest in what was going on in that country. On the contrary they clearly saw Italian manufacturing and exports as a vital element in the trading relationship between the two countries. Such a perception is reflected in the organization of *Italy at Work*, an exhibition of Italian goods that toured the United States in 1951. The show was essentially an American initiative, conceived in the United States by an American body called the House of Italian Handicrafts, backed by a number of American museums, sponsored by the Export Import Bank of the United States, and supported in Italy by the Economic Administration Council, which was directly tied to the Marshall Plan. It represented, therefore, an attempt to develop trade links between the United States and Italy and to make the American marketplace aware of craft and design developments in Italy. In 1950 Walter Dorwin Teague was a member of a group that visited Italy to select goods for the exhibition. This direct connection between an eminent American industrial design practitioner and the nascent Italian industrial design movement is a clear instance of the United States wanting to establish links with Italy in this arena. It provides evidence of an American physical presence and suggests that active attempts were being made on the part of the United States to encourage the development of design awareness within Italy, an awareness that was clearly tied to the export trade. The visitors toured a range of Italian workshops and factories, and Teague wrote, in the introduction to a catalogue that accompanied the exhibition, that Italian design "represented the vigorous flowering of an early spring, an upsurge of the Italian vitality that seems to have stored itself up during the long gray fascist interim, waiting for this day of the sun again." [12]

Such a statement was loaded with ideological overtones, as Teague was committed to the symbolic role of design in the kind of democracy that he favored, that is, the conservative American example. In 1950 he saw signs that Italy was moving in a similar direction. At the same time, however, the model of design that emerged from *Italy at Work* was characterized by its strong craft bias. As such it had little in common with the much more industrially and marketing-oriented American version. This suggests that Teague and his team were looking for an Italian design that would be an equivalent to (in the sense of representing Italy's culture), rather than a mirror of, American design.

The artifacts selected for *Italy at Work* ranged from objects of local craft manufacture that had remained unchanged for centuries—faience figurines, mosaics, and straw goods—to industrially manufactured furniture in the Modern style and in modern materials by such designers as Franco Albini (see cat. no. 754) and Mollino, and mass-produced consumer appliances and machinery, among them an adding machine by Nizzoli for Olivetti and a home coffeemaker from the Robbiati company. Tradition and innovation stood alongside each other, and craft and industrial production were seen as two ends of a single, continuous process.

The catalogue itself recognized the way in which Italian design, especially in the area of furniture, was both influenced by the United States and yet functioned independently of it:

Much interesting work is being done by those architect designers who are particularly devoted to the functionalist theory. Here the influence of advanced American design is very apparent. This approach is evident in the combination living and dining room by Carlo Mollino. In contrast with this is the free decorative style of the group led by the architect Gio Ponti whose fertile imagination and decorative ingenuity produced the unique design for the living room. [13]

In this context it was the difference, and therefore the special appeal, of Italian goods that was of interest to the United States. At the same time, however, America continued to provide a model on the level of both manufacturing and consumption and in the area of professional design practice. The very notion of modernity in 1950s Italy reverberated with American associations of Fordism and conspicuous consumption. This was especially apparent at the end of the decade, with the economic miracle. At this time the expanded home market for consumer goods became increasingly materialistic and status conscious, such that ownership of a car, a washing machine, and a television was seen as a vital component of a modern lifestyle by an increasingly large section of the population. With television also came the influx of American television programs and, with them, the exposure of Italian audiences to American kitchens and living spaces. This was also the time when it was relatively more expensive to buy meat in Italy than to invest in a new refrigerator. [14]

It does not necessarily follow, however, that the similarity in manufacturing and consumption patterns between the United States and Italy led to an identical approach to the question of design. Italy evolved its own way of thinking about design, even in the context of large-scale manufacturing. Fiat, for example, moved into a Fordist manufacturing mode in the early 1950s, resulting in the mass production of the Fiat 500 and Fiat 600 (see fig. 7). For many Italians, a *Cinquecento* or *Seicento* was their first car purchase, just as the Model-T Ford had been for Americans back in the early part of the century. At the same time, although Fiat made a deliberate decision to develop small, functional, and basic automobiles, the result reflected a sophisticated sense of design and marketing in which difference was a key element. These Fiats, which exhibited the stripped-down streamlining particular to Italian design, provide yet another example of the evolution of a consistent and characteristically Italian aesthetic.

Similarities in methods of mass production, differences in models of design and marketing strategies, was a pattern applied to other large-scale Italian industries as well, among them plastics and office machinery. Following the example of the United States, Italy expanded its production of petrochemical materials in the postwar years and moved into the manufacture of plastic consumer goods as a means of using those materials. Even in the production of such mundane goods as buckets and washing-up bowls, however, the model of design that was utilized had more in common with fine art than with mass marketing. The work of Gino Colombini for Kartell (see fig. 8), for instance,

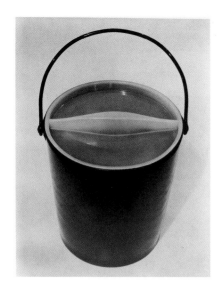

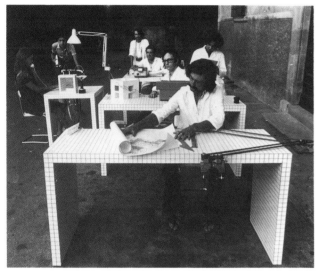

fig. 8. Gino Colombini, Covered polyethylene pail, model KS 1146, 1954. The Museum of Modern Art, New York. Gift of Philip Johnson.

fig. 9. Superstudio, Quaderni table, 1971. Manufactured by Zanotta.

brightly colored and aesthetically pleasing, was presented as an exercise in pure form.

The Italian design profession was consolidated in 1956 with the formation of its own body, the ADI (Associazione per il Disegno Industriale/Association for Industrial Design). Like the Americans before them, Italian designers worked for the most part on a free-lance basis servicing the needs of a wide range of industries. Also like the Americans, they worked on the body shells of such goods as typewriters, vacuum cleaners, radios, and sewing machines, having little or nothing to do with their inner components or their technological requirements. They were all therefore stylists of a sort. There, however, the resemblance ends. Italy's designers were mostly architects rather than graphic artists by training, and they worked, for the most part, either singly or in small teams, without the collaboration of the marketing and business partners who were so vital to their American counterparts. Most American industrial designers worked with several offices numbering more than a hundred employees, including teams of draftsmen and technical assistants. While the Americans offered a wide spectrum of services, from packaging to corporate identity to market research to prototyping to product design, the Italians tended to work only on such architecturally oriented projects as interiors, exhibitions, furniture design, and lighting, with small forays into product design. If the Italian designers were architects by training in the postwar years, they functioned more like fine artists in small studios, in the tradition of their Renaissance ancestors. Some, like Ettore Sottsass, Jr., who was also a sculptor, carried on both artistic and craft practices at the same time.

It was in the second half of the 1950s that the American notion of "industrial design" (as opposed to the indigenous term "industrial aesthetics") entered into the Italian design debate in a visible way. Growing adherence to this concept meant that the designers increasingly saw themselves operating within an international arena, rather than simply within a strictly Italian context. While this coincided with Italy's increasingly important role within the international economy, the country also began to emancipate itself from the American economy and to become more dependent upon that of Europe, where "Italian design" had a strong presence by the end of the decade.

As the economic boom began to tail off in the early 1960s, signs of an "Italian dualism" began to manifest themselves. Such a dualism refers not only to the cultural differences between Italy's North and South but also to the country's dual industrial structure, which included both large, capital-intensive companies and small firms (many of them functioning within the tax-evading "black economy"). The idea also had increasing relevance in the area of design, denoting, for instance, Italy's capacity to absorb American ideas and strategies but also, simultaneously, to evolve an indigenous design movement based not only upon its own traditions but also upon its own postwar cultural identity and economic strategies.

Throughout the 1950s and into the early 1960s the Italian design movement went from strength to strength, proving to be one of the country's most powerful assets in the international economy and earning for Italy a high level of respect for its renewed cultural identity. Like the United

States before it, Italy had used design as a key strategy both in its trade tactics and in establishing an image for itself at home and abroad. In the United States, however, that image had focused on the idea of a democracy that allowed a high standard of living for all its inhabitants, a democracy that was, in turn, represented by material possessions and by its commitment to technological progress. Italy defined its postwar entry into international economic and cultural life with a much more overtly high-culture message.

By the mid-1960s, however, there were signs both of a shift away from the impact of American ideas and a loss of faith in the ideology that had hitherto underpinned the movement known as "Italian design." As workers went on strike and, in the second half of the decade, students protested, many younger architect-designers—among them such groups as Archizoom (see cat. no. 778), Gruppo Strum, and Superstudio (see fig. 9), and such individuals as Sottsass—began to question the idea of design as a symbol of status and as a handmaiden to the manufacturing industry. In some ways this represented a turning away from the American model of design pragmatism and a search for a new way forward that might embrace a more idealistic and radical role for both designer and design.

The influence of the United States on the formation of an Italian industrial design movement is ultimately hard to quantify. Through the agency of the aid it gave to Italy in the postwar years, the United States provided Italy with a strong model on many fronts. It is also clear that American precedents influenced both the framework within which design functioned and many of its internal characteristics. More than that, however, it is difficult to assess. American influence, throughout the period under review, was continually offset by forces that were particular to Italy— by, for example, the special way in which its industry functioned, its social structure operated, and the designers defined themselves in relation to both. Above all, the unprecedented international success and influence of Italy's own design movement, which was fully formed by the middle of the 1950s, suggests that Italy not only learned much from the United States but also that it went significantly beyond that lesson to evolve a model of design that was, in the final analysis, indubitably its own. Italian design has never functioned solely as part of a commercial strategy, but has always been a deeply rooted cultural and ideological phenomenon stimulating debates that have both mirrored and influenced broader sociocultural issues in postwar Italy.

1. Martin Clark, *Modern Italy 1871–1980* (London: Longman, 1984), p. 348.
2. See, for example, Penny Sparke, "From a Lipstick to a Steamship: the Birth of the American Industrial Design Profession," in Terry Bishop, ed., *Design History: Fad or Function?* (London: Design Council, 1978); and Jeffrey Meikle, *Twentieth-Century Limited: Industrial Design in America 1925–1939* (Philadelphia: Temple University Press, 1979).
3. See Stuart Durant, *Christoper Dresser* (London: Academy Editions, 1993), p. 23, where this claim is made.
4. The Italian architect Gio Ponti collaborated with the ceramics manufacturer Richard Ginori from 1923 to 1939. Much of Ponti's work for Ginori was in the neoclassical Novecento style. He also provided designs, in the 1930s, for the decorative-arts company Fontana Arte.
5. Ernesto Nathan Rogers, "Editorial," *Domus*, no. 205 (January 1946), p. 3.
6. Rogers coined the phrase "from a spoon to a city" as the title for an exhibition in Turin in 1940.
7. Raymon Loewy, *Never Leave Well Enough Alone* (New York, 1951), p. 32.
8. Rogers, p 5.
9. Gio Ponti, "Italy's Bid on the World Market," *Interiors*, February 1953, p. 79.
10. These are described in an article written by the French graphic designer Frédérick Henrion, "Italian Journey," *Design* (Design Council, London), January 1949, p. 23.
11. This much-quoted phrase derives from Louis Sullivan, "The Tall Office Building Artistically Considered," *Lippincotts*, January 1896.
12. Walter Dorwin Teague, "Foreword," *Italy at Work: Her Renaissance in Design Today* (Rome: Compagnia Nazionale Artigiana, 1950), p. i.
13. *Italy at Work*, p. 27.
14. Donald Sassoon, *Contemporary Italy: Politics, Economy and Society Since 1945* (London: Longman, 1986), p. 33.

724. Achille and Pier Giacomo Castiglioni
Children's camera, 1964. Wood model, fabricated in 1993 by Giovanni Sacchi (based on original plaster prototype), 10 x 15 x 10 cm. Collection of Achille Castiglioni, Milan.

725. Achille and Pier Giacomo Castiglioni
RR 126 stereo system, 1966. Lacquered wood shell and aluminum; closed: 92 x 62 x 36.5 cm; open: 70 x 140 x 36.5 cm. Manufactured by Brionvega. Lent by the manufacturer, Cernusco sul Naviglio (MI).

726. Achille and Pier Giacomo Castiglioni
Spalter vacuum cleaner, 1956. Plastic, leather, metal, and felt, 38.8 x 14.6 x 15 cm. Manufactured by R.E.M. di Rossetti Enrico. The Museum of Modern Art, New York, Gift of the manufacturer.

727. Marco Zanuso and Richard Sapper
Doney 14 portable television, 1962. ABS plastic housing, 35 x 36 x 30 cm. Manufactured by Brionvega. Lent by the manufacturer, Cernusco sul Naviglio (MI).

728. Marco Zanuso and Richard Sapper
Grillo (*Cricket*) folding telephone, 1965. ABS plastic housing, 7 x 16 x 8 cm. Manufactured by Società Italiana Telecommunicazioni Siemens. The Museum of Modern Art, New York, Gift of the manufacturer.

729. Marcello Nizzoli
Lettera 22 (*Letter 22*) portable typewriter, 1950. Enameled metal housing, 8.3 x 29.8 x 32.4 cm. Manufactured by Olivetti, S.p.A. The Museum of Modern Art, New York, Gift of Olivetti Corp. of America.

730. Ettore Sottsass, Jr. and Perry A. King
Valentine portable typewriter, 1969. ABS plastic housing, 10.2 x 34.3 x 35 cm. Manufactured by Olivetti, S.p.A. The Museum of Modern Art, New York, Gift of Olivetti Underwood.

731. Mario Bellini
TCV 250 video display terminal, 1966. Body: sheet steel and vacuum-cast ABS plastic plate; cover: cast-injected ABS plastic, 93.5 x 91.6 x 55.8 cm. Manufactured by Olivetti, S.p.A. The Museum of Modern Art, New York, Gift of the manufacturer.

732. Gino and Nani Valle, John Myer, and Michele Provinciali
Cifra 5 (*Number 5*) clock, 1955. Plastic housing, 17 x 27 x 11 cm. Manufactured by Solari. Collection of the Estate of Alfredo Carnelutti, Udine.

733. Rodolfo Bonetto
Magic Drum portable radio, 1968. ABS plastic housing, 12 cm high, 10 cm diameter. Manufactured by Autovox. Bonetto Design Collection.

734. Ermenegildo Preti
Isetta automobile, 1952–53. 132 x 225 x 134 cm. Manufactured by Iso. Collection of Enrico Mirani, Piacenza.

735. Corradino D'Ascanio
Vespa (*Wasp*) motorscooter, 1946. 120 x 191 x 71 cm. Manufactured by Piaggio Veicoli Europei S.p.A. Lent by the manufacturer.

736. Dante Giacosa
Nuova 500 (New 500) automobile, 1954. Wood prototype, fabricated by Reparto modellatori Fiat Mirafiori, 130 x 290 x 130 cm. Fiat S.p.A., Centro Storico.

737. Battista Pinin Farina
250 Le Mans automobile, 1963. Fiberglass model, fabricated by Pininfarina, 23 x 84.5 x 33.5 cm. Manufactured by Ferrari. Pininfarina Collection.

738. Battista Pinin Farina
250 Le Mans automobile, 1963. Fiberglass model, fabricated by Pininfarina, 23 x 88 x 33.5 cm. Manufactured by Ferrari. Pininfarina Collection.

739. Battista Pinin Farina
Cisitalia 202 automobile, 1947. Sheet metal model, fabricated by Pininfarina, 24 x 78.2 x 30 cm. Manufactured by Fiat S.p.A. Pininfarina Collection.

740. Gio Ponti
Superleggera (*Superlight*) two-tone chair, 1957. Lacquered wood prototype with plastic-covered seat, 82.5 x 40 x 45 cm. Collection of Lisa Ponti, Milan.

741. Piero Fornasetti
Decorated plate, ca. 1950–55. Transfer-printed porcelain, 26 cm diameter. Manufactured by Fornasetti. Fornasetti Collection, Milan.

742. Piero Fornasetti
Decorated plate, ca. 1950–55. Transfer-printed porcelain, 26 cm diameter. Manufactured by Fornasetti. Fornasetti Collection, Milan.

743. Piero Fornasetti
Decorated plate, ca. 1950–55. Transfer-printed porcelain, 26 cm diameter. Manufactured by Fornasetti. Musée des Arts Décoratifs de Montréal, Gift of Fornasetti S.r.l.

744. Joe Colombo
Chair, model 4867, 1968. Injected ABS plastic, 70 x 50 x 50 cm. Manufactured by Kartell.S.p.A. Lent by the manufacturer, Noviglio.

745. Giandomenico Belotti
Chair for indoors and outdoors, 1962. Glazed steel and PVC, 83.5 x 40 x 53.5 cm. Manufactured in 1979 by Alias as the *Spaghetti* chair. Private collection, Milan.

746. Vico Magistretti
Selene stacking chair, 1969. Fiberglass-reinforced plastic, 74.9 x 47 x 50.2 cm. Manufactured by Artemide S.p.A. The Museum of Modern Art, New York, Gift of the manufacturer.

747. Gae Aulenti
Pipistrello (*Bat*) table lamp, 1966. White opal methacrylate and stainless steel, with lacquered base, 86 cm high, 55 cm diameter. Manufactured by Martinelli. Private collection, Milan.

748. Bruno Munari
Calza (*Stocking*) tubular pendant lamp, 1964. Elastic-fabric tubing and metal rings, 165 cm high, 40 cm diameter. Manufactured by Bruno Danese. Courtesy Association Jacqueline Vodoz and Bruno Danese, Milan.

749. Achille Castiglioni and Pio Manzù
Parentesi (*Parenthesis*) lamp, 1971. Stainless steel and rubber; maximum height: 400 cm; base: 10 cm diameter. Manufactured by Flos S.p.A. Courtesy Flos Inc., Huntington Station, N.Y.

750. Achille and Pier Giacomo Castiglioni
Splugen Bräu suspension lamp, 1960. Polished aluminum, 20 cm high, 36 cm diameter. Manufactured in 1962 by Flos S.p.A. Courtesy Flos Inc., Huntington Station, NY.

751. Achille and Pier Giacomo Castiglioni
Taccia (*Notoriety*) lamp, 1958. Lacquered metal and glass, 54 cm high, 49.5 cm diameter. Manufactured by Flos S.p.A. Courtesy Flos Inc., Huntington Station, N.Y.

752. Roberto Mango
String chair, 1952. Metal and PVC plastic, refabricated in 1994 by the designer (based on original prototype), 71 x 75 x 62 cm. Collection of the designer.

In some cases, archival photographs have been used in this catalogue to illustrate the design objects in the exhibition. Most of these photographs date from the time of the objects' first production, and depict objects identical to those on view. Descriptions of the specific design items in the exhibition follow.

753. Franco Albini
Gala armchair, 1950. Rattan and wicker, 106 x 90 x 90 cm. Manufactured by Vittorio Bonacina & C. Lent by the manufacturer, Lurago d'Erba.

754. Franco Albini and Franca Helg
PL 19 armchair, 1957. Metal, foam rubber, and fabric, 93.5 x 81.5 x 76.5 cm. Manufactured by Poggi Snc. Lent by the manufacturer, Pavia.

755. Vittorio Gregotti, Lodovico Meneghetti, and Giotto Stoppino
Cavour armchair, 1959. Laminated wood and foam rubber, 108 x 62 x 69 cm. Manufactured by SIM Talea. Lent by the manufacturer, Novara.

756. Achille and Pier Giacomo Castiglioni
San Luca armchair, 1960. Wood, foam rubber, and fabric, 96 x 87 x 100 cm. Manufactured in 1994 by Bernini. Lent by the manufacturer, Carate Brianza.

757. Osvaldo Borsani
P40 reclining chair, 1955. Metal and rubber; upright: 90 x 72 x 85 cm; reclining: 70 x 72 x 150 cm. Manufactured by Tecno S.p.A. Lent by the manufacturer.

758. Carlo Mollino
Arabesco (*Arabesque*) table, 1951. Wood, glass, and brass, 50 x 124 x 50 cm. Manufactured by Apelli and Varesio. Courtesy of Bruno Bischofberger, Zurich.

759. Gio Ponti
Cat, 1956. Enameled copper, 50 x 53 x 10 cm. Made by Paolo De Poli. Paolo De Poli Collection, Padua.

760. Gio Ponti
Swan, 1956. Enameled copper, 22 x 32 x 10 cm. Made by Paolo De Poli. Paolo De Poli Collection, Padua.

761. Gio Ponti
Devil, 1956. Enameled copper, 15 x 22 x 9 cm. Made by Paolo De Poli. Paolo De Poli Collection, Padua.

762. Enzo Mari
Ashtray with iron sheath, 1958. Glazed iron, 11 x 13 x 10 cm. Manufactured by Bruno Danese. Courtesy Association Jacqueline Vodoz and Bruno Danese, Milan.

763. Ettore Sottsass, Jr.
Object from the *Rocchetti* (*Spool*) series, ca. 1964. Ceramic prototype, 10.7 cm high, 21.8 cm diameter. Collection of Fulvio Ferrari, Turin.

764. Ettore Sottsass, Jr.
Object from the *Rocchetti* (*Spool*) series, model 985, ca. 1964. Ceramic, 18 cm high, 26.7 cm diameter. Collection of Fulvio Ferrari, Turin.

765. Enzo Mari
Tray with iron sheath, 1958. Glazed iron, 8 x 46 x 13 cm. Manufactured by Bruno Danese. Courtesy Association Jacqueline Vodoz and Bruno Danese, Milan.

766. Ettore Sottsass, Jr.
Object from the *Rocchetti* (*Spool*) series, model 487, ca. 1964. Ceramic, 13 cm high, 18.5 cm diameter. Collection of Fulvio Ferrari, Turin.

767. Ettore Sottsass, Jr.
Object from the *Rocchetti* (*Spool*) series, ca. 1964. Ceramic prototype, 16.5 cm high, 20.2 cm diameter. Collection of Fulvio Ferrari, Turin.

768. Ettore Sottsass, Jr.
Praxis 48 typewriter, 1964. Plastic, metal, and rubber, 15.7 x 45.5 x 34 cm. Manufactured by Olivetti, S.p.A. Musée des Arts Décoratifs de Montréal, gift of Barry Friedman and Patricia Pastor.

769. Roberto Sambonet
Fish serving dish, 1954. Stainless steel, 7 x 16 x 51 cm. Manufactured by Sambonet. Philadelphia Museum of Art.

770. Bruno Munari
Eyeglasses, 1955. Cardboard; open: 4 x 13.8 x 13 cm. Collection of the designer, Milan.

771. Bruno Munari
Desk set, 1958. Melamine and anodized aluminum, 6.5 x 24.5 x 6.5 cm. Manufactured by Bruno Danese. Courtesy Association Jacqueline Vodoz and Bruno Danese, Milan.

772. Enzo Mari
Java table container, 1969. Melamine, 6 cm high, 14 cm diameter. Manufactured by Bruno Danese. Courtesy Association Jacqueline Vodoz and Bruno Danese, Milan.

773. Bruno Munari
Ashtray, 1957. Anodized aluminum, 8 x 8 x 8 cm. Manufactured by Bruno Danese. Courtesy Association Jacqueline Vodoz and Bruno Danese, Milan.

774. Paolo Gatti, Cesare Paolini, and Franco Teodoro
Sacco (*Sack*) beanbag chair, 1968. Plastic with polystyrene bead filling; dimensions variable, approx. 114 cm high, 76 cm diameter. Manufactured by Zanotta S.p.A. The Museum of Modern Art, New York, Gift of the Gimbels Department Store.

775. Achille and Pier Giacomo Castiglioni
Mezzadro (*Farmer*) stool, 1957. Chromed steel, enameled metal, and wood, 51 x 50 x 50 cm. Manufactured in 1971 by Zanotta S.p.A. The Museum of Modern Art, New York, Gift of the manufacturer.

776. Jonathan De Pas, Donato D'Urbino, Paolo Lomazzi, and Carla Scolari
Blow lounge chair, 1967. Transparent PVC plastic, 82 x 110 x 88 cm. Manufactured in 1990 by Zanotta S.p.A. Donato D'Urbino and Paolo Lomazzi, DDL Studio, Milan.

777. UFO {Carlo Bachi, Lapo Binazzi, Patrizia Cammeo, Riccardo Foresi, and Titti Maschietto}
Dollar lamp for the Sherwood restaurant, Florence, 1968–69. Gold-plated metal and stone, 70 x 50 x 15 cm. Archivio UFO, Florence.

778. Archizoom {Dario Bartolini, Lucia Bartolini, Andrea Branzi, Gilberto Corretti, Paolo Deganello, and Massimo Morozzi}
Superonda (*Superwave*) sofa, 1967. Polyurethane and PVC fabric, two pieces; 89 x 237.5 x 36 cm; 48 x 237 x 36 cm. Manufactured by Poltronova. Musée des Arts Décoratifs de Montréal.

724. Achille and Pier Giacomo Castiglioni

Children's camera, 1964. Plaster prototype, 10 x 15 x 10 cm.

725. Achille and Pier Giacomo Castiglioni

RR 126 stereo system, 1966. Lacquered wood shell and aluminum; closed: 92 x 62 x 36.5 cm; open: 70 x 140 x 36.5 cm. Manufactured by Brionvega.

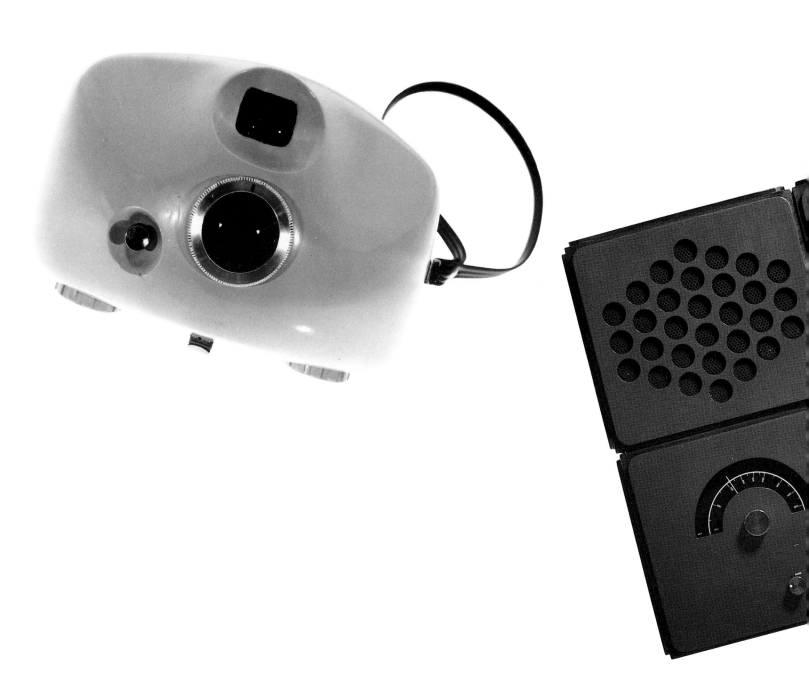

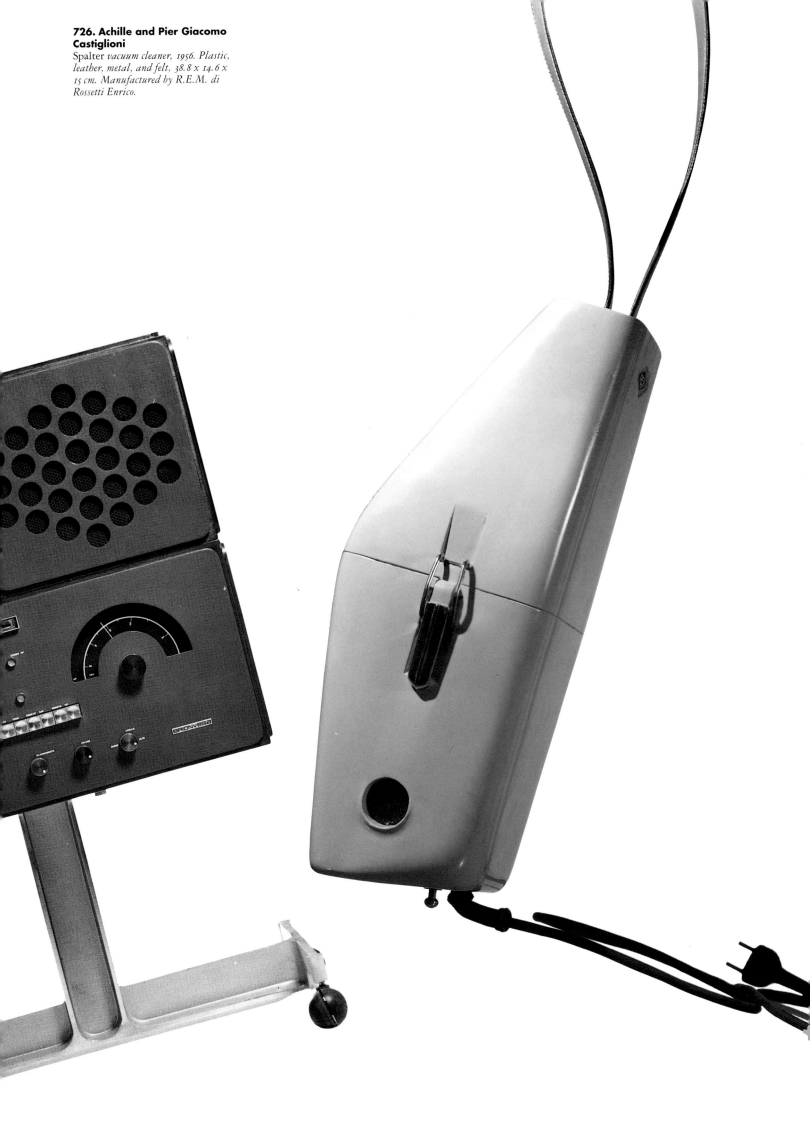

727. Marco Zanuso and Richard Sapper
Doney 14 *portable television, 1962. ABS plastic housing, 35 x 36 x 30 cm. Manufactured by Brionvega.*

728. Marco Zanuso and Richard Sapper
Grillo (Cricket) *folding telephone, 1965. ABS plastic housing, 7 x 16 x 8 cm. Manufactured by Società Italiana Telecommunicazioni Siemens.*

729. Marcello Nizzoli
Lettera 22 (Letter 22) *portable typewriter, 1950. Enameled metal housing, 8.3 x 29.8 x 32.4 cm. Manufactured by Olivetti, S.p.A.*

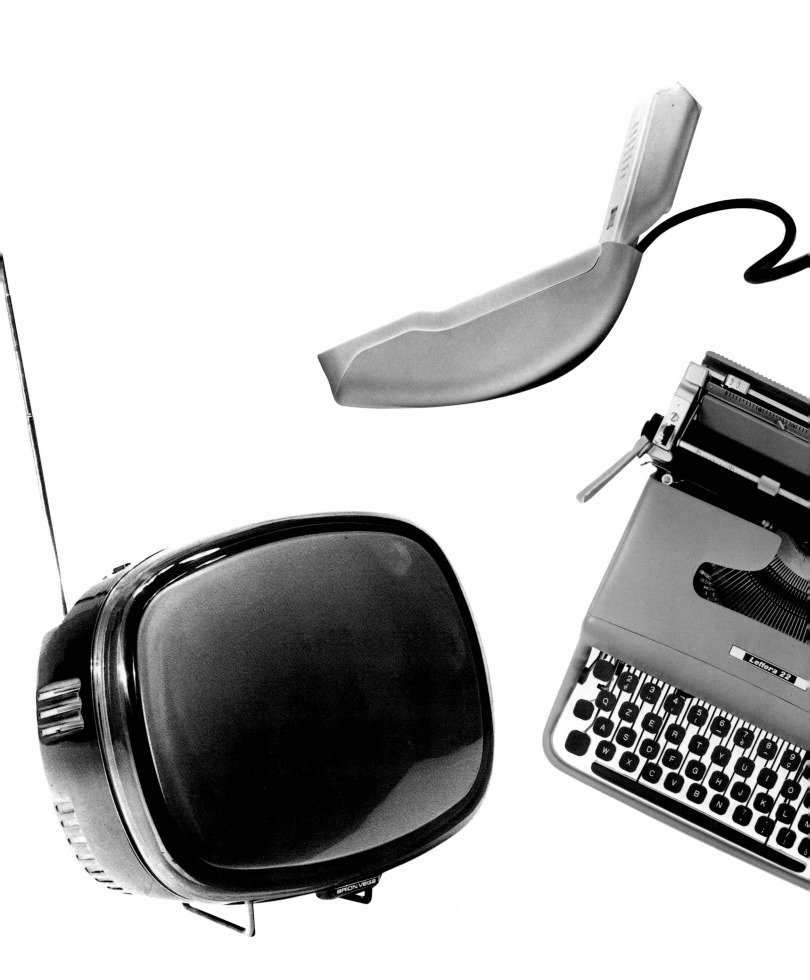

730. Ettore Sottsass, Jr. and Perry A. King
Valentine *portable typewriter, 1969. ABS plastic housing, 10.2 x 34.3 x 35 cm. Manufactured by Olivetti, S.p.A.*

731. Mario Bellini
TCV 250 *video display terminal, 1966. Body: sheet steel and vacuum-cast ABS plastic plate; cover: cast-injected ABS plastic, 93.5 x 91.6 x 55.8 cm. Manufactured by Olivetti, S.p.A.*

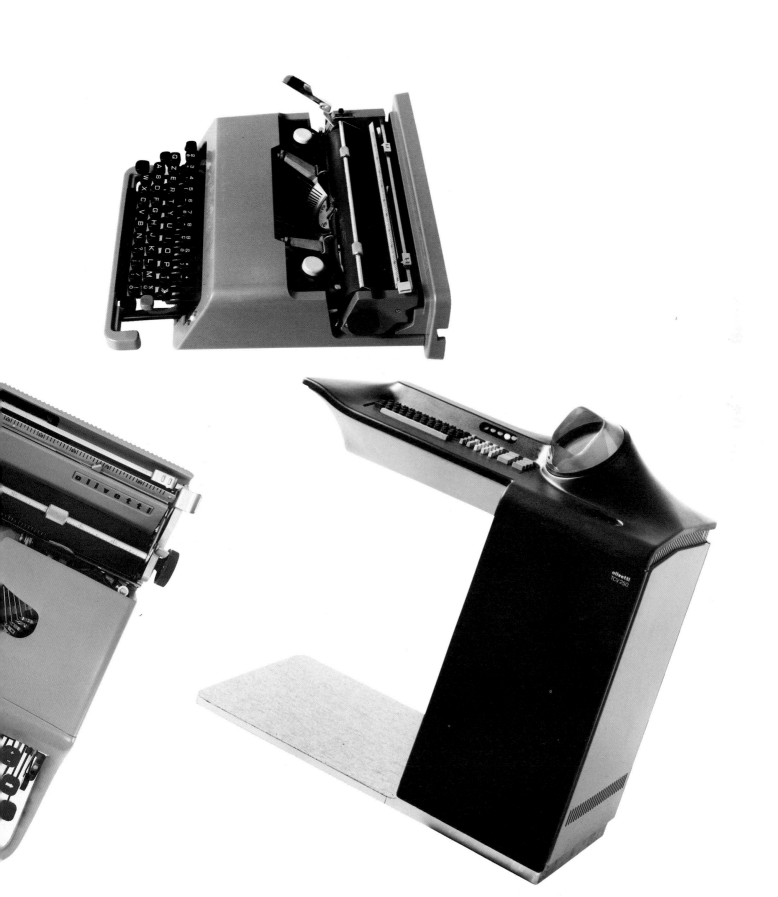

732. Gino and Nani Valle, John Myer, and Michele Provinciali
Cifra 5 (Number 5) *clock, 1955. Plastic housing, 17 x 27 x 11 cm. Manufactured by Solari.*

733. Rodolfo Bonetto
Magic Drum *portable radio, 1968. ABS plastic housing, 12 cm high, 10 cm diameter. Manufactured by Autovox.*

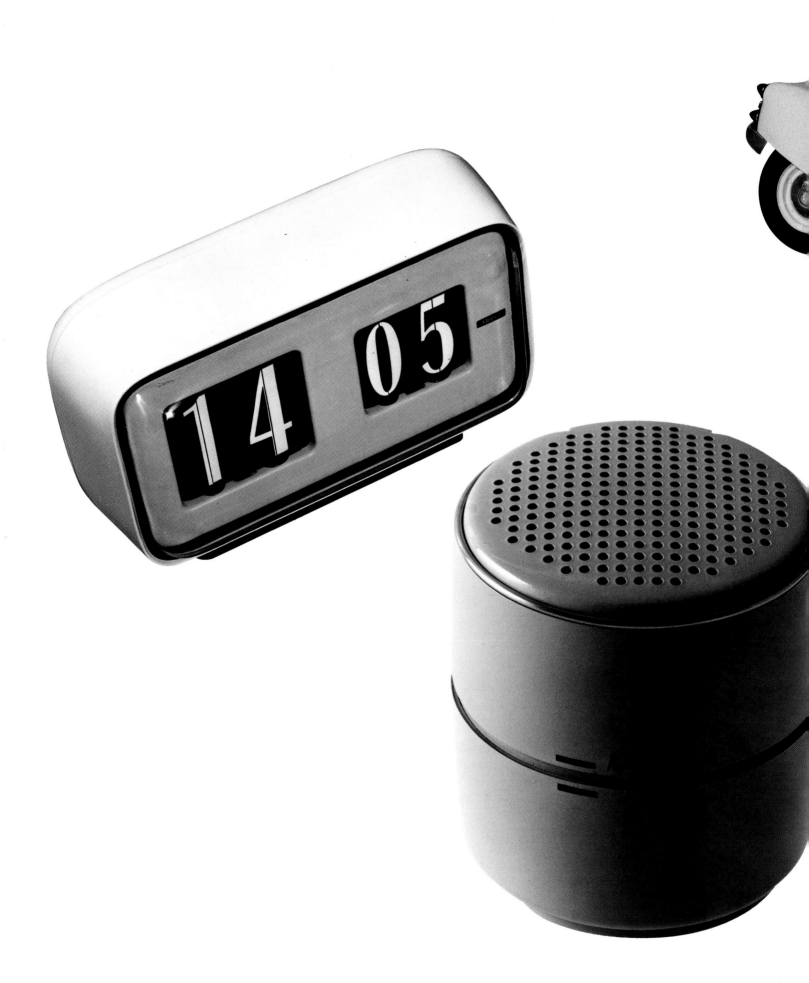

734. Ermenegildo Preti
Isetta *automobile,* 1952–53. 132 x 225 x 134 cm. Manufactured by Iso.

735. Corradino D'Ascanio
Vespa (Wasp) *motorscooter, 1946.* 120 x 191 x 71 cm. Manufactured by Piaggio Veicoli Europei S.p.A.

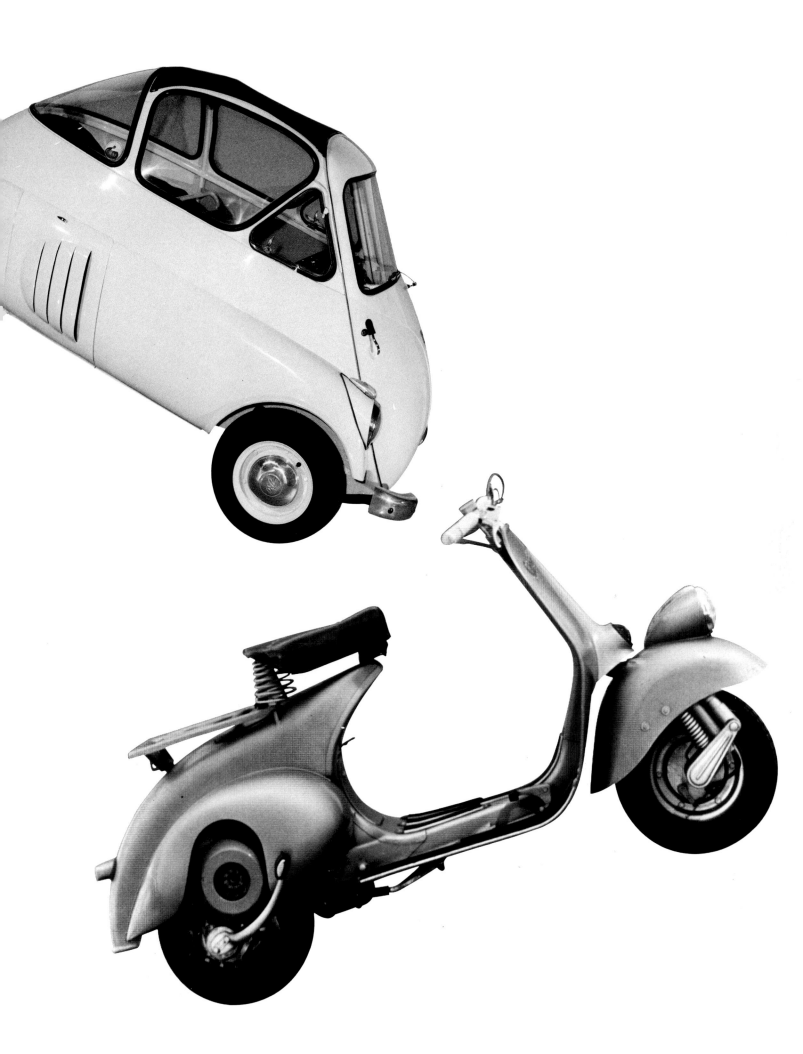

736. Dante Giacosa
Nuova 500 *(New 500) automobile,*
1954. Wood prototype, fabricated by
Reparto modellatori Fiat Mirafiori,
130 x 290 x 130 cm.

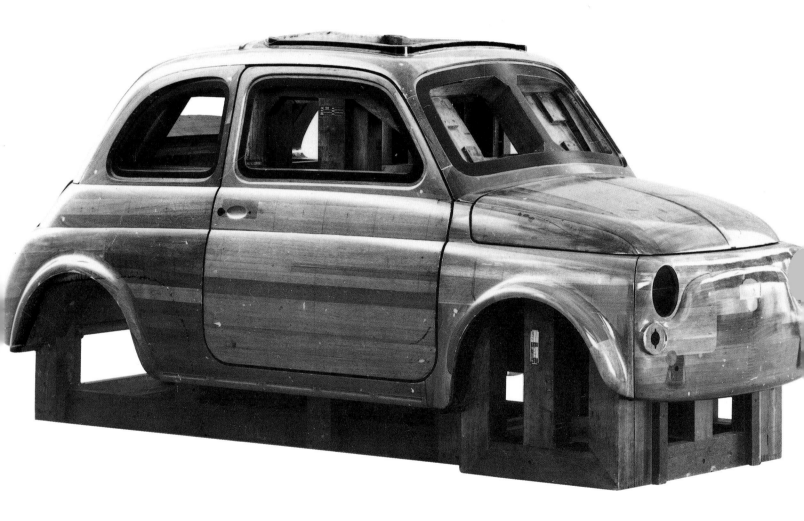

737. Battista Pinin Farina
250 Le Mans *automobile, 1963.*
Fiberglass model, fabricated by
Pininfarina, 23 x 84.5 x 33.5 cm.
Manufactured by Ferrari.

738. Battista Pinin Farina
250 Le Mans *automobile, 1963.*
Fiberglass model, fabricated by
Pininfarina, 23 x 88 x 33.5 cm.
Manufactured by Ferrari.

739. Battista Pinin Farina
Cisitalia 202 *automobile, 1947.*
Sheet metal model, fabricated by
Pininfarina, 24 x 78.2 x 30 cm.
Manufactured by Fiat S.p.A.

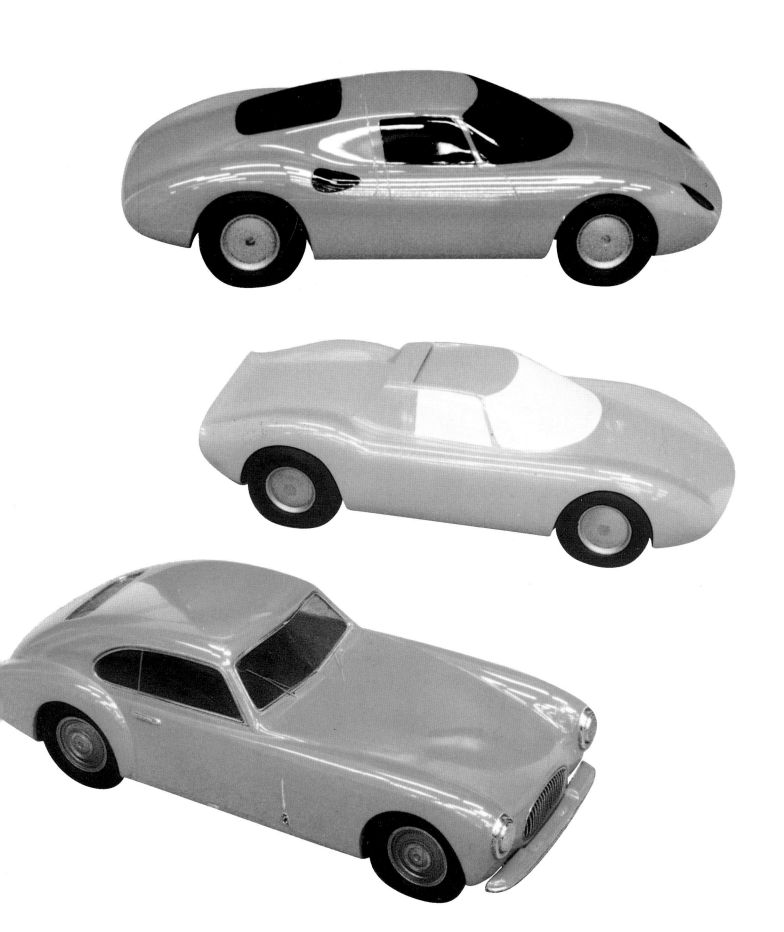

740. Gio Ponti
Superleggera (Superlight) *two-tone*
chair, 1957. Lacquered wood
prototype with plastic-covered seat,
82.5 x 40 x 45 cm.

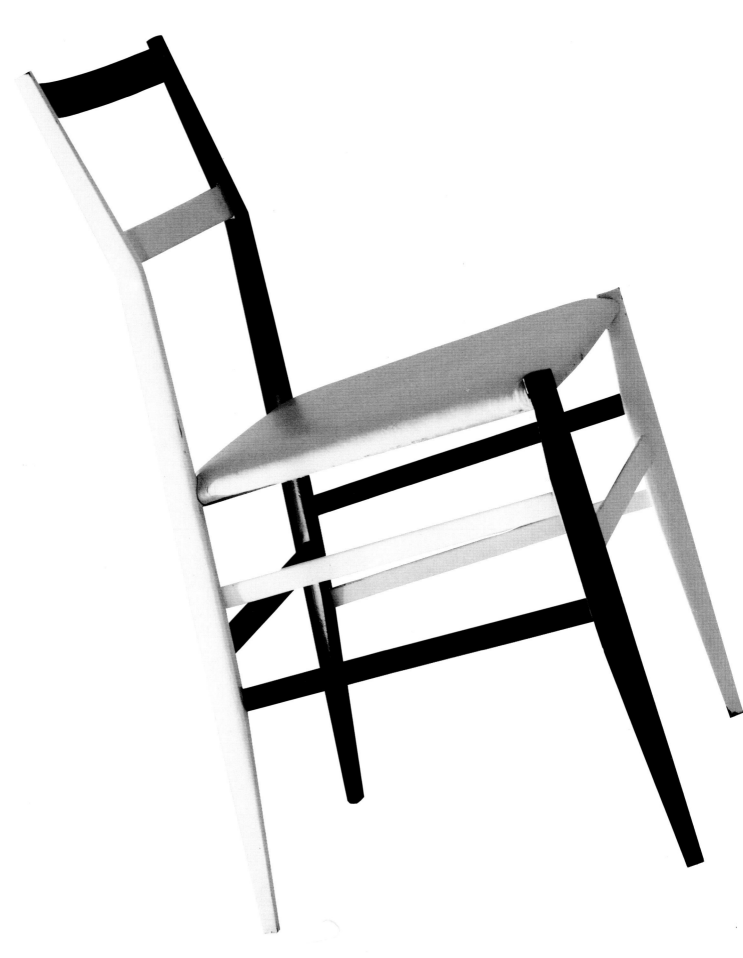

741. Piero Fornasetti
Decorated plate, ca. 1950 – 55.
Transfer-printed porcelain,
26 cm diameter. Manufactured by
Fornasetti.

742. Piero Fornasetti
Decorated plate, ca. 1950 – 55.
Transfer-printed porcelain,
26 cm diameter. Manufactured by
Fornasetti.

743. Piero Fornasetti
Decorated plate, ca. 1950 – 55.
Transfer-printed porcelain,
26 cm diameter. Manufactured by
Fornasetti.

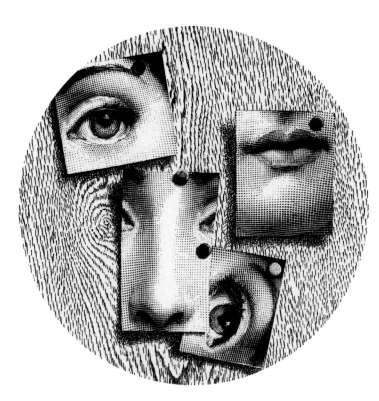

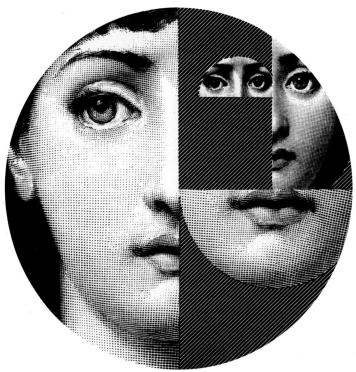

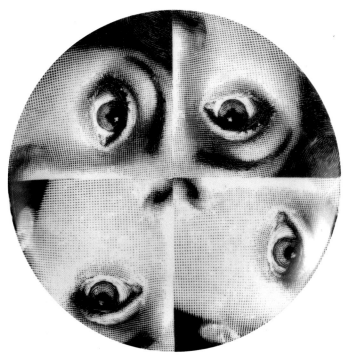

744. Joe Colombo
Chair, model 4867, 1968. Injected ABS
plastic, 70 x 50 x 50 cm. Manufactured
by Kartell S.p.A.

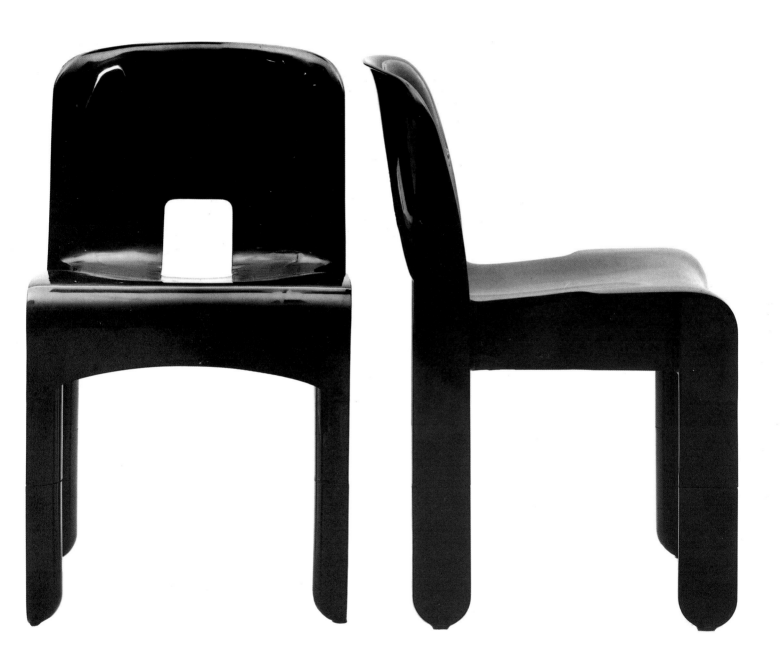

745. Giandomenico Belotti
Chair for indoors and outdoors, 1962.
Glazed steel and PVC, 83.5 x 40 x
53.5 cm. Manufactured in 1979 by Alias
as the Spaghetti *chair.*

746. Vico Magistretti
Selene *stacking chair, 1969. Fiberglass-*
reinforced plastic, 74.9 x 47 x 50.2 cm.
Manufactured by Artemide S.p.A.

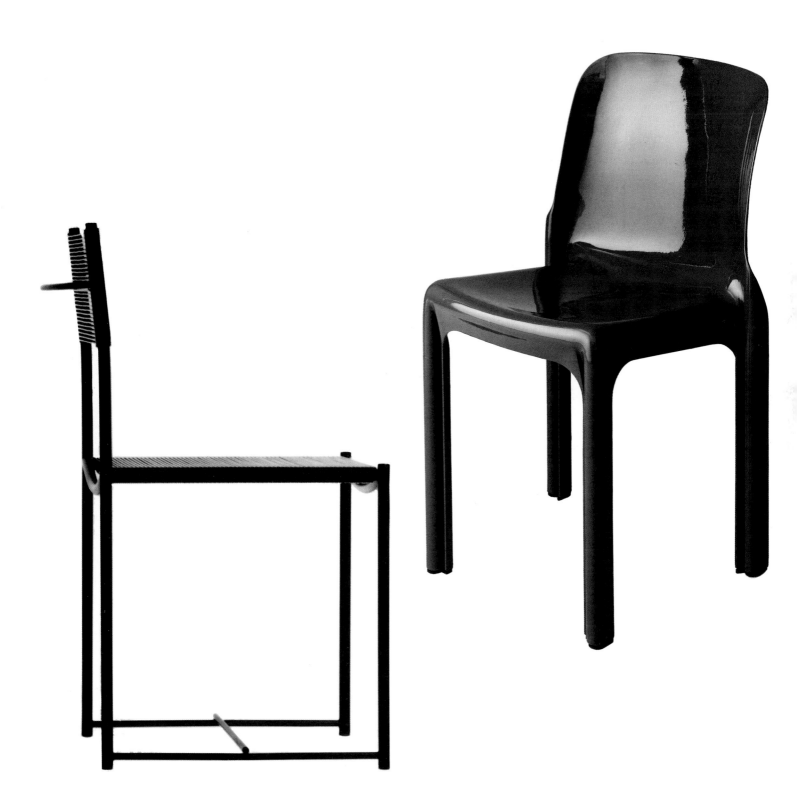

747. Gae Aulenti
Pipistrello (Bat) *table lamp, 1966.*
White opal methacrylate and stainless
steel, with lacquered base, 86 cm high,
55 cm diameter. Manufactured by
Martinelli.

748. Bruno Munari
Calza (Stocking) *tubular pendant*
lamp, 1964. Elastic-fabric tubing and
metal rings, 165 cm high, 40 cm
diameter. Manufactured by Bruno
Danese.

749. Achille Castiglioni and
Pio Manzù
Parentesi (Parenthesis) *lamp, 1971.*
Stainless steel and rubber; maximum
height: 400 cm; base: 10 cm diameter.
Manufactured by Flos S.p.A.

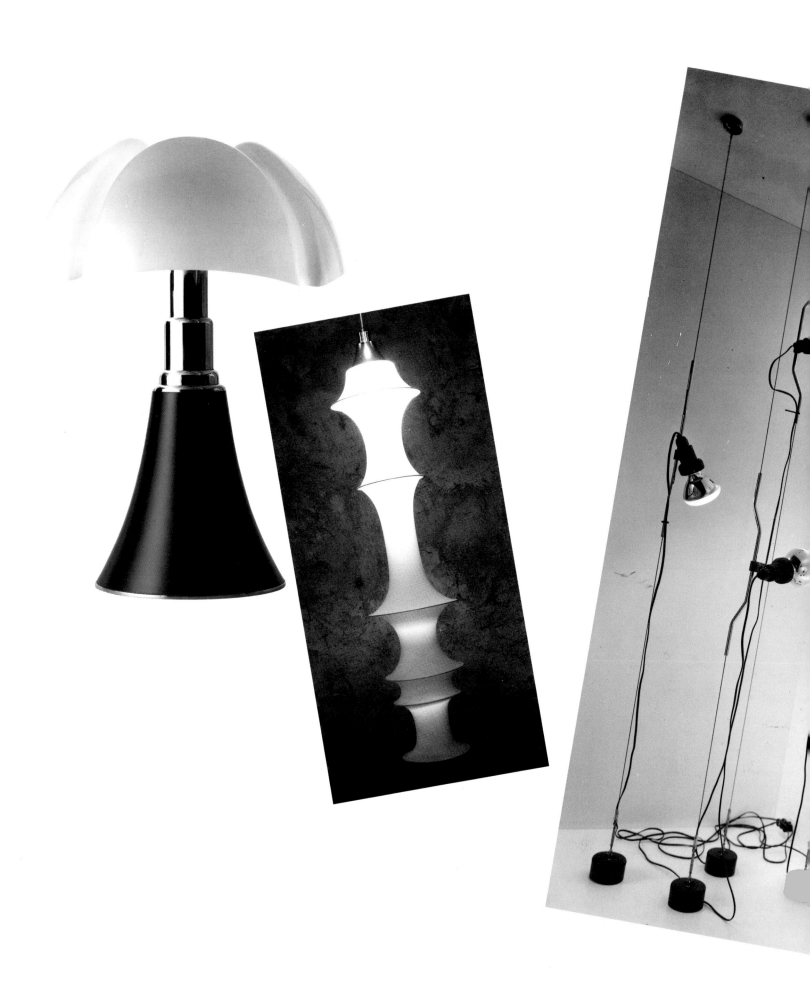

750. Achille and Pier Giacomo Castiglioni
Splugen Bräu suspension lamp, 1960. Polished aluminum, 20 cm high, 36 cm diameter. Manufactured by Flos S.p.A.

751. Achille and Pier Giacomo Castiglioni
Taccia (Notoriety) lamp, 1958. *Lacquered metal and glass, 54 cm high, 49.5 cm diameter. Manufactured by Flos S.p.A.*

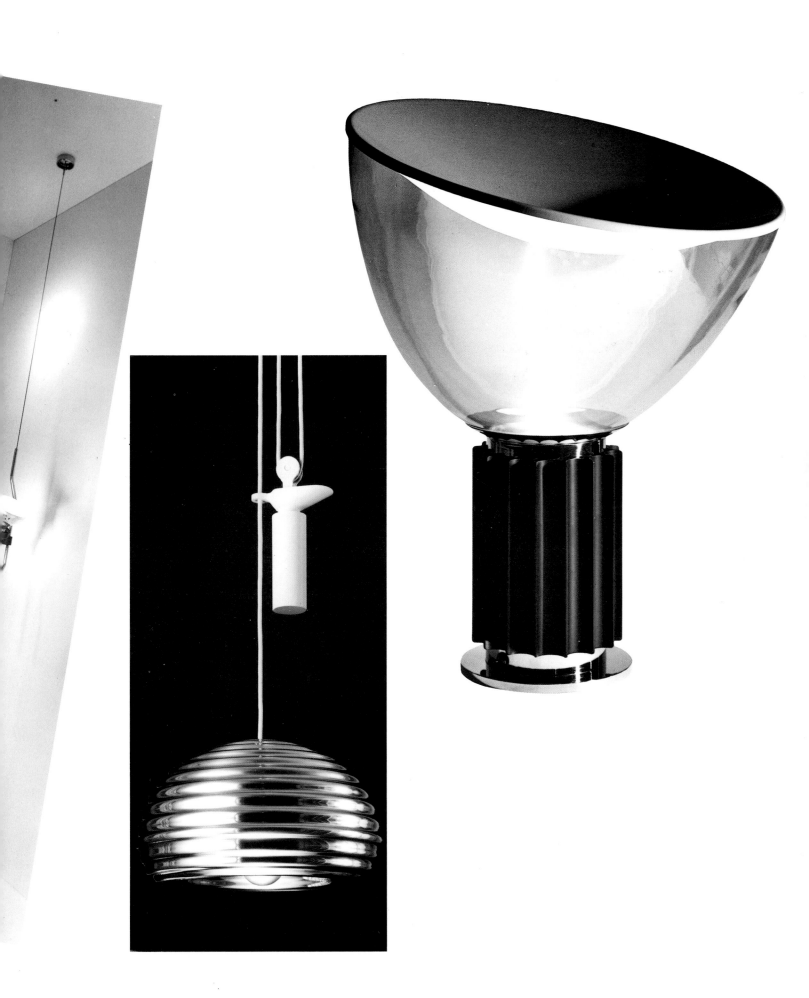

752. Roberto Mango
String *chair, 1952. Metal and PVC plastic, 71 x 75 x 62 cm. Manufactured by Allan Gould Designs, Inc.*

753. Franco Albini
Gala *armchair, 1950. Rattan and wicker, 106 x 90 x 90 cm. Manufactured by Vittorio Bonacina & C.*

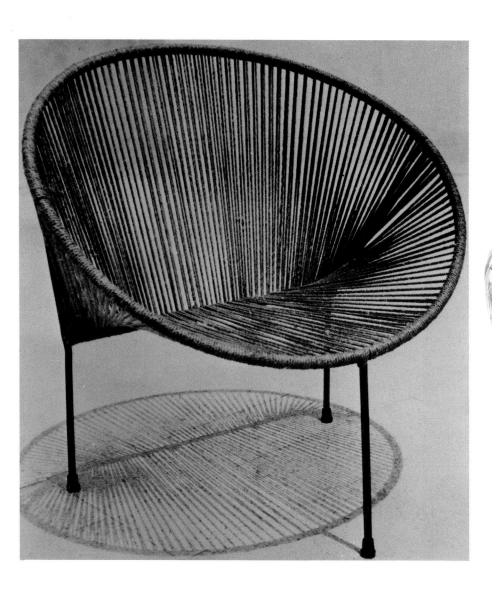

754. Franco Albini and Franca Helg
PL 19 *armchair, 1957. Metal, foam rubber, and fabric, 93.5 x 81.5 x 76.5 cm. Manufactured by Poggi Snc.*

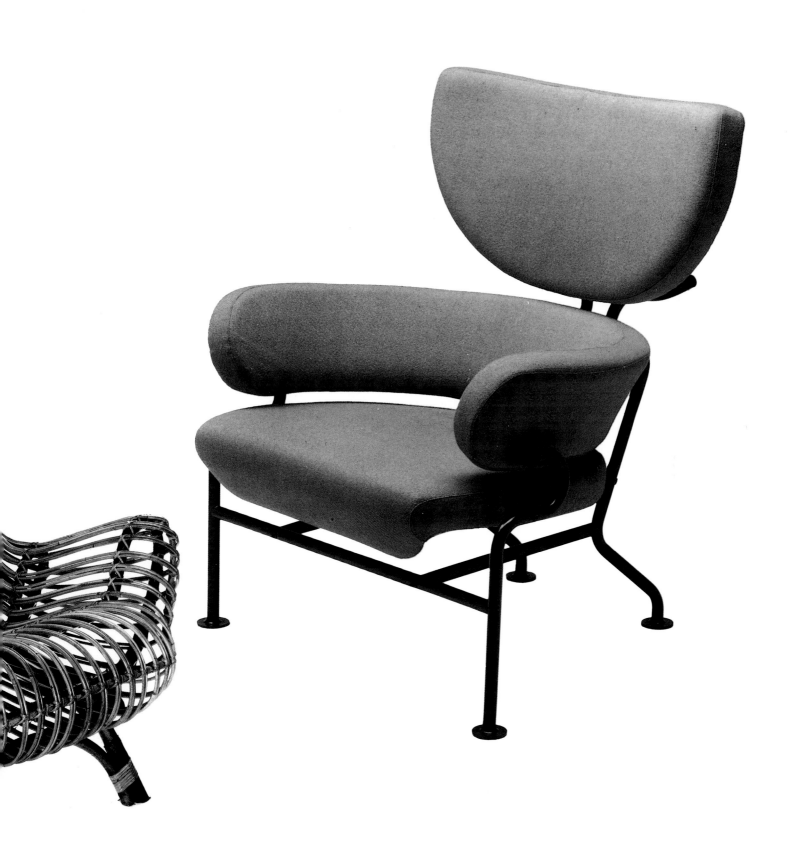

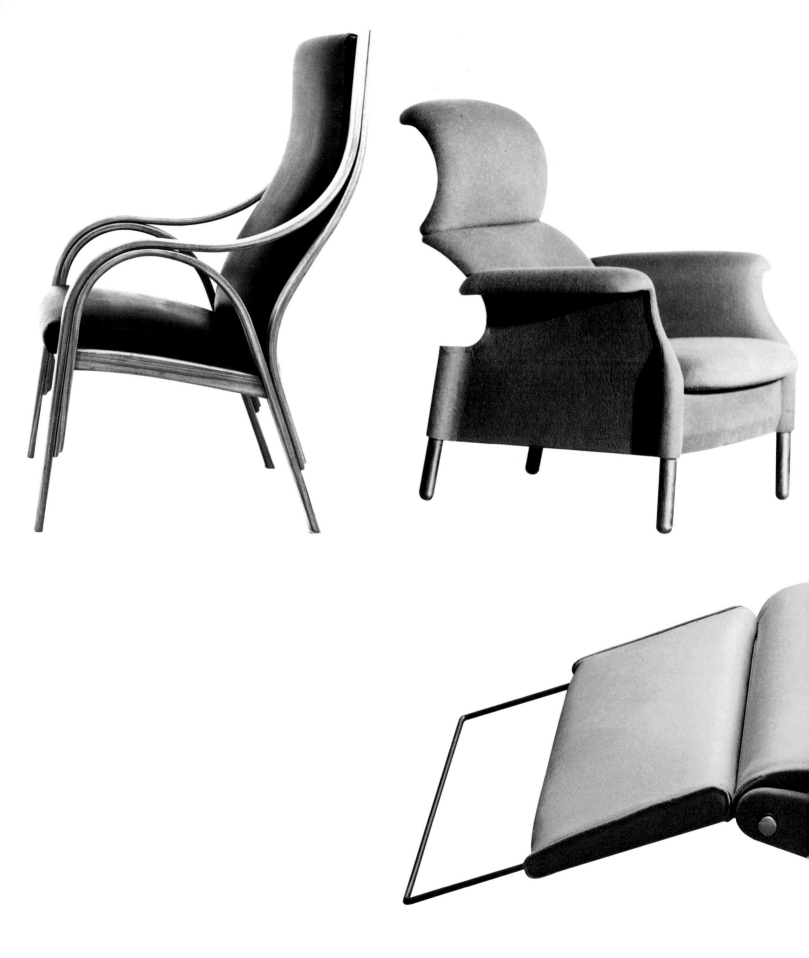

755. Vittorio Gregotti, Lodovico Meneghetti, and Giotto Stoppino
Cavour *armchair, 1959. Laminated wood and foam rubber, 108 x 62 x 69 cm. Manufactured by SIM Talea.*

756. Achille and Pier Giacomo Castiglioni
San Luca *armchair, 1960. Wood, foam rubber, and fabric, 96 x 87 x 100 cm. Manufactured by Gavina.*

757. Osvaldo Borsani
P40 *reclining chair, 1955. Metal and rubber; upright: 90 x 72 x 85 cm; reclining: 70 x 72 x 150 cm. Manufactured by Tecno S.p.A.*

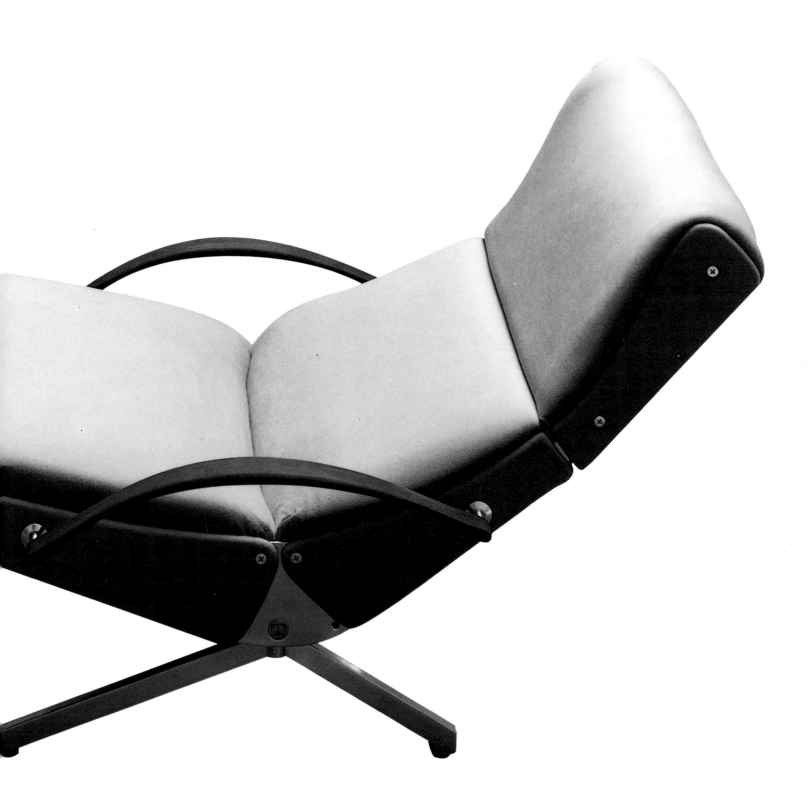

758. Carlo Mollino
Arabesco (Arabesque) *table,*
1951. Wood, glass, and brass, 50 x
124 x 50 cm. Manufactured by Apelli
and Varesio.

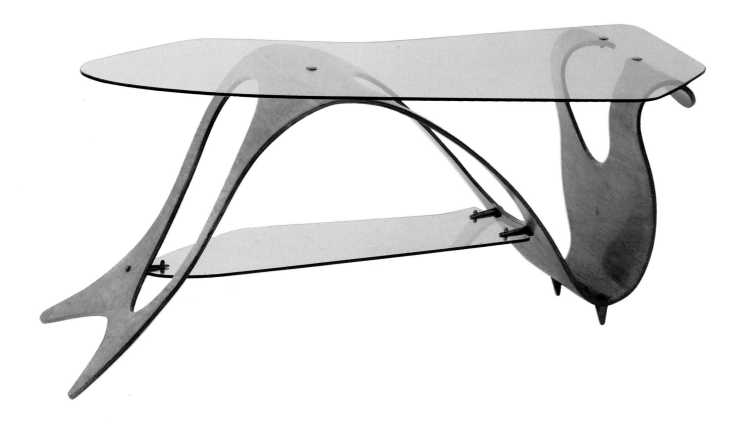

759. Gio Ponti
Cat, *1956. Enameled copper, 50 x 53 x 10 cm. Made by Paolo De Poli.*

760. Gio Ponti
Swan, *1956. Enameled copper, 22 x 32 x 10 cm. Made by Paolo De Poli.*

761. Gio Ponti
Devil, *1956. Enameled copper, 15 x 22 x 9 cm. Made by Paolo De Poli.*

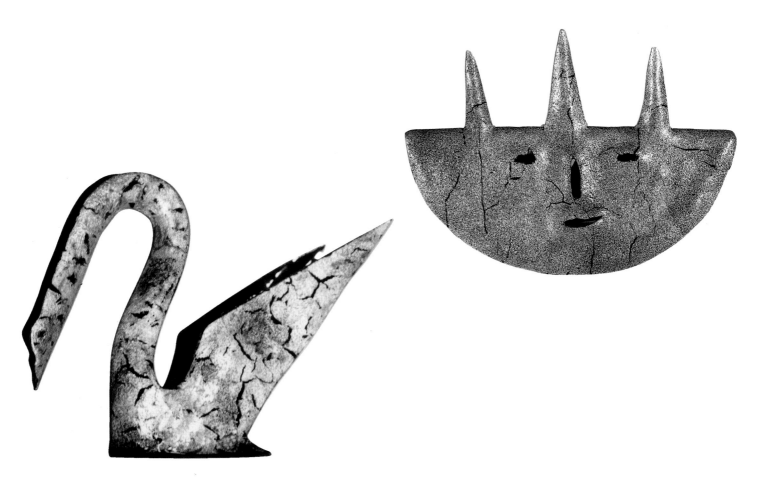

762. Enzo Mari
Ashtray with iron sheath, 1958. Glazed iron, 11 x 13 x 10 cm. Manufactured by Bruno Danese.

763. Ettore Sottsass, Jr.
Object from the Rocchetti (Spool) *series, ca. 1964. Ceramic prototype, 10.7 cm high, 21.8 cm diameter.*

764. Ettore Sottsass, Jr.
Object from the Rocchetti (Spool) *series, model 985, ca. 1964. Ceramic, 18 cm high, 26.7 cm diameter.*

765. Enzo Mari
Tray with iron sheath, 1958. Glazed iron, 8 x 46 x 13 cm. Manufactured by Bruno Danese.

766. Ettore Sottsass, Jr.
Object from the Rocchetti *(Spool)*
series, model 487, ca. 1964. Ceramic,
13 cm high, 18.5 cm diameter.

767. Ettore Sottsass, Jr.
Object from the Rocchetti *(Spool)*
series, ca. 1964. Ceramic prototype,
16.5 cm high, 20.2 cm diameter.

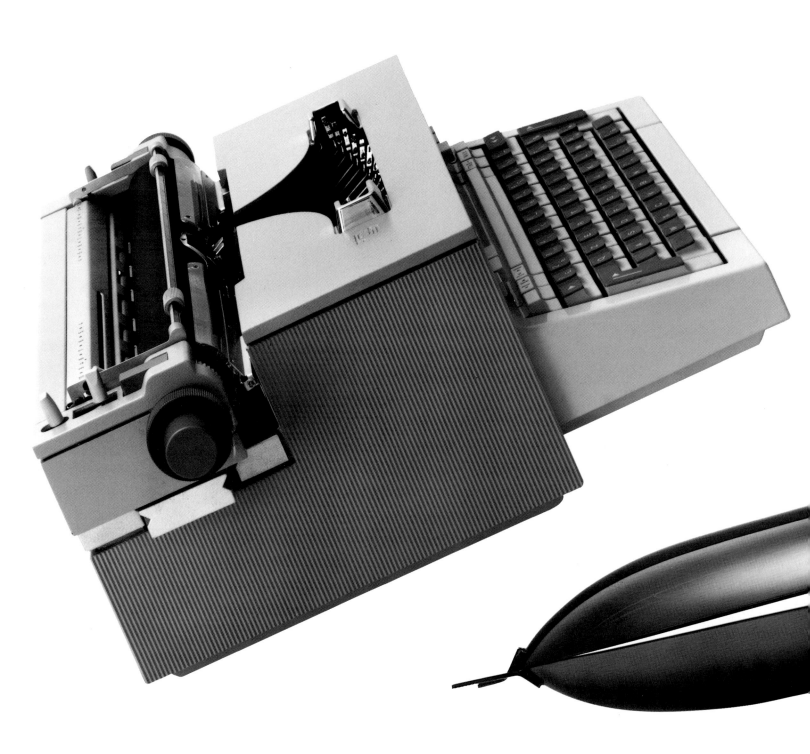

768. Ettore Sottsass, Jr.
Praxis 48 *typewriter, 1964. Plastic,*
metal, and rubber, 15.7 x 45.5 x 34 cm.
Manufactured by Olivetti, S.p.A.

769. Roberto Sambonet
Fish serving dish, 1954. Stainless steel,
7 x 16 x 51 cm. Manufactured by
Sambonet.

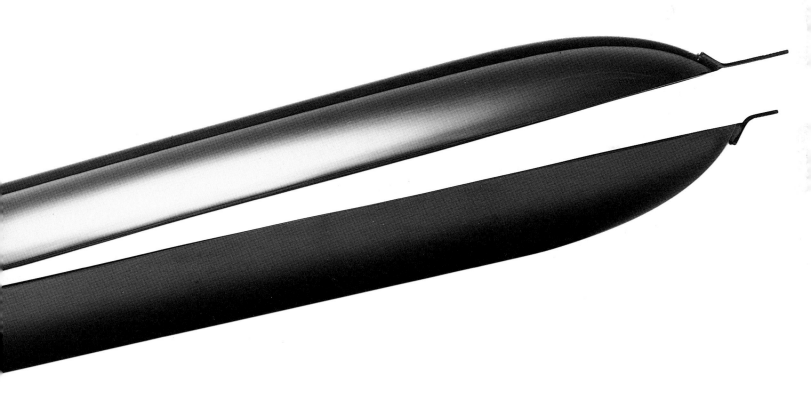

770. Bruno Munari
*Eyeglasses, 1955. Cardboard; open:
4 x 13.8 x 13 cm.*

771. Bruno Munari
*Desk set, 1958. Melamine and anodized
aluminum, 6.5 x 24.5 x 6.5 cm.
Manufactured by Bruno Danese.*

772. Enzo Mari
*Java table container, 1969. Melamine,
6 cm high, 14 cm diameter.
Manufactured by Bruno Danese.*

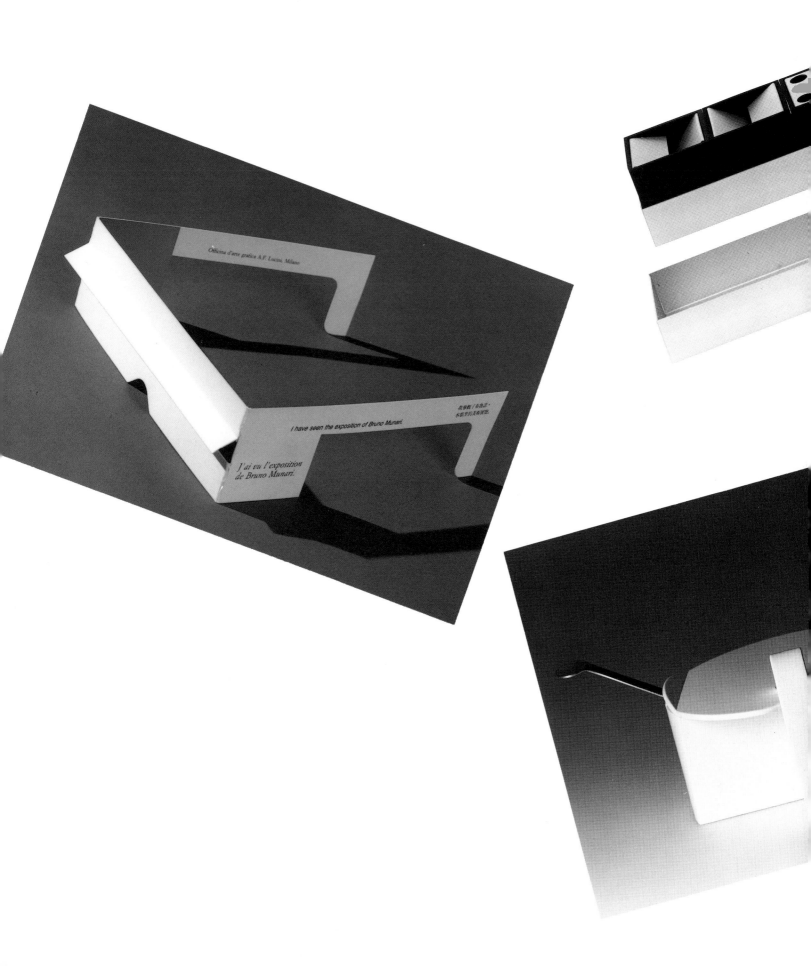

773. Bruno Munari
Ashtrays, 1957. Anodized aluminum,
56 x 8 x 8 cm; 8 x 8 x 8 cm; 42 x 6 x
6 cm; 15 x 5 x 5 cm; 6 x 6 x 6 cm.
Manufactured by Bruno Danese.

774. Paolo Gatti, Cesare Paolini, and Franco Teodoro

Sacco (Sack) *beanbag chair, 1968. Plastic with polystyrene bead filling; dimensions variable, approx. 114 cm high, 76 cm diameter. Manufactured by Zanotta S.p.A.*

775. Achille and Pier Giacomo Castiglioni

Mezzadro (Farmer) *stool, 1957. Chromed steel, enameled metal, and wood, 51 x 50 x 50 cm. Manufactured in 1971 by Zanotta S.p.A.*

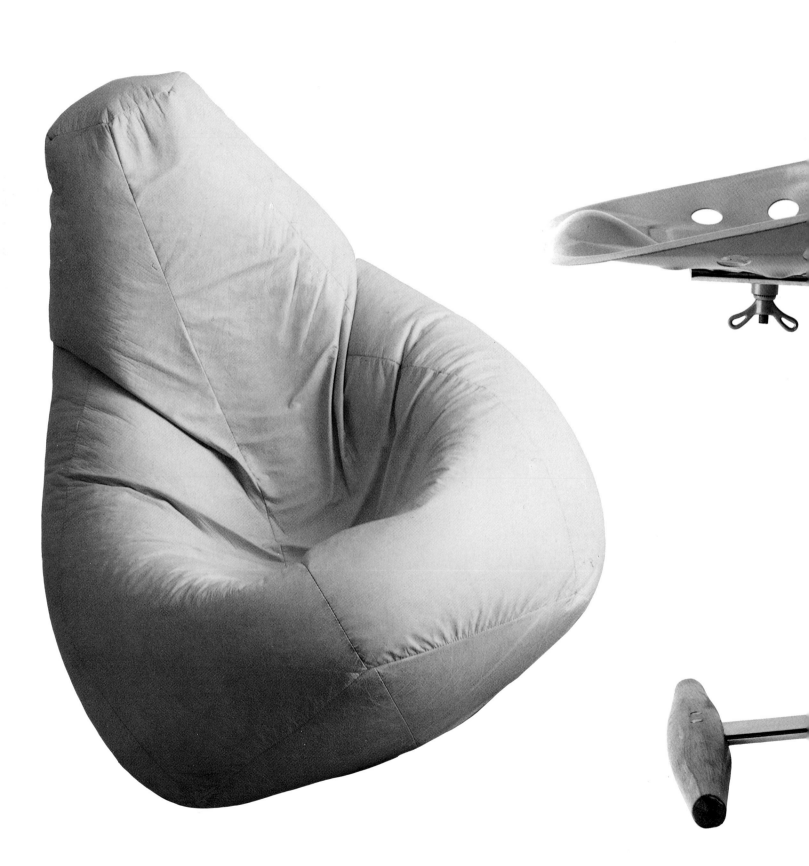

776. Jonathan De Pas, Donato D'Urbino, Paolo Lomazzi, and Carla Scolari
Blow *lounge chair, 1967. Transparent PVC plastic, 82 x 110 x 88 cm. Manufactured by Zanotta S.p.A.*

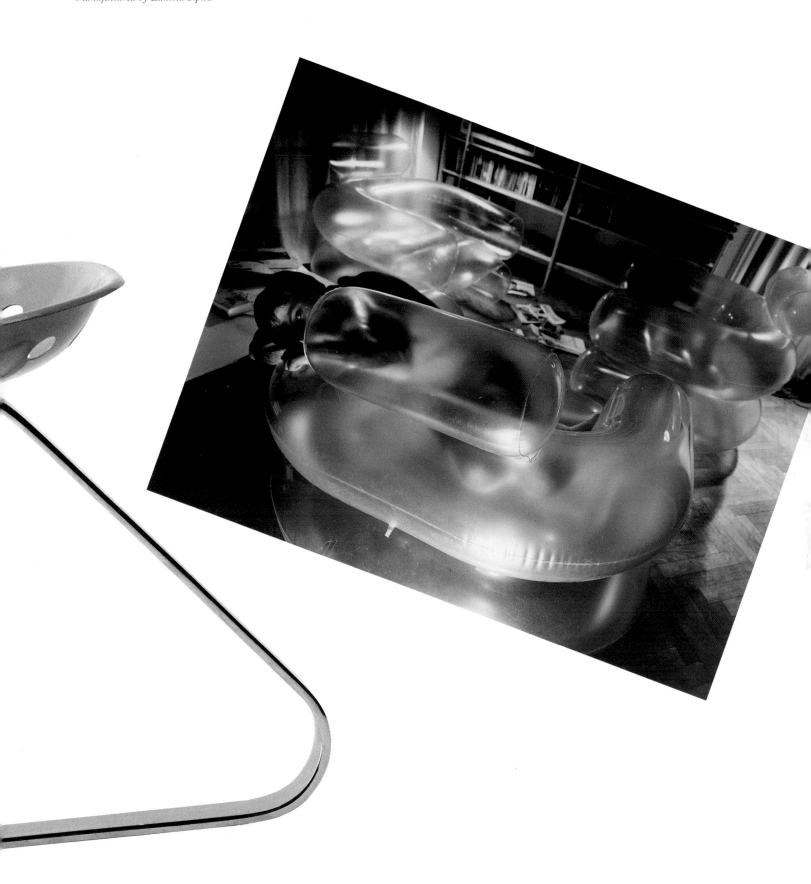

777. UFO
[Carlo Bachi, Lapo Binazzi,
Patrizia Cammeo, Riccardo
Foresi, and Titti Maschietto]
Dollar *lamp for the Sherwood
restaurant, Florence, 1968–69.
Gold-plated metal and stone,
70 x 50 x 15 cm.*

778. Archizoom
[Dario Bartolini, Lucia Bartolini,
Andrea Branzi, Gilberto Corretti,
Paolo Deganello, and Massimo
Morozzi]
Superonda (Superwave) *sofa, 1967.
Polyurethane and PVC fabric, two
pieces; 89 x 237.5 x 36 cm; 48 x 237 x
36 cm. Manufactured by Poltronova.*

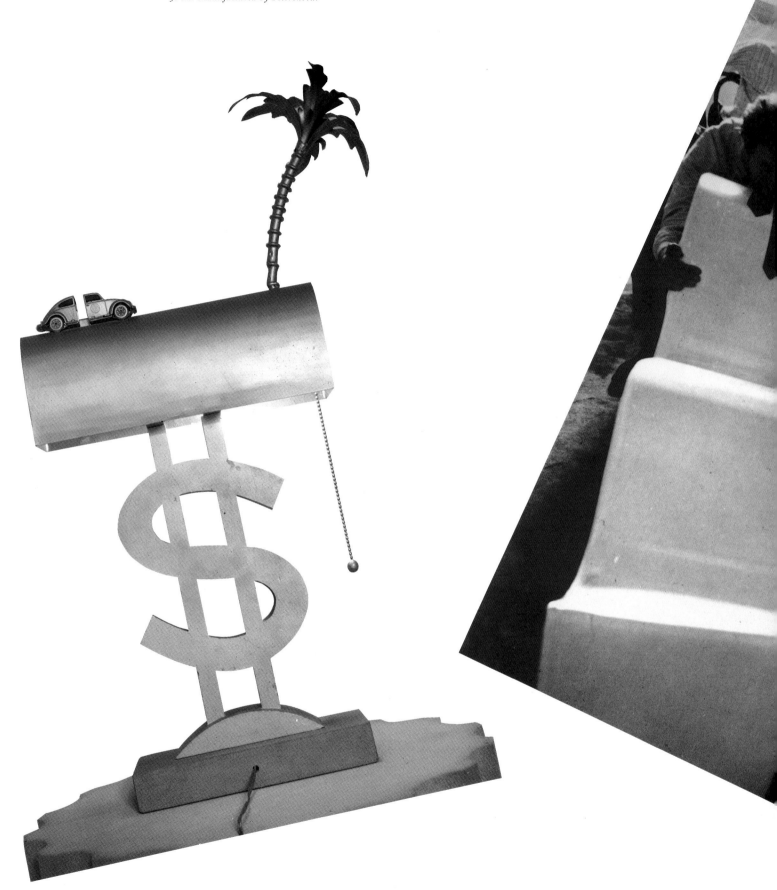

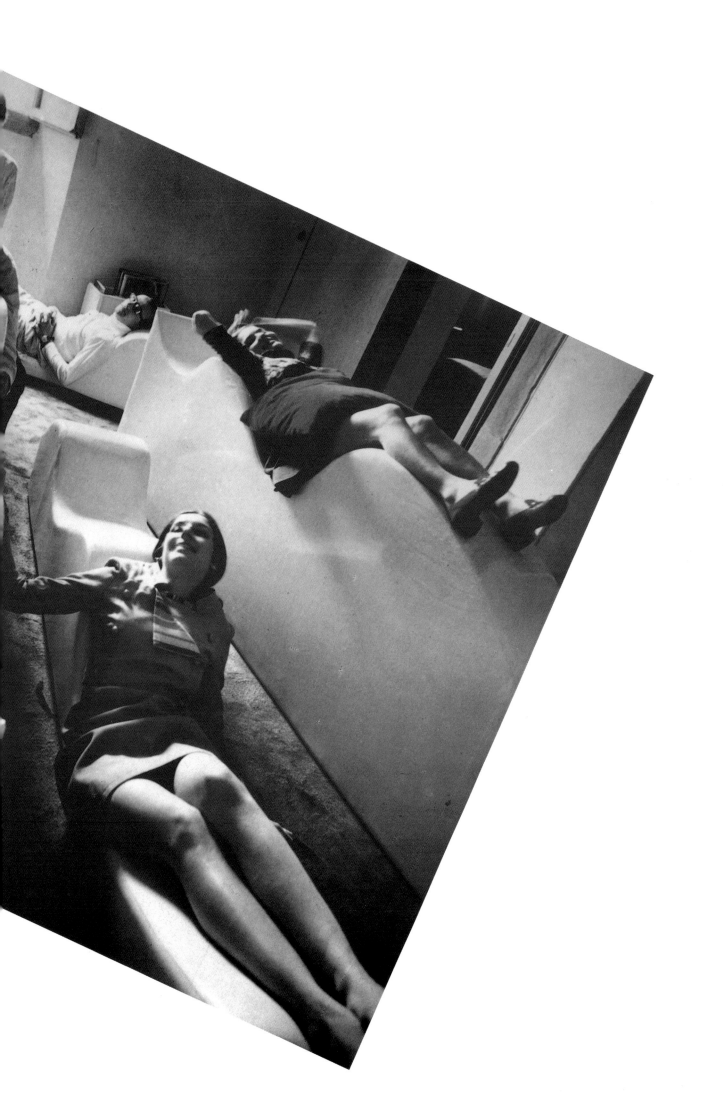

The landing of the Allies
their rapid advance into
Rome on July 19 were dec
fall of Benito Mussolini a
until the 1968 contestazio
history can be divided int
phase of international con
postwar years and the sta
the time of economic grow
miracle," to 1960; and the
Center-Left Italian gover

Sicily on July 10, 1943,
aly, and the bombing of
ive in bringing about the
July 25. From that event
he (protests), Italian
four periods: the final
ict, to 1945; the immediate
of the Cold War, to 1948;
known as the "Italian
period of reforms by the
ment, to 1968. The first

The Political History of Italy from the Fall of Fascism to the Student Revolts

Giorgio Galli

period opened with the armistice between Italy and the Allies, drafted on September 3, 1943 and announced on September 8. It concluded with the Partisan uprising in the German-occupied North on April 25, 1945—the date later made the national holiday of the liberation—two weeks in advance of the German surrender in Europe on May 8.

In these final years of the war, Italy experienced three conflicts related to the wider international struggle. German troops still occupied the country's North, although Italy now fought with the Allies against Fascist Germany. Throughout the country, clashes occurred between Fascist supporters and anti-Fascists. Finally, a class conflict evolved, as the Resistance, which was seen as the legitimizing foundation of the new democratic system through its central axis, the CLN (Comitato di Liberazione Nazionale/National Liberation Committee), was dominated by the Communists—champions of the labor class—while the upper-middle tiers of Italian society—which had been tied to the former Fascist government—were also seeking political representation. The three conflicts had all the bitterness of a civil war. Resulting instances of summary justice continued for some months after the end of the international conflict.

The most important political event of this period was the dissolution of the monarchy. In the winter of 1943–44, the three leftist parties of the CLN—the PCI (Partito Comunista Italiana/Italian Communist Party), PSIUP (Partito Socialista Italiano di Unità Proletaria/Italian Socialist Party of Proletarian Unity), and Azionisti (Actionist party)—demanded the immediate abdication of King Vittorio Emanuele III for his support of the Fascist regime. The three moderate parties of the CLN—the DC (Democrazia Cristiana/Christian Democratic party), PLI (Partito Liberale Italiano/Italian Liberal Party), and Demolaburisti (Democratic Labor party)—remained undecided. The government of Marshal Pietro Badoglio, which had been set up by the king after the arrest of Mussolini, lacked the support of the major political parties and was therefore utterly stripped of authority.

The political stalemate ended after the arrival of PCI leader Palmiro Togliatti from the Soviet Union in March 1944. Togliatti proposed a compromise, which the CLN accepted: the king would delegate his powers to his son, Umberto, upon the installation of a government in Rome (which was occupied by the Germans and would be conquered by the Allies on June 4, 1944). A constituent assembly to be elected after the war's end would determine the institutional form of the new state. (Although Vittorio Emmanuele handed over sovereign control to his son, he would not abdicate until May 1946; Umberto would then become king.)

An interim government was formed from the six parties of the CLN and led by a pre-Fascist politician, Demolaborista Ivanoe Bonomi. In December, the PSIUP and Azionisti quit the government, claiming that Bonomi was too conservative and partial to the monarchy.

After the liberation—the event that marked the opening of the second period—a new government with representatives of all of the parties of the CLN was formed and presided over by Azionista Ferruccio Parri, who had been the leader of the Resistance in the North. The

following three years saw the start of reconstruction, in a country half destroyed by the war and beset by social conflicts. Tensions were aggravated by economic difficulties, which affected the poor above all, and by the political aspirations fostered by the PCI and also in part by the PSIUP. For these two parties, Soviet experience, exemplified by the October Revolution and the victory against Adolf Hitler, formed the model for a new social order. In December 1945 tensions between Parri and the PCI and PSIUP members of his cabinet placed the government in crisis. Parri resigned and was replaced by the leader of the DC, Alcide De Gasperi, who then formed a new six-party coalition cabinet.

The first general election took place on June 2, 1946. Moderates had argued against the constituent assembly's determining the institutional form of the new state, and instead had called for a referendum, which was held in tandem with the election. The referendum affirmed the republic over the monarchy by 54 percent of the vote. (Following this result, and just one month after he assumed the monarchy, Umberto went into exile.) In the vote for the constituent assembly, the DC won over 35 percent, the PSIUP came in second with over 20 percent, and the PCI came in a close third with 19 percent. The resulting distribution of seats, which fragmented the political system while still leaving the three major parties with the support of three-fourths of the electorate, would be typical of the immediate postwar period.

Among the minor parties, the PRI (Partito Repubblicano Italiano/Italian Republican Party)—which had not participated in the CLN governments while the monarchy was in place—won just over 4 percent of the vote and joined De Gasperi's new government; and L'Uomo Qualunque (Common-Man Movement) won 5 percent of the vote, finding the sector that would later support the neo-Fascist party MSI (Movimento Sociale Italiano/Italian Social Movement).

To heal the wounds of civil war, PCI leader Togliatti, now Minister of Justice, declared an amnesty for Fascist criminals. Meanwhile, a new confrontation, accentuated by the start of the Cold War, divided the government. In response to the struggling economy, high inflation, and unremitting social conflicts, the DC and PLI demanded an economic policy supporting private initiative, while the PSIUP and PCI pressed for greater public intervention. The differences paralyzed the government and caused a split within the PSIUP: a predominantly reformist faction, led by Giuseppe Saragat, broke off from the pro-Communist majority and founded the PSLI (Partito Socialista dei Lavoratori Italiani/Italian Socialist Workers' Party); the PSIUP, under the leadership of Pietro Nenni, changed its name to PSI (Partito Socialista Italiano/Italian Socialist Party). In January 1947 De Gasperi constituted a new government, formed around the three "mass" parties (the DC, PSIUP, and PCI) but with fewer representatives of the Left in the economic ministries. (The PSLI did not join the new government.) He maintained that business interests—which were expected to revive the economy—effectively constituted a "fourth party" that also had to be taken into account. Business was represented by the Confindustria (Italian Manufacturers' Association) and its president, Angelo Costa, a Catholic from Genoa. Pitted against the Confindustria was the CGIL (Confederazione Generale Italiana del Lavoro/Italian General Confederation of Labor), whose leadership was Communist but whose members included Socialist, Catholic, Republican, and Anarchist workers.

Two months after the formation of De Gasperi's new government, in March, the United States announced the Truman Doctrine, a program of economic and military aid promulgated to protect Greece and Turkey from Communist threat. In May, the Communist party was banished from the French government. De Gasperi took the same initiative in Italy, forming a new government without PCI or PSI members; liberal independent Luigi Einaudi, head of the Banca d'Italia, was named Deputy Prime Minister and Budget Minister, bearing the task of defining the new economic policies. In July, the Marshall Plan was unveiled. Another United States initiative designed to contain the growing Soviet influence, like the Truman Doctrine before it, the plan aimed to foster economic recovery in certain European countries affected by the war. The Soviet Union objected and prohibited the Eastern European "popular democracies" with Communist leadership from participating. In September the Cominform (Committee of Information among the Communist Parties of Europe) was instituted. At its first meeting, Soviet representative Andrej Zdanov criticized French and Italian Communists for the passivity with which they accepted their exclusion from government. The two parties then stirred up some rather spectacular (if ineffectual) agitation during the autumn. In one case, a group of armed ex-Partisans briefly occupied the prefecture building in Milan to prevent the new prefect appointed by Minister of the Interior Mario Scelba from taking up office; their attempt failed, however.

The Cominform's campaign against the United States and Western European governments—especially against the Social-Democratic parties—led to the hardening of opposing positions. In January 1948, De Gasperi broadened the foundations of his government, taking in PSLI (which, in 1951, would become the PSDI [Partito Sociale-Democratico Italiano/Italian Social-Democratic Party]) and PRI members.

On January 1, 1948 the new constitution went into effect. The constitution calls for a parliament—elected by universal suffrage—which elects a president for a seven-year term. The president appoints a prime minister, who forms a government, or cabinet. The government must then receive the *fiducia* (trust) of parliament; if the trust is revoked, the government collapses. The date for the Republic's first election was set for April 18, 1948. During the electoral campaign, which saw the DC and its allies opposed by the Fronte Democratico Popolare (Democratic Popular Front, a unity of the PCI and PSI), Czechoslovakia fell to the Communists in a coup d'état in Prague. Debate in Italy centered on the danger that a victory by the Fronte might prevent further Western support and push the country toward the Eastern Bloc. This was a determining factor in the election results, which saw the DC win 48 percent of the vote. The Fronte was frozen at 31 percent and the Social-Democratic slate won 7 percent. Overall, the De Gasperi coalition came away with more than two-thirds of the votes.

Tensions remained, however. On July 14, Antonino Pallante, a Sicilian student associated with the Right and perhaps prompted by the Mafia, seriously wounded Togliatti. A general strike from Liguria to Tuscany, called by the CGIL in response to the attack, led to quasi-insurrectional conditions, which were defused by PCI leaders. Their action confirmed that the party had no intention of taking power by force; nor did they have the consensus to take it by popular vote. Italy was in no danger of a Communist takeover, despite what is now the popular perception of this period.

With the events surrounding July 14 the immediate postwar period came to an end. The PCI found itself stalemated at this point, with its defeat in the elections, the revocation of the general strike, and the relinquishing of former Partisan arms depots. The Fronte was dissolved. Union solidarity was ruptured as a Catholic faction left the CGIL to found the LCGIL (Libera Confederazione Generale Italiana del Lavoro/Free General Italian Confederation of Labor; later called the CISL [Confederazione Italiana Sindicati Lavoratori/Italian Confederation of Syndicated Laborers]). The following year, Republican and Social-Democratic factions also left the CGIL to found the UIL (Unione Italiana Lavoratori/Italian Laborers Union).

The period of economic growth known as the "Italian miracle," which began in 1948, was initially slowed by conservative spending policies inspired by the DC Budget Minister, Giuseppe Pella. (Pella had succeeded Einaudi when the latter was elected President of the Republic in May 1948.) The policies were criticized by representatives of the Marshall Plan in Italy.

Strong social imbalances persisted and in the early 1950s would create a new space for the Left—the alliance of the PCI and PSI—and also for an opposition of the Right, made up of the MSI and PNM (Partito Nazionale Monarchico/National Monarchist Party). (The Right was particularly strong in the South; shipowner Achille Lauro, leader of the PNM, became Mayor of Naples in 1952.)

In this state of affairs, De Gasperi's Center (made up of the DC, PSDI, PRI, and PLI) attempted to maintain a consensus by proposing a majority-system electoral law, based on the French model, whereby the coalition of parties winning at least 50 percent plus one of the votes would be assigned 65 percent of the seats. The bill was passed in March 1953. The Center thus confronted the coalitions of the Left and Right on these terms during the election of June 7, 1953, but were defeated by a slim margin. They gained 49.3 percent of the vote (the DC fell to 40 percent); the parties of the Left stood at 37 percent; and those of the Right won 13 percent. The old electoral law, a revised proportional system, remained in effect, guaranteeing the centrist coalition a slight majority.

The three other parties of the Center coalition refused to join De Gasperi's new government, however, and he was forced to form a government with only DC members. When this cabinet was refused, De Gasperi resigned in August 1953. After a period of uncertainty, during the caretaker government of Giuseppe Pella, the Center re-formed at the start of 1954 and stayed in place through successive governments led by Christian Democrats Scelba, Antonio Segni, and Adone Zoli. Following the death of

De Gasperi, in August 1954, leadership of the DC was assumed by its Secretary, Amintore Fanfani. In April 1955, at the end of Einaudi's term as president, the former speaker of the Chamber of Deputies Giovanni Gronchi, of the DC, was elected in his place.

It was therefore with a dominance of the DC in the legislature that the economy began to grow. A determining role was played by private enterprise, especially the largest companies such as Fiat (automobiles), Montecatini (chemicals), Edison (electricity), and Pirelli (rubber). Public intervention also played a role, especially in the case of ENI (Ente Nazionale Idrocarburi/National Hydrocarbon Company). ENI, headed by Enrico Mattei, a former commander of the DC Partisans during the war, gained a monopoly over the extraction of methane in the Po Valley, and sought to obtain another, over the management of Italian oil policy, in competition with international cartels. Mattei's goal was to guarantee Italy the greatest possible autonomy in energy provision, and to achieve this he had to finance the DC, as well as other parties to a lesser extent. He had the support of president Gronchi and DC secretary Fanfani, both of whom favored expanding government intervention in the economy, as well as that of the Budget Minister, Ezio Vanoni.

The hegemony of the DC in the overall political system was also strengthened during this period by a crisis that beset the PCI. By 1955, the CGIL was losing its majority status in the most important companies, including Fiat. Nikita Kruschev's 1956 report on the crimes of Joseph Stalin, as well as the rebellions in Poland and Hungary (the latter put down forcibly by Soviet troops), prompted some 200,000 members to quit the Communist party in Italy; membership dropped from 2 million to 1.8 million over a two-year period between 1956 and 1958.

In response to the crisis suffered by the PCI, a faction within the PSI under the guidance of party leader Nenni, a former champion of the Communist line, sought autonomy from the Communist party. As this alliance was still considered valid by a large segment of the Socialists, the PSI underwent a great internal struggle, which would eventually see Nenni emerge victorious at the party congress in January 1959.

With the passing of Pope Pius XII after a long pontificate begun in 1939, and the subsequent election of John XXIII, a new phase in the history of Catholicism was begun. At the Second Vatican Council in 1962–65, broad scope would be given to ecclesiastical reforms—such as changes in the Liturgy of the Mass—that would take on great symbolic value. This situation influenced Italian political life as well, especially the ongoing struggle within the DC over economic policy. One faction, led by Fanfani, favored intense public intervention in the economy; the other, led by Giulio Andreotti and former followers of Party Secretary Fanfani (called the "dorotei," or "Dorotheans," because they defined their position at a meeting at the convent of Saint Dorothy), refused to compromise relations between the DC and major business groups. The debate within the DC reflected the debate over reform in the Catholic world. A polarization resulted, with progressives, favoring government intervention in the economy as well as reform in the church, pitted against conservatives, who opposed both positions.

Elections were held again in 1958, with the DC winning 42 percent of the vote. The PCI won 22 percent; and the PSI progressed slightly, with over 14 percent. The coalition of the Right suffered from the split of the PNM (now headed by Alfredo Covelli), with Achille Lauro leaving to form his own party, PMP (Partito Monarchico Popolare/Popular Monarchist Party). After the elections, Fanfani retained the position of Secretary of the DC and became Prime Minister and Foreign Minister as part of a centrist coalition. The PLI felt increasingly uneasy within the coalition because of their opposition to any limitation of private initiative. The majority was a weak one, in any case; the Fanfani government was placed in the minority in Parliament several times during winter 1958–59, when a faction of the DC (called "snipers") voted against him in secret ballot on a number of legislative measures.

Nenni's victory at the PSI congress served to strengthen Fanfani and his allies' position within the DC. They had been considering replacing the PLI coalition with an alliance with the PSI (a Center-Left coalition), which would give the DC the twofold advantage of weakening the Left (which, when united, had 37 percent of the vote) and having a broader majority supporting public intervention in the economy. After the attempt to rebuild a majority with the PLI had proven to be difficult (and, even if successful, would have yielded a very weak majority) and because the lingering conflicts within the party and the resultant political uncertainties were creating an atmosphere of great tension in the country as a whole, the potential advantage for the party—which stood to increase the number of positions at its disposal in government-run businesses—ended up convincing the Dorotheans to accept this strategy.

Wearied by the opposition he had faced from within his party, however, Fanfani resigned from all posts in February 1959. Aldo Moro succeeded him as DC Secretary, and the new Prime Minister was Antonio Segni. While the struggle within the DC did not abate until after the party congress in October 1959, Segni found the support of the Center.

The turning point of this period, and its close, would be defined, as in July 1948, by clashes in the streets. Yet the result would be the opposite this time: in 1948, the Left had suffered from the protests; twelve years later, in 1960, it would gain from them.

The political situation collapsed in February 1960, when the PLI withdrew its support for the Segni government. A long crisis began, resolved only by the formation of a single-party DC cabinet. The government, headed by Fernando Tambroni—a former ally of Fanfani who had the support of President Gronchi—no longer enjoyed the support of the PLI or PSI, and won a vote of confidence due only to the decisive vote of the far-right MSI. Some of its ministers subsequently quit the government and a new crisis set in, without any visible solution. Gronchi endorsed the Tambroni government, which pledged to resign in October following the approval of its budget, to give the party time to decide on its definitive policies.

At a moment of renewed international tension provoked by Soviet successes in space and missile technology, Tambroni presented himself as a bulwark against the Communist threat and the potential champion of a Center-Right coalition that might include the MSI. At its party

congress scheduled for June in Genoa, the MSI indicated that it might abandon its neo-Fascist agenda and reconstitute itself as an aggregation of the moderate Right. This very congress, however, became the spark that set tensions afire. The Left ordered demonstrations that were joined by certain sectors of the DC hostile to the Tambroni plan. As in July 1948, the Genoa police force was overwhelmed during clashes in the streets. To avoid the same situation in the city of Reggio Emilia, the police there fired on the crowd, which resulted in the deaths of five demonstrators. Other clashes took place in Rome and Sicily, with further fatalities and injuries.

The President of the Senate, Cesare Merzagora, a businessman of moderate politics elected into the DC, proposed a truce that would involve the replacement of the Tambroni government. Discouraged, Tambroni resigned, and a new government was then formed by Fanfani. The single-party DC government, supported by the four parties of the old Center, enjoyed a majority, which was maintained through what Moro would term "parallel convergences": the opposition of the MSI on the Right was offset by that of the PCI on the Left, with similarly parallel abstentions by the PSI and PNM. (The parallelism was only temporary, however. The PNM, which had 4 percent of the vote, was on the path to extinction—ten years later it would be absorbed into the MSI, which would expand its acronym by adding the letters DN, for *Destra Nazionale* [National Right]. The PSI, on the other hand, would be the DC's future ally.)

The formation of the new Center-Left coalition, with the PSI taking the place of the PLI in the coalition with the DC, marked the beginning of the final period. The formation process was troubled. Throughout 1961 a stalemate held sway. At the DC party congress in Naples in February 1962, however, a consensus was reached. A broad majority, extending as far as Andreotti, formed around the position of Moro and Fanfani in favor of allying with the PSI; the opposition, led by Scelba and future President Oscar Luigi Scalfaro, took only 20 percent of the vote.

A new government came into office in March 1962. Headed again by Fanfani, it included members of the PSDI and PRI and rested on an agreed-upon abstention by the PSI. Its program included three main points: the nationalization of the electric industry; the institution of a single middle school; and the establishment of regions of ordinary status—that is, with less autonomy. (The regions of ordinary status had been called for in the 1948 constitution but were never instituted, unlike the regions of special status: Sicily, Sardinia, Valle d'Aosta, Trentino-Alto Adige, and Friuli-Venezia Giulia.)

The plans for the nationalization of the electric industry conformed to the DC's stated direction of government intervention in the economy, which the PSI saw as a step toward state planning. The program for a single middle school, an initiative that would end the division of junior-high-school—age students between grammar schools of classical-humanist studies and schools of vocational training, was for children up to fourteen years of age and corresponded to a law that made school obligatory up to that age. Entailing severe limitation of the study of Latin (which was also penalized in the new Church liturgy), the

program aroused the opposition of traditional Catholics, while the PSI welcomed the reform as part of a process of secularization.

After the Gronchi mandate expired in May 1962, the DC—with the votes of the Center-Right—managed to bring former Prime Minister Segni to the presidency, a move designed to satisfy moderate Catholics hostile to their programs. The last phase of the legislature was characterized by Moro's politics of delicate balances. The nationalization of the electric industry and the institution of a single middle school were passed into law, but the DC postponed establishing the regions of ordinary status. Elections were set for April 1963. The PSI revoked its abstention, and the future fate of the Center-Left coalition was left up to the voters.

The election results were disappointing for the majority. The DC went from 42 percent of the vote in 1958 to 38 percent, to the benefit of the PLI, which doubled its vote, from 3.5 percent to 7 percent. The PSDI gained, going from 4.6 percent to 6 percent, and the PRI remained stable at slightly more than 1 percent. The PSI fell to less than 14 percent of the vote; the PCI exceeded 25 percent; and the Right declined.

On paper, a Center-Left coalition that included the PSI would have enjoyed a broad majority, close to 60 percent. But following their electoral failure, the DC were divided and feared further defections to the PLI on the part of moderates in its electorate. In the PSI, the struggle between autonomists and pro-Communists continued. Negotiations to form the new government remained blocked by conflicts, particularly those regarding legislation on urban development that would allow greater localization of political processes, especially in the overcrowded metropolitan areas. (The absence of these measures would be at the center of the conflicts of 1968 and thereafter.) An initial agreement was rejected by the PSI, with some of Nenni's followers voting with the left wing of the party. Thus, while waiting for the PSI to clarify its position at a congress set for October, a single-party DC government was formed, headed by the Speaker of the Chamber of Deputies, Giovanni Leone.

At the October congress, Nenni wrested a majority in favor of an accord with the DC. The PSI's left wing planned a split, however, which it would carry out in early 1964, forming a new party that adopted the old name PSIUP (Partito Socialista Italiano di Unità Proletaria/Socialist Party of Proletarian Unity). The negotiations for a new Center-Left government presided over by Moro—with Nenni as Deputy Prime Minister and representatives of the PSDI, PRI, and PSI among its members—were concluded in late November 1963, in an emotional atmosphere created by the assassination of John F. Kennedy, whose administration had encouraged the Center-Left's experiments. While the PSI was splitting, discontent within the DC was also great. Scelba wanted a vote of no-confidence to be cast, but was dissuaded by a call for party unity by the Vatican.

The government took power at a moment of economic difficulty. Productivity was down, and the resources available for reforms to such areas as urban development, high schools, and universities had to be reduced to stem the rising inflation. (The reforms would never take place,

and this would be at the source of tensions in 1968.) By June 1964 the executive branch was in crisis. The DC and PSI were fighting over public financing of private (mostly Catholic) schools. Moro resigned as Prime Minister. The crisis dragged on, giving rise to rumors of a coup d'état being planned by General Giovanni De Lorenzo, commander of the *Carabinieri* (police) forces, and supported by President Segni.

The crisis was finally resolved by the formation of a new government by Moro, who then postponed reforms, though he presented an economic program (which would never be implemented) that he entrusted to the Socialist minister Giovanni Pieraccini. With President Segni paralyzed by a stroke, political activity was slowed down during the summer. In August, Togliatti died in the Soviet Union. (After resigning in December, Segni would soon die also.)

At year's end, the election of PSDI leader Saragat to the presidency seemed to augur new impetus for the Center-Left, although this was not the case. The moderate sectors of the DC blocked reforms, fearing they would lose conservative votes. The whole party did agree, however, on the issue of expanding government intervention, which would create a widespread state economy with proceeds for enacting reforms that would be sufficient to satisfy even the Socialists. By early 1966 the government was again in crisis over questions of schooling, this time over the maintenance by religious organizations of nursery schools, a problem obviously secondary to others taking shape.

The Moro government, in the process of being reinstituted, took all year in 1967 to draft a law for the reform of universities. This would prove to be the fuse that would ignite the student protests. The rebellion had deeper roots, of course. Internationally, the 1966 Cultural Revolution in China had a great influence on the Italian Left, as did the Vietnam War, which induced the students to identify with General Nguyen Giap and proclaim, "The university will be our Vietnam." On the domestic front, the university had become open to the masses, but the services were woefully inadequate; the metropolitan areas were overcrowded and also suffered from a lack of services; and workers were demanding higher wages, after the sacrifices made during the economy's downturn and its subsequent recovery.

Nineteen sixty-eight was therefore the year of *contestazione*, which began in the schools with continuous demonstrations, occupations, and clashes with police, and spread into the factories. In this atmosphere of conflict, the Center-Left coalition achieved what appeared to be satisfactory results in the April election. About 55 percent of the vote was shared between the DC (over 38 percent), the Socialist party, now a union of the PSI and PSDI (over 14 percent), and the PRI (over 2 percent).

Yet the success of the PCI, which grew to 27 percent and together with the PSIUP led a strong leftist opposition with 30 percent of the vote, indicated that there existed a situation of social tension that extended well beyond the election results. Once again, as in 1948 and 1960, the transition from one period to the next was characterized by the moving of the political process out of institution offices and into the streets.

Translated, from the Italian, by Stephen Sartarelli.

Chronology

Lisa Panzera

1943

The political situation forces Renato Guttuso to leave Rome. The previous year his painting *La crocifissione* (*The Crucifixion*) won second prize at the *IV Premio Bergamo*, and its implicit criticism of the Fascist government sparked an intensely negative reaction from both the Fascist regime and the Catholic church. In the newspaper *L'osservatore romano*, Celso Costantini expressed his outrage at Guttuso's work, claiming it to be an affront to the Catholic faith.

Artist Fausto Melotti returns to Milan from Rome (where he moved in 1941) to discover that his studio and his work there were destroyed during the war.

The Corrente artists' group writes the *Manifesto di pittori e scultori* (Manifesto of painters and sculptors) in Milan in the last weeks of 1942 and the first weeks of 1943. The manifesto, which is not published, proclaims an abstracted realism and calls for a painting that assumes a revolutionary function. Pablo Picasso's work serves as the group's primary model; his painting *Guernica* (1937) is its emblematic work. Corrente had founded a journal, edited by Ernesto Treccani, that was published in Milan between January 1938 and May 1940; first called *Vita giovanile* (Youth), then *Corrente di vita giovanile* (The current of youth), it finally became *Corrente* (Current). On June 10, 1940, the review was suppressed by the Fascist regime, yet Corrente continued to publish books and opened a gallery. The group brought together many important artists, intellectuals, poets, critics, and filmmakers, who often held differing points of view. Members included Sandro Bini, Renato Birolli, Bruno Cassinari, Dino Del Bo, Giansiro Ferrata, Guttuso, Alberto Lattuada, Giuseppe Marchiori, Giuseppe Migneco, Ennio Morlotti, Duilio Morosini, Luigi Rognoni, Aligi Sassu, Vittorio Sereni, Treccani, Italo Valenti, and Emilio Vedova.

Stile (Style), a design review founded in Milan in 1941, continues publication (until 1947) under the direction of editor and founder Gio Ponti.

The Gruppo Editoriale Domus, publishers of *Domus*, an architecture and design magazine founded in Milan in 1928 by Ponti, prints a yearbook on Italian photography, *Fotografia: prima rassegna dell'attività fotografica in Italia* (Photography: first survey of photographic activity in Italy), which would become an important source on the history of Italian photography. Ponti would be editor of *Domus* until 1941, and then again from 1948 until his death in 1979.

Jean-Paul Sartre's treatise on existentialism *L'Etre et le néant* (published in English as *Being and Nothingness*) is published. Sartre, who promotes a sociopolitically committed art, would become very influential in Italy. In October 1945, he would found the journal *Les Temps modernes* (Modern times) in Paris.

Cinecittà, a vast filmmaking complex opened by Benito Mussolini in 1937, had by this time produced nearly 300 feature films, eighty-five shorts, and 248 dubbed versions of foreign films.

Controversy surrounding Luchino Visconti's first feature film *Ossessione* (Obsession; released in English as *Ossessione*) continues. Released in 1942, the film was not well received by Italian government officials and censors, although it would later come to be highly influential in the development of Italian neorealist cinema. (An unauthorized interpretation of James M. Cain's novel *The Postman Always Rings Twice*, the film would not be permitted to be shown in the United States until 1975.)

Michelangelo Antonioni directs his first film, the short documentary *Gente del Po* (The people of the Po).

Giovanna, Micol, and Zoe Fontana open their first fashion atelier, Sorelle Fontana [Fontana Sisters], in Rome. Catering primarily to the Roman nobility and film stars including Audrey Hepburn, Myrna Loy, and Elizabeth Taylor, they would become best known for their evening gowns and costume designs, such as Linda Christian's wedding dress for her marriage to Tyrone Power in 1948 and Ava Gardner's wardrobe for Joseph L. Mankiewicz's 1954 film *The Barefoot Contessa*. In 1960 they would create a prêt-à-porter line for the American market.

The furrier Jole Veneziani establishes a dressmaking division (which would become haute couture in 1946 and close in 1969). In 1952 she would be featured on the cover of *Life* and in American fashion shows. From 1951 to 1957 she would produce a boutique line, Veneziani Sport, and in 1957 launch her own perfume.

March
A wave of industrial strikes sweeps Turin and Milan, sparked by the severe privations caused by the war effort.

May
–*July*. The IV *Quadriennale d'Arte Nazionale* (Fourth quadrennial of national art) is held at the Palazzo delle Esposizioni in Rome. A large number of artists exhibit, including Afro [Afro Basaldella], Giuseppe Capogrossi, Giorgio de Chirico, Filippo De Pisis, Guttuso, Enrico Prampolini, Giulio Turcato, and Vedova.

8–10. The conflict in North Africa comes to an end when Allied forces expel Axis troops.

Renato Guttuso at Palazzo del Grillo. Archivio de'Foscherari.

Plaster copies of artworks in a prop room of Cinecittá in 1953. AP/Wide World Photos.

Ava Gardner, with the assistance of Micol Fontana, tries on a gown for The Barefoot Contessa; *in the film Gardner wears twenty-six gowns designed by Fontana. AP/Wide World Photos.*

July
9–10. The Allied invasion of Italy begins; forces land in Sicily.

19. Allied forces bomb Rome.

24–25. The Grand Council meets and votes to remove Mussolini. King Vittorio Emanuele III dismisses him from office and has him arrested. The Fascist dictatorship is replaced by a military one, and Marshal Pietro Badoglio is named head of the government, serving as Prime Minister under the monarch.

28. Badoglio orders the dissolution of the Fascist party. (To the present day, it remains illegal for the Fascist party to be part of the governing body of Italy.)

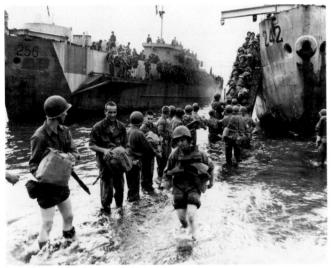

A block of flats in Rome that were
damaged during an Allied bombing
raid in 1943. AP/Wide World Photos.

While shipmates unload gear, an
American nurse wades ashore at Naples
in 1943. AP/Wide World Photos.

The abbey at Monte Cassino after its
capture by Allied troops in 1944.
AP/Wide World Photos.

September
Alberto Burri is taken prisoner while serving as a doctor in
the Italian army in North Africa. After eighteen months he
would be moved to a prisoner-of-war camp in Hereford,
Texas, where he would begin to paint; his earliest works
would be executed on sugar sacks.

3. An armistice between the Badoglio regime and the Allies
is reached, at Cassibile, and is announced by Badoglio on
September 8. Badoglio, his ministers, and the king flee
Rome—which is still occupied by German forces—for the
South, leaving the army without guidance. This marks the
beginning of the armed Resistance in the German-
occupied North. The Partisans consist of two groups: those
from disbanded units of the Italian army (and supportive of
the royal government in the South) and those from the
CLN (Comitato di Liberazione Nazionale/National
Liberation Committee). The CLN is a reformist group
representing the five anti-Fascist parties: PCI (Partito
Comunista Italiano/Italian Communist Party); PSIUP
(Partito Socialista Italiano di Unità Proletaria/Italian
Socialist Party of Proletarian Unity); Azionisti (Action
party); DC (Democrazia Cristiana/Christian Democratic
party); and PLI (Partito Liberale Italiano/Italian Liberal
Party). Despite the profound political differences among
the groups, the CLN is held together until the end of the
war, primarily by PCI leader Palmiro Togliatti and Alcide
De Gasperi of the DC.

12–13. Mussolini is rescued from prison in the Abruzzi
mountains by the Germans. Taken briefly to Germany, he
is soon returned to Italy to head the puppet republic of
Salò in the North.

October
1. Allied forces enter Naples. The city is in ruins due to
German bombing.

November
25. The Italian Social Republic of Salò is officially
proclaimed. Located on Lago di Garda in northern Italy,
this is Mussolini's final Fascist regime. The Republic would
fall to Allied and Partisan forces in April 1945.

28–December 1. The Tehran Conference takes place.
Winston Churchill, Franklin Delano Roosevelt, and Joseph
Stalin meet to discuss the Allied offensive against Nazi
Germany and the future partition of Europe.

December
The Fascist regime in Italy temporarily stops publication of
the architecture and design magazine *Costruzioni casabella*
(House beautiful constructions). It would resume
publication briefly between March and December 1946, but
would resume continuous publication only in 1953. (The
magazine, first published in Milan in 1928, changed its
name several times over the years: from *La casa bella* to
Casabella, *Casabella costruzioni*, *Costruzioni casabella*,
Casabella continuità, and finally to *Casabella* once more.)

1944

The death penalty is abolished in Italy.

RAI (Radio Audizione Italia), the Italian state radio, is established. In 1954 RAI would become known as Radiotelevisione Italiana.

Il triste minotauro (The unhappy minotaur), a collection of poems by artist Fausto Melotti, is published in Milan.

January
22. Allied troops land in Anzio (the province of Rome).

March
The USSR recognizes the Badoglio government in Italy.

23–24. Members of GAP (Gruppi di Azione Patriottica/Patriotic Action Group), a segment of the armed Resistance, attack a group of German soldiers on via Rasella, Rome. In retaliation, the following day the German army massacres 385 Italians in caves outside Rome on via Ardeatina, then seal the bodies inside the caves by exploding mines. After Rome is liberated in June, the caves are opened and the bodies identified. A competition for a monument on the site is initiated and the resulting design is a collaboration between two groups: Nello Aprile, Cino Calcaprina, Aldo Cardelli, Mario Fiorentino, and Giuseppe Perugini, with sculptors Mirko [Mirko Basaldella] and Francesco Coccia. The monument to the Ardeatine caves massacre would be completed in 1947.

April
22. The Badoglio cabinet resigns, and is immediately reelected.

May
German troops evacuate Monte Cassino after four months of fighting with Allied forces. The battle—among the most difficult fought in Italy—was one of the heaviest artillery and aerial bombardments of the war and had resulted in the deaths of 3,000 Italian civilians.

June
Prince Umberto II becomes Lieutenant-General of the Kingdom of Italy, assuming much of his father's authority.

4. Allied troops take Rome.

6. Allied troops land in Normandy.

18. Badoglio is forced to resign and Ivanoe Bonomi, of the PSIUP (Partito Socialista Italiano di Unità Proletaria/Italian Socialist Party of Proletarian Unity), becomes Prime Minister. A new opposition cabinet is formed under PCI (Partito Comunista Italiano/Italian Communist Party) leader Palmiro Togliatti.

August
Allied forces liberate Florence and Paris.

December
Esposizione d'arte contemporanea (Exhibition of contemporary art) is held at the Galleria Nazionale d'Arte Moderna, Rome. Participants include Afro [Afro Basaldella], Carlo Carrà, Felice Casorati, Giorgio de Chirico, Filippo De Pisis, Renato Guttuso, Leoncillo [Leoncillo Leonardi], Mario Mafai, Giacomo Manzù, Mirko, Giorgio Morandi, Medardo Rosso, and Toti Scialoja. Palma Buccarelli writes the catalogue text.

1945

British and American troops liberate Buchenwald, Dachau, and Belsen, three of the most notorious Nazi concentration camps.

The unemployed in Italy number more than 2 million.

Bruno Zevi's *Verso un'architettura organica* (published in English as *Towards an Organic Architecture*) is published after his return to Italy from political exile in the United States. Zevi, having become familiar with Frank Lloyd Wright's publication *An Organic Architecture: The Architecture of Democracy* (1939) and architectural work during his stay in the United States, becomes a staunch promoter of Organic architecture and a central figure in Italian architecture. In opposition to the Rationalists, the Organic architecture movement favors organic rather than geometric forms and a freer approach to design.

Architect Giovanni Michelucci founds *La nuova città* (The new city), a journal primarily addressing reconstruction, in Florence. In 1948 Michelucci would move to Bologna, where he would teach in the Faculty of Engineering at the Politecnico di Bologna and continue publication of the journal. *La nuova città* would appear at irregular intervals until 1954; in 1950 its name would change to *Panorami della nuova città* (Panoramas of the new city), although it would once again become *La nuova città* in 1952.

Cesare Pavese, one of the most influential writers of the period and known for his numerous translations of American fiction (among them Herman Melville's *Moby-Dick*), becomes editorial director of the publishing house Einaudi in Turin. He also joins the PCI (Partito Comunista Italiano/Italian Communist Party).

The first of the six volumes of Antonio Gramsci's *Quaderni del carcere* (published in English as *The Prison Notebooks*) is published. (The final volume would be published in 1948.) Gramsci's ideas would become central to PCI policy under Palmiro Togliatti.

Carlo Levi's novel *Cristo si è fermato a Eboli* (published in English as *Christ Stopped at Eboli*) is published. (It would be made into a film by Francesco Rosi in 1979.)

Elio Vittorini's novel about the Resistance in Milan toward the end of World War II, *Uomini e no* (Men and not men), is published.

Roberto Rossellini's *Roma città aperta* (Rome open city; released in English as *Open City*) becomes an unexpected box-office hit. (Most neorealist films are not well attended.)

*Left to right: the bodies of the former
Secretary of the Fascist party, Achille
Starace, Benito Mussolini, and his
mistress, Claretta Petacci, hang publicly
in Milan after they were executed near
the city in 1945. AP/Wide World Photos.*

Germana Marucelli reopens her atelier in Milan. (First
opened in 1938, it was closed in 1940 due to the war.) She is
known for her unusual work with fabric, particularly with
appliqués and elaborate embroidery, as in the dress she
would create in 1949 for Eva Perón. Her fashion shows,
which become gala social events, are attended by many
artists and writers, including Getulio Alviani, Massimo
Campigli, Giuseppe Capogrossi, Felice Casorati, Lucio
Fontana, Gio Ponti, Alberto Savinio, Paolo Scheggi, and
Piero Zuffi.

MSA (Movimento di Studi per l'Architettura/Movement of
Studies for Architecture) is founded in Milan to insure a
unified plan for reconstruction. The group, which promotes
Rationalist architecture, includes well-established
architects and firms—including BBPR (Belgiojoso,
Peressutti, Rogers)—as well as younger architects, such as
Giancarlo De Carlo and Marco Zanuso. Formally
conceived in 1926 by Gruppo 7, a group of young architects
that included Luigi Figini, Gino Pollini, and Giuseppe
Terragni, Rationalism was the dominant architectural style
under Fascism.

January
20–February 4. Libera Associazione Arti Figurative holds
an exhibition at Galleria San Marco, Rome. Participants
include Carlo Aymonino, Capogrossi, Ettore Colla, Renato
Guttuso, Leoncillo [Leoncillo Leonardi], Carlo Levi, Mario
Mafai, Concetto Maugeri, Salvatore Scarpitta, Toti Scialoja,
and Giulio Turcato. The catalogue text is written by
Associazione president Gino Severini.

February
4–11. The Yalta Conference takes place: Roosevelt,
Winston Churchill, and Joseph Stalin meet in Crimea to
plan the final defeat and occupation of Nazi Germany and
the configuration of Europe after the war.

19. Ezra Pound, an American pro-Fascist poet who is
wanted for treason in the United States, is seized by
American forces in Genoa.

April
22. Architect Giuseppe Pagano, editor of *Casabella* until
the journal was closed in 1943, dies in the Mathausen
concentration camp. Pagano had been arrested and
transferred to Germany due to his involvement with the
Resistance.

25. Allied forces liberate Venice and Milan.

28. Benito Mussolini, after entering into negotiations with
the Partisans to surrender himself, flees from Rome with
his mistress, Claretta Petacci. They are captured and
executed by a Partisan squad in Giulino di Mezzegra and
their bodies hung upside-down in the Piazzale Loreto in
Milan in an act of public humiliation. Mussolini's wife,
Rachele, who was promoted by Fascist propaganda as the
model wife and mother, would try to escape to Switzerland,
but would be captured and interned for several months;
she would return to her hometown of Forlì following her
release.

30. Adolf Hitler commits suicide in Berlin.

May
2. One million German troops surrender in Italy and Austria.

7. In Rheims, Germany signs unconditional surrender to Allied forces throughout Europe. The surrender is ratified in Berlin on May 8.

June
21. Ferruccio Parri, of the Azionisti (Action Party), is named Prime Minister. He would remain in power through December 10.

July
Italy declares war on Japan.

15. Zevi and a group of young architects found APAO (Associazione per l'Architettura Organica/Association for Organic Architecture) in Rome.

26. The Potsdam Conference takes place: Clement Attlee, Stalin, and Harry S Truman meet. Tensions between the USSR and Western Allies become clear.

August
The first issue of *Metron*, under the editorship of Luigi Piccinato, Silvio Radiconcini, and Zevi, is published in Rome. Addressing popular housing and reconstruction, its writers criticize much of the reconstruction effort and point to the lack of intelligent planning, caused primarily by ideological conflicts between various planning groups. *Metron* would cease publication in 1954.

14. Japan surrenders to Allied forces.

September
Renato Birolli founds the Nuova Secessione Artistica Italiana in Venice. Its manifesto would be written in October 1946 and signed by Birolli, Bruno Cassinari, Guttuso, Leoncillo, Levi, Ennio Morlotti, Armando Pizzinato, Giuseppe Santomaso, Turcato, Emilio Vedova, and Alberto Viani.

The first issue of Vittorini's journal *Il politecnico* (Polytechnic) is published in Milan. Vittorini, whose landmark novel *Conversazione in Sicilia* (Conversation in Sicily; published in English as *In Sicily*) was published in 1941, envisages the journal as a platform for discussing the role of the intellectual in postwar society. He argues that political ideology should not dictate culture, leading him to a debate in the press with Palmiro Togliatti, head of the PCI. Photography is a central component of the journal, which would be published through April 1946 as a weekly, and from May 1946 to December 1947 as a monthly.

The city of Milan holds a competition for reconstruction proposals, during which the AR (Architetti Riuniti) plan is presented. A plan for the city of Milan, AR was designed by a team of architects (Franco Albini, Lodovico Belgiojoso, Piero Bottoni, Ezio Cerutti, Ignazio Gardella,

Gabriele Mucchi, Giancarlo Palanti, Enrico Peressutti, Mario Pucci, Aldo Putelli, and Ernesto Nathan Rogers) in 1944. It contains several major elements, most of which would never be constructed—including a canal, lined with modern workers' housing, that would link Locarno, Switzerland, with Venice for the export of Italian goods to the rest of southern Europe; a new commercial center in the area of Milan known as Fiera Sempione, which would allow the historic area of the city to become a residential zone, thus minimizing traffic and allowing for the restoration and protection of historic structures; and the re-creation of an airport, subway system, parks, and sports centers in Milan. The scheme would be published in 1946 in *Costruzioni casabella* (House beautiful constructions). Approximately half of Milan's housing was destroyed by bombing during the war and the city is the site of much experimentation in city planning by architectural groups.

December
Mussolini's daughter, Edda, is jailed for two years for aiding Fascism.

The first issue of *Numero* (Number) is published in Milan. One of many short-lived northern Italian art journals of this period, *Numero* would last until April 1946. Many of the previous members of Corrente are involved with the journal, as well as with *Il '45* (1945) and *Pittura* (Painting).

10. Alcide De Gasperi becomes Italy's first Christian Democratic Prime Minister. He would remain in this position through eight different governments, until August 17, 1953.

1946
Alberto Burri returns to Italy and devotes himself to painting.

The *Manifesto blanco* (White manifesto) is written by Lucio Fontana's students in Buenos Aires. Although the manifesto represents Fontana's ideas, his name does not appear on the document, which is signed by Bernardo Arias, Pablo Arias, Enrique Benito, César Bernal, Rodolfo Burgos, Horacio Cazenueve, Luis Coll, Marcos Fridman, Alfredo Hansen, and Jorge Rocamonte.

Franco Albini and Giancarlo Palanti become editors of the temporarily revived journal *Casabella*.

Comunità (Community), a review of Italian culture, begins publication in Rome. The magazine would put out six issues—which would include writings by prominent cultural critics and intellectuals such as Cesare Brandi, Alberto Moravia, Ernesto Rossi, and Lionello Venturi—before moving in April 1947 to Turin. There, *Comunità* would put out twenty-six issues edited by Adriano Olivetti. In 1949 the review would move to Milan and begin to concentrate on art, philosophy, culture, and politics.

Il Manuale dell'Architetto (The architect's manual), edited by Aldo Cardelli, Mario Fiorentino, Mario Ridolfi, and

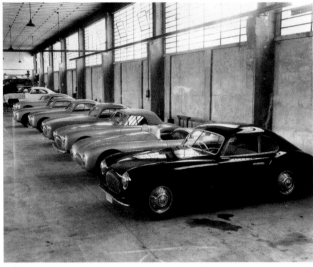

Princess Luciana Pignatelli, Valentino {Valentino Garavani}, and Irene Galitzine arrive in New York to participate in the first International Haute Couture Fashion benefit in September 1965. AP/World Wide Photos.

The Cisitalia auto factory in Turin, 1948. AP/Wide World Photos.

Crown Prince Umberto (left), Lieutenant General of the Realm, who assumes the title King Umberto II in 1946, and King Vittorio Emanuele III (right). AP/Wide World Photos.

Bruno Zevi and sponsored by the CNR (Consiglio Nazionale delle Ricerche/National Council of Research) and USIS (United States Information Service) is published in Rome.

Rossellini's film *Paisà* (Compatriot; released in English as *Paisan*) is released. Documenting the Allied invasion of Italy and the encounter of Italian and American cultures, the film conveys, with a striking sense of immediacy, the tragedy and desperation wrought by the war. Rossellini's brand of documentary realism, known as neorealismo (neorealism), is marked by its commitment to social realism, employing nonprofessional actors, shooting on location, and even using actual newsreel footage, and is characterized by its *reportage*, or documentarylike quality.

Vittorio De Sica's *Sciuscià* (released in English as *Shoeshine*) is released. This story of two shoeshine boys documents the loss of innocence and youth.

Luigi Zampa's film *Vivere in pace* (released in English as *To Live in Peace*) is released, and is awarded the 1947 New York Film Critics' Award for best foreign feature. Closer to traditional Italian comedy than to stark neorealism, Zampa's film traces the events that occur in a small Italian village when two escaped American prisoners-of-war encounter a German soldier.

Irene Galitzine opens her own atelier in Rome. Although she would take part in fashion shows during the 1960s, she would decline an invitation to participate in the first *Italian High Fashion Show*, in Florence in 1951, unsure of Italy's ability to create a distinctive national style that could compete with the dominant French aesthetic. In 1960, she would become known as the inventor of the loose-fitting, wide-legged pants named (by Diana Vreeland in an article for *Vogue* magazine) the Palazzo pyjama.

Fernanda Gattinoni opens her own studio in Rome. In 1952 she would create the costumes for Ingrid Bergman in Roberto Rossellini's film *Stromboli, terra di Dio* (Stromboli, land of God; released in English as *Stromboli*). She would also design Audrey Hepburn's wardrobe for the film *War and Peace*, in 1959.

RIMA (Riunione Italiana Mostre Arredamento/Italian Conference of Furnishings Exhibitions) is founded by a group of architects interested in interior design.

Aldo Della Rocca, Mario De Renzi, Luigi Piccinato, and Mario Ridolfi are charged with planning a new traffic system for Rome. The project increases in scope, developing into a major structural design for a new city plan. It initiates a ten-year debate on Roman urban renewal, dividing architects into two camps: those who are in favor of city planning and those who are against it.

BBPR's Rationalist design for a monument to the fallen in German concentration camps is constructed at the Cimitero Monumentale, Milan. The open, metal-grid structure holds at its center an urn filled with earth taken from German concentration camps. (Among those whose

lives the monument commemorates is Gian Luigi Banfi—the first "B" of BBPR).

Olivetti renews its activity on the foreign market and establishes a New York sales office. Between 1946 and 1954 the company would revise its entire line of products, becoming known internationally for its calculators. The *Elettrosumma 14* (an electric printing adding machine designed by Natale Capellaro) would be the first model in a series that would bring Olivetti to prominence in this field.

The *Vespa 98* (*Wasp 98*), a motor scooter designed by Corradino d'Ascanio that represents a revolutionary and inexpensive new form of transportation, is produced by Piaggio. The *Vespa*'s organic design, with its full, rounded forms, does not disguise its utilitarian purpose. The *Vespa* would remain in production until 1987.

The *Cisitalia* car is designed by Battista Pinin Farina for Fiat. Notions of wealth and sophistication would come to be associated with many Italian design objects, especially with this ultramodern, sleek vehicle.

Vico Magistretti designs a bookcase formed of steel tubes anchored between the floor and ceiling. His design pushes the traditional limits of furniture design by exposing its component elements.

January
The first issue of *Domus* under the editorship of Ernesto Nathan Rogers, who has replaced Gio Ponti, is published.

February
The first issue of *Il '45* (1945) is published in Milan. The journal would cease publication in May.

The *Manifesto del realismo* (Manifesto of realism), also called *Oltre Guernica* (Beyond Guernica), is published in Milan in the magazine *Numero* (Number). Giuseppe Ajmone, Rinaldo Bergolli, Egidio Bonfante, Gianni Dova, Ennio Morlotti, Giovanni Paganini, Cesare Peverelli, Vittorio Tavernari, Gianni Testori, and Emilio Vedova sign the manifesto, which outlines a broad notion of realism not attached to verism. The artists, many of whom were involved in Corrente, do not insist on a single, dominant ideology, but rather allow for the coexistence of different styles.

March
The first show of work by members of the artists' group Arte Sociale is held on the via Veneto in Rome. Exhibitors include Piero Dorazio, Achille Perilli, and Renzo Vespignani, all three of whom would later become members of the group Forma. Arte Sociale would also publish a review entitled *La fabbrica* (The factory), the sole issue of which would appear in August.

May
9. Umberto II is crowned King after his father, Vittorio Emanuele III, abdicates because of his ties to the former Fascist regime.

June
The first *Salon des Réalités Nouvelles* (Salon of new realities) is held, at the Palais des Beaux-Arts, Paris. Pietro Consagra, Dorazio, Perilli, and Giulio Turcato participate. The only exhibition criterion of this yearly salon, founded by Frédo Sidès, is that the work be nonfigurative.

2. A general election (the first with universal suffrage) and referendum are held in Italy. The referendum allows the Italian population to determine the country's political structure. Votes for a republic outweigh those for the monarchy by a comfortable margin: 54 percent to 46 percent. King Umberto II, who would challenge the result and refuse to abdicate, would be forced into exile. In the election, three parties dominate: the DC (Democrazia Cristiana/Christian Democratic party), formed in July 1943 with ties to the church; PCI (Partito Comunista Italiano/Italian Communist Party), which was founded in January 1921 and would emerge as the major opponent to the DC after the war; and PSIUP (Partito Socialista Italiano di Unità Proletaria/Italian Socialist Party of Proletarian Unity), founded in 1892, the leaders of which went into exile during Fascist rule. Thus the first free election establishes the balance of power that would characterize most of the postwar period.

28. Enrico De Nicola, an independent associated with the PLI (Partito Liberale Italiano/Italian Liberal Party), is elected provisional President of the Republic of Italy. Although the office's powers are limited, the president is the highest figure in government. Elected by the parliament (made up of the House of Representatives and the Senate, who are themselves elected by the people) by no less than a two-thirds margin, the president is granted a seven-year term. The president in turn appoints a prime minister. The prime minister–elect chooses cabinet ministers, who are officially appointed by the president. The government (constituted by the prime minister and the cabinet) then must be approved by the members of parliament, who give their *fiducia*, or trust, to the government. If the parliament does not agree with the prime minister's choices for cabinet, or becomes unhappy with the prime minister's policies, it may refuse or withdraw its trust, causing the government to collapse. In that case, the president appoints a new prime minister and the process is repeated.

September
–*January 1947*. *Pittura Francese d'Oggi* (French painting today) is held at Galleria Nazionale d'Arte Moderna, Rome. The show, which includes work by Georges Braque, Robert Delaunay, Raoul Dufy, Henri Matisse, and Pablo Picasso strongly influences a number of younger Italian artists, who would soon after create the group Forma.

October
The Nuova Secessione Artistica Italiana forms in Venice and publishes its *Manifesto di fondazione della Nuova Secessione Artistica Italiana* (Founding manifesto of the Nuova Secessione Artistica Italiana). (The group would reorganize as the Fronte Nuovo delle Arti in 1947.) Brought together by Renato Birolli and championed by critic

Natalia Ginzburg receiving the Strega Prize in 1963; at left in the foreground is Luigi Barzini, Jr. AP/World Wide Photos.

Giuseppe Marchiori, the group is composed of artists with differing artistic styles, much like Corrente before it. The manifesto is signed by Birolli, Bruno Cassinari, Renato Guttuso, Leoncillo [Leoncillo Leonardi], Morlotti, Armando Pizzinato, Giuseppe Santomaso, Emilio Vedova, and Alberto Viani; it calls for a separation of aesthetics and politics, proposing a unity through a common moral concern rather than a predetermined aesthetic. Eventually, however, the differing political ideologies of members of the Fronte Nuovo delle Arti would cause a profound rift in the group, with Communist proponents of social realism opposing other leftist artists, who would argue for stylistic freedom.

December
The first issue of *Pittura* (Picture) is published. (Another of the short-lived art journals of this period, it would fold in August 1947.)

1947
Accusations of corruption, scandals, and revelations of Mafia ties surround the Italian government throughout the year.

Military conscription is instituted in Italy.

The Marshall Plan (a United States–sponsored program for European economic recovery) is developed, and would be in effect from 1948 to 1952.

Primo manifesto dello spazialismo (First manifesto of Spazialismo) is written in the months after Lucio Fontana returns to Milan from Argentina in April (most likely in May). The manifesto, signed by Fontana, Beniamino Joppolo, Giorgio Kaisserlian, and Milena Milani, claims that art is made eternal through the creative act, not through matter, which eventually decomposes.

Italo Calvino's novel *Il sentiero dei nidi di ragno* (The path of the spider's nests; published in English as *The Path to the Nest of Spiders*) is published.

Natalia Ginzburg's *È stato così* (It was like this), a small volume of two novellas, is published and receives critical acclaim. In 1963 Ginzburg would win the Strega prize for *Lessico famigliare* (Family lexicon).

La Gondola, a group of photographers, is founded in Venice by Gino Bolognini, Alfredo Bresciani, Giuseppe Bruno, Paolo Monti, and Luciano Scattola. Later, Toni Del Tin, Gianni Berengo Gardin, and Fulvio Roiter would join the group. Monti, who employs a direct, documentary approach in his photographs, would be president of the group until 1953.

Roberto Rossellini's *Germania anno zero* (released in English as *Germany Year Zero*) is released. Shot in bombed-out Berlin and focusing on a destitute boy and his ailing father, the film is dedicated to Rossellini's son, who died the year before.

Giuseppe De Santis's *Caccia tragica* (released in English as *Tragic Hunt*), with a script by Michelangelo Antonioni, is released. The film chronicles the disruption wrought by war in the lives of two peasants and depicts the ravaged Italian countryside.

Princess Giovanna Caracciolo di Avellino Giannetti establishes her fashion firm, Carosa, in Rome. She would participate in the 1951 *Italian High Fashion Show* in Florence, where she would have great success with American buyers.

Paris-based designer Elsa Schiaparelli licenses her name, becoming one of the first fashion designers to do so.

CIAM (Congrès Internationaux d'Architecture Moderne/International Congresses of Modern Architecture) VI, the first postwar congress, is held in Bridgwater, England. Founded in 1928 with the intention to free architecture from the traditional and the academic, CIAM promotes Modernist architecture.

The commission for Rome's Stazione Termini—awarded through competition, as many of the major architectural commissions of the reconstruction era are—is won by the architectural team of Leo Calini, Massimo Castellazzi, Vasco Fadigati, Eugenio Montuori, Achille Pintonello, and Annibale Vitellozzi. Their design would become one of the most important examples of Italian functionalist architecture.

The Olivetti factory at Ivrea is enlarged (from 1947–49) following designs by Luigi Figini and Gino Pollini, the architects who designed the original plant in the late 1930s. (Olivetti would greatly expand between 1946 and the late 1950s.)

The *VIII Triennale*, the first since the war, is held. It is devoted to the problem of reconstruction, especially of lower-income housing. Piero Bottoni, Ezio Cerutti, Vittorio Gandolfi, Pollini, Mario Pucci, Aldo Putelli, and Mario Morini exhibit their plan (designed in 1946) for the first experimental lower-income neighborhood in Milan, called the QT–8 (Quartiere Triennale–8/Eighth Triennial Quarter). (Established in 1923 as an international survey of decorative arts, the *Triennale* would slowly shift its emphasis toward industrial design.)

Carlo Mollino designs an armchair with reclining back for Casa del Sole, a newly developed condominium made up of studio apartments, in Cervinia. Employing bent, laminated wood along with cushions to create a chair that is both contemporary in design and comfortable, Mollino is perhaps influenced by the designs of Harry Bertoia, Charles Eames, and Eero Saarinen, which appeared in early postwar issues of *Domus*.

Gio Ponti designs an espresso machine for La Pavoni. Its organic form is similar to that of many other products of the period. The coffee-bar and espresso-coffee cult would burgeon in the 1950s, with a growing clientele in cities across Europe and the United States.

January
Marchese Emilio Pucci is photographed at Zermatt with a woman friend, both in ski clothes of Pucci's design. The photographs would be published in *Harper's Bazaar* in 1948 and the designs would be well received. The following year, Pucci would present his "Capri look," comprised of brightly colored tailored silk shirts and matching tapered pants; the look would become quite popular. Pucci would participate in the *Italian High Fashion Show* in Florence in 1951.

Ferrania, a monthly review of photography, cinema, and figurative arts directed by Guido Bezzola, begins publication in Milan. Its editorial committe is made up of Paolo Arnaldo Cassinis, Domenico Cantator, Alfredo Ornano, and Luigi Veronesi. The review would continue publication into the 1960s.

1–February 9. Mostra Internazionale d'Arte Astratta e Concreta (International exhibition of abstract and concrete art), organized by Max Bill, Max Huber, and architect Girolamo Bombelli, is presented at Palazzo Reale, Milan. Italian participants include Gillo Dorfles, Osvaldo Licini, Galliano Mazzon, Bruno Munari, Mario Radice, Manlio Rho, Ettore Sottsass, Jr., and Luigi Veronesi.

February
10. Following the Paris Peace Conference, in which twenty-one countries participate, the Treaty of Paris is signed. Italy agrees to pay reparations to the USSR, Yugoslavia, Greece, and Ethiopia; it also agrees to renounce claims to Libya, Somalia, Albania, and Ethiopia, and to cede parts of Istria and certain Adriatic islands to Yugoslavia. Trieste becomes a free territory.

March
15. Forma unites in Rome and writes a manifesto, which is signed by Carla Accardi, Ugo Attardi, Pietro Consagra, Piero Dorazio, Lorenzo Guerrini, Achille Perilli, Antonio Sanfilippo, and Giulio Turcato. The manifesto is published in April, in Forma's first and only issue of their review, *Forma 1*. Several essays are also included in *Forma 1*, among them: "Teorema della scultura" (Theorem of sculpture), by Consagra; "Perché la pittura" (Why painting), by Guerrini; "Crisi della Pittura" (The crisis of painting), by Turcato; "Stile e tradizione" (Style and tradition), by Dorazio; and "Gli espressionisti del secolo" (The expressionists of the century) and "Astrattisti a Milano" (Abstractionists in Milan), by Perilli. Forma is the first pro-abstraction group to form after World War II and would last until 1951. Concrete art of the 1930s, exemplified by Theo van Doesburg's work (seen by the group in the catalogue to the *Exposition internationale d'art abstrait et concret* [International exposition of abstract and concrete art] at Palais Royal, Paris, which opened in January), is an important influence. The group rejects realism in favor of a purely expressive style, a choice defined in political terms, with its members declaring themselves both "formalists and Marxists."

April
The photography group La Bussola is founded in Senigallia

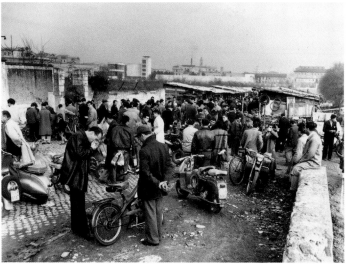

In Salvatore Ferragamo's factory in Florence, a workman attaches the heel to a shoe. AP/Wide World Photos.

Motor scooters and bicycles, many stolen, for sale at the Porta Portese flea market on the outskirts of Rome in 1952. AP/Wide World Photos.

Luchino Visconti's La terra trema, *1948. Photofest, New York.*

(near Ancona). The group includes Giuseppe Cavalli, Mario Finazzi, Ferruccio Leiss, and Federico Vender. Cavalli, who is especially interested in the aesthetics of photography and adopts a photography-for-photography's-sake position, writes the manifesto, which is published in *Ferrania* in May. (The group would last until 1956.)

May
12. Alcide De Gasperi, in response to American promises of support, resigns. On May 31 he forms a new, one-party DC (Democrazia Cristiana/Christian Democratic party) government, expelling Communists and far-left Socialists from his government. The Left responds violently and the threat of civil war reinforces United States support of De Gasperi. Giuseppe Saragat splits from the PSIUP (Partito Socialista Italiano di Unità Proletaria/Italian Socialist Party of Proletarian Unity), which he believes is becoming too leftist, and forms the PSDI (Partito Socialista Democratico Italiano/Italian Social Democratic Party). The excluded far-left Socialists are led by Pietro Nenni.

June
12–July 12. The first exhibition of Fronte Nuovo delle Arti is held, at Galleria della Spiga, Milan. Curated by critic Giuseppe Marchiori, the exhibition includes work by Renato Birolli, Antonio Corpora, Pericle Fazzini, Nino Franchina, Renato Guttuso, Leoncillo [Leoncillo Leonardi], Ennio Morlotti, Armando Pizzinato, Giuseppe Santomaso, Turcato, Emilio Vedova, and Alberto Viani. The Fronte Nuovo is a reorganization of the Nuova Secessione group, founded in September 1945, which included Bruno Cassinari and Carlo Levi (they do not join the new group).

July
Alberto Burri has his first solo exhibition, of figurative works with traditional still-life and landscape themes, at Galleria La Margherita, Rome. The catalogue introduction is written by poet-critics Libero del Libero and Leonardo Sinisgalli.

August
Italy and Austria are barred from the United Nations by Soviet veto.

September
8. Shoe designer Salvatore Ferragamo is awarded the Fashion Oscar by Neiman Marcus in Dallas, Texas. The Ferragamo brothers emigrated to California and opened a shoe store in Santa Barbara in the 1910s. In 1922 Salvatore opened his own store in Los Angeles and soon began working for the film industry. He created footwear for Hollywood films and for private clients. In 1927 he returned to Italy and established a business in Florence.

October
–November. An exhibition of work by Forma members, including Dorazio, Guerrini, Concetto Maugeri, Perilli, and Turcato, is organized by the Art Club and held at Galleria di Roma.

November
Italy is admitted to UNESCO.

Accardi, Attardi, and Sanfilippo (who were not included in the October Forma exhibition) have an exhibition at Studio d'Arte Moderna, Rome.

December
13. The last American troops withdraw from Italy.

1948

Alcide De Gasperi's coalition government has been deadlocked on major issues of reconstruction and unable to institute reforms since 1946. Among the many bitter protests by Southern peasants and workers and clashes between unions and the government that will continue until 1950, Italian workers hold a forty-eight-hour general strike.

Ettore Colla, who stopped sculpting in 1942, dedicates himself to painting.

Irenio Diotallevi and Franco Marescotti's *Il Problema sociale, economico e construttivo dell'abitazione* (The social, economic, and construction problem of housing), a book of research on different types of housing that is the result of the *VIII Triennale*, is published. Diotallevi and Marescotti are associated with German functionalist architecture from the interwar period.

The first issue of the cultural magazine *Pirelli*, managed by Gio Ponti and others, is published in Milan. (It would remain in publication until 1972.)

Elsa Morante's novel *Menzogna e sortilegio* (Lie and witchcraft; published in English as *The House of Liars*) is published.

Vittorio De Sica's *Ladri di biciclette* (Bicycle thieves; released in English as *The Bicycle Thief*) is released. Through the story of a bill poster whose bicycle is stolen, the film reflects the crushing social problems facing postwar Italy. *Ladri* would win the 1949 Academy Award for best foreign film.

Alberto Lattuada's *Senza pietà* (released in English as *Without Pity*) is released. Scripted by Federico Fellini and Tullio Pinelli, with music by Nino Rota (who would later compose the music for Fellini's internationally acclaimed films), *Senza pietà* traces the socio-economic difficulties of postwar Italy through the story of an African-American soldier and his love affair with an Italian prostitute.

Luchino Visconti's *La terra trema* (released in English as *The Earth Trembles*) is released. The film, which focuses on the lives of poor Sicilian fishermen, exemplifies Italian neorealism; the fishermen play themselves and their unscripted dialogue, spoken in Sicilian dialect, is incorporated into the film.

Giovanni Michelucci leaves the School of Architecture at the Università di Firenze due to controversy over his involvement with a reconstruction plan for the city. The conflict results from wide, ideologically driven differences over how best to reconstruct historical centers such as that of Florence. On one side of the debate are those who want the city rebuilt as a type of historical re-creation (Bernard Berenson was outspoken in his support of this plan); on the other are those, like Michelucci, who feel that the reconstruction must address exigencies particular to modern life.

The *Lexicon 80* typewriter, designed by Marcello Nizzoli, goes into production at Olivetti. Made of a two-piece, die-cast metal shell and with a full-formed organic design, the *Lexicon 80* is an especially elegant machine.

January
1. The Italian constitution, signed in 1947, goes into effect.

5–15. De Gasperi visits the United States and meets with President Harry S. Truman, Secretary of State James F. Byrnes, and congressional leaders.

February
The United States and Italy sign a pact of friendship, commerce, and navigation.

March
The PCI (Partito Comunista Italiano/Italian Communist Party) makes a formal resolution to resist what they perceive as the Americanization of Italian culture.

Arte Astratta in Italia (Abstract art in Italy), organized by the Art Club, is presented at Galleria di Roma. Among those who participate are Lucio Fontana, Osvaldo Licini, Alberto Magnelli, Mauro Reggiani, and Atanasio Soldati; and Armando Pizzinato, Emilio Vedova, and Alberto Viani of Fronte Nuovo delle Arti. The catalogue includes texts by Max Bill, Gillo Dorfles, Vasily Kandinsky, Le Corbusier, Fernand Léger, Piet Mondrian, and Ettore Sottsass, Jr.

The *V Rassegna Nazionale d'Arti Figurative promossa dall'Ente Quadriennale* (Fifth national review of figurative art organized by the quadrennial organization) is held in Rome at Galleria Nazionale d'Arte Moderna. The first *Quadriennale* since the war, the exhibition includes 1,334 works by 912 artists.

18. The *Secondo manifesto dello spazialismo* (Second manifesto of Spazialismo) is signed by Gianni Dova, Fontana, Beniamino Joppolo, Giorgio Kaisserlian, and Antonino Tullier. (The manifesto was preceded in February by an unsigned broadside pamphlet entitled *Spaziali*, which was distributed at Galleria del Naviglio, Milan.)

April
18. Parliamentary elections are held in Italy, the first since the adoption of the new constitution. Public-opinion polls predict a Communist victory. (The PCI is the largest postwar Communist party in Europe; its membership would rise from 5,000 in 1943—when, under Fascist law, it was an illegal organization—to more than 2.3 million by early 1949.) As the elections approach, the United States openly gives verbal and financial support to the DC (Democrazia Cristiana/Christian Democratic party),

In Rome's Piazza Colonna Galleria, DC (Democrazia Cristiana) and pro-American posters dominate a pillar during pre-election campaign. AP/Wide World Photos.

Prime Minister Alcide de Gasperi holding initial voting returns on April 19, the second day of national elections. AP/Wide World Photos.

Peggy Guggenheim entertains at her Venice palazzo in 1950. Photo by Milton Gendel.

claiming Palmiro Togliatti (head of the PCI) to be a supporter of Soviet expansionism. The CIA, mounting its first major covert operation, clandestinely funnels money into the DC. In the United States, Italian-Americans are encouraged to write to their relatives in Italy to persuade them to vote against the PCI. The Vatican joins the initiative, pitting Communism against God. The DC wins 48 percent of the votes and acquires a parliamentary hegemony, which it would retain for several decades.

May
Alberto Burri has his second solo show, at Galleria La Margherita, Rome, displaying abstract works.

11. Luigi Einaudi, an independent liberal, is elected President of Italy.

June
Fotografia (Photography), the bimonthly review of the Circolo Fotografico Milanese, begins publication in Milan. Directed by Ezio Croci and with Pietro Donzelli as a member of its editorial committee, the review is attentive to neorealist photography. (It would become a monthly in 1950.)

6–October 10. The *XXIV Biennale* is held in Venice. The first since the end of the war, it is organized by Rodolfo Pallucchini (who would oversee the next several Biennales, through 1956). An entire room is devoted to the Fronte Nuovo delle Arti artists Renato Birolli, Antonio Corpora, Nino Franchina, Renato Guttuso, Leoncillo [Leoncillo Leonardi], Ennio Morlotti, Pizzinato, Giuseppe Santomaso, Giulio Turcato, Vedova, and Viani. Carla Accardi and Fontana—who shows *Scultura spaziale* (*Spatial Sculpture*)— also exhibit. Guttuso writes the introduction to the exhibition of work by Pablo Picasso. The winners of the *Biennale*'s awards are Georges Braque, Marc Chagall, Mino Maccari, Giacomo Manzù, Henry Moore, and Giorgio Morandi. Peggy Guggenheim's collection is also presented and attracts enormous interest. (It would then travel to the Strozzina in Florence in February–March 1949, and the Palazzo Reale in Milan in June 1949.) Giulio Carlo Argan organizes the show of 136 works by seventy-eight artists from Guggenheim's collection, including Jean Arp, Constantin Brancusi, Alexander Calder, Theo van Doesburg, Hans Hartung, Vasily Kandinsky, Paul Klee, El Lissitzky, Kazimir Malevich, Mondrian, and New York School artists William Baziotes, Arshile Gorky, Robert Motherwell, and Jackson Pollock. This is the first major showing of the New York School in Europe. (In 1949 Peggy Guggenheim would purchase the Palazzo Venier dei Leoni in Venice, which from 1951 would permanently house her collection.)

24. The Cold War intensifies as the USSR blockades the Western-held section of Berlin. The blockade would be lifted on May 12, 1949.

July
–August. Pietro Consagra, Piero Dorazio, Achille Perilli, and Turcato show their work in the third *Salon des Réalités Nouvelles* at the Palais des Beaux-Arts de la Ville de Paris.

14. A neo-Fascist attempts to assassinate Togliatti. Togliatti urges calm to prevent any violent protest.

October
17–November 5. Prima Mostra Nazionale d'Arte Contemporanea (First national show of contemporary art), curated by the Alleanza della Cultura, is held in Bologna. Many of the artists who exhibit are associated with Fronte Nuovo delle Arti and Forma. *Rinascita* (Rebirth), the PCI's official journal published in Rome, publishes a scathing review of the exhibition, signed "Roderigo di Castigla," the recognized pseudonym of Togliatti, in its November issue. The attack shocks members of the art community, many of whom are Communists or Leftists, as the party had not previously favored any one artistic tendency. The debate between abstraction and realism becomes a bitter and divisive one, ultimately leading to the dissolution of the Fronte Nuovo. Ex–Fronte Nuovo member Guttuso would become a leading proponent of the newly established realist movement, which would align itself with the PCI.

December
22. The first exhibition of MAC (Movimento Arte Concreta/Concrete Art Movement) opens at Libreria Salto, Milan. Giuseppe Marchiori produces the catalogue, which contains twelve reproductions, of work by Dorazio, Dorfles, Fontana, Augusto Garan, Lorenzo Guerrini, Galliano Mazzon, Gianni Monnet, Bruno Munari, Perilli, Atanasio Soldati, Sottsass, and Luigi Veronesi. Founded by Dorfles, Monnet, Munari, and Soldati, MAC embraces a broad stylistic definition of geometric abstraction. The works of van Doesburg and Arp are central influences on the group, as is van Doesburg's 1930 manifesto *Art Concret* (Concrete art).

1949
Lucio Fontana creates his first *Buchi* (Holes) works, in which he disrupts the two-dimensional plane of the canvas by repeatedly puncturing it.

Carlo Mollino's *Il messaggio dalla camera oscura: fotografia, storia ed estetica* (The message of the darkroom: photography, history, and aesthetics) is published. Mollino, an architect and designer who took documentary photographs of his own work throughout the 1930s and 1940s, also produces portrait photography. His later photographic work would be Surrealist in character.

Mimmo Rotella writes the *Manifesto dell'epistaltismo* (Manifesto of "epistaltismo") and his first phonetic poems.

Urbanistica (Urban planning), the architecture and city-planning magazine of the Istituto Nazionale di Urbanistica of Rome, resumes publication in Turin. (It was first active in the 1930s.) The magazine would remain under the directorship of Adriano Olivetti until 1950 (issue no. 5), at which time Giovanni Astengo would take over. Others involved with the magazine's direction include Luigi Cosenza, Giovanni Michelucci, Ludovico Quaroni, and Giuseppe Samonà. (The review would cease publication in 1974.)

Vitaliano Brancati's novel *Il bell'Antonio* (Beautiful Antonio) is published. (It would be made into a film, starring Marcello Mastroianni, by Mauro Bolognini in 1960.)

Alberto Moravia's 1947 novel *La Romana* (The Roman woman; published in English as *The Women of Rome*) is published in English translation and establishes Moravia on the international literary scene.

Luciano Berio, who would become one of the major figures in contemporary music, composes the choral work *Magnificat*.

Italian cinema experiences an economic crisis, with film production falling from sixty-five films in 1946 to forty-nine in 1948. At the same time, there is a growing movement toward censorship in Italy. Throughout the late 1940s and early 1950s, political pressure is strong; journalists and critics can be arrested and tried by a military tribunal for printing anything perceived as damaging to the country. Giulio Andreotti would head the ministry concerned with public entertainment (which includes cinema) until 1953.

Giuseppe De Santis's film *Riso amaro* (released in English as *Bitter Rice*) is released. Set in the Po valley, the film stars the nineteen-year-old actress Silvana Mangano as a laborer in the rice fields who dreams of going to America. This role transforms Mangano into an internationally known sexual icon. She would go on to make a number of American films.

Au-delà des grilles (Beyond the iron bars; released in English as *The Walls of Malapaga*), a Franco-Italian film directed by René Clément, wins the Academy Award for best foreign film.

As part of the Fanfani Plan (a government-sponsored national housing program), legislation is passed creating INA (Istituto Nazionale Abitazioni/National Housing Institute) Casa. INA Casa's fundamental aims are to construct housing and alleviate unemployment. The institute does not provide for comprehensive urban planning, however, which many architects advocate.

Construction begins on the INA–Casa complex on via Tiburtino, Rome (1949–54), designed by Ludovico Quaroni, Mario Ridolfi, and others. Approaching working-class housing with progressive, socialist aspirations, and combining the influences of Scandinavian housing projects and Frank Lloyd Wright's organic architecture with indigenous Italian building forms, the architects create a series of small, attached brick structures. The project functions as a manifesto of neorealism in architecture.

Giulio Castelli founds the design company Kartell in Noviglio. The firm would become well known for its design objects, such as Joe Colombo's chair, model 4867 (1968), and Gino Colombini's colander, model K1036 (1959). It would begin producing plastic products for the home in 1953. Almost all of the designs produced between 1953 and 1962 would be by Colombini.

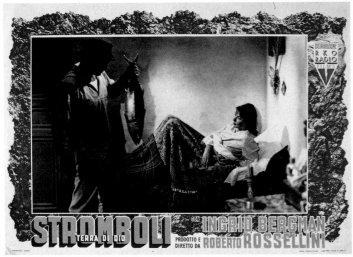

Michelangelo Antonioni (left) and Luchino Visconti (right) at a November 1960 meeting in a Rome movie theater, where film personalities protest against the authorities' ordering of the cutting of scenes considered sexy or violent in pictures already cleared through the regular censorship. AP/World Wide Photos.

Poster for Roberto Rossellini's Stromboli, terra di Dio. *1949. Collection of Gian Piero Brunetta, Padua.*

Tancredi at Rome's Piazza di Spazia in 1950. Photo by Milton Gendel.

January
Ingrid Bergman leaves her husband, Peter Lindstrom, for Roberto Rossellini, who also leaves his spouse. Their action scandalizes the American public and an unofficial boycott of Rossellini's films takes place in the United States. The couple goes to Italy, where they begin work on Rossellini's film *Stromboli, terra di Dio* (Stromboli, land of God; released in English as *Stromboli*), which would be released later in the year.

February
5–11. Lucio Fontana exhibits his first environmental piece, *Ambiente spaziale con forme spaziali ed illuminazione a luce nera* (*Spatial Environment with Spatial Forms and Black Light*)—also called *Ambiente nero* (*Black Environment*)—consisting of a darkened room with suspended forms lit by ultraviolet light, at Galleria del Naviglio, Milan.

April
Italy enters NATO (North Atlantic Treaty Organization), despite strong resistance from the Italian Left and from other countries, especially Great Britain. NATO was founded in March as a military alliance providing a united front against Communism.

May
The Turin soccer team is killed in an airplane crash.

Tancredi [Parmeggiani Tancredi] has his first solo exhibition, at Galleria Sandri, Venice. The catalogue texts are written by Virgilio Guidi and Tancredi.

June
Arte d'Oggi (Art of today), an international exhibition, is held at the Strozzina, Florence. Forma artists exhibit, along with a large number of international artists, including Afro [Afro Basaldella], Vinicio Berti, Gianni Bertini, Renato Birolli, Enrico Bordoni, Silvano Bozzolini, Bruno Brunetti, Corrado Cagli, Mario Davico, Jean Dewasne, Gillo Dorfles, Fernando Farulli, Lucio Fontana, Robert Jacobsen, Augusto Garau, Emile Gilioli, Jean Messagier, Gianni Monnet, Alvaro Monnini, Mattia Moreni, Luigi Moretti, Ennio Morlotti, Richard Mortensen, Bruno Munari, Gualtiero Nativi, Mario Nuti, Jean Piaubert, Armando Pizzinato, Serge Poliakoff, Mario Prassinos, Marcel Raymond, Atanasio Soldati, Victor Vasarely, Emilio Vedova, Luigi Veronesi, and Alberto Viani.

10. Leoncillo [Leoncillo Leonardi]'s first solo exhibition, curated by Roberto Longhi, opens at Galleria del Fiore, Florence.

28–September 18. The Museum of Modern Art, New York presents *Twentieth-Century Italian Art*, curated by Alfred H. Barr and James Thrall Soby. Included are works by Afro, Cagli, Pericle Fazzini, Fontana, Renato Guttuso, Marino Marini, and Giuseppe Santomaso.

July
13. Pope Pius XII threatens to excommunicate Catholics who join the Communist Party. A controversial figure, Pius XII is actively involved in postwar politics and outspoken

in his support of the DC (Democrazia Cristiana/Christian Democratic party).

22–31. CIAM VII is held in Bergamo.

October
Libreria Salto publishes the fourth portfolio of Concrete Art. Giulio Carlo Argan writes the introduction to the portfolio, which includes twenty-four lithographs by Afro, Sebastiano Bombelli, Bordoni, Dorfles, Fontana, Garau, Max Huber, Galliano Mazzon, Monnet, Munari, Soldati, and Veronesi.

November
5–11. The annual *Mostra Internazionale dell'Art Club* (International exhibition of the Art Club) is held at Galleria Nazionale d'Arte Moderna, Rome. Forma artists exhibit, along with Alberto Burri, Giuseppe Capogrossi, Mirko [Mirko Basaldella], Rotella, Angelo Savelli, Nino Franchina, Lorenzo Guerrini, and Maurizio Mannucci. The catalogue foreword is written by Enrico Prampolini.

1950
CGIL (Confederazione Generale Italiana del Lavoro/Italian General Confederation of Labor) launches its Piano del lavoro (Labor plan), designed to alleviate unemployment and desperate living conditions, especially in the South, by employing workers to help bring water, energy, housing, hospitals, and schools to devastated areas. The CGIL, which is associated with the Socialists, was founded in 1906 in Milan; it was dissolved under Fascist rule, but resumed after the war. Most labor unions in Italy are aligned with a political party. The other major unions are CISL (Confederazione Italiana Sindacati Lavoratori/Italian Confederation of Syndicated Workers), which is affiliated with the PLI (Partito Liberale Italiano/Italian Liberal Party), and UIL (Unione Italiana Lavoratori/Italian Workers Union), which is affiliated with the DC (Democrazia Cristiana/Christian Democratic party). There is also a national industrial organization, CGII (Confederazione Generale Industria Italiana/General Confederation of Italian Industry, known as Confindustria), which was first established in 1910 to protect industrial interests.

Tancredi [Parmeggiani Tancredi] moves from Venice to Rome, where he shares a studio with Milton Gendel, the Rome correspondent for *Artnews*. Upon Tancredi's return to Venice a year later he would meet Peggy Guggenheim through the American painter Bill Congdon.

The *Manifesto dell'astrattismo classico* (Manifesto of classical abstraction), edited by Ermanno Migliorini, is signed by Vinicio Berti, Bruno Brunetti, Alvaro Monnini, Gualtiero Nativi, and Mario Nuti.

A special issue of *Cahiers d'art* dedicated to Italian art is published. Entitled *Un demi-siècle d'art italien* (A half-century of Italian art), it includes an introduction by art historian and literary critic Christian Zervos and reproductions of work by Alberto Burri and Giuseppe Capogrossi.

L'Unione Fotografica is founded in Milan by photographer Pietro Donzelli. Andrea Buranelli, Davide Clari, Piero Di Blasi, Flavio Gioia, Arrigo Orsi, and Luigi Veronesi make up the group. L'Unione Fotografica would organize numerous photography exhibitions, among them *Mostra della fotografia europea* (Exhibition of European photography) in 1951, and *Fotografi italiani* (Italian photographers) at the Accademia di Brera in 1953.

Several directors begin to make significant departures from neorealism and its focus on the social, political, and economic conditions of postwar Italy. The films of Michelangelo Antonioni and Federico Fellini in particular become more abstract and less temporally linear, exploring psychological and emotional realms.

Luci del varietà (released in English as *Variety Lights*), co-directed by Fellini and Alberto Lattuada and starring Giulietta Masina and Carla Del Poggio, is released. Through the story of a variety actor and his relationship with a young amateur actress, Fellini and Lattuada explore the masks people wear in their various social roles. (This is a theme Fellini would pursue in numerous other films.)

Cronaca di un amore (released in English as *Story of a Love Affair*), Antonioni's first feature film, is released. The film focuses on two lovers who plot to kill the woman's husband. Recalling typical American detective tales of the 1940s, it departs from conventional narrative to concentrate on the story's emotional and psychological elements.

Vittorio De Sica's *Miracolo a Milano* (released in English as *Miracle in Milan*), a fantasy tale that relates the story of a young boy who is given a dove that grants wishes, is released.

The Torre Velasca, Milan (1950–58) is designed by Lodovico Barbiano di Belgiojoso, Enrico Peressutti, and Ernesto Nathan Rogers of the firm BBPR. BBPR's initial designs (of 1950–51) experiment with metal-and-glass skyscraper structures, varying from zig-zag to T-shaped in plan. The final design—a T-shaped structure—would be determined as much by cost as by formal concerns, and would represent a departure from utopian ideals. The building would be sympathetic to Milan's history and cityscape, especially to its monumental Gothic cathedral.

Franco Albini's renovation of the Palazzo Bianco, Genoa (1950–51), transforms the palazzo into a public art gallery. His design, which also encompasses the installation of the Palazzo Bianco's collection, maintains a respectful balance between new and historical forms and includes an innovative method of presenting art, by which paintings are projected away from the walls on minimal supports.

Mario Ridolfi and Wolfgang Frankl's INA (Istituto Nazionale Abitazioni/National Housing Institute)–Assicurazioni residential towers on viale Etiopia, Rome (1950–54), financed by the Istituto Nazionale delle Assicurazioni (National Insurance Institute), are constructed. This densely structured complex is made up of eight apartment towers and a row of stores.

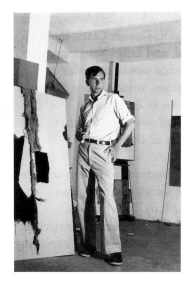

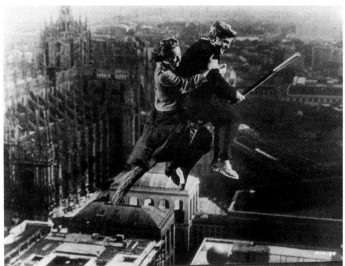

Milton Gendel in Alberto Burri's Rome studio in 1954. Photo by Josephine Powell.

Vittorio De Sica's Miracolo a Milano, *1950. Photofest, New York.*

On the grounds of their villa at Santa Marinella, Ingrid Bergman and Roberto Rossellini enjoy a game of bocce. Photofest, New York.

Construction begins on Ignazio Gardella's residential building for Borsalino employees, in Alessandria (1950–52). Through a play of movement and projecting eaves, Gardella goes beyond purely Rationalist design to create a refined and lyrical structure.

The Olivetti Corporation of America is established in New York.

Achille and Piergiacomo Castiglioni design the *Tubino* desk light, which is manufactured by Flos and would be shown at the 1951 *Triennale*. The light's simple design is determined by functional concerns and technological constraints.

The *Margherita* armchair is designed by Albini and produced by Bonacina. Although Albini uses cane—a traditional material—the form of the chair is highly original and illustrates the integration of innovation and tradition characteristic of Italian design of this period.

Lettera 22 (*Letter 22*), the first Italian portable typewriter, and *Lexicon Elettrica* (*Electric Lexicon*), an electric typewriter, both designed by Marcello Nizzoli, are produced by Olivetti.

January
The first issue of the monthly art magazine *Paragone* (Paragon) is published.

The first exhibition of abstract works by Capogrossi, curated by Corrado Cagli, is held at Galleria del Secolo, Rome. The show would travel to Galleria del Milione, Milan, and Galleria del Cavallino, Venice.

24–February 18. Five Italian Painters is presented at the Catherine Viviano Gallery, New York, and includes work by Afro [Afro Basaldella], Cagli, Renato Guttuso, Ennio Morlotti, and Armando Pizzinato. The show inaugurates Viviano's gallery, which would become noted for its emphasis on contemporary Italian art.

February
A son is born to Ingrid Bergman and Roberto Rossellini, fueling the scandal of their affair. A bill designed to censor the disregard of public morals by actresses and producers and in films is introduced in the United States Congress. Rossellini's affront to American values—first leaving his wife for Bergman and then having a child out of wedlock with her—is seen to be particularly insulting due to the extensive American aid being given to Italy via the Marshall Plan. Rossellini and Bergman would marry in Mexico City in May.

April
2. Proposta di un regolamento del movimento spaziale (Proposal for a regulation of the Movimento Spaziale, sometimes called the *Terzo manifesto del spazialismo* [Third manifesto of Spazialismo]) is signed by Carlo Cardazzo, Roberto Crippa, Lucio Fontana, Giampiero Giani, Beniamino Joppolo, and Milena Milani. The manifesto reiterates the tenets of the Movimento Spaziale, recognizing the

movement's commitment to art employing revolutionary mediums and Lucio Fontana as its founder.

May
12. Law #253, the "Sila Law," begins the process of land reform in the South of Italy.

15–June 9. Afro's first solo show in the United States is held, at the Catherine Viviano Gallery. The artist visits the country for eight months on the occasion of the exhibition.

June
3–October 15. The *XXV Biennale* opens in Venice. Among the Italians exhibiting are former members of the dissolved Fronte Nuovo delle Arti, who form two opposing groups: abstractionists (such as Renato Birolli, Antonio Corpora, Morlotti, Giuseppe Santomaso, Giulio Turcato, and Emilio Vedova) and realists (such as Guttuso, Pizzinato, Ernesto Treccani, Renzo Vespignani, and Giuseppe Zigaina). The realists' presence makes a strong impact; Guttuso exhibits his *Occupazione delle terre incolte in Sicilia* (*Occupation of Uncultivated Land in Sicily*, 1950). The Italians Capogrossi, Fontana, Leoncillo [Leoncillo Leonardi], Osvaldo Licini, Enrico Prampolini, Mario Radice, Mauro Reggiani, Manlio Rho, and Atanasio Soldati also exhibit, along with the Americans Willem de Kooning, Arshile Gorky, John Marin, and Jackson Pollock. Prize winners are Carlo Carrà, Marcello Mascherini, Frans Masereel, Henri Matisse, Luciano Minguzzi, Giuseppe Viviani, and Ossip Zadkine.

July
22–August 12/15. An exhibition of twenty works by Pollock from Peggy Guggenheim's collection is held at the Sala Napoleonica, Venice. (A catalogue is published in two editions; one, which includes an introductory text by Guggenheim, lists the closing date as August 12; the second gives the closing date as August 15.)

August
The Cassa per il Mezzogiorno (a fund for the development of the South of Italy), apparently modeled on Franklin Delano Roosevelt's Tennessee Valley Authority, is formed to promote economic and social development in southern Italy. The Cassa makes easy loans to small businesses, but the bulk of funds are spent on the development of agriculture, sewage and water systems, transport, and communications.

27. Cesare Pavese commits suicide in Turin.

December
Domenico Gnoli, a painter and set designer, has his first solo exhibition, at Galleria La Cassapanca, Rome. He shows a series of drawings entitled *Mes Chevaliers* (*My Knights*).

1951
Lucio Fontana writes the *Manifesto tecnico dello spazialismo* (Technical manifesto of Spazialismo), subtitled *Noi continuiamo l'evoluzione del mezzo dell'arte* (We continue the evolution of the medium of art).

Alberto Moravia's novel *Il conformista* (The conformist) is published. In 1969 it would be made into a film by Bernardo Bertolucci, which would become very popular.

Roberto Capucci opens his first dressmaking shop in Rome. While he does not present his creations at the first *Italian High Fashion Show* on February 12, he does present them to the American buyers in Florence the following day. Capucci, who would receive a Fashion Award from Filene's of Boston in 1958, is known for the sculpted forms of his garments, in which the fabric is bent and manipulated into fantastic shapes.

CIAM VIII is held in Hoddesdon, England.

Luigi Agati, Federico Gorio, Piero Maria Lugli, Ludovico Quaroni, and Michele Valori design La Martella village, Matera (1951–54). To avoid using urban models in a southern rural community, the designers base this residential complex on the natural, spontaneously generated architecture common to the region. La Martella would meet with much criticism after the relocation of families to this artificially created community.

Construction begins on the Olivetti factory in Pozzuoli, designed by Luigi Cosenza with Piero Porcinai (landscape architect) and Marcello Nizzoli (color designer). Their rationalist design would be completed in 1954 but enlarged after a design by Cosenza in 1970.

The *Lady* armchair, designed by Marco Zanuso, is manufactured by Arflex. The chair is highly innovative in its use of lightweight foam rubber instead of upholstery.

Carlo Mollino designs the *Arabesco* (*Arabesque*) table. Its organically shaped glass tabletop is based on the contour of a woman's body drawn by Leonor Fini.

January
–February. Renato Birolli has his first solo exhibition in the United States, at the Catherine Viviano Gallery, New York.

15. The first exhibition of works by members of Origine, a group formed at the end of 1949, opens at Galleria Origine, Rome. The accompanying catalogue includes a short manifesto signed by the group's members: Mario Ballocco, Alberto Burri, Ettore Colla, and Giuseppe Capogrossi. (The director of Galleria Origine is Colla; from 1952 on the gallery would be known as Fondazione Origine. Burri would exhibit his *Catrami* [*Tar*] works and his *Muffe* [*Mold*] works for the first time there.)

February
3–28. *Arte Astratta e Concreta in Italia* (Abstract and concrete art in Italy), curated by Age d'Or (Piero Dorazio and Achille Perilli's gallery and editing house) and the Art Club, is held at Galleria Nazionale d'Arte Moderna, Rome. Participants include artists from Forma and MAC, as well as Burri, Corrado Cagli, Antonio Corpora, Roberto Crippa, Gianni Dova, Rotella, Salvatore Scarpitta, Tancredi [Parmeggiani Trancredi], and Vedova. The catalogue is edited by Giulio Carlo Argan, Pietro Consagra, Ernesto

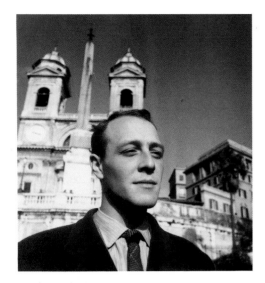

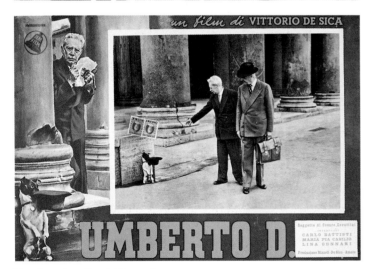

Piero Dorazio at Rome's Piazza di Spagnia in 1950. Photo by Milton Gendel.

Achille Perilli and Carla Vasio with a Perilli painting in the background at Venice Biennale in 1962. Photo by Milton Gendel.

Poster for Vittorio De Sica's Umberto D, *1952. Collection of Gian Piero Brunetta, Padua.*

Nathan Rogers, Enrico Prampolini, Gillo Dorfles, Achille Perilli, and others.

5–March 3. Vedova has his first solo show in the United States, at the Catherine Viviano Gallery, New York.

12. The first *Italian High Fashion Show* is held in Florence, at Villa Torrigiani, the home of the show's organizer, Giovan Battista Giorgini (known as Bista). Participants include Carosa [Giovanna Caracciolo di Avellino Giannetti], Alberto Fabiani, Sorelle Fontana [Fontana Sisters], Baronessa Clarette Gallotti, Germana Marucelli, Mirsa [Marchesa Olga de Gresy], Noberasco, Emilio Pucci, Emilio Schuberth, Vanna Visconti, Jole Veneziani, and Simonetta [Simonetta Colonna di Cesarò Visconti]; Franco Bertoli and Giuliano Fratti show accessories.

April
The first issue of *Diorama*, a review of photography, cinema, and figurative art that provides an alternative to the reviews *Ferrania* and *Fotografia* (Photography), is published in Mantua by Foto Lini Ottica. After the first few issues, Enrico Genovesi, who is interested in the interdisciplinary qualities of graphics, painting, and photography, would take over from Aldo Lini as editor of the magazine. A special issue of *Diorama* would be dedicated to Paolo Monti in 1955.

7–16. An exhibition of work by members of MAC is held at Galleria Bompiani, Milan.

May
Afro [Afro Basaldella] has a solo exhibition at Studio d'Arte Palma in Rome.

–October. The *IX Triennale* is held at the Palazzo dell'Arte, Milan. This *Triennale* includes industrial design for the first time, in the exhibition *La Forma dell'Utile* (The form of the useful). Fontana collaborates with architect Luciano Baldessari to create a cirrus-shaped work for the palazzo's entrance, using 300 meters of intertwined neon tubing. In honor of the first Congresso Internazionale delle Proporzioni (International Congress of Proportions) that takes place at the same location, Fontana reads the *Manifesto tecnico dello spazialismo*.

Summer
Galleria Chiurazzi, Rome, presents Mimmo Rotella's first solo show. (The gallery is directed by Italian-American Antonio Virduzzo.)

July
The second *Italian High Fashion Show* is held at Villa Torrigiani in Florence. Maria Antonelli, Avolio, Carosa, Fabiani, Favro, Sorelle Fontana, Gallotti, Germana Marucelli, Mirsa, Noberasco, Emilio Pucci, Vanna, Simonetta, and Jole Veneziani all participate. More than 300 spectators attend; the show is especially successful with American buyers.

August
Rotella, on a Fulbright fellowship, goes to the University of

Kansas City in Missouri, where he paints a large mural for the Department of Geology. He would return to Italy a year later.

September
Igor Stravinsky conducts the premiere of his opera *The Rake's Progress* in Venice.

October
An exhibition of the work of Enrico Baj and Sergio Dangelo is held at Galleria San Fedele, Milan. The catalogue refers to *pittura nucleare* (nuclear painting) for the first time. Baj and Dangelo would found the Arte Nucleare movement and would publish the first manifesto of Nuclear painting on February 1, 1952.

November
The first issue of the MAC bulletin, edited by Giulia Sala-Mazzon, is published in Milan.

26. The *Quarto manifesto dell'arte spaziale* (Fourth manifesto of Spatial art), signed by Antonio Ambrosini, Adolfo Carozzi, Crippa, Mario De Luigi, Dova, Lucio Fontana, Virgilio Guidi, Beniamino Joppolo, Milena Milani, Berto Morucchio, Cesare Peverelli, and Vinicio Vianello, is published by Galleria del Naviglio, Milan.

1952
Italy enters the ECSC (European Coal and Steel Community). Initiated by French foreign minister Robert Schuman, the organization's purpose is to abolish trade barriers, coordinate industry, and provide a common market for member countries' coal and steel products. Italy's entry into the foreign market through this and other organizations profoundly improves its economy.

Peggy Guggenheim helps support Tancredi [Parmeggiani Tancredi] until his death in 1964.

In his book *Un Art autre* (An other art), which is published in Paris, Michel Tapié uses the term *informel* for the first time. The term (*informale* in Italian) refers to a loose, gestural form of painting akin to American Abstract Expressionism. Italians associated with this style include Alberto Burri, Lucio Fontana, and Emilio Vedova.

Bruno Maderna composes *Musica su due dimensioni* (*Music in Two Dimensions*) for flute, percussion, and tape, the first musical work to combine live and electronic resources. Maderna, a teacher, conductor, and composer, is perhaps the leading figure in the development of postwar Italian music, influencing such composers as Luciano Berio and Franco Donatoni.

Photographer Toni del Tin has his first solo exhibition in Italy, entitled *Sirena* (Siren), at the Circolo Fotografico Corrado Ricci, Ravenna.

Vittorio De Sica's *Umberto D* is released. This neorealist film, which De Sica dedicates to his father, focuses on an old-age pensioner who is unable to pay his rent and points to the indifference of modern society to the poor and the elderly, and, ultimately, to suffering itself. Much of *Umberto D* was shot in the Cinecittà studios rather than on location.

Federico Fellini's *Lo sceicco bianco* (released in English as *The White Sheik*) is released. In this comic film, featuring Alberto Sordi as the absurdly Valentino-like "White Sheik," Fellini relates the exploits of a young woman on her honeymoon in Rome, who gets caught up in the world of the *fotoromanzo* (photo-romance magazines). For this take-off on the effects of popular culture, Fellini employs a montagelike editing technique, a method at odds with that of the neorealists, who generally refuse to alter "reality" through the manipulation of film.

Alberto Fabiani opens his own store in Rome, and marries Simonetta [Simonetta Visconti], who also has an atelier in Rome. Their careers would remain separate until 1962, when they would move to Paris and establish the firm Fabiani–Simonetta.

Construction begins on Luigi Cosenza's INA (Istituto Nazionale Abitazioni/National Housing Institute) Olivetti residential quarter, Pozzuoli (1952–55). The project would allow Olivetti employees to move from inadequate housing into modern apartments. A second group would be built in 1957–59, and a third in 1961–63.

Franco Albini and Franca Helg's design for the treasury museum of San Lorenzo, Genoa (1952–56), is executed. Made up of three central circular forms, the museum is designed to resemble Christian crypts.

Gio Ponti's designs for a building and furnishings for the Casino at San Remo are executed. Ponti adds a light-hearted touch to the otherwise sober interior by employing a playing-card design on the casino's chairs.

February
23–29. *Arte Spaziale* (Spatial art) is held at Galleria del Naviglio, Milan. Lucio Fontana shows his *Buchi* (Holes) for the first time. In May he would have a solo exhibition, curated by Giampiero Giani, at Galleria del Naviglio, where he would again show these works.

March
4–17. *Baj et Dangelo. Peintures Nucléaires* (Baj and Dangelo: nuclear paintings) is held at Galerie Apollo, Brussels. The exhibition's brochure includes Baj and Dangelo's *Manifeste de la peinture Nucléaire* (Manifesto of Nuclear painting). The Nuclear artists consider abstraction to be detached and elitist; the manifesto documents their desire to abolish traditional artistic forms while retaining figuration.

April
Omaggio a Leonardo (Homage to Leonardo) is held at the Fondazione Origine, Rome. Gruppo Origine exhibits, along with Carla Accardi, Burri, Corrado Cagli, Piero Dorazio, Lorenzo Guerrini, Matta [Roberto Sebastian Matta], Maurizio Mannucci, Mirko [Mirko Basaldella], Achille Perilli, Enrico Prampolini, Antonio Sanfilippo, and Angelo Savelli.

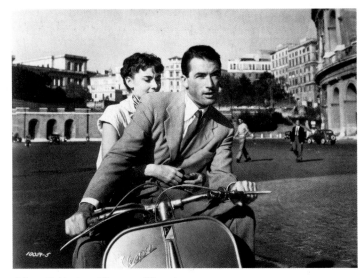

Alberto Fabiani and Simonetta Visconti in their Rome apartment following their joint business announcement in 1962. AP/Wide World Photos.

Left to right: Pietro Cascella, Phillip Guston, and Mimmo Rotella at Caffè Rosati, Rome, in August 1960. Photo by Virginia Dortch.

Gregory Peck and Audrey Hepburn in William Wyler's Roman Holiday, *1953. The Museum of Modern Art, New York.*

May

16. Mostra d'Arte Nucleare (Nuclear art exhibition) opens at the Associazione Amici della Francia, Milan. Baj creates his *Manifesto BUM*, a word-picture in the shape of a nuclear mushroom cloud.

17. The *Manifesto del movimento spaziale per la televisione* (Manifesto of the spatial movement for television) is signed by Antonio Ambrosini, Burri, Roberto Crippa, Mario De Luigi, Bruno De Toffoli, Enrico Donati, Gianni Dova, Fontana, Giancarozzi [Giancarlo Carozzi], Virgilio Guidi, Beniamino Joppolo, Guido La Regina, Milani, Berto Morucchio, Cesare Peverelli, Tancredi, and Vinicio Vianello.

June

The first issue of the review *Realismo* (Realism) is published in Milan and becomes the official mouthpiece of the realist movement. The review is directed by Raffaele De Grada; contributors include Renato Guttuso, Corrado Maltese, Mario De Micheli, Armando Pizzinato, Ernesto Treccani, Francesco Trombadori, and Giuseppe Zigaina. (It would continue publication until May 1956.)

14–October 16. The *XXVI Biennale* is held in Venice. Burri is invited to exhibit for the first time; he shows two studies for his *Sacchi* (collage pieces made from stretched burlap bags), which are not well received. Afro [Afro Basaldella] is given his own room and displays twelve works. Also exhibiting are members of Otto, a group formed earlier in the year by Lionello Venturi. (Its members include six abstract artists from the recently disbanded Fronte Nuovo delle Arti—Renato Birolli, Antonio Corpora, Ennio Morlotti, Giuseppe Santomaso, Giulio Turcato, and Emilio Vedova—as well as Afro and Mattia Moreni. The group would last until 1954.) A slim catalogue entitled *Otto pittori italiani* (Eight Italian painters) is published in Rome in conjunction with Otto's exhibition; Venturi's introduction stresses artistic freedom and spontaneity. The winners of this *Biennale* are Alexander Calder, Bruno Cassinari, Raoul Dufy, Marino Marini, Emil Nolde, Bruno Saetti, and Tono Zancanaro.

July

The first issue of *Arti visive* (Visual arts), a review of contemporary art established by Fondazione Origine (the group announces its name change—from Gruppo Origine—in this issue), is published in Rome. Ettore Colla, Dorazio, and Emilio Villa are the principals involved.

22. The *Italian High Fashion Show* is held at the Palazzo Pitti, Florence. Three hundred-fifty spectators attend and nine haute-couture houses are featured—Maria Antonelli, Roberto Capucci, Carosa [Giovanna Caracciolo di Avellino Giannetti], Ferdinandi, Germana Marucelli, Polinober, Giovanelli Sciarra, Vanna, and Jole Veneziani—as well as sixteen houses presenting sportswear and boutique fashion.

October

American artists Robert Rauschenberg and Cy Twombly leave the United States for an extended trip to Italy.

21–November 30. *Olivetti: Design in Industry* is held at the Museum of Modern Art, New York. This is the first time the museum invites a European industrial company to show its products and graphic work.

November
20. Benedetto Croce, the anti-Fascist Italian philosopher and historian, dies in Naples.

December
16–*January 6, 1953.* MAC exhibits at Galleria dell'Annunciata and Saletta dell'Elicottero, Milan. The exhibition includes work by Baj, Colombo, Dangelo, Nino Di Salvatore, Giancarlo Iliprandi, Umberto Mariani, Gianni Monnet, Bruno Motta, Bruno Munari, Regina, and Luigi Veronesi.

1953
Mimmo Rotella begins his *décollage* works.

The bimonthly journal *Civiltà delle macchine* (Culture of the machines) begins publication in Rome. The review, published by Finmeccanica, a government firm, is edited by Leoncillo [Leoncillo Leonardi] and Leonardo Sinisgalli.

Casabella (House beautiful) resumes continuous publication under the direction of Ernesto Nathan Rogers.

Luciano Berio composes *Chamber Music*, a vocal setting of three early poems by James Joyce.

The photography group Misa is formed in Senigallia. Founded by Giuseppe Cavalli as a training ground for La Bussola—a more elite photographers' group—its members include Piergiorgio Branzi, Alfredo Camisa, Mario Giacomelli, and Nino Migliori.

The first postwar historical exhibition of Italian photography, *Fotografi italiani* (Italian photographers), organized by L'Unione Fotografica, is held at the Accademia di Brera, Milan.

The Hollywood film *Roman Holiday*, directed by William Wyler, projects Italian style via fashion and design, as in the classic scene that shows Gregory Peck and Audrey Hepburn riding through Rome on a *Vespa*. Hepburn wins the Academy Award for best actress for her role in this film.

Federico Fellini's *I vitelloni* (The loafers; released in English as both *The Loafers* and *The Young and the Passionate*) is released. The film focuses on a group of young wastrels and daydreamers living in a small seacoast town, depicting the loss of innocence while satirizing small-town life. The first Fellini movie to receive foreign distribution, the film is very successful.

Roberto Rossellini's *Viaggio in Italia* (Voyage to Italy; released as both *Strangers* and *The Lonely Woman*) is released. Loosely based on James Joyce's story *The Dead*, *Viaggio in Italia* follows a couple (played by George Sanders and Ingrid Bergman) on their trip to Naples, the pressures of which eventually lead to a break in their marriage. The film would be hailed by *Cahiers du cinéma* in 1958 as one of the twelve greatest films ever made.

Construction begins on Roberto Gabetti and Aimaro Isola's Erasmo store, Turin (1953–54). The design, which employs aspects of late-eighteenth-century and early nineteenth-century design, would become the manifesto of the Neo-Liberty style in architecture. It would be much discussed and criticized in the pages of *Casabella* in 1957.

Ignazio Gardella designs the Cicogna house on the Zattere, Venice (1953–58). This building, which is influenced by the surrounding traditional Venetian architecture and is directly related to BBPR's Torre Velasca, is considered too historicist by some of Gardella's contemporaries.

CIAM IX is held in Aix-en-Provence, France.

Battista Pinin Farina designs a coupé for Ferrari, with a longer form than standard Italian models, to be produced specifically for the American market.

January
Asger Jorn, a member of the former COBRA movement, founds the Mouvement International pour une Bauhaus Imaginiste, in Villers, Switzerland. Jorn's manifesto would be translated into Italian by Sergio Dangelo.

10–23. Giuseppe Capogrossi has a solo exhibition at Galleria del Naviglio, Milan. The catalogue introduction is written by Michel Seuphor.

March
3–10. Robert Rauschenberg has an exhibition, entitled *Bob Rauschenberg: Scatole e Feticci Personali* (Bob Rauschenberg: boxes and personal fetishes), at Galleria dell'Obelisco, Rome.

14. *Scatole e Costruzioni contemplative di Bob Rauschenberg* (Boxes and contemplative constructions by Bob Rauschenberg) opens at Galleria d'Arte Contemporanea in Florence and shows concurrently at the same gallery with *Mostra di Arazzi di Cy Twombly* (Show of tapestries by Cy Twombly).

April
Alberto Burri has his first solo exhibition in the United States, at Frumkin Gallery, Chicago; he shows his *Sacchi*.

18. A solo exhibition of Lucio Fontana's *Buchi* opens at Galleria del Naviglio, Milan.

18–30. Burri has a solo exhibition of his *Sacchi* at Fondazione Origine, Rome. The catalogue text is written by Emilio Villa.

June
De Gasperi is elected Secretary of the DC (Democrazia Cristiana/Christian Democratic party). He champions the cause of European unity.

Left to right: Gabriella Drudi Scialoja (seated), Toti Scialoja, and Alberto Burri (with a Burri work in background). Photo by Milton Gendel.

An agreement between Italy and Yugoslavia, ending a nine-year dispute over Trieste, is signed in London. AP/Wide World Photos.

Piero Dorazio leaves Italy for the United States to attend the Summer International Seminar at Harvard University. (He would remain in the United States for a year following the seminar, returning to Rome in June 1954.)

16–25. Galleria dell'Obelisco, Rome, presents *Twenty Imaginary Views of the American Scene by Twenty Young Italian Artists*, for which collector Helena Rubenstein invited twenty Italian painters to present "their" America. Among the participants are Afro [Afro Basaldella] (with a work called *Chicago*), Burri (with *Jazz*), and Mirko [Mirko Basaldella] (with *Los Angeles*).

August
17. Giuseppe Pella of the DC becomes Prime Minister after the DC fails to obtain a clear majority in parliamentary elections and De Gasperi resigns.

September
15. Stable Gallery, New York, holds an exhibition of work by Rauschenberg and Twombly, their first since returning from Italy earlier in the year.

November
23–December 12. Burri has his first solo exhibition in New York at the Stable Gallery. He establishes a strong presence in the American art scene with this show.

December
Italy and Yugoslavia agree to pull troops out of the long-disputed Trieste border area. The controversy was temporarily resolved in 1947 when Trieste was made a free territory; the permanent resolution is to give the city of Trieste and a strip of land along the coast to Italy, with the rest of the territory going to Yugoslavia.

2–February 21. Younger European Painters opens at the Solomon R. Guggenheim Museum, New York. Burri and Capogrossi are among the thirty painters whose work is shown. The catalogue text is written by museum director James Johnson Sweeney.

1954

The Museum of Modern Art, New York, buys the United States *Biennale* pavilion in Venice from Grand Central Galleries, which constructed the pavilion in 1930. The Solomon R. Guggenheim Museum would acquire the pavilion from the Museum of Modern Art in 1986. (Today it is the only privately owned *Biennale* pavilion.)

The design magazine *Stile industria* (Industrial style) begins publication in Milan under Alberto Rosselli. (It would continue publication until 1963.)

La rivista dell'arredamento (Magazine of interior design) begins publication in Milan. In 1957, the magazine would change its name to *Interni* (Interiors).

Photographer Ugo Mulas begins to concentrate on portraiture. Until 1968, he would document artists and the art scene in Italy and New York.

Federico Fellini's *La strada* (The road; released in English as *La Strada*), starring Giulietta Masina (Fellini's wife) and with music by Nino Rota, is released. The film's worldwide popularity would establish Fellini's international reputation; *La strada* would win an Academy Award for best foreign film in 1956.

Roberto Rossellini's films *La paura* (released in English as *Fear*) and *Giovanna d'arco al rogo* (released in English as *Joan of Arc at the Stake*), both starring Ingrid Bergman, are released.

Luchino Visconti's *Senso* (Sense; released in English as both *Senso* and *The Wanton Contessa*), his first color film, is released. A romance set in 1866 Venice, the film stars Farley Granger and Alida Valli and was originally shot in English, with dialogue by Paul Bowles and Tennessee Williams.

Gina Lollobrigida appears in John Huston's *Beat the Devil*, starring Humphrey Bogart. The film would later become a cult movie.

Three Coins in the Fountain, a Hollywood film directed by Jean Negulesco about three American girls who find romance in Rome, is released. The film becomes a huge success in the United States; it helps to popularize Italian style and to promote tourism in Italy.

Olivetti's first New York showroom is inaugurated. Costantino Nivola, an Italian sculptor who moved to the United States in 1939 and was once the art director for Olivetti, Milan, decorates the new showroom with two large, sand-cast bas-reliefs.

The Compasso d'Oro award for design is instituted by La Rinascente department store. Marcello Nizzoli's *Lettera 22* (*Letter 22*) typewriter wins the inaugural prize. The award is given to both the designer and producer of the winning product, based on aesthetics and technical production. The Compasso d'Oro would become one of the most important awards in Italian industrial design.

Gino Colombini's bucket with cover (*Secchio* KS 1146), one of the first plastic objects produced for the home, is manufactured by Kartell. The extremely functional and durable bucket would win the Compasso d'Oro in 1955 for the originality of its design.

The *Isetta* car, designed by Ermengildo Preti, is produced by Iso. Due to the *Isetta*'s economical design, the compact, fashionable automobile would become widely available in Italy in the 1950s. Later, it would be produced by BMW in West Germany.

January
18. Amintore Fanfani, of the DC (Democrazia Cristiana/Christian Democratic party), becomes Prime Minister of Italy.

February
10. The Fanfani government dissolves and Mario Scelba, of the DC, becomes Prime Minister.

25. Plinio de Martiis opens Galleria La Tartaruga on via del Babuino, Rome. The gallery would host a number of significant exhibitions, among them the first solo shows of many younger artists, such as Jannis Kounellis and Pino Pascali.

April
27–May 22. Piero Dorazio has a solo exhibition at the Rose Fried Gallery, New York.

June
6. The Eurovision network, which allows special programs to be broadcast simultaneously in a number of European countries, is inaugurated in Rome.

8. A solo exhibition of work by Mario Merz opens at Galleria La Bussola, Turin.

19–October 17. The *XXVII Biennale* opens in Venice. Both Lucio Fontana and Leoncillo [Leoncillo Leonardi] have solo shows. Artists exhibiting in the Italian pavilion include Afro [Afro Basaldella], Guido La Regina, Carlo Levi, Mario Mafai, Giuseppe Migneco, Mirko [Mirko Basaldella], Armando Pizzinato, Enrico Prampolini, Ottone Rosai, Giuseppe Santomaso, Alberto Savinio, Luigi Spazzapan, Giulio Turcato, and Emilio Vedova. Other artists whose work is exhibited include Karel Appel, Henry Moore, Ben Nicholson, David Smith, and Antoni Tàpies.

August
19. Alcide De Gasperi dies in Sella di Vasugana (Trento).

28–November 22. The *X Triennale* is held. Buckminster Fuller, the American mathematician, theorist, and designer, exhibits two of his geodesic domes made of curved, waterproof cardboard triangles that are easy to ship and assemble; one is set up as a house and the other as an exhibition site. The *I Congresso Internazionale dell'Industrial Design* (First international congress of industrial design) is held in conjunction with the exhibition.

Fall
MAC merges with the French Groupe Espace and becomes Movimento MAC–Groupe Espace Italiano.

October
A convention exploring the abstraction-figuration debate, entitled *Arte figurativa e arte astratta* (Figurative art and abstract art), is held at the Fondazione Cini, Venice. Participants, representing both sides of the debate, include Giulio Carlo Argan, Gillo Dorfles, Enrico Prampolini, Emilio Vedova, and Lionello Venturi.

1955
Two books that would influence the work of many Italian photographers are published: Cesare Zavattini's *Un paese* (A country), with photographs by Paul Strand, in Turin, and William Klein's *New York*, in Milan.

The architecture and criticism review *La Casa* (The home) begins publication in Rome, under the direction of Pio

Burt Lancaster and Anna Magnani in Daniel Mann's The Rose Tattoo, *1955. Photofest, New York.*

An exhibition of works by Domenico Gnoli at Galleria de'Foscherari, Bologna in 1967. Photo by Antonio Masotti, courtesy of Archivio de'Foscherari.

Gio Ponti, Antonio Fornaroli, Alberto Rosselli, Giuseppe Valtolina, and Egidio Dell'Orto, with Pier Luigi Nervi and Arturo Danusso (structural engineers), Pirelli skyscraper, Milan, 1956–61. Archivio Casabella/Archivio Gregotti.

Montesi. (It would cease publication in 1962.)

Pier Paolo Pasolini's novel *Ragazzi di vita* (Boy prostitutes; published in English as *The Ragazzi*) is published.

Alberto Moravia's novel *Il disprezzo* (Contempt; published in English as *A Ghost at Noon*) is published. (In 1963 it would be made into the film *Le Mépris* [released in English as *Contempt*], starring Brigitte Bardot, Michel Piccoli, and Jack Palance, by Jean-Luc Godard.)

Anna Maria Ortese's *L'iguana* (published in English as *The Iguana*), a novel of magic realism loosely based on Shakespeare's *The Tempest*, is published.

Luciano Berio and Bruno Maderna found the Studio di Fonologia at the Milan station of Radio Audizioni Italiane. An electronic music studio, it provides a working place for international composers.

Giacinto Scelsi composes the piano piece *Action Music*.

Federico Fellini's *Il bidone* (released in English as *The Swindle*) is released. Focusing on three petty thieves who disguise themselves as priests to cheat the poor, the film stars Broderick Crawford (in a role that Fellini originally created for Humphrey Bogart). With this harsh drama, Fellini hoped to satisfy critics who had objected to his abandoning neorealism in *Lo sceicco bianco* and *La strada*.

Michelangelo Antonioni's *Le amiche* (released in English as *The Girl Friends*) is released. Based on a novel by Cesare Pavese entitled *Tra donne sole* (Among women only), the film traces the lives of four women living in Turin, and in its style and subject matter anticipates Antonioni's later work.

Anna Magnani wins the Academy Award for best actress for her role in Tennessee Williams's *The Rose Tattoo*, directed by Daniel Mann.

The Olivetti building on via Clerici, Milan, is unveiled. The building, which houses the main offices of the sales organization, is designed by Gianantonio Bernasconi, Annibale Fiocchi, and Marcello Nizzoli; the interior design is by Mattia Moreni, Nizzoli, and Giovanni Pintori.

Ignazio Gardella receives the Olivetti prize for architecture; Luigi Piccinato wins the prize for town planning. (The Olivetti prizes for architecture and town planning would be awarded until 1957, by a panel of eight judges: Giulio Carlo Argan, Riccardo Musatti, Adriano Olivetti, Enzo Paci, Roberto Pane, Carlo Ludovico Ragghianti, Ernesto Nathan Rogers, and Geno Pampaloni.)

Franco Albini is awarded the Compasso d'Oro for his design of the *Luisa* armchair. Designed in 1951 for Poggi, the chair has a rosewood frame and upholstered seat and back.

The *P40* sofa is designed by Osvaldo Borsani for Tecno. With his innovative use of materials (rubber and steel),

Borsani creates a highly flexible design that allows the back of the couch to be released to create a bed.

Alfa Romeo's *Giulietta*, designed by Battista Pinin Farina, goes into production. This compact and elegant two-seat convertible sportscar—the style is referred to as a *ragno* (spider) in Italian—embodies Italian style. It would be sold only on the American market until 1957, when it would become available in Italy.

Gino Sarfatti's *Lamp 1055* is produced by Arteluce. The design features a directional spotlight at the end of a long, adjustable pole. Italian lighting design comes to be highly regarded internationally during this period.

Kartell manufactures Gino Colombini's plastic trashcans (*Bidone* KS 1152). In an extraordinarily simple and functional design, Colombini uses vertical ribs to strengthen the wall of the container, making it resistant to heavy loads. These light and inexpensive containers— trashcans were previously made of metal—would be used for myriad functions.

January
The first issue of the art and literature review *Circolare sinistra* (Leftist bulletin) is published in Turin. The journal is directed by Italo Cremona and Mino Maccari, who are particularly interested in French Symbolism and Surrealism. (It would cease publication in 1956.)

24–May 8. Family of Man is presented at the Museum of Modern Art, New York. Curated by Edward Steichen, this photography show includes more than 400 works and travels to twenty-four countries, including Italy.

February
2–11. Lucio Fontana has a solo exhibition at Galleria del Naviglio, Milan. He shows his *Pietre* (*Stones*) series, which he began in 1952.

March
Giulio Turcato has a solo exhibition at Galleria La Tartaruga, Rome.

April
23. Esposizione di arte attuale (Exhibition of current art) opens at the Zattere del Ciriola, Rome. Mimmo Rotella exhibits his first *décollage* works; in his review of the show in *Artnews*, Milton Gendel categorizes Rotella's work as neo-Dada.

29. Giovanni Gronchi, of the DC (Democrazia Cristiana/Christian Democratic party) is elected President of Italy with Socialist and Communist support.

May
Galleria dell'Obelisco, Rome, publishes a monograph on Burri written by James Johnson Sweeney.

10–August 7. The New Decade: Twenty-two European Painters and Sculptors, curated by Andrew C. Ritchie, is held at the Museum of Modern Art, New York. (It would subsequently travel to the Minneapolis Institute of Arts, Los Angeles County Museum, and San Francisco Museum of Art.) The Italians included are Afro [Afro Basaldella], Alberto Burri, Giuseppe Capogrossi, Luciano Minguzzi, and Mirko [Mirko Basaldella]. On the occasion of the show, Burri travels to New York, where he meets and would later marry the American dancer and choreographer Minsa Craig.

June
18–July 18. Il gesto. Rassegna internazionale delle forme libere (The gesture: international review of free forms), a group exhibition organized by Movimento Nucleare and the review *Phases*, is held at Galleria Schettini, Milan. The exhibition includes work by Pierre Alechinsky, Enrico Baj, Guillaume Corneille, Sergio Dangelo, Gianni Dova, Max Ernst, Lucio Fontana, Simon Hantai, Paul Jenkins, Asger Jorn, and Matta [Roberto Sebastián Matta Echaurren]. The second issue of *Bollettino internazionale d'informazione della Bauhaus immaginista* (International information bulletin of the imaginist Bauhaus) is published on the occasion of the exhibition; the bulletin would be considered the first issue of the review *Il gesto*.

July
6. Antonio Segni, of the DC, becomes Italy's Prime Minister.

16–September 18. Documenta I is held in Kassel, West Germany. The *Documenta* series of exhibitions, which would be held every four years, is founded by Arnold Bode to reinstate Germany's position within the international avant-garde and to create a forum for the presentation of international trends.

29. In Alba, Giuseppe Pinot Gallizio, Jorn, and Piero Sismondo found the Primo Laboratorio di Esperienze Immaginiste del Movimento Internazionale per una Bauhaus Immaginista. In November, Jorn would write the manifesto flyer entitled *Che cosa è il Movimento Internazionale per una Bauhaus Immaginista?* (What is the Movimento Internazionale per una Bauhaus Immaginista?).

November
A solo exhibition of Rotella's work is held at Galleria del Naviglio, Milan. The catalogue essay is written by Leonardo Sinisgalli.

–April 1956. An exhibition of work by Burri is held on the occasion of the *VII Quadriennale* in Rome. Sweeney writes the catalogue introduction.

1956
The USSR invades Hungary. This, coupled with other events in Eastern Europe, precipitates a crisis within the PCI (Partito Comunista Italiano/Italian Communist Party). Nikita Kruschev's report on the crimes of Joseph Stalin prompts some 200,000 members to leave the party.

Domenico Gnoli abandons his work in the theater to concentrate on painting and drawing. He would become one of the leading Italian artists of the 1960s.

Achille and Pier Giacomo Castiglioni,
Spalter *vacuum cleaner, 1956. Archivio
Castiglioni.*

*Athletes listen to welcoming address at
the VII Winter Olympics at Cortina
d'Ampezzo in 1957. AP/Wide World
Photos, New York.*

*Left to right: Italian President
Giovanni Gronchi and Signora Gronchi
are welcomed at a dinner by their hosts,
Patricia Nixon, Vice President Richard
Nixon, and Clare Boothe Luce, United
States Ambassador to Italy. AP/Wide
World Photos.*

Jannis Kounellis, a Greek citizen, moves from Greece to Rome, where he settles permanently.

Leonardo Sciascia's *Le parrocchie di Regalpetra* (The parishes of Regalpetra; published in English as *Salt in the Wound*), an imaginary history of a typical Sicilian town, is published.

Antonio Cederna writes *I vandali in casa* (The vandals at home), on the problem of Italian land preservation. Due to speculative building and lack of planning, coastlines, wooded areas, and natural waterways have been destroyed throughout Italy.

Giovan Battista Giorgini organizes a promotional tour of Italian fashion to New York. Eight countesses model creations by Maria Antonelli, Emilio Schuberth, Alberto Fabiani, Jole Veneziani, Carosa [Giovanna Caracciolo di Avellino Giannetti], Germana Marucelli, Roberto Capucci, and Simonetta [Simonetta Colonna di Cesarò Visconti]. The show, which is broadcast on American television, receives favorable notice from the influential fashion editor Diana Vreeland.

CIAM X, the final congress, is held in Dubrovnik.

Arturo Danussi, Egidio Dell'Orto, Antonio Fornaroli, Pier Luigi Nervi, Gio Ponti, Alberto Rosselli, and Giuseppe Valtolina design the Pirelli skyscraper, Milan (1956–61). This relatively small, International Style skyscraper (127 meters high) abandons the rectangular form customary in skyscraper design to follow an irregular plan set back from the street, allowing for parking, traffic circulation, and direct light.

Carlo Scarpa is awarded the Olivetti prize for architecture; Ludovico Quaroni receives the prize for town planning.

The founding of the ADI (Associazione per il Disegno Industriale/Association for Industrial Design) helps consolidate the design profession and signals the growing importance of design in Italy.

The first *Mostra Internazionale Estetica Materie Plastiche* (International exhibition of plastic materials) is held at the *XXXIV Fiera Campionaria* in Milan. The exhibition is sponsored by the industrial design magazines *Stile industria* (Industrial style)—which devotes an entire issue (no. 7) to the show—and *Materie plastiche* (Plastic materials).

The *Spalter* vacuum cleaner, designed by Achille and Pier Giacomo Castiglioni, is manufactured by Rem. The light, compact design—with a plastic casing over an aluminum mechanism—allows the *Spalter* to be slung over the shoulder, like a knapsack.

January
Fausto Melotti has his first solo show since 1935, at Galleria L'Annunciata, Milan.

26–February 5. The VII Winter Olympics are held in Cortina d'Ampezzo, Italy.

February
Italian President Giovanni Gronchi travels to the United States for a State visit.

May
The French group L'Internationale Lettriste (Michèle Bernstein, Mohamed Dahou, Guy Ernest Debord, and Gil J. Wolman) joins the Movimento Internazionale per una Bauhaus Immaginista to form a new group that would be called International Situationiste (IS).

June
16–October 21. The *XXVIII Biennale* takes place in Venice and includes work by Afro [Afro Basaldella], Alberto Burri, Pietro Consagra, Antonio Corpora, Piero Dorazio, Gianni Dova, Mattia Moreni, Ennio Morlotti, Achille Perilli, Fausto Pirandello, Giulio Turcato, and Emilio Vedova. The United States is represented by Willem de Kooning, Franz Kline, Jackson Pollock, Frank Stella, and Mark Tobey. The prize winners are Afro, Lynn Chadwick, Emilio Greco, Aldemir Martins, Carlo Mattioli, Shiko Munakata, Anton Music, Anna Salvatore, and Jacques Villon. Scarpa designed the Venezuela pavilion building.

25. The Andrea Doria, the first luxury ocean liner to have been built in Italy since World War II, is rammed by the S.S. Stockholm (which is unequipped with radar and sailing in heavy fog) and sinks off the coast of Nantucket, Massachusetts. Forty-three Andrea Doria passengers are killed and 1,663 are rescued.

September
Ettore Colla has a solo exhibition, curated by Mario Attilio Levi, at Gargano, Lago di Garda. He exhibits, for the first time, his welded-metal sculptures made from discarded industrial materials, which he began in 1955.

2–8. The first world congress of Le Arti Libere e le Attività Industriali (The Free Arts and Industrial Activities) takes place at the Salone Municipale, Alba. The congress is organized by Enrico Baj, Giuseppe Pinot Gallizio, Asger Jorn, Pravoslav Rada, Piero Sismondo, Ettore Sottsass, Jr., and Elena Verrone. Baj and the Movimento Arte Nucleare group withdraw on the first day of the congress.

October
8–November 3. Toti Scialoja has a solo show at the Catherine Viviano Gallery, New York. He travels to New York for the exhibition and remains there for several months.

December
9. The manifesto *Per la scoperta di una zona di immagini* (Toward the discovery of a realm of images) is signed in Milan by Camillo Corvi-Mora, Piero Manzoni, Ettore Sordini, and Giuseppe Zecca and printed in leaflet form. There would be a second, undated version of the manifesto, which would be signed probably in spring 1957.

1957

The first American-style supermarket opens in Milan.

Cy Twombly moves to Rome, where he settles permanently. In 1959 he would marry Tatiana Franchetti.

The interior design magazine *Il mobile italiano* (Italian furniture) begins publication in Milan. (It would cease publication in 1960.)

Carlo Emilio Gadda's *Quer pasticciaccio brutto de via Merulana* (That awful mess on via Merulana), a Joycean novel cast as a detective story set in Rome in 1927, is published. The book would come to be regarded as a modern Italian classic.

Michelangelo Antonioni's film *Il grido* (The scream; released in English as *The Outcry*) is released. Set in Antonioni's native Po River Valley, *Il grido* is a tragic story of a sugar refinery worker and is notable for its poetic use of landscape.

Federico Fellini's *Le notti di Cabiria* (released in English as both *The Nights of Cabiria* and *Cabiria*) is released, with Giulietta Masina playing a young prostitute. The film wins the Academy Award for best foreign film. (*Le notti di Cabiria* would inspire Neil Simon's Broadway musical *Sweet Charity*, which would itself be made into a film directed by Bob Fosse in 1969.)

Movie producer Carlo Ponti marries Sophia Loren after obtaining a Mexican divorce from his previous wife. The divorce is not recognized in Italy and Ponti and Loren are charged with bigamy. In 1962 they would be forced to have their marriage annulled and to become French citizens in 1966 in order to marry again.

Three American films, all released in 1957, establish Loren as a star in the United States: *Boy on a Dolphin*, directed by Jean Negulesco; *Legend of the Lost*, directed by Henry Hathaway; and *The Pride and the Passion*, directed by Stanley Kramer.

Franco Albini and Franca Helg's design for La Rinascente department store, Rome, is awarded the Olivetti prize for architecture. Giuseppe Samonà is awarded the prize for town planning. These are the final Olivetti awards to be granted; conflicts within the company bring the competition to an abrupt end.

Work begins on a new Olivetti plant, designed by Marco Zanuso, in São Paulo, Brazil. The structure would be inaugurated in 1959.

The Fiat Nuova 500 (New 500), designed by Dante Giacosa, is produced. It replaces the old Fiat 500, known as the *Topolino* (Little mouse), which was first manufactured in 1936. The compact Fiat Nuova 500 provides a cheaper alternative to Giacosa's Fiat 600 of 1953, and would remain the best-selling car in Italy through the end of the 1960s.

Adapting a familiar and ordinary object, the tractor seat,

The first American-style supermarket opens in Milan in 1957. AP/World Wide Photos.

Sophia Loren and Carlo Ponti.

Afro in his studio at Mills College in Oakland, California in 1957. Catherine Viviano Estate, New York.

Achille and Pier Giacomo Castiglioni create a highly innovative chair, known as the *Mezzadro* stool. The chair would be manufactured by Zanotta in 1971.

Gio Ponti designs the *Superleggera* (Superlight) chair, which is produced by Cassina with immense success. This small, wooden, cane-seated design originates from a chair traditionally made in the small fishing village of Chiavari.

January
2–12. Yves Klein: Proposte Monochrome, Epoca Blu (Monochrome proposals, the blue epoch) is presented at Galleria Apollinaire, Milan. Eleven identical blue monochrome paintings hang in one room; several monochromes of different colors hang in another. Lucio Fontana buys a blue monochrome; collector Count Giuseppe Panza di Biumo buys a red one.

February
4. Arshile Gorky's first solo show in Italy opens at Galleria dell'Obelisco, Rome. The catalogue includes a text by Afro [Afro Basaldella]. The summer issue of the review *Arti visive* (Visual arts) is devoted to Gorky's work.

March
1–23. Italy, the New Vision, curated by A. R. Krakusin, is held at the World House Galleries, New York. The exhibition includes works by forty artists, among them Afro, Alberto Burri, and Giuseppe Capogrossi.

25. The Treaty of Rome is signed by France, West Germany, Italy, Belgium, Luxembourg, and the Netherlands, creating the EEC (European Economic Community). The EEC's objective is the eventual economic and political union of member nations. Great Britain, the Republic of Ireland, and Denmark would enter in January 1973.

27–June 7. The *Guggenheim International Award, 1956* is held at the Solomon R. Guggenheim Museum, New York. (The exhibition is the first of a series of shows to be held every two years. A jury of international members awards $1,000 preliminary prizes by nationality, in addition to a single grant of $10,000 to the winner.) The Italian artists whose work is included in this year's exhibition are Renato Guttuso, Francesco Menzio, Ennio Morlotti, Mauro Reggiani, and Emilio Vedova (who wins the prize for the Italian section).

April
9–May 26. Trends in Watercolors Today, Italy–U.S., curated by Lionello Venturi and John Gordon and including work by Afro, Burri, and Capogrossi, is held at the Brooklyn Museum, New York.

May
Piero Manzoni, Ettore Sordini, and Angelo Verga sign the manifesto *L'arte non è vera creazione* (Art is not real creation) in Milan. In June, the three artists would join the Movimento Arte Nucleare, which distributes the manifesto.

14–23. Burri has a solo exhibition at Galleria dell'Obelisco,

Rome, where he shows his *Combustioni* (Combustion) pieces (wood surfaces that are burnt or marked by flame).

19. Adone Zoli, of the DC (Democrazia Cristiana/Christian Democratic party), becomes Prime Minister of Italy.

June
The manifesto *Per una pittura organica* (Toward an organic painting) is signed in Milan by Guido Biasi, Mario Colucci, Manzoni, Sordini, and Verga.

July
—September. An exhibition is held at the Rome–New York Art Foundation, on the Isola Tiberina, Rome, inaugurating the newly founded organization created by American painter Frances McCann to promote cultural exchange. The group show of Italian, French, and American artists, jointly curated by Herbert Read, Michel Tapié, and Venturi, includes work by Carla Accardi, Francis Bacon, Burri, Capogrossi, Ettore Colla, Pietro Consagra, Willem de Kooning, Fontana, Sam Francis, Franz Kline, Jackson Pollock, and Vedova.

August
1–15. The *Manifesto di Albisola Marina* is signed by Biasi, Colucci, Manzoni, Sordini, and Verga.

Autumn
Afro leaves for his second trip to the United States, to serve as painter-in-residence at Mills College, Oakland, California.

September
The manifesto *Contro lo stile* (Against style) is signed by Arman, Enrico Baj, Franco Bemporad, Gianni Bertini, Stanley Chapmans, Jacques Colonne, Colucci, Sergio Dangelo, Enrico de Miceli, Reinhout D'Haese, Wout Hoeber, Fritz Hundertwasser, Yves Klein, Theodore Koenig, Manzoni, Nando, Joseph Noiret, Arnaldo Pomodoro, Giò Pomodoro, Pierre Restany, Antonio Saura, Sordini, Serge Vandercam, and Verga.

22–December 31. A retrospective of Pollock's work is held at the *IV Bienal*, São Paulo, Brazil. The show, organized by Museum of Modern Art curator and poet Frank O'Hara, would travel to Galleria d'Arte Nazionale, Rome, in March 1958 and then to Basel, Amsterdam, Hamburg, Berlin, London, and Paris.

October
The first issue of *Zodiac*, a magazine of contemporary architecture, is published in Milan, with an introduction by Adriano Olivetti. Published in four languages (Italian, French, English, and German), the magazine is directed to an international audience. It has an international editorial committee and a general committee; the latter is made up of Giulio Carlo Argan, Pierre Janlet, Riccardo Musatti, Enzo Paci, Geno Pampaloni, and Carlo Lodovico Ragghianti.

12–30. *Arte Nucleare* (Nuclear art) is presented ated at Galleria San Fedele, Milan. The exhibition includes work by Baj,

Bemporad, Dangelo, Asger Jorn, Klein, Manzoni, Arnaldo and Giò Pomodoro, Mario Rossello, Sordini, Vandercam, and Verga.

November
9. *Mostra di Giovani Pittori al Bar Giamaica* (Exhibition of young painters at Bar Giamaica) opens in Milan. A manifesto is signed by the participants: Biasi, Aldo Calvi, Piero Manzoni, Silvio Pasotti, Antonio Recalcati, Sordini, Verga, and Alberto Zilocchi. Bar Giamaica is a central meeting place for the Milanese avant-garde.

18. Colla's first solo exhibition at a major gallery opens at Galleria La Tartaruga, Rome. He shows new sculpture.

December
10 – January 25, 1958. World House Galleries, New York, holds its annual exhibition of contemporary paintings and sculpture. The show includes work by Afro, Capogrossi, and Consagra.

1958
Italy accepts the placement of American thermonuclear warheads in its territory.

The industrial exportation of Italian goods increases with the EEC (European Economic Community) accord, leading to substantial economic growth in Italy.

The Casa Italiana of Columbia University, New York, presents *Painting in Post-War Italy, 1945–1957*. Curated by Lionello Venturi (who also writes the catalogue introduction) and Nello Ponente, the show includes work by Afro [Afro Basaldella], Alberto Burri, Giuseppe Capogrossi, and Emilio Vedova.

In the last months of the year, Lucio Fontana begins his series of *Tagli* (Cuts), slashed-canvas works.

Alberto Moravia's *La Ciociara* (The woman from Ciociara; published in English as *Two Women*) is published. It would be made into a film by Vittorio De Sica, starring Sophia Loren in an Academy Award–winning performance, in 1960.

Il Ponte, a photographers' group, is founded in Venice by Gianni Berengo Gardin, a freelance photographer for such magazines as *Epoca* (Epoch), *Il Mondo* (The world), *Time*, *Harper's*, *L'espresso* (Express), and *Vogue*.

Mario Monicelli's spoof of a crime caper, *I soliti ignoti* (The usual characters; released in English as *Big Deal on Madonna Street*), is released. Starring Marcello Mastroianni, Vittorio Gassman, and Totò, the film is an international success.

Mila Schön opens her fashion atelier in Milan. She would be invited by Neiman Marcus to show in the United States, and in 1965 would show her haute-couture collection at Palazzo Pitti, Florence.

Left to right: Alberto Moravia (seated),
Mario Bex (standing), Leonida Repaci,
and Jean-Paul Sartre at a dinner in
honor of Sartre and Simone De
Beauvoire in 1956. AP/World Wide
Photos.

Vittorio Gassman (center) and Marcello
Mastroianni (right) in Mario
Monicelli's I soliti ignoti, 1958.
Photofest, New York.

Harold Rosenberg (left) and Toti
Scialoja (right) at a picnic near Rome,
October 1963. Photo by Milton Gendel.

Renato Balestra opens his first fashion studio in Rome,
after working for many years for Sorelle Fontana [Fontana
Sisters] and Emilio Schuberth, as well as designing
costumes for films.

Carlo Scarpa finishes the first phase of the restoration and
installation of the Castelvecchio museum, Verona
(1956–67), on the occasion of the exhibition *Da Altichiero a
Pisanello* (From Altichiero to Pisanello). In large part due to
Scarpa's rigorous attention to history, this design would
become one of the most significant examples of Italian
museography of the 1950s.

Gino Valle designs a minimal, streamlined, and highly
functional stove for Zanussi.

January
23–*February 10*. Francis Bacon has a solo exhibition at
Galleria Galatea, Turin. (The exhibition would travel to
Galleria Ariete, Milan, and Galleria dell'Obelisco, Rome.)
Bacon is included in numerous group exhibitions during
this period; his work influences many young Italian artists,
especially Michelangelo Pistoletto.

February
27. Franz Kline's first solo exhibition in Europe opens at
Galleria La Tartaruga, Rome.

March
1–30. Galleria Nazionale d'Arte Moderna, Rome, holds the
first retrospective in Europe of work by Jackson Pollock.
The show is organized by the Museum of Modern Art,
New York.

3–29. Tancredi [Parmeggiani Tancredi] has his first solo
exhibition in the United States, at the Saidenberg Gallery,
New York.

April
7–28. Renato Guttuso has his first solo exhibition in New
York, at the ACA–Heller Gallery.

24. Otto Piene, founder of Zero Group with Heinz Mack,
holds an exhibition entitled *The Red Picture* in his studio in
Düsseldorf. An exhibition of monochrome paintings, *The
Red Picture* includes work by forty artists, among them
Mack, Piene, and Yves Klein. Mack and Piene had begun
holding regular exhibitions in 1957; *The Red Picture* is the
seventh of a series of evening studio exhibitions. The
accompanying catalogue serves as the first volume of the
Zero Group's magazine, *ZERO*. (The second volume would
also be published in 1958, although the third would not
appear until 1961.) Zero Group departs radically from
traditional artistic forms; wishing to establish a "point
zero" from which to formulate new artistic conceptions, the
group abandons concrete shape and form in favor of effects
of color and light through such unconventional mediums as
balloons and colored gases.

May
New Trends in Italian Art is held at the Rome–New York
Foundation, Rome. Curated by Venturi, the exhibition

includes work by Carla Accardi, Afro, Corrado Cagli, Capogrossi, Mirko [Mirko Basaldella], Mimmo Rotella, and Emilio Vedova.

17. Cy Twombly's first solo exhibition, at Galleria La Tartaruga, Rome, opens. The exhibition is organized by Palma Bucarelli, director of Galleria Nazionale d'Arte Moderna, Rome, and a highly influential critic.

26. A solo exhibition of work by Salvatore Scarpitta—an Italian-American artist living in Rome during the 1940s and 1950s—opens at Galleria La Tartaruga, Rome. The catalogue introduction is written by Leonardo Sinisgalli.

June
Gruppo '58, formed by Guido Biasi, Lucio Del Pezzo, Bruno Di Bello, Sergio Fergola, Luca, and Mario Persico, publish a manifesto and join with the Movimento Arte Nucleare.

The *XXIX Biennale* is held in Venice. Giulio Turcato and Fontana have solo exhibitions. Work by Enrico Baj, Roberto Crippa, Sergio Dangelo, Piero Dorazio, and Achille Perilli is shown in the young-artist pavilion. Jasper Johns, Mark Rothko, and Mark Tobey represent the United States. The prize winners are Eduardo Chillida, Osvaldo Licini, Umberto Mastroianni, Fayga Ostrower, Luigi Spacal, and Tobey.

July
1. Amintore Fanfani, of the DC (Democrazia Cristiana/ Christian Democratic party), becomes Prime Minister of Italy once again.

October
9. Pope Pius XII dies in Castelgandolfo, Rome; John XXIII succeeds him.

22–February 23, 1959. Solomon R. Guggenheim Museum, New York, holds the exhibition *Guggenheim International Award, 1958*, which includes work by Burri, Capogrossi, Alberto Magnelli (who wins the Italian section), Giuseppe Santomaso, and Turcato.

November
Luciano Fabro moves from Turin to Milan, where he befriends Piero Manzoni and Enrico Castellani.

John Cage goes to Milan at the invitation of Luciano Berio and works at the electronic music studio at RAI (established by Berio and Bruno Maderna), where he would compose his electronic collage piece *Fontana Mix*. While in Milan, Cage would become an Italian television sensation by winning the popular quiz show "Lascia o Raddoppia" (Double or nothing) by answering a series of questions on mushrooms. (He would remain in Milan through March 1959.)

7. An exhibition of work by Toti Scialoja, *3 dipinti recenti* (Three recent paintings), opens at Galleria La Salita, Rome, and includes his first *Impronte* (Impressions) works, in which color is coated on paper and then pressed onto canvas.

December
The American magazine *Atlantic Monthly* publishes a special supplement, *Perspective on Italy*, which includes a series of articles on contemporary Italian painting and sculpture, fashion, architecture, and film, by such writers as Venturi and Bruno Zevi.

1–31. Burri has a solo exhibition at Galleria Blu, Milan. He shows his *Ferri* (Irons)—works made of fused and welded sheet metal.

1959

Gruppo T, also known as Miriorama, is founded in Milan. The group, which is especially interested in kinetic art, includes as members Giovanni Anceschi, Davide Boriani, Gianni Colombo, Gabriele De Vecchi, and Grazia Varisco (who would join in 1960).

Giuseppe Samonà's *L'urbanistica e l'avvenire della città negli stati europei* (Urbanism and the future of the city in European countries) is published in Bari.

Giuseppe Turroni publishes *Nuova fotografia italiana* (New Italian photography) in Milan.

Piero Paolo Pasolini's novel *Una vita violenta* (published in English as *A Violent Life*) is published.

Sylvano Bussotti composes *Five Piano Pieces for David Tudor*, based on an elaborately drawn score that composer-artist Tudor created in 1949.

Roberto Rossellini's *Il Generale della Rovere* (released in English as *General Della Rovere*) is released. It stars Vittorio De Sica as a con man who is enlisted by the Nazis to pose as an Italian general to gain information about the Resistance. The film, which recalls Rossellini's earlier work, would win the best picture award at the 1958 Venice Film Festival.

Mario Monicelli's *La grande guerra* (released in English as *The Great War*) is released. The film, which stars Vittorio Gassman and Alberto Sordi as two carefree, womanizing soldiers during World War I, is a satire of the war.

Work begins on the Autostrada del Sole, a highway connecting Milan to Naples through Bologna and Rome. The plans for a national highway network were initiated in 1954–56; in 1961 parliament would approve a ten-year plan for a complete national highway system 3,200 kilometers in length.

Construction begins on Gino Valle's Zanussi office building, Porcia (1959–61). Valle's interest in the interaction between a structure and its environment is reflected in the long, bridgelike shape of the office building, which stretches across a flat terrain.

Lodovico Quaroni, Massimo Boschetti, Adolfo De Carlo, Gabriella Esposito, Luciano Giovannini, Aldo Livadiotti, Luciana Menozzi, Alberto Polizzi, and Ted Musho design

Gruppo T.

Gino Valle's Zanussi office building, Porcia (Pordenone), 1959–61. Archivio Gino Valle.

Gruppo N in their studio in Piazza Duomo, Padua, 1964.

the CEP residential quarter, on the sandbanks of San Giuliano, Mestre. Their design, which is characterized by large circular structures that face the Venetian lagoon, proposes a new urban landscape.

In a competition sponsored by the Illinois Institute of Technology at Chicago, 100 of the world's best-known designers select Marcello Nizzoli's *Lettera 22* (*Letter 22*) typewriter as the best industrial product of the last 100 years.

Ettore Sottsass, Jr., consultant designer for Olivetti, creates the *Elea 9003* computer, which features color-coding on the extensive control panel.

Gino Colombini designs his plastic lemon squeezer for Kartell. The brightly colored, utilitarian object exemplifies Italian designers' innovative use of plastic, which has come to be seen as a colorful, handsome alternative to traditional materials.

January
Piero Manzoni is formally invited to exhibit with ZERO Group.

Manifeste de Naples (Manifesto of Naples) is published by the Neapolitan section of the Movimento Arte Nucleare. Signed by Enrico Baj, poet and novelist Nanni Balestrini, poet Edoardo Sanguineti, and others, the manifesto supports the anti-abstraction position of the Movimento Arte Nucleare.

The manifesto *Arte interplanetaria* (Interplanetary art) is written and signed by Giuseppe Alfano, Giovanni Anceschi, Enrico Baj, Sandro Bajini, Nanni Balestrini, Guido Biasi, Lucio Del Pezzo, Bruno di Bello, Farfa, Sergio Fergola, Dino Grieco, Luca, Leo Paolazzi, Mario Persico, Paolo Radaelli, Antonio Recalcati, Ettore Sordini, and Angelo Verga.

The first issue of *Ana eccetera* is published in Genoa. The review, subtitled *Esercizi, notizie di lavoro* (Exercises, work notices), includes articles on philosophy, literature, and art. It would continue publication through 1971 (ten issues).

After studying and working in Paris for many years, Valentino [Valentino Garavani] opens a fashion studio in Rome. In 1967 he would present his first collection at the Palazzo Pitti, Florence, and in 1969 would win the Neiman Marcus Fashion Award.

15. The Fanfani government resigns. Amintore Fanfani also resigns as Secretary of the DC (Democrazia Cristiana/ Christian Democratic party).

27–February 14. Salvatore Scarpitta, who moved back to New York in 1958, has his first solo show in New York, at the Leo Castelli Gallery.

February
Lucio Fontana exhibits his *Tagli* for the first time, at

Galleria del Naviglio, Milan. The catalogue essay is written by Agnoldomenico Pica, a prominent curator. In March the exhibition would travel to the Galerie Stadler, Paris.

10. Giovane Pittura di Roma (Young Roman painting) opens at Galleria La Tartaruga, Rome. The exhibition includes work by Carla Accardi, Umberto Bignardi, Gino Marotta, Gastone Novelli, Nuvolo, Achille Perilli, Mimmo Rotella, Antonio Sanfilippo, and Scarpitta.

15. Antonio Segni, of the DC, becomes Prime Minister.

27. The first congress of the Partito Radicale (Radical Party) of Italy is held. The Radical Party, which was established in 1955, is in constant opposition to the status quo.

March
Aldo Moro becomes Secretary of the DC.

April
3–15. Bonalumi, Castellani, Manzoni is held at Galleria Appia Antica, Rome. Piero Manzoni exhibits his *Achromes* (colorless canvases coated with such materials as wool and rabbit fur). He travels from Milan to Rome for the opening, where he meets a number of Roman artists and critics, among them Franco Angeli, Piero Dorazio, Tano Festa, Novelli, Perilli, Mario Schifano, and Emilio Villa.

May
3. Renato Birolli dies in Milan.

23. Enrico Castellani's first solo exhibition, at the Galerie Kasper in Lausanne, Switzerland, opens. On the same day Schifano's first solo show at Galleria Appia Antica, Rome, opens; the catalogue introduction is written by Villa.

30. An exhibition of Robert Rauschenberg's *Combines* opens at Galleria La Tartaruga, Rome.

July
The Festival dei Due Mondi (Festival of Two Worlds), Spoleto, presents an exhibition of work by scenographic students from the Accademia di Belle Arti, Rome. Included are pieces by Pino Pascali, who works in advertising to support himself during this period.

11–October 11. Documenta II is held in Kassel, West Germany. Directed by Arnold Bode, the exhibition includes work by Afro [Afro Basaldella], Alberto Burri, Giuseppe Capogrossi, Pietro Consagra, Pericle Fazzini, Fontana, Luciano Minguzzi, Ennio Morlotti, Arnaldo Pomodoro, and Emilio Scanavino.

July–November. Moments of Vision is held at the Rome–New York Art Foundation, Rome. Organized by Herbert Read, the exhibition includes work by Julius Bissier, Sam Francis, Barbara Hepworth, Agnes Martin, Barnett Newman, Isamu Noguchi, Jean Piaubert, Raymond Rocklin, Francesco Somaini, Scanavino, Tony Stubbing, and Mark Tobey.

August
The *Manifesto della pittura industriale* (Manifesto of industrial painting) is written and signed by Giuseppe Pinot Gallizio at his Situationist Laboratory in Alba.

–October. Vitalità nell'arte (Vitality in art) is held at Palazzo Grassi, Venice. The exhibition presents work by contemporary international avant-garde artists, including Burri, COBRA artists, Willem de Kooning, Jean Dubuffet, Mattia Moreni, Jackson Pollock, Arnaldo and Giò Pomodoro, Antoni Tàpies, and Emilio Vedova.

18–24. Manzoni exhibits a number of works from his *Linee* series—lines of varying length painted on long sheets of paper, which are rolled and placed in tubes—at Galleria Pozzetto Chiuso, Albisola Mare.

September
The final issue of the Arte Nucleare movement's review *Il gesto* (The gesture), which is dedicated to "interplanetary art," is published.

October
An agreement in New York between the Underwood Company and Olivetti initiates a close collaboration between the two corporations.

21. The Solomon R. Guggenheim Museum opens its new building, designed by Frank Lloyd Wright, in New York. The *Inaugural Selection* exhibition includes work by Afro and Burri.

Winter
Gruppo N is founded in Padua. The group, which is primarily interested in Op and Environmental art, includes as members Alberto Biasi, Ennio Chiggio, Giovanni Antonio Costa, Edoardo Landi, and Manfredo Massironi.

The art review *Azimuth* is founded in Milan by Castellani and Manzoni. The first issue contains reproductions of *Target with Plaster Casts* (1955) by Jasper Johns, Rauschenberg's *Monogram* (1959), a blue monochrome by Yves Klein, and works by Castellani, Heinz Mack, Manzoni, and Rotella.

December
–January 1960. De Kooning travels to Rome and works in Afro's studio on via Tartaruga.

4. Galleria Azimut, in Milan, is inaugurated with a solo exhibition of Manzoni's *Linee*. The catalogue essay is written by Vincenzo Agnetti. (Biasi, Landi, and Massironi of Gruppo N would later participate in shows at the gallery.)

1960
Italian wages are extremely low, due primarily to high unemployment and the surge in migration from rural areas into cities.

Piero Dorazio returns to the United States to present a

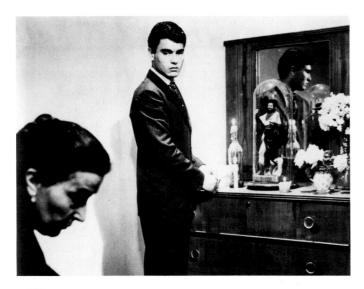

Luchino Visconti's Rocco e i suoi
Fratelli, *1960. The Museum of Modern
Art, New York.*

Anita Eckberg in Federico Fellini's La
Dolce Vita, *1960. Photofest, New York.*

series of lectures at the Graduate School of Fine Arts, University of Pennsylvania, in Philadelphia. Between 1961 and 1969 he would teach one semester a year there.

Toti Scialoja travels for the second time to New York, where he moves into a loft in Greenwich Village.

The *Manifesto contro niente per l'esposizione internazionale di niente* (Manifesto against nothing for the international exhibition of nothing) is signed in Basel by Bazon Brock, Enrico Castellani, Carl Laszlo, Heinz Mack, Piero Manzoni, Onorio, Otto Piene, and Herbert Schuldt.

Luigi Nono composes the electronic piece *Omaggio a Emilio Vedova* (Homage to Emilio Vedova).

Michelangelo Antonioni's *L'avventura* (The adventure; released in English as *L'Avventura*) is released. The film stars Monica Vitti as a woman whose best friend disappears while they and a group of wealthy friends visit a desolate Sicilian island. Though the film centers on the woman's growing relationship with her friend's lover, it departs from traditional narrative by concentrating to an unusual degree on mood and setting. Revolutionary in its use of space and landscape, the film wins the Special Jury Prize at the Cannes International Film Festival and would become extremely influential.

Luchino Visconti's *Rocco e i suoi fratelli* (released in English as *Rocco and His Brothers*) is released. This film, a conscious effort by Visconti to return to neorealism, focuses on a mother and her four grown sons who leave their home in the South to seek a better life in Milan, only to be faced with the harsh social and economic realities of the city.

Vittorio De Sica's *La ciociara* (The woman from Ciociara; released in English as *Two Women*) is released. Based on a story by Alberto Moravia, the film follows a mother and daughter as they flee the South after the Allied bombing of Rome in 1943. The film stars Sophia Loren, in a role that would win her both an Academy Award for best actress and the best actress prize at the Cannes International Film Festival in 1961.

Emilio Schuberth begins a prêt-à-porter line destined mainly for the American, Swiss, and West German markets. Schuberth opened his haute-couture studio in Rome in 1939; his name also appears on eyeglasses, perfumes, underwear, table linen, ties, costumes, and a doll.

Construction begins on Giovanni Michelucci's organic church of San Giovanni Battista on the Autostrada del Sole, in Campi Bisenzio, Florence (1960–64). The church serves as a monument to the workers who died during the construction of the Autostrada del Sole.

Ettore Sottsass, Jr. designs the main entrance to the *XII Triennale.* Dedicated to the themes of the home and the school, the *Triennale* presents two commemorative exhibitions, one dedicated to Adriano Olivetti and the other (with an installation by Carlo Scarpa) dedicated to Frank Lloyd Wright.

January
An exhibition of Alberto Burri's work of 1948–55 is held at Galleria La Medusa, Rome.

4–February 1. La nuova concezione artistica (The new artistic conception) is held at Galleria Azimut, Milan. The show includes work by Kilian Breier, Castellani, Oskar Holweck, Yves Klein, Mack, Manzoni, and Almir Mavignier. The second issue of *Azimuth*, which includes texts by Castellani, Udo Kultermann, Manzoni, and Piene, is dedicated to the show.

15. Miriorama 1 opens at Galleria Pater, Milan. More an installation or Happening than a conventional exhibition, *Miriorama 1* is Gruppo T's first show. The group presents its *Grande oggetto pneumatico* (*Large Pneumatic Object*) and *Pittura in fumo* (*Smoke Painting*). On the walls hang photographs of works by Umberto Boccioni, Alexander Calder, Paul Klee, and Manzoni, accompanied by excerpts of these artists' writings. On the occasion of the exhibition, Gruppo T—which was founded in 1959—signs its manifesto.

16. Francesco Lo Savio's first solo exhibition, at Galleria d'Arte Selecta, Rome, opens. He shows his *Spazio-luce* (*Space-Light*) works.

February
Burri has a solo exhibition at the Martha Jackson Gallery, New York, where he shows his *Ferri* (*Irons*).

5. The world premiere of Federico Fellini's *La dolce vita* (The sweet life; released in English as *La Dolce Vita*) is held in Milan. The film would immortalize the *paparazzi*—the assault-style photographers who provoked as much scandalous, tabloid news as they documented—whose characterization in the film Fellini based on the Roman photographer Tazio Secchiaroli. The film would win the Grand Prize at the 1961 Cannes International Film Festival.

5–22. An exhibition of Castellani's monochromes is held at Galleria Azimut, Milan.

March
Nuovi disegni per il mobile italiano (New designs for Italian furniture), curated by Guido Canella and Vittorio Gregotti and with an installation by Gae Aulenti, Canella, and Alfredo Casella, is held in Milan at Galleria Osservatore delle Arti Industriali.

18–May 8. The Stadtisches Museum, Leverkusen, West Germany, presents *Monochrome Malerei* (Monochrome painting). The exhibition includes work by Enrico Bordoni, Castellani, Piero Dorazio, Lucio Fontana, Lo Savio, Manzoni, and Salvatore Scarpitta. The catalogue includes texts by Castellani and Kultermann.

25. Fernando Tambroni, of the DC (Democrazia Cristiana/Christian Democratic party), becomes Prime Minister of Italy.

30–April 15. Michelangelo Pistoletto has his first solo exhibition, at Galleria Galatea, Turin. He shows a series of oil paintings.

April
2. Miriorama 7, Gruppo T's first show outside of Milan, opens at Galleria San Matteo, Genoa. Although the previous five exhibitions in the *Miriorama* series were solo shows devoted to individual members, this exhibition, like the first, is devoted to the group as a whole.

9. La nuova concezione artistica opens at the Circolo del Pozzetto, Padua. The exhibition includes work by Alberto Biasi, Castellani, Mack, Manfredo Massironi, and Manzoni.

16. To accompany an upcoming exhibition at Galleria Apollinaire, Milan, Pierre Restany publishes (in Milan) a text entitled "Les Nouveaux Réalistes" (The new realists), which uses this term for the first time. Restany intends the text as the manifesto of the Nouveau Réaliste movement. The artists whose work would be included in the exhibition—Arman, François Dufrêne, Raymond Hains, Yves Klein, Jean Tinguely, and Jacques de la Villeglé (Mimmo Rotella would join the group later in the year)—incorporate objects from everyday life, often urban debris such as torn posters and automobile parts. Nouveau Réalisme is often considered a parallel movement to neo-Dada.

27. Mark Rothko's first retrospective in Italy opens at Galleria Nazionale d'Arte Moderna, Rome.

29. An exhibition of works by Sam Francis opens at Galleria Notizie, Turin. Francis's work would be included in numerous exhibitions in Italy during this period.

May
Manzoni has his first exhibition of *Fiato d'artista* (*Artist's Breath*) works, at Galleria Azimut, Milan. Samples of Manzoni's breath, stored in balloons, are sold as works of art.

9. Contemporary Italian Art opens at the Illinois Institute of Design, Chicago. The exhibition and a related auction have been organized to raise scholarship funds. Artists who donate work include Carla Accardi, Afro [Afro Basaldella], Giovanni Anceschi, Franco Angeli, Aldo Biglione, Giovanni Bonalumi, Davide Boriani, Burri, Giuseppe Capogrossi, Pietro Cascella, Castellani, Ettore Colla, Gianni Colombo, Pietro Consagra, Antonio Corpora, Roberto Crippa, Dorazio, Gianni Dova, Tano Festa, Giosetta Fioroni, Fontana, Nino Franchina, Manzoni, Luciano Minguzzi, Achille Perilli, Giò Pomodoro, Mauro Reggiani, Mario Rossello, Rotella, Antonio Sanfilippo, Marco Santini, Giuseppe Santomaso, Scialoja, Ettore Sordini, Guido Strazza, Giulio Turcato, and Emilio Vedova. The exhibition would travel to the Frumkin Gallery, Chicago, from May 23 to 27.

25. Possibilità di relazione (Possibility of relation) opens at Galleria l'Attico, Rome. The exhibition includes work by Valerio Adami, Rodolfo Aricò, Vasco Bendini, Mino

Left to right: Gillo Dorfles, Enrico Baj,
Raymond Queneau, and André Pieyre
de Mandiarque in Venice for the 1956
Biennale. Photo by Ugo Mulas, courtesy
of Gillo Dorfles.

Piero Manzoni "signing" hard-boiled
eggs. Archivio Germano Celant.

Left to right, front: Franscesco Lo Savio,
Tano Festa, and Mario Schifano; back:
Piero Dorazio and Giulio Turcato, at
the opening of 5 Pittori–Roma 60 at
Galleria La Salita, Rome in 1960.
Archivio Germano Celant.

Ceretti, Dova, Cesare Peverelli, Concetto Pozzati, Giuseppe
Romagnoli, Piero Ruggeri, Emilio Scanavino, Guido
Strazza, Sergio Vacchi, and Tino Vaglieri. The catalogue
essays are written by Enrico Crispolti, Roberto Sanesi, and
Emilio Tadini.

June
Cesare Vivaldi publishes *Crack*, a collection of documents
related to the group Crack, whose members are Andrea
Cascella, Dorazio, Gino Marotta, Fabio Mauri, Gastone
Novelli, Perilli, Rotella, and Turcato.

4. Jannis Kounellis's first solo exhibition opens at Galleria
La Tartaruga, Rome. He shows his large works on paper
composed of letters, signs, and symbols for the first time.
The following year *L'alfabeto di Kounellis* (*Kounellis's
Alphabet*), with a text by Mario Diacono, would be
published in the gallery's journal *Quaderni La Tartaruga*
(La Tartaruga notebooks).

6–24. New Media–New Forms is held at the Martha
Jackson Gallery, New York. The show includes work by
Burri, Enrico Donati, Arnaldo Pomodoro, and Salvatore
Scarpitta, as well as Jim Dine, Dan Flavin, Red Grooms,
Jasper Johns, Allan Kaprow, Claes Oldenburg, and Robert
Rauschenberg.

18–October 7. The XXX *Biennale* is held in Venice. Renato
Birolli, Burri, Dorazio, Renato Guttuso, Alberto Magnelli,
and Leoncillo [Leoncillo Leonardi] are given solo rooms.
Vedova receives the Comune di Venezia prize and Burri
receives the AICA (Associazione Internazionale dei Critici
d'Arte/International Association of Art Critics) prize. The
other *Biennale* winners are Jean Fautrier, Hans Hartung,
and Consagra.

20. ICAR (International Center of Aesthetic Research)
opens in Turin. The founders—Michel Tapié, Luigi
Moretti, and Ada Minola—use ICAR to promote Art
Informel in Italy. The inaugural show, *Ensemble*, is curated
by Tapié and includes work by Carla Accardi, Fontana,
Giuseppe Pinot Gallizio, Antonio Sanfilippo, and
Francesco Somaini.

July
5–7. Anti-Fascist demonstrators are fired upon by police
during protests in Rome, Reggio-Emilia, and Licata;
several deaths result.

*16–September 18. Arte Italiana del XX Secolo da Collezioni
Americane* (Twentieth-century Italian art from American
collections), curated by Palma Bucarelli, Bliss Parkinson,
and James Thrall Soby, is held at Galleria Nazionale d'Arte
Moderna, Rome. The show includes work by Afro, Burri,
and Capogrossi.

21. Manzoni's exhibition *Consumazione dell'arte dinamica del
pubblico, divorare l'arte* (Public consumption of dynamic art,
to devour art) is held at Galleria Azimut, Milan. Manzoni
signs hard-boiled eggs with his thumbprint and distributes
these artworks to the spectators, who eat them.

26. Amintore Fanfani becomes Prime Minister of Italy for the third time.

August
7. Salvatore Ferragamo dies in Florence. His eldest daughter, Fiamma, takes over the company.

25. The XVII Summer Olympics open in Rome.

October
Burri Consagra De Kooning Rothko is held at Galleria La Tartaruga, Rome.

November
From Space to Perception, a group show of work by four American painters—including Morris Louis, whose work is shown for the first time in Italy—is held at the Rome–New York Foundation, Rome.

An exhibition of work by Kenneth Noland and Louis is held at Galleria L'Ariete, Milan.

1–January 29, 1961. Guggenheim International Award, 1960 is presented at the Solomon R. Guggenheim Museum, New York. Italy is represented by Afro, Dova, Mattia Moreni, Piero Ruggeri, and Sergio Vacchi; Afro wins the Italian section.

18. *5 pittori—Roma 60* (Five painters—Rome sixty) opens at Galleria La Salita, Rome. The show includes work by Franco Angeli, Tano Festa, Francesco Lo Savio, Mario Schifano, and Giuseppe Uncini. The catalogue text is written by Restany.

23. Studio N, the gallery of Gruppo N, opens in Padua with a group show of work by N members. The gallery would also hold exhibitions of work by Burri, Fontana, and Jackson Pollock, and would stage performances of experimental music.

December
The first issue of *Metro*, a biannual review, is published in Milan (the publication would later move to Venice). The review is directed by Bruno Alfieri; the editorial staff consists of Giuseppe Marchiori, Rodolfo Palluchini, and Marco Valsecchi; and the art director is Roberto Sambonet. Contributors to the review would include Alberto Boatto, Giorgio De Marchis, Maurizio Fagiolo dell'Arco, Alain Jouffroy, Marchiori, Filiberto Menna, Nello Ponente, Sandra Pinto, and Restany. In 1968 (from no. 13 on), *Metro* would be headed by a new editorial staff including Alfieri, Giulio Carlo Argan, and Gillo Dorfles.

1961

Mario Schifano signs a contract with the art dealer Ileana Sonnabend. Sonnabend is living in Rome and intends to open a gallery there with Plinio de Martiis (of Galleria La Tartaruga). The contract with Schifano lasts approximately one year. (Sonnabend's project with de Martiis would never be realized.)

James Johnson Sweeney's monograph on Afro [Afro Basaldella] is published (in Italian) in Rome.

Luigi Nono composes *Intolleranza* (Intolerance), an opera concerning the plight of an immigrant in a hostile state.

Piero Paolo Pasolini's first feature film, *Accattone!* (Beggar!; released in English as *Accattone*) is released. The film, which is based on Pasolini's 1959 novel *Una vita violenta* (published in English as *A Violent Life*), recalls neorealist cinema as it relates the story of a young, small-time pimp living in the Roman ghetto.

La notte (released in English as *The Night*), the second film in Michelangelo Antonioni's trilogy that began with *L'avventura*, is released. It, too, explores the theme of alienation by examining a day in the life of an unhappy married couple (Marcello Mastroianni and Jeanne Moreau) who wander through the cold, modern landscape of Milan.

Ermanno Olmi's *Il posto* (The job; released in English as both *The Sound of Trumpets* and *The Job*), is released. Gently comic, the film focuses on a young man who gets his first job working as a clerk in a large Milan office and captures the dehumanizing effect of daily, routine work.

Pietro Germi's *Divorzio all'italiana* (released in English as *Divorce Italian Style*) is released. The film tells the comic story of a bored, ridiculously debonair Sicilian nobleman (Mastroianni) who, unable to divorce his wife legally, devises a plot to kill her. The film satirizes both the classic Italian lover and Sicilian divorce laws.

Vittorio De Seta's first feature film, *Banditi a Orgosolo* (released in English as *Bandits of Orgosolo*), a drama enacted by Sardinian shepherds, is released. In the 1950s, De Seta directed documentary films about life in Sicily and Sardinia.

Maria Antonelli debuts Antonelli Sport, a prêt-à-porter line.

January
13. Piero Manzoni executes the first of his *Scultura vivente* (*Living Sculpture*) series, in which he transforms people into artworks by signing them. His "sculptures" then receive a certificate of authenticity, which is numbered and also signed by Manzoni.

February
The artists' group Continuità has an exhibition of the same name at Odyssia Gallery, Rome. Curated by Giulio Carlo Argan, the exhibition includes work by Franco Bemporad, Pietro Consagra, Piero Dorazio, Fontana, Gastone Novelli, Achille Perilli, Arnaldo and Giò Pomodoro, and Giulio Turcato. Continuità calls for a return to Italy's tradition of great art and promotes continuity within the artwork, as opposed to the disorderliness of Art Informel.

14–March 4. World House Galleries, New York, holds *Venice Biennial Prize Winners 1960.* Curated by Virginia Fields, the exhibition includes work by Alberto Burri.

Marcello Mastroianni in Pietro Germi's
Divorzio all'italiana, *1961. The*
Museum of Modern Art, New York.

Prime Minister Amintore Fanfani
addresses the eighth congress of the DC
(Democrazia Cristiana/Christian
Democrat party) in Naples, January
1962. AP/Wide World Photos.

April
14. Miriorama 10, an exhibition of works by Gruppo T, opens at Galleria La Salita, Rome. The exhibition catalogue includes a text by Fontana.

21–May 28. Salute to Italy: 100 Years of Italian Art 1861–1961, an exhibition commemorating the centennial of the unification of Italy, is held at the Wadsworth Atheneum, Hartford, Connecticut. The catalogue introduction is written by Filippo Donini, director of the Italian Cultural Institute of New York.

22. An exhibition of work by Enrico Castellani and Manzoni opens at Galleria La Tartaruga, Rome. Manzoni presents his *Achromes* and *Sculture viventi*.

May
3. Tano Festa has his first solo exhibition, at Galleria La Salita, Rome. Cesare Vivaldi writes the catalogue text.

17– June 10. A 40° au-dessus de Dada (Forty degrees above Dada), organized by Pierre Restany, is held at Galerie J, Paris. This is the second group exhibition of the Nouveaux Réalistes and includes work by Arman, César [César Baldaccini], François Dufrêne, Raymond Hains, Yves Klein, Mimmo Rotella, Niki de Saint-Phalle, Daniel Spoerri, Yves Tinguely, and Jacques de la Villegle. (Manzoni travels to Paris to see the exhibition. He meets Arman and Tinguely, and also introduces himself to Klein, proclaiming "You are the monochrome blue and I am the monochrome white, we must work together"; however, no collaboration between the two would result.) The exhibition catalogue contains the Nouveaux Réalistes' second manifesto, written by Restany, declaring the artists of the group to be descendants of Dada. Klein and other members object to the Dada reference and only Restany signs the manifesto. On October 8, Klein, Hains, and Martial Raysse would declare the Nouveaux Réalistes dissolved, although this would not put an end to the group's activities.

June
The periodical *Il Verri* (the title of the magazine refers to the Verri brothers, Italian illuminists) devotes its entire third issue to Informale. The issue includes texts by Argan, Renato Barilli, Enrico Crispolti, Umberto Eco, Willem de Kooning, and Jackson Pollock.

Klein has a solo exhibition at Galleria La Salita, Rome.

Italia '61. Mostra della Moda Stile Costume (Italy 1961. Exhibition of fashion style costume) is held in Turin. A pavilion called "Fonti di Energia" (Fountains of Energy) is created for the exposition by architects Gianemilio, Piero, and Anna Monti; Lucio Fontana creates *Soffitto al neon* (*Neon Ceiling*)—seven planes of neon light and a neon arabesque; and Fausto Melotti makes a large decoration using small enameled ceramic forms.

September
The *XII Premio Lissone* is held in Lissone. Festa, Gruppo N, Lo Savio, Giulio Paolini (who exhibits for the first time),

and Mario Schifano participate in the section "Rassegna della Pittura Italiana" (Review of Italian painting). Jannis Kounellis exhibits in the international section.

October
Robert Rauschenberg has a solo exhibition at Galleria L'Ariete, Milan.

2–November 12. The Art of Assemblage is held at the Museum of Modern Art, New York. The show is organized by William Seitz and features the work of 142 American and European artists, including Arman, Burri, César, Ettore Colla, Joseph Cornell, Hains, Jasper Johns, Rauschenberg, Rotella, and Tinguely.

December
Mostra della critica (Critics' exhibition) is held at Galleria d'Arte Moderna, Milan. The show of work by Italian artists chosen by a jury of critics includes work by Afro, Enrico Baj, Dorazio, Perilli, Turcato, and Emilio Vedova.

Galleria La Tartaruga, Rome, holds an exhibition of work by Kounellis, Rauschenberg, Schifano, Tinguely, and Cy Twombly.

1962
Abitare (Living), an interior design magazine, begins publication in Milan.

Dibattito (Debate), an insert in the magazine *Fotofilm*, is initiated. The insert is edited by Antonio Arcari, Traquillo Casiraghi, and Cesare Colombo.

Renato Poggioli's *Teoria dell'arte d'avanguardia* (published in English as *The Theory of the Avant-Garde*) is published in Bologna.

Umberto Eco's theoretical study *Opera aperta* (published in English as *The Open Work*), a study of the "open form" in literature, art, music, and philosophy, is published. A complex, anti-Crocean concept, the "open form" refers to works of multiple meanings that require the audience's involvement and participation. James Joyce's *Finnegans Wake* is, for Eco, the prime example of the modern open work.

Ugo Mursia's *Invito a Venezia* (Invitation to Venice), with text by art historian Michelangelo Muraro, photographs by Ugo Mulas, and an introduction by Peggy Guggenheim, is published.

Giorgio Bassani's novel *Il giardino dei Finzi-Contini* (published in English as *The Garden of the Finzi-Contini*), which Vittorio De Sica would make into a popular film in 1970, is published.

Michelangelo Antonioni's *L'eclisse* (The eclipse; released in English as *Eclipse*) is released. *L'eclisse*, the final film in Antonioni's trilogy about modern alienation, explores the inability to communicate in the contemporary world as it relates the story of a woman (Monica Vitti) who leaves her

lover to begin a new, problematic relationship with a young, aggressive stockbroker (Alain Delon). The final moments of the film, as night falls on a sterile but oddly beautiful modern city, would become one of the most famous sequences in movie history.

Bernardo Bertolucci's first film, *La commare secca* (released in English as *The Grim Reaper*), is released. Based on a story line by Pier Paolo Pasolini and shot in a semidocumentary style, the film centers on the investigation of the murder of a prostitute in Rome, presenting the events that made up the victim's last day from the different perspectives of those involved.

Carlo Ponti releases *Boccaccio '70*, a production made up of three short films by Federico Fellini, De Sica, and Luchino Visconti.

Nanni Loy's film *Le quattro giornate di Napoli* (released in English as *The Four Days of Naples*), a documentary drama about the 1943 Neapolitan uprising against the Nazis, is released.

Francesco Rosi's *Salvatore Giuliano* (released in English as *Salvatore Giuliano*), a film that re-creates the story of the legendary modern Sicilian outlaw, is released.

Construction begins on subway stations in Milan designed by Franco Albini and Franca Helg (with graphic design by Bob Noorda).

Marco Zanuso and Richard Sapper design the *Doney 14* television set for Brionvega. This compactly designed, portable set is the first completely transistorized television produced in Italy.

February
Amintore Fanfani forms Italy's first Center-Left government. The PSI (Partito Socialista Italiano/Italian Socialist Party) abstains. With the election of Pope John XXII in 1958 and a subsequent lessening of clerical influence, support for the Right had diminished, while on the Left a loosening of ties between the Communists and the Socialists under Pietro Nenni had allowed room for an association between the Socialists and Christian Democrats to form; both factors made a Center-Left coalition possible. Among the coalition's main concerns are the nationalization of the electrical industry; the democratization of the educational system; the expansion of regional governments; and the easing of East–West tensions.

Toti Scialoja has a solo exhibition, entitled *Collages 57–61*, at Galleria La Salita, Rome. The catalogue introduction is written by art critic Milton Gendel.

March
9–25. Tentoonstelling Nul (Zero exhibition), an international survey of monochromatic work, is held at the Stedelijk Museum, Amsterdam. It includes work by Enrico Castellani, Dadamaino, Piero Dorazio, Lucio Fontana, Francesco Lo Savio, and Piero Manzoni. The catalogue is a

Left to right: Carlyle Brown, Catherine Viviano, Afro, two unidentified people, and Toti Scialoja. Estate of Catherine Viviano, New York.

Palma Bucarelli (left) and Giulo Carlo Argan (right) at the XXXI Biennale in 1962. Photo by Milton Gendel.

Luchino Visconti directing Claudia Cardinale in Il gattopardo, 1963. Photofest, New York.

patchwork of texts and statements by the artists.

April
11. Dipinti di Merz (Paintings by [Mario] Merz) opens at Galleria Notizie, Turin. The catalogue essay is written by Italian art critic Carla Lonzi.

May
Arte Programmata (Programmed art, the Italian term for kinetic art) is held at the Olivetti showroom in Milan. The exhibition, curated by Bruno Munari and Giorgio Soavi, includes work by members of GRAV (Groupe de Recherche d'Art Visuel/Visual Art Research Group), Gruppo N, and Gruppo T, and Enzo Mari and Bruno Munari. The catalogue text is written by Umberto Eco, who coined the term "arte programmata."

6. Antonio Segni, of the DC (Democrazia Cristiana/Christian Democratic party), is elected President of Italy.

23–September 28. Paintings, Sculptures—American and European, an exhibition that includes work by Afro [Afro Basaldella], is held at the Catherine Viviano Gallery, New York.

June
Lucio Fontana has an exhibition at Galleria dell'Ariete, Milan. He shows his *Metalli* (*Metals*)—works made of cut and perforated sheet metal—for the first time. The catalogue includes poetry by Raffaele Carrieri.

16–October 7. The *XXXI Biennale* opens in Venice. Winners are Antonio Berni, Aldo Calò, Giuseppe Capogrossi, Alberto Giacometti, Alfred Manessier, Umberto Milani, Ennio Morlotti, and Antonio Virduzzo.

July
Alternative Attuali. Rassegna Internazionale Architettura Pittura Scultura d'Avanguardia (Alternative reality. International review of avant-garde architecture, painting, and sculpture) is held at the Castello Cinquecentesco, L'Aquila. Alberto Burri's works from 1948 to 1961 are presented in a section entitled "Omaggio a Burri" (Homage to Burri); the exhibition also includes work by Valerio Adami, Pierre Alechinsky, Enrico Baj, Lucio Del Pezzo, Leoncillo [Leoncillo Leonardi], Concetto Pozzati, and Mimmo Rotella. The catalogue includes essays by Renato Barilli, Eugenio Battisti, Alberto Boatto, and Enrico Crispolti.

September
1–23. George Maciunas (founder of the Fluxus movement) organizes a series of concerts entitled *Fluxus Internationale Neuester Musik* at the Hoersaal des Städtischen Museums in Wiesbaden, West Germany. Over time the Fluxus group would grow to include such artists as George Brecht, John Lennon, Yoko Ono, Takako Saito, Daniel Spoerri, and Robert Watts. Editions of work by Fluxus artists are sold at Fluxus shops in Amsterdam, Montreal, New York, Nice, Rome, and Tokyo.

November
1–December 1. New Realists is held at the Sidney Janis Gallery, New York. The exhibition includes work by Arman, Baj, Gianfranco Baruchello, Peter Blake, Christo, Jim Dine, Tano Festa, Robert Indiana, Klein, Roy Lichtenstein, Claes Oldenburg, Martial Raysse, James Rosenquist, Rotella, Mario Schifano, George Segal, Spoerri, Yves Tinguely, Andy Warhol, and Tom Wesselmann.

December
Marlborough Gallery, Rome, holds an exhibition of Burri's *Plastiche* (*Plastics*) series. Produced during 1961–62, the *Plastiche* are made of large sheets of plastic that have been stretched and then marred or ripped by smoke or flame. Art historian and critic Cesare Brandi writes the catalogue text.

1963

Piero Dorazio and Angelo Savelli, with a group of students from the University of Pennsylvania, establish the Institute of Contemporary Art at the university. The inaugural exhibition is a retrospective of the work of Clyfford Still.

Lucio Fontana begins his *Fine di Dio* (*End of God*) series. The large, ovoid paintings are marked by an irregular network of holes punched through the canvas.

Federico Fellini's *Otto e mezzo* (released in English as *8 1/2*) is released. One of the director's most personal and blatantly autobiographical films, *Otto e mezzo* tells the story of a famous movie director (Marcello Mastroianni) who can't find the inspiration for his next film. Filled with striking, dreamlike images, the film anticipates much of Fellini's later work. It wins the Academy Award for best foreign film.

Pietro Germi's *Sedotta e abbandonata* (released in English as *Seduced and Abandoned*) is released. A satire of Sicilian moral codes and behavior, it tells the story of a fifteen-year-old girl who becomes pregnant by her sister's fiancé.

Mario Monicelli's *I compagni* (The comrades; released in English as *The Organizer*) is released. In this black comedy, a socialist (Mastroianni) abandons his upper-class background to serve the cause of the worker.

Francesco Rosi's *Le mani sulla città* (released in English as *Hands Over the City*), starring Rod Steiger and with a supporting cast primarily of nonprofessionals, wins the award for best picture at the Venice Film Festival. The film follows the political repercussions of a building collapse in a poor district of Naples, pointing to corrupt Italian building speculation of the early 1960s.

Luchino Visconti's *Il gattopardo* (released in English as *The Leopard*), based on the internationally famous novel by Giuseppe Tomasi di Lampedusa, is released. The film wins the Golden Palm award at the Cannes International Film Festival.

Construction begins on the town hall in Segrate (1963–66),

designed by Guido Canella, with Michele Achilli, Daniele Brigidini, and Laura Lazzari. The building provides both a civic center (with a library and auditorium) and offices; the two functions are housed in separate and essentially autonomous sections.

January
28. Francesco Lo Savio commits suicide in Marseilles.

February
9. Galleria La Tartaruga, Rome (in its new location in piazza del Popolo), presents *13 Pittori a Roma* (Thirteen painters in Rome). The exhibition, which marks the beginning of the so-called Scuola di Piazza del Popolo, includes work by Franco Angeli, Umberto Bignardi, Tano Festa, Giosetta Fioroni, Jannis Kounellis, Renato Mambor, Fabio Mauri, Gastone Novelli, Achille Perilli, Mimmo Rotella, Peter Saul, Cesare Tacchi, and Cy Twombly. The catalogue includes poetry by Nanni Balestrini, Alfredo Giuliani, Elio Pagliarani, Antonio Porta, and Edoardo Sanguineti, and essays by Gillo Dorfles, Umberto Eco, and Cesare Vivaldi (who together would form Gruppo '63—the second group of that name—in October). Vivaldi publishes an article entitled "La giovane scuola di Roma" (The young school of Rome) in a special issue of *Il Verri* (no. 12) later in the year.

6. Piero Manzoni dies in his studio in Milan. Ben Vautier "signs" Manzoni's death as an artwork just as he had signed Yves Klein's death in June 1962.

22–March 15. Galleria Quadrante, Florence, holds *Sei Pittori Romani* (Six Roman painters). The six—Gastone Biggi, Nicola Carrino, Nato Frascà, Achille Pace, Pasquale Santoro, and Giuseppe Uncini—would name themselves Gruppo Uno later in the year. Particularly interested in the relationship between art and science, the group distances itself from Informale and begins to experiment with optical effects, neo-Constructivist forms, and fluorescent color.

March–April. L'Informale in Italia fino al 1957 (The Informale in Italy until 1957) is held at the Palazzo del Museo, Livorno. The show, curated by art critic-historians Dario Durbé and Maurizio Calvesi, includes work by Alberto Burri, Giuseppe Capogrossi, Roberto Crippa, Gianni Dova, Fontana, Giuseppe Pinot Gallizio, Leoncillo [Leoncillo Leonardi], Ennio Morlotti, Rotella, Toti Scialoja, and Emilio Vedova.

April
27–May 14. Michelangelo Pistoletto has an exhibition at Galleria Galatea, Turin, in which he shows his reflecting steel pieces.

June
Giovanni Leone, of the DC (Democrazia Cristiana/ Christian Democratic party), becomes Prime Minister of Italy.

3. Pope John XXIII dies in the midst of the Second Vatican Council. An ecumenical council of the Roman Catholic

Left to right: Mimmo Rotella, Achille
Perilli, Fabio Mauri, Tino Marotta,
Piero Dorazio, Giulio Turcato, and
Gastone Novelli in Rome's Piazza del
Popolo. Photo by Virginia Dortch.

Gruppo Uno (left to right: Gastone
Biggi, Nato Frascá, Nicola Carrino,
and Giuseppe Uncini) in Rome in 1964.

Monica Vitti and Richard Harris in
Michelangelo Antonioni's Deserto
rosso, 1964. Photofest, New York.

Church, Vatican II was convened by John XXIII on
October 11, 1962 with the purpose of reconsidering the
Church's position in relation to the modern world. In four
sessions that would conclude on December 8, 1965, the
council would drastically change the structure and liturgy
of the Catholic church. Paul VI would be elected Pope on
June 21.

5–18. The first exhibition of Gruppo '63 is held at Galleria
Numero, Rome. The group—formed earlier in the year by
Lucia De Luciano, Lia Drei, Francesco Guerrieri, and
Giovanni Pizzo—is short-lived; after their break-up, Drei
and Guerrieri would form Sperimentale P and De Luciano
and Pizzo would form Operativo R.

11. Nuova Figurazione (New figuration) opens at Galleria La
Strozzina, Florence. The show includes work by Karel
Appel, Eduardo Arroyo, Enrico Baj, Crippa, Lucio Del
Pezzo, Jean Dubuffet, Fritz Hundertwasser, Asger Jorn,
Matta [Roberto Sebastián Matta Echaurren], Novelli,
Perilli, Rotella, Antonio Saura, Mario Schifano, and Sergio
Vacchi.

July
The *IV Biennale* of San Marino, entitled *Oltre l'Informale*
(Beyond the Informale) is held at the Palazzo del Kursal.
The exhibition includes work by Getulio Alviani, Angeli,
Alberto Biasi, Davide Boriani, Enrico Castellani, Ettore
Colla, Gianni Colombo, Dadamaino, Piero Dorazio, Gianni
Dova, Festa, Gruppo Uno, Bruno Munari, Mario Nigro,
Novelli, Perilli, Concetto Pozzati, Rotella, Schifano, Giulio
Turcato, and Tancredi [Parmeggiani Tancredi]. The
exhibition catalogue includes texts by Giulio Carlo Argan,
Anguilera Cerni, Umbro Apollonio, Palma Bucarelli,
Giuseppe Gatt, and Pierre Restany.

September
The *XII Convegno Internazionale Artisti, Critici, Studiosi
d'Arte* (Twelfth international convention of artists, critics,
and art scholars) is held in Verucchio. Participants include
Argan (who presides over the conference), Pierre Francastel,
Giuseppe Gatt, Filiberto Menna, Nello Ponente, and
Restany. Carla Accardi, Pietro Consagra, Antonio Corpora,
Umberto Mastroianni, Novelli, Perilli, Antonio Sanfilippo,
Giuseppe Santomaso, Scialoja, and Turcato sign a protest
addressed to the convention, stating their objection to
what they see as the attempt by critics (Argan in
particular) to determine the avenues of artistic research.
(The polemic would continue in the pages of the
newspaper *L'Avanti* through January 1964.)

The *VII Bienal* is held in São Paulo, Brazil. In the Italian
pavilion, work by Rodolfo Aricò, Baj, Dorazio, Novelli,
Pozzati, and Rotella is shown.

October
Gruppo '63 (the second group of this name) forms and
holds its first congress in Palermo. Luciano Anceschi,
Balestrini, Eco, Sanguineti, and others—most of whom
have ties to the magazine *Il Verri*—join together in a
literary movement that tends to reject traditional
definitions and rationalizations in favor of more open and

expressive possibilities. The group would found the journal *Quindici* (Fifteen) in 1967.

November
The first issue of *Marcatré*, an arts magazine directed by Eugenio Battisti, is published in Genoa. Others involved as part of the managerial committee or as contributors include Alberto Boatto, Maurizio Calvesi, Diego Carpitella, Germano Celant, Enrico Crispolti, Dorfles, Eco, Vittorio Gelmetti, Paolo Portoghesi, and Sanguineti. The review would continue publishing (later in Rome) until 1971.

5–December 1. Galleria Civica d'Arte Moderna, Turin, holds an exhibition entitled *Franz Kline*. Frank O'Hara is the curator of the show, which has been organized in collaboration with the International Council of the Museum of Modern Art, New York.

December
Schifano travels to New York, where he remains for several months and sees Pop art first-hand.

Il Museo Sperimentale d'Arte Contemporanea—which is devoted to the "open work" (defined by Eco in his 1962 book *Opera aperta*)—opens in Genoa. Battisti founds the museum; organizers include Umbro Apollonio, Barilli, Germano Beringhelli, Calvesi, Crispolti, Gian Alberto Dell'Acqua, Dorfles, Angelo Dragone, Oreste Ferrari, and Nello Ponente; Battisti is aided by his assistant, Ezia Gavazza, and student Celant. (The museum's collection would be donated to the city of Turin in 1965, at which time its collection would contain approximately 100 works by ninety-five artists. By 1969 the collection would contain 360 works by 260 artists.)

Vedova exhibits *I plurimi* (*Multiples*) at the Marlborough Gallery, Rome. These works, a cross between painting and sculpture, are constructed of large, irregular pieces of wood nailed or hinged together and then painted with broad, gestural brushstrokes. Vedova would later add sound and light to the *Plurimi*, expanding them into total environments. The catalogue text is written by Argan.

Il Verri devotes the December issue (no. 12) to *Dopo l'Informale* (After Informale). The issue includes texts by Renato Barilli, Boatto, Calvesi, Crispolti, Dorfles, Gruppo N, Enzo Mari, Filiberto Menna, Emilio Tadini, Vivaldi, and Marisa Volpi.

4. Aldo Moro, of the DC, becomes Prime Minister of Italy.

1964

Michelangelo Antonioni's *Deserto rosso* (released in English as *Red Desert*), his first color film, is released. It focuses on the unhappy wife (Monica Vitti) of an electronics engineer in Ravenna who has an affair. Antonioni uses color expressively and radically (painting over buildings, walls, and even apples) to reflect the shifting moods of his characters as well as the beauty and alien quality of modern industry.

Sergio Leone's *Per un pugno di dollari* (released in English as *A Fistful of Dollars*), starring Clint Eastwood, is released and would be followed by a sequel, *Per qualche dollaro in più* (*For a Few Dollars More*), the following year. *Per un pugno di dollari* in large part launches the phenomenon of the "spaghetti Western"—films set in the Wild West that are produced in Italy, often with American financing.

Pier Paolo Pasolini's *Il Vangelo secondo Matteo* (released in English as *The Gospel According to St. Matthew*) is released. Unlike the popular Hollywood extravaganzas based on biblical epics, *Il Vangelo secondo Matteo* is filmed in a neorealistic manner, in remote areas of southern Italy and using primarily nonprofessional actors. Telling the story of the life and death of Christ, the film is notable for its inventive editing, contemporary allusions, and stark realism.

Vittorio De Sica's *Ieri oggi domani* (released in English as *Yesterday Today and Tomorrow*) wins the Academy Award for best foreign film.

Leonardo Savioli and Danilo Santi's apartment house on via Piagentina, Florence, is completed. The external concrete walls are punctuated irregularly by windows, and the central space of the building, which contains the staircase and elevator, echo the rounded street corner outside.

Gae Aulenti, Carlo Aymonino, Ezio Bonfanti, Cesare Macchi Cassia, Jacopo Gardella, Antonio Ghirelli, and Steno Paciello design *L'arrivo al mare* (The arrival at the sea), a display for the Italian section, dedicated to "Leisure Time and Water," of the *XIII Triennale*.

The *Tekne 3* typewriter, designed by Ettore Sottsass, Jr., is manufactured by Olivetti.

January
16–March 9. Guggenheim International Award, 1964 is held at the Solomon R. Guggenheim Museum, New York. Luigi Boillé, Giuseppe Capogrossi, Enrico Castellani, and Lucio Fontana represent Italy.

February
13. Giuseppe Pinot Gallizio dies in Alba.

May
9. Galleria Sperone, Turin, opens with the inaugural exhibition *Rotella, Mondino, Pistoletto, Lichtenstein*. Founder Gian Enzo Sperone would work with Ileana Sonnabend, in particular, introducing many American Pop artists to Italy and Italian artists to New York.

June
20–October 18. The *XXXII Biennale* is held in Venice. Italians whose work is exhibited include Carla Accardi, Enrico Baj, Ettore Colla, Pinot Gallizio, Gruppo N, Gruppo T, Mario Nigro, Gastone Novelli, Mimmo Rotella, Giuseppe Santomaso, and Toti Scialoja. The exhibition in the American pavilion is curated by Alan Solomon, who includes work by John Chamberlain, Jim Dine, Jasper Johns, Morris Louis, Kenneth Noland, Claes Oldenburg,

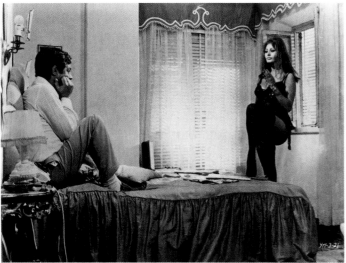

Clint Eastwood in Sergio Leone's Un pugno di dollari *(1964). The Museum of Modern Art, New York.*

Marcello Mastroianni and Sophia Loren in Vittorio De Sica's Ieri oggi domani, *1963. The Museum of Modern Art, New York.*

Hundreds of thousands gather at the funeral of PCI (Partito Comunista Italiano) leader Palmiro Togliatti in Rome in 1964; speakers include the vice secretary of the Communist Party, Luigi Longo, and Leonid Brezhnev, former President of the Soviet Union (behind the coffin are huge portraits of Togliatti and Antonio Gramsci). AP/Wide World Photos.

Robert Rauschenberg, and Frank Stella. Rauschenberg wins the grand prize and Accardi wins the Carena prize. The other winners are Andrea Cascella, Joseph Fassbinder, Zoltan Kemeny, Arnaldo Pomodoro, and Angelo Savelli.

28–October 6. Documenta III is held in Kassel, West Germany. Curated by Arnold Bode, the exhibition includes work by Afro [Afro Basaldella], Alberto Burri, Pietro Consagra, Marino Marini, Giò Pomodoro, Santomaso, and Emilio Vedova. Vedova exhibits *Spazio/Azione (Space/Action)*, a work made up of seven *Plurimi* coupled with recorded sound.

August
21. PCI (Partito Comunista Italiano/Italian Communist Party) leader Palmiro Togliatti dies in Yalta.

September
27. Tancredi [Parmeggiani Tancredi] commits suicide in Rome.

December
28. Giuseppe Saragat, of the PSDI (Partito Sociale-Democratico Italiano/Italian Social-Democratic Party), is elected President of Italy.

1965

Socialist deputy Loris Fortuna proposes a bill, which would pass in December 1970, allowing divorce after five years of legal separation. Following Catholic protests, however, a referendum that could overturn the decision would be held in May 1974. At that time, 59.1 percent would vote for legal divorce.

49 percent of Italian families own a television at this time, compared to 12 percent in 1958.

Carla Accardi's interest in color becomes pronounced; she begins painting with fluorescent colors on transparent plastic sheets.

Luciano Berio composes the theater piece *Laborintus II*, based on a collage of quotations from Dante, T. S. Eliot, Ezra Pound, and Edoardo Sanguineti.

Federico Fellini's *Giulietta degli spiriti* (released in English as *Juliet of the Spirits*) is released. The film, one of Fellini's most ornate exercises, tells the story of a bored middle-aged housewife (Giulietta Masina) who lives in a world of elaborate fantasies and dreams.

Marco Zanuso and Richard Sapper design the *Grillo (Cricket)* telephone for Siemens. The innovative design features a handset that folds over the rotary dial when not in use, a sophisticated concept that becomes popular in the 1960s.

January
11. Pino Pascali's first solo exhibition opens at Galleria La Tartaruga, Rome. Cesare Vivaldi writes the catalogue text.

February
20. An exhibition of work by Andy Warhol opens at Galleria Sperone, Turin. Warhol's work is included in numerous exhibitions in Italy during this period.

23–April 25. The Museum of Modern Art, New York, presents *The Responsive Eye*, curated by William Seitz, who coins the term Optical Art on the occasion of this show. The exhibition includes work by Getulio Alviani, Alberto Biasi, Enrico Castellani, Giovanni Antonio Costa, Piero Dorazio, GRAV, Gruppo N, Gruppo Zero, Edoardo Landi, and Enzo Mari. The show would travel to St. Louis, Seattle, Pasadena, and Baltimore.

April
Realtà dell'Immagine (Reality of the image) is held at the Libreria Feltrinelli, Rome. The exhibition includes work by Mario Ceroli, Jannis Kounellis, Pino Pascali, Mimmo Rotella, Mario Schifano, Cesare Tacchi, and Giulio Turcato.

Una Generazione (A generation) is held at Odyssia Gallery, Rome. The exhibition includes work by Valerio Adami, Franco Angeli, Rodolfo Aricò, Castellani, Lucio Del Pezzo, Tano Festa, Mari, Concetto Pozzati, Antonio Recalcati, and Mario Schifano.

V Rassegna Arti Figurative di Roma e del Lazio (Fifth review of figurative arts of Rome and Lazio) is held at the Palazzo delle Esposizioni, Rome. The exhibition includes work by Angeli, Mario Ceroli, Festa, Giosetta Fioroni, Kounellis, Sergio Lombardo, Renato Mambor, Mimmo Rotella, Schifano, and Cesare Tacchi.

20–May 10. Luciano Fabro has his first solo exhibition, *Della Falsità* (Of falsehood), at Galleria Vismara, Milan. Fabro, whose work often has a theoretical component, also writes the catalogue text. Lucio Fontana, who is very influential to many artists of this period and, together with Fausto Melotti, is especially important to Fabro, buys one of the works in the show.

October
Pino Pascali organizes a Happening at Galleria La Salita, Rome. Participants include Ceroli, Festa, Lombardo, Mambor, Schifano, and Tacchi.

23. An exhibition of work by Jim Dine opens at Galleria Sperone, Turin.

1966
The first sporadic student occupations of the universities in Trento, Naples, and Rome occur throughout the year.

Gruppo T and Gruppo N dissolve.

Mario Merz shifts away from painting to experiment with neon light. In 1967 he would begin creating work in which a variety of objects (such as raincoats, bottles, and umbrellas) are pierced with neon tubing.

Aldo Rossi's *L'architettura della città* (The architecture of

the city) and Vittorio Gregotti's *Il territorio dell'architettura* (The territory of architecture) are published. Both books are extremely influential in architectural theory and practice in Italy.

Ottagono (Octagon), a magazine of architectural, interior, and industrial design, begins publication in Milan.

Quaderni piacentini (Piacentini notebooks), Turin, publishes a series of articles on the Berkeley Free Speech Movement; the series has a great influence on the Italian student movement, especially in Turin.

Rivolta femminile (Feminine revolt), by the feminist group Demau, is published.

Michelangelo Antonioni's first English-language film, *Blow-Up*, with music by Herbie Hancock, is released. Set in hip London in the early 1960s, it centers on a successful young fashion photographer who inadvertently photographs what appears to be a murder. Based on a short story by Latin American writer Julio Cortázar, the film explores the theme of illusion and reality, and would become a great international success.

Marco Bellocchio's first film, *I pugni in tasca* (Fists in pockets; released in English as *Fist in His Pocket*), is released. Produced on a shoestring budget, the film—which symbolizes social decay through an emotionally ill middle-class family of epileptics—would establish Bellocchio as an important new Italian director.

Sergio Leone's *Il Buono il Brutto il Cattivo* (released in English as *The Good, the Bad and the Ugly*) is released. The Italian-American collaboration, starring Clint Eastwood, is a Western set during the American Civil War.

Pier Paolo Pasolini's film *Uccellacci e uccellini* (Good birds and bad birds; released in English as *The Hawks and the Sparrows*) is released. A picaresque tale of a father (the comic actor Totò) and son who set out on a St. Francis–like journey, the film explores the struggle between Marxist philosophy and Church doctrine.

Patrick de Barentzen develops a prêt-à-porter line, mainly for the American market. Both his prêt-à-porter and haute-couture lines would cease production in 1972.

January
Michelangelo Pistoletto holds an exhibition in his Turin studio of his *Oggetti in meno* (*Minus Objects*). These works include *Rosa bruciata* (*Burnt Rose*), *Paesaggio* (*Landscape*), *Sfera di giornali (Mappamondo)* (*Sphere of Newspapers {Globe}*), all late 1965–early 1966.

–February. Pino Pascali has a solo exhibition at Galleria Sperone, Turin, in which he exhibits his *Cannons* (nonfunctioning metal artillery). The catalogue includes texts by Vittorio Rubiù and Maurizio Calvesi.

March
Aspetti dell'Arte Italiana Contemporanea (Aspects of

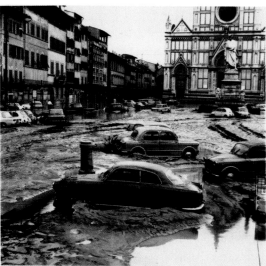

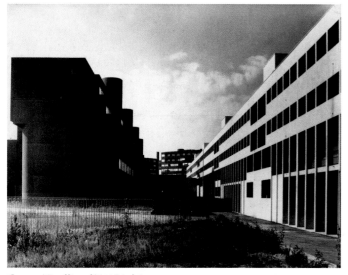

Gastone Novelli and Toti Scialoja at the 1966 exhibition of works by Novelli, Achille Perilli, Scialoja, and Cy Twombly at Galleria de'Foscherari, Bologna. Galleria de'Foscherari.

View of Piazza Santa Croce in Florence on November 6, 1966, two days after the Arno river overflowed, causing the worst flood in Italy's history. AP/Wide World Photos.

Carlo Aymonimo's Monte Amiata residential complex in Gallaratese, Milan, 1967–74; including a building by Aldo Rossi, 1969-73. Archivio Aymonino.

contemporary Italian art) is held at Galleria Nazionale d'Arte Moderna, Rome. The exhibition includes work by Carla Accardi, Valerio Adami, Getulio Alviani, Franco Angeli, Rodolfo Aricò, Enrico Baj, Alberto Burri, Giuseppe Capogrossi, Enrico Castellani, Mario Ceroli, Ettore Colla, Gianni Colombo, Pietro Consagra, Giovanni Antonio Costa, Lucio Del Pezzo, Tano Festa, Lucio Fontana, Jannis Kounellis, Sergio Lombardo, Francesco Lo Savio, Piero Manzoni, Enzo Mari, Gastone Novelli, Pino Pascali, Achille Perilli, Mimmo Rotella, Emilio Scanavino, Salvatore Scarpitta, Mario Schifano, Cesare Tacchi, and Giulio Turcato.

April

Marcatrè publishes an interview by Florentine critic Carla Lonzi with Luciano Fabro, who had been introduced to Lonzi by Castellani. Lonzi would become the link between Galleria Notizie, Turin (for which she is the curator), and Fabro, Kounellis, Giulio Paolini, and Pascali.

Pistoletto has a solo exhibition, co-organized by Martin Friedman and Dean Swanson, at the Walker Art Center, Minneapolis.

27. A student, Paolo Rossi, is killed in a clash with pro-Fascist students at La Sapienza, Università di Roma.

May

3. An exhibition of work by Piero Gilardi opens at Galleria Sperone, Turin. He exhibits his *Tappeti-Natura* (*Nature-Carpets*)—"carpets" made of artificial materials such as polyurethene resin that resemble natural environments—for the first time. The catalogue text is written by Michael Sonnabend.

24. Richard Serra's first solo exhibition opens at Galleria La Salita, Rome. Serra is living in Florence for a year on a Fulbright grant. His show, which includes work incorporating both live and stuffed animals, causes a scandal.

June

18. The XXXIII *Biennale* opens in Venice. Participants include Burri, Castellani, Ceroli, Sergio Dangelo, Del Pezzo, Piero Dorazio, Öyvind Fahlström, Fontana, Helen Frankenthaler, Gruppo Uno, Renato Guttuso, Johannes Itten, Ellsworth Kelly, Julio Le Parc, Roy Lichtenstein, Bruno Munari, Luca Patella, Pistoletto, Jesús Soto, and Turcato. Fontana is awarded the Gran Premio Internazionale. The other winners are Ezio Gribaudo, Masuo Ikeda, Robert Jacobsen, Le Parc, Etienne Martin, and Alberto Viani.

24–September 30. Cinquant'anni a Dada. Dada in Italia: 1916–66 (Fifty Dada years. Dada in Italy: 1916–66) is presented at Civico Padiglione d'Arte Contemporanea, Milan. The exhibition includes work by Baj, Gianfranco Baruchello, Colla, Roberto Crippa, Del Pezzo, Festa, Fontana, Manzoni, Edoardo Persico, Rotella, and Gianni Emilio Simonetti. The catalogue contains texts by Arturo Schwarz and Daniela Palazzoli and an anthology of writings by Dada artists.

July
Maurizio Fagiolo dell'Arco's *Rapporto 60* ('60s report), the first attempt to systematize recent Italian art, is published in Rome.

August
The *Nuclear Painting Manifesto*, written in 1952, is published in English translation in *Art and Artists* magazine, London.

September
23–October. Alberto Burri and Lucio Fontana, curated by Renée Sabatello Neu, is organized by the Museum of Modern Art, New York, for circulation within the United States and shown at Wells College, Aurora, New York; it would then travel to ten other venues.

October
Maurizio Calvesi's *Le due avanguardie* (The two avant-gardes), an important collection of essays on Modern art, is published in Rome.

29–November 21. Pascali has an exhibition, entitled *Nuove sculture* (New sculpture), at Galleria L'Attico, Rome, showing his sculptures based on animals. The catalogue texts are written by Alberto Boatto and Calvesi.

November
4. The Arno river floods Florence. Water levels reach fifteen feet, killing approximately seventy people, causing extensive damage to the city, and destroying and damaging hundreds of works of art. Venice is also badly flooded, with water levels reaching six feet.

1967
Some 60,000 immigrants from southern Italy arrive in Turin during the year. As vast numbers of laborers migrate northward in search of work, none of the major northern cities is able to accommodate them, which leads to a housing crisis. Compounding the problem is the local workers' hostility toward the southerners, who are generally unskilled and nonunionized. This resentment triggers a number of strikes by workers in many of the large industrialized cities of the North.

Joseph Beuys founds the German Student Party in Düsseldorf, West Germany. Beuys would come to have a profound influence on Italian art during the 1970s.

Zero Group dissolves.

Galleria Toninelli, Milan, holds an exhibition of Fausto Melotti's work. Melotti began working primarily in ceramics after World War II, and the exhibition presents some of his first sculptural works from the postwar period. It is very well received and has great influence on the younger generation of Italian artists.

Michelangelo Pistoletto starts a theater group, Zoo, which performs the Happening *Cocapicco e Vestitotiro* at Piper, a theater in Turin. They also perform *L'uomo ammaestrato*

several times in the course of the year on the streets of various cities, including Rome, Manarola, and Amalfi. For the latter performance, the actors dress as vagrants and "live" in the streets.

New York: The New Art Scene, a book documenting the New York avant-garde, with text by Alan Solomon and photographs by Ugo Mulas, is published in Milan and New York. Mulas met Leo Castelli and Solomon at the 1964 Venice *Biennale*. During 1964–65 he traveled to New York, where Castelli and Solomon introduced him to artists, collectors, and dealers; Mulas documented the scene in numerous black-and-white photographs, many of which appear in the book.

The Italian edition of Marshall McLuhan's *Understanding Media, I persuasori occulti*, is published.

Priest Don Lorenzo Milani's *Lettera a una professoressa* (Letter to a female professor), which examines the discriminatory nature of the Italian public school system, is published. The book would have a profound influence on the Italian student movement, which seeks to democratize the university system.

Pier Paolo Pasolini's film *Edipo Re* (released in English as *Oedipus Rex*) is released. Its unusual cast includes Julian Beck, of New York's Living Theater, and Pasolini himself.

Luchino Visconti's film *Lo straniero* (released in English as *The Stranger*), based on the novel *L'Etranger* by Albert Camus and starring Marcello Mastroianni and Anna Karina, is released.

Construction begins on Carlo Aymonino's Monte Amiata residential complex in Gallaratese, Milan (1967–74). Built in the suburbs of Milan, the complex is composed of dense residential blocks more reminiscent of urban structures. Its fanlike plan is based on the open-air theater. One of the large residential units is designed by Aldo Rossi.

The Paris Olivetti showroom, designed by Gae Aulenti, opens on rue Faubourg St.-Honoré.

The inflatable, transparent *Blow* chair is designed by Jonathan De Pas, Donato D'Urbino, and Paolo Lomazzi for Zanotta. Originally intended as a pool raft, it would become popular in the late 1960s as the quintessential accessory for Pop interiors.

January
Students occupy La Sapienza, Università di Roma, demanding a democratic system of representation at the university, like that of a trade union. By February the universities of Pisa, Milan, Turin, Florence, Bologna, and Naples would be occupied by students demanding educational reform.

Alighiero Boetti has his first solo exhibition, at Galleria Christian Stein, Turin.

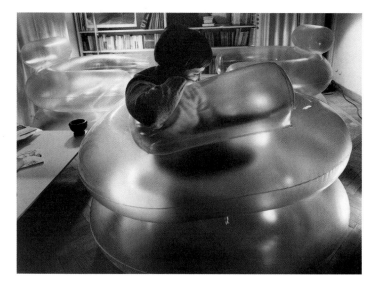

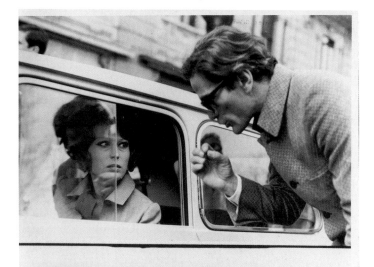

Jonathan De Pas, Donato D'Urbino, and Paolo Lomazzi, Blow *lounge chair, 1967. Photo by Toni Nicolini, courtesy of Archivio DDL.*

Germano Celant at the exhibition Arte Povera, *Galleria de' Foscherari, Bologna in 1968. Archivio de'Foscherari.*

Pier Paolo Pasolini directing Silvana Mangano in Teorema, *1968. The Museum of Modern Art, New York.*

February
14–March 15. Dan Flavin has his first solo exhibition in Italy, at Galleria Sperone, Turin.

March
11–April 8. Jannis Kounellis has an exhibition at Galleria L'Attico, Rome. Entitled *Il giardino/i giochi* (The garden/the games), the show contains a series of large canvases with snap-on cotton roses. The largest work is a canvas framed by twenty-four birdcages housing live birds.

April
Students occupy the Istituto Universitario di Architettura di Venezia.

–May. Situation, an exhibition of work collected by Eugenio Battisti and donated to the city of Turin, is presented at Galleria Civica d'Arte Moderna, Turin. Two hundred and seven artists are represented, among them Alighiero Boetti (who would soon begin signing his name Alighiero e Boetti), Enrico Castellani, Luciano Fabro, Gruppo T, Kounellis, Piero Manzoni, Mario Merz, Concetto Pozzati, and Mimmo Rotella. The catalogue contains texts by Battisti, Germano Celant, Luigi Mallè, and Aldo Passoni.

May
24. Tom Wesselmann's first solo exhibition in Italy opens, at Galleria Sperone, Turin.

June
Students occupy the Università di Torino for six days.

The first issue of the magazine *Flash*, founded and directed by Giancarlo Politi, is published in Milan. (*Flash*'s name would change to *Flash Art* with its fourth issue. The fifth issue [November–December 1967] would present the first reports from other European countries and New York, and the English-language international edition would begin publication in 1979.)

8. Lo spazio degli elementi. Fuoco, immagine, acqua, terra (The space of the elements. Fire, imagination, water, earth) opens at Galleria L'Attico, Rome. The exhibition, which is curated by Alberto Boatto and Maurizio Calvesi, includes work by Umberto Bignardi, Mario Ceroli, Gilardi, Kounellis, Pino Pascali, Pistoletto, and Mario Schifano.

Marisa Merz has her first solo exhibition, at Galleria Sperone, Turin. She exhibits *Senza titolo* (*Untitled*, 1966), a sculpture made of aluminum sheets.

July
The *VI Biennale* of San Marino, entitled *Nuove tendenze dell'immagine* (New tendencies of the image), includes work by Getulio Alviani, Gianfranco Baruchello, Castellani, Ceroli, Lucio Del Pezzo, Gruppo Uno, Pascali, Luca Patella, Pistoletto, Rotella, Paolo Scheggi, and Schifano.

Lo spazio dell'immagine (The space of the image), the first exhibition of contemporary installations presented in a historical setting, organized by Umbro Apollonio, Calvesi,

Giorgio de Marchis, and Gillo Dorfles, is held at the Palazzo Trinci, Foligno. Fabro's *In cubo* (literally *In Cube*, although *incubo* is the Italian for nightmare) is shown in a small gallery decorated with medieval frescoes.

September
27–October 20. Arte Povera—*IM Spazio*, curated by Celant, is held at Galleria La Bertesca, Genoa. The two-part exhibition unites work by diverse groups working in Rome, Milan, Turin, and Genoa according to underlying commonalities. The *IM Spazio* section of the exhibition includes work by Umberto Bignardi, Ceroli, Paolo Icaro, Renato Mambor, Eliseo Mattiacci, and Cesare Tacchi. The *Arte Povera* section includes work by Boetti, Fabro, Kounellis, Giulio Paolini, Pascali, and Emilio Prini. "Arte Povera," a term coined by Celant, is used here for the first time to identify work employing rough or base materials, often in contrast with industrial ones, and often in direct relation to the human body. Celant would later state that the definition of Arte Povera would have to be sufficiently versatile to incorporate many differing and complex forms, as Arte Povera is a way of being and not a definable art movement. (Celant's *Art Povera* would be published in New York in 1969; in this broad and international survey, he would discuss work by Joseph Beuys, Walter De Maria, Fabro, Kounellis, Richard Long, Robert Morris, Pistoletto, Lawrence Weiner, and the theater group Zoo. In 1971 Celant would argue for a suspension of the use of the term to avoid hindering artists from pursuing unique paths.)

November
Students occupy the Università di Napoli and the Università di Milano.

Celant's essay "Arte povera, appunti per una guerriglia" (Arte Povera, notes for a guerilla war)—in which he draws a parallel between the radical quality of this new artistic tendency and the Italian social revolution of the same period—is published in *Flash Art*.

14. Gilberto Zorio's first solo exhibition opens, at Galleria Sperone, Turin. The catalogue text is written by Tommaso Trini.

28–December 14. Ugo Mulas has his first solo exhibition, at Galleria Il Diaframma, Milan.

December
The first issue of *Pianeta fresco* (Fresh planet) is published. (The second, final issue would be published in 1968.) The magazine, edited by Fernanda Pivana and Allen Ginsberg, would cover a wide variety of subjects, from designs by young architects and poems by Italian and American poets to songs by Bob Dylan. Three hundred copies of each trilingual issue (English, Italian, and Japanese) would be produced and distributed by hand.

4. Con temp l'azione (Contemplation/With time action), curated by Daniela Palazzoli, opens in three galleries—Galleria Il Punto, Galleria Christian Stein, and Galleria Sperone—in Turin. The exhibition includes work by Getulio Alviani, Giovanni Anselmo, Boetti, Fabro, Mario

Merz, Aldo Mondino, Ugo Nespolo, Gianni Piacentino, and Pistoletto.

13–21. The second Arte Povera exhibition, *Collage 1*, curated by Celant, is held at the Istituto della Storia d'arte, Genoa, and includes work by Anselmo, Boetti, Ceroli, Fabro, Piero Gilardi, Icaro, Mambor, Paolini, Pascali, Gianni Piacentino, Pistoletto, Prini, Gianni Emilio Simonetti, Cesare Tacchi, and Zorio. In conjunction with the opening, the Istituto holds a debate, in which Boetti, Celant, Mambor, Prini, and others participate.

1968
Ettore Colla dies in Rome.

Casa Vogue (Vogue home), a magazine of contemporary interior design, begins semi-annual publication in Milan, under the direction of Franco Sartori.

Pier Paolo Pasolini's *Teorema* (Theorem; released in English as *Teorema*) is released. The film follows an allegorical story of a young, seductive stranger who visits a middle-class family and profoundly affects their traditional lives and values.

Sergio Leone's Western *C'era una volta il West* (released in English as *Once Upon a Time in the West*) is released.

Joe Colombo's stacking chair is manufactured by Kartell. Colombo's functional plastic design allows for easy moving and storage. The removable legs can be substituted with legs of different dimensions to create chairs of varying heights.

Paolo Gatti, Cesare Paolini, and Franco Teodoro design the *Sacco* (*Sack*) beanbag chair, which would become a Pop culture icon.

January
A series of earthquakes in Sicily leave more than 200 people dead and some 50,000 homeless. The United States offers aid and its congress proposes a bill to facilitate the immigration of earthquake victims to the United States.

Alighiero Boetti publishes a manifesto listing the names of artists of his generation: Boetti himself, Mario Ceroli, Luciano Fabro, Piero Gilardi, Jannis Kounellis, Mario Merz, Aldo Mondino, Ugo Nespolo, Giulio Paolini, Pino Pascali, Gianni Piacentino, Michelangelo Pistoletto, Mario Schifano, Gianni Emilio Simonetti, and Gilberto Zorio.

19–February 8. Mario Merz has an exhibition at Galleria Sperone, Turin, where he exhibits his assemblages. The catalogue text is written by Germano Celant.

February
The occupation of Italian universities continues; clashes between students and police occur throughout Italy.

24–March 15. Arte Povera, curated by Celant, is held at Galleria de' Foscherari, Bologna. The exhibition includes

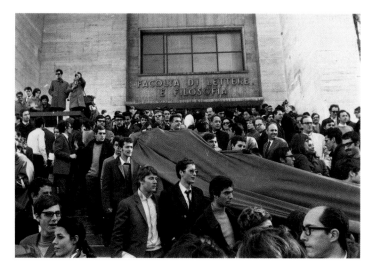

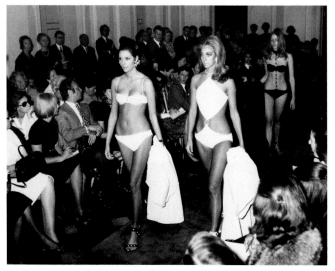

Student protest at the University of Rome in March 1968. AP/Wide World Photos, New York.

Gilberto Zorio inside a work by Michelangelo Pistoletto at the exhibition Arte Povera *at Galleria de' Foscherari, Bologna in 1968. Archivio de'Foscherari.*

Alighiero Boetti (left) and Giulio Paolini (right) at the exhibition Arte Povera *at Galleria de' Foscherari, Bologna in 1968. Archivio de'Foscherari.*

A bathing-suit fashion show presented by Emilio Pucci at the November 6, 1968 opening of the 1969 Spring-Summer ready-to-wear fashion show in Florence. AP/World Wide Photos.

work by Boetti, Fabro, Kounellis, Paolini, Pascali, and Emilio Prini (all of whom had exhibited in the first Arte Povera exhibition in 1967), as well as Giovanni Anselmo, Mario Merz, Piacentino, Pistoletto, and Zorio.

March
23–April 16. Percorso (Route), a group show including work by Anselmo, Boetti, Mario Merz, Ugo Nespolo, Paolini, Gianni Piacentino, Pistoletto, and Zorio, is held at the Arco d'Alibert Gallery, Rome.

April
Strikes occur at Fiat factories in Italy.

I materiali (Materials), which includes work by Claudio Cintoli, Laura Grisi, Kounellis, Sergio Lombardo, Mario Merz, and Maurizio Mochetti, is held at Galleria Qui Arte Contemporanea, Rome.

Anselmo has his first solo exhibition, at Galleria Sperone, Turin. The exhibition catalogue contains texts by Celant and Maurizio Fagiolo dell'Arco.

29. An exhibition of work by Fabro, Kounellis, and Paolini, organized by art critic Marisa Volpi, opens at Qui Arte Contemporanea, Rome. Including numerous works by each artist, Volpi creates, in effect, three solo shows representing distinct areas in Italy: Milan (Fabro), Turin (Paolini), and Rome (Kounellis). Qui Arte Contemporanea sponsors a roundtable discussion on the evening of the opening, which includes the three artists and Volpi as well as Alberto Boatto, Maurizio Calvesi, and Giovanni Carandente.

May
A series of strikes begins at the Fiat plant in Turin, with workers demanding a forty-hour work week. Many students also picket in support of the workers. The Student-Worker League of Turin is formed, marking the beginning of the worker-student alliance. (Whereas in France the student protests last about eight weeks, the student movement in Italy would last for several years. By the end of 1969 Italian students would begin to form political groups, some of which would be militant; in the summer of 1970, the Red Brigade—the most radical of these groups—would form and begin a series of bombing attacks.)

General elections are held in Italy. The distribution of seats is: DC (Democrazia Cristiana/Christian Democratic party), 39 percent; PCI (Partito Comunista Italiano/Italian Communist Party), 26.9 percent; and PSI (Partito Socialista Italiano/Italian Socialist Party), 14.5 percent.

Students occupy the *XIV Triennale*. The scheduled exhibition of installations by young artists (including Fabro), *Nuovo paesaggio* (New landscape), is canceled.

24–September 2. Recent Italian Painting and Sculpture, curated by Kynaston McShine, is held at the Jewish Museum, New York. The exhibition includes work by Carla Accardi, Alberto Burri, Giuseppe Capogrossi, Ettore Colla, Pietro Consagra, Lucio Fontana, and Mimmo Rotella.

June
22–September 30. The *XXXIV Biennale* is held in Venice. Included is work by Pascali and Leoncillo [Leoncillo Leonardi] (each of whom has a solo show), Valerio Adami, Arman, Anthony Caro, Ceroli, Jasper Johns, Donald Judd, Yves Klein, Roy Lichtenstein, Francesco Lo Savio, Gastone Novelli, Achille Perilli, Robert Rauschenberg, Bridget Riley, Nicolas Schöffer, and Andy Warhol. Gianni Colombo, Horst Janssen, Pascali, Riley, and Schöffer win prizes. (This is the final year that grand prizes are awarded by the *Biennale*.) The central pavilion is closed due to student protests (Emilio Vedova takes part) and Novelli, Pistoletto, and others withdraw their work.

24. Giovanni Leone, of the DC, becomes Prime Minister of Italy.

September
The *Assemblea Nazionale del Movimento Studentesco* (National assembly of the students' movement) is held in Venice.

Prospect 68, organized by Konrad Fischer and Hans Strelow, who invited fifteen American and European dealers to select work that represented a new artistic direction, is held at the Kunsthalle, Düsseldorf. Gian Enzo Sperone and Ileana Sonnabend together exhibit Arte Povera artists Anselmo and Zorio with Americans Robert Morris and Bruce Nauman.

3. Leoncillo dies in Rome.

7. Fontana dies in Comabbio, Varese.

11. Pascali dies in Rome.

October
4–6. *Arte Povera Più Azioni Povere* (Arte Povera plus poor actions) is held at the Arsenali dell'Antica Repubblica, Amalfi. "Actions" (similar to Happenings but with political implications) take place around the city. These events coincide with the most intense phase of the student occupations. A discussion is held in conjunction with the exhibition, and critics Celant, Achille Bonito Oliva, Gillo Dorfles, Filiberto Menna, Daniela Palazzoli, Angelo Trimarco, and Tommaso Trini participate.

November
6. Emilio Pucci presents his 1969 swimsuit line in Florence.

December
4–28. *Nine in a Warehouse* is held at the warehouse space of the Leo Castelli Gallery, New York. The exhibition, curated by Morris, includes work by Bill Bollinger, Alan Saret, and Richard Serra, as well as Eva Hesse, Stephen Kaltenbach, Nauman, Keith Sonnier, and the Italians Anselmo and Zorio. (The Italians' work is presented with American anti-form artists for the first time in the United States.)

13. Mariano Rumor, of the DC, becomes Prime Minister of Italy.

I would like to thank the following individuals for their assistance: Marta Arzac, Gaia Battaglioli, Camilla Bertoni, Jenny Blessing, Vivien Greene, Micaela Martegani Luini, Marta García Maruri, Maura Pozzati, and Hilde Werkschkul.

Manifesto del realismo di pittori e scultori
(Manifesto of realism for painters and sculptors)

1. Painting and sculpting is for us an act of participation in the total reality of mankind, in a specific time and place, a reality that is contemporaneity and, in its continuity, history.

We therefore consider the positive function of individualism to be exhausted, and we reject those aspects in which it has become corrupted (escape, sensibility, intuition).

2. Reality exists objectively, and man is part of it.

3. In art, reality is not the real, it is not visibility, but rather the conscious emotion of the real become organism. Through this process the work of art acquires its necessary autonomy.

Realism therefore does not mean naturalism or verism or expressionism, but rather the concretized reality of one person, when this participates in, coincides with, and is equivalent to the reality of others; when it becomes, in short, a common measurement of reality itself.

4. This common measurement does not imply a common subjection to preestablished canons, in other words, a new academy, but rather the common elaboration of identical formal premises.

5. These formal premises have been provided us, in painting, by the process that runs from Cézanne to *Fauvism* (the rediscovery of the origins of color) and *Cubism* (the rediscovery of structural origins).

The means of expression are, therefore: line and plane rather than module and modeling; the painting's rhythm and reasons rather than perspective and perspectival space; color in and of itself, with its laws and prerogatives, rather than tone, ambience, atmosphere.

Sculpture has not undergone a comparable process: while the cycles of the great civilizations came to a close with Michelangelo, sculpture nevertheless carried on, exhausting its characteristic features, up to the point of Impressionism (Medardo Rosso), which marked its final contradiction of itself. Today we declare that the means of expression are: construction and architecture of volumes in space, construction and architecture that determine weight.

6. We further declare that the role of galleries has been exhausted, for their reasons for existing are purely mercantile, and they force and bind art to a restricted, predetermined category. The reality that we must express involves all people and therefore requires the possibility of being concretized by every suitable means.

Today these means are—as they once were for the great civilizations of Egypt, Greece, and the Middle Ages— great walls and blocks of stone, or even the single square or single sculpture, so long as they form part of a broader organism relating to the common activity and the common need.

The new reality will of necessity establish among architects, painters, and sculptors a plan of agreement that will make it possible for us to create a figurative equivalent

to the temples of the Greeks and the cathedrals of the Christians.

Milan, February 1946.
Giuseppe Ajmone, Rinaldo Bergolli, Egidio Bonfante, Gianni Dova, Ennio Morlotti, Giovanni Paganin, Cesare Peverelli, Vittorio Tavernari, Gianni Testori, Emilio Vedova.

First appeared in *Numero* (Number), Milan, 2, no. 2 (March, 1946).

Manifiesto blanco
(White manifesto)

We are carrying forward the evolution of art

Art is in a period of dormancy. There is a force man cannot reveal. We are expressing it literally in this manifesto.

For this reason we ask all the world's men of science who know that art is a need vital to the species to direct part of their research toward the discovery of that luminous and malleable substance and of instruments that will produce sound, which will allow the development of four-dimensional art.

We will supply the researchers with the necessary documentation.

Ideas cannot be refuted. They exist within society in germ form; then thinkers and artists express them.

All things arise out of necessity and have a value in their time.

Throughout history, transformations in the material conditions of life have determined man's psychic states.

The system that has directed civilization since its beginnings is now undergoing a transformation.

Its place is being occupied, progressively, by the system opposite to it in its essence and in all forms. All the conditions of society's life and the lives of each individual will change. Every man will live according to an integral organization of labor.

The enormous discoveries of science lead inexorably to that new organization of life.

The discovery of new physical forces, the domination of matter and space gradually imposes conditions on man that never before existed in history. The application of those discoveries to all the forms of life produces a modification in man's nature. Man is acquiring a different psychic structure.

We are living the age of mechanics.

Painted cardboard and erect plaster no longer make any sense.

Ever since the known forms of art were discovered, an analytic process has been carried out within each art during different moments of history. Each art had its ordering systems independent of the others.

All possibilities were known and developed, everything that could be expressed was expressed.

Identical conditions of the spirit were expressed in music, in architecture, in poetry.

Man divided his energies into different manifestations responding to that need for knowledge.

Idealism was practiced when existence could not be explained in a concrete fashion.

The mechanisms of nature were unknown. The processes of intelligence were known. Everything rested on the possibilities peculiar to intelligence. Knowledge consisted in tangled speculations that very rarely reached the truth.

The plastic arts consisted of ideal representations of known forms, of images to which reality was ideally attributed. The spectator imagined one object behind the other, imagining the difference between the muscles and the clothing represented.

Today, experimental knowledge is replacing imaginative knowledge. We are conscious of a world that exists and that is explained in its own terms, and that cannot be modified by our ideas.

We need an art valid for itself. An art in which the idea we may have of it does not intervene.

The materialism established in all consciousness requires an art that possesses its own values, distanced from representation, which today is merely a farce. We men of this century, forged in that materialism, have grown insensible to the representation of known forms and the narration of constantly repeated experiences. Abstraction was conceived, which was reached progressively through deformation.

But this new state of things does not satisfy the demands of today's man.

What is needed is a change in essence and in form. What is needed is the transcending of painting, of sculpture, of poetry, and of music. We need a greater art that is in accord with the demands of the new spirit.

The fundamental conditions of modern art can be clearly seen from the thirteenth century, when the representation of space begins. The great masters who appear thereafter give a new impetus to that tendency. Space is represented with greater and greater amplitude over the course of several centuries.

Baroque artists in this sense make a leap forward: They represent space with a a grandeur that is yet to be outdone and add to the plastic arts the idea of time. The figures seem to leave the plane and to continue the represented movements in space.

This conception was the result of the concept of existence that was forming in man. The physics of that period explained, for the first time, nature through dynamics. It was determined that movement is a condition immanent to matter as a principle of the comprehension of the universe.

Once this stage in development was reached, the need for movement was so great that the plastic arts could not respond to it. So the development was continued by music. Painting and sculpture entered the neoclassical period, a genuine mire in the history of art, and were reduced to nothing by the art of the age. Once time was conquered, the need for movement was revealed completely. The progressive liberation from the canons of art gave music an ever greater dynamism (Bach, Mozart, Beethoven). Art continued developing in the sense of movement.

Music retained its preeminence for two centuries, and since Impressionism it has had a parallel development to the plastic arts. *Since then the evolution of man is a march toward movement developed in time and space. In painting, those elements that do not allow the impression of dynamism are progressively suppressed.*

The Impressionists sacrificed drawing and composition. In Futurism, some elements were eliminated and others lost their importance because they were subordinated to sensation. Futurism adopted movement as its only principle and only goal. The Cubists denied that their painting was dynamic; the essence of Cubism is the vision of nature in movement.

When music and the plastic arts combine their development in Impressionism, music is based on plastic sensations, painting seems dissolved in an atmosphere of sound. In the majority of Rodin's works, we see that the volumes seem to spin in that same atmosphere of sound. His conception is essentially dynamic and often reaches an exacerbation of movement. And in recent times, hasn't the "form" of sound been intuited—Schoenberg? Hasn't there been a coincidence or correlation of "sonorous planes"—*Scriabin?* The similarity between Stravinsky's forms and Cubist planimetry is obvious. Modern art finds itself at a movement of transition in which a break with previous art is required to make way for new conceptions. This condition, seen through a synthesis, is the step from the static to the dynamic. Located in that transition, art could not detach itself completely from its Renaissance heritage. It used the same materials and the same disciplines to express a completely transformed sensibility. Traditional elements were employed in an opposite sense. They were opposed forces struggling against each other. The known and the unknown, the future and the past. For that reason, tendencies multiplied, supported by opposing values and seeking apparently different objectives. We gather up that experience and project it toward a clearly visible future.

Aware or unaware of this search, modern artists could not reach this goal. They lacked the technical means necessary to give movement to bodies, being only able to give movement in an illusory way by representing it using conventional means.

Thus was determined the need for new technical resources which would allow the sought-for objective to be attained. This circumstance, linked to the development of mechanics, has produced cinema, and its triumph is one more testimony to the orientation taken by the spirit toward the dynamic.

Man is tired of pictorial and sculptural forms. Their own experiences, their overwhelming repetitions testify to the fact that these arts are fixed in values alien to our civilization, with no possibility of developing in the future.

The tranquil life has disappeared. The notion of rapidity is constant in man's life.

The artistic era of colors and paralytic forms is coming to an end. Man is becoming more and more insensible to stock images with no signs of vitality. The old, immobile images do not satisfy the appetites of the new man formed in the need for action, in constant contact with mechanics, which imposes on him a constant dynamism. The esthetic of organic movement replaces the worn-out esthetic of fixed forms.

Invoking this mutation which has taken place in the nature of man, in the psychic and moral changes, and in all human relationships and activities, *we are abandoning the practice of known forms of art and embarking on the development of an art based on the unity of time and space.*

The new art takes its elements from nature.

Existence, nature, and matter are a perfect unity. They develop in time and space.

Change is the essential condition of existence.

Movement, the property of evolving and developing, is the basic condition of matter. This exists in movement and in no other way. Its development is eternal. Color and sound are found in nature connected to matter.

Matter, color, and sound in movement are the phenomena whose simultaneous development makes up the new art.

Color in volume developing in space, taking on successive forms. Sound produced by as yet unknown devices. Musical instruments do not respond to the need for great sonorities and do not produce the required sensations of amplitude.

The construction of voluminous forms in mutation by means of a plastic, malleable substance.

Arranged in space, they act in synchronic form, making up dynamic images.

Thus we exalt nature in all its meaning.

Matter in movement manifests its total and eternal existence, developing in time and in space, adopting as it mutates different states of existence.

We conceive man in his re-encounter with nature, in his need to link himself to nature in order to take up once again the exercise of its original values. We postulate a complete comprehension of the primary values of existence, which is why we restore to art the solid values of nature.

We present the substance not the superfluities. We do not represent man, the other animals, or other forms. They are only manifestations of nature and will mutate over time, change and disappear according to the succession of phenomena. Their physical and psychic conditions are subject to matter and its evolution. We turn our attention to matter and its evolution, the generative sources of existence.

We take the energy specific to matter, its need to exist and develop.

We postulate an art free of all esthetic artifice. We practice what man has in him that is natural, true. We reject the esthetic falsities invented by speculative art.

We place ourselves close to nature, closer than art has ever been in its history.

Loving nature does not impel us to copy it. The feeling of beauty the form of a plant or a bird brings us or the sexual feeling the body of a woman brings us develops and works within man according to his sensibility. We reject the private emotions specific forms produce in us. Our intention is to take into account all of man's settings which, united with the function of his natural conditions, constitute a manifestation of being.

We take as a beginning the first artistic experiences. Those prehistoric men who first perceived a sound produced by blows made on an empty form were entranced by its rhythmic combinations. Impelled by suggestive powers of the beat, they must have danced until they were intoxicated. Everything in primitive men was sensation. Sensation in the face of unknown nature, musical sensations, rhythmic sensations. Our intention is to develop that original condition of man.

The subconscious, a magnificent receptacle where all the images understanding perceives are stored, adopts the essence and the forms of those images, stores the ideas that make up the nature of man. Thus, when the objective world changes, what the subconscious assimilates also changes, all of which produces modifications in the form of conceiving man.

The historical heritage received from those stages prior to civilization along with our adaptation to new conditions of life functions through that working of the subconscious. The subconscious molds the individual, integrates him, and transforms him. It gives him the ordering it receives from the world, which the individual adopts. All artistic conceptions derive from the functioning of the subconscious.

The plastic arts developed on the basis of the forms of nature. The manifestations of the subconscious adapted to them completely because of the idealist conception of existence.

The materialist consciousness, that is, the need for clearly provable things, demands that forms of art arise directly from the individual, thus suppressing adaptation to natural forms.

An art based on forms created by the subconscious, balanced by reason, constitutes a true expression of being and a synthesis of the historical moment.

The position of the rationalist artists is false. In their effort to impose reason and to deny the function of the subconscious, they only manage to make its presence less visible. In each one of their works, we note that this faculty has functioned.

Reason does not create. In the creation of forms, its function is subordinated to that of the subconscious.

In all activities, man functions with the totality of his faculties. The free development of all of them is a fundamental condition in the creation and interpretation of the new art. Analysis and synthesis, meditation and spontaneity, construction and sensation are all values that participate in their integration within a functional unity. And their development in experience is the only road that leads to a full revelation of being.

Society suppresses any separation of its forces and integrates them into a single, greater force. Modern science is based on the progressive unification of its elements.

Humanity unites its values and knowledge. This is a movement that has been rooted in history for several centuries of development.

Out of this new state of awareness arises an integral art in which being functions and reveals itself in its totality.

After several millennia of analytic artistic development, the moment of synthesis has arrived. Before, the separation was necessary. Today it constitutes the disintegration of the conceived unity.

We conceive the synthesis as a sum total of physical elements: color, sound, movement, time, space, all making up a psycho-physical unity. Color, the element of space, sound the element of time, and the movement that develops in time and in space, are the fundamental forms of the new art, which contains the four dimensions of existence. Time and space.

The new art requires the functioning of all the energies of man, both in creation and in interpretation. Being reveals itself completely, with the plenitude of its vitality.

Buenos Aires, 1946.
Bernardo Arias, Horacio Cazeneuve, Marcos Fridman, Pablo Arias, Rodolfo Burgos, Enrique Benito, César Bernal, Luis Coll, Alfredo Hansen, Jorge Rocamonte.

Manifesto di fondazione della nuova secessione artistica italiana
(Founding manifesto of the Nuova Secessione Artistica Italiana) [Excerpt]

Eleven Italian artists, replacing the aesthetics of form with a dialectics of form, intend to make their efforts—which are only apparently contrasting—converge toward a synthesis that will be recognizable only in the future of their works, in sharp contrast to all prior syntheses reached through theoretical or a priori decisions; they intend to make their observations and individual affirmations in the world of images approach an initial foundation of ethical and moral necessity, bringing them together as acts of life. Painting and sculpture, having thus become tools of declaration and free exploration of the world, shall attend reality in ever greater degree. Art is not the conventional face of history, but history itself, which cannot do without people.

Venice, 1 October 1946.
Renato Birolli, Bruno Cassinari, Renato Guttuso, Carlo Levi, Leoncillo Leonardi, Ennio Morlotti, Armando Pizzinato, Giuseppe Santomaso, Giulio Turcato, Emilio Vedova, Alberto Viani.

Manifesto del gruppo di Forma
(Manifesto of the Forma group)

We hereby proclaim ourselves *formalists* and *Marxists*, convinced as we are that the terms Marxism and formalism are not *irreconcilable*, especially today, when the progressive elements of our society must maintain a *revolutionary and avant-garde* position instead of settling into the mistake of a spent and conformist realism that in its most recent experiences in painting and sculpture has shown what a limited and narrow road it really is.

The need to bring Italian art to the level of the current European language forces us to take a clear-cut position against every silly and biased nationalist ambition and against the gossipy and useless province that present-day Italian culture is today.

For these reasons, we assert that:

I) In art the traditional, inventive reality of pure form is all that exists.

II) We recognize formalism as the only means to avoid decadent, psychological, and expressionistic influences.

III) The painting, the sculpture, have as their means of expression color, draughtsmanship, plastic masses, and as their goal a harmony of pure forms.

IV) Form is a means and an end; the painting must also be able to function as a decorative complement to a bare wall, and the sculpture as a furnishing in a room—the goal of a work of art is usefulness, harmonious beauty, weightlessness.

V) In our work we use the forms of objective reality as means to attain objective abstract forms; we are interested in the form of the lemon, and not the lemon.

We reject:

1) Every tendency aimed at inserting human details in the free creation of art, by the use of deformations, psychologisms, and other contrivances; the human is determined through the form created by man-as-artist and not by his a posteriori preoccupations with contact with other men. Our humanity is realized through the act of life and not through the act of art.

2) Artistic creation that posits nature, sentimentally intended, as the starting point.

3) Everything not of interest to the goals of our work. Every assertion of ours originates from the need to divide artists into two categories: those of interest to us, who are positive, and those not of interest to us, who are negative.

4) The arbitrary, the apparent, the approximative, sensibility, false emotionality, psychologism, spurious elements that compromise free creation.

Rome, 15 March 1947.
Accardi, Attardi, Consagra, Dorazio, Guerrini, Perilli, Sanfilippo, Turcato.

First appeared in *Forma 1. Mensile di arti figurativi* (Form 1. Monthly of figurative arts), Rome, April 1947.

Primo manifesto dello spazialismo
(First manifesto of Spazialismo)

Art is eternal, but it cannot be immortal. It is eternal inasmuch as any gesture on its part, like any other kind of completed gesture, cannot continue to linger in man's spirit like a self-perpetuating race. Thus paganism, Christianity, and everything that has had to do with the spirit are completed, eternal gestures that remain and will forever remain in man's spirit. Yet the fact of being eternal in no way means being immortal. Indeed, art is never immortal. It may live for a year or for millennia, but the hour of its material destruction will always come. It will remain eternal as gesture, but will die as material. Now, we have reached the conclusion that until today artists, whether conscious or unconscious, have always confused the terms *eternity* and *immortality*, and thus have always sought, for every art, the material most likely to make it last longest; they have, that is, remained conscious or unconscious victims of material; they have let the pure, eternal gesture devolve into the lasting gesture, in the vain hope of achieving immortality. We believe we can free art from material, to free the sense of the eternal from the preoccupation with immortality. And it does not matter to us if a gesture, once completed, lives but a moment or a millennium, because we are truly convinced that, once completed, it is eternal.

Today the human spirit aspires, in a transcendent reality, to transcend the particular to arrive at the United, the Universal, through an act of the spirit freed from all material. We refuse to think of science and art as two distinct phenomena; that is, we refuse to consider that the gestures completed by one of the two disciplines might not also belong to the other. Artists prefigure scientific acts, and scientific acts always provoke artistic acts. Neither radio nor television could have sprouted from the human spirit without the existence of an urgency that, arising from science, tends to art. It is impossible for man not to pass from canvas, bronze, plaster, plastiline to the pure image of air, universal and suspended, just as it was impossible not to pass from graphite to the canvas, to bronze, plaster, and plastiline, without in any way negating the eternal validity of the images created with graphite, bronze, canvas, plaster, and plastiline. It will not be possible to adapt to new demands the images already fixed by the demands of the past.

We are convinced that, hereafter, nothing of the past will be destroyed, neither means nor ends; we are convinced that people will continue to paint and sculpt even with the materials of the past, yet we are equally convinced that these materials, hereafter, will be confronted and regarded with different hands and different eyes, and will be imbued with a keener sensibility.

Milan, May 1947.
Beniamino Joppolo, Lucio Fontana, Giorgio Kaisserlian, Milena Milani.

Secondo manifesto dello spazialismo
(Second manifesto of Spazialismo)

The work of art is destroyed by time.

When, in the final pyre of the universe, time and space also cease to exist, no memory will remain of the monuments erected by man, even though not a single hair from his head will have been lost.

But we do not wish to abolish the art of the past or to stop life: we want the painting to come out from its frame and the sculpture from its bell jar. A minute's airy expression of art is the same as if it had lasted a millennium, in eternity.

To this end, using the resources of modern technology, we shall make appear in the sky:
artificial forms,
rainbows of wonder,
luminous writings.

If, at first, the artist, shut up in his tower, represented himself and his amazement and saw the landscape only through the panes of glass and later, descending from his castles and into the cities, knocking down walls and mixing with other men, he saw the trees and objects from up close, today we, the spatial artists, have fled our cities, broken our shells, our physical crust, and seen ourselves from above, photographing the Earth from flying rockets.

By this we do not mean to glorify the primacy of our minds over this earth; rather, we wish to recover our true face, our true image, a transformation anxiously awaited by all creation.

The spirit casts its light, in the freedom that has been granted us.

Milan, 18 March 1948.
Lucio Fontana, Gianni Dova, Beniamino Joppolo, Giorgio Kaisserlian, Antonino Tullier.

Manifesto del gruppo Origine
(Manifesto of the Gruppo Origine)

Among the many and often divergent tendencies in the painting and sculpture of our time, within the limits of their "nonfigurative" aspects, the Gruppo Origine aims to distinguish itself from the rest, starting with certain specific exigencies of expression.

In the face of the historic course of "abstractionism," now considered an artistic question resolved and concluded, both in its stance of reaction against all content-oriented figuration and as a development in a direction ever more oriented, as a whole, toward decorative and, in short, manneristic complacency, the Gruppo Origine aims to reestablish and repropose the morally most valid starting point of the "nonfigurative" exigencies of expression.

In other words, in the very renunciation of an openly three-dimensional form, in the reduction of color to its simplest though peremptory and incisive expressive function, in the evocation of graphic nuclei, lineations, and pure and elementary images, the artists of our *group* express the necessity of a rigorous, coherent, and energy-rich vision. One, however, that is above all antidecorative and thus averse to any complacent allusion to a form of expression that is not one of humble but concrete concentration, precisely inasmuch as it is decidedly founded upon the spiritual significance of the "moment of departure" and its human reassertion deep within the consciousness of the artist.

Rome, January 1951.
Capogrossi, Ballocco, Colla, Burri.

Manifesto tecnico dello spazialismo
(Technical manifesto of Spazialismo)

We are carrying on the evolution of the medium in art

All things arise out of necessity and exploit the needs of their age. Transformations of the material means of life determine man's states of mind throughout history. The system guiding civilization since its beginnings is always transforming itself. Little by little a system opposed to another already accepted system replaces it in its essence and in all its forms. The conditions of life, society, and every individual are also transformed. In this progression, man strives to live on the basis of a total organization of labor. The discoveries of science affect all organization of life. The discovery of new physical forces, the domination of matter and space gradually impose on man conditions that had never previously existed in his history. The application of these discoveries to all of life's forms transforms the very substance of thought. The painter's cartoon, the upright stone, no longer have any meaning; the plastic arts consisted in ideal representations of known forms and images to which realities were ideally attributed. The materialism now established in everyone's consciousness demands an art far from representation, which today would be a farce. Molded to this materialism, the people of this century have remained insensitive to the representation of known forms and to the narration of

constantly repeated experiences. The abstraction we have attained was progressively conceived through deformations. This new phase, however, does not correspond to the needs of contemporary man.

A change in essence and form is therefore necessary. We must surpass painting, sculpture, poetry. What is needed now is an art based on the necessity of this new vision. The Baroque has guided us in this sense: it is represented as a grandeur not yet surpassed where the notion of time is united to plasticity, where the figures seem to abandon the flat plane and continue their depicted movements out into space. This conception resulted from the idea of the existence that takes shape within man. The physics of that age revealed for the first time the nature of dynamics; it was determined that movement is a condition emanating from matter as a principle of the comprehension of the universe. Having arrived at this point of evolution, the necessity of movement was so important that it exceeded the reach of the plastic arts, and thus that evolution was carried on by music while the arts entered the phase of neo-Classicism, a perilous quagmire in the history of art. Once time has been conquered, the necessity of movement becomes fully manifest. The Impressionists sacrifice compositional drawing to color-light. In Futurism, some elements are eliminated, while others lose their importance by remaining subordinate to sensation. Futurism adopted movement as its principle and singular goal. The development of a bottle in space, unique forms of the continuity of space, begin the only true and great evolution in modern art (plastic dynamism): the spatialists go beyond this idea: neither painting nor sculpture but "forms, colors, sounds through space." Conscious as well as unconscious in this quest, the artists could not have reached their goal without having at their disposal the necessary new technical means and new materials. This justifies the evolution of the medium in art. The triumph of the cinematic frame, for example, is a direct testimony of the direction taken by the human spirit toward the dynamic. Applauding this transformation in man's nature, we abandon the use of known art forms and turn to the development of an art based on the unity of time and space. Existence, nature, and matter form a perfect unity and unfold in time and space. Movement, the property of evolution and development, is the fundamental condition of matter, which exists henceforth in movement and in no other form; its development is eternal, and color and sound are the phenomena through whose simultaneous development the new art becomes whole. The subconscious, where all images lie harbored, and which perceives understanding, adopts the essence and forms of these images, accepts the notions informing the nature of man. The subconscious shapes the individual, completes and transforms him, gives him the guidance it receives from the world and which he adopts from time to time. Society seeks to suppress the separation between the two forces in order to reunite them in a single, greater form, and science is based on the progressive unification of its various elements. From this new state of consciousness arises a whole art in which Being functions and manifests itself in its totality.

After the many millennia of its analytical artistic development, the moment of synthesis has arrived. First the separation was necessary, whereas today it constitutes a disintegration of the conceived unity. We conceive of the synthesis as a sum of physical elements: color, sound, movement, space, completing a unity of idea and matter. *Color, the element of space; sound, the element of time; and movement, which develops in space and time.* These are the fundamental forms of the new art, which contains the four dimensions of existence.

These are the theoretical concepts of spatial art. I shall briefly explain the technical part and its possibility for development, which contains the four dimensions of existence.

Architecture is volume, base, height, and depth, contained in space; the ideal fourth dimension of architecture is art.

Sculpture is volume, base, height, depth.

Painting is description.

Reinforced concrete (the medium) has revolutionized the styles and statics of modern architecture. Decorative style is taken over by rhythm and volume; statics, by the freedom to build independently of the laws of gravity (I have seen a project for a house in the shape of an egg, or for another thrown in the middle of a lawn with no whit of concern for divine proportion). This new architecture is then taken over by an art based on new techniques and media; spatial art, for now, neon, Wood lights, television— the ideal fourth dimension of architecture. Allow me to have some fantasies about the cities of the future, just as the cities of sun, of light, have remained fantasies: the conquest of space and the atom bomb suggest that man should protect himself. Underground factories are already being built; centers that could be ensembles of cells are being born; man will finally end his intrusion on the beauties of nature. In art people are talking about the fourth dimension, about space, about spatial art; they have only vague or erroneous notions about all this. A stone with a hole in it, an element rising toward the sky, a spiral; these are the illusory conquest of space; they are forms contained in the space of their dimensions, minus one. (Example: 1, 2, 3, 4.)

The Tower of Babel is a very ancient example of man's pretense to conquering space. Man's true conquest of space is his *detachment from the earth, from the horizon line*, which for thousands of years was the basis of his aesthetics and proportions. Thus the fourth dimension is born, volume is now truly contained in space in all its dimensions. The first spatial form constructed by man is the aerostat. With the conquest of space, man constructs the first architecture of the *Space Age*: the airplane. Onto these spatial architectures he will project the new fantasies of art.

A new aesthetics is being formed, luminous forms crossing through space. Movement, color, time, and space are the concepts of the new art. In the subconscious of the man in the street a new conception of life is being formed; the creators are slowly but inexorably beginning the conquest of the man in the street. The work of art is not eternal, man and his creation exist in time, in man's finitude the infinite continues.

1951.
Lucio Fontana.

Quarto manifesto dell'arte spaziale
(Fourth manifesto of spatial art)

In the five years since the first manifesto of spatial art was drafted, many "events" have occurred in the field of the arts. We'll not examine them one by one, but one specific "event" is worthy of mention: the collapse of those currents that wished to remain caught in the grip of a "contingent and earthly reality in every sense" or to deny all reality by escaping into an abstract daydreaming that by now has become mere sterile, empty, desperate abstrusity. These five years have steered artists precisely in our direction: to consider as reality those spaces and that vision of universal matter with which science, philosophy, and art have nourished man's spirit in the realm of knowledge and intuition. We have also witnessed a series of demonstrations aimed at attacking the new vision of creation in the *micros* immersed in space, seeking to represent figuratively that energy, now proven to be "strict matter," and those spaces seen as "sculptural matter." We hereby reassert art's priority as the intuitive force of creation and proceed along the same road, to intuit through our works the points of the spirit that consciousness will attain.

Milan, 26 November 1951.
Anton Giulio Ambrosini, Giancarlo Carozzi, Roberto Crippa, Mario De Luigi, Gianni Dova, Lucio Fontana, Virgilio Guidi, Beniamino Joppolo, Milena Milani, Berto Morucchio, Cesare Peverelli, Vicinio Vianello.

Manifeste de la peinture nucléaire
(Manifesto of nuclear painting)

The nuclears want to strike down all "isms" of a painting that falls invariably into academicism, whatever its genesis might be. They can and will reinvent painting.

All forms disintegrate: the new forms of man are those of the atomic universe. The forces are electronic charges. Ideal beauty no longer belongs to a caste of stupid heroes; to robots. It coincides with the representation of nuclear man and his space.

Our consciousness, charged with unforeseen explosives, prefigures *an event*. The nuclear lives in this sort of situation, which only people with spent eyes are unable to see.

Truth does not belong to you: it is in *the atom*.
Nuclear painting documents the search for this truth.

Brussels, 1 February 1952.
Enrico Baj, Sergio Dangelo.

Manifesto del movimento spaziale per la televisione
(Manifesto of the spatialist movement for television)

For the first time anywhere, we spatialists are broadcasting, through the medium of television, our new forms of art, which are based on the concepts of space as seen from a twofold point of view:

the first, that of the spaces formerly considered mysterious but which are now known and explored, and therefore used by us as material for shaping;

the second, that of the still unknown spaces of the cosmos, which we want to approach as facts of intuition and mystery, typical of art as divination.

Television, for us, is a medium that we have been waiting for, to integrate our concepts. We are pleased that this spatial manifestation of ours, which is destined to renew all fields of art, will be broadcast from Italy.

It is true that art is eternal, yet it has always been bound to matter; we, on the other hand, want to release it from matter, so that, through space, it may last a millennium, even in a one-minute broadcast.

Our artistic expressions multiply the horizon lines to infinity, in infinite dimensions: they seek an aesthetics whereby the painting is no longer a painting, sculpture is no longer sculpture, and the written page quits its typographical form.

We spatialists feel that we are the artists of today, since the triumphs of technology are now in the service of the art that we profess.

Milan, 17 May 1952.
Ambrosini, Burri, Crippa, Deluigi, De Toffoli, Donati, Dova, Fontana, Giancarozzi, Guidi, Joppolo, La Regina, Milena Milani, Morucchio, Peverelli, Tancredi, Vianello.

Per la scoperta di una zona di immagini
(For the discovery of a zone of images)

Without myth there can be no art.
The work of art finds its cause in an unconscious impulse, the birth and death of a collective substratum, yet the artistic act lies in the awareness of the gesture; an intuitive awareness, for the true technique of artistic activity is intuitive clarification (*inventio*).
Once the gesture is consummated, the work becomes a document of the occurence of an artistic act.
With discovery is born the clear consciousness of the historical development of the work of art.
We therefore understand art as discovery (*inventio*) in the continuous historical emergence of authentic, virgin zones.

Our manner is an alphabet of primary images.
The painting is our area of freedom; in its space we set out to discover and invent images, virgin images that are their own justification, and whose validity is determined only the joy of life *they contain.*

Milan, 9 December 1956.
Piero Manzoni, Camillo Corvi-Mora, Ettore Sordini, Giuseppe Zecca.

L'arte non è vera creazione
(Art is not true creation)

Art is not true creation or foundation except insofar as it creates and founds where mythologies have their own ultimate foundation and origin.
In order to assume the meaning of one's own time, it is therefore necessary to attain one's own individual mythology at the same point at which this becomes identified with the universal mythology.
The difficulty lies in freeing oneself from extraneous details and useless gestures; details and gestures that are polluting the customary art of our day and sometimes actually acquire such prominence that they become banners of artistic trends. The sifter that enables us to perform this separation of wheat from chaff, and which leads us to discover a coherent and ordered complex of meanings in an incomprehensible and irrational sequence of images, is a process of self-analysis. With it we are able to get back in touch with our origins, eliminating all useless gestures, all that there is of a personal and literary nature within us, in the worst sense: nebulous childhood memories, sentimentalisms, impressions, willed constructions, painterly, symbolic, and descriptive concerns; false anxieties, unconscious, unacknowledged facts, lighting up brightly on Saturday nights, the continuous hedonistic repetition of exhausted discoveries—all this must be eschewed.
By means of this process of elimination, humanly attainable originality becomes manifest, taking the form of images, primary images, our "totems," which are ours and the artists' and the spectators', since they are historically determined variations of primordial mythologems (individual mythology and universal mythology become identical).
Everything must be sacrificed to this possibility of discovery, this need to assume one's own gestures.
The customary conception of the painting itself must be abandoned; the space-surface involves the self-analytic process only as a "space of freedom."
And neither can stylistic coherence be of any concern to us, because our sole concern can only be the continuous search, the continuous self-analysis by which means alone we may arrive at establishing morphemes "recognizeable" to all in the sphere of our civilization.

Milan, May 1957.
Piero Manzoni, Guido Biasi, Mario Colucci, Ettore Sordini, Angelo Verga.

Per una pittura organica
(For an organic painting)

We want to organicize disintegration. In a disintegrated world, we want to be able to discover and reveal to ourselves the inner structures. We want to establish these presences unequivocally.

Beyond all surface hedonism, all impression, all memory, we disintegrate phenomena and acts in order to find their innermost impulses, to separate the essential from the gratuitous and monodize it with absolute precision, so as to highlight each in its most authentic seed.

The painting is our space of freedom, in which we continuously reinvent painting, in continuous search of our primary images.

Milan, June 1957.
Piero Manzoni, Guido Biasi, Mario Colucci, Ettore Sordini, Angelo Verga.

Manifesto di Albisola Marina
(Manifesto of Albisola Marina)

Against all irreality our work proclaims a most lucid awareness of our physical strength.

Contrary to all abstraction and all vain decorativism, we are realizing not an ideal vision but a kind of plastic translation of the innermost emotions of our consciousness: art thus has a chance to become a natural and spontaneous continuation of our psychobiological processes, an offshoot of our organic life itself, which develops through the attentive control of consciousness and the immaculate astonishment of the senses.

Our sole ideal is, therefore, Reality.

The canvas will no longer be an arid invention devoid of meaning, the utopia of an aesthetic order, a harmony of relationships of a style, the folly of a pure idealism without concrete, human origin, or an impersonal program whose sole and squalid presence resides in the creation of a manner; rather, it will be living flesh, a direct, scalding, unaltered version of the innermost dynamics of the artist and his most secret emotions.

Concentric circles, arisen from the innermost needs of the *ego*, will expand and reach a total aperture: this will be the birth of a language legitimated by a new moral sense. The dictates of our conscience, the attention of our senses in their vital vibration, the attempt to organize a poetics of pure exaltation not caught in the limits of a preordained aesthetic will make it possible to open up worlds as vast as the absolute freedom we feel capable of attaining. Now, every chaos seeks a meaning that might justify it; a spot of anonymous and unexpected color demands the dignity of a name, a purpose, a meaning; demands that its free and violent action be legitimized. All this induces us to believe that our experiences, despite their many different directions, herald the possibility of a new moral organism.

Albisola Marina, 1–15 August 1957.
Piero Manzoni, Guido Biasi, Mario Colucci, Ettore Sordini, Angelo Verga.

Contro lo stile
(Against style)

In February 1952 the first nuclear manifesto affirmed our will to fight all concession to any sort of academicism. This was an expession of our revolt against the domination of the right angle, of mechanisms and machines, against cold and geometric abstraction.

Since then we have continued our experimentation in every possible technical resource, from "tachiste" or objective automatism to subjective automatism, graphism, "Action Painting," gesture, calligraphism, emulsions, flottages, polymaterialism, and lastly, the heavy waters of Baj and Bertini (1957).

The technical experimentation was accompanied, through mutual suggestion, by new languages: from the imaginary spaces (see Pierre Restany) and "states of matter" of 1951 (Baj and Dangelo) to the "prefigurations" of 1953 (Baj, Dangelo, Colombo and Mariani), to the "new flora" (Dangelo) and "characters, animals and fables" (Baj and Jorn, 1956), and up to the "atomized situations" of 1957 (Baj and Pomodoro).

Yet every new invention is now at risk of becoming the object of stereotyped repetitions of a purely mercantile character; it is therefore urgent to take vigorous antistylistic action for an art that wishes always to be "other" (cf. Michel Tapiè [sic]).

"De Stijl" is dead and buried, and it is now up to its opposite—antistyle—to break down the last barriers of convention and cliché, the last that official stupidity might still hold up against the definitive liberation of Art.

Impressionism liberated painting from conventional subjects; Cubism and Futurism in turn removed the imperative of objective imitation, and then Abstraction came along to dispel any remaining hint of an illusory need for representation. The final link in this chain is today about to be destroyed: we Nuclear artists hereby denounce the last remaining convention—style. We accept as the last possible forms of stylization the "monochrome propositions" of Yves Klein (1956–57): after them, all that remains is the *tabula rasa* or Capogrossi's rolls of wallpaper. Wallpaperers or painters: one must choose which to be.

Painters of an ever new and inimitable vision, for whom the canvas is each time the changeable stage of an unforeseeable "Commedia dell'Arte."

We assert the inimitability of the work of art: and that its essence should be a "modifying presence" in a world that no longer needs celebrative representations but presences.

Milan, September 1957.
Enrico Baj, Armand Bemporad, Gianni Bertini, Jacques Colangelo, Enrico de Miceli, Reinhout D'Hause, Wout Hoeber, Friedrich Hundertwasser, Yves Klein, Theodore Koenig, Piero Manzoni, Giò Pomodoro, Pierre Restany, Antonio Saura, Ettore Sordini, Serge Vandercam, Angelo Verga.

Manifesto del Gruppo 58
(Manifesto of Gruppo 58)

Magic spells are no longer enough to satisfy our consciousness, and probably our senses desire no additional drugs either. We have been ruined by too many dreams.

A possibility of new beginnings may yet arise from the hopeless disgust that takes hold of us as we wander about the ghostly ruins of surrealist paradises; it may arise from our very nature—from the most primitive of our thousands of natures—as it suddenly rebels against trumped-up suggestions and attempts to re-create the most spontaneous, purest *gesture*, to establish the most authentic relationship between our civilization and the primordial myths still living within its fabric.

We do not wish to negate the truth of the unconscious, yet we deem it necessary for this unconscious to stop curling up and biting its own tail, in order to find at last the key to an ethical architecture free of illusion and gibberish.

Until now we have forced ourselves to adopt a formal syntax (or better yet, an a-syntax) that would make possible an encounter between the most intimate ego and that remote region of ancestral memory so dear to the artist of today. But it is now necessary, in banishing all destructive nihilism, to proceed to the discovery of a mythical nature inside and outside of us, and to give our creation a celebrative involvement; we must stamp out the ashes of a still Romantic despair and continue our fantastic voyage toward brighter, happier regions.

After all, the audacity of having squeezed out of our inner psyches a whole troubling series of images, atmospheres, memories, and secret wounds, presupposes in essence a kind of deserved redemption, an open door onto a hygienic future landscape where one might finally relax one's nerves. . . .

We believe, in short, that the moment has come to turn off the troublesome faucet of the unconscious and to cast a bridge between our present-day spiritual culture and the Origin, showing how this culture is still capable of singing with simplicity the primordial morning songs pulsating in the memory of its blood.

Naples, 5 June 1958.
Guido Biasi, Lucio Del Pezzo, Bruno Di Bello, Sergio Fergola, Luca, Mario Persico.

Manifeste de Naples
(Manifesto of Naples)

Abstraction is not art but merely a philosophical and conventional concept. Art is not abstract, although there can be an abstract concept of art.

This neo-neoplatonism has long been surpassed by the events of modern science; it therefore no longer has any reason to be considered a vital and current phenomenon.

Having arrived at Naples the morning of 9 January 1959, we climbed to the top of Vesuvius, which, bubbling furiously, immediately spewed out towering clouds of smoke. We sought shelter, throwing ourselves to the ground until silence returned. We then raised our eyes to the sky, and there appeared the writing:

Still trembling, we stood back up and one of us, walking toward the chasm, said: "*May our works be meteors, lava and lapilli, cosmic dust, flaming carbide, orbits of violence, trajectories of senses, radioactive intuitions, sulphur, phosphorus and mercury. . . .*"

Descending from the crater, we dived into the waters of the gulf and landed at Cumae to consult the oracle. The sybil emerged from her cave, and her words further confirmed the fact:

"Get outta here! . . . Abstractionism is old, and stinks worse than me!"

Naples, January 1959.
Nanni Balestrini, Paolo Redaelli, Leo Paolazzi, Sandro Bajini, Edoardo Sanguinetti, Luca, Bruno Di Bello, Lucio Del Pezzo, Mario Persico, Guido Biasi, Giuseppe Alfano, Donato Grieco, Enrico Baj, Angelo Verga, Ettore Sordini, Recalcati, Sergio Fergola.

Manifesto della pittura industriale
Per un arte unitaria applicabile
(Manifesto of industrial painting
For a unitary applied art)

The macromolecules of colloids have already made their appearance in the field of art, and although they have not yet found their Poet, thousands of artists are struggling to master them.

The great age of resins has begun, and with it the use of material in movement; the colloidal macromolecule will have a profound effect on the concept of relativity, and the constants of material will suffer a definitive collapse: the concepts of *eternity* and *immortality* will crumble and the yearnings for eternalized material will progressively die out, leaving the artists of chaos with the endless joy of the *always-new*—the *new* having been conceived amid the risk of endless imagination and obtained from the free energies

Contro lo stile
(Against style)

In February 1952 the first nuclear manifesto affirmed our will to fight all concession to any sort of academicism. This was an expession of our revolt against the domination of the right angle, of mechanisms and machines, against cold and geometric abstraction.

Since then we have continued our experimentation in every possible technical resource, from "tachiste" or objective automatism to subjective automatism, graphism, "Action Painting," gesture, calligraphism, emulsions, flottages, polymaterialism, and lastly, the heavy waters of Baj and Bertini (1957).

The technical experimentation was accompanied, through mutual suggestion, by new languages: from the imaginary spaces (see Pierre Restany) and "states of matter" of 1951 (Baj and Dangelo) to the "prefigurations" of 1953 (Baj, Dangelo, Colombo and Mariani), to the "new flora" (Dangelo) and "characters, animals and fables" (Baj and Jorn, 1956), and up to the "atomized situations" of 1957 (Baj and Pomodoro).

Yet every new invention is now at risk of becoming the object of stereotyped repetitions of a purely mercantile character; it is therefore urgent to take vigorous antistylistic action for an art that wishes always to be "other" (cf. Michel Tapiè [sic]).

"De Stijl" is dead and buried, and it is now up to its opposite—antistyle—to break down the last barriers of convention and cliché, the last that official stupidity might still hold up against the definitive liberation of Art.

Impressionism liberated painting from conventional subjects; Cubism and Futurism in turn removed the imperative of objective imitation, and then Abstraction came along to dispel any remaining hint of an illusory need for representation. The final link in this chain is today about to be destroyed: we Nuclear artists hereby denounce the last remaining convention—style. We accept as the last possible forms of stylization the "monochrome propositions" of Yves Klein (1956–57): after them, all that remains is the *tabula rasa* or Capogrossi's rolls of wallpaper. Wallpaperers or painters: one must choose which to be.

Painters of an ever new and inimitable vision, for whom the canvas is each time the changeable stage of an unforeseeable "Commedia dell'Arte."

We assert the inimitability of the work of art: and that its essence should be a "modifying presence" in a world that no longer needs celebrative representations but presences.

Milan, September 1957.
Enrico Baj, Armand Bemporad, Gianni Bertini, Jacques Colangelo, Enrico de Miceli, Reinhout D'Hause, Wout Hoeber, Friedrich Hundertwasser, Yves Klein, Theodore Koenig, Piero Manzoni, Giò Pomodoro, Pierre Restany, Antonio Saura, Ettore Sordini, Serge Vandercam, Angelo Verga.

Manifesto del Gruppo 58
(Manifesto of Gruppo 58)

Magic spells are no longer enough to satisfy our consciousness, and probably our senses desire no additional drugs either. We have been ruined by too many dreams.

A possibility of new beginnings may yet arise from the hopeless disgust that takes hold of us as we wander about the ghostly ruins of surrealist paradises; it may arise from our very nature—from the most primitive of our thousands of natures—as it suddenly rebels against trumped-up suggestions and attempts to re-create the most spontaneous, purest *gesture*, to establish the most authentic relationship between our civilization and the primordial myths still living within its fabric.

We do not wish to negate the truth of the unconscious, yet we deem it necessary for this unconscious to stop curling up and biting its own tail, in order to find at last the key to an ethical architecture free of illusion and gibberish.

Until now we have forced ourselves to adopt a formal syntax (or better yet, an a-syntax) that would make possible an encounter between the most intimate ego and that remote region of ancestral memory so dear to the artist of today. But it is now necessary, in banishing all destructive nihilism, to proceed to the discovery of a mythical nature inside and outside of us, and to give our creation a celebrative involvement; we must stamp out the ashes of a still Romantic despair and continue our fantastic voyage toward brighter, happier regions.

After all, the audacity of having squeezed out of our inner psyches a whole troubling series of images, atmospheres, memories, and secret wounds, presupposes in essence a kind of deserved redemption, an open door onto a hygienic future landscape where one might finally relax one's nerves. . . .

We believe, in short, that the moment has come to turn off the troublesome faucet of the unconscious and to cast a bridge between our present-day spiritual culture and the Origin, showing how this culture is still capable of singing with simplicity the primordial morning songs pulsating in the memory of its blood.

Naples, 5 June 1958.
Guido Biasi, Lucio Del Pezzo, Bruno Di Bello, Sergio Fergola, Luca, Mario Persico.

Manifeste de Naples
(Manifesto of Naples)

Abstraction is not art but merely a philosophical and conventional concept. Art is not abstract, although there can be an abstract concept of art.

This neo-neoplatonism has long been surpassed by the events of modern science; it therefore no longer has any reason to be considered a vital and current phenomenon.

Having arrived at Naples the morning of 9 January 1959, we climbed to the top of Vesuvius, which, bubbling furiously, immediately spewed out towering clouds of smoke. We sought shelter, throwing ourselves to the ground until silence returned. We then raised our eyes to the sky, and there appeared the writing:

Still trembling, we stood back up and one of us, walking toward the chasm, said: "*May our works be meteors, lava and lapilli, cosmic dust, flaming carbide, orbits of violence, trajectories of senses, radioactive intuitions, sulphur, phosphorus and mercury. . . .*"

Descending from the crater, we dived into the waters of the gulf and landed at Cumae to consult the oracle. The sybil emerged from her cave, and her words further confirmed the fact:

"Get outta here! . . . Abstractionism is old, and stinks worse than me!"

Naples, January 1959.
Nanni Balestrini, Paolo Redaelli, Leo Paolazzi, Sandro Bajini, Edoardo Sanguinetti, Luca, Bruno Di Bello, Lucio Del Pezzo, Mario Persico, Guido Biasi, Giuseppe Alfano, Donato Grieco, Enrico Baj, Angelo Verga, Ettore Sordini, Recalcati, Sergio Fergola.

Manifesto della pittura industriale
Per un arte unitaria applicabile
(Manifesto of industrial painting
For a unitary applied art)

The macromolecules of colloids have already made their appearance in the field of art, and although they have not yet found their Poet, thousands of artists are struggling to master them.

The great age of resins has begun, and with it the use of material in movement; the colloidal macromolecule will have a profound effect on the concept of relativity, and the constants of material will suffer a definitive collapse: the concepts of *eternity* and *immortality* will crumble and the yearnings for eternalized material will progressively die out, leaving the artists of chaos with the endless joy of the *always-new*—the *new* having been conceived amid the risk of endless imagination and obtained from the free energies

that man will use in the dissolution of the *gold value*: this being the congealed energy of the vile banking system now falling apart. Trademarked society, conceived and based on simple ideas, on the elementary gestures of artists and scientists kept in captivity like lice by ants, is about to come to an end; man is giving expression to a collective sense and forging a tool suited to turning it into a potlatch system of donations that can only be payed with other poetic experiences. It is possible that the machine is the tool capable of creating an inflationistic industrial art based on the Antitrademark; the new industrial culture shall only be "Made by the People" or it shall not be! The time of the Scribes is over.

Only a continual and implacable creation and destruction will create an anxious and useless search for objects-things of momentary use, undermining the foundations of the Economy, destroying its values or thwarting their formation; the *always-new* will destroy boredom and the anguish created by the slavery of the *infernal machine*, queen of the *all-the-same*; the new possibilities will create a new world of *all-different*. *Quantity* and *quality* will merge: it will be the culture of *standard luxury*, which will annul traditions. Proverbs will no longer make sense. For example, the proverb, "He who leaves the old road for the new road," etc., will be replaced by: "The proverbs of the old make the young die of hunger." A new, ravenous force of dominion will lead men into an unimaginable epic. Not even the custom of setting the *time* will be saved. Henceforth *time* will be only an emotional value, a new coin of *shock*, and it will be based on the sudden changes in the moments of creative life and on the very rare moments of boredom. Men *without memory* will be created; men in continuous violent ecstasy, always starting from a *zero-point*: this will be *critical-ignorance*, with distant roots in the long prehistory of primitive man, magus of the caves. The new magic will be fed its most recent fuel by the sparks of the great fire of the *Library of Alexandria*, which was the synthesis of the neolithic revolution and to this very day still burn the remains of the urban Sumerian civilizations and Phoenician nomadism, feeding *man*'s hopes like an intoxicating incense.

So great will be the artistic production made by the machines submissively bent to our wills, that we won't even have the time to preserve any of it in our memories: the machines will do the remembering for us. Other machines will intervene to destroy, determining situations of *nonvalue*: there will no longer be *sample-artworks* but exchanges of *ecstatic-artistic-air* among peoples.

The world will be the stage and backstage of a continuous performance; the earth will turn into a vast amusement park, creating new emotions and new passions. The cosmic spectacle presented by humanity will manage to become in effect *universal* and visible in its *all-together* from a telescopic distance, forcing *man* to climb up to take in the entire spectacle: the front seats will be reserved in Heaven. Thus is *man* launched in search of *myth*. In the past, the epic could be created on earth: the lack of communication, wars, epidemics, great fears and the confusion of tongues and customs favored eventual deformations and distortions of reality: these transformed action, and synthesized to create the epic. Today a myth can only be created where *man* with difficulty, and in

special conditions, manages to arrive: either taking off into the macrocosmos with great tools or descending with little tools into the microcosmos. We must for this reason paint the streets of the future in an unknowable material, and mark the long roads *of the Heavens* with signals equal to the grandeur of the undertakings. Whereas today we have sodium rockets for signals, tomorrow we shall use new rainbows, mirages, and aurorae borealis that we will have made for ourselves, and the stripteases of the constellations, the rhythmic dances of the asteroids, and the ultrasonic music of millions of broken sounds will grant us moments worthy of demigods.

For all of these things, *O still powerful men of earth*, sooner or later you will give us the machines to play with or else we will make them ourselves to fill up that *free time* that you, with mad avidity, cannot wait to fill with banality and the gradual mashing of people's brains. We shall use these machines to paint the superhighways, to fashion the most fantastic and unique fabrics, which joyous mobs shall don with a sense of art, for only a minute. Kilometers of printed, engraved, colored papers will raise hymns to the oddest and most thrilling crowds. Houses of painted, embossed, and patent leather, houses of metal, of alloys, of resins, of vibrating concrete will create all over the earth an unequal and continuous moment of *shock*. We shall capture at will, with movie-picture and television cameras, the images that the collective genius of the people has created and which you until now have wretchedly used to end up in the *absolute realm of boredom*. Everyone will experience the joy of color, of music; the architectural airs of colored gases, the warm walls of infra-red rays that will bring us eternal springtime: we will make *Man play from the cradle to the grave*, even Death will be only a game. Poetic colored signs will create emotional moments and give us the infinite joy of the *magic-creative-collective* moment, platform of new myths and new passions. With automation there will be no more work in the traditional sense, and there will be no more after-work clubs: rather, there will be *free time* for free, antieconomical energies. We want to found the first institute *of industrial poetry* and out of this unimaginable offspring bestowed on us by machines we shall create alongside it institutions of *immediate destruction* to immediately destroy the just created emotional products, so that our brains might be forever immune to plagiarism and that we might find ourselves pointedly in the state of grace of the *zero-point*. Only a people of artists can survive under the leadership of minorities of genius: the *creators of beliefs*. Ancient cultures give us examples of this with their inflation; all was unique, and this vast production was not possible except through the concurrence of popular elements dragged into their works by the vastness of the poetry. Once the poetic source dried up, it was a short step to the ruins of the Mayas, the Cretans, the Etruscans, etc.

Today man is part of the machine that he created, the machine now denied him, by which he is dominated. This nonsense must be reversed, or there will be no more creation; we must dominate the machine and force it to make the single, useless, antieconomic, artistic gesture, to create a new antieconomic society that is poetic, magical, artistic.

Powerful and symmetrical gentlemen, asymmetry,

henceforth the basis of modern biology, is spilling over into the fields of art and science, undermining the foundations of your symmetrical world, which is based on the axioms of poetic moments from a remote past and has now reached the absolute immobility of your Star System's crystalline Boredom. The latest modern creations of art instilled with a magical-prophetic sense have destroyed your space; kilometer-long canvases can now be translated and measured by chronometer, like films, like Cinerama (20 minutes, 30 minutes, an hour of painting). Time, the magic box by which the people of ancient agrarian cultures regulated their vital and poetic experiences, has stopped and forced you to change speed. The fundamental instruments of your dominion: space and time, will become useless toys in your hooked, paralytic, childlike hands. Useless are your ideal notions of the Superman and genius; useless your decors, your vast urbanistic constructions that will only bring boredom to the sleepless nights of aristocratic geniuses capable only of hobbling through vast empty palaces, like bats and owls in search of the foul victuals of artifical paradises. Useless and vain was your urbanism over the centuries, for to you and for you alone had the people devoted in vain the best of their free, creative energies, believing you to be the effective representatives of a poetic message. Today antimatter, the physical antiworld has been discovered and your whole vast abode is collapsing on your backs. The *antiman* has already appeared on the dramatic stage of physics. In the future the people won't even use your decors, which won't be of any use whatsoever, for they will be nothing more than the vast cemeteries in which for centuries you have been burying all the sufferings and poetries that man had created for himself. New, movable decors are now required, present-day nomadism requires removable settings for camping grounds, for trailers, for weekends. The return to nature with modern instrumentation will enable man, after thousands of centuries, to go back to the places where the paleolithic hunters overcame their great fear; modern men will seek to relinquish their own fear, built up by the idiocy of progress, through contact with the humble things that nature in her wisdom has preserved as a check against the tremendous arrogance of the human brain.

Still powerful men of East and West, you have built underground cities to protect yourselves against the radiations you have savagely unleashed: and yet ingenuous artists will transform your sewers into sanctuaries and atomic cathedrals, tracing with emotional magic the signs of industrial culture which will quickly turn into the symbols of new Zodiacs, new calendars of moments. New energies gathered by sensitive minorities that the masses will have brought forth in their long hibernation will transform your termites' nests of concrete into luxurious, transmissible, exchangeable moments. Artists will be the teddy boys of the old culture; what you have not destroyed yourselves they will destroy, so that no memory of anything should remain, since your stupidity has reached the point of having destroyed the last possibility for rebirth that you had: war. This had always been your resource, for destruction made renewal necessary; today your cowardice, your fear, has blown up in your face. You are invincible manufacturers of Boredom. Your progress will sterilize your last remaining sensibilities, and nothing, if not your

place, in man's consciousness (or even only in his intuition), of a fixed and immutable reality, we have noticed in the arts a tendency to express reality in terms of becoming.

therefore if one considers the *work* as a *reality* made up of the same elements that constitute the *reality that surrounds us*, it becomes necessary for the work itself to be in a state of continuous variation.

by this we do not mean to reject the validity of media such as color, form, light, etc.; rather, we are reappraising them, placing them in the work in the actual situation in which we recognize them in reality, that is, in continuous variation, which is the result of their mutual interrelationship.

Bellinzona, October 1959.
Giovanni Anceschi, Davide Boriani, Gianni Colombo,
Gabriele Devecchi.

First appeared in a brochure for the exhibition *Miriorama 1* (Milan, Galleria Pater), January 1960.

Manifesto contro niente per l'esposizione internazionale di niente
(Manifesto against nothing for the international exposition of nothing)

Delegation of Avant-gardism, Conventionalism, Modernism, Conservatism, Consumerism, Capitalism, Patriotism, Internationalism, Monochromy, Monotony, Zen, Surrealism, Dadaism, Lettrism, Informale, Constructivism, Neoplasticism, and Tachism.

One canvas is almost as valid as no canvas.
One sculpture is almost as good as no sculpture.
One car is almost as beautiful as no car.
Music is almost as likeable as no sound.
No art market is as fruitful as the art market.
Something is almost nothing (no thing).

Basel, 1960.
Carl Laszlo (Basel), Onorio (Basel), Bazon Brock (Itrehoe),
Herbert Schuldt (Amburgo), Piero Manzoni (Milan), Enrico
Castellani (Milan), Heinz Mack (Düsseldorf), Otto Piene
(Düsseldorf).

All manifestos have been reprinted in Germano Celant, *L'inferno dell'arte italiana: materiali 1946-1964* (The inferno of Italian art: materials 1946-1964. Genoa: Costa & Nolan, 1990). The *Manifiesto blanco* was translated, from the Spanish, by Alfred Mac Adam. All other manifestos were translated, from the Italian, by Stephen Sartarelli.

Lenders to the Exhibition

Nico Abramo, Genoa
Carla Accardi
Agenzia Publifoto, Milan
Salvatore Ala Gallery, New York
Lucio Amelio, Naples
Roberto Antonini, Novara
Archivi Alinari, Archivio Lattuada
Archivio Federico Patellani, Milan
Archivio Gabetti e Isola
Archivio Giorgio Raineri
Archivio Gregotti Associati
Archivio Guido Canella
Archivio Storico Bolaffi, Turin
Archivio UFO, Florence
Archivio Ugo Mulas
Federico Bano, Padua
Mr. and Mrs. Armand Bartos
Association Jacqueline Vodoz and Bruno Danese, Milan
Gianni Berengo Gardin
Bernini, Carate Brianza
Bruno Bischofberger, Zurich
Romilda Bollati
Vittorio Bonacina & C., Lurago d'Erba
Bonetto Design Collection
Gianni Borghesan, Spilimbergo
Onorina Brion
Brionvega, Cernusco sul Naviglio (MI)
Federico and Maria Luisa Brook
Gian Piero Brunetta, Padua
Nicola Bulgari, New York
Alberto Burri
Angelo Calmarini, Milan
Giancarlo Calza, Milan
Alfredo Camisa
Roberto Capucci, Rome
Estate of Alfredo Carnelutti, Udine
Laura Carpenter Fine Art
Antonio Caruana
Bianca M. Casadei, Rome
Achille Castiglioni, Milan
Daniele Cavalli, Rome
Centro di Documentazione Giovanni Michelucci, Comune di Pistoia
Centro Studi e Archivio della Comunicazione,
 Università degli Studi di Parma, Sezione Progetto
Carla Cerati
Civico Museo d'Arte Contemporanea, Milan
Civico Museo Revoltella, Trieste
Amedeo Cocchi, Milan
Rosangela Cochrane
Attilio Codognato, Venice
Cesare Colombo
Paolo Consolandi, Milan
Consuelo Crespi, Rome
Anna D'Ascanio, Rome
Donato D'Urbino and Paolo Lomazzi, DDL Studio, Milan
Avv. Mario D'Urso, Rome
Dadamaino
Mario De Biasi
Agnese De Donato, Rome
Paolo De Poli, Padua
Piero Dorazio
Liliane and Michel Durand-Dessert, Paris
Luciano Fabro, Milan
FAE Musée d'Art Contemporain, Pully-Lausanne
Maurizio Fagiolo dell'Arco
Sartoria Farani, Rome
Fendi, Rome
Salvatore Ferragamo S.p.A., Florence
Fulvio Ferrari, Turin
Fiat S.p.A., Centro Storico
Flos Inc., Huntington Station, New York

Flos S.p.A., Brescia
Fondazione Lucio Fontana, Milan
Fondo Rivetti per l'Arte, Turin
Teresita Fontana, Milan
Fornasetti Collection, Milan
Fototeca 3M, Milan
Giorgio Franchetti, Rome
Giuseppe Fusari, Milan
Irene Galitzine, Rome
Galerie Neuendorf, Frankfurt
Galleria Christian Stein, Turin-Milan
Galleria Civica d'Arte Moderna e Contemporanea, Turin
Galleria Comunale d'Arte Moderna, Spoleto
Galleria d'Arte Niccoli, Parma
Galleria del Costume, Florence
Galleria del Naviglio, Milan
Galleria Gian Enzo Sperone, Rome
Galleria Internazionale d'Arte Moderna-Cà Pesaro, Venice
Galleria L'Isola, Rome
Galleria Nazionale d'Arte Moderna e Contemporanea, Rome
Susi Giusti, Florence
Marian Goodman Gallery, New York
Luigi Grampa, Busto Arsizio
Solomon R. Guggenheim Museum, New York
Guido Guidi
Fabio Carapezza Guttuso
Herning Kunstmuseum
Hirschl & Adler Modern, New York
Istituto Universitario di Architettura di Venezia,
 Archivio Progetti Angelo Masieri
Istituto di Fotografia Paolo Monti, Milan
Mimmo Jodice
Kartell S.p.A., Noviglio
Krizia, Milan
Krugier-Ditesheim Art Contemporain, Geneva
Jan and Marie-Anne Krugier-Poniatowski, Geneva
Kunstsammlung Nordrhein-Westfalen, Düsseldorf
Pino Lancetti, Rome
Alba P. Lisca, Milan
Gian Tomaso Liverani, Galleria La Salita, Rome
Gabriella Lo Faro, Rome
Carla Serafini Lombardi
Ferruccio Malandrini, Florence
Roberto Mango
Manzoni Family, Milan
Achille and Ida Maramotti, Albinea
Marcella Marchese, Genoa
Giorgio Marconi, Milan
Flaminia Marignoli, Rome
Cristina Melotti, New York
Marta Melotti, Milan
Marisa Merz
David Mezzacane, Rome
Nino Migliori, Bologna
Galleria Minini, Brescia
A. Minola
Enrico Mirani, Piacenza
Angioletta Miroglio, Milan
Missoni, Milan
Giancarlo Montebello
Beatrice Monti della Corte
Danielle and François Morellet, Cholet
Bruno Munari
Musée des Arts Décoratifs de Montréal
Musée National d'Art Moderne, Centre Georges Pompidou, Paris
Museo di Storia della Fotografia Fratelli Alinari, Florence
Museo Fortuny, Venice
Museo Marino Marini, Florence
The Museum of Fine Arts, Houston
The Museum of Modern Art, New York
Susan Nevelson, Florence
The Newark Museum
Marta Nistri

Project Team

Curators
Andrea Branzi, Design
Gian Piero Brunetta, Cinema
Germano Celant, Art
Maurizio Fagiolo dell'Arco, The Literature of Art
Vittorio Gregotti, Architecture
Luigi Settembrini, Fashion
Pandora Tabatabai Asbaghi, Artists' Crafts
Italo Zannier, Photography

Exhibition Design
Gae Aulenti
Vittoria Massa, Architect
Giovanna Buzzi, Costume Designer

Graphic Design
Massimo Vignelli

Project Management
Jennifer Blessing, Assistant Curator

European Coordinators
Anna Costantini
Marco Mulazzani

Curatorial Assistants
Vivien Greene
Lisa Panzera
Carole Perry

European Consultants
Carlotta Bettanini
Anna Pazzagli

Research Interns
Marta Arzac
Gaia Battaglioli
Camilla Bertoni
Francesca Doria
Marta Garcia Maruri
Jennifer Miller
Giorgio Pace
Maura Pozzati
Alessandra Pugliese
Erika Rafalaf
Hilda Werschkul

Registrars
Marion Kahan, Project Registrar
Kathleen Hill
Lynne Addison

Conservator
Carol Stringari, Associate Conservator

Publications
Anthony Calnek, Director of Publications
Elizabeth Levy, Production Editor
Laura Morris, Associate Editor
Edward Weisberger, Assistant Managing Editor
Jennifer Knox, Assistant Editor

Mary Haus
Paul Lipari
Ron de Feo
Deborah Drier
Scott Gutterman

Translators
Stephen Sartarelli
Antony Shugaar
Alfred Mac Adam

Videotape Production:

Bellissime
by Gian Piero Brunetta, Francesco Conversano, and Nene Grignaffini.
Produced by Movie Movie, Bologna.

Miss Italy: The Screen as Runway for Dreams
by Gian Piero Brunetta and Mirco Melanco.

Photo credits

621. Courtesy of Archivio Casabella/Archivio Gregotti. 622. Courtesy of Archivio Casabella/Archivio Gregotti. 623. Courtesy of Archivio Casabella/Archivio Gregotti. 624. Courtesy of Archivio Casabella/Archivio Gregotti. 625. Courtesy of Archivio Casabella/Archivio Gregotti. 626. Courtesy of Archivio Casabella/Archivio Gregotti. 627. Courtesy of Archivio Casabella/Archivio Gregotti. 628. Courtesy of Archivio Casabella/Archivio Gregotti. 629. Courtesy of Archivio Ignazio Gardella. 630. Courtesy of Archivio Centro Studi e Archivio della Communicazione, Università di Parma, Sezione Progetto. 631. Courtesy of Archivio Casabella/Archivio Gregotti. 632. Courtesy of Archivio Casabella/Archivio Gregotti. 633. Coutesy of Archivio Olivetti Corporate Image. 634. Courtesy of Archivio Olivetti Corporate Image. 635. Technifoto. 636. Courtesy of Archivio Olivetti Corporate Image. 637. Courtesy of Archivio Olivetti Corporate Image. 638. Courtesy of Archivio Casabella/Archivio Gregotti. 639. Federico Brunetti. 640. Courtesy of Archivio Casabella/Archivio Gregotti. 641. Walter Vitturi. 642. Courtesy of Archivio Casabella/Archivio Gregotti. 643. Foto Gabetti. 644. Courtesy of Archivio Caccia Dominioni. 645. Courtesy of Archivio Casabella/Archivio Gregotti. 646. Walter Vitturi. 647. Courtesy of Archivio Casabella/Archivio Gregotti. 649. Courtesy of Archivio Casabella/Archivio Gregotti. 650. Courtesy of Archivio Casabella/Archivio Gregotti.

651. Courtesy of Archivio Vittorio Gregotti. 652. Courtesy of Archivio Giorgio Raineri. 654. Courtesy of Archivio Casabella/Archivio Gregotti. 655. Courtesy of Archivio Casabella/Archivio Gregotti. 656. Walter Vitturi. 657. Courtesy of Archivio Casabella/Archivio Gregotti. 658. Courtesy of Archivio Casabella/Archivio Gregotti. 659. Courtesy of Archivio Casabella/Archivio Gregotti. 660. Oscar Savio. 661. Oscar Savio. 662. Courtesy of Archivio Casabella/Archivio Gregotti. 663. Courtesy of Archivio Casabella/Archivio Gregotti. 664. Courtesy of Archivio Casabella/Archivio Gregotti. 665. Courtesy of Archivio Casabella/Archivio Gregotti. 666. Courtesy of Archivio Casabella/Archivio Gregotti. 667. Courtesy of Archivio Casabella/Archivio Gregotti. 668. Courtesy of Archivio Casabella/Archivio Gregotti. 669. Courtesy of Archivio Casabella/Archivio Gregotti. 670. Courtesy of Archivio Casabella/Archivio Gregotti. 671. Courtesy of Archivio Casabella/Archivio Gregotti. 672. Technifoto. 673. Courtesy of Archivio Gino Valle. 675. Federico Brunetti. 676. Courtesy of Archivio Casabella/Archivio Gregotti. 677. Courtesy of Archivio Casabella/Archivio Gregotti. 678. Courtesy of Archivio Casabella/Archivio Gregotti. 679. Courtesy of Archivio Casabella/Archivio Gregotti. 680. Courtesy of Archivio Casabella/Archivio Gregotti. 681. Courtesy of Archivio Olivetti Corporate Image. 682. Courtesy Archivio Olivetti Corporate Image. 684. Courtesy of Archivio Marco Zanuso. 685. Courtesy of Centro Michelucci. 686. Grazia Sgrilli. 687. Courtesy of Archivio Casabella/Archivio Gregotti. 688. Courtesy of Archivio Casabella/Archivio Gregotti. 689. Walter Vitturi. 690. Courtesy of Archivio Casabella/Archivio Gregotti. 691. Courtesy of Archivio Casabella/Archivio Gregotti. 692. Studio Ciapetti. 693. Courtesy of Archivio Leonardo Savioli. 694. Courtesy of Archivio Storico delle arti contemporanea della Biennale. 695. Luca Carrà. 696. Courtesy of Archivio Casabella/Archivio Gregotti. 697. Italo Zannier. 698. Courtesy of Archivio Olivetti Corporate Image. 699. Courtesy of Archivio Casabella/Archivio Gregotti. 700. Courtesy of Archivio Casabella/Archivio Gregotti.

701. Courtesy of Archivio Albani. 702. Courtesy of Archivio Casabella/Archivio Gregotti. 703. Courtesy of Archivio Gregotti. 704. Courtesy of Archivio Casabella/Archivio Gregotti. 705. Courtesy of Archivio Triennale. 706. Courtesy of Archivio Casabella/Archivio Gregotti. 707. Courtesy of Archivio Casabella/Archivio Gregotti. 708. Courtesy of Archivio Casabella/Archivio Gregotti. 709. Courtesy of Archivio Centro Studi e Archivio della Communicazione, Università di Parma, Sezione Progetto. 710. Courtesy of Archivio Costantino Dardo. 711. Courtesy of Archivio Costantino Dardo. 712. Photograph Oscar Savio. 713. Courtesy of Archivio Giancarlo De Carlo. 714. Courtesy of Archivio Canella. 715. Courtesy of Archivio Casabella/Archivio Gregotti. 716. Courtesy of Archivio Accademia di San Luca. 717. Courtesy of Archivio Casabella/Archivio Gregotti. 718. Courtesy of Archivio Casabella/Archivio Gregotti. 719. Courtesy Archivio Olivetti Corporate Image. 720. Courtesy of Archivio Luciano Semerani. 721. Luigi Filetici. 722. Courtesy of Archivio Vittorio Gregotti. 723. Courtesy of Archivio Vittorio Gregotti724. Courtesy of Archivio Castiglioni. 726. Courtesy of Archivio Castiglioni. 725. Courtesy of Archivio Castiglioni. 727. Courtesy of Archivio Zanuso. 728. Courtesy of Archivio Zanuso. 729. Aldo Ballo/Courtesy of Archivio Olivetti Corporate Image. 731. Courtesy of Archivio Olivetti Corporate Image. 730. Courtesy of Archivio Olivetti Corporate Image. 733. Aldo Ballo/Courtesy of Archivio Bonetto. 732. Courtesy of Archivio Valle. 734. Courtesy of Archivio Mirani. 735. Courtesy of Archivio Piaggio V. E. Spa. 736. Courtesy of Archivio Fiat. 737. Courtesy of Achivio Pininfarina. 738. Courtesy of Archivio Pininfarina. 739. Courtesy of Archivio Pininfarina. 740. Courtesy of Archivio Gio Ponti. 741. Courtesy of Archivio Barnaba Fornasetti. 742. Courtesy of Archivio Barnaba Fornasetti. 743. Courtesy of Musée des Arts Décoratifs de Montréal. 744. Studio Favata/Courtesy of Archivio Colombo. 745. Courtesy of Archivio Belotti. 746. Photograph by Aldo Ballo/Courtesy of Archivio Artemide. 748. Courtesy of Jacqueline Vodoz. 747. Aldo Ballo/Courtesy of Arch. Martinelli Luce. 749. Courtesy of Archivio Castiglioni. 750. Courtesy of Achivio Castiglioni. 751. Courtesy of Archivio Mango. 752. Courtesy of Archivio Mango. 753. Courtesy of Archivio Vittorio Bonacina. 754. Courtesy of Archivio Poggi Snc. 757. Courtesy of Archivio Tecno. 755. Courtesy of Archivio SIM Talea. 756. Courtesy of Archivio Castiglioni. 758. Courtesy of Galerie Bischofberger. 759. Foto Lux/Courtesy of Archivio De Poli. 760. Foto Lux/Courtesy of Archivio De Poli. 761. Walter Vitturi, Venice. 765. Courtesy of Jacqueline Vodoz. 762. Benvenuto Saba/Courtesy of Archivio Danese. 767. Fulvio Ferrari. 766. Fulvio Ferrari. 764. Fulvio Ferrari. 763. Fulvio Ferrari. 768. Courtesy of Archivio Olivetti Corporation Image. 769. Serge Libiszewski/Courtesy of Archivio Sambonet. 772. Aldo Ballo/Courtesy of Archivio Danese. 770. David Heald. 771. Studio Clari/Courtesy of Archivio Danese. 773. Courtesy of Jacqueline Vodoz. 774. Courtesy of Archivio Zanotta. 775. Aldo Ballo/Courtesy of Archivio Castiglioni. 776. Toni Nicolini/Courtesy of Archivio DDL Studio. 777. Carlo Bachi. 778. Courtesy of Archivio Branzi.

By page number

p. 21, fig. 1, Fondazione Palazzo Albizzini, "Collezione Burri," Città di Castello. p. 23, fig. 3, Archivio Santomaso, courtesy of Galleria Blu, Milan p. 23, fig. 5, Giorgio Liverani. p. 25, fig. 6, © 1994 The Museum of Modern Art, New York. p. 26, fig. 9, Giacomelli, courtesy of Emilio Vedova p. 28, fig. 11, Galleria Nazionale d'Arte Moderna e Contemporanea, Rome. p. 34, fig. 4, Archivio Afro, Rome. p. 36, fig. 8, Catherine Viviano Estate, New York. p. 37, fig. 10, Archivio Galleria La Salita, Rome. p. 225, fig. 6, Barovier & Toso, Murano. p. 226, EditorialeDomus, Rozzano. p. 325, fig. 2, The New York Public Library for the Performing Arts, New York, courtesy of Republic Pictures Corporation, Los Angeles. p. 325, fig. 3, Reprint by Luigi Carnevali, Rome/Courtesy of Luigi Carnevali, Rome. p. 327, fig. 6, courtesy of Pier Marco de Santi. p. 327, fig. 7, Photofest, New York. p. 328, fig. 8, The New York Public Library for the Performing Arts, New York, courtesy of Republic Pictures Corporation, Los Angeles. p. 328, fig. 9, Reprint by Luigi Carnevali, Rome/Courtesy of Luigi Carnevali, Rome. p. 330, Walter Vitturi, Venice. pp. 441–47, Collection of Gian Piero Brunetta, Padua. p. 452, fig. 1, The New York Public Library for the Performing Arts, New York, courtesy of Janus Films, New York. p. 452, fig. 2, The Museum of Modern Art, New York. p. 453, Collection of Gian Piero Brunetta, Padua. p. 454, figs. 4, 5, The New York Public Library for the Performing Arts, New York, courtesy of Janus Films, New York. p. 455, figs. 6, 7, The New York Public Library for the Performing Arts, New York, courtesy of Janus Films, New York. pp. 460–61, Photofest, New York. pp. 462–63, Collection of Gian Piero Brunetta, Padua. pp. 464–65, The Museum of Modern Art, New York. pp. 466–67, Photofest, New York. pp. 468–69, Photofest, New York. pp. 470–71, Collection of Gian Piero Brunetta, Padua. pp. 472–73, Collection of Gian Piero Brunetta, Padua. pp. 474–75, Collection of Gian Piero Brunetta, Padua. pp. 476–77, Photofest, New York. pp. 478–79, Photofest, New York. pp. 587–93, Dennis P. Doordan. p. 604, fig. 6, technifoto, Venice. p. 611, fig. 4, Olivetti, Milan. p. 614, fig. 8, © 1994 The Museum of Modern Art, New York. p. 684, middle, Photofest, New York.